FIRE EMBLEM
Awakening

Original Japanese Edition

Director (Dengeki Kouryaku Book Editorial Dept.)
Kunichi Miyamoto

Editors (Milesplus Ltd.)
Jun Kawauchi
Michiaki Kataoka
Tenyoku Takahashi
Ririn Ochiai
Hideyuki Yoshizawa
Hiroshi Shibano

Writers (Milesplus Ltd.)
Hiroshi Shibano
Tenyoku Takahashi

Manga (Old School)
Hinomaru Izumi

Designers (Milesplus Ltd.)
Toshihisa Funaba
Chiaki Miyayama

Cover Designer
Tsuyoshi Kusano Design Co., Ltd.

Producer (Dengeki Kouryaku Book Editorial Dept.)
Takeshi Matsumoto

English-Language Edition

Publisher
Mike Richardson

Editor
Patrick Thorpe

Assistant Editor
Cardner Clark

Translator
William Flanagan

Designer
Brennan Thome

Digital Art Technician
Christina McKenzie

Hand Lettering
Cary Grazzini

Originally published by ASCII Media Works, an imprint of Kadokawa Corporation.

Special thanks to Jeremy Krueger-Pack, Rich Amtower and Nintendo's Treehouse localization team, Nick McWhorter, Michael Gombos, Annie Gullion, and Dakota James.

Neil Hankerson Executive Vice President **Tom Weddle** Chief Financial Officer **Randy Stradley** Vice President of Publishing **Michael Martens** Vice President of Book Trade Sales **Matt Parkinson** Vice President of Marketing **David Scroggy** Vice President of Product Development **Dale LaFountain** Vice President of Information Technology **Cara Niece** Vice President of Production and Scheduling **Nick McWhorter** Vice President of Media Licensing **Ken Lizzi** General Counsel **Dave Marshall** Editor in Chief **Davey Estrada** Editorial Director **Scott Allie** Executive Senior Editor **Chris Warner** Senior Books Editor **Cary Grazzini** Director of Specialty Projects **Lia Ribacchi** Art Director **Vanessa Todd** Director of Print Purchasing **Matt Dryer** Director of Digital Art and Prepress **Mark Bernardi** Director of Digital Publishing **Sarah Robertson** Director of Product Sales **Michael Gombos** Director of International Publishing and Licensing

Fire Emblem: Shadow Dragon and the Blade of Light © 1990 Nintendo / INTELLIGENT SYSTEMS
Fire Emblem Gaiden © 1990 Nintendo / INTELLIGENT SYSTEMS
Fire Emblem: Mystery of the Emblem © 1994 Nintendo / INTELLIGENT SYSTEMS
Fire Emblem: Genealogy of the Holy War © 1996 Nintendo / INTELLIGENT SYSTEMS
Fire Emblem: Thracia 776 © 1999 Nintendo / INTELLIGENT SYSTEMS
Fire Emblem: The Binding Blade © 2002 Nintendo / INTELLIGENT SYSTEMS
Fire Emblem © 2003 Nintendo / INTELLIGENT SYSTEMS
Fire Emblem: The Sacred Stones © 2004 Nintendo / INTELLIGENT SYSTEMS
Fire Emblem: Path of Radiance © 2005 Nintendo / INTELLIGENT SYSTEMS
Fire Emblem: Radiant Dawn © 2007 Nintendo / INTELLIGENT SYSTEMS
Fire Emblem: Shadow Dragon © 2008 Nintendo / INTELLIGENT SYSTEMS
Fire Emblem: New Mystery of the Emblem: Heroes of Light and Shadow © 2010 Nintendo / INTELLIGENT SYSTEMS
Fire Emblem Awakening © 2012 Nintendo / INTELLIGENT SYSTEMS
Fire Emblem Fates © 2015 Nintendo / INTELLIGENT SYSTEMS
Super Smash Bros. Melee © 2001 Nintendo / HAL Laboratory, Inc.
Super Smash Bros. Brawl © 2008 Nintendo / HAL Laboratory, Inc.
Super Smash Bros. for Wii U © 2014 Nintendo
Super Smash Bros. for Nintendo 3DS © 2014 Nintendo
Code Name: S.T.E.A.M. © Nintendo / INTELLIGENT SYSTEMS

THE ART OF FIRE EMBLEM: AWAKENING

Published by Dark Horse Books
A division of Dark Horse Comics, Inc.
10956 SE Main Street
Milwaukie, OR 97222

DarkHorse.com
International Licensing: (503) 905-2377
First edition: December 2012
First English edition: October 2016

ISBN 978-1-61655-938-0
1 3 5 7 9 10 8 6 4 2
Printed in China

Names: Flanagan, William, translator.
Title: The art of Fire emblem, awakening / translated by William Flanagan
Description: First English edition. | Milwaukie, Or. : Dark Horse Books, 2016. | "All concept illustrations that originally contained handwritten notes in Japanese have been translated into English and updated for this version of the book."
Identifiers: LCCN 2016008226 | ISBN 9781616559380 (paperback)
Subjects: LCSH: Video games--Pictorial works. | Video games in art. | BISAC: GAMES / Video & Electronic.
Classification: LCC GV1469.37 .A638 2016 | DDC 794.8--dc23
LC record available at https://lccn.loc.gov/2016008226

The Art of
FIRE EMBLEM™
Awakening

All concept illustrations that originally contained handwritten notes in Japanese have been translated into English and updated for this version of the book.

CONTENTS

Character Dialogue

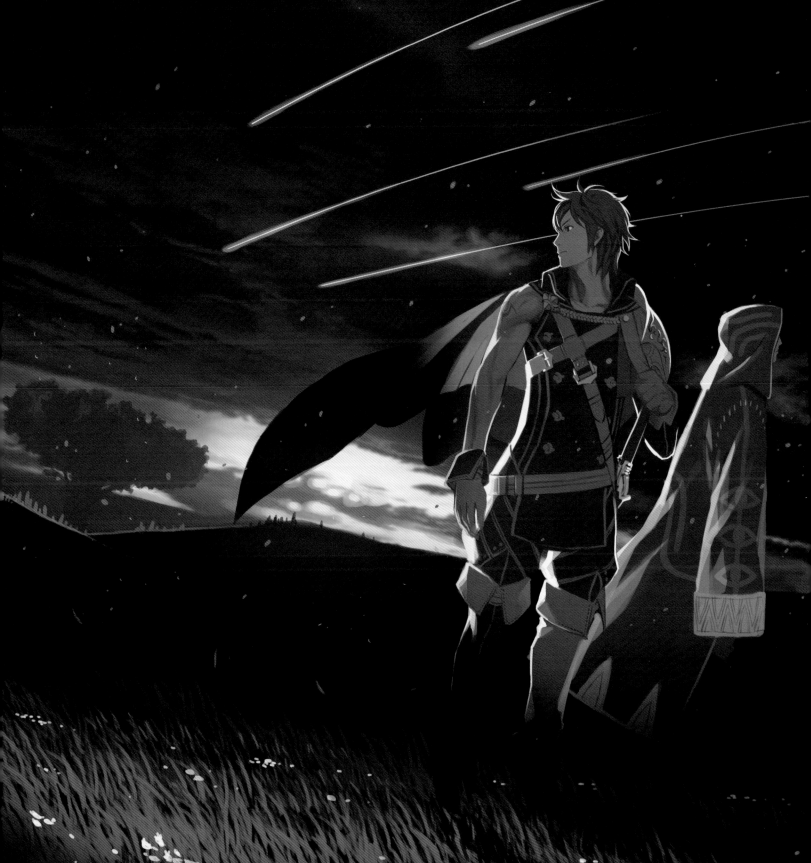

Section 1

\\\\\

OFFICIAL ILLUSTRATION GALLERY

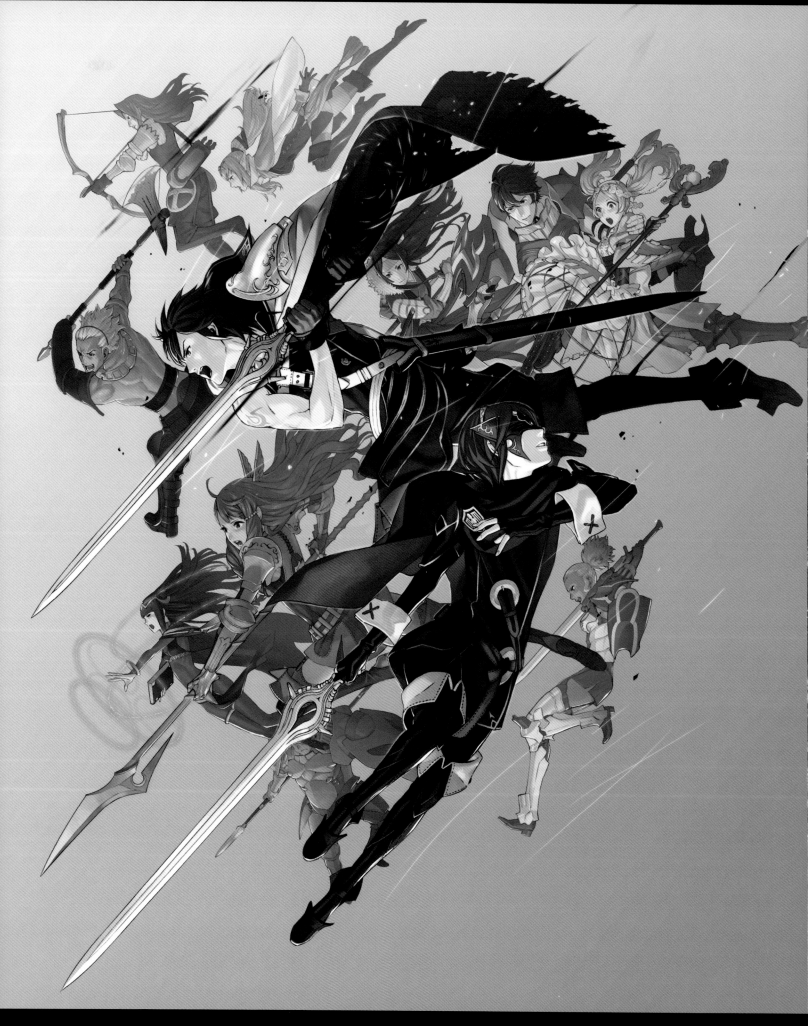

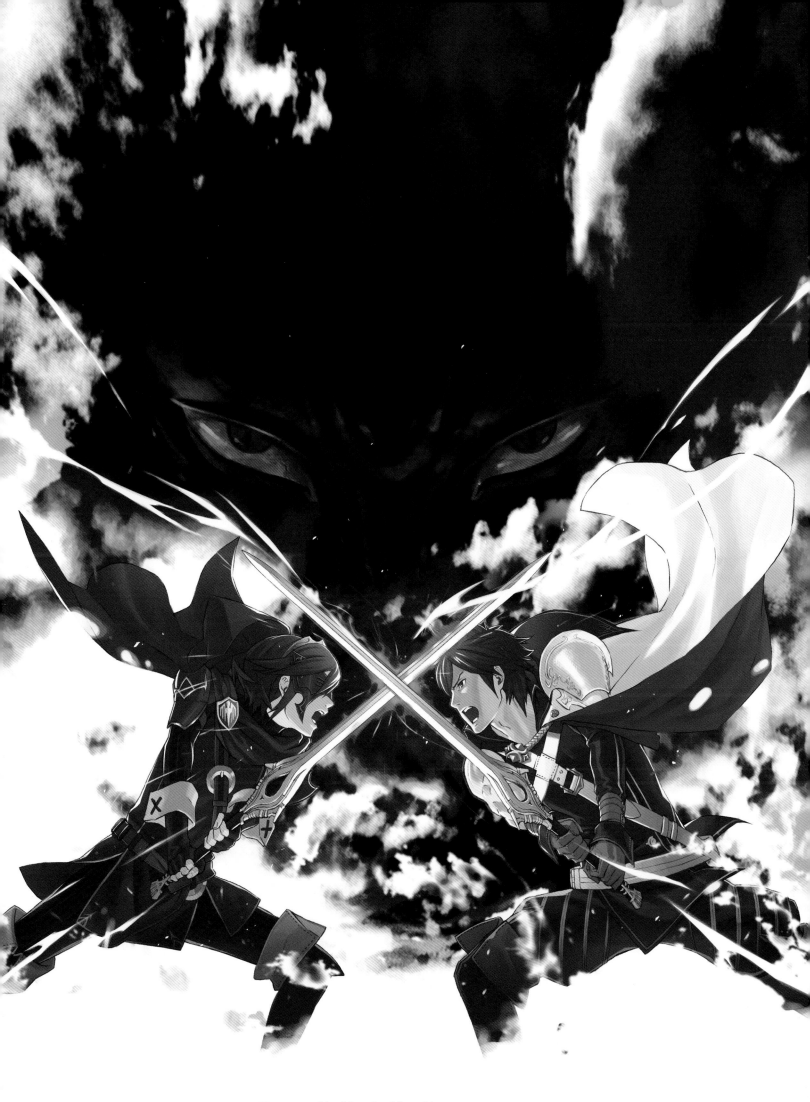

Nintendo Prepaid Card Illustration **Illustrated by Yusuke Kozaki**

Cover Illustration **Illustrated by Yusuke Kozaki**

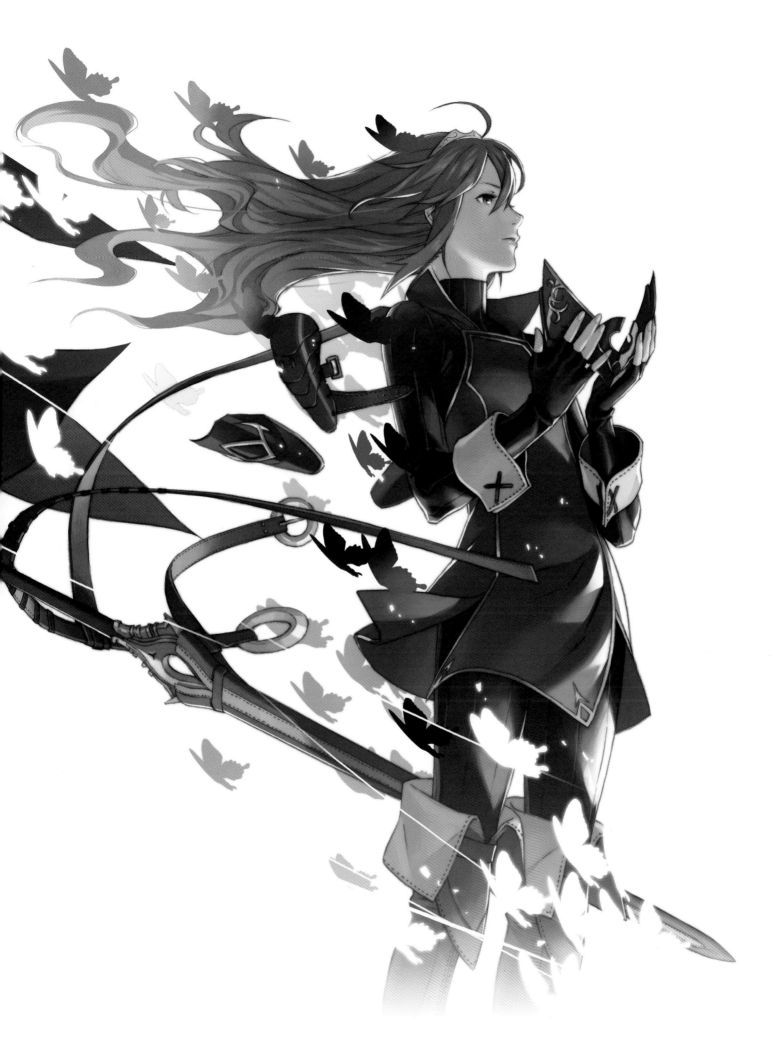

A young prince who fights for what is right and just

Chrom

"You're one of us . . . and no destiny can change that!"

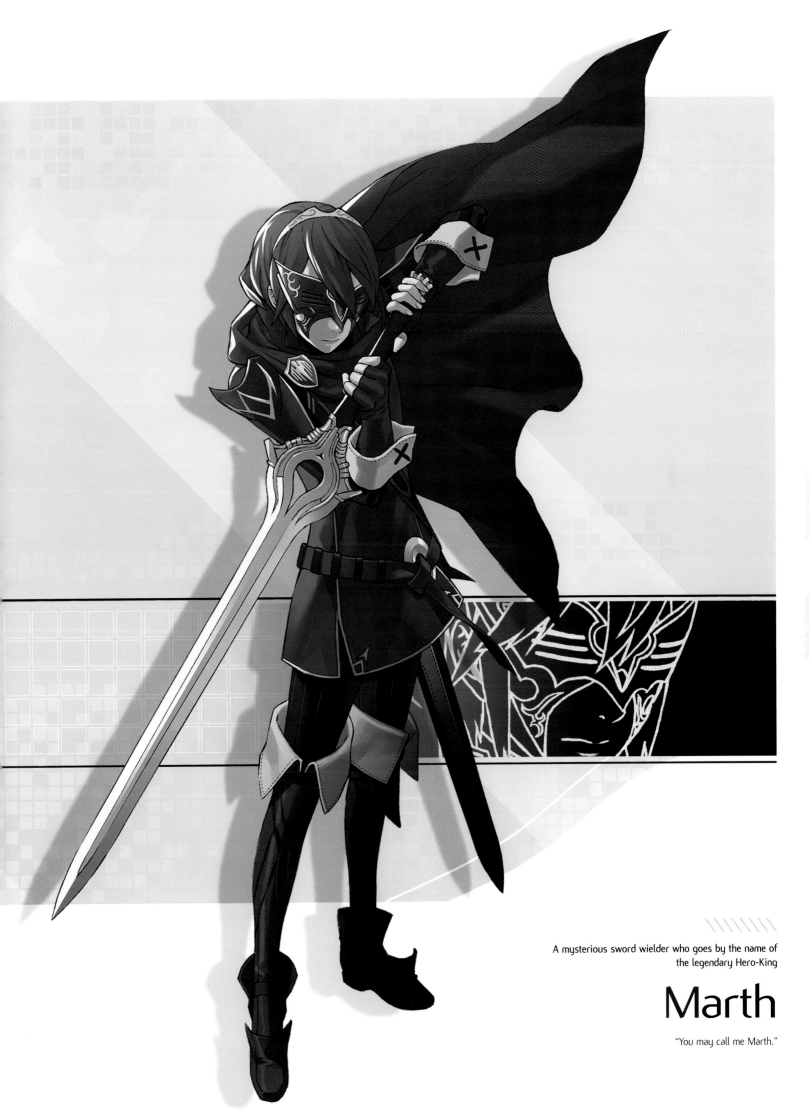

A mysterious sword wielder who goes by the name of
the legendary Hero-King

Marth

"You may call me Marth."

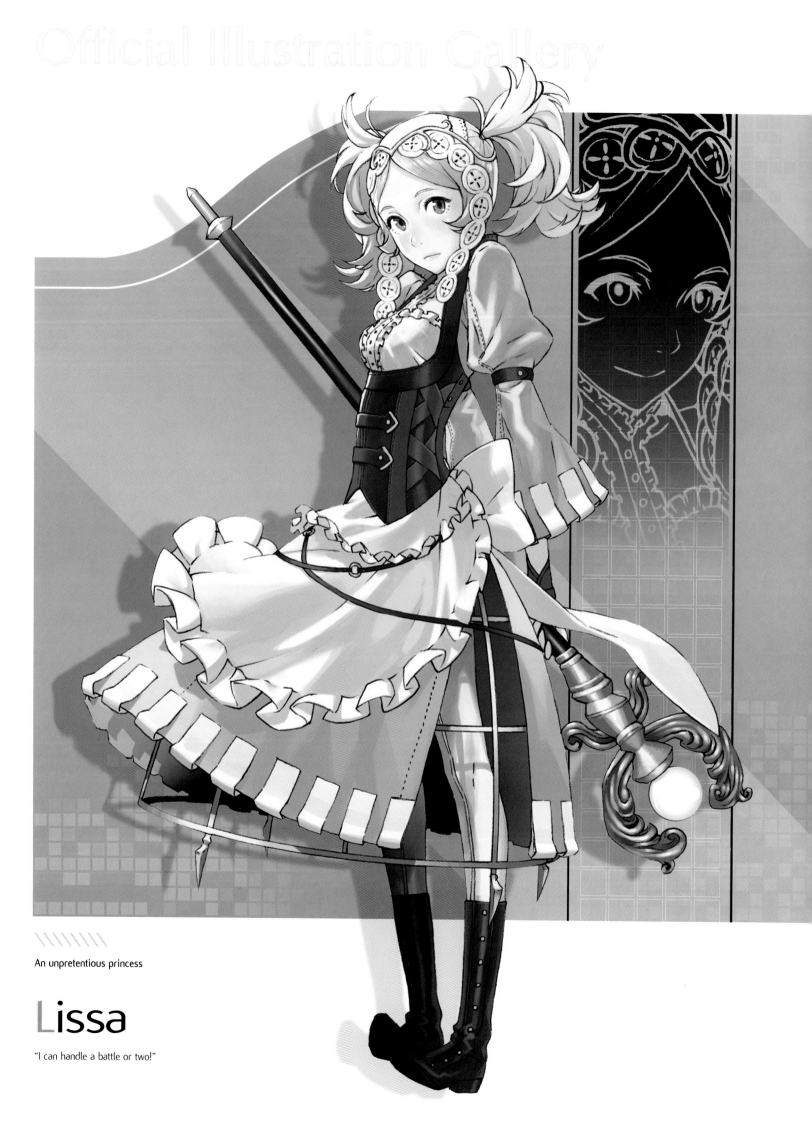

An unpretentious princess

Lissa

"I can handle a battle or two!"

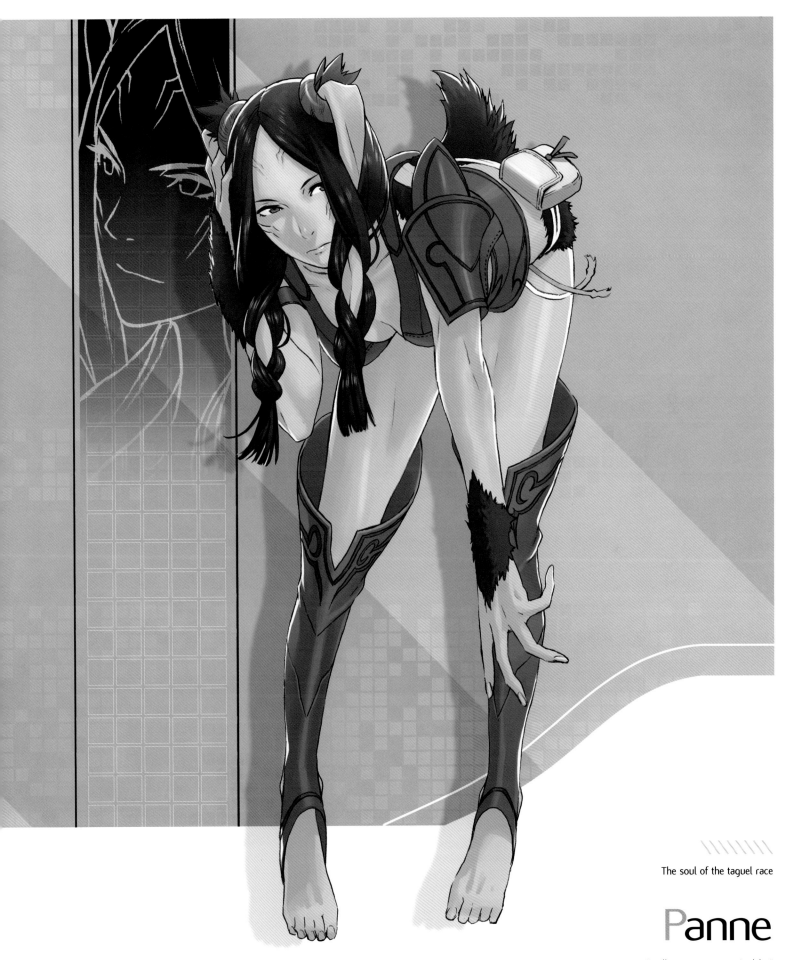

The soul of the taguel race

Panne

"I will repay my warren's debt."

\\\\\\\\

The overly serious second in command of the Shepherds

Frederick

"I exist to serve and protect!"

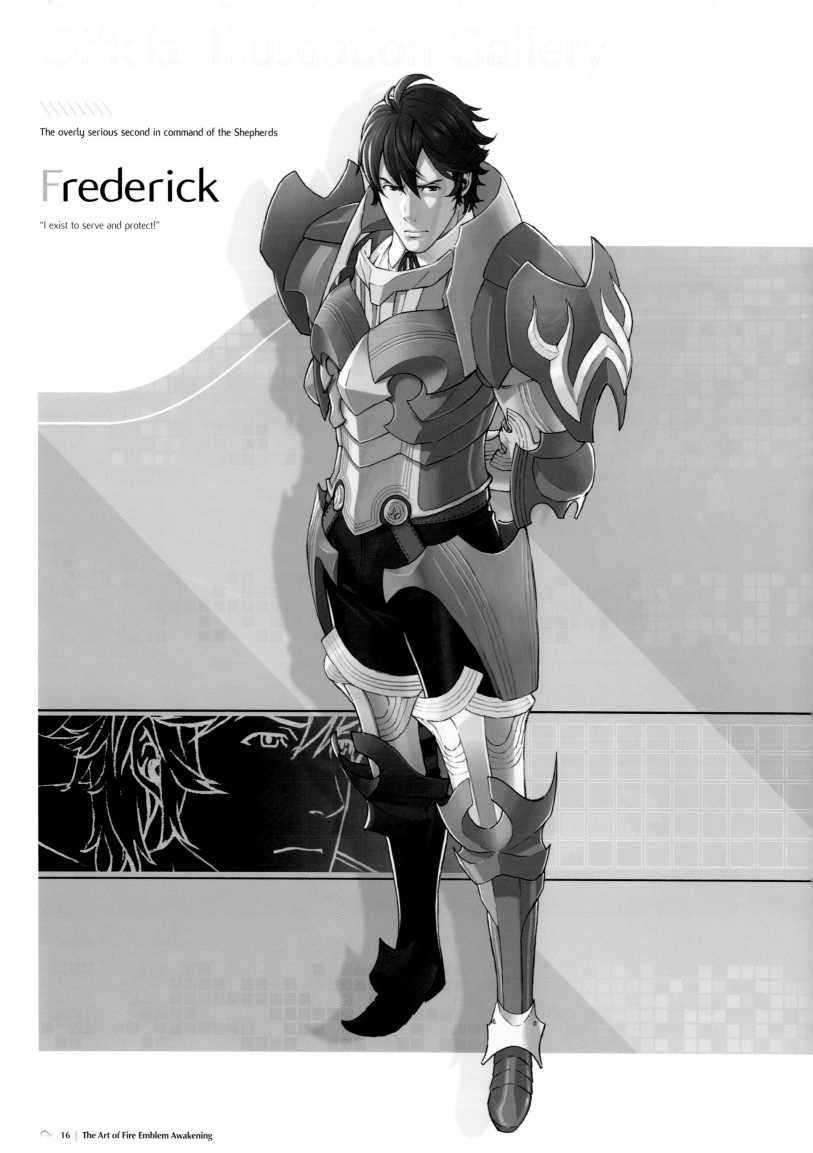

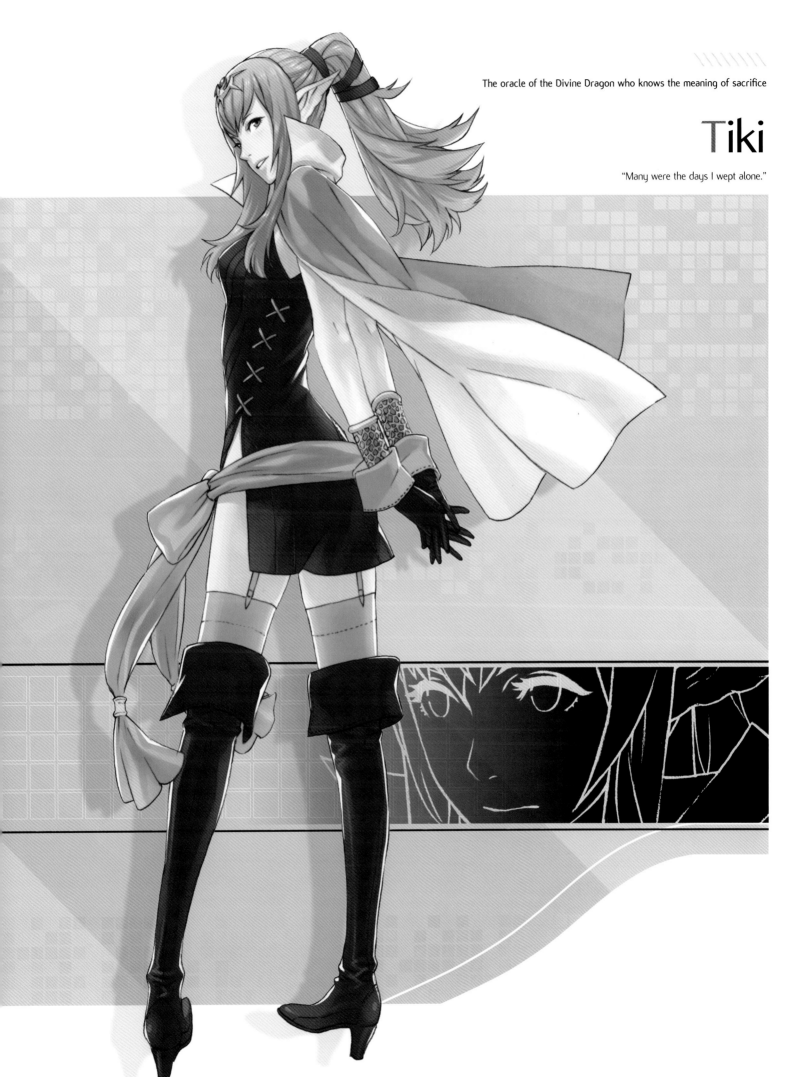

The oracle of the Divine Dragon who knows the meaning of sacrifice

Tiki

"Many were the days I wept alone."

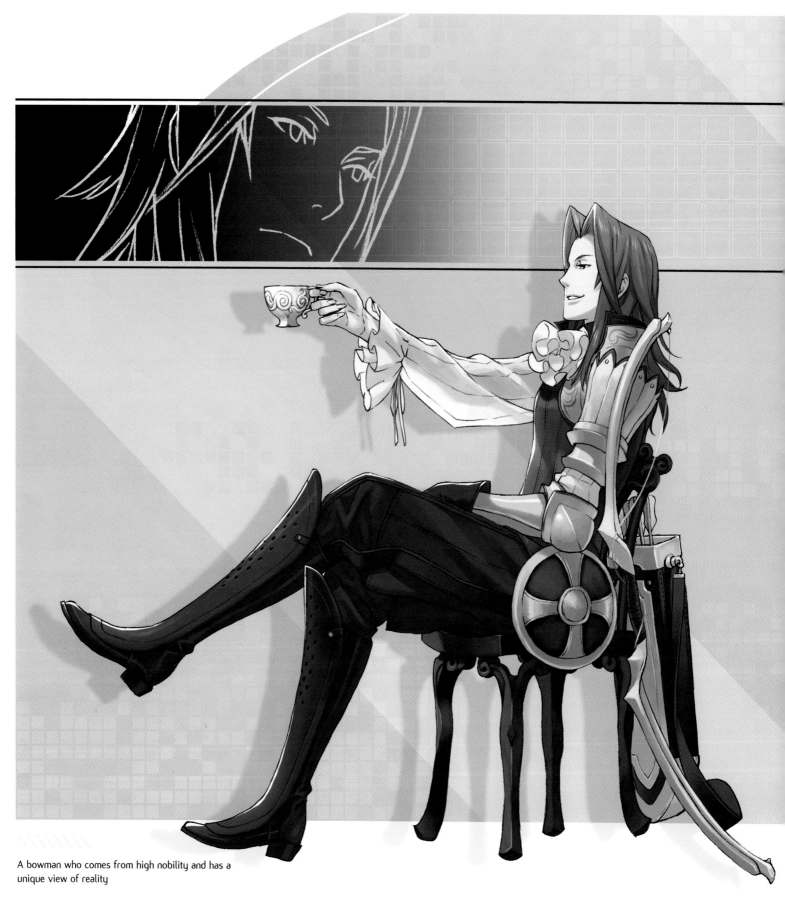

A bowman who comes from high nobility and has a
unique view of reality

Virion

"I realize my manly figure and noble bearing can be overwhelming!"

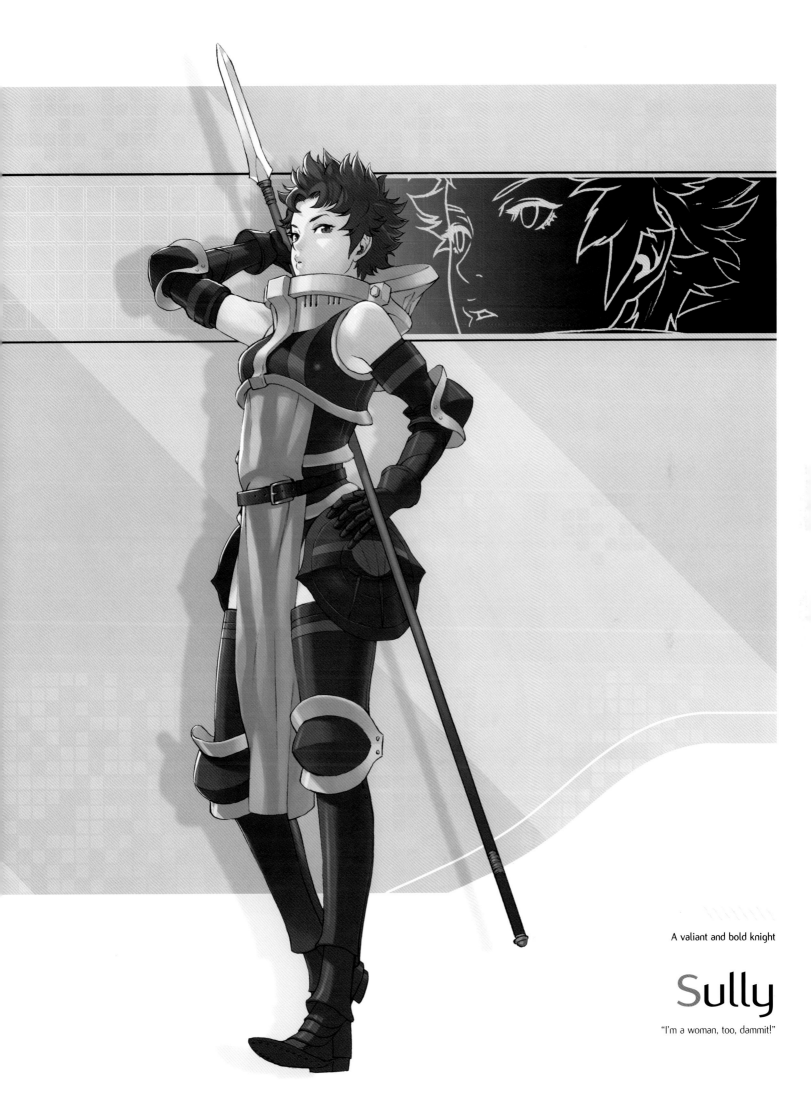

A valiant and bold knight

Sully

"I'm a woman, too, dammit!"

\\\\\\\

Chrom's greatest rival . . . in his own mind

Vaike

"Never doubt the Vaike!"

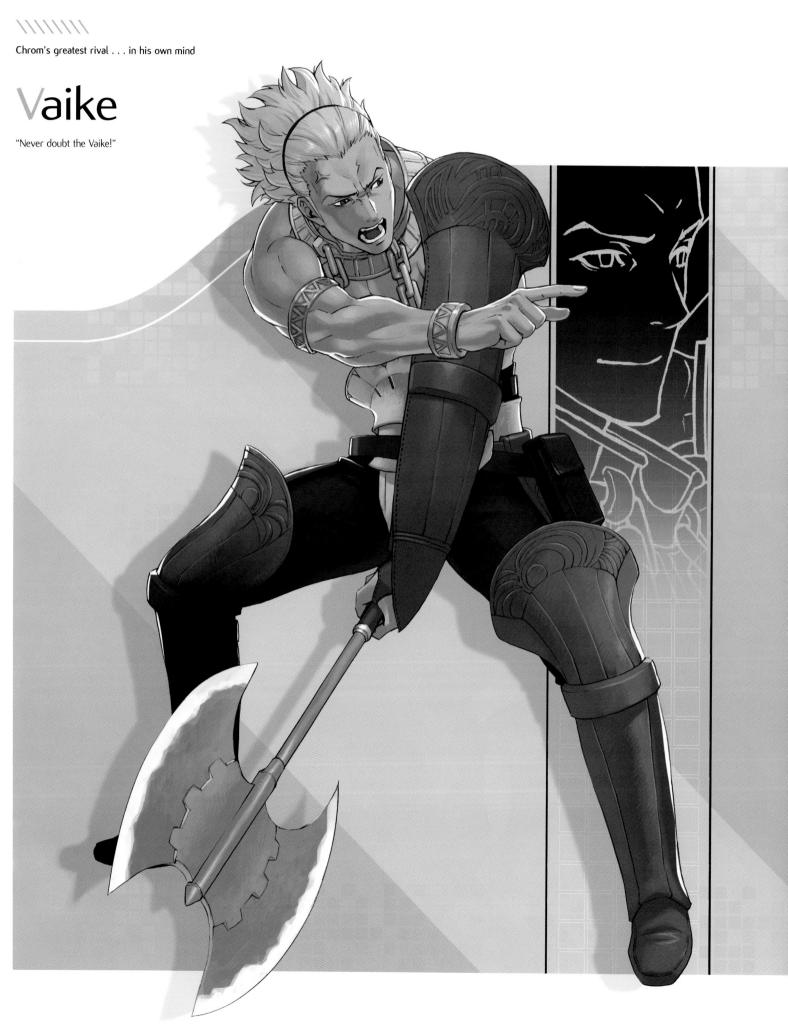

Gaius

"If you sweeten the deal."

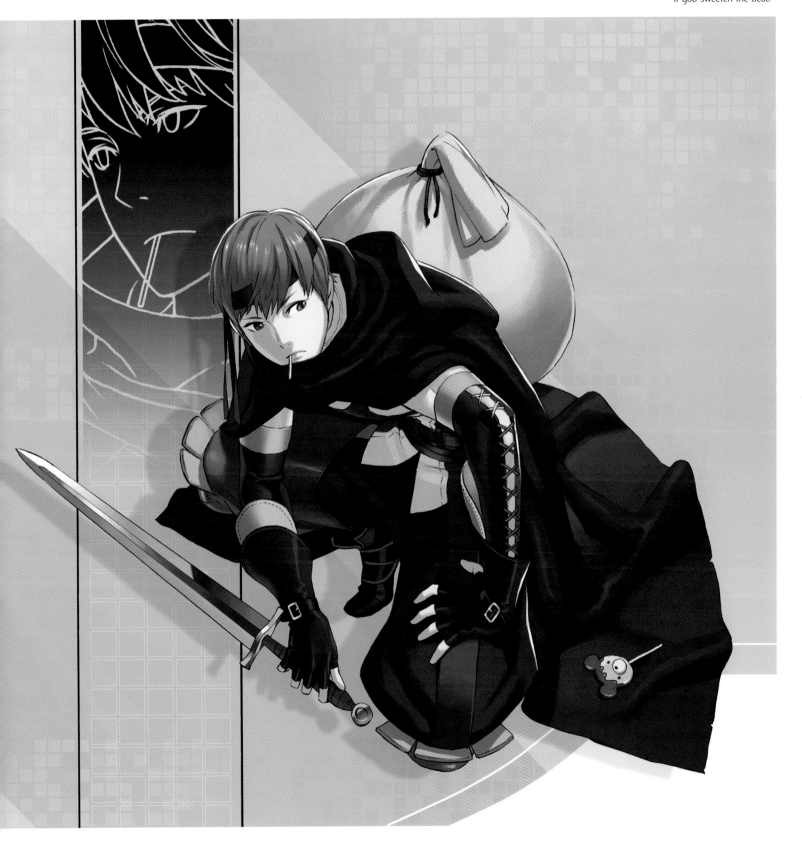

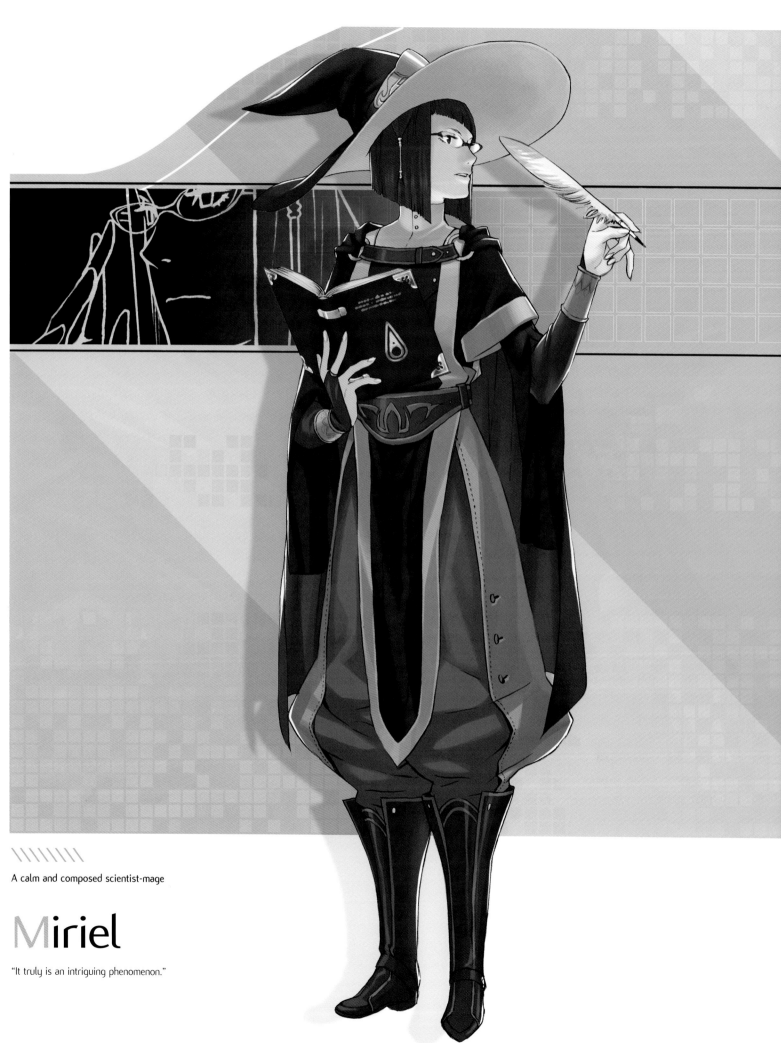

A calm and composed scientist-mage

Miriel

"It truly is an intriguing phenomenon."

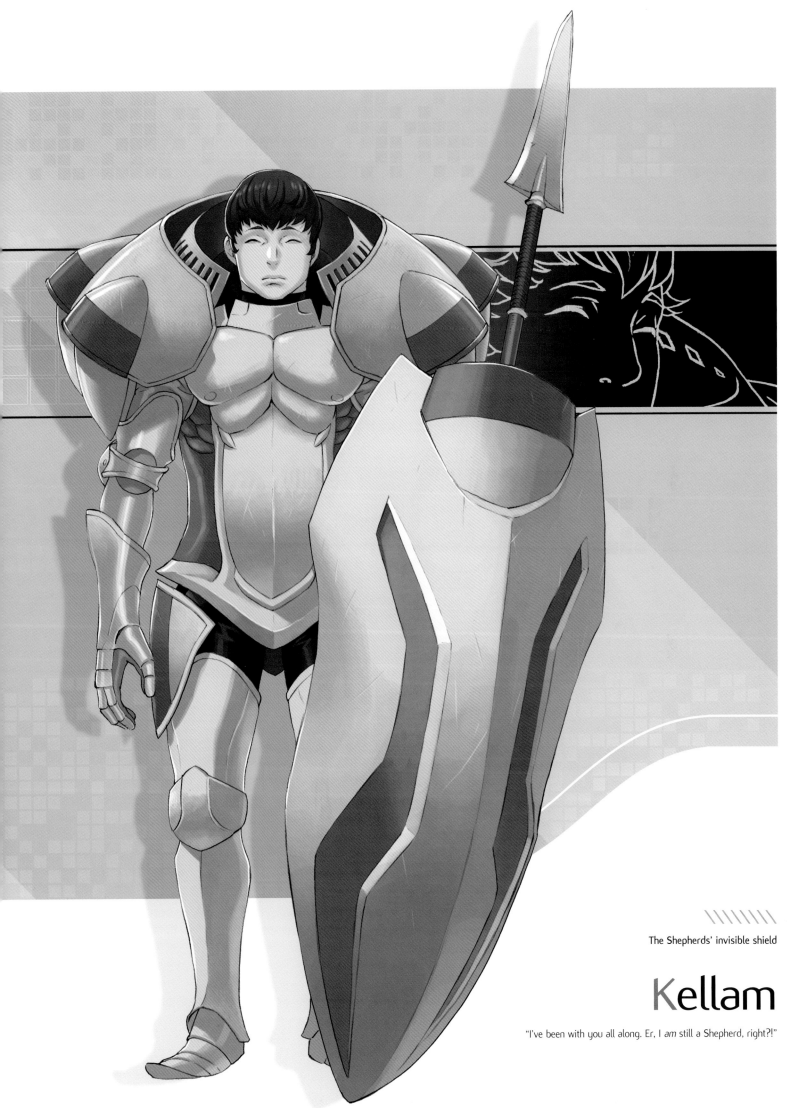

The Shepherds' invisible shield

Kellam

"I've been with you all along. Er, I *am* still a Shepherd, right?!"

\\\\\\\\

A gifted young pegasus rider

Cordelia

"I won't be going easy on you!"

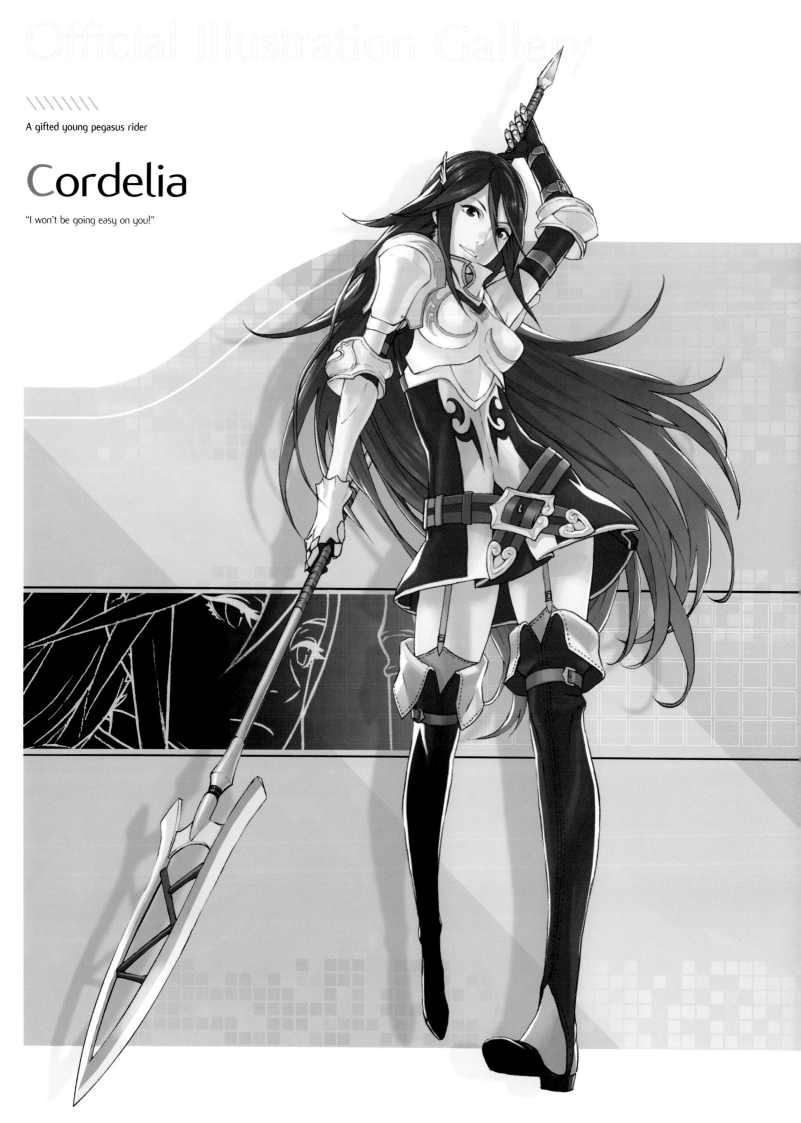

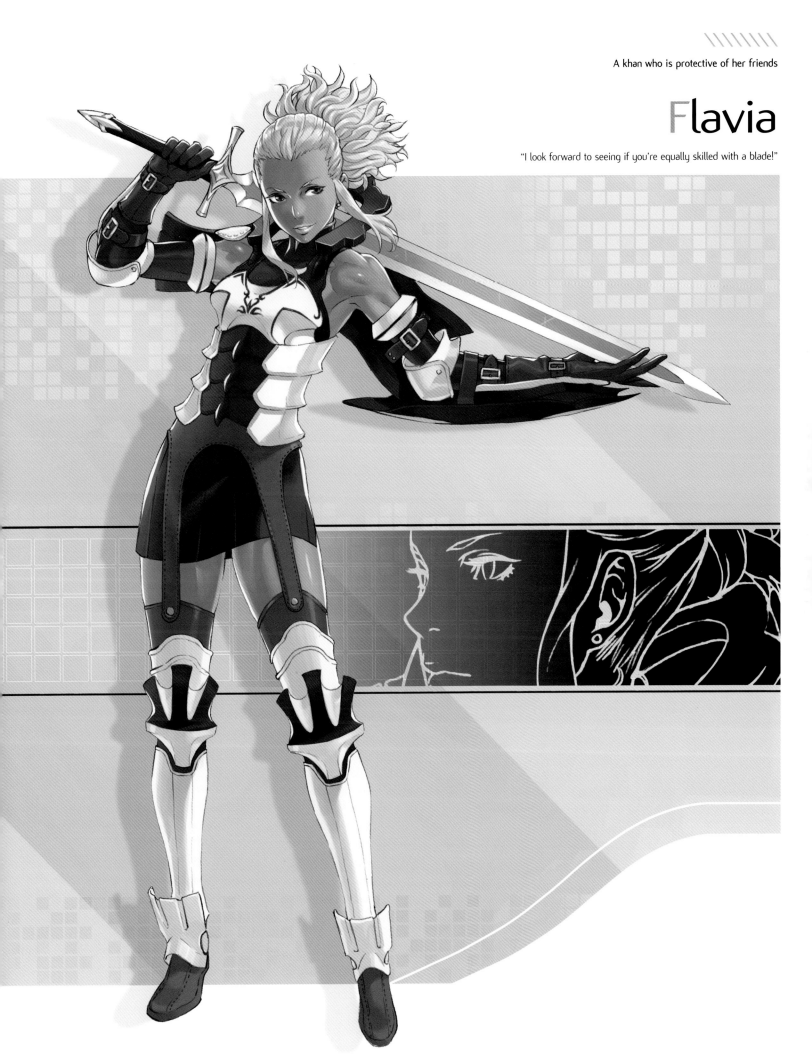

Flavia

"I look forward to seeing if you're equally skilled with a blade!"

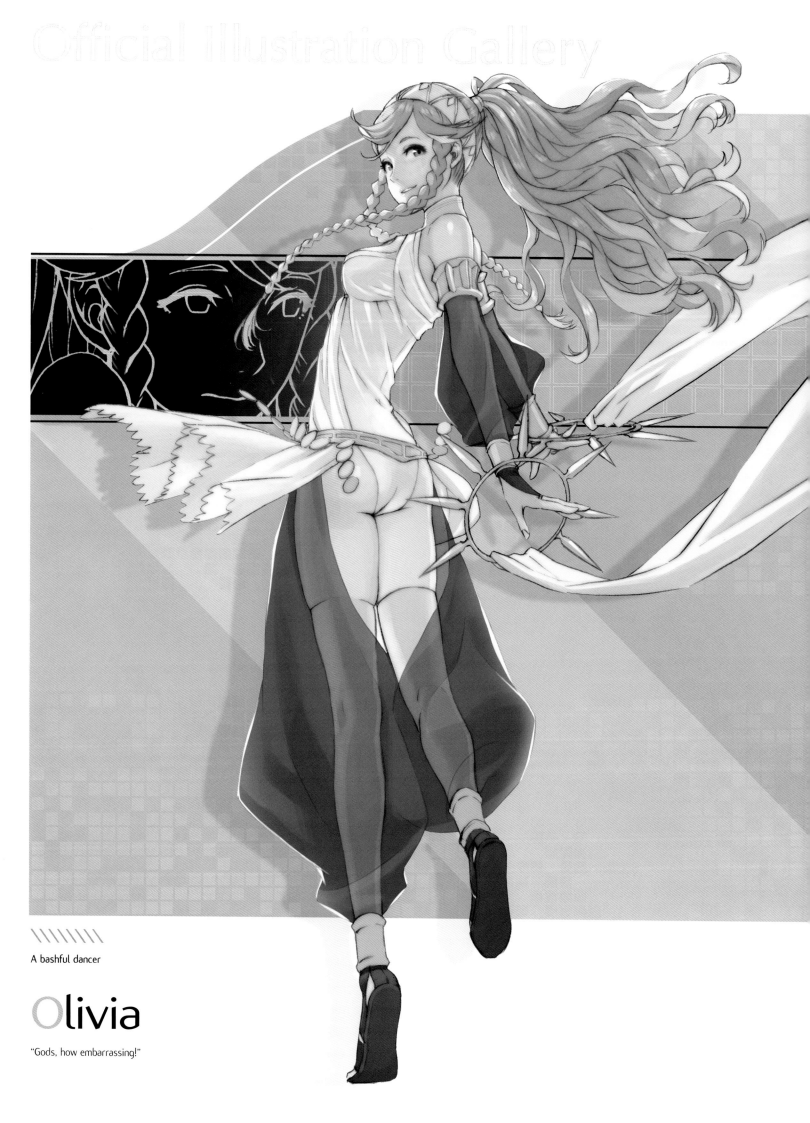

\\\\\\\

A bashful dancer

Olivia

"Gods, how embarrassing!"

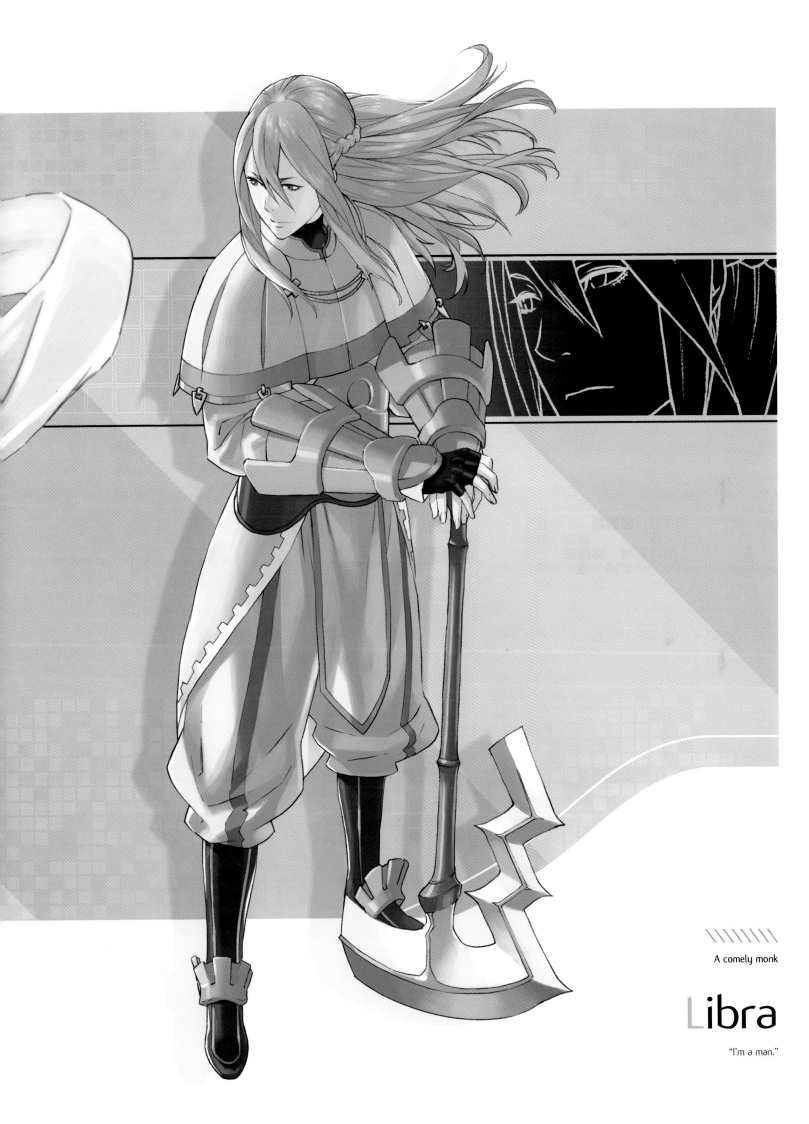

A comely monk

Libra

"I'm a man."

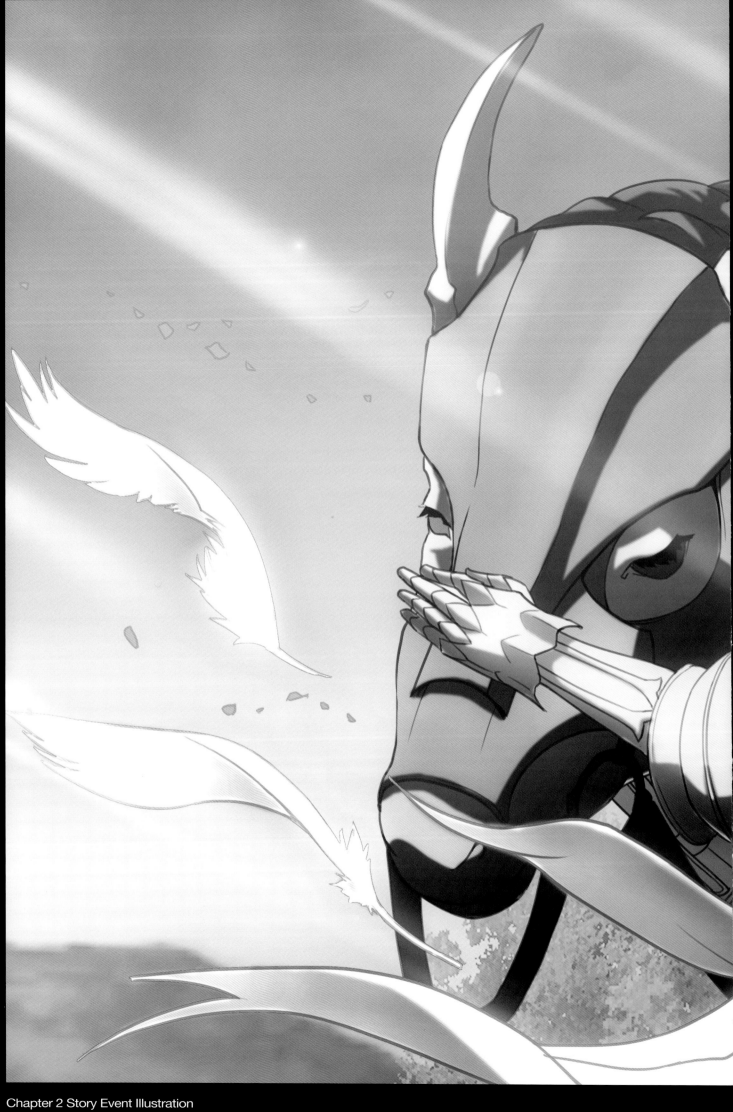

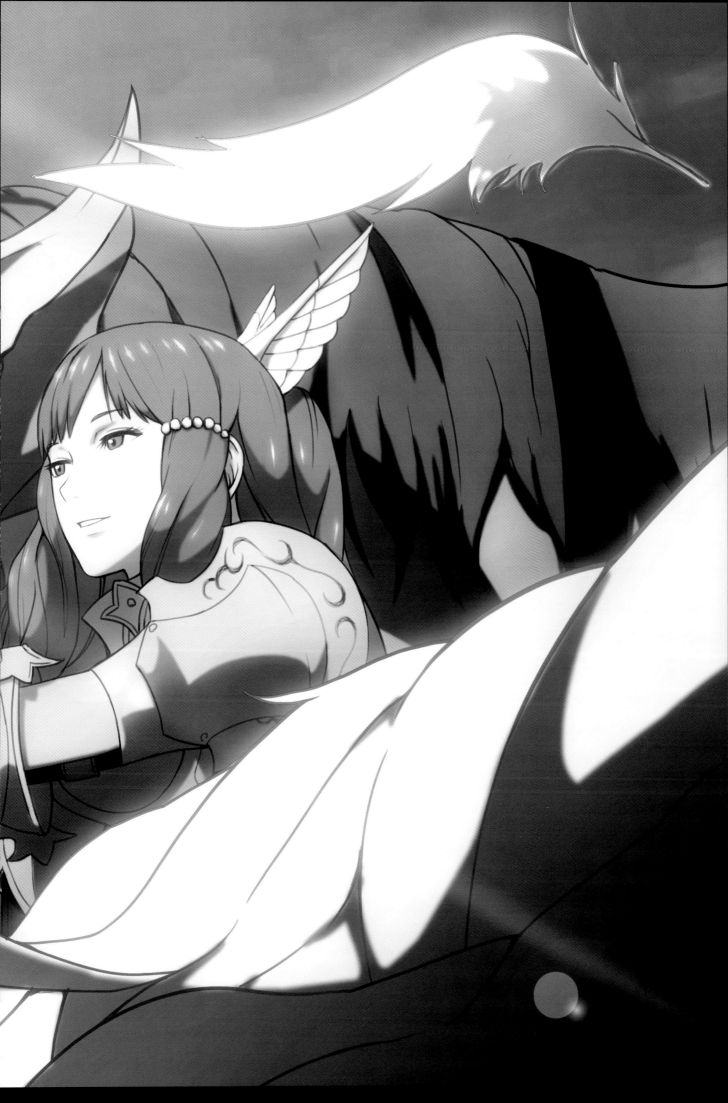

\\\\\\

A socially awkward dark mage

Tharja

"I cursed you. Some time ago, in fact."

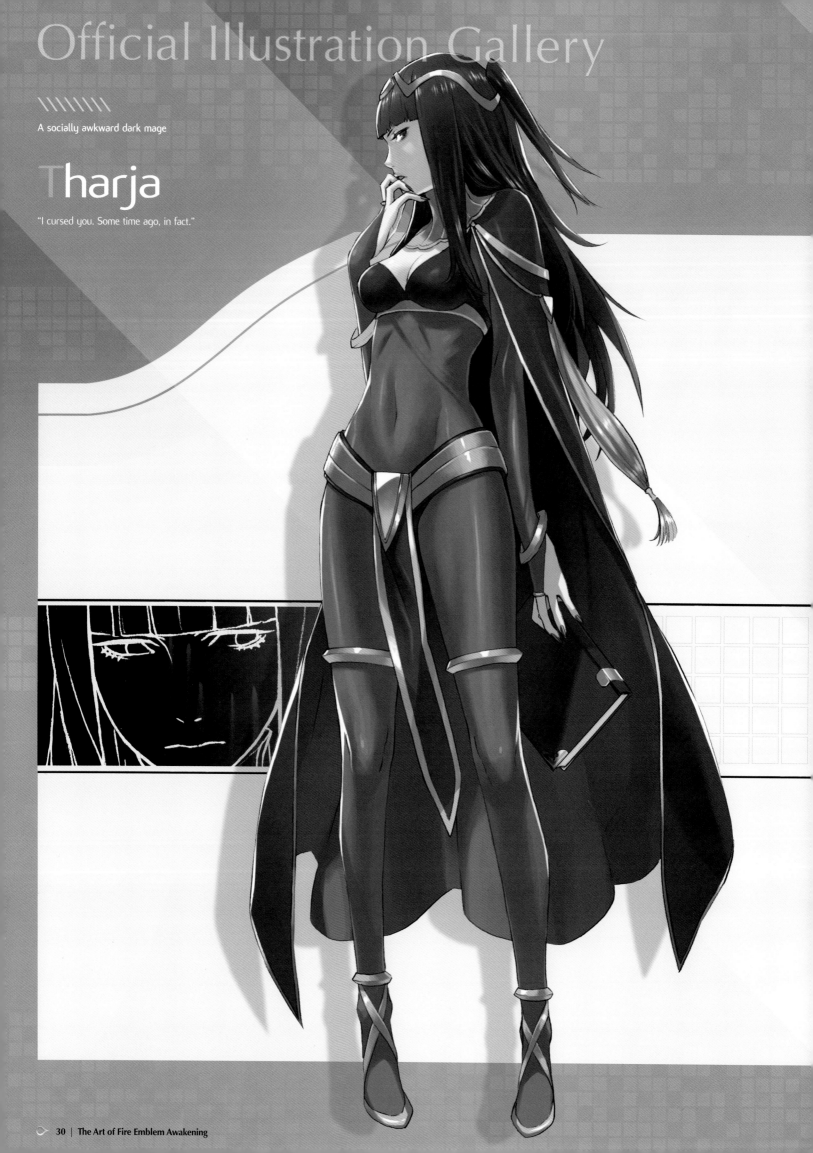

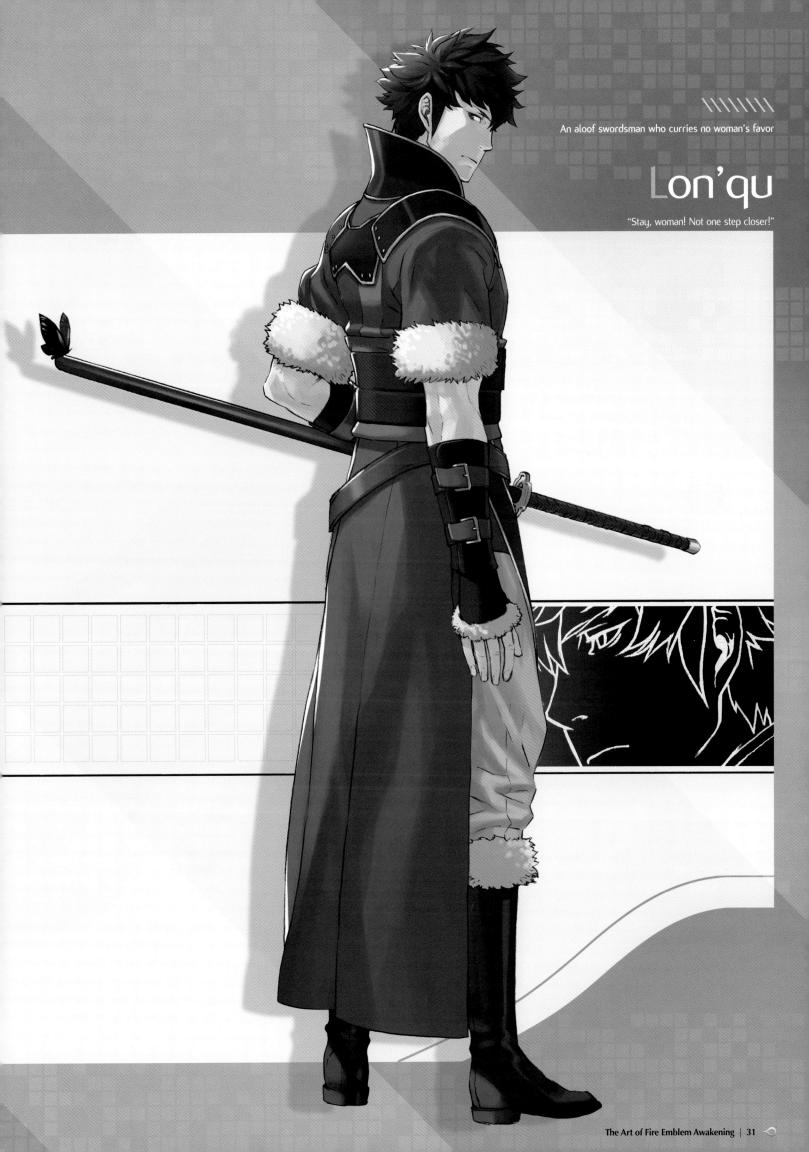

Lon'qu

"Stay, woman! Not one step closer!"

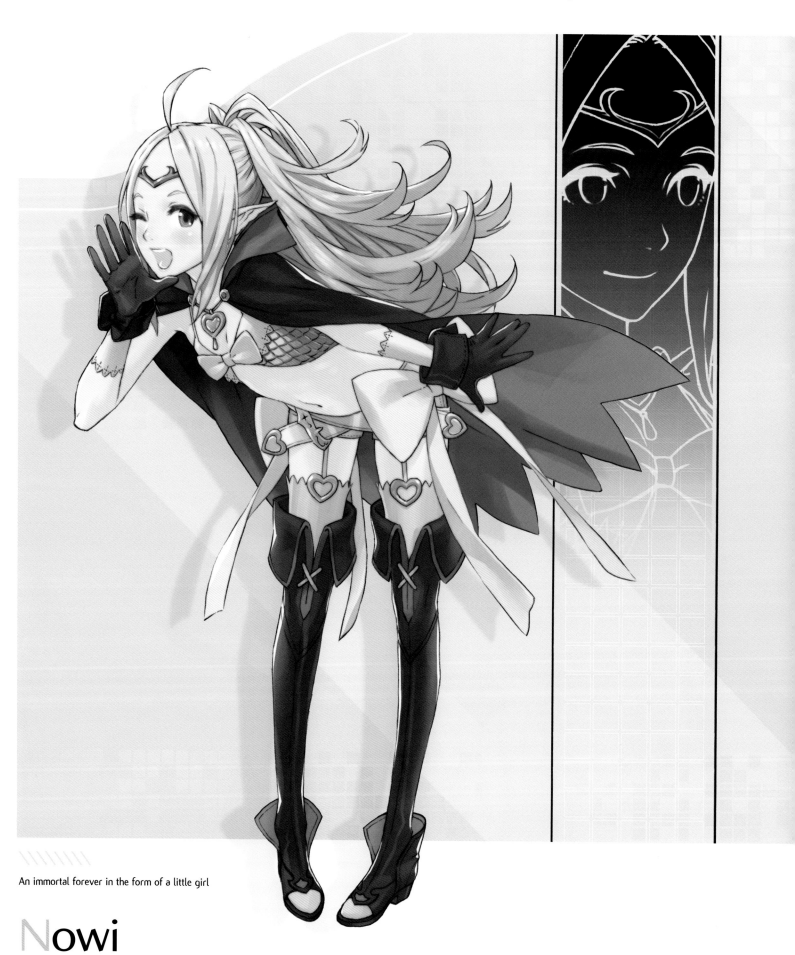

An immortal forever in the form of a little girl

Nowi

"I'm older than you . . . much older."

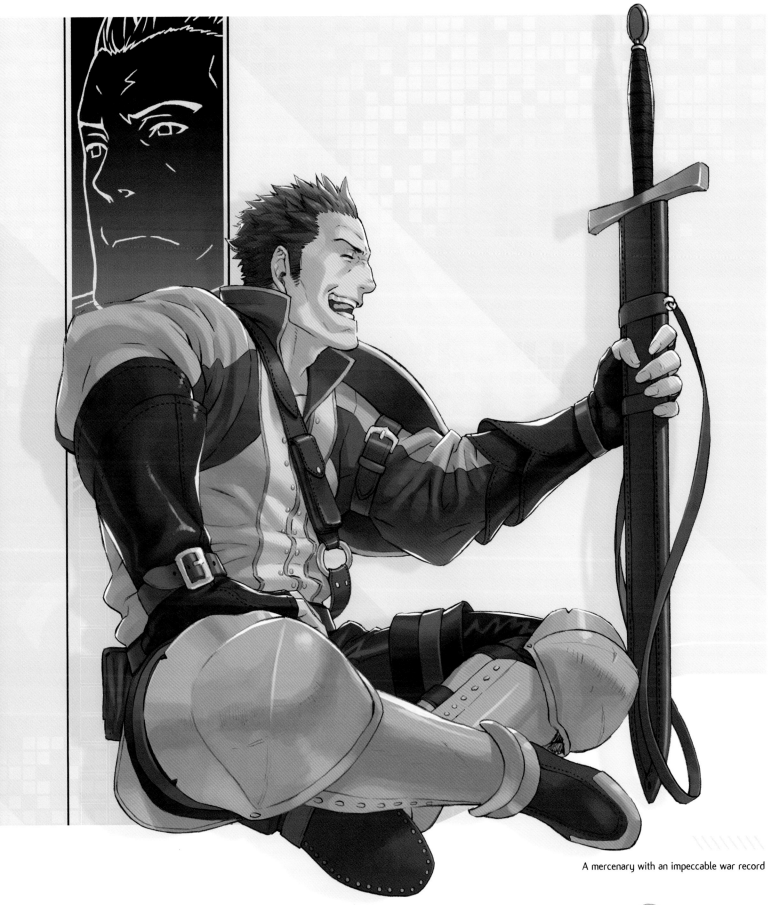

A mercenary with an impeccable war record

Gregor

"Gregor is fearing no man."

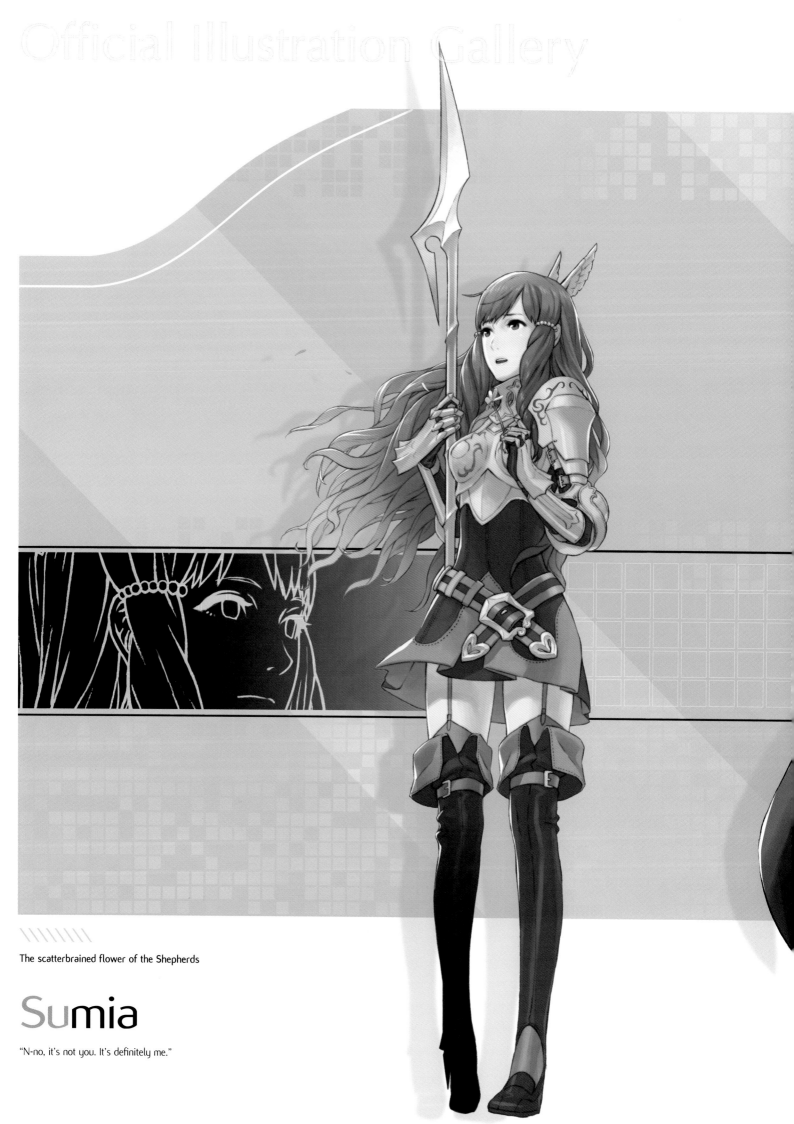

\\\\\\\\

The scatterbrained flower of the Shepherds

Sumia

"N-no, it's not you. It's definitely me."

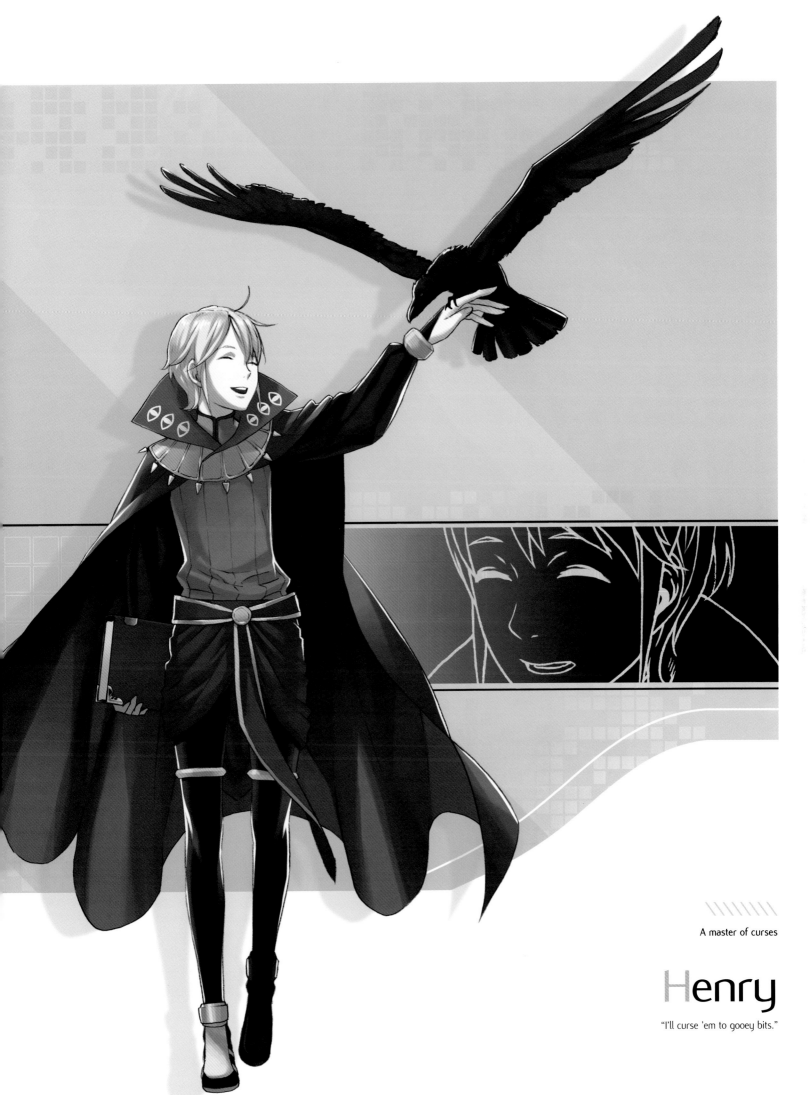

Henry

"I'll curse 'em to gooey bits."

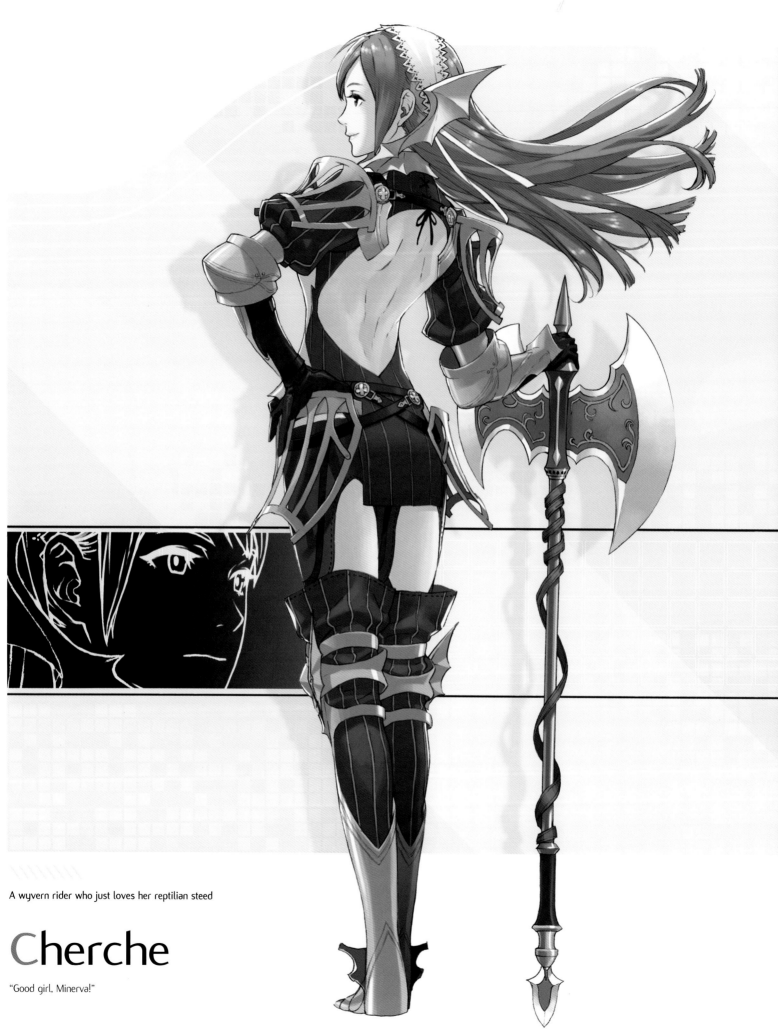

A wyvern rider who just loves her reptilian steed

Cherche

"Good girl, Minerva!"

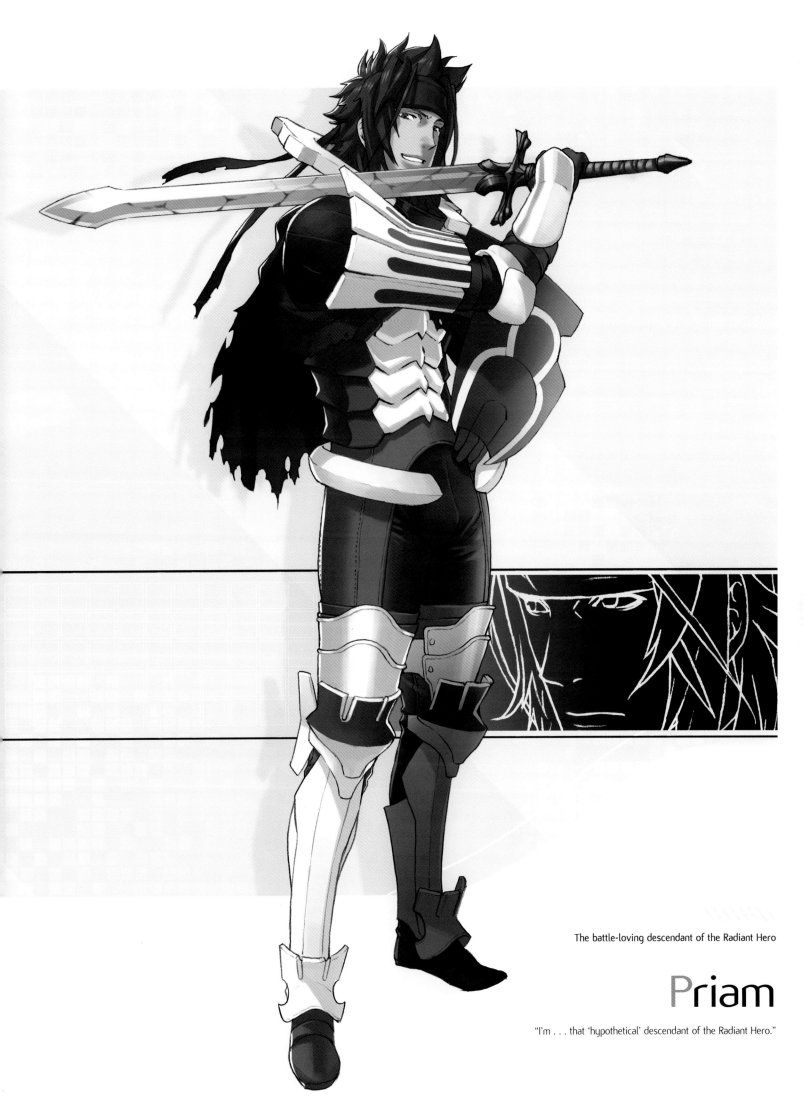

The battle-loving descendant of the Radiant Hero

Priam

"I'm . . . that 'hypothetical' descendant of the Radiant Hero."

Official Illustration Gallery

Ricken

"Don't talk down to me!"

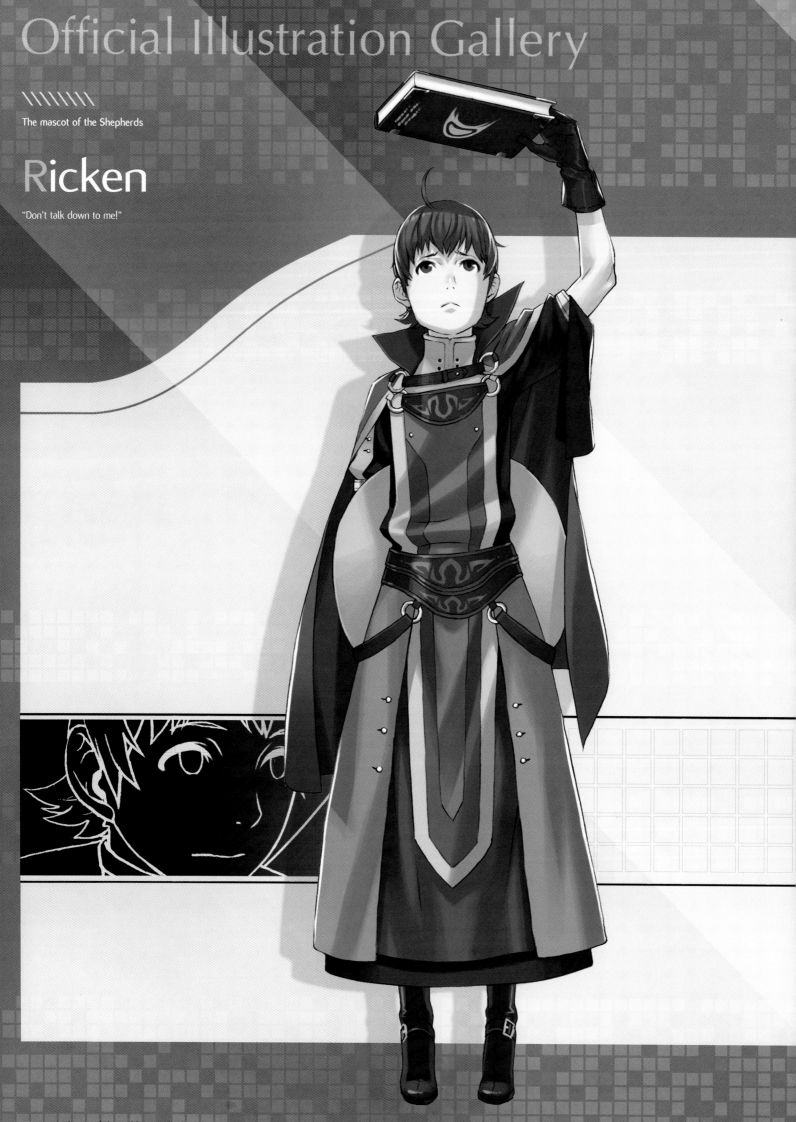

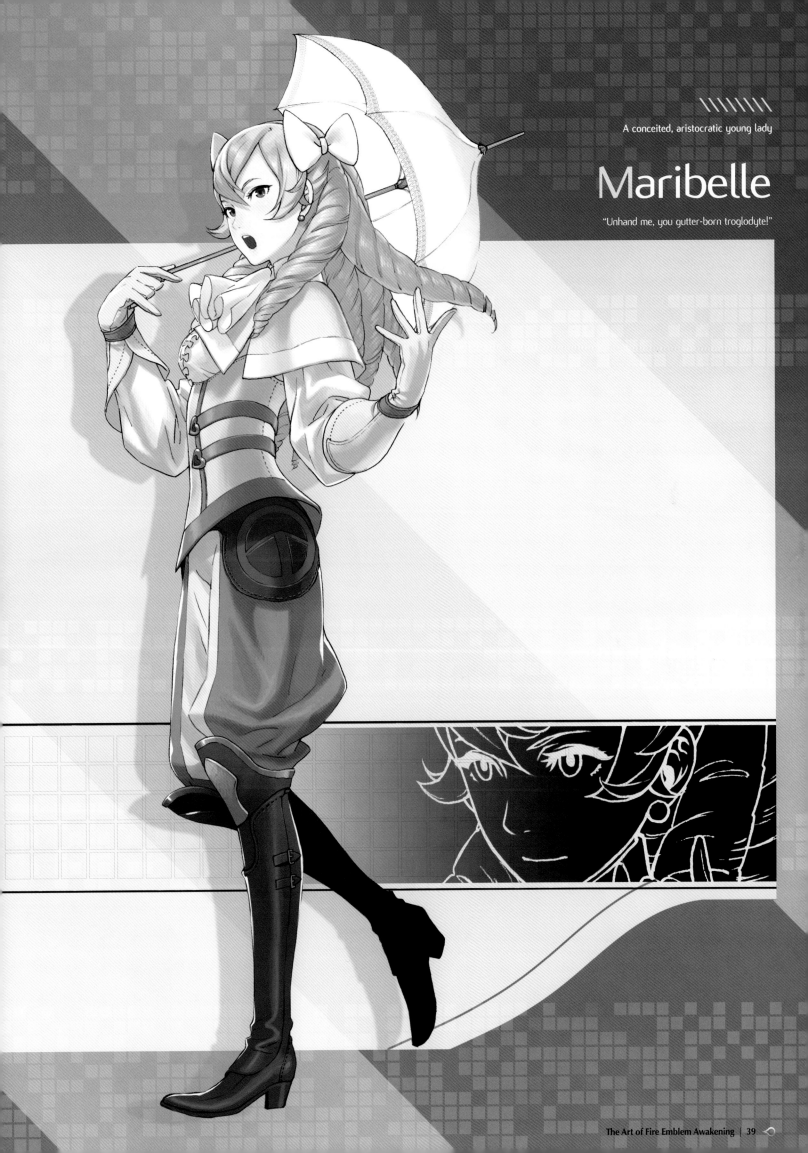

Maribelle

"Unhand me, you gutter-born troglodyte!"

A khan who looks after the avatar like a father (or a mafia boss)

Basilio

"Let the dead whine about their fate!"

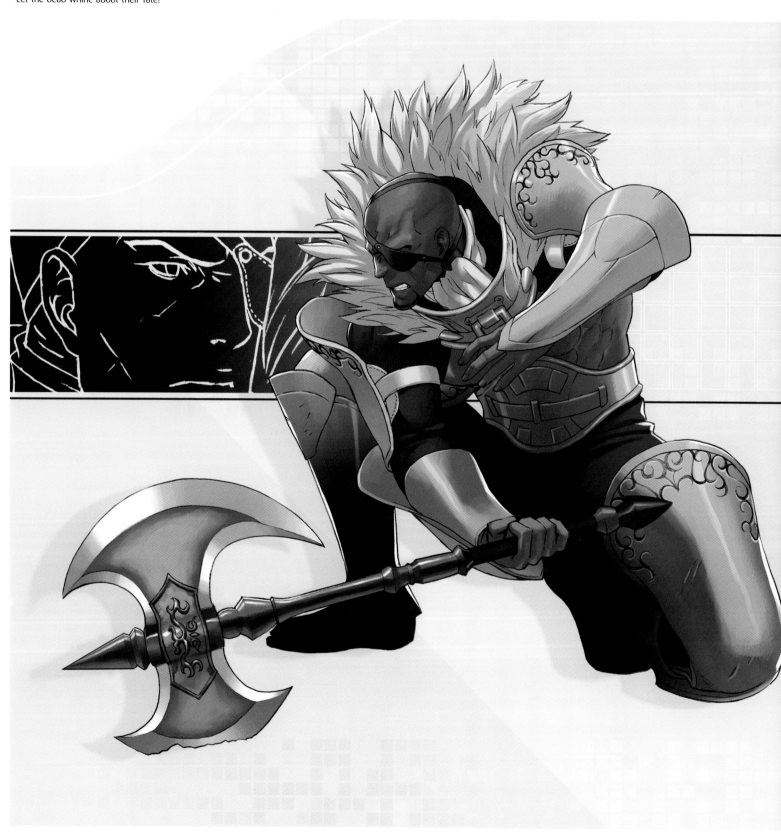

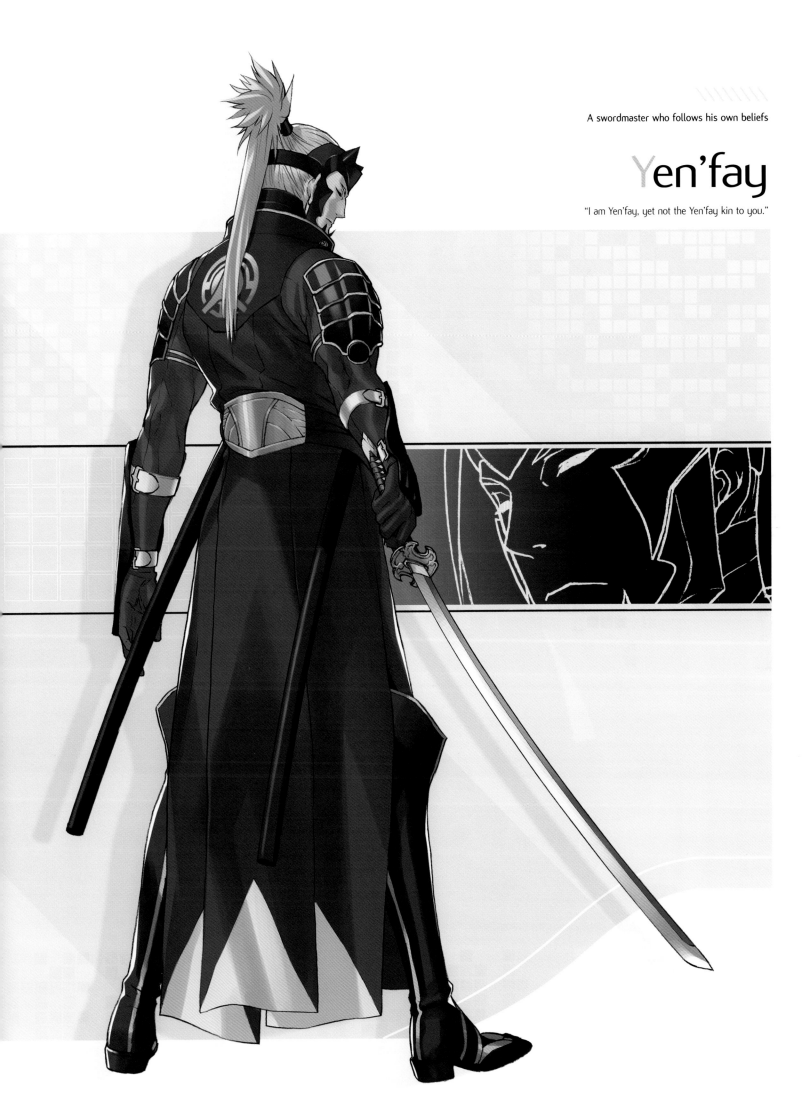

A swordmaster who follows his own beliefs

Yen'fay

"I am Yen'fay, yet not the Yen'fay kin to you."

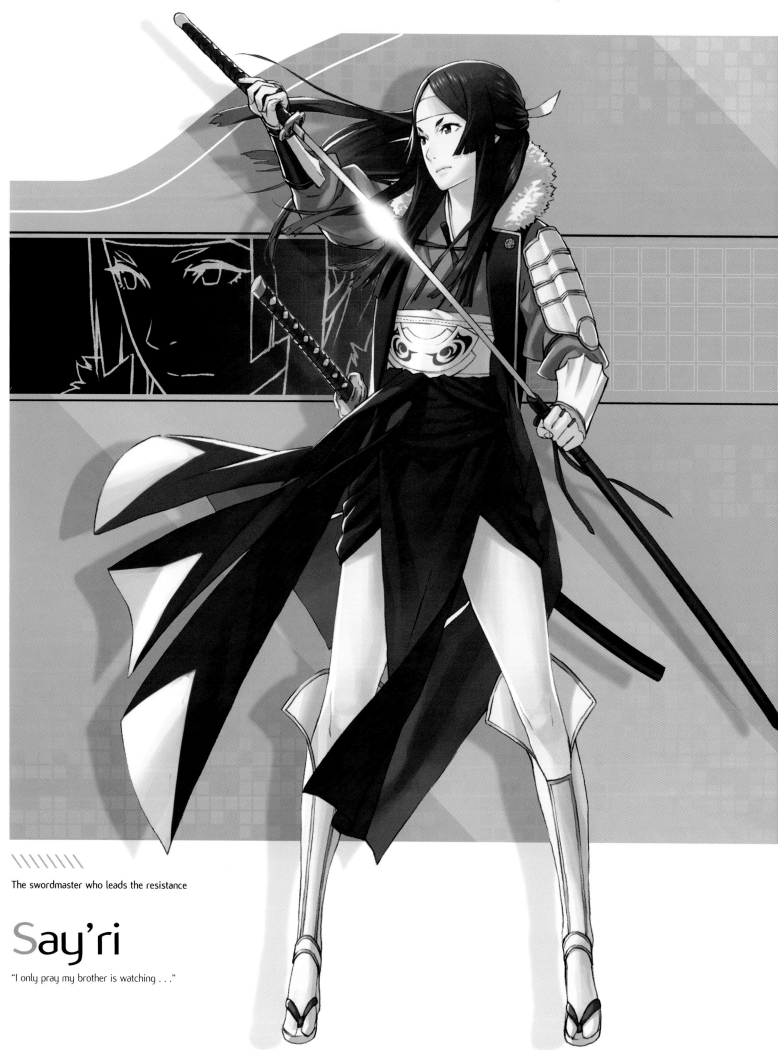

\\\\\\\\\

The swordmaster who leads the resistance

Say'ri

"I only pray my brother is watching . . ."

A likable, youthful knight

Stahl

"I was in such a hurry, I had to miss breakfast!"

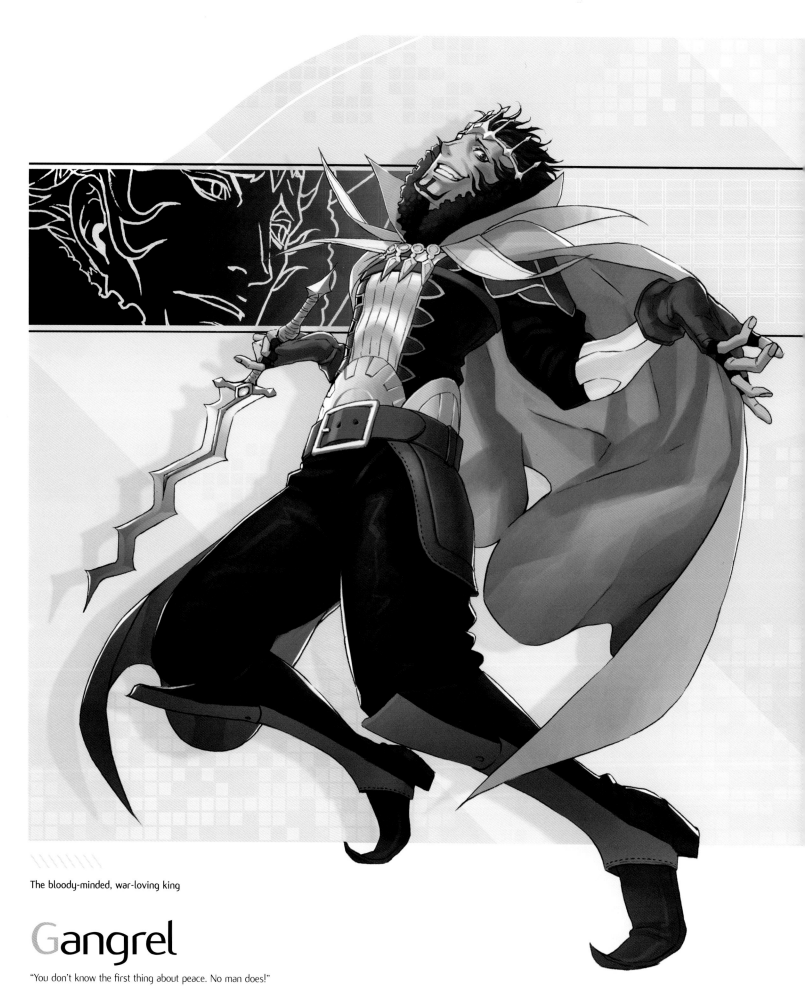

The bloody-minded, war-loving king

Gangrel

"You don't know the first thing about peace. No man does!"

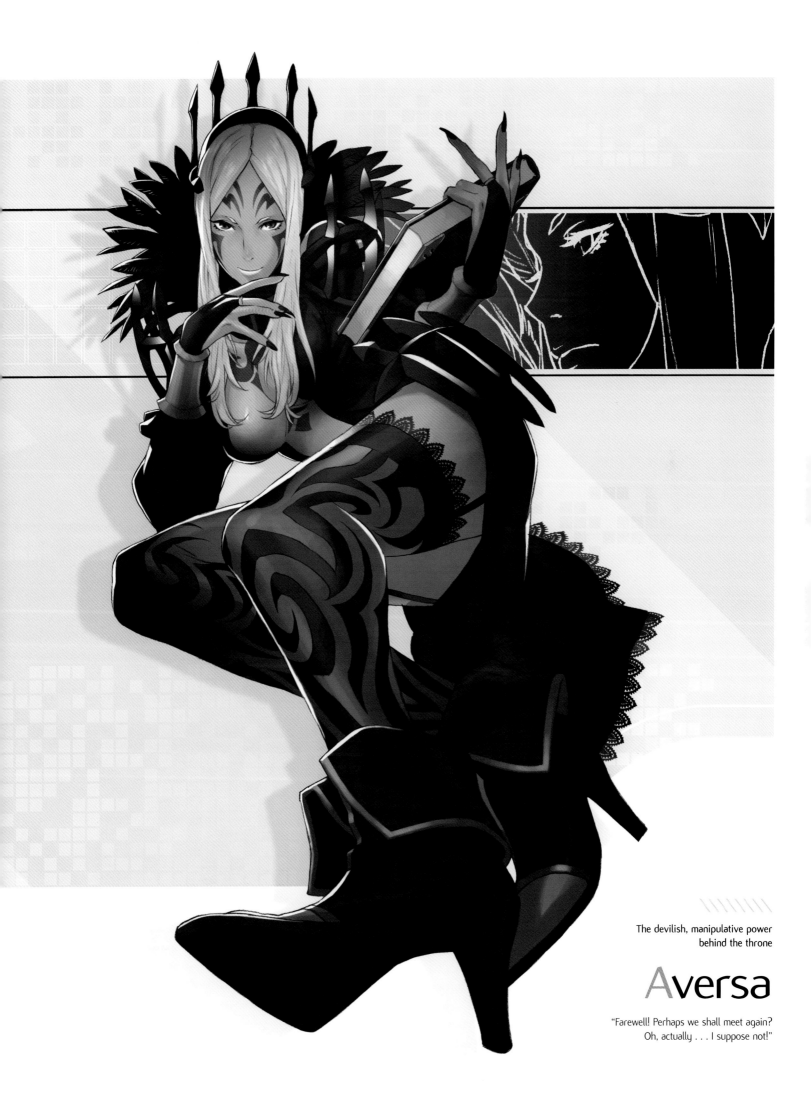

The devilish, manipulative power
behind the throne

Aversa

"Farewell! Perhaps we shall meet again?
Oh, actually . . . I suppose not!"

\\\\\\\

The emperor of Valm

Walhart

"Pah! You think to challenge me?"

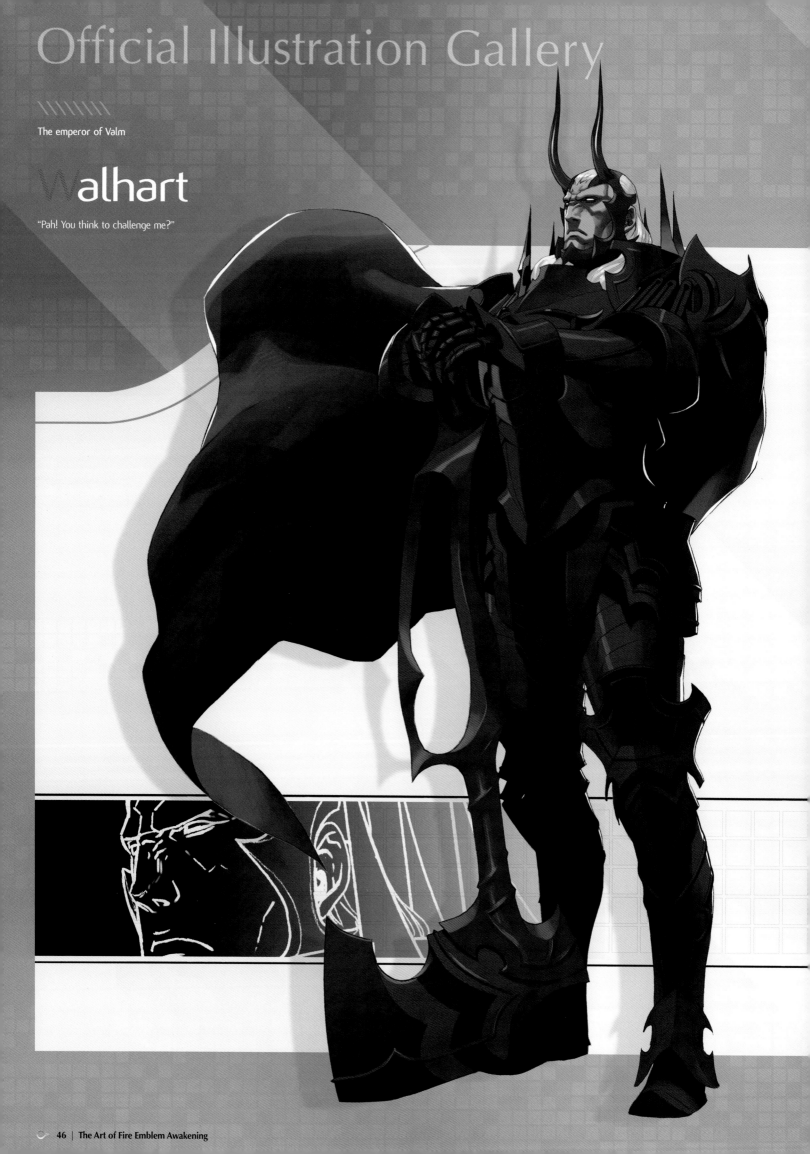

Emmeryn

"I am not giving up, Chrom. I am only giving what I can."

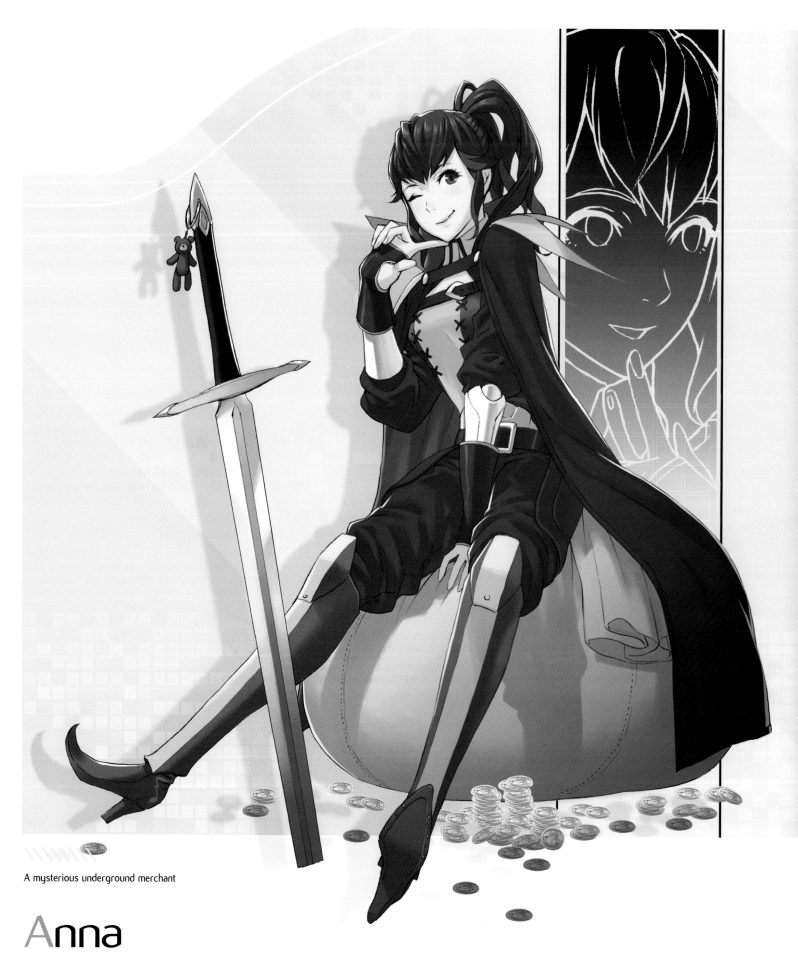

A mysterious underground merchant

Anna

"I'll be sure to cut you an extra-special deal."

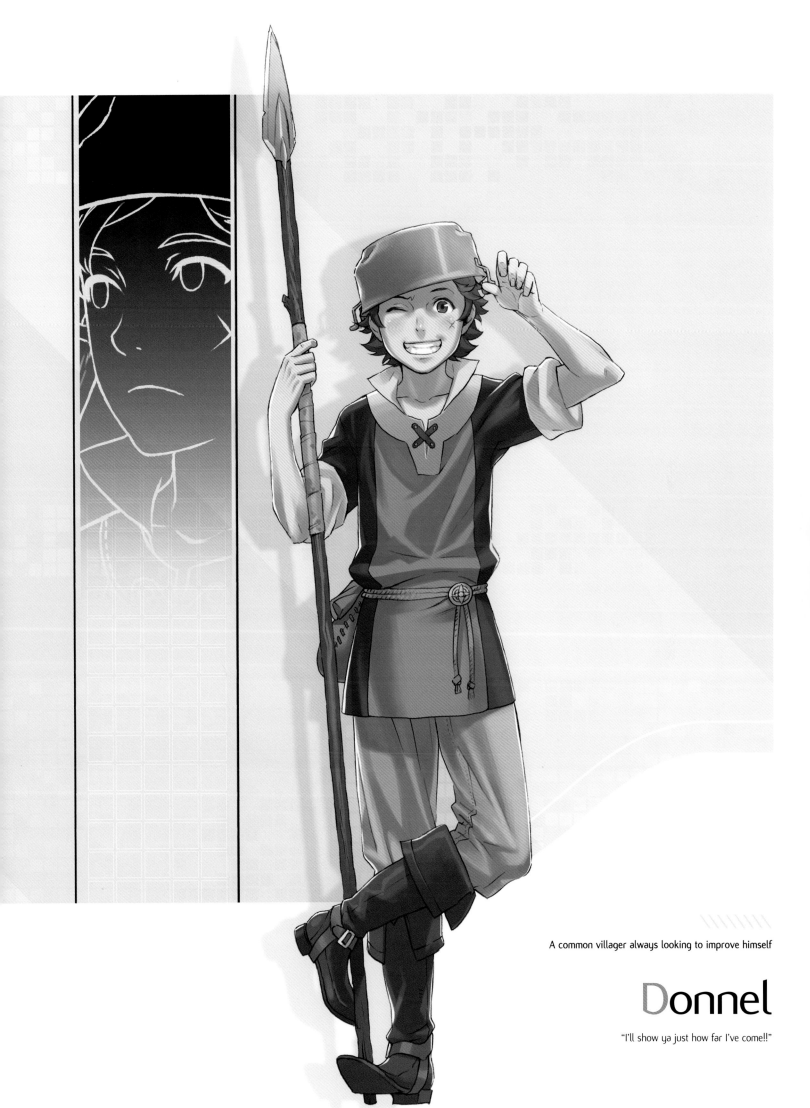

A common villager always looking to improve himself

Donnel

"I'll show ya just how far I've come!!"

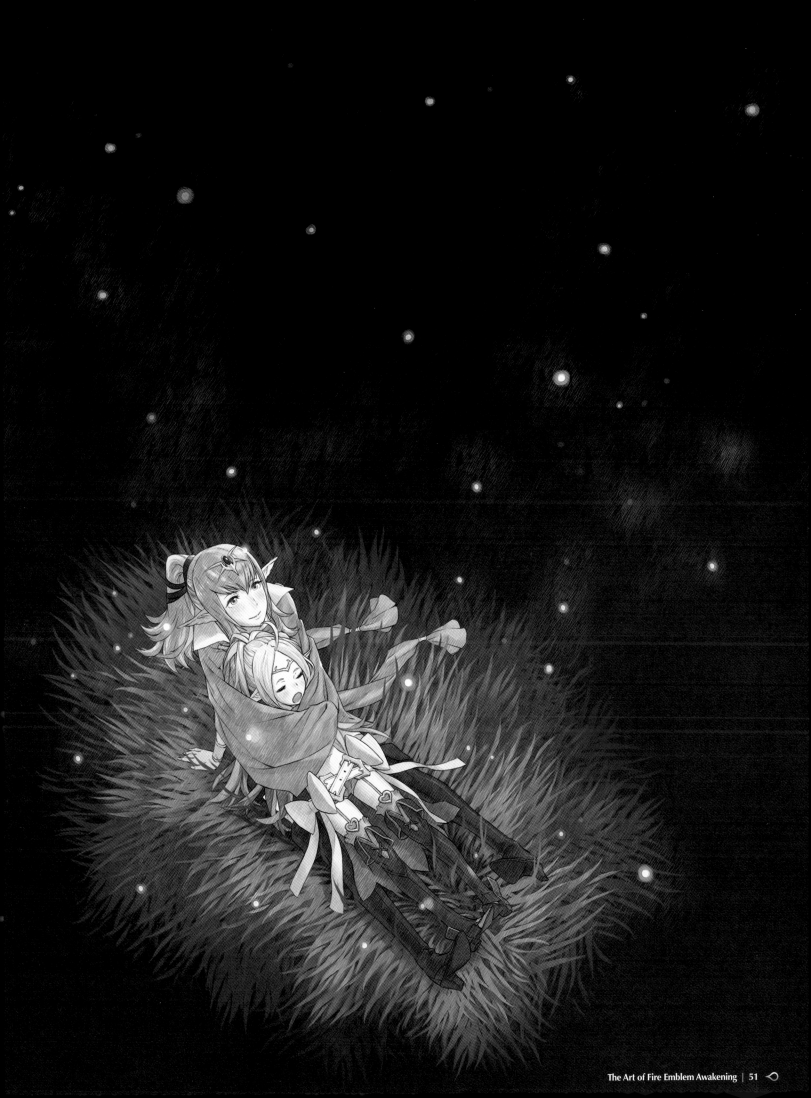

\\\\\\\\

Harbinger of the future

Lucina

"We cannot—we MUST not—lose this war."

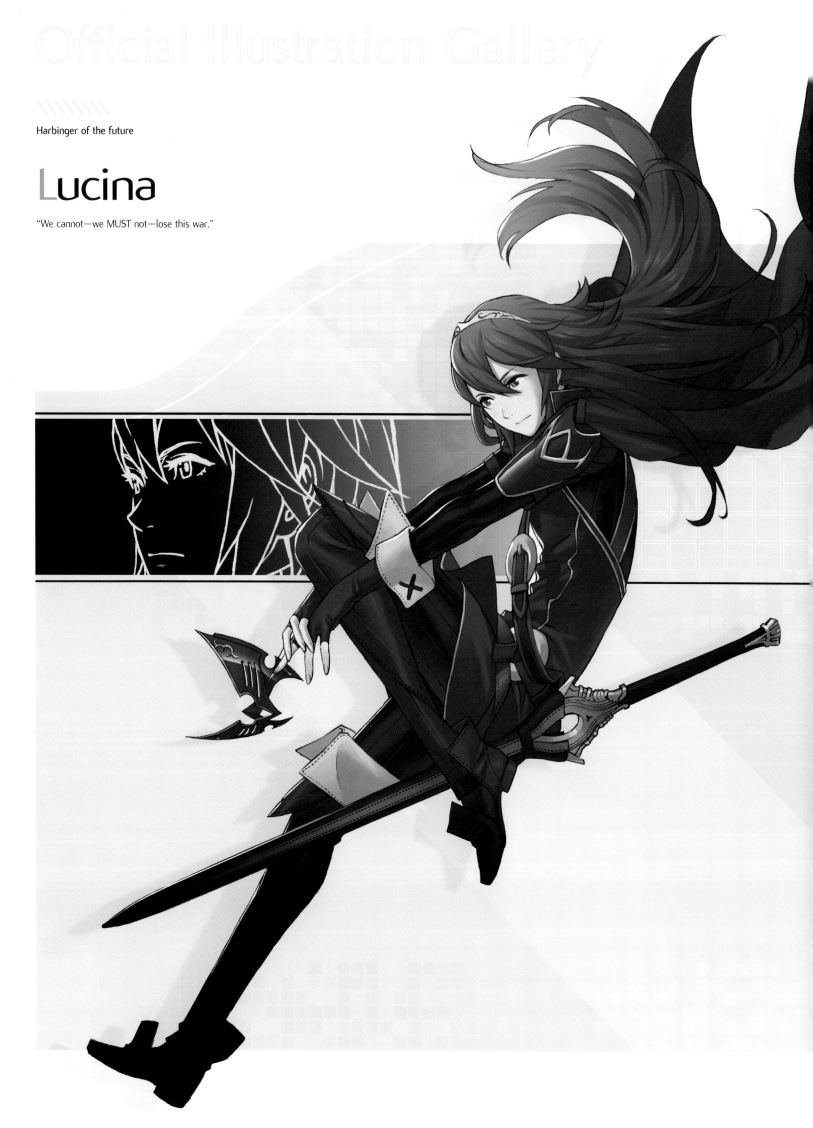

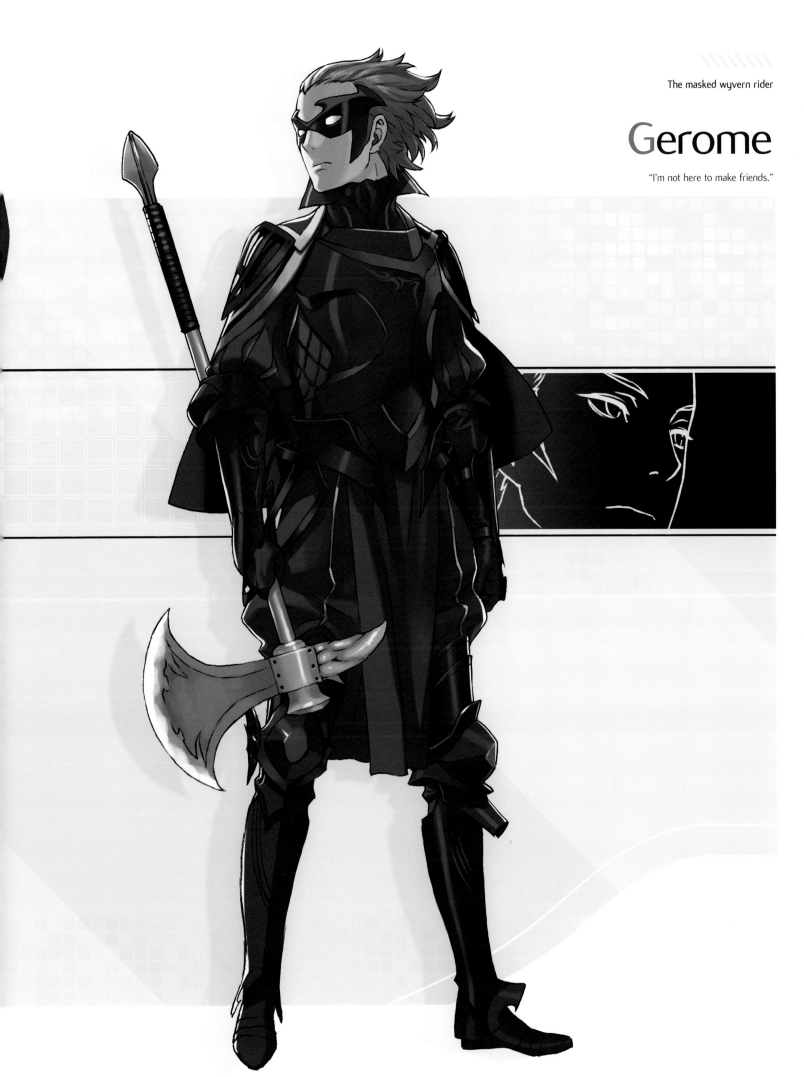

The masked wyvern rider

Gerome

"I'm not here to make friends."

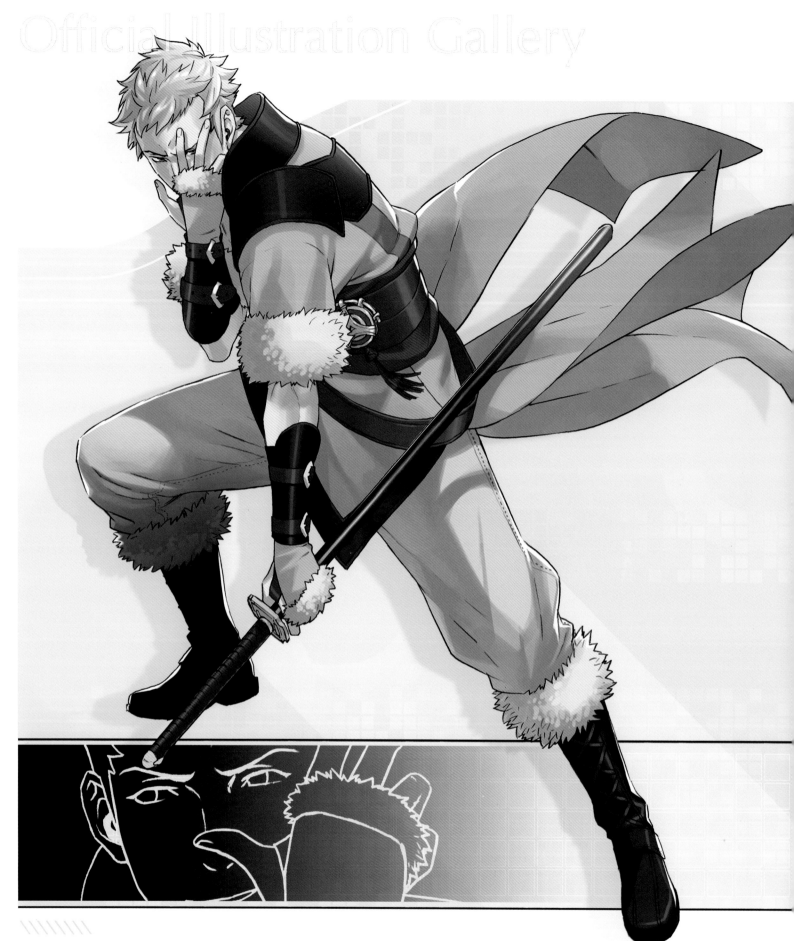

A myrmidon who does his best to control his sword hand

Owain

"Hnngh . . . B-blood . . . boiling once again . . ."

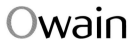

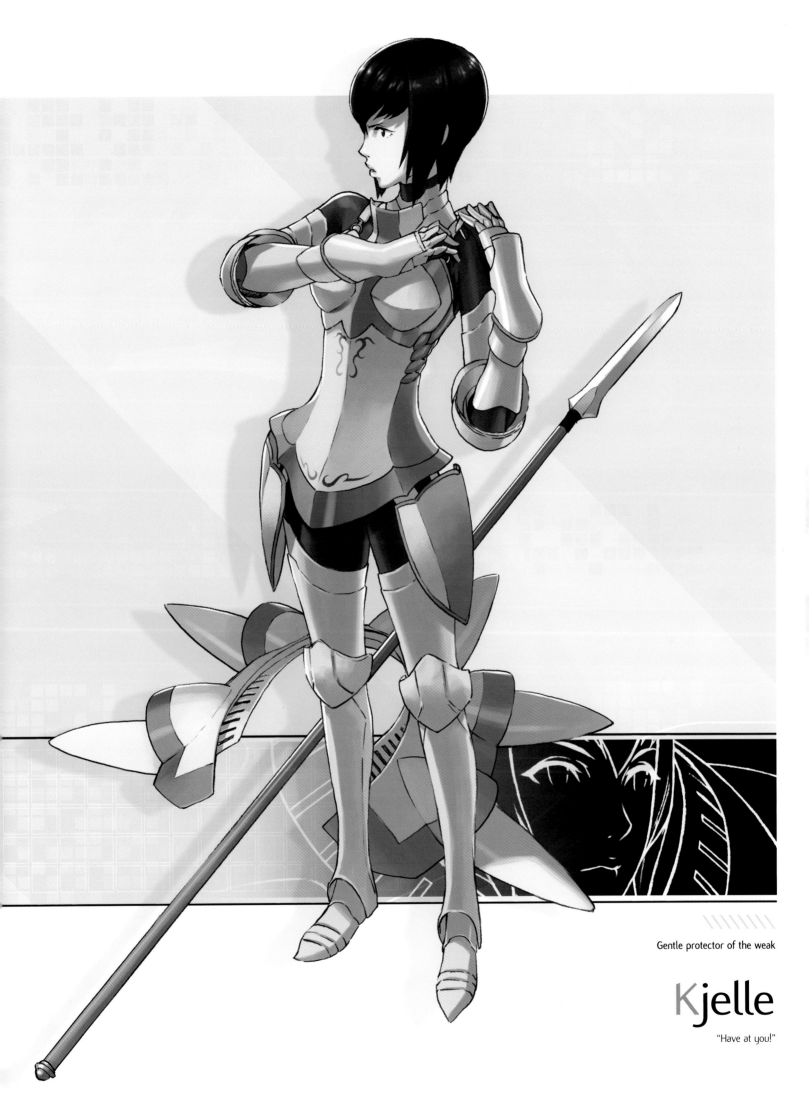

Gentle protector of the weak

Kjelle

"Have at you!"

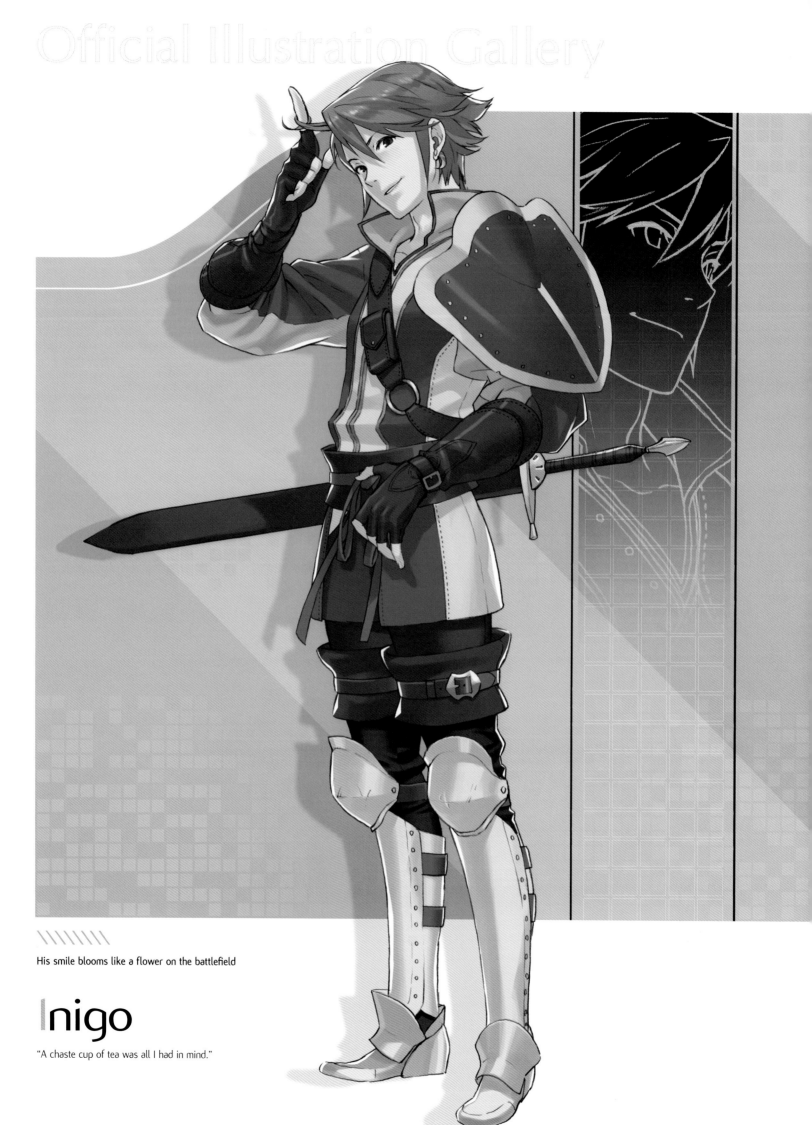

\\\\\\\\

His smile blooms like a flower on the battlefield

Inigo

"A chaste cup of tea was all I had in mind."

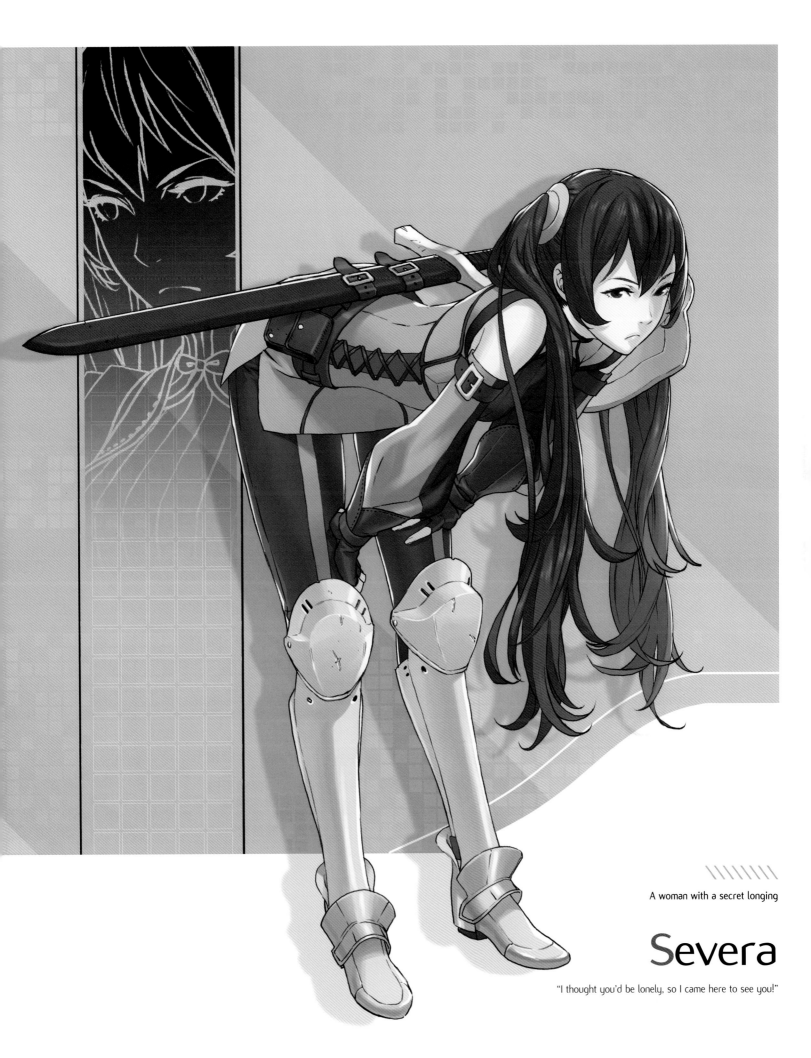

A woman with a secret longing

Severa

"I thought you'd be lonely, so I came here to see you!"

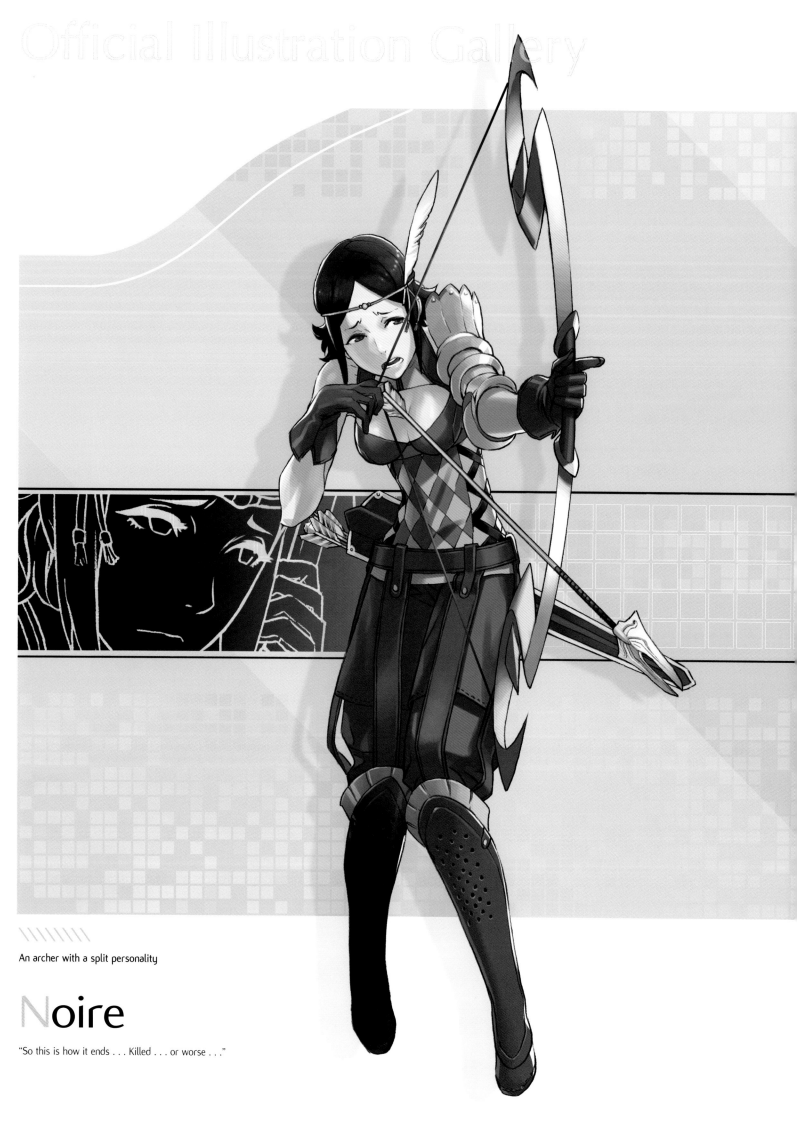

\\\\\\\\\

An archer with a split personality

Noire

"So this is how it ends . . . Killed . . . or worse . . ."

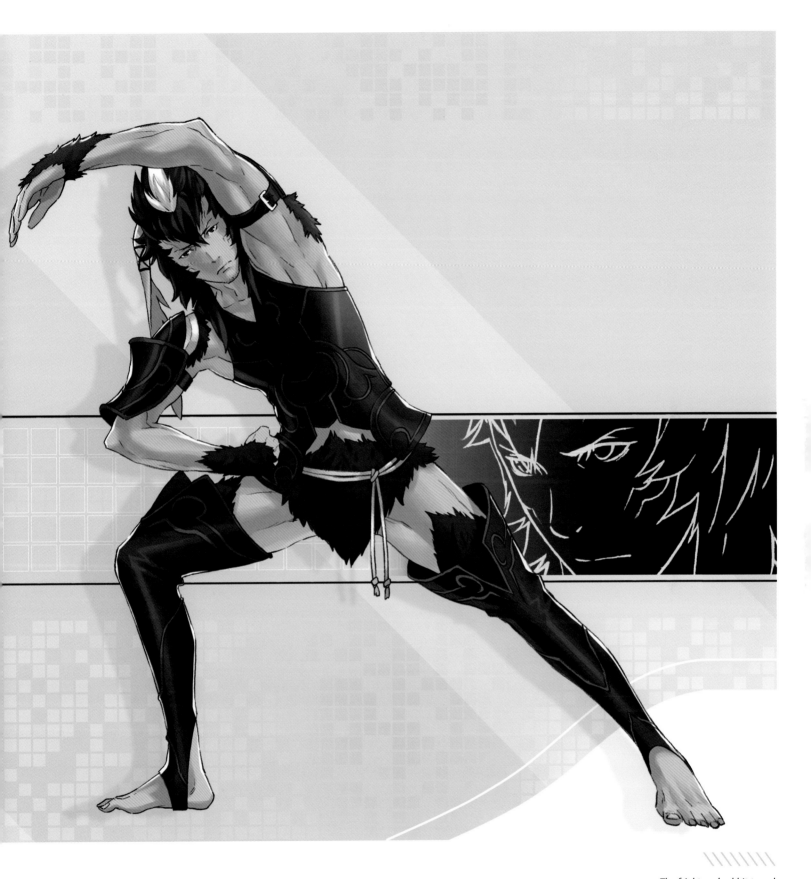

The frightened-rabbit taguel

Yarne

"I'm going to vanish as a result!"

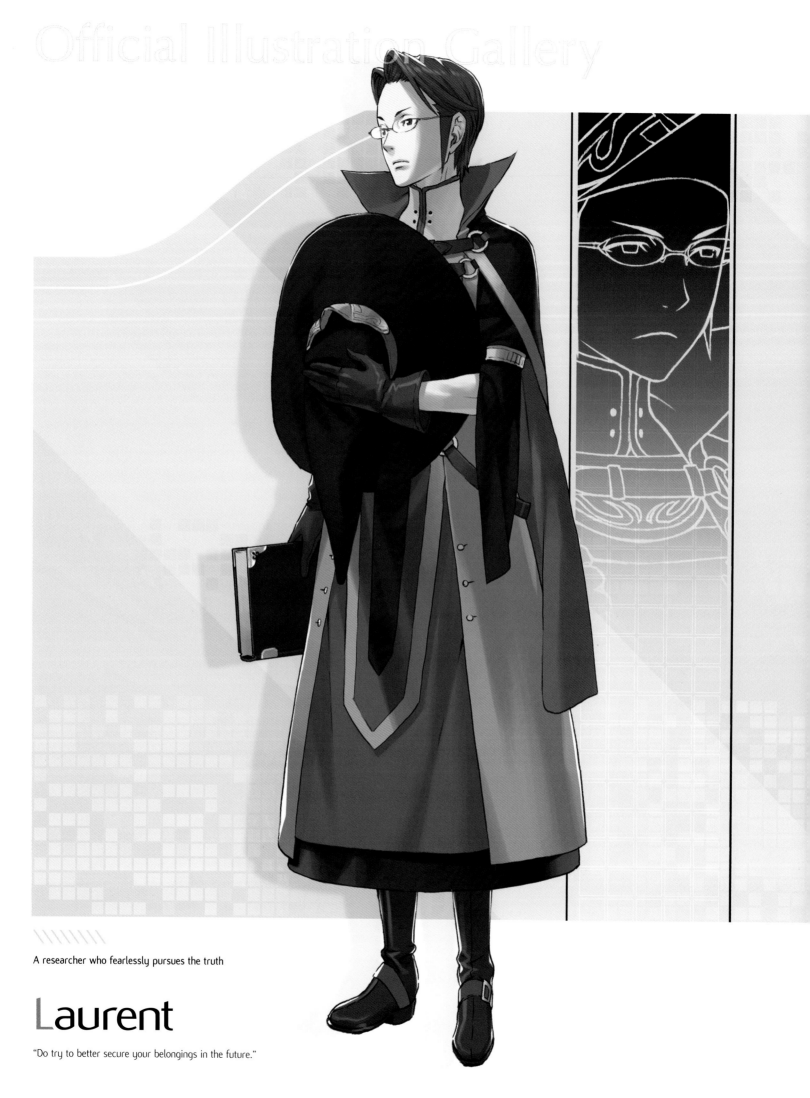

A researcher who fearlessly pursues the truth

Laurent

"Do try to better secure your belongings in the future."

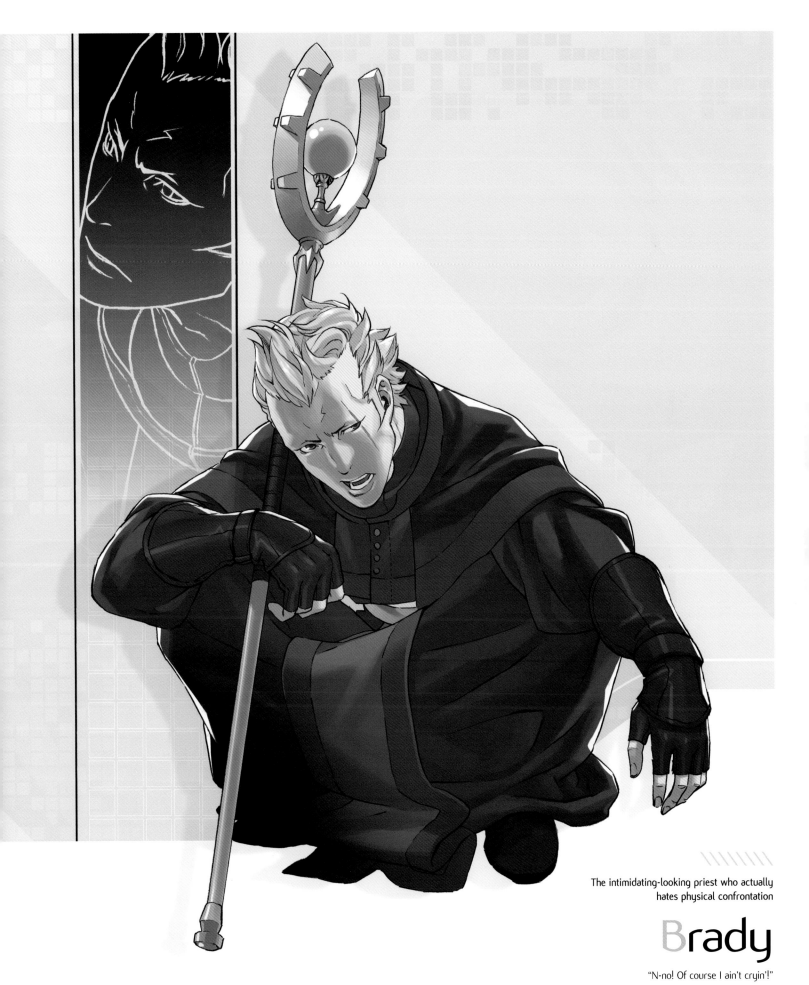

The intimidating-looking priest who actually
hates physical confrontation

Brady

"N-no! Of course I ain't cryin'!"

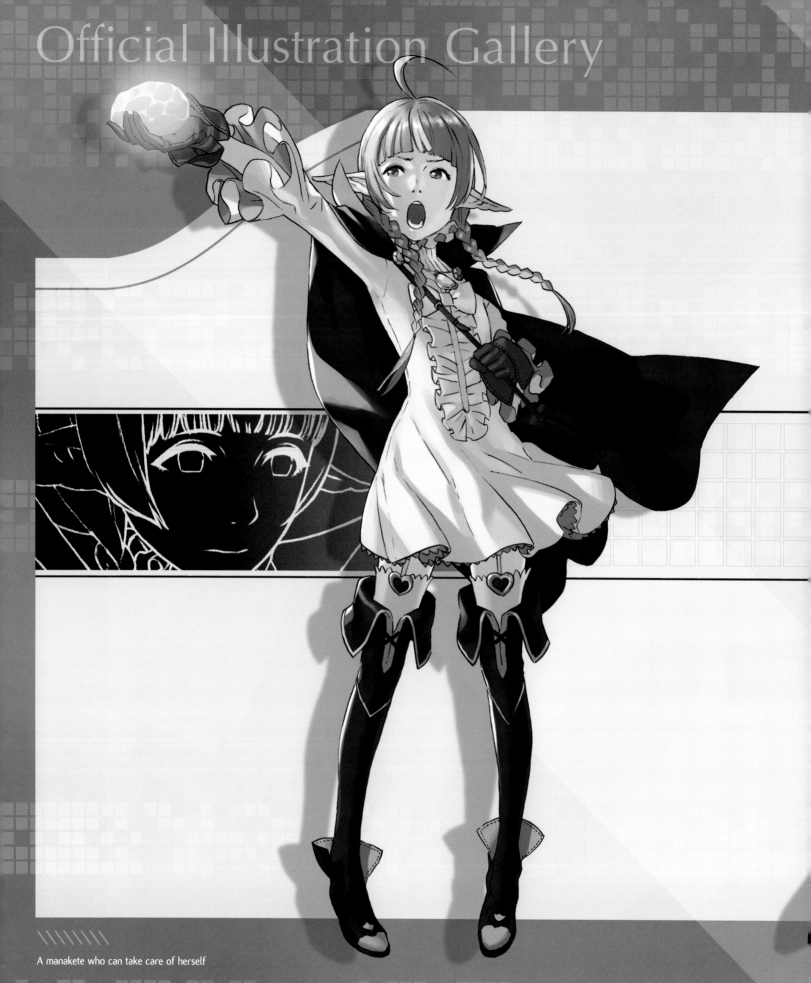

A manakete who can take care of herself

Nah

"All right, Nah . . . You can do this. You're strong!"

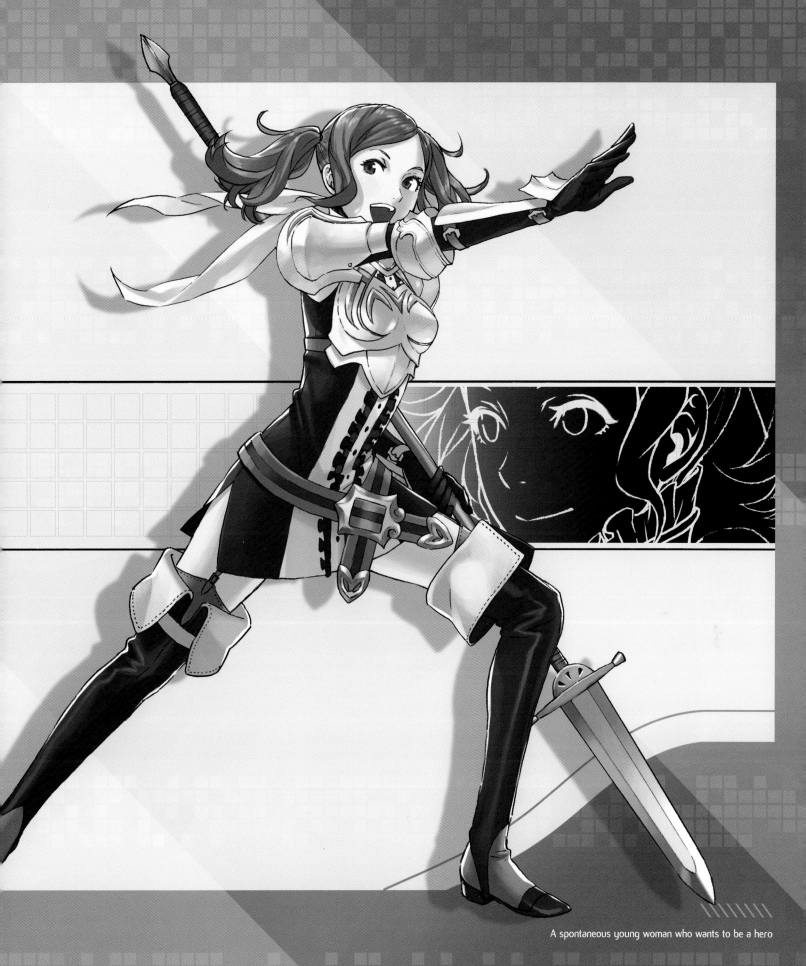

A spontaneous young woman who wants to be a hero

Cynthia

"Cry 'justice' into the dark of night, and it will echo back, 'Cynthia!'"

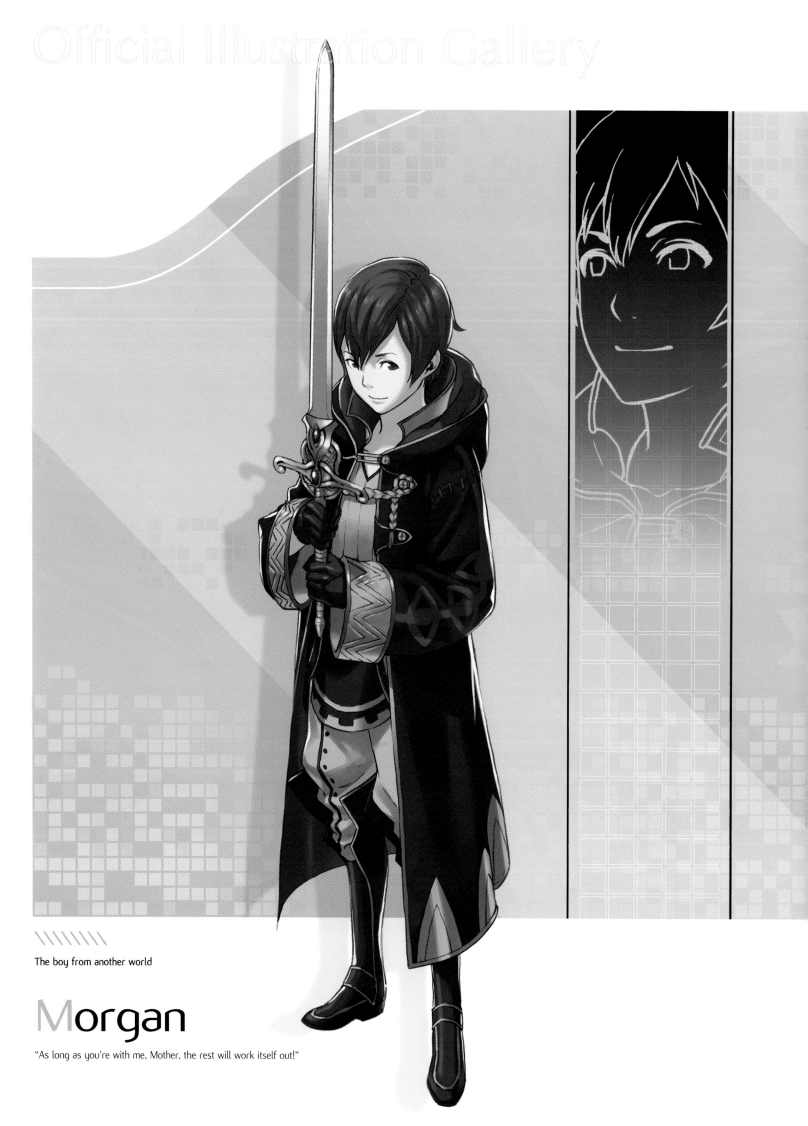

\\\\\\\\

The boy from another world

Morgan

"As long as you're with me, Mother, the rest will work itself out!"

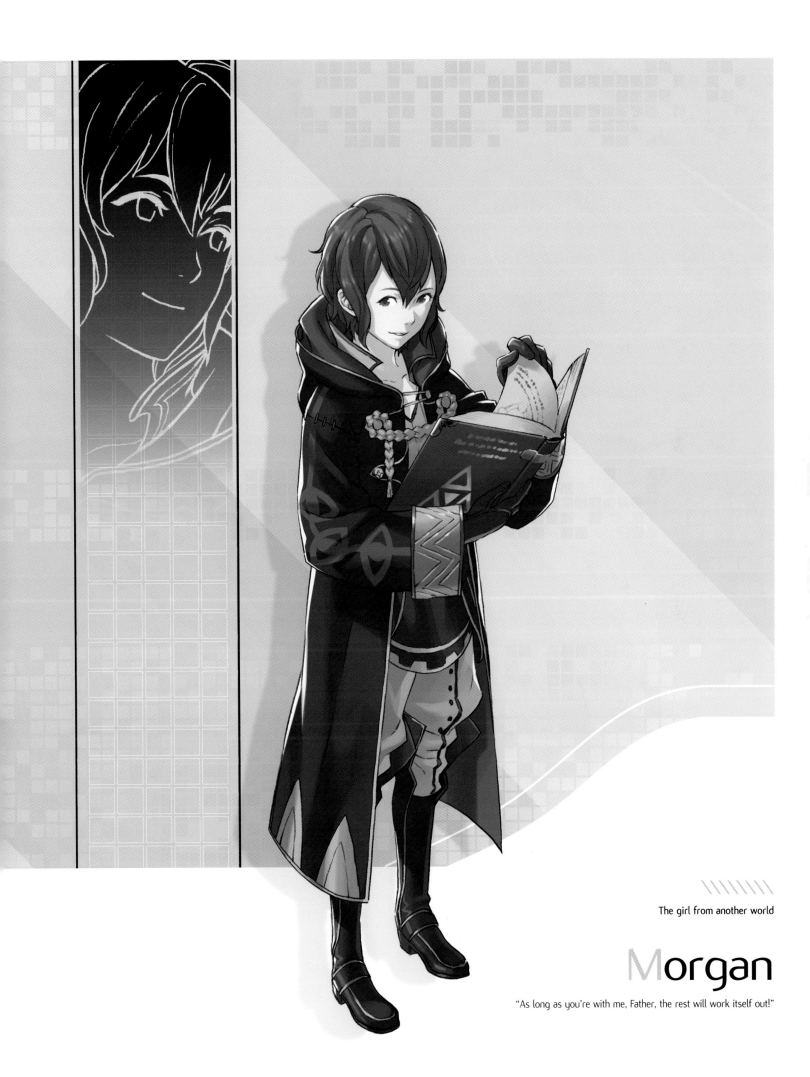

The girl from another world

Morgan

"As long as you're with me, Father, the rest will work itself out!"

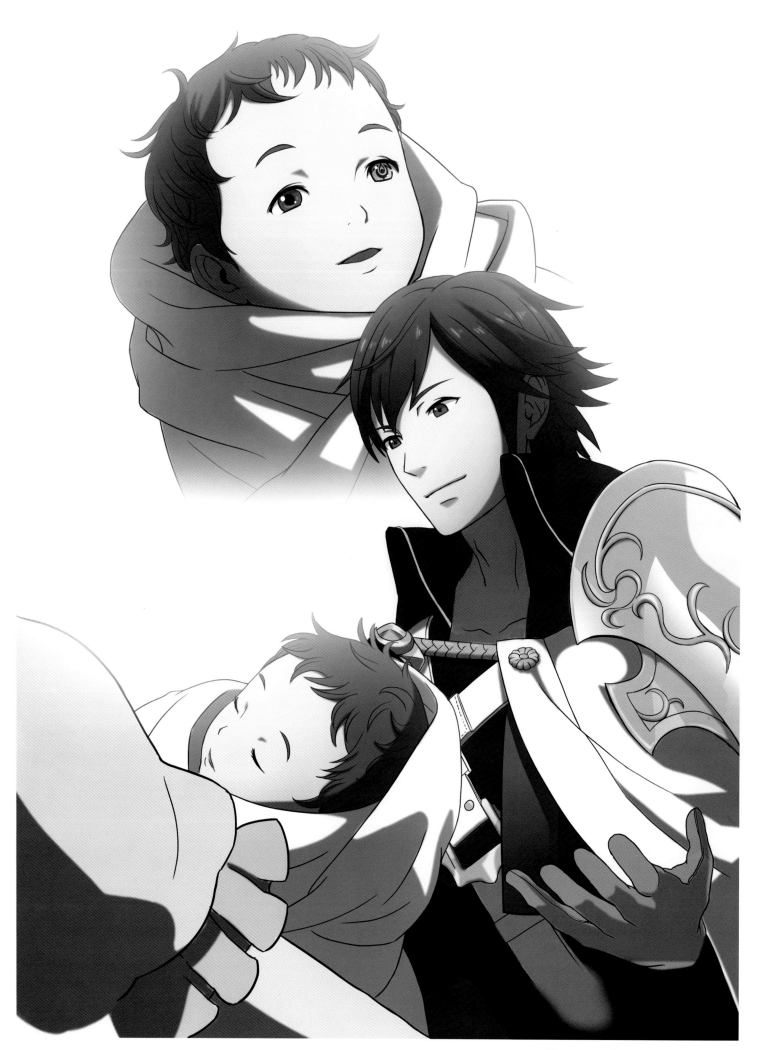

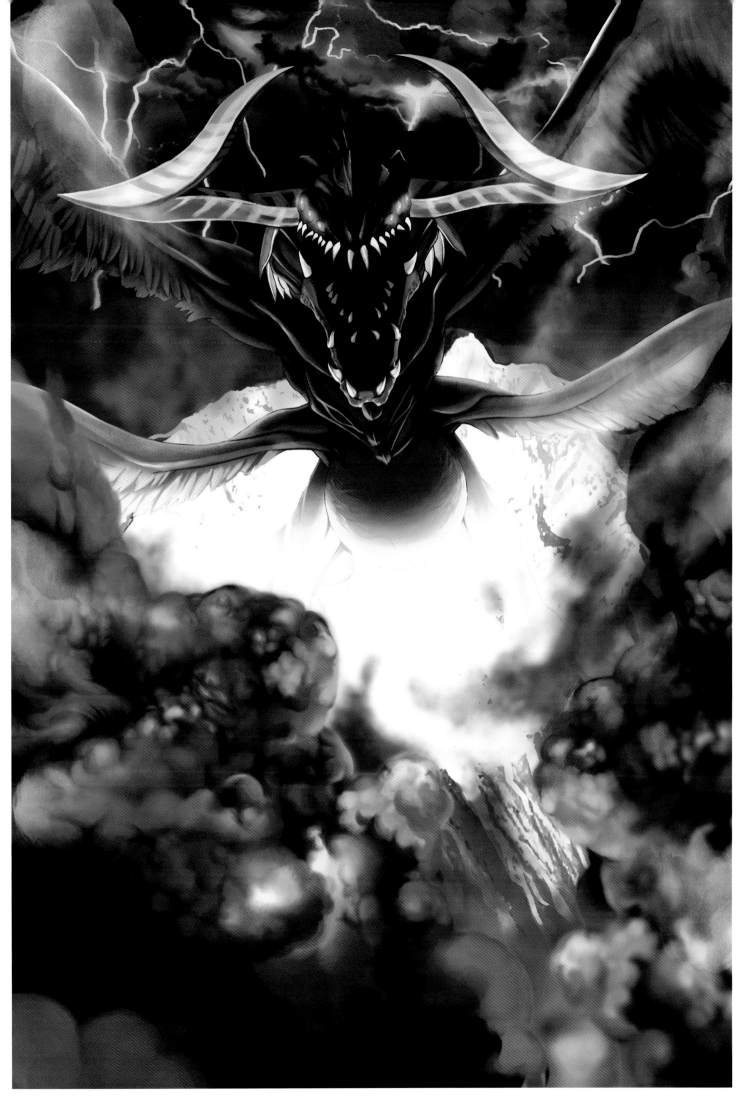

Chapter 25 Story Event Illustration

\\\\\\\

A dark mage who worships the fell dragon

Validar

"You cannot unwrite what is already written!"

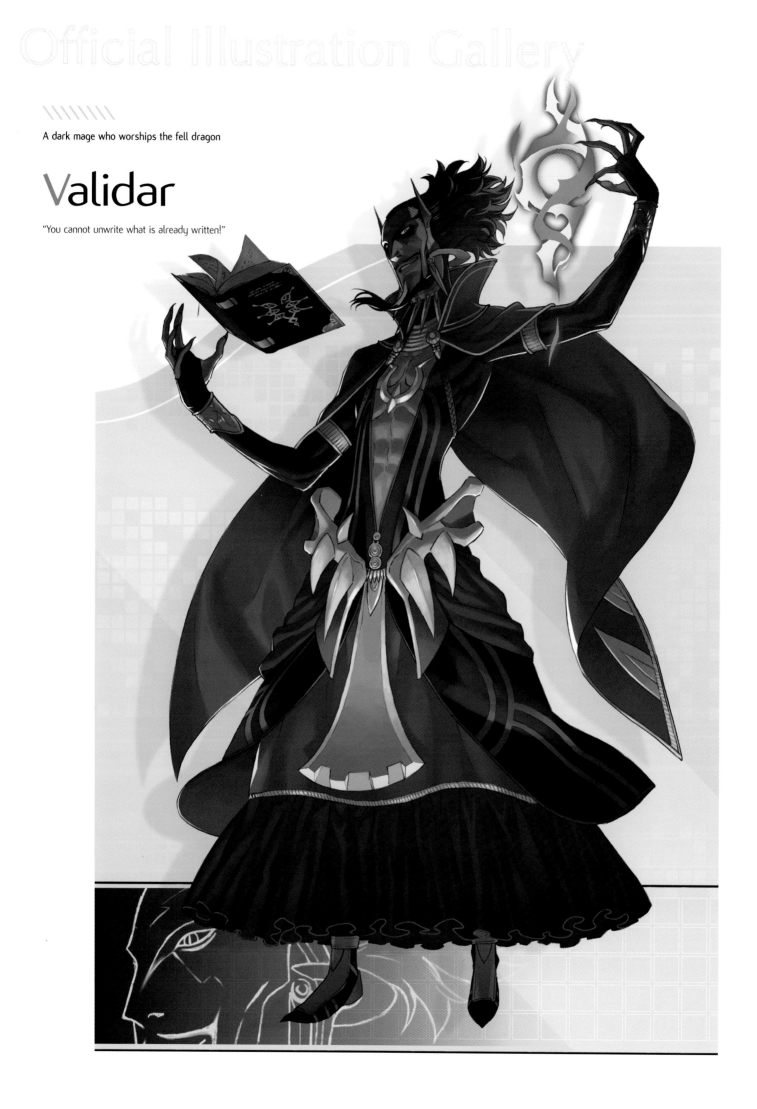

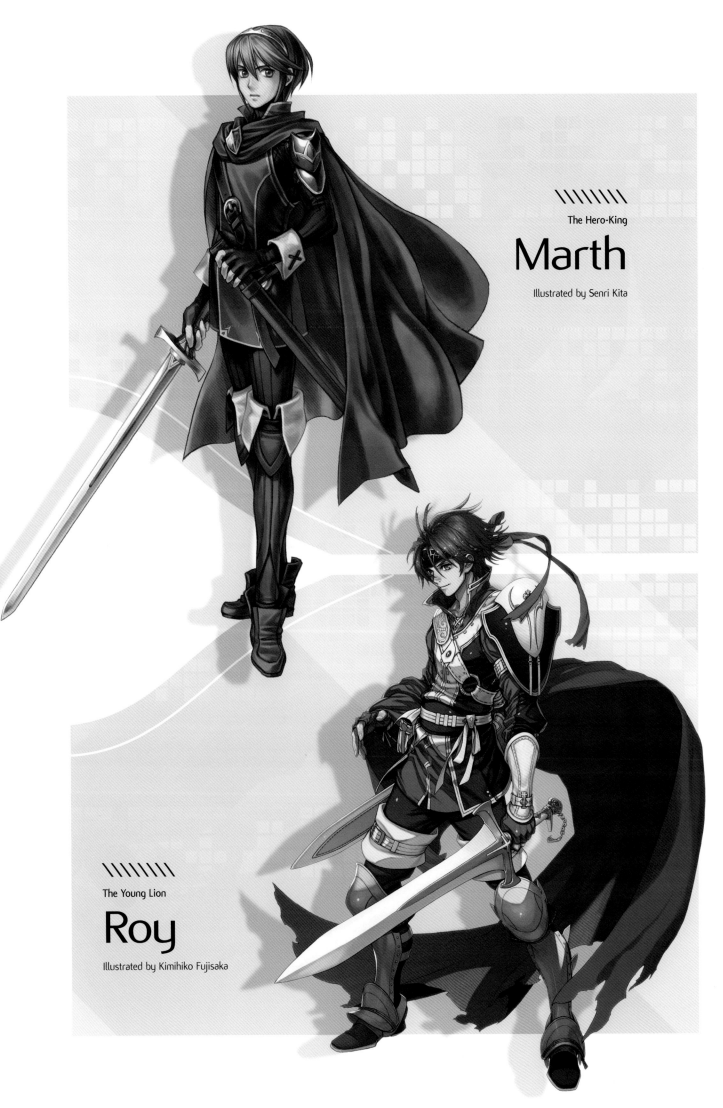

The Hero-King
Marth
Illustrated by Senri Kita

The Young Lion
Roy
Illustrated by Kimihiko Fujisaka

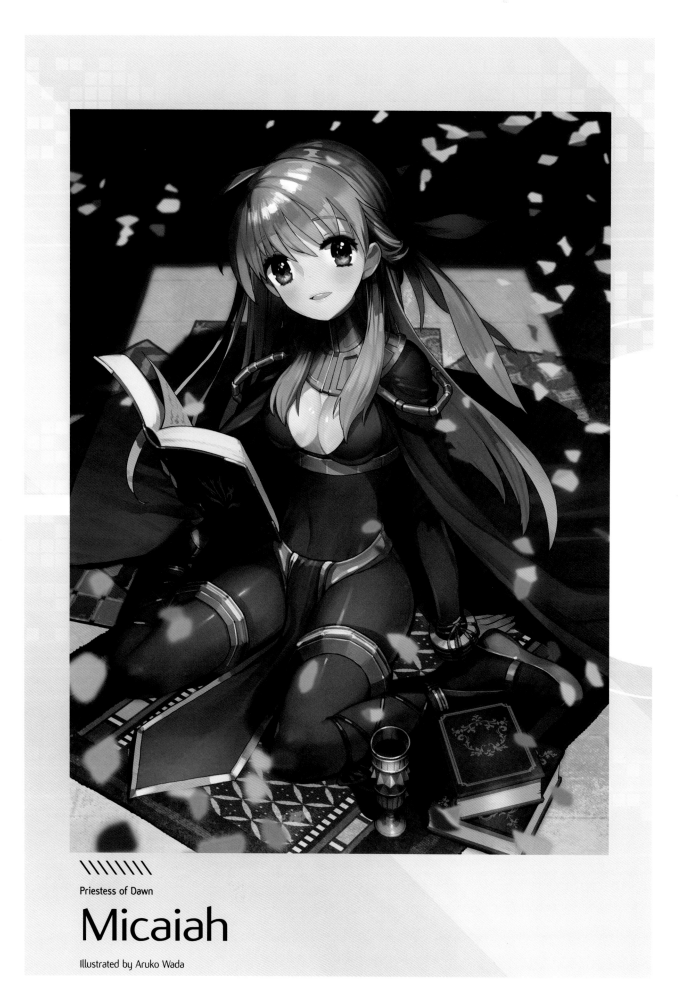

\\\\\\\\\\

Priestess of Dawn

Micaiah

Illustrated by Aruko Wada

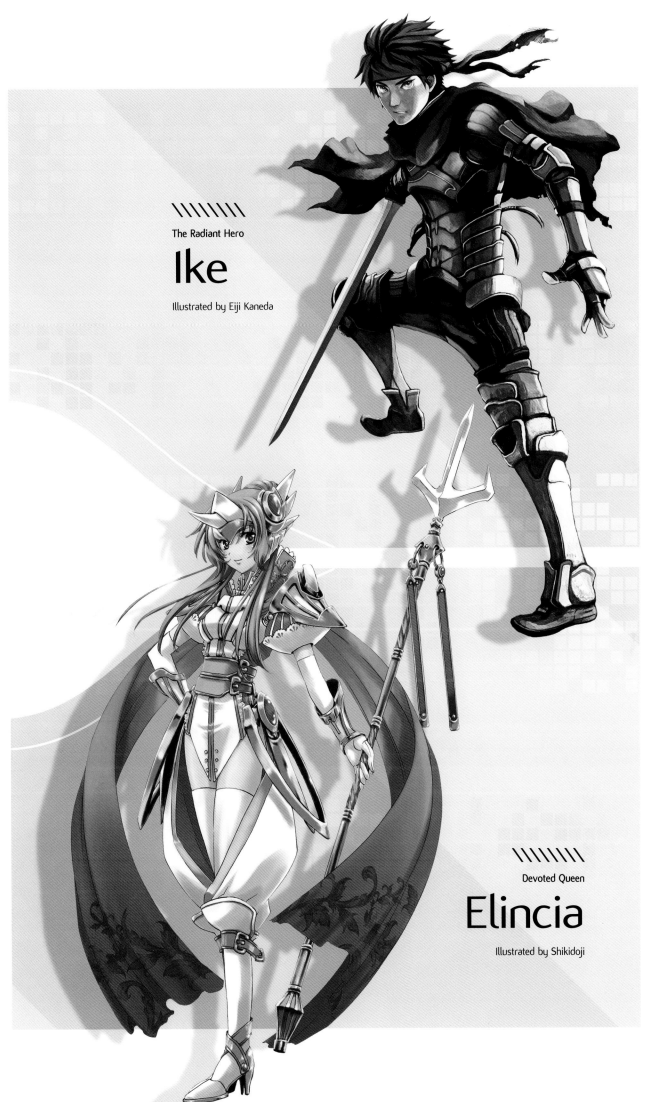

\\\\\\\\

The Radiant Hero

Ike

Illustrated by Eiji Kaneda

\\\\\\\\

Devoted Queen

Elincia

Illustrated by Shikidoji

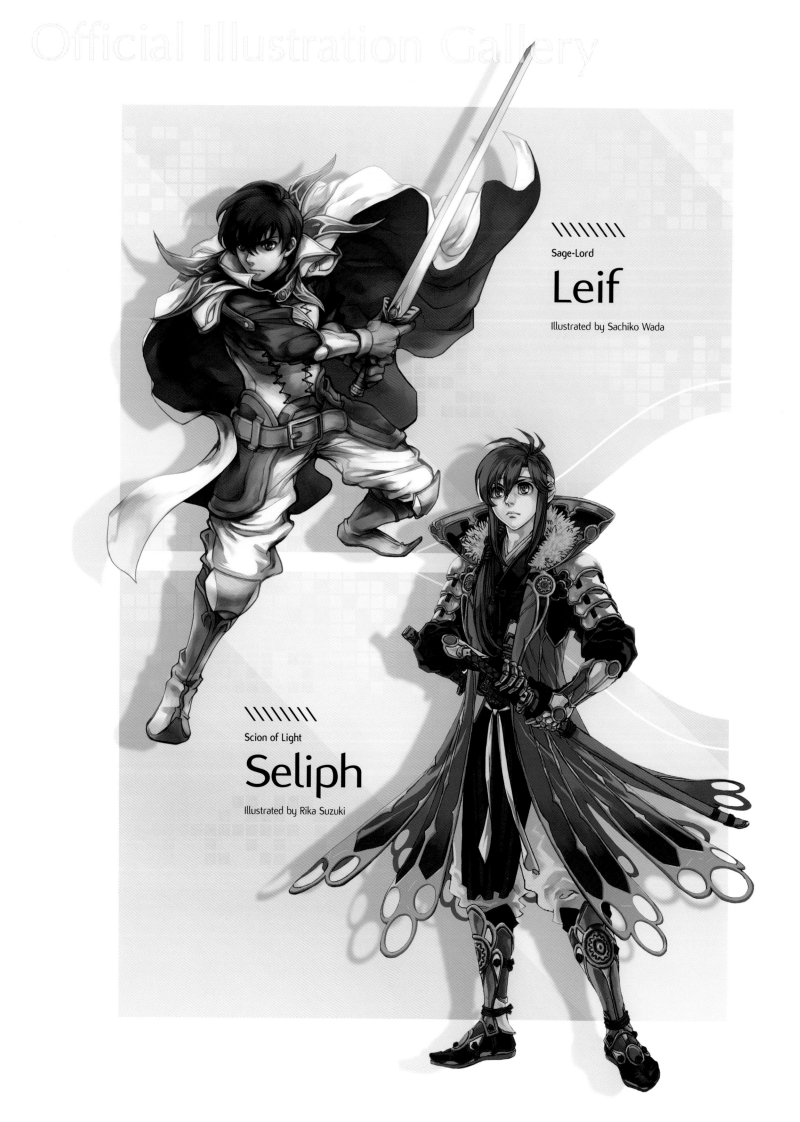

\\\\\\\

Sage-Lord

Leif

Illustrated by Sachiko Wada

\\\\\\\

Scion of Light

Seliph

Illustrated by Rika Suzuki

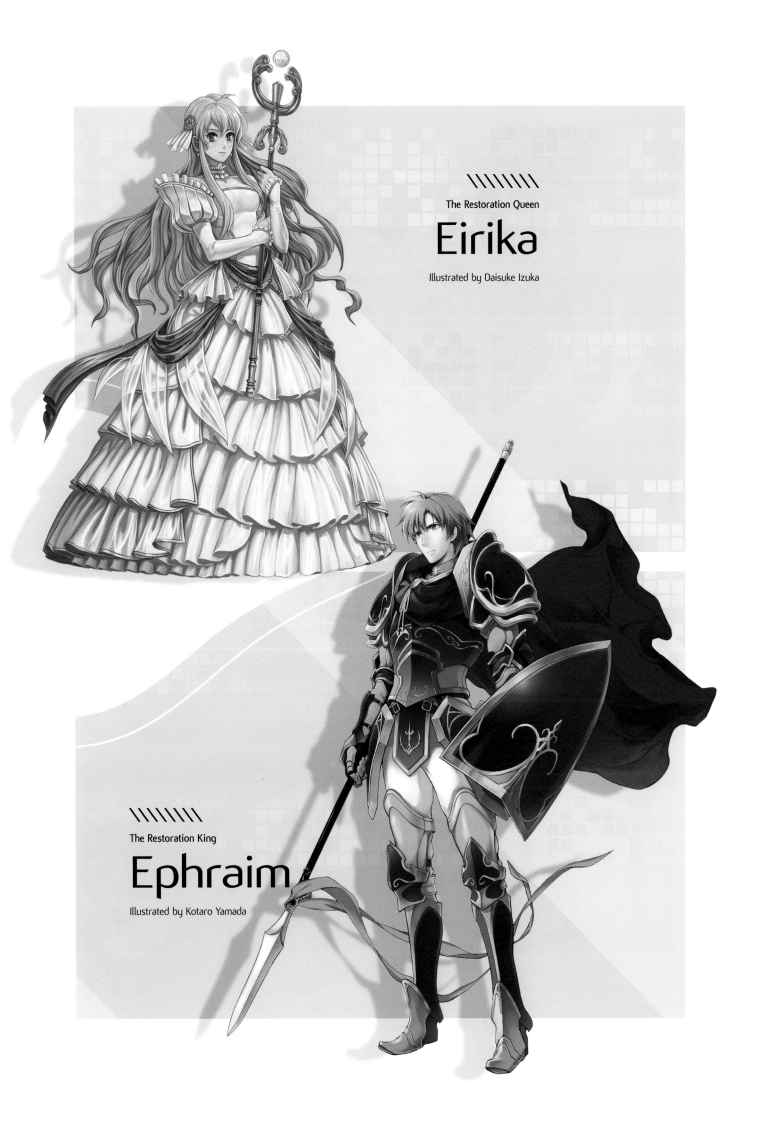

The Restoration Queen

Eirika

Illustrated by Daisuke Izuka

\\\\\\

The Restoration King

Ephraim

Illustrated by Kotaro Yamada

\\\\\\\

Exalted King

Alm

Illustrated by HACCAN

\\\\\\\

Blessed Maiden

Celica

Illustrated by Masatsugu Saito

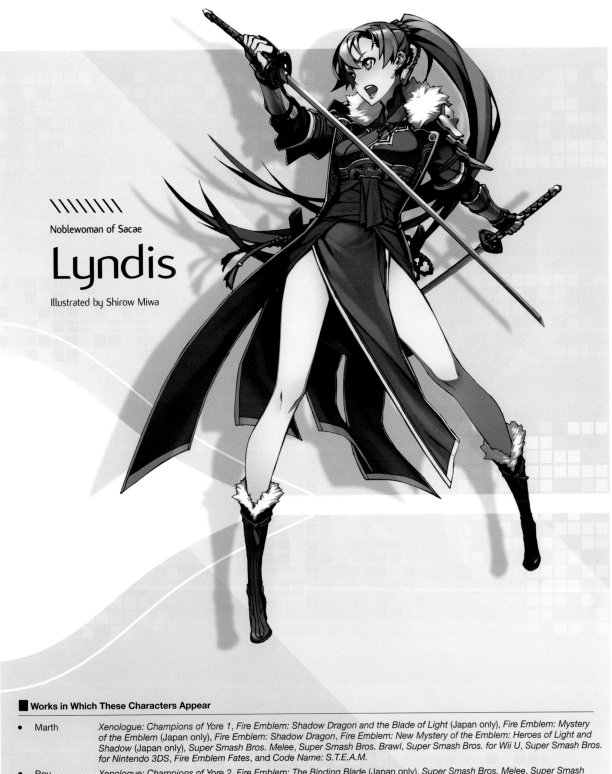

\\\\\\\\

Noblewoman of Sacae

Lyndis

Illustrated by Shirow Miwa

■ Works in Which These Characters Appear

•	Marth	*Xenologue: Champions of Yore 1*, *Fire Emblem: Shadow Dragon and the Blade of Light* (Japan only), *Fire Emblem: Mystery of the Emblem* (Japan only), *Fire Emblem: Shadow Dragon*, *Fire Emblem: New Mystery of the Emblem: Heroes of Light and Shadow* (Japan only), *Super Smash Bros. Melee*, *Super Smash Bros. Brawl*, *Super Smash Bros. for Wii U*, *Super Smash Bros. for Nintendo 3DS*, *Fire Emblem Fates*, and *Code Name: S.T.E.A.M.*
•	Roy	*Xenologue: Champions of Yore 2*, *Fire Emblem: The Binding Blade* (Japan only), *Super Smash Bros. Melee*, *Super Smash Bros. Brawl*, *Super Smash Bros. for Wii U*, and *Super Smash Bros. for Nintendo 3DS*
•	Micaiah	*Xenologue: Champions of Yore 3* and *Fire Emblem: Radiant Dawn*
•	Ike	*Xenologue: Rogues & Redeemers*, *Fire Emblem: Path of Radiance*, *Fire Emblem: Radiant Dawn*, *Super Smash Bros. Brawl*, *Super Smash Bros. for Wii U*, *Super Smash Bros. for Nintendo 3DS*, *Fire Emblem Fates*, and *Code Name: S.T.E.A.M.*
•	Elincia	*Xenologue: Smash Brethren 1*, *Fire Emblem: Path of Radiance*, and *Fire Emblem: Radiant Dawn*
•	Leif	*Xenologue: Lost Bloodlines 1* and *Fire Emblem: Thracia 776* (Japan only)
•	Seliph	*Xenologue: Lost Bloodlines 3* and *Fire Emblem: Genealogy of the Holy War* (Japan only)
•	Eirika	*Xenologue: Smash Brethren 2* and *Fire Emblem: The Sacred Stones*
•	Ephraim	*Xenologue: Rogues & Redeemers 1* and *Fire Emblem: The Sacred Stones*
•	Alm	*Xenologue: Lost Bloodlines 2* and *Fire Emblem Gaiden* (Japan only)
•	Celica	*Xenologue: Rogues & Redeemers* and *Fire Emblem Gaiden* (Japan only)
•	Lyndis	*Xenologue: Smash Brethren 3*, *Fire Emblem*, *Super Smash Bros. Brawl*, *Super Smash Bros. for Wii U*, and *Super Smash Bros. for Nintendo 3DS*

Section 2

CONCEPT ART

Character Design

::: Rough Character Sketches and Concept Art

Here we bring you rough sketches and concept art of the main characters.
Most of them are drawn by the character designer, Yusuke Kozaki.

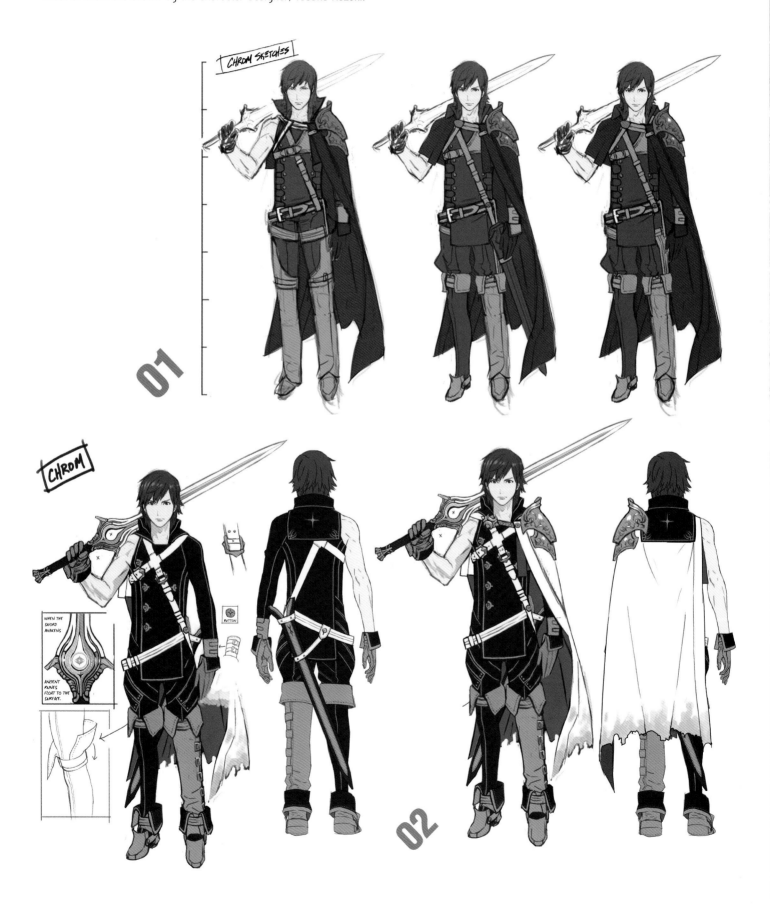

CHROM SKETCHES

01

CHROM

WHEN THE SWORD AWAKENS

ANCIENT RUNES FLOAT TO THE SURFACE.

BUTTON

02

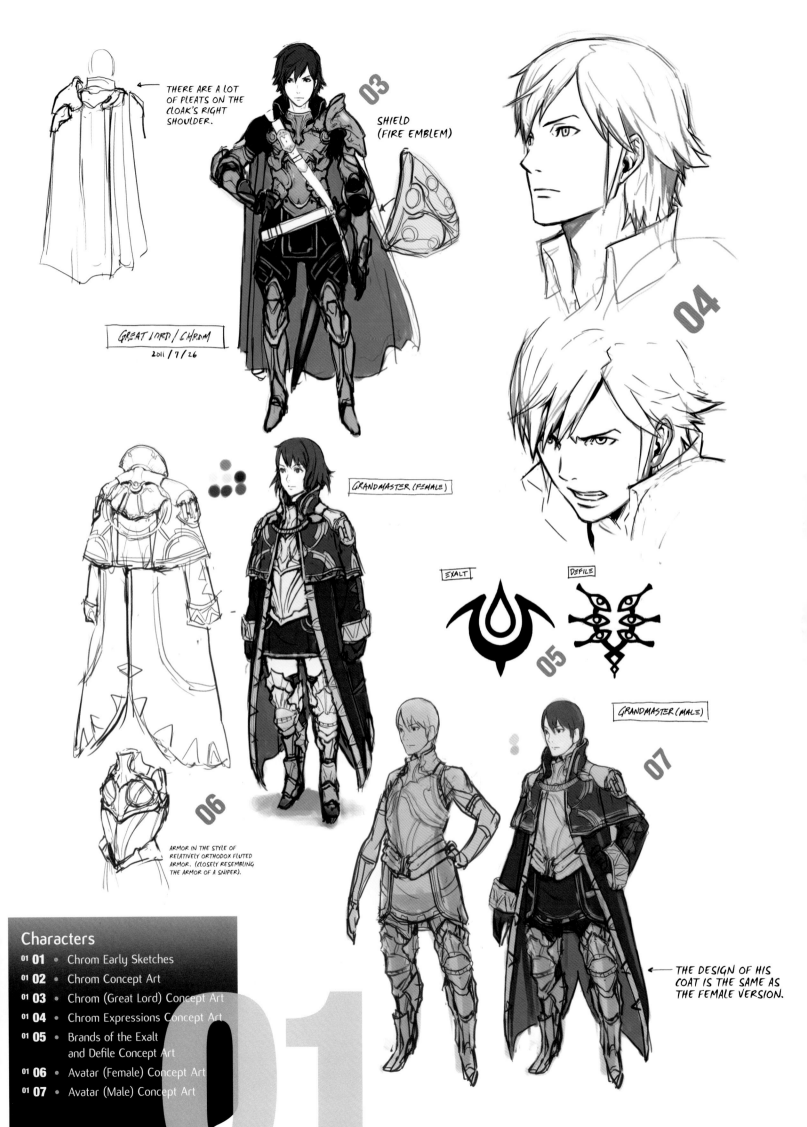

THERE ARE A LOT OF PLEATS ON THE CLOAK'S RIGHT SHOULDER.

03

SHIELD (FIRE EMBLEM)

GREAT LORD / CHROM
2011 / 7 / 26

04

GRANDMASTER (FEMALE)

EXALT DEFILE

05

06

ARMOR IN THE STYLE OF RELATIVELY ORTHODOX FLUTED ARMOR. (CLOSELY RESEMBLING THE ARMOR OF A SNIPER).

GRANDMASTER (MALE)

07

THE DESIGN OF HIS COAT IS THE SAME AS THE FEMALE VERSION.

Characters

01

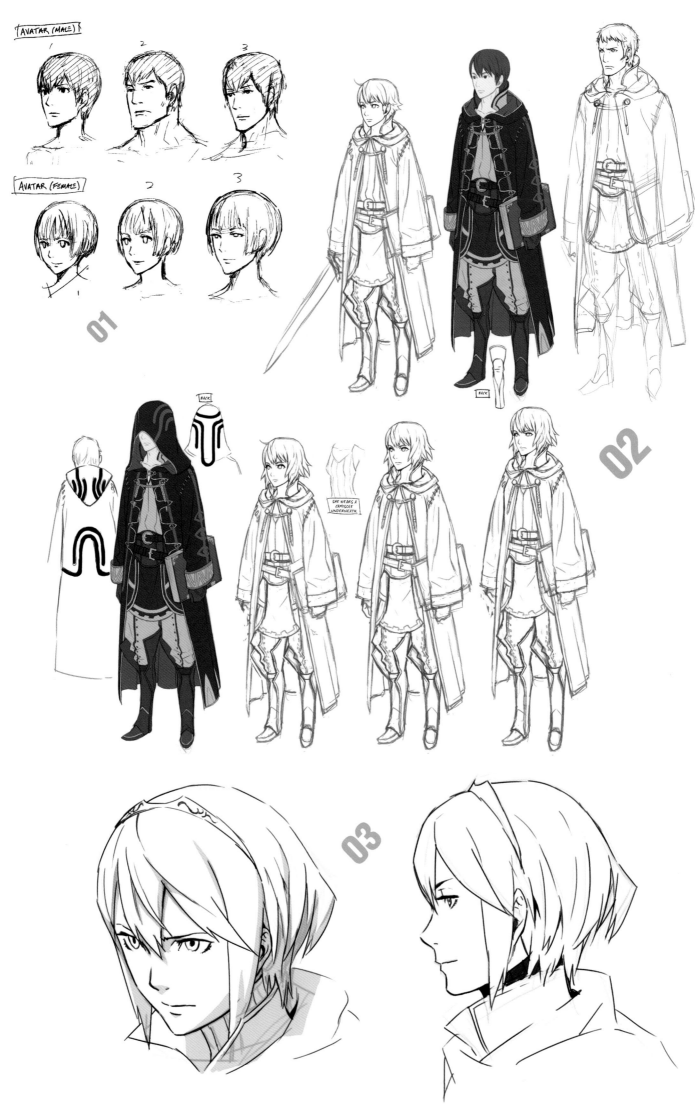

AVATAR (MALE)

AVATAR (FEMALE)

BACK

BACK

SHE WEARS A CAMISOLE UNDERNEATH.

01

02

03

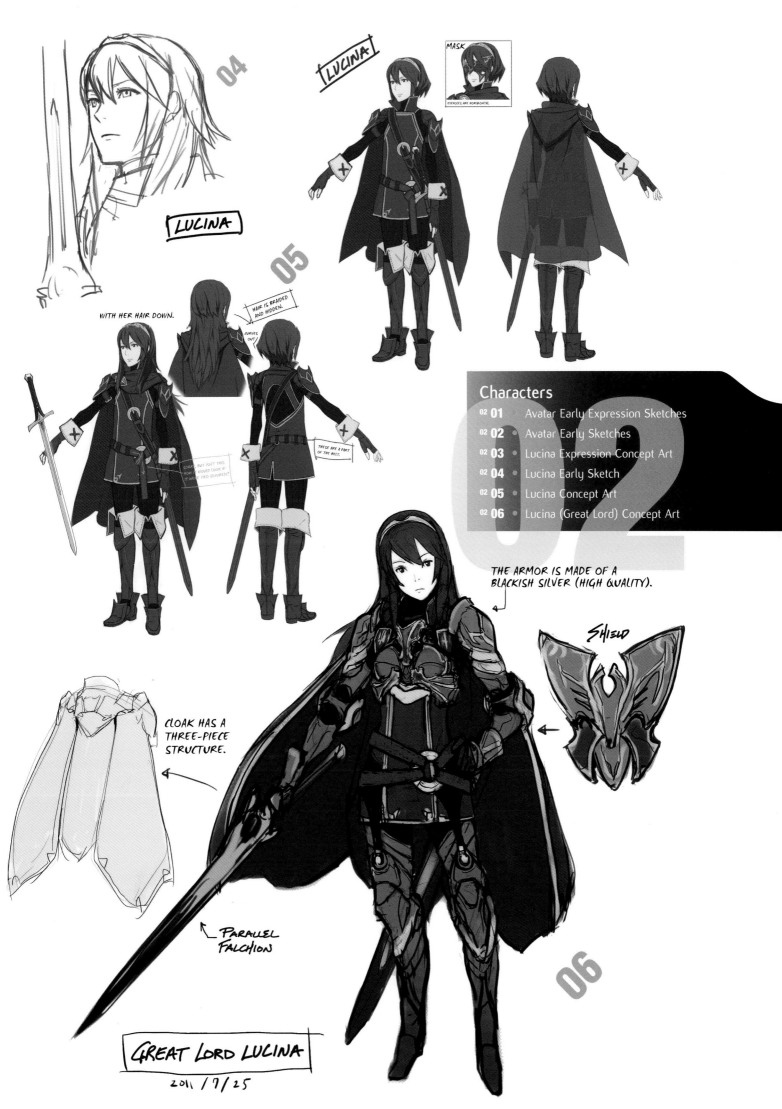

04

[LUCINA]

05

[LUCINA]

MASK

EYEHOLES ARE HORIZONTAL.

WITH HER HAIR DOWN.

HAIR IS BRAIDED AND HIDDEN.

CURVES OUT!

SORRY, BUT ISN'T THIS HORN... WOULD LOOK IF IT WERE TIED SECURELY?

THESE ARE A PART OF THE BELT.

02

THE ARMOR IS MADE OF A BLACKISH SILVER (HIGH QUALITY).

SHIELD

CLOAK HAS A THREE-PIECE STRUCTURE.

PARALLEL FALCHION

06

[GREAT LORD LUCINA]

2011 / 7 / 25

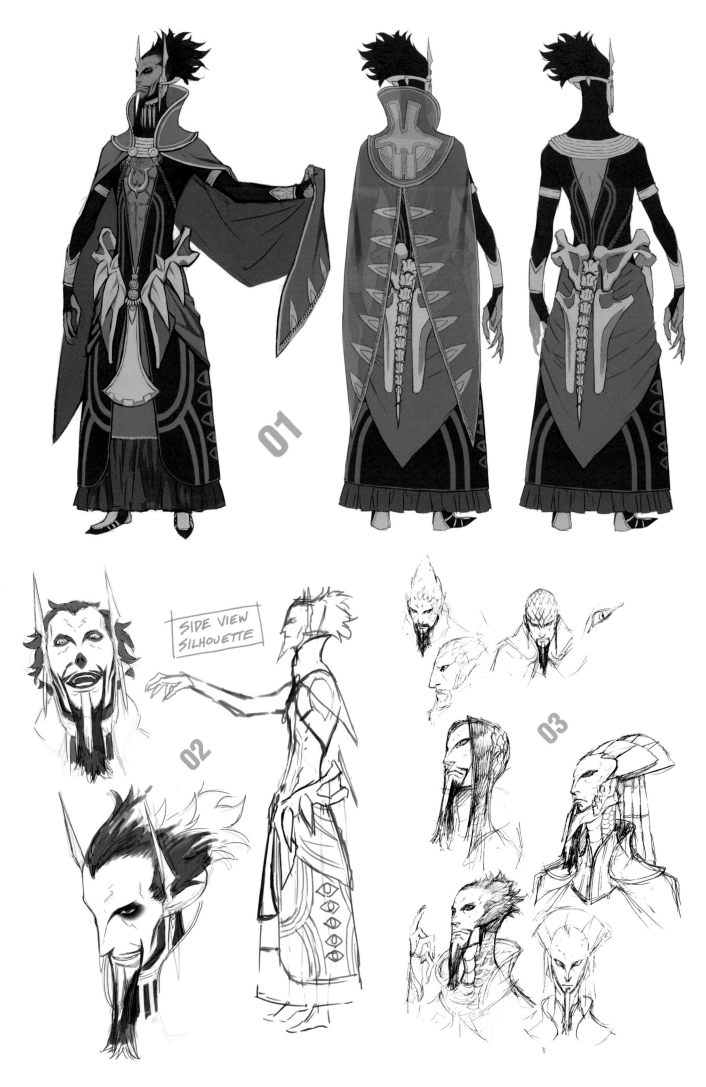

SIDE VIEW
SILHOUETTE

01

02

03

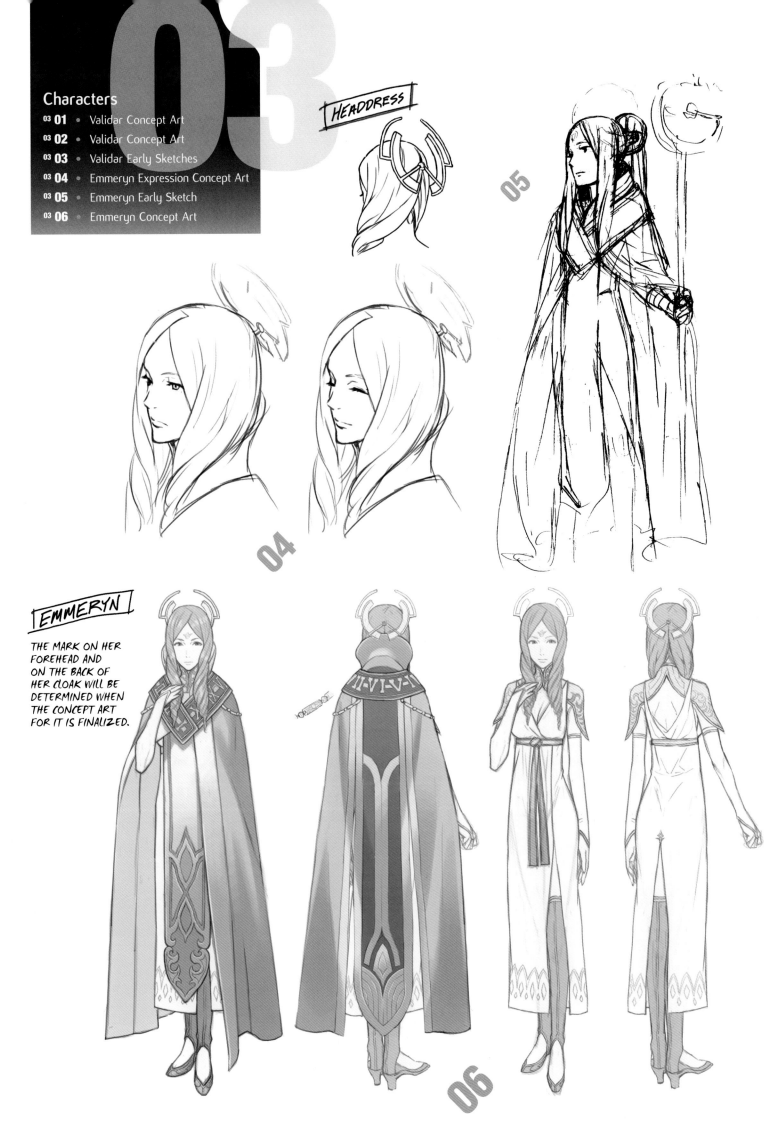

03

Characters

HEADDRESS

05

04

EMMERYN

THE MARK ON HER
FOREHEAD AND
ON THE BACK OF
HER CLOAK WILL BE
DETERMINED WHEN
THE CONCEPT ART
FOR IT IS FINALIZED.

06

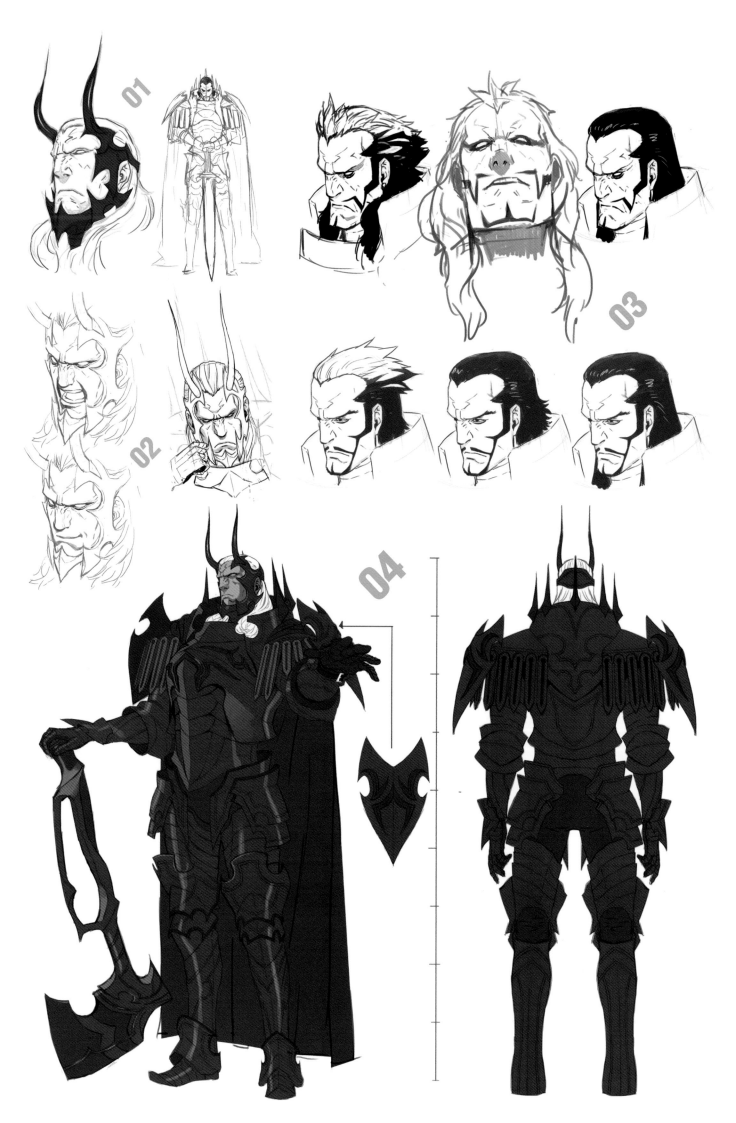

01

02

03

04

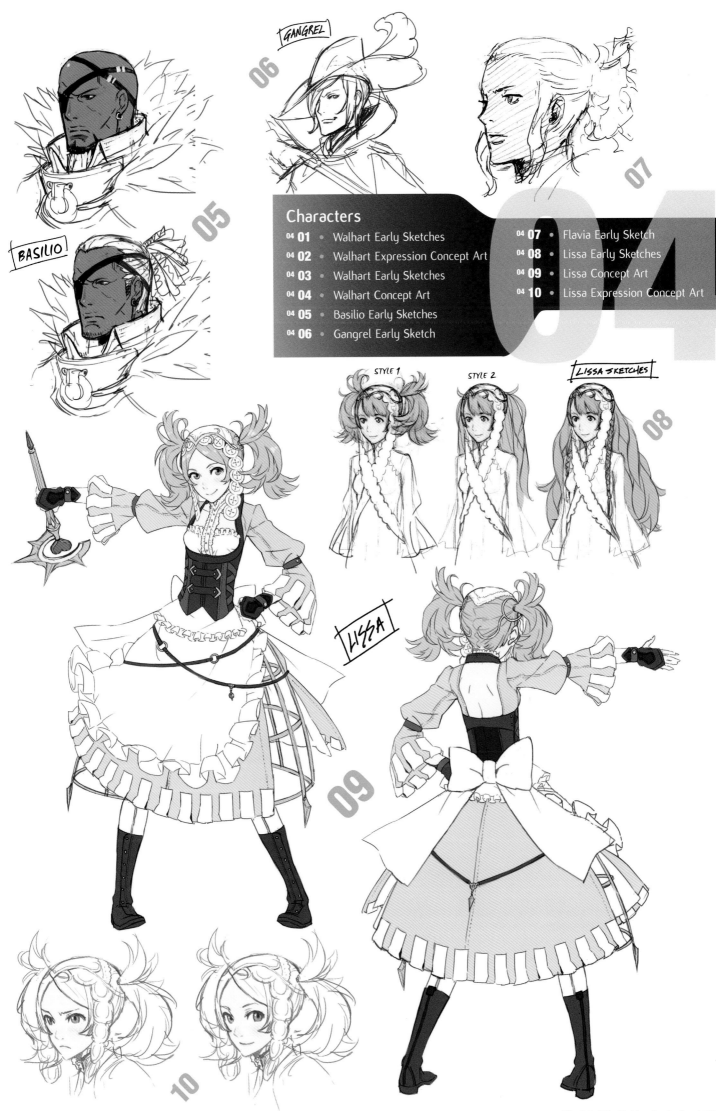

GANGREL

06

07

BASILIO

05

04

STYLE 1 STYLE 2 LISSA SKETCHES

08

LISSA

09

10

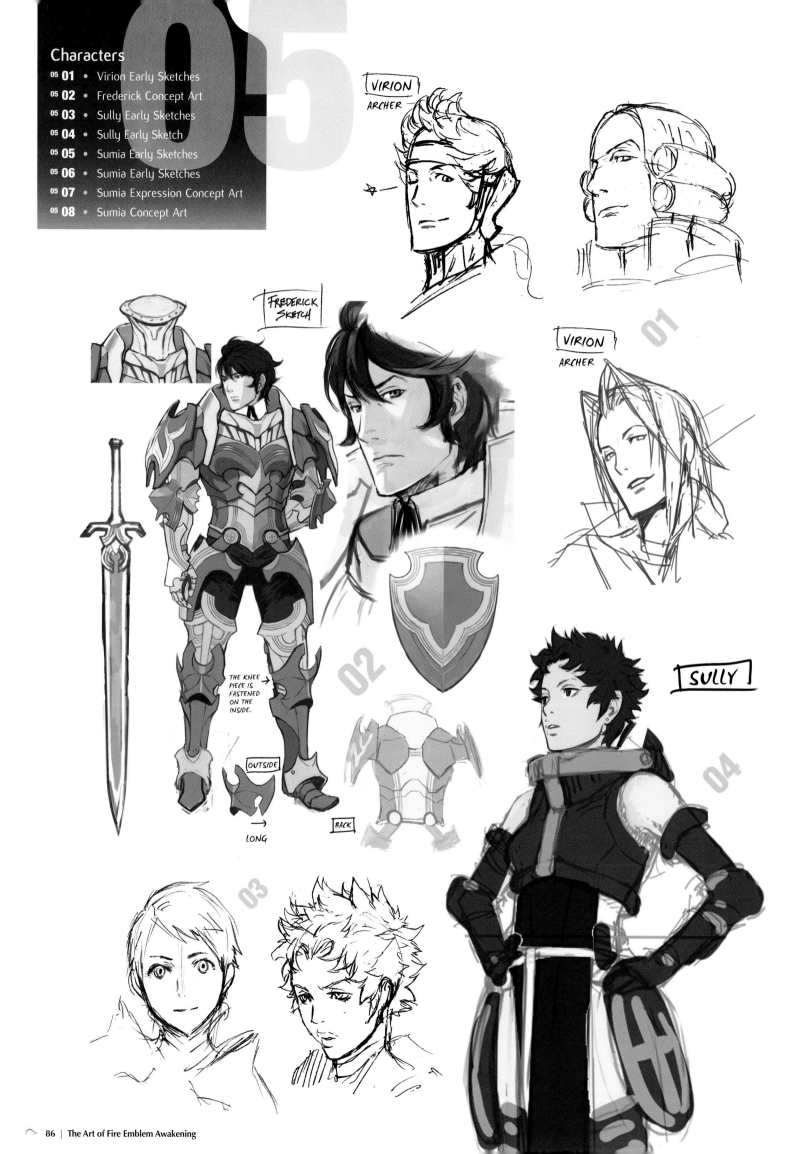

Characters

05

VIRION
ARCHER

FREDERICK SKETCH

VIRION
ARCHER

01

THE KNEE PIECE IS FASTENED ON THE INSIDE.

02

OUTSIDE

LONG

BACK

SULLY

04

03

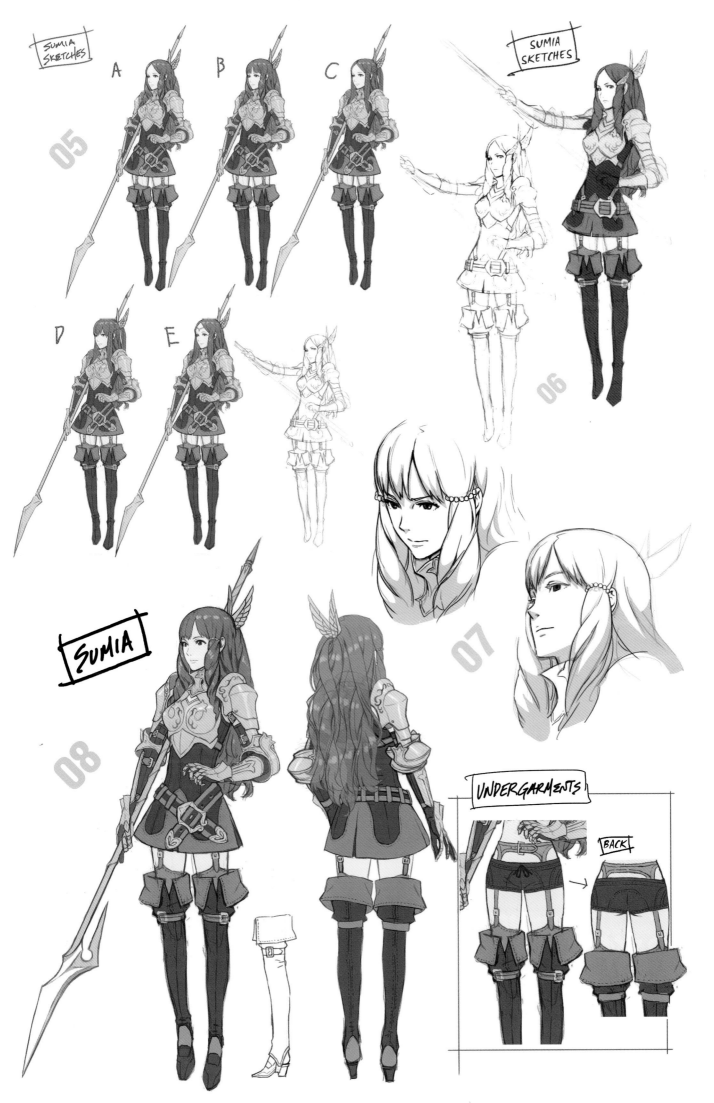

SUMIA SKETCHES

A B C

05

D E

SUMIA SKETCHES

06

07

SUMIA

08

UNDERGARMENTS

BACK

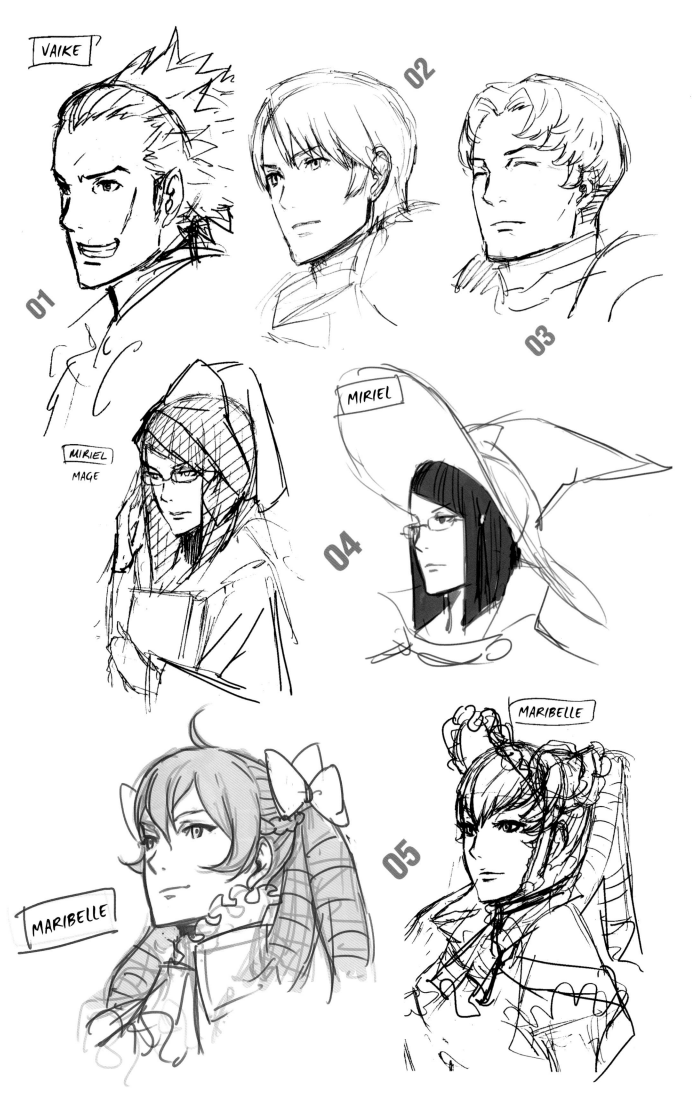

VAIKE

01

02

03

MIRIEL
MAGE

MIRIEL

04

MARIBELLE

MARIBELLE

05

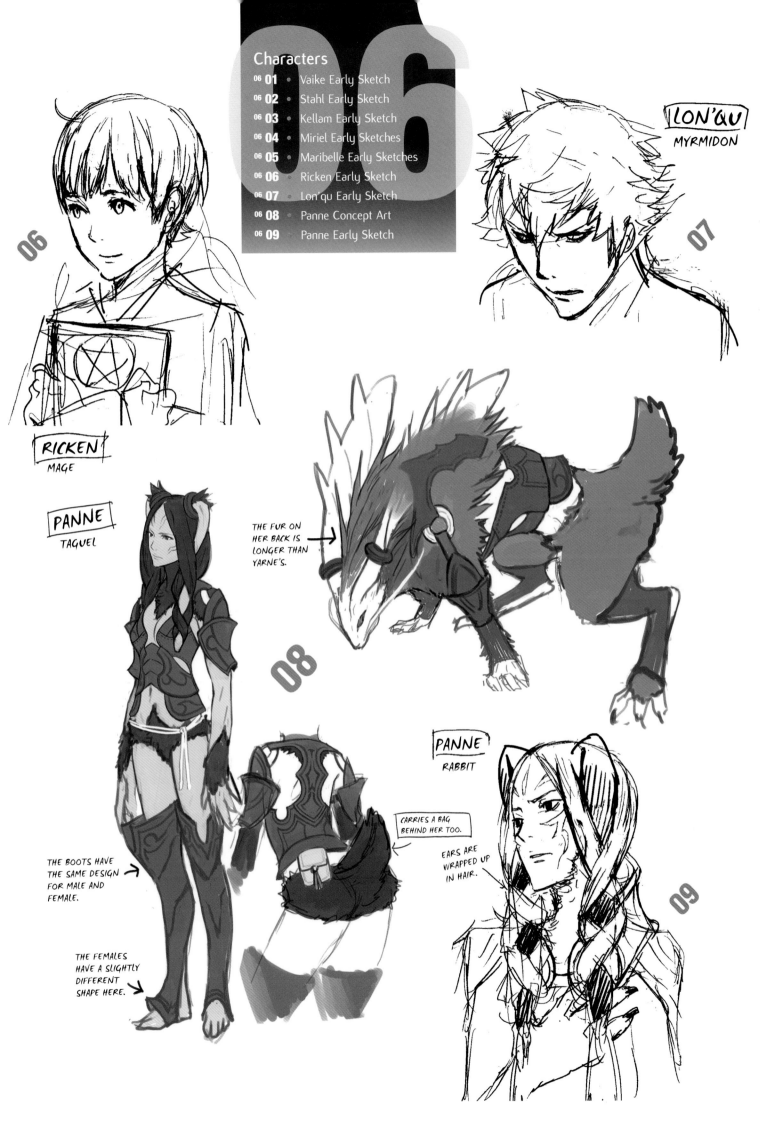

06

LON'QU
MYRMIDON

07

RICKEN
MAGE

PANNE
TAGUEL

THE FUR ON
HER BACK IS
LONGER THAN
YARNE'S.

08

THE BOOTS HAVE
THE SAME DESIGN
FOR MALE AND
FEMALE.

THE FEMALES
HAVE A SLIGHTLY
DIFFERENT
SHAPE HERE.

CARRIES A BAG
BEHIND HER TOO.

PANNE
RABBIT

EARS ARE
WRAPPED UP
IN HAIR.

09

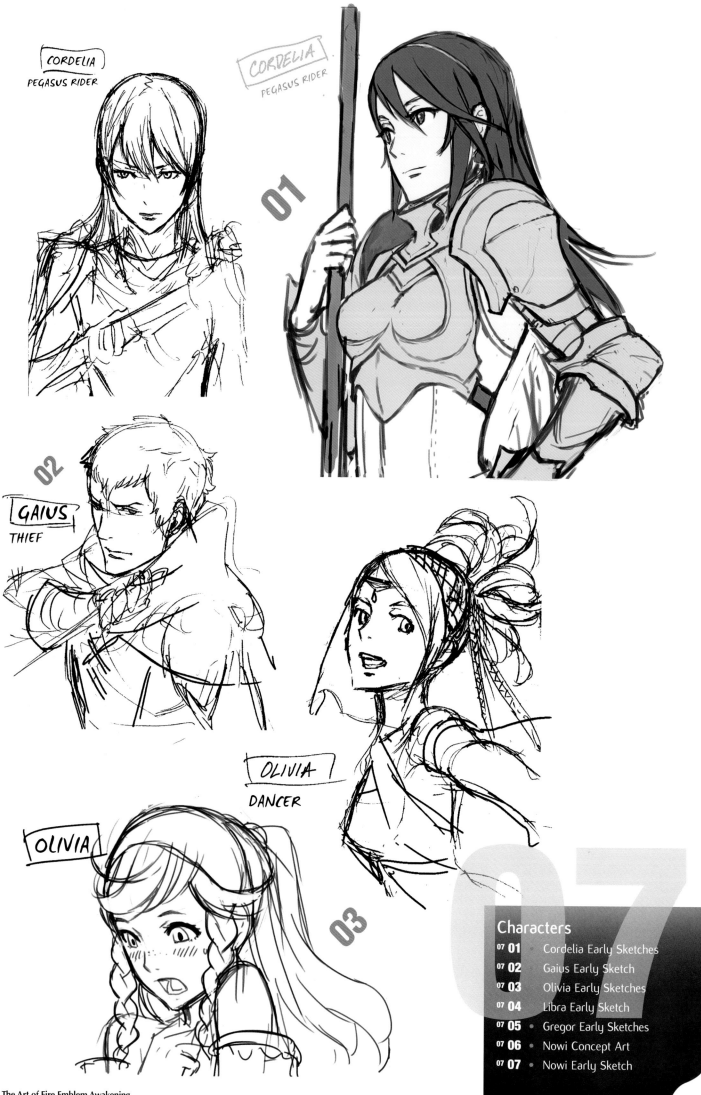

CORDELIA
PEGASUS RIDER

CORDELIA
PEGASUS RIDER

01

02

GAIUS
THIEF

OLIVIA
DANCER

OLIVIA

03

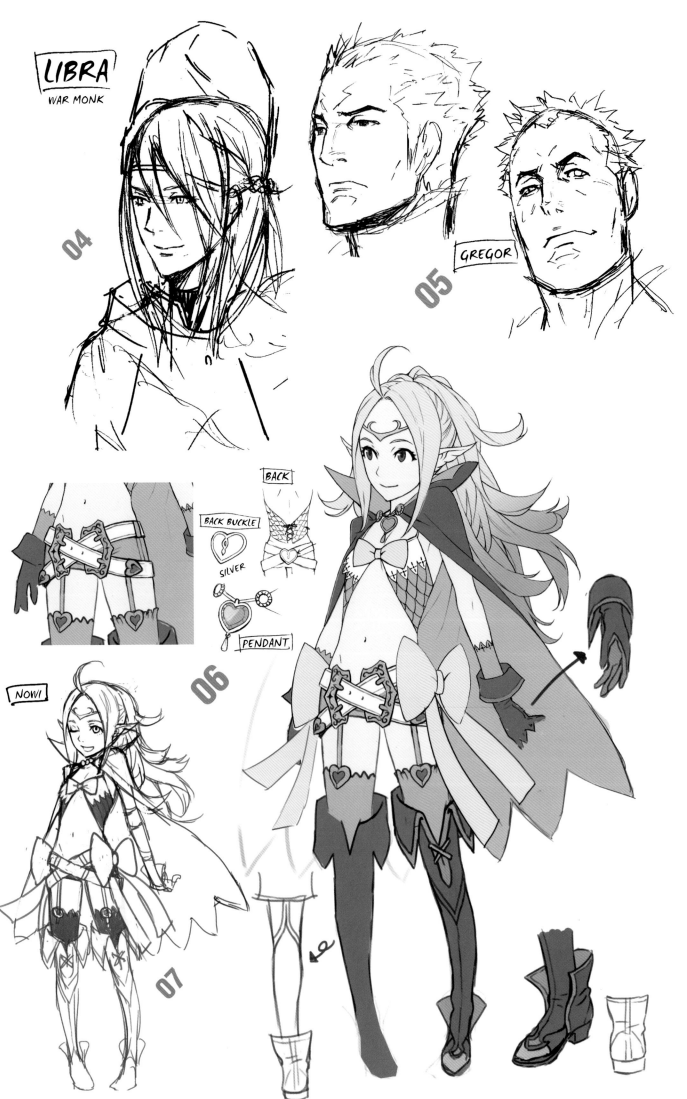

LIBRA
WAR MONK

04

05

GREGOR

BACK

BACK BUCKLE

SILVER

PENDANT

06

NOWI

07

MANAKETE (AFTER TRANSFORMATION) 1
DIVINE DRAGON TRIBE TYPE
(THEY HAVE FINS ALL OVER THEIR BODIES, LIKE LEAFY SEA DRAGONS)

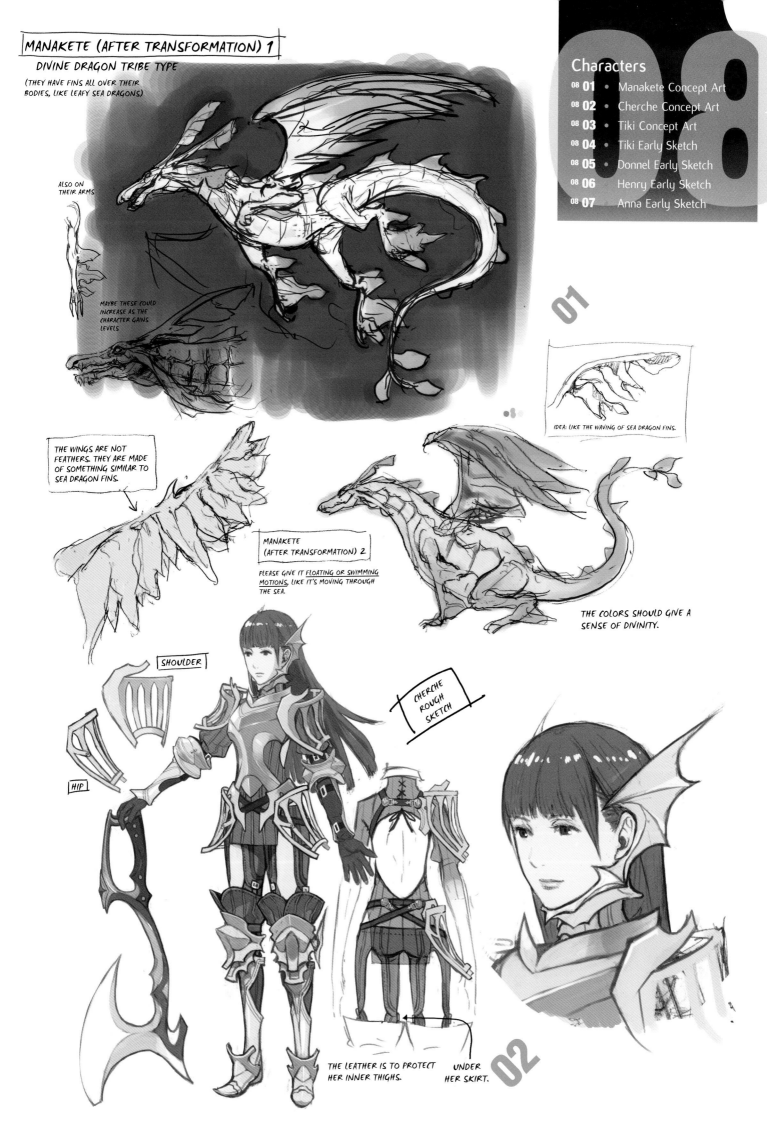

ALSO ON THEIR ARMS

MAYBE THESE COULD INCREASE AS THE CHARACTER GAINS LEVELS

01

IDEA: LIKE THE WAVING OF SEA DRAGON FINS.

THE WINGS ARE NOT FEATHERS. THEY ARE MADE OF SOMETHING SIMILAR TO SEA DRAGON FINS.

MANAKETE
(AFTER TRANSFORMATION) 2

PLEASE GIVE IT FLOATING OR SWIMMING MOTIONS, LIKE IT'S MOVING THROUGH THE SEA.

THE COLORS SHOULD GIVE A SENSE OF DIVINITY.

SHOULDER

HIP

CHERCHE ROUGH SKETCH

THE LEATHER IS TO PROTECT HER INNER THIGHS.

UNDER HER SKIRT.

02

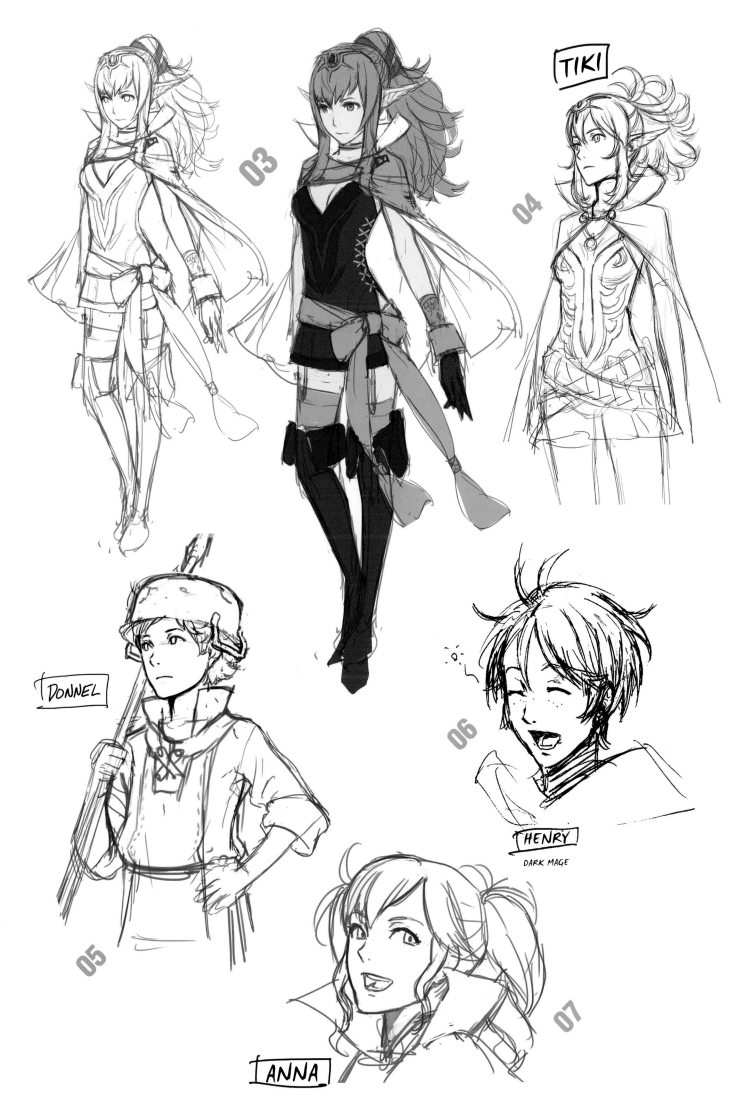

03

04

TIKI

DONNEL

05

06

HENRY

DARK MAGE

07

ANNA

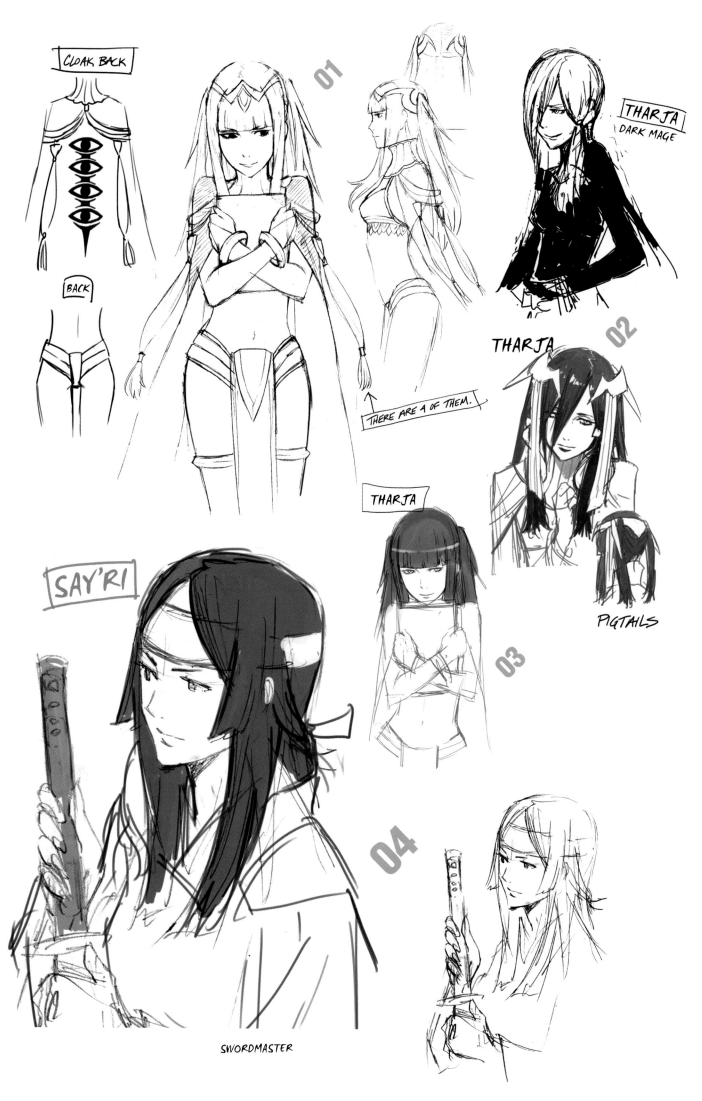

CLOAK BACK

BACK

01

THARJA
DARK MAGE

THERE ARE 4 OF THEM.

THARJA

02

THARJA

PIGTAILS

SAY'RI

03

04

SWORDMASTER

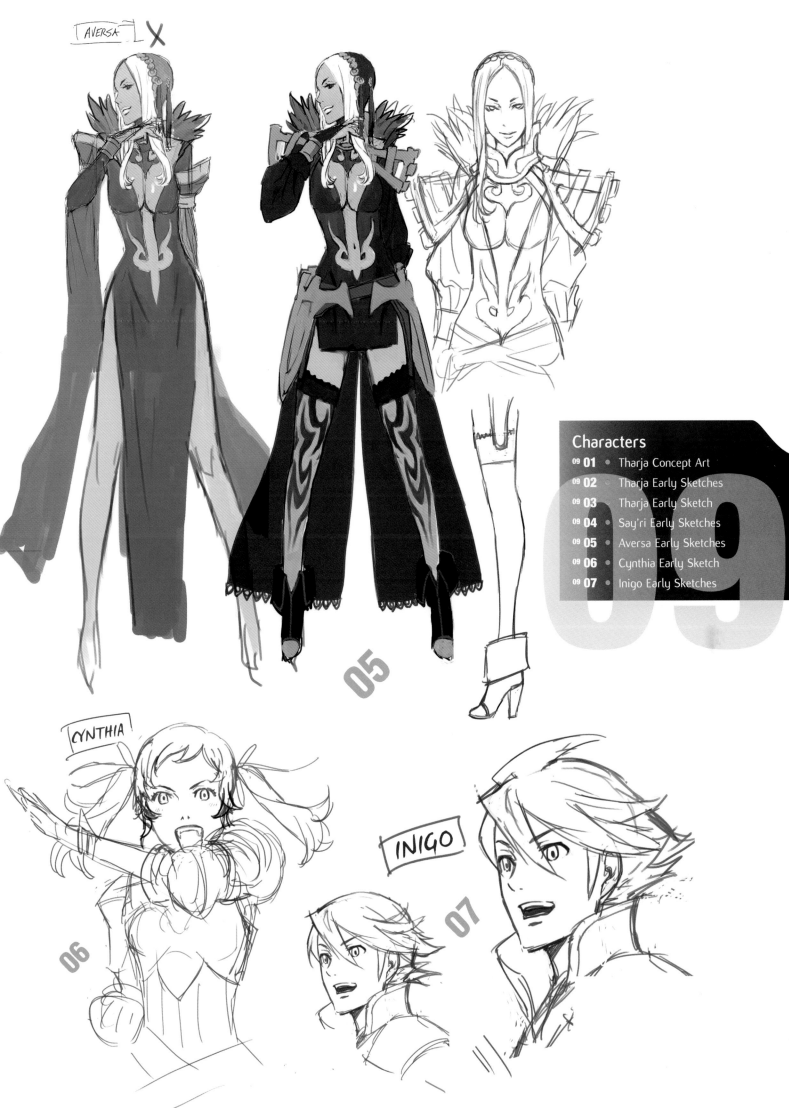

AVERSA ✗

05

CYNTHIA

06

INIGO

07

Characters

09

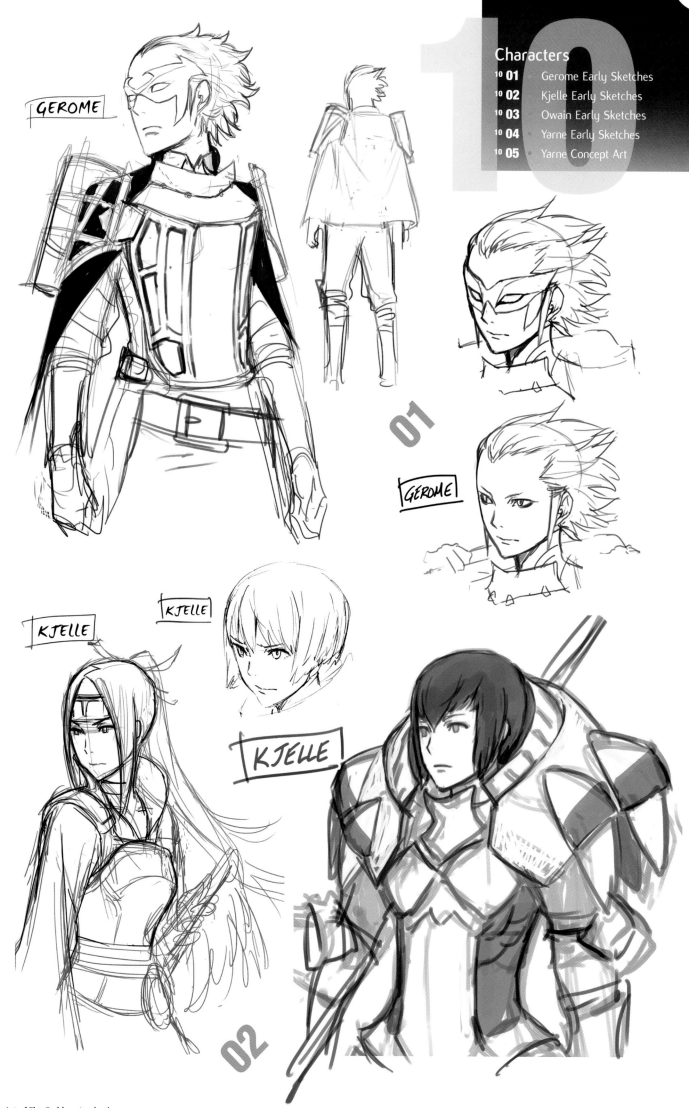

GEROME

01

GEROME

KJELLE

KJELLE

KJELLE

02

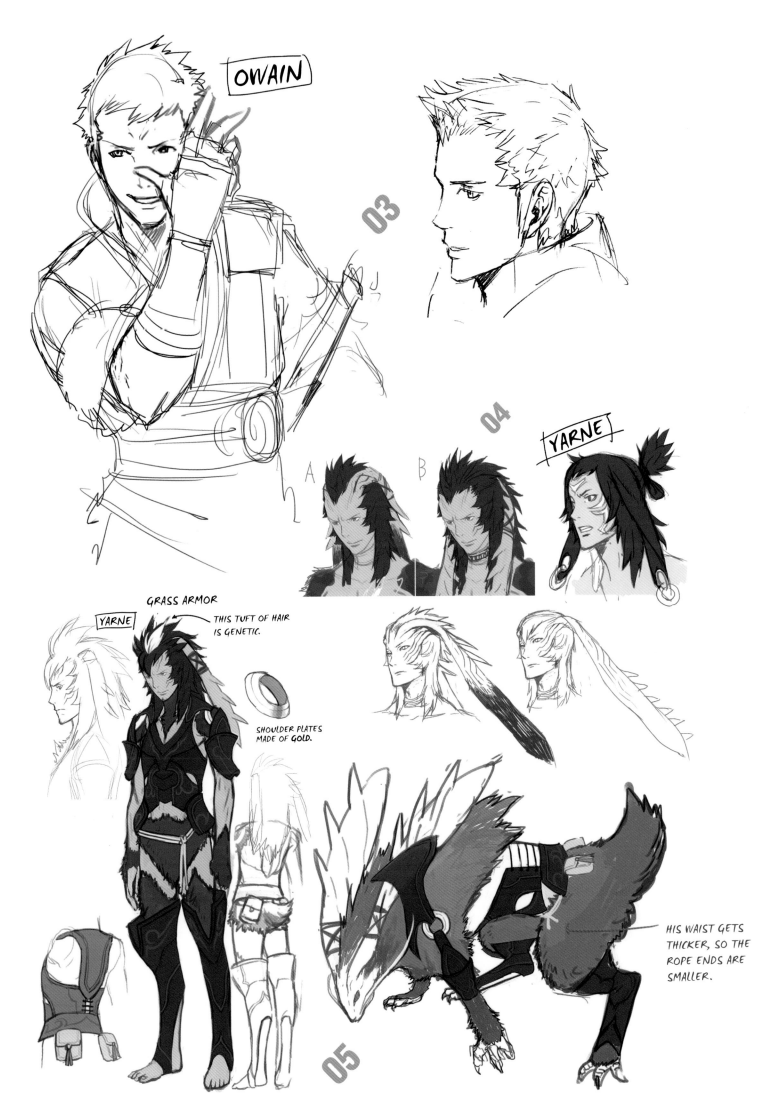

OWAIN

03

04

YARNE

A

B

YARNE

GRASS ARMOR

THIS TUFT OF HAIR IS GENETIC.

SHOULDER PLATES MADE OF GOLD.

05

HIS WAIST GETS THICKER, SO THE ROPE ENDS ARE SMALLER.

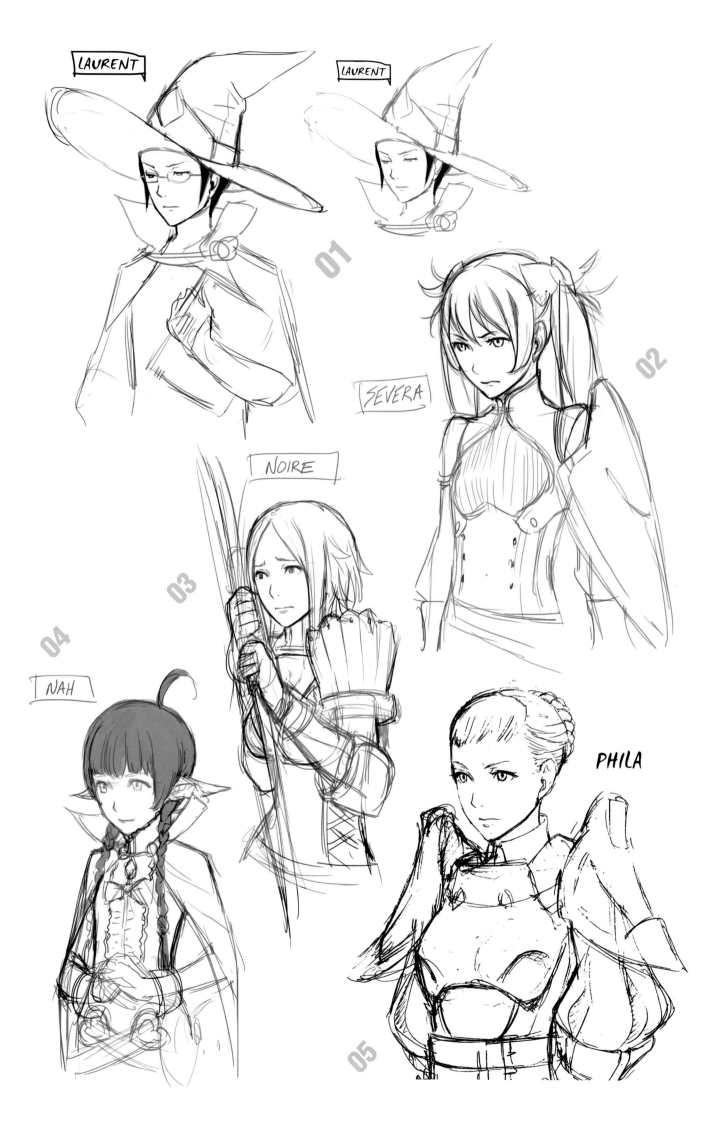

LAURENT

LAURENT

01

SEVERA

02

NOIRE

03

04

NAH

05

PHILA

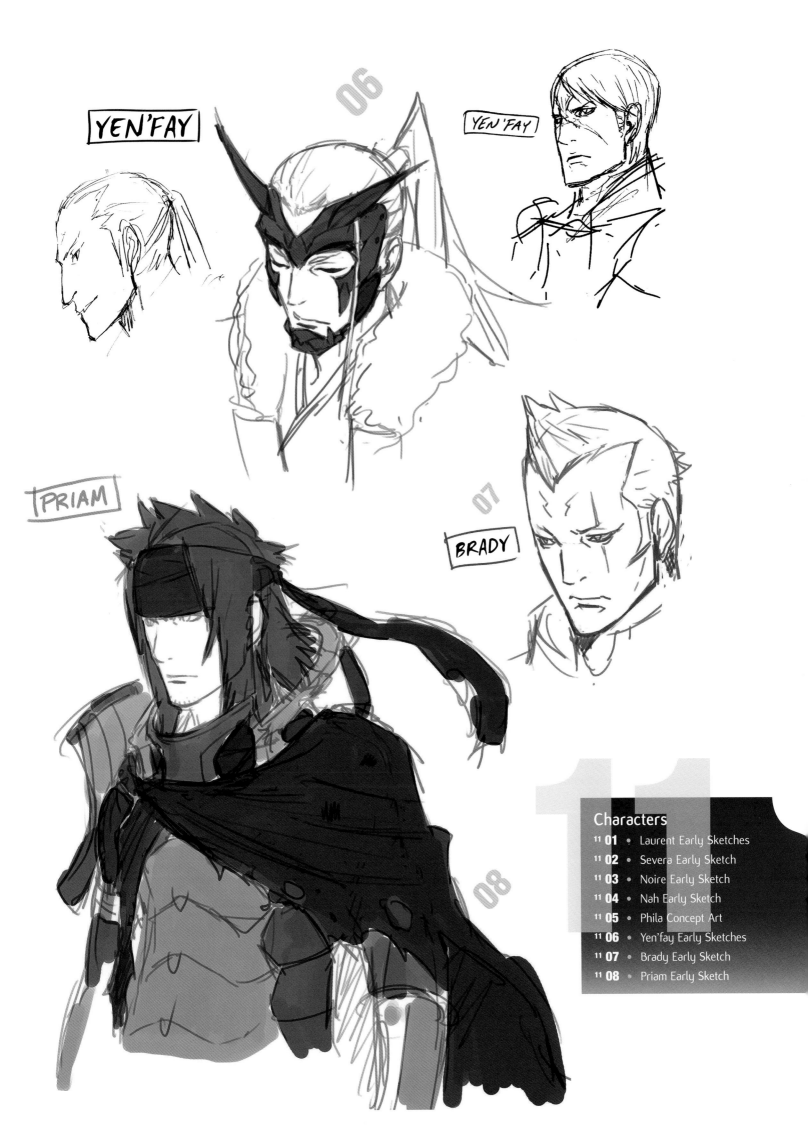

YEN'FAY

YEN'FAY

PRIAM

BRADY

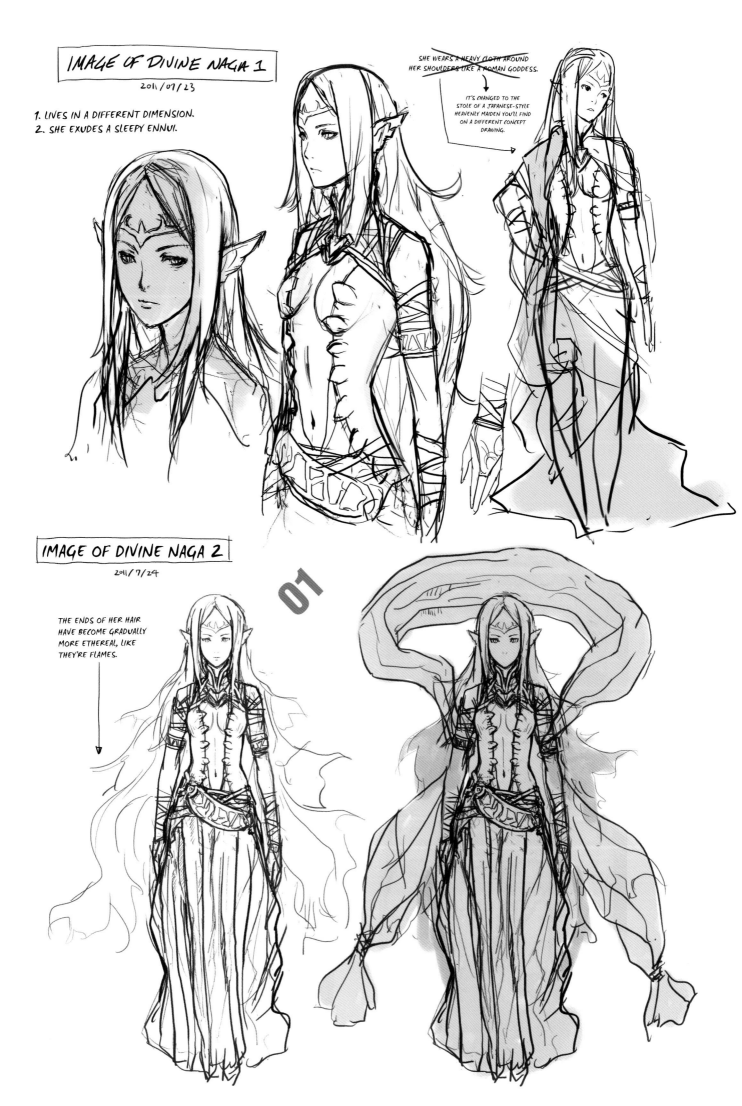

IMAGE OF DIVINE NAGA 1

2011/07/23

1. LIVES IN A DIFFERENT DIMENSION.
2. SHE EXUDES A SLEEPY ENNUI.

SHE WEARS A HEAVY CLOTH AROUND HER SHOULDERS LIKE A ROMAN GODDESS.

IT'S CHANGED TO THE STOLE OF A JAPANESE-STYLE HEAVENLY MAIDEN YOU'LL FIND ON A DIFFERENT CONCEPT DRAWING.

IMAGE OF DIVINE NAGA 2

2011/7/24

THE ENDS OF HER HAIR HAVE BECOME GRADUALLY MORE ETHEREAL, LIKE THEY'RE FLAMES.

01

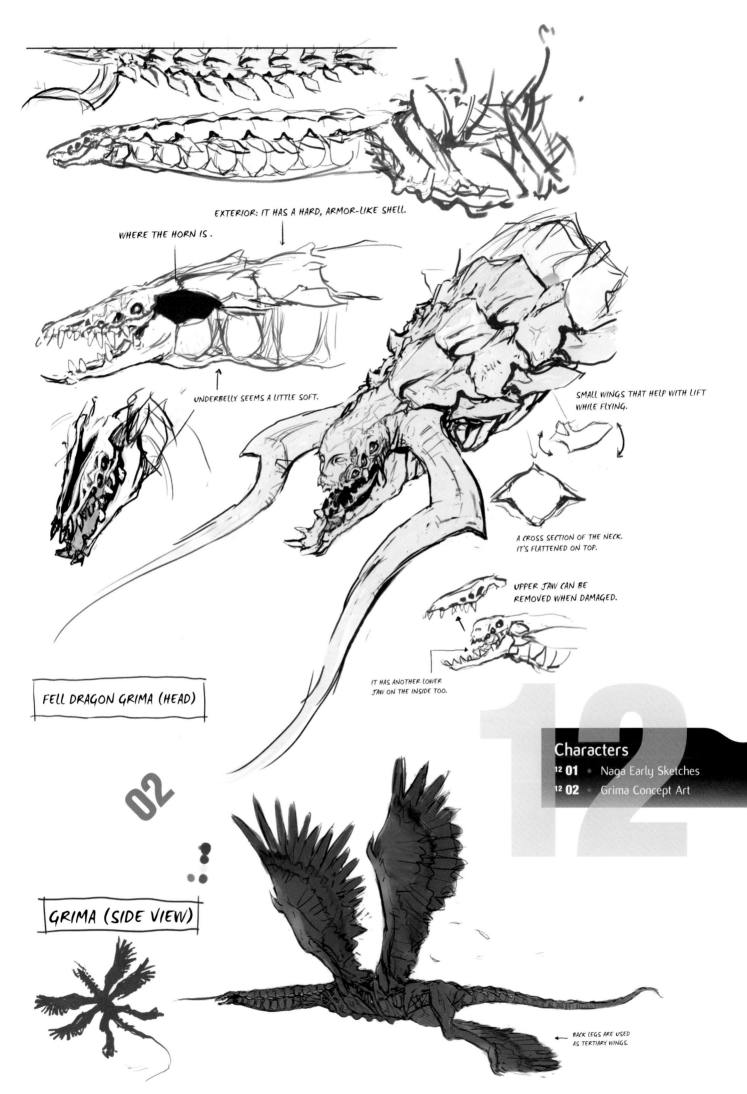

EXTERIOR: IT HAS A HARD, ARMOR-LIKE SHELL.

WHERE THE HORN IS.

UNDERBELLY SEEMS A LITTLE SOFT.

SMALL WINGS THAT HELP WITH LIFT WHILE FLYING.

A CROSS SECTION OF THE NECK. IT'S FLATTENED ON TOP.

UPPER JAW CAN BE REMOVED WHEN DAMAGED.

IT HAS ANOTHER LOWER JAW ON THE INSIDE TOO.

FELL DRAGON GRIMA (HEAD)

02

GRIMA (SIDE VIEW)

BACK LEGS ARE USED AS TERTIARY WINGS.

12

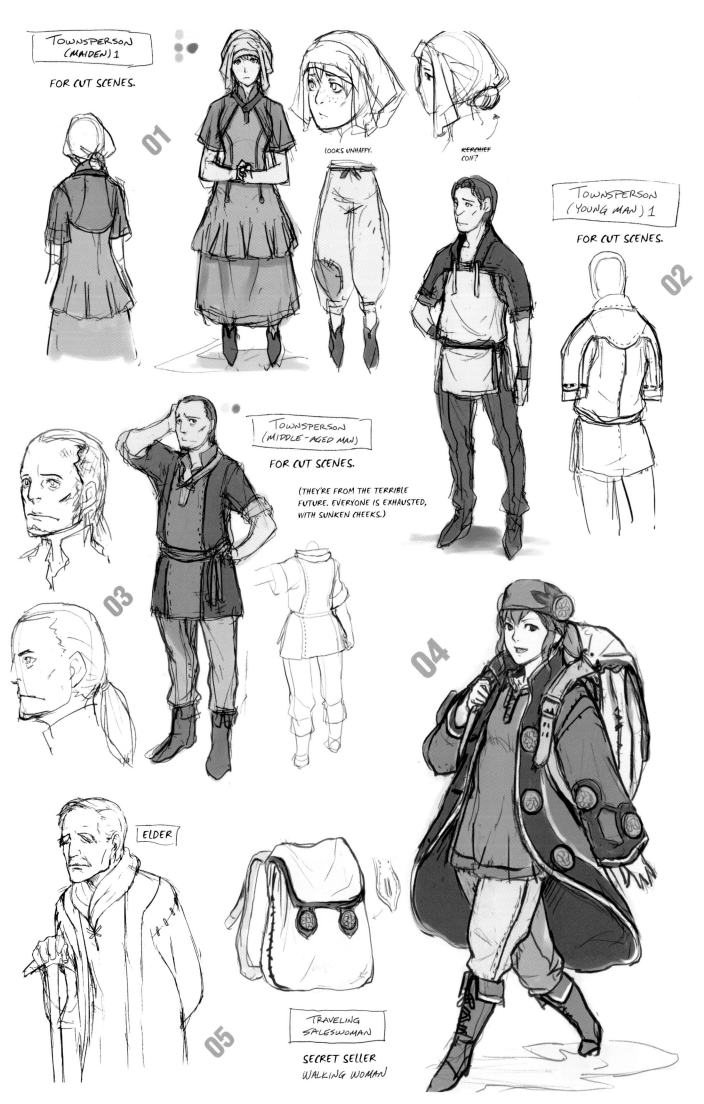

TOWNSPERSON
(MAIDEN) 1

FOR CUT SCENES.

01

LOOKS UNHAPPY.

KERCHIEF
COIF?

TOWNSPERSON
(YOUNG MAN) 1

FOR CUT SCENES.

02

TOWNSPERSON
(MIDDLE-AGED MAN)

FOR CUT SCENES.

(THEY'RE FROM THE TERRIBLE
FUTURE. EVERYONE IS EXHAUSTED,
WITH SUNKEN CHEEKS.)

03

04

ELDER

TRAVELING
SALESWOMAN

SECRET SELLER
WALKING WOMAN

05

GARRICK

06

RAIMI

07

ORTON

08

CHALARD

09

VASTO

10

MUSTAFA

11

CAMPARI

12

IGNATIUS

13

14

DALTON

Characters

01 FARBER
CERVANTES
PHEROS
03

EXCELLUS
04
ALGOL
05
GECKO, JAMIL
06

CASSIUS
07
VICTOR & VINCENT
08

14

Costume Design

Costume Design and Concept Art of the Military Units

The costume designs for the countless types of military units were ably handled by art director Toshiyuki Kusakihara and his design team.

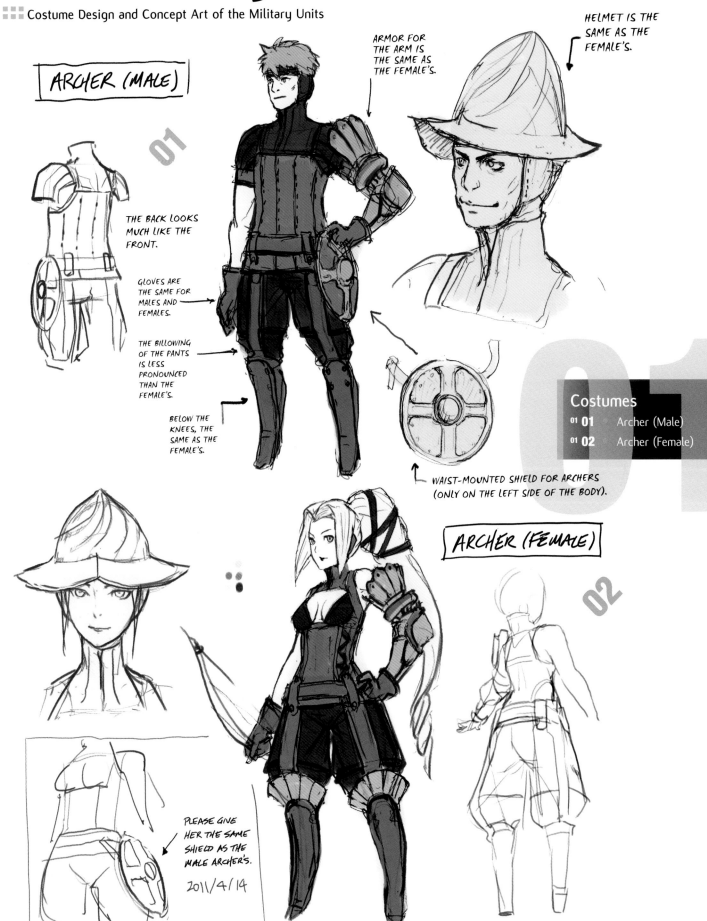

ARCHER (MALE)

01

HELMET IS THE SAME AS THE FEMALE'S.

ARMOR FOR THE ARM IS THE SAME AS THE FEMALE'S.

THE BACK LOOKS MUCH LIKE THE FRONT.

GLOVES ARE THE SAME FOR MALES AND FEMALES.

THE BILLOWING OF THE PANTS IS LESS PRONOUNCED THAN THE FEMALE'S.

BELOW THE KNEES, THE SAME AS THE FEMALE'S.

WAIST-MOUNTED SHIELD FOR ARCHERS (ONLY ON THE LEFT SIDE OF THE BODY).

ARCHER (FEMALE)

02

PLEASE GIVE HER THE SAME SHIELD AS THE MALE ARCHER'S.

2011/4/14

Costumes

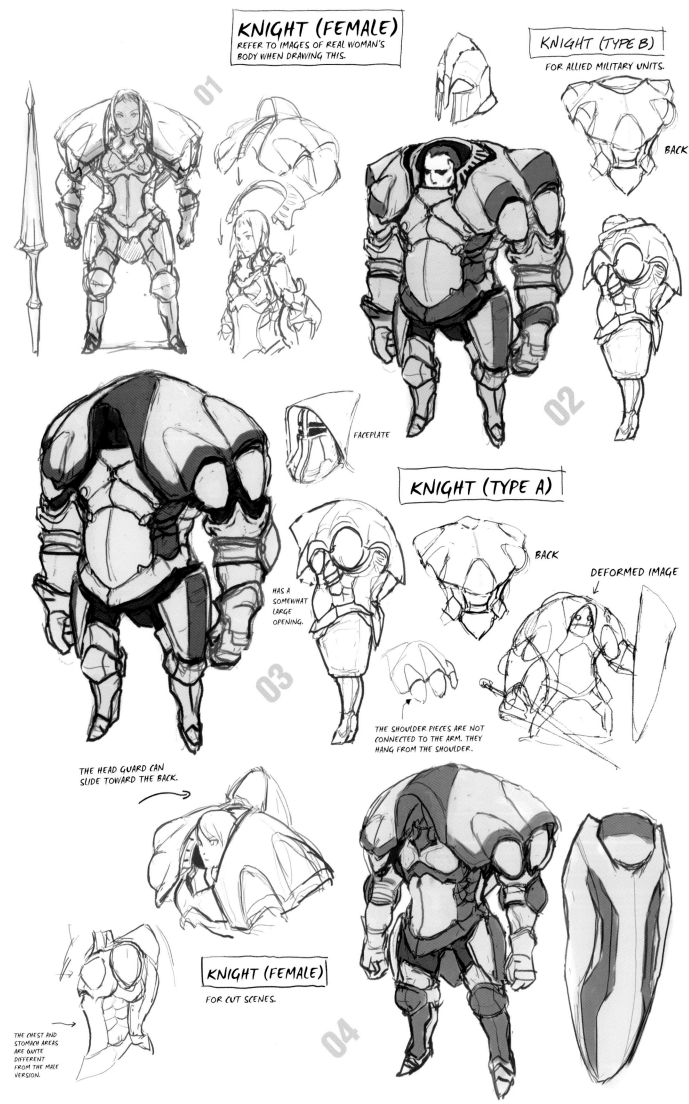

KNIGHT (FEMALE)
REFER TO IMAGES OF REAL WOMAN'S BODY WHEN DRAWING THIS.

01

KNIGHT (TYPE B)
FOR ALLIED MILITARY UNITS.

BACK

02

FACEPLATE

KNIGHT (TYPE A)

HAS A SOMEWHAT LARGE OPENING.

BACK

DEFORMED IMAGE

THE SHOULDER PIECES ARE NOT CONNECTED TO THE ARM. THEY HANG FROM THE SHOULDER.

03

THE HEAD GUARD CAN SLIDE TOWARD THE BACK.

KNIGHT (FEMALE)
FOR CUT SCENES.

THE CHEST AND STOMACH AREAS ARE QUITE DIFFERENT FROM THE MALE VERSION.

04

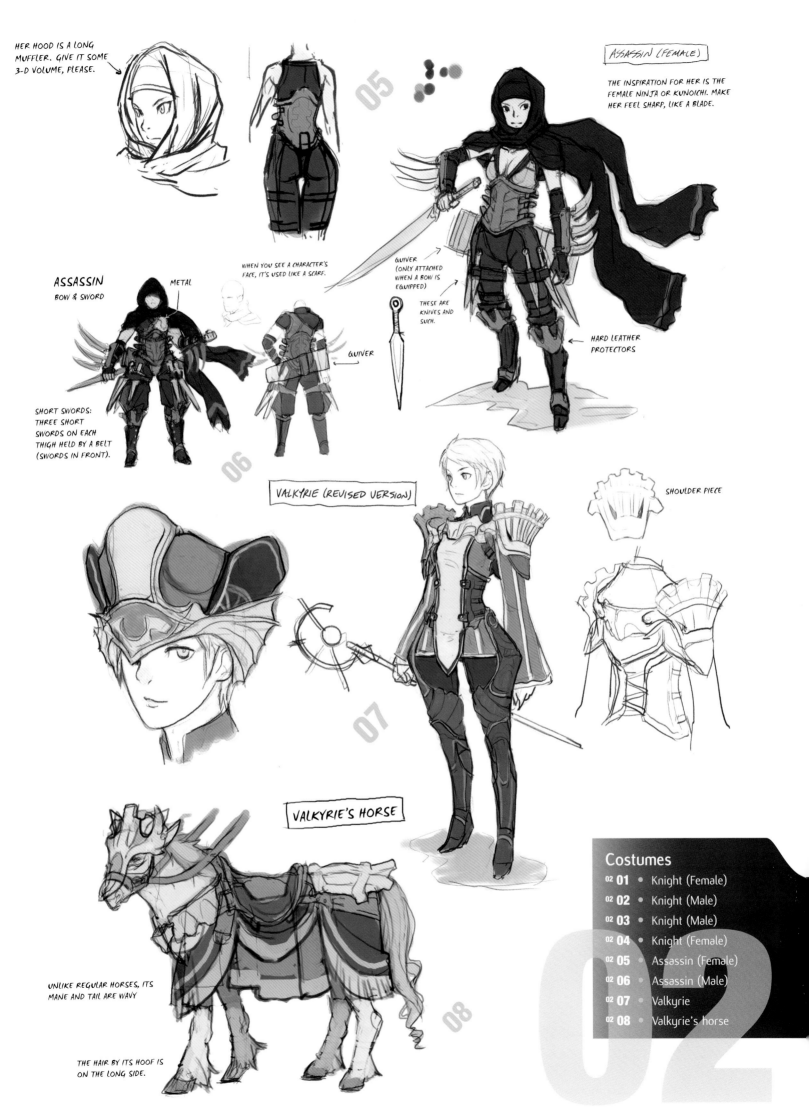

HER HOOD IS A LONG MUFFLER. GIVE IT SOME 3-D VOLUME, PLEASE.

05

ASSASSIN (FEMALE)

THE INSPIRATION FOR HER IS THE FEMALE NINJA OR KUNOICHI. MAKE HER FEEL SHARP, LIKE A BLADE.

ASSASSIN
BOW & SWORD

METAL

WHEN YOU SEE A CHARACTER'S FACE, IT'S USED LIKE A SCARF.

QUIVER (ONLY ATTACHED WHEN A BOW IS EQUIPPED)

THESE ARE KNIVES AND SUCH.

QUIVER

SHORT SWORDS: THREE SHORT SWORDS ON EACH THIGH HELD BY A BELT (SWORDS IN FRONT).

HARD LEATHER PROTECTORS

06

VALKYRIE (REVISED VERSION)

SHOULDER PIECE

VALKYRIE'S HORSE

07

UNLIKE REGULAR HORSES, ITS MANE AND TAIL ARE WAVY

THE HAIR BY ITS HOOF IS ON THE LONG SIDE.

08

02

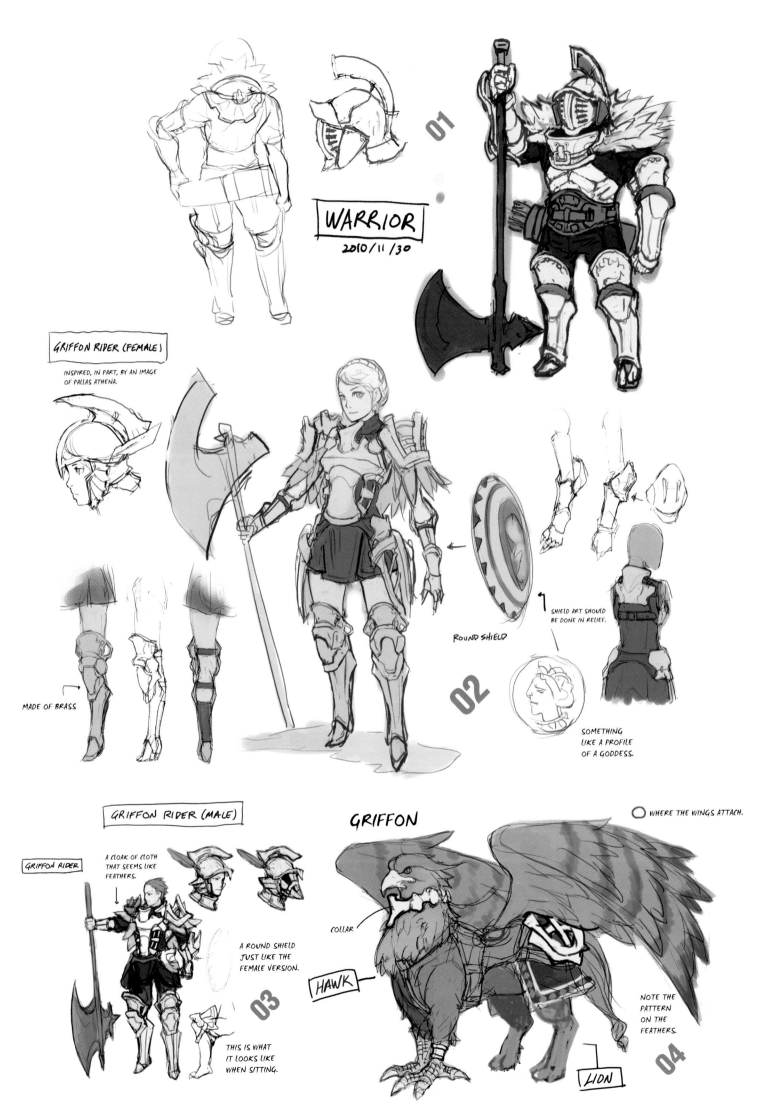

WARRIOR

2010/11/30

01

GRIFFON RIDER (FEMALE)

INSPIRED, IN PART, BY AN IMAGE OF PALLAS ATHENA.

MADE OF BRASS

ROUND SHIELD

SHIELD ART SHOULD BE DONE IN RELIEF.

SOMETHING LIKE A PROFILE OF A GODDESS.

02

GRIFFON RIDER (MALE)

GRIFFON RIDER

A CLOAK OF CLOTH THAT SEEMS LIKE FEATHERS.

A ROUND SHIELD JUST LIKE THE FEMALE VERSION.

THIS IS WHAT IT LOOKS LIKE WHEN SITTING.

03

GRIFFON

WHERE THE WINGS ATTACH.

COLLAR

HAWK

LION

NOTE THE PATTERN ON THE FEATHERS.

04

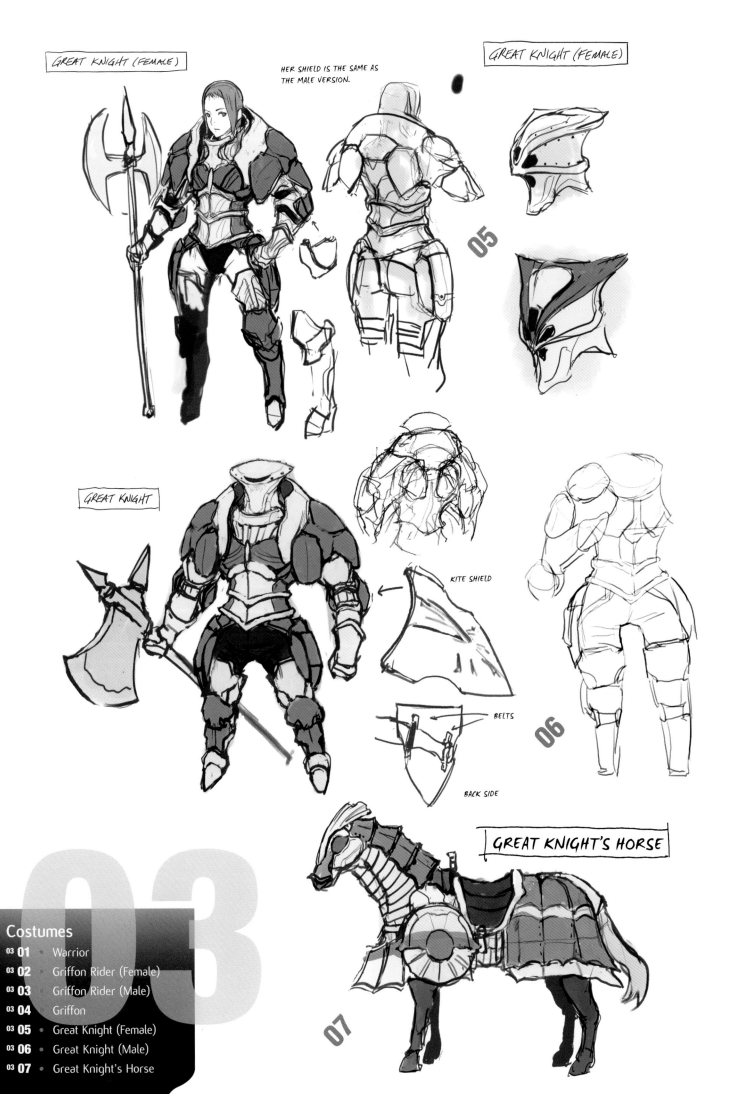

GREAT KNIGHT (FEMALE)

HER SHIELD IS THE SAME AS THE MALE VERSION.

GREAT KNIGHT (FEMALE)

05

GREAT KNIGHT

KITE SHIELD

BELTS

BACK SIDE

06

GREAT KNIGHT'S HORSE

07

03

Costumes

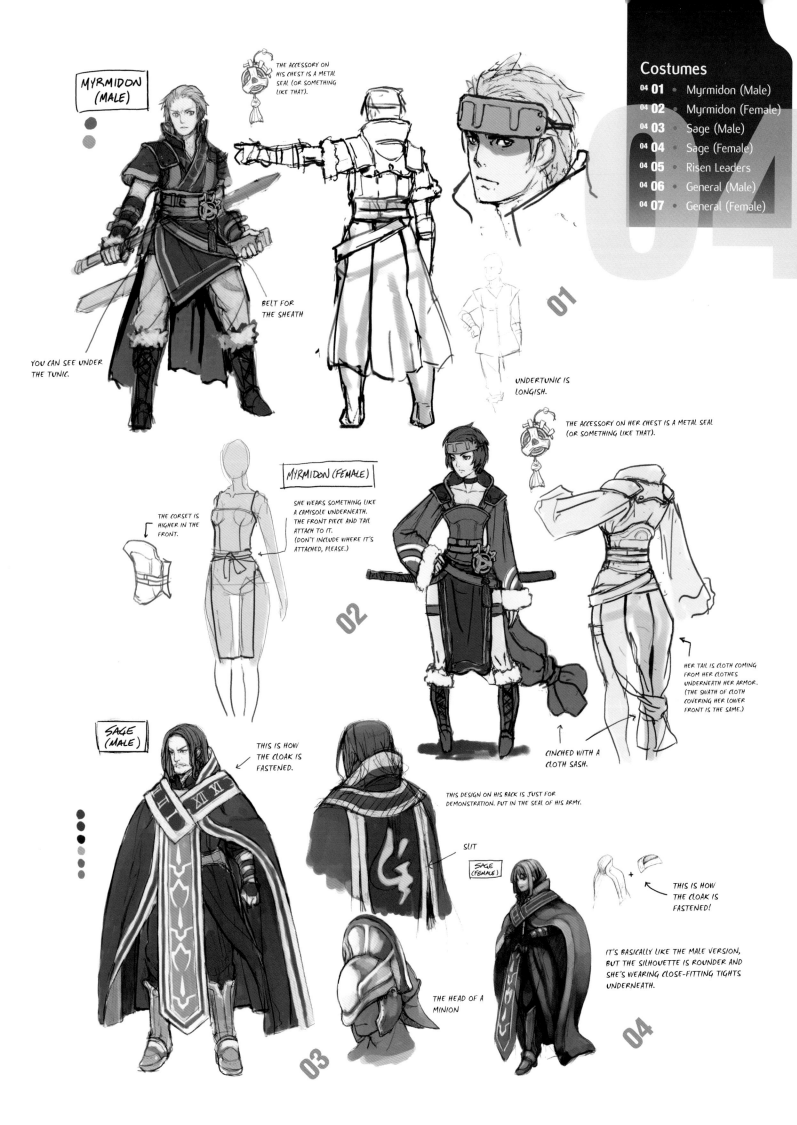

MYRMIDON (MALE)

THE ACCESSORY ON HIS CHEST IS A METAL SEAL (OR SOMETHING LIKE THAT).

BELT FOR THE SHEATH

YOU CAN SEE UNDER THE TUNIC.

UNDERTUNIC IS LONGISH.

01

THE CORSET IS HIGHER IN THE FRONT.

MYRMIDON (FEMALE)

SHE WEARS SOMETHING LIKE A CAMISOLE UNDERNEATH. THE FRONT PIECE AND TAIL ATTACH TO IT. (DON'T INCLUDE WHERE IT'S ATTACHED, PLEASE.)

THE ACCESSORY ON HER CHEST IS A METAL SEAL (OR SOMETHING LIKE THAT).

HER TAIL IS CLOTH COMING FROM HER CLOTHES UNDERNEATH HER ARMOR. (THE SWATH OF CLOTH COVERING HER LOWER FRONT IS THE SAME.)

CINCHED WITH A CLOTH SASH.

02

SAGE (MALE)

THIS IS HOW THE CLOAK IS FASTENED.

THIS DESIGN ON HIS BACK IS JUST FOR DEMONSTRATION. PUT IN THE SEAL OF HIS ARMY.

SLIT

SAGE (FEMALE)

THE HEAD OF A MINION

THIS IS HOW THE CLOAK IS FASTENED!

IT'S BASICALLY LIKE THE MALE VERSION, BUT THE SILHOUETTE IS ROUNDER AND SHE'S WEARING CLOSE-FITTING TIGHTS UNDERNEATH.

03

04

RISEN

05

THE HEAD OF THE
ONE POSSESSED.

FEMALE DEATH MASK

FOR MALES

PUFF PUFF

IT'S POURING OUT
OF THE MOUTH.

CHARACTERISTICS
1) EYES GLOW RED.
2) SMOKE COMES OUT OF MOUTH.
3) THE MASK CANNOT BE TAKEN OFF.

(IF SOMEONE TRIES TO PRY THE
MASK OFF, MOST OF THE FACE WILL
COME OFF WITH IT.)

GENERAL (MALE)

IMAGE OF THE GENERAL FROM BEHIND.

06

GENERAL (FEMALE)

07

LIKE IT'S
FLARED OUT.

BACK

A NORMAL
GENERAL'S
SHIELD

SIDE

BACK SIDE

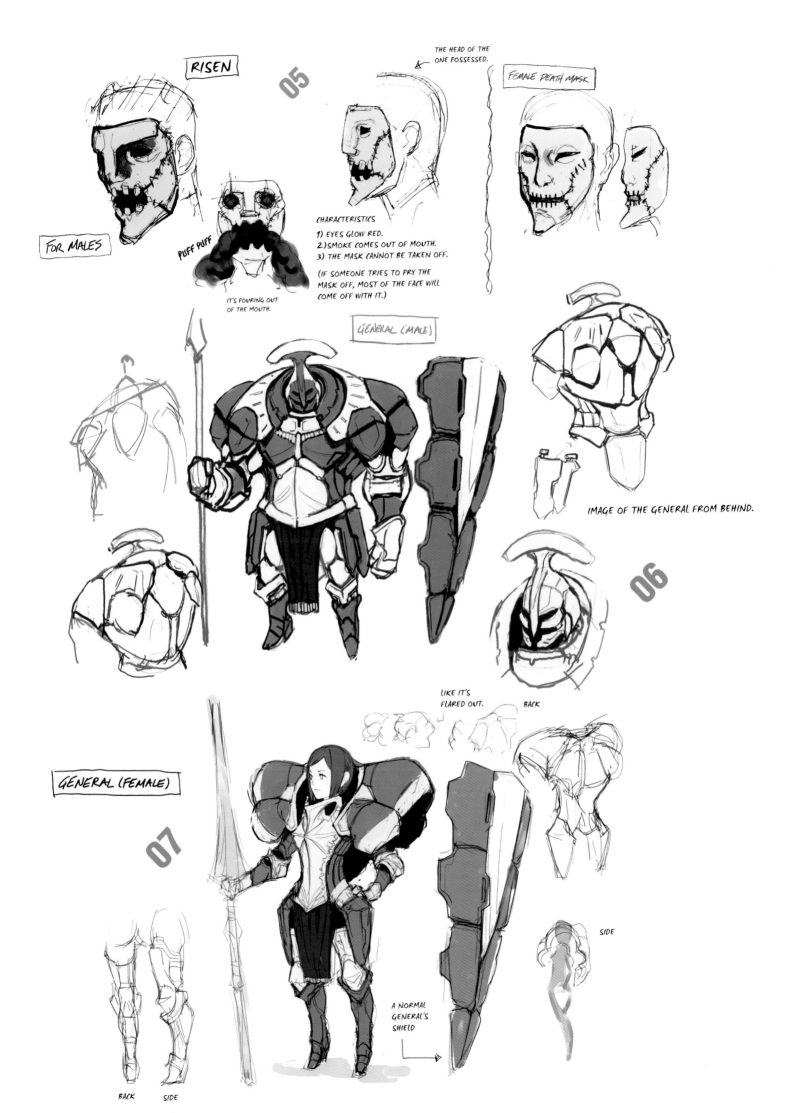

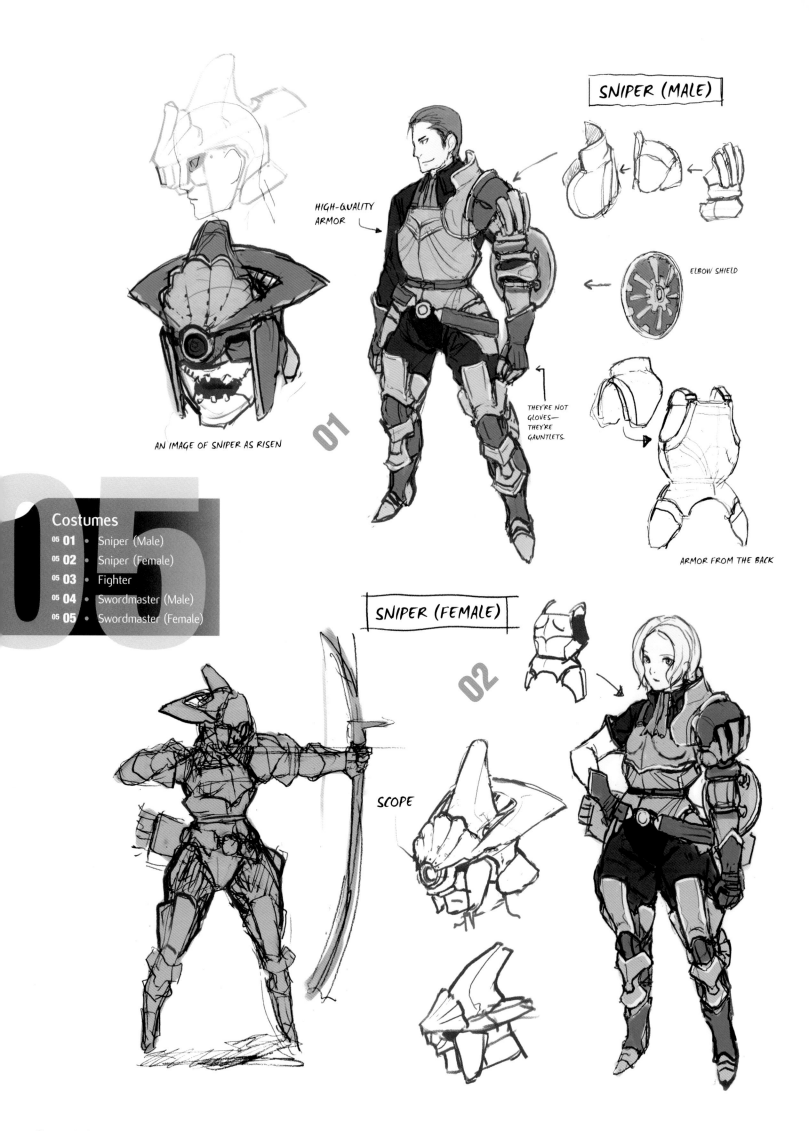

AN IMAGE OF SNIPER AS RISEN

HIGH-QUALITY ARMOR

01

SNIPER (MALE)

ELBOW SHIELD

THEY'RE NOT GLOVES— THEY'RE GAUNTLETS.

ARMOR FROM THE BACK

SNIPER (FEMALE)

02

SCOPE

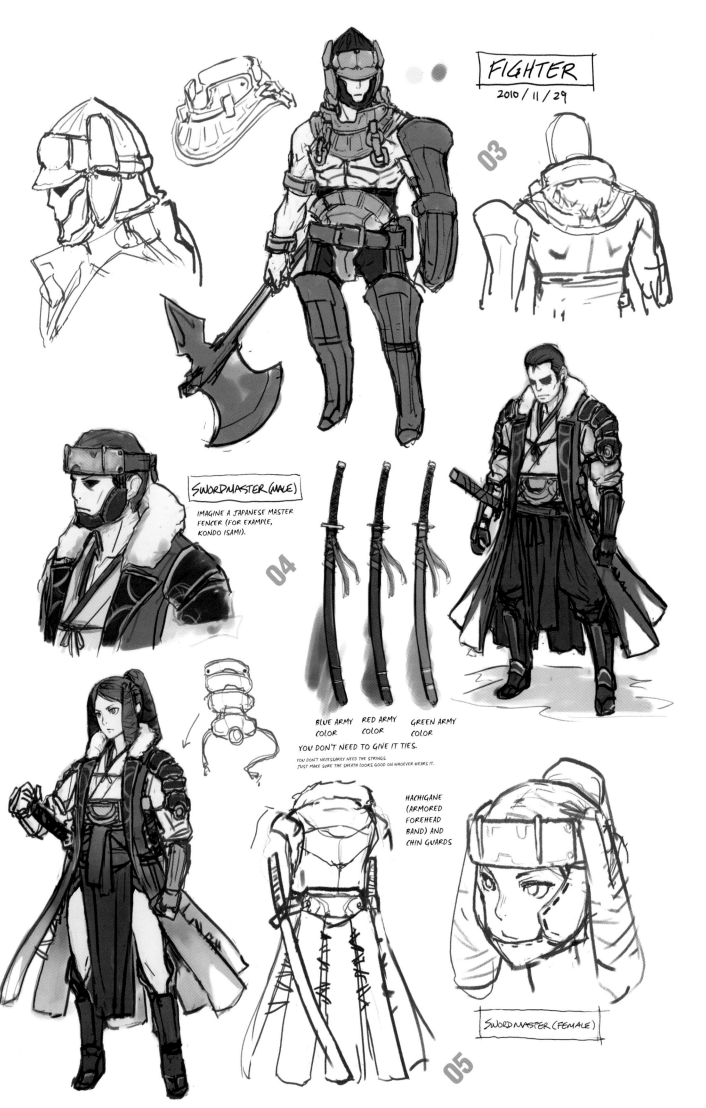

FIGHTER
2010 / 11 / 29

03

SWORDMASTER (MALE)

IMAGINE A JAPANESE MASTER FENCER (FOR EXAMPLE, KONDO ISAMI).

04

BLUE ARMY COLOR RED ARMY COLOR GREEN ARMY COLOR

YOU DON'T NEED TO GIVE IT TIES.

YOU DON'T NECESSARILY NEED THE STRINGS.
JUST MAKE SURE THE SHEATH LOOKS GOOD ON WHOEVER WEARS IT.

HACHIGANE (ARMORED FOREHEAD BAND) AND CHIN GUARDS

05

SWORDMASTER (FEMALE)

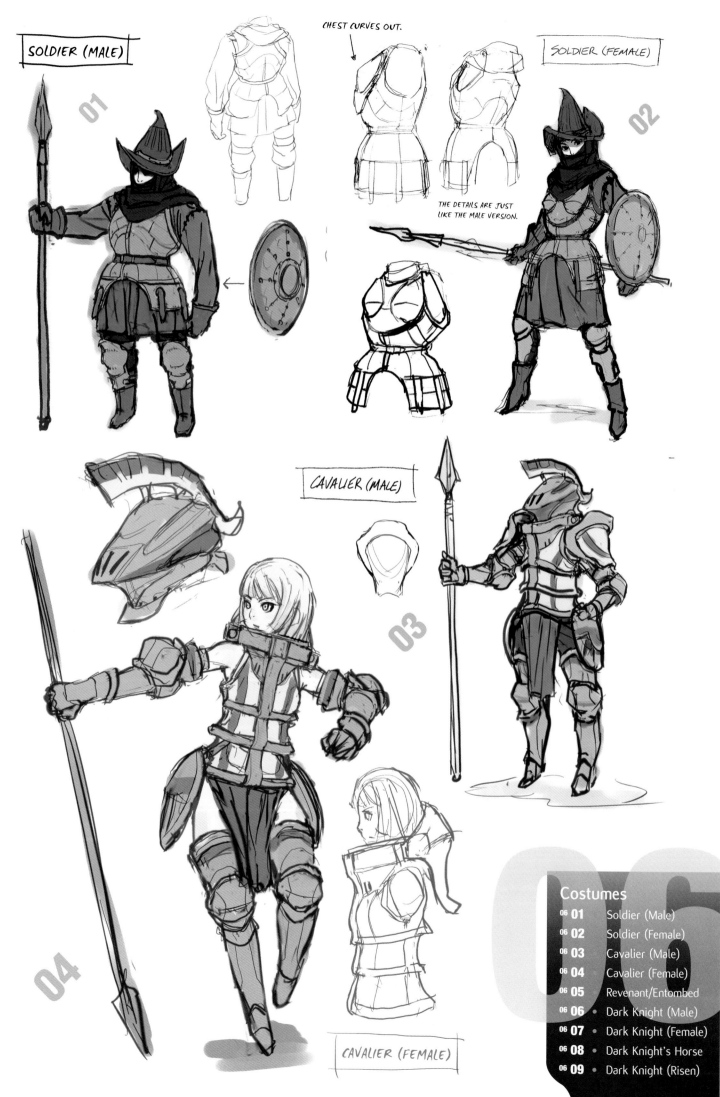

SOLDIER (MALE)

01

CHEST CURVES OUT.

SOLDIER (FEMALE)

02

THE DETAILS ARE JUST
LIKE THE MALE VERSION.

CAVALIER (MALE)

03

04

CAVALIER (FEMALE)

Costumes

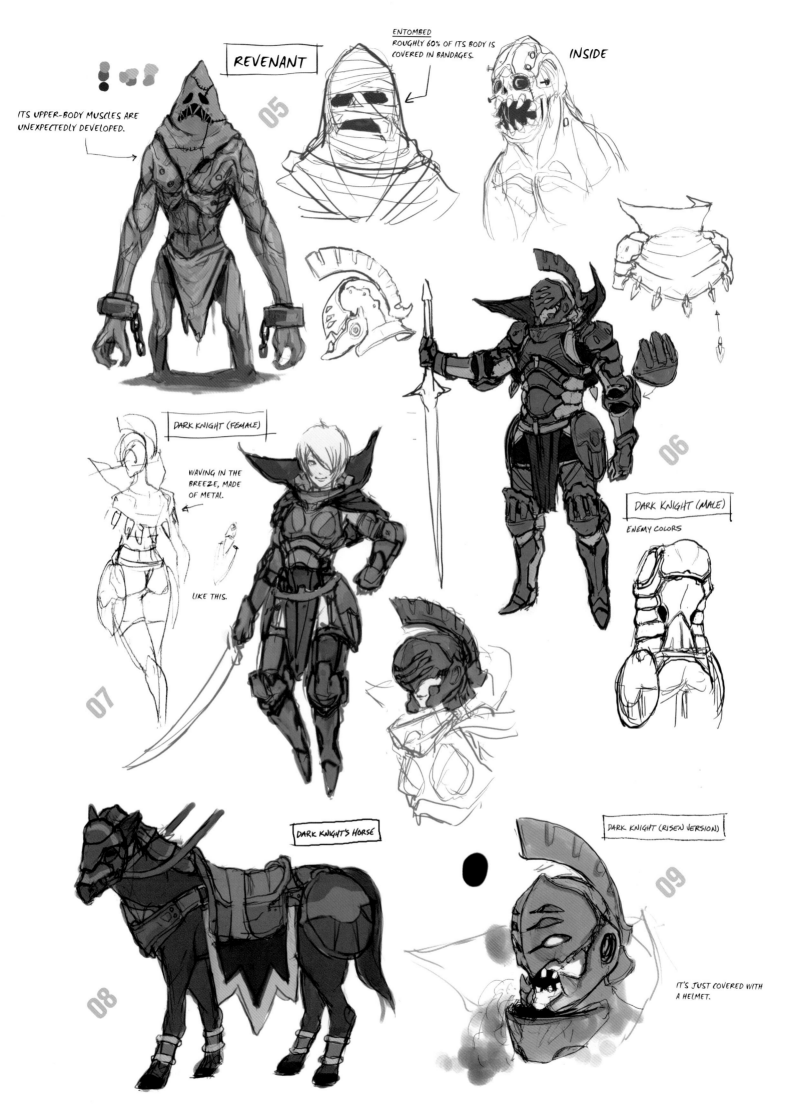

ITS UPPER-BODY MUSCLES ARE UNEXPECTEDLY DEVELOPED.

REVENANT

05

ENTOMBED
ROUGHLY 60% OF ITS BODY IS COVERED IN BANDAGES.

INSIDE

06

DARK KNIGHT (FEMALE)

WAVING IN THE BREEZE, MADE OF METAL.

LIKE THIS.

07

DARK KNIGHT (MALE)
ENEMY COLORS

08

DARK KNIGHT'S HORSE

DARK KNIGHT (RISEN VERSION)

09

IT'S JUST COVERED WITH A HELMET.

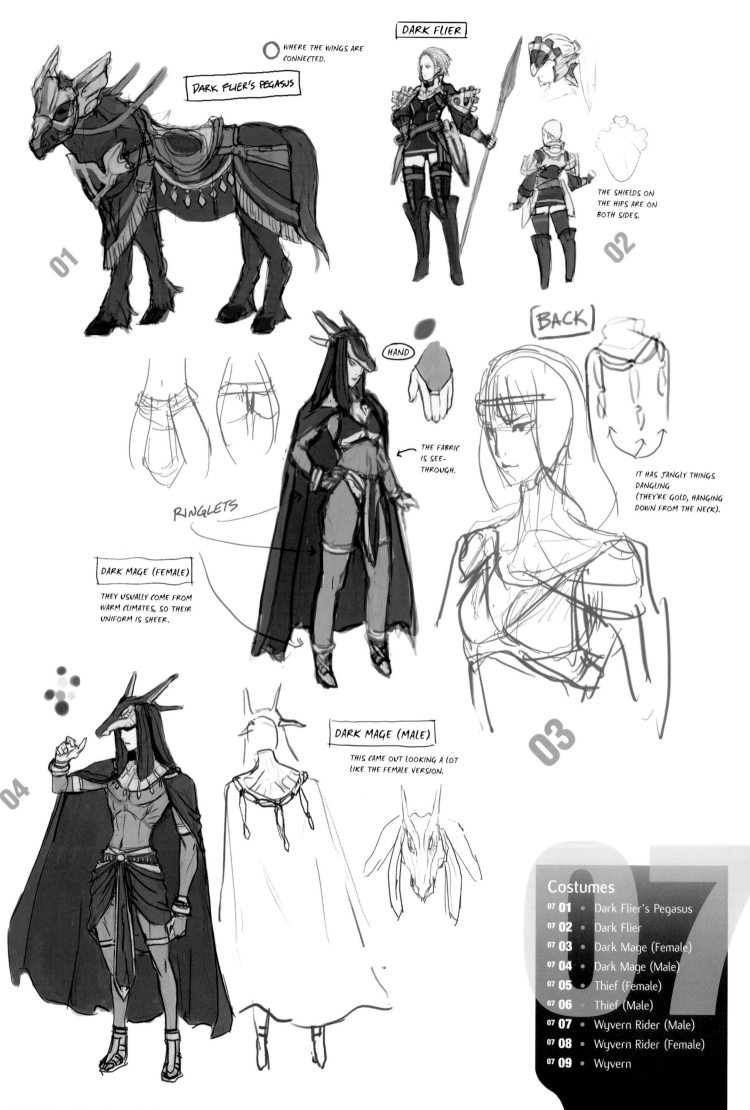

DARK FLIER'S PEGASUS

○ WHERE THE WINGS ARE CONNECTED.

DARK FLIER

THE SHIELDS ON THE HIPS ARE ON BOTH SIDES.

01

02

HAND

THE FABRIC IS SEE-THROUGH.

(BACK)

RINGLETS

IT HAS JANGLY THINGS DANGLING (THEY'RE GOLD, HANGING DOWN FROM THE NECK).

DARK MAGE (FEMALE)

THEY USUALLY COME FROM WARM CLIMATES, SO THEIR UNIFORM IS SHEER.

03

DARK MAGE (MALE)

THIS CAME OUT LOOKING A LOT LIKE THE FEMALE VERSION.

04

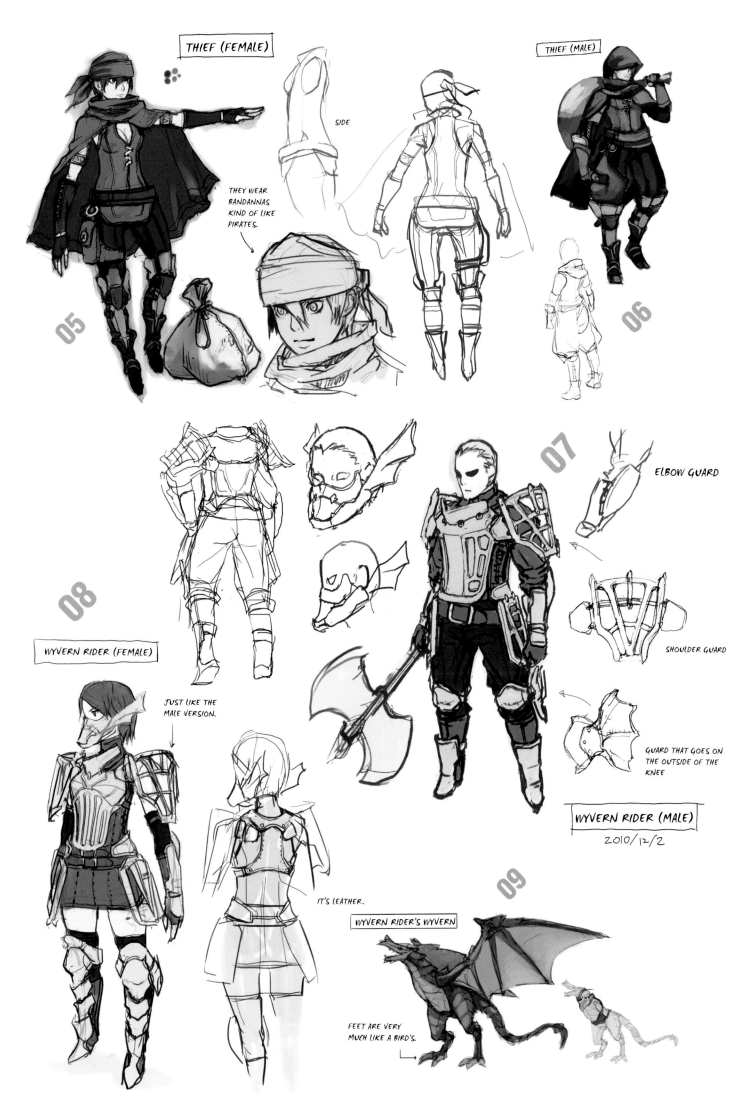

THIEF (FEMALE)

SIDE

THIEF (MALE)

THEY WEAR BANDANNAS KIND OF LIKE PIRATES.

05

06

07

ELBOW GUARD

SHOULDER GUARD

GUARD THAT GOES ON THE OUTSIDE OF THE KNEE

08

WYVERN RIDER (FEMALE)

JUST LIKE THE MALE VERSION.

WYVERN RIDER (MALE)

2010/12/2

IT'S LEATHER.

09

WYVERN RIDER'S WYVERN

FEET ARE VERY MUCH LIKE A BIRD'S.

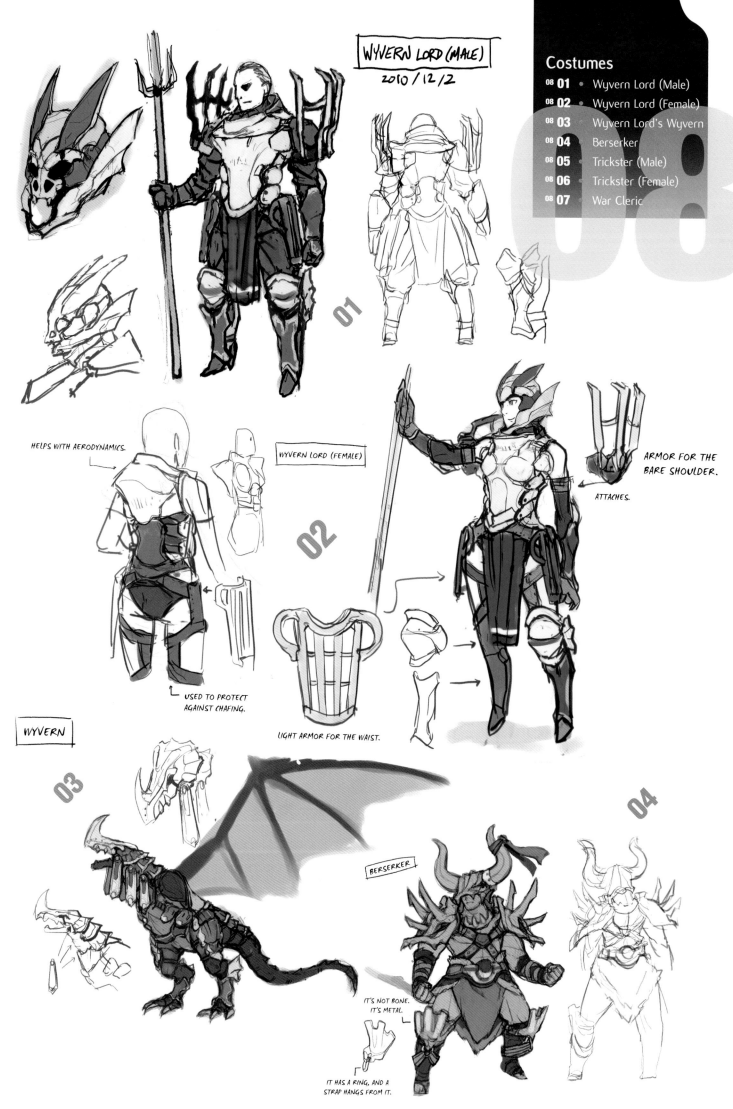

WYVERN LORD (MALE)
2010 / 12 / 2

01

HELPS WITH AERODYNAMICS.

WYVERN LORD (FEMALE)

ARMOR FOR THE BARE SHOULDER.

ATTACHES.

02

USED TO PROTECT AGAINST CHAFING.

LIGHT ARMOR FOR THE WAIST.

WYVERN

03

04

BERSERKER

IT'S NOT BONE. IT'S METAL.

IT HAS A RING, AND A STRAP HANGS FROM IT.

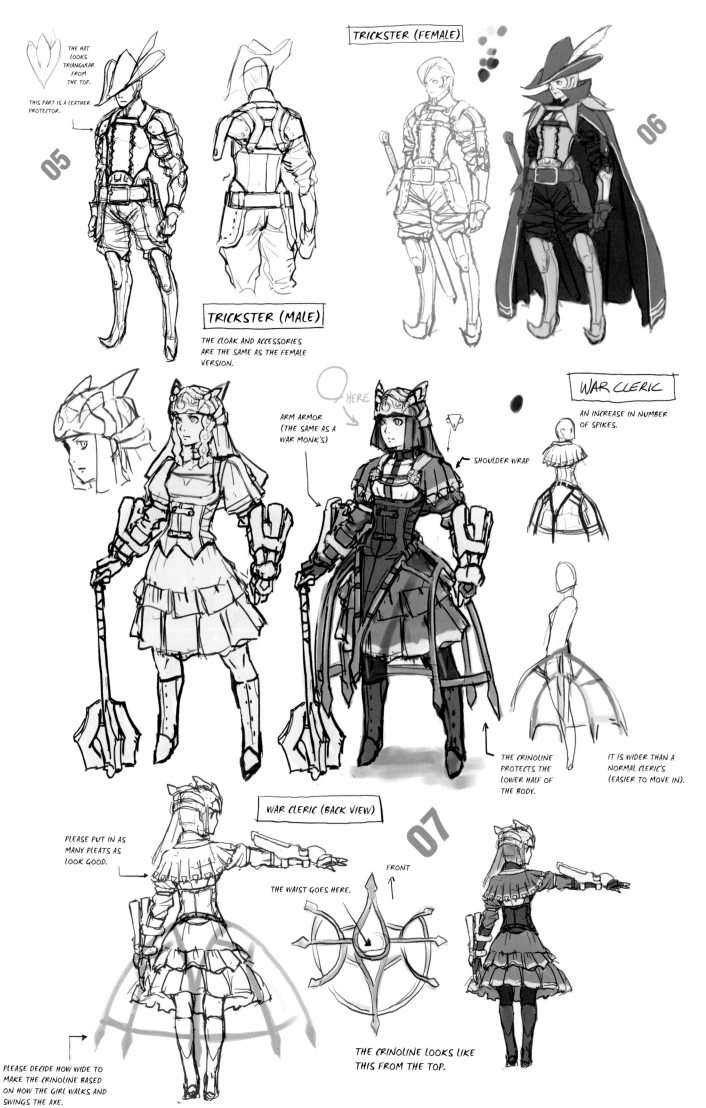

THE HAT LOOKS TRIANGULAR FROM THE TOP.

THIS PART IS A LEATHER PROTECTOR.

05

TRICKSTER (MALE)

THE CLOAK AND ACCESSORIES ARE THE SAME AS THE FEMALE VERSION.

TRICKSTER (FEMALE)

06

ARM ARMOR (THE SAME AS A WAR MONK'S)

HERE

SHOULDER WRAP

WAR CLERIC

AN INCREASE IN NUMBER OF SPIKES.

THE CRINOLINE PROTECTS THE LOWER HALF OF THE BODY.

IT IS WIDER THAN A NORMAL CLERIC'S (EASIER TO MOVE IN).

PLEASE PUT IN AS MANY PLEATS AS LOOK GOOD.

WAR CLERIC (BACK VIEW)

07

THE WAIST GOES HERE.

FRONT

PLEASE DECIDE HOW WIDE TO MAKE THE CRINOLINE BASED ON HOW THE GIRL WALKS AND SWINGS THE AXE.

THE CRINOLINE LOOKS LIKE THIS FROM THE TOP.

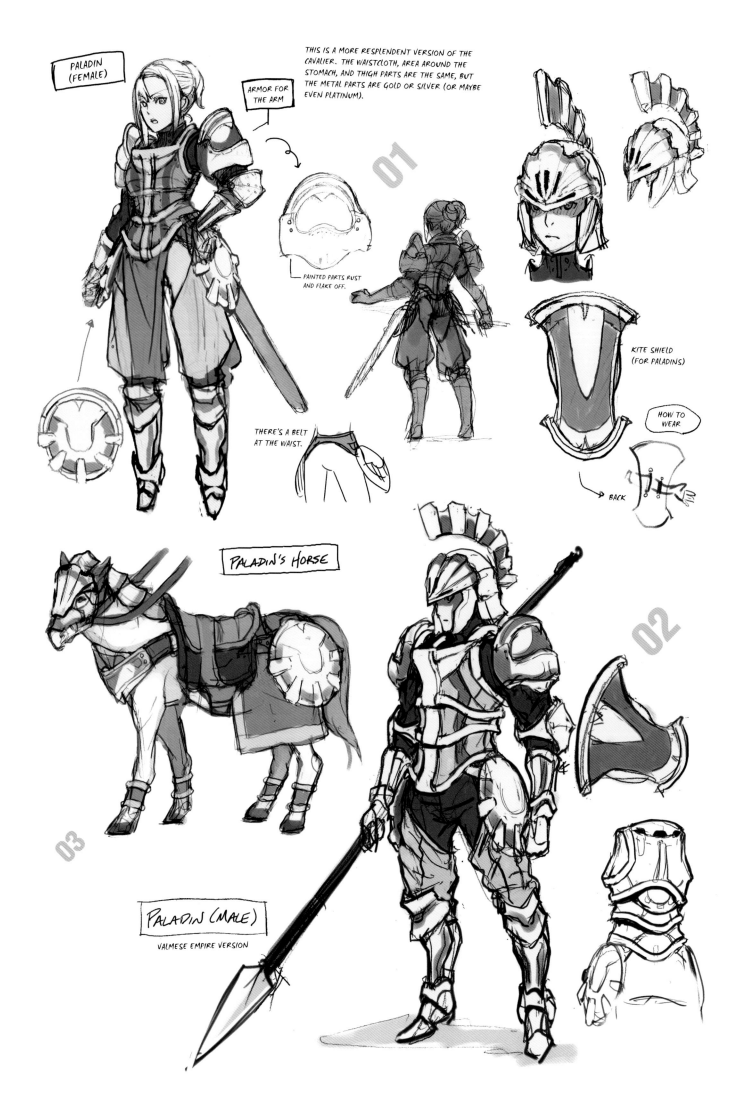

PALADIN
(FEMALE)

ARMOR FOR
THE ARM

THIS IS A MORE RESPLENDENT VERSION OF THE
CAVALIER. THE WAISTCLOTH, AREA AROUND THE
STOMACH, AND THIGH PARTS ARE THE SAME, BUT
THE METAL PARTS ARE GOLD OR SILVER (OR MAYBE
EVEN PLATINUM).

01

PAINTED PARTS RUST
AND FLAKE OFF.

THERE'S A BELT
AT THE WAIST.

KITE SHIELD
(FOR PALADINS)

HOW TO
WEAR

BACK

PALADIN'S HORSE

02

03

PALADIN (MALE)

VALMESE EMPIRE VERSION

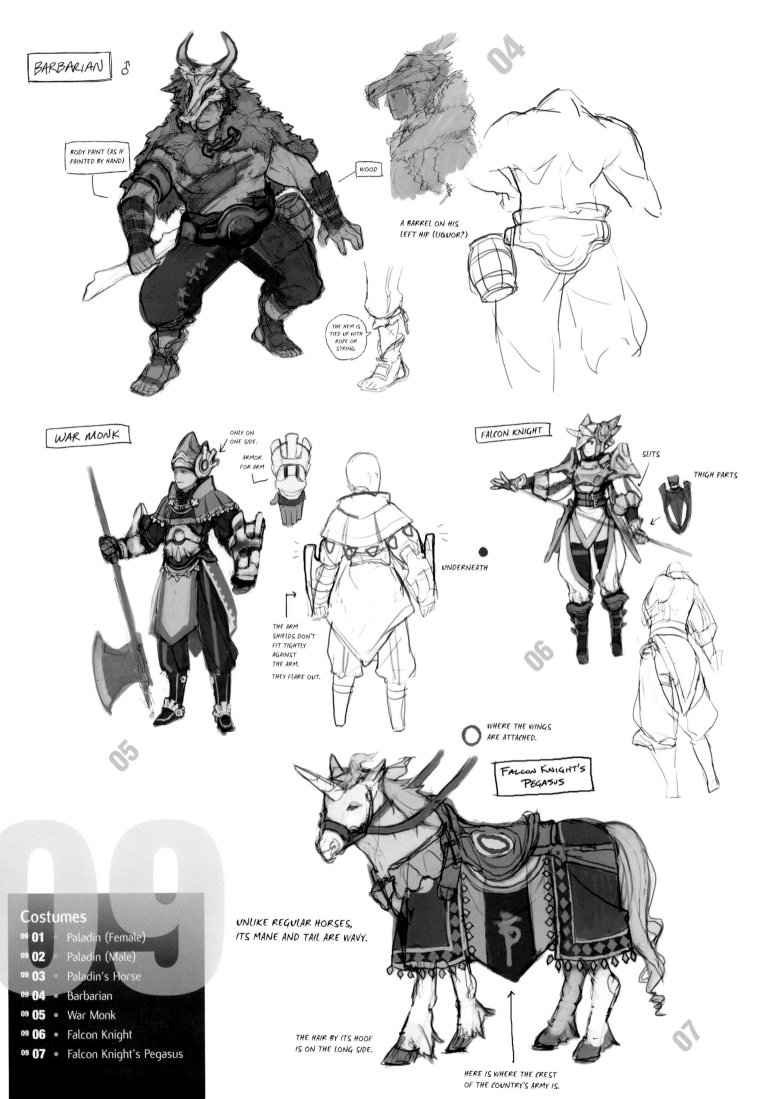

BARBARIAN ♂

BODY PAINT (AS IF PAINTED BY HAND)

04

WOOD

A BARREL ON HIS LEFT HIP (LIQUOR?)

THE HEM IS TIED UP WITH ROPE OR STRING.

WAR MONK

ONLY ON ONE SIDE.

ARMOR FOR ARM

UNDERNEATH

THE ARM SHIELDS DON'T FIT TIGHTLY AGAINST THE ARM. THEY FLARE OUT.

05

FALCON KNIGHT

SLITS

THIGH PARTS

06

WHERE THE WINGS ARE ATTACHED.

FALCON KNIGHT'S PEGASUS

UNLIKE REGULAR HORSES, ITS MANE AND TAIL ARE WAVY.

07

THE HAIR BY ITS HOOF IS ON THE LONG SIDE.

HERE IS WHERE THE CREST OF THE COUNTRY'S ARMY IS.

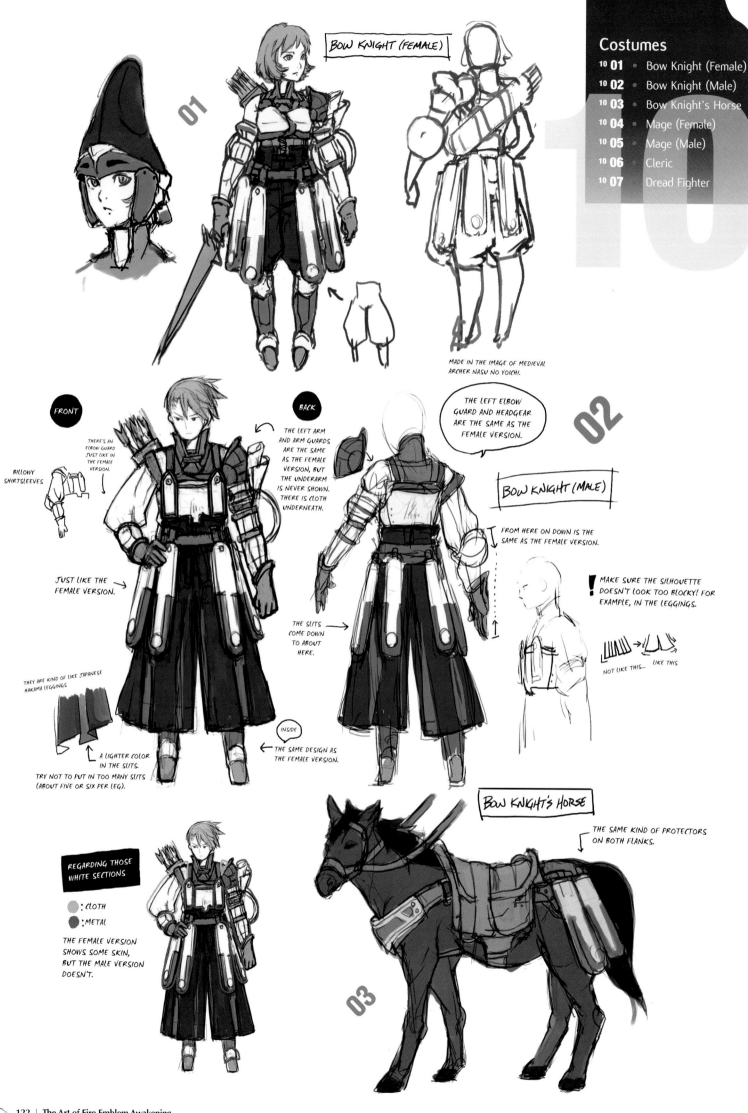

BOW KNIGHT (FEMALE)

01

MADE IN THE IMAGE OF MEDIEVAL ARCHER NASU NO YOICHI.

FRONT

BACK

02

THE LEFT ELBOW GUARD AND HEADGEAR ARE THE SAME AS THE FEMALE VERSION.

BOW KNIGHT (MALE)

THERE'S AN ELBOW GUARD JUST LIKE IN THE FEMALE VERSION.

BILLOWY SHIRTSLEEVES

THE LEFT ARM AND ARM GUARDS ARE THE SAME AS THE FEMALE VERSION, BUT THE UNDERARM IS NEVER SHOWN. THERE IS CLOTH UNDERNEATH.

FROM HERE ON DOWN IS THE SAME AS THE FEMALE VERSION.

JUST LIKE THE FEMALE VERSION.

THE SLITS COME DOWN TO ABOUT HERE.

! MAKE SURE THE SILHOUETTE DOESN'T LOOK TOO BLOCKY! FOR EXAMPLE, IN THE LEGGINGS.

THEY ARE KIND OF LIKE JAPANESE HAKAMA LEGGINGS

NOT LIKE THIS... LIKE THIS

A LIGHTER COLOR IN THE SLITS.
TRY NOT TO PUT IN TOO MANY SLITS (ABOUT FIVE OR SIX PER LEG).

INSIDE

THE SAME DESIGN AS THE FEMALE VERSION.

BOW KNIGHT'S HORSE

THE SAME KIND OF PROTECTORS ON BOTH FLANKS.

REGARDING THOSE WHITE SECTIONS

: CLOTH
: METAL

THE FEMALE VERSION SHOWS SOME SKIN, BUT THE MALE VERSION DOESN'T.

03

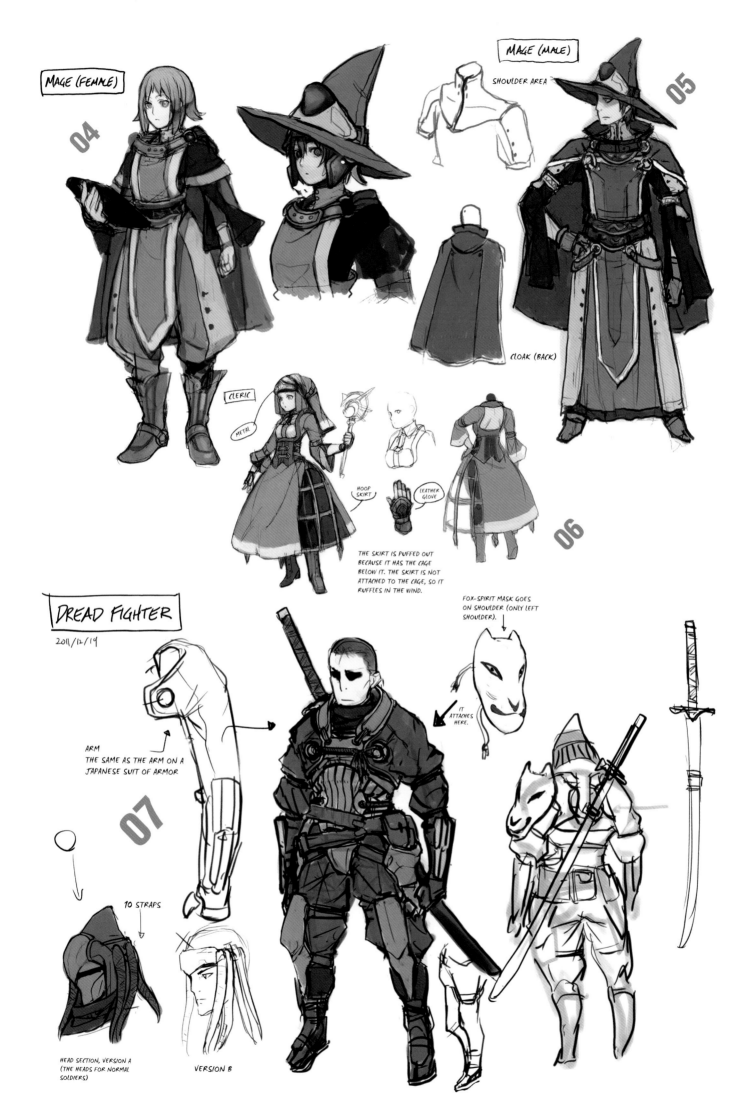

MAGE (FEMALE)

04

MAGE (MALE)

05

SHOULDER AREA

CLOAK (BACK)

CLERIC

METAL

HOOP SKIRT

LEATHER GLOVE

06

THE SKIRT IS PUFFED OUT BECAUSE IT HAS THE CAGE BELOW IT. THE SKIRT IS NOT ATTACHED TO THE CAGE, SO IT RUFFLES IN THE WIND.

DREAD FIGHTER

2011/12/14

ARM
THE SAME AS THE ARM ON A JAPANESE SUIT OF ARMOR

07

10 STRAPS

HEAD SECTION, VERSION A (THE HEADS FOR NORMAL SOLDIERS)

VERSION B

FOX-SPIRIT MASK GOES ON SHOULDER (ONLY LEFT SHOULDER).

IT ATTACHES HERE.

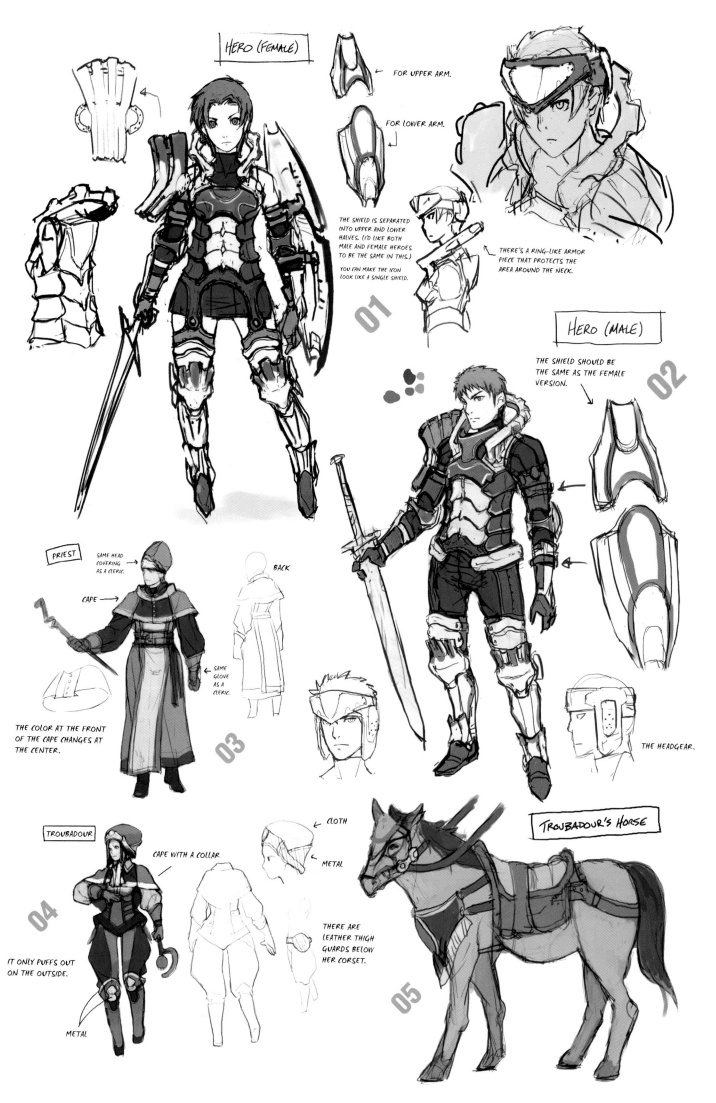

HERO (FEMALE)

FOR UPPER ARM.

FOR LOWER ARM.

THE SHIELD IS SEPARATED INTO UPPER AND LOWER HALVES. (I'D LIKE BOTH MALE AND FEMALE HEROES TO BE THE SAME IN THIS.)

YOU CAN MAKE THE ICON LOOK LIKE A SINGLE SHIELD.

01

THERE'S A RING-LIKE ARMOR PIECE THAT PROTECTS THE AREA AROUND THE NECK.

HERO (MALE)

THE SHIELD SHOULD BE THE SAME AS THE FEMALE VERSION.

02

PRIEST

SAME HEAD COVERING AS A CLERIC.

CAPE

BACK

SAME GLOVE AS A CLERIC.

THE COLOR AT THE FRONT OF THE CAPE CHANGES AT THE CENTER.

03

THE HEADGEAR.

TROUBADOUR

CAPE WITH A COLLAR

CLOTH

METAL

IT ONLY PUFFS OUT ON THE OUTSIDE.

04

THERE ARE LEATHER THIGH GUARDS BELOW HER CORSET.

TROUBADOUR'S HORSE

05

METAL

Costumes

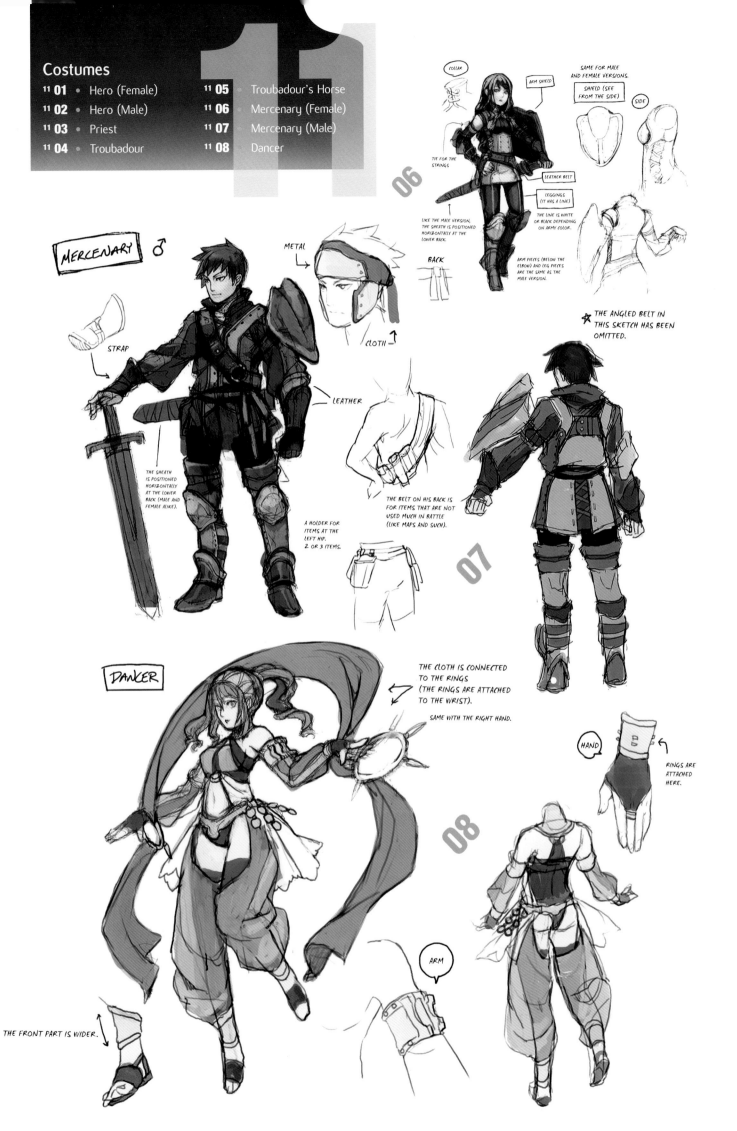

COLLAR

ARM SHIELD

SAME FOR MALE AND FEMALE VERSIONS.

SHIELD (SEE FROM THE SIDE)

SIDE

TIE FOR THE STRINGS

(LEATHER BELT)

LEGGINGS (IT HAS A LINE)

THE LINE IS WHITE OR BLACK DEPENDING ON ARMY COLOR.

06

BACK

LIKE THE MALE VERSION, THE SHEATH IS POSITIONED HORIZONTALLY AT THE LOWER BACK.

ARM PIECES (BELOW THE ELBOW) AND LEG PIECES ARE THE SAME AS THE MALE VERSION.

MERCENARY ♂

METAL →

STRAP

← CLOTH

LEATHER

THE SHEATH IS POSITIONED HORIZONTALLY AT THE LOWER BACK (MALE AND FEMALE ALIKE).

A HOLDER FOR ITEMS AT THE LEFT HIP. 2 OR 3 ITEMS.

THE BELT ON HIS BACK IS FOR ITEMS THAT ARE NOT USED MUCH IN BATTLE (LIKE MAPS AND SUCH).

☆ THE ANGLED BELT IN THIS SKETCH HAS BEEN OMITTED.

07

DANCER

THE CLOTH IS CONNECTED TO THE RINGS (THE RINGS ARE ATTACHED TO THE WRIST).

SAME WITH THE RIGHT HAND.

HAND

RINGS ARE ATTACHED HERE.

08

THE FRONT PART IS WIDER.

ARM

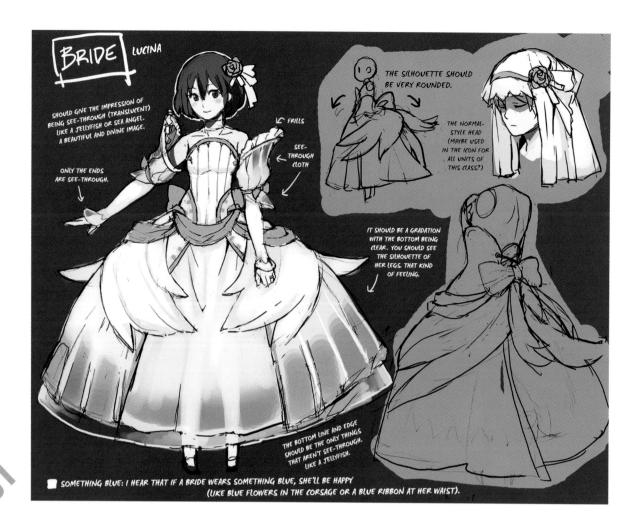

BRIDE LUCINA

SHOULD GIVE THE IMPRESSION OF BEING SEE-THROUGH (TRANSLUCENT) LIKE A JELLYFISH OR SEA ANGEL. A BEAUTIFUL AND DIVINE IMAGE.

ONLY THE ENDS ARE SEE-THROUGH.

FRILLS

SEE-THROUGH CLOTH

THE SILHOUETTE SHOULD BE VERY ROUNDED.

THE NORMAL-STYLE HEAD (MAYBE USED IN THE ICON FOR ALL UNITS OF THIS CLASS?)

IT SHOULD BE A GRADATION WITH THE BOTTOM BEING CLEAR. YOU SHOULD SEE THE SILHOUETTE OF HER LEGS. THAT KIND OF FEELING.

THE BOTTOM LINE AND EDGE SHOULD BE THE ONLY THINGS THAT AREN'T SEE-THROUGH. LIKE A JELLYFISH.

☐ SOMETHING BLUE: I HEAR THAT IF A BRIDE WEARS SOMETHING BLUE, SHE'LL BE HAPPY (LIKE BLUE FLOWERS IN THE CORSAGE OR A BLUE RIBBON AT HER WAIST).

01

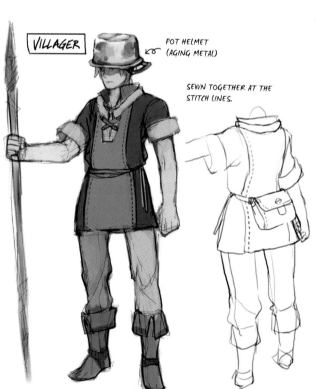

VILLAGER

POT HELMET (AGING METAL)

SEWN TOGETHER AT THE STITCH LINES.

02

Creator Commentary

In previous *Fire Emblem* titles, the graphics for generic soldiers were symbolic representations of the whole of each class (known as "class panels"). But for this game, we wanted these graphics to be similar to those of the regular characters. We wanted to draw generic soldier units with the same kinds of faces as the characters. Although we expected this to be a difficult task, we were surprised with how much work this entailed once we actually started.

◆

Mr. Kozaki was in charge of the illustrations for the main characters, but we couldn't possibly ask him to work on images for the generic soldiers as well. Instead, we asked the IS internal staff and the good people of Madhouse to help us with these drawings.

◆

Because *Awakening* uses a 3-D screen with polygonal characters in the background, we wanted to find a way for players to easily read the facial expressions of the characters. This is how we landed on the anime style for the drawn images of the characters in the foreground. This had another advantage in that we could keep the coloring consistent even if Mr. Kozaki wasn't coloring them himself (as coloring characters in anime style can reduce how much of one's own personality shows through in the process).

—Art director Toshiyuki Kusakihara

12

Costumes
12 01 • Bride
12 02 • Villager

Weapon Design

▪▪▪ Concept Art for the Weapons in the Game

Art director Toshiyuki Kusakihara personally oversaw most of the weapon design. He would often be found in Mr. Kozaki's studio checking on or urging the character designs forward and drawing one rough sketch of the weapons after another.

LEGEND FOR THE ANCIENT LETTERS

FIRE EMBLEM

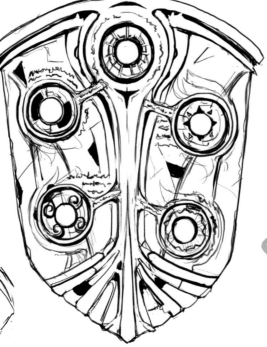

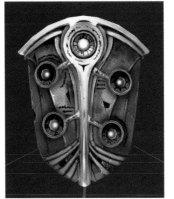

01

Weapons
01 **01** Falchion
01 **02** Fire Emblem

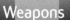

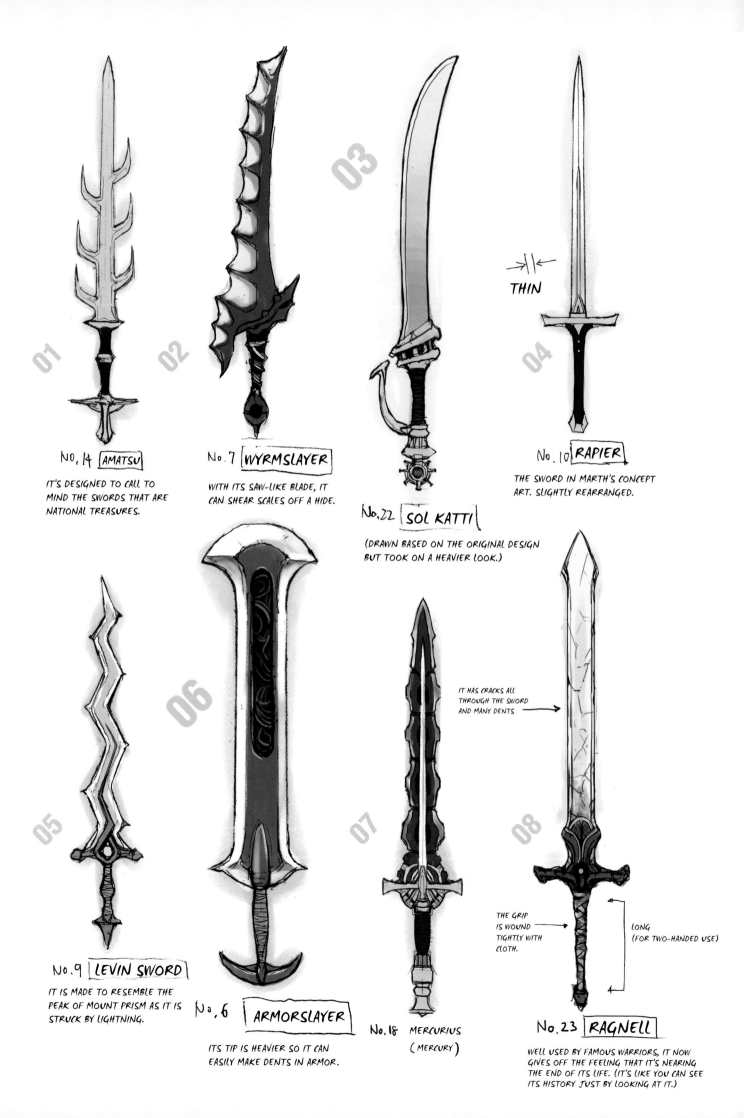

No. 14 |AMATSU|

IT'S DESIGNED TO CALL TO MIND THE SWORDS THAT ARE NATIONAL TREASURES.

No. 7 |WYRMSLAYER|

WITH ITS SAW-LIKE BLADE, IT CAN SHEAR SCALES OFF A HIDE.

No. 22 |SOL KATTI|

(DRAWN BASED ON THE ORIGINAL DESIGN BUT TOOK ON A HEAVIER LOOK.)

THIN

No. 10 |RAPIER|

THE SWORD IN MARTH'S CONCEPT ART. SLIGHTLY REARRANGED.

No. 9 |LEVIN SWORD|

IT IS MADE TO RESEMBLE THE PEAK OF MOUNT PRISM AS IT IS STRUCK BY LIGHTNING.

No. 6 |ARMORSLAYER|

ITS TIP IS HEAVIER SO IT CAN EASILY MAKE DENTS IN ARMOR.

No. 18 MERCURIUS (MERCURY)

IT HAS CRACKS ALL THROUGH THE SWORD AND MANY DENTS

THE GRIP IS WOUND TIGHTLY WITH CLOTH.

LONG (FOR TWO-HANDED USE)

No. 23 |RAGNELL|

WELL USED BY FAMOUS WARRIORS, IT NOW GIVES OFF THE FEELING THAT IT'S NEARING THE END OF ITS LIFE. (IT'S LIKE YOU CAN SEE ITS HISTORY JUST BY LOOKING AT IT.)

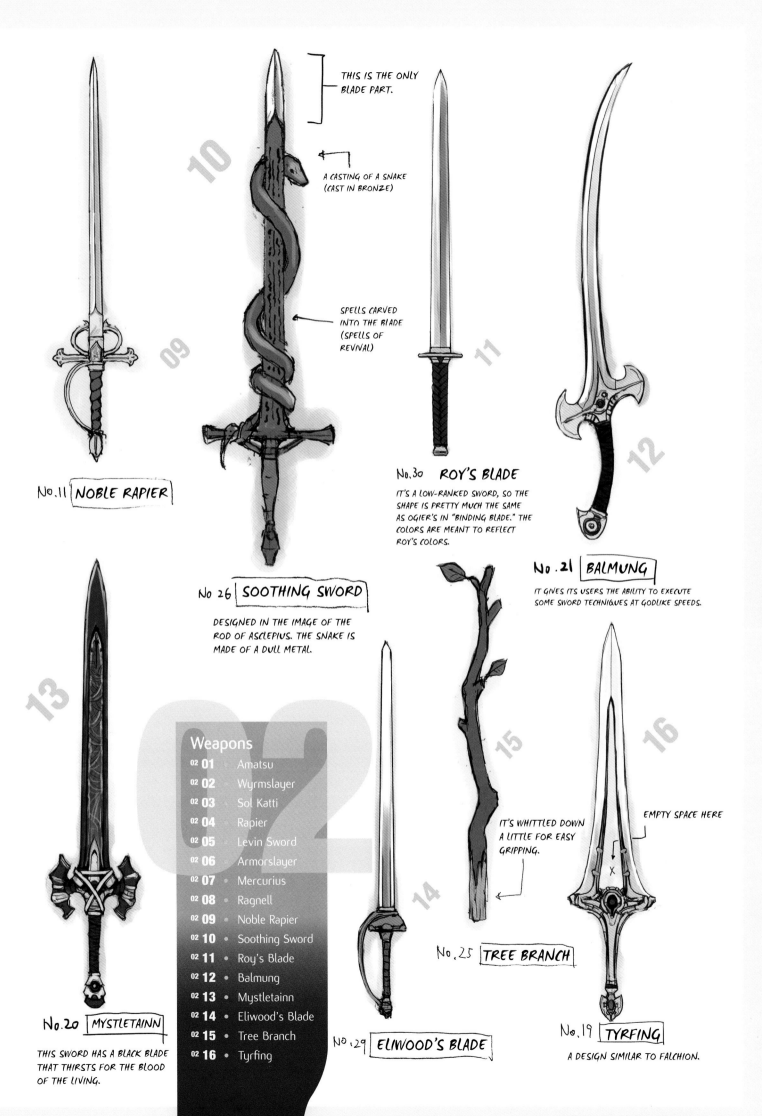

THIS IS THE ONLY BLADE PART.

A CASTING OF A SNAKE (CAST IN BRONZE)

SPELLS CARVED INTO THE BLADE (SPELLS OF REVIVAL)

No.11 NOBLE RAPIER

No 26 SOOTHING SWORD

DESIGNED IN THE IMAGE OF THE ROD OF ASCLEPIUS. THE SNAKE IS MADE OF A DULL METAL.

No.30 ROY'S BLADE

IT'S A LOW-RANKED SWORD, SO THE SHAPE IS PRETTY MUCH THE SAME AS OGIER'S IN "BINDING BLADE." THE COLORS ARE MEANT TO REFLECT ROY'S COLORS.

No.21 BALMUNG

IT GIVES ITS USERS THE ABILITY TO EXECUTE SOME SWORD TECHNIQUES AT GODLIKE SPEEDS.

Weapons

02	01	Amatsu
02	02	Wyrmslayer
02	03	Sol Katti
02	04	Rapier
02	05	Levin Sword
02	06	Armorslayer
02	07	Mercurius
02	08	Ragnell
02	09	Noble Rapier
02	10	Soothing Sword
02	11	Roy's Blade
02	12	Balmung
02	13	Mystletainn
02	14	Eliwood's Blade
02	15	Tree Branch
02	16	Tyrfing

IT'S WHITTLED DOWN A LITTLE FOR EASY GRIPPING.

EMPTY SPACE HERE

No.25 TREE BRANCH

No.20 MYSTLETAINN

THIS SWORD HAS A BLACK BLADE THAT THIRSTS FOR THE BLOOD OF THE LIVING.

No.29 ELIWOOD'S BLADE

No.19 TYRFING

A DESIGN SIMILAR TO FALCHION.

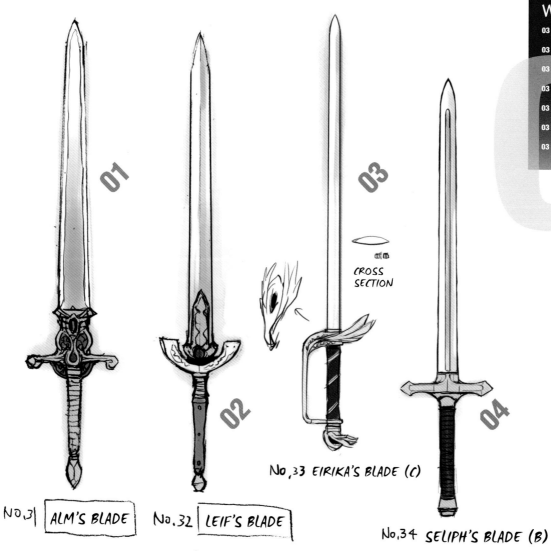

01

02

03

04

CROSS SECTION

NO.31 ALM'S BLADE

NO.32 LEIF'S BLADE

No.33 EIRIKA'S BLADE (C)

No.34 SELIPH'S BLADE (B)

05

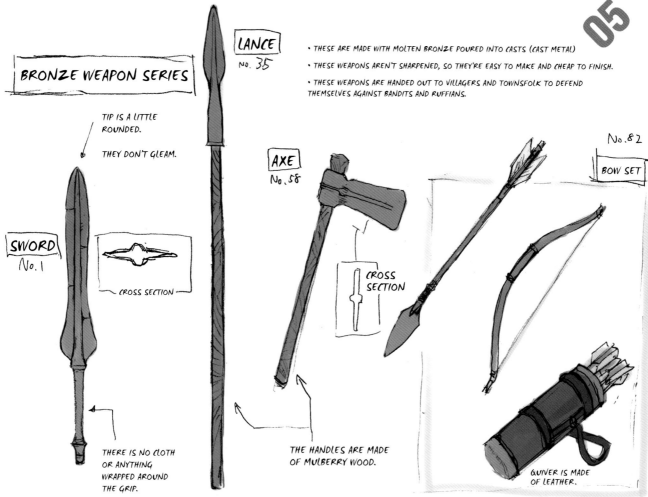

BRONZE WEAPON SERIES

LANCE No. 35

• THESE ARE MADE WITH MOLTEN BRONZE POURED INTO CASTS (CAST METAL)

• THESE WEAPONS AREN'T SHARPENED, SO THEY'RE EASY TO MAKE AND CHEAP TO FINISH.

• THESE WEAPONS ARE HANDED OUT TO VILLAGERS AND TOWNSFOLK TO DEFEND THEMSELVES AGAINST BANDITS AND RUFFIANS.

TIP IS A LITTLE ROUNDED.

THEY DON'T GLEAM.

No.82 BOW SET

AXE No. 58

SWORD No. 1

CROSS SECTION

CROSS SECTION

THERE IS NO CLOTH OR ANYTHING WRAPPED AROUND THE GRIP.

THE HANDLES ARE MADE OF MULBERRY WOOD.

QUIVER IS MADE OF LEATHER.

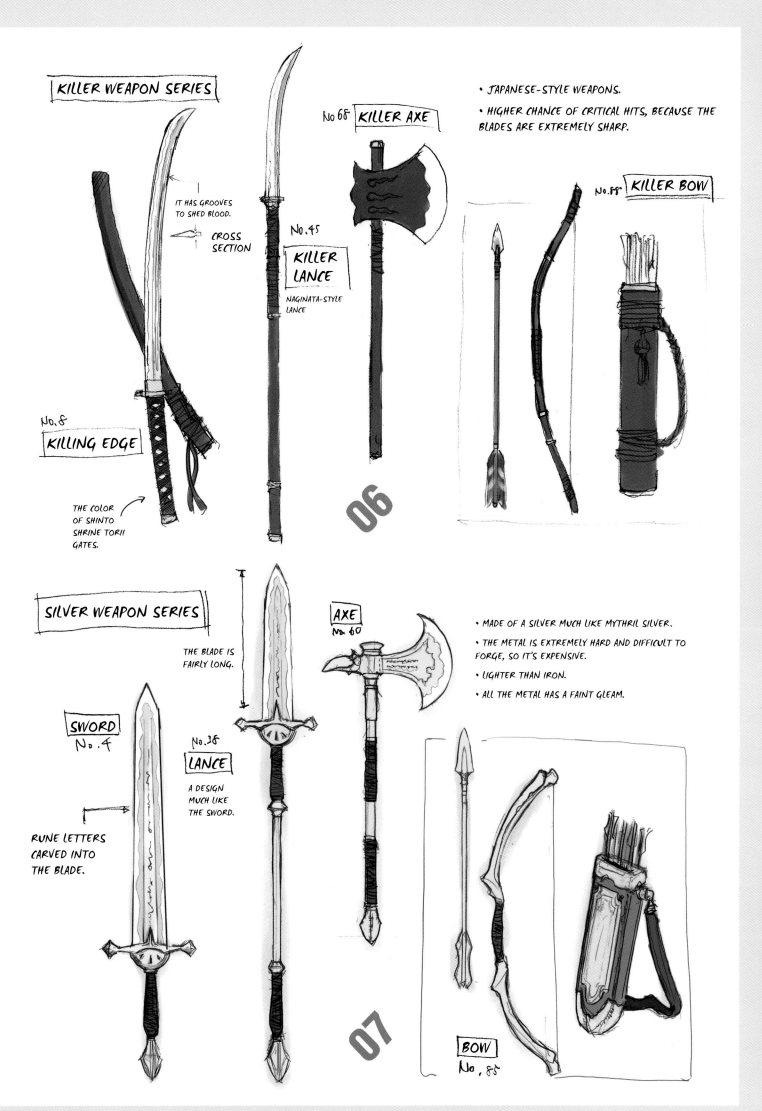

KILLER WEAPON SERIES

No.6 KILLER AXE

• JAPANESE-STYLE WEAPONS.
• HIGHER CHANCE OF CRITICAL HITS, BECAUSE THE BLADES ARE EXTREMELY SHARP.

No.88 KILLER BOW

IT HAS GROOVES TO SHED BLOOD.

CROSS SECTION

No.45 KILLER LANCE

NAGINATA-STYLE LANCE

No.6 KILLING EDGE

THE COLOR OF SHINTO SHRINE TORII GATES.

06

SILVER WEAPON SERIES

AXE No.60

THE BLADE IS FAIRLY LONG.

• MADE OF A SILVER MUCH LIKE MYTHRIL SILVER.
• THE METAL IS EXTREMELY HARD AND DIFFICULT TO FORGE, SO IT'S EXPENSIVE.
• LIGHTER THAN IRON.
• ALL THE METAL HAS A FAINT GLEAM.

SWORD No.4

No.38 LANCE

A DESIGN MUCH LIKE THE SWORD.

RUNE LETTERS CARVED INTO THE BLADE.

07

BOW No.85

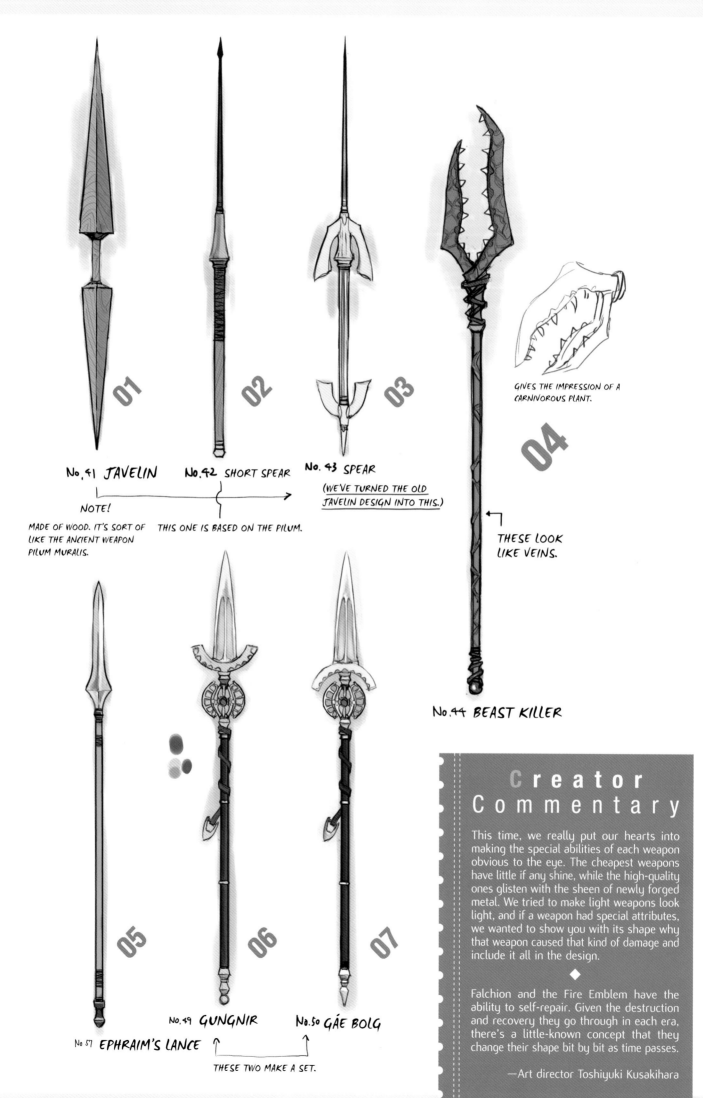

No.41 JAVELIN

NOTE!

MADE OF WOOD. IT'S SORT OF
LIKE THE ANCIENT WEAPON
PILUM MURALIS.

No.42 SHORT SPEAR

THIS ONE IS BASED ON THE PILUM.

No.43 SPEAR

(WE'VE TURNED THE OLD
JAVELIN DESIGN INTO THIS.)

GIVES THE IMPRESSION OF A
CARNIVOROUS PLANT.

THESE LOOK
LIKE VEINS.

No.44 BEAST KILLER

No.57 EPHRAIM'S LANCE

No.49 GUNGNIR

No.50 GÁE BOLG

THESE TWO MAKE A SET.

Creator Commentary

This time, we really put our hearts into making the special abilities of each weapon obvious to the eye. The cheapest weapons have little if any shine, while the high-quality ones glisten with the sheen of newly forged metal. We tried to make light weapons look light, and if a weapon had special attributes, we wanted to show you with its shape why that weapon caused that kind of damage and include it all in the design.

◆

Falchion and the Fire Emblem have the ability to self-repair. Given the destruction and recovery they go through in each era, there's a little-known concept that they change their shape bit by bit as time passes.

—Art director Toshiyuki Kusakihara

Weapons

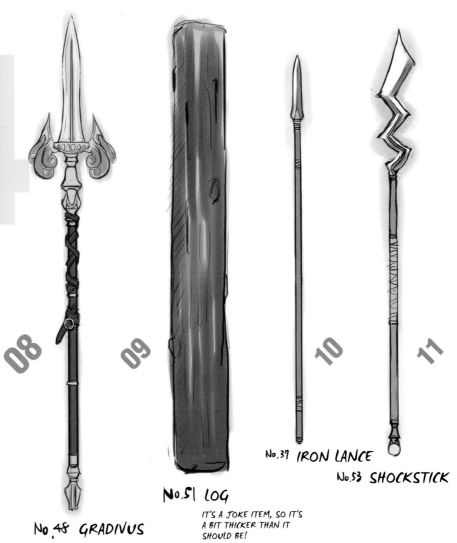

08

09

10

11

No.48 GRADIVUS

No.51 LOG

IT'S A JOKE ITEM, SO IT'S
A BIT THICKER THAN IT
SHOULD BE!

No.37 IRON LANCE

No.53 SHOCKSTICK

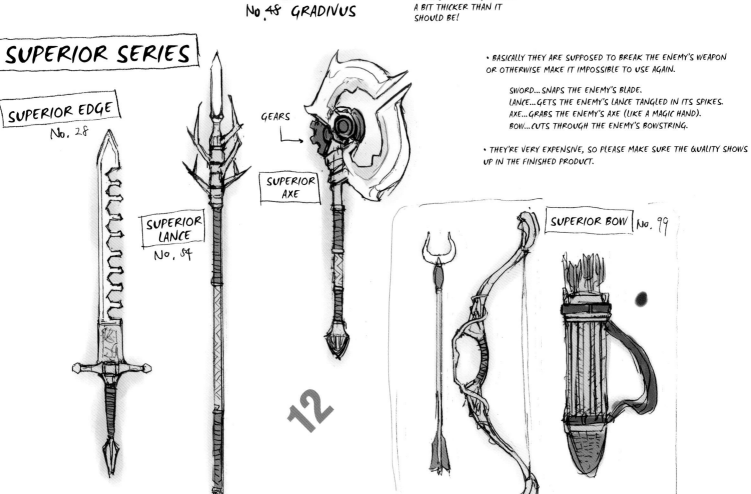

SUPERIOR SERIES

SUPERIOR EDGE

No. 28

SUPERIOR
LANCE

No. 54

GEARS

SUPERIOR
AXE

12

SUPERIOR BOW No. 99

• BASICALLY THEY ARE SUPPOSED TO BREAK THE ENEMY'S WEAPON
OR OTHERWISE MAKE IT IMPOSSIBLE TO USE AGAIN.

SWORD...SNAPS THE ENEMY'S BLADE.
LANCE...GETS THE ENEMY'S LANCE TANGLED IN ITS SPIKES.
AXE...GRABS THE ENEMY'S AXE (LIKE A MAGIC HAND).
BOW...CUTS THROUGH THE ENEMY'S BOWSTRING.

• THEY'RE VERY EXPENSIVE, SO PLEASE MAKE SURE THE QUALITY SHOWS
UP IN THE FINISHED PRODUCT.

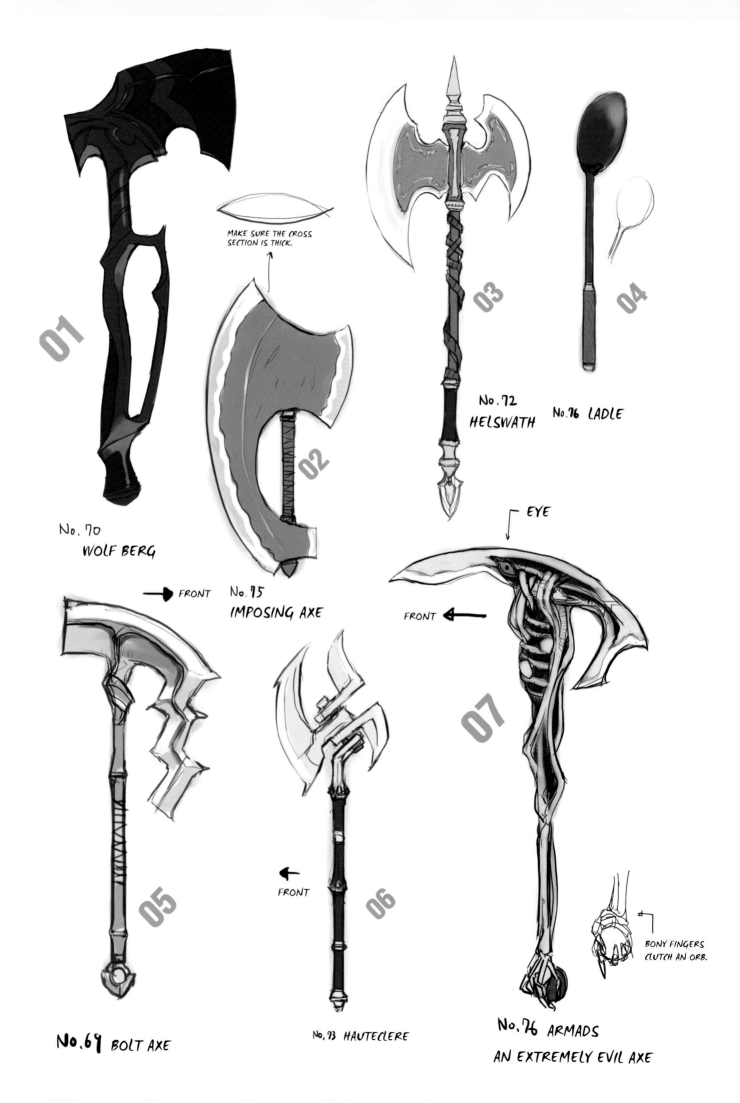

MAKE SURE THE CROSS
SECTION IS THICK.

01

No. 70
WOLF BERG

02

No. 75
IMPOSING AXE

03

No. 72
HELSWATH

04

No. 76 LADLE

05

→ FRONT

No. 69 BOLT AXE

06

FRONT ←

No. 73 HAUTECLERE

07

EYE

FRONT ←

BONY FINGERS
CLUTCH AN ORB.

No. 76 ARMADS
AN EXTREMELY EVIL AXE

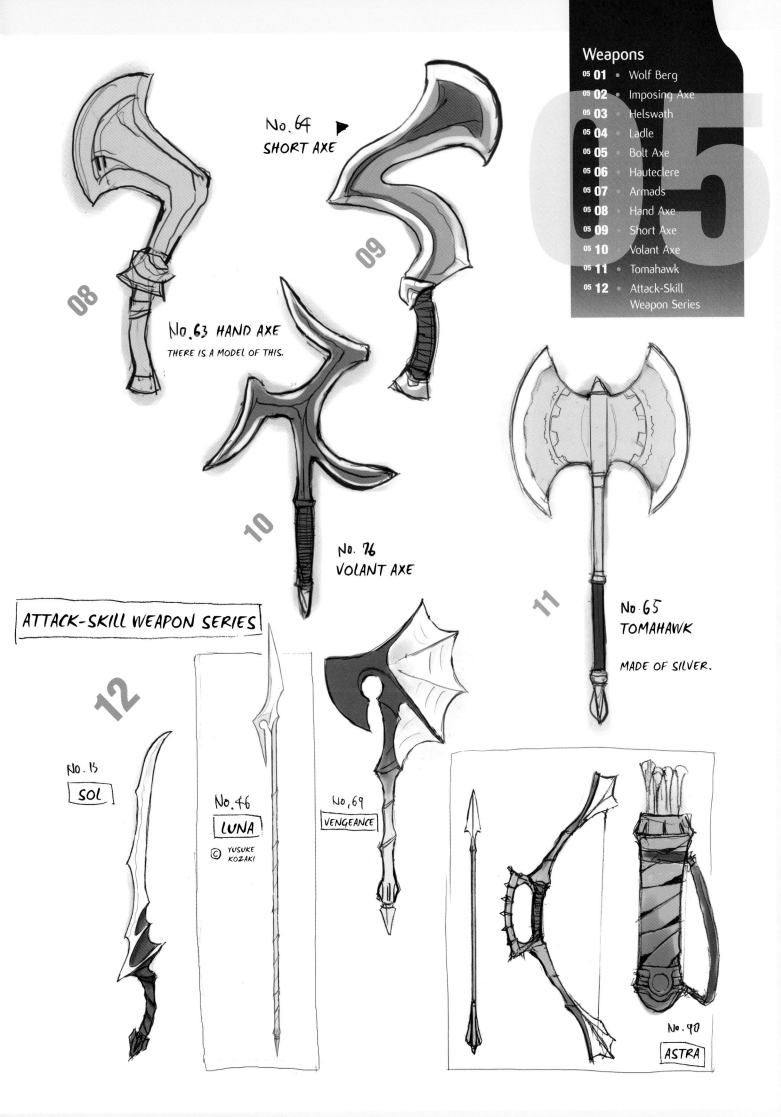

05

08

No. 64 ▶
SHORT AXE

09

No. 63 HAND AXE
THERE IS A MODEL OF THIS.

10

No. 76
VOLANT AXE

11

No. 65
TOMAHAWK

MADE OF SILVER.

ATTACK-SKILL WEAPON SERIES

12

No. 13
SOL

No. 46
LUNA

© YUSUKE
KOZAKI

No. 69
VENGEANCE

No. 40
ASTRA

GLASS WEAPON SERIES

SWORD
No. 27

LOOKS LIKE CRYSTAL.

AXE
No. 77

LANCE
No. 53

BOW
No. 95

· GLASS WEAPONS ARE ALL HIGH-QUALITY WEAPONS.

· THEY'RE ALL ANCIENT ARTIFACTS—NO ONE IN THIS AGE CAN MAKE THEM.

· EACH IS CUT FROM A SINGLE PIECE OF GLASS.

· SINCE THEY'RE MADE OF CUT GLASS, THEY GIVE THE IMPRESSION OF SOPHISTICATED GLASS ARTWORK.

THEY'RE ALL DONE IN ART NOUVEAU STYLE

01

BRAVE WEAPON SERIES

WEAPONS THAT ALLOW TWO HITS AT ONCE.

SWORD
No. 5

LANCE
No. 39

AXE
No. 62

· THEY'RE MADE LIKE A SKELETAL FRAME.

· THEY'RE AS LIGHT AS POSSIBLE SO ONE CAN ATTACK TWICE AS OFTEN.

· ONLY ONE WITH THE MOST ADVANCED WEAPON SKILLS CAN USE IT (OTHERWISE IT BREAKS EASILY).

· THEY LOOK AS THOUGH THEY ARE MADE OF SILVER.

· THE REINFORCEMENT IS IN ART DECO STYLE.

BOW No. 86

KIND OF THIN WHEN SEEN FROM THE SIDE.

02

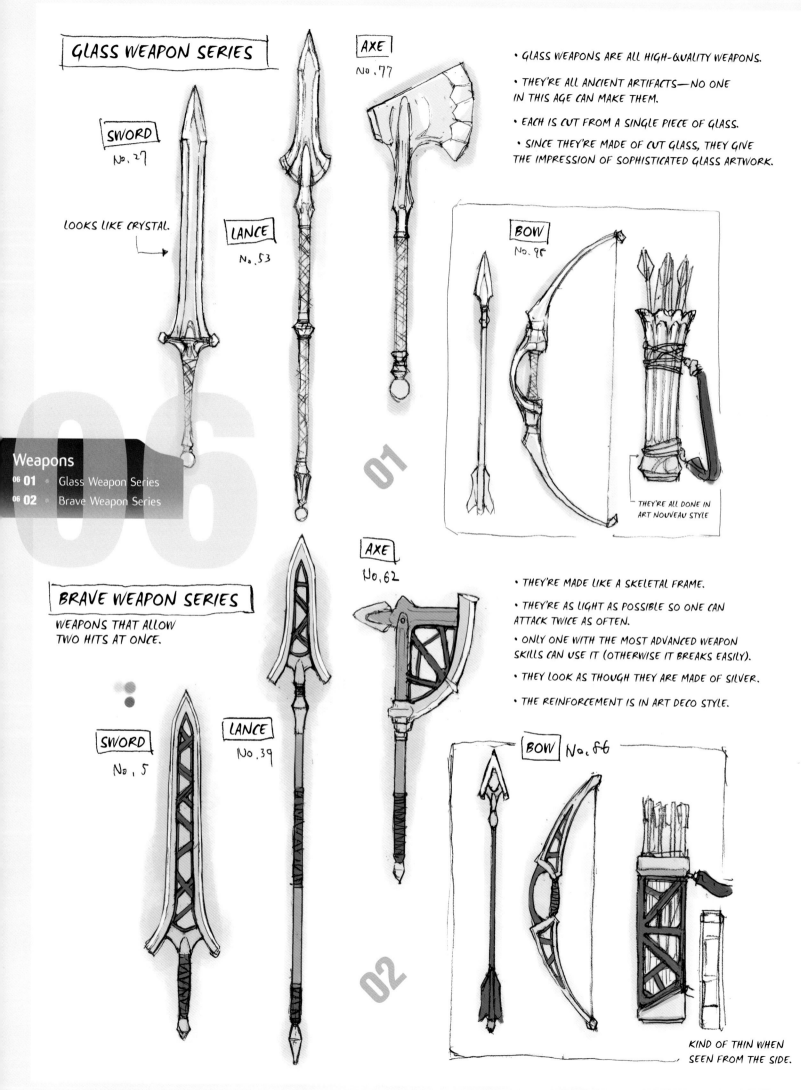

Character Dialogue

Barracks Dialogue

Here we present the words that the characters utter in the barracks or when an event happens on the battle map. "[Robin]" is used here as the avatar's name.

■ AVATAR (MALE)

Talking to self: Heh, somehow I always end up here whenever I'm feeling lonely . . .

Picking something up: What's this? Hmm . . . Perhaps we could use it . . .

Increase in stats: I'm in top form today!

Added experience: I reviewed some historical battle texts. One can glean many tactics from the past.

Higher weapon level: All right! I managed to sneak some practice in.

■ AVATAR (FEMALE)

Talking to self: Heh, somehow I always end up here whenever I'm feeling lonely . . .

Picking something up: What's this? Hmm . . . Don't mind if I do . . .

Increase in stats: I'm in top form today!

Added experience: I studied up on some practical combat strategies. No one will die on my watch!

Higher weapon level: All right! I managed to sneak some practice in.

■ CHROM

Talking to self: I hope soon the realm can be at peace . . .

Picking something up: Huh? Did someone drop this?

Increase in stats: Where is all this strength coming from? I feel like I could topple a mountain!

Added experience: A leader must never rest, never surrender, and most of all never stop learning . . .

Higher weapon level: I got some quick training in. A leader should always be at the top of his game.

■ LISSA

Talking to self: Is that a crack in the wall? Chrom is always breaking things during training . . .

Picking something up: Whoa! Did I just step on something? I hope I didn't break it . . .

Increase in stats: I'm doing great today! I wonder why . . . ? I guess I'll just go with it.

Added experience: I'm trying to be more ladylike, but I think I might've pulled a pinky muscle . . .

Higher weapon level: I snuck in some practice. Gotta keep up with the others, after all.

■ FREDERICK

Talking to self: I was thinking of knitting everyone matching gloves, but what color to make them . . . ?

Picking something up: . . . Hmm? I'd better pick this up lest someone stumble on it . . .

Increase in stats: What's gotten into me today? I feel as if I could protect the realm single-handed!

Added experience: I took it upon myself to clear away a bit of gravel here. Safety first!

Higher weapon level: I managed some extra training. I must stay sharp to protect my comrades.

■ VIRION

Talking to self: I am truly and utterly bored. But at least I have the grace to admit it.

Picking something up: What is this filthy thing? Ah well, I suppose I may as well give it a noble home.

Increase in stats: What is this boost of excellence I sense within my noble self? Even I am amazed!

Added experience: See how well I polished my equipment? The bards shall sing of Virion's legendary shine!

Higher weapon level: This extra training has left me exhausted, but at least I have the grace to not look it.

■ SULLY

Talking to self: Any man who thinks a woman can't fight deserves a punch in the . . . Well, anywhere!

Picking something up: Hey! Who left this crap lying around?!

Increase in stats: Hot damn! I am cooking with fire today! Watch me tear up the field!

Added experience: All done polishing the weapons. Can't fight jack squat without a trusty blade or bow!

Higher weapon level: I snuck in a little extra training. Felt damn good, too.

■ VAIKE

Talking to self: Hmm, maybe "You can't spell 'victory' without 'Vaike'!" Oh yeah, I like that one . . .

Picking something up: Huh? A present from one of Ol' Vaike's fans? How thoughtful!

Increase in stats: The Vaike never has an off day, but today he's definitely having an "onner" day.

Added experience: Teach just did 10 sit-ups and didn't even break a sweat. Oh yeah!

Higher weapon level: Teach worked in a little practice. . . . Not that it's needed!

■ STAHL

Talking to self: I am SO hungry . . .

Picking something up: What's this? Is it edible? I haven't eaten in minutes . . .

Increase in stats: That extra helping at dinner kicked in. I feel great today!

Added experience: Sometimes it's good to stop a moment, get off your horse, and see things a new way.

Higher weapon level: I got in a quick practice, but boy did I ever work up an appetite . . .

■ MIRIEL

Talking to self: Is that rubbish in the corner? Surely we have not stooped to so odious a level?

Picking something up: Did someone misplace this? People ought properly secure their possessions . . .

Increase in stats: What a commendable day. Every item is precisely where it's supposed to be.

Added experience: Ah, contentment. I have finally organized my personal library by author and subject.

■ KELLAM

Talking to self: My name didn't come up at roll call this morning. . . . Again.

Picking something up: . . . Huh? Hidden in plain sight. . . . Just like someone I know . . .

Increase in stats: Is it just me, or do I have more presence today?

Added experience: I've been practicing my war cry to get me noticed. I scared away two birds already!

Higher weapon level: I snuck in some training while no one was looking . . . and no one's ever looking . . .

■ SUMIA

Talking to self: Could it be true that pegasus feathers are the key to divining the future . . . ?

Picking something up: What's this? Ooh, I can't wait to show Chrom . . .

Increase in stats: I haven't tripped in at least an hour! . . . That's amazing. Was it something I ate?

Added experience: You can learn a lot about this world from a pegasus's back. I see new things every day.

Higher weapon level: I snuck in some practice. If anyone needs it, it's me . . .

■ LON'QU

Talking to self: At last, some peace and quiet.

Picking something up: . . . Urgh. What did I just step on?

Increase in stats: . . . I feel more nimble than usual.

Added experience: I . . . I thought a bit more about how to talk to women. I can do this . . .

Higher weapon level: I just cut down a couple brigands in the meantime. Gotta keep my arms loose . . .

■ RICKEN

Talking to self: *Grunt* Nnnnnngh! Why don't I ever get any TALLER?

Picking something up: Huh? Did somebody lose this? That is so irresponsible.

Increase in stats: I'm on fire today! I feel like I could run across the world and back!

Added experience: I tried frying some fish with my Fire tome. Modern men should know how to cook!

Higher weapon level: I snuck in some practice. Gotta prove that I can hold my own!

■ MARIBELLE

Talking to self: I should talk to Chrom about turning this into a tearoom. It needs . . . something . . .

Picking something up: Hmm, what's this? . . . Well, I see little point in just leaving it here.

Increase in stats: I declare, I am in fine form! Perhaps only natural for a woman of my breeding.

Added experience: I managed a quick bit of violin practice. I try to stay abreast of

the noble pursuits.

Higher weapon level: I managed additional training. But then, I've always been conscientious of such matters.

■ PANNE

Talking to self: Gods, I could really go for a carrot right about now . . .

Picking something up: Hmm? The man-spawn use such strange tools.

Increase in stats: Ha, yes! I haven't felt this good since the old days with the warren.

Added experience: Humans do seem more comfortable around me when I pretend to have buck teeth . . .

Higher weapon level: I snuck in some extra training. I must represent my people proudly.

■ GAIUS

Talking to self: No . . . No! That pastry I pilfered got all crumbled in my pocket!

Picking something up: What's this? Candy? Not candy?

Increase in stats: A little sugar has really got my brain spinning again, and I got energy to spare!

Added experience: I don't care what they say—taking candy from a baby is not very easy at all.

Higher weapon level: I snuck in some practice, but I could use a sugar boost in a big bad way.

■ CORDELIA

Talking to self: Sigh . . . Oh gods! Did I truly just say the word "sigh" out loud? I'm getting worse . . .

Picking something up: Oh, did someone lose this? Perhaps I might deliver it . . .

Increase in stats: I'm really outdoing myself today. I wonder if he's noticed . . .

Added experience: I just finished my copy of "Make Him Fall for You in a Fortnight." So embarrassing . . .

Higher weapon level: I snuck in some training. Effort is the start of excellence.

■ GREGOR

Talking to self: Gregor need less-dangerous contract. Is crazy, this war!

Picking something up: Oy! Why is junk lying around?

Increase in stats: Gregor is running the circle around everyone today! Is match for ANYONE!

Added experience: Gregor take little time-out. Do side job, yes?

Higher weapon level: There! Is good to sneak in extra training. Makes Gregor ready for more fighting!

■ NOWI

Talking to self: I'm ready to kick some tail for the team! Lemme at 'em!

Picking something up: Ooh! What's this? Finders keepers!

Increase in stats: I am just BURSTING with energy today! Maybe I'll transform into a bigger dragon!

Added experience: I met a new dragon friend! His name was . . . Banta? . . . Banter?! Wait, what was it . . . ?

Higher weapon level: I practiced my

dragon RAWR! Hopefully it'll scare away more baddies now.

■ LIBRA

Talking to self: O wise Naga, guide us to safety and victory . . .

Picking something up: . . . What's this? Oh, Naga be praised!

Increase in stats: Gods be praised, I feel wonderful today!

Added experience: I've offered up a few prayers for our safety.

Higher weapon level: I managed to sneak in some practice, but I must admit I'm better with prayers.

■ THARJA

Talking to self: Any who would harm [Robin] will burn . . . Heh heh, oh yes indeed . . .

Picking something up: What have we here? Maybe I can use it for my hexes.

Increase in stats: I feel ickier than usual today . . . Splendid! Oh, the curses I could hex up now . . .

Added experience: Ah, finally, a perfect voodoo doll. [Robin] will have eyes only for me . . .

Higher weapon level: Me, weaving horrible, awful hexes? Oh, those were just PRACTICE curses. Honest.

■ OLIVIA

Talking to self: Everyone works so much harder than me. I need to do more.

Picking something up: What's that? It's just lying there . . . I suppose it'd be all right to take it . . . ?

Increase in stats: This has been a fantastic day for me. I feel like I'm dancing on air!

Added experience: I put together a new, edgier dance routine, but I'm too embarrassed to show anyone!

Higher weapon level: I snuck in some weapon practice. Can't rely on dancing all the time, after all.

■ CHERCHE

Talking to self: Oh, look—a cute wittle caterpillar! Here, witty-bitty caterpillar . . .

Picking something up: Did you find something, Minerva? Here, let me see it.

Increase in stats: Is there something in the air today? I feel so invigorated!

Added experience: I mended everyone's tattered clothes. They should feel as good as new.

Higher weapon level: I snuck in a bit of training, but I still have much to learn . . .

■ HENRY

Talking to self: Do you think we could breed Risen in here? I love pets!

Picking something up: Ooh . . . Mysterious object!

Increase in stats: Wow! My blood's pumping so hard today, I think my thumbs might explode!

Added experience: I've seen a man transform into a raven before. Maybe with enough study . . .

Higher weapon level: If practice makes perfect, then an extra bit of practice is perfectly fine by me.

LUCINA

Talking to self: Mother. Father. Let us pray our efforts to stay the future will succeed in the end.

Picking something up: Hmm? What have we here?

Increase in stats: Something agrees with me today. I must have at least twice my normal strength!

Added experience: I tried out some of Father's sword moves and smashed a hole in the wall. . . . Success?

Higher weapon level: I snuck in some practice, but will it be enough . . .

SAY'RI

Talking to self: How to proceed? . . . What would my brother do?

Picking something up: From whence did this come?

Increase in stats: The fates favor me, it seems. Today I feel ready to cut down the fiercest enemies.

Added experience: I have taken up the study of politics. I must do all I can to help lead my people.

Higher weapon level: I train with every free moment, yet still it does not suffice.

BASILIO

Talking to self: Ah, the life of a warrior in a time of strife . . . This is just too much fun! Gahar har har!

Picking something up: What in the world . . . Did Chrom drop this?

Increase in stats: What a day I'm having. I could level an entire army!

Added experience: I went a couple rounds with the younger sprogs. Gotta keep myself in shape, har!

Higher weapon level: I snuck in some training. Well, more like a warm-up . . .

FLAVIA

Talking to self: There's never a dull day in THIS army.

Picking something up: Someone misplaced this, eh? I'll ask Chrom about it later.

Increase in stats: Whew! I feel as though the gods' very breath is in me. I can do anything!

Added experience: Some thugs picked their last fight with me. What kind of strumpet did they take me for?

Higher weapon level: I snuck in some practice. Even a khan needs to stay on top of her game.

DONNEL

Talking to self: I sure hope all them back home is doin' all right.

Picking something up: What in tarnation? I ain't seen nothin' like this back on the farm.

Increase in stats: Dang if I ain't outdoin' m'self today! Might be I can even keep up with the others.

Added experience: I been takin' me some combat lessons! I gots a lot to learn, but I'm gettin' better.

Higher weapon level: Whew! Bit'a extra practice is tougher'n plowin' the fields any which day!

ANNA

Talking to self: The enemy sure had some nice weapons. I should look into their suppliers.

Picking something up: What's this? Well, well, it'll look great in my shop.

Increase in stats: Holy smokes! Is this my lucky day? My performance AND my profits are up!

Added experience: Who knew you could meet suppliers in a place like this? Dang, I'm good.

Higher weapon level: I snuck in some practice. I need to be able to slash brigands AND prices!

OWAIN

Talking to self: The time to unleash my true power is nigh . . .

Picking something up: What is this? Have I found the legendary item of . . . er . . . legend?

Increase in stats: The blood of heroes courses through me! Today I will mete out great justice!

Added experience: I hereby dub my weapon "Shadowdarkness." Yes . . . it will be a fitting brand.

Higher weapon level: Secret Art . . . BINDING BLADE! Heeyaah! Yes, I can feel the extra training working . . .

INIGO

Talking to self: It's so dull here alone . . . I should see where the others have gotten off to.

Picking something up: What's this on the ground? . . . Perhaps some lovely lass dropped it?

Increase in stats: Today is a fine day—I can smell it. Watch me sweep the ladies off their feet!

Added experience: I was just practicing a few dance moves. I hope no one was watching . . .

Higher weapon level: I snuck in some practice, if you know what I mean. . . . What? No, FIGHTING practice.

BRADY

Talking to self: I can't believe Mother used my staff as a laundry pole . . .

Picking something up: Some bloke must'a lost this, yah? . . . Suppose I'd better hang on to it.

Increase in stats: What a day! I've been scatterin' foes with a single glance from my mean mug!

Added experience: I worked out a little melody on the violin. "Noble pursuits," as Ma would say.

Higher weapon level: I snuck in some practice. Now if I could just keep my weapon from flyin' outta my hand . . .

KJELLE

Talking to self: Those last ruffians were a handful. I need more training.

Picking something up: Huh? I had better pick this up before someone trips on it.

Increase in stats: I feel as though I could conquer anything today! Has my training finally paid off?

Added experience: I polished and oiled my armor. You never know when battle will erupt, after all.

Higher weapon level: I snuck in some good practice, but it's not the same without a real body to beat on.

CYNTHIA

Talking to self: Is my pegasus losing feathers? Is that a thing? . . . Should I be worried?

Picking something up: Ooh, free stuff! I call dibs!

Increase in stats: What a killer day I'm having! The forces of evil will stay home if they're smart.

Added experience: "I am Cynthia. Now, die in the name of a Brighter Future!" . . . Oh, that's good!

Higher weapon level: See that? The practice session of champions! I'm so strong now, it's scary.

SEVERA

Talking to self: I can fight like my mother. I'll PROVE I'm every bit as brave as her.

Picking something up: Ugh! Who left this here?! Oh, now I guess I'm supposed to pick it up, is that it? *sigh*

Increase in stats: I must have slept well or something. My skin feels so supple. And my hair? Perfect!

Added experience: I found this book "Make Him Fall for You in a Fortnight." Who reads this stuff?!

Higher weapon level: I snuck in some practice, but now I'm all sweaty. I HATE practice.

GEROME

Talking to self: I often wonder if meddling with the past is the right thing to do?

Picking something up: Minerva, must you pick up every little . . . Wait—what do you have there? Let me see.

Increase in stats: Something about today makes me feel that I will do great things.

Added experience: I've stitched some holes in our clothes. . . . Sewing is a hidden skill of mine.

Higher weapon level: I snuck in some practice. You'd think I would be beyond that by now . . .

MORGAN (MALE)

Talking to self: Hmm, what shall I read today?

Picking something up: What's this? I'd better hold on to it.

Increase in stats: I'm in fantastic form today! I just hope I can put it to good use.

Added experience: I started on some of Mother's tactical guidebooks. I want to help!

Higher weapon level: I snuck in some practice. Maybe there's hope for me as a tactician yet!

MORGAN (FEMALE)

Talking to self: Hmm, perhaps another book to pass the time . . .

Picking something up: What's this? I'd better hold on to it.

Increase in stats: I'm in fantastic form today! I just hope I can put it to good use.

Added experience: I started on some of Father's tactical guidebooks. I must learn all I can!

Higher weapon level: I snuck in some practice. Maybe there's hope for me as a tactician yet!

YARNE

Talking to self: Agh! I've been stung by a bee! The last seconds of my life have begun! Nooo!

Picking something up: Ah! A rabbit trap! . . . Oh, wait, it's just some human junk.

Increase in stats: Wow! What is it about today? I never felt this good in the future.

Added experience: Why does everyone look at me funny when I make buck teeth? Mom lied!

Higher weapon level: I snuck in some practice. HIDING practice! . . . What else is a bunny to do?

LAURENT

Talking to self: So strange, to experience a world where hope has not been snuffed out.

Picking something up: My word—a misplaced item? Does no one adequately secure their belongings?

Increase in stats: What a remarkable day I'm having. If only I always felt this formidable!

Added experience: I've been organizing our weapons by name and make. Our old system was a farce!

Higher weapon level: I snuck in some practice. Thanks to my mother's guidance, it went perfectly.

NOIRE

Talking to self: Why is this room empty? Are there spies? Traps? . . . WELL BRING THEM ON!

Picking something up: Ack! What is this? An enemy trap? A curse from my mother?!

Increase in stats: Today has been remarkable. I bet I could withstand ANY of Mother's curses!

Added experience: I've done it—a new talisman to protect me from all likely misfortune! Please work . . .

Higher weapon level: I snuck in some practice . . . NOW WHO DARES FACE ME!

NAH

Talking to self: It's so relaxing here—the perfect place to rest one's body and mind.

Picking something up: What is this? . . . Well, if nobody else wants it . . .

Increase in stats: The way today's been going, I feel like I could transform into a superdragon!

Added experience: "Talk my age," my mother says. I may as well practice drooling before a mirror!

Higher weapon level: I circled the peak and shook the heavens with my roar. Does that count as practice?

TIKI

Talking to self: *Yawn* I'm getting sleepy . . .

Picking something up: . . . What is this?

Increase in stats: Look at me go! I could not ask for a better day.

Added experience: Ah, it's good to catch up with people. So much of the world has changed!

Higher weapon level: It felt good to sneak in some practice. How long has it been?

GANGREL

Talking to self: When you hit rock bottom, the only way out is up.

Picking something up: What's this junk?!

Increase in stats: Gya ha ha! What is in the water? I feel like I could stamp out armies like anthills today!

Added experience: I did meet a maid the other day that made me think perhaps things aren't all so bad . . .

Higher weapon level: I snuck in some practice to see how it felt, but I admit, I prefer executions to exercise.

WALHART

Talking to self: What manner of future will Chrom mold? I look forward to discovering for myself . . .

Picking something up: What is this? Ha ha, an item! KNEEL BEFORE YOUR NEW MASTER!

Increase in stats: I am always in top form, but today I have shattered even my high expectations!

Added experience: I have no need of rest. Every moment can be another step toward my ultimate victory.

Higher weapon level: I have trained more. Complacency is weakness—I will never stop training.

EMMERYN

Talking to self: Who . . . am I . . .

Picking something up: What . . . Who . . .

Increase in stats: Today . . . I feel . . . strong . . .

Added experience: I learn more . . . about . . . this place . . .

Higher weapon level: I . . . practiced . . .

YEN'FAY

Talking to self: I wonder . . . what were my last thoughts as I left this world . . .

Picking something up: . . . An item?

Increase in stats: The day has proven to favor me. My blade sings songs I feared forgotten.

Added experience: . . .These are the times that try a man's soul, sure as any forge's flames.

Higher weapon level: . . . I have trained more, though one can never train enough.

AVERSA

Talking to self: Validar . . . I can never forget . . .

Picking something up: Well, now. Who's the naughty boy dropping his things all about . . .?

Increase in stats: Now this is my kind of day! It's like the whole world dances in the palm of my hand.

Added experience: I'm trying out a new scent . . . It takes work to keep men wrapped around your finger.

Higher weapon level: I just exercised some new muscles. Shall I show you what I can do with them?

PRIAM

Talking to self: Will I ever find a challenger worthy?

Picking something up: What's this little thing?

Increase in stats: I feel on top of the world today. Let any enemy challenge me—they will fail!

Added experience: I dispatched a few minor enemies just now—nothing worth mentioning.

Higher weapon level: I managed a quick training session. None will ever surpass me now.

Section 3

STORY EVENT ILLUSTRATIONS

Story Event Illustrations

▪▪▪ Fully Rendered Illustrations from the Major Chapters

There are gorgeous illustrations scattered throughout the game's story and we have collected them here for you. These illustrations were overseen by Madhouse and checked and corrected by Yusuke Kozaki, the character designer.

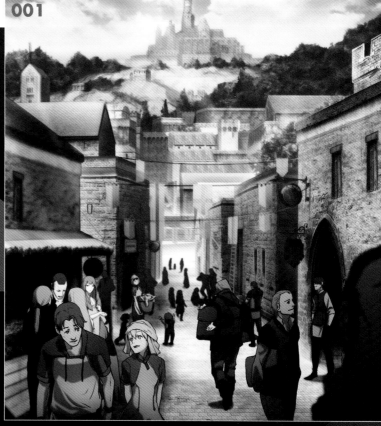

001

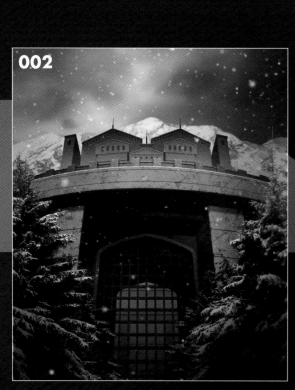

002

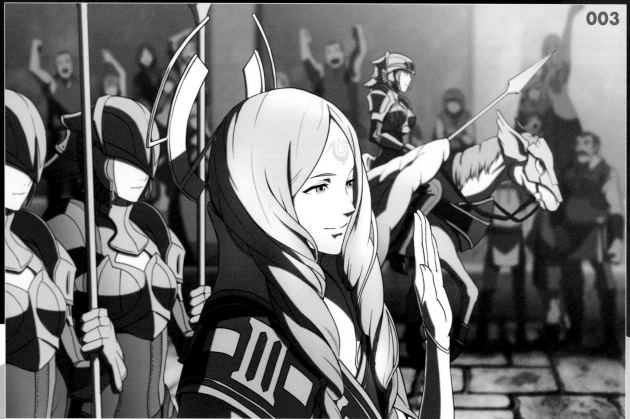

003

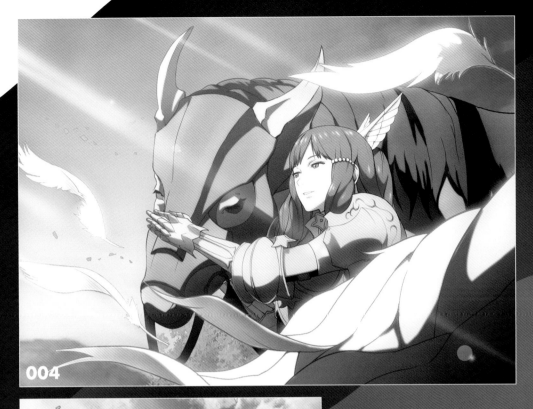

004

005

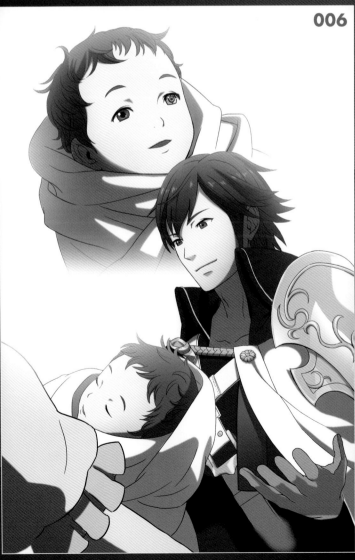

006

007

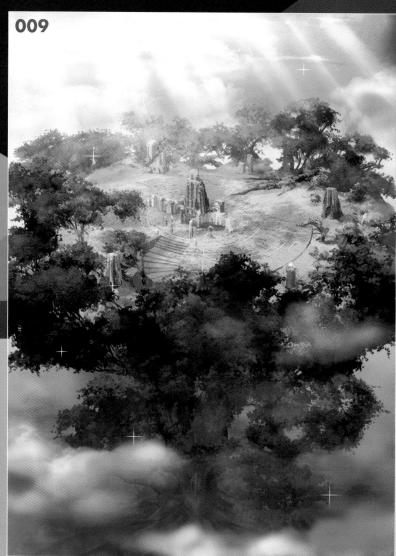

009

008

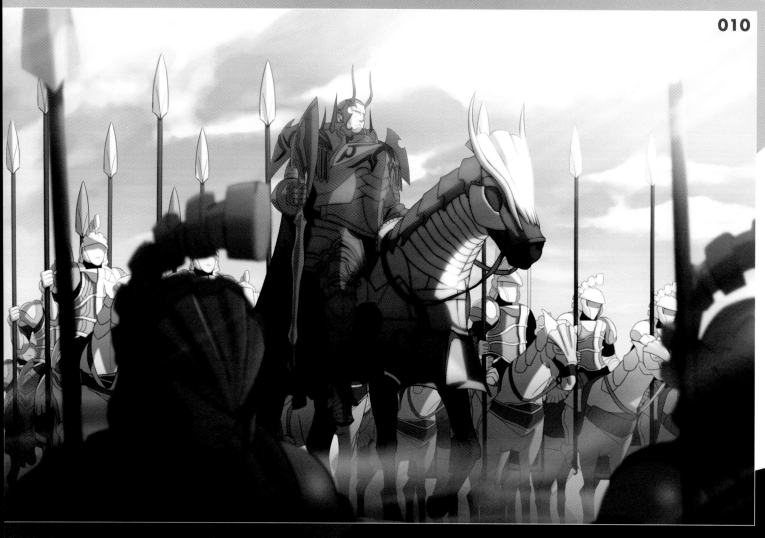

010

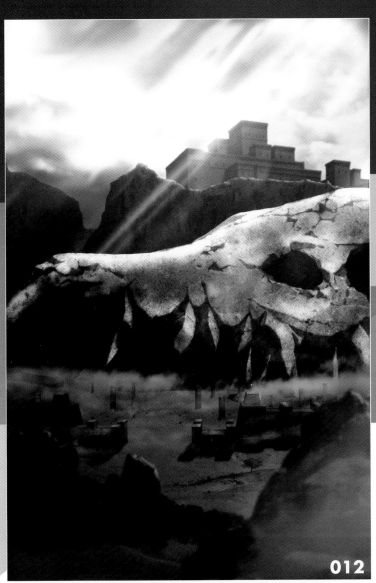

012

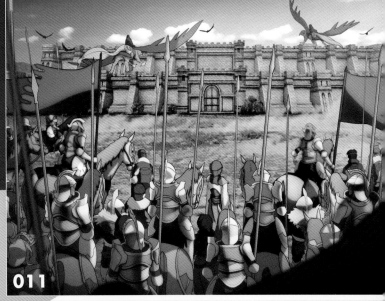

011

013

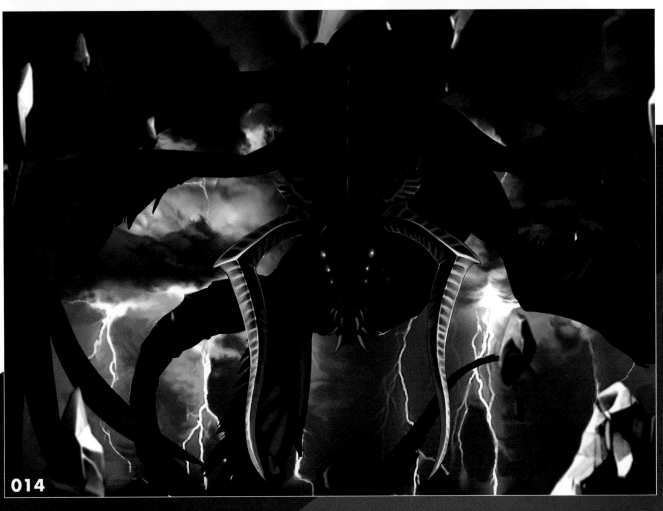

014

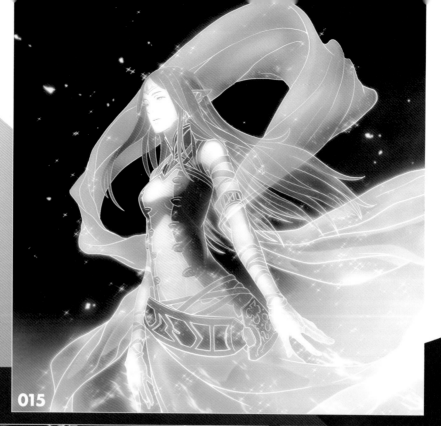

015

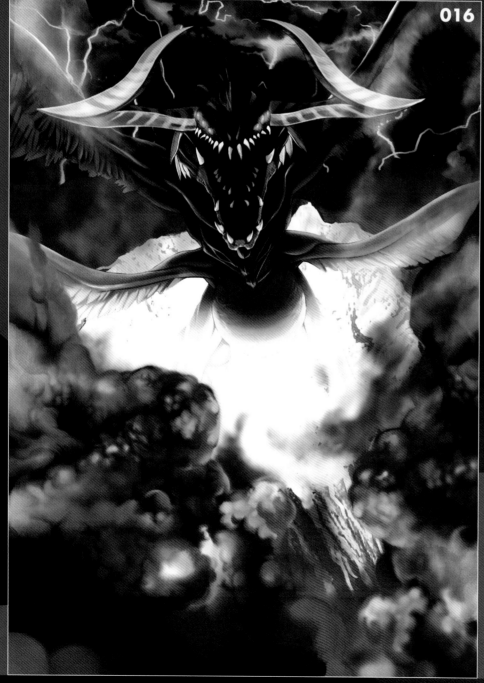

016

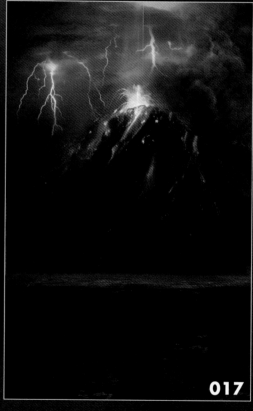

017

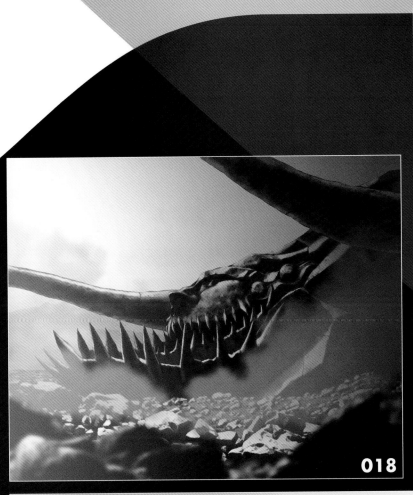

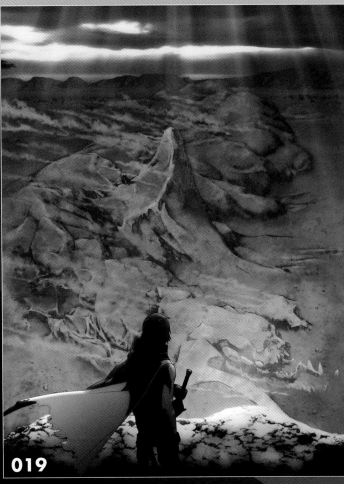

018

019

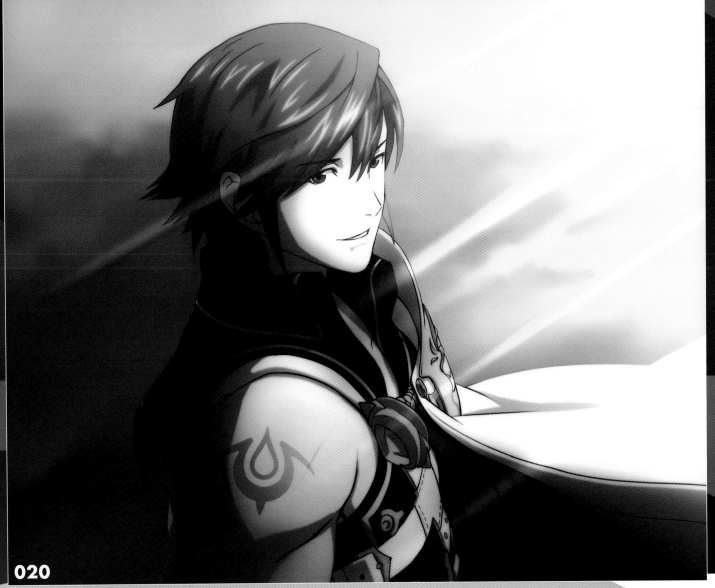

020

Proposal Event Illustrations

When the player's character reaches support level S
with another character, there is a beautifully illustrated
proposal event. We are including every illustration here,
including everyone in the second generation and the
characters available through the paralogues, too.

001

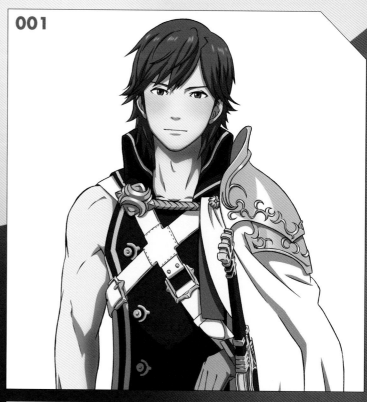

002

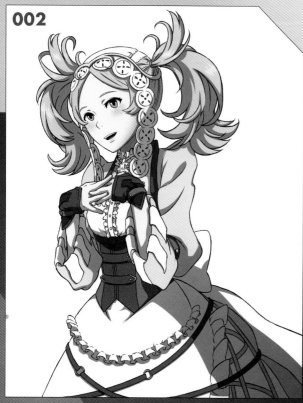

003

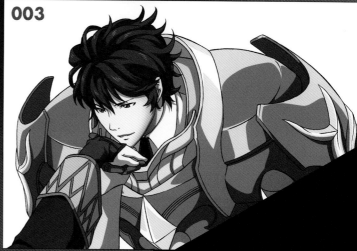

005

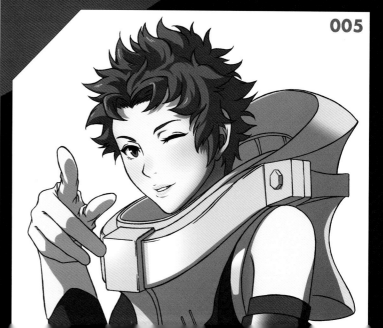

004

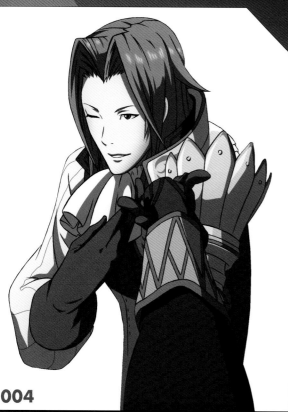

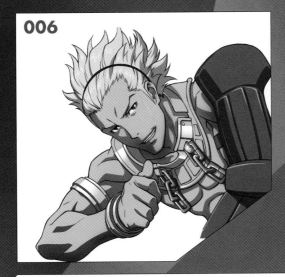

006

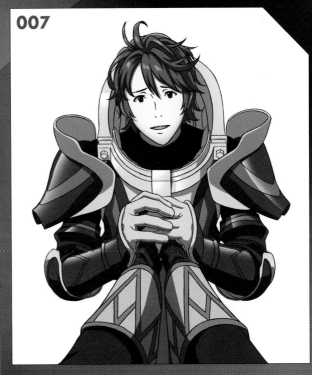

007

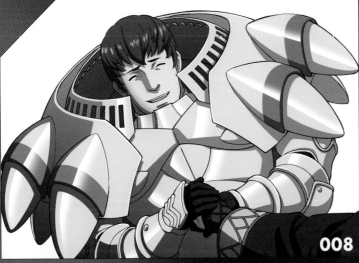

008

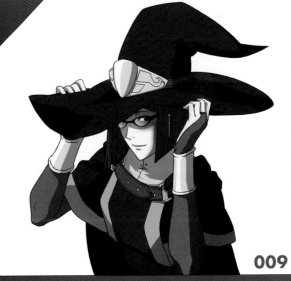

009

Proposal

001	Chrom	007	Stahl
002	Lissa	008	Kellam
003	Frederick	009	Miriel
004	Virion	010	Lon'qu
005	Sully	011	Sumia
006	Vaike		

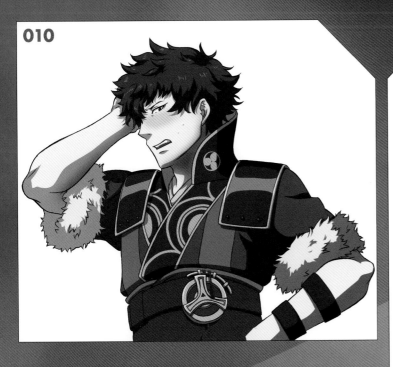

010

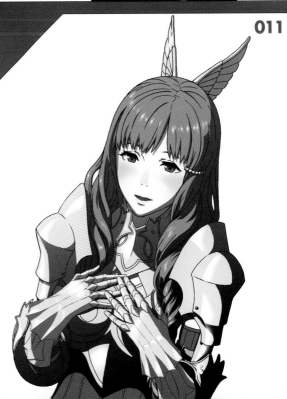

011

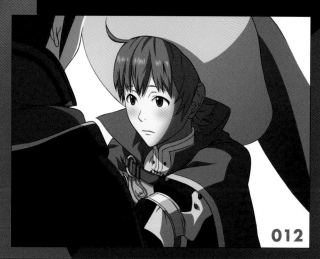

012

013

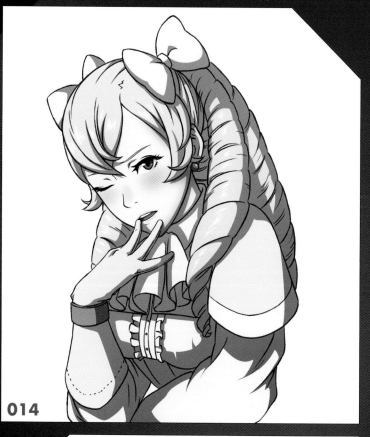

014

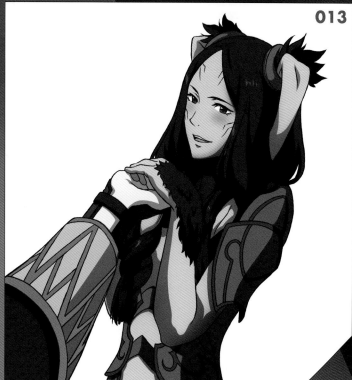

015

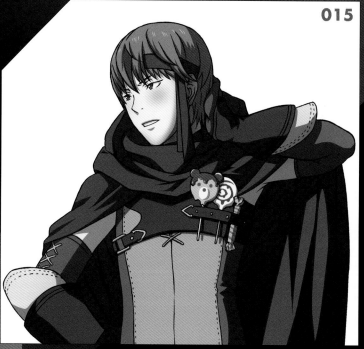

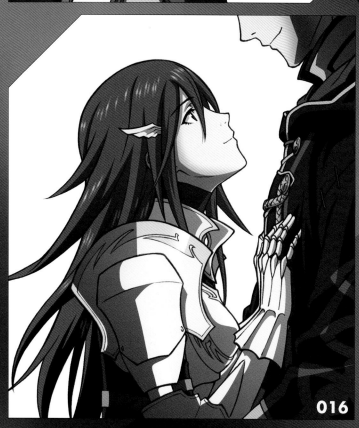

016

017

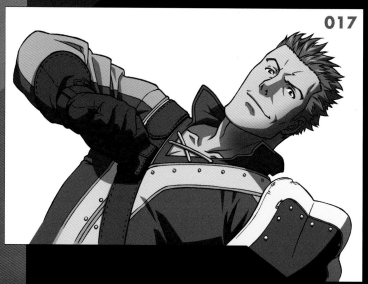

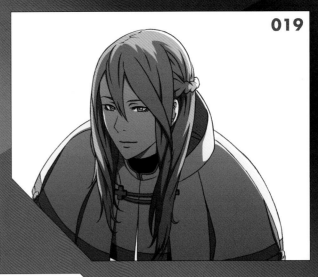

018

019

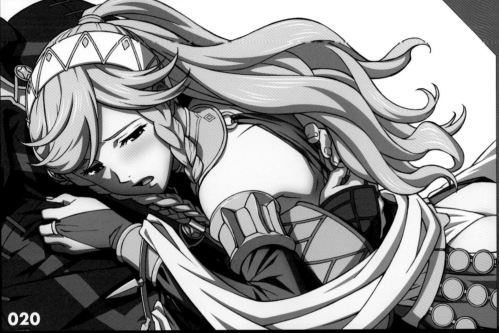

020

Proposal

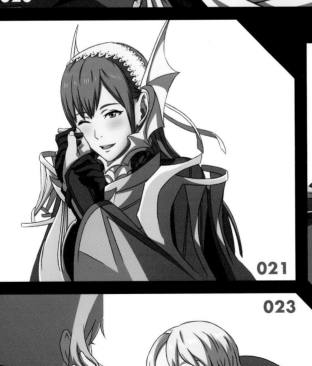

021

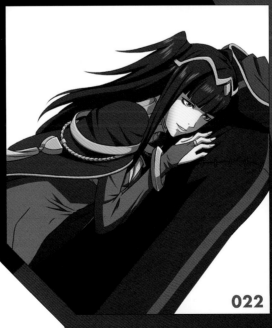

022

023

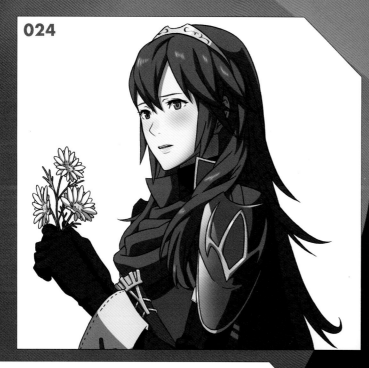

024

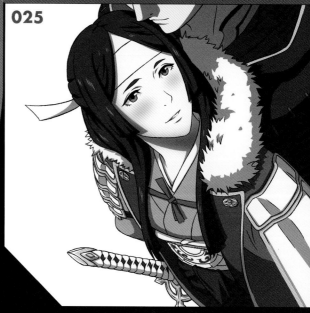

025

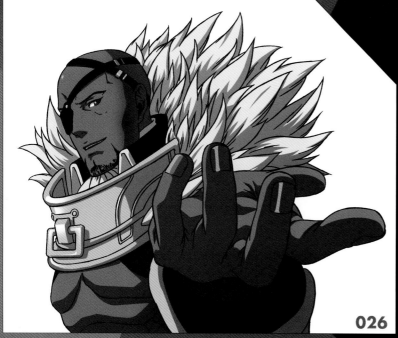

026

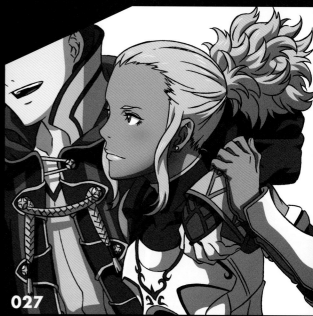

027

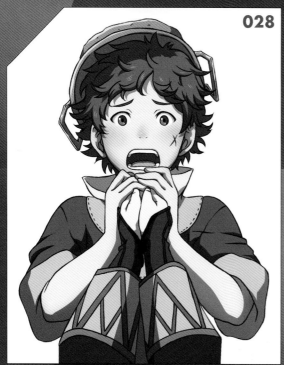

028

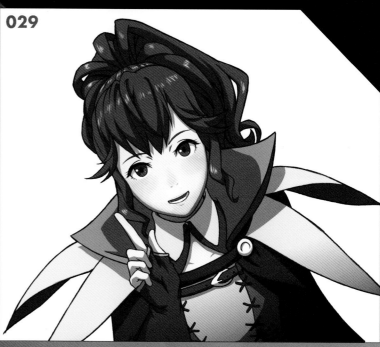

029

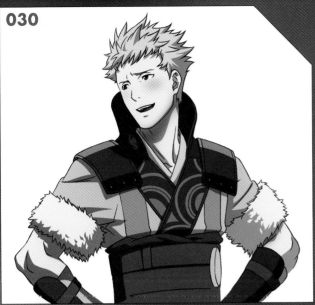

030

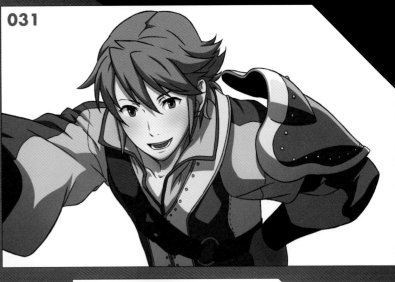

031

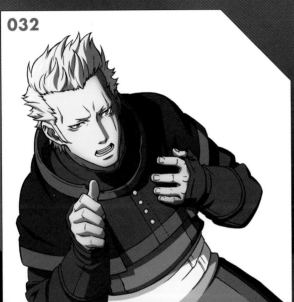

032

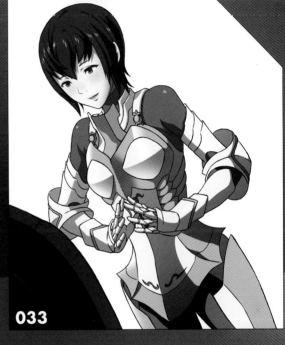

033

Proposal

024	Lucina	028	Donnel	032	Brady
025	Say'ri	029	Anna	033	Kjelle
026	Basilio	030	Owain	034	Cynthia
027	Flavia	031	Inigo	035	Severa

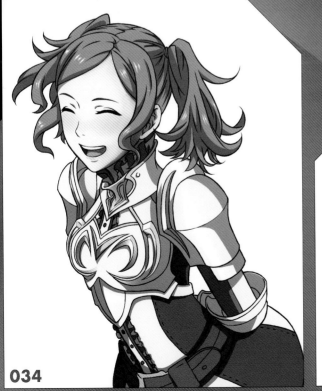

034

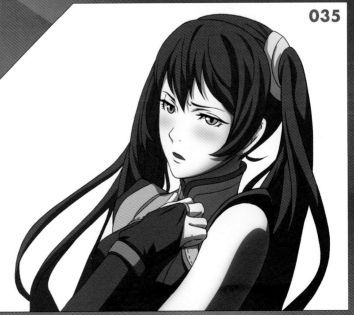

035

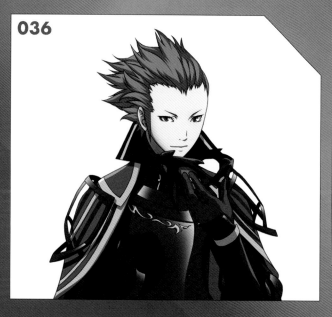

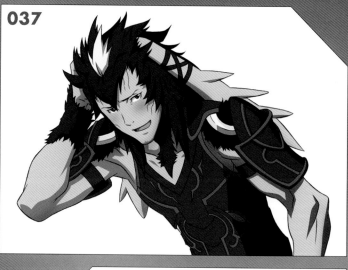

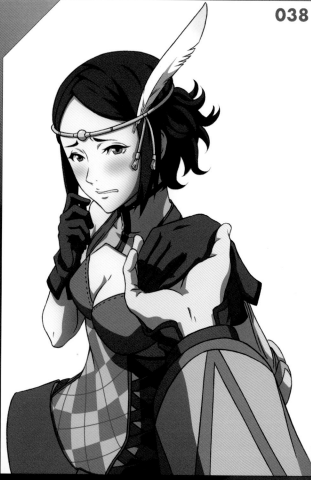

Proposal

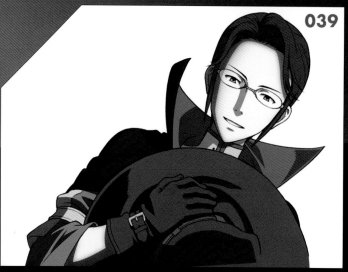

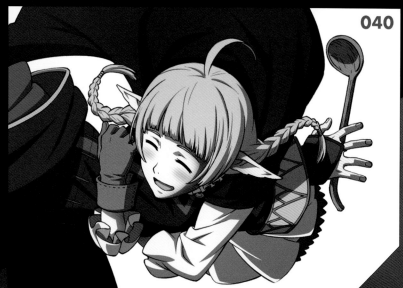

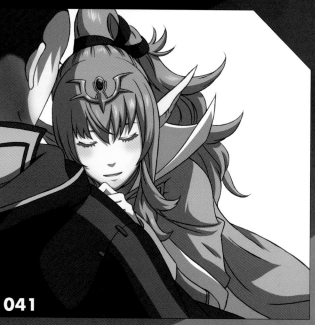

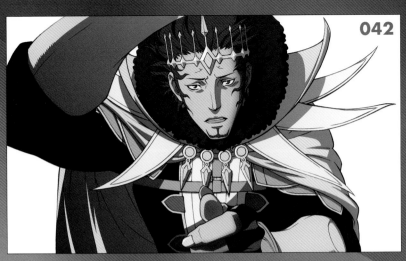

042

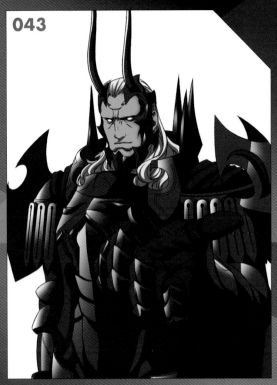

043

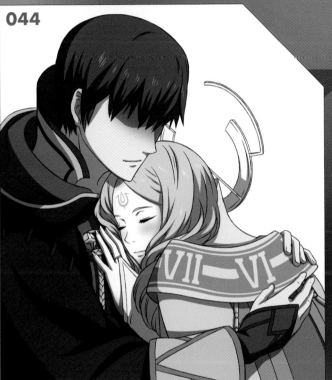

044

045

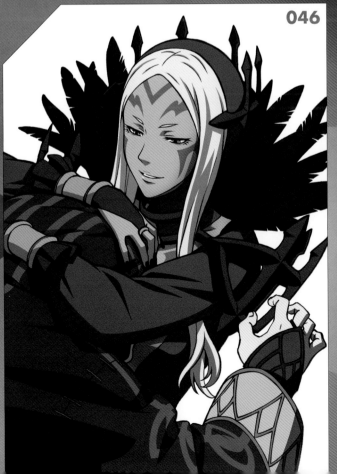

046

047

Cutscene
Storyboards

■■■ A Look behind the Scenes at the Storyboards

There are twelve cutscenes in this overview section, and as a special treat, we're bringing you all of the storyboards for each scene. The talent behind these scenes are from studios like Anima and Kamikaze Douga with excellent, established reputations for high-quality animation.

Fated Clash

01

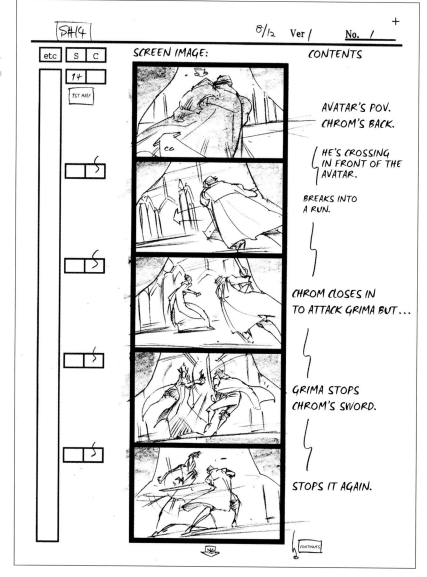

SH14 8/12 Ver 1 No. 1

| etc | S | C | SCREEN IMAGE: | CONTENTS |

AVATAR'S POV.
CHROM'S BACK.

{ HE'S CROSSING
IN FRONT OF THE
AVATAR.

BREAKS INTO
A RUN.

CHROM CLOSES IN
TO ATTACK GRIMA BUT...

GRIMA STOPS
CHROM'S SWORD.

STOPS IT AGAIN.

CONTINUES

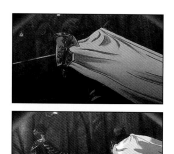
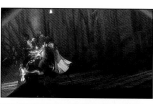
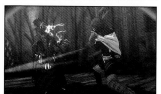

Fated Clash

05

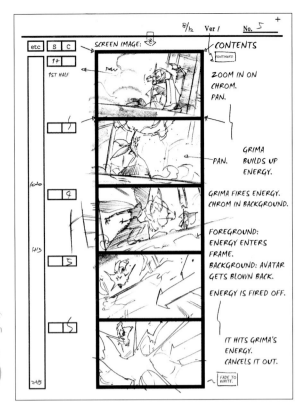

Fated Clash II

02

etc	S	C	SCREEN IMAGE:	CONTENTS

8/12 Ver / No. 5

etc | S | C

14
1ST HALF

SCREEN IMAGE: ※

CONTENTS
continued

ZOOM IN ON CHROM. PAN.

PAN. GRIMA BUILDS UP ENERGY.

GRIMA FIRES ENERGY. CHROM IN BACKGROUND.

FOREGROUND: ENERGY ENTERS FRAME. BACKGROUND: AVATAR GETS BLOWN BACK.

ENERGY IS FIRED OFF.

IT HITS GRIMA'S ENERGY. CANCELS IT OUT.

FADE TO WHITE.

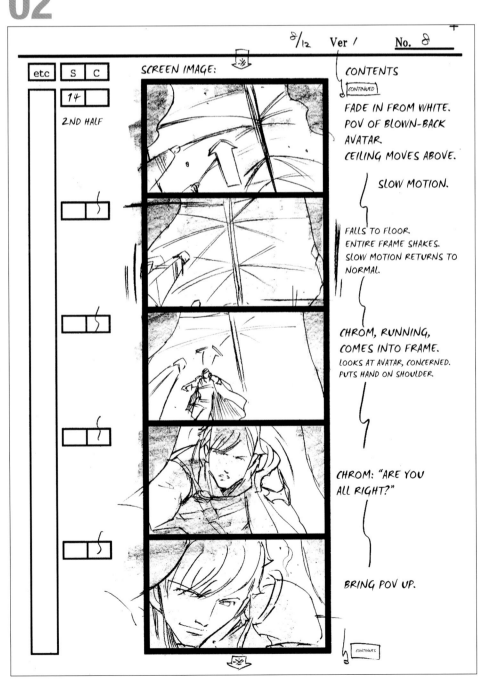

8/12 Ver / No. 8

etc | S | C

14
2ND HALF

SCREEN IMAGE:

CONTENTS
continued

FADE IN FROM WHITE.
POV OF BLOWN-BACK AVATAR
CEILING MOVES ABOVE.

SLOW MOTION.

FALLS TO FLOOR.
ENTIRE FRAME SHAKES.
SLOW MOTION RETURNS TO NORMAL.

CHROM, RUNNING, COMES INTO FRAME.
LOOKS AT AVATAR, CONCERNED.
PUTS HAND ON SHOULDER.

CHROM: "ARE YOU ALL RIGHT?"

BRING POV UP.

CONTINUES

04

Fated Clash
05

05

06

Moment of Destiny (Ending)

01

Fated Clash II
02

02

03

04

//////////
Fated Clash II

04

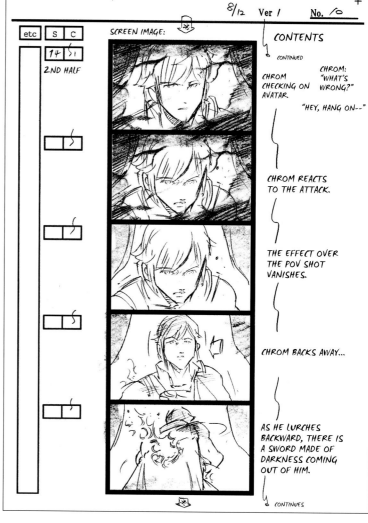

etc	S	C
	14	51

2ND HALF

SCREEN IMAGE:

CONTENTS

CONTINUED

CHROM
CHECKING ON
AVATAR.

CHROM:
"WHAT'S
WRONG?"

"HEY, HANG ON--"

CHROM REACTS
TO THE ATTACK.

THE EFFECT OVER
THE POV SHOT
VANISHES.

CHROM BACKS AWAY...

AS HE LURCHES
BACKWARD, THERE IS
A SWORD MADE OF
DARKNESS COMING
OUT OF HIM.

CONTINUES

01

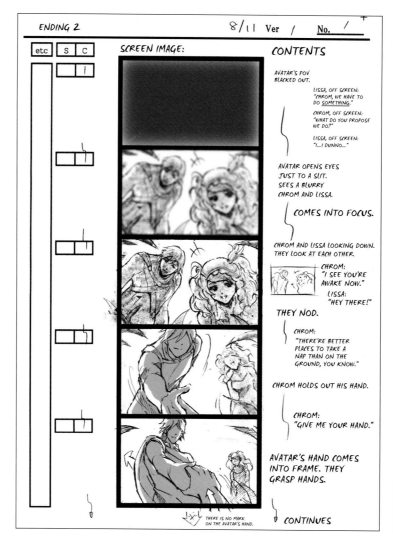

ENDING 2 8/11 Ver 1 No. 1

etc	S	C
		1

SCREEN IMAGE:

CONTENTS

AVATAR'S POV
BLACKED OUT.

LISSA, OFF SCREEN:
"CHROM, WE HAVE TO
DO SOMETHING."

CHROM, OFF SCREEN:
"WHAT DO YOU PROPOSE
WE DO?"

LISSA, OFF SCREEN:
"I...I DUNNO..."

AVATAR OPENS EYES
JUST TO A SLIT.
SEES A BLURRY
CHROM AND LISSA.

COMES INTO FOCUS.

CHROM AND LISSA LOOKING DOWN.
THEY LOOK AT EACH OTHER.

CHROM:
"I SEE YOU'RE
AWAKE NOW."

LISSA:
"HEY THERE!"

THEY NOD.

CHROM:
"THERE'RE BETTER
PLACES TO TAKE A
NAP THAN ON THE
GROUND, YOU KNOW."

CHROM HOLDS OUT HIS HAND.

CHROM:
"GIVE ME YOUR HAND."

AVATAR'S HAND COMES
INTO FRAME. THEY
GRASP HANDS.

THERE IS NO MARK
ON THE AVATAR'S HAND.

CONTINUES

//////////
Third Meeting

01

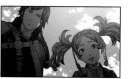

#504

CUT	PICTURE	DESCRIPTION	(TIME)
01		(FADE IN FROM BLACK.) THE CAMERA FOLLOWS A FAST-RUNNING AND PANTING CHROM. CHROM: "...HAHH...HAHH..." (3.0)	
02		CHROM STARTS THE SCENE LARGE IN THE FRAME AND RUNS TOWARD THE BACKGROUND. THE CAMERA PANS, FOLLOWING CHROM'S LINE OF SIGHT, AND IN THE DISTANCE IS EMMERYN STANDING ON TOP OF THE DRAGON'S HORN. (4.5)	

Pg. 1 ()

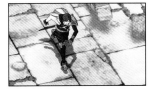

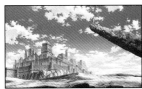

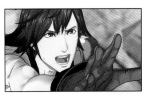

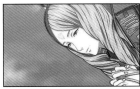

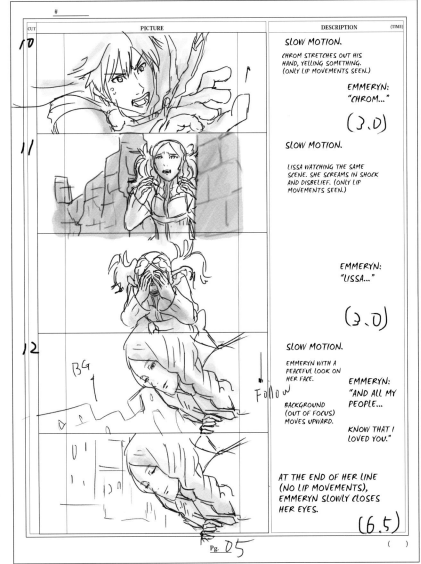

CUT	PICTURE	DESCRIPTION	(TIME)
10		SLOW MOTION. CHROM STRETCHES OUT HIS HAND, YELLING SOMETHING. (ONLY LIP MOVEMENTS SEEN.) EMMERYN: "CHROM..." (3.0)	
11		SLOW MOTION. LISSA WATCHING THE SAME SCENE. SHE SCREAMS IN SHOCK AND DISBELIEF. (ONLY LIP MOVEMENTS SEEN.) EMMERYN: "LISSA..." (3.0)	
12		SLOW MOTION. EMMERYN WITH A PEACEFUL LOOK ON HER FACE. EMMERYN: "AND ALL MY PEOPLE... KNOW THAT I LOVED YOU." BACKGROUND (OUT OF FOCUS) MOVES UPWARD. AT THE END OF HER LINE (NO LIP MOVEMENTS), EMMERYN SLOWLY CLOSES HER EYES. (6.5)	

BG 1
Follow

Pg. 05 ()

\\\\\\\\\\\\\
Emmeryn

05

07

07

Cataclysm

01

02

Cataclysm

04

04

05

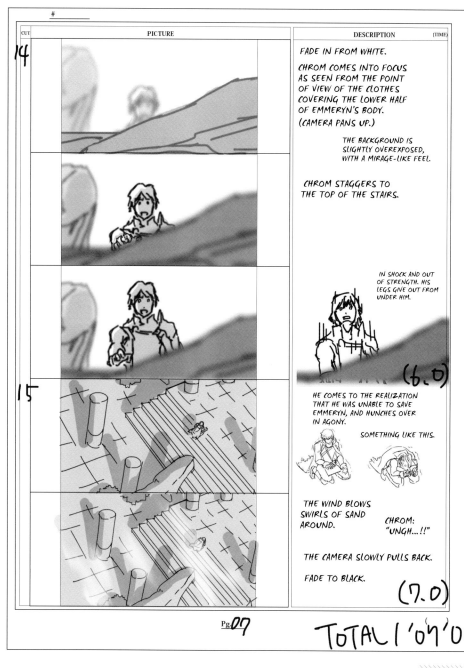

#

CUT	PICTURE	DESCRIPTION	(TIME)
14		FADE IN FROM WHITE. CHROM COMES INTO FOCUS AS SEEN FROM THE POINT OF VIEW OF THE CLOTHES COVERING THE LOWER HALF OF EMMERYN'S BODY. (CAMERA PANS UP.) THE BACKGROUND IS SLIGHTLY OVEREXPOSED, WITH A MIRAGE-LIKE FEEL. CHROM STAGGERS TO THE TOP OF THE STAIRS.	
		IN SHOCK AND OUT OF STRENGTH. HIS LEGS GIVE OUT FROM UNDER HIM. (6.0)	
15		HE COMES TO THE REALIZATION THAT HE WAS UNABLE TO SAVE EMMERYN, AND HUNCHES OVER IN AGONY. SOMETHING LIKE THIS. THE WIND BLOWS SWIRLS OF SAND AROUND. CHROM: "UNGH...!!" THE CAMERA SLOWLY PULLS BACK. FADE TO BLACK. (7.0)	

Pg 07

TOTAL 1'07"0

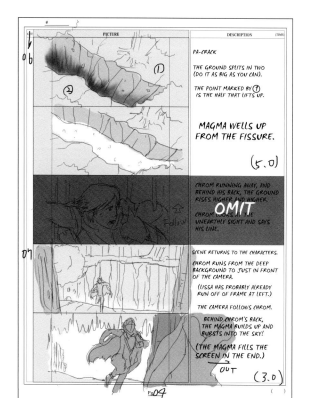

#

	PICTURE	DESCRIPTION	(TIME)
06		PA-CRACK THE GROUND SPLITS IN TWO (DO IT AS BIG AS YOU CAN). THE POINT MARKED BY ① IS THE HALF THAT LIFTS UP. MAGMA WELLS UP FROM THE FISSURE. (5.0)	
		CHROM RUNNING AWAY, AND BEHIND HIS BACK, THE GROUND RISES HIGHER AND HIGHER CHROM ~~SEES THE UNEARTHLY SIGHT AND SAYS HIS LINE.~~ OMIT	
07		SCENE RETURNS TO THE CHARACTERS. CHROM RUNS FROM THE DEEP BACKGROUND TO JUST IN FRONT OF THE CAMERA. (LISSA HAS PROBABLY ALREADY RUN OFF OF FRAME AT LEFT.) THE CAMERA FOLLOWS CHROM. BEHIND CHROM'S BACK, THE MAGMA BUILDS UP AND BURSTS INTO THE SKY! (THE MAGMA FILLS THE SCREEN IN THE END.) OUT (3.0)	

Pg 04

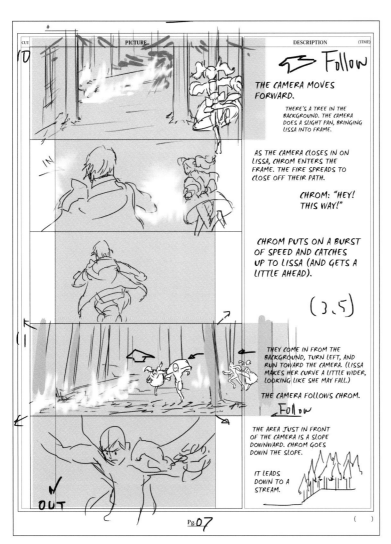

Pg.07 — Cut 10

Follow — THE CAMERA MOVES FORWARD.

THERE'S A TREE IN THE BACKGROUND. THE CAMERA DOES A SLIGHT PAN, BRINGING LISSA INTO FRAME.

AS THE CAMERA CLOSES IN ON LISSA, CHROM ENTERS THE FRAME. THE FIRE SPREADS TO CLOSE OFF THEIR PATH.

CHROM: "HEY! THIS WAY!"

CHROM PUTS ON A BURST OF SPEED AND CATCHES UP TO LISSA (AND GETS A LITTLE AHEAD).

(3.5)

THEY COME IN FROM THE BACKGROUND, TURN LEFT, AND RUN TOWARD THE CAMERA. (LISSA MAKES HER CURVE A LITTLE WIDER, LOOKING LIKE SHE MAY FALL.)

THE CAMERA FOLLOWS CHROM.

Follow

THE AREA JUST IN FRONT OF THE CAMERA IS A SLOPE DOWNWARD. CHROM GOES DOWN THE SLOPE.

IT LEADS DOWN TO A STREAM.

IN · OUT

Pg.07 ()

Cataclysm

07

Cataclysm

10

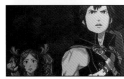

Pg.10 — Cut 13

THE TWO ARE LEFT SPEECHLESS.

CHROM IS ROOTED TO THE GROUND IN AMAZEMENT.

LISSA'S SHOULDERS ARE STILL HEAVING AS SHE PANTS.

LISSA SUDDENLY BECOMES AWARE OF A CHANGE.

PANICKING, SHE POINTS WITH HER FINGER. (THE CAMERA FOLLOWS LISSA'S MOVEMENTS.)

"CHROM, WHAT IS THAT?!"

CHROM TURNS QUICKLY TO LOOK.

(HAVE CHROM TURN TO LOOK AT HER FOR A MOMENT ABOUT WHEN SHE SAYS HIS NAME, BEFORE HE TURNS TO LOOK WHERE SHE'S POINTING.)

(AS THE CAMERA PANS TO CHROM, IT CHANGES FOCUS FROM LISSA TO CHROM.)

(4.5)

Pg.10 ()

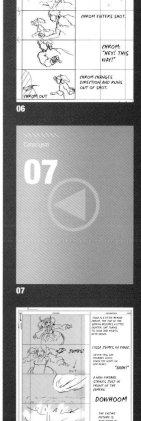

Cataclysm

07

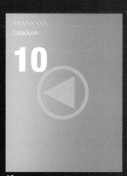

Cataclysm

10

12

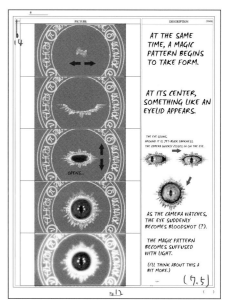

	PICTURE	DESCRIPTION (TIME)

AT THE SAME TIME, A MAGIC PATTERN BEGINS TO TAKE FORM.

AT ITS CENTER, SOMETHING LIKE AN EYELID APPEARS.

THE EYE GLOWS. AROUND IT IS JET-BLACK DARKNESS. THE CAMERA SLOWLY CLOSES IN ON THE EYE.

OPENS...

AS THE CAMERA WATCHES, THE EYE SUDDENLY BECOMES BLOODSHOT (?).

THE MAGIC PATTERN BECOMES SUFFUSED WITH LIGHT.

(I'LL THINK ABOUT THIS A BIT MORE.)

(7.5)

Pg. 12

CUT	PICTURE	DESCRIPTION	(TIME)

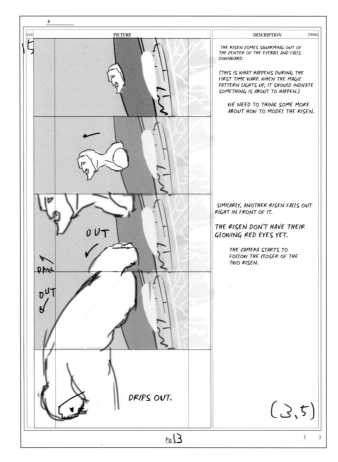

SOME CAMERA POSITION AS OUT BE.

THE TWO HUMAN FORMS FALL FROM THE EYE.

(THE CAMERA FOLLOWS THEM DOWN, THEN SLOWLY TRACKS IN.)

PAN THUD

THUD (2.5)

THE RISEN COMES SQUIRMING OUT OF THE CENTER OF THE EYEBALL AND FALLS DOWNWARD.

(THIS IS WHAT HAPPENS DURING THE FIRST TIME WARP. WHEN THE MAGIC PATTERN LIGHTS UP, IT SHOULD INDICATE SOMETHING IS ABOUT TO HAPPEN.)

WE NEED TO THINK SOME MORE ABOUT HOW TO MODEL THE RISEN.

SIMILARLY, ANOTHER RISEN FALLS OUT RIGHT IN FRONT OF IT.

THE RISEN DON'T HAVE THEIR GLOWING RED EYES YET.

THE CAMERA STARTS TO FOLLOW THE CLOSER OF THE TWO RISEN.

OUT

PAN

OUT

DRIPS OUT.

(3.5)

Pg. 13

13

15

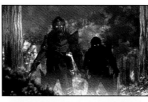

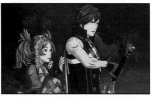

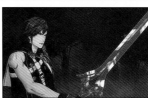

WHERE A PERSON HAS FALLEN, ALL THAT REMAINS IS A MASK.

ANOTHER MASK FALLS OUT OF THE EYEBALL.

SHIRK

THE FIRST RISEN COMES INTO FRAME. (IT SHOULD BE A LITTLE IN FRAME AT THE START.)

AND DIRECTLY AFTER, THE SECOND ONE ENTERS FRAME.

(THE CAMERA PANS WITH THEIR MOVEMENT.)

THE RISEN ROARS. BLACK SMOKE EMANATES FROM HIS MOUTH. HE PARTS HIS OWN SMOKE AS HE BEGINS HIS RUSH.

(5.5)

THE RISEN RUSH FORWARD.

THEY RUN WITH A MOVEMENT THAT DOESN'T SEEM HUMAN.

PAN

JUST BEFORE REACHING THE CAMERA, ONE JUMPS.

FOR A MOMENT, THE CAMERA CAN'T FOLLOW IT UPWARD.

THEN THE CAMERA PANS UP AND FINDS IT AGAIN.

CUT FOR TIME.

PAN

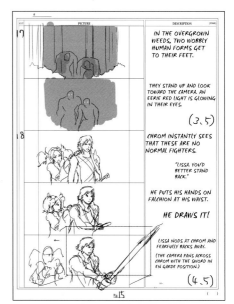

CUT	PICTURE	DESCRIPTION	(TIME)

IN THE OVERGROWN WEEDS, TWO WOBBLY HUMAN FORMS GET TO THEIR FEET.

THEY STAND UP AND LOOK TOWARD THE CAMERA. AN EERIE RED LIGHT IS GLOWING IN THEIR EYES.

(3.5)

CHROM INSTANTLY SEES THAT THESE ARE NO NORMAL FIGHTERS.

"LISSA, YOU'D BETTER STAND BACK."

HE PUTS HIS HANDS ON FALCHION AT HIS WAIST.

HE DRAWS IT!

LISSA NODS AT CHROM AND FEARFULLY BACKS AWAY.

(THE CAMERA PANS ACROSS CHROM WITH THE SWORD IN EN GARDE POSITION.)

(4.5)

Pg. 15

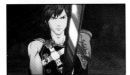
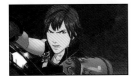

Cataclysm

18

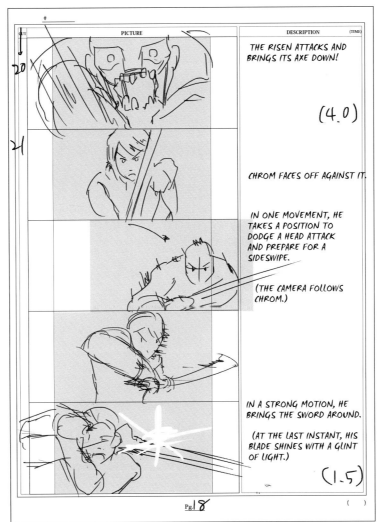

CUT	PICTURE	DESCRIPTION	(TIME)
20		THE RISEN ATTACKS AND BRINGS ITS AXE DOWN!	(4.0)
21		CHROM FACES OFF AGAINST IT.	
		IN ONE MOVEMENT, HE TAKES A POSITION TO DODGE A HEAD ATTACK AND PREPARE FOR A SIDESWIPE. (THE CAMERA FOLLOWS CHROM.)	
		IN A STRONG MOTION, HE BRINGS THE SWORD AROUND. (AT THE LAST INSTANT, HIS BLADE SHINES WITH A GLINT OF LIGHT.)	(1.5)

Pg. 18

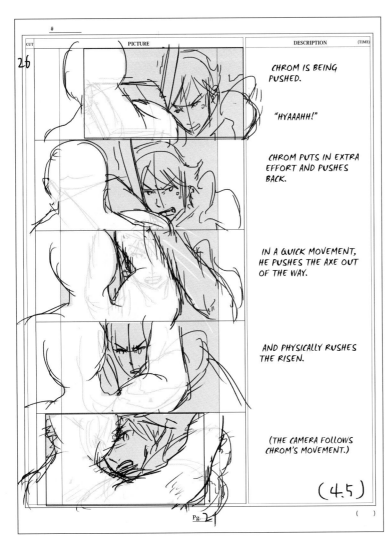

CUT	PICTURE	DESCRIPTION	(TIME)
26		CHROM IS BEING PUSHED. "HYAAAHH!"	
		CHROM PUTS IN EXTRA EFFORT AND PUSHES BACK.	
		IN A QUICK MOVEMENT, HE PUSHES THE AXE OUT OF THE WAY.	
		AND PHYSICALLY RUSHES THE RISEN.	
		(THE CAMERA FOLLOWS CHROM'S MOVEMENT.)	(4.5)

Pg. 21

Cataclysm

21

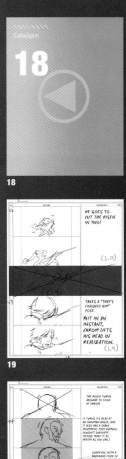

18

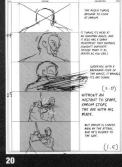

19

20

21

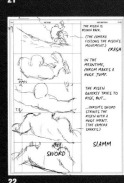

22

23

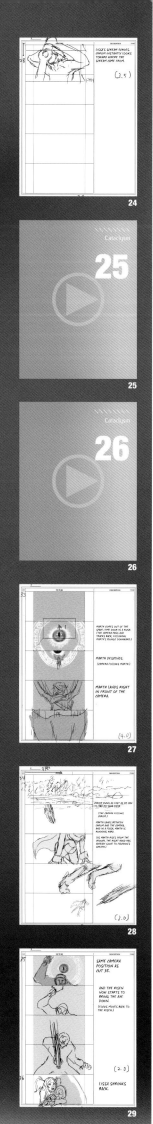

24

Cataclysm
25
25

Cataclysm
26
26

27

28

29

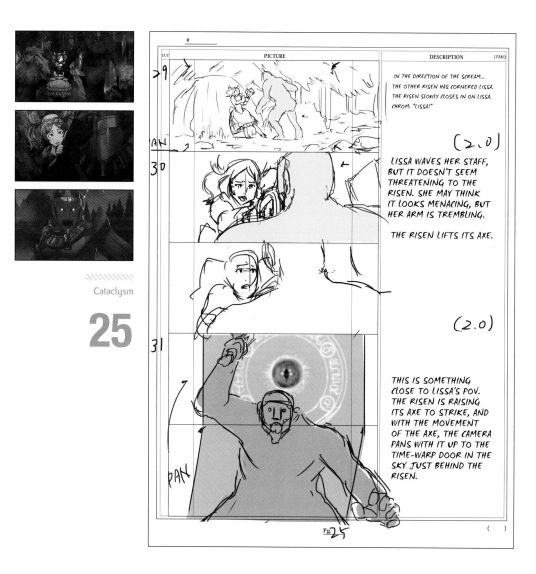

Cataclysm
25

CUT	PICTURE	DESCRIPTION	(TIME)

IN THE DIRECTION OF THE SCREAM...
THE OTHER RISEN HAS CORNERED LISSA.
THE RISEN SLOWLY CLOSES IN ON LISSA.
CHROM: "LISSA!"

(2.0)

LISSA WAVES HER STAFF, BUT IT DOESN'T SEEM THREATENING TO THE RISEN. SHE MAY THINK IT LOOKS MENACING, BUT HER ARM IS TREMBLING.

THE RISEN LIFTS ITS AXE.

(2.0)

THIS IS SOMETHING CLOSE TO LISSA'S POV. THE RISEN IS RAISING ITS AXE TO STRIKE, AND WITH THE MOVEMENT OF THE AXE, THE CAMERA PANS WITH IT UP TO THE TIME-WARP DOOR IN THE SKY JUST BEHIND THE RISEN.

Pg.25

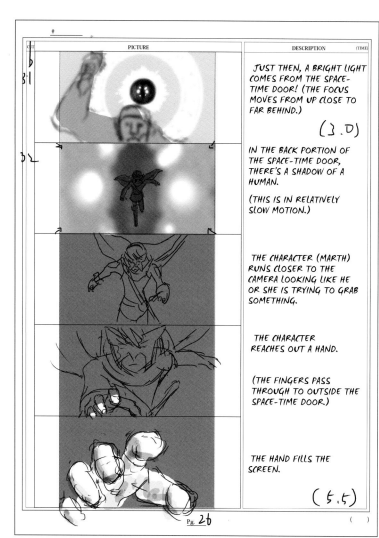

CUT	PICTURE	DESCRIPTION	(TIME)

JUST THEN, A BRIGHT LIGHT COMES FROM THE SPACE-TIME DOOR! (THE FOCUS MOVES FROM UP CLOSE TO FAR BEHIND.)

(3.0)

IN THE BACK PORTION OF THE SPACE-TIME DOOR, THERE'S A SHADOW OF A HUMAN.

(THIS IS IN RELATIVELY SLOW MOTION.)

THE CHARACTER (MARTH) RUNS CLOSER TO THE CAMERA LOOKING LIKE HE OR SHE IS TRYING TO GRAB SOMETHING.

THE CHARACTER REACHES OUT A HAND.

(THE FINGERS PASS THROUGH TO OUTSIDE THE SPACE-TIME DOOR.)

THE HAND FILLS THE SCREEN.

(5.5)

Pg.26

Cataclysm
26

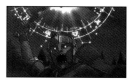
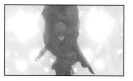
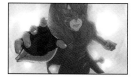

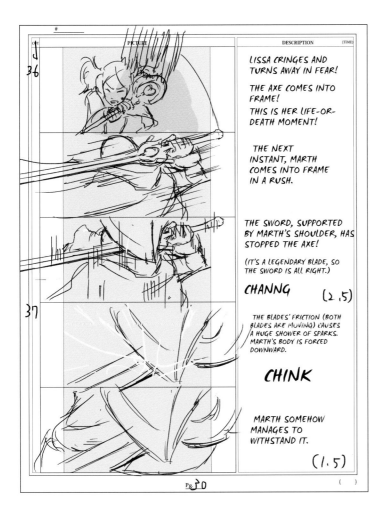

#	PICTURE	DESCRIPTION	(TIME)

LISSA CRINGES AND TURNS AWAY IN FEAR!

THE AXE COMES INTO FRAME!

THIS IS HER LIFE-OR-DEATH MOMENT!

THE NEXT INSTANT, MARTH COMES INTO FRAME IN A RUSH.

THE SWORD, SUPPORTED BY MARTH'S SHOULDER, HAS STOPPED THE AXE!

(IT'S A LEGENDARY BLADE, SO THE SWORD IS ALL RIGHT.)

CHANNG (2.5)

THE BLADES' FRICTION (BOTH BLADES ARE MOVING) CAUSES A HUGE SHOWER OF SPARKS. MARTH'S BODY IS FORCED DOWNWARD.

CHINK

MARTH SOMEHOW MANAGES TO WITHSTAND IT.

(1.5)

Pg.

()

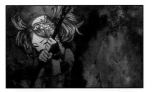

\\\\\\\\\\\\
Cataclysm

30

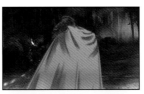

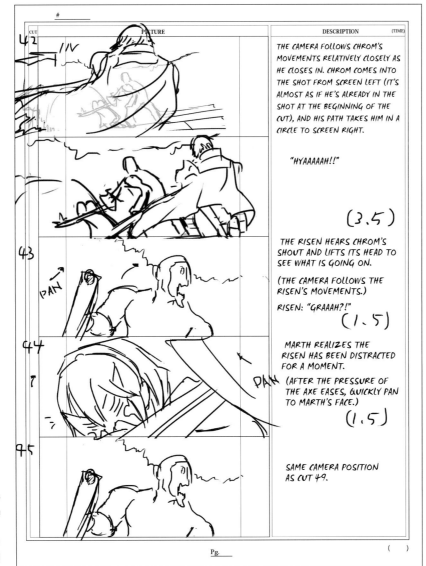

CUT	PICTURE	DESCRIPTION	(TIME)

THE CAMERA FOLLOWS CHROM'S MOVEMENTS RELATIVELY CLOSELY AS HE CLOSES IN. CHROM COMES INTO THE SHOT FROM SCREEN LEFT (IT'S ALMOST AS IF HE'S ALREADY IN THE SHOT AT THE BEGINNING OF THE CUT), AND HIS PATH TAKES HIM IN A CIRCLE TO SCREEN RIGHT.

"HYAAAAAH!!"

(3.5)

THE RISEN HEARS CHROM'S SHOUT AND LIFTS ITS HEAD TO SEE WHAT IS GOING ON.

(THE CAMERA FOLLOWS THE RISEN'S MOVEMENTS.)

RISEN: "GRAAAH?!"

(1.5)

MARTH REALIZES THE RISEN HAS BEEN DISTRACTED FOR A MOMENT.

(AFTER THE PRESSURE OF THE AXE EASES, QUICKLY PAN TO MARTH'S FACE.)

(1.5)

SAME CAMERA POSITION AS CUT 49.

\\\\\\\\\\\\
Cataclysm

33

Pg.

()

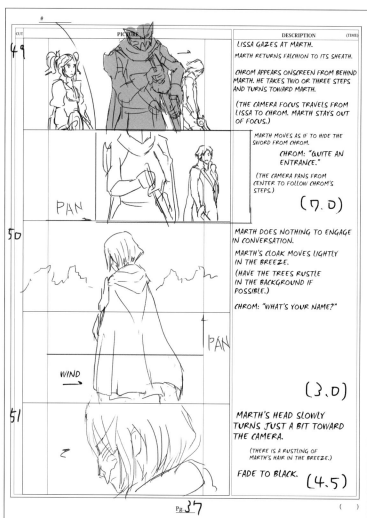

CUT	PICTURE	DESCRIPTION (TIME)
49		LISSA GAZES AT MARTH. MARTH RETURNS FALCHION TO ITS SHEATH. CHROM APPEARS ONSCREEN FROM BEHIND MARTH. HE TAKES TWO OR THREE STEPS AND TURNS TOWARD MARTH. (THE CAMERA FOCUS TRAVELS FROM LISSA TO CHROM. MARTH STAYS OUT OF FOCUS.)
	PAN	MARTH MOVES AS IF TO HIDE THE SWORD FROM CHROM. CHROM: "QUITE AN ENTRANCE." (THE CAMERA PANS FROM CENTER TO FOLLOW CHROM'S STEPS.) (7.0)
50		MARTH DOES NOTHING TO ENGAGE IN CONVERSATION. MARTH'S CLOAK MOVES LIGHTLY IN THE BREEZE. (HAVE THE TREES RUSTLE IN THE BACKGROUND IF POSSIBLE.) CHROM: "WHAT'S YOUR NAME?"
	↑PAN WIND →	(3.0)
51		MARTH'S HEAD SLOWLY TURNS JUST A BIT TOWARD THE CAMERA. (THERE IS A RUSTLING OF MARTH'S HAIR IN THE BREEZE.) FADE TO BLACK. (4.5)

Pg. 37 ()

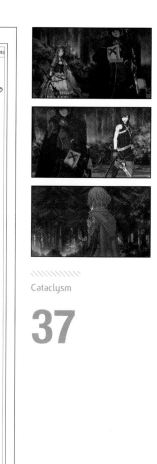

Cataclysm

37

Two Falchions

02

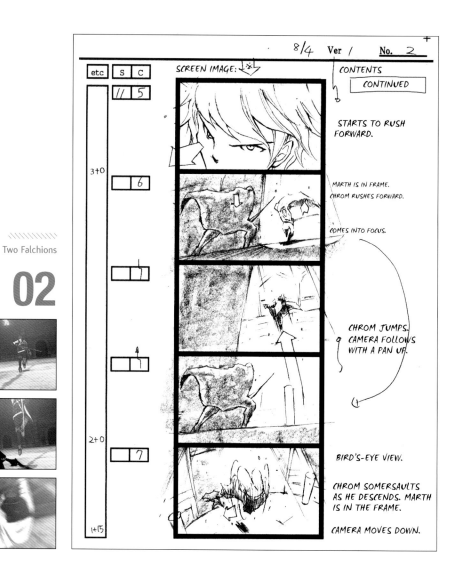

8/4 Ver / No. 2

etc	S	C	SCREEN IMAGE:	CONTENTS CONTINUED
	11	5		STARTS TO RUSH FORWARD.
3+0		6		MARTH IS IN FRAME. CHROM RUSHES FORWARD. COMES INTO FOCUS.
				CHROM JUMPS. CAMERA FOLLOWS WITH A PAN UP.
		4		
2+0		7		BIRD'S-EYE VIEW. CHROM SOMERSAULTS AS HE DESCENDS. MARTH IS IN THE FRAME. CAMERA MOVES DOWN.
1+15				

Two Falchions

03

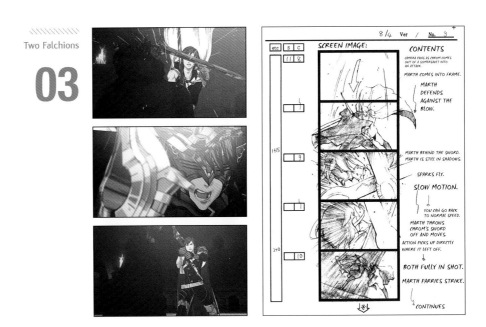

8/4 Ver / No. 3

etc	S	C	SCREEN IMAGE:	CONTENTS

CAMERA PANS AS CHROM COMES OUT OF A SOMERSAULT INTO AN ATTACK.

MARTH COMES INTO FRAME.

MARTH DEFENDS AGAINST THE BLOW.

MARTH BEHIND THE SWORD. MARTH IS STILL IN SHADOWS.

SPARKS FLY.

SLOW MOTION.

YOU CAN GO BACK TO NORMAL SPEED.

MARTH THROWS CHROM'S SWORD OFF AND MOVES.

ACTION PICKS UP DIRECTLY WHERE IT LEFT OFF.

BOTH FULLY IN SHOT.

MARTH PARRIES STRIKE.

CONTINUES

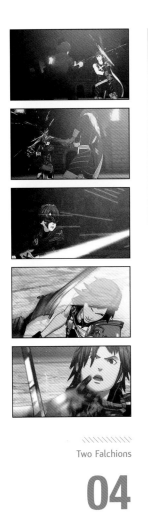

Two Falchions

04

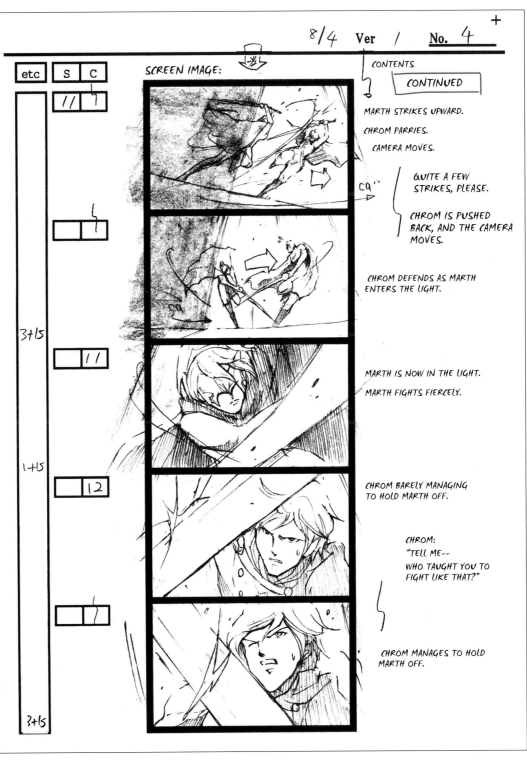

8/4 Ver / No. 4

etc	S	C	SCREEN IMAGE:	CONTENTS

CONTINUED

MARTH STRIKES UPWARD.

CHROM PARRIES.

CAMERA MOVES.

QUITE A FEW STRIKES, PLEASE.

CHROM IS PUSHED BACK, AND THE CAMERA MOVES.

CHROM DEFENDS AS MARTH ENTERS THE LIGHT.

MARTH IS NOW IN THE LIGHT.

MARTH FIGHTS FIERCELY.

CHROM BARELY MANAGING TO HOLD MARTH OFF.

CHROM:
"TELL ME--
WHO TAUGHT YOU TO FIGHT LIKE THAT?"

CHROM MANAGES TO HOLD MARTH OFF.

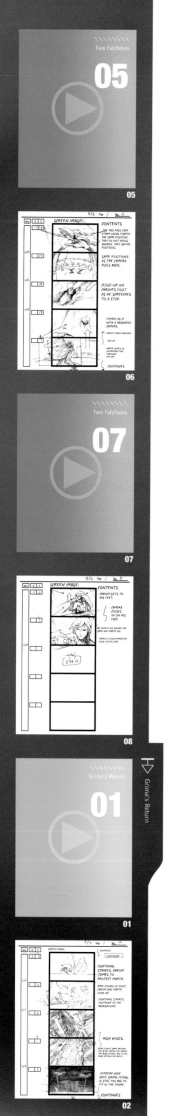

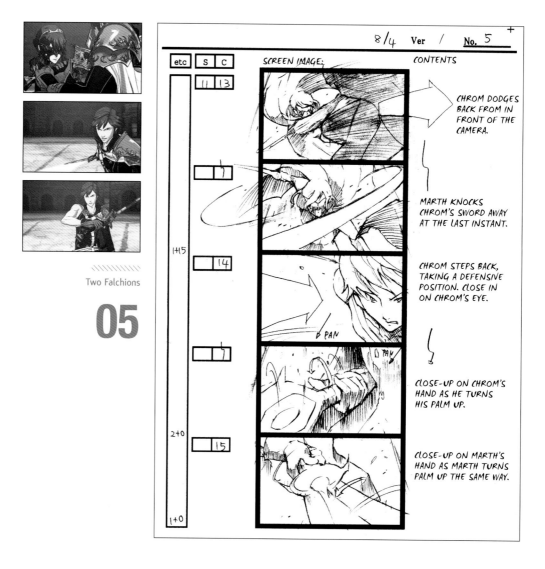

Two Falchions

05

8/4 Ver / No. 5

etc	S	C	SCREEN IMAGE:	CONTENTS

CHROM DODGES BACK FROM IN FRONT OF THE CAMERA.

MARTH KNOCKS CHROM'S SWORD AWAY AT THE LAST INSTANT.

CHROM STEPS BACK, TAKING A DEFENSIVE POSITION. CLOSE IN ON CHROM'S EYE.

CLOSE-UP ON CHROM'S HAND AS HE TURNS HIS PALM UP.

CLOSE-UP ON MARTH'S HAND AS MARTH TURNS PALM UP THE SAME WAY.

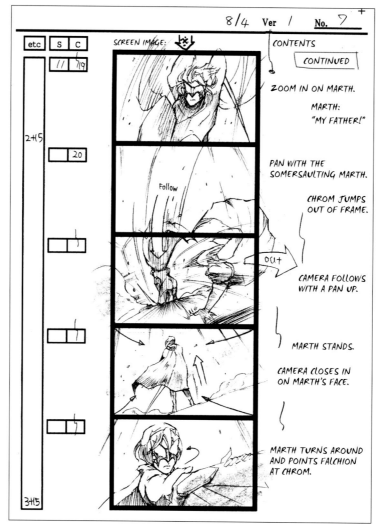

8/4 Ver / No. 7

etc	S	C	SCREEN IMAGE:	CONTENTS

CONTINUED

ZOOM IN ON MARTH.

MARTH: "MY FATHER!"

PAN WITH THE SOMERSAULTING MARTH.

CHROM JUMPS OUT OF FRAME.

CAMERA FOLLOWS WITH A PAN UP.

MARTH STANDS.

CAMERA CLOSES IN ON MARTH'S FACE.

MARTH TURNS AROUND AND POINTS FALCHION AT CHROM.

Two Falchions

07

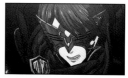

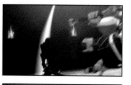

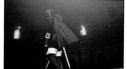

etc	S	C
	3	1

SCREEN IMAGE:

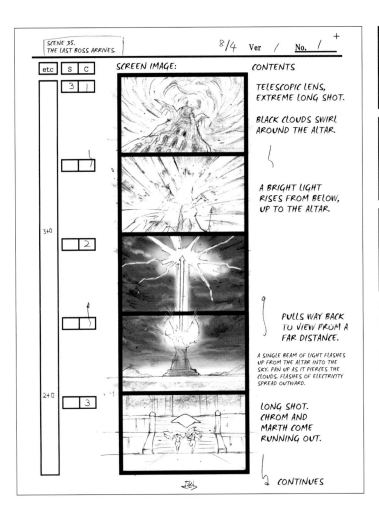

CONTENTS

TELESCOPIC LENS,
EXTREME LONG SHOT.

BLACK CLOUDS SWIRL
AROUND THE ALTAR.

A BRIGHT LIGHT
RISES FROM BELOW,
UP TO THE ALTAR

PULLS WAY BACK
TO VIEW FROM A
FAR DISTANCE.

A SINGLE BEAM OF LIGHT FLASHES
UP FROM THE ALTAR INTO THE
SKY. PAN UP AS IT PIERCES THE
CLOUDS. FLASHES OF ELECTRICITY
SPREAD OUTWARD.

LONG SHOT.
CHROM AND
MARTH COME
RUNNING OUT.

CONTINUES

3+0

2+0

2

3

/////////////
Grima's Return

01

\\\\\\\\
Grima's Return

03

03

04

etc	S	C
	3	6

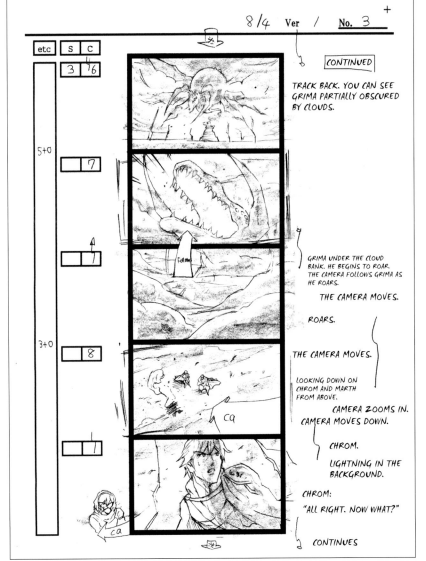

CONTINUED

TRACK BACK. YOU CAN SEE
GRIMA PARTIALLY OBSCURED
BY CLOUDS.

GRIMA UNDER THE CLOUD
BANK. HE BEGINS TO ROAR.
THE CAMERA FOLLOWS GRIMA AS
HE ROARS.

THE CAMERA MOVES.

ROARS.

THE CAMERA MOVES.

LOOKING DOWN ON
CHROM AND MARTH
FROM ABOVE.

CAMERA ZOOMS IN.
CAMERA MOVES DOWN.

CHROM.

LIGHTNING IN THE
BACKGROUND.

CHROM:
"ALL RIGHT. NOW WHAT?"

CONTINUES

5+0

3+0

7

7

8

Follow

CQ

cq

/////////////
Grima's Return

03

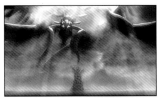

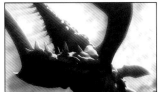

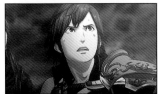

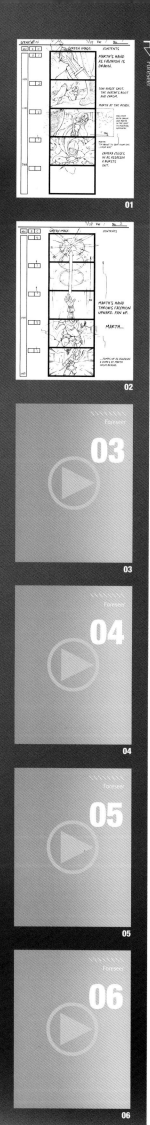

01

02

03

Foreseer

03

Foreseer

04

Foreseer

05

Foreseer

06

Foreseer

03

7/29 Ver / No. 3

etc	S	C	SCREEN IMAGE	CONTENTS
		6		LOOKING DOWN ON MARTH. CATCHES THE SWORD. SLOW MOTION.
		1		SOMERSAULTS.
1+15		7		MARTH COMES OUT OF THE SOMERSAULT WITH SWORD OUT. Follow
		1	PAN	CUTS ASSASSIN A AND LANDS.
1+15		8		CHROM. LIGHTNING IN THE BACKGROUND. THE WOUNDED ASSASSIN A.

CONTINUES

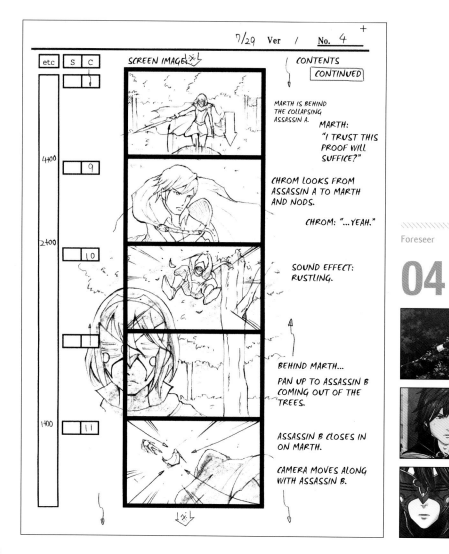

7/29 Ver / No. 4

etc	S	C	SCREEN IMAGE	CONTENTS CONTINUED
		1		MARTH IS BEHIND THE COLLAPSING ASSASSIN A. MARTH: "I TRUST THIS PROOF WILL SUFFICE?"
1+00		9		CHROM LOOKS FROM ASSASSIN A TO MARTH AND NODS. CHROM: "...YEAH."
2+00		10		SOUND EFFECT: RUSTLING.
				BEHIND MARTH... PAN UP TO ASSASSIN B COMING OUT OF THE TREES.
1+00		11		ASSASSIN B CLOSES IN ON MARTH. CAMERA MOVES ALONG WITH ASSASSIN B.

Foreseer

04

7/29 Ver / No. 5

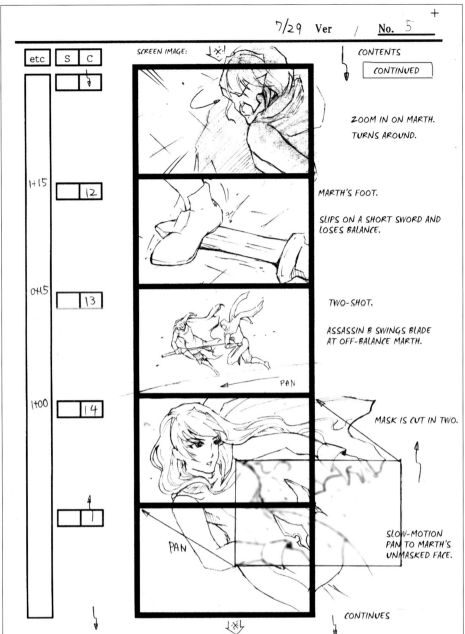

etc	S	C	SCREEN IMAGE: ↓✗!	CONTENTS →

CONTINUED

ZOOM IN ON MARTH.
TURNS AROUND.

MARTH'S FOOT.

SLIPS ON A SHORT SWORD AND
LOSES BALANCE.

TWO-SHOT.

ASSASSIN B SWINGS BLADE
AT OFF-BALANCE MARTH.

PAN

MASK IS CUT IN TWO.

SLOW-MOTION
PAN TO MARTH'S
UNMASKED FACE.

PAN

CONTINUES

1+15 12
0+15 13
1+00 14

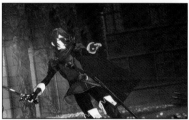

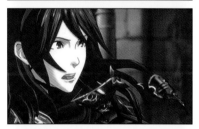
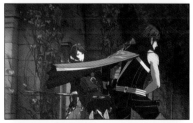
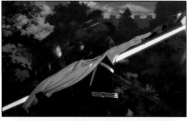
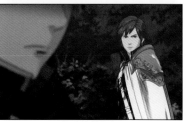

7/29 Ver / No. 6

etc	S	C	SCREEN IMAGE: ↓✗!	CONTENTS

CONTINUED

CHROM CUTS IN
FROM THE SIDE.

WIPE CUT
FOLLOWING HIS
MOVEMENT.

THREE-SHOT.

CHROM SLICES ASSASSIN B
WITH SWORD.

RUNNING PAN.

ASSASSIN B FALLS
IN FOREGROUND.

IN THE BACKGROUND
ARE MARTH AND CHROM.

CHROM NOW
NOTICES MARTH'S
LONG HAIR.

CHROM:
"WAIT, YOU'RE--
YOU'RE A WOMAN?"

3+15 15
1+15 16
2+00 17
4+15

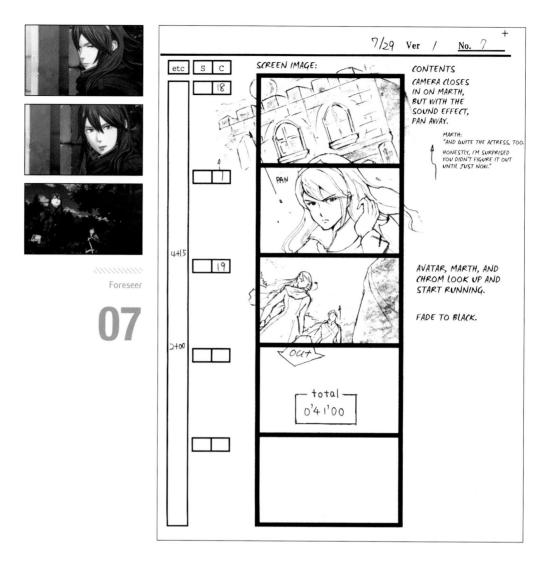

Foreseer

07

7/29 Ver 1 No. 7

etc	S	C	SCREEN IMAGE:
		18	
		1	PAN
4+15		19	
2+00			OUT

CONTENTS
CAMERA CLOSES
IN ON MARTH,
BUT WITH THE
SOUND EFFECT,
PAN AWAY.

MARTH:
"AND QUITE THE ACTRESS, TOO.

HONESTLY, I'M SURPRISED
YOU DIDN'T FIGURE IT OUT
UNTIL JUST NOW."

AVATAR, MARTH, AND
CHROM LOOK UP AND
START RUNNING.

FADE TO BLACK.

total
0'41'00

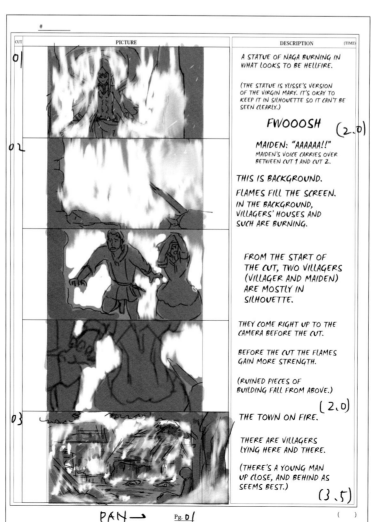

CUT	PICTURE	DESCRIPTION	(TIME)
01		A STATUE OF NAGA BURNING IN WHAT LOOKS TO BE HELLFIRE. (THE STATUE IS YLISSE'S VERSION OF THE VIRGIN MARY. IT'S OKAY TO KEEP IT IN SILHOUETTE SO IT CAN'T BE SEEN CLEARLY.) *FWOOOSH* (2.0) MAIDEN: "AAAAAA!!" MAIDEN'S VOICE CARRIES OVER BETWEEN CUT 1 AND CUT 2.	
02		THIS IS BACKGROUND. FLAMES FILL THE SCREEN. IN THE BACKGROUND, VILLAGERS' HOUSES AND SUCH ARE BURNING. FROM THE START OF THE CUT, TWO VILLAGERS (VILLAGER AND MAIDEN) ARE MOSTLY IN SILHOUETTE. THEY COME RIGHT UP TO THE CAMERA BEFORE THE CUT. BEFORE THE CUT THE FLAMES GAIN MORE STRENGTH. (RUINED PIECES OF BUILDING FALL FROM ABOVE.) (2.0)	
03		THE TOWN ON FIRE. THERE ARE VILLAGERS LYING HERE AND THERE. (THERE'S A YOUNG MAN UP CLOSE, AND BEHIND AS SEEMS BEST.) (3.5)	

PAN → Pg. 01

Dire Future

01

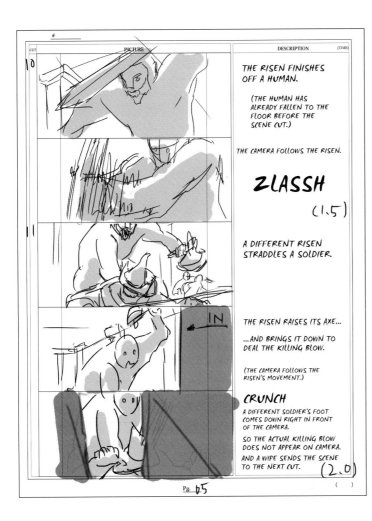

CUT	PICTURE	DESCRIPTION	(TIME)

THE RISEN FINISHES OFF A HUMAN.

(THE HUMAN HAS ALREADY FALLEN TO THE FLOOR BEFORE THE SCENE CUT.)

THE CAMERA FOLLOWS THE RISEN.

ZLASSH

(1.5)

A DIFFERENT RISEN STRADDLES A SOLDIER.

THE RISEN RAISES ITS AXE...

...AND BRINGS IT DOWN TO DEAL THE KILLING BLOW.

(THE CAMERA FOLLOWS THE RISEN'S MOVEMENT.)

CRUNCH

A DIFFERENT SOLDIER'S FOOT COMES DOWN RIGHT IN FRONT OF THE CAMERA.

SO THE ACTUAL KILLING BLOW DOES NOT APPEAR ON CAMERA.

AND A WIPE SENDS THE SCENE TO THE NEXT CUT.

(2.0)

Pg. 05

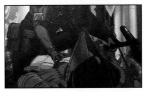
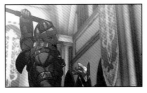

Dire Future

05

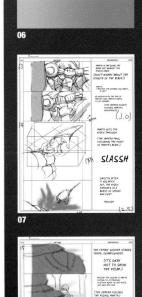

06

07

08

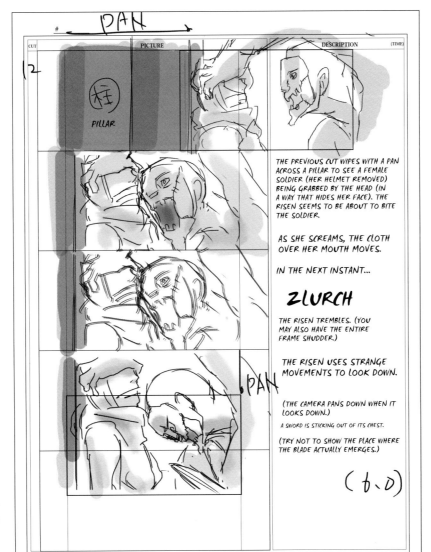

PAN

PILLAR

THE PREVIOUS CUT WIPES WITH A PAN ACROSS A PILLAR TO SEE A FEMALE SOLDIER (HER HELMET REMOVED) BEING GRABBED BY THE HEAD (IN A WAY THAT HIDES HER FACE). THE RISEN SEEMS TO BE ABOUT TO BITE THE SOLDIER.

AS SHE SCREAMS, THE CLOTH OVER HER MOUTH MOVES.

IN THE NEXT INSTANT...

ZLURCH

THE RISEN TREMBLES. (YOU MAY ALSO HAVE THE ENTIRE FRAME SHUDDER.)

THE RISEN USES STRANGE MOVEMENTS TO LOOK DOWN.

(THE CAMERA PANS DOWN WHEN IT LOOKS DOWN.)

A SWORD IS STICKING OUT OF ITS CHEST.

(TRY NOT TO SHOW THE PLACE WHERE THE BLADE ACTUALLY EMERGES.)

(6.0)

PAN

Pg. 06

Dire Future

06

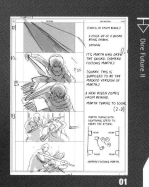

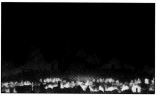

01

02

Dire Future II
03

03

Dire Future II
04

04

05

06

PICTURE — DESCRIPTION (TIME)

04

MARTH COMES INTO THE SHOT.

THERE ARE RISEN READY TO ATTACK MARTH IN THE BACKGROUND.

THERE ARE A NUMBER OF HUMAN BODIES ON THE GROUND.

(IT SEEMS THE HUMAN ARMY WAS OUTMATCHED.)

MARTH LANDS AND SLIDES BACK A LITTLE.

A RISEN COMES IN TO ATTACK.

MARTH RISES, READY TO MEET THE ATTACK.

WHEN...!

AS THE CAMERA FRAME SHAKES VIOLENTLY, THE WALL IN THE BACKGROUND IS SUDDENLY BLOWN APART.

HUMANS AND RISEN ALIKE ARE BLOWN BACK IN THE EXPLOSION.

THERE IS SOME CAMERA SHAKING HERE.

Pg. 03

THE BLAST CONTINUES FROM THE BACKGROUND TO JUST IN FRONT OF THE CAMERA, SPREADING WANTON DESTRUCTION.

THE RISEN THAT WAS ABOUT TO ATTACK MARTH IS CRUSHED BY DEBRIS AND PUSHED OUT OF THE FRAME.

MARTH QUICKLY CROUCHES IN A POSE OF SELF-PROTECTION.

BUT MARTH'S LOCATION GETS DESTROYED TOO, AND MARTH IS SWALLOWED UP IN THE DESTRUCTION.

FOR AN INSTANT, DUST COVERS THE SCREEN.

(4.5)

A LONG SHOT OF THE YLISSE CASTLE.

A SCENE OF THE CASTLE AND THE STILL-BURNING TOWN.

BEYOND IT IS AN ENORMOUS "SOMETHING" THAT IS SO BIG IT WOULD FILL THE SCREEN.

(IT'S GRIMA WITH HIS WINGS FOLDED.)

PERHAPS HE HAS ONLY JUST NOW LANDED.

THE PLACE WHERE HE LANDED NOW HAS CLOUDS OF DUST RISING FROM IT.

IT IS THE DUST FROM THE PART OF THE PALACE WHICH HELD MARTH AND THE OTHERS.

RUMMMBBLE

THE CAMERA SHAKES.

GRIMA

THE PORTION THAT WAS DESTROYED.

(3.0)

Pg 04

Dire Future II

04 **03**

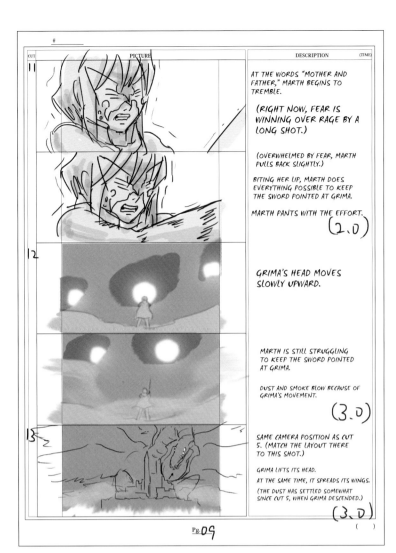

CUT	PICTURE	DESCRIPTION	(TIME)

11

AT THE WORDS "MOTHER AND FATHER," MARTH BEGINS TO TREMBLE.

(RIGHT NOW, FEAR IS WINNING OVER RAGE BY A LONG SHOT.)

(OVERWHELMED BY FEAR, MARTH PULLS BACK SLIGHTLY.)

BITING HER LIP, MARTH DOES EVERYTHING POSSIBLE TO KEEP THE SWORD POINTED AT GRIMA.

MARTH PANTS WITH THE EFFORT.

(2.0)

12

GRIMA'S HEAD MOVES SLOWLY UPWARD.

MARTH IS STILL STRUGGLING TO KEEP THE SWORD POINTED AT GRIMA.

DUST AND SMOKE BLOW BECAUSE OF GRIMA'S MOVEMENT.

(3.0)

13

SAME CAMERA POSITION AS CUT 5. (MATCH THE LAYOUT THERE TO THIS SHOT.)

GRIMA LIFTS ITS HEAD.
AT THE SAME TIME, IT SPREADS ITS WINGS.
(THE DUST HAS SETTLED SOMEWHAT SINCE CUT 5, WHEN GRIMA DESCENDED.)

(3.0)

Pg.09

()

Dire Future II

09

Dire Future II

10

CUT	PICTURE	DESCRIPTION	(TIME)

14

THE FIRST PART OF THE SCENE STARTS WITH HIM RAISING HIS HEAD.

GRIMA STARTS TO OPEN HIS MOUTH.

IT LOOKS LIKE HE'S MOCKING MARTH AND ALL THE HUMANS.

(THE CAMERA FOLLOWS THE MOVEMENTS OF GRIMA'S HEAD.)

(4.5)

15

MARTH FACING OFF AGAINST GRIMA. (GRIMA LOOKS LIKE A MOUNTAIN TOWERING ABOVE MARTH.)

GRIMA BEGINS TO OPEN HIS MOUTH WIDE. (THE CAMERA IS FOLLOWING GRIMA'S MOVEMENTS.)

GRIMA:
"AND NOW IT IS YOUR TURN..."

MARTH STILL STRUGGLING TO HOLD FALCHION POINTED AT GRIMA.

GRIMA'S OPEN MAW LOOKS BLACKER THAN BLACK.

GRIMA:
"...TO DIE!"

(5.5)

Pg.10

()

Marth No More

Marth No More

02

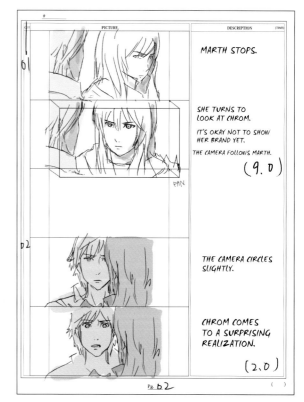

CUT	PICTURE	DESCRIPTION	(TIME)
01		MARTH STOPS. SHE TURNS TO LOOK AT CHROM. IT'S OKAY NOT TO SHOW HER BRAND YET. THE CAMERA FOLLOWS MARTH. (9.0)	
02	PAN	THE CAMERA CIRCLES SLIGHTLY.	
		CHROM COMES TO A SURPRISING REALIZATION. (2.0)	

Pg. ▷2

03

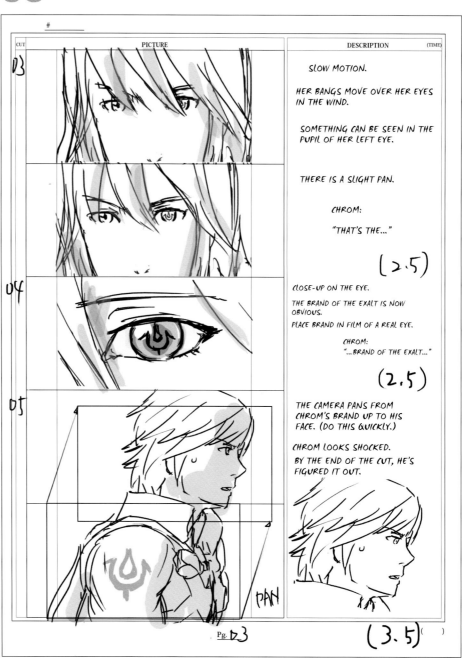

CUT	PICTURE	DESCRIPTION	(TIME)
03		SLOW MOTION. HER BANGS MOVE OVER HER EYES IN THE WIND. SOMETHING CAN BE SEEN IN THE PUPIL OF HER LEFT EYE. THERE IS A SLIGHT PAN. CHROM: "THAT'S THE..." (2.5)	
04		CLOSE-UP ON THE EYE. THE BRAND OF THE EXALT IS NOW OBVIOUS. PLACE BRAND IN FILM OF A REAL EYE. CHROM: "...BRAND OF THE EXALT..." (2.5)	
05	PAN	THE CAMERA PANS FROM CHROM'S BRAND UP TO HIS FACE. (DO THIS QUICKLY.) CHROM LOOKS SHOCKED. BY THE END OF THE CUT, HE'S FIGURED IT OUT. (3.5)	

Pg. ▷3

Marth No More

04

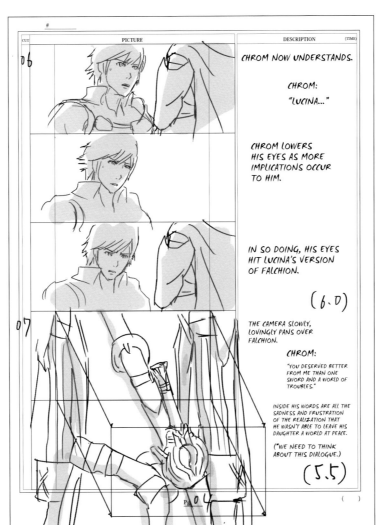

CUT	PICTURE	DESCRIPTION	(TIME)

CHROM NOW UNDERSTANDS.

CHROM:
"LUCINA..."

CHROM LOWERS HIS EYES AS MORE IMPLICATIONS OCCUR TO HIM.

IN SO DOING, HIS EYES HIT LUCINA'S VERSION OF FALCHION.

(6.0)

THE CAMERA SLOWLY, LOVINGLY PANS OVER FALCHION.

CHROM:
"YOU DESERVED BETTER FROM ME THAN ONE SWORD AND A WORLD OF TROUBLES."

INSIDE HIS WORDS ARE ALL THE SADNESS AND FRUSTRATION OF THE REALIZATION THAT HE WASN'T ABLE TO LEAVE HIS DAUGHTER A WORLD AT PEACE.

("WE NEED TO THINK ABOUT THIS DIALOGUE.)

(5.5)

07

Marth No More

08

08

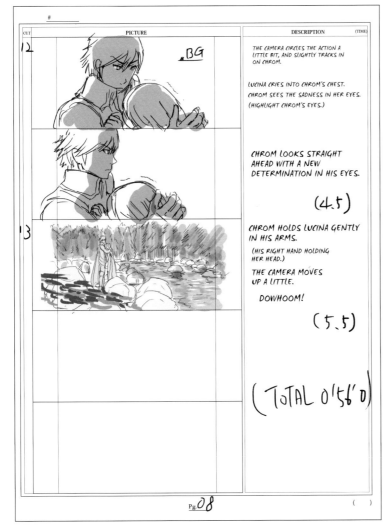

CUT	PICTURE	DESCRIPTION	(TIME)

THE CAMERA CIRCLES THE ACTION A LITTLE BIT, AND SLIGHTLY TRACKS IN ON CHROM.

LUCINA CRIES INTO CHROM'S CHEST. CHROM SEES THE SADNESS IN HER EYES. (HIGHLIGHT CHROM'S EYES.)

CHROM LOOKS STRAIGHT AHEAD WITH A NEW DETERMINATION IN HIS EYES.

(4.5)

CHROM HOLDS LUCINA GENTLY IN HIS ARMS.
(HIS RIGHT HAND HOLDING HER HEAD.)

THE CAMERA MOVES UP A LITTLE.

DOWHOOM!

(5.5)

(TOTAL 0'56'0)

Marth No More

08

Character Dialogue

Shop Dialogue

Here are the lines the characters say when they are visiting shops, armorers, or traveling peddlers. "[Robin]" is used here as the avatar's name.

■ Avatar (male)
Buying: Hmm, what to buy...
Selling: Hmm, what to sell...
Forging: Hmm, which weapon...

■ Avatar (female)
Buying: Hmm, what to buy...
Selling: Hmm, what to sell..
Forging: Hmm, which weapon...

■ Chrom
Buying: What do you think I need, [Robin]?
Selling: [Robin]... Are we strapped for funds?
Forging: Which of my weapons did you want to forge?

■ Lissa
Buying: I love shopping! Oh...for me?! Thanks!
Selling: Hey, [Robin], which will fetch the most gold?
Forging: Thanks! I could use a stronger weapon.

■ Frederick
Buying: You are buying me something? How thoughtful.
Selling: My possessions are Ylisse's possessions.
Forging: A keen weapon can make or break a knight.

■ Virion
Buying: Sell me true love, and I would pay any price.
Selling: What?! Are we truly so impoverished?
Forging: ...Improve on perfection? Pah. I dare you to try.

■ Sully
Buying: For me? Hot damn!
Selling: Hell, take it. I don't need any of this crap.
Forging: You hone the weapon. I'll hone the knight.

■ Vaike
Buying: You need Teach to walk you through shopping basics?
Selling: Anything the Vaike touched should fetch a good price!
Forging: You can forge weapons, but you can't forge the Vaike.

■ Stahl
Buying: I wonder if they sell hair-brushes... No, seriously.
Selling: Wait... My stuff is actually worth something?
Forging: What, my weapons? Sure, forge away!

■ Miriel
Buying: Would a modicum of frugality hurt now and then?
Selling: A scholar once said: if you thirst for gold, liquidize.
Forging: May I watch? I find this whole process fascinating.

■ Kellam
Buying: I doubt I need anything of significance. You know me.
Selling: Go ahead. Sell my life. I'll be over here.
Forging: Paint it a bright color... I'm trying to turn heads.

■ Sumia
Buying: Oh no! You're spending our gold and it's all my fault...
Selling: I wish I had more valuable things to offer...
Forging: It's a shame they can't forge a less clumsy me.

■ Lon'qu
Buying: ...For me?
Selling: ...What are you taking from me now?
Forging: ...Make it a strong one.

■ Ricken
Buying: Ooh! I want that one! Get me that one!
Selling: You're selling my stuff? Oh...oh, all right...
Forging: You'd better not dumb my weapons down. Promise!

■ Maribelle
Buying: I'll take two tins of your finest tea and a silk bonnet.
Selling: Surely there are easier ways to line our war chest?
Forging: Give me something that will shame my lowborn foes.

■ Panne
Buying: What silly things you humans will trade gold for!
Selling: I am amazed we can profit from such meager supplies.
Forging: Oh, a "forge"? And here I was all dressed to forage.

■ Gaius
Buying: Is this the sweet shop? ...Hey, you lied to me!
Selling: I demand 10% of the take for, uh, sugary diversions.
Forging: You can use an anvil, sure. But can you use an oven?

■ Cordelia
Buying: Please don't get anything too expensive...
Selling: Help yourself. These items belong to all of us.
Forging: Strength should come from the wielder.

■ Gregor
Buying: Gregor better at cutting throat than cutting deal.
Selling: Oy, I am sellsword, yes? Not sword seller!
Forging: If you are having forging money, maybe pay Gregor?

■ Nowi
Buying: A present for Nowi? How did you know?!
Selling: Nowi's stuff! Hands off!
Forging: Why pay for a forge? I've got built-in bellows!

■ Libra
Buying: I need only the earth at my feet and the heavens above.
Selling: May these belongings bless us with what funds we need.
Forging: I am honored you think my weapons a wise investment.

■ Tharja
Buying: A gift? If you try to sell it back later, I may hurt you.

■ Olivia
Buying: You're shopping for me? Oh, but I... Thank you!
Selling: Sell whatever you need to. I don't mind.
Forging: I do feel a little safer with a strong weapon in hand...

■ Cherche
Buying: What a charming little establishment they run here.
Selling: Oh, am I holding surplus? I had no idea.
Forging: I'll let Minerva decide if you did a good job.

■ Henry
Buying: Yay! Excessive spending!
Selling: Should we mention the hex or just sell it as is?
Forging: Ooh! Put spikes on it! Make it something brutal!

■ Lucina
Buying: I long for the day shopping is all we need worry about.
Selling: Go ahead. The gold will serve a greater cause.
Forging: Would you like to name the new weapon for me?

■ Say'ri
Buying: Forgive me... I know these funds belong to Ylisse.
Selling: Mayhap I have a thing or two we could put to market.
Forging: Aye, a sharp weapon is second only to a sharp wit.

■ Basilio
Buying: I must be getting old if you're doing my shopping!
Selling: I should have brought some Feroxi treasure to sell...
Forging: You design the weapon, [Robin]. I'll swing it!

■ Flavia
Buying: Loosening those purse strings for me? Very kind.
Selling: You dare sell the khan's royal treasure? Ha ha.
Forging: A little fire can temper a man as well as a sword.

■ Donnel
Buying: Reckon I could cobble somethin' together instead!
Selling: Ya think my stuff is worth anythin'? 'Cause I doubt it.
Forging: Ya think they can upgrade my ol' tin hat?

■ Anna
Buying: Hmph. Not much of a selection, is there?
Selling: Think you can get a good price? At my shop you can.
Forging: Perhaps I should start my own upgrading service.

■ Owain
Buying: Get me something mighty! Something...LEGENDARY!
Selling: Please, no! All my stuff

has sentimental value!
Forging: A cool new weapon is going to need a cool new name...

■ Inigo
Buying: There's so much I want... How will we decide?!
Selling: Imagine the shame if they refused to buy my things!
Forging: I want something that looks as good as it feels!

■ Brady
Buying: Got anything that'll make me automatically stronger?
Selling: Hey, be my guest. Sell whatever you want.
Forging: Wish they could instantly upgrade me, too!

■ Kjelle
Buying: I wonder if they have any cool-looking armor.
Selling: You can sell anything except my armor.
Forging: I have to upgrade myself just to keep up!

■ Cynthia
Buying: I could spend all day just admiring the wares.
Selling: Can we actually sell things brought from the future?
Forging: I want a weapon fit for a hero like me!

■ Severa
Buying: I want this, that, and everything!
Selling: What cheek! You can't sell my things!
Forging: Are you saying I'm not strong enough?

■ Gerome
Buying: Only buy what you need, okay?
Selling: Sell whatever you like. I don't mind.
Forging: Craft me a weapon not even Minerva could bite in half.

■ Morgan (male)
Buying: Oh gods, I love shopping! What shall we buy?
Selling: I bet we could get a lot more money for your gear!
Forging: You're going to upgrade my weapons? Thanks!

■ Morgan (female)
Buying: Oh gods, I love shopping! What shall we buy?
Selling: I bet we could get a lot more money for your gear!
Forging: You're going to upgrade my weapons? Thanks!

■ Yarne
Buying: Something to keep me safe and sound, if you please.
Selling: With each item sold, my sense of unease grows.
Forging: Make it as strong as humanly possible!

■ Laurent
Buying: I'll be satisfied if it meets my basic requirements.
Selling: If you don't need it, there's no point hanging on to it.

Forging: I'm amazed what they can do with old gear nowadays.

■ Noire
Buying: I hope none of their wares have a sinister history...
Selling: Don't tell me our money is running out!
Forging: How do they do it? Not with a hex, I pray!

■ Nah
Buying: Don't worry. I won't beg and plead for the best.
Selling: Sell whatever. I don't care about material goods.
Forging: Can we call the new weapon anything we like?

■ Tiki
Buying: Ah, shopping! Finally, a concept older than I am.
Selling: I wish I kept my old stuff. It'd be worth a fortune now.
Forging: A fine weapon develops a history all its own.

■ Gangrel
Buying: Shopping for Gangrel? How times have changed.
Selling: Hoping for a king's riches? I'm just a dog now.
Forging: I want something so deadly it KILLS to look at it!

■ Walhart
Buying: Save your gold. I will not be coddled.
Selling: Hmph. Gold for the war is gold for Walhart.
Forging: I have no need of a forge. I make my own strength.

■ Emmeryn
Buying: For...me...?
Selling: What is mine...is yours...
Forging: Give me...strength...

■ Yen'fay
Buying: I need nothing fancy. Any old items ought do.
Selling: Aye, help yourself. These are naught but objects.
Forging: Mercy, [Robin]. My weapon could use work.

■ Aversa
Buying: For me? How unusually thoughtful of you.
Selling: You want to sell this? Careful. I might get pouty.
Forging: I deserve a more... rugged weapon, don't you agree?

■ Priam
Buying: You're going to buy me something? Well, thanks.
Selling: Sell what you will. I don't care.
Forging: A good weapon ages well, like friends or wine.

Section 4

\\\\\

PLAYERS' VOICES

Poll Results
As Reported by Dengeki Online

In August 2012, the Japanese-language anime news site Dengeki Online (http://news.dengeki.com) hosted a questionnaire focused on *Fire Emblem Awakening*. Although the polls were only up for a short time and there was little advance warning, they got passionate responses from an estimated seven hundred fans! Here are the results.

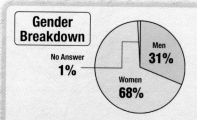

Gender Breakdown

No Answer 1%
Men 31%
Women 68%

The die-hard female fan base didn't fail to make an appearance when it came to this poll; in fact, while the Dengeki editorial department knew that the female fan base was incredibly devoted, they didn't quite expect it to be such a landslide! *Fire Emblem* has always had a stalwart and dedicated female fan base, so it was great to see their support come through and get a grasp of just how treasured this series is to them!

Q WHO IS YOUR FAVORITE MALE CHARACTER?

Among a host of strong male characters, Chrom topped the charts as fan favorite. It seems he lived up to his main-character billing! The race for runner-up was neck and neck, with Owain taking second and Gaius an extremely close third. In the end, despite his status as a second-generation character, Owain took second place fair and square—but only by one vote.

1 Chrom11.2%

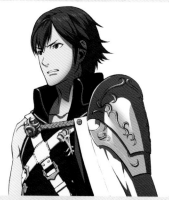

- Come on, princes are just cool no matter what! (Kurako)
- I loved his sense of justice, and his vigilance in protecting his family! (Asagi)
- A man other men can look up to. (Ooamanozaku)
- He isn't the brightest, but honestly, the brawny types are my favorites anyway! (Samecho)
- Love when he plays the straight man! (Jene)
- You just gotta love the way that the freshness of youthful inexperience and dignity that one might have as a prince stack together to create a gestalt of cool. (Kurobana)
- I think his voice is great! Especially when he's yelling about how anything can change! (y2)
- He's gentle, but at the same time doesn't pull punches unless necessary; his straightforward nature, coupled with his sincere and trustworthy core, just shines through, an example of his great upbringing. (Togana)
- Strong like a main character should be. He's the son of royalty, but manages to maintain his humbleness and modesty. I just love that kind of character! (Kairu)
- I fell in love with him when I came to the "Prepare yourself, because I'm going to say it!" part of his proposal. Lol! (Jelo ★ Nimo)

2 Owain8.9%

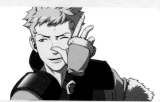

- He's just cool and rad! Hehe! (turnstone)
- His lighthearted pursuit of whatever interests him just gets me excited about what he might do next! (Oberst)
- A character like I'd never seen before! Even his map icon is cute! (nm)
- He's always putting on airs and has a sort of outward-facing persona most of the time, so it's just cool as heck during those few times he shows his true personality. (Loopa)
- The first time he showed up made a real impact on me! I love the support dialogues with his mother, Lissa! (Riko)
- I can totally relate to this guy! (Disciple of Leif the Priest)
- Yeah, he can be an over-the-top character, but he also shows common sense, a passion for protecting his mother and friends, and an empathic but carefree personality. (Hiro)
- I think the older someone gets, the more they'll be able to appreciate this type of character. (Yonaoshi)

3 Gaius8.8%

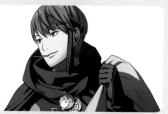

- A character with a personality like nothing I've seen before! (Shadou)
- The sudden breaks between his absolute coolness and then his unslakable sweet tooth are just too much! (*´∀｀*) (Yuzu-Lemon)
- It was far too cute how happy he was to be called "father." (Pochi)
- I love how he'd betray somebody for candy! (Falchion)
- I think it was cool how he acts so frivolous and careless, but deep down, really cares for his friends. (Osebi)
- Simply put, "This dude is cool," and that's all that need be said. (Zetsumetsu-san)
- His sweet tooth was so adorable it made my heart skip a beat. (Himari)
- Men who love sweets are way too cute! (Suzuki)

Character Dialogue

Humorous and Strange Dialogue

Here we bring you a collection of lines where the character interactions are funny or a little...strange. "[Robin]" is used here as the avatar's name.

■ Frederick and Bear Meat

Chrom: Just eat it, Lissa. Meat is meat.

Lissa: Since when does meat smell like old boots?! Wait, I take that back—boots smell better!

Frederick: Every experience makes us stronger, milady. Even those we don't enjoy.

Lissa: Really? **Then why don't I see YOU eating,** Frederick?

Frederick: Me? Oh, well... I'm not hungry. I...I had a large lunch! Yes, quite.

Lissa: Yeah right, Frederick!

(From the prologue)

■ Virion Has Arrived!

Virion: Hold, milady!

Sully: Muh?

Virion: Life may be long, but attraction is fleeting! Would you leave me in your sweet dust? Leave war to the warriors, dear bird! A beauty such as you need wage only love.

Sully: ...The hell are you?!

Virion: Ha! Is the lady intrigued? Of course you are—it's only natural. I am myth and legend! I am he who strides large across history's greatest stage! The man who puts the "arch" in "archer"! My name, dear lady, is Vi—

Sully: Sorry, Ruffles—no time for this. Onward!

Virion: Virion! ...Er, my name. It's Virion. W-wait! Where are you going? Pray, at least tell me your name!

Sully: I'm Sully. ...And I'm a Shepherd.

Virion: "Sully"! How divine! A starkly beautiful name, as befits its owner, truly. Will you marry me, my dearest Sully?

Sully: Will I what now? Oh wait, I get it... **This is a joke. And when I put my boot through your face—that's the punch line.**

Virion: I realize my manly figure and noble bearing can be overwhelming. 'Tis common! So please, don't feel pressured to answer right a—

Sully: How's THIS for an answer?!

Virion: OOF! G-goodness, but **those shapely legs certainly can kick,** can't they... P-please, milady! Allow me to accompany you, at least! Mine is a cold, empty world without you. I shall be your most willing servant, and you, in turn, will give my life purpose...

(From chapter 1)

■ I Sense a Presence!

Chrom: Why do I feel like I'm being watched...?

???: Um, sir? ...Sir! Right here, sir!

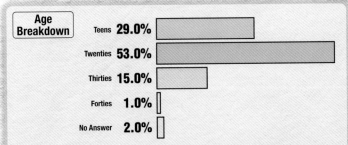

Age Breakdown	Teens	**29.0%**
	Twenties	**53.0%**
	Thirties	**15.0%**
	Forties	**1.0%**
	No Answer	**2.0%**

Unsurprisingly, over 50 percent of questionnaire respondents were players in their twenties. And since this series has been going on for over twenty years, a large number of those in their thirties or older began playing on the NES and SNES systems. There are also the teen *Fire Emblem* fans for whom *Awakening* is their very first *Fire Emblem* game; they brought fresh perspectives to the table.

4
Henry
......7.8%

- At first, I thought he was a little cruel and scary, but later I found out he's actually childlike and it's pretty cute! I love him! (Lucky)
- Honestly, his voice took a little getting used to, but by the time I did, I found he had become my favorite character! (Tama)
- It's because he's crazy! (Tamusuko)
- The best part about him is that he's so insane! (Blue Storm)
- At first, I didn't know what to make of him, but after seeing the support dialogues, I fell in love! (Saaya)

5
Avatar
......6.6%

- Maybe my love for the character developed because he's an aspect of me! (Ze)
- His friendship with Chrom really came through, and during the story, no matter how bad it was, I loved the fact that he was always straight with everybody. (Maccha)
- Among the male characters, he seems the most reasonable and levelheaded. (Chris)
- He was hot in the story and the support dialogues from beginning to end, and his final lines—when he sacrificed himself—just solidified it. (Om)
- One of the big attractions of this story is that you, yourself, are the main character! (Mori-kun)

1	Chrom	11.20%
2	Owain	8.90%
3	Gaius	8.80%
4	Henry	7.80%
5	Avatar	6.60%
6	Inigo	5.20%
7	Virion	5.00%
8	Frederick	4.80%
9	Lon'qu	4.30%
10	Gregor	4.00%
10	Gerome	4.00%
12	Stahl	3.60%
13	Libra	3.30%
14	Brady	3.20%
15	Morgan (Male)	2.90%
16	Gangrel	2.70%
17	Vaike	1.70%
17	Donnel	1.70%
17	Basilio	1.70%
20	Yarne	1.60%
20	Laurent	1.60%
22	Yen'fay	1.30%
23	Kellam	1.20%
24	Priam	0.90%
24	No Preference	0.90%
26	Walhart	0.70%
27	Ricken	0.30%

What If: Fire Emblem

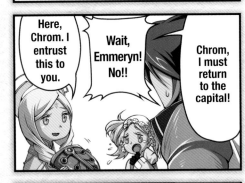

Emmeryn: Here, Chrom. I entrust this to you.

Chrom: Wait, Emmeryn! No!!

Chrom: Chrom, I must return to the capital!

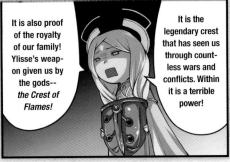

Emmeryn: It is also proof of the royalty of our family! Ylisse's weapon given us by the gods—*the Crest of Flames!*

Emmeryn: It is the legendary crest that has seen us through countless wars and conflicts. Within it is a terrible power!

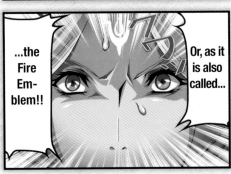

Emmeryn: ...the Fire Emblem!!

Emmeryn: Or, as it is also called...

Emmeryn: Fire Emblem!!

Grem... lim?

D-dire...

Chrom: Who's there? Show yourself!

Kellam: I'm standing in plain sight, sir. Right he—

Chrom: BWAAAH! Oh! I-is that you, Kellam? When did you arrive?

Kellam: ...The same time as you. I've been with you all along. Er, I AM still a Shepherd, right? It's quite the honor, after all. I'd hate to lose it. Sometimes I—

Chrom: Of course, Kellam. Forgive me. **You're just so...quiet, I completely—**

Kellam: Quite all right, sir, quite all right. I've been told I'm easy to miss.

Chrom: **At least the Feroxi didn't find you.**

Kellam: **I've been calling to you and waving my arms for several minutes...** I don't think they've so much as glanced this way.

Chrom: You almost sound disappointed.

Kellam: Well, I just... I'm glad you finally saw me! Just try to keep an eye out from now on?

(From chapter 3)

■ Lon'qu Comes to a Realization

Basilio: Hold, boy. Before you go, I have a little present for you.

Lon'qu:

Basilio: This is Lon'qu, my former champion. Not much for talking, mind you, but he's peerless with a sword. As good as Marth, in my mind. To be honest, I can't figure out how Marth bested him so quickly.

Lissa: Marth beat him? But he looks so big and strong...

Lon'qu: **Away, woman!**

(From chapter 4)

■ Is Aversa More Forgiving Than You Thought?

Maribelle: Unhand me, you gutter-born troglodyte!

Lissa: Maribelle!

Maribelle: Lissa? Darling, is that you?

Aversa: This girl crossed the Plegian border without our consent. And what's more... She wounded the brave Plegian soldiers who sought only to escort her safely home.

Maribelle: LIES! You speak nothing but lies, hag! **Did they not teach the meaning of the word "truth" in wretched-crone school?!**

Aversa: ...You see? **No manners at all.** Such a nasty little bird simply had to be caged.

(From chapter 5)

■ The Candy Mercenary

Chrom: You want gold? ...Fine, you scoundrel. Let me just—oops.

Gaius: Looks like you dropped something. What's in the satchel, mmm?

Chrom: Nothing—candies from my little sister. I'm sure you—

Gaius: "Candies"? As in, sugar candies?

Chrom: Well...yes, I assume they'd be sweet? But—

Gaius: IT'S A DEAL!

Chrom: **...You'll risk your life for us if I give you...a bag of candy?**

(From chapter 6)

WHO IS YOUR FAVORITE FEMALE CHARACTER?

The female character who takes the number-one spot is, of course, Lucina. She and Chrom make a fine father-daughter pair in the top spots. The battle for second between Cordelia and the avatar was fierce. Tharja kept up the pace, never falling far behind the leaders. In the end, she kept Sumia from overtaking her and captured the fourth spot.

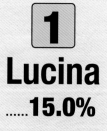

1
Lucina
...... 15.0%

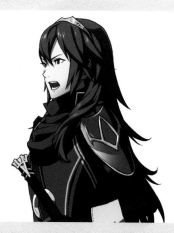

- I think it's just wonderful how she remains diligent in her mission but also shows her feminine side from time to time. (Kurosunaitsu)
- Her support conversations with Chrom made me smile! (^_^) Lucina is so cute! ♪ (Marimo)
- She's taken on the biggest burden of anyone, and she's battled through it all. I think that's so beautiful! (Furufuki)
- My first bride! After her, how could I ever get married again... Teru)
- She's got such a strong and unshakable sense of justice, but there's also a touch of the dreamer that shows itself at just the right times—I can't help myself! (Bion)
- She just moved me in how she gallantly sacrifices herself and comes back from the future to save Chrom! (Mitako)
- She goes from being a man to a princess. Isn't she the greatest?! (Karakuri Mania)
- She's strong to the core! Her feelings for her father and her loyalty to her friends make her really cool! (Ameko)
- She is so amazingly cute when you have her marry the avatar! (Marina)
- There should be a law against being this cute! It should be banned! (Sere)

2
Cordelia
...... 10.1%

- She's cool and cute! I think she's wonderful. (Tama)
- I think she's heroic in her crush on Chrom! I wanted to make it so Chrom married her!! (Kuu)
- I liked the fact that she was a strong, cute pegasus rider! (nemi)
- She's gallant, earnest, strong, wholehearted, sweet, and beautiful, but sometimes she allows fleeting glimpses of weakness to come through. I think that realism is charming! (Yuu-chan)
- Not only beautiful, but the perfect woman. What I like best are those brief mistakes that she makes. (Riko)
- It doesn't seem like she has any support dialogues with Chrom, but it's in other dialogues that her personality really shines through. (RAID)
- I made her my wife. What more can I say? (Tomona)
- I love her slender beauty! (Chris)

3
Avatar
...... 9.9%

- My kind of girl! Loved her more than anyone else. (Raiden-ume)
- Since, you know, it represents me, there's obviously a strong emotional attachment there. (Pirate Dial)
- I think this character worked just as well as a normal character that'd appear in-game, and less as an avatar. (Dreamer Tactician Intern)
- With her strength, accommodating and unrelenting attitude, and witty, instant comebacks, how can someone not love the avatar?! (Ruriha)
- I loved the avatar's cheeky and witty comebacks! (Chapuro)
- Since the avatar is, you know, yourself, you find yourself totally immersed. (Yuka)
- The default character with pigtails was the one I loved the best! (3)
- The avatar with straight bangs was so cute! And I liked how she could pair up with any of the male units! (Hino)

WHAT IS THE BEST MARRIED COUPLE?

This was the part of the questionnaire that was the most varied and complex. There are countless combinations to choose from, and so the players put together all sorts of couples. The number of valid votes was upward of 7,600, and on average, each person could have more than fifteen different couple patterns. Of course, the couple that was most popular was the avatar and Chrom. The second most popular pairing was Virion and Cherche. Tied for third were Henry and Olivia and Stahl and Sully. Beyond that, the most common pairing for the male avatar was with Lucina.

1	Avatar (Female) x Chrom	2.40%		11	Libra x Tharja	1.20%
2	Virion x Cherche	2.10%		11	Lon'qu x Lissa	1.20%
3	Henry x Olivia	1.90%		13	Gaius x Sumia	1.10%
3	Stahl x Sully	1.90%		13	Lon'qu x Cordelia	1.10%
5	Gregor x Nowi	1.70%		13	Virion x Sully	1.10%
6	Vaike x Miriel	1.60%		16	Frederick x Sumia	1.00%
7	Ricken x Maribelle	1.50%		16	Chrom x Sumia	1.00%
8	Frederick x Lissa	1.40%		16	Gaius x Cordelia	1.00%
8	Avatar (Male) x Lucina	1.40%		19	Stahl x Cordelia	0.90%
10	Chrom x Olivia	1.30%		19	Henry x Tharja	0.90%

Character Dialogue

■ Sumia's Enthusiasm

Chrom: OW! ...What the hell was that for?!

Sumia: Oh no! ...Did I do it wrong? Captain Phila said sometimes a good slap will break someone out of their doldrums.

Lissa: Sumia, when you slap someone, you do it with an open palm. **You just punched Chrom in the face!**

Sumia: Um... It's the thought that counts?

Chrom: Gods, that seriously hurt...

(From chapter 7)

■ Gregor's Expressions

Gregor: Oy, this is most terrible! Do you see now? They make with the catching of us!

Chrom: Why are you all after the girl?

Gregor: All? What is this "all"? Gregor is not one of "all"! Look close! Maybe you not see so far? Gregor have innocent-baby face!

Chrom: Hmm...

Lissa: Well...

[Robin]: Yeah... Not sure "innocent baby" is how I'd describe it...

Gregor: **Gah! Never be minding!** Gregor is not enemy! You must believe!

(From chapter 8)

■ Gaining Chrom's Trust

Chrom: You there! Are you with the Plegians? You seem reluctant to fight.

Tharja: Death comes for all of us eventually. Why invite it early, fighting for a cause I don't believe in?

Chrom: So...I should take that as a no, or...

Tharja: Let's just say I'm keeping my options open. I mean, long live the king and all, but I'd like to keep living as well. And I have a bit of a rebellious streak, I'm afraid. A...dark side.

Chrom: Then perhaps you would rebel now and fight for our cause?

Tharja: ...You would trust me? What if this is all just a ploy to plunge a dagger in your back?

Chrom: My sister, the exalt—I think she would trust you. And I'm trying to learn from her. Besides, I already need to watch my back, whether you're with us or not.

Tharja: Well, that's odd... **Usually when I bring up the backstabbing bit the discussion is over.** All right, then—consider me your new ally. ...For now.

(From chapter 9)

■ Libra's Heartfelt Prayers

Chrom: You there! Who are you? Why do you fight alone?

Libra: Good heavens! You're Prince Chrom, brother to Her Grace the Exalt!

Chrom: You know me?

Libra: Know you? Of course, sire! All

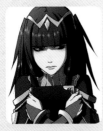

4
Tharja
......8.4%

1	Lucina	15.00%
2	Cordelia	10.10%
3	Avatar (Female)	9.90%
4	Tharja	8.40%
5	Sumia	6.80%
6	Olivia	6.10%
7	Lissa	5.90%
8	Cherche	5.50%
9	Morgan (Female)	4.30%
10	Severa	3.60%
11	Maribelle	3.30%
11	Noire	3.30%
11	Tiki	3.30%
14	Nowi	3.20%
15	Miriel	2.90%
16	Nah	1.40%
17	Sully	1.30%
18	Panne	0.90%
18	Anna	0.90%
18	Cynthia	0.90%
21	Say'ri	0.70%
21	Kjelle	0.70%
23	Flavia	0.60%
23	Emmeryn	0.60%
25	Aversa	0.30%
25	No Preference	0.30%

- At first, I didn't like her because she seemed a little dark and gloomy, but when she started talking, it turned out she was cute and really grew on me! (Pochi)
- She was too cute! Too cute! Waaay too cute!! (A Really Nice Person in Ibaraki Prefecture)
- She's bleak, but her dialogue is so cute! And her outfits are the best! (Ratosuke)
- Her adorable nature made my avatar character really fall for her! (Voggioko)
- I love everything about Tharja! (Neojimata)

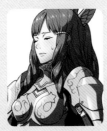

5
Sumia
......6.8%

- I love the contrast between how clumsy she normally is and the demon she can be on the battlefield. (Konayan)
- She's pretty, brave, and earnest!! Nothing better than that!! (Chiaki)
- Her pleasant voice is enough to keep me relaxed, even during battle. (´▽`) (Canned Mackerel)
- I loved the part at the beginning, when she's talking about the flower fortune regarding whether she and Chrom will be happy—I loved that! (Myuu)
- I love the clumsy girls! (Rikopin)

Q IN THE DOWNLOADABLE CONTENT, WHAT CHARACTER DID YOU FEEL MOST NOSTALGIC ABOUT?

1	Marth	2.40%
2	Lyndis	2.10%
3	Roy	1.90%
4	Eirika	1.80%
5	Sigurd	1.70%
6	Alm	1.60%
7	Ephraim	1.50%
8	Seliph	1.40%
8	Leif	1.40%
10	Ike	1.30%

As you might know from all the online discussion, there is downloadable content available in which some of the characters from the past *Fire Emblem* games appear. For longtime fans of the entire series, these encounters could be emotional, much like reuniting with old friends. The rankings are a long list of the main characters from all those previous games. The top spot, naturally, went to Marth. Second place went to Lyndis from *Fire Emblem*. Roy from *The Binding Blade* took third.

Ignored Recommendations

Do you have any suggestions, Chrom?

I think we should give a name to those creatures that have been popping up everywhere.

I guess we could call them an army of minions who are acting under instructions from some godlike, or devil-like, controller! Yes!

Judging from their looks--they're scary, like skulls. And the minute they see prey, they rush in hordes to make violent attacks!

We'll call them "Risen."

Hell's Missionaries!!

Ah!

They are emissaries from the underworld!

GRR

Hell's Missionaries!!

Very well. Throughout the empire, we shall call these monsters "the Risen"...

Meanwhile, in the Valmese Empire...

Ylissean clergy do. I must thank the gods for uniting us! Oh, dearest and most heavenly fa—

Chrom: **With all respect, now is not the time for prayer**—it's action that's called for.

Libra: Ah, too true! We hurried here to help as soon as word came of the execution.

Chrom: We? Then there are more of you?

Libra: Alas, there were. I lost many brave comrades along the way. In truth, I was starting to doubt the purpose of my struggle... But no longer! Pray, sire, let my axe serve you and your party!

Chrom: Your love for my sister is clear.

I would be honored to be joined by such a formidable woman of the cloth.

Libra: ...Man, sire. Man of the cloth.

Chrom: You're a... ...You're not a woman?

Libra: No, sire. Women are clerics. I am a priest. Well, technically a war monk, if you care to split hairs...

Chrom: Oh. Yes, well, I'm... I didn't mean to imply... Well, this is rather awkward.

Libra: Oh, it's all right, sire. You realized your mistake quickly enough. It could have become much more awkward. MUCH more...

Chrom: Right! Let's stop there.

(From chapter 9)

■ **Chrom and His Wife**

Wife: ...Chrom? My husband?

Chrom: I know. I'd stay with you if I could, but we owe Regna Ferox a great debt. I must apprise myself of the facts there before deciding on a course of action.

Wife: Yes, I suppose you do.

Chrom: You stay here with Lucina. A newborn should be with her mother.

Wife: But, Chrom, I... *sigh* I suppose there is little wisdom in my going. I know nothing of battle. But I will watch over our daughter while you are away. Lucina is a strong child; she takes after her father. The Brand in her left eye was not your only gift to her. Still, you must promise you will stay

safe. For her sake...

Lissa: Aww... You two are so sweet to each other. To think, just a couple years ago: strangers. Now: married with a child!

Chrom: A lot can happen in two years, Lissa. One day you'll understand.

(From chapter 11)

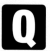 **WHICH CHARACTER WAS MOST HELPFUL IN THE STORY?**

The avatar took the top spot by a huge margin. Unsurprising, perhaps, as this question combined both the male and female avatar versions. Coming in second was "Donny" (Donnel). It seems more than a few fans were surprised at his development.

1	Avatar	28.50%
2	Donnel	7.30%
3	Morgan (Male)	5.00%
4	Morgan (Female)	4.50%
4	Tharja	4.50%

6	Cordelia	3.90%
7	Inigo	3.60%
8	Chrom	3.20%
9	Lucina	2.70%
9	Frederick	2.70%

1 Avatar28.5%

- Not only is this me, but also since the avatar can rise in support levels with anyone, the character just naturally appears in every battle. (Mijinko)
- Since the avatar is the player, the character receives the most attention and always stands out in the crowd. (Okuto)
- The avatar easily burns through the opposition. (Yumashii)
- Tacticians and grandmasters can use both swords and magic from the start, so the character ends up at a very high level by the end. (Cho)
- There was a lot of choice in skills and promotions, so the avatar was very easy to use. (Nogihen)
- I liked how the character could have support levels with anyone and had a wide range of skills. (Junrei)
- Before I knew it, this character was incredibly advanced. (Sumida River)
- The avatar tends to be the center of the battle. After he learns Galeforce, Chrom and the avatar can easily take out the enemy by themselves. It's a really good thing the character learned magic! (Blue Moon)

2 Donnel......7.3%

- At the beginning, he was hardly any help at all, but after raising his level, he becomes so strong that by the end, he's a match for any legion of men! (Oberst)
- I would always make him a part of the party, and before I knew it, he was stronger than Chrom or the avatar. (Kiyo)
- He's so strong that I feel he should just be the main character. (Machine King)

3 Morgan (Male)......5.0%

- My avatar's kid is super awesome! Can't stop his major magic skills! (Oshian)
- From the moment he was added to the party, he and his mother made an unstoppable team! (Bunzy)
- I was moved by the strength he inherited from his parents and his outstanding, lighthearted personality. He just makes me feel good! Go, him! (Sekira)
- After a few go-rounds, he was the strongest in my army! (Veggieko)

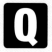 **WHAT PHRASE LEFT THE BIGGEST IMPRESSION?**

The phrase that got the most votes overall was Chrom's iconic "Anything can change!" And by a narrow margin, the one that came in second was Basilio's "Your 'future,' it can kiss my big brown Feroxi arse!" It seems that this crude but bold statement made by the Feroxi king struck to the heart of quite a few people!

1	Anything can change! (Chrom)	10.80%
2	My big brown Feroxi arse! (Basilio)	10.60%
3	Don't speak her name! (Chrom)	5.20%
4	Welcome back. It's over now. (Chrom)	3.70%
5	Hey there, Fredericson! (Avatar)	3.50%
6	I will not fail! (Chrom)	2.10%
7	May we meet again, in a better life... (Avatar)	2.00%
7	I challenge my fate! (Lucina)	2.00%
9	Unless...you rushed into marriage for some reason? Like you got her— (Nah)	1.80%
10	I had no choice but to ru...Er, that is, to RECRUIT new allies. (Virion)	1.30%

1......10.8% **3**......5.2% **4**......3.7%

Anything can change!

Welcome back. It's over now.

Don't speak her name!

Your "future," it can kiss my big brown Feroxi arse!

2......10.6% **5**......3.5%

Hey there, Fredericson!

 ## Character Dialogue

■ The Dignity of Duke Virion

Virion: Good day, lords and ladies. How fare you all? Allow me the great pleasure, and indeed honor, of introducing myself...

Chrom: We all know who you are, Virion. Although I don't believe we've met your companion?

Virion: Hmph! You know nothing! Prepare for my great unmasking! Long have I posed as archest of archers! Yet that was but a ruse! Yea, an artifice, to disguise myself as a mere above-average man. In truth, I am—

Cherche: *Ahem* May I present Duke Virion. I am his humble servant, Cherche. Greetings, sire. You honor us with your presence.

Virion: Cherche! You stole my moment!

Chrom: A pleasure, Cherche. Perhaps you could speak on your master's behalf?

Cherche: **That may speed things along, yes...**

Chrom: Then please. Time is of the essence.

Cherche: Very well, then. First, concerning our origins... We hail from Rosanne, a fertile territory on the continent of Valm. Milord is the head of House Virion, and the rightful ruler of Rosanne. **A fact he often reminds us of—and loudly.**

Virion: Ha! Is she not a true wit? She gets it all from me, you know.
(From chapter 11)

■ Burning Jealousy... Sumia Version

Sumia: He loves me... He loves me not...

Chrom: Er, Sumia? Why in the gods' names are you shredding those poor flowers?

Sumia: **I'm not spying on you!** You can't prove that I am! Oh, gods! You brought...HER! *sniff sniff*

Chrom: Can we tell her, Lucina?

Lucina: Of course.
(From chapter 13)

■ Burning Jealousy... Sully Version

Sully: Hyah! Kah! Yah!

Chrom: Um, Sully? Isn't it a little late to be practic—

Sully: You've got some nerve bringing that damn hussy around here! **Now get her away from me before I start practicing on HER!**

Chrom: ...I think we should tell her, Lucina.

Lucina: Of course.
(From chapter 13)

■ Burning Jealousy... Maribelle Version

Maribelle: All right, Maribelle. Be calm, and handle this like a true woman of good breeding... Or just punch him in his cheating, lying face! Grrr...

Chrom: Maribelle? You seem upset.

Maribelle: Oh, upset?! Upset, is it?!

Q WHAT ENEMY LEFT THE BIGGEST IMPRESSION?

According to the poll, the enemy with the biggest impact was Mustafa. This Plegian general's feelings for his wife and children and calling of a retreat for the sake of the young soldiers touched the hearts of a lot of people.

1	Mustafa	21.90%	6	Grima	7.00%
2	Gangrel	13.00%	7	Aversa	6.90%
3	Walhart	9.60%	8	Cervantes	6.40%
4	Excellus	9.10%	9	Validar	4.10%
5	Victor and Vincent	8.70%	10	Yen'fay	3.70%

Q WHAT EVENT LEFT THE BIGGEST IMPRESSION?

1	Lucina Held at Sword Point (Chapter 21)	18.90%
2	Emmeryn Throws Herself Off the Cliff (Chapter 9)	15.10%
3	Marth's Real Face Is Revealed (Chapter 13)	12.50%
4	The Ending (Final Chapter)	8.70%
5	Chrom's Wedding (Chapter 11)	2.90%

Q WHAT SKILL WAS THE GREATEST HELP?

1	Galeforce	32.20%	6	Lethality	6.10%
2	Sol	10.00%	7	Rally Spectrum	3.10%
3	Armsthrift	9.80%	8	Lifetaker	2.90%
4	Ignis	7.60%	9	Renewal	2.70%
5	Aether	6.60%	10	Vengeance	2.40%

Q WHAT CHARACTER WOULD YOU MOST LIKE TO COSPLAY?

1	Avatar	27.60%	6	Owain	3.30%
2	Lucina	9.90%	7	Cordelia	3.00%
3	Donnel	3.80%	8	Gerome	2.80%
4	Lissa	3.50%	8	Chrom	2.80%
4	Gaius	3.50%	8	Nah	2.80%

- I can choose the hairstyle and color I like the best, and the grandmaster costume is just the coolest! (I Love the Avatar)
- The camisole inside the robe is so cute! (Kinako-mochi)
- It's because the avatar's outfit is a little mysterious and so cool! (Isshi)
- It's because nobody knows your body type when you're in it! Ha ha! (Shion)

An Omen of Destruction

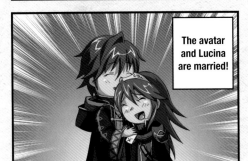

The avatar and Lucina are married!

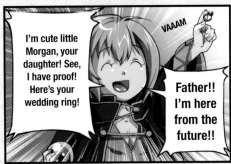

I'm cute little Morgan, your daughter! See, I have proof! Here's your wedding ring!

VAAAM

Father!! I'm here from the future!!

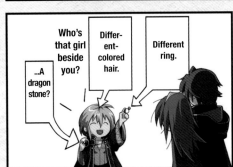

Who's that girl beside you?

Different-colored hair.

Different ring.

...A dragon stone?

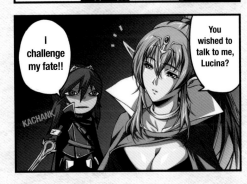

I challenge my fate!!

KACHANK

You wished to talk to me, Lucina?

Is that why you're flocking to other women? And you brought her HERE! Why? Just to rub my nose in it?!

Chrom: I think we should tell her, Lucina.

Lucina: Of course.

(From chapter 13)

■ Burning Jealousy... Olivia Version

Olivia: Oh, Chrom... I thought we would last forever! *sob*

Chrom: **Olivia? Why are you crying?**

Olivia: It's all right. She's beautiful, and your happiness should come first... WAAAAAAAAAAAAH!

Chrom: We have to tell her, Lucina.

Lucina: Of course.

(From chapter 13)

■ The Grudge of the Whiskers

Cervantes: ...Eh wot?! It cannot be! Say'ri—my mortal enemy...

Say'ri: General Cervantes... Your reputation—and your gut—precedes you.

Cervantes: But we have met in battle before, girl! Have you forgotten?! Not long ago, you and I, locked in deadly combat. I was sure we had won the day until you appeared...

Say'ri: ...Your beard again? Can you talk of nothing else, you imperial pig?!

Cervantes: **Ap-PEARED!** I said "appeared"! Just...never mind!

(From chapter 15)

■ The Twins and Identical Sisters

Anna: Hate to be the bearer of bad news, but I'm afraid this village is closed.

Victor: You! We have business, you and I, and I aim to settle the debt. Vincent will be avenged today!

Anna: Oh, dear. Have we met?

Victor: Playing dumb won't save you, girly. **The gold you net from the slavers will build Vincent the finest grave in the land!**

Anna: Careful, love. Us traders are known to make some very deep cuts.

(From paralogue 2)

■ The Legendary Sword?

Sage: You're a kind soul to fight for strangers so. Here, you must take this.

Owain: By the ghost of Ike! I've found it at last! **The fated mate to my sword hand! ...The divine blade, Mystletainn!**

Sage: Er, I'm afraid this is a blade of extremely common make, sir. I was using it to dig a well, but I figured you might—

Owain: Come, Mystletainn! Destiny beckons!

Sage: I also used it to cut small vegetables before it got dull. ...Er, hello?

(From paralogue 5)

IN *FIRE EMBLEM AWAKENING*, THIS IS WHAT I LOVE BEST!

Here we bring you the messages of Japan's grandmasters in one big list! What do you love best about *Fire Emblem Awakening*?! "This part was the coolest!"..."This system was great"..."I loved how Chrom made my heart race!"...These were just some of the many passionate messages! Thank you so much!

● You can have all different kinds of characters supporting each other, and there are so many great characters! And thanks to the avatar, I found myself completely absorbed in it! (Asuka)

● **I loved *Fire Emblem: Genealogy of the Holy War*'s system where you could couple up characters at will. I was so happy to see that revived!** (Necohira)

● Kinda creepy how Chrom was basically stalking my female avatar. (Ichigo)

● I love how you can train your characters as much as you like, how the enemy characters mostly become allies, how characters from past games show up, how you can pair up the characters, the wedding system, and the unrestricted amount of character support! (The Third Villager)

● The background music was wonderful! (haryu703)

● This is my first in the *Fire Emblem* series. I thought it would be difficult because you never get your characters back—one mean mother of an RPG. But in reality, every scene had funny aspects, and it was built so a first-timer could have fun too! (Yuu)

● **The main character was so tough and didn't seem "royal" at all! That was wonderful!** (Gita)

● The DLC was so fun; I always looked forward to it! Keep adding more, please! (Haruhiko)

● Just when I thought I had all the DLC they were going to put out, they put out a second series! (Zaha)

● **It was worth the wait for a completely new addition to the *Fire Emblem* series!! It was really fun!** (99)

● This is like a combination of all the previous *Fire Emblem* games, and playing this one seemed both new and nostalgic. It was a really fun game! As to the degree of difficulty, I see the map has gotten easier, which can't really be helped. But I'd like to see a map that is more strategically challenging. (Uraran)

● I've been playing ever since *Fire Emblem: Genealogy of the Holy War*, and I liked that the support dialogues weren't all the same; rather, the contents could change drastically depending on the person! That was just amazing! Also the female Morgan was incredibly cute! (Kiritanpo)

● I was incredibly invested in this game! And it has so much replay value! (Namagome)

● I like how you can go on playing it forever! I'm also impressed with the sheer number of support dialogues; it took forever to get them all done! I also loved the bonuses for fans! I want to play it for a long time to come! (Heppoko Yuusuke)

● **Making couples is so much fun!! (Kira)**

● The characters were just amazing! I really loved Frederick! I loved his rare weak points. He's so good looking, but... the meat thing... Ha ha! (Toto)

● All the characters are so charming! There's so much conversation, and no matter how many times I do it, pairing people up to get married is so fun! The user interface is easy and never causes problems! (nemi)

● I've been a fan ever since *Mystery of the Emblem* on the SNES. This time, Lunatic mode was...really interesting. I wound up playing more than three hundred hours! (Hitonatsu)

● **I never liked SRPGs before, but this is the game that allowed me to finally appreciate them. (Esskayeff)**

● I love the detailed ways in which you can control the avatar after the *New Mystery of the Emblem* game. I also love all the different marriages that are possible and the kids of the next generation, how all the characters are distributed, and how every character has a pro voice actor attached to it... Among many other things. (Azamaru)

● **Have you added the DLC where Chrom and Cordelia can have a support level S yet? (RATOsuke)**

● I love how the characters are so fleshed out! (Furofuki Daikon)

● **I fear nothing when Tharja is with me! (yakei)**

● Thank you so much for creating Tharja! (Arutairu)

● I like how we meet Tiki again after so many years! (Teru)

● It was so much fun; the game makes me long for a sequel or a side story! (Tomona)

● **I think these characters are the most unique in history! (Ylisse)**

● All the characters have their own individual expressions; it's just fun to watch. Also, the battle scenes are really cool! (mika)

● **The cut scenes are so beautifully done! The true characters of Emmeryn, Sumia, and Lucina shine through! I love the cut-scenes so much, I could watch them over and over!** (Towawa)

● The way characters have relationships, and the historical characters were so good! It was so fun—I could go on forever! (Sui)

● **This was my introduction to *Fire Emblem*, and it was loads of fun! I've played for more than 500 hours, and I'm not ready to finish it yet!** (Panie)

● Yes, *Awakening* has stolen away a lot of my time, but at the same time, I've made new friends who love the same characters I do, and I've tried new things I'd never tried before! It was truly a wonderful use of my time! Thank you so much! I'm going to keep on playing!! (Hiyoto)

● This is my first *Fire Emblem*, and I had a great time the entire play through! Thanks to an easy-to-understand user interface, wonderful characters, and a choice of the degree of difficulty, I was able to play this with ease, even though I had never played a strategy RPG game before! (tyt)

● **I think the main reason I love it is because I was sucked right into *Awakening*'s world! The wonderful characters with all their charming quirks were just fantastic!** (Shori-Mizore)

● I want a sequel using this same system! (Tiga33)

● **So when's the next game from you guys, again? (Pink Lightning)**

Character Dialogue

■ Mother-and-Son Shy-Off

Inigo: Er sort of, yes. That is to say, I try my best. But some people don't appreciate male dancers. Not that I care! I'm content to just shake my hips for the ladies.

Olivia: Oh, don't listen to them! I think it's wonderful! I'd...love to watch you dance sometime.

Inigo: N-no! Impossible! I'd be far too embarrassed for that! Besides, I'd rather watch you dance.

Olivia: What?! N-no! I couldn't possibly!

Inigo: I'm shyer than you are, Mother!

Olivia: You are not!

Inigo:

Olivia:

Chrom: **Would you two stop it already? Now I'm the one who's getting embarrassed...**

(From paralogue 6)

■ THIS Is My Son?!

Maribelle: I'm sorry, but I only cure physical ailments. Broken bones and the like. You're clearly a deeply troubled individual whose diseased mind is beyond my healing.

Brady: Stop talking for a minute and look at this!

Maribelle: That's...my ring! Then, that makes you...

Brady: Right. Like I was trying to say, I'm—

Maribelle: A thief! A rapscallion! A common lowborn cutpurse! How dare you sneak in here and steal my prized possessions!

Brady: Gawds! Stop interruptin' for one blessed second, and check yer ring!

Maribelle: ...Oh. It's still here.

Brady: That clear things up any, Ma?

Maribelle: **Everything save how I gave birth to a common thug!**

(From paralogue 7)

■ The Jester

Chrom: You there! Hold!

Yarne: Gyah! D-don't surprise me like that! I could die of heart failure!

Chrom: ...I was standing right in front of you. Ought I have waved first, or would that have been too threatening?

Yarne: Oh, aren't we the jester! People die from much lesser things, you know. It's no laughing matter! What if you scare me and I trip and fall and cut my head open? What then?!

Chrom: Er...right. Look, if you're so worried about death, maybe you should just surrender. I have no desire to spill unnecessary blood.

Yarne: Wait, surrender is an option?! Wh-why didn't you say so?!

(From paralogue 13)

■ Chrom's Response

Frederick: Slavers, milord. Such damnable scum...

Chrom: We'll have to hurry if we hope to catch them.

Tharja: Or we could stay right here and just let me go to work on them. A curse to wither them away, perhaps? A slow death over a year? Oh, fie. Let's make it two.

Chrom: **I think their captive would likely appreciate something a bit more immediate. Shepherds! Saving the girl is our top priority! Now move out!**

(From paralogue 15)

■ Confusing Name

Nowi: All right, I've told you my name. Now you tell me yours.

Nah: Nah.

Nowi: Oh, come on, why not?!

Nah: No, NAH. N-A-H. That's my name.

Nowi: That's a confusing name...

Nah: **And whose fault is that?!**

Nowi: How the heck should I know? Anyway, this place isn't safe. Let's get you out of here!

Nah: After you...

(From paralogue 15)

Section 5

CHARACTER PROFILES

Character Profiles

■■■ Profiles of the Characters in the Main Story Line

In this section, we bring you profiles of all the characters in the *Fire Emblem Awakening* main story line, including the main characters, allies, enemies, NPCs, and even the general units found in the game, all in one place. For the major characters, this information includes their titles, character art, voice actors' names, and more, and also what happens to them after the events of the game.

Avatar

Title: High Deliverer

Original Class: Tactician Birthday: — Character Voices: Dave Vincent, Brandon Karrer, Chris Smith, Michelle Ruff, Wendee Lee

Official Profile

A traveler who remembers nothing

prior to being found by the wayside.

Chrom realized (his/her) tactical genius

and enlisted (him/her) in the Shepherds,

where (he/she) is well liked.

The biggest mystery of the group.

Taken from Historical Records

The legendary exploits of

[Robin] filled many a saga

and delighted children hungry for

a dashing tale of heroism.

But what was the man really like?

...Few yet live who remember.

Male
Build: 01
Face: 01
Hair: 01
Hair Color: 01
Voice: 01

Male
Build: 02
Face: 01
Hair: 01
Hair Color: 01

Male
Build: 03
Face: 01
Hair: 01
Hair Color: 01

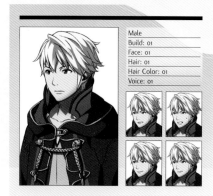

Male
Build: 01
Face: 02
Hair: 02
Hair Color: 19

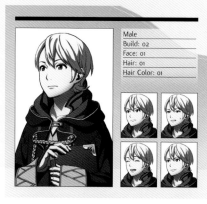

Male
Build: 01
Face: 03
Hair: 04
Hair Color: 15

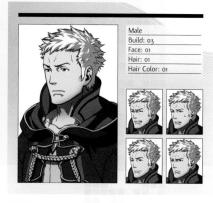

Male
Build: 01
Face: 04
Hair: 05
Hair Color: 02

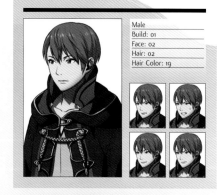

Male
Build: 01
Face: 05
Hair: 03
Hair Color: 08

Male
Build: 02
Face: 02
Hair: 05
Hair Color: 11

Male
Build: 02
Face: 03
Hair: 04
Hair Color: 18

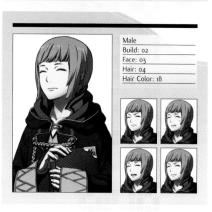

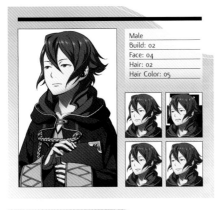

Male
Build: 02
Face: 04
Hair: 02
Hair Color: 05

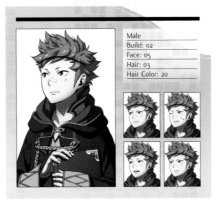

Male
Build: 02
Face: 05
Hair: 03
Hair Color: 20

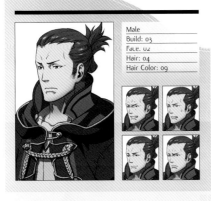

Male
Build: 03
Face: 02
Hair: 04
Hair Color: 09

Male
Build: 03
Face: 05
Hair: 03
Hair Color: 04

Male
Build: 03
Face: 04
Hair: 02
Hair Color: 12

Male
Build: 03
Face: 05
Hair: 03
Hair Color: 07

Female
Build: 01
Face: 01
Hair: 01
Hair Color: 01

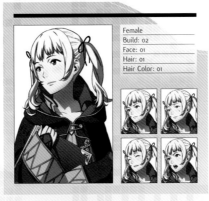

Female
Build: 02
Face: 01
Hair: 01
Hair Color: 01

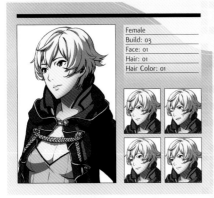

Female
Build: 03
Face: 01
Hair: 01
Hair Color: 01

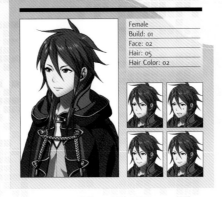

Female
Build: 01
Face: 02
Hair: 05
Hair Color: 02

▢▢▢ Epilogues

Married Life, as Recorded in Historical Records

Once a couple reaches support level S, the descriptions recorded in the historical records change. We bring them all to you here. "[Robin]" is used here as the avatar's name.

■ AVATAR (MALE) X WIFE
Many wrote of [Robin]'s legendary exploits, but accounts of his origins and character varied. Scholars, poets, and bards agreed on one thing alone—he loved his wife, [Wife], above all else.

■ AVATAR (FEMALE) X HUSBAND
Many wrote of [Robin]'s legendary exploits, but accounts of her origins and character varied. Scholars, poets, and bards agreed on one thing alone—she loved her husband, [Husband], above all else.

■ CHROM X AVATAR (FEMALE)
Many wrote of [Robin]'s legendary exploits, but accounts of her origins and character varied. Scholars, poets, and bards agreed on one thing alone—she loved her husband, Chrom, above all else.

■ CHROM X SULLY
After Grima's defeat, Chrom was officially welcomed as Ylisse's new exalt. Queen Sully rode far and wide on his behalf, her gallant and radiant figure the envy of women everywhere.

■ CHROM X SUMIA
After Grima's defeat, Chrom was officially welcomed as Ylisse's new exalt. Queen Sumia lived and breathed for him, and her flower-petal readings were said to bring good luck to all who received them.

■ CHROM X MARIBELLE
After Grima's defeat, Chrom was officially welcomed as Ylisse's new exalt. Queen Maribelle kept him always on his toes while she strove tirelessly to become a magistrate and reform the halidom's laws.

■ CHROM X OLIVIA
After Grima's defeat, Chrom was officially welcomed as Ylisse's new exalt. Queen Olivia gave him a much-needed shoulder to lean on as she traveled the land, dancing and mending the scars of war.

■ FREDERICK X LISSA
As Ylisse's new knight captain, Frederick took charge of keeping the peace and training new recruits. Lissa often visited his charges in town to report concerns—and transgressions—to her husband.

■ FREDERICK X SULLY
As Ylisse's new knight captain, Frederick took charge of keeping the peace and training new recruits. His wife, Sully, assisted him, becoming an object of admiration for strong women the world round.

■ FREDERICK X MIRIEL
As Ylisse's new knight captain, Frederick took charge of keeping the peace and training new recruits. Alas, his wife, Miriel, would often vanish for weeks at a time as she pursued her studies.

■ FREDERICK X SUMIA
As Ylisse's new knight captain, Frederick took charge of keeping the peace and training new recruits. His wife, Sumia, traded her lance for a peaceful stretch of pasture and raised a happy group of pegasi.

Female
Build: 01
Face: 03
Hair: 02
Hair Color: 11
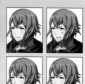

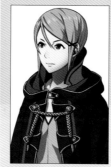
Female
Build: 01
Face: 04
Hair: 04
Hair Color: 14
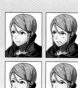

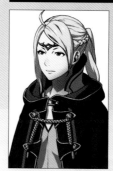
Female
Build: 01
Face: 05
Hair: 03
Hair Color: 17

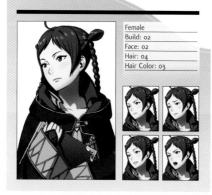
Female
Build: 02
Face: 02
Hair: 04
Hair Color: 03

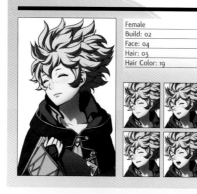
Female
Build: 02
Face: 04
Hair: 03
Hair Color: 19

Female
Build: 02
Face: 04
Hair: 03
Hair Color: 19

Female
Build: 05
Face: 05
Hair: 02
Hair Color: 10

Female
Build: 03
Face: 02
Hair: 04
Hair Color: 15

Female
Build: 03
Face: 03
Hair: 05
Hair Color: 06

Female
Build: 03
Face: 04
Hair: 02
Hair Color: 04

Female
Build: 03
Face: 05
Hair: 03
Hair Color: 13

Epilogues

Married Life, as Recorded in Historical Records

■ FREDERICK X MARIBELLE

As Ylisse's new knight captain, Frederick took charge of keeping the peace and training new recruits. His wife, Maribelle, did her own part for Ylisse by studying hard and becoming a respected magistrate.

■ FREDERICK X PANNE

As Ylisse's new knight captain, Frederick took charge of keeping the peace and training new recruits. His wife, Panne, showed no interest in his work but gradually learned to enjoy human life.

■ FREDERICK X CORDELIA

As Ylisse's new knight captain, Frederick took charge of keeping the peace and training new recruits with his wife. Teaching was hard for Cordelia, however, as she was forced to neglect her own gifts.

■ FREDERICK X NOWI

As Ylisse's new knight captain, Frederick took charge of keeping the peace and training new recruits. His wife, Nowi, frequently came to the training yard to lend a hand or instill terror in a new charge.

■ FREDERICK X THARJA

As Ylisse's new knight captain, Frederick took charge of keeping the peace and training new recruits. Tharja's rare appearances at the training yard sent terrified recruits screaming into the night.

■ FREDERICK X OLIVIA

As Ylisse's new knight captain, Frederick took charge of keeping the peace and training new recruits. His wife Olivia's dances were said to keep his resolve strong and open the minds of his charges.

■ FREDERICK X CHERCHE

As Ylisse's new knight captain, Frederick took charge of keeping the peace and training new recruits with his wife, Cherche. Students quickly learned to fear the couple's famously disarming smiles.

Chrom

Title: Newly Exalted

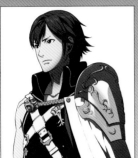
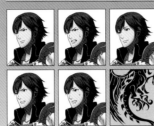

- Original Class: Lord
- Birthday: May 27th
- Character Voice: Matthew Mercer

Official Profile

The prince of Ylisse and descendant of the Hero-King. While of noble blood, he also leads a militia known as the Shepherds. His strong conviction makes him a fine captain. The most likely to break things.

Taken from Historical Records

After Grima's defeat, Chrom was officially welcomed as Ylisse's new exalt. His unflinching perseverance through countless hardships made him a beacon of hope for his people.

Lissa

Title: Sprightly Cleric

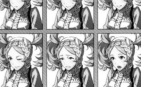

- Original Class: Cleric
- Birthday: March 6th
- Character Voice: Kate Higgins

Official Profile

Chrom's tomboyish little sister, the princess of Ylisse. With nary an ounce of nobility in her personality, she is among the most likeable and approachable of the Shepherds. The girl most likely to snort.

Taken from Historical Records

Lissa's wild nature led her to travel the world and relay its wisdoms to her brother. The princess's exploits live on in many a droll tale told by the crackling fire.

Frederick

Title: Cold Lieutenant

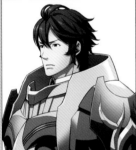

- Original Class: Great Knight
- Birthday: August 26th
- Character Voice: Kyle Hebert

Official Profile

Chrom's lieutenant, an Ylissean knight who is sincere to a fault. He tends to demand tremendous effort for seemingly trivial things, and prefaces such exercises with a grin. The fondest of starting fires.

Taken from Historical Records

As Ylisse's new knight captain, Frederick took charge of keeping the peace and training new recruits. Few ever forgot his glowing smile and idle quips, even as he doled out tasks that would break a wyvern.

Virion

Title: Archest Archer

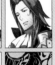
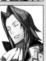
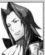

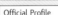

- Original Class: Archer
- Birthday: December 10th
- Character Voice: Dan Woren

Official Profile

A secretive noble from some land or another. While many would brand him a buffoon or a braggart, his boasts are often founded. He is swift to propose to anything female. The most prolonged primper.

Taken from Historical Records

Virion returned home to Rosanne, where he was labeled a traitor and a coward, or else ignored entirely. He never battled these claims, but history shows he gave the rest of his life to the people.

Sully

Title: Crimson Knight

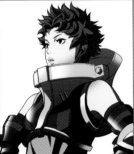

- Original Class: Cavalier
- Birthday: December 5th
- Character Voice: Amanda C. Miller

Official Profile

A no-nonsense, capable Shepherd with a mouth that would make brigands blush. Ylissean women admire her strength and call her "The Woman to End All Men." The last one you want cooking.

Taken from Historical Records

Sully continued her knightly duties and soon became a trusted leader on the field and off. Her dashing figure and significant skills made her a hero to women everywhere.

Vaike

Title: Zero to Hero

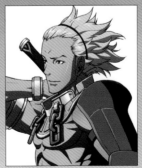
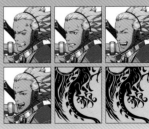

- Original Class: Fighter
- Birthday: December 26th
- Character Voice: Michael Sorich

Official Profile

A rough-hewn Shepherd with a loud personality and far more confidence than his ability warrants. He sees himself as exemplary and reverently refers to himself in the third person. The best at misplacing things.

Taken from Historical Records

Vaike returned to the streets that raised him and was welcomed as a hero. His unflinching self-assurance was the perfect medicine for the town's postwar squabbles, earning him the nickname "Brother Vaike."

Stahl
Title: Viridian Knight

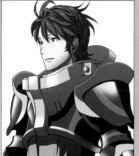

- Original Class: Cavalier
- Birthday: June 16th
- Character Voice: Sam Regal

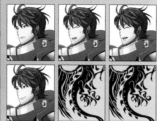

Official Profile
A surprisingly normal Shepherd with a big heart and perpetual cowlick. He has a good head on his shoulders, but the rest of him often has trouble keeping up. The most eager to clean a plate.

Taken from Historical Records
Stahl continued his service as an Ylissean knight and led crucial missions across the realm. His placid nature and scatterbrained charm made him a favorite hero of the people.

Miriel
Title: Rapier Intellect

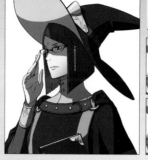

- Original Class: Mage
- Birthday: February 12th
- Character Voice: Tara Platt

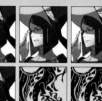

Official Profile
A grandiloquent but fastidious Shepherd who grows irascible if so much as a single arrow sits ajar in its quiver. She adores research and obsesses over her object of study. The most superfluous packer.

Taken from Historical Records
Miriel remained in Ylisse but would vanish for days at a time when her discoveries prompted further inquiry. In her final years, these excursions culminated in a historic invention of supreme import.

Kellam
Title: Oft Forgotten

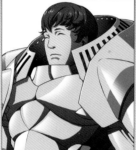

- Original Class: Knight
- Birthday: June 24th
- Character Voice: Orion Acaba

Official Profile
A laconic, blank-faced Shepherd whose infamous lack of presence causes him to pass by the others as if invisible. Despite his protests, he is actually quite proud of that. The tallest while seated.

Taken from Historical Records
After the battle was over, Kellam departed Ylisse for a long journey. Of course, it took Chrom and the others several years to notice his absence.

Sumia
Title: Maid of Flowers

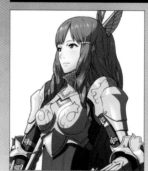

- Original Class: Pegasus Knight
- Birthday: November 24th
- Character Voice: Eden Riegel

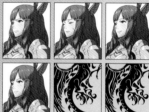

Official Profile
An absentminded, klutzy Shepherd with a shocking lack of self-worth. However, she exhibits one-of-a-kind talent, particularly when it comes to working with animals. The best at tripping over nothing.

Taken from Historical Records
With Chrom's permission, Sumia traded her lance for a peaceful stretch of pasture on which to raise pegasi. Her flower-petal readings were said to bring good luck, and many asked her to tell their fortunes.

Lon'qu
Title: Gynophobe

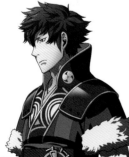

- Original Class: Myrmidon
- Birthday: October 10th
- Character Voice: Travis Willingham

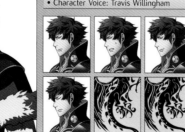

Official Profile
A swordsman raised in Regna Ferox, where Khan Basilio has vouched for his skill. While cool and curt around most people, the very sight of a woman turns him beet red. The deftest potato peeler.

Taken from Historical Records
Lon'qu returned to Regna Ferox and served as Basilio's right-hand man. Later, he apparently challenged the West-Khan to a duel, though no record remains of why it was fought or who emerged the victor.

Ricken
Title: Upcoming Mage

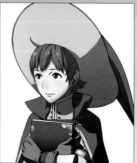

- Original Class: Mage
- Birthday: May 23rd
- Character Voice: Yuri Lowenthal

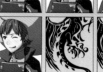

Official Profile
A novice Shepherd who looks and acts like a child. While this endears him to the others, he hates being treated as anything less than an equal. He sees Chrom as a brother. The most popular with cute animals.

Taken from Historical Records
While continuing to study magic, Ricken realized how childish some of his actions had been. The sting of that revelation caused him to redouble his efforts, and soon he was a mage of the highest order.

Maribelle

Title: Dire Damsel

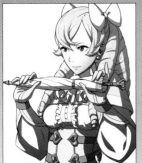

- Original Class: Troubadour
- Birthday: April 14th
- Character Voice: Melissa Fahn

Official Profile

Lissa's best friend. A proud and sharp-tongued noble from one of Ylisse's most well-to-do houses. She is cold to strangers, particularly commoners, but warms quickly. The most likely to toss in her sleep.

Taken from Historical Records

After returning home to Themis, Maribelle became a magistrate who demanded equal justice for nobles and commoners alike.

Panne

Title: Proud Taguel

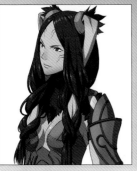

- Original Class: Taguel
- Birthday: November 18th
- Character Voice: Jessica Gee

Official Profile

A nationless shape-shifter and the last of the taguel. While cool and sensible by nature, she shows little interest in finding a partner and remedying the fate of her race. The fastest at wolfing down a meal.

Taken from Historical Records

Once the fighting was done, Panne vanished. Some say she returned to live in her warren alone; others claim she eventually found fellow taguel survivors.

Gaius

Title: Candy Stealer

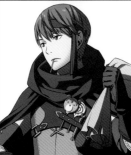

- Original Class: Thief
- Birthday: January 2nd
- Character Voice: Gideon Emery

Official Profile

A cool and capable Ylissean thief who will take any job for the right price. He is absolutely obsessed with sweets and hides 50 varieties of "emergency snacks" in his cloak. The most frequent nosebleeder.

Taken from Historical Records

Gaius never lost his sweet tooth, though he ultimately returned to less savory enterprises. Tales of Sticky-Fingers Gaius are still told in taverns everywhere.

 Epilogues

Married Life, as Recorded in Historical Records

■ VIRION X LISSA

Virion returned home to Rosanne, where he was labeled a traitor and a coward, or else ignored entirely. But none of it fazed his wife, Lissa, who won the populace over with good old-fashioned charm.

■ VIRION X SULLY

Virion returned home to Rosanne, where he was labeled a traitor and a coward, or else ignored entirely. But in time he was forgiven, largely thanks to the bold (and slightly terrifying) nature of his wife, Sully.

■ VIRION X MIRIEL

Virion returned home to Rosanne, where he was labeled a traitor and a coward, or else ignored entirely. But Miriel's discoveries improved their quality of life, and they soon came to love him once more.

■ VIRION X MARIBELLE

Virion returned home to Rosanne, where he was labeled a traitor and a coward, or else ignored entirely. But his wife, Maribelle, treated the people fairly and equally, and in time, they learned to forgive him.

■ VIRION X PANNE

Virion returned home to Rosanne, where he was labeled a traitor and a coward, or else ignored entirely. But his wife Panne's dedication did much to bring him back into good standing among his people.

■ VIRION X CORDELIA

Virion returned home to Rosanne, where he was labeled a traitor and a coward, or else ignored entirely. But Cordelia defended her husband vehemently and ultimately won him a second chance with his people.

■ VIRION X NOWI

Virion returned home to Rosanne, where he was labeled a traitor and a coward, or else ignored entirely. Thankfully, his wife Nowi's flair for drama was entertaining enough to keep the mob's pitchforks at bay.

■ VIRION X THARJA

Virion returned home to Rosanne, where he was labeled a traitor and a coward, or else ignored entirely. But a few well-placed hexes from his wife, Tharja, eventually brought the populace to their senses.

■ VIRION X OLIVIA

Virion returned home to Rosanne, where he was labeled a traitor and a coward, or else ignored entirely. Over time, however, Olivia's dancing managed to bring him back into the populace's favor.

■ VIRION X CHERCHE

Virion returned home to Rosanne, where he was labeled a traitor and a coward, or else ignored entirely. But Cherche's smarts and kindness eventually brought her husband back into good standing.

■ VAIKE X LISSA

Vaike returned to the streets that raised him and was welcomed as a hero and brother to all. Still, he was no match for Lissa, who fit in with the people instantly despite her royal upbringing.

■ VAIKE X SULLY

Vaike returned to the streets that raised him and was welcomed as a hero and brother to all. Still, he was no match for Sully, who dragged her poor husband on countless missions in the name of Ylisse.

■ VAIKE X MIRIEL

Vaike returned to the streets that raised him and was welcomed as a hero and brother to all. He lived out his days with Miriel, whose sharp mind and tongue refused to be dulled by any change of scenery.

■ VAIKE X MARIBELLE

Vaike returned to the streets that raised him and was welcomed as a hero and brother to all. But people were fonder still of Maribelle, who worked tirelessly to win them equal rights in the eyes of the law.

■ VAIKE X PANNE

Vaike returned to the streets that raised him and was welcomed as a hero and brother to all. Still, the people were even fonder of Panne—and she, in turn, grew to love the town's wild and woolly nature.

■ VAIKE X CORDELIA

Vaike returned to the streets that raised him and was welcomed as a hero and brother to all. Still, he was never a match for Cordelia, whose shining talents and beauty tended to make her husband look dull.

■ VAIKE X NOWI

Vaike returned to the streets that raised him and was welcomed as a hero and brother to all. Still, the children were even fonder of his wife, Nowi, who played with them every day and never seemed to age.

■ VAIKE X THARJA

Vaike returned to the streets that raised him and was welcomed as a hero and brother to all. Still, he was no match for Tharja, whose frequent curse slinging put her husband in an understandably foul mood.

■ VAIKE X OLIVIA

Vaike returned to the streets that raised him and was welcomed as a hero and brother to all. Still, he was no match for his wife, Olivia, whose modest but mesmerizing dances made her more popular by far.

 Epilogues

Married Life, as Recorded in Historical Records

■ VAIKE X CHERCHE

Vaike returned to the streets that raised him and was welcomed as a hero and brother to all. Still, the children were fonder of Cherche, who spent her time feeding and clothing orphans everywhere.

■ STAHL X LISSA

Stahl continued his service as an Ylissean knight and led crucial missions across the realm. His scattered nature blended well with his wife Lissa's cheerful banter, making for a happy life indeed.

■ STAHL X SULLY

Sully and Stahl became the left and right arms of Ylisse and conducted crucial missions across the realm. Their red-and-green banners soon became known everywhere as a symbol of justice and strength.

■ STAHL X MIRIEL

Stahl continued his service as an Ylissean knight and led crucial missions across the realm. His scatterbrained gaffes were met with criticism from Miriel, but the two still built a happy life together.

■ STAHL X MARIBELLE

Stahl continued his service as an Ylissean knight and led crucial missions across the realm. Maribelle was quick to whip his scatterbrained nature out of him, and the two lived a long and happy life.

■ STAHL X PANNE

Stahl continued his service as an Ylissean knight and led crucial missions across the realm. His scatterbrained gaffes sometimes got on Panne's nerves, but the two still made a happy life together.

■ STAHL X CORDELIA

Stahl continued his service as an Ylissean knight and led crucial missions across the realm. Cordelia accepted her husband, scatterbrained gaffes and all, and the two built a happy life together.

■ STAHL X NOWI

Stahl continued his service as an Ylissean knight and led crucial missions across the realm. His scatterbrained charm complimented his wife Nowi's constant quips, making for a happy home indeed.

■ STAHL X THARJA

Stahl continued his service as an Ylissean knight and led crucial missions across the realm. His scatterbrained gaffes caused Tharja's eyes to roll, but the pair still made a happy life together.

■ STAHL X OLIVIA

Stahl continued his service as an

Ylissean knight and led crucial missions across the realm. Olivia spent years trying to get her husband to pay attention, but the two still built a fine life together.

■ STAHL X CHERCHE

Stahl continued his service as an Ylissean knight and led crucial missions across the realm. He eventually grew fat on his wife Cherche's tremendous cooking, and the two had a long and happy life.

■ KELLAM X LISSA

Lissa's wild nature led her to travel the world and relay its wisdoms to her brother. These exploits live on in droll tales told by the campfire. Her husband's name has been lost to history.

■ KELLAM X SULLY

Sully continued her knightly duties and led vital missions, soon becoming a role model for women everywhere. Her husband's name has been lost to history.

■ KELLAM X MIRIEL

Miriel remained in Ylisse but would vanish for days at a time to pursue her studies. In her final years, this research led to a historic invention. Her husband's name has been lost to history.

■ KELLAM X MARIBELLE

After returning home to Themis, Maribelle became a magistrate who demanded equal justice for nobles and plebeians alike. Her husband's name has been lost to history.

■ KELLAM X PANNE

Once the fighting was done, Panne vanished. Some say she returned to her warren alone; others claim she found fellow taguel survivors. Her husband's name has been lost to history.

■ KELLAM X CORDELIA

Not even peace could dull the lovely Cordelia's knightly edge, as she became a figurehead for all Ylissean warriors. Her husband's name has been lost to history.

■ KELLAM X NOWI

Nowi tried living away from humankind but soon longed for their company and set off to find her old comrades around the world. Her husband's name has been lost to history.

■ KELLAM X THARJA

Even after her return to Plegia, Tharja kept an unhealthy obsession with [Robin] that led her to vanish for weeks or months at a time. Her husband's name has been lost to history.

■ KELLAM X OLIVIA

Though she never overcame her stage fright, Olivia danced across the land, mending the scars of war. Her husband's name has been lost to history.

Cordelia
Title: Knight Paragon

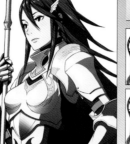

- Original Class: Pegasus Knight
- Birthday: July 7th
- Character Voice: Julie Ann Taylor

Official Profile	Taken from Historical Records
An Ylissean pegasus knight who has been friends with Sumia since childhood. Her beauty, skill, and record are surpassed by few, but she cannot seem to win Chrom's heart. The deepest, most frequent sigher.	Not even peacetime could dull the lovely Cordelia's knightly edge, and she became a figurehead for all Ylissean warriors. It was unrequited love that drove her, many said—though she never stated for whom.

Gregor
Title: Swell Sword

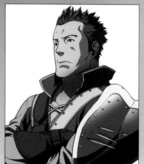

- Original Class: Mercenary
- Birthday: January 27th
- Character Voice: George C. Cole

Official Profile	Taken from Historical Records
A likeable merc whose feet have touched the soil of many a land. Years of experience have hardened him—mostly—but he still winces when people harp on about his age. The first to get a crick in his back.	With his more epic battles behind him, Gregor soon sank into a life of excess. When his purse got light, he was said to work as a bodyguard to make ends meet.

Nowi
Title: Eternal Youth

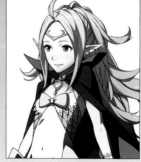

- Original Class: Manakete
- Birthday: September 21st
- Character Voice: Hunter Mackenzie Austin

Official Profile	Taken from Historical Records
A manakete from no land in particular. While she looks young and likes to play outside with children, she is actually over 1,000 years old and counting. The biggest oversleeper.	Nowi tried living away from humankind, but she soon longed for their company and set off to find her old comrades around the world.

Libra

Title: Fetching Friar

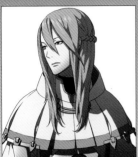
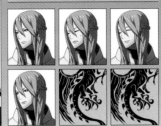

- Original Class: War Monk
- Birthday: July 1st
- Character Voice: Cindy Robinson

Official Profile

An Yissean priest with a calming mien. So lovely are his features that strangers often mistake him for a woman. His one flaw is a tendency to get caught up in details.

Taken from Historical Records

Many an unfortunate child found joy in the small orphanage Libra built after the war. People believed the kind, beautiful priest to be an incarnation of Naga, and he was courted by women and men alike.

Tharja

Title: Grim Stalker

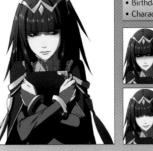

- Original Class: Dark Mage
- Birthday: April 2nd
- Character Voice: Stephanie Sheh

Official Profile

A mopey Plegian dark mage with a jealous streak. She usually keeps to herself and chants disturbing hexes but openly stalks [Robin], in whom she has an unhealthy interest. The one with the darkest thoughts.

Taken from Historical Records

Tharja's jealous obsession with [Robin] never subsided, even after her return to Plegia. Anecdotal evidence suggests she devoted most of her effort to hexes and curses that might reunite them.

Olivia

Title: Shrinking Violet

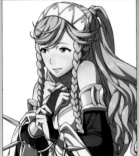
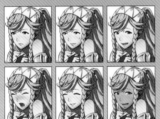

- Original Class: Dancer
- Birthday: August 20th
- Character Voice: Karen Strassman

Official Profile

A shy, introverted caravan dancer who goes above and beyond to help others. Despite her stage fright, she is unparalleled in her craft and has admirers around the world. The most mesmerizing singer.

Taken from Historical Records

Though she never overcame her stage fright, Olivia danced across the land, mending the scars of war. The flush in her cheeks remained a staple of her beauty.

Cherche

Title: Wyvern Friend

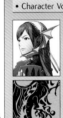
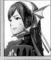

- Original Class: Wyvern Rider
- Birthday: October 17th
- Character Voice: Amanda C. Miller

Official Profile

A wyvern rider in the service of House Virion. She was raised with simple values and likes to cook and sew, but loves her "sweet, adorable" wyvern Minerva even more. The most terrifying when angry.

Taken from Historical Records

Cherche and her beloved Minerva returned to Rosanne and struggled to reclaim the country Virion had managed to lose. Rider and wyvern were never seen apart.

Henry

Title: Twisted Mind

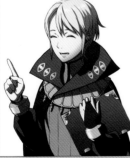
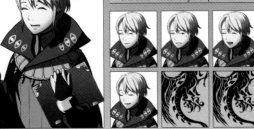

- Original Class: Dark Mage
- Birthday: November 13th
- Character Voice: Bryce Papenbrook

Official Profile

A Plegian dark mage with a fetish for bloodshed and an indelible grin. While disarmingly optimistic, he shows a gruesome lack of mercy while on the battlefield. The one with the lowest heart rate.

Taken from Historical Records

After Grima's demise, Henry made a cold, clean break with history, never to stain its pages again.

Lucina

Title: Foreseer

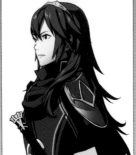

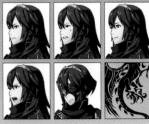

- Original Class: Lord
- Birthday: April 20th
- Character Voice: Laura Bailey

Official Profile

Chrom's future daughter, a kind and just princess who has made it her duty to save the world. She loves her father and would do anything to keep him safe. The least likely to get a joke.

Taken from Historical Records

Lucina disappeared after whispering these words to her infant self: "Yours will be a happy future." Did she journey to another land or back to her own time? ...No one knows for certain.

Say'ri
Title: Blade Princess

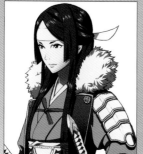

- Original Class: Swordmaster
- Birthday: January 11th
- Character Voice: Stacy Okada

Official Profile

The upright and dignified princess of the Chon'sin dynasty. Her old-fashioned speech and manners set her apart from the Ylisseans. She loves her brother Yen'fay fiercely. The most talented skin diver.

Taken from Historical Records

After returning to Chon'sin, Say'ri worked tirelessly with the other dynasts to secure a peaceful future for the Valmese continent. She was occasionally seen visiting her brother Yen'fay's grave.

Basilio
Title: Intrepid Khan

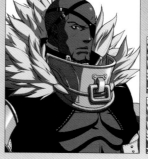

- Original Class: Warrior
- Birthday: August 13th
- Character Voice: Patrick Seitz

Official Profile

The West-Khan of Regna Ferox. His rival, Flavia, calls him "oaf" due to his attitude, but he is actually quite quick witted. He exhibits a fatherly side around Chrom's group. The guy with the biggest reactions.

Taken from Historical Records

With Grima a done deed, Basilio returned to Ferox and applied himself to dethroning Flavia. If his army of champions failed, he knew he could always wait for little Lucina to grow up (and lend her a mask).

Flavia
Title: Khan Lioness

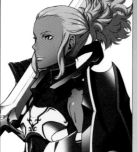

- Original Class: Hero
- Birthday: October 28th
- Character Voice: Tara Platt

Official Profile

The East-Khan and current ruler of Regna Ferox. She has a swagger about her and dislikes formalities, but nonetheless looks after her own. Basilio is her rival and best friend. The first to push for push-ups.

Taken from Historical Records

After Grima was vanquished, Flavia returned home and did a marvelous job of whipping Regna Ferox back into shape. They say that each time a tournament drew close, she would ask Chrom to lend his sword.

Donnel
Title: Village Hero

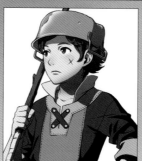
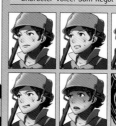

- Original Class: Villager
- Birthday: June 4th
- Character Voice: Sam Regal

Official Profile

A villager from a remote corner of Ylisse who came to the fight with little more than farming experience. However, he is eager to learn and shows a great deal of promise. The one with the curliest hair.

Taken from Historical Records

Donnel returned to his tiny village and lived a quiet life with his mother. He never took up arms again—a blessing for which he thanked the exalt daily.

 Epilogues

Married Life, as Recorded in Historical Records

■ KELLAM X CHERCHE

Cherche and her beloved Minerva returned to Rosanne and struggled to reclaim the country Virion had managed to lose. Her husband's name has been lost to history.

■ LON'QU X LISSA

Lon'qu returned to Regna Ferox and served as Basilio's right-hand man. Lissa decided to leave Ylisstol and join her husband, strengthening the bond between the realms even further.

■ LON'QU X SULLY

Lon'qu returned to Regna Ferox and served as Basilio's right-hand man. He and Sully carried out countless missions together, and the latter became close friends with another outspoken woman—Flavia.

■ LON'QU X MIRIEL

Lon'qu returned to Regna Ferox and served as Basilio's right-hand man. Miriel went with him and focused her studies on Ferox's unusual weather conditions.

■ LON'QU X MARIBELLE

Lon'qu returned to Regna Ferox and served as Basilio's right-hand man. Maribelle, for her part, could not stand her new home's nonsensical laws and eventually guided both khans to an era of reform.

■ LON'QU X PANNE

Lon'qu returned to Regna Ferox and served as Basilio's right-hand man. Panne had no problems with the cold winters and would often forage for rare snow herbs used in steaming pots of tea.

■ LON'QU X CORDELIA

Lon'qu returned to Regna Ferox and served as Basilio's right-hand man. Cordelia exhibited her usual resilience toward Ferox's cold winters and enjoyed a peaceful, happy life with her husband.

■ LON'QU X NOWI

Lon'qu returned to Regna Ferox and served as Basilio's right-hand man. His wife, Nowi, disliked the cold Feroxi winters and used her gift for theatrics to secure everything from fur coats to long tropical holidays.

■ LON'QU X THARJA

Lon'qu returned to Regna Ferox and served as Basilio's right-hand man. The cold Feroxi winters proved too much for Tharja, who left time and again in search of heat more in line with a Plegian desert.

■ LON'QU X OLIVIA

Lon'qu returned to Regna Ferox and served as Basilio's right-hand man. When the West-Khan sent Olivia on errands across the globe, Lon'qu accompanied her without fail and ensured her safety.

■ LON'QU X CHERCHE

Lon'qu returned to Regna Ferox and served as Basilio's right-hand man. Cherche knit many wool caps to shield her husband from the bitter Feroxi winters—and, of course, a cap for her dear wyvern, Minerva.

■ RICKEN X LISSA

While continuing to study magic, Ricken realized how childish some of his actions had been. He and Lissa learned from these mistakes and grew old and wise together.

Anna

Title: Secret Seller

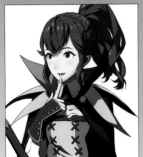

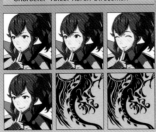

- Original Class: Trickster
- Birthday: June 11th
- Character Voice: Karen Strassman

Official Profile

An enigmatic merchant with a bevy of identical sisters—more than she can count. Like most merchants, she is a smooth talker who loves both gold and rich customers. The one with the fattest nest egg.

Taken from Historical Records

With nary a word, Anna left the others and returned to her free-spirited merchant life. She was later sighted across the continent, haggling with suppliers and beating down the cost of goods.

Owain

Title: Chosen One

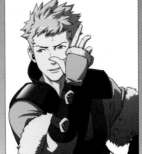

- Original Class: Myrmidon
- Birthday: July 15th
- Character Voice: Kaiji Tang

Official Profile

Lissa's future son. His elaborate theatrics suggest a need to stand out, as do the absurd names he bestows upon his weapons and his "special moves."
The most apt to shout "Level up!"

Taken from Historical Records

Owain tried settling down in Ylisse but ultimately set off on a lengthy quest to "stay his sword hand." Oddball heroes matching his description continue to crop up in local legends to this day.

Inigo

Title: Flower Picker

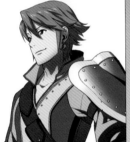

- Original Class: Mercenary
- Birthday: August 7th
- Character Voice: Liam O'Brien

Official Profile

Olivia's future son. A friendly young man with an insatiable love for women. However, the ladies see his flirting as shallow and seldom bite. He secretly wants to be a dancer. The biggest night owl.

Taken from Historical Records

Inigo traveled the world, ever ready with a smile or a solution when trouble started to brew. His services and performances were rewarded with the best currency—the joy and gratitude of others.

Brady

Title: Daunting Priest

- Original Class: Priest
- Birthday: February 22nd
- Character Voice: Travis Willingham

Official Profile

Maribelle's future son. While he looks terrifying, he is more likely to burst into tears than bust out a weapon. The scar on his face is from a stray violin string. The most likely to incur friendly fire.

Taken from Historical Records

Brady left the priesthood to become the world's scariest violinist. His rondos were apocalyptic, and his requiems so full of melancholy that everyone in the room—performer included—burst into tears.

■ RICKEN X SULLY

While continuing to study magic, Ricken realized how childish some of his actions had been. Sully made for a strict, but fair, companion, and the couple thrived together.

■ RICKEN X MIRIEL

While continuing to study magic, Ricken realized how childish some of his actions had been. Miriel's intellect inspired him greatly, and together they unlocked the secrets of the universe.

■ RICKEN X MARIBELLE

While continuing to study magic, Ricken realized how childish some of his actions had been. Maribelle went on to be a magistrate, and the couple leaned on each other for the rest of their days.

■ RICKEN X PANNE

While continuing to study magic,

Ricken realized how childish some of his actions had been. Panne took him to the wilds, reminding him he was a small part of a greater plan.

■ RICKEN X CORDELIA

While continuing to study magic, Ricken realized how childish some of his actions had been. Cordelia herself advanced as a knight, and the couple lived for many long years.

■ RICKEN X NOWI

While continuing to study magic, Ricken realized how childish some of his actions had been. Behind closed doors, people whispered as to how he aged while his wife, Nowi, never did.

■ RICKEN X THARJA

While continuing to study magic, Ricken realized how childish some of his actions had been. Tharja

stayed with him and perfected her hexes, and the couple's magical talents soared.

■ RICKEN X OLIVIA

While continuing to study magic, Ricken realized how childish some of his actions had been. Thanks to Olivia's dances, however, the years hence were full of joy and laughter.

■ RICKEN X CHERCHE

While continuing to study magic, Ricken realized how childish some of his actions had been. But Cherche's caring and patience saw him through to the end.

■ GAIUS X LISSA

Gaius never lost his sweet tooth, though he ultimately returned to less savory enterprises. Lissa always insisted on going along, and the two survived many a comically dire predicament together.

■ GAIUS X SULLY

Gaius never lost his sweet tooth, though he ultimately returned to less savory enterprises. Sully disapproved and was said to pester her husband to take the examination for Ylissean knighthood instead.

■ GAIUS X MIRIEL

Gaius never lost his sweet tooth, though he ultimately returned to less savory enterprises. Miriel soon began researching new and more-powerful sweeteners for her husband to enjoy.

■ GAIUS X SUMIA

Gaius never lost his sweet tooth, though he ultimately returned to less savory enterprises. His wife, Sumia, raised pegasi, and her flower-petal readings were said to bring good luck to all.

Kjelle
Title: Fair Fighter

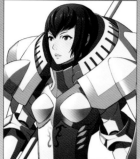

- Original Class: Knight
- Birthday: September 29th
- Character Voice: Stephanie Sheh

Official Profile

Sully's future daughter, a model of chivalry. She believes the strong must protect the weak and loves to better herself through sport, but is reckless about who she challenges. The most attached to her armor.

Taken from Historical Records

Knowing her battle had not yet ended, Kjelle set off on a new quest of self-discovery. Her sincerity led to much heartbreak along the way, but each painful lesson further hardened her as a warrior.

Cynthia
Title: Hero Chaser

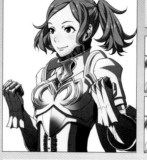

- Original Class: Pegasus Knight
- Birthday: May 14th
- Character Voice: Stacy Okada

Official Profile

Sumia's future daughter. A veritable force of nature when it comes to enthusiasm. She longs to be a hero (the epic kind) but, like her mother, slips up more often than not. The most baffling sleep talker.

Taken from Historical Records

Cynthia never gave up on becoming a hero and traveled the land in the name of justice. While she impacted the world of comedy more than the world of legend, people still loved her for trying.

Severa
Title: Secret Dreamer

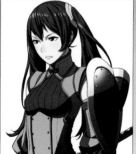

- Original Class: Mercenary
- Birthday: January 21st
- Character Voice: Julie Ann Taylor

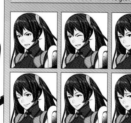

Official Profile

Cordelia's future daughter. Growing up in the shadow of her mother has given her an inferiority complex and an attitude to match. She likes using words to get her way. The most wasteful shopper.

Taken from Historical Records

Eager to shrug off any kind of intimacy, Severa began a solitary journey—but once a year she was said to visit her family and yell at them for old times' sake.

Gerome
Title: Masked Rider

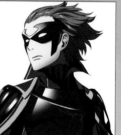

- Original Class: Wyvern Rider
- Birthday: September 1st
- Character Voice: Orion Acaba

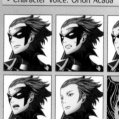

Official Profile

Cherche's future son. He has concerns about meddling with the past and wears a mask to minimize interactions—but like the other children, he wants his parents back. The last to fall asleep at night.

Taken from Historical Records

Gerome and Minerva set out for Wyvern Valley. Many saw the rider and mount through the years, though most described the man as distant and contemplative.

Morgan (Male)
Title: Gift from Afar

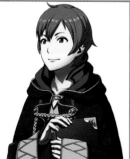

- Original Class: Varies
- Birthday: May 5th
- Character Voice: Todd Stone

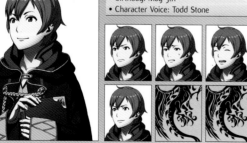

Official Profile

[Robin]'s future son. An upbeat boy who remembers little about the future—not even which future he came from. He wants to be a tactician like his mother. The most shamelessly self-driven.

Taken from Historical Records

Morgan's memory never returned, but he didn't seem to miss it much. Later, scholars would speculate that he had come from a different future than the other children.

Morgan (Female)
Title: Gift from Afar

- Original Class: Varies
- Birthday: May 5th
- Character Voice: Nicole Karrer

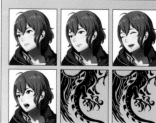

Official Profile

[Robin]'s future daughter. An upbeat girl who remembers little about the future—not even which future she came from. She wants to be a tactician like her father. The most shamelessly self-driven.

Taken from Historical Records

Morgan's memory never returned, but she didn't seem to miss it. Later, scholars would speculate she had come from a different future than the other children.

Yarne

Title: Timid Taguel

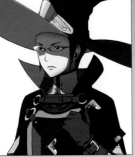

- Original Class: Taguel
- Birthday: March 14th
- Character Voice: Chris Smith

Official Profile

Panne's future son. Terrified that his race (i.e., himself) will go extinct, he has become a colossal coward—but he might put himself out on a limb for a comrade's sake. The loudest talker.

Taken from Historical Records

Yarne traveled the world in search of a safer haven, a journey that was ironically fraught with danger. Nevertheless, he is said to have beaten his fears and lived to a ripe old age.

Laurent

Title: The Elucidator

- Original Class: Mage
- Birthday: April 25th
- Character Voice: George C. Cole

Official Profile

Miriel's future son. A sharp but overserious wunderkind. Folks take advantage of his wisdom and empathy, but his attention to detail makes him a natural problem solver. The one with the worst lens glare.

Taken from Historical Records

Longing to meet his mother's intellectual standards, Laurent went on an expedition around the world. His curious nature led to many adventures, which he later put to paper in a rousing novel.

Noire

Title: Miss Personality

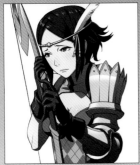

- Original Class: Archer
- Birthday: October 7th
- Character Voice: Michelle Ruff

Official Profile

Tharja's future daughter. Repeated doses of her mother's hexes turned her into an extreme coward and pessimist—but beware her terrifying alter ego when pushed too far. The first to flee when danger hits.

Taken from Historical Records

Noire stayed with her mother after the war as her assistant. Was she simply trying to protect her infant self from Tharja's curses? Or did Noire find solace with the woman who brought her into the world?

Epilogues

Married Life, as Recorded in Historical Records

■ **GAIUS X MARIBELLE**

Gaius never lost his sweet tooth, though he ultimately returned to less savory enterprises. Having studied to become a magistrate, Maribelle feared the day she would meet her own husband in court.

■ **GAIUS X PANNE**

Gaius never lost his sweet tooth, though he ultimately returned to less savory enterprises. Amazingly, Panne dirtied her hands right along with her husband, using her keen night vision to expedite jobs.

■ **GAIUS X CORDELIA**

Gaius never lost his sweet tooth, though he ultimately returned to less savory enterprises. As his wife, Cordelia, was in charge of keeping law and order, Gaius dreaded the thought of seeing her on the job.

■ **GAIUS X NOWI**

Gaius never lost his sweet tooth, though he ultimately returned to less savory enterprises. Nowi found her husband's work intriguing and was said to often come along and help out.

■ **GAIUS X THARJA**

Gaius never lost his sweet tooth, though he ultimately returned to less savory enterprises. Meanwhile, his wife, Tharja, set up shop and hexed people for a living. The pair were said to get many odd looks.

■ **GAIUS X OLIVIA**

Gaius never lost his sweet tooth, though he ultimately returned to less savory enterprises. His wife, Olivia, wandered down more than one dark alley just to make sure he was safe and sound.

■ **GAIUS X CHERCHE**

Gaius never lost his sweet tooth, though he ultimately returned to less savory enterprises. When her work in Rosanne was done, Cherche would return home and cook for her husband, much to his delight.

■ **GREGOR X LISSA**

After the war, Gregor briefly sank into a life of excess, but when Lissa decided to travel the world incognito, her worldly husband came along to keep the roads safe and the conversation lively.

■ **GREGOR X SULLY**

After the war, Gregor briefly sank into a life of excess. Sully pestered her husband to take the Yllissean knighthood examination, but he instead continued his mercenary work on the sly.

■ **GREGOR X MIRIEL**

After the war, Gregor briefly sank into a life of excess, but when his wife began to treat him like part of the woodwork, he resumed work as a sellsword. Miriel helped out by researching Gregor's targets.

■ **GREGOR X MARIBELLE**

After the war, Gregor briefly sank into a life of excess, but fear of his wife's verbal abuse led him to resume work as a sellsword. Maribelle's family never approved of Gregor, and he never cared.

■ **GREGOR X PANNE**

After the war, Gregor briefly sank into a life of excess. It was his wife, Panne, who broke the cycle and invited him to see her warren, after which the two traveled from land to land as mercenaries.

■ **GREGOR X CORDELIA**

After the war, Gregor briefly sank into a life of excess, but when he saw Cordelia working diligently as a knight of Ylisse, he decided to clean up his own act and fight by his wife's side.

■ **GREGOR X NOWI**

After the war, Gregor briefly sank into a life of excess, but his wife, Nowi, pestered him into traveling the world with her. Their journey was packed with more chaos than the war that preceded it.

■ **GREGOR X THARJA**

After the war, Gregor briefly sank into a life of excess, but fear of his wife's hexes led him to resume work as a sellsword. Tharja secretly tagged along and used her talents to keep him safe.

■ **GREGOR X OLIVIA**

After the war, Gregor briefly sank into a life of excess, but when he saw his wife dancing in the streets at night to make ends meet, he resumed work as a sellsword. ...Olivia was most grateful.

■ **GREGOR X CHERCHE**

After the war, Gregor briefly sank into a life of excess, but at his wife Cherche's request, he found work in Valm. After a successful stint there, offers flooded in from around the world.

■ **LIBRA X LISSA**

Many an unfortunate child found joy in the small orphanage Libra and his wife built after the war. The children loved Libra like a mother and treated Lissa as one of their own.

■ **LIBRA X SULLY**

Many an unfortunate child found joy in the small orphanage Libra and his wife built after the war. To this day, the children call Libra "Mother" and Sully "Boss."

■ **LIBRA X MIRIEL**

Many an unfortunate child found joy in the small orphanage Libra and his wife built after the war. The children were said to love Libra like a mother but flee in terror at the sight of Miriel.

 Epilogues

Married Life, as Recorded in Historical Records

■ LIBRA X MARIBELLE

Many an unfortunate child found joy in the small orphanage Libra and his wife built after the war. Sadly, Maribelle's sharp tongue and proud attitude rubbed off on the tykes, making them quite the handful.

■ LIBRA X PANNE

Many an unfortunate child found joy in the small orphanage Libra and his wife built after the war. The children loved Libra like a mother and often pestered Panne to transform and give them bunny rides.

■ LIBRA X CORDELIA

Many an unfortunate child found joy in the small orphanage Libra and his wife built after the war. The children loved Libra like a mother and respected Cordelia like an elder sister.

■ LIBRA X NOWI

Many an unfortunate child found joy in the small orphanage Libra and his wife built after the war. Nowi tried her best to take care of the children, but more often than not, they took care of her.

■ LIBRA X THARJA

Many an unfortunate child found joy in the small orphanage Libra and his wife built after the war. The younger tykes were very fond of Tharja—who feigned annoyance but secretly enjoyed the attention.

■ LIBRA X OLIVIA

Many an unfortunate child found joy in the small orphanage Libra and his wife built after the war. The children especially loved Olivia's vibrant dances, which often filled them with glee.

■ LIBRA X CHERCHE

Many an unfortunate child found joy in the small orphanage Libra and his wife built after the war. Cherche was a natural mother to the children, who were also quite fond of her wyvern, Minerva.

■ HENRY X LISSA

Henry settled down with Lissa and turned out to be a surprisingly good father. Their newborn son, however, developed a notably bizarre personality—in no small part because of his colorful parents.

■ HENRY X SULLY

Henry settled down with Sully and turned out to be a surprisingly good father. Sully trained their newborn daughter hard in the art of war, and the girl rose to every expectation.

■ HENRY X MIRIEL

Henry settled down with Miriel and turned out to be a surprisingly good father. Their newborn son grew up surrounded by his parents' vast library, dooming him to a future as a bookworm.

■ HENRY X SUMIA

Henry settled down with Sumia and turned out to be a surprisingly good father. Their newborn daughter was enthralled by her mother's pegasus and was soon begging for a place in the saddle.

■ HENRY X MARIBELLE

Henry settled down with Maribelle and turned out to be a surprisingly good father. Their newborn son inherited his mother's noble blood—but also her sharp tongue, as time would reveal.

■ HENRY X PANNE

Henry settled down with Panne and turned out to be a surprisingly good father. Their newborn son was far more taguel than human and would come to be known as his dying race's last hope.

■ HENRY X CORDELIA

Henry settled down with Cordelia and turned out to be a surprisingly good father. Their newborn daughter grew up in a peaceful world with two loving parents and was said to be a likeable girl.

■ HENRY X NOWI

Henry settled down with Nowi and turned out to be a surprisingly good father. However, their daughter had to grow up faster than most other girls since her parents showed no sign of doing it.

■ HENRY X THARJA

Henry settled down with Tharja and turned out to be a surprisingly good father. Their newborn daughter's mood was said to shift violently, perhaps a side effect of having two dark mages for parents.

■ HENRY X OLIVIA

Henry settled down with Olivia and turned out to be a surprisingly good father. Their newborn son inherited both his father's grin and his mother's undying love for entertaining others.

■ HENRY X CHERCHE

Henry settled down with Cherche and turned out to be a surprisingly good father. Their newborn son was said to be quiet but also fond of wyverns, like his mother.

Nah — Title: Little Miss

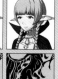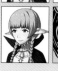

- Original Class: Manakete
- Birthday: March 29th
- Character Voice: Eden Riegel

Official Profile

Nowi's future daughter. Unlike her mother, she is remarkably grown up and keeps her feelings in check—especially about her weird name. She has a knack for reading people. The one with the nicest teeth.

Taken from Historical Records

The manakete Nah still had many human lifetimes ahead, and she availed herself of this time to caution future generations away from the mistakes that led to the return of Grima.

Tiki — Title: Divine Voice

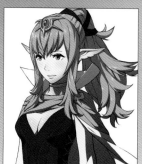

- Original Class: Manakete
- Birthday: February 28th
- Character Voice: Mela Lee

Official Profile

The Voice of the divine dragon. While mature, she also has a child-like side. Being a dragonkin, she has lived since days of yore and was friends with the Hero-King, Marth. The most likely to sleep in.

Taken from Historical Records

Exhausted from the war, Tiki returned to the Divine Dragon Grounds and slept for several days. Afterward, she was said to come down and visit the people regularly.

Gangrel — Title: Mad King

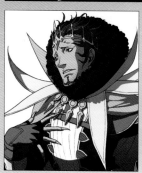

- Original Class: Trickster
- Birthday: March 16th
- Character Voice: Anthony Jenkins

Official Profile

The wild and ruthless former king of Plegia. He once took sick pleasure in hurting others, but his own life was not easy, and he has shown signs of reform since joining Chrom. The most hopeless acrophobe.

Taken from Historical Records

With the slaughter done, Gangrel retired to obscurity. While some claim he found another kingdom to rule and ruin, others insist he ended in the gutter. All agree he was dead within a matter of years.

198 | The Art of Fire Emblem Awakening

Walhart
Title: The Conqueror

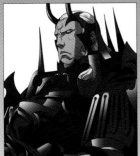

- Original Class: Conqueror
- Birthday: September 14th
- Character Voice: Richard Epcar

Official Profile

The unforgiving man who forged the Valmese Empire. He loathes losers and cowards and sought to unite the world through absolute power. (He's calmed down since. ...A bit.) The most devout vegetarian.

Taken from Historical Records

Walhart was said to leave this world in pursuit of new conquests. Some surviving legends go so far as to place him in the Outrealms, where he reputedly found a new continent to subjugate and rule.

Emmeryn
Title: Gentle Heart

- Original Class: Sage
- Birthday: December 23rd
- Character Voice: Erin Fitzgerald

Official Profile

Chrom's elder sister, the former exalt of Ylisse. A fall in Plegia took most of her memory and impaired her speech, but the love in her heart could not be diminished. The hardest to kill.

Taken from Historical Records

Sadly, Emmeryn's fractured memory never fully mended. She took refuge in Ferox after the war and started anew as an ordinary woman—a life that one can hope held fewer pressures than her exalted one.

Yen'fay
Title: Blade Legend

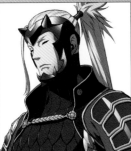

- Original Class: Swordmaster
- Birthday: July 23rd
- Character Voice: Kirk Thornton

Official Profile

The former Chon'sin dynast, but not the Yen'fay who died in the volcano; like Lucina, he hails from the future. Earnest and meditative to a fault, he longs to protect his sister Say'ri. The best under high temperatures.

Taken from Historical Records

Yen'fay vanished like the mist, never to be seen again. Some say he returned to the Outrealm from whence he came, but none were able to witness the great swordsman's departure.

Aversa
Title: Dark One

- Original Class: Dark Flier
- Birthday: November 3rd
- Character Voice: Cindy Robinson

Official Profile

A cunning vixen who once served Validar faithfully and leveraged her "assets" to lead men to their ruin. She has sought to atone since learning Validar manipulated her. The fondest of taking long swims.

Taken from Historical Records

Having reclaimed the truth, Aversa returned to the town of her birth and started life anew as an ordinary girl—as if making up for the time that was stolen from her.

Priam
Title: Radiant Hero

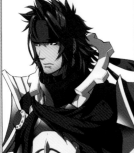

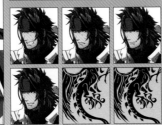

- Original Class: Hero
- Birthday: February 9th
- Character Voice: Jamieson Price

Official Profile

The descendant of a certain radiant hero. He has scoured the world in search of worthy opponents. While affable enough outside of battle, he is clearly more brawn than brains. The most insatiable meat eater.

Taken from Historical Records

Priam vanished like a breath on the wind. Did his pursuit of true power lead him to a quiet corner of the map? Or did he move to another continent—one where the Radiant Hero's legend held more meaning?

Validar
Title: Mysterious Sorcerer of Evil

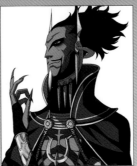

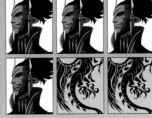

- Original Class: Sorcerer
- Birthday: Unknown
- Character Voice: Kyle Hebert

Official Profile

The sorcerer enemy of Chrom's Shepherds. He can use frightfully powerful dark magic. He is the leader of a religion that worships Grima, the fell dragon who attempted to destroy the world a thousand years prior.

Taken from Historical Records

Naga

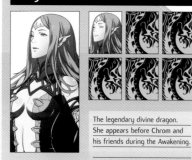

The legendary divine dragon.
She appears before Chrom and
his friends during the Awakening.

Phila

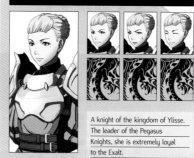

A knight of the kingdom of Ylisse.
The leader of the Pegasus
Knights, she is extremely loyal
to the Exalt.

Garrick

Appears in the prologue chapter.
The leader of the Plegian bandits.
He is a violent and cruel man.

Raimi

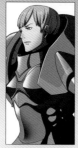

Introduced as the boss of chapter 3
but appears elsewhere as well.
This Feroxi general is vigorous in
the pursuit of duty.

Orton

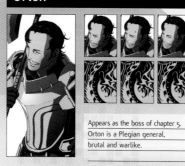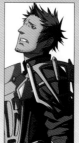

Appears as the boss of chapter 5.
Orton is a Plegian general,
brutal and warlike.

Vasto

The boss of chapter 7.
A Plegian general, he is cruel and
extremely sadistic.

Chalard

Appears as the boss of chapter 8.
This Grimleal priest
is a religious fanatic.

Campari

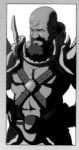

Appears as the boss of chapter 9.
Campari is a Plegian general
who is strong willed and
stubborn.

Mustafa

The boss of chapter 10.
This Plegian general
has no wish for war.

Dalton

Introduced as the boss of chapter 12.
A general of the Valmese Empire,
he is an elitist who looks down
on others.

Ignatius

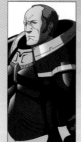

First seen as the boss of chapter 14.
As a general of the Valmese Empire,
this soldier prizes valor.

Farber

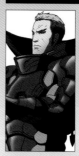

Makes his entrance as the boss of
chapter 15. He is a general of the
Valmese Empire who obeys his
emperor to the point of worship.

Cervantes

Appears as the boss of chapter
16. A general of the Valmese
Empire, Cervantes would never
neglect his precious whiskers.

Pheros

The boss of chapter 17.
This general of the Valmese
Empire is enamored with the
emperor.

Excellus

Appears in chapter 20, among
others. This tactician of the
Valmese Empire is effeminate
and conceited.

Algol

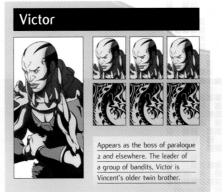

Appears as the boss in chapter 21.
A priest of the Grimleal,
he has an obstinate and malicious
personality.

Victor

Appears as the boss of paralogue
2 and elsewhere. The leader of
a group of bandits, Victor is
Vincent's older twin brother.

Vincent

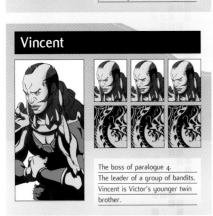

The boss of paralogue 4.
The leader of a group of bandits.
Vincent is Victor's younger twin
brother.

Gecko

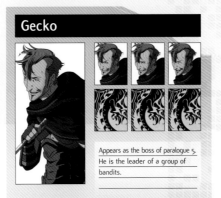

Appears as the boss of paralogue 5.
He is the leader of a group of
bandits.

Cassius

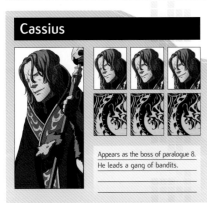

Appears as the boss of paralogue 8.
He leads a gang of bandits.

Risen Chief

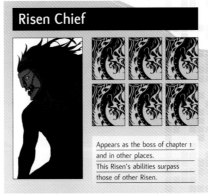

Appears as the boss of chapter 1
and in other places.
This Risen's abilities surpass
those of other Risen.

Hierarch

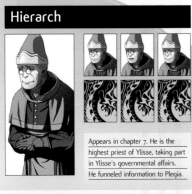

Appears in chapter 7. He is the
highest priest of Ylisse, taking part
in Ylisse's governmental affairs.
He funneled information to Plegia.

Donnel's Mother

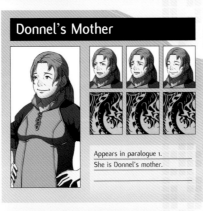

Appears in paralogue 1.
She is Donnel's mother.

Old Hubba

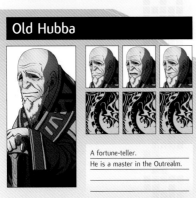

A fortune-teller.
He is a master in the Outrealm.

Armorer

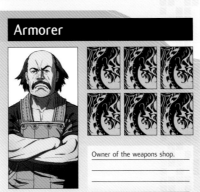

Owner of the weapons shop.

Epilogues

Married Life, as Recorded in Historical Records

■ DONNEL X LISSA
Donnel returned to his tiny village and built a happy life with his mother and Lissa. Still, the latter insisted on breaking up the monotony, and the couple often traveled to far-flung markets.

■ DONNEL X SULLY
Donnel returned to his tiny village and built a happy life with his mother and wife, Sully. The latter established a militia much like the Shepherds to arm the villagers against the threat of brigands.

■ DONNEL X MIRIEL
Donnel returned to his tiny village and built a happy life with his mother and his wife, Miriel. The latter directed her studies on the local flora; Donny was shocked that trees could have ten-syllable names.

■ DONNEL X MARIBELLE
Donnel returned to his tiny village and built a happy life with his mother and Maribelle. Still, he was careful not to pester his new bride about working in the fields, lest she lift a scythe for other reasons.

■ DONNEL X PANNE
Donnel returned to his tiny village and built a happy life with his mother and his wife, Panne. This new "warren" had more than enough nature to please any taguel, and her heart found a home at last.

■ DONNEL X CORDELIA
Donnel returned to his tiny village and built a happy life with his mother and his wife, Cordelia. The latter, however, continued to train hard as a knight and often answered the exalt's call.

■ DONNEL X NOWI
Donnel returned to his tiny village and built a happy life with his mother and his wife, Nowi. She loved her new home and scampered through fields and mountains with the fervor of a village cat.

■ DONNEL X THARJA
Donnel returned to his tiny village and built a happy life with his mother and his wife, Tharja. The latter never warmed to the villagers, but she was said to smile around her family.

■ DONNEL X OLIVIA
Donnel returned to his tiny village and built a happy life with his mother and his wife, Olivia. Their forgotten hamlet glowed during festivals, when Olivia's dancing warmed more than any fire.

■ DONNEL X CHERCHE
Donnel returned to his tiny village and built a happy life with his mother and his wife, Cherche. The latter's easy laugh and many skills quickly earned the love and respect of her new family.

■ OWAIN X LUCINA
Owain set off on a lengthy quest with Lucina to "stay his sword hand." Did they simply journey to another land, or did they return to their own time? None know for certain.

■ OWAIN X KJELLE
Owain set off on a lengthy quest with Kjelle to "stay his sword hand." ...The idea was actually Kjelle's, and he was just along while she trained, but she had the grace to let his delusions continue.

■ OWAIN X CYNTHIA
Owain set off on a lengthy quest with Cynthia to "stay his sword hand." Their semidelusional journey was said to be one of much mayhem and mirth.

Elder

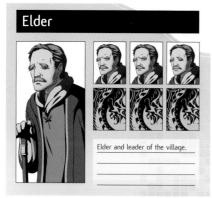

Elder and leader of the village.

Townsman

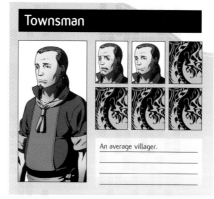

An average villager.

Maiden

An average villager.

Archer

Wields bows.
A soldier who can attack enemies from a distance.

Knight

Wields lances.
A heavily armored knight who has great defensive skill but is weak against magic.

Assassin

Wields swords and bows.
A seasoned, deadly thief or myrmidon—a trained killer who lives in the shadows.

Valkyrie

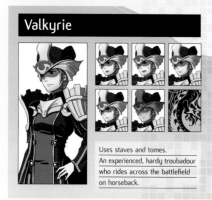

Uses staves and tomes.
An experienced, hardy troubadour who rides across the battlefield on horseback.

Warrior

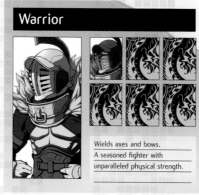

Wields axes and bows.
A seasoned fighter with unparalleled physical strength.

Griffon Rider

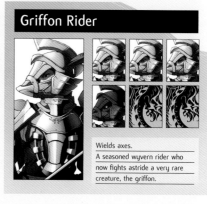

Wields axes.
A seasoned wyvern rider who now fights astride a very rare creature, the griffon.

 Epilogues

Married Life,
as Recorded in Historical Records

■ OWAIN X SEVERA
Owain set off on a lengthy quest with Severa to "stay his sword hand." Though Severa nagged her husband mercilessly, she also provided much love and support.

■ OWAIN X MORGAN (FEMALE)
Owain set off on a lengthy quest with Morgan to "stay his sword hand." While Morgan's memory never returned, she didn't seem to miss it, and the two lived out their days most happily.

■ OWAIN X NOIRE
Owain set off on a lengthy quest with Noire to "stay his sword hand." Noire worried endlessly about what terrors her husband's sword hand might hold, but as it turned out, there were none.

■ OWAIN X NAH
Owain set off on a lengthy quest with Nah to "stay his sword hand." Nah got much eye-rolling practice during the tiresome journey, but

she stayed by her husband's side nonetheless.

■ INIGO X LUCINA
Inigo traveled the world, ever ready with a smile or a solution when trouble started to brew. Lucina journeyed with him, and their home of the moment was always brimming with joy and laughter.

■ INIGO X KJELLE
Inigo traveled the world, ever ready with a smile or a solution when trouble started to brew. He and Kjelle continued to perfect their respective skills as crowd pleaser and champion.

■ INIGO X CYNTHIA
Inigo traveled the world, ever ready with a smile or a solution when trouble started to brew. Cynthia made for an enthusiastic partner, and before long the outrageous duo became a social sensation.

■ INIGO X SEVERA
Inigo traveled the world, ever ready with a smile or a solution when trouble started to brew. Severa was a vocal opponent of

working for free, but she stayed with Inigo and helped him realize his dream.

■ INIGO X MORGAN (FEMALE)
Inigo traveled the world, ever ready with a smile or a solution when trouble started to brew. While Morgan's memory never returned, she didn't really seem to miss it.

■ INIGO X NOIRE
Inigo traveled the world, ever ready with a smile or a solution when trouble started to brew. For better or worse, he and Noire were said to be a good match, trading doses of glee for doses of glum.

■ INIGO X NAH
Inigo traveled the world, ever ready with a smile or a solution when trouble started to brew. Nah, the responsible one, ensured they were well packed and always had multiple maps at the ready.

■ BRADY X LUCINA
Brady left the priesthood to become the world's scariest violinist. Every new rondo he composed passed first through the ears of his beloved wife and critic, Lucina.

■ BRADY X KJELLE
Brady left the priesthood to become the world's scariest violinist. Never one to pass up an opportunity for self-improvement, Kjelle took up music, too. Their tight duets were said to spring from a single muse.

■ BRADY X CYNTHIA
Brady left the priesthood to become the world's scariest violinist. His original rondos caught the heart of Cynthia, who insisted he play them everywhere he went as a sort of theme song.

■ BRADY X SEVERA
Brady left the priesthood to become the world's scariest violinist. Severa would roll her eyes and gripe about the noise, but the dew in her eyes after a touching melody was perhaps the more honest critique.

■ BRADY X MORGAN (FEMALE)
Brady left the priesthood to become the world's scariest violinist. While Morgan's memory never returned, she didn't seem to miss it much, and the two lived out their days most happily.

Great Knight

Wields swords, lances, and axes.
A mounted knight or cavalier
protected by heavy armor.

Myrmidon

Wields swords.
A swift warrior who strives for
mastery of the sword
and makes for a tricky target.

Sage

Uses tomes and staves.
A mage or healer with strong
magical powers.

General

Wields lances and axes.
A heavily armored, battle-
hardened knight with superior
attack and defense capabilities.

Merchant

Wields lances.
A peddler who travels all over
the map and might be a good
unit to rescue...

Sniper

Wields bows.
A master bowman who has
perfected the art of archery.

Fighter

Wields axes.
A scrappy, axe-wielding warrior
with punishing strength.

Sorcerer

Uses tomes.
A seasoned dark mage with
fearsome magical skills.

Swordmaster (Male)

Wields swords.
A quick, skillful myrmidon who
has mastered the art of
swordsmanship.

■ BRADY X NOIRE
Brady left the priesthood to become the world's scariest violinist. Noire tried to talk him out of it for fear his divine talents as musician and composer would curse them both to an early grave.

■ BRADY X NAH
Brady left the priesthood to become the world's scariest violinist. Nah, who considered herself quite the singer, often accompanied him; the sheer volume of her strains was said to flatten audiences.

■ GEROME X LUCINA
Gerome and Lucina were married and settled down near Wyvern Valley. While her husband never minced the few words he had to say, Lucina understood, and the two built a happy life.

■ GEROME X KJELLE
Gerome and Kjelle were married and settled near Wyvern Valley, which Kjelle soon refashioned into her ideal training ground. Many claimed to see her running uphill in full armor for days on end.

■ GEROME X CYNTHIA
Gerome and Cynthia were married

and settled down near Wyvern Valley. Astride her pegasus, Cynthia labored endlessly to concoct more dashing ways for her husband to make an entrance.

■ GEROME X SEVERA
Gerome and Severa were married and settled down near Wyvern Valley. Severa had a knack for landing mercenary work, and as a fighting duo, she and her husband became known throughout the land.

■ GEROME X MORGAN (FEMALE)
Gerome and Morgan were married and settled down near Wyvern Valley. While Morgan's memory never returned, she didn't really seem to miss it, and the two lived out their days most happily.

■ GEROME X NOIRE
Gerome and Noire were married and settled down near Wyvern Valley. Noire was said to be nervous around the wyverns and rarely left her husband's side.

■ GEROME X NAH
Gerome and Nah were married and settled down near Wyvern Valley. The wyverns bowed to their new dragonkin mistress, and the couple

became the first true lords of the valley.

■ MORGAN (MALE) X LUCINA
Morgan's memory never returned, but he didn't seem to miss it much and lived happily with Lucina. Later, scholars would speculate that he had come from a different future than the other children.

■ MORGAN (MALE) X KJELLE
Morgan's memory never returned, but he didn't seem to miss it much and lived happily with Kjelle. Later, scholars would speculate that he had come from a different future than the other children.

■ MORGAN (MALE) X CYNTHIA
Morgan's memory never returned, but he didn't seem to miss it much and lived happily with Cynthia. Later, scholars would speculate he had come from a different future than the other children.

■ MORGAN (MALE) X SEVERA
Morgan's memory never returned, but he didn't seem to miss it much and lived happily with Severa. Later, scholars would speculate that he had come from a different future than the other children.

■ MORGAN (MALE) X NOIRE
Morgan's memory never returned, but he didn't seem to miss it much and lived happily with Noire. Later, scholars would speculate that he had come from a different future than the other children.

■ MORGAN (MALE) X NAH
Morgan's memory never returned, but he didn't seem to miss it much and lived happily with Nah. Later, scholars would speculate that he had come from a different future than the other children.

■ YARNE X LUCINA
Yarne tried desperately to find a safe haven after the battles were done, but even that journey was fraught with danger—especially since Lucina was quick to dash to the rescue of every stranger.

Swordmaster (Female)

Wields swords.
A quick, skillful myrmidon who has mastered the art of swordsmanship.

Cavalier

Wields lances and swords.
A mounted knight with many talents.

Soldier

Wields lances.
A fighter in the ranks.

Revenant

Wields claws.
A low-level Risen who rends the living with its claws.

Dark Knight (Male)

Wields swords and tomes.
A veteran knight and mage who rides a black horse.

Dark Knight (Female)

Wields swords and tomes.
A veteran knight and mage who rides a black horse.

Dark Flier

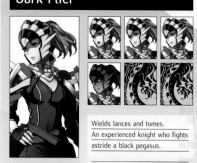

Wields lances and tomes.
An experienced knight who fights astride a black pegasus.

Dark Mage

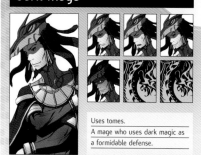

Uses tomes.
A mage who uses dark magic as a formidable defense.

Thief

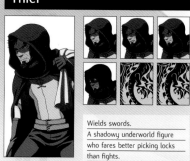

Wields swords.
A shadowy underworld figure who fares better picking locks than fights.

Wyvern Rider

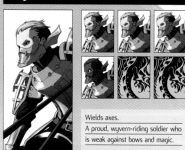

Wields axes.
A proud, wyvern-riding soldier who is weak against bows and magic.

Wyvern Lord

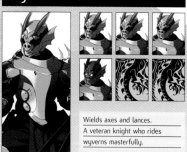

Wields axes and lances.
A veteran knight who rides wyverns masterfully.

Trickster

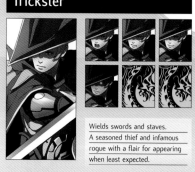

Wields swords and staves.
A seasoned thief and infamous rogue with a flair for appearing when least expected.

Berserker

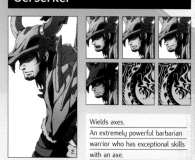

Wields axes.
An extremely powerful barbarian warrior who has exceptional skills with an axe.

War Cleric

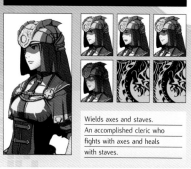

Wields axes and staves.
An accomplished cleric who fights with axes and heals with staves.

War Monk

Wields axes and staves.
A skillful priest who fights with axes and heals with staves.

Paladin

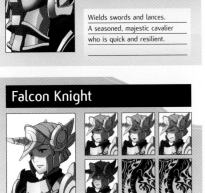

Wields swords and lances.
A seasoned, majestic cavalier who is quick and resilient.

Barbarian

Wields axes.
A savage thug who plunders villages with great strength and speed.

Falcon Knight

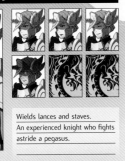

Wields lances and staves.
An experienced knight who fights astride a pegasus.

Pegasus Knight

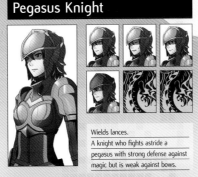

Wields lances.
A knight who fights astride a pegasus with strong defense against magic but is weak against bows.

Bow Knight

Wields swords and bows.
A veteran knight and swordsman who is practiced in loosing arrows from horseback.

Mage

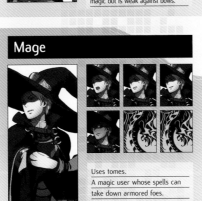

Uses tomes.
A magic user whose spells can take down armored foes.

Entombed

Wields claws.
A powerful Risen who rends the living with its claws.

Villager

Wields lances.
An average townsperson who may be weak now but whose future is wide open.

Hero

Wields swords and axes.
An expert fighter or mercenary with exceptional fighting skills.

Mercenary

Wields swords.
A combat professional with many strengths.

 # Epilogues

Married Life, as Recorded in Historical Records

■ YARNE X KJELLE
Yarne tried desperately to find a safe haven after the battles were done, but even that journey was fraught with danger—especially as Kjelle insisted on facing every foe to better herself as a warrior.

■ YARNE X CYNTHIA
Yarne tried desperately to find a safe haven after the battles were done, but even that journey was fraught with danger—especially as Cynthia wouldn't stop challenging brigands in the name of justice.

■ YARNE X SEVERA
Yarne tried desperately to find a safe haven after the battles were done, but even that journey was fraught with danger—especially as Severa continued to take on dangerous jobs to make ends meet.

■ YARNE X MORGAN (FEMALE)
Yarne tried desperately to find a safe haven after the battles were done. While Morgan's memory never returned, she didn't really seem to miss it, and the two lived out their days happily.

■ YARNE X NOIRE
Yarne tried desperately to find a safe haven after the battles were done, but even that journey was fraught with danger...despite Noire's best attempts to steer them out of trouble.

■ YARNE X NAH
Yarne tried desperately to find a safe haven after the battles were done. While Nah endeavored to steer them clear of trouble, they soon realized the best place was Ylisse, where their journey began.

■ LAURENT X LUCINA
Longing to meet his mother's intellectual standards, Laurent took his wife on an expedition around the world. Lucina was reunited with Tiki and Naga and thanked them for helping to usher in peace.

■ LAURENT X KJELLE
Longing to meet his mother's intellectual standards, Laurent took his wife on an expedition around the world. As Kjelle, too, valued self-discovery, the pair were said to be nearly inseparable.

■ LAURENT X CYNTHIA
Longing to meet his mother's intellectual standards, Laurent took his wife on an expedition around the world. The hidden wonders they uncovered awed Cynthia, who had known only a world of ruin.

■ LAURENT X SEVERA
Longing to meet his mother's intellectual standards, Laurent took his wife on an expedition around the world. Severa set out in search of treasure but instead discovered something much, much greater.

■ LAURENT X MORGAN (FEMALE)
Longing to meet his mother's intellectual standards, Laurent took his wife on an expedition around the world. While Morgan's memory never returned, she didn't really seem to miss it much.

■ LAURENT X NOIRE
Longing to meet his mother's intellectual standards, Laurent took his wife on an expedition around the world. Noire seemed startled at first by many of their discoveries but knew she was in good hands.

■ LAURENT X NAH
Longing to meet his mother's intellectual standards, Laurent took Nah on an expedition around the world. Their curious nature led to many adventures, which they later put to paper in a rousing novel.

 # Character Dialogue

Level Up Collection

Here we bring you a collection of everything the characters say when leveling up or changing classes. "[Robin]" is used here as the Avatar's name.

■ Avatar (Male)

Level Up 1: Hmm, I don't feel very different...
Level Up 2: I can tell I've gotten stronger.
Level Up 3: Now that's what I call progress!
Level Up 4: Wow... Sometimes I surprise even myself!
Level Up Limit: Maybe I should learn some new skills...
Class Change: Time to start building up some experience.

■ Avatar (Female)

Level Up 1: Hmm, I don't feel very different...
Level Up 2: I can tell I've gotten stronger.
Level Up 3: Now that's what I call progress!
Level Up 4: Wow... Sometimes I surprise even myself!
Level Up Limit: Maybe I should learn some new skills...
Class Change: Time to start building up some experience.

■ Chrom

Level Up 1: Well, that was underwhelming...
Level Up 2: My strength comes from diligence.
Level Up 3: I can feel a huge difference!
Level Up 4: No one can stop me now!
Level Up Limit: I think I've come about as far as any man can.
Class Change: Let's see what I'm capable of now.

■ Lissa

Level Up 1: I really have to do better than this...
Level Up 2: Hey, look at me go!
Level Up 3: I've still got a few tricks up my sleeve!
Level Up 4: I think I'm ready for the front lines!
Level Up Limit: I've come so far since meeting [Robin].
Class Change: Ta-da! Do I look good, or do I look GREAT?!

■ Frederick

Level Up 1: I suppose I need to apply myself more.
Level Up 2: No knight fears the slow-but-steady road.
Level Up 3: I must admit, I've outdone myself!
Level Up 4: I will use this power to protect us all!
Level Up Limit: There's not much more to learn from this class.
Class Change: I shall always be a knight at heart.

■ Virion

Level Up 1: Wh-what astonishing mediocrity...
Level Up 2: This is the least of my most noble efforts.
Level Up 3: Am I not a thing of beauty?
Level Up 4: Please! Avert your envious gazes!
Level Up Limit: What majestic heights have I left to attain?
Class Change: Before, I got looks...but now I AM the look.

■ Sully

Level Up 1: Damn, why didn't I train harder?
Level Up 2: Not bad, but I've got a hell of a way to go.
Level Up 3: Turns out the business end of my sword is ME.
Level Up 4: One giant leap across the chasm of greatness.
Level Up Limit: I guess you can only train so much. Damn.
Class Change: Ready to smash heads! ...Is that still my job?

■ Vaike

Level Up 1: Hmph. Teach just didn't want you all to feel bad.
Level Up 2: Anybody want to touch my muscles?
Level Up 3: Heh! The Vaike just got a lot Vaiker!
Level Up 4: I am invincible!
Level Up Limit: Hot damn! The Vaike can get no stronger!
Class Change: Watch Teach take you through the motions.

■ Stahl

Level Up 1: Sorry. I'll try to do better...
Level Up 2: Yes! Progress!
Level Up 3: Just look at me go!
Level Up 4: Amazing! I can hardly believe I'm still me!
Level Up Limit: When did I get so... well versed?
Class Change: All right. Back to square one.

■ Miriel

Level Up 1: Someone must preserve the status quo.
Level Up 2: Propitious growth, if I may say so.
Level Up 3: I am a staunch believer in amelioration.
Level Up 4: Never sate yourself with middling returns!
Level Up Limit: Alas, I fear the glass ceiling is Miriel-proof.
Class Change: What a fascinating way to acquire new trades...

■ Kellam

Level Up 1: Well, that's no way to get noticed...
Level Up 2: Hey, did you see how—Oh, no one's looking.
Level Up 3: Well...at least one of us is impressed!
Level Up 4: People have to notice me now! ...Right?
Level Up Limit: For once, I've gotten too big for my britches.
Class Change: Does this class make me stand out more?

■ Sumia

Level Up 1: I just can't do anything right, can I?
Level Up 2: About time I made some progress.
Level Up 3: Maybe I can finally make a difference.
Level Up 4: If I can come this far, I can do anything!
Level Up Limit: Look at all that you can accomplish if you try!
Class Change: I'll give it my best shot.

■ Lon'qu

Level Up 1: ...Hmph.
Level Up 2: ...Acceptable.
Level Up 3: ...Better.
Level Up 4: This is only the start of what I can do.
Level Up Limit: Most warriors never learn their limits.
Class Change: I could get used to this.

■ Ricken

Level Up 1: I've gotta try harder.
Level Up 2: Do I look any taller? I hope so.
Level Up 3: See? I can hold my own!
Level Up 4: Nobody will talk down to me now!
Level Up Limit: Wait... When did I get so ridiculously strong?
Class Change: This officially makes me grown up!

■ Maribelle

Level Up 1: This is completely unacceptable.
Level Up 2: Anything to set myself apart from the rabble.
Level Up 3: I won't be satisfied until I'm the very best!
Level Up 4: One step closer and I'll be forced to maim you.
Level Up Limit: I think I've sufficiently proven my superiority.
Class Change: Look at me! Classier than ever!

■ Panne

Level Up 1: Not my brightest showing, I will admit.
Level Up 2: Fine work for a man, and decent for a Taguel.
Level Up 3: Any taguel would be pleased.
Level Up 4: My strength is that of all taguel!
Level Up Limit: This taguel has pushed her body to its limits.
Class Change: What strange tools you man-spawn use...

■ Gaius

Level Up 1: Ugh. That was bland.
Level Up 2: Sweet.
Level Up 3: A little sugar in my tank, and watch out!
Level Up 4: Someone should reward me for this!
Level Up Limit: I've climbed this ladder to the topmost rung.
Class Change: I'll wear any pockets... as long as you line 'em.

■ Cordelia

Level Up 1: I'll prove myself in time.
Level Up 2: There. Now I must do it again.
Level Up 3: I hardly knew I had such strength!
Level Up 4: I would do all this and more to be with him...
Level Up Limit: I must find my strength within from now on.
Class Change: I am yours to mold as you see fit.

■ Gregor

Level Up 1: Oh dear. Gregor not make good impression.
Level Up 2: Gregor no run-of-the-miller guy, yes?
Level Up 3: What is this? Gregor's biceps tingling!
Level Up 4: Who say only young have the growth spurts?
Level Up Limit: Gregor already plenty strong, yes?
Class Change: Ha ha! Gregor feel like new and younger man!

■ Nowi

Level Up 1: Aw, I can do better than this...
Level Up 2: Yes! Now we're talking!
Level Up 3: Yeah! Don't even think of messing with Nowi!
Level Up 4: I feel like I could take on a whole army!
Level Up Limit: I'm so strong, I don't have to try anymore!
Class Change: Ooh, nice! I feel two hundred years younger!

■ Libra

Level Up 1: Why, gods? Do I not deserve your strength?
Level Up 2: Many thanks, O great ones.
Level Up 3: My prayers have been answered!
Level Up 4: I feel reborn!
Level Up Limit: I suppose I have walked this path to its end.
Class Change: May this new experience forge me.

■ Tharja

Level Up 1: You had better not hold this against me.
Level Up 2: Hee hee hee...
Level Up 3: And this is before I even sharpen my nails.
Level Up 4: I can feel the darkness growing ever stronger...
Level Up Limit: My vast powers will win [Robin]'s gaze!
Class Change: These new powers give me some wicked ideas...

■ Olivia

Level Up 1: Don't look so disappointed...
Level Up 2: I learned some new steps!
Level Up 3: You know, I think I'm really helping!
Level Up 4: Everyone's staring! How embarrassing..
Level Up Limit: Dancing sure brought the best out of me.
Class Change: Um, could you turn the other way?

■ Cherche

Level Up 1: Oh! Shame on me.
Level Up 2: All in a day's work.
Level Up 3: I'd say I've made quite a bit of progress.
Level Up 4: I feel invigorated! How about you, Minerva?
Level Up Limit: Oh my...these muscles! None of my dresses fit.
Class Change: I have always been fairly adaptable.

■ Henry

Level Up 1: Nya ha! I hardly learned a thing!
Level Up 2: Ooh, wow! When did I grow that?
Level Up 3: My body's pulsing! I wonder if I'll explode!
Level Up 4: I'm a hex of a lot stronger now. GET IT?
Level Up Limit: I'm done growing...but still no sixth finger..
Class Change: This looks so silly! Can I keep it?

■ Lucina

Level Up 1: I cannot settle for this!

Level Up 2: Good. I must stay this course.
Level Up 3: This strength serves more than me alone.
Level Up 4: I will not watch another Ylissean life be taken!
Level Up Limit: All this strength means little unless I succeed.
Class Change: Perhaps change is my best hope.

■ Say'ri
Level Up 1: Fie! I've little to show for my effort.
Level Up 2: I must do more!
Level Up 3: I shall use this power for the people!
Level Up 4: Rarely have I felt such a surge of strength!
Level Up Limit: I have come this far in the company of friends.
Class Change: Every sword must be tempered in its time.

■ Basilio
Level Up 1: What do you expect? I'm already perfect.
Level Up 2: Ha! And I thought I was past self-improvement!
Level Up 3: Don't count me out of the action just yet.
Level Up 4: Take a leaf out of THIS book, sprogs!
Level Up Limit: Once you hit my age, you've grown enough.
Class Change: This brings back some of the old fire!

■ Flavia
Level Up 1: Hmph. This isn't like me at all.
Level Up 2: Like I say: rap on some foes, reap the rewards.
Level Up 3: I know I've made bigger strides than this!
Level Up 4: Who wants to get destroyed first?
Level Up Limit: I'd say I've pushed myself as far as I can.
Class Change: Ha ha! I feel younger already!

■ Donnel
Level Up 1: Aw, shucks, I'm real sorry. I'll try harder!
Level Up 2: I still got a long ways left to go.
Level Up 3: This little piggie's learnt some new tricks!
Level Up 4: Heh, no more holdin' the others back now!
Level Up Limit: I'm happy as a pig in slop to've got this far!
Class Change: Feels funny... Like I'm a whole different fella!

■ Anna
Level Up 1: I think someone forgot to give me my change.
Level Up 2: I wonder just how much I can branch out.
Level Up 3: This sure beats gold! ...Wait, no it doesn't.

Level Up 4: If only my profits grew this fast!
Level Up Limit: Minds are like wallets. They only hold so much.
Class Change: Everything must go!

■ Owain
Level Up 1: Sinister forces conspire to hinder my growth!
Level Up 2: I'd expect no less from the hero of an epoch.
Level Up 3: Heh... My true power has been unleashed.
Level Up 4: Hnngh?! P-power... surging uncontrollably!
Level Up Limit: I've surpassed my final limit. ...I am complete.
Class Change: Behold the scope of my newly awakened powers!

■ Inigo
Level Up 1: Please don't let any girls have seen that...
Level Up 2: Ah, another solid step in the right direction.
Level Up 3: All right! Luck is on my side tonight!
Level Up 4: Please let all the girls have seen that...
Level Up Limit: I'd say that's strong enough. Bulk is...tacky.
Class Change: Oh, I look good in this. Popularity, here I come!

■ Brady
Level Up 1: Argh. Typical...
Level Up 2: Wow, I actually kinda improved.
Level Up 3: Am I dreamin' here?
Level Up 4: Hah! Bring it on!
Level Up Limit: Wow. Never thought I'd see the day...
Class Change: Heh, stand back, world. I'm a whole new man!

■ Kjelle
Level Up 1: I was derelict in my training...
Level Up 2: I'll not settle for this... But it's a start.
Level Up 3: Growing stronger is life's greatest pleasure.
Level Up 4: I'd like to see the man who can keep my pace!
Level Up Limit: I can't expect more strength. But finesse...
Class Change: This marks the start of a new training regimen!

■ Cynthia
Level Up 1: Eek... Being a hero is harder than I thought.
Level Up 2: A journey of a thousand miles and all that!
Level Up 3: Woo-hoo! Feeling good!
Level Up 4: Look upon my might, ye wicked, and despair!
Level Up Limit: I guess a long career of heroing has paid off!

Class Change: Ooh, that was certainly heroic!

■ Severa
Level Up 1: Excuse me?! I clearly deserve better!
Level Up 2: Mmm, yes. An excellent showing. Naturally.
Level Up 3: I-I'm not grinning... This is my war snarl!
Level Up 4: I suppose this would be nothing to you, Mother.
Level Up Limit: Hmph. No room for improvement, obviously.
Class Change: Sorry to disappoint, but it's the same me inside.

■ Gerome
Level Up 1: ...Hmph. Fate is feeling stingy today.
Level Up 2: It's a start.
Level Up 3: This changes nothing... but it does feel good.
Level Up 4: You seem pleased as well, Minerva.
Level Up Limit: I've flown about as high as I'm likely to reach.
Class Change: ...Anything to attain greater power.

■ Morgan (Male)
Level Up 1: Hrm... Gotta say, that's kind of a letdown.
Level Up 2: Nice! Getting stronger, one step at a time!
Level Up 3: That's a big step closer to achieving my dream!
Level Up 4: Whew... I'm catching up quick as I can, Mother!
Level Up Limit: All right... Now to focus on getting wiser, too!
Class Change: Do I... Do I look like my mother in this?

■ Morgan (Female)
Level Up 1: Hrm... Gotta say, that's kind of a letdown.
Level Up 2: Nice! Getting stronger, one step at a time!
Level Up 3: That's a big step closer to achieving my dream!
Level Up 4: Whew... I'm catching up quick as I can, Father!
Level Up Limit: All right... Now to focus on getting wiser, too!
Class Change: Do I... Do I look like my father in this?

■ Yarne
Level Up 1: Ack! If I don't pick up the pace, I'm extinct!
Level Up 2: Yes! I'm actually getting better!
Level Up 3: Maybe now I can stop being quite so anxious.
Level Up 4: The future of the Taguel is lookin' bright!
Level Up Limit: I'm the toughest Taguel in the world! By default.
Class Change: I hope you're watching this, Mother!

■ Laurent
Level Up 1: My sincerest apologies. I'll strive to improve.
Level Up 2: A fair result.
Level Up 3: It seems I've reaped unexpected gains.
Level Up 4: A logical consequence of tireless diligence.
Level Up Limit: By my analysis, I've hit my theoretic potential.
Class Change: Truly, these seals hold wondrous power...

■ Noire
Level Up 1: Aieee! I... I don't feel any different at all!
Level Up 2: I... I feel a bit stronger. ...Whew.
Level Up 3: I never knew I was capable of this...
Level Up 4: This growth is... It's unnatural. A CURSE?!
Level Up Limit: INSOLENCE! Why won't I grow still stronger?!
Class Change: Eep! A-all I did was touch the seal!

■ Nah
Level Up 1: I'm sorry. I'll do better next time, I promise.
Level Up 2: Good. I feel stronger.
Level Up 3: Excellent. I'm feeling tougher than ever.
Level Up 4: Wow... I feel like I could ravage an entire army!
Level Up Limit: Well, I suppose all that fighting finally paid off.
Class Change: Fascinating. And I'm used to transforming!

■ Tiki
Level Up 1: At 3,000, it gets harder to learn new things...
Level Up 2: I feel a little stronger.
Level Up 3: I miss being in the heat of battle like this!
Level Up 4: I must protect this world my friends saved.
Level Up Limit: There's not much more I can learn this century.
Class Change: Our journey together continues, I see.

■ Gangrel
Level Up 1: Bah! A turd would turn more heads than this!
Level Up 2: My best? You haven't SEEN my best.
Level Up 3: Yes... I feel a bout of nastiness coming on!
Level Up 4: Someone pinch me! No—let me pinch them!
Level Up Limit: You want me to get stronger?! Look at me!
Class Change: Is this the new me? The old me is asking.

■ Walhart
Level Up 1: Hmph... Barely perceptible.

Level Up 2: I balk at no conquest, great or small.
Level Up 3: Yes... I am in fine form.
Level Up 4: A Conqueror's role is to dominate, after all!
Level Up Limit: Have I conquered... everything?
Class Change: I refuse no road to power!

■ Emmeryn
Level Up 1: Sorry... I'll try... harder...
Level Up 2: Anything I can... do to...help...
Level Up 3: You're safe... with me...
Level Up 4: It's my turn...to stand up and fight...
Level Up Limit: I have come... so far...
Class Change: Is this...who I'm meant to be...?

■ Yen'fay
Level Up 1: Alas, I have made scant progress...
Level Up 2: This blade feels all the keener now.
Level Up 3: Potential hides where we least expect it.
Level Up 4: I fight on for you, Say'ri.
Level Up Limit: So even a dead man can surpass the living...
Class Change: What trickery is this?

■ Aversa
Level Up 1: Not the growth you were hoping for?
Level Up 2: I feel more supple already.
Level Up 3: Do I look ravishing, or do you just stare a lot?
Level Up 4: All this crushing power gets me a bit steamy...
Level Up Limit: I've turned into a well-rounded girl, haven't I?
Class Change: I can tell you like what you see. Heh heh...

■ Priam
Level Up 1: Hmm... I'm getting soft.
Level Up 2: Still not enough. Nowhere near enough.
Level Up 3: Nothing beats the feel of accomplishment.
Level Up 4: I intend to grow strong. Stronger than anyone...
Level Up Limit: I've learned all I can from this class... Next!
Class Change: A fork in the road to true strength.

Website Background Illustrations

Background Illustrations from the Official Website

On Nintendo's official website for *Fire Emblem Awakening*, a set of original illustrations were published as webpage backgrounds. These gorgeous scenes were drawn by the talented design team at Intelligent Systems.

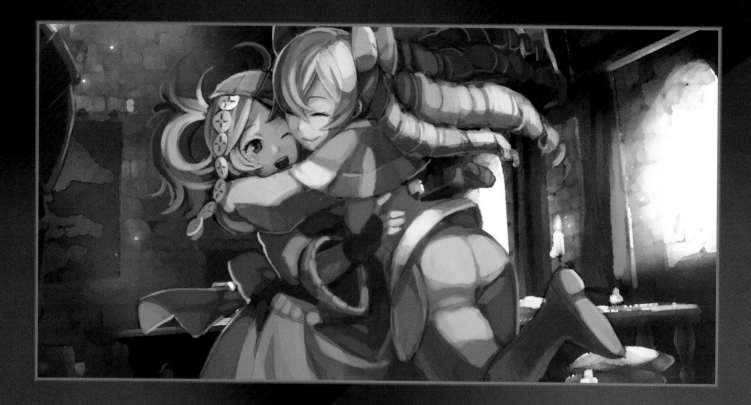

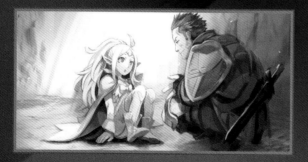

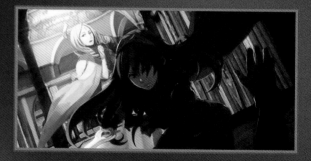

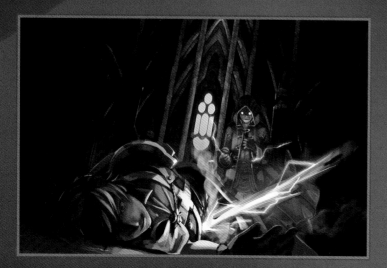

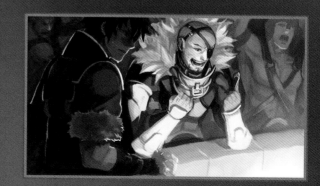

Character Cards

::: Illustrations from the Einherjar Cards

In the downloadable content, the player can collect Einherjar cards, which feature many of the characters found throughout the history of the *Fire Emblem* series. Here are all 133 illustrations from these Einherjar cards. So the question is: did you manage to meet all of these Einherjar?

Outrealm Marth

Outrealm Roy

Outrealm Micaiah

Outrealm Leif

Outrealm Alm

Outrealm Seliph

Outrealm Elincia

Outrealm Eirika

Outrealm Lyndis

Outrealm Ephraim

Outrealm Celica

Outrealm Ike

Marth

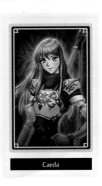

Caeda

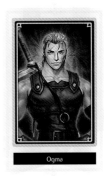

Ogma

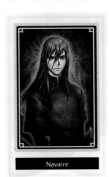

Navarre

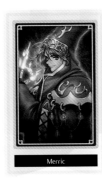

Merric

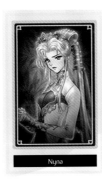

Nyna

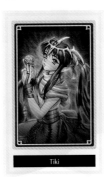

Tiki

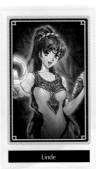

Linde

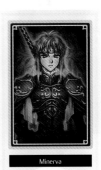

Minerva

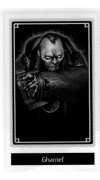

Gharnef

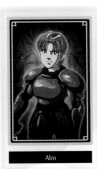

Alm

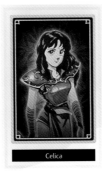

Celica

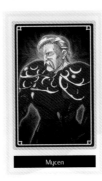

Mycen

Clair

Nomah

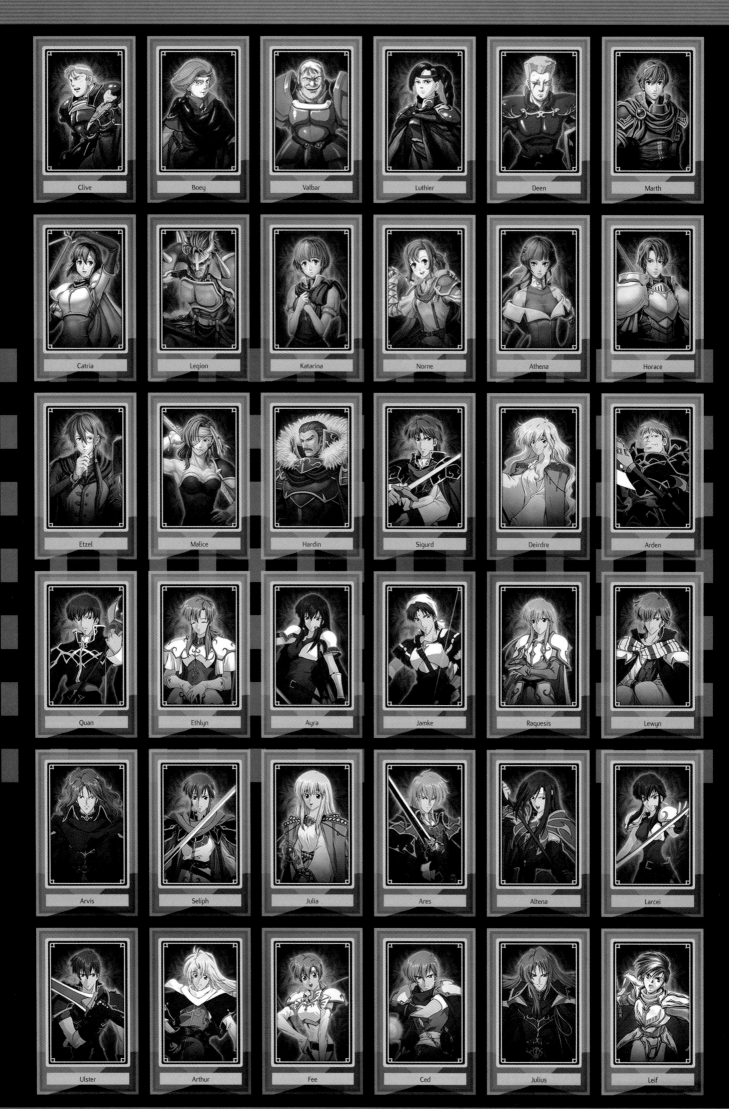

Clive
Boey
Valbar
Luthier
Deen
Marth

Catria
Legion
Katarina
Norne
Athena
Horace

Etzel
Malice
Hardin
Sigurd
Deirdre
Arden

Quan
Ethlyn
Ayra
Jamke
Raquesis
Lewyn

Arvis
Seliph
Julia
Ares
Altena
Larcei

Ulster
Arthur
Fee
Ced
Julius
Leif

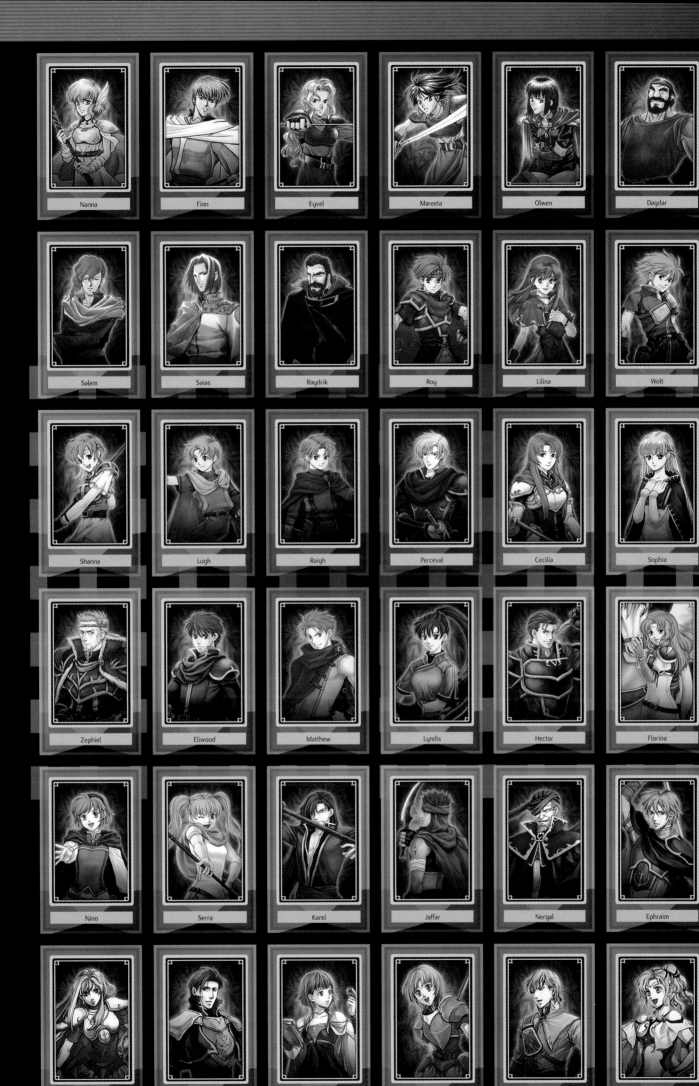

Nanna Finn Eyvel Mareeta Olwen Dagdar

Salem Saias Raydrik Roy Lilina Wolt

Shanna Lugh Raigh Perceval Cecilia Sophia

Zephiel Eliwood Matthew Lyndis Hector Florina

Nino Serra Karel Jaffar Nergal Ephraim

Eirika Seth Lute Amelia Innes L'Arachel

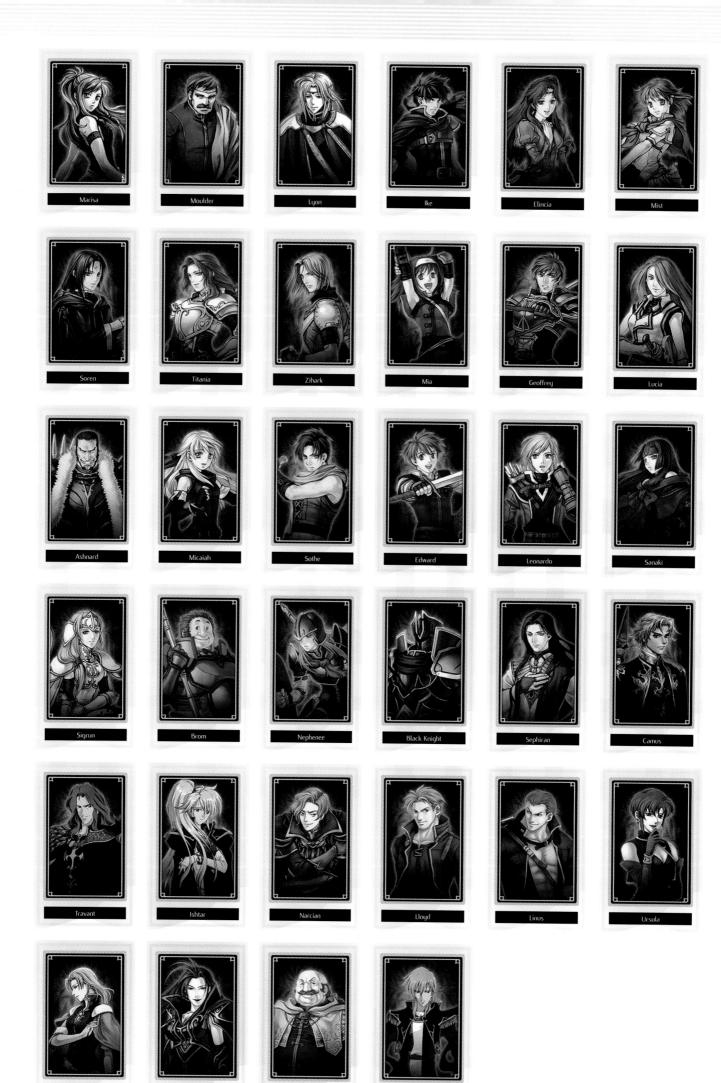

Marisa　　Moulder　　Lyon　　Ike　　Elincia　　Mist

Soren　　Titania　　Zihark　　Mia　　Geoffrey　　Lucia

Ashnard　　Micaiah　　Sothe　　Edward　　Leonardo　　Sanaki

Sigrun　　Brom　　Nephenee　　Black Knight　　Sephiran　　Camus

Travant　　Ishtar　　Narcian　　Lloyd　　Linus　　Ursula

Selena　　Petrine　　Oliver　　Eldigan

Character Dialogue

Retreat and Death Quotes

When a character dies or retreats, they speak their last words. The characters die or retreat in classic mode and retreat in casual mode. Quotes from classic mode are listed here first, followed by quotes from casual mode. "[Robin]" is used here as the avatar's name.

■ Avatar (Male)

Death: [Robin]: Chrom... everyone... F-forgive me...

Chrom: No! Not you, [Robin]! Open your eyes! OPEN YOUR EYES!

■ Avatar (Female)

Death: [Robin]: Chrom... everyone... F-forgive me...

Chrom: No! Not you, [Robin]! Open your eyes! OPEN YOUR EYES!

■ Chrom

Death: Chrom: I'm...sorry, everyone... Leave me... Save yourselves...if you can...

[Robin]: Chrom, NO! You can't die! Not now!

■ Lissa

Retreat: I-I can't go on... I'm sorry... This war...is over for me... I'm sorry...I couldn't help you... through to the end...

Retreat: S-sorry, but I can't risk... more wounds... It's up to you, Chrom...

■ Frederick

Retreat: Damn my carelessness! For the sake of my liege, I cannot fall here... Forgive me! Retreat is my only recourse!

Retreat: I cannot fight with such a grievous wound. I'm sorry, but I must withdraw...

■ Virion

Retreat: I cannot allow the final curtain to fall... and inflict such grief on womankind... Instead...I shall retreat, and live...far from this bloody battlefield...

Retreat: It would be tawdry to fight on like this. Instead, I shall make a dignified exit...

■ Sully

Retreat: *Huff, huff...* Damn my eyes... I was foolish...and careless... Hate to do this to ya, but I've got no choice... I gotta retreat...

Retreat: Gods damn their eyes! Sorry, Chrom, but I'm out...

■ Vaike

Death: GAR! Vaike the Mighty... falls at last... C-Chrom...take up the torch...

Retreat: Ogre's teeth! Not even ol' Teach can keep fightin' in this state... Oww...

■ Stahl

Death: Ungh... If only...I'd trained harder... Made myself...stronger...

Retreat: Ungh... End of the road for me... I have to...withdraw...

■ Miriel

Retreat: I still have so much to do. Discoveries to make, new knowledge to uncover... Science would be dealt a terrible blow were I to perish here, so I shall withdraw...

Retreat: In such a wounded state, I will only hinder my comrades. Logic dictates I withdraw...

■ Kellam

Death: I-I'm done for... I wonder if... anyone will notice...I'm gone...

Retreat: G-gotta retreat...or I'm done for... Not that...anyone will notice...

■ Sumia

Retreat: Ungh... C-can't fight...like this...just taking up space... Sorry to...let you down...again... I'll try... not to fall...on my way out...

Retreat: Ugh, it's always ME who goofs up... Sorry, guys, gotta go...

■ Lon'qu

Death: So...this is how it ends...

Retreat: S-sorry... Have to retreat... For now, at least...

■ Ricken

Death: I'm sorry, Chrom... I can't fight anymore...

Retreat: Can't fight...in this state. No choice but...to pull back...

■ Maribelle

Retreat: I've done...all I could... and now...I can only retreat... I must stay alive...I couldn't bear... to make Lissa grieve for me...

Retreat: What a horrible mess I've made of this... Time to go powder my nose...

■ Panne

Retreat: I can't die. Not here. Not now. I'm sorry, everyone. I've done all I can do...

Retreat: This foe is too strong, even for me. I have no choice... but to retreat.

■ Gaius

Death: Didn't see...that coming... No more...sweets for me...

Retreat: Crivens. Got careless and paid the price. Time to beat feet outta here...

■ Cordelia

Retreat: I was given this life by my friends... It is not mine to throw away... Sorry, Chrom, but I have to retreat...and save myself...

Retreat: I did my best, but that wasn't good enough. I'm leaving now...

■ Gregor

Death: Easy come...easy go... It was...a good ride...

Retreat: Gregor's finely honed instinct become dull with age! He make with the leaving now...

■ Nowi

Retreat: Wh-what's happening...to me...? I feel faint... I'm sorry, Chrom. I truly am... But I've got to retreat...

Retreat: Owowow! This is hurting WAY too much! I'm going home...

■ Libra

Death: Gods...I beg of you... Take me...but do not forsake...my friends...

Retreat: W-with these wounds, I'll only be a burden. I must withdraw...gracefully...

■ Tharja

Retreat: Curses! I can't die HERE in the filth and mud of a battlefield! I'm sorry, [Robin]! But I can't help you anymore...

Retreat: Ow, that HURTS! I've gotta pull back...but I won't forget this insult!

■ Olivia

Retreat: I'm no good to anyone now... I can barely walk, let alone dance... The curtain's closing on me... Up to you to...finish the show...

Retreat: I can't help anyone, limping like this... Time to exit... stage left...

■ Cherche

Retreat: Damn,,, This is not my time... Sorry, but I'm pulling out. Today is not my day to die...

Retreat: Ungh... Can't fight...with this wound... Must retreat... Live to fight...another day...

■ Henry

Death: Argh, this is the end for me... So dark... So quiet... So beautiful...

Retreat: Nya ha! They got me good. Can't see with the blood in my eyes... I'd better go...

■ Lucina

Retreat: I-I can't die until we've seen this through to the end... Even if I cannot fight—even if I can do nothing. I want to stay with you... Forgive me, Father. I have to live...

Retreat: Dammit... I had better pull back... Can't afford to...die l-like this...

■ Say'ri

Retreat: Gah... No... I can't die here! Not now! Chrom, [Robin]... I'm sorry, but I must withdraw...

Retreat: I cannot die yet. My country needs me... I shall retreat, and fight another day.

■ Basilio

Retreat: Dammit... I was given a second lease on life, and I ain't wastin' it... Sorry, but I'm gone!

Retreat: Damn... Pushed my luck too far... Sorry, all, but this oaf must withdraw...

■ Flavia

Retreat: Ungh, no! I have to save myself...for the people of Regna Ferox... Sorry, but I'm packing it in... Can't die here...while my kingdom needs me...

Retreat: Hmph. A powerful foe, this one... Apologies, but I must withdraw...

■ Donnel

Death: Unnngh... I-I did m'best... Made the village proud...

Retreat: YEOWCH! I ain't never been hit so hard! Better get outta here and heal up.

■ Anna

Death: It's true...what they say... In the end, material possessions mean nothing...

Retreat: Another wound like that, and the shop's closed for good. I'd better fall back...

■ Owain

Death: Ungh... Stupid weapon... doesn't work... Should have... given it...a better name...

Retreat: Though it goes against

every instinct in my body, I fear I must retreat...

■ Inigo

Death: It's...the end of the road. Thank you...everyone...

Retreat: This is more than...a flesh wound... Better get back...to med tent...

■ Brady

Death: Ha... In the end...I'm just baggage... No help...to anyone...

Retreat: Aw, crap, I'm just slowin' ya down... Gotta go...try and heal up...

■ Kjelle

Death: L-looks like...it's my time... at last... Will I see you again... Mother...?

Retreat: Too...strong for me... Have no choice... Need to get back...to safety...

■ Cynthia

Death: I just...wanted to be a hero...

Retreat: Oh, crackers... I hate to do this, but I'm done for the day. Good luck!

■ Severa

Death: I couldn't do it, Mother...I'm sorry...

Retreat: Ungh... Sorry... Can't stay here... Don't want to go the way... of my mother...

■ Gerome

Death: This was my...destiny...all along... Now I go...to join my parents...

Retreat: Damn, they aren't fooling around... Time for me to get out of here...

■ Morgan (Male)

Death: Mother... W-will I...see you again...?

Retreat: Can't fight like this... No point... Sorry, but I'd better pull back...

■ Morgan (Female)

Death: Father...where are you? Let me see your face...once more...

Retreat: Can't fight like this... No point... Sorry, but I'd better pull back...

■ Yarne

Death: And so a race...goes extinct...

Retreat: C-can't let my race...go extinct... Must retreat...while I still can!

■ Laurent

Death: Ha... This world of the past... Fades before me...like a dream...

Retreat: I was careless...and paid the price... Now I must retreat. Forgive me...

■ Noire

Death: Farewell...my friends...

Retreat: YEEEOW! I-I'm done for... Sorry, everyone...

■ Nah

Death: It's going to get terribly dark now...but that's okay... I'll be brave...

Retreat: Ow. Th-think I overdid it... Sorry, everyone, but I gotta go...

■ Tiki

Death: I won't have to be alone... anymore...

Retreat: I'm s-sorry. Chrom... I can't fight... Not like this...

■ Gangrel

Death: So this is...truly the end... Didn't expect it...to end like this...

Retreat: ARRRGH, HOW ANNOYING! How DARE they defeat me!

■ Walhart

Death: Curses! To lose now, in such a way! I don't deserve...to live...

Retreat: It is a formidable foe indeed who defeats the mighty Walhart...

■ Emmeryn

Death: I...I finally remember... But alas...I am too late... Lissa... Chrom...forgive me...

Retreat: Ow... H-hurts...too much... I need to...leave you... alone...

■ Yen'fay

Death: Regrets? I have none. In this world... I am already dead.

Retreat: Ungh... C-can't shrug this wound off... Have to retreat...heal up...

■ Aversa

Death: So in the end...this is all I'm worth... Ha... 'Tis no worse... than I deserve...

Retreat: Hmph. A worthy foe, for a change. Sadly, the battle is over for me...

■ Priam

Death: This is the end...for me... Keep going, Chrom... Don't...give up...

Retreat: Looks like...this is all I'm good for... Forgive me, my friends, but I'm leaving...

The story of *Fire Emblem Awakening* takes place thousands of years after Marth and his comrades performed their heroic deeds in previous games in the series, and their feats are now legend. This section sheds light on some of the main terms in the *Awakening* story.

Halidom of Ylisse

A peaceful country ruled by the exalt Emmeryn. Its people worship the divine dragon Naga as a god. They dislike war and have no more troops than is absolutely necessary to protect the halidom and its people. Emmeryn inherited the throne before she was ten years old upon the sudden death of her father. Ylisse had been at war with Plegia for fifteen years before she inherited her title.

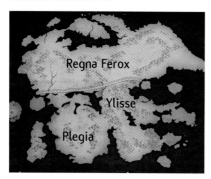

Valmese Empire

A realm on the continent of Valm. As the self-appointed supreme ruler, the emperor Walhart rules with intimidation and an iron fist. Because he shows no mercy to opposing views, a resistance force has arisen in opposition to his reign. The three countries of Ylisse, Regna Ferox, and Plegia make up the continent of Valm, known as Archanea in previous *Fire Emblem* games and Valentia in *Fire Emblem Gaiden*.

Hero-King Marth

The hero of many tales who, together with a small group of rebels, defeated the evil dragon and brought about the return of world peace. But in the time of Chrom and his friends, more than two thousand years later, Marth is the stuff of legends. According to Tiki, who knew him personally, he was a gentle soul who was able to embrace the differences in others, a man

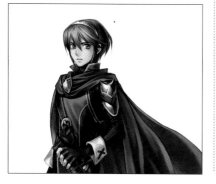

with a wonderful smile who showed a calm kindness to everyone.

Einherjar Cards

Cards that contain the images of legendary heroes who perished long ago but can be mysteriously summoned back to the present day. It is unknown who made these cards and when, but they are possessed and maintained by a fortuneteller named Old Hubba who lives in the Outrealms.

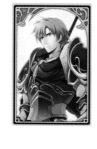 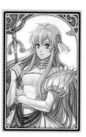

The Awakening Ceremony

A ceremony that bestows the powers of Naga or Grima. When Naga is invoked, the one who performs the ceremony is granted some of Naga's powers. When Grima is called forth, he is brought back to life through the vessel of the one who performs the ceremony.

Triangle Attack

An attack performed by a trio of pegasus knight sisters during the celebrated days of King Marth. This attack went down in legends as being able to take down any enemy. Cynthia, who wanted to be like the sisters, enlisted Lucina into special training for it, but unfortunately they were never able to carry out the attack successfully.

The Grimleal

The national religion of Plegia, in which the fell dragon Grima is worshiped as a god. Using Aversa to do his will and gain the attention of the nation's citizens, Gangrel popularized the religion, but the actual goal of the cult was to create a human vessel to embody the resurrected Grima.

Tactician

A commander who plans an army's missions and movements. In *Awakening*, the tactician's strategic expertise is embodied by the Avatar, whom Chrom finds lying unconscious in a field and takes under his wing. In the Outrealms, Lyndis mentions she knew a tactician who was found passed out in a field three times, so being passed out in a field seems to be oddly common among tacticians in this series.

Risen

Unknown monsters who appear early in the adventure. Ever since an explosive cataclysm, they've appeared throughout the world. They are inhuman soldiers created by Grima's magic.

Carrion Isle

A solitary island in Plegian territory. Top-level international talks are held there to discuss the intentions of the Valmese Empire.

The Shepherds

The self-defense forces of the halidom of Ylisse. They are led by Chrom, and Frederick is his second in command. Because the exalt of the halidom, Emmeryn, is a devout pacifist, the country does not arm its citizenry. Chrom's Shepherds are not an officially sanctioned force. Since they are an unofficial, volunteer force, they are made up of civilians who, while they may or may not love battle, undoubtedly love the peaceful Ylisse. Whether one is accepted into or rejected from the Shepherds is a decision traditionally made by Frederick.

The Fell Dragon Grima

An evil entity who attempted to destroy the world in the Age of Sacrifice but was thwarted and sealed away by a band of brave humans, assisted by the divine dragon Naga. According to oral tradition, Grima took the form of a huge dragon who may have been a descendant of a tribe of earth dragons who had a very advanced culture on the continent of Archanea tens of thousands of years ago. Even armed with the power of the divine dragon, no one can eliminate Grima for good. He can only be sealed away for a time. The only way Grima can die is if he takes his own life.

Twelve Deadlords

A group of extremely powerful Risen who appear in chapter 22 and the xenologue "Infinite Regalia." They first appear during *Fire Emblem: Genealogy of the Holy War* as members of the Loptyrian Sect. They are said to have a connection to the Twelve Crusaders, but what that connection is remains a mystery.

Dark Magic

The power to call a curse down upon a target. But dark magic is not necessarily evil. It can also be used to divine a person's location or, depending on the spell, to increase someone's health. Therefore, it can be considered a neutral magic. There are also dark magic techniques that can allow one to switch bodies, to make someone else relive time, or even to speak with the dead. Plegia, the stronghold of worship of Grima, has advanced the art of dark magic and boasts many extremely accomplished sorcerers—starting with the head of the Grimleal, Validar.

The Wellspring of Truth

A miraculous spring found in the inner sanctum of the ruins in paralogue 22. It is said to have the power to allow you to see your true self. It is here that

Aversa was able to recover her memories of being abducted and used by Validar. The continents are dotted with ancient ruins like this, and rumors abound of the unique treasures that may lie waiting there.

The Divine Dragon Naga

The divine dragon who helped save the world from destruction in the Age of Sacrifice. Since then, she has been worshiped as a protector god because she provided the power to seal the fell dragon Grima away. According to oral tradition, Naga has appeared in borrowed human form, but accounts differ as to whether that form was male or female. While Grima is thought to be a descendant of the earth dragon tribe, Naga is conjectured to be the spirit of King Naga of the divine dragon tribe.

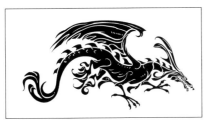

Chon'sin

A small country on the continent of Valm that is home to such unusual customs as eating a rice-based diet and consuming raw fish. Yen'fay and Say'ri were part of the royal family of Chon'sin until an invasion by the Valmese Empire stole away their sovereign rights. Lon'qu was also born in Chon'sin.

Brand of the Exalt and Brand of the Defile

Ever since ancient times, the exalts have passed down a mark through their bloodline that appears on the bodies of their descendants. In *Awakening*, the Brand of the Exalt appears on the royal family of the exalt, ruler of the halidom of Ylisse. The brand appears on Emmeryn (the exalt herself) and the crown prince, Chrom, but not on the youngest daughter of the family, Lissa. However, Owain (Lissa's child who comes from the future) and Chrom's future child, Lucina, are also born marked with the brand. On the other side of the coin, those who inherit the blood of the fell dragon Grima bear a mark known as the Brand of the Defile. But those born with that brand have no memory of it, nor even the knowledge that they possess the brand itself. For that reason, neither Chrom nor any of those who are with him when he meets the avatar take notice of the Brand of the Defile on the avatar's left hand.

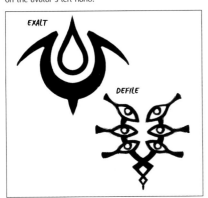

Radiant Hero

A hero said to have come from another world long, long ago. They say he was blessed by the gods with supreme sword skills and is able to defeat countless enemies.

Taguel

A race of beings driven to the brink of extinction after their habitat was destroyed by humans. Though they have far greater physical abilities than humans, it's said they were man's servants and laborers at the time of the first exalt and were treated sometimes as pets, and other times even worse than beasts of burden. When the first exalt saw how they were treated, he freed them. In their oral traditions, they still tell of their debt to the exalt in recognition of what he did for them—a debt for which they are willing to lay down their lives. They use beaststones to change into beast forms, which differ from taguel to taguel. The forms of rabbits, lions, and wolves are all said to have been used. Another shape-changing race, the laguz, appeared in *Fire Emblem: Path of Radiance*; it is suggested that the taguel may have descended from those tribes.

Pegasus Knight Squadron

A division of the Ylissean military made up solely of pegasus knights. They have existed since the Age of Sacrifice and have a long and storied history.

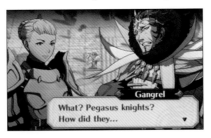

Mount Prism

A mountain which is filled with the power of the divine dragon Naga. This is the sacred ground where exalts of the past performed Naga's Awakening ceremony.

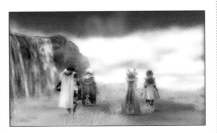

Origin Peak

An isolated island to the west of Plegia where the final battle occurs after the resurrection of Grima.

Falchion

A national treasure of the halidom of Ylisse. There is only one sword like it in the world. Presently it is in the possession of the crown prince of Ylisse, Chrom. Legend has it that during the Age of Sacrifice, the first exalt used its power to seal away the fell dragon, and it has since been passed down to those carrying the blood of the first exalt, granting them some of Naga's power. Since it is a blade that allows only those who have certain attributes to wield it, even some who are part of the exalt's bloodline are unable to use it.

Regna Ferox

A northern kingdom where it is believed the strong should rule. It is divided into east and west powers, and

each has its own khan. Ever since ancient times, a tournament has been held every few years to determine which of the two khans is the true ruler of both east and west. The winner becomes the highest power in the kingdom. At present, Basilio is khan of the west and Flavia is khan of the east.

Plegia

A country in the southwest portion of the continent that shares a border with Ylisse. The previous exalt oversaw a holy war between Ylisse and Plegia due to their worship of the fell dragon. The war was long and bloody and nearly destroyed both nations. When the country came under the rule of the mad king Gangrel, a devotee of the fell dragon Grima, it underwent a revival as a religious state. Under his rule, the country became prosperous due to commerce and industry, which resulted in the nation's military growing very robust. Despite a nonaggression pact with Ylisse, Gangrel repeatedly incited provocative acts, such as illegal border crossings to attack villages, perhaps hoping to instigate open warfare. After the death of Gangrel, the Grimleal took over the government, giving even more strength to the religious faction of the country.

Jewels

Spheres in which the divine power of Naga rests. There are five jewels: Argent, Sable, Gules, Azure, and Vert. When placed upon the Fire Emblem, they allow the Awakening ceremony to occur.

Fire Emblem

A magical shield that, along with Falchion, is one of the national treasures of Ylisse. Oral tradition has it that it can grant whatever wish the wielder may desire. It is said that Tiki, the priestess of the divine dragon, gave the Fire Emblem its name.

Tomes

Books of magic written in the Age of Sacrifice and consulted by mages and other users of magic in the search for knowledge. These books cover many subjects, such as the history of the gods and the use of sacred powers, and they become handy tools for those who pursue the ways of magic.

Manakete

A tribe of beings who, through the use of dragonstones, can change into dragon form. They age much slower than human beings and have a natural lifetime that spans many millennia; even those who look like children may have already lived over a thousand years. Their ancestors may have been the dragon tribes who ruled the world in ancient times. They sealed their dragon powers into stones and live out their lives as humans do, or so historians believe. Until Chrom's shepherds encountered Nowi, no manakete had been seen for many years—with the exception of Tiki, the priestess of the divine dragon.

Mila Tree

A sacred tree on the Valm continent. The priestess of the divine dragon is imprisoned in the vicinity of a shrine near the top of the enormous tree's branches.

Dragon's Table

An altar on which the life of a living sacrifice is offered. Validar tries to make use of the power of the altar and the Fire Emblem in order to revive Grima.

Credits

■Producer
Tohru Narihiro

■Producer
Hitoshi Yamagami

■Project Manager
Masahiro Higuchi

■Director
Kouhei Maeda

■Director
Genki Yokota

■Codirector
Hideaki Araki

■Technical Director
Takafumi Kaneko

■Game System Programming
Yuji Ohashi

■User Interface Programming
Yuya Ishii

■Battle Programming
Takafumi Kaneko

■Battle Map and World Map Programming
Susumu Ishihara

■Programming
Yusuke Murakami
Yusuke Shibata
Taichi Ishioka

■Tool Support
Junko Tanaka

■Art Director
Toshiyuki Kusakihara

■Design Supervisor
Takayasu Morisawa

■Character Design and Illustration
Kozaki Yusuke

■Map Unit Design
Mayuko Tsukamoto
Chie Yamamoto
Naoko Tsukamoto
Satoko Kurihara

■Map Design
Shigeki Osaka
Hiromi Tanaka

■Battle Unit Design
Toshiyuki Kusakihara
Mai Watanabe

■Battle Unit Modeling
Mai Watanabe
Erina Mori (Proge)
Ayaha Mochizuki (Proge)
Hiroko Tamada (Proge)

■Battle Unit Motion
Yoshihisa Isa
Yuki Takenaka (Proge)
Zizzo Ishiguro (Proge)
Kanako Migaki (Proge)

■Battlefield Design
Isabel Ozawa
Takuya Nishino

■User Interface Design
Takako Sakai

■Effects Design
Hiroyuki Tashiro

■Graphic Support
Tsutomu Tei

■Event Illustration
Madhouse

■Event Illustration and Scenario Coordination
Yuu Ohshima (Red Entertainment Corporation)

■Movie Producer
Takeshi Nagasawa

■Movie Director
Toshihisa Yokoshima

■Movie Technical Director
Shunsuke Tsuchiya

■Movie Concept Art
Yoshiyuki Okada
Ayako Okubo

■Movie Storyboard
Kiyoshi Okuyama
Asami Ando

■Movie Visual Effects Coordinators
Kei Yonezuka
Kaori Satake
Shingo Sanada

■Movie Character Modeling Director
Tomohisa Ishikawa

■Movie Character Modeling Chief
Hiroto Shibata

■Movie Character Modeling
Hiroyuki Tokudome
Kyohei Kurosaki
Kenichi Kimura
Toru Ehara
Ippei Suzuki
Airi Ishikawa
Yoshimasa Okada
Riku Kou
Satomi Nakao
Tetsuya Sasaki
Takuya Ueda
Takanori Urakawa
Nozomi Ishii
Shinya Seno
Daisuke Suzuki
Katsuyoshi Miyajima
Akira Nakamura
Mai Nakamura
Takashi Yoshimura
Tao Yong
Zhao XinYuan
Feng Han
Xia XiSheng
Yu Kun
Shan FengSong
Hou XuDong
Lin ChunTao

■Movie Background Modeling Director
Shinji Tsutsumi

■Movie Background Modeling
Asuka Ogiwara
Nobunao Ono

■Movie Art Design
Yutaka Terada
Wakako Hideshima
Ai Kishimoto
Motohiro Sasaki

■Movie Art Director
Hiroshi Kato

■Movie Artwork
Rie Suzuki
Tomoe Nakano
Mimu Sato
Kana Hayashi
Azusa Kakoi
Hirotsugu Kakoi
Naoko Yanagita
Hirofumi Sakagami
Naoya Watabe
Izumi Hoki
Kumiko Watanabe
Wataru Chihara
Tatsuro Ogi
Izumi Kondou

■Movie Animation
Manabu Konno
Housei Takakubo
Kentarou Narimatsu
Mitsugu Ohara
Takahiro Miura
Misaki Higuchi
Masashi Matsumoto
Aya Yamaguchi
Mika Oba
Hiroaki Miura
Hidekazu Yamada
Tsuyoshi Nishikawa
Kazuki Eigen
Yukiko Fujioka
Tetsuya Takakuwa
Temari Kondo
Yurie Kubo
Mayumi Makino
Honoka Ogata
Keniti Sakata

■Movie Effects
Katsuyoshi Yoshizawa
Toru Okazawa
Takayuki Shigekawa

Yasutake Hirata
Kazuo Mitsuyama
Hiroyuki Sagara

■Movie Composition
Kaori Nishimoto
Yuki Oshima
Yuta Matsumoto
Naoki Yoshibe
Kodai Tanaka

■Movie Facial Supervisor
So Nagata

■Opening Movie Editing
Masaki Ishii

■Movie Video Continuity Editing
Ryousuke Omae

■Movie Action Coordinator
Akira Sugihara

■Movie Motion Capture Acting
Wataru Koga
Tony Hosokawa
Yutaka Kambe

■Parts Model (Eye)
Isabelle Weissenberger

■Movie Motion Capture Producer
Shigeki Yamamoto

■Movie Motion Capture Director
Ken Hatsuumi

■Movie Motion Design
Masaki Sato
Aiko Suzuki
Mitsutaka Nakamura
Shogo Ikejima

■Movie Staff Coordinator
Nao Takahashi

■Movie Stereoscopic Supervising Producer
Masahiro Yamaura

■Movie Lead Digital Artist/ Stereoscopic Lead
Ryosuke Takeuchi

■Movie Digital Artist
Kenji Goto

■Movie Stereoscopic Digital Artists
Yosuke Inoue
Koichi Hirata

■Movie Production Coordinators
Daisuke Shirasawa
Yin Ping

■Movie Stereoscopic Producer
Teppei Wakabayashi

■Movie Stereoscopic Assistant Producer
Masaki Takaoka

■Movie Stereoscopic Director
Takaomi Seki

■Movie Stereoscopic Quality Checker
Xiang Ren

■Movie Stereoscopic Operators
Yujiao Kang
Bo Jiang
Hong Kang
Ying Fu

■Level Design Director
Yuji Ohashi

■Level Design Planning
Ryuichiro Kouguchi

■Character Planning
Nami Komuro

■Scenario
Kouhei Maeda
Nami Komuro
Masayuki Horikawa
Yuichiro Kitaoka (Lepton)
Sou Mayumi (Lepton)
Shuntaro Ashida (Red Entertainment Corporation)

■Scenario Supervisor
Yurie Hattori

■Scenario Support
Edgeworks, Inc.

■Event Director
Masahiro Higuchi

■Event Script
Ryuichiro Kouguchi
Nami Komuro
Masayuki Horikawa
Hiroki Morishita
Satoko Kurihara
Mayuko Tsukamoto

■Sound Supervisor and Extra Map Music Composition
Yuka Tsujiyoko

■Sound Director and Sound Effects
Yasuhisa Baba

■Music Director and Main Music Composition
Hiroki Morishita

■Music Composition
Rei Kondoh (T's Music)

■Voice Cast

Chrom	Matthew Mercer
Lucina	Laura Bailey
Lissa	Kate Higgins
Emmeryn	Erin Fitzgerald
Frederick	Kyle Hebert
Flavia	Tara Platt
Basilio	Patrick Seitz
Say'ri	Stacy Okada
Sully	Amanda C. Miller
Virion	Dan Woren
Stahl	Sam Regal
Vaike	Michael Sorich
Miriel	Tara Platt
Sumia	Danielle Judovits
Kellam	Orion Acaba
Lon'qu	Travis Willingham
Maribelle	Melissa Fahn
Ricken	Yuri Lowenthal
Gaius	Gideon Emery
Panne	Jessica Gee
Cordelia	Julie Ann Taylor
Nowi	Hunter Mackenzie Austin
Gregor	George C. Cole
Libra	Cindy Robinson
Tharja	Stephanie Sheh
Olivia	Karen Strassman
Cherche	Amanda C. Miller
Henry	Bryce Papenbrook
Donnel	Sam Regal
Anna	Karen Strassman
Owain	Kaiji Tang
Inigo	Liam O'Brien
Brady	Travis Willingham
Kjelle	Stephanie Sheh
Cynthia	Stacy Okada
Severa	Julie Ann Taylor
Gerome	Orion Acaba
Morgan (Male)	Todd Stone
Morgan (Female)	Nicole Karrer
Yarne	Chris Smith
Laurent	George C. Cole
Noire	Michelle Ruff
Nah	Danielle Judovits
Tiki	Mela Lee
Priam	Jamieson Price
Naga	Mary Elizabeth McGlynn
Gangrel	Anthony Jenkins
Aversa	Cindy Robinson
Walhart	Richard Epcar
Yen'fay	Kirk Thornton
Validar	Kyle Hebert
Excellus	Spike Spencer
Avatar	Michelle Ruff
	Wendee Lee
	Dave Vincent
	Brandon Karrer
	Chris Smith

■Video Sound
Yoshito Sekigawa

■Music Support
Hiroyuki Hamada (T's Music)

■Violin (Solo)
Hanako Uesato

■Violin
Syoko Miki
Natsu Kuriyama
Tairiku Sada

■Music Coordination
Kazuki Chiba
Chiharu Chiba (E-Smart, Inc.)

■Recording Engineer
Hiroyuki Akita

■Japanese Voice Casting Support
Bungo Fujiwara (Twofive Studio)

■Japanese Voice Recording Director
Hitomi Matsuki (Twofive Studio)

■Japanese Voice Edit Support
Junpei Ikawa (Twofive Studio)
Shuhei Okada (Twofive Studio)

■Japanese Recording Studios
Memory-Tech Audio Studio
Wonder Station
Twofive Studio
Mit Studio
The Tokyo Television Center Co., Ltd.

■Project Assistance
Tsutomu Kitanishi
Masayuki Horikawa

■Publicity
Yusuke Kitanishi

■Artwork
Kazuya Yoshioka
Shintaro Ishii

■Technical Support
Kenta Nakanishi
Norihito Ito
Shuhei Furukawa
Tomohiro Umeda
Toru Inage

■Debug
Ryosuke Yamada
Kentaro Nishimura
Ryuji Hamaguchi
Yuichiro Ushijima
Nobuaki Maeda
Takeshi Nishizawa
Akie Sogo
Akihito Fujiki
Hirokatsu Nishimura
Mario Club Co., Ltd.
Daisuke Kiuchi
Kenta Aoki
Tetsuro Yamagishi
Kouichi Maruyama
Digital Hearts Co., Ltd.

■Special Thanks
Kenji Imai
Takashi Akiyama
Yasuharu Narao
Ashura Benimaru Itoh
Yoshiharu Ohashi
Kenji Kobayashi
Mitsuo Ueda
Syuji Kawaguchi
Fukuji Kohama
Yoshihiro Yamazaki
Kenji Kaji
Kazuo Shinoda
Mika Sekiguchi
Kentaro Takeda
Tokio Hattori
Koujiro Shinya

■General Producer
Shinya Takahashi

■Executive Producer
Toshiyuki Nakamura

■Executive Producer
Satoru Iwata

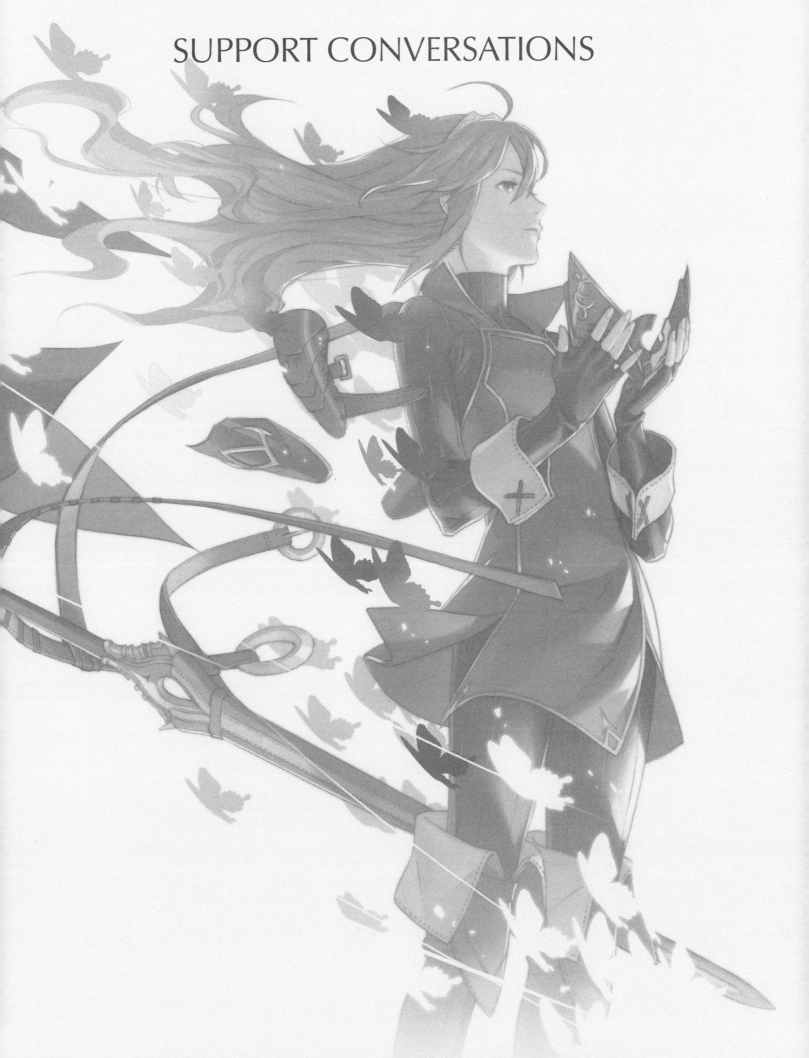

Section 6

\\\\\

SUPPORT CONVERSATIONS

Avatar (male)

For the purposes of the conversations we will call the avatar "Robin."

Chrom

■ CHROM X AVATAR (MALE) [ROBIN] C

[Robin]: Can I ask you something, Chrom?

Chrom: Uh-oh. Should I be nervous?

[Robin]: When you found me collapsed and without memory, why did you take me in?

Chrom: Well... Because you were collapsed and without memory?

[Robin]: Isn't that enough?

Chrom: Isn't that enough?

[Robin]: Did you never stop to consider if it was some kind of trap?

Chrom: Heh, that's what I have Frederick for.

[Robin]: But why didn't—

Chrom: Robin, if I see someone hurt or in need, I'm going to help them. That's just who I am, and there's no changing it. Or would you rather I'd left you there, face down in the muck?

[Robin]: No, of course not. I'm thankful for what you did, I truly am. But it scares me all the same. Chivalry and longevity don't often go hand in hand.

Chrom: Ha! I wish I had a gold coin for every time I got this lecture.

[Robin]: I can only offer advice, I'm afraid. You really should be more careful in the future.

Chrom: I'm sorry, but no. If it happened again today, I'd do the same exact thing.

[Robin]: But—

Chrom: Peace, Robin. I have heard your counsel, and I know you mean well. But as I said, this is who I am. I cannot change that, nor would I want to.

[Robin]: I... I understand. If that is your decision, then so be it. Just do try and be careful, Chrom. For my peace of mind, if not your own?

Chrom: I will. I promise.

■ CHROM X AVATAR (MALE) [ROBIN] B

[Robin]: Chrom! Are you all right?!

Chrom: Er, yes, I'm fine. ...What's got you so excited?

[Robin]: I heard you were attacked behind the mess tent!

Chrom: Pfft! Some local thug approached with a dagger, but he bolted when I drew iron. The poor fellow probably thought he was mugging a merchant! Ha!

[Robin]: You challenged him alone?!

Chrom: Well, I wouldn't say "challenged," exactly. More like "shooed away." Can we very well leave that sort around the camp now, can we?

[Robin]: By the gods, Chrom! Please, I beg you, do not take any more of these foolish risks.

Chrom: Hah! You do realize we're at war, right? Just walking onto the battlefield is a risk.

[Robin]: I don't fear anyone besting you head-on; I fear you being stabbed in the back! Many of our enemies do not share your sense of honor.

Chrom: Do you really think some random cutpurse would get the better of me?

[Robin]: Shall I list every hero who said that before being poisoned, sniped, or snared?

Chrom: Enough... I don't think a list is necess—

[Robin]: You're our COMMANDER, Chrom... Battlefield victories mean nothing if an army loses its leader. You are no longer simply your own man. You stand for all of us.

Chrom: Enough... You have a point. You're right... as you always are. I will be more careful. Thank you, Robin.

■ CHROM X AVATAR (MALE) [ROBIN] A

[Robin]: I hear you've been going on patrol with a couple of the men.

Chrom: Only to patrol the immediate area.

[Robin]: ...You know what I'm going to say, don't you?

Chrom: That it's too risky, and I need to be more careful. Yes, thank you, mother.

[Robin]: But if you know this, then why—

Chrom: Look. I understand enemies could be lying in wait to try and kill me... But there could also be others who need my help! There's a war going on, and people are suffering. I can't ignore that. I won't.

[Robin]: So why not send your men to search for these hapless innocents?!

Chrom: Because.

[Robin]: Becauuuse...?

Chrom: Because...of you. If I hadn't been there—if Frederick alone had found you—would we have ever met?

[Robin]: ...Probably not.

Chrom: You see? And it's not just you, Robin. It's everyone like you. I know going out there exposes me to danger, and I haven't always been careful. But it's a risk I'm willing to take in order to connect with the people. To forge bonds.

[Robin]: Bonds? Between who?

Chrom: You and me. Me and the others. All of us. The bonds we've met, the world we've seen... Such bonds are the true strength of this army. Without them, we're lost. Others may disagree, but that's one benefit of leadership: I make the final call.

[Robin]: It's hard to argue when you use me as your example. But at least let me come with you.

Chrom: So you can watch my back?

[Robin]: That's part of it, yes. But I also want to be there when you find the next one, face down in a field. I want to help you make this army stronger. I want to help you forge new bonds.

Lissa

■ LISSA X AVATAR (MALE) [ROBIN] C

Lissa: Robin? Where aaare yooou?

[Robin]: ...Zzz.

Lissa: There you are! I was just... Oh! (You're sleeping...?)

[Robin]: Snnrk! Zzzzzzz...

Lissa: (You must really be wiped out. Not that I blame you, getting wrapped up in all this. Hee hee! Looks like it's time to quiiietly... geeently... hold your nose!)

[Robin]: Nh...gnnkh...nnrrrrgh...! BWARGH! Wha—?! Risen! Wolves! Risen riding wolves! They're...all... Wait a moment...

Lissa: Hee hee hee hee hee hee! AAAAH ha ha ha! "BWARGH"?! Oh gods, that was HILARIOUS! Heeeee hee hee hee hee!

[Robin]: Lissa, gods bless it... I was fast asleep!

Lissa: And dreaming of Risen and wolves, apparently? Tee hee hee! I'm sorry. I tried to resist—I really did. But it was just too perfect!

[Robin]: Who does such things? Is that really how your parents raised you?!

Lissa: I...I don't know... I never really knew my parents...

[Robin]: Oh... Oh, right. That was... Er...

Lissa: Oh, don't worry about it. I know you didn't mean anything by it. And actually, there's something else that I should be apologizing for...

[Robin]: Whatever it is, I'm sure I can forget it if you can forgive my heartless behavior.

Lissa: Really? That's great! Oh, I was SO sure you were going to be SO angry. See, I was kinda doodling a pic of you in your big, new book of battle strategies... ...Aaand then I kinda spilled the ink and kinda...ruined the battlefield a little, kinda...completely. Ireallyreallyreallydidn'tmeanto!

[Robin]: WHAT?! But that was a rare text! I had just started to... ...Er, "ahem" I mean... It's... It's fine. Accidents...happen.

Lissa: Oooh pheeew!

■ LISSA X AVATAR (MALE) [ROBIN] B

Lissa: Phew! I am beat.

Lissa: All tuckered out, Robin? How about a quick, refreshing shoulder rub?

[Robin]: ...What are you practicing now?

Lissa: Oh, please. One little joke, one little time and you get all paranoid. This isn't about pranking anybody. I figure I owe you...

[Robin]: How do you figure?

Lissa: Because you've taken a huge weight off my brother's shoulders, silly! And what's Chrom's like. He never asks for help, even when he needs it. But he trusts you, Robin. Enough to rely on you. He's not the type to come out and say it, but I know he's grateful.

[Robin]: You...think so?

Lissa: I know so! Nobody knows my big brother like me.

[Robin]: Well, that is nice to hear...

Lissa: So, what do you say? Free massage? Going once... Gooooooing twiiice...

[Robin]: Okay, I accept! I accept! ...Thanks, Lissa.

Lissa: Okay then... Urgh! Geez, your muscles are just one big knot back here...

[Robin]: ...Aaaaah, yes, right there... Oooh, that feels amazing...

Lissa: Aww, what about...this?

[Robin]: WhaAAAUGH! Cold! Cold and slimy and cooooooold! AUGH! IT MOVED! WHAT DID YOU DO, LISSA?! WHAT IN BLAZES WAS THAT?!

Lissa: Teee hee hee hee hee! Oh, relax. It's just a frog. You were just so perfectly calm, tee hee. I couldn't resist! It had to be done!

[Robin]: I'm pretty sure it did NOT! And weren't you just saying yesterday that frogs make you "all pukey"?

Lissa: I'm willing to put up with a lot for the sake of comedy.

[Robin]: Well, that makes one of us!

■ LISSA X AVATAR (MALE) [ROBIN] A

Lissa: Hey there, Robin.

[Robin]: Get away from me, she-devil!

Lissa: Aw, don't go getting your hackles up! I'm not here to prank you.

[Robin]: Fool me once, shame on you. Fool me twice...don't talk to me again.

Lissa: Hee hee! Aw, come on! ...Wait, are you really mad?

[Robin]: Of course I'm mad! You dumped a toad down my collar!

Lissa: I'm pretty sure that was a frog.

[Robin]: I'm pretty sure I don't care!

Lissa: Okay, okay! I'm sorry, Robin! I'm super-super-duper 100 percent sorry. And I won't do it anymore, so please be my friend again. Okay?

[Robin]: ...You're really sorry?

Lissa: Terribly!

[Robin]: ...And you SWEAR you won't do it again?

Lissa: Princess's honor!

[Robin]: ...Well...all right. In that case I suppose I can forgive you... Let's just shake hands and put this silliness behind us.

Lissa: Thanks, Robin! You're the bes... AAAAAUGH! Wh-what is that, in your hand?! It's a sna... A sn-n-n...

[Robin]: A snake? Oh, no, Lissa. I'm pretty sure this is a worm. ...Gotcha!

Lissa: Gya! I thought my heart was going to jump out of my throat! You're terrible, Robin! AND a total hypocrite!

[Robin]: Uh huh... Why don't you show me what's in YOUR hand?

Lissa: O-oh! What? ...This? Hee hee... Why, how did this frog get here...?

[Robin]: ...Sorry, you were saying something about hypocrites?

Lissa: Aw, it's no fun if you see it coming!

[Robin]: I'd have to be blind not to at this point.

Lissa: Oooooo! Next time I'm gonna prank you good!

[Robin]: And next time I'll seriously stop talking to you.

Lissa: What?! Oh...fiiiine! Fine! I guess I'll stop. For real this time. *Sigh* Guess I still have a long way to go...

[Robin]: Till you grow up?

Lissa: No, to the pond! ...I've got about a dozen frogs to put back.

[Robin]: *Grooooaaan*

■ LISSA X AVATAR (MALE) [ROBIN] S

Lissa: *Sigh* I thought "dying of boredom" was just an expression...

[Robin]: All those pranks, and you're still bored?

Lissa: Oh, hi, Robin. Yeah, it's not that much fun messing with the others... Their reactions are all quiet and stale and...blaaah. I mean, they just stare, or sigh, or walk away shaking their head... Nobody else does that rubbery thing with their face that you do.

[Robin]: I do a rubbery thing with my face?

Lissa: But don't worry! Your safe. A promise is a promise, after all. I'm not thrilled about it, but I don't want you to hate me. So...no more pranks.

[Robin]: *Sigh* All right, Lissa. I give you permission to prank me again. I won't hate you for it, I promise.

Lissa: Wait, really?!

[Robin]: BUT! On one condition... You have to open this box first.

Lissa: Ha! No way, mister! I know this trick! A bunch of snakes or bugs or guts or whatever is gonna pop out!

[Robin]: ...Perhaps. It's up to you. I'm not forcing you.

Lissa: Hmm... I'm scared, but... Gya, that thing with your face, I miss it SO much! Okay then. Here goes... YAAAAAH!

[Robin]:

Lissa: A...ring? Wait, Robin, what's going on?

[Robin]: I...love you, Lissa. I love your loyalty, I love your candor, I love your spirit... Gods bless me, I think I even love your pranks! So...what do you say? Will you be my wife?

Lissa: *Sniff*

[Robin]: Are you crying? Don't cry! I'm sorry! You can say no; it won't hurt my feelings!

Lissa: No, stupid! I'm happy! I just... I've loved you for so long!

[Robin]: What?! Really? ...Since when?

Lissa: Yes, really! And since the very beginning! ...I only pranked you to get your attention. Chrom gets to be close to you all the time, when you meet, or when you talk strategy... But I didn't have anything like that...

[Robin]: Lissa, you could have talked to me about anything, anytime... I can't believe I never noticed...

Lissa: Me either... But now we've got all the time in the world to spend together! Oooo! Plus I opened the box, so I get to prank you again, right?!

[Robin]: ...I thought the dramatic pause was just to get my attention. And if we're getting married, I'd say you got my attention. Sooo...

Lissa: You think I'm going to marry that face and never make it do that crazy rubbery thing?! You're nuts!

[Robin]: What?! Hey! I'm not sure I... Ah, well. If that's what it takes to make you happy...then so be it. Just go easy. We won't have all the time in the world together if I die of a heart attack.

Lissa: Heh ha, okay, I promise, Robin. Wow, what a day... You must be tired out from all the excitement! Sooo...how about a quick shoulder rub from your new wife-to-be, hmm?

[Confession]

Lissa: Oh my gosh, this ring is huge! Oh, we're gonna have such a great life together.

Frederick

■ FREDERICK X AVATAR (MALE) [ROBIN] C

Frederick: Your grip, stance, and breathing are wrong. Focus, Robin. ...Again!

[Robin]: Ready!

Frederick: That's enough for today. Your form has improved considerably. The pace of your progress is remarkable.

[Robin]: Huff, huff* Th-thanks... I feel like...I've got the basics *huff* down now... But... S-so tired..."huff* I think I'm dying...

Frederick: Ha! You're exaggerating! Or at least I pray so. Otherwise you might as well die here—you won't last long on the battlefield.

[Robin]: I suppose...but I'm exhausted nonetheless... But you... You've hardly broken a sweat?

Frederick: I should certainly hope not. If a little training winded me, I would be in no shape to serve Chrom.

[Robin]: I'm impressed. You must train hard to build such endurance.

Frederick: Well, I awaken before dawn each day to build the campfires... Then, whenever we march, I scout the trail ahead, removing rocks and such... Wouldn't you want to have someone turn an ankle mid-campaign, now would you?

[Robin]: (So that's why... I always thought it was just a fixation with pebble collecting...)

Frederick: Beg pardon, did you say something?

[Robin]: Er, nothing important! But I owe you for this training session, so let me help you with tomorrow's fire. It'll be a snap with my magic. Find a tree, hit it with a lightning bolt, and presto!

Frederick: ...Instant forest fire.

[Robin]: Oh! Well, yes, I suppose that...could happen... In any case, I do still owe you a favor. Whatever you like—name it and it's yours. You needn't decide today, of course. Think it over for the next time we meet.

Frederick: I am unaccustomed to asking favors, but if you insist, I will think of something.

■ FREDERICK X AVATAR (MALE) [ROBIN] B

Frederick: Hello, Robin. I've thought about your previous offer.

[Robin]: The favor? Oh, good! What'll it be? Just say the word.

Frederick: I recall seeing you eat bear with great relish shortly after we first met. I should like you to teach me this skill. ...Eating bear, that is.

[Robin]: I remember that night! Lissa was in a froth. Said it smelled like...old boots, was it? Wait, so you didn't eat any, either?

Frederick: For I fear I've rarely been able to choke down wild game, and bear least of all. But as the war grows harsher, I can no longer afford to be picky. There may come a day when bear is the only food available to us. Best I train to overcome my aversion now, when our situation is not so dire.

[Robin]: True, and even the finest knight isn't much use on an empty stomach... All right then, you're on. Let's get you eating some bear!

Frederick: Yes, I will train till I can stomach anything, without concern for taste or decorum. Like an animal, or a savage... Or like you, Robin.

Frederick:

[Robin]: Er, Frederick? ...Did I say something wrong?

Frederick: Um, no, nothing. Don't worry about it. So, Frederick. You don't have a problem with more common meats, do you?

Frederick: Beef and pork are fine. I also enjoy a good chicken on occasion.

[Robin]: Then let's start simple. Take a bite of this jerky.

Frederick: I shall tear into it with gusto! *munch, munch* B-gamey! G-so gamey! What... *cough* What IS this?!

[Robin]: It's bear. Leftovers from the same bear we ate that night, in fact! I saved some.

Frederick: Eeaaaaaagh! Healer! I need a healer!

[Robin]: Animal or savage, indeed. How rude of him... Guess he wasn't joking about his aversion to bear, though...

■ FREDERICK X AVATAR (MALE) [ROBIN] A

[Robin]: Hey there, Fredericson! I've got some new cured meat for you to try...

Frederick: I'll thank you not to refer to me by that ridiculous name. And I'm not so gullible as to fall for your bear-jerky trick twice.

[Robin]: Oh? I thought you were serious about getting over this, Frederick. Look, I prepared a whole series of meats in order of gaminess. We can take it slow.

Frederick: ...Well, I suppose I did ask for this.

[Robin]: All right then. We'll start with chicken, then pork, then beef.

Frederick: *Munch, munch* ...Hmm, excellent so far.

[Robin]: Next is mutton. It starts to get a little tricky here.

Frederick: *Munch, munch* ...This is...manageable.

[Robin]: You're doing great! Okay, this one's venison.

Frederick: *Munch, munch*

[Robin]: ...By which I mean bear.

Frederick: PFFFFFFFT! Augh! By the gods! I'm d-dying! Dying! Ah... It's-so dark... T-tell Chrom that...

[Robin]: Oh, stop exaggerating! Otherwise you might as well die here—you won't last long on the battle...field? Whoa. I just had intense déjà vu.

Frederick: I said the same to you, once upon a training session. And I was right. If I succumb to this, I can't well protect everyone on the front lines... My body is ready, Robin! The next sample, if you please!

[Robin]: You talked yourself back into it? Impressive. And perhaps a little disturbing... Ah, well. Whatever works. Let's finish this, Frederick! Open wide!

Virion

■ VIRION X AVATAR (MALE) [ROBIN] C

[Robin]: So if the cavaliers spread out in a fan... And the pegasus knights sweep in from the flank...

Virion: Goodness, I can practically see smoke rising from your head. Whatever could have you working at such a fevered tilt?

[Robin]: I'm practicing strategies and scenarios on this game board. After a hundred forced marches, these pieces are still ready for them. It saves me from running everyone ragged with training exercises.

Virion: How very clever. You even carved little enemy forces for them to fight. I'm impressed. And that doesn't happen often...with other people, I mean.

[Robin]: Well, as long as I control friend and foe alike, it's not as effective as I'd prefer. After all, I can't plan for the unexpected when I know all the moves ahead of time.

Virion: Then permit me to be your opponent. I shall strike with the nobility of the lion and defend with the grace of the swan!

[Robin]: Because swans are...good defenders? Er, never mind. I accept. So even. We'll take turns moving units until one of us claims the other's commander. Agreed?

Virion: Agreed and agreed again! Oh, what fun! ...Begin, please. If you dare.

[Robin]: Hold! I need to retract my last move.

Virion: Ha ha! Were that all enemy generals so generous! But alas, this is war. ...Checkmate, my good sir.

[Robin]: ...Blast! I hate to admit it, but I am well and truly beaten.

Virion: Oh ho! I told you I was both a lion and a swan, did I not?

[Robin]: More like a chicken and the far end of a horse! You're no noble lord, but your strategy wasn't exactly what I'd call honorable.

Virion: Heavens! Aren't we plainspoken.

[Robin]: Still, I appreciate the practice. Thank you, Virion.

Virion: If you wish to unleash my dishonorable strategies again, you have but to ask.

■ VIRION X AVATAR (MALE) [ROBIN] B

[Robin]: Ho, Virion! Care for a rematch? I've found a method to defeat you this time for certain!

Virion: Oh? How thrilling! I do so love a challenge. Though I do recall you saying something similar before the last 20 attempts... One moment. You're not, by any chance, losing on purpose, are you, sir? I see now! This was all a ruse to spend more time with your noble Virion! Charming, I suppose, but I fear my heart has room only for the fairer sex.

[Robin]: And my heart has no room for a grown man in a bib.

Virion: B-bib?! Now see here, you uncouth barbarian! This is a CRAVAT! This is the very height of fashion among sartorially minded nobility.

[Robin]: ...Sounds fancy. Your move.

Virion: Gya! I can forgive ignorance, but sarcasm is another matter! You've made a mockery of the delicate art of hollow flattery! I demand satisfaction on the field of battle, sir. Have at you!

[Robin]: Do your worst!

[Robin]: Blast and blast again! Why can't I beat you?!

Virion: It seems my cravat is vindicated.

[Robin]: I'll not speak to your fashion sense, but you have a real knack for strategy, Virion. Perhaps you should be giving the orders instead of me.

Virion: Inadvisable, my dear lad. I fear we'd never last the war. Spare a second glance at the board and tell me: Who has more soldiers left alive?

[Robin]: Ah...

Virion: I won, yes, but at what cost? Half the moves I made in this game could never be used in a real battle. My own men would have my head on a pike before the enemy even reached me. No, this army needs a tactician who loathes the sacrifice of even a single man. It needs you, Robin.

[Robin]: Virion? That was almost...kind. Perhaps even sensible. Are you feeling well? You're starting to sound like a normal person.

Virion: I am ever the definition of sensibility. And "normal" is just another word for "common," thank you very much! Still, I'm confident you'll come to share my uniquely elegant sensibilities with time. Why, people shall think us twins!

[Robin]: I'd sooner you put an arrow through my head...

■ VIRION X AVATAR (MALE) [ROBIN] A

[Robin]: *Sigh* I lose. ...Again.

Virion: It was your gambit with the wyvern rider seven moves back that doomed you.

[Robin]: ...Ah, I see. Because that left my vanguard's flank exposed. You really are excellent at this, Virion. I just can't compete.

Virion: Nonsense! Why, you're winning almost one match in three as of late. The pace of your progress is frankly somewhat frightening.

[Robin]: Any strides I've made have been due to your patience. Thank you for working with me. I've really come to look forward to our matches. The sad part is, unless I manage to best you at least once, I have trouble sleeping!

Virion: Do not feel ashamed. You're not the first to be vexed by my tactical prowess! But I am happy to be of service, even if it is as your personal jousting dummy. If our matches help ease the burden you carry, then it is my honor to continue them.

[Robin]: ...And I am burdened, Virion. Sometimes I feel as if I could drown on dry land. The army relies on me to plan their every move and tactic. I lack the experience for such responsibility. It's enough to make a man free in terror.

Virion: And yet here you remain, when a lesser soul might have turned craven and ran. Such actions have earned you the respect of us all, you must know that? And regardless of this game, your skill on a true battlefield approaches genius. It needs you, Robin.

[Robin]: I don't know what to say... Thank you, Virion. I'll do my best to remain worthy of your trust.

Virion: And I shall strive to aid you in all things, my friend.

Sully

■ SULLY X AVATAR (MALE) [ROBIN] C

Sully: Ah, crap. Come on, Sully, get your damn act together...

[Robin]: Sully? What are you mumbling about? ...And why are you holding your side? Is everything all right?

Sully: I'm fine! It's nothing! ...Leave me alone!

[Robin]: You look anything but fine, Sully. You're not hurt, are you?

Sully: No, I... All right, I put on weight and my muscle mass is down. You believe that? We're fighting a war, and I'm getting a gut.

[Robin]: What? Are you sure? You look great to me—same as ever.

Sully: Then you aren't looking hard enough.

[Robin]: Well, this is a side of you I've never seen.

Sully: The hell you talking about?

[Robin]: Well, I just...didn't think you were the kind of person to worry about her figure.

Sully: Gods, but you are a blooming ninny. This isn't about LOOKS! I said my muscle mass had dropped! And that's going to affect combat, which could get my arse KILLED!

[Robin]: Eeeep! I mean, um, yes! Of course! I get it! ...P-please don't hurt me...

Sully: Hurt you? Why in the hell would I do that?

[Robin]: *Ahem* Well, if you ARE worried about weight redistribution, I may have a solution...

Sully: *Sniff* Gods, it smells like horse slop! What is it, some kind of jerky?

[Robin]: It's a rare form of dried seaweed, actually. I bought it back in town. The shopkeeper said it contained "insane quantities of fiber." He just kept saying "insane" and cackled while doing a little dance. ...So an odd fellow, really.

Sully: Hmm... Sounds risky.

[Robin]: Well, I know how brave you are...

Sully: Is that a dare? Fine then! I'll try it!

[Robin]: Great! To tell the truth, I've put on a few pounds myself lately... I've been meaning to try the seaweed but was too scar—er, busy! Too busy.

Sully: HA! Too much pie—that's your problem! All right then, [Robin]. Let's see who can get in shape faster!

SULLY X AVATAR (MALE) [ROBIN] B

Sully: Nnngh... Yearrrgh.

[Robin]: S-Sully? Oh, gods, Sully, what's wrong?! You look like a corpse! So worn out and thin! ...And your skin—it's GREEN! Have you been poisoned? What have you eaten lately?!

Sully: J-just the...dried seaweed...you gave me... Ate the...whole bag...last night... Oooooo... Un-nngh...

[Robin]: Wait...did you say... the WHOLE bag?

Sully: Is...that bad...?

[Robin]: Sully, you're supposed to tear off a tiny piece and rehydrate it with water first. The chunk I gave you was a month's supply. If you ate the whole thing... Oh, dear heavens. Your poor bowels!

Sully: Kill... Kill... you...for this...

[Robin]: Sully, I am so, so sorry! I should have explained in more detail!

Sully: Grr... My own...d-damn fault, taking...short-cuts... But I won't...make that mistake again... Gonna start training... Rebuild muscles... Soon as I'm better...

[Robin]: You must let me help you somehow. I just feel so awful about this.

Sully: Well... I don't know... Maybe... Oh g-gods... Here it comes again... HPPPMF!

[Robin]: ...Yikes, that did not sound good...

SULLY X AVATAR (MALE) [ROBIN] A

Sully: Hah! Yaaah!

[Robin]: Looking good, Sully! Feeling better, I take it? And just LOOK at those muscles! I'd say your training's paid off.

Sully: I'm getting there. Still got a bit of flab right here though.

[Robin]: Where? Here?

Sully: Hey! Hands off the merchandise!

[Robin]: Um, Sully? That's not fat. That's loose skin.

Sully: Huh?

[Robin]: I knew something was weird when you told me you were worried about getting flabby. You train harder than anyone I know.

Sully: Skin, huh?

[Robin]: It's probably a result of the seaweed. You lost a lot of weight during your trial, and the muscle is still filling in. Give it another week of combat and eating right, and it'll disappear soon enough.

Sully: Huh. I guess that makes sense.

[Robin]: Trust me. You're in perfect shape. I should know—I've been training with you all week!

Sully: Huh ... Well, all right then.

[Robin]: I guess that means you win our contest. My belly hasn't shrunk an inch.

Sully: Well, just don't go trying any of that damn seaweed! Har har har!

[Robin]: Er...heh heh heh, n-no, that would be a foolish thing to— HuuuRRRRRGH?! ...Uh-oh.

Sully: Oh, don't tell me... You ate the seaweed?!

[Robin]: Y-you kept getting...skinnier... I h-had to...catch up...

Sully: You idiot! You saw what that stuff did to me!

[Robin]: N-no, you're... Urk! You're right... S-s-so right... Gotta go! *GURRRF*

Sully: Yikes, that did not sound good...

SULLY X AVATAR (MALE) [ROBIN] S

Sully: Feeling better, [Robin]?

[Robin]: I think the storm has passed, thank goodness. Plus all the training's starting to finally pay off! My muscles are hard as rocks! Just look at them! Rrrrrr...

Sully: Whoa, that IS impressive. Hey, and check out my skin! It's all back to normal! See? Feel it!

[Robin]: Er...

Sully: ...What?

[Robin]: N-no, I just... L-last time I touched you, you threatened to take my hands off.

Sully: Yeah, well... Maybe I don't mind quite so much now.

[Robin]: No...? In that case, maybe it's time I gave you this...

Sully: ...A ring? Are you... Are you proposing to me?

[Robin]: I love you, Sully! I can't think about anything else! When we started out, I just saw you as this intimidating stranger... But the more we trained, the more I saw what an amazing person you really are.

Sully: ...I see.

[Robin]: So, wh-what do you say?

Sully: ...I guess I've been thinking about you a lot as well, [Robin]. Heh, even as I was cursing your name for that damn weight-loss seaweed... Of course, you giving it to me didn't hurt either, heh heh... What I want to say is...I feel the same way. So yes, I accept.

[Robin]: YES! Oh, I'm so happy! I can finally quit all these workouts. And what do you say, shall we have a few pies to celebrate?

Sully: OH NO YOU DON'T!

[Confession]

Sully: I...ah... I love you, you bastard. There, I said it. Now don't ask me again!

Vaike

VAIKE X AVATAR (MALE) [ROBIN] C

[Robin]: ...Vaike? What are you up to out here?

Vaike: Eh? Me? Up to? Nothin'! Yessir, just a whoooole lot of nothin'. Oh, lookie there!

Pretty flowers! I sure do love me a pretty flower, don't you? Yep! Love 'em. All of 'em! ...Say what's your favorite flower, [Robin]?

[Robin]: ...Okay, now I KNOW you're up to something.

Vaike: Har har! Nope, not me! Just lookin' at all them pretty flowers is all. Nice, ain't they?

[Robin]: Liar. You're trying to see who's bathing in the spring over there.

Vaike: S-spring? There's a spring? Why, I had NO idea!

[Robin]: Don't play dumb with me, Vaike! Now stop leering and get back to camp.

Vaike: Aw, come on now! You're a man! You know how it is! Don't you ever—

[Robin]: No, I don't. ...Thank the gods.

Vaike: Right little goody two-shoes, ain't ya? Interrupting my fun just when... Oh, fine. Guess I'm done lookin' at flowers. But don't think you can keep me— Huh? What's that?

[Robin]: That's Sully's horse isn't it? Gods, but it's a fierce-looking brute. Do you see how it's glaring at us? It's almost as if it thinks...

Vaike: IT'S GONNA CHARGE! RUN! RUN FOR YOUR LIIIIIIFE!

[Robin]: B-but I didn't do anything! Gyaaaaaa!

VAIKE X AVATAR (MALE) [ROBIN] B

Vaike: Har! It's the Vaike's lucky day! Sully's horse is dozin' away, and that meddling little—

[Robin]: Meddling little...what?

Vaike: Blast! You again? Er, I mean... Oh, look! A four-leaf clover! Lucky me!

[Robin]: For that lie to work, you actually need to have a four-leaf clover. You were spying on bathing women again, weren't you?! Don't deny it!

Vaike: I DO deny it! ...Besides, what are YOU doing skulkin' around the bushes?

[Robin]: I was collecting elderberries. For tea. Not that it's any concern of yours! Now keep your voice down! You might wake up Sully's devil steed.

Vaike: What do you care if it wakes? I'm the one he's got it in for.

[Robin]: Not anymore, thanks to you! Ever since that time I caught you snooping, the beast has made me its sworn enemy. If I get within half a league, it's after me like a hound from hell!

Vaike: Har har! So the beast has the evil eye for Lord Goody Two-Shoes himself? There's a word for that... What is it... Tip of my tongue... Oh, I know! ...IRONIC! HAR HAR!

[Robin]: Frankly, being tarred with the same brush as you is punishment enough. In any case, neither of us want to be here if that horse wakes. Come on, let's get back to camp.

Vaike: ...Curses, I truly thought today was going to be the Vaike's lucky... Wait. That evil horse—it's gone!

[Robin]: V-Vaike... D-don't turn around... It's right...behind you...

Vaike: It's...b-behind me? ARRRRRRRRRRRGH! RUUUUUUUN! FOR THE LOVE OF ALL THAT'S GOOD AND HOLY, RUUUUUUUUUUUUN!

[Robin]: WHY MEEEEEEEEE?!

VAIKE X AVATAR (MALE) [ROBIN] A

[Robin]: Hey, Vaike. Why the long face?

Vaike: ...Oh. Hello, [Robin]. So, uh...I've been thinkin'. The Vaike's caused ya a lot of grief. I feel bad about it.

[Robin]: It's not like you to be so introspective. Why does it worry me...

Vaike: Well, I was having a bath—you know, down by the spring—and well... These ladies appeared outta nowhere and started pointin' and laughin' at poor Teach! I was stark naked, with my clothes hung up on the far side of the creek! I reckon they were gettin' revenge for those times I...accidentally spied on 'em.

[Robin]: Huh.

Vaike: And that blasted horse was there, grinnin' like a rabid crocodile! It was humiliatin'!

[Robin]: Well, that does sound unpleasant. Even if you only have yourself to blame. One might even call it...it, what's the word? Ah, yes: ironic! In any case, can we please assume that you've finally learned your lesson?

Vaike: Yeah, now that I know what it's like to be the victim, the Vaike's spyin' days are over.

[Robin]: Good. I think when you look back on this later, you'll be glad it happened. But, come. No use moping about what's done. The Shepherds need their Teach. They need his passion and his willingness to take on anything or anyone, damn the odds!

Vaike: Har har. Now that's the truth! ...You're all right, [Robin]. A good friend through and through.

[Robin]: You...consider me a friend?

Vaike: Darn right! You're in the Vaike circle of trust. Not many folk earn that privilege! ...But now that we're friends and all, that means we can ask each other favors.

[Robin]: Favors? Well, I suppose if there's something—

Vaike: I've given up spying, but I owe those girls a good scare! No one makes a mockery of Teach and gets away with it! So put your thinkin' cap on and brew up some kinda revenge scheme, okay? Maybe some way to dump puddin' on their heads or somethin'.

[Robin]: Pudding, Vaike? Honestly?

Stahl

STAHL X AVATAR (MALE) [ROBIN] C

[Robin]: Now, what would he want more than anything? Hmm... Maybe a sword? Wait, what am I thinking? He already owns the most treasured sword of all...

Stahl: Heya, [Robin]! You thinking up a birthday present for old man Chrom?

[Robin]: He's hardly "old," Stahl... But yes, I am. And to be honest, I'm at a bit of a loss for ideas.

Stahl: Ha! Isn't that a pickle!

[Robin]: Buying for royalty would be hard enough, but we're in the middle of a war. It'd have to be small, to transport easily with the caravan, and nothing excessive...

Stahl: Yeah, cheap is good. Chrom's never been much for gold and glitter, anyway. I was actually thinking of brewing up a special concoction for him.

[Robin]: You mean like a potion or tonic? I didn't know you dabbled in such!

Stahl: My father was an apothecary, and he taught me the trade.

[Robin]: Homemade gifts are always the best! Would that I possessed any such talents...

Stahl: Er, say. My ingredients are quite costly and difficult to find in the wild...

[Robin]: Perhaps I could help gather them?

Stahl: Yes, exactly! Then the present could be from the both of us.

[Robin]: Perfect! We can solve both our problems in one fell swoop.

Stahl: Then it's a deal!

STAHL X AVATAR (MALE) [ROBIN] B

[Robin]: Chrom loved the gift, Stahl! Thanks so much for letting me chip in.

Stahl: Not at all! I should be thanking YOU. I doubt I could have afforded everything without your fat purse!

[Robin]: Oh, come now. Don't think I'll fall for that old trick... You helped me and just made it seem like I was helping you. I don't know how you do it, but I'm grateful nonetheless!

Stahl: Heh. I guess I've always been good at reading people. Even when I was young, I could tell what folks wanted before they even said it. It's not much of a secret ability, but it's the only one I've got!

[Robin]: On the contrary, I think being sensitive to others is a precious skill indeed.

Stahl: I don't know if I'm sensitive, exactly. I just find it easy to read people. You'd be amazed how much you can read from a face, if you know what to look for.

[Robin]: And you can always read these thoughts?

Stahl: Absolutely!

[Robin]: Stahl, that's a remarkable talent! Truly.

Stahl: Ha! Not at all! It's just the coping mechanism of an overly dull man.

[Robin]: Reading thoughts from faces or gestures? That's every bit as impressive as magic. I bet you're always one step ahead of your rivals, on the battlefield and off.

Stahl: Hmm... I guess it has saved my skin a time or two.

[Robin]: Like how you read my mind when I was wondering what to get Chrom...

Stahl: Er, actually, that time, I just overheard you talking to yourself.

[Robin]: Was I? Oh! Ah ha ha...

STAHL X AVATAR (MALE) [ROBIN] A

Stahl: *Sigh*

[Robin]: What's wrong, Stahl? You sound a bit down.

Stahl: Well, I apparently need to practice, then! It was supposed to be a sigh of relief. Some friends were in a bit of a row, but I managed to calm the waters.

[Robin]: You're always doing things like that, aren't you? Helping others with their problems. Most of us are too busy looking after ourselves, but you always find the time.

Stahl: Well, in a way it was for my own sake. Troubled folks make me uncomfortable. When I see friends fighting, my first instinct is to intervene and restore the peace.

[Robin]: Ha! And now you're acting humble and deflecting praise from yourself.

Stahl: Er, sorry. Is that annoying?

[Robin]: Not annoying, no. But you should stand up for yourself from time to time, too. For example, you could start by telling people that today is your birthday.

Stahl: Huh? You knew?

[Robin]: I found out, yes, but not from you! Friends should be able to tell each other that much. War may be raging around us, but that doesn't mean we can't have fun sometimes.

Stahl: I suppose...

[Robin]: You spend so much time looking after other people that someone has to look after you. And I've decided that someone is going to be me! So, here. Have a couple of fried fig cakes in honor of your birthday.

Stahl: Aw, my favorite! Thanks, [Robin]. You're a true friend.

Miriel

MIRIEL X AVATAR (MALE) [ROBIN] C

Miriel: ...How discomposing.

[Robin]: That looked like a pretty bad spill, Miriel. Are you hurt?

Miriel: A minor contusion. Benign.

[Robin]: Everything you were carrying went flying. I see your herbs, some papers, a... What is this? A book? A journal?

Miriel: Unhand that, sir!

[Robin]: Sorry! Sorry. I didn't realize it was so important.

Miriel: Important? Hmm...

[Robin]: Miriel?

Miriel: I suppose it does bear some import, yes. It's a lodestar, of sorts. One that points the way to the truth.

[Robin]: Wow. Who wrote it? A famous mage or something?

Miriel: Not famous at all, no. The author was my mother.

[Robin]: Ah, that explains the rough binding. Er, no offense intended. Still, that's amazing. Was your mother a mage as well? Or perhaps a scientist?

Miriel: What is the impetus for your inquiry?

[Robin]: Impetus for my... You mean, why do I ask? Er, I don't know. ...I'm curious? Wouldn't most people be?

Miriel: An autonomic reaction to conversational stimulus. I see...

[Robin]: Um, did I say something strange?

Miriel: Curious, perhaps. Meriting closer study, certainly. Spontaneous reactive curiosity. Fascinating. But what is the underlying mechanism?

[Robin]: ...I really think you're reading too much into this.

MIRIEL X AVATAR (MALE) [ROBIN] B

[Robin]: Oh, blast! My item pouch is gone. I must have dropped it somewhere...

Miriel: Is this the object in question?

[Robin]: Ah, yes! My thanks, Miriel. I keep it tied to my belt, but it's always falling off for some reason.

Miriel: Such actions are indicative of a pervasive downward force exerted on the object. My mother's book contained a passage espousing a similar theory...

[Robin]: So, um, can I have my pouch back now?

Miriel: ...Ah, yes. Here is the relevant passage in question: "On all objects there acts a force which pulls them ever groundward. Though invisible and without apparent cause, it exists nonetheless. I posit that it is by this principle we remain rooted to the ground." ...Most intriguing!

[Robin]: ...Miriel? ...Hello?

Miriel: ...Yet birds fly unencumbered by this force. The sun and stars and clouds do not fall. What explains these exceptions?

[Robin]: Miriel? Miiiriel? MIRIEL!

Miriel: Wah!

[Robin]: S-sorry! ...Didn't mean to startle you.

Miriel: My respiratory functions ceased for a moment. This is very disruptive. Please do not scatter my thoughts further.

[Robin]: Er, sorry...

Miriel: I require a period of quiet solitude to marshal my thoughts. Farewell.

[Robin]: Wait! My...pouch...

MIRIEL X AVATAR (MALE) [ROBIN] A

Miriel: So, given these conditions, a body with a mass of X falls at a rate of Y...

[Robin]: Um... What are you doing with my item pouch, Miriel?

Miriel: Experimenting in an attempt to establish a unified theory of falling. Whether thrown, catapulted, or dropped from great heights, it falls to the ground. The results have been consistent across hundreds of trials.

[Robin]: H-hey! I had a lot of fragile things in that pouch! Potions and baubles and... *Sigh* ...You know what? Keep it.

Miriel: Thank you.

[Robin]: Sometimes I wish you'd show half as much interest in people as you do in science.

Miriel: Well, I am interested in certain people. You, for example.

[Robin]: Me? Why me?

Miriel: You have a virtuosic proficiency in strategy, despite your amnesia. It is truly fascinating. From this, we can extrapolate two possible hypotheses. One: talent is wholly independent from memory and experience. Two: memories and experience related to the use of one's talents cannot be lost.

[Robin]: Miriel? Are you still talking to me?

Miriel: I am now, yes.

[Robin]: Er, you're not going to tell me not to disrupt your thoughts again?

Miriel: I can if you wish it.

[Robin]: N-no, thanks. I'm just happy to know I wasn't a bother, I guess.

Miriel: That would be difficult. You are the focus of intense interest on my part.

[Robin]: O-kay. I just don't like to think that I'm bothering a friend. That's all.

Miriel: I was unaware that our interactions had acquired the label of friendship.

[Robin]: Why not? I think it must have happened somewhere along the way, right? ...No?

Miriel: Fascinating...

MIRIEL X AVATAR (MALE) [ROBIN] S

Miriel: Might I have a moment, [Robin]? The pouch you donated to my research the other day contained...this.

[Robin]: Ah!

Miriel: Judging from the toroid shape and material properties, it is some manner of ring. Quite beautifully crafted, if naive in design. Is this your handiwork?

[Robin]: Oh, no. I bought it in town a ways back. It was too pretty to pass up. I figured if I ever found someone to marry, I could...give it to them.

Miriel: Ah. My apologies, then, for not returning it to you sooner.

[Robin]: Er... Actually, how about... How about you keep it?

Miriel: Are you certain? ...But you claimed it a ring you would give your future wife?

[Robin]: Yeah, that's... That's kind of my point, actually.

Miriel: I see. The ring is for your wife, yet you give the ring to me. Ergo, I would be your wife.

[Robin]: Well, that's one way to think of it, sure... But yes, that's the idea.

Miriel: How interesting. No concrete boundary demarcates the entrance to friendship, yet the spousal relationship is strictly codified with explicit cues and rituals? ...Very well. From this moment on, the transitive property holds that I am yours.

[Robin]: You do have a choice in the matter, you know?

Miriel: I'm well aware of this. Call it spontaneous reactive affection. Or an autonomic reply to emotional stimuli. Or perhaps it's an invisible, inexorable force that draws me to you. Whatever the

causation, I suspect I've fallen for you. ...Ah! This calls for a new unified theory!

[Robin]: Heh, well we've got the rest of our lives to figure it out. (...And the rest of my life to try and understand what the heck you're saying.)

Miriel: Yes! Let us begin the experimentation immediately.

[Confession]

Miriel: What rapture... To have an astute significant other with whom to scrutinize this world's illimitable mysteries!

Kellam

KELLAM X AVATAR (MALE) [ROBIN] C

[Robin]: The others claim it's a ghost, but I refuse to put stock in such things.

Kellam: WAAAAAAAAAAH! ...Oh! It's you, Kellam. You surprised me.

Kellam: Sorry. You looked a little worried... I just wanted to see if you were all right.

[Robin]: Well, there IS something troubling me... The men are reporting strange incidents—baffling phenomena that defy explanation.

Kellam: Goodness! Like what?

[Robin]: Well, for example, whenever a group of us gather, drinks materialize on the table. Also, there's always one more cup than people present. But everyone denies that they brought the cup or served the drinks! It's most peculiar. So peculiar, in fact, that some are claiming it's the work of spirits...

Kellam: It's not a ghost.

[Robin]: Oh, of course it's not. I just don't know what it could possibly—

Kellam: It's me. I serve the drinks.

[Robin]: You? ...But wait. Why would you bring one cup too many?

Kellam: That's my cup. I guess it's just that no one ever...notices me.

[Robin]: What?! That's almost as absurd as the ghost theory!

KELLAM X AVATAR (MALE) [ROBIN] B

[Robin]: La de dah de dum... ♪ Shanty Pete danced on a barrel of rum... ♪ Oh, hullo?! Where did this drink come from? ...Kellam, are you there?

Kellam: Right here. ...In front of you.

[Robin]: Ah, yes, of course—now I see you. Thank you for the drink!

Kellam: I didn't want to interrupt while you were humming. Sorry...

[Robin]: N-hey! I was just taken aback when the cup seemed to appear by my elbow...

Kellam: Um, yes. Sorry...again...

[Robin]: You know, Kellam, if you want people to notice you more, you should speak up.

Kellam: Oh, I'm not looking to be noticed. Not especially, anyway.

[Robin]: Well, if that's your plan, I have to say you are succeeding brilliantly.

Kellam: Plus whenever I do speak, people start screaming about hearing voices... At least, that's what happened at dinner last night...

[Robin]: Heh, so that WAS you? Half the camp refused to come out of their tents for fear of the "ghost"!

Kellam: Sorry!

[Robin]: Stop being sorry! It's their own fault for being such superstitious hens.

Kellam: Yes, but I understand now why people react so strangely whenever I do them favors. Next time I bring tea for everyone, I'll be sure to shout what I'm doing. And I'll try to stop standing sideways... Or in shadows. Or behind barrels...

[Robin]: Splendid idea, Kellam! That's the spirit! We'll get you noticed yet.

KELLAM X AVATAR (MALE) [ROBIN] A

Kellam: Eh? A slice of crowberry pie? What's this doing here?

[Robin]: It's for you, Kellam.

Kellam: [Robin]! Y-you saw me!

[Robin]: The trick is to squint and look sideways. I've been working on it here and there. Anyway, you're always so helpful to everyone else, I wanted to return the favor.

Kellam: ...Thanks.

[Robin]: Not at all. It's the least I can do.

Kellam: Gosh, you really are good to me, [Robin]. I know I said I don't do it for thanks, but it IS nice to hear...especially from you. ...Well, guess I'll be going now.

[Robin]: What in the... How did he DO that?! He just vanished!

Kellam: Er, I'm right over here. Straightening up these axes.

[Robin]: ...Oh, right. Of course. I knew that. It's just that you gave this enigmatic smile, turned to the left, and then...disappeared! Almost as if you'd achieved enlightenment and transcended this mortal plane!

Kellam: ...That's some imagination you have.

[Robin]: Ha ha. Yes, well...perhaps I've read a few too many morality plays as of late. In any case, forget the axes for now—everyone is waiting to see you.

Kellam: Me? ...But why?

[Robin]: They all want to apologize for making such a fuss about the supposed hauntings.

Kellam: ...Oh, um, I don't know. That sounds like an awful lot of attention...

[Robin]: Sometimes, Kellam, we all have to stand up and be noticed.

Kellam: All right. But if I'm feeling shy, I might have to transcend to a higher plane again.

[Robin]: Ah-HA! I KNEW IT!

Kellam: That was a joke! A joke? ...Ha ha ha? ...[Robin]? Why are you backing away from me like that...?

Sumia

■ SUMIA X AVATAR (MALE) [ROBIN] C

[Robin]: That's a lot of books you've got there, Sumia. Are you going to read all of them?

Sumia: Oh, hello, [Robin]! Yes, this IS a lot of books, isn't it? Someone threw them out of a wagon, so I figured I'd give them a good home.

[Robin]: What a good idea! I always find it relaxing to do a little light reading in the evening.

Sumia: Oh, you can borrow some if you want? I certainly can't read them all at once.

[Robin]: You don't mind?

Sumia: Of course not! Here, which one looks good?

[Robin]: I'm not sure. What do you recommend?

Sumia: Let's see... Ooh, this one looks like a real page-turner! "Shanty Pete and the Haunted Pirates"!

[Robin]: Er, thank you, but I don't like to read scary stories before bed.

Sumia: Oh, of course. Well, what about... "A Simpleton's Guide to Pegasus Care"?

[Robin]: I'm not really that into animal nonfiction...

Sumia: Well, maybe third time's the charm. Let's see now... Oh, this looks great! "Wyvern Wars: Terror at High Noon"!

[Robin]: ...Do you perhaps have anything a bit more... literary?

Sumia: ...Oh, pegasus poop! I'm USELESS at this! Useless, useless, useless! Just pick him out a book, Sumia! It's so easy, Sumia! But nooooo! I'm too... darn... USELESS! *Sniff* Waaaaaaaaaah!

[Robin]: Oh, goodness! Please don't cry! I didn't mean to imply... A-actually, the book on "Wyvern Wars"? I've always wanted to read that one! I mean, it has terror at high noon and everything, right? You, uh, can't beat that...

Sumia: *Sniff* R-really? You want that one? Oh, I'm so happy... I hope you like it!

[Robin]: (Pretty sure I have to at this point...)

■ SUMIA X AVATAR (MALE) [ROBIN] B

[Robin]: Here's that book I borrowed, Sumia. It was actually pretty interesting. The encounter at high noon was epic! I stayed up far too late reading it.

Sumia: Oh, I'm so glad you liked it! I'll bump it to the top of my pile.

[Robin]: So, what are you reading now?

Sumia: "Ribald Tales of the Faith War."

[Robin]: I've never heard of it. Is it a novel?

Sumia: Yes. It's roughly based on historical events, but all the characters are made up. And there's lots of... Well, ribald parts. But I suppose that's obvious.

[Robin]: You don't say?

Sumia: Do you like novels, [Robin]? Or are you more of a nonfiction type?

[Robin]: Novels are good. Although I suppose I read a little bit of everything.

Sumia: Oh, I just LOVE a good novel! I get so caught up in them I sometimes forget they're not real. I can pretend to be a knight in shiny armor! ...Or maybe an evil mage. Bwa ha ha!

[Robin]: I know what you mean. I always feel a bit sad when a good story comes to an end.

Sumia: Oh, I know. Then it's back to reality for Sumia! Back to sad, sad reality. Er, but then I think about the next story and get excited all over again!

[Robin]: So then? What are you planning to read next?

Sumia: "Mad Tales of a Bloodthirsty Falcon Knight"! ...Volume one. Of thirty-seven.

[Robin]: Oh. Well, that certainly sounds...like...a thing...

■ SUMIA X AVATAR (MALE) [ROBIN] A

Sumia: Hold, [Robin]! Do you think me insane?!

[Robin]: Well, I didn't...

Sumia: For I see that which others cannot! Demons and devils lurk in shadows dark!

[Robin]: A-are you feeling all right, Sumia? Perhaps I should summon a healer...

Sumia: ...What? Hee hee! Oh, no, I'm fine! See, I'm reading a new book. I was just pretending to be the heroine. Her name is Madame Shambles, and she sees what others cannot in shadows dark! Anyway, I've been saying her lines to try and get inside her head and be more like her. ...Do you think that's weird?

[Robin]: Yes, it's actually very weird.

Sumia: Oh, pegasus dung! I was worried it might be. But see, I thought if I could act like her, I'd maybe become less of a clod.

[Robin]: You don't need to pretend to be someone else, Sumia. You're perfect as you are! ...Well, maybe not perfect. But pretty good. Anyway, if you did end up changing, we'd lose the Sumia we know and love.

Sumia: R-really? Gosh, I never figured anyone would give two hoots. But if YOU'D miss me, [Robin]...

[Robin]: Of course I would!

Sumia: Well, all right then! My next book will be about a girl who's clumsy and plain like me!

[Robin]: Er, I think you're missing the point of—

Sumia: Ooo, wait! Look at this one! "The Princess Who Fell Down the Stairs"! It's PERFECT!

[Robin]: Yes... Yes, I suppose it is.

■ SUMIA X AVATAR (MALE) [ROBIN] S

[Robin]: ...Sumia? I can't help but notice that you aren't carrying a book.

Sumia: I'm done with books! No more make-believe for me! At least, not until I gain more confidence in who I am.

[Robin]: Oh? What brought this on?

Sumia: I realized I was using those stories to run away from myself. Every time I messed up, I'd read a book and pretend I was someone else. Well, that's just not healthy! ...Plus I was running out of books. Anyway, I decided it was time to stop before I became totally hopeless.

[Robin]: You're not hopeless, Sumia.

Sumia: Oh, posh! It's nice of you to say for my sake, but you can be honest with me.

[Robin]: I am being honest, Sumia. I've been thinking of you ever since we started sharing books. In truth I...I think about you all the time. And I've grown incredibly fond of you.

Sumia: Um, are YOU pretending to be a character now? Because I can't believe that—

[Robin]: I bought a ring! ...For you, I mean. I'm a simple man with little in the way of wealth or land or social opportunity. And I certainly can't make you a princess like the heroines in your stories. But I can promise to love you more each day that we are together. Sumia, will you marry me?

Sumia: Oh, [Robin]... I don't need to be a princess! I don't need anything else if I have you! I accept! I accept with all my heart!

[Robin]: Oh, Sumia, I'm so happy! It's like we're in a storybook of our very own.

Sumia: And we'll live happily ever after! I've been thinking of you ever since we started sharing books. In truth I...I think about you all the time. And I've grown incredibly fond of you.

Sumia: Um, are YOU pretending to be a character now? Because I can't believe that—

[Robin]: I bought a ring! ...For you, I mean. I'm a simple man with little in the way of wealth or land or social opportunity. And I certainly can't make you a princess like the heroines in your stories. But I can promise to love you more each day that we are together. Sumia, will you marry me?

Sumia: Oh, [Robin]... I don't need to be a princess! I don't need anything else if I have you! I accept! I accept with all my heart!

[Robin]: Oh, Sumia, I'm so happy! It's like we're in a storybook of our very own.

Sumia: And we'll live happily ever after!

[Confession]

Sumia: It's so nice to feel special for once. To love someone more than anything in the world, and have them love me back...

Lon'qu

■ LON'QU X AVATAR (MALE) [ROBIN] C

Lon'qu: ..."Ahem" ...I cannot focus with you leering at me.

[Robin]: Oh! Sorry, Lon'qu. I just got caught up watching you practice. Your style is a perfect blend of accuracy, power, and speed. They really know what they're doing up in Regna Ferox.

Lon'qu: Strength is everything there. Weakness is weeded out and eliminated.

[Robin]: Would you mind teaching me a few moves?

Lon'qu: ...I am no teacher. Besides, you are of Ylisse. The knights of your people have their own style. You would be better served learning from Frederick.

[Robin]: Oh, I already am. But with the two styles being so different, why not learn what both can offer? It's possible a mix of the two would be stronger than either one alone.

Lon'qu: A naive thought. ...But not impossible. Very well. Draw your sword.

[Robin]: Wait, we're jumping right into sparring?

Lon'qu: I told you, I am no teacher. You will have to learn for yourself. Come! Show me how a man of Ylisse fights! You will not be the only one to learn here.

[Robin]: So be it!

■ LON'QU X AVATAR (MALE) [ROBIN] B

Lon'qu: Here for another round?

[Robin]: Thank you, but no. I'm still recovering from the last one... I'll say this—I'm glad we're not at war with Ferox!

Lon'qu: And I'm far from my strongest. I am...inexperienced, yet. Raw.

[Robin]: I find that hard to believe. You're a beast! But I guess you got where you are now by being tough on yourself.

Lon'qu: No. Just truthful. If you saw what I have seen... If you saw him fight, you would know how far I have to go.

[Robin]: You mean Khan Basilio?

Lon'qu: His command of his weapon lends it a weight. A...depth. I may as well be swinging a feather by comparison. Knowing his power, I would not dare call myself strong.

[Robin]: But he's given you something to strive for. I'm envious.

Lon'qu: If you would grow stronger, find a paragon of your own to pursue. Meanwhile, if you wish to spar, you need only ask.

[Robin]: I will, thanks.

■ LON'QU X AVATAR (MALE) [ROBIN] A

Lon'qu:

[Robin]: Did you need something, Lon'qu?

Lon'qu: It's been too long since we fought. I feared you were neglecting your training, but... Is this mountain of books all treatises on warcraft?

[Robin]: Yes. I have to balance training my sword arm with honing my tactician's eye. We're a small force up against a big enemy. We need to fight smart to survive.

Lon'qu: ...You are a strange one. Strategist or soldier—most men make their choice and do not look back.

[Robin]: Then I choose to be the first man to pick both. I want to keep my friends safe. And the townspeople and everyone else, too. So when my sword won't reach, I'll protect them with my tactics.

Lon'qu: You once said you envied me because you had no one to serve as your goal. Perhaps that's because you aim for heights no man has yet achieved.

[Robin]: Is what I said really so revolutionary?

Lon'qu: What you propose is a tremendous undertaking. ...But a worthy one. A worthy one. I suspect there is much I can learn from you, yet.

Ricken

■ RICKEN X AVATAR (MALE) [ROBIN] C

Ricken: Hrmmm...

[Robin]: Still writing a reply to that letter? You've been staring at a blank page for an hour. Was it bad news? Nothing serious, I hope.

Ricken: No, just an average letter from my parents. "Hope you're well," and all that.

[Robin]: Then why are you so strapped for a reply?

Ricken: It's...tricky. I just don't know what to say.

[Robin]: There're plenty of things you could write about! Especially after that last battle. Tell them about how you dodged one brush with death and the next! Impress them!

Ricken: Are you insane?! The object is to make them worry about me LESS!

[Robin]: Oh. Right. Well, why not tell them about that fight against the Risen? Talk about how you tore them limb from limb and flung the pieces to the winds!

Ricken: But I did no such thing! Besides, that would have them worried about me in a whole other way... See the problem? I can't LIE, but if I write about how things really are, they'll worry. And if I write about how much I miss them, that only makes it worse...

[Robin]: How about just a few words to let them know you're all right?

Ricken: ...I don't know. Maybe I'll just hold off until I do something that makes them proud.

[Robin]: Well, if they could've heard you just now, they already would be.

■ RICKEN X AVATAR (MALE) [ROBIN] B

Ricken: Hmm...

[Robin]: Still haven't written a reply to your parents, have you?

Ricken: Yep. Stuck again. I can't think of the right words to say.

[Robin]: You could always just head back.

Ricken: Head back where? Home?

[Robin]: Why not? Stop by for a quick visit. Spend some time with your family. I'm not saying to drop everything and go home tomorrow, but once things settle down.

Ricken: ...No. I can't go back yet.

[Robin]: Why not?

Ricken: I don't know how much you know about me, but I come from an old, respected house. And lately, my family name—and name—has fallen into serious disrepair. So this war is about more than saving the world, at least for me. It's about restoring my family name. And I can't go home until I've done it.

[Robin]: That's a lot to put on yourself, Ricken. Your parents are lucky to have you. Hard to imagine such a model son running around dismembering Risen and flinging—

Ricken: Stop with the dismembering already! What kind of monster do you think I am?

[Robin]: Ha ha, I'm just teasing. Seriously, though, if you won't visit, you should write. Sparing your parents from worry is part of restoring your family name.

Ricken: Yeah, I know you're right... Okay, I'll keep it real basic. "Dear Mom and Dad, I hope you're well."

[Robin]: "Today I saved the life of my beloved, and the field ran red with the blood of my foes!"

Ricken: "Today I saved the..." ARRRGH! Will you NOT do that?!

[Robin]: I'm helping.

Ricken: YOU ARE NOT!

■ RICKEN X AVATAR (MALE) [ROBIN] A

Ricken: Hey, [Robin]. Would you mind sending this out with the other deliveries?

[Robin]: Letter to the family, eh? So did you finally figure out what to write?

Ricken: I just wrote the truth: that I miss them and hope to see them again soon.

[Robin]: No tales of glory? No brave words? ...No dismemberment?

Ricken: Hah! Not this time. I guess restoring the family name will have to wait a bit longer. I simply wrote that I've come a long way, but there's still more to be done. Not the greatest news in the world, but better than silence, I guess.

[Robin]: But it IS great news! I'm sure it'll put their minds at ease.

Ricken: By telling them how weak I still am?

[Robin]: No, by telling them you know your limits and you're working to overcome them. That's a very mature way of thinking. I'm sure they'll be proud.

Ricken: Heh heh! You really think so?

[Robin]: I guarantee it! You did great, Ricken. Now get over here!

Ricken: EWWW! Leggo! No noogies! Stop treating me like a kid! Didn't you JUST finish saying how mature I was?!

[Robin]: Ha ha! Sorry, it's just that hat and those cute wittle cheeks just begging to be pinc—

Ricken: Come on, knock it off!

Maribelle

■ MARIBELLE X AVATAR (MALE) [ROBIN] C

[Robin]: Crepuscule... Crepuscule... What did that mean again?

Maribelle: Are you studying, [Robin]?

[Robin]: Oh, hello, Maribelle. Just reading up a bit.

Maribelle: Reading up, how lovely. I hadn't realized the lowborn read at all!

[Robin]: Did you just drop by to look down your nose at me, or was there something else?

Maribelle: A noble's nose engages in no such activities! I was sincerely interested. If my turn of phrase offended, I apologize. Forgive me.

[Robin]: Er, all right. I take it back. But was there something you needed?

Maribelle: Yes. I had hoped to learn more about you.

[Robin]: Me? Why me? I'm not that interesting, you know.

Maribelle: Can you fault me for being curious about an amnesiac with a genius for strategy? You've also earned quite a bit of trust from my dear friend Lissa. It's only natural that I'd want to learn more about the stranger in our midst. I simply say that I hoped there could become a...friends. Unless you object, of course.

[Robin]: No, I don't object, per se. But...weren't we already friends?

■ MARIBELLE X AVATAR (MALE) [ROBIN] B

Maribelle: A question about the material we covered yesterday, [Robin].

[Robin]: Ah, you mean about my lessons on the language of the unwashed?

Maribelle: Precisely, yes. I immediately set about to practice what you'd taught me, but... Well, everyone I spoke to looked askance, or avoided eye contact altogether. Others still contorted with glee, as if they were stifling laughter.

[Robin]: Wait, you used that slang? Out loud? In public?

Maribelle: If you hope to communicate with a person, you must first speak their language, no? And the quickest way to internalize new knowledge is to put it into practice!

[Robin]: Yeeees, both of those are technically true. But, Maribelle, when we talked, I... Look. The examples I taught you are reserved for intimate friends.

Maribelle: What?! You knew this and didn't tell me? Did you hope to ruin me?! Wait... So when I told Chrom he was "a right sweet bit'a fruit"...? You mean to tell me that was inappropriate?

[Robin]: I'm sorry! It was all in good fun! I never thought you'd actually—

Maribelle: One moment. If you taught me this slang, then you must consider us intimate friends?

[Robin]: Uh...

Maribelle: I'm afraid I had no idea! I'm flattered, [Robin], truly. In that case, I ought to have begun my practice with you. Forgive me.

[Robin]: No, that's... I don't...

Maribelle: Why so modest, pet? Everythin' luvverly jubberly, ain't it? 'Ave a bit'a rabbit!

[Robin]: MARIBELLE! Stop! Please! I can literally hear everything you stand for screaming and dying in agony! Look, I'll clear things up with everyone. Okay? I'll take the blame. Just please, please, PLEASE promise you'll never talk like that again.

Maribelle: Well, I suppose if it's that important to you...

[Robin]: Thank you.

Maribelle: Hey, no skin off my arse, is it? I'll shut me north and south!

[Robin]: ...Wait a minute. I didn't teach you that. Damnation! Who has done this to you, Maribelle? Who?!

Maribelle: Hm-hm! I'm afraid THAT is my little secret...

■ MARIBELLE X AVATAR (MALE) [ROBIN] A

[Robin]: Er, Maribelle? I have an idea... Why don't we skip the slang lesson today? Instead, maybe you could teach me about the aristocratic life?

Maribelle: Any chance to educate my social inferiors is a chance I will take. Now then! What would you like to know?

[Robin]: Well, you hear people talk about a noble bearing, yes? What is that, exactly?

Maribelle: Well, I suppose it begins with learning to stand properly.

[Robin]: Am I not really standing now? Because it feels like I'm standing.

Maribelle: You have the posture of a damp noodle! The resolute promise of a souffle! A noble stands... thusly. The spine forms a straight line. Pretend an invisible thread pulls your head ever skyward. ...Go on, give it a try.

[Robin]: Let's see. Straight spine... Invisible thread... Like this?

Maribelle: Why are you jutting your chin out?

[Robin]: It happens naturally when I force my head up.

Maribelle: A pauper's instinct! Cast it away!

[Robin]: Is this better?

Maribelle: Your shoulders are raised. Lower them and hold your chest high.

[Robin]: So like...this?

Maribelle: Yes! Just so! There, now. That wasn't so hard, was it? I say, you're quite the apt pupil, [Robin]. With enough practice, you could become a gentleman fit for the highest court! Well, I may exaggerate. Perhaps one of the more middling courts.

[Robin]: You think? Wow, I never—

Maribelle: Then it's settled! I shall make it my personal mission to shape you into a man of high society. I'll instruct you until you're fit to walk with kings! ...Or at least a baron or two.

[Robin]: Er, you really don't have to—

Maribelle: Bup-bup-bup! Nothing is less noble than leaving a task half done! You needn't be shy. We're intimate friends, after all.

[Robin]: Wait... This is revenge for the slang incident, isn't it?

Maribelle: Less talking, more walking! ...ARISTOCRATIC walking, please! Then we will work on ballroom dance and how to properly wield a fork!

[Robin]: Heeeeelp meeeeeee!

■ MARIBELLE X AVATAR (MALE) [ROBIN] S

Maribelle: Well, shall we conclude today's etiquette lesson here, then? You've been very patient, [Robin]. Go on and rest up for tomorrow.

[Robin]: Actually, Maribelle? I was hoping you could teach me one more thing...

Maribelle: Quite the eager student today, aren't we? Very well, what shall we cover?

[Robin]: How to give a present to a lady. ...Specifically a ring.

Maribelle: What? ...Since when is there a lady in your life, [Robin]?

[Robin]: For a while now, actually.

Maribelle: But..."ahem" not a word of it to your dear friend Maribelle? For shame! Name the strumpet!

I'll see that she is... Er... "Ahem" I mean...that's fine. You are entitled to your privacy. But I'm afraid even I can't teach the proper etiquette in this case. For such matters, it's best to set protocol aside and show your feelings honestly.

[Robin]: Oh, good. Come here, then.

Maribelle: ...I beg your pardon?!

[Robin]: Your hand. Give it here.

Maribelle: Wh-what are you... Be gentle!

[Robin]: Aaand, there! ...It looks good on you.

Maribelle: ...A gold band? Forgive me, but what is this, precisely?

[Robin]: A proposal.

Maribelle: As in marriage?! So then the lady was to give it to is...

[Robin]: Wearing it. Heh, when would I have had time to consort with some "strumpet," anyway? Thanks to these etiquette lessons, I've been spending every day with you.

Maribelle: Well, apparently it hasn't been enough—your proposal was most ungainly! But it was also... wonderful. Oh, [Robin], you've made me so very happy.

[Robin]: Then your answer is yes?

Maribelle: Of course! I have the rest of our lives to shape you into my perfect gentleman.

[Confession]

Maribelle: My lord, you saw to the very core of my heart...and may gods help you, if you break it.

Panne

■ PANNE X AVATAR (MALE) [ROBIN] C

[Robin]: Er, Panne?

Panne: What?

[Robin]: Would you tell me more about the taguel? I barely know a thing about them, and I thought... I mean, if you don't mind...

Panne: I do not.

[Robin]: ...Wait, really?

Panne: No, I do not mind. Why do you doubt me?

[Robin]: I don't know, I guess I just didn't imagine you saying yes so easily. I was all ready to argue my case. You kind of took the wind out of my sails.

Panne: Is it I who frighten you so, man-spawn? Or the fact I am taguel?

[Robin]: N-no, neither! Nothing like that. It's just... I thought you might not take kindly to me asking about your people. I know it was humans like me who killed them, after all...

Panne: Humans like you, yes. But not you. You do not bear the blame for what was done, so do not bear the guilt. Guilt creates distance. If you would learn of my people, cast it aside.

[Robin]: All right.

Panne: Mmm. At last you are calm. Your heart has slowed.

[Robin]: You can hear my heartbeat?

Panne: Lesson one—taguel have strong ears. A heart's beat always betrays its owner.

[Robin]: Heh. Remind me never to play cards against you... Oh, I have a meeting, but I would love to know more... Can we talk again soon?

Panne: Of course. It is nice to find someone who is curious about my people.

■ PANNE X AVATAR (MALE) [ROBIN] B

[Robin]: So, do all shape-shifters turn into rabbits, Panne?

Panne: No. There were others, far from here. Tribes of cat-wearers and bird-wearers.

[Robin]: Whoa, I would have loved to see that... I bet they were so cuddly and cute! Er...sorry. I probably shouldn't call a race of proud warriors "cute."

Panne: They were not cute. At least, not like the rabbit-wearers are cute. But then, what is? Nothing.

[Robin]: Heh heh, r-right. So, did you ever meet these other tribes yourself?

Panne: Long ago. How they fare now, I do not know. Perhaps they shared the same bloody fate as my own people...

[Robin]: I... I didn't mean to.

Panne: I am sorry. There is no call for you to share in my gloom. So, another question?

[Robin]: Oh... Um, well, what do you like to eat?

Panne: Taguel eat many things.

[Robin]: No, I mean you, specifically. I'm on kitchen duty tonight—I'll cook whatever you want. It was my being nosey that made you sad, right? Let me cheer you back up!

Panne: You are...oddly kind.

[Robin]: So, let me guess... Carrot stew?

Panne: ...How did you know?

[Robin]: Ha ha, sorry! I know, just because you're a rabbit doesn't mean you... Wait, I was right?

■ PANNE X AVATAR (MALE) [ROBIN] A

Panne: *Sniff* Ah! Is that your famous carrot stew I smell? I hope you don't mind if I sneak a taste before dinner?

[Robin]: No, Panne, wait! That's not for—

Panne: *Sluuuurp*

[Robin]: ...Oh dear. I'm SO sorry, Panne, but I messed up the recipe on that batch. Everybody said it tasted...off. Well, actually they said it tasted like last month's dishwater, but...

Panne: It seems perfectly fine to me.

[Robin]: ...You've got to be joking.

Panne: Taguel never joke about food. Nothing seems off here. It tastes exactly the same as every other time you have made it.

[Robin]: It does?! You mean, ALL the stews tasted like this to you? And you ate them? Taguel taste buds must not work like ours. ...Or at all.

Panne: Would you mind if I had a bowl?

[Robin]: Hey, take the whole pot if you want! No one else will touch the stuff.

Panne: Many thanks. You really are too kind, [Robin].

[Robin]: Soup-er happy to hear you say that, Panne!

PANNE X AVATAR (MALE) [ROBIN] S

Panne: Mmm, that was excellent. Delicious, as always, [Robin].

[Robin]: Not a widely held opinion, but thanks.

Panne: That suits me fine. I get your food all to myself. More warmth for me.

[Robin]: I suppose it is warm, at least... Not a very high bar, is it?

Panne: No. Not that warmth. I mean it warms my heart. I had forgotten what that felt like. I was alone for so long...

[Robin]:

Panne: ...Heh, I am being gloomy again. Forget I said anything.

[Robin]: Panne, I... Here.

Panne: Wait, this is...?

[Robin]: It's a ring, Panne. I want you to marry me.

Panne: ...Marry?

[Robin]: Oh, well... Marriage is when two people promise to stay with each other for life. You mean so much to me. It tears me up to think of you being alone... You've had too much of that already. ...Let me be your family.

Panne: You would do that?

[Robin]: If you'll let me, yes.

Panne: And I would never be alone again?

[Robin]: Not for as long as I lived.

Panne: And will you cook for me every day?

[Robin]: If you want, sure.

Panne: ...I knew you were kind, [Robin]. But this... I'm happier than I believed possible! This is better than the first time I tried your carrot stew!

[Robin]: Well I should HOPE I'm better than that!

[Confession]

Panne: To think that I might love a human... What a strange world this is.

Gaius

GAIUS X AVATAR (MALE) [ROBIN] C

[Robin]: Gaius, I am SO sorry about earlier! I had no idea you were in the bath...

Gaius: Aw, no worries. At least I hadn't taken off my smallclothes yet, eh?

[Robin]: Yes, but...I still may have seen more than you intended.

Gaius: WHAT?! You saw THAT?! Gods, how embarrassing... It's just...uh...some poison oak I got into the other day, I swear—

[Robin]: I'm talking about the tattoo on your arm. It's the one they use to mark convicted criminals, isn't it?

Gaius: Oh, that? Yeah, I got caught once doing a favor for a mate. Paid the price. But, uh, I'd appreciate it if you kept that little nugget under your hat, Bubbles.

[Robin]: ...Did you just call me Bubbles? Er, but don't worry. I won't tell any—

Gaius: You'll tell everyone, you say? So it's to be blackmail, is it? Fine then. I can understand taking an opportunity to line your pockets. You can have my portion of dinner tonight, okay? Will that slake your greed for bear?

[Robin]: Er, one helping of bear is already more than enough, thanks. Also, I'm not blackma—

Gaius: You drive a hard bargain, Bubbles! Very well. Take this custard pie!

[Robin]: ...No, thank you. I'm not—

Gaius: If you are looking for ransom, I can assure you I don't have any money. But what I do have are a very particular set of honey cakes...

[Robin]: Look, I don't want any treats from you, all right?! I'll keep your blasted secret!

Gaius: Whoa, easy there, Bubbles! Here, maybe a little sweet wine will put you in a better mood...

GAIUS X AVATAR (MALE) [ROBIN] B

[Robin]: Gaius? I didn't know you ran a market stall...

Gaius: Oh, sure. I like to get out, meet the common folk, sell the odd trinket... Speaking of which, see anything you fancy? I've got silk smallclothes from exotic ports, genuine leather belts, top-quality figs...

[Robin]: Do you have any books? Strategy books, specifically? I've been hoping to expand my tactical knowledge to better serve the Shepherds. However, I can't find a single volume in these parts. It really is most strange...

Gaius: Strategy books, is it? Wait right there, Bubbles!

[Robin]: Huh? Where'd he go? ...Oh, you're back! That was fast.

Gaius: Take a gander at this lot, and tell me if any of 'em tickle your fancy!

[Robin]: By the... Gaius, this crate is FULL of books! Did you buy every tome in the market?!

Gaius: Sort of. Here, they're yours. Every last one, my gift to you! But that makes us even about the whole "wink-wink" thing!

[Robin]: Gods, but you are pigheaded. For the last time, Gaius, I am NOT blackmailing you! Now please, return these books. I can't take them in good conscience.

Gaius: Oh, I see! Books aren't good enough? Still holding out for something better?!

[Robin]: Sometimes I wonder why I even try... Hey, that's a handsome cloak. Looks warm, too.

Gaius: You like that cloak? I can buy it for you!

[Robin]: GAIUUUUUUS!

Gaius: Guess not!

GAIUS X AVATAR (MALE) [ROBIN] A

Gaius: Here, Bubbles. I got you something.

[Robin]: Is this...a belt? With stones inlaid? Er, thank you, Gaius, but—

Gaius: Yep. Just a plaaaaaain old belt that's worth a big sack of gold down at the market.

[Robin]: Then I must refuse. I can't accept such an extravagant gift.

Gaius: All right, maybe I stretched the truth just a little... It'd be worth a sack of gold IF they paid for sentimental value, see? ...'Cause I made it myself.

[Robin]: YOU made this? But, it's magnificent!

Gaius: Pleased you like it, Bubbles. Makes all the effort worthwhile.

[Robin]: But why did you—

Gaius: Oh, no particular reason! None at all! Just...one good turn and all that.

[Robin]: You're trying to bribe me again, aren't you?! I've already told you a hundred times, I'll keep your secret! I gave you my word, and that should be the end of it!

Gaius: Look, I trust you. Honest and truly. It's just that in my business, there's no such thing as a free lunch. Guy who says he'll do something for nothing? Well, he's the first one wanting payback down the line!

[Robin]: ...Oh, very well. I was hoping it wouldn't come to this. I have something important to tell you.

Gaius: Important?

[Robin]: It's a secret. A very embarrassing one. You see... *whisper, whisper*

Gaius: BWAAA HA HA HA! And the cow...?! Oh, you did NOT do that!

[Robin]: Oh, but I did. And now you are the only one who knows. So in return for you keeping it safe, I promise to safeguard YOUR secret. Do we have a deal?

Gaius: ...Heh, I see what you did there. And...I appreciate it. All right. Deal. ...You have to keep the belt! It's not a bribe, now. More like a... I don't know... A thank-you gift.

[Robin]: In that case, I accept.

Cordelia

CORDELIA X AVATAR (MALE) [ROBIN] C

[Robin]: Ow! I used the last of the salve yesterday, but this cut still stings... What to do, what to do...

Cordelia: You're not out of salve. I restocked your medical supplies this morning.

[Robin]: You did? Ah, that's great. Thank you, Cordelia. You never miss a detail, do you?

Cordelia: I just like to stay on top of things. By taking stock of everyone's equipment, I know when anything needs replacing.

[Robin]: Wait, you keep track of EVERYONE'S equipment?! ...All in your head?

Cordelia: Of course. Imagine the chaos if our potions and equipment ran out at the same time.

[Robin]: ...Gods. I can certainly see why everyone calls you a genius.

Cordelia: Do not call me that!

[Robin]: Oh, I'm sorry... I meant no offense.

Cordelia: ...No, of course you didn't. Please forgive me. It's just that...my superiors called me that from the moment I joined the knights. It was so very hard sometimes... "Little Lady Genius," they called me. They teased and taunted me...

[Robin]: Oh...

Cordelia: They mocked me, too... My appearance, and my javelin technique...

[Robin]: Gracious! I had no idea members of the pegasus knights could be so spiteful. I assure you, when I called you a genius, I meant it only as a compliment.

Cordelia: I know. I'm just overly sensitive, that's all.

[Robin]: Well, if you ever need to talk, just let me know.

Cordelia: Well, since you offered... What do you think of this javelin? I'm not sure about the balance, myself.

[Robin]: Er, I meant if you ever need to talk about... Never mind.

CORDELIA X AVATAR (MALE) [ROBIN] B

Cordelia: [Robin]! Look, I crafted a new javelin based on your feedback.

[Robin]: You MADE one?

Cordelia: Er, yes?

[Robin]: As in, you forged it yourself? You didn't assemble it...from a kit, or something?

Cordelia: No... I cut a sapling, fashioned a grip, hammered the point in the forge. I suppose I could have waited around for the javelin fairy, but she's so unpredictable. Here, look. See the pattern on the shaft? It's my own design. ...Well? What do you think?

[Robin]: I think that I wasn't expecting you to go and fashion a whole javelin from scratch! You really ARE a genius!

Cordelia: I beg your pardon?

[Robin]: Oh, I... Sorry, I know you're sensitive about that word. I take it back. Anyway, I'm glad I was able to help. If there's anything else I can do...

Cordelia: Heh, [Robin], you are far too kind! Why, if I... N-no, wait. We can't be doing this. People will get the wrong idea!

[Robin]: Doing what? What wrong idea?

Cordelia: If you're so kind to me all the time, people will start to think...we're friends.

[Robin]: ...Oh. I thought you were going to say something else... Er, but why would that be so bad? We are friends, aren't we?

Cordelia: D-do you think so?! Truly?

[Robin]: Of course. Why not?

Cordelia: Oh, I'm sorry. I guess... I guess I grew accustomed to not having any. I was the youngest recruit in the Pegasus knights. All of my comrades were veterans, and there was no one whom I could truly call my "friend."

[Robin]: That's...so very sad.

Cordelia: Oh, well as I said, I grew accustomed to it. Besides, I did have my pegasus to talk to. Even if the chats were a bit one-sided...

[Robin]: Heh, I guess they would be...

CORDELIA X AVATAR (MALE) [ROBIN] A

Cordelia: [Robin]! Guess what? I showed my new javelin to everyone in camp. They were all so complimentary! Thank you again for the help.

[Robin]: Don't thank me! You're the one who went out and learned smithing. I'm just glad it all worked out. If only those pegasus knights could see you now!

Cordelia: Heh, perhaps they are looking on from the afterlife.

[Robin]: Er, the afterlife?

Cordelia: Yes, if you believe in such things. ...You do know the story, don't you? How my fellow knights gave their lives so I could escape and warn your party?

[Robin]: Gracious, no! I mean, I knew that some of them... I just... I didn't think those were the same knights who... I'm sorry. I didn't fully understand until this moment.

Cordelia: That's all right. I suppose how I put things is partly to blame.

[Robin]: So despite all the teasing, they loved you enough in the end to die for you?

Cordelia: I was surprised, too! It turns out they'd pretty much decided I was the future. The insults and so forth were just the usual hazing of a new recruit. *Sniff* My only regret is... I wish we'd had more time to...get to know each other. I only learned...how much they loved me... in those last, awful moments...

[Robin]: Cordelia...

Cordelia: *Sniff* R-right, then. Enough self-pity. I don't want to try your patience. ...But I must say, it does feel good to get this off my chest.

[Robin]: I understand now why you don't like to be called a genius.

Cordelia: You do?

[Robin]: Remember how upset you got the first time I called you that? I thought it reminded you of a sarcastic insult, but in fact it was the opposite. When your comrades sacrificed themselves for you, you realized that they meant it.

Cordelia: You're rather clever yourself, working all that out on your own.

[Robin]: Not clever, no. Just blessed with the kind of insight close friends share. Because I AM a close friend now, and I'll always be here for you.

Cordelia: *Sniff* Oh, [Robin]. ...Th-thank you.

CORDELIA X AVATAR (MALE) [ROBIN] S

Cordelia: [Robin], what are you doing?

[Robin]: Cordelia, I'm going to see how far I can throw my homemade javelin.

Cordelia: From the top of this cliff?! You'll never see it again!

[Robin]: That's the idea. Seeing it only reminds me of my fallen comrades. If I'm ever going to be the knight they hoped I'd be, I have to let go of the past.

Cordelia: ...I daresay you're right.

[Robin]: So, here goes. ONE! TWO! THREEEEEEEEE!

Cordelia: Whoa, what a throw! That javelin sailed like the wind! You really are a geniu— Er, you are skilled at many things.

[Robin]: Oh, it's all right. I'm not going to get upset about that word anymore. And I promise not to collapse weeping into your arms ever again!

Cordelia: Oh, er... Right. Ha ha! I'd forgotten about that...

[Robin]: Cordelia, are you blushing? Don't tell me you've fallen for me!

[Robin]: Er, actually...

Cordelia: Hee hee, just a joke.

[Robin]: I know, but... Um... You were right.

Cordelia: ...Ah, I get it! Trying to get me back? Ha ha. Good one, [Robin]!

[Robin]: No...I'm not joking. In fact I've never been more serious. And to prove it...here.

Cordelia: Oh, heavens. It's... It's a ring.

[Robin]: Will you marry me, Cordelia?

Cordelia: Why, [Robin]... The thing is... Yes! Oh yes, with all that I am! I accept with all my heart!

[Robin]: Truly?! Th-that's wonderful! Oh, Cordelia, you've made me so happy!

Cordelia: Not half as happy as you've made me!

[Confession]

Cordelia: Thank you. I thought nothing could warm my heart again. I shall love you above all others, for the rest of my days.

Gregor

GREGOR X AVATAR (MALE) [ROBIN] C

Gregor: Here, [Robin]. You will drink this, yes?

[Robin]: Hmm? What is it?

Gregor: Is special medicine Gregor drinks on hard journey! Tastes like bottom of old well, but is very good for you.

[Robin]: I don't need medicine, Gregor. I feel fine.

Gregor: You have no hurting throat? No hacking up of lung?

[Robin]: Well, now that you mention it, my throat has been a little sore...

Gregor: In battle, Gregor hear you breathe. Is raspy like old dying donkey.

[Robin]: You must have a terrific sense of hearing to notice that over the din of combat.

Gregor: For sellsword like Gregor, health very important. Soldier must be strong, yes?

[Robin]: I daresay you're right. I don't pay as much attention to my health as I should. What kind of precautions do you take to avoid becoming ill?

Gregor: Gregor have three rules: gargle, wash hands, and take temperature!

[Robin]: Oh. That sounds easy enough. Any other tricks?

Gregor: Gregor may have one more thing, but is very secret. Only men can do. You are man too, yes? Maybe Gregor share with you...

[Robin]: This sounds interesting.

Gregor: Well, how about sleep in same bed as Gregor? Then we share body heat!

[Robin]: I beg your pardon?

Gregor: Gregor body becomes very cold at night, yes? This keeps muscles limber!

[Robin]: An extra blanket will do just fine, thank you.

GREGOR X AVATAR (MALE) [ROBIN] B

[Robin]: Say, Gregor? I wanted to thank you for that medicine you gave me. I was feeling great after taking it...but I think it gave me strange dreams.

Gregor: Is Gregor maybe in these dreams?

[Robin]: Er...

Gregor: Ho ho ho! Is true! You dream of sharing bed with Gregor!

[Robin]: We weren't in a bed! We were flying through the air... Then we landed...on the sun, I think. And I rested my head on your knee... Gods, it was horrible...

Gregor: Do not be feeling special. Gregor have that effect on many people.

[Robin]: Since then, I haven't slept in days! Days! Look at my eyes! They're bloodshot!

Gregor: Sometimes Gregor have this effect... Usually on the women, but—

[Robin]: It's not funny! It is most definitely not funny! I have ch-chills up my back as we speak...

Gregor: Chills? Hmm... Here, [Robin]. Let Gregor look in eyes.

[Robin]: No! Stay away from me!

Gregor: You are strange person. Now make with the hushing!

[Robin]:

Gregor: Bloodshot eyes... Chills on spine... Strange dream... You had insect bite not long ago, yes?

[Robin]: Er, yes, actually. A great big millipede bit me on the ankle the other day, but...

Gregor: Oy, is so terrible! You suffer dangerous infection carried by large bug! We must render treatment with no delay. Gregor fear your life is at stake.

[Robin]: R-really?! It's that serious?

GREGOR X AVATAR (MALE) [ROBIN] A

Gregor: Ah, [Robin]. How is recovery?

[Robin]: Good, thanks to you. The healers said if you hadn't caught the infection when you did, I'd have died. I owe you my life, Gregor.

Gregor: Oh ho ho! Sometimes batty old man knows thing or two, yes? You are clever young lad, but old man like Gregor can be teaching you many things. You listen to elders, and one day you might be smart like Gregor.

[Robin]: Heh, yes, I'll certainly pay closer attention from now on.

Gregor: That is water running under bridge. But...

[Robin]: What? Is something still troubling you?

Gregor: You still have nightmare dream? Where you fly and put head on Gregor's knee?

[Robin]: Not anymore, thank the gods.

Gregor: Is good. ...Because Gregor has to charge performance fee for appearing in dream.

[Robin]: A performance fee? For a dream?! That's ridiculous!

Gregor: But if you say no more dream, then is okay. We call first one rehearsal. Gregor give steep discount. Now, you look after health so you see no more bad dreams, yes? If you get weak again, you can rest head on knee, no charge.

[Robin]: I assure you, I will be watching my health very carefully.

Gregor: You sound very with the motivation! Gregor believes you!

Nowi

NOWI X AVATAR (MALE) [ROBIN] C

Nowi: HIYAAA!

[Robin]: Yeowch!

Nowi: Argh! Sorry, [Robin]! Are you all right?

[Robin]: You mean, apart from this lump on my head? What is this you threw at me?

Nowi: That shiny rock that happens to be my most treasured possession. It took AGES to find.

[Robin]: If it's so precious, why are you tossing it around?

Nowi: I was trying to hit that big snake! Did you see it? It slithered away real fast.

[Robin]: ...So you're hunting game? With a rock?

Nowi: Exactly! I almost got him, too. ...Oh, look! There it is again! See?

[Robin]: Here, let me try.

Nowi: You think you can hit it?

[Robin]: Casting magic or hurling stones, it's all about focus and control. And you hoped to lead your target... Like...THIS!

Nowi: Oh, WOWZERS! Nailed it right in the head! That was great!

[Robin]: Well, I have my moments.

Nowi: How did you do it?! You've got to show me!

[Robin]: All right. First of all, you want to grip the stone like this...

Nowi: Okay...

NOWI X AVATAR (MALE) [ROBIN] B

Nowi: Hey. [Robin]! Look what I got!

[Robin]: My, that's a big snake! Did you catch it yourself?

Nowi: Yep! But only because of your rock-throwing lessons. Oh, and to thank you for all the help, I want you to have this...

[Robin]: But...this is your shiny rock. Your most treasured possession?

Nowi: Oh, I'm not THAT fond of it. Besides, I'll just find another one.

[Robin]: Well, that's...very generous of you. Thank you, Nowi.

Nowi: Say, [Robin]. You're a good teacher. Is there anything else you can show me?

[Robin]: Well, how about trying your hand at field cooking? You know, campfire cuisine? Frederick has just started teaching me the basics, so I'm not very good yet, but...

Nowi: That's perfect! We'll practice together and be gourmet chefs before you know it!

[Robin]: With that kind of enthusiasm, we just might, heh heh.

Nowi: ...Well, it looks...edible? At least?

[Robin]: At LEAST? I think it smells totally scrumptious.

Nowi: The proof is in the flavor. Which, I don't know... Looks like it could fall anywhere between mud and toenails...

[Robin]: Nowi, what ARE you mumbling about? Let's hurry up and eat already!

[Robin]: Er, right. H-here goes nothing. *Munch, munch*

Nowi: *Chomp, chomp* Hee hee! See? It's DELICIOUS! It came out just right!

[Robin]: It did, didn't it? Thank goodness Frederick is such a good teacher.

Nowi: No, YOU'RE a good student! I wish I could remember things as well as you. I've lived a thousand years, and what can I do? Nothing, that's what.

[Robin]: Don't say that. You've got time to learn all kinds of things. And of course I'll help, if you like.

Nowi: Aw, thanks, [Robin].

NOWI X AVATAR (MALE) [ROBIN] A

[Robin]: So you split the blade of grass, cup it in your hands like so, and blow... FfffffvvvVVVVVWW-WEEEEEE!

Nowi: Wow! It's just like a flute!

[Robin]: Er, okay. Here I go... Pffffth... Thffffptht... Aw, that didn't sound like anything! Maybe I'm not puffing hard enough? If I turned into a dragon, I could blow—

[Robin]: Er, probably not a good idea. We don't want to start a wildfire.

Nowi: *Sigh* Yeah, I guess not.

[Robin]: Look, I'll help you practice until you've got it. Sound good?

Nowi: I guess. Though I still think if I just transformed...

[Robin]: Let's just try it my way, okay?

Nowi: Hey look, [Robin]! There's another giant snake!

[Robin]: So there is. And it's quite a bit bigger than the last one you caught. ...Er, Nowi? What are you doing?

Nowi: I'm gonna show you how well I've learned to throw! Ready? Here goes! HIYAAA!

[Robin]: Well done, Nowi! You hit him right between the eyes! That must be the biggest snake I've ever seen taken down by a single rock!

Nowi: Pretty impressive, huh?

[Robin]: The Shepherds will eat well tonight! ...If we can haul that thing back to camp.

Nowi: I can do it! Give a snake that size is no problem for a mighty dragon. Now I just have to transform and... Oh. Oh! Where's my dragonstone?!

[Robin]: Er, you didn't just use it to knock out that snake, did you?

Nowi: Oh, gosh. I think I did! *Sniff* Wh-what am I going to do?! I can't ever turn into a dragon again, and no one will get to eat snaaaaaake! WAAAAAAAAAH!

[Robin]: Easy, Nowi, easy. It's all right. We just have to search a little. I promise I won't leave until we've found it. All right?

Nowi: Gosh, you'd do that for me? [Robin], you're the best!

NOWI X AVATAR (MALE) [ROBIN] S

Nowi: Thanks for your help the other day, [Robin].

[Robin]: You mean searching for the dragonstone? Not at all. I'm just glad we found it. Listen, Nowi. I actually wanted to talk to you about something else...

Nowi: Sure! What is it?

[Robin]: The shiny rock that you gave me—was it really precious to you?

Nowi: Oh, yes. Very much so. But it's yours now. I AM looking for a new one, but I haven't found anything yet.

[Robin]: Yes, right. That's what I thought. ...Here, I want you to have this.

Nowi: Wow, it's SO shiny and pretty! But...it isn't a normal rock, is it?

[Robin]: No, it isn't. Not anymore. That was the stone you gave me... I've made it into a ring.

Nowi: Er, [Robin]?

[Robin]: Yes, Nowi?

Nowi: I know what kind of ring this is. You want us to promise each other to stay together forever.

[Robin]: Oh, so you DO know the custom? Good. I was afraid I'd have to explain.

Nowi: Come on, [Robin], I'm not a total dummy!

[Robin]: Heh. Right, sorry. I forget sometimes how long you've spent with us humans. But if you know about this ring...then you also know what it means to accept it.

Nowi: I do! And I DO! In every sense of the words, I do, [Robin]! I've wanted to be with you for ever so long—I thought you'd never ask!

[Robin]: Then my only regret is not doing so sooner. Oh, Nowi, we'll be so happy together!

Nowi: Oh, I know we will, [Robin]! I know we will!

[Confession]

Nowi: Oh I'm so happy! I've always wanted a husband! Think of all the wonderful centuries—uh, years we'll have!

Libra

LIBRA X AVATAR (MALE) [ROBIN] C

Libra: ...:..

[Robin]: Oh, hello, Libra. What are you up to?

Libra: I'm drawing a picture.

[Robin]: Whoa, that's very good! Great shading, exquisite detail, and through it all, an air of melancholy... It's very like you.

Libra: Melancholy? Truly?

[Robin]: I don't mean that in a bad way! Actually, you should probably just ignore me... I know very little when it comes to fine art.

Libra: Well, to be honest, I don't know much about it either.

[Robin]: Really? But you're so talented!

Libra: I've been told my pictures are technically proficient, but lack artistic soul.

[Robin]: Poppycock! I mean look at this sketch—it's BURSTING with soul! I bet whoever told you that was simply jealous of your talent!

Libra: Well, I appreciate the sentiment. Here, you can have this if you like it so much.

[Robin]: Are you sure? You didn't draw it on commission or anything?

Libra: I don't ever do drawings on request. ...No exceptions.

[Robin]: Well, if it's not meant for anyone else, then yes, I'll gladly accept. Thank you.

■ LIBRA X AVATAR (MALE) [ROBIN] B

[Robin]: Tsk! I just can't get this color right.

Libra: Er, [Robin]? You have paint on your cheek. ...And your chin. ...AND behind your ear.

[Robin]: Oh, er, so I do. Whoops!

Libra: Are you trying your hand at painting?

[Robin]: Yes! Seeing your drawing has inspired me to take up the palette myself... But, I fear I'm wasting my time. Just look at this muddy slop! Clearly when the gods distributed artistic talent, I was in the outhouse.

Libra: The gods would have waited for you, I'm sure. But let's take a look... Oh...dear. Er, it's a portrait of Lissa, is that right? You picked an odd color for her face... And the left eye is rather...oblong. Still, a fine first effort! You can't expect to be perfect straightaway.

[Robin]: ...It's a pegasus. And it's NOT my first try. It's my 100th.

Libra: Oh. ...Oh, dear.

[Robin]: You don't have to say anything. I can see it in your face—I should just give up.

Libra: N-no, I wouldn't go that far!

[Robin]: I would. Still, this little experiment helps me realize just how talented YOU are. I look at that picture you gave me every day, you know?

Libra: Not EVERY day, surely?

[Robin]: Each night before I sleep! It fills me with a wonderful sense of peace. I'm always worried it'll get damaged when we march, so I pack it very carefully.

Libra: You're the first person who's ever valued one of my works so highly. And though pride be a sin, I'm... pleased that you treasure it so.

■ LIBRA X AVATAR (MALE) [ROBIN] A

[Robin]: *Sigh*

Libra: What's wrong, [Robin]? You seem most upset.

[Robin]: I am, Libra. I am... That wonderful drawing you gave me was torn to shreds. It's ruined completely.

Libra: During the last battle, I assume? When we were suddenly forced to break camp?

[Robin]: Yes, exactly. I had no time to pack it away properly, and so... Oh, I miss it already...

Libra: Don't get upset, [Robin]. I can draw you another one.

[Robin]: But you said you never draw pictures by request. Remember?

Libra: For you, I will be delighted to make an exception!

[Robin]: Really? Oh, thank you! What will it be?!

Libra: Well, I haven't thought about it. What kind of picture would you like?

[Robin]: How about a self-portrait?

Libra: Er, you want to hang a picture of me on your tent wall? The picture that you look at every night before sleeping?

[Robin]: Why not? You are one of my closest friends, after all. Is that a problem?

Libra: Well, it's just that the last time I did a self-portrait, everyone thought it was a woman. Even after I specifically tried to play up my manly features...

[Robin]: That...must have been embarrassing.

Libra: Well, not that it matters. It's hardly my fault if people can't see the blindingly obvious, is it?

[Robin]: Er, right. So, no self-portraits... How about a portrait of me, then? It can be a keepsake for when I get old, to remind me I was once young and handsome!

Libra: A most challenging request, but I will pray that Naga guide my hand!

[Robin]: Er, someone less understanding could take that the wrong way, you know...

 Tharja

■ THARJA X AVATAR (MALE) [ROBIN] C

Tharja:

[Robin]: Tharja? ...Are you following me?

Tharja: ...Maybe.

[Robin]: Maybe?! I've seen you hiding behind tents and wagons all week!

Tharja: So you finally noticed...my love.

[Robin]: Sorry, what? Your...love?

Tharja: Oh yes. I realized the first moment we locked eyes. "He isn't like the others," I thought. "He's the one I've been seeking!"

[Robin]: Riiiiight. Well, um, thank you? ...I guess?

Tharja: That's why I've been watching your every... single...move. Yesterday you read two books and part of a third. You snacked on an apple. And last night, you turned over 12 times in your sleep. ...Well below your average.

[Robin]: You've been watching me sleep?!

Tharja: I thought you'd be grateful.

[Robin]: No, I think "disturbed" is more the word. You mean to tell me you've been following me every single day since we met?

Tharja: ...Yes.

[Robin]: I suddenly feel very ill.

Tharja: Don't worry. I'll take care of you. ...Veeery good care.

[Robin]: Coming from a normal friend, I'd probably be happy to hear that. But somehow when you say it, it's not quite so comforting...

Tharja: Is that what you want, [Robin]? Someone...normal?

[Robin]: Well, I...suppose that's to say—

Tharja: All I needed to hear.

■ THARJA X AVATAR (MALE) [ROBIN] B

Tharja: Why good day, [Robin]! How fare you? Enjoying this weather?

[Robin]: ...Tharja? What are you doing?

Tharja: What, me? Ho ho! Whatever do you mean? Just a normal greeting on a typical day. ...Why? Are you concerned for my welfare, good sir?

[Robin]: Um, well... I suppose, in a way.

Tharja: You ARE?! Why, how sweeeeeet!

[Robin]: Actually, I'm more concerned about whatever you're planning for me.

Tharja: Of course I have a plan for you, silly-billy! Now close your eyes, and get ready for... A slice of liver-and-eel pie! That's your favorite, correct? Oh, I do so adore baking.

[Robin]: ...Are you SURE you're all right, Tharja? You didn't eat anything strange, did you? Miscast a hex? Hit your head on a rock?

Tharja: Oh ho ho, goodness me! Such an imagination you have, good sir. I'm sure I wouldn't know anything about anything strange, much less eat it! Just a typical day for a typical girl like me!

[Robin]: This is about our conversation from before, isn't it?

Tharja: Don't be silly. Now have some pie!

[Robin]: Look, I don't want—MMPH! *Munch, munch, munch* ...Actually, that's delicious.

Tharja: Oh, huzzah! I've been working on the recipe every day after normal practice!

[Robin]: "Normal practice"...? You mean you've been practicing being normal?

Tharja: Indeed! And it worked! I'm perfectly normal now! Ho ho! My, yes, so typically normal plain.

[Robin]: Do you realize that your "typical normal" is actually very, very unusual?

Tharja: Oh my, huzzah? Goodness, I simply must... something?

[Robin]: Tharja, I'm sorry about what I said before. You shouldn't have listened to me. I liked you more the way you were, so can you go back to being the old Tharja?

Tharja: Gracious, I... I have been practicing so diligently as of late, I'm not sure I can stop!

■ THARJA X AVATAR (MALE) [ROBIN] A

Tharja: (...Heh heh heh!)

[Robin]: I'm glad Tharja's acting like her old self again. A-although... I feel... Urk! Ch-chills up spine... G-goose bumps... C-can't stop sh-sh-shivers...

Tharja: [Robin]? ...You all right? [Robin], you're shaking like a leaf! And your forehead's on fire! Okay, Tharja, think. We need cold water and a spell to bring down the fever.

[Robin]: Nnnrgh...

Tharja: Hello.

[Robin]: Huh? Wh-what happened? Why am I lying here?

Tharja: You lost consciousness and collapsed. It was because of the fever.

[Robin]: Yes, I-I've been feeling unwell for a while. Probably been working too hard.

Tharja: I thought you might accuse me of putting a curse on you.

[Robin]: I'd never assume that! What kind of monster would curse their friend...

Tharja: ...Oh. Right. That would be crazy! Heh heh.

[Robin]: Anyway, thank you so much for taking care of me.

Tharja: Did you once say you wouldn't want me taking care of you?

[Robin]: Clearly, I was mistaken.

Tharja: You're just saying that because I helped you out.

[Robin]: No, it's true! In fact, I wonder if you wouldn't mind...staying... "Yaaaaawn" Just...just for a while...

Tharja: Aw, how sweet. He's sleeping. Sleeping and... helpless. Hee hee hee hee!

■ THARJA X AVATAR (MALE) [ROBIN] S

Tharja: [Robin]?

[Robin]: Tharja? Yes?

Tharja: Don't you think it's time you stopped standing right behind me?

Tharja: Why?

[Robin]: Because I can't see your face.

Tharja: Why would you want to?

[Robin]: Fine. I'll just turn around.

Tharja: That's better. ...Now that I think about it, this is the first time we've stood like this... So close... face-to-face.

Tharja: Perhaps.

[Robin]: I rather like it. Maybe we should do it more often... Maybe we could stand together...forever.

Tharja: ...Forever?

[Robin]: ...Forever.

Tharja: Wait, what are you giving... [Robin], is this a ring?

[Robin]: I love you, Tharja. I want to be with you, forever.

Tharja: N-no! I can't! Not like this!

[Robin]: Oh.

Tharja: ...There. Now try it again.

[Robin]: Um, well, I guess if this makes you more comfortable... In truth, I'm getting used to it myself...

Tharja: Good. Heh heh...

[Confession]

Tharja: I can't believe you made me love you! ...Of course if you back out, I'll murder you in your sleep.

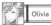 Olivia

■ OLIVIA X AVATAR (MALE) [ROBIN] C

Olivia: 248... 249... 250! Phew, that's all of 'em!... Still a long way to go, though.

[Robin]: What are you doing, Olivia?

Olivia: EEEEEEEEEK!

[Robin]: Oh, I'm sorry! I didn't mean to startle you.

Olivia: It's okay. I just didn't see you there.

[Robin]: Um, so if you don't mind me asking, what's in the bag there?

Olivia: Hm? Bag? What bag? Oooooooh, THIS bag! Er, it's nothing really. Just a few coins, is all.

[Robin]: Keeping a secret stash, are you?

Olivia: It's money I've been saving out of my wages. I'll have you know! Sheesh. "Secret stash" indeed. You make it sound so sinister.

[Robin]: I'm sorry. I certainly didn't mean to imply anything untoward. I'm just impressed is all. It takes real dedication to save on a soldier's pay.

Olivia: Oh! Thank you, [Robin]. Such praise means quite a lot coming from you...

[Robin]: It does? Huh. I've never thought of myself as anything spec—

Olivia: Aaaaaaaaanyway, I've got to run. I'm on mess duty tonight. You know what they say, right? A hungry Shepherd is a big jerk!

[Robin]: Is that what they say? I had no idea. ...Ah! Olivia, wait! You dropped your secret stash!

Olivia: Will you PLEASE stop calling it that?! You make it sound like I stole it or something. People will get suspicious!

[Robin]: Well, whatever you want to call it, you're losing it as we speak! Look at all the coins rolling down the hill!

Olivia: ARRRGH! Why do coins have to be so darn round!

■ OLIVIA X AVATAR (MALE) [ROBIN] B

[Robin]: So, Olivia. How goes the saving?

Olivia: Pah-fectly whell, my good mahn! Now be a dear and fetch me some cav-iah?

[Robin]: Um, are you all right?

Olivia: Of course! I found a book that teaches how to talk like a noble, so I'm practicing.

[Robin]: Oh. I thought maybe a bee had stung your tongue...

Olivia: I did NOT sound like that! ...Or did I? Oh, gods, I DID! This stupid book is useless! Do you realize I've been talking like that all day? Gods, how embarrassing!

[Robin]: Oh, it wasn't as bad as all that. Just unexpected is all. I'm sure if you keep practicing you'll get the hang of it.

Olivia: You really think so?!

[Robin]: Er...sure. But listen, I wanted to ask something. What are you saving up for?

Olivia: You mean my big bag of loot? ...I want to build a theater.

[Robin]: A theater? You mean, with a stage and stands and seats and everything?

Olivia: YES! And fly lofts and trapdoors and a huge proscenium arch! A place where people from all walks of life can experience the wonder of dance.

[Robin]: When you say dance, are you referring to YOUR dancing?

Olivia: Well...kinda, yeah. Why? Does that sound egotistical? Because I—

[Robin]: Wonderful! I'll be first in line when it opens!

Olivia: Why, thank you, [Robin]. How kind of you!

[Robin]: But building a theater is quite an undertaking. It'd cost a fair bit of coin.

Olivia: I know, I know. I suppose it's all a bit of a pipe dream...

[Robin]: Say, I have an idea. Why don't we join forces and construct it ourselves?

Olivia: Oh, gosh no! I don't even know which way to point a hammer.

[Robin]: Well, I might not look it, but I know a thing or two about carpentry. Come on, it'll be fun!

Olivia: Okaaay, but...you really think we can pull this off ourselves?

■ OLIVIA X AVATAR (MALE) [ROBIN] A

[Robin]: ...Phew! Finished at last!

Olivia: We did it. I still find it hard to believe, but we actually did it.

[Robin]: What do you think? Do you like it?

Olivia: It's...it's even more beautiful than I imagined! *sniff*

[Robin]: Good! It's nice to know that all that work wasn't in vain.

Olivia: ...There's just that one teeeeeny-tiny issue with the size.

[Robin]: ...Ah.

Olivia: It's going to be difficult to dance in a theater that fits in the palm of my hand. ...Not that I'm complaining or anything.

[Robin]: Heh, I know. In any case, as small as it is, it's still a theater that WE built. Now that we know how it's done, it should be a simple matter to scale everything up.

Olivia: You think so?

[Robin]: Absolutely! Always have a plan, I say.

Olivia: Well, if you think so, then I believe it! Besides, working with you is so much fun, it hardly feels like work at all. So, only...what? A few more decades? And we'll build a fabulous, human-size theater! ...Hmm. You sure it wouldn't just be easier to save up my money?

[Robin]: Now, now! You promised not to talk about that again, remember?

Olivia: Oh, right. Sorry. Well, I have a new, special dance I made to celebrate our new performance space! Would you... Um, would you like to see it? I mean, if you're busy, that's fine.

[Robin]: I can always make the time to watch one of your dances!

Olivia: Hee hee! Okay. I might be a bit rusty, but I'll do my best. I've been saving this for when the new theater was ready...

[Robin]: Ah, this IS fun, isn't it? The only thing better than having a dream, is making it come true with a friend!

Olivia: Thanks, [Robin]. I couldn't've done it without you.

■ OLIVIA X AVATAR (MALE) [ROBIN] S

Olivia: *Siiiiigh*

[Robin]: What's the matter, Olivia? That's your third sigh in as many minutes.

Olivia: I've had a lot of expenses recently... I haven't saved so much as a copper. By the time my theater's built, I think it's about time I gave up this silly dream—

[Robin]: You can't! You've already rehearsed your opening-night performance!

Olivia: I'm sorry to let you down, [Robin]. I appreciate all the help. Really, I do.

[Robin]: Oh no, you aren't getting rid of me that easily! If we work together, we can make this dream come true.

Olivia: I don't know... Maybe it's all too much... I don't want our friendship to suffer over our silly little theater.

[Robin]: ...What if we weren't friends?

Olivia: What?! But...

[Robin]: ...What I mean is...what if we pursued your dream...as husband and wife?

Olivia: [Robin]?!

[Robin]: ...What I want to say is...I love you. ...Will you marry me?

Olivia: Oh! You even brought a ring and... *sniff* Oh, [Robin]. I don't care if I get that theater or not... So long as I'm with you.

[Robin]: But I care! Now put that ring on and grab a hammer!

Olivia: Hee hee! Maybe we can use the theater for our reception.

[Robin]: Heh ha, what a great idea! We'll have cake, and music, and dancing into the night!

Olivia: Oh! And those little bears that balance on wheels! Let's get them, too! Guess I better start saving again!

[Confession]

Olivia: I've been in love with you forever. I only wish I had the courage to tell you sooner.

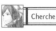 Cherche

■ CHERCHE X AVATAR (MALE) [ROBIN] C

Cherche: Oh, this one is cute! Er, then again, maybe not. Hmm, this one has some nice horns, but I think it's the wrong type for Minerva. Dear me, this is harder than I expected.

[Robin]: Cherche? What are you up to?

Cherche: Ah, perfect timing, [Robin]. I want to ask you something.

[Robin]: What about?

Cherche: Among your many friends, are there any particularly beautiful wyverns?

[Robin]: ...Did you just ask if I have good-looking wyvern friends?

Cherche: Well, it was worth a shot. I'm looking for a partner for Minerva. I must have searched through dozens of portraits and letters of introduction. And yet, not a single one has been up to Minerva's very exacting standards.

[Robin]: Minerva? That massive thing you ride into battle? I, er, didn't know that anyone offered match-making services for wyverns.

Cherche: No one does! That's what is making this so very difficult. I've been doing everything all on my own so far...

[Robin]: Impressive. You're breaking new ground in wyvern relations.

Cherche: It's a giant leap for mankind and wyvernkind alike, I'll wager. ...Want to pitch in?

[Robin]: Well, if you think I can help! Ha ha ha? Wait... You were being serious?

Cherche: Did you hear that, Minerva? [Robin] is going to help us!

Cherche: Oh, look how happy you've made Minerva!

[Robin]: That bloodcurdling sound was happiness?!

■ CHERCHE X AVATAR (MALE) [ROBIN] B

[Robin]: I've assembled an extensive dossier on prospective wyvern mates, Cherche. I can't believe I just said that.

Cherche: Oh, thank you! This is so exciting! Let's see what you have.

[Robin]: Here you go.

Cherche: Ah, you've included oil portraits of all the wyverns! What a nice touch. Hmm...no...No...Nope. ...Ugh, not a chance. ...No. ...Aaand, no um, [Robin]? Did you know that these are all female wyverns?

[Robin]: Er, right. Is that a problem?

Cherche: Minerva is a girl. ...Who likes boys.

[Robin]: Is? ...I-mean, she is?!

Cherche: Yes, SHE is! ...It's perfectly obvious if you just bother to look.

[Robin]: (Why in blazes would I ever be looking at—)

Cherche: I'm sorry? I didn't quite catch that.

[Robin]: J-just scolding myself for making such an obvious blunder! Ha ha! ...Ha. Well, I guess I'll be starting over then.

Cherche: You can probably find someone good-looking at court, but Minerva is VERY picky. So do make sure that you bring her only the most handsome candidates.

[Robin]: ...You do realize that I have no concept of what makes a wyvern handsome, right?

Cherche: The shape and length of his horns, the shine of his scales, and the span of his wings. Also consider overall musculature, roar volume, and fire-breath heat. ...Oh, and if he happens to be rich, so much the better.

[Robin]: Oh, you have GOT to be joking!

■ CHERCHE X AVATAR (MALE) [ROBIN] A

[Robin]: Cherche, I believe I've found the perfect wyvern for Minerval Here, look at this... ...Well? What do you think? Not bad, eh?

Cherche: If this oil painting is accurate, he appears absolutely perfect! Look, Minerval What do you think? Isn't he terribly handsome?

[Robin]: Oh, she definitely likes him.

[Robin]: Thank heavens! I was just about at the end of my rope with all this wyvern business...

Cherche: Thank you, [Robin]. We both appreciate everything you've done for us. You're truly too kind.

[Robin]: Well, if I do succeed, I imagine my name will go down in the history books.

Cherche: As the first-ever chaperone for a wyvern blind date? Oh yes. I wager you'll be famous for centuries.

[Robin]: ...Wait. I'M not going to be there when they meet? That's absurd! I've never even matched up people, let alone giant reptiles!

Cherche: Oh, you're a quick study. I'm sure it will all go swimmingly.

[Robin]: I'm not!

Cherche: If it makes you feel better, I'll be there as well. I'm very familiar with the nitty-gritty of wyvern romance.

[Robin]: No, knowing you are familiar with wyvern romance does NOT make me feel better! Besides, why don't you just take over from here and enjoy all the glory? I mean, I'm just blundering around in the dark, and frankly—

[Robin]: WAAAAAAH! WH-WHAT WAS THAT?! MY EARS ARE RINGING! HELLO?! CAN YOU HEAR ME?! WAS THAT A CRY OF HAPPINESS OR INSANE RAGE?!

Cherche: Rage. ...She's concerned you might abandon the project.

[Robin]: BRANDON THE REJECT?! WHO?!

Cherche: She seems sure that you are the key to all of this working.

[Robin]: A BEE IS LURKING?! I CAN'T... WAIT, HOLD ON! *sniiiifff* ...Oh, gods, that's better. My ears just popped. But look, I still have no idea what I'm actually doing... *Sigh* Aw, heck. I started this. I suppose I might as well see it through to the end.

Cherche: Oh, I'm so glad to hear you say that! And so is Minerva. Aren't you, Minerva?

[Robin]: WAAAH GODS! NOT AGAIN!

■ CHERCHE X AVATAR (MALE) [ROBIN] S

Cherche: Oh, [Robin], I'm sorry Minerva's date didn't work out so well... Especially after you went to all that trouble! He was such a fine-looking wyvern, too— I truly thought Minerva would take to him.

[Robin]: I wasn't sure what I was in for, honestly, but I certainly didn't expect them to fight! They would have burned down the entire village if you hadn't intervened!

Cherche: They just needed a good scolding to get them to settle down.

[Robin]: *Sigh* I suppose it's back to square one again then, eh?

Cherche: Actually, I'm starting to think Minerva is simply too old for marriage now. I suppose we'll both just be a couple of old maids until the ends of our days.

[Robin]: Have you ever...looked for a husband?

Cherche: Oh, sure. But it never really worked out for one reason or another. Well, actually, it usually didn't work because of Minerva. She tends to scare people off. A couple men even asked me to leave her for them, but I couldn't do it. I guess a wife with a wyvern just isn't an enticing prospect...

[Robin]: Then Minerva has my eternal gratitude.

Cherche: ...What do you mean?

[Robin]: She chased away her rivals. Thanks to her, I get to be the one to give you this.

Cherche: A ring? An...engagement ring?

[Robin]: Cherche, all of this matchmaking has made me think about my own prospects. And also it's made me think of you and...how much I love you. I swear I will look after you and Minerva till the end of our days. ...Will you marry me?

Cherche: Why, [Robin]! Th-this is so surprising! I accept! Oh, I gladly accept!

[Robin]: I won't let you down, Cherche. You or Minerva. I promise.

Cherche: It's funny how this all started with me trying to find a mate for Minerva. And now she's still alone, but I managed to find a man of my own!

[Robin]: I'd call that a happy twist of fate! Heh heh, no offense, Minerva. ...What, Minerva? What is that look? Wait, not the fire breath! I didn't mean it!

[Confession]

Cherche: Heh, it's funny. Being close like this just feels...right. It's as if it was always meant to be.

Henry

■ HENRY X AVATAR (MALE) [ROBIN] C

Henry:

[Robin]: Henry? What are you doing? ...Why are you all hunched over? Are you unwell? Is your stomach... Oh, gods, are you hurt?! Somebody, HELP! Henry's been—

Henry: Hey-o, [Robin]! What's all the ruckus?

[Robin]: Wait, you're...okay? You were all crouched down and quiet... I thought you were wracked with pain.

Henry: Nya ha ha! Nope! I'm completely fine.

[Robin]: Ah, well, that's a relief... But, then, what were you doing?

Henry: Guess I was having way too much fun playing with this to notice you come in...

[Robin]: What is it, some kind of—AAAAAAAAH!

Henry: Don't worry, it's perfectly safe! *poke, poke* See? Dead as a doornail.

[Robin]: An arm?! A disembodied Risen arm?! Ew... Did you bring it back from the battlefield?

Henry: Yep. I was interested in seeing what makes them tick. I thought I'd perform a little dissection and get some "inside" information. Hey, why don't you examine it with me? Maybe we can discover some new weakness!

[Robin]: Ugh! D-don't want that thing in my face! I don't want it anywhere near me.

Henry: Suit yourself! Now where did I put that finger...

■ HENRY X AVATAR (MALE) [ROBIN] B

Henry: Lah-di-da, do-di-doh. ♪ fee-fi-fo-fum, bom bom bom...♪

[Robin]: Henry, what are you drawing in the soil? A magic sigil? Do you mind me asking what it's for? I must say it looks rather sinister...

Henry: Aw, [Robin], you worry too much. It isn't sinister at all! Not one bit! I'm just going to use it to summon an army of Risen.

[Robin]: Wh-what?!

Henry: If I get it to work, we can have them all fight on our behalf! Then we can sip tea for the rest of the war and collect the accolades once it's over.

[Robin]: Well I understand the idea in theory. It could reduce casualties on our side... But there is one slight problem... Have you given any thought to how you'll control these soulless warriors?

Henry: Oh, they can't be controlled. You just let them loose to attack anything that moves. But we'll be safe so long as I draw the sigils far enough away from camp.

[Robin]: WE might be safe, but won't they turn on local villages, wreaking death and mayhem?

Henry: Yeah, probably. Would be surprising if they didn't, actually. Still, we'd win the battle.

[Robin]: Unacceptable. We cannot sacrifice innocent lives for the sake of victory.

Henry: See, now you're just not thinking logically. We've killed countless people in this war—what's a few more souls on the ledger?

[Robin]: Those deaths were necessary. We had to kill our foes or be killed ourselves. But killing the enemy isn't the same as sacrificing innocents for victory.

Henry: Seems like an arbitrary line to me... But all right. You're the tactician! No more unholy summoning sigils.

[Robin]: Good.

HENRY X AVATAR (MALE) [ROBIN] A

[Robin]: Henry, I wanted to congratulate you on that last battle.

Henry: Oh?

[Robin]: Yes. Especially when those Risen appeared out of nowhere. You placed the village at your back, even though it was tactically disadvantageous. By holding the line, you saved the lives of countless civilians.

Henry: Yeah, well, you said we shouldn't sacrifice innocents to win a battle.

[Robin]: I know what I said, but I was surprised you'd taken it to heart.

Henry: Heh, I just do what I'm told.

[Robin]: I didn't realize you were so obedient and... conscientious.

Henry: Heck, I always obey orders! Well, except for stupid ones like "don't fight the enemy." Someone tried to tell me that, I'd cut 'em in half and feed them to the crows!

[Robin]: I...see... Well! We wouldn't want that happening to me, eh? Ha ha! ...Ha.

Henry: Hey, you're looking a little pale and sweaty there. Everything okay?

[Robin]: Oh, n-never mind that! I have another task for you. Would you help me organize my library of strategy books? I've accumulated so many recently, I just can't keep track of them.

Henry: You got it!

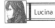

Lucina

LUCINA X AVATAR (MALE) [ROBIN] C

[Robin]: Phew! I think that's enough work for one day.

Lucina: Good evening, [Robin]. I wonder if I might have a word.

[Robin]: Hello, Lucina. What can I do for you?

Lucina: There's something important I want to talk to you about. ...And only to you.

[Robin]: That sounds a bit ominous...

Lucina: Specifically, it's about the future events of my own terrible time. I've told you tale before, but I want you, more than anyone, to understand its import.

[Robin]: I see. Please, continue.

Lucina: In the future, almost no corner of our world is safe for humans. Risen prowl the land as masters of all. The people cower in terror, helpless.

[Robin]: It sounds like a nightmare come true. I can scarce imagine it...

Lucina: This is a hell on earth. That is why, we cannot—we MUST not—lose this war. Do you see that? You must ensure that Chrom and this brave army avert catastrophe.

[Robin]: I will do everything in my power, Lucina. I swear it. I will never stop fighting for you, and Chrom, and all the people of the world.

Lucina: ...That is what I wanted to hear. Thank you, [Robin].

[Robin]:

LUCINA X AVATAR (MALE) [ROBIN] B

Lucina:

[Robin]: Lucina? What are you doing out here all alone?

Lucina: Ah, [Robin]. I was just thinking about the future. My future, I mean. I wonder how everyone is managing now. Do they still live, or...?

[Robin]: I can scarce imagine what horrors you experienced in such a hard, cruel world. A future that was lost... That we could not save... Tell me, are there others like you there? People who fight against the Risen?

Lucina: Of course. Remnants of armies from the old dynasts survived here and there. We gathered in the last safe corner of the land and united to fight against the tide. But we knew that one day even that final refuge would be overrun.

[Robin]: Then the future of humanity depends on what we do in the here and now.

Lucina: Yes, and my father is the key. Without him, that future WILL come to pass. Our struggle there can only postpone the inevitable, not alter it. When I fight for my father, no matter how terrible the foe, or how powerful... I know that I have no choice. I simply cannot lose.

[Robin]: You are burdened by the knowledge that you must conquer fate itself. I'm sure it is a terrible weight to bear, but you must remember something...

Lucina: What is that?

[Robin]: You don't have to do it alone. You have friends ready to aid you against whatever you face. And your father has an entire army ready to fight and die for him. ...And you also have me, for whatever that may be worth.

Lucina: It is worth a great deal, [Robin].

[Robin]: Perhaps I can never truly understand where you come from and the world you lived in. But I do know that we can help you.

Lucina: Th-thank you, [Robin]. Your words give me strength.

LUCINA X AVATAR (MALE) [ROBIN] A

[Robin]: Hello, Lucina.

Lucina: Hello, [Robin]. Were you looking for me?

[Robin]: Yes, actually. I wanted to ask you something about the future.

Lucina: What do you want to know?

[Robin]: In your future, Chrom is dead, correct?

Lucina: ...Yes. He was betrayed by his closest friend, or so the story goes. That is why I placed him here in my army—because I trust no one close to him.

[Robin]: You've made it your mission to save him—and indeed, nothing is more important. But it must be a hard thing to suspect and distrust every ally.

Lucina:

[Robin]: Lucina, you're very important to me, and I can't stand to see you neglect yourself.

Lucina: [Robin]... I...

[Robin]: You have to look after yourself, as well as your father. I mean, what would happen to him if you were to collapse under the strain?

Lucina: I...can handle it.

[Robin]: Perhaps. Just... Will you promise me to take better care of yourself?

Lucina: For you...yes.

[Robin]: Ah...a relief to hear.

Lucina: And a relief for me that you care, [Robin]. Thank you.

LUCINA X AVATAR (MALE) [ROBIN] S

[Robin]: Hello, Lucina.

Lucina: [Robin]? Fancy meeting you here.

[Robin]: Actually, I followed you. I, er...wanted to give you these.

Lucina: Oh, [Robin]! Did you pick flowers for me? They're absolutely beautiful, and they smell heavenly!

[Robin]: ...I'm glad you like them.

Lucina: We have no flowers in my world. The whole land is barren. ...But enough of that. Tell me, [Robin], what are we celebrating?

[Robin]: Nothing, really. I just thought you could use some cheer.

Lucina: You really shouldn't worry about me so...

[Robin]: It's no trouble... I... You're a dear friend, and I want to do anything I can to help.

Lucina:

[Robin]:Actually, I'm not being entirely honest. You ARE dear to me, of course, and the daughter of a true friend. But...

Lucina: But...?

[Robin]: But you are more than that. Much more! I didn't pick that bouquet to cheer you up. I did it because... Because I'm in love with you.

Lucina: What are you—?

[Robin]: Lucina, I've fallen helplessly in love with you! I tried not to, but I couldn't help it!

Lucina: Oh, [Robin]...

[Robin]: We've been through so much, and I know many trials still await us... But no matter what happened or is yet to come, my feelings cannot change! I love you, Lucina. With all my heart.

Lucina: I... I'm so glad you told me all this. ...Because you are in my heart as well.

[Robin]: Truly? Oh, those must be the sweetest words I've ever heard! Lucina, I promise you, no matter what: I will be here for you and Chrom. Whatever road you choose to follow, I shall follow it at your side.

Lucina: And we won't rest until we reach the end! Together!

[Confession]

Lucina: I love you. And no matter what the future holds, I'm going to cherish every moment.

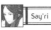

Say'ri

SAY'RI X AVATAR (MALE) [ROBIN] C

[Robin]: I have a question for you, Say'ri.

Say'ri: Then I shall strive to answer it.

[Robin]: It's about your armor. I've never seen anything like it. Where did you get it?

Say'ri: This? It's a common enough sight in Chon'sin. All warriors wear a variation.

[Robin]: The shape is unusual, but clever in its design. The plating looks tough as well.

Say'ri: Hardened lacquer. It keeps the armor light while providing excellent defense. It's quite rare to see heavy armor where I come from. And we wield a curved, single-edged blade in both hands, so we do not carry shields.

[Robin]: That's a far cry from what I used to... Are there any other important differences?

Say'ri: Aye, a world's worth, sir! You'd find much of Chon'sin culture curious. Food, dress...most everything.

[Robin]: I'd love to hear more sometime. ...If you don't mind, that is.

Say'ri: Of course. I would be honored. Talk of my homeland keeps it close to my heart.

SAY'RI X AVATAR (MALE) [ROBIN] B

[Robin]: Are you free, Say'ri? I was hoping to hear more about Chon'sin culture.

Say'ri: Aye, I am always free for such a thing! Where shall I begin?

[Robin]: Well, how is the food different between there and here?

Say'ri: Rice is our mainstay. 'Twas only recently that I first tasted bread or cheese.

[Robin]: Interesting.

Say'ri: Raw fish is also a Chon'sin delicacy.

[Robin]: ...Raw? Is it any good?

Say'ri: Quite so, provided the fish is fresh. If not...well, it can be an ugly sight indeed.

[Robin]: Seems our foods are as different as our weapons and armor. It must have been difficult to grow accustomed to life in the camp.

Say'ri: I find your cuisine quite palatable, in truth. Though I do miss the tastes of home.

[Robin]: I'd love to try it myself someday.

Say'ri: Aye! If ever the opportunity arises, it would be my honor to treat you.

SAY'RI X AVATAR (MALE) [ROBIN] A

[Robin]: Hello, Say'ri.

Say'ri:

[Robin]: (Did she not hear me? Or is she distracted by something?) (Oh, I say! She's painting! ...Huh, she's actually quite skilled.) Ho there, Say'ri!

Say'ri: Wha—?!

[Robin]: Sorry! I didn't mean to startle you.

Say'ri: Oh, [Robin]! Fie, but you gave me quite the start... I should be the one to apologize for shouting as I did. Er, I was just... That is... Please don't concern yourself with this.

[Robin]: What, with the painting? Whyever not? It's breathtaking... You're really talented. There's no reason to hide it, is there?

Say'ri: I suppose not. ...And less still, if you've already seen it.

[Robin]: What a lovely tree... But why are the leaves that color?

Say'ri: 'Tis a tree called the cherry. The pink you call out its blossoms, not its leaves.

[Robin]: Interesting. I've never seen one like it.

Say'ri: It's unique to Chon'sin and blooms but briefly once a year.

[Robin]: It must be quite a sight.

Say'ri: It is a dearly-beloved symbol of my people. The river near my childhood home was lined with these trees. When in full bloom, 'twas a spectacle fit to steal one's breath away. I think of it often, of late...

[Robin]: ...Say'ri?

Say'ri: Ah, apologies! I lost myself in nostalgia, it seems. I don't know what came over me.

[Robin]: Not at all. I enjoy listening to your stories.

Say'ri: Saying so is the greatest reward you could offer. My thanks.

SAY'RI X AVATAR (MALE) [ROBIN] S

Say'ri:

[Robin]: You're awfully quiet, Say'ri. Is everything all right?

Say'ri: Ah, [Robin]. Apologies. My head swims with memories of Chon'sin as of late.

[Robin]: It wasn't my asking questions that brought this on, was it? If so, that was certainly never my intention.

Say'ri: No, no. It's quite all right. Better than all right, in fact... Because in looking to the past, I've found my way forward...

[Robin]: Oh?

Say'ri: I realize that I'm not sad anymore. Even far from Chon'sin, I feel as I belong here. I've found someone whose breast is home, you see, and my place is at his side.

[Robin]: You...have? Er, I mean, that's...great. I'm happy...for you...

Say'ri: Ha! See how your face falls at the news... But fear not: that someone is you.

[Robin]: ...What?

Say'ri: I'll never be far from home as long as I'm with you, [Robin]. Please...stay with me.

[Robin]: Oh, Say'ri! I want to spend the rest of my life with you, too!

Say'ri: I...I would be honored.

[Robin]: And I'd still love to see Chon'sin once the war is over. I want to see the place that could produce someone as amazing as you.

Say'ri: Then I will show you.

[Robin]: It's a promise. You can bring your new home to your old one.

Say'ri: Perhaps under the cherry trees, we can be joined. Together, as one...

[Confession]

Say'ri: To think my greatest joy should be found within this chaos. Your heart and mine shall be bound forever.

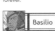

Basilio

BASILIO X AVATAR (MALE) [ROBIN] C

[Robin]: Ah, Basilio. Hello.

Basilio: Greetings, [Robin]. What can I do for you?

[Robin]: I wanted to ask you something about your days as the reigning khan. Is it true you used to leave the castle and strike out on journeys?

Basilio: Aye, that I did, when the mood took me! Why, do you think it foolhardy for a ruler to venture outside his castle walls?

[Robin]: Of course I do! Even if your post was only temporary, you were lord of the realm. What if you were to run into trouble?

Basilio: IF? Bwa ha ha! Oh, my boy! Khan Regnant Basilio ALWAYS ran into trouble! And he always made it home in one piece.

[Robin]: You can't be serious!

Basilio: Well, I'm sure as hell not making it up for YOUR benefit!

[Robin]: No, of course not. It's just that... Well, I'm flabbergasted, truth be told.

Basilio: Pah, it wasn't any momentous event. I often went roamin' by myself, in fact.

[Robin]: Alone?! Without even the kingsguard?! What fools allowed you to take such risks?! If I'd been on your council, I would never have permitted you to wander off like that!

Basilio: That's exactly what my counselors said. ...So I never told 'em I was going! Ha!

[Robin]: You left without escort AND without telling the council where you were going?!

Basilio: It wasn't easy, mind. I had to pull a few tricks.

[Robin]: Tricks?

Basilio: Yep. Come here, lean in close... *whisper, whisper*

[Robin]: No! Really?! With THAT? You're pulling my leg!

Basilio: Keep your voice down, fool!

[Robin]: Oh, right. Sorry. But...

Basilio: A man can solve most any problem, so long as he's willing to think around corners. Remember that, [Robin], when you get lost in your maps and dusty old books! BWAAA HA HA!

[Robin]: ...Was that a joke? I don't get it?

BASILIO X AVATAR (MALE) [ROBIN] B

[Robin]: Basilio?

Basilio: Oh-ho! [Robin] strikes again! What can I do for you?

[Robin]: I was thinking about your clandestine adventures when something struck me... How did you pay for all the costs? You'd have inns, provisions, horses...

Basilio: Easy! I'd hire myself out as a sellsword or join a traveling theater troupe.

[Robin]: ...The reigning khan was consorting onstage with ACTORS?!

Basilio: We would've been hell to pay if I were caught, but looking back now, it just seems funny! Remind me to tell you about a little mishap with a cat and a sandbag! Bwaaa ha ha!

[Robin]: Yes, I'm sure it was a laugh riot.

Basilio: Gods, but I miss my travelin' days. I grew so bored sitting in his life! A mug in his hand, a lady on his arm... Sure wouldn't kill you to let your hair down occasionally, [Robin]!

[Robin]: I am the tactician for an entire army. I don't have time for solo adventures.

Basilio: No, I suppose not. Especially with this blasted war dragging on.

[Robin]: Exactly. I'm glad you appreciate—

Basilio: So what about a woman? You've got time for that, surely?

[Robin]: Good heavens!

Basilio: Heh heh. Come now, boy! Don't tell me it hasn't crossed your mind. We've seen some fine ladies in this army, no? Surely one or two of them tickle your fancy.

[Robin]: Well, I... That is to say... We are not having this conversation! I have vital matters of strategy to ponder.

Basilio: Don't get testy with me now, boy! Especially not when I'm about to share my fail-proof tip for meeting ladies...

[Robin]: ...I really should get back.

Basilio: Hush now, and lean in close! It's all about... *whisper, whisper*

[Robin]: N-no! Really?! That actually works?!

Basilio: Ha ha ha! Well, I'll leave the rest to you and your imagination. Good luck!

[Robin]: ...It truly frightens me to think that man once led an entire nation.

BASILIO X AVATAR (MALE) [ROBIN] A

Basilio: Ahoy there, [Robin]!

[Robin]: Ah, Basilio.

Basilio: I bet you haven't pulled your nose out of those tactical plans since we last spoke.

[Robin]: Yes, well, I'm afraid I haven't had much time for jollying around.

Basilio: Pah. You're wound up so tight it's a wonder your arse doesn't explode! Still, you're in good company, I suppose. Chrom and his gang are busy just the same.

[Robin]: Indeed. When this war is over, I think we're all going to take time to unwind.

Basilio: You might be an old man by then! Nay, boy, you need to have fun while you're still YOUNG! It's not just about amusing yourself. It's about making friends! Forging ties!

[Robin]: Yes, I...I suppose you have a point.

Basilio: If you don't take time to chat with friends, you forget how to be persuasive. Now you tell me—what use is a tactician who can't convince soldiers to obey him?

[Robin]: ...You certainly make a strong case. Very well. I will try to be more...sociable.

Basilio: You're missing my point, you thick-skulled ninny! It's not about TRYING anything! You just need to make time for your friends and have some fun! That's all.

[Robin]: Er, do you have any suggestions? Specifics would be useful...

Basilio: One or two, one or two. Here, lean in close... *whisper, whisper*

[Robin]: WHAT?! You must be joking, sir! I... I couldn't do THAT! NEVER!

Basilio: Sure you could! You just need to lay the groundwork properly.

[Robin]: How so?

Basilio: Come on, you're the master tactician! What do you do before a fight? Marshal your men, prepare your weapons, match strengths to weaknesses, and strike!

[Robin]: I don't quite see the connection...

Basilio: BWA HA HA! By the gods, youth is wasted on the young! Just think about it, fool!

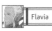

Flavia

FLAVIA X AVATAR (MALE) [ROBIN] C

Flavia: Ah. [Robin], isn't it? I want a word with you.

[Robin]: Oh, Khan Flavia. What can I do for you?

Flavia: I just wanted to say that I am very much an admirer of yours. You are quick witted, bold, and decisive... Everything a superior tactician should be.

[Robin]: I'm honored by the compliment, but I only—

Flavia: Please dispense with the humility. I find it terribly dull and, in your case, ill fitting. You have great talent, and it's only through your efforts that still I draw breath.

[Robin]: It was nothing. Truly.

Flavia: Let me speak plainly: the post of chief tactician in the kingdom of Regna Ferox is currently vacant. I want you to fill it.

[Robin]: Khan Flavia?

Flavia: Of course, I am talking about after the war. You must see Chrom through to victory.

[Robin]: Milady, I...I don't know what to say. Might I have some time to think on it?

Flavia: Of course. You mull it over, then return to me when you are ready to accept.

FLAVIA X AVATAR (MALE) [ROBIN] B

[Robin]: Hmmm... But then, if they hit us here, our flank would be exposed. Unless...

Flavia: [Robin], is that you?

[Robin]: Oh, Khan Flavia.

Flavia: What are you doing out here? Everyone else is resting. Ah, yes, yes, yes.

[Robin]: Er, yes what?

Flavia: Not only are you skilled, smart, and brave, but also hardworking and diligent! We simply MUST have you.

[Robin]: I'm sorry?

Flavia: Come, come, [Robin]. Have you forgotten our talk?

[Robin]: Is this about the tactician position?

Flavia: I don't mind waiting until after the war, but I'm anxious to know your intentions.

[Robin]: I'm honored by the offer, but I just don't have time to consider the proposal.

Flavia: Too busy serving Chrom, I suppose.

[Robin]: He's placed a great deal of trust in me, and I couldn't bear to let him down.

Flavia: I'm going to have my work cut out prying the two of you apart! I can see how strong the bonds are between you—such deep trust is rare. But you must think about your future. This war will end one day... And when it does, you need to decide what's best for you. ...Not Chrom.

[Robin]: Er, I suppose so...

FLAVIA X AVATAR (MALE) [ROBIN] A

Flavia: [Robin], may I have a word?

[Robin]: Ah, Khan Flavia. Is this about the tactician position? As I explained before, I don't have much time to think about it, what with—

Flavia: No, it's not that. Actually, I've been doing some thinking of my own...

[Robin]: Oh?

Flavia: As a tactician, your judgment is supreme. Frankly, I've never seen your equal. But I have started to notice that perhaps your powers are not...all of your own. What I mean is, you seem only able to do what you do when you fight with Chrom.

[Robin]: Huh?

Flavia: I've been watching the two of you very closely these past few weeks. The bonds of trust are so strong between you—it's as if you feed off each other. ...It's quite remarkable.

[Robin]: It is true that when we fight together, I feel more confident and clearheaded.

Flavia: You never had any intention of accepting my offer to join Ferox, did you?

[Robin]: It's not that at all! I swear I was going to give it serious consideration! It's just—

Flavia: Oh, it's all right. I don't mind, truly. In any case, I've decided to stop pestering you about the position. After all, we're due for a long run of peace, wouldn't you say? Perhaps my kingdom won't even NEED a tactician! Ha!

[Robin]: Heh, I pray that day comes...

FLAVIA X AVATAR (MALE) [ROBIN] S

[Robin]: Khan Flavia?

Flavia: What is it?

[Robin]: I wanted to talk about the position, as Ferox's tactician...

Flavia: Oh? I thought we decided that we won't be needing your services.

[Robin]: Well, it's just that...it's true what you said, about how Chrom and I work together. And that made me realize that I need to give myself a new challenge.

Flavia: How do you mean?

[Robin]: If I stay with Chrom, I'll never learn how to be a tactician in my own right. So I think that when this war is over, I'm going to strike out on my own. If I don't do it then, I never will.

Flavia: So you will consider my offer?

[Robin]: If it is still available, yes.

Flavia:

[Robin]: Khan Flavia? Did you hear me? I said that—

Flavia: I'm most grateful, but I must confess... I have not been completely honest with you.

[Robin]: What do you mean?

Flavia: At first, I did want you to come to Regna Ferox as my tactician. But then, almost without knowing it, I found myself wanting you for different reasons. In short, I wanted you as my...companion.

[Robin]: Wh-what are you saying?

Flavia: It shames me to admit it, and I'm sorry for misleading you... Of course, I will understand if you want nothing to do with me...

[Robin]: Heh, you won't get rid of me that easy...

Flavia: Hmm?

[Robin]: You promised me a job, Flavia.

Flavia: Are you mocking my affections? ...I've killed men for far less, tactician.

[Robin]: I wish to serve you for the rest of my life—as tactician AND husband.

Flavia: You... I... Are you certain about this, [Robin]?

[Robin]: I have never been more certain about anything in my life.

Flavia: Oh, this is wonderful, [Robin]! The whole kingdom will rejoice! And I...

[Robin]: But, I still don't understand how I'm supposed to have fun if... He is a baffling man. A bold warrior, but a baffling man... *Sigh* In any case, where's my map for the next battle? Ah... So, if we deploy here...

Flavia: Heh, I think you mean "we" most of all. Today I'm the luckiest man in all the realm.

[Robin]: Right! Then let's hurry up and get this blasted war over with already, eh?

[Confession]

Flavia: In the name of Regna Ferox, I'll tear the whole world down if you but ask it of me. That's a Khan's promise.

■ DONNEL X AVATAR (MALE) [ROBIN] C

Donnel: Nah, still no good. The hook's too big. Maybe if I... Naw, that ain't it neither!

[Robin]: Donnel? What are you trying to do?

Donnel: This dang fishin' hook I'm makin' just don't wanna work for me. See here? Way it is now, the fish'll just slip right off soon as it starts fightin'.

[Robin]: Ah, yes. It needs a barb on the inside. Here, may I? ...There we go.

Donnel: Wow, thanks! I owe ya one, [Robin]. How'd you know so much about fishin' hooks anyhow?

[Robin]: Oh, just something I read about at one time or another.

Donnel: Shoulda guessed. You always got yer nose in one dusty book or another. I just wish there was some way I could return the favor. Say, you know anythin' 'bout buildin' snares? I'm actually a pretty good trapper.

[Robin]: Not much, I'm afraid. Perhaps you'd teach me some basic traps sometime?

Donnel: Darn tootin' I will! We can start with a box trap. Ain't nothin' to it.

[Robin]: Sure, sounds great!

■ DONNEL X AVATAR (MALE) [ROBIN] B

[Robin]: Hey, Donny! You remember that box trap you helped me make? Well, I caught a boar! Just look at the size of this thing!

Donnel: It's near as big as this fish I caught thanks to yer tricky hook!

[Robin]: Goodness, I think we're going to have leftovers tonight.

Donnel: Heck, if we smoke that boar'a yours, we'll be set for a month.

[Robin]: Boar jerky? My mouth's watering just thinking about it... Oh, and speaking of, I was working on ways to improve that trap. I think I've got a better trigger figured out. You should come by and take a look.

Donnel: Swell! I got a new hook I wanted to show ya, anyhow.

[Robin]: Ha ha, listen to us! We're obsessed.

Donnel: Heh, ain't that the truth. We ain't even on larder duty!

[Robin]: We should be, the way we're stockpiling provisions.

Donnel: I wager the others'd think we're a right pair of greedyguts, way we's goin'.

[Robin]: I know! Ah ha ha!

■ DONNEL X AVATAR (MALE) [ROBIN] A

[Robin]: Do you cook, Donny?

Donnel: Sure—if I ain't got a choice. You?

[Robin]: I've only poisoned myself twice!

Donnel: You say that like yer proud! But ain't much use to all this meat if we can't do nothin' with it.

[Robin]: Although, you know what I say? At cooking it, I mean? I'll bet if the two of us put our heads together we could come up with something.

Donnel: No harm in tryin'.

[Robin]: Gah! The fish! You're burning it!

Donnel: And yer stew's a boilin' over!

[Robin]: HOOOOOT! Hot! Hot! Hot!

Donnel: You all right?!

[Robin]: Ow— Y-yes, I think so. It's just a little burn.

Donnel: You gotta cool that, quick! Take this... Aw, horse apples! We're outta water! I'll go draw some. Don't move! I got the water! Stick yer hand in there!

[Robin]: Ahhhhhhhhh...

Donnel: I reckon there WAS harm in us tryin' to cook.

[Robin]: Still, I'd say it was worth it. At least I got to learn something about you.

Donnel: And what's that?

[Robin]: You've got a cool head in a crisis. You were quick on your feet and kept it together. Thanks again for the water.

Donnel: Shucks. Ain't nothin' nobody else wouldn'ta done...

[Robin]: Don't be so modest. You certainly... *sniff* *sniiiiiiff* Er, Donny? Is something burning?

Donnel: The fish! The fish is still on the goldurn fire!

[Robin]: I think the harm is starting to outweigh the benefit here. Let's just throw some dirt over these cookfires and slink away. Er, and perhaps we'll not mention this to anyone else, eh?

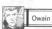

■ ANNA X AVATAR (MALE) [ROBIN] C

Anna: Tee hee hee!

[Robin]: Ha! Someone's cheerful today.

Anna: EEEEEEEEK! Oh! Sorry! I didn't notice you there.

[Robin]: No, I'M sorry! I didn't mean to scare you like that. I was just wondering what you were laughing about?

Anna: Well, I just sold some inventory at three times the price I paid for it!

[Robin]: That's great! ...So long as I wasn't one of the suckers who fell for it?

Anna: Hey, if you don't know the game, you shouldn't make the deal! But don't worry. It wasn't you. ...Ah, there's nothing like the feeling of when the coins hit your hand.

[Robin]: If you say so.

Anna: Oh, I do! I tell ya, the path to happiness is paved with gold!

[Robin]: ...But there are some things money can't buy. Important things.

Anna: Pffft. That's a load of bull plop! And even if it was true, money makes you care less about not having those things.

[Robin]: I don't know...

Anna: I love money! Money, money, money! Clink clink click go the coins!

[Robin]:

■ ANNA X AVATAR (MALE) [ROBIN] B

[Robin]: Hello, Anna.

Anna: Oh! Hello, [Robin]!

[Robin]: I've been thinking about our last talk... I must say, I'm a bit concerned. You do know there are things money can't buy, right?

Anna: Well, everyone says that, but it's not really true. Money can buy loyalty. It can buy safety. ...Power. ...Strength. Even love is for sale, if the price is right.

[Robin]: You can't possibly believe that!

Anna: Believe it? Heck, I've SEEN it! I can't tell you how many men I've had to turn away. Besides, even the noblest soul considers finances when looking for a partner. No one wants to marry a broke joker, no matter how sweet he might be.

[Robin]: I don't... Hmm...

Anna: Or say there was a girl you were completely in love with. What would you do? Take her to nice restaurants... Buy her expensive gifts... That's money at work right there... And there's nothing wrong with it!

[Robin]: I suppose your argument has some merit, though it still seems extreme. And even if true, isn't it kind of... I don't know. Sad?

Anna: Look, I'd love to live in a rainbow-sprinkle world where money didn't matter, too. And it's important to be realistic about things, even when reality isn't pretty.

[Robin]: I guess that's fair...

■ ANNA X AVATAR (MALE) [ROBIN] A

[Robin]: Something wrong, Anna?

Anna: Rragh! What gives today?!

[Robin]: Something wrong, Anna?

Anna: Yes, something's wrong! I didn't make a single sale all day! And my merch is top notch, too. The world's gone topsy-turvy!

[Robin]: Sorry to hear it.

Anna: Times like this, a girl needs a shoulder to cry on.

[Robin]: Perhaps you could rent one?

Anna: Oh, ha ha. Very funny... Look, I may be pragmatic, but I'm still human. I need companionship, too.

[Robin]: ...Really?

Anna: YES! Do you really have to ask? Sheesh, why can't you just listen like you always do?

[Robin]: Maybe I'm holding out for more money.

Anna: Now just a... Come on! Stop it already!

[Robin]: Hah! Okay, okay, I'm sorry. But after all you said before, I had to razz you a little. I'm happy to listen, free of charge.

Anna: Good! Now wipe that smirk off your face. And get comfortable. This may take a while.

[Robin]: Sure, I'll just start a tab...

Anna: *Sigh* ...You just don't give up, do you?

■ ANNA X AVATAR (MALE) [ROBIN] S

[Robin]: Hello, Anna. I brought you something.

Anna: Ooh! A present? For me?!

[Robin]: It's not much, but...

Anna: Aw, it's a necklace! That is SO SWEET! But, um... Why?

[Robin]: Well, it's your birthday, isn't it?

Anna: Is it? ...Wait, it is! I completely forgot! I'm surprised you even knew.

[Robin]: I wouldn't let a good friend's birthday slip past unnoticed.

Anna: I'm a...good friend?

[Robin]: Of course you are.

Anna: Um... Gosh, you really ARE sweet.

[Robin]: Thanks.

Anna:

[Robin]: Something wrong?

Anna: No, I'm just...realizing something. People say "it's the thought that counts"...and it's actually true.

[Robin]: You realized that because of my gift?

Anna: I did. And you know what, [Robin]? You're right. Some things money can't buy. I love you!

[Robin]: Wh-what?! What's this, all of a sudden?

Anna: What can I say? I'm a whimsical girl. So you wanna get married now or what?

[Robin]: Okay, that's REALLY sudden!

Anna: I TOLD you I was whimsical! Better decide quick, before my whimsy takes me in a new direction.

[Robin]: Looks like I'm feeling whimsical myself. Let's do it! Let's get married! Just don't ask me to help out with the business. I'm terrible with money.

Anna: It's a deal! Now let's go find a ring and talk the owner down to half price...

[Confession]

Anna: Keep this up and someday I may love you more than money! Haha...no, seriously.

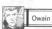

■ OWAIN X AVATAR (MALE) [ROBIN] C

Owain: ...I leap into the center of the enemy formation, blade drawn, and spin! I'm no longer a man, but a whirling dervish of death and steel!

[Robin]: ...What are you doing, Owain?

Owain: Oh, greetings, [Robin]. I'm chronicling the saga of Owain Dark, Avenger of Righteous Justice. It's a tale of blood and honor and me being generally amazing.

[Robin]: Owain Dark?

Owain: A title bestowed upon me by the masses, born of equal parts fear and respect! What began as rumor soon became legend, and my name spread throughout the world!

[Robin]: Do people actually call you that? I mean, real people? Who exist?

Owain: ...Not yet. But they will!

[Robin]: Well, it's good to dream big, I suppose.

Owain: Any man can dream. But only a legend can become a myth!

[Robin]: Only a legend can become... You know what? Good for you. Whatever floats your boat. But as a tactician, I'd advise against jumping into a pack of enemies.

Owain: HA HA HA! WORRY NOT, MORTAL!

[Robin]: Gah?!

Owain: I spy a pack ten men strong and charge into the fray! One swipe, and two fall! I lock swords with the third... CHING! His guts spill forth upon the earth! As the fifth falls, the sixth flees, driven mad. A cut and a slash and three more are down! "I bear you no ill will," I cry as I slay. "Rest in peace! Or rest in PIECES!" As the dust settles, only two men yet stand. My showdown with the evil general begins!

[Robin]: (It's like watching some kind of bizarre one-man theater performance...)

Owain: My sword flashes out, a flickering blur of cold blue steel. Ka-thwack! Schwing! "Ha ha ha! I'm impressed, General. No one has blocked that before." The general wobbles on unsteady feet and then drops to his knees in shame. "Mercy, Owain Dark! Have mercy on me! For I cannot abide another mighty blow!"

[Robin]: I don't...

■ OWAIN X AVATAR (MALE) [ROBIN] B

Owain: Time to weave another brilliant tapestry of tactics for use in my future battles. Today, I run the gauntlet through the very heart of enemy territory: Castle Doom! Which means it's guaranteed to end with a dramatic rooftop showdown. Here we go... I take the vanguard, sprinting toward the castle gates a step ahead of my allies!

[Robin]: Hello, Owain. Are you...visualizing future combat scenarios again?

Owain: I am indeed, my inquisitive friend. And in this week's thrilling episode, I conquer Castle Doom!

[Robin]: (Single-handedly, no doubt...)

Owain: What was that, [Robin]?

[Robin]: Nothing! Nothing at all.

Owain: Then let the carnage begin! The mission is simple: take the wicked lord of Castle Doom...alive! For he is the only one who knows the location of the orphan hostages!

[Robin]: Wait, why would anyone hold orphans hostage? Who would pay the rans—

Owain: But at the lord's side stands a stunning female knight of legendary skill. I don't have the luxury of a cautious fight. If we dance, the cowardly lord will flee! I trust my allies to guard the exits, and the rooftop duel commences!

[Robin]: Wait, wait, which way did you get on the roof?

Owain: I lock eyes with a woman whose sword has toppled dynasties! Our blades meet, and in that instant we each understand the mettle of the other. She smiles then, a slender thing, as a single tear works down her cheek. "At last," she whispers, "a worthy foe."

[Robin]: ...Yes? And then?! Don't stop when it's actually getting good!

■ OWAIN X AVATAR (MALE) [ROBIN] A

Owain: Ahoy hoy, [Robin]!

[Robin]: Oh, hello, Owain.

Owain: Any interest in hearing the next episode in the ongoing saga of Owain Dark?

[Robin]: Um...I don't know. I was going over these plans for our next bat—

Owain: Right then! This time we finish it, for once and for good! It's time to wrest peace from the clutches of evil!

[Robin]: —tle. Okay, then. Never mind. I guess we'll all just be killed.

Owain: You say something?

[Robin]: Nothing important.

Owain: Right, then. Where were we? Ooh, yes! We left off at the big showdown between me and the legendary knight! Okay, so I beat her.

[Robin]: ...That's it? You beat her...? Isn't that a bit, I don't know...anticlimactic?

Owain: She was good. No, great! But even she was no match for the fearsome Owain Dark! AND YET! Our tortured hero now finds himself in a throbbing crisis!

[Robin]: Here we go, that's more like it...

Owain: It seems the cowardly lord of Castle Doom is even stronger than his shapely knight! My allies drop their weapons and flee for their lives, leaving me as the only hope! We circle each other for what seems an eternity, then begin a clash for the ages! He raises his blade and brings it down with earth-shattering force! SCHWOO! But I leap to the side with feline grace, and his sword finds only air! He changes his grip and slashes upward, but is speared by my blinding thrust!

[Robin]: ...Oh. That wasn't so tough, was it?

Owain: Y-yeah, well, I read his intent by watching his right shoulder and leading foot. The speed of my thrust came from shifting my weight to the back leg.

[Robin]: ...Huh. I'm surprised you put that much thought into the details.

Owain: You wound me, sir! The Saga of Owain Dark has always been a simulated training exercise. Every prudent warrior envisions possible scenarios and crafts tactics to best them.

[Robin]: So this is just your way of practicing sword forms?

Owain: ...Something like that, I guess. Except that my method is a lot more entertaining.

[Robin]: I suppose people learn more quickly with a training style that suits them. I owe you an apology, Owain. I thought this was but egotistical fluff. You've shown me that there are many ways to train as there are to fight.

Owain: I'm glad you finally ken the true genius of Owain Dark, mortal!

[Robin]: You may make a legend after all, my friend. I look forward to future installments.

Owain: Owain Dark never disappoints. Just be sure to come back next time for the next thrilling installment!

Owain's father/son dialogue can be found on page 289.

■ INIGO X AVATAR (MALE) [ROBIN] C

Inigo: Hello, [Robin]. You busy?

[Robin]: No, not really. Did you need a favor?

Inigo: Ha ha! No, it's nothing like that. I just figured it wouldn't kill me to spend time with the fellas once in a while.

[Robin]: Ha! You mean instead of chasing girls hither and yon? Yes, I'd say taking a break once in a while is definitely healthy.

Inigo: Oh! Speaking of healthy, did you try that vegetable cantina in the last town? You would not BELIEVE how cute the serving wench was!

[Robin]: You're taking a break from chasing girls by telling me about...chasing girls?

Inigo: She actually blushed when I said hello. Talk about sweet? I could bottle that! You can't tell me you wouldn't want to share a cup of tea with a lady like that? Plus if she's blushing, that usually means she's interested. Grrrawl!

[Robin]: I...suppose so? So what happened next? Did you have that cup of tea?

Inigo: ...Alas, she dashed my hopes. I asked when her shift ended, and she said "After your bedtime"! Ha! But what a wit! She must get many such requests.

[Robin]: She must get many such requests. Perhaps she's simply tired of them.

Inigo: Or perhaps I just need to ask with more confidence! Ladies love confidence.

[Robin]: Heh, you don't let much slow you down, do you?

Inigo: I can't waste time moping about one rejection when so many ladies remain! Still, thanks for cheering me on, [Robin].

[Robin]: ...Is that what I was doing?

■ INIGO X AVATAR (MALE) [ROBIN] B

Inigo: Heeeeey, [Robin]!

[Robin]: Well, you sound chipper, Inigo.

Inigo: Of course! Nothing scares the ladies away like a frown, so I'm all smiles, all the time!

[Robin]: It always comes back to that, doesn't it?

Inigo: Oh, that reminds me! So I told you about that restaurant I ate at, right? The one with the cute waitress?

[Robin]: Let me guess: you met another woman there.

Inigo: She was absolutely gorgeous! And sitting just one bench away!

[Robin]: How did I know?

Inigo: Well, we both finished eating, but right before I turn on the ol' Inigo charm... I suddenly feel lumbers up and gives me the stink eye! Well, actually he started yelling in some weird language and waving a sword around. But that's close enough to the stink eye where I come from.

[Robin]: Sounds like you made a narrow escape.

Inigo: Ha! I know! I was out of there like a greased pig at the harvest festival. Even I'm not crazy enough to hit on another man's special lady friend.

[Robin]: This could be a good learning experience. Maybe next time you'll think twice before leering at every woman you see.

Inigo: Oh no! The way I see it, each failure is just more practice for my next encounter! And speaking of which, there's this redhead...

[Robin]: ...This boy is utterly hopeless. Still, I guess everyone needs a hobby. I just hope he doesn't end up on the end of a lance one day...

Inigo: [Robin]? [Robin], are you listening to this?

■ INIGO X AVATAR (MALE) [ROBIN] A

Inigo: Say, [Robin]? Got a minute?

[Robin]: Sure, what is it?

Inigo: You have to listen to my tale of woe!

[Robin]: I bet I know how it ends...

Inigo: I'd been hearing rave reviews about a new tavern in town, so I headed there for lunch. And it was amazing! Even better than what I'd heard, honestly.

[Robin]: Oh? What's the name? I'd love to try it. And I must say, I'm surprised. I thought for sure you'd tell me about some worn—

Inigo: ANYWAY! When I finished eating, I went to give my compliments to the chef... And she was a TOTAL KNOCKOUT!

[Robin]: ...Right.

Inigo: I told her how much I enjoyed the food, and her face just lit up! We started talking about the culinary arts, and things took off from there.

[Robin]: Didn't you say something about this being a tale of woe?

Inigo: Well, at one point I mentioned how smokin' hot she was. Innocent compliment, right? Apparently not, because boy, was she mad! I apologized right away, but she wouldn't have it. She said I was more interested in her body than her food. Then she said she'd rather sleep in an iron maiden than talk to me again! ...Er, and she may have also mentioned something about a chastity belt.

[Robin]: I suppose she wanted to be acknowledged for her skill more than her appearance.

Inigo: You mean she thought I had an ulterior motive for complimenting her cooking? Boy, you tacticians really are smart. After outwitting enemy generals, I bet the ladies must be easy prey.

[Robin]: ...You get slapped a lot, don't you, Inigo?

Inigo: Oh yeah, all the time. I mean, when I'm not getting kneed in the groin. Still, I really did mean what I said. She was an amazing chef.

[Robin]: So the bit about her looks was...what then? Habit?

Inigo: Exactly! Habit! ...And THAT'S why I have to go apologize to her right now.

[Robin]: I really don't know if that's a good—

Inigo: I'll apologize for the comment and tell her I loved her cooking. AND I'll tell her it would be delicious even if she was ugly enough to scare a wyvern!

[Robin]: That's...um...not really... Oh dear.

Inigo: I flirt because I love, you know. The last thing I want to do is hurt people.

[Robin]: Then perhaps you should stop hitting on every woman in sight?

Inigo: What? ...Don't be silly! It would be cruel to let one mistake deprive all other women of my charms!

Inigo's father/son dialogue can be found on page 293.

■ BRADY X AVATAR (MALE) [ROBIN] C

[Robin]: Ah, there you are.

Brady: Lookin' for me, [Robin]?

[Robin]: We haven't had much chance to chat. I thought I'd rectify that.

Brady: Afraid I ain't much of a conversationalist. I'd probably bore ya stiff.

[Robin]: I'm sure that's not true.

Brady: Plus, I got no place talkin' to an overachiever like you to begin with. We two just ain't a good fit, see?

[Robin]: Well, what sort of person WOULD be a good fit?

Brady: Oh, I dunno. Maybe somebody like that...one fella. The one with the axe. ...Wait a sec, who do I usually talk to? Gotta be SOMEONE, right? Hells bells... Do I not have any friends?

[Robin]: Wow, I, uh... I'm sorry I asked?

Brady: Augh, it's embarrassing enough without you pitying me! I guess I don't really have much in the way of buddies... But what I need is a mentor! Someone who knows how a real organization works and does it all by the book. Yessir, I'm ironclad hierarchy for me!

[Robin]: You want an ironclad hierarchy?

Brady: Course! The sort of outfit I wanna be a part of is run by the boys up top. When the saps down below screw up, they get smacked right back in line!

[Robin]: Sounds like you'd make for a pretty stern boss.

Brady: Eventually, maybe. But I ain't planning to be the big cheese anytime soon. I'm the new kid. I want somebody who's gonna show me what's what. A guy with gravitas, yeah? Manly and tough, but dedicated. Little fire in my belly! The sort of fella what I can admire.

[Robin]: Sounds pretty stoic.

Brady: Yeah, exactly! Stoic! Respect for authority mixed with a liberal dose of old-fashioned male bonding! The boss has his boys into men, and the men defend the boss with their lives!

[Robin]: Heh, well I guess the trick is finding the right boss, then.

Brady: I'm hoping to find somebody up for the job right in this here army.

[Robin]: I can keep my eye out for likely candidates if you want.

Brady: Naw, forget it! This ain't the sort of thing what you can find lookin' for it. It's fate as much as anything else. I'll see who the stars lead me to.

[Robin]: If you're sure...

■ BRADY X AVATAR (MALE) [ROBIN] B

Brady: Hmm... Everybody likes him... They trust him as a tactician... His orders are so darn precise... He keeps his eye on the whole field... I know I wouldn't be scrappin' half as well if he wasn't telling me what to do. Plus the guy's a beast in combat, always defending the rest of us...

[Robin]: Hmm? Who's that over there...?

Brady: I think I've found my man!

[Robin]: Oh, hello, Brady. What'd you find?

Brady: Wha—? I-I found it! ...N-no, nothin'.

[Robin]: You sure? If there's something on your mind, I'm always happy to listen.

Brady: ...Okay, well... When you make a plan, what's the most important thing?

[Robin]: Huh? Where's this coming from?

Brady: Don't clam up now, just answer the question.

[Robin]: Hmmm... I suppose it's finding a clear path.

Brady: A path's an awfully literal answer. I was expecting something... I dunno. Fluffier. "Faith in one another" or "ties that bind." That sorta malarkey. Or at least some kinda wacky concept like "efficiency" or "finesse."

[Robin]: I think everything you just mentioned is important. But I view my job as charting a path from wherever we are to victory. That way, when I give out the directions, there's a context. A logical continuity. I'd say that's first and foremost for me.

Brady: So you DO mean it as more of an abstract thing!

[Robin]: Well, literal roads are important too, but yes. I'm navigating our way through this war, and everyone else is on the ship. We all share in the journey, so I need to be sure we agree on the course.

Brady: So it's important it has a "logical continuity"... Huh.

[Robin]: Does that answer your question?

Brady: I dunno. Gimme some time to mull it over. ...Alone.

[Robin]: I wonder what that was all about.

■ BRADY X AVATAR (MALE) [ROBIN] A

Brady: Hey, [Robin]! I want to be yer boy, and I want you to make me a man!

[Robin]: ...I'm sure I must be misunderstanding you.

Brady: I want you to be the boss what keeps me in line! Remember? We talked about this! I've been looking for someone I could lay my life down for in this here army. A mentor! A big cheese who shows me the ropes!

[Robin]: Riiight. I remember that much.

Brady: Well, I decided YOU'RE gonna be that someone! Sure, you're not exactly the gruff, manly type, and "gravitas" ain't a word I'd use... But what you said before, about seeing a clear path? It kinda got me right here.

[Robin]: Er, I'm flattered, but I don't know if I'm the sort of superhuman you're looking for.

Brady: Whoa, whoa. Hold it right there. A boss has gotta ACT like a boss, you know? Have some bravado. Some swagger! Never play modest, especially in front of the boys! Now, let's try this again. Lay some orders on me, boss! Lemme have it!

[Robin]: I'm still not really sure what you're looking for me to do here...

Brady: Put me to work! Send me on errands! Whatever ya needs! If anyone in the camp's givin' you lip, lemme 'em around. Fellas? Dames? Old ladies? Don't matter none to ol' Brady!

[Robin]: I don't want anybody smacked around!

Brady: When you walk around camp, I'll be one step ahead, clearin' your path. When you go to eat, I'll stoop people away from your special table!

[Robin]: It's starting to sound like you want a gang kingpin, not a mentor.

Brady: Exactly! You'd be the boss, which would make me your second! All I ask is that ya work me ragged. If I can draw my last breath after taking an arrow for ya, I'll be happy!

[Robin]: What?! I don't want you dying, for me or otherwise!

Brady: ...What, I don't make the cut? Not good enough to be one of your boys?

[Robin]: Ugh, Brady...

Brady: Yeah, boss?! Whaddya need? Just name it!

[Robin]: I'll do my best to mentor you, but not in the way you're thinking. I'm not looking for "boys," and I don't want to be anyone's "boss." I want everyone here to support each other as equals. Not as pawns and kingpins.

Brady: ...Sure I can't change your mind? We could get a gang together...

[Robin]: We have a gang together, Brady! Our army, a field of equals. I consider all of you brothers and sisters—peers—as should you. We're already bound together, and that's not going to change.

Brady: Fair enough, boss. Er, [Robin]. After all, I wouldn't have chose to serve ya if ya didn't have a magnanimous streak.

[Robin]: Brady, I just said...

Brady: Oh, I heard ya. And don't worry. In my heart of hearts, you're still the boss, even if ya wanna just be small potatoes.

[Robin]: Thanks, Brady. Not exactly what I was hoping for, but I'll take it. I'm proud to consider you a friend, as well as an ally.

Brady: Heh, I guess if I can't have a boss, I'll settle for a partner.

[Robin]: Welcome to the gang, Brady.

Brady (Father/son)

Brady's father/son dialogue can be found on page 297.

Kjelle

■ KJELLE X AVATAR (MALE) [ROBIN] C

Kjelle: "Huff, huff" [Robin]!

[Robin]: Goodness, what's wrong?! You look like you sprinted here!

Kjelle: Spar with me! No practice weapons! No quarter! Spar with me for real!

[Robin]: I...didn't see this coming.

Kjelle: Those who lack strength have no place in this army. I will be the one to test you!

[Robin]: You think me weak?

Kjelle: I will save judgment until we have crossed weapons. But I advise you not to take me lightly. I'm stronger than most men!

[Robin]: I refuse your challenge. Only a fool risks injury in anything more than practice. And by your tone of voice, I'm guessing this is more than simple training.

Kjelle: Ha! Look at the craven! Are you so afraid of losing to a woman?

[Robin]: I'm afraid that satisfying your idle curiosity isn't reason enough for me to fight. We've more than enough fighting to do as it is. Save it for our opponents.

Kjelle: Coward! Craven! Yellow belly! Gutless, recreant, fainthearted cur!

[Robin]: Oh, for the love of... *sigh* Fine! Fine. We'll spar. But just this once!

Kjelle: Once will be enough. Have at you!

■ KJELLE X AVATAR (MALE) [ROBIN] B

Kjelle: [Robin]! I demand one more round!

[Robin]: ...All right. But this is honestly the last and final time. Truly.

Kjelle: Then have at you!

[Robin]: You've lost.

Kjelle: What?! We've not even started!

[Robin]: Look at your stance. You're too tense. You've lost before you've begun.

Kjelle: Are you mocking me, sir?!

[Robin]: No, I'm informing you. That's the stance of someone relying solely on brute force. It won't work on me.

Kjelle: A hollow boast! But let's see how you handle... THIS! ...Gwaaagh?! S-so fast! How did you—

[Robin]: You seem to forgo any tactic beyond blindly charging your foe. If so, you'd best get used to this bite of steel at your throat.

Kjelle: ...I yield.

[Robin]:

Kjelle: I challenged you with the idea of gauging your skills, [Robin]. But instead, I find my own prowess has been called into question. ...When you said I relied on brute force, it...upset me.

[Robin]: You're a talented fighter, Kjelle. Just... reckless. I only know your weakness because I've watched you work. However, I'm hardly the best this world has to offer. Some opponents will see you coming a mile away. You won't stand a chance.

Kjelle:

[Robin]: Perhaps I spoke too harshly. Forgive me. I'll leave you to your thoughts.

Kjelle: Damn him... He's right.

■ KJELLE X AVATAR (MALE) [ROBIN] A

Kjelle: ...Hngh!

[Robin]: Something wrong, Kjelle?

Kjelle: Er, I'm... It's nothing.

[Robin]: You're hurt, aren't you?

Kjelle: I said it's nothing. A scratch.

[Robin]: Even the smallest wound can fester. Let's have a look.

Kjelle: Ah!

[Robin]: It's fresh... This is from that last battle! It's a clean cut, at least. Shouldn't even leave a scar, if treated soon enough. It must have been some opponent if they were able to leave such a memento.

Kjelle: She was...quite fearsome. The old me might not have survived the encounter.

[Robin]: Before training, you mean?

Kjelle: Before sparring with you. Your words have made me stronger.

[Robin]: You mean the bit about not relying on brute force? I'm happy to hear it was useful.

Kjelle: I had fought every previous battle on pure momentum. I fancied myself better than any man. Stronger. That's why I needed to face you twice; I couldn't believe the initial result. But strength is more than muscle alone. A keen eye, a quick mind... Any of these things can decide a battle as sure as might. It was you who taught me that.

[Robin]: Glad to hear that, indeed, especially coming from your lips... Aaand...there. Wrapped up and ready to go. How does the bandage feel?

Kjelle: ...Just fine. Thank you.

[Robin]: My pleasure.

■ KJELLE X AVATAR (MALE) [ROBIN] S

Kjelle: [Robin]!

[Robin]: Kjelle... Is everything all right?

Kjelle: I need you to spar with me one last time. ...Please.

[Robin]: I'm guessing your reasons are different than before?

Kjelle: They are. So will you grant me this request?

[Robin]: No holding back. Agreed?

Kjelle: I'll come at you with all I have!

[Robin]: Hyaaah!

Kjelle: Yaaah!

[Robin]: Ngh! ...Yield! I yield! ...You win today, Kjelle. ...And now that you read me as well as I can read you, I doubt I'll ever win again. I'm certainly no match for your power.

Kjelle: Thank you for indulging me. My head feels clear again. It's put my feelings in order.

[Robin]: Oh?

Kjelle: I wasn't sure before, but now I know that... That I love you.

[Robin]: Wait, you... I mean, I don't... Do you mean it?

Kjelle: I haven't stopped thinking of you since my first defeat at your hands. At first I thought I was just angry. My wounded pride and all... But that wasn't it. Or not all of it, anyway. Somewhere along the way, spite gave way to affection. I realized it was not anger that kept you in my thoughts. It was love.

[Robin]: Kjelle, I... Thank you. It's hard for me to believe you really feel this way. Especially since I, too, have been entranced ever since our first duel. Seeing you throw yourself into training... It was quite the impressive sight. And attractive, if I may be so bold.

Kjelle: You may be so bold, sir. For you've become the source of that drive in me.

[Robin]: Then I'm the one who should feel flattered. You're an incredible woman, Kjelle. From here on, we can spur each other on to greater heights. Be each other's drive.

Kjelle: I'd be honored, [Robin]!

[Confession]

Kjelle: With you at my side, I feel as strong as newly-forged steel. I...I adore you.

Kjelle (Father/daughter)

Kjelle's father/daughter dialogue can be found on page 299.

Cynthia

■ CYNTHIA X AVATAR (MALE) [ROBIN] C

[Robin]: The scouts picked up signs of an enemy force ahead. Could be as many as 50.

Cynthia: I'm on my way! I'll have 'em begging for mercy in no time!

[Robin]: What? No, it's too dangerous to go alone. We'll wait here until support arrives.

Cynthia: A hero does not wait for backup! A hero charges into the fray alone! And now, I ride!

[Robin]: Cynthia, wait! Come back! CYN-THIAAAAAAAAAA!

Cynthia: Gyaaa!

[Robin]: Cynthia! Are you all right?! What happened?! ...And why are you covered in mud?!

Cynthia: Oh, it was awful! I headed to where they said the enemy was, but it was a SWAMP! I charged in and couldn't stop in time... Next thing I knew, I was stuck and...and... It wasn't heroic in the slightest!

[Robin]: And...the enemy?

Cynthia: Not a one. The scouts must have been mistaken, I guess. Oh it was awful... All our soldiers who came in behind me got stuck in the mud, too. They're probably just crawling back now.

[Robin]: Ugh... Good thing there weren't enemies after all. We would have been like fish in a barrel, mired in that swamp.

Cynthia: The worst part is that I had a REALLY good victory line picked out for when I won! Now it's totally wasted...

[Robin]: I'm not sure that's the WORST part...

■ CYNTHIA X AVATAR (MALE) [ROBIN] B

[Robin]: Hey, Cynthia?

Cynthia:

[Robin]: Is everything all right? I can practically see the dark cloud hanging over your head. Are you still upset over the whole charging-in-alone-oh-wait-it's-a-swamp thing?

Cynthia: Shouldn't I be? It's my fault. If I hadn't gone off half cocked, the others would have spent a day wallowing in mud.

[Robin]: It's just mud. I think they'll survive.

Cynthia: I... I need to apologize to you, too, [Robin]. I was a big fat idiot! I'm really sorry!

[Robin]: Don't be so hard on yourself. It's all right. It worked out, and no one was hurt.

Cynthia: No, it's NOT all right! I'm supposed to fight to keep everyone else safe! Gods, it's all so embarrassing...

[Robin]: Your heart's in the right place, Cynthia. But sometimes you forget that you fight as part of a team. Even the greatest hero has to have sidekicks, right?

Cynthia: I know that, but...

[Robin]: You'll have a lot more success keeping everyone safe if you work with the team. And people really admire those who work well with others, you know.

Cynthia: ...You think?

[Robin]: Hey, we already consider you pretty darn heroic.

Cynthia: Aw, REALLY?! All right! That settles it! Starting today, I'm a team player! Thanks, [Robin]!

[Robin]: Glad to help.

■ CYNTHIA X AVATAR (MALE) [ROBIN] A

[Robin]: Cynthia!

Cynthia: Huh? What's wrong? Did something happen?

[Robin]: You were amazing in the last battle!

Cynthia: ...I was?

[Robin]: The last few, actually. Keep this up and we won't even need a tactician!

Cynthia: That's great to hear! I mean, not that we wouldn't need you... Oh, you know what I mean.

[Robin]: It seems like you're aware of everyone else's situation and only go where you're needed. Honestly it's been a huge help.

Cynthia: Just doing what you said, [Robin]!

[Robin]: Er, what did I say again?

Cynthia: You said I needed to fight as part of the team.

[Robin]: Oh, right. I mean, of course I did! Well, I'm glad it helped.

Cynthia: I just had to be less of a lone-wolf hero and more of a Justice Alliance hero, you know?

[Robin]: I don't think...I'm quite familiar with that organization? But whatever works for you.

Cynthia: Yep! I'm gonna give it my all, just like a real member of the Justice Alliance! "Never capitulate, never succumb!" That's the Justice Alliance creed!

[Robin]: Er, all right, then.

■ CYNTHIA X AVATAR (MALE) [ROBIN] S

Cynthia: [Robin], do you have a minute? There's... something I want to talk to you about.

[Robin]: Is everything all right? You seem rather... subdued today.

Cynthia: I just... I wanted to thank you.

[Robin]: Heh, you've already thanked me. Many times over, in fact.

Cynthia: No, not for that. Well, it IS for that, but also for a different reason... What I mean is, I kept thinking about what you said, and I realized something new.

[Robin]: What's that?

Cynthia: I always thought protecting other people meant charging in alone, you know? It always felt good to think that. I...I liked it. But it wasn't quite right.

[Robin]: How so?

Cynthia: I was running ahead of the pack so I could feel like I was the one winning the war. But after what you said to me that day, I started watching you. I saw that you were always in the heart of the group. Not charging ahead, not taking all the glory. And yet, you were doing more than anyone to keep us safe.

[Robin]: Well, I'm just doing my part.

Cynthia: As our tactician, you know us all even better than we know ourselves. You make us all better. You're like our ringleader or something. What's that called?

[Robin]: Er, I'm not sure "ringleader" would be the best... You know what? Never mind. Thank you, Cynthia.

Cynthia: So, I was hoping...maybe you would help me be a better person...off the field, too?

[Robin]: I'd be delighted. Er, wait. Do you mean...

Cynthia: I think I'm... I'm in love with you, [Robin]. So I was hoping when you aren't busy being the heart of the group, maybe... Maybe it could just be the two of us?

[Robin]: I'd like that a very great deal, Cynthia.

Cynthia: Oh? Yes? Oh, thank the gods! I was worried you would say no!

[Robin]: It's easy to love someone who gives so much of herself for the sake of others.

Cynthia: Oh my gosh! I love you so much!

[Robin]: And I you. I'll be counting on you to make me the best man I can be, too.

Cynthia: Now that's one job I know I can still handle on my own!

[Confession]

Cynthia: I love you best of all! You're like my own personal hero!

Cynthia (Father/daughter)

Cynthia's father/daughter dialogue can be found on page 303.

Severa

■ SEVERA X AVATAR (MALE) [ROBIN] C

Severa: Hold it right there, [Robin]!

[Robin]: Something wrong?

Severa: Well, duh! Yes, something's wrong! What was that nonsense at the war council just now?!

[Robin]: What, with the battle scenario simulations?

Severa: On the last one, you said we should let the enemy retreat. Are you daft?! Anyone with half a brain would know to pursue and finish off the enemy! Gawds!

[Robin]: I considered pursuit, but it seemed too risky. Factoring in everyone's exhaustion from the first round, it seemed safest to stay put. Chasing a bear into its den can be asking for trouble, especially after a long fight.

Severa: Unless you actually want to SLAY the bear, in which case it's exactly what you do!

[Robin]: I think it really depends on the circumstances... In that scenario, we would've been chasing them into rugged, mountainous terrain.

Severa: So?!

[Robin]: So they can't travel at speed through those mountains. It's just not possible. That leaves us plenty of time to finish them off once we're back at full strength. Besides, if a storm hit while we were marching, we'd be devastated. Mountains are fickle things. I thought it best to play it safe in that case.

Severa: ...You just think you've got ALL the answers, don't you? You sure have gotten a big head since Chrom made you our tactician...

[Robin]: Hey, I hardly think that's fair...

Severa: Oh, so you DON'T think you're the smartest one here? How humble of you!

[Robin]: All right, then. Let's say you were the tactician in the same situation. What would you do, Severa? How would you direct the Shepherds to pursue the enemy?

Severa: HA! Don't think you can trick me with your... trickery!

[Robin]: It's not a trick. I'm honestly curious. If you have a solid plan, then great. I don't want to let them retreat any more than you do, after all. Take a while to think on it, and let me know. Right now, I need to meet with Chrom.

Severa: Ooooh! The big man has a big meeting! ...Gawds, he thinks he's so clever.

■ SEVERA X AVATAR (MALE) [ROBIN] B

Severa: Ha! Found you!

[Robin]: Did you need something, Severa?

Severa: Don't play dumb with me. I'm here with an answer to your little question.

[Robin]: Ah, how best to pursue enemies fleeing into mountainous terrain! Excellent! And what is your solution?

Severa: You let the main force rest, but send a small strike force of your best fighters. That way, you minimize risk while also having the best chance of killing the foe. What do you think about that?!

[Robin]: It sounds reasonable enough... But what if their retreat was just a ruse, and they littered the mountain with traps?

Severa: H-hey! You didn't say anything about traps!

[Robin]: Without knowing anything about the path ahead, sending anyone is a risk.

Severa: Yeah, and so that's why you send your best men and minimize casualties!

[Robin]: ...Not good enough.

Severa: ...Not good enough?!

[Robin]: Chrom and I aren't trying for fewer casualties, Severa. We're trying for none. Anytime we lose a fighter, the operation is a failure—no matter the end result. Your plan is a compromise we're just not willing to take.

Severa: Oh. My. Gawds. Are you serious?! You think you can win a war with pretty ideals and zero casualties? Wake up! You think the war fairy is gonna come flying over and sprinkle victory dust everywhere? ...This isn't about the plan at all, is it? You're just making fun of ME! Well, I'm so sorry if I'm not as smart as my mother!

[Robin]: Er, I think you're misunderstanding what I'm saying, Severa.

Severa: Well I think you're being a big, fat tactical jerk!

[Robin]: ...Well, that could have gone better. But at least now I see what this is about.

■ SEVERA X AVATAR (MALE) [ROBIN] A

[Robin]: Oh. Hello, Severa.

Severa: ...Hey.

[Robin]: I should apologize. For before. I... I shouldn't have been so quick to dismiss your plan. I know you spent time on it.

Severa: No, I'm sorry. I was immature and angry. ...I didn't mean it when I called you fat.

[Robin]: Heh, I admit, I did check myself on the scales afterwards.

Severa: Um, so, I thought more about the scenario, and I think I've got an answer.

[Robin]: I'm all ears.

Severa: What if we sent a scout group by air? Like pegasus knights or whatever. They map out the area, nail down the enemy's position, and sniff out any traps. THEN we send a ground force to take out the enemy.

[Robin]: ...That is a nuanced, well-considered plan. I'm quite impressed!

Severa: Right? The aerial units just avoid archers, and the ground troops aren't going in blind. It's the perfect scheme!

[Robin]: It's a B+ plan, with an A+ for effort!

Severa: B PLUS?!

[Robin]: It's a great idea, Severa, but the scenario we ran at that meeting lacked air support. In this hypothetical situation, there ARE no pegasus knights or... whatever to send. That's why we decided not to pursue the enemy in the first place.

Severa: Y-you can't do this! You can't keep making up new rules all the time!

[Robin]: Heh, sorry, Severa. Really, I am. I thought that was clear from the start.

Severa: Now I feel like a total idiot for wasting all that time thinking about it!

[Robin]: Oh, I wouldn't call it a waste. Considering a problem from different angles often leads to useful discoveries. In fact, your answers have given me ideas for new strategies down the line.

Severa: Yeah, my WRONG answers! Bah, I'm done talking about this!

[Robin]: Hey, I'm sorry! Don't be mad, Severa! Come back!

■ SEVERA X AVATAR (MALE) [ROBIN] S

Severa: Hey, [Robin]?

[Robin]: Yes?

Severa: ...How come you don't avoid me like everyone else does?

[Robin]: Wait, do people do that to you?

Severa: Not always... But whenever I contradict someone or start to get angry, they usually stop listening. I think most people think I'm...difficult.

[Robin]: Well, for what it's worth, I don't think so. You're emotional, yes, and you say what's on your mind. Forcefully, usually... But that doesn't really bother me. In fact, I find it refreshing.

Severa: Refreshing?!

[Robin]: Sure! I mean, look at me. I'm pretty dull when you get right down to it. And even when you say something unkind, there's still a bit of... Hmm, how to say it... If I read between the lines of what you say, there's usually some good in there.

Severa: So...can you read between the lines of what I'm saying now?

[Robin]: I'm afraid I may need a little more to go on.

Severa: Ugh, you can be SO dim sometimes!

[Robin]: ...Am I missing something here?

Severa: I love you, [Robin]! That obvious enough for you?! You're always so caring, and it makes me feel... special, I guess. You make me happy.

[Robin]: Wow, Severa...

Severa: L-look, I'm sorry for being so snarky and competitive all the time. But maybe in the future we can be more of a team?

[Robin]: You mean a couple? I'd like that.

Severa: REALLY?! ...You would?

[Robin]: ...Heh. I love you too, Severa. I love your passion and your drive. I love how you never hide what you're feeling, for better and for worse.

Severa: Well, this time I think it was definitely for the better.

[Robin]: Heh, that much is obvious, even to a big, fat tactical jerk like me.

[Confession]

Severa: I...I love you... Hey, pay attention for once, and say something sweet why don'tcha!

Severa (Father/daughter)

Severa's father/daughter dialogue can be found on page 305.

Gerome

■ GEROME X AVATAR (MALE) [ROBIN] C

[Robin]: Say, Gerome? I've been meaning to ask you something for a while now...

Gerome:

[Robin]: Why do you always wear that mask?

Gerome:

[Robin]: Is it merely for show, or does it have a deeper meaning?

Gerome:

[Robin]: I'd appreciate some kind of response, if it's not too much trouble...? After all, we are comrades-in-arms.

Gerome: This will sound rude, but I have no desire to talk to you. Or anyone. I'm trying to associate as little as possible with anyone from this era.

[Robin]: Oh? Why is that?

Gerome: For people from the future, like me, this world seems unreal. A dream. We are not meant to be here. This is not our place.

[Robin]: Yes, but—

Gerome: No. The safest thing is to avoid contact as much as possible.

[Robin]: I understand we are divided by time and history. But isn't that all the more reason to reach across the chasm and forge bonds?

Gerome: What you suggest is impossible. Now leave me be.

[Robin]: Very well. I will leave it there, for now. But we will discuss this again, you and I.

Gerome:

■ GEROME X AVATAR (MALE) [ROBIN] B

[Robin]: Greetings, Gerome.

Gerome: I told you, I want nothing to do with you.

[Robin]: Yes, I remember. And I'll try to honor that as best I can. But, please, do me one favor—tell me why you always wear that mask. It has something to do with combat, doesn't it? That must be the reason.

Gerome: It is indeed for battle. By masking my face, I can prevent the enemy from reading my emotions.

[Robin]: Ah! To keep an enemy guessing about your intentions confers a decided advantage. Much like the "fog of war" that strategists exploit to confound and unbalance a foe.

Gerome: It also makes it harder for the foe to read the target for my next attack. I'm prepared to exploit any tactic that gives me an edge in battle.

[Robin]: But it must also narrow your field of vision, yes? Make it easier to be caught unaware?

Gerome: And I must make up for that drawback through rigorous training. I have honed my instincts and senses to their absolute limits. The movement of the wind, the scent of sweat, the whisper of steel through air... I can sense these from any direction, even obscured by the mask. This is why I need no battle companions. My skill is more than enough.

[Robin]: Hmm... The mask hides your emotions from foes on the battlefield... But I imagine it also serves to hide your inner self from allies as well?

Gerome: I fight without allies.

[Robin]: I know you have made yourself strong enough to survive in this world alone. But is mere survival the only goal worth striving for?

Gerome: Of course not. My ultimate aim is victory over evil.

[Robin]: Then you are going about it entirely the wrong way.

Gerome: Explain yourself.

[Robin]: It's obvious, isn't it? Imagine that you, and you alone, survive. Around you lay the cooling bodies of foe and comrade alike. You are completely, utterly alone. Now ask yourself this: is that a victory worth winning?

Gerome: You twist my words.

Gerome: Hmph. Then the sermon is over? You weave a lovely tapestry with your words, master tactician. But talk is cheap. In the real world, where I must live, power is everything. Power is right, it is truth, it is victory. And I'll prove as much on the battlefield.

[Robin]: Surely you do not truly believe that...

[Robin]: I only pray he learns before it is too late...

■ GEROME X AVATAR (MALE) [ROBIN] A

[Robin]: Gerome.

Gerome: What do you want, [Robin]?

[Robin]: I've been watching you more closely on the battlefield.

Gerome: And?

[Robin]: Your strength and ability are more than my words can do justice. Your battlefield feats would seem to validate your methods. I underestimated you, and for that, I apologize.

Gerome: Actually...

[Robin]: Yes?

[Robin]: Do you remember when I told you I wanted nothing to do with people from this era? It was true when I said it...but perhaps I went too far in avoiding your kind.

[Robin]: Oh?

Gerome: I've learned a lot from these grueling battles, about myself as much as anything. Why do I crave battle? Why do I seek power with such single-minded purpose? Once I thought to ask the questions, the answer was clear enough... I was raised in a nightmarish world haunted by the ghouls called Risen. I have SEEN the future and would do anything in my power to unmake it.

[Robin]: I understand.

Gerome: But I see now that I cannot build this future alone, no matter how strong I am. Until we unite, peace shall forever elude our grasp.

[Robin]: You are wiser than I credited you, Gerome. The task before us is indeed far too great for any one man. We must transform this world, change history, AND overcome fate.

Gerome: Do you think it's possible?

[Robin]: I do, so long as we all work together. We must rely on the ties that bind us. We must lend each other aid, support each other, and act as one. Then, there is hope.

Gerome: There is wisdom in your words, tactician. Perhaps I should spend more time listening to people of this age.

[Robin]: Heh, I like to think we have our moments.

 Gerome (Father/son)

Gerome's father/son dialogue can be found on page 307.

 Morgan (female) (Father/daughter)

■ MORGAN (FEMALE) X AVATAR (MALE) [ROBIN] (FATHER/DAUGHTER) C

Morgan (female): Oh, Father! Over here! Come with me a minute!

[Robin]: What is it, Morgan?

Morgan (female): Oh, nothing. It's just... C'mon! I need to talk to you about something.

[Robin]: Well, I'm afraid I'm a bit busy at the moment. Can we talk here?

Morgan (female): H-here? Er, that's not really... I can just wait there.

[Robin]: Are you sure it's nothing urgent?

Morgan (female): Um, no, it's... Ha ha! ...I'll be right back.

Morgan (female): Okay, all set! Now to lure Father into this pitfall trap...

Morgan (female): Phew, I'm back! Hey, let's take a walk, shall we? Right this way, Father!

[Robin]: You're acting very strange, Morgan.

Morgan (female): Allllmost... Just a couple more steps...)

[Robin]: ...Huh? A pitfall? Now that's a classic!

Morgan (female): Dang! How did you know?! I was super careful in disguising it. It didn't look suspicious at all!

[Robin]: True, your work on the pit is first class. But your odd behavior made it obvious. Subterfuge and misdirection are half a good trap, Morgan.

Morgan (female): Dang. I'll get you next time!

[Robin]: By the way, as long as you're here, mind helping me fill this hole in? If someone fell in by accident, they could really hurt themselves.

[Robin]: Wait, how deep did you make it?!

■ MORGAN (FEMALE) X AVATAR (MALE) [ROBIN] (FATHER/DAUGHTER) B

[Robin]: Hmm... Now where did I put it...?

Morgan (female): Looking for that treatise on tactics, Father? Blue cover? Fairly thick?

[Robin]: Yes. How did you... Waaait a minute.

Morgan (female): Yup! I hid it! Think you can find it?

[Robin]: Is that today's challenge, then?

Morgan (female): It's somewhere in camp—I'll tell you that. You have until sundown today! Though I could give you weeks, and you'd never find my diabolical hiding—

[Robin]: Found it.

Morgan (female): WHAT?!

[Robin]: It's in that bag you're holding, isn't it?

Morgan (female): Hmph... Fine.

[Robin]: Guess I win this round.

Morgan (female): How did you figure it out so fast?

[Robin]: You know me well, Morgan. And that includes knowing how much that book means to me. I knew you'd never hide it anywhere it might be damaged or stolen. So it needed to be somewhere you could keep a close eye on it...yet still concealed.

Morgan (female): You read my entire thought process! ...And here I thought I was being so clever.

[Robin]: All right, that settles today's challenge. Now come take a seat.

Morgan (female): Huh?

[Robin]: Let's read that book together. You wanted to work on your strategic thinking, right?

Morgan (female): Right!

■ MORGAN (FEMALE) X AVATAR (MALE) [ROBIN] (FATHER/DAUGHTER) A

Morgan (female): I'd draw your forces out to this line, then strike with an ambush team from the woods.

[Robin]: Then I would move...here. Now you find yourself trapped in a pincer movement.

Morgan (female): Crud. You win again.

[Robin]: At least it was just pieces on a board. In real life, that would've cost lives. A tactician is responsible for their army's survival, and a single mistake can be fatal. But you cannot allow the pressure of that responsibility to stymie you. Running scenarios like this will help prepare you for anything.

Morgan (female): Thanks, Father. I'll give some of your strategy texts another read-through. But know this—one of these days, I WILL outmaneuver you!

[Robin]: Okay, we'll see about that, kiddo. But you're welcome to take a challenge. All right then, we're done for today.

Morgan (female): Okay! See you tomorrow!

[Robin]: ...Phew, that was a close one. I was one step shy of getting completely wiped out. I'd hoped that to be an unattainable goal for a little longer so she would push herself. In actuality, I'M the one who needs a push. Better dust off a few of these books myself.

 Yarne

■ YARNE X AVATAR (MALE) [ROBIN] C

Yarne: Yeesh, that last battle got pretty hairy... My knees are shaking just thinking back. One wrong step, and I would've been—

[Robin]: Ah! Yarne. Good, I found you.

Yarne: GAH! D-don't DO that, [Robin]!

[Robin]: Do...what, exactly? Did I startle you? I apologize...

Yarne: No, it's... Sorry, you're fine. Don't worry about it.

[Robin]: You all right, Yarne? You know you can talk to me if something's bothering you, right?

Yarne: ...Did you need me for something?

[Robin]: ...Well, I just wanted to talk to you about that last fight. Can you explain what happened? You fled halfway through the battle! You were more than a match for that foe. It should have been an easy victory.

Yarne: Maybe so, but there are no guarantees in war. You can never be too careful. I'm the last of the taguel, you know? When I get to thinking I might go extinct, my whole body just locks up!

Yarne: So that's it.

Yarne: I can't take the fear. And if it's not the fear, it's the pressure!

[Robin]: I can understand the survival instinct, especially to protect the taguel line. But in some situations, running like that can actually harm your chances for survival. Sometimes the only way out is through. You have to brace and face danger head-on.

Yarne: My head knows that, but somehow my body just disagrees. I WANT to fight. Honest, I do, but...

[Robin]: ...But the fate of an entire race is riding on your shoulders. I understand. Look, there's no rush. No one's asking you to become fearless overnight. But it's a serious issue, so I do ask you think hard on it and how it can be solved.

Yarne: ...All right. I will.

■ YARNE X AVATAR (MALE) [ROBIN] B

Yarne: Hey, [Robin], I've been giving a lot of thought to what you said before...

[Robin]: How sometimes running away can be more dangerous than standing your ground?

Yarne: Right.

[Robin]: I'm glad to hear that. But like I said, we needn't rush a solution...

Yarne: But I think I have one. I've thought on it, and I don't see running away as cowardice. You know what's riding on my shoulders. It's being the last of the taguel bloodline. That's too important to risk. I don't belong on the front lines. As the last surviving member, my first priority should be staying alive. ...Is that so wrong?

[Robin]: Not at all. I don't want you to be reckless with your life either. But you carry more than just taguel blood. You carry their spirit. Have you ever stopped to think about how your ancestors lived their lives? Or asked yourself if they would want you to run?

Yarne: How do you mean?

[Robin]: They were persecuted and hunted down. Each and every one had to fight to live. If they had all chosen to give up and flee, I bet you wouldn't be here right now.

Yarne: You...you think so?

[Robin]: I do. And soon the day will come when you have to fight as well. Running from the fear of extinction was never what kept the taguel alive. And frankly, I don't think it will help you restore your race in the future.

Yarne: Maybe... Maybe you're right. I need to think...

■ YARNE X AVATAR (MALE) [ROBIN] A

[Robin]: Yarne!

Yarne: Y-yes?

[Robin]: You were amazing out there today! I've never seen you so brave!

Yarne: Ha! I was mostly just desperate.

[Robin]: Well, the hole you punched in the enemy line let us evacuate all our wounded safely. A half-dozen people owe you their lives!

Yarne: I'm glad I could help. I sure didn't feel like a hero, though. I barely knew what I was doing. Even now, it's all a little hazy.

[Robin]: You should be proud! Have some confidence! Everyone was impressed. Sounds like the legacy of the taguel warriors lives on!

Yarne: I'm really glad to hear that, [Robin]. Especially from you. I couldn't have come this far without your help.

[Robin]: What? This is all your hard work.

Yarne: When you told me I carried more than just taguel blood, it clicked. I'm carrying their history, their pride. And that's just as important as blood.

[Robin]: You sound like you've changed.

Yarne: I'll be honest. When the enemy is running at me, I'm still quaking in my fur... But then I hear what you said echo in my head, and it steels my nerves.

[Robin]: Well, I'm certainly glad to hear it.

Yarne: I'll give everything I can to do my heritage proud!

[Robin]: In my eyes, you already have, Yarne. You already have.

 Yarne (Father/son)

Yarne's father/son dialogue can be found on page 314.

 Laurent

■ LAURENT X AVATAR (MALE) [ROBIN] C

[Robin]: Hello, Laurent.

Laurent: [Robin].

[Robin]: Catching up on your reading?

Laurent: Indeed.

[Robin]: That's quite the book collection you've got.

Laurent: Thank you. I'm particularly avid in my acquisition of magical tomes. As you're well aware, they serve both as a mage's weapon and a history. Some tell of the ages of the gods; others are treatises on nature and its energies. Reading and analyzing their contents is an extremely satisfying pursuit.

[Robin]: Combat know-how and abstract knowledge in one convenient package! I can certainly see the appeal.

Laurent: Just so. Though I am particularly drawn to tomes of a somewhat...peculiar nature.

[Robin]: Peculiar how?

Laurent: Some tomes offer precious little in practical use, but hide wildly entertaining powers. And whenever I find a book of that sort, I simply must acquire it for my collection.

[Robin]: Useless but entertaining powers, huh? So... different from attack spells and arcane curses and the like?

Laurent: Don't get me wrong—I am deeply interested in tomes of that nature as well. But the sort I speak of are cut from a different cloth altogether.

[Robin]: Can you give me an example?

Laurent: Hmm... I fear words could not do them justice. Perhaps you'll allow me to select a few from my shelf to show you in person?

[Robin]: Absolutely! I look forward to it.

■ LAURENT X AVATAR (MALE) [ROBIN] B

Laurent: Ah, [Robin].

[Robin]: Hmm?

Laurent: Might I have a moment of your time?

[Robin]: Of course.

Laurent: I brought a few examples of the useless but curious tomes I spoke of earlier.

[Robin]: Ooh, right! The entertaining ones! I've been eager to have a look.

Laurent: Ha ha, excellent! Then let us begin! ...This tome conjures forth a whirlwind.

[Robin]: That's a sort of wind magic seen in battle, isn't it? I'd hardly name it useless.

Laurent: Not when the whirlwind in question can fit atop the palm of one's hand. I assure you, it's as lethal as a kitten.

[Robin]: You're kidding, that small?

Laurent: Shall we have a demonstration? ...Haah!

[Robin]: Whoa! Look at the little guy go! It really does fit in your hand! ...Ah! It disappeared!

Laurent: It is as short-lived as it is diminutive! And with zero practical value. Unless you find yourself in need of a light breeze on a warm day, that is.

[Robin]: Ha ha! Adorable...

Laurent: Next, an incantation that summons a faint magical light.

[Robin]: That sounds like it would have plenty of practical applications as well. What's the catch?

Laurent: Very astute of you to ask. The spell is broken the moment the caster ceases the incantation. To make matters worse, the text dates all the way back to the dawn of magic. It's rife with words near impossible to say, and one mistake will leave you in the dark.

[Robin]: Wow. Even magic was less convenient back in the old days.

Laurent: This beautiful thing is a tome of proximal telepathy.

[Robin]: Telepathy? That sounds amazing! How does it work?

Laurent: I shall demonstrate. ...Huuup! (Well...? Can you hear my voice within your head?)

[Robin]: Wha—?! Your lips aren't moving, but I hear you in my mind! That's incredible, Laurent! How is THAT not useful?!

Laurent: ...GAAAAAAAASP! ...I fear the spell's effects last only as long as the caster holds his breath. What's more, the range extends only slightly past arm's length.

[Robin]: Ha ha! I see! Speaking normally seems like the all-around winner, then. Still, hearing your voice echo inside my head... What a fascinating experience. Thank you for sharing all these with me, Laurent.

Laurent: My pleasure. There are others as well, each as hollow a novelty as the next.

[Robin]: But you were certainly right about them being entertaining!

Laurent: I am glad you found them agreeable.

[Robin]: Actually, I suppose providing a bit of fun IS a useful quality, isn't it?

Laurent: Hmm... Yes, I'm inclined to agree. It is precisely because they are so useless that they are so endearing.

[Robin]: You say you have others like these, yes? Would you mind sharing them sometime?

Laurent: It would be my pleasure.

■ LAURENT X AVATAR (MALE) [ROBIN] A

Laurent: *Huff, huff* [Robin]!

[Robin]: Laurent? What's wrong? Has something happened?!

Laurent: *Pant* ...I've acquired a...new tome! There's talk it's an original manuscript thought to have been lost to the ages!

[Robin]: Really? What does it do?!

Laurent: It conjures forth RAINBOWS!

[Robin]: ...Like, a rainbow one might see after it rains? That's it?

Laurent: Yes, but it creates them from nothing! Rainless rainbows!

[Robin]: I suppose that's impressive, but... Well actually, I'm not sure. If you wanted to see a rainbow, you could just wait for it to rain like normal, no? Or perhaps acquire a prism from any local apothecary.

Laurent: Ah, but you're forgetting our previous conversations, [Robin]. Sometimes the most useless of novelties can serve a vital purpose—as entertainment! Bringing laughter and joy to a war-worn army sounds like powerful magic to me.

[Robin]: Fair enough.

Laurent: Well, no time like the present. Stand back, and I'll begin the incantation immediately.

[Robin]: Right...

Laurent: Luminous gods of earth and sky, cast thy tears upon us... May your fulgurous incandescence set each drop ablaze in chromatic exaltation! Arc of color, COME FORTH!

[Robin]: Amazing! Laurent, you did it! You made a rainbow! Wait, so why... Pffffaaa I'm all...

Laurent: Hmm? Strange, I don't see... [Robin], where is the rainbow? I can't see it in any corner of the sky.

[Robin]: AAAAAAH HA HA HA!

Laurent: ...[Robin]?

[Robin]: Heha ha, d-down, Laurent! Look down!

Laurent: ...Waugh?! I nearly stepped on it! I've never seen such a miniscule thing! It's scarcely the size of a mouse... Some ancient manuscript this is!

[Robin]: Ha ha... Haaa... Hooooo, boy! Maybe not calm, but as for joy, that gave me the best laugh I've had in weeks!

Laurent: ...I noticed.

[Robin]: Well, I think it's a great addition to your collection. It certainly brought a smile to this tired soldier's face.

Laurent: I'm thrilled to hear you say that.

[Robin]: You should show these off to a bigger audience next time. I'm sure everyone would enjoy the show.

Laurent: Capital idea! I'll start the preparations at once. Thank you, [Robin]!

 Laurent (Father/son)

Laurent's father/son dialogue can be found on page 316.

Noire

■ NOIRE X AVATAR (MALE) [ROBIN] C

Noire: *Siiigh*

[Robin]: Something on your mind, Noire?

Noire: Eep! Oh. [Robin]! N-no, nothing... Just a bit tired, I suppose.

[Robin]: Then you should rest up and take a nap. We don't have anything planned for today.

Noire: Is that so? Yes, perhaps I'll do as you suggest. Hmm, but...

[Robin]: No buts! Whatever you're worried about can clearly wait. You always push yourself too hard, Noire. I'm sure the exhaustion is just built up.

Noire: B-but it's hardly fair to rest while the others are still working! Otherwise I'm only holding everyone back.

[Robin]: Well, do what you have to do, but just promise me you'll take care of yourself.

Noire: I will. I'm...sorry you had to see me like this.

■ NOIRE X AVATAR (MALE) [ROBIN] B

Noire: *Siiigh*

[Robin]: What's wrong, Noire? Tired again?

Noire: N-no, that's not it. Well, I AM tired, but...

[Robin]: Yes?

Noire: I was trying to think of ways I might grow a bit... sturdier. So lately I've been watching the other girls and trying to identify differences.

[Robin]: And have you found any?

Noire: Well, the others are healthier, obviously, and their bodies seem more resilient. Also, their figures are just a little bit more...robust.

[Robin]: Phrased with the delicacy of a diplomat! Er, and I suppose you would be on the...slight side?

Noire: Slight? Ha! I'm skin and bone! I fall over in a stiff breeze! They're all so full of energy; it's like staring into the sun... They make me feel like a troll! ...Er, if trolls were scrawny. Oh, what do you think I should do, [Robin]?!

[Robin]: W-well, I do think you have a tendency to worry more than most... And that stress is bound to harm the body in one way or another...

Noire: INSOLENCE! HOW DARE YOU CLAIM ME DECREPIT!

[Robin]: Whoa! N-no, Noire! Never! I didn't say anything like that!

Noire: THEN SPEAK, MORTAL! WHAT WOULD YOU HAVE ME DO?!

[Robin]: W-well... *ahem* They say that clothes make the man, right? Perhaps they can make the woman, as well! Why not try getting into the role form-first?

Noire: Oh! So you think I should maybe dress more... festively?

[Robin]: Y-yes! That's the perfect word! Festive! Maybe that will energize you a bit!

Noire: ...Huh. Well, I guess I'll consider it.

■ NOIRE X AVATAR (MALE) [ROBIN] A

Noire: *Siiigh*

[Robin]: Still sighing away, Noire?

Noire: Oh. Hello.

[Robin]: Troubles still not resolved, then?

Noire: I wanted to take your advice, but...I don't know what constitutes festive attire.

[Robin]: Ah. Well, even if you had, I'm not sure where you'd find any, with the war and all...

Noire: Is there no way to become more girly? I just want to shine like all the others, even for a day...

[Robin]: Well, worrying about it isn't going to help. Worry might just be your biggest enemy. Why don't you try unwinding a little? Go do something you enjoy!

Noire: I see. Yes, perhaps I'll treat myself to... Um, to what, exactly?

[Robin]: Why not head into town and enjoy a nice meal?

Noire: I couldn't be the only one to enjoy such luxury! Not in times like this.

[Robin]: Aww, live a little. You like sweets, right? I don't think anyone could fault you for indulging in a little cake or two.

Noire: You're sure?

[Robin]: Sure I am! And if you really don't want to be the only one eating, I'll go with you.

Noire: You...wouldn't mind?

[Robin]: Eating cake? Only if you twist my arm! ...So, it's a date? Next time we're in town, we'll swing by the bakery and see what's on offer. Agreed?

Noire: Agreed!

■ NOIRE X AVATAR (MALE) [ROBIN] S

[Robin]: Everything all right, Noire? You seem down.

Noire: Eep! Oh. [Robin]. No, just the same-old, same-old. Thinking about how to be more vibrant... How to be more like the other girls... It just seems so hopeless! I feel like I haven't made a bit of progress.

[Robin]: Hmm, well... W-well... Have you tried falling in love?

Noire: Wh-what?

[Robin]: They say a woman's never as radiant as when she's in love. Why not give it a try? If, um... Well, you know, I guess you'd need to find someone special first...

Noire: W-well, I...I suppose I think I might... have someone in mind. There's someone who... Well, he's always listening to me and offering advice. *Mumble, mumble*

[Robin]: ...Sorry? I didn't catch that.

Noire: *Mumble* ...You really want to know?

[Robin]: Yes I do.

Noire: Well, all right... Here goes.

[Robin]: Hmm?

Noire: It... It's you, [Robin]. I...love...you.

[Robin]: What?

Noire: I SAID I LOVE YOU, FOOL OF A MAN!

[Robin]: Gah! S-sorry! I'm sorry! I heard you! I was just surprised! ...Er, so did you mean it? This isn't something to feel more vibrant?

Noire: No, I mean it! Of course I mean it! I've had feelings for you from the start.

[Robin]: Wow. Really?

Noire: H-hey! What's so funny?

[Robin]: Ha ha ha! Ha ha... I'm sorry. All this talk of being vibrant and such... Who could be more vibrant than you?! Don't change a thing, Noire. I think you're amazing just as you are. Delicate and sweet, always more worried about others than yourself... And prone to the occasional...flight of fancy, shall we say? I love it all.

Noire: You really mean that?!

[Robin]: Of course I do, Noire! So stop pushing yourself to become someone you're not... And let's enjoy the amazing person you already are.

Noire: I... Oh, [Robin]... Thank you.

[Confession]

Noire: You fill me with the strength I never thought to have. Please, stay with me always...

 Noire (Father/daughter)

Noire's father/daughter dialogue can be found on page 317.

Nah

■ NAH X AVATAR (MALE) [ROBIN] C

Nah: Oooo! Look at all those berries!

[Robin]: Do you know if they're edible?

Nah: Yup, they're safe to eat! Really sweet, too!

[Robin]: Mmm, we'll have to pick a few, then.

Nah: The leaves are a little bitter, but they're not half bad, either.

[Robin]: The, uh... The leaves?

Nah: Oh, and if you chew on the roots enough, they make a juice that's pretty okay. Plus it keeps you from feeling hungry, so that's convenient for long marches.

[Robin]: No kidding...

Nah: I don't think I've ever seen this many berries at once, though. This is great! Whoa, and there's a ton more over there!

[Robin]: ...Just what sort of diet did she grow up on, anyway?

■ NAH X AVATAR (MALE) [ROBIN] B

[Robin]: Hey, Nah?

Nah: Hmmm?

[Robin]: Earlier, it sounded like you'd eaten roots and leaves and whatnot before, yes?

Nah: On the good days, anyway. But at least it was food!

[Robin]: Well, of a sort, I suppose.

Nah: Oh! You can eat the leaves of these plants growing by the road too! See? *Munch, munch, munch*

[Robin]: Those are just weeds, Nah!

Nah: Yeah, but the un-poison kind! They're a lot tastier than you'd think. Wanna try a bite?

[Robin]: No, I'm sure they're great. But, uh, Nah? We have food now, you know. Plenty of it. It's tastier than weeds.

Nah: I think anything that keeps the walls of your belly from clanging together is good. Hey, look! Those fruity things over there are great, too! Once you get used to the sourness and the itchy tongue and the dizziness, anyway.

[Robin]: There's got to be SOMETHING I can do for her...

■ NAH X AVATAR (MALE) [ROBIN] A

[Robin]: Do you have a minute, Nah?

Nah: Sure! Whatcha need?

[Robin]: A taste tester, actually. I fixed a little something and wanted you to help me out.

Nah: Me? Oh, yay!

[Robin]: Don't get too excited till you've tried it.

Nah: It looks great! Gimme! *munch, munch, munch*

[Robin]: ...Well?

Nah: What...what IS this?! I've never tasted anything so amazing! It's incredible! It's life changing! It's... It's... AAAAAAAAAA!

[Robin]: Heh heh, I'm glad you like it.

Nah: Hey, so no offense, but you lost all your memories, didn't you? How do you know how to cook?

[Robin]: Oh, I've just been reading up a bit. The first few attempts were ghastly, but I finally got it to taste almost normal. Anyway, I wanted you to be the first to try it.

Nah: Wow, [Robin]... Thank you! It's so nice of you to think of me!

[Robin]: Of course, Nah! I'm always thinking of you.

■ NAH X AVATAR (MALE) [ROBIN] S

[Robin]: I tried out a new recipe today, Nah. Want to give it a try?

Nah: You bet!

[Robin]: Here you go.

Nah: *Munch, munch* ...Hey, this is great! Everything you've made has been tasty, but this may be the best dish yet!

[Robin]: Glad to hear it.

Nah: Hey, can I ask you something? ...Why are you so nice to me?

[Robin]: Why am I...nice?

Nah: It may not seem like it to you, but cooking like this is a really big deal to me. In the future, there was never enough to eat, you know? Just finding enough to fill your belly for a day was cause for celebration. Especially for a manakete. We need to eat way more than you to survive. So, um, yeah. Your food just makes me really...so happy.

[Robin]: Nah, I don't know what to say...

Nah: And you have your own troubles to worry about with the amnesia and all, right? So why go all out of your way for me?

[Robin]: Well... At first, I just wanted to introduce you to all the flavors you've been deprived. But after a while, I guess I got hooked on seeing how happy it made you...

Nah: Um, [Robin]?

[Robin]: Hmm?

Nah: Would you, um... After the war is over, will you still cook for me?

[Robin]: As long as you're willing to eat what I come up with, it'd be my pleasure.

Nah: Oh, [Robin]! I... I love you!

[Robin]: Y-you LOVE me? Why, that's... I mean, I hoped, but... Nah, if my cooking tastes good, it's only because it's filled with MY love for you!

Nah: Mmm... Your love is delicious... Hee hee!

[Confession]

Nah: Look, it's gonna be you. Better just give up and accept it now!

Nah (Father/daughter)

Nah's father/daughter dialogue can be found on page 318.

Tiki

■ TIKI X AVATAR (MALE) [ROBIN] C

Tiki:

[Robin]: Erm...

Tiki: *Sigh*...

[Robin]: ...Can I help you, Tiki? You've been...uh, staring at me a very long time.

Tiki: Oh, I'm sorry, [Robin]. Was I bothering you?

[Robin]: I was more worried that something might be bothering you?

Tiki: Well, it's just that you look remarkably like someone I used to know.

[Robin]: Oh?

Tiki: Yes. Specifically, a man named Marth. Many ages past, this was. He was wise, calm, and fair, but possessing an inner strength as resilient as steel.

[Robin]: Marth? You mean the warrior king of legend?

Tiki: The one and same. I had the honor to call King Marth a friend. So perhaps you can understand why I gazed upon you with nostalgia and...longing.

[Robin]: Er, sorry, did you say...?

Tiki: Still, it was rude of me to stare. I apologize.

[Robin]: Oh, not at all! It's exciting to know that I resemble someone so storied...

■ TIKI X AVATAR (MALE) [ROBIN] B

[Robin]: Ah, Tiki. Just the person I was looking for.

Tiki: What is it, [Robin]?

[Robin]: Remember when you told me about your friendship with King Marth?

Tiki: Yes? What of it?

[Robin]: You were referring to THE King Marth, right? The man from two millennia ago? Well, he's a distant relation to Chrom, is he not?

Tiki: That is correct.

[Robin]: So, I was wondering, wouldn't Chrom resemble him more than me?

Tiki: Perhaps because Chrom is not like Marth. He is much more direct, and committed to what he believes is right. Chrom might more resemble a different ancestor, from the age I was born in. Another great man in their line, from 1000 years before Marth... But the Marth of my time was wise and fair, and won hearts with his kindness.

[Robin]: I see. So when you say I resemble Marth, you weren't talking about his appearance.

Tiki: No. I was referring to your soul. An aura of kindness and goodness surrounds you, [Robin]. Just as it did wise King Marth.

[Robin]: Well, that is...most flattering. I don't know what to say.

[Robin]: What is it, Mar-Mar?

[Robin]: ...Mar-Mar?

Tiki: Ah! Forgive me! I was in the habit of calling Marth by that name... It must have slipped out by mistake. Gracious, the resemblance is so uncanny, it's making me forget what millennium it is!

[Robin]: Heh, I suppose there are worse people to be mistaken for...

Tiki: Please, forgive me.

[Robin]: Actually, I must admit, I rather enjoyed the attention...

■ TIKI X AVATAR (MALE) [ROBIN] A

Tiki: [Robin]?

[Robin]: Hello, Tiki. It's just me today... No Mar-Mar here, I'm afraid.

Tiki: Oh, I know who you are, [Robin]. I apologize again for my mistake. You have no memories of your past, do you, [Robin]? It must be especially unnerving, then, for someone to confuse you with another. For all I know, you might start thinking that you ARE that person...

[Robin]: Please, I was only fooling. Don't give it another thought.

Tiki: Even so... It must be frightening to look into your past and see nothing there. I know that better than most, for long ago, I fell under the control of an evil man...

[Robin]: I'm touched by your concern, but you don't have to worry about me. Still friends?

Tiki: Oh, I hope so.

[Robin]: To be honest, I don't even mind if you do call me Mar-Mar. After all, it's not so strange for close friends to share nicknames, is it, Tikiwiki?

Tiki: Heh hah... Well, maybe not.

■ TIKI X AVATAR (MALE) [ROBIN] S

Tiki: [Robin].

[Robin]: So you're not going to call me Mar-Mar after all, huh?

Tiki: Heh. I much prefer [Robin]. ...Don't you?

[Robin]: Yes, of course I do. It's just that...well... I have no family here, nor even memories of a family. When you called me by a nickname, the truth is, I rather liked it. Even if it was someone else's nickname.

Tiki: I understand, and I considered it... But there is only one Mar-Mar, and that was Marth, the great king of ages past.

[Robin]: Yes, well. Fair enough, I suppose. I'm hardly qualified to fill his shoes.

Tiki: And there is one more reason I cannot call you by that name...

[Robin]: *Gulp* ...And that is?

Tiki: Because you, too, are a singular—and very special—man to me. You are the man with whom I've... fallen in love.

[Robin]: T-Tiki?!

Tiki: That is why you must be [Robin].

[Robin]: Phew, what a relief! I thought you were going to say it's because I reminded you of someone else!

Tiki: Hah, don't be absurd!

[Robin]: Truth is, I've been hoping against hope that we might be together, but dared not ask...

Tiki: Why not?

[Robin]: Well, you've lived for millennia... Seen the legendary heroes with your own eyes... You knew the Hero-King of legend himself! And compared to him, what am I? I felt that I had to be as great as him, as mighty and powerful... Otherwise, you couldn't help but find me lacking in comparison.

Tiki: Oh, [Robin]...

[Robin]: Are my fears truly groundless? Can I...allow myself to love you?

Tiki: Of course, [Robin]!

[Robin]: Then the two of us together shall build a new world of peace.

Tiki: Oh, that's just what I want as well...

[Confession]

Tiki: I know that to love another, I must watch the world move past him. But such short years make an eternity worth living.

Gangrel

■ GANGREL X AVATAR (MALE) [ROBIN] C

[Robin]: Ah. Greetings, Gangrel.

Gangrel: [Robin].

[Robin]: Why the solemn face?

Gangrel: ...I was reflecting on times past.

[Robin]: You mean, when you were king?

Gangrel: Yes... Thinking back, I realize that perhaps my rule was overly harsh. ...Wicked, even.

[Robin]: That's fair. Perhaps a bit of an understatement, but...

Gangrel: Hah! Don't mince words, do you?

[Robin]: It would be silly to deny it. We fought and overthrew you for that very reason.

Gangrel: I would expect a man of your caliber to say nothing else. But I had my reasons, you know. We were threatened by Valm and Walhart. But if I could somehow unite us...

[Robin]: By "we," I assume you refer to Ylisse, Regna Ferox, and Plegia?

Gangrel: It was a desperate time. None of us knew how far Valm might go. But if I could subjugate the continent and exploit an inner mighty empire... Then maybe we could halt their advance. ...Or at least, that's how I saw it.

[Robin]: Yours was a brutal reign that terrorized your subjects and your neighbors. An alliance built on intimidation and threats is doomed to failure from the beginning.

Gangrel: Don't lecture me, you arrogant whelp! I didn't say I was right! I was blinded by circumstances and unable to see any other way... Bah! Why am I explaining myself to you? What do you know of running a nation?!

[Robin]: Well, I suppose I don't.

Gangrel: Pff... Enough of this.

■ GANGREL X AVATAR (MALE) [ROBIN] B

[Robin]: Gangrel?

Gangrel: [Robin].

[Robin]: What are you doing out here all alone?

Gangrel: Nothing in particular.

[Robin]: Thinking about the past again?

Gangrel: ...I thought I had good reasons for my war, [Robin]. I swear I did. But in the end, it was Chrom and you lot who stopped Valm.

[Robin]: We did, didn't we?

Gangrel: A smug grin does not suit you, tactician! In my mad quest for strength, I unleashed horror upon thousands of innocents. How many have I killed? How many families did I rend apart? ...And for what? For nothing.

[Robin]: I cannot argue. What you did is difficult to forgive, or forget...

Gangrel: How does it feel to be so untainted by mistakes that you can judge others?

[Robin]: If you truly started a war to try and save your people, you should own the deed. Your time would be better spent on things besides self-pity.

Gangrel: Oh? Then tell me, wise one, what "things" should I be doing?

[Robin]: You can join us in bringing peace to the land once and for all. You could walk in the past the rest of your days; you will find no absolution there.

Gangrel: Your words are daggers, [Robin]... But only because they ring true.

[Robin]: And so?

Gangrel: I'm a king no longer—just a mad dog roaming the land without a leash. I would rouse myself and fight for peace because you say so?! Bah! I don't need one of Chrom's lackeys to give me purpose! Look out, world! This time, I've got a better plan! A whole new outlook!

[Robin]: That sounds more like the Gangrel I know. In a good way.

Gangrel: GYAAAAAAA! Gangrel is back, and he's spoiling for a fight!

[Robin]: For once, I'm happy to hear that.

■ GANGREL X AVATAR (MALE) [ROBIN] A

Gangrel: Gwa ha ha! If it isn't my good friend, [Robin]!

[Robin]: Hello, Gangrel.

Gangrel: Did you see the shock on that Risen's face? He wasn't expecting THAT! Hya ha!

[Robin]: Sadly, I had the chance before you lopped off his head. You certainly have become quite the force on the battlefield as of late.

Gangrel: Bwa ha ha! And you know who we have to thank for it? YOU! You and your barbed words that finally goaded me into action!

[Robin]: Glad to be of service... But that does remind me of something...

Gangrel: What might that be?

[Robin]: You once worshipped Grima, correct? As a member of the Grimleal?

Gangrel: Pah, those wrinkled old warts with their dusty tomes? I was Grimleal in name only. Course, it was the faith of the realm, so I knew most of its rituals.

[Robin]: Religion can be a powerful tool for uniting people behind a single cause. I wager Aversa used it to convince your subjects to take up arms?

Gangrel: ...Perhaps. But in the end, I'd say she used me as much as anyone.

[Robin]: And what did the people of Plegia really think of the faith?

Gangrel: Think? Ha! They DIDN'T think! Between my iron-fisted rule and Aversa's inquisitions, they had no choice about it. ...But as I said, it was a cruel time.

[Robin]: Your people were cowed by your political might, but the temples offered solace...

Gangrel: Ah, yes. The solace of the damned.

[Robin]: Thank you, Gangrel.

Gangrel: Hmm? What for?

[Robin]: We can't help the people of Plegia if we don't understand their situation. Our cause is simple—to save this world and all the people in it. And that includes the poor wretches of Plegia who remain in the thrall of Grima.

Gangrel: ...You are an odd one. Plegia has given you hardship and horror, and yet you would fight to save us. I'm almost impressed.

[Robin]: Now is not the time for recriminations or revenge. If we are to save the world, we must band together with every willing soul. We must be prepared to offer forgiveness.

Gangrel: Gwa ha ha! I see it's not just barbs on your tongue, but honey as well! You are right. There'll be time aplenty for judgment in the next life.

[Robin]: Exactly.

Gangrel: If I want to right past wrongs, how better than to save my own people? Gangrel will return, not as a tyrant, but as a liberator!

[Robin]: Indeed. The road to redemption is long, but it begins with a single step.

Walhart

■ WALHART X AVATAR (MALE) [ROBIN] C

[Robin]: Are you here all by yourself, Walhart?

Walhart: Hmph.

[Robin]: ..."Cough* *Ahem* Well, since we're allies now, I was thinking we might talk... Um, yes. Of course, if it's too much trouble, I could just leave you be...

Walhart: We shall talk if you wish it, tactician. Let us discuss military matters. In your opinion, what is the key element needed to secure victory?

[Robin]: Oh! I wasn't expecting a quiz! Ha ha ha... Er, ha.

Walhart: I will have your answer now. A strategist should already have an opinion on such a fundamental question.

[Robin]: Yes, you're right, of course... Well, I'd say fostering the bonds between soldiers is most important.

Walhart: A tepid answer more suited to mewling babes than men of combat. The key to victory is power, tactician. Overwhelming power.

[Robin]: I see.

Walhart: Power to smash your enemies. Power to subjugate their people. Or, if necessary, the power to wipe them both out entirely.

[Robin]: But victory gained through might alone often brings insurrection in its wake. It sows discontent and discord, which become the seeds of a new war.

Walhart: If discord arises, it only means you had insufficient power in the first place. With truly overwhelming might, such trivial obstacles can be brushed aside. But then you think "bonds" matter. I do not expect you to understand such things.

[Robin]: To a man such as yourself, my method seems ludicrous. I understand that. But you will soon see for yourself the importance of unit cohesion, of bonds. You are one of us now—a member of the Shepherds and a comrade-in-arms.

Walhart: I am none of these things. I am a wraith set loose to destroy all who block the path. ...But I admit, your thinking intrigues me. We will meet again and continue this.

[Robin]: That didn't sound like a question, but sure. I'd like that.

■ WALHART X AVATAR (MALE) [ROBIN] B

Walhart: Greetings, tactician.

[Robin]: Hello, Walhart.

Walhart: Have you thought about our discussion? Do you see now the error in your thinking? Surely you know now that bonds of friendship are irrelevant to victory.

[Robin]: No. I believe in them more than ever.

Walhart: Hmph. Then I am wasting my breath. Overwhelming power is the only thing that will enable men to build true peace!

[Robin]: True peace?

Walhart: One that is unshakable and invulnerable. One that lasts for all eternity. If we are to eradicate war, we must destroy all borders. Tear down the nation-state. Eradicate all notion of religion. Bring everything under one rule, and we can stamp out the strife that fuels war.

[Robin]: Hmm... Perhaps your vision has merit.

Walhart: Of course it does. Think of the possibilities! With my might and your tactical mind, we could conquer this world. Through sheer strength of mind, steel, and will, we would make it reality.

[Robin]: War on that scale would inflict death and suffering on uncountable innocents. I could not be party to such horror, no matter how noble the goal.

Walhart: Think bigger! If we were to succeed, we would eliminate all future wars! What is the sacrifice of even a million people if it builds a golden eternal future? What are they when weighed against peace and safety for generations to come?

[Robin]: But war is not a matter of numbers and balances!

Walhart: And I say it is! You do not display the same distaste for war when it comes to slaying your enemies. Your cunning killed many of my men. Where were your qualms then? ...Yes, exactly. You had no qualms, for you valued those lives less than others. THAT is the matter of numbers and balances, tactician! THAT is war! We are the same, you and I, even if you would pretend otherwise.

[Robin]: N-no, that's not...

Walhart: Think, tactician! Look at what you do. You cannot save everyone. No man can! So you place every life on the balance, and like a god, you decide. "This man shall live..." "This man shall die..." Someday, you will learn this truth: might rules, or nothing does. ...We shall talk of this again. Until then, farewell.

[Robin]: B-but, it's not like that... ...Is it?

■ WALHART X AVATAR (MALE) [ROBIN] A

[Robin]: Walhart.

Walhart: Tactician.

[Robin]: I wonder if we might talk.

Walhart: Something troubles you. I can see it in your mien. Do your hand-wringing on your own time. Do not waste mine with it.

[Robin]: I am trying to determine what is the right thing to do, and what I should believe in. If that is hand-wringing in your eyes, then so be it. I came only to seek advice.

Walhart: You hem and haw like an old maid. I thought you more decisive than this.

[Robin]: I have considered your arguments carefully, and they have a compelling logic. Nevertheless, I cannot agree. The world you paint leaves no room for human compassion or feeling. People are merely values arrayed on a playing field.

Walhart: You speak of my willingness to sacrifice the few for the greater good. I concede my approach is ruthless and calculating. But so is the battlefield.

[Robin]: We cannot allow ourselves the luxury of denying our own humanity! Yes, it would be easy to treat deaths like so many numbers on a balance... But the loss of even one life is a terrible tragedy—an enormity beyond reckoning. We are meant to save people, and that is what we must do. We fight alongside friends. Stout allies. Stalwart comrades. A world without such friendship is no world I want, no matter how safe it may be. ...I am sorry. But on this matter, I will not change my mind.

Walhart: Well, well. A rousing speech indeed... We shall do it your way.

[Robin]: ...You changed your mind, just like that?

Walhart: YOU defeated ME, tactician! Remember? Clearly, you have proven the truer path. You have proven yourself the mightier, and therefore I must bend to your will. It is a simple matter.

[Robin]: But...then why did you argue?

Walhart: Because I wanted to test the strength of your convictions. As long as your belief is firm, I will follow the path you set. But if those convictions waver? If your beliefs are beset with doubt? Then Walhart will again rise up and demand his voice be heard!

[Robin]: Your forthrightness is shocking in its intensity, Walhart. But in time, I truly believe you will come to accept the wisdom of my way.

Walhart: I will march by your side and grant my all to your cause. Let us see if you have the strength to change my mind!

[Robin]: I plan to do exactly that.

Emmeryn

■ EMMERYN X AVATAR (MALE) [ROBIN] C

[Robin]: How are you feeling, Your Grace?

Emmeryn: ...Your Grace? ...Emmeryn?

[Robin]: Mmm...

Emmeryn:

[Robin]: Is this a good time, Your Grace?

Emmeryn:

[Robin]: Can I tell you something? I know this may seem forward, but... Your words and actions have always meant so much to me.

Emmeryn: So much to me...?

[Robin]: I know it sounds a bit silly when I say it out loud like that. But it's the truth. Your commitment to peace inspired me. Even when it was clear that war was inevitable, you stood by your principles. I know you and Chrom clashed over it, but in the end... Well, he wants peace as badly as you. He shares your dream. If there was a path that avoided war, I'm sure he would have taken it.

Emmeryn: I don't... Don't understand...

[Robin]: It's okay, Your Grace. You're tired, and I'm not making much sense. Just know that we'll build the world you envisioned. One without fear or war. We're working every day to make it happen.

Emmeryn:

[Robin]: Forgive me. I should let you get your rest.

Emmeryn: No, I... It's all right.

[Robin]: I'll come see you again soon. Take care, Emmeryn.

Emmeryn: And...you.

■ EMMERYN X AVATAR (MALE) [ROBIN] B

[Robin]: How's it going today, Your Grace?

Emmeryn: Where...we...going?

[Robin]: No, it's... It's just an expression. It means "how are you feeling?"

Emmeryn: I...am well.

[Robin]: That's wonderful! Truly it is! If there's anything I can do for you, please don't hesitate to ask.

Emmeryn: Do for...me?

[Robin]: Well, you know. If you're hungry or bored or something, I could try to help... Oh! I could tell you all about what happened before you returned!

Emmeryn: Before I...returned?

[Robin]: Right! Chrom defeated Gangrel and then stopped a huge Valmese invasion! It hasn't exactly been a field of roses, but Chrom strives for peace in his own way. He's keeping your dream alive.

Emmeryn:

[Robin]: Your brother is a fine ruler, and his people love him. I know you'd be proud of that. Hopefully you can tell him one day...

Emmeryn: Chrom...

[Robin]: Oh, but no rush, of course. There'll be plenty of time once more of your memory returns.

Emmeryn: Y-yes... My memory.

[Robin]: I think it would mean a lot to him to hear it.

Emmeryn: Mean...lot...to him? ...Or you?

[Robin]: W-well, yes. I suppose it would mean something to me as well.

Emmeryn: All...right.

■ EMMERYN X AVATAR (MALE) [ROBIN] A

[Robin]: How's it going today, Emmeryn? Er, I mean...

Emmeryn: It is...going well. Th-thank you.

[Robin]: Goodness! You're getting better and better each time I see you! So then. Do you have time to talk?

Emmeryn: ...You do.

[Robin]: Hmm?

Emmeryn: You always take...the time. ...Th-thank you.

[Robin]: Emmeryn! That's not... Look, you don't have to thank me. I... I like spending time with you.

Emmeryn: You.

[Robin]: Huh? Sorry, did you need something?

Emmeryn: Your... Your name...

[Robin]: Oh, wait. I suppose you've forgotten that, too. Well, my name is—

Emmeryn: [Robin].

[Robin]: Wh-what did you just say?

Emmeryn: ...[Robin].

[Robin]: That's... Yes. That's my name. But how did you...?

Emmeryn: I remember you.

[Robin]: Emmeryn! You remember me?!

Emmeryn: ...Yes.

[Robin]: Are more of your memories coming back? Do you recall anything else?

Emmeryn: I don't... I'm not sure, but... I heard your name...in my head.

[Robin]: Emmeryn... *sniff*

Emmeryn: Don't cry...

[Robin]: I'm too happy to stop! I thought I might never hear you speak my name again!

Emmeryn: Well...now you did.

[Robin]: Everyone, come here! It's Emmeryn! She's remembering things again!

Emmeryn: Ah...

EMMERYN X AVATAR (MALE) [ROBIN] S

[Robin]: Hello, Emmeryn.

Emmeryn: Hello, [Robin].

[Robin]: Listen, I... I need to apologize to you.

Emmeryn: Why?

[Robin]: Before, when you said my name, I... I got a little too excited. I shouldn't have called everyone over. Especially when you should be resting. So anyway, I'm sorry. It won't happen again, I promise.

Emmeryn: ...It's fine. I didn't mind.

[Robin]: Thanks. That's good of you to say. ...It makes me so happy to see you doing so well, Emmeryn.

Emmeryn: I know. ...I'm happy, too.

[Robin]: We'll just keep taking this slowly for a bit. Let time work its magic.

Emmeryn: ...

[Robin]: Is something wrong?

Emmeryn: I'll get better.

[Robin]: I don't doubt it!

Emmeryn: You have been...so good to me. I like having you near. Will you...stay with me?

[Robin]: Hmm?

Emmeryn: I want you to stay with me... Always.

[Robin]: Emmeryn! O-of course I will! You're getting better by the day, and I want to be around to see every minute.

Emmeryn: Thank you...

[Robin]: And someday, when you're better and I've grown into a man worthy of you, maybe... Maybe we can be together...forever?

Emmeryn: You are already worthy.

[Robin]: I don't know...

Emmeryn: I'm...better. But I'm not...healed. Will you stay until then? Will you...wait for me?

[Robin]: Until the end of time...

[Confession]

Emmeryn: Thank you...for this chance. I...love you. You make me...whole again.

Yen'fay

YEN'FAY X AVATAR (MALE) [ROBIN] C

[Robin]: Yen'fay? Might I have a word?

Yen'fay: Ah, [Robin]. ...What is it?

[Robin]: I'm trying to understand how you are different from the Yen'fay I once met. If you're willing, I'd know more of you and the cruel future from whence you came.

Yen'fay: What is there to say about me? Past or future, I am little more than a ghost.

[Robin]: A ghost? Yes, perhaps so... But do you not carry any memories imprinted in your soul? Can you not tell me of wars fought, dynasts lost, missions accomplished?

Yen'fay: ...Yes. I had a mission once. I swore to protect a grave.

[Robin]: A grave?

Yen'fay: The grave of my beloved sister, she who died for my foolishness.

[Robin]: ...I'm sorry. I don't mean to remind you of painful events.

Yen'fay: The deeds are done—it is only right I pay the price for them. In any case, you need not concern yourself with my feelings. I care for nothing. I yearn only for the day when I, too, can crawl into my tomb.

[Robin]: Yen'fay, you mustn't think like that! You've traveled to the past, and your fate is in your hands. With our help, you can change the future of the world!

Yen'fay: Like a ballad sung to an empty theater, your exhortations are wasted on me. ...There is no fertile ground here for your kindness to take root. My heart is barren.

[Robin]: Yen'fay...

YEN'FAY X AVATAR (MALE) [ROBIN] B

Yen'fay: HAH! YAH!

[Robin]: Yen'fay, are you still out here practicing?

Yen'fay: Yes, [Robin]. Practicing and thinking. Perhaps I can use this unwanted lease on life in the service of you and your allies.

[Robin]: That is a fine thought, and we're grateful, but you must allow yourself rest. You've been on the training ground since daybreak.

Yen'fay: To grow strong, it is necessary. The pain felt by this vessel of flesh is nothing to me. If I can make it serve a greater cause, then for a short time my soul might know peace.

[Robin]: You did more than just protect graves, didn't you, Yen'fay?

Yen'fay: How do you mean?

[Robin]: I mean, you don't seem the type to waste his talent on such a duty. You're the kind of man who always tries to aid others, even in a benighted future.

Yen'fay: [Robin], you are perceptive indeed. Yes, I defended villagers and farmers from the Risen—or at least, I tried. Dead though my soul was, the corporeal flesh still demanded its daily sustenance. I was no hero, but a sellsword taking bread from any who couldn't fight themselves.

[Robin]: Come now! Surely you fought for more than a handful of coin... Was it because you couldn't bear to ignore the plight of the innocent?

Yen'fay: You overestimate me. Back then, I barely had the will to live, let alone save others.

[Robin]: If you say so, perhaps. But I believe you're better than that. You're still fighting to help people, just as you always have.

Yen'fay: It seems you're hell-bent on thinking the best of me, no matter what I say.

[Robin]: I can be stubborn that way. But we can continue this another time. Until then, farewell.

Yen'fay:

YEN'FAY X AVATAR (MALE) [ROBIN] A

[Robin]: Yen'fay? What are you doing so far away from camp?

Yen'fay: The frivolities and easy conversations of camp are distractions I must avoid. I dedicated myself to becoming stronger. Until then, I pledge not a moment's respite. Say'ri died because of me. Such a thing must never happen twice.

[Robin]: You speak of Say'ri in the future.

Yen'fay: Yes. Sweet, innocent Say'ri, cursed with a coward of a brother who let her die. I loved her more than anything—yet even so, I did not save her. I am disgraced.

[Robin]: Tell me this, Yen'fay. Say'ri of the future loved you as you loved her, yes?

Yen'fay: I believe it so.

[Robin]: Then if she could speak to you now, you know exactly what she'd say. She'd tell you to keep living. To forgive yourself. To find what joy you can.

Yen'fay: She was the kindest person I ever knew. Everything she did was for me. I loved her—I STILL love her—with all that remains of my heart...

[Robin]: Then you owe it to her to not give up.

Yen'fay: ...Yes. Of course you are right. If she saw me wallowing in self-pity, what a scolding she would deliver!

[Robin]: It's high time you picked yourself up, dusted off, and started living life again. I know, Say'ri is gone... I can only guess at the pain that must bring. But here in the present, you have countless comrades who need you.

Yen'fay: You speak the truth, [Robin]. How selfish I have been. I have become a burden when I should have been acting as relief.

[Robin]: You are a stalwart ally, Yen'fay. I only want you to open your eyes.

Yen'fay: Rest assured, you've pried them open. I see the truth at last.

[Robin]: Excellent. Now, why don't you come back to camp with me?

Yen'fay: Yes. It is high time I took my proper place in the ranks of this army. Thank you, [Robin]...my friend.

[Robin]: It's my pleasure, friend.

Aversa

AVERSA X AVATAR (MALE) [ROBIN] C

[Robin]: Hey there, Aversa.

Aversa: I beg your pardon, little man?

[Robin]: Um...hey there? It's a greeting. You know? ..."Hey there"?

Aversa: A greeting that borders on insolence! Your familiar tone mocks me. What is your business here? Did Chrom send you to spy on me?

[Robin]: What?! No! I was just seeing what you were... doing.

Aversa: Also called "spying"!

[Robin]: Look, we don't spy on each other in the Shepherds. And you're one of us now.

Aversa: Am I now? My, my, my... You ARE a trusting bunch.

[Robin]: Look, Aversa. I know this... I mean... Everyone's sitting down for supper. Why don't you join us?

Aversa: Trusting AND stupid! Oh, but what a delightful combination. Your friends would sooner slit their throats than break bread with me, little man. Or have you forgotten how many times I tried to take their lives?

[Robin]: No, we all remember that quite well. But you're here now, and so... Look, you're going to have to break the ice sometime. Might as well be tonight.

Aversa: When it comes to former foes, I'll take ice over fire any day.

[Robin]: But...

Aversa: We are finished here.

[Robin]: *Sigh* Always such a pleasure...

AVERSA X AVATAR (MALE) [ROBIN] B

[Robin]: Oh, hey there, Aversa! Uh, I mean... Hello! Er, greetings. I hope the day...finds you...well?

Aversa: Are you speaking to me, little man?

[Robin]: You know, I DO have a name. And it's not "little man."

Aversa: ...What do you want?

[Robin]: Want? Um, nothing really. I just saw you over here and thought maybe—

Aversa: What? That we could be friends? That we might share secrets and giggle long after dark like idiot schoolgirls?

[Robin]: No! I just thought you might like to sleep at camp instead of out here in the woods.

Aversa: So you can slit your throat in the night?

[Robin]: No one is slitting anyone's throat!

Aversa: My, my, my. SUCH the gentleman. Truly, you are your father's son.

[Robin]: ...Don't say that.

Aversa: Oh, please. Don't deny it. Not to me. We're FAMILY, after all!

[Robin]: We are NOT family! You're adopted! And I didn't even know my family!

Aversa: What a convoluted family tree we make! More like a figurative shrub, in fact. I'm older than you, and yet I was adopted AFTER your birth. Hmm... I suppose in a way that makes you my older brother? How delightful!

[Robin]: I'm not your brother, and you know it.

Aversa: Silence, the matter is settled. ...Big Brother.

[Robin]: ...Are you coming back to camp or not?

Aversa: Only if my biiiiig bwother pwomises to pwotect me!

[Robin]: That's IT! That is IT! Shut up! Just shut up already!

Aversa: Aww, really? Will you really be so cruel to your wittle sister?

[Robin]: You know what? Stay here. Get eaten by a bear. I don't give a damn.

Aversa: Aww, pweeeeeeease, big bwother! Don't weave me here with the big scary bweahs! Kyaaa ha ha ha!

AVERSA X AVATAR (MALE) [ROBIN] A

[Robin]: ...Hey.

Aversa: Goodness! I feel the icy chill of a cold shoulder. I find that rather sad, Big Brother.

[Robin]: Just... Look, please don't call me that.

Aversa: Where's the harm? It's just the two of us. There are no eavesdroppers here. Besides, I thought you wanted to be friends! You...did...want to be friends? *Sigh* I'm... all right. I'm sorry. I won't call you that anymore. I suppose it's good that someone in this camp even comes to see me.

[Robin]: Oh, come on. Lots of people... Well... Okay, people have been busy. But I can say for a fact they've been talking about you!

[Robin]: What is it?

Aversa: I've just been thinking... I really don't have a place in this world. I worked to play a fool by my father. Now I fight for my former enemies... I'm a slack-eyed puppet that dances to music everyone but me can hear.

[Robin]: No you're not. You're Aversa.

Aversa: That's just a name.

[Robin]: Yes, but it's yours! You know where you come from and who you are. I don't have that. Hell, I don't even have my memories to keep me. I came into this world without friends or family, but now I have both. The Shepherds gave me a new chance, and they could do the same for you. You just have to trust them.

Aversa: That sounds...nice. Gods, I can't believe I just said that...

[Robin]: You're starting to feel like this could be home. ...Aren't you?

Aversa: How...did you know?

[Robin]: ...I've been spying on you.

Aversa: I KNEW it!

AVERSA X AVATAR (MALE) [ROBIN] S

[Robin]: Er, Aversa? What are you doing?

Aversa: Cleaning and oiling our weapons, checking our food stores...

[Robin]: You cleaned that entire rack of swords?!

Aversa: I thought I could make myself useful. Is there a problem? Do the Shepherds think I would sabotage their weapons? I may not be their friend, but I'm certainly not their foe. Not anymore...

[Robin]: Of course we trust you.

Aversa: Well, all right. Maybe I misspoke. I feel I do have one friend. One person I feel close to.

[Robin]: Oh?

Aversa: It's kind of odd, because... Well, because it's you.

[Robin]: This better not be about that "Big Brother" thing again. You do realize we're not actually related in the slightest, right?

Aversa: I know, [Robin]. And in truth, I'm...glad. I'm not all sarcasm and snark, you know. I have emotions, too. And lately, I've found myself thinking about you. ...A lot.

[Robin]: Eh?

Aversa: I know this must sound mad, seeing how we fought each other for so long.

[Robin]: You're thinking about me...how?

[Robin]: As... As allies?

Aversa: Gods, but you're dense! I want to be with you!

[Robin]: You...with me?!

Aversa: Dunderhead! I want to BE with you! I want to marry you!

[Robin]: But...why?

Aversa: Because there's no one else. Chrom believed in me, but not like you... You make me want to be a better person. You give me hope. And...you make me smile. Is that enough?

[Robin]: ...I'd be lying if I said I hadn't thought about this myself.

Aversa: I imagine your friends will have all sorts of objections...

[Robin]: Let them. I'm a grown man who can make his own decisions.

Aversa: It's strange. I spent so much time fighting and scheming that I never...

[Robin]: ...Realized what you wanted was right in front of you?

Aversa: Something like that, yes. Kya hee hee!

[Confession]

Aversa: From now on, I live only for you. And as you may have noticed, I'm the fiercely loyal type.

Priam

PRIAM X AVATAR (MALE) [ROBIN] C

Priam: Ah, [Robin]. Perfect timing.

[Robin]: Hmm?

Priam: I was just about to go looking for you. I am prepared to pass along all I know of fighting to you!

[Robin]: Er, you are? Well, fantastic! I'm sure anything you have to say would be tremendously helpful.

Priam: As this army's tactician, you hold its fate in your hands. If the knowledge I've amassed can be of use, I'm pleased to help.

[Robin]: Then I humbly accept your offer.

Priam: Right, then! Let us begin. First, all strength stems from a warrior's breathing.

[Robin]: Oh?

Priam: By drawing in the ambient energies that permeate the air, we gain their strength. Therein lies the origin of a fighter's ability and the determinant to how far they'll go. So, if the breath is the source of all strength, what ought a warrior do?

[Robin]: Um... Seek out the purest air possible?

Priam: Indeed! Air quality is of critical importance when training. This is why warriors have labored in deep woods and under waterfalls for ages.

[Robin]: I didn't expect you to be quite so...intense. This is pretty heady stuff.

Priam: You want intense? Let's talk about my first training expedition in the woods. I was but a boy, 11 or 12 perhaps, and was attacked by a ferocious bear!

[Robin]: A bear attacked you when you were 12?!

Priam: It did.

[Robin]: So...did you defeat it?

Priam: A foolish question! How else would I be telling you this blistering tale if I hadn't?!

[Robin]: ...Oh. Um, right.

Priam: I owe my victory to the crisp mountain air. With every breath, I drew into me the very spirit of the woods. The sighs of trees ages old whorled about me just waiting to be utilized! And as I breathed deep, I began to refine that energy. To temper it...

[Robin]: It's really something seeing you get so excited... You're usually so quiet. But, er, is there an end to this story? ...In the near future?

Priam: Hmm? Did you say something?

[Robin]: Er, no... Not a thing.

Priam: Anyway, yes, my story... So by fusing the air with my own intrinsic energies and releasing it, I created a new...

PRIAM X AVATAR (MALE) [ROBIN] B

[Robin]: Hmm, nothing else to take care of... Why don't I sharpen some weapons? Everyone seems to take care of their own gear, but it can't hurt to check. Some of these swords lose their edge if you so much as look at them cross eyed!

Priam: For all its hardened wood and metal, a sword is a delicate thing!

[Robin]: WHA—?! ...Priam? I didn't see you there!

Priam: An elegant blade! A spear tip hewn to a razor point! They're strong enough to take a life, but exquisitely fragile at the same time. A warrior's life extends no further than that of the weapon he wields. Fail to perform maintenance, and it may well cost you... EVERYTHING!

[Robin]: Sounds like something you might say... A stern maxim to live by, but fair.

Priam: Ideally, a weapon would never be handled save by the one who wields it.

[Robin]: Er, so I shouldn't help the others maintain their equipment?

Priam: I mean only that creating and tending to a weapon aids in growing accustomed to it. To claim as one's own a weapon made and honed by another is folly!

[Robin]: Doesn't it seem a bit much to have an entire army learn smithing?

Priam: It is only an ideal. I would never presume to force my methods on anyone else. But a man must have a code, and this is mine!

[Robin]: Wow, Priam. Anything about war and weapons and you get worked up. I had you pegged as the strong, silent type, but you're actually quite passionate. (Though I might've preferred the strong-and-silent version, emphasis on silent...)

Priam: Hmm? What was that?

[Robin]: ...Nothing at all.

Priam: Legends from the far north say that blades handled with love ultimately gain souls. They cease to be mere objects and become something tremendous. Miraculous, even! Once imbued with a soul, a weapon's bond to its wielder can transcend into a new...

PRIAM X AVATAR (MALE) [ROBIN] A

[Robin]: Ah, my first hot meal of the day! It warms both body and soul.

Priam: Few things are so important to a warrior as proper sustenance!

[Robin]: GAH! Priam! Must you keep sneaking up on me, only to yell in my ear?

Priam: How else would I convey to you my thoughts on food and its role in war?

[Robin]: ...Oh boy. You've got a philosophy of eating, too?

Priam: Of course! Food is another cornerstone of a warrior's physical and mental training. The act of eating is to take the life of other beings and make it into one's own flesh. That's why wasting food is a crime on par with murder itself! We should eat with an awareness of the sacrifices of others and a spirit of thanks.

[Robin]: Awfully talkative again today, aren't we, Priam? (...Now where did I put that cotton for my ears...?)

Priam: ...Mmm? What was that?

[Robin]: Er, no, I just... Nothing! It's only...er... When you get on a topic you like to talk about, you really like to talk about it.

Priam: ...I have been talking your ears blue, haven't I? Apologies. When I speak on matters of combat, I tend to lose track of time. Honestly, I think hanging around you people is starting to influence me! I suppose it's for the better. I'd hate to think I was getting soft.

[Robin]: Oh, I don't think you need to worry. Just the fact that you ARE worried is the best proof of why you don't need to. You're as tough—and tough on yourself—as ever. I guarantee it.

Priam: A guarantee from you is a serious thing indeed.

[Robin]: I do feel you've grown a bit...kinder. Even gentler, perhaps. But this is not a bad thing. In fact, it's helped our army. For example, passing along your wisdom to me was an act born of kindness, no?

Priam: Well, I suppose I did want to feel I was doing all I could to help everyone...

[Robin]: It makes me all the more eager to learn how I might follow in your footsteps.

Priam: Heh, fair enough! Then I'll continue to teach you everything I know. If you think you can handle it, that is?

[Robin]: Of course! Only maybe we could take it in smaller—

Priam: In that case, back to food! To consume a meal is to consume the very souls of everything on your plate.

[Robin]: (Oof, this one's gonna be long... I can feel it in my bones.)

Priam: Just as the wheel of reincarnation turns ever onward, crushing all in its path... With each passing meal, muscle builds on food and passes on a new soul. Each shares in your flesh and becomes part of your spirit! And in turn...

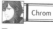

Avatar (female)

For the purposes of the conversations we will call the avatar "[Robin]."

Chrom

CHROM X AVATAR (FEMALE) [ROBIN] C

Chrom: Finished training for today, [Robin]?

[Robin]: With combat practice, yes. But I thought I might review a few battle histories—

Chrom: You should relax a bit. Put your feet up. Experienced soldiers rest when they can. On a campaign like this, you never know when the next battle might break out.

[Robin]: Heh, so I've noticed. With all that's happened recently, we've barely had time to even eat.

Chrom: It's been a tough road, to be sure. And it's only going to get harder.

[Robin]: I do try and rest when I can, though. A lady needs her beauty sleep, after all.

Chrom: Er...

[Robin]: ...What? Did I say something?

Chrom: Er, no... No, it's nothing. It's just that... Well, I just didn't consider you the type to care after beauty and such... I suppose I've never really thought of you as a lady.

[Robin]: Excuse me?!

Chrom: No! I mean—I didn't mean—not like that! That is to say, a "lady," per se... Er... You know, how you fight and strategize, and... Not to say a lady can't fight, but... Gods, this is coming out all wrong.

[Robin]: My goodness, Chrom. You're the scion of a noble family, aren't you? Didn't they teach you manners at your fancy schools growing up?

Chrom: Oh, gods, yes. Of course they did. We spent a whole term on etiquette.

[Robin]: Perhaps you could use another term, this time on how to talk with a lady.

Chrom: It's just my image of a lady is someone so prim and proper...perfumed, and pretty... Nothing like you at all! When I look at you, I just don't see a "lady." Does that— ...Er, [Robin]? What... What are you doing with that rock?

[Robin]: I'm thinking a sharp blow to the head might help fix your eyesight.

Chrom: N-no, wait! It was a just a joke! Ha ha...ha? ...Gotta go!

[Robin]: I don't believe it. The little craven actually ran away! What kind of manners... Sheesh... Oh, well. Perhaps it's only fair. It's not like I think of him as a gentleman, let alone some fancy noble.

CHROM X AVATAR (FEMALE) [ROBIN] B

Chrom: Hey, [Robin]? ...[Robin]! Are you in here? [Robin]! ...HELLO? I HAVE A QUESTION ABOUT OUR NEXT MOVE!

[Robin]: Chrom?! I-is that you? Er, if you could just wait outside, I'll just be a moment...

Chrom: What? Come on in? ...Gods, why is it so steamy in here? Did someone leave—

[Robin]: KYAAAAAAAAAAAA!

Chrom: Ah, there you are. I can hardly see a thing through all this blasted steam... Anyway, I wanted to consult with you on tomorrow's march. You see... Er, is there any special reason you aren't wearing any clothing?

[Robin]: Chrom? Rather than stand there like a slack-jawed village idiot... PERHAPS YOU COULD WAIT OUTSIDE LIKE I ASKED?!

Chrom: But, I... No... oh gods, I'm SO sorry! I didn't mean to! That is to say—

[Robin]: OOOOOOOOOOOOOOOOOUT!

Chrom: R-right! Absolutely! Straightaway! I'll, er, just wait outside the tent.

[Robin]: All right, you! What sort of idiot blunders straight into the women's bathing tent?!

Chrom: I'm sorry! Very, very sorry! I misheard you, I swear it. I had no intention of peeping!

[Robin]: *Sigh* ...Just... Fine. Apology accepted. Now what was so damned important?

Chrom: Oh, er. I was hoping you could offer some advice on tomorrow's route.

[Robin]: Fine. What are the options?

Chrom: Well, according to this map, one route is this steep trail through the hills. Or we could circle the hills and follow the main road across the plain. I imagine either would work but wanted to see if you had a preference.

[Robin]: Hmm... I'd say the path through the hills. The main road would be easier, but we'd be more exposed if we encountered foes.

Chrom: Right... That's what I was thinking. Thanks for the advice. And, er... Yes! Well, that's it, I guess! So...yes. Bye.

[Robin]: Good-bye.

Chrom: ...And [Robin]? I'm really sorry about the bath thing. I truly didn't mean to catch you like that.

[Robin]: It's fine. Water under the bridge. Let's forget about it and move on.

Chrom: Er, right. Yes. Good idea. So! I'll catch you later... Argh, no! I mean, I'll SEE you later! ...ARGH! NO! I mean... Good-bye!

CHROM X AVATAR (FEMALE) [ROBIN] A

Chrom: I feel so awkward around [Robin]. Ever since that bathing-tent run-in... *sigh* Whenever I end up alone with her, I'm just frozen in embarrassment. Argh, what should I do? I've never had this problem before. ...Ah, I know: a bath! Yes, perhaps a nice hot bath is just the thing for my nerves... I'll have a soak and then find [Robin] for a relaxed conversation, like always.

[Robin]: Let's see... The lances and axes are kept around here somewhere... I'll just take a quick inventory and see if any need repairs or replacing... Somewhere...around here... Ah, here—the arms storage tent, I presume? All right then, I'll just head in and—AAAAAAGGGGGGHHH!

Chrom: [Robin]?! Where'd you come from?

[Robin]: KYAAAAAAAAAAAA!

Chrom: Blazes, what are YOU screaming for? If anyone should be screaming it's me, isn't it? You aren't supp—OUCH! OW! Stop throwing things! Hey, that's sharp! Don't—YEOWCH!

[Robin]: ARGH! Have you NO shame?! Noble or not, you should AT LEAST wear a towel when you address a lady!

Chrom: B-but, you—OW!—you were the one who walked in on me!

[Robin]: I...I... I'm sorry, Chrom.

Chrom: Are we done throwing things?

[Robin]: I think... I don't know what happened. Something just snapped and...

Chrom: Well, no harm done. The gods' justice, perhaps, for my earlier blunder! Ha ha!

[Robin]: Well, anyway, thanks for being so good natured about it all. I feel terrible about this soap dish. How's your ear doing?

Chrom: Better. It still stings a little, but better. In any case, look on the bright side: we've seen each other naked now, right? So I guess we've got nothing left to hide. In a way, we're closer than ever.

[Robin]: Not the most appropriate way for a man and woman to get to know each other... But...I suppose as long as nobody else knows...

Chrom: Ha ha! It's like we're partners in crime sharing an unsavory past! Anything that brings us closer will make us stronger on the battlefield. Just you wait.

[Robin]: Partners in crime? Heh heh, I like the thought of that. Well, partner, your secret's safe with me...

■ CHROM X AVATAR (FEMALE) [ROBIN] S

[Robin]: Chrom! Just the man I wanted to see. We need to talk.

Chrom: *Gulp* [Robin]?!

[Robin]: It's about the route you drew up for tomorrow's march. I was looking at the map and I noticed... Chrom? Are you listening to me?

Chrom: Er, oh. Of course! ...Actually, no. I kind of had something to...do.

[Robin]: Chrom, you're acting very strange. Are you hiding something from me?

Chrom: H-hide? You mean, HIDE hide? Oh, gosh! No! N-nothing at all... Nope.

[Robin]: Then why are you fidgeting like you've got a squirrel in your pantaloons?

Chrom: I-I'm not fidgeting! I'm perfectly relaxed. ...And, er, normal.

[Robin]: And refusing to meet my eye? Listen, Chrom. Didn't you say that we're also friends, with no secrets between us? Didn't you mean that?

Chrom: N-no! I mean, yes! I mean... I swear, it's not like that!

[Robin]: *Sigh* I know you've been avoiding me recently. And I'd like to know why, Chrom. I think I deserve an explanation. Please. I can't go on pretending there's nothing wrong. Do you dislike my company now?

Chrom: D-dislike you?! Egads, [Robin], of course I don't dislike you! Nothing could be further from the truth.

[Robin]: Then why are you avoiding me?

Chrom: Er...

[Robin]: Chrom?

Chrom: D-don't look at me like that... It's just that... we've been fighting a lot together. We've always side by side. At first, I thought of you as an ally, then a comrade, and finally a friend. I've felt the bonds of trust grow between us, stronger and stronger. And then I realized...you were more than just a friend.

[Robin]: ...What do you mean?

Chrom: I mean I care about you, [Robin]. As a man, and you as a woman.

[Robin]: Chrom, we can't possibly—

Chrom: Wait, please! You've made me come this far, and now I'm going to say my piece.

[Robin]: ...But when you're worked up like this, you might say something you regret.

Chrom: I don't care! I've tried to keep this bottled up, and I can't do it anymore. I'm going to tell you how I feel, even if your head explodes in embarrassment.

[Robin]: O-kay?

Chrom: All right, deep breath... FHOOOOOO! ...Hold...and out... HAAAAAAAAAAAAH. Once more... FHOOOOOOOOO! Holding...holding... and out... HAAAAAAAAAAAAAAAAAAH. Right, I'm set now. Here goes. Prepare yourself, because I'm going to say it!

[Robin]: ...Then say it already!

Chrom: [Robin]...I'm in love with you.

[Robin]: ...Oh.

Chrom: I have been from the very first moment I laid eyes on you. I just didn't realize it until the last little while.

[Robin]:

Chrom: Look, I know this is sudden and I'm coming on like a wyvern in heat. But I'm not trying to force you into a decision, believe me. Whatever your answer, I shall abide by it—no matter how painful. And come what may, we'll always be friends. That I promise.

[Robin]: This is... I'm sorry, Chrom, but this is impossible. The general and his chief tactician? It just... It wouldn't be right. Our first responsibility must be to the soldiers we lead, not to each other. You understand that, don't you?

Chrom: Yes, I do.

[Robin]: But someday this war will end. We'll emerge victorious and bring peace back to the world. And when that happens, we'll be free to follow our hearts.

Chrom: ...OUR hearts?

[Robin]: Yes...because I love you as well.

Chrom: You do? But that's...but that's... Wonderful! Ah ha ha ha! This is the best day of my life! [Robin]... listen to me...

[Confession]

Chrom: You are the wind at my back, and the sword at my side. Together, my love, we shall build a peaceful world, just you and me.

| Lissa |

■ LISSA X AVATAR (FEMALE) [ROBIN] C

Lissa: [Robin]? Where aaare yooou?

[Robin]: ...Zzz...

Lissa: There you are! I was just... Oh! (You're sleeping...?)

[Robin]: Snnrk! Zzzzzzzz.

Lissa: (You must really be wiped out. Not that I blame you, getting wrapped up in all this.) (Hee hee!) Looks like it's time to get a little quiiietly... geeently...hold your nose!)

[Robin]: Nh...gnnkh...nnnrrrgh...! BWARGH! Wha—?! Risen! Wolves! Risen riding wolves! They're...all... Wait a moment...

Lissa: Hee hee hee hee hee! AAAH ha ha ha ha! "BWARGH"?! Oh gods, that was HILARIOUS! Heeeee hee hee hee hee!

[Robin]: Lissa, gods bless it... I was fast asleep!

Lissa: And dreaming of Risen and wolves, apparently? Tee hee hee! I'm sorry. I tried to resist—I really did. But it was just too perfect!

[Robin]: Who does such things? Is that really how your parents raised you?!

Lissa: ...I...I don't know... I never really knew my parents...

[Robin]: Oh... Oh, right. That was... Er...

Lissa: Oh, don't worry about it. I know you didn't mean anything by it. And actually, there's something else that I should be apologizing for...

[Robin]: Whatever it is, I'm sure I can forget it if you can forgive my heartless comment...

Lissa: Really? That's great! Oh, I was SO sure you were going to be SO angry... See, I was kinda doodling a pic of you in your big, new book of battle strategies... ...Aaand kinda spilled the ink and kinda...ruined the book, kinda...completely. Ireallyreallyreallydidn'tmeanto!

[Robin]: WHAT?! But that was a rare text! I had just started to... ...Er, "ahem" I mean... It's... It's fine. Accidents...happen.

Lissa: Oooh pheeew!

■ LISSA X AVATAR (FEMALE) [ROBIN] B

[Robin]: Phew! I am beat.

Lissa: All tuckered out, [Robin]? How about a quick, refreshing shoulder rub?

[Robin]: ...What are you plotting now?

Lissa: Oh, please. One little joke, one little time and you get all paranoid. This isn't about pranking anybody. I figure I owe you...

[Robin]: How do you figure?

Lissa: Because you've taken a huge weight off my brother's shoulders, silly. You know who Chrom's like. He never asks for help, even when he needs it. But he trusts you, [Robin]. Enough to rely on you. He's not the type to come out and say it, but I know he's grateful.

[Robin]: You...think so?

Lissa: I know so! Nobody knows my big brother like me.

[Robin]: Well, that is nice to hear...

Lissa: So, what do you say? Free massage? Going once... Goooooing twiiice...

[Robin]: Okay, I accept! I accept! ...Thanks, Lissa.

Lissa: Okay then... Urgh! Geez, your muscles are just one big knot back here...

[Robin]: ...Aaaaaah, yes, right there... Oooh, that feels amazing...

Lissa: How about...this?

[Robin]: WhaAAAAUGH! Cold! Cold and slimy and cooooooold! AUGH! IT MOVED! WHAT DID YOU DO, LISSA? WHAT IN BLAZES WAS THAT?!

Lissa: Teee hee hee hee! Oh, relax. It's just a frog. You were just so perfectly calm, tee hee. I couldn't resist! It had to be done!

[Robin]: I'm pretty sure it did NOT! And weren't you just saying yesterday that frogs make you "all pukey"?

Lissa: I'm willing to put up with a lot for the sake of comedy.

[Robin]: Well, that makes one of us!

■ LISSA X AVATAR (FEMALE) [ROBIN] A

Lissa: Hey there, [Robin].

[Robin]: Get away from me, she-devil!

Lissa: Aw, don't go getting your hackles up! I'm not here to prank you.

[Robin]: Ha! Fool me once, shame on you. Fool me twice...don't talk to me again.

Lissa: Hee hee! Aw, come on! ...Wait, are you really mad?

[Robin]: Of course I'm mad! You dumped a toad down my collar.

Lissa: I'm pretty sure that was a frog...

[Robin]: I'm pretty sure I don't care!

Lissa: Okay, okay! I'm sorry, [Robin]! I'm super-duper 100 percent sorry. And I won't do it anymore, so please be my friend again. Okay?

[Robin]: ...You're really sorry?

Lissa: Terribly!

[Robin]: ...And you SWEAR you won't do it again?

Lissa: Princess's honor!

[Robin]: ...Well...all right. In that case I suppose I can forgive you... Let's just shake hands and put this silliness behind us.

Lissa: Thanks, [Robin]! You're the bes... AAAAAUGH! Wh-what is that, in your hand?! Is it a sna... A sn-n-n...

[Robin]: A snake? Oh no, Lissa. I'm pretty sure this is a worm. ...Gotcha!

Lissa: Gya! I thought my heart was going to jump out of my throat! You're terrible, [Robin]! AND a total hypocrite!

[Robin]: Uh huh... Why don't you show me what's in YOUR hand, then.

Lissa: O-oh! What? ...This? Hee hee... Why, how did this frog get here?

[Robin]: ...Sorry, you were saying something about hypocrites?

Lissa: Aw, it's no fun if you see it coming!

[Robin]: I'd have to be blind not to at this point.

Lissa: Oooooo! Next time I'm gonna prank you good!

[Robin]: And next time I'll seriously stop talking to you.

Lissa: What?! Oh...fiiiine! Fine! I guess I'll stop. For real this time. *Sigh* Guess I still have a long way to go...

[Robin]: Till you grow up?

Lissa: No, to the pond! ...I've got about a dozen frogs to put back.

[Robin]: *Grooooaan*

| Frederick |

■ FREDERICK X AVATAR (FEMALE) [ROBIN] C

Frederick: Your grip, stance, and breathing are wrong. Focus, [Robin]. ...Again!

[Robin]: Ready!

Frederick: That's enough for today. Your form has improved considerably. The pace of your progress is remarkable.

[Robin]: "Huff, huff" Th-thanks... I feel like...I've got the basics "huff" down now... But... S-so tired..."huff" I think I'm dying...

Frederick: Ha! You're exaggerating! Or at least I pray so. Otherwise you might as well die here—you won't last long on the battlefield.

[Robin]: I suppose...but I'm exhausted nonetheless... But you... You've hardly broken a sweat!

Frederick: I should certainly hope not. If a little training winded me, I would be in no shape to serve Chrom.

[Robin]: Well, I'm impressed. You must train hard to build such endurance.

Frederick: Well, I awaken before dawn each day to build the campfires... Then, whenever we march, I scout the trail ahead, removing rocks and such... Wouldn't do to have someone turn an ankle mid-campaign, now would it?

[Robin]: (So that's why... I always thought it was just a fixation with pebble collecting...)

Frederick: Beg pardon, did you say something?

[Robin]: Er, nothing important! But I owe you for this training session, so let me help you with tomorrow's fire. It'll be a snap with my magic. Find a tree, hit it with a lightning bolt, and presto!

Frederick: ...Instant forest fire.

[Robin]: Oh! Well, yes, I suppose that...could happen... In any case, I do still owe you a favor. Whatever you like—name it and it's yours. You needn't decide today, of course. Think it over for the next time we meet.

Frederick: I am unaccustomed to asking favors, but if you insist, I shall field something.

■ FREDERICK X AVATAR (FEMALE) [ROBIN] B

Frederick: Hello, [Robin]. I've thought about your previous offer.

[Robin]: The favor? Oh, good! What'll it be? Just say the word.

Frederick: I recall seeing you eat bear with great relish shortly after we first met. I should like you to teach me this skill. ...Eating bear, that is.

[Robin]: I remember that night! Lissa was in a froth. Said it smelled like...old boots, was it? Wait, so you didn't eat any, either?

Frederick: I fear I've rarely been able to choke down wild game, and bear least of all. But as the war grows harsher, I can no longer afford to be picky. There may come a day when bear is the only food available to us. Best I train to overcome my aversion now, when our situation is not so dire.

[Robin]: True, and even the finest knight isn't much use on an empty stomach... All right then, you're on. Let's get you eating some bear!

Frederick: Yes, I will train till I can consume anything, without concern for taste or decorum. Like an animal, or a savage... Or like you, [Robin].

[Robin]:

Frederick: Er, [Robin]? ...Did I say something wrong?

[Robin]: Um, no, nothing. Don't worry about it. So, Frederick. You don't have a problem with more common meats, do you?

Frederick: Beef and pork are fine. I also enjoy a good chicken on occasion.

[Robin]: Then let's start simple. Take a bite of this jerky.

Frederick: Yes, I shall tear into it with gusto! *munch munch* BLEAGH! G-gamey! S-so gamey! What... *cough* What IS this?!

[Robin]: It's bear. Leftovers from the same bear we ate that night, in fact! I saved some.

Frederick: Eeeaaaaagh! Healer! I need a healer!

[Robin]: Animal or savage, indeed. How rude of him... Guess he wasn't joking about his aversion to bear, though...

■ FREDERICK X AVATAR (FEMALE) [ROBIN] A

[Robin]: Hey there, Freddy Bear! I've got some new cured meat for you to try...

Frederick: I'll thank you not to refer to me by that ridiculous name. ...And I'm not so gullible as to fall for your bear-jerky trick twice.

[Robin]: Oh? I thought you were serious about getting over this, Frederick. Look, I'm not a monster. I prepared a whole series of meats in order of gaminess. We can take it slow.

Frederick: ...Well, I suppose I did ask for this.

[Robin]: All right then. We'll start with chicken, then pork, then beef.

Frederick: *Munch, munch* ...Hmm, excellent so far.

[Robin]: Next is mutton. It starts to get a little tricky here.

Frederick: *Munch, munch* ...This is...manageable.

[Robin]: You're doing great! Okay, this one's venison.

Frederick: *Munch, munch*

[Robin]: ...By which I mean bear.

Frederick: PFFFFFFFT! Augh! By the gods! I'm d-dying! Dying! Ah... It's s-so dark... T-tell Chrom that...

[Robin]: Oh, stop exaggerating! Otherwise you might as well die here—you won't last long on the battle... field? Whoa. I just had intense déjà vu.

Frederick: I said the same to you, once upon a training session. And I was right. If I succumb to this, I can't well protect everyone on the front lines... My body is ready, [Robin]! The next sample, if you please!

[Robin]: You talked yourself back into it? Impressive. And perhaps a little disturbing... Ah, well. Whatever works. Let's finish this, Frederick! Open wide!

■ FREDERICK X AVATAR (FEMALE) [ROBIN] S

[Robin]: You did it! You chomped down on that crocodile jerky like it was a candied fig!

Frederick: *Groan* I h-have...to thank... Giving me...the strength...

[Robin]: And last, but certainly not least...

[Robin]: W-wild-bear meat?

[Robin]: You can do it.

Frederick: *Nibble* *Nibble*

[Robin]: You did it, Frederick! You swallowed the whole thing! You've conquered your phobia of bear meat!

Frederick: Thank...you.

[Robin]: Er, but you look a little pale. Do you feel all right?

Frederick: I'll be fine. Better than fine, in fact. Thanks to you, I needn't ever battle on an empty stomach. I stand in your debt.

[Robin]: Glad to be of service. After all, you have to be in tip-top shape to protect the rest of us.

Frederick: I should tell you that last night, I made a promise to myself... I swore that if I could keep the bear meat down, I would offer you...this.

[Robin]: ...Huh? A ring? ...But why?

Frederick: I would like you to be my wife.

[Robin]: What?! Oh Frederick... I did NOT see this coming!

Frederick: I was thinking about what would happen if I managed to overcome my weakness. We would have no more reason to spend so much time together. And yet, I cannot bear the thought of leaving your side, [Robin]. So after much thought, I determined that I had no choice but to propose.

[Robin]: ...I don't know what to say. Except...deciding to marry a girl when you didn't upchuck a mouthful of bear? It might be the most unromantic thing I've ever heard!

Frederick: Well, yes, but...

[Robin]: Oh, I don't care, Frederick! I've been in love with you since our first bear dinner!

Frederick: You do me a great honor, milady. You will not regret it, I swear to you!

[Confession]

Frederick: My heart is yours, milady. I vow to defend you as knight and husband until death should part us.

| Virion |

■ VIRION X AVATAR (FEMALE) [ROBIN] C

Virion: So if the cavaliers spread out in a fan... And the pegasus knights sweep in from the flank...

Virion: Goodness, I can practically see smoke rising from your head. Whatever could have you working at such a fevered tilt?

[Robin]: I'm practicing strategies and scenarios on this game board. After a hundred forced marches, these pieces are still ready for more. It saves me from running everyone ragged with training exercises.

Virion: ...How very clever. You even carved little enemy forces for them to fight... I'm impressed. And that doesn't happen often...with other people, I mean.

[Robin]: Well, as long as I control friend and foe alike, it's not as effective as I'd prefer. After all, I can't plan for the unexpected when I know all the moves ahead of time.

Virion: Then permit me to be your opponent. I shall strike with the nobility of the lion and defend with the grace of the swan!

[Robin]: Because swans are...good defenders? Er, never mind. I accept. So then. We'll take turns moving units until one of us claims the other's tactician. Agreed?

Virion: Agreed and agreed again! Oh, what fun! ...Begin, please. By all means.

[Robin]: Hold! I need to retract my last move.

Virion: Ha ha! Were that all enemy generals so generous! But alas, this is war. ...Checkmate, my good lady.

[Robin]: ...Blast! I hate to admit it, but I am well and truly beaten.

Virion: Oh ho! I told you I was both a lion and a swan, did I not?

[Robin]: More like a chicken and the far end of a horse! I'm no noble lord, but my strategy wasn't exactly what I'd call honorable.

Virion: Heavens! Aren't we plainspoken.

[Robin]: At any rate, I appreciate the practice, but I must return for a meeting.

Virion: But I've barely had time to gloat!

[Robin]: Ah, well, all part of the simulation. In actual war, you see, the loser is never present to witness gloating.

Virion: No, wait! Don't leave, [Robin]! Let us play again!

■ VIRION X AVATAR (FEMALE) [ROBIN] B

[Robin]: Ho, Virion! Care for a rematch? I have a method to defeat you this time for certain!

Virion: Oh? How thrilling! I do so love a challenge. Though I do recall you saying something similar before the last 20 attempts... One moment. You're not, by any chance, losing on purpose, are you, dear lady? I see now! This was a ruse to spend time with your noble Virion! Well, you're not the first to resort to such tricks with me, I must admit...

[Robin]: For a grown man in a bib? I think not. Now make your move.

Virion: B-bib?! Now see here, you uncouth barbarian! This is a CRAVAT! This is the very height of fashion among sartorially minded nobility.

[Robin]: ...Sounds fancy. Your move?

Virion: Gya! I can forgive ignorance, but sarcasm is another matter! You've made a mockery of the delicate art of hollow flattery! I demand satisfaction on the field of battle, milady. Have at you!

[Robin]: Do your worst!

Virion: Blast and blast again! Why can't I beat you?!

[Robin]: I'll not speak to your fashion sense, but you have a real knack for strategy, Virion. Perhaps you should be giving the orders instead of me.

Virion: Inadvisable, my good lady. I fear we'll never last the war. Spare a second glance at the board and tell me: Who has more soldiers left alive?

[Robin]: Ah...

Virion: I won, yes, but at what cost? Half the moves I make in this game could never be used in a real battle. My own men would have my head on a pike before the enemy even reached me. No, this army needs a tactician who loathes the sacrifice of even a single man. It needs you, [Robin].

[Robin]: Virion? That was almost...kind. Perhaps even sensible. Are you feeling well? You're starting to sound like a normal person.

Virion: I am ever the definition of sensibility. And "normal" is just another word for "common," thank you very much! Still, perhaps milady would see fit to reward the victor with a kiss?

[Robin]: Nice try.

■ VIRION X AVATAR (FEMALE) [ROBIN] A

[Robin]: *Sigh* I lose. ...Again.

Virion: It was your gambit with the wyvern rider seven moves back that doomed you.

[Robin]: ...Ah, I see. Because that left my vanguard's flank exposed. You really are excellent at this, Virion. I just can't compete.

Virion: Nonsense! Why, you're winning almost one match in three as of late. The pace of your progress is frankly somewhat frightening.

[Robin]: Any strides I've made have been due to your patience. Thank you for working with me. I've really come to look forward to our matches. The sad part is, unless I manage to best you at least once, I have trouble sleeping!

Virion: You would not be the first damsel to be kept awake by thoughts of me, you know... But I am happy to be of service, even if it is as your personal gamesman. If our matches help ease the burden you carry, then it is my honor to continue.

[Robin]: ...And I am burdened, Virion. Sometimes I feel as if I could drown on dry land. The army relies on me to plan their every move and tactic. I lack the experience for such responsibility. It's enough to make a woman flee in terror.

Virion: And yet here you remain, when a lesser soul might have turned craven and ran. Such actions have earned you the respect of us all, you must know that? And regardless of this game, your skill on a true battlefield approaches genius. I am content to place my life in your hands, and that says a very great deal.

[Robin]: Goodness, Virion! I think that's—

Virion: And if those honeyed words are not enough to aid your slumber? Then I shall be happy to lie in your cot and whisper a sweet lullaby while you—

[Robin]: Not happening.

Virion: Ah, a pity. I am told I have quite the soothing effect, you know.

■ VIRION X AVATAR (FEMALE) [ROBIN] S

Virion: I have a proposal, [Robin]. For today only, let us play our game by a different set of rules.

[Robin]: What do you have in mind?

Virion: In the place of your carved commander, you will play with this.

[Robin]: ...A ring? That's...an odd change to request...

Virion: I'm not finished! For if I win the match, you must accept the ring as a gift.

[Robin]: Er, but wouldn't that mean you lose either way?

Virion: Of course, I'll win something else. ...Namely, your hand in marriage!

[Robin]: Is... Is this some kind of joke?

Virion: On the contrary, milady! I have never been more serious in my entire life. So what say you? Will you play the Virion Gambit?

[Robin]: ...What happens if I win?

Virion: Then I shall withdraw my offer and bow out like a true gentleman. I mean for this to be a true demonstration of the depths of my feelings for you. I would do anything to win your love!

[Robin]: ...Then I must refuse.

Virion: B-but why?

[Robin]: Because if I win, you're prepared to take the ring back and leave me be. ...And I don't want that.

Virion: Do you mean to tell me...you wish to marry me, win or lose? B-but then I win either way! Er, I mean, that is to say... Is that what you truly want?

[Robin]: You've played this game for me, day after day, patiently teaching me all the while... Helping me build up my skills... Perhaps even helping me surpass your own skills... It seems you're willing to have a wife who is your better in ways—I like that!

Virion: Egads! I sense a domestic hierarchy already being locked into place... But, no matter! For one so beautiful, Virion is happy to play the role... A slave to love I shall be. Now please, accept my ring!

[Robin]: Thank you, Virion. This is the happiest day of my life... Even better than the first time I beat you at that blasted game!

[Confession]

Virion: I love you, no, I am enamored with you, no, we are soulmates! Oooh, the sultry sonnets we will spin!

| Sully |

■ SULLY X AVATAR (FEMALE) [ROBIN] C

Sully: Ah, crap. Come on, Sully, get your damn act together...

[Robin]: Sully? What are you mumbling about? ...And why are you holding your side? Is everything all right?

Sully: I'm fine! It's nothing! ...Leave me alone!

[Robin]: You look anything but fine, Sully. You're not hurt, are you?

Sully: No, I... All right, I put on weight and my muscle mass is down. You believe that? We're fighting a war, and I'm getting a gut.

[Robin]: What? Are you sure? You look great to me— same as ever.

Sully: Then you aren't looking hard enough.

[Robin]: Well, this is a side of you I've never seen.

Sully: The hell you talking about?

[Robin]: Well, I just...didn't think you were the kind of person to worry about her figure.

Sully: Gods, but you are a blooming ninny. This isn't about LOOKS! I said my muscle mass had dropped! And that's going to affect combat, which could get my arse KILLED!

[Robin]: Eeeep! I mean, um, yes! Of course I get it! ...P-please don't hurt me...

Sully: Hurt you? Why in the hell would I do that?

[Robin]: *Ahem* Well, if you ARE worried about weight redistribution, you could try this.

Sully: *Sniff* Gods, it smells like horse slop! What is it, some kind of jerky?

[Robin]: It's a rare form of dried seaweed, actually. I bought it back in town. The shopkeeper said it contained "insane quantities of fiber." Then he just kept saying "insane" and cackled while doing a little dance... Quite an odd fellow, really.

Sully: Hmm... Sounds risky.

[Robin]: Well, I know how brave you are...

Sully: Is that a dare? Fine then! I'll try it!

[Robin]: Great! To tell the truth, I've put on a few pounds myself lately... I've been meaning to try the seaweed but was too scar—er, busy! Too busy.

Sully: HA! Too much pie—that's your problem! All right then, [Robin]. Let's see who can get in shape faster!

■ SULLY X AVATAR (FEMALE) [ROBIN] B

Sully: Nnngh... Yearrgh.

[Robin]: S-Sully?! Oh, gods, Sully, what's wrong?! You look like a corpse! So worn out and thin! ...And your skin—it's GREEN! Have you been poisoned? What have you eaten lately?!

Sully: J-just the...dried seaweed...you gave me... Ate the...whole bag...last night... Oooooo... Unnngh...

[Robin]: Wait...did you say... the WHOLE bag?

Sully: Is...that bad...?

[Robin]: Sully, you're supposed to tear off a tiny piece and rehydrate it with water first. The chunk I gave you was a month's supply. If you ate the whole thing... Oh, dear heavens. Your poor bowels!

Sully: Kill... Kill...you...for this...

[Robin]: Sully, I am so, so sorry! I should have explained in more detail!

Sully: Grr... My own...d-damn fault, taking...short-cuts... But I won't...make that mistake again... Gonna start training... Rebuild muscles... Soon as I'm better...

[Robin]: You must let me help you somehow. I just feel so awful about this.

Sully: Well... I don't know... Maybe... Oh g-gods... Here it comes again...HPPPMF!

[Robin]: ...Yikes, that did not sound good...

■ SULLY X AVATAR (FEMALE) [ROBIN] A

Sully: Hah! Yaaah!

[Robin]: Looking good, Sully! Feeling better, I take it? And just LOOK at those muscles! I'd say your training's paid off.

Sully: I'm getting there. Still got a bit of flab right here, though.

[Robin]: Where? Here?

Sully: Hey! Hands off the merchandise!

[Robin]: Um, Sully? That's not fat. That's loose skin.

Sully: Huh?

[Robin]: I knew something was weird when you told me you were worried about getting flabby. You train harder than anyone I know.

Sully: Skin, huh?

[Robin]: It's probably a result of the seaweed. You lost a lot of weight during your trial, and the muscle is still filling in. Give it another week of combat and eating right, and it'll disappear soon enough.

Sully: Huh. I guess that makes sense.

[Robin]: Trust me. You're in perfect shape. I should know—I've been training with you all week!

Sully: Huh. ...Well, all right then.

[Robin]: I guess that means you win our contest. My belly hasn't shrunk at all.

Sully: Well, just don't go trying any of that damn seaweed! Har har har!

[Robin]: Er...heh heh, n-no, that would be a foolish thing to—HuuuRRRRRRGH! ...Uh-oh.

Sully: Oh, don't tell me... You ate the seaweed?

[Robin]: Y-you kept getting...skinnier... I h-had to... catch up...

Sully: You idiot! You saw what that stuff did to me!

[Robin]: N-no more... Urk! You're right... S-s-so right... Gotta go! *GURRRF*

Vaike

■ VAIKE X AVATAR (FEMALE) [ROBIN] C

[Robin]: ...Vaike? What are you up to out here?

Vaike: Eh? Me? Up to? Nothin'! Har har! Yessir, just a whooole lot of nothin'. Oh, lookie there! Pretty flowers! I sure do love me a pretty flower, don't you? Yep! Love 'em. All of 'em! ...Say what's your favorite flower, [Robin]?

[Robin]: ...Okay, now I KNOW you're up to something.

Vaike: Har har! Nope, not me! Just lookin' at all them pretty flowers is all. Nice, ain't they?

[Robin]: Liar. You're trying to see who's bathing in the spring over there.

Vaike: S-spring? There's a spring? Why, I had NO idea!

[Robin]: Don't play dumb with me, Vaike! Now stop leering and get back to camp.

Vaike: Aw, come on! You don't understand! You ain't a man! Sometimes a man's just gotta...see what can be seen, ya know?

[Robin]: No, not really... Thank the gods.

Vaike: Right little goody two-shoes, ain't ya? Interrupting my fun just when... Oh, fine. Guess I'm done lookin' at flowers. But don't think you can keep me—Huh? What's that?

[Robin]: That's Sully's horse isn't it? Gods, but it's a fierce-looking brute. Do you see how it's glaring at us? It's almost as if it thinks—

Vaike: IT'S GONNA CHARGE! RUN! RUN FOR YOUR LIIIIIIFE!

[Robin]: B-but I didn't do anything! Gyaaaaaa!

■ VAIKE X AVATAR (FEMALE) [ROBIN] B

Vaike: Har! It's the Vaike's lucky day! Sully's horse is dozin' away, and that meddling little—

[Robin]: Meddling little...what?

Vaike: Blast! You again? Er, I mean... Oh, look! A four-leaf clover! Lucky me!

[Robin]: For that lie to work, you actually need to have a four-leaf clover. You're spying on bathing women again, weren't you? Don't deny it!

Vaike: I DO deny it! ...Besides, what are YOU doing skulkin' in the bushes?

[Robin]: I was helping my friends bathe in peace without some scoundrel leering at them! Now keep your voice down! You might wake up Sully's devil steed.

Vaike: What do you care if it wakes? I'm the one he's got it in for.

[Robin]: Not anymore, thanks to you! Ever since that time I caught you snooping, the beast has made me its sworn enemy. If I get within half a mile of me like a hound from hell!

Vaike: Har har! So the beast has the evil eye for Madam Goody Two-Shoes herself? There's a word for that... What is it... Tip of my tongue... Oh, I know! ...IRONIC! HAR HAR!

[Robin]: Frankly, being tarred with the same brush as you is punishment enough. In any case, one of us want to be here if that horse wakes up. Come on, let's get back to camp.

Vaike: ...Curses, I truly thought today was going to be the Vaike's lucky... Wait. That evil horse—it's gone!

[Robin]: V-Vaike... D-don't turn around... It's right... behind you...

Vaike: It's...b-behind me? ARRRRRRRRRRGH! RUUUUUUN! FOR THE LOVE OF ALL THAT'S GOOD AND HOLY, RUUUUUUUUUUUUN!

[Robin]: WHY MEEEEEEEEE?!

■ VAIKE X AVATAR (FEMALE) [ROBIN] A

[Robin]: Hey, Vaike. Why the long face?

Vaike: ...Oh. Hello, [Robin]. So, uh...I've been thinkin'. The Vaike's caused ya a lot of grief. I feel bad about it.

[Robin]: It's not like you to be so introspective. Why does it worry me...

Vaike: Well, I was having a bath—you know, down by the spring—and well... These ladies appeared outta nowhere and started pointin' and laughin' at poor Teach! I was stark naked, with my clothes hung up on the far side of the creek! I reckon they were gettin' revenge for those times I...accidentally spied on 'em.

[Robin]: Huh.

Vaike: And that blasted horse was there, grinnin' like a rabid crocodile! It was humiliatin'!

[Robin]: Well, that does sound unpleasant. Even if you only have yourself to blame. One might even call it... Oh, what's the word? Ah, yes: ironic! In any case, can we please assume that you've finally learned your lesson?

Vaike: Yeah, now that I know what it's like to be the victim, the Vaike's spyin' days are done.

[Robin]: Good. I think when you look back on this later, you'll be glad it happened. But, come. No use moping about what's done. The Shepherds need their Teach. They need his passion and his willingness to take on anything or anyone, damn the odds!

Vaike: Har har. Now that's the truth! ...You're all right, [Robin]. A good friend through and through.

[Robin]: You...consider me a friend?

Vaike: Darn right! You're in the Vaike circle of trust. Not many folk earn that privilege! ...But now that we're friends and all, that means we can ask each other favors.

[Robin]: Favors? Well, I suppose if there's something—

Vaike: I've given up spying, but I owe those girls a good scare! No one makes a mockery of Teach and gets away with it! So put your thinkin' cap on and brew up some kinda revenge scheme, okay? Some way to dump puddin' on their heads or somethin'.

[Robin]: Pudding, Vaike? Honestly?

■ VAIKE X AVATAR (FEMALE) [ROBIN] S

Vaike: Aw, snakebellies! Where could it have gotten to? If I don't find it soon...

[Robin]: What's all the fuss about, Vaike? Have you lost something?

Vaike: WAH! [Robin]! Why're ya always sneakin' up on me like that?! I... I just somethin'. It's a pouch of, uh, herbs! ...Yeah, that's it.

[Robin]: ...Okay, now tell me what you REALLY lost, and perhaps I can help.

Vaike: It's, er... Well, how do I put it? It's a round thing with a hole in the middle. All glittery.

[Robin]: Hm. Any other identifying characteristic... Vaike? What is it? You've gone deathly pale!

Vaike: D-don't look now... B-b-b-behind you...

[Robin]: Behind ME? You don't mean... AAAAAAAAARRRGH! IT'S THE HORSE! THE EQUINE FROM HELL! SAVE US! SAVE US ALL FROM ITS... ...Huh? He's not charging. He's not even mad. He's... nuzzling me. Wait, he has something in his mouth!

Vaike: Hey, that's...

[Robin]: A ring. A beautiful, glittery ring... This is what you were looking for, isn't it?

Vaike: Er, yeah.

[Robin]: Well, isn't this lucky! You found your ring. Is it new? I don't remember ever seeing you wear it. Or maybe...it's meant for someone else? Someone... special to you...

Vaike: Well, er...it's actually for you.

[Robin]: ...Me?

Vaike: Yep.

[Robin]: Gracious!

Vaike: It's just... I got to thinkin' how enjoyable it's been hangin' around with you. Stumblin' around in bushes, fleein' that devil horse, all the witty banter... The Vaike ain't had that much fun since I was an anklebiter back home! So I said to myself, "Vaike, you should marry this girl before she gets snapped up!"

[Robin]: I...don't know what to say, Vaike. I'm overwhelmed. When I first saw the ring and thought you had a special someone... Well, my heart leapt into my throat. Because I've grown quite fond of you. I can't tell you how thrilled I am that this ring is meant for me!

Vaike: So you'll say yes? You'll marry me?! YIP-PEEEEEE! Dash it, [Robin], I'll have to give that horse a big, slobbery kiss of gratitude!

[Robin]: Heh, shouldn't I get one, too? ...Preferably BEFORE the horse!

[Confession]

Vaike: This has gotta be the first time I've ever rated someone else first! Is this...love? The Vaike is stunned!

Stahl

■ STAHL X AVATAR (FEMALE) [ROBIN] C

[Robin]: Now, what would he want more than anything? Hmm... Maybe a sword? Wait, what am I thinking? He already owns the most treasured sword of all...

Stahl: Heya, [Robin]! You thinking up a birthday present for old man Chrom?

[Robin]: Stahl! He's hardly "old," Stahl... But yes, I am. And to be honest, I'm at a bit of a loss for ideas.

Stahl: Ha! Isn't that a pickle!

[Robin]: Buying for royalty would be hard enough, but we're in the middle of a war. It'd have to be small, to transport easily with the caravan, and nothing excessive...

Stahl: Yeah, cheap is good. Chrom's never been much for gold and glitter, anyway. I was actually thinking of brewing up a special concoction for him.

[Robin]: You mean like a potion or tonic? I didn't know you dabbled in such!

Stahl: My father is an apothecary, and he taught me the trade.

[Robin]: Homemade gifts are always the best! Would that I possessed any such talents...

Stahl: Perhaps I could help gather them?

Stahl: Er, say. My ingredients are quite costly and difficult to find in the wild...

[Robin]: Perhaps I could help gather them?

Stahl: Yes, exactly! Then the present could be from the both of us.

[Robin]: Perfect! We can solve both our problems in one fell swoop.

Stahl: Then it's a deal!

■ STAHL X AVATAR (FEMALE) [ROBIN] B

[Robin]: Chrom loved the gift, Stahl! Thanks so much for letting me help.

Stahl: Not at all—I should be thanking YOU. I doubt I could have afforded everything without your fat purse!

[Robin]: Oh, come now. Don't think I'll fall for that old trick... You helped me and just made it seem like I was helping you. I don't know how you do it, but I'm grateful nonetheless!

Stahl: Heh. I guess I've always been good at reading people. Even when I was young, I could tell what folks wanted before they even said it. It's not much of a secret ability, but it's the only one I've got.

[Robin]: On the contrary, I think being sensitive to others is a precious skill indeed.

Stahl: I don't know if I'm sensitive, exactly. I just find it easy to read people. You'd be amazed how much you can read from a face, if you know what to look for.

[Robin]: And you can always read these thoughts?

Stahl: Absolutely!

[Robin]: Stahl, that's a remarkable talent! Truly.

Stahl: Ha! Not at all! It's just the coping mechanism of an overly dull man.

[Robin]: Reading thoughts from faces or gestures? That's every bit as impressive as magic. I bet you're always one step ahead of your rivals, on the battle-field and off.

Stahl: Hmm... I guess it has saved my skin a time or two.

[Robin]: Like how you read my mind when I was wondering what to get Chrom...

Stahl: Er, actually, that time, I just overheard you talking to yourself.

[Robin]: Was I? Oh! Ah ha ha...

■ STAHL X AVATAR (FEMALE) [ROBIN] A

Stahl: *Sigh*

[Robin]: What's wrong, Stahl? You sound a bit down?

Stahl: Well, I apparently need to practice, then! It was supposed to be a sigh of relief. Some friends were in a bit of a row, but I managed to calm the waters.

[Robin]: You're always doing things like that, aren't you? Helping others with their problems. Most of us are too busy looking after ourselves, but you always find the time.

Stahl: Well, in a way it was for my own sake. Troubled folks make me uncomfortable. When I see friends fighting, my first instinct is to intervene and restore the peace.

[Robin]: Ha! And now you're acting humble and deflecting praise from yourself.

Stahl: Er, sorry. Is that annoying?

[Robin]: Not annoying, no. But you should stand up for yourself from time to time, too. For example, you could start by telling people that today is your birthday.

Stahl: Huh? You knew?

[Robin]: I found out, yes, but not from you! Friends should be able to tell each other that much. War may be raging around us, but that doesn't mean we can't have fun sometimes.

Stahl: I suppose...

[Robin]: You spend so much time looking after other people that someone has to look after you. And I've decided that someone is going to be me! So here, have a couple of fried fig cakes in honor of your birthday.

Stahl: Aw, my favorite! Thanks, [Robin]. You're a true friend.

■ STAHL X AVATAR (FEMALE) [ROBIN] S

Stahl: Here I go. I'll do it again.

Stahl: Did what again?

[Robin]: Scratched your nose. You've got something you want to ask me, don't you?

Stahl: How did you know?

[Robin]: Oh, I've been doing a bit of observing of my own, trying to read faces. After you described your special talent, I realized how useful it could be. First thing I learned is that you scratch your nose before you ask for anything.

Stahl: Ha! You'd think I'd know my own tells, but I guess not...

[Robin]: So? What is it? You shouldn't be shy about asking me for anything. You've helped me so much, I'd love a chance to return the favor.

Stahl: Er...right. Guess I'll ask.

[Robin]: I'm all ears.

Stahl: Well, I, um...got this ring for you. And...I want you to wear it.

[Robin]: Why?

Stahl: ...Because I love you.

[Robin]: What?! Gods, I had no idea!

Stahl: I was kind of hoping you'd picked up on my cues...

[Robin]: Er, you're not going to tell me not to disrupt your thoughts again?

Miriel: I can if you wish.

[Robin]: N-no, thanks. I'm just happy to know I wasn't a bother, I guess.

Miriel

■ MIRIEL X AVATAR (FEMALE) [ROBIN] C

Miriel: ...How discomposing.

[Robin]: That looked like a pretty bad spill, Miriel. Are you hurt?

Miriel: A minor contusion. Benign.

[Robin]: Everything you were carrying went flying. I see your herbs, some papers, a... What is this? A book? A journal?

Miriel: Unhand that, madam!

[Robin]: Sorry! Sorry. I didn't realize it was so important.

Miriel: Important? Hmm...

[Robin]: Miriel?

Miriel: I suppose it does bear some import, yes. It's a lodestar, of sorts. One that points the way to the truth.

[Robin]: Wow. Who wrote it? A famous mage or something?

Miriel: Not famous at all, no. The author was my mother.

[Robin]: Ah, that explains the rough binding. Er, no offense intended. Still, that's amazing. Was your mother a mage as well? Or perhaps a scientist?

Miriel: What is the impetus for your inquiry?

[Robin]: Impetus for my... You mean, why do I ask? Er, I don't know. ...I'm curious. Wouldn't most people be?

Miriel: An autonomic reaction to conversational stimulus. I see...

[Robin]: Um, did I say something strange?

Miriel: Curious, perhaps. Meriting closer study, certainly. Spontaneous reactive curiosity. Fascinating. But what is the underlying mechanism?

[Robin]: ...I really think you're reading too much into this.

■ MIRIEL X AVATAR (FEMALE) [ROBIN] B

[Robin]: Oh, blast! My item pouch is gone. I must have dropped it somewhere...

Miriel: Is this the object in question?

[Robin]: Ah, yes! My thanks, Miriel. I keep it tied to my belt, but it's always falling off for some reason.

Miriel: Such actions are indicative of a pervasive downward force exerted on the object. My mother's book contained a passage espousing a similar theory...

[Robin]: So, um, can I have my pouch back now?

Miriel: ...Ah, yes. Here is the passage in question: "On all objects there acts a force which pulls them ever groundward." "Though invisible and without apparent cause, it exists nonetheless." "I posit that it is by this principle we remain rooted to the ground." ...Most intriguing!

[Robin]: ...Miriel? ...Hello?

Miriel: Yet birds fly uncumbered by this force. The sun and stars and clouds do not fall. What explains these exceptions?

[Robin]: Miriel? ...Miiiriel? ...MIRIEL!

Miriel: Wah!

[Robin]: S-sorry! ...Didn't mean to startle you.

Miriel: My respiratory functions ceased for a moment. This is very disruptive. Please do not scatter my thoughts further.

[Robin]: Er, sorry.

Miriel: I require a period of quiet solitude to marshal my thoughts. Farewell.

[Robin]: Wait! My...pouch...

■ MIRIEL X AVATAR (FEMALE) [ROBIN] A

Miriel: So, given these conditions, a body with a mass of X falls at a rate of Y...

[Robin]: Um... What are you doing with my item pouch, Miriel?

Miriel: Experimenting in an attempt to establish a unified theory of falling. Whether thrown, catapulted, or dropped from great heights, it falls to the ground. The results have been consistent across hundreds of trials.

[Robin]: H-hey! I had a lot of fragile things in that pouch! Potions and baubles and... *Sigh* ...You know what? Keep it.

Miriel: Thank you.

[Robin]: Sometimes I wish you'd show half as much interest in people as you do in science.

Miriel: Well, I am interested in certain people. You, for example.

[Robin]: Me? Why me?

Miriel: You have a virtuosic proficiency in strategy, despite your amnesia. I find that fascinating. From this, we can extrapolate two possible hypotheses. One: talent is wholly independent from memory and experience. Two: memories and experience related to the use of one's talents cannot be lost.

[Robin]: Miriel? Are you still talking to me?

Miriel: I am now, yes.

[Robin]: Er, you're not going to tell me not to disrupt your thoughts again?

Miriel: I can if you wish.

[Robin]: N-no, thanks. I'm just happy to know I wasn't a bother, I guess.

Miriel: That would be difficult. You are the focus of intense interest on my part.

[Robin]: Can you see what I'm thinking?

Stahl: ...Yes. Yes I can! You're happy!

[Robin]: Exactly! See, if you'd have paid more attention, you'd have seen—

Stahl: ...that you're in love with me, too.

[Robin]: Recently you've been avoiding my gaze. It was... Well, it was horrible, frankly.

Stahl: Oh, you noticed? I'm sorry. I guess I just got bashful around you.

[Robin]: But if you'd seen my eyes, you'd have known the answer was yes before you even asked!

Stahl: Oh, [Robin], even a blind man could see you've made me so happy!

[Confession]

Stahl: My lady, I may never take my eyes off you again! ...Unless I'm about to run into a wall.

Kellam

■ KELLAM X AVATAR (FEMALE) [ROBIN] C

[Robin]: The others claim it's a ghost, but I refuse to put stock in such things.

Kellam: Claim what is a ghost?

[Robin]: WAAAAAAAAAAH! ...Oh! It's you, Kellam. You surprised me.

Kellam: Sorry. You looked a little worried... I just wanted to see if you were all right.

[Robin]: Well, there IS something troubling me... The men are reporting strange incidents—baffling phenomena that defy explanation.

Kellam: Goodness! Like what?

[Robin]: Well, for example, whenever a group of us gather, drinks materialize on the table. Also, there's always one more cup than people present. But everyone denies that they brought the cup or served the drinks! It's most peculiar. So peculiar, in fact, that some are claiming it to be the work of spirits...

Kellam: It's not a ghost.

[Robin]: Oh, of course it's not. I just don't know what it could possibly—

Kellam: It's me. I serve the drinks.

[Robin]: You? ...But wait. Why would you bring one cup too many?

Kellam: That's my cup. I guess it's just that no one ever...notices me...

[Robin]: What?! That's almost as absurd as the ghost theory!

■ KELLAM X AVATAR (FEMALE) [ROBIN] B

[Robin]: La de dah de dum... ♪ Shanty Pete danced on a barrel of rum... ♪ Oh, hullo?! Where did this drink come from? ...Kellam, are you there?

Kellam: Right here. ...In front of you.

[Robin]: Ah, yes, of course—now I see you. Thank you for the drink!

Kellam: I didn't want to interrupt while you were humming there. Sorry...

[Robin]: Not at all! I was just taken aback when the cup seemed to appear by my elbow...

Kellam: Um, yes. Sorry...again.

[Robin]: You know, Kellam, if you want people to notice you more, you should speak up.

Kellam: Oh, I'm not looking to be noticed. Not especially, anyway.

[Robin]: Well, if that's your plan, I have to say you're succeeding brilliantly.

Kellam: Plus whenever I do speak, people start screaming about hearing voices... At least, that's what happened at dinner last night...

[Robin]: Heh, so that WAS you... Half the camp refused to come out of their tents for fear of the "ghost"!

Kellam: Sorry!

[Robin]: Stop being sorry! It's their own fault for being such superstitious hens.

Kellam: Yes, but I understand now why people react so strangely whenever I do them favors. Next time I bring tea for everyone, I'll be sure to shout when I'm doing. And I'll try to stop standing sideways... Or in shadows. Or behind barrels.

[Robin]: Splendid idea, Kellam! That's the spirit! We'll get you noticed yet!

■ KELLAM X AVATAR (FEMALE) [ROBIN] A

Kellam: Eh? A slice of crowberry pie? What's this doing here?

[Robin]: It's for you, Kellam.

Kellam: [Robin]? Y-you saw me!

[Robin]: The trick is to squint and look sideways. I've been working on it in here and there. Anyway, you're always so helpful to everyone else, I wanted to return the favor.

Kellam: ...Thanks.

[Robin]: Not at all. It's the least I can do.

Kellam: Gosh, you really are good to me, [Robin]. I know I said I don't do it for thanks, but it IS nice to hear...especially from you. ...Well, guess I'll be going now.

[Robin]: What in the... How did he DO that?! He just vanished!

Kellam: Er, I'm right over here. Straightening up these axes.

[Robin]: ...Oh, right. Of course. I knew that. It's just that you gave this enigmatic smile, turned to the left, and then...disappeared! Almost as if you'd achieved enlightenment and transcended this mortal plane!

Kellam: ...That's some imagination you have.

[Robin]: Ha ha. Yes, well...perhaps I've read a few too many morality plays as of late. In any case, forget the axes for now—everyone is waiting for you.

Kellam: Me? ...But why?

[Robin]: They all want to apologize for making such a fuss about the supposed hauntings.

Kellam: ...Oh, um. I don't know. That sounds like an awful lot of attention...

[Robin]: Sometimes, Kellam, we all have to stand up and be noticed.

Kellam: All right. But if I'm feeling shy, I might have to transcend to a higher plane again.

[Robin]: Ah-HA! I KNEW IT!

Kellam: That was a joke? A joke? ...Ha ha ha? ...[Robin]? Why are you backing away from me like that...?

■ KELLAM X AVATAR (FEMALE) [ROBIN] S

[Robin]: Wow, what a party the other day, eh, Kellam? So much fun!

Kellam: Um, I suppose so...

[Robin]: When you got out of your seat and disappeared into thin air? Half of them believed me when I said you'd transcended the mortal plane! Heh ha!

Kellam: Yes...

[Robin]: Oh, but listen to me natter away! I'm not letting you get a word in edgewise! ...Er, I'm not boring you, am I?

Kellam: Golly, no. Not at all. I like you, and I like hearing you talk... I could listen to the sound of your voice all day long...

[Robin]: Oh, well, thank you, Kellam. ...Hey, wait a sec! Wh-what do you mean, "like" me?! As in, LIKE like?

Kellam: Um, I'm sorry...is that a problem?

[Robin]: Er, no! Of course it isn't... I'm just...surprised, is all...

Kellam: Then get ready for a BIG surprise.

[Robin]: Wh-what's going on? Why are you giving me a...ring?

Kellam: Do you like it?

[Robin]: G-gracious, Kellam, I LOVE it! ...Can I keep it?

Kellam: I sure hope you do!

[Robin]: I'm so happy... I feel like I could just float off into the clouds.

Kellam: It's all right. I'll grab your ankle before you get too high. That is, if you really DO want to stick around and...be my wife.

[Robin]: I want that more than anything, Kellam. In truth, I've adored you for so long...

Kellam: I'm glad you found me, [Robin]. Not many people have, you know.

[Robin]: You won't have to worry about being missed, ever again. No matter where you go or what you do, I'll be there, watching you. And what I'll see is my friend, and my one true love.

Kellam: As long as you see me that way, no one else even matters...

[Confession]

Kellam: You make me feel like I-I'm really here. Like I mean something. I am yours...forever.

Sumia

■ SUMIA X AVATAR (FEMALE) [ROBIN] C

[Robin]: That's a lot of books you've got there, Sumia. Are you going to read all of them?

Sumia: Oh, hello, [Robin]! Yes, this IS a lot of books, isn't it? Someone threw them out of a wagon, so I figured I'd give them a good home.

[Robin]: What a good idea! I always find it relaxing to do a little light reading in the evening.

Sumia: Oh, you can borrow some if you want! I certainly can't read them all at once.

[Robin]: You don't mind?

Sumia: Of course not! Here, which one looks good?

[Robin]: I'm not sure. What do you recommend?

Sumia: Let's see... Ooh, this one looks like a real page-turner! "Shanty Pete and the Haunted Pirates"!

[Robin]: Er, thank you, but I don't like to read scary stories before bed.

Sumia: Oh, of course. Well, what about... "A Simpleton's Guide to Pegasus Care"?

[Robin]: I'm not really that into animal nonfiction...

Sumia: Well, maybe third time's the charm. Let's see now... Oh, this looks great! "Wyvern Wars: Terror at High Noon"!

[Robin]: ...Do you perhaps have anything a bit more... literary?

Sumia: ...Oh, pegasus poop! I'm USELESS at this! Useless, useless, useless! Just pick her out a book, Sumia! It's so easy, Sumia! But noooooo! I'm too... darn...USELESS! *Sniff* Waaaaaaaaah!

[Robin]: Oh, goodness! Please don't cry! I didn't mean to imply... A-actually, did you say "Wyvern Wars"? I've always wanted to read that one! I mean, it has terror at high noon and everything, right? You, uh, can't beat that...

Sumia: *Sniff* R-really? You want that one? Oh, I'm so happy... I hope you like it!

[Robin]: (Pretty sure I have to at this point...)

■ SUMIA X AVATAR (FEMALE) [ROBIN] B

[Robin]: Here's that book I borrowed, Sumia. It was actually pretty interesting. The encounter at high noon was epic! I stayed up far too late reading it.

Sumia: Oh, I'm so glad you liked it! I'll bump it to the top of my pile.

[Robin]: So, what are you reading now?

Sumia: "Ribald Tales of the Faith War."

[Robin]: I've never heard of it. Is it a novel?

Sumia: Yes. It's roughly based on historical events, but all the characters are made up. And there's lots of... Well, ribald parts. But I suppose that's obvious.

[Robin]: You don't say?

Sumia: Do you like novels, [Robin]? Or are you more of a nonfiction type?

[Robin]: Novels are good. Although I suppose I read a little bit of everything.

Sumia: Oh, I just LOVE a good novel! I get so caught up in them I sometimes forget my own sad little life. I can pretend to be a knight in shining armor! ...Or maybe an evil mage. Bwa ha ha!

[Robin]: I know what you mean. I always feel a bit sad when a good story comes to an end.

Sumia: Oh, I know. Then it's back to reality for Sumia! Back to sad, sad reality... Er, but then I think about the next story and get excited all over again!

[Robin]: So then? What are you planning to read next?

Sumia: "Mad Tales of a Bloodthirsty Falcon Knight"! ...Volume one. Of thirty-seven.

[Robin]: Oh. Well, that certainly sounds...like...a thing...

■ SUMIA X AVATAR (FEMALE) [ROBIN] A

Sumia: Hold, [Robin]! Do you think me insane?!

[Robin]: Well, I didn't...

Sumia: You do! For I see that which others cannot! Demons and devils lurk in shadows dark!

[Robin]: A-are you feeling all right, Sumia? Perhaps I should summon a healer...

Sumia: What? Hee hee! Oh, no, I'm fine! See, I'm reading a new book. I was just pretending to be the heroine. Her name is Madame Shambles, and she sees what others cannot in shadows dark! Anyway, I've been saying her lines to try and get inside her

head and be more like her. ...Do you think that's weird?

[Robin]: Yes, it's actually very weird.

Sumia: Oh, pegasus dung! I was worried it might be. But see, I thought if I could act like her, I'd maybe become less of a clod.

[Robin]: You don't need to pretend to be someone else, Sumia. You're perfect as you are! ...Well, maybe not perfect. But pretty good. Anyway, if you did end up changing, we'd lose the Sumia we know and love.

Sumia: R-really? Gosh, I never figured anyone would give two hoots. But if YOU'D miss me, [Robin]...

[Robin]: Of course I would!

Sumia: Well, all right then! My next book will be about a girl who's clumsy and plain like me!

[Robin]: Er, I think you're missing the point of—

Sumia: Ooo, wait! Look at this one! "The Princess Who Fell Down the Stairs"! It's PERFECT!

[Robin]: Yes... Yes, I suppose it is.

Lon'qu

■ LON'QU X AVATAR (FEMALE) [ROBIN] C

[Robin]: Well, Lon'qu. It looks like we're partners for today's training session. You'll go easy on me, won't you?

Lon'qu: Hmph.

[Robin]: ...Was that a yes or a no? In any case, let's get on with it.

Lon'qu: ...!

[Robin]: Ha! You're as good as they say...

Lon'qu: Thank you.

[Robin]: But not even bothering to draw your sword? It comes off as just a bit condescending.

Lon'qu: Swordplay is a man's pursuit. What does a woman know of— WHA—?

[Robin]: HYAAAAAARGH!

Lon'qu: What in blazes are you doing, woman? Why are you...throwing...figs?!

[Robin]: If you can't get close to a foe, you must engage him at long range. Basic tactics, really! I'm surprised you'd be unfamiliar with them.

Lon'qu: Well, no matter. It's not as if you'll ever hit me with one...

[Robin]: Ooooh, that sounds like a challenge! All right, twinkle toes, dodge this! HIYA! HIYA! HIYA!

Lon'qu: S-stop it! Don't come...any closer! Please...stop tossing...figs!

[Robin]: We have to...HIYA!...get close, to...HIYA!... train properly...HIYA!... Just a bit farther...

Lon'qu: ARGH! I won't stand here to be pelted with fruit by a madwoman! I'm leaving!

[Robin]: Coward! Get back here!

■ LON'QU X AVATAR (FEMALE) [ROBIN] B

[Robin]: Hello, Lon'qu. Hey, where'd you get that nasty bruise on your chin?

Lon'qu:

[Robin]: Ah, right. Fig wound. Sorry about that. ...Gracious, it looks rather swollen.

Lon'qu: I never imagined you'd continue your fruity assault while I slept!

[Robin]: But it was the only way I was ever going to hit you...

Lon'qu: And how reckless of you to be sneaking into my tent at night. What if you'd been seen? Imagine what people would've thought!

[Robin]: Oh, it's all right. I know exactly when and where everyone sleeps. I made sure I wouldn't be spotted.

Lon'qu: I honestly cannot tell sometimes if you are a genius or a complete dimwit.

[Robin]: Well, silly can be cuter than clever, don't you think?

Lon'qu: I...have absolutely no idea what you mean by that.

[Robin]: ...Er, yes. I think I was trying to be clever and disproved my own point...

Lon'qu: (Heh.)

[Robin]: Wait...did you just laugh?!

Lon'qu: No.

[Robin]: Yes you did! I distinctly heard you say "heh."

Lon'qu: Never! You are incapable of provoking so much as a chuckle from me.

[Robin]: Ooooooh, THAT sounds like another challenge...

Lon'qu: Damn.

[Robin]: Right! The game's afoot! I shall make you laugh one more time, no matter what!

Lon'qu: How do I get myself into these things...

■ LON'QU X AVATAR (FEMALE) [ROBIN] A

Lon'qu: Enough, [Robin]!

[Robin]: What? What's wrong?

Lon'qu: You've been mocking both me and your training. Don't deny it.

[Robin]: How so?

Lon'qu: When we spar, you adopt a curious expression and poke me in the ribs.

[Robin]: And haven't you noticed how much more relaxed you've been?

Lon'qu: What are you talking about?

[Robin]: I'm talking about how I stand close, and you don't even break a sweat.

Lon'qu: Gods above... It's true... How could I not notice? What witchcraft is this?!

[Robin]: No magic, I swear. Just two comrades-in-arms who've grown accustomed to fighting side-by-side. I'm sorry if my behavior seemed strange, but I was only trying to help. I saw all about your phobia of women, so I came up with a plan. I thought if I acted strangely enough, you'd be so distracted, you'd forget all about it!

Lon'qu: Heh. You are a con artist of the highest order...

[Robin]: Hey! I made you laugh again!

■ LON'QU X AVATAR (FEMALE) [ROBIN] S

Lon'qu: "Cough* *ahem* Er, [Robin]? May I have a word?

[Robin]: Oh, hello, Lon'qu. Something wrong? It's not like you to initiate a conversation.

Lon'qu: In our recent battle, did you...do something to me? Cast a spell? Slip me a potion?

[Robin]: No, of course not... Why do you ask?

Lon'qu: I see... Then this feeling in my heart is from natural causes.

[Robin]: Er, Lon'qu, are you feeling all right?

Lon'qu: No, it's frightening...but wonderful... You see, [Robin]... It appears that I've grown...quite... fond of you.

[Robin]: ...What?

Lon'qu: It's true. These feelings have grown despite my best efforts...

[Robin]: It seems my plot to make you laugh had some unforeseen consequences.

Lon'qu: I must know—do you share my feelings? Even a little bit?

[Robin]: Well, at first, I couldn't stand you... But then... something happened...

Lon'qu: Yes?

[Robin]: Amazingly, yes. I...I've come to care for you, too, Lon'qu. Deeply.

Lon'qu: Ah. Right then... I am not used to dealing with women. What step should I take next?

[Robin]: Er, you could embrace me, I suppose?

Lon'qu: Very well... Like this?

[Robin]: Amazing... Your phobia of women is completely gone!

Lon'qu: No. It just... it's only gone with you.

[Robin]: Well, that might be the greatest compliment I've ever been paid.

Lon'qu: The next step I do know... Will you accept this?

[Robin]: You bought me a ring? Wait, so you had this planned the whole time?

Lon'qu: Our time, yes. I bought it in town for you a few days back. ...I cannot tell you how hard it was to enter a women's jewelry store.

[Robin]: And yet you did it for my sake!

Lon'qu: Never in my worst nightmares did I envision doing such a thing for a mere woman... But yes, I did it. For you. I hope you like it.

[Robin]: ...A "mere" woman?!

[Confession]

Lon'qu: I-I confess... I do have feelings for...gods, must all these emotions be so vexing?

Ricken

■ RICKEN X AVATAR (FEMALE) [ROBIN] C

Ricken: Hrmmm...

[Robin]: Still writing a reply to that letter? You've been staring at a blank page for an hour. Was it bad news? Nothing serious, I hope.

Ricken: No, just an average letter from my parents. "Hope you're well," and all that.

[Robin]: Then why are you so strapped for a reply?

Ricken: It's...tricky. I just don't know what to say.

[Robin]: There's plenty of things you could write about! Especially after that last battle. Tell them about how you dodged one brush with death after the next! Impress them!

Ricken: Are you insane?! The object is to make them worry about me LESS!

[Robin]: Oh. Right. Well, why not tell them about that fight against the Risen? Talk about how you tore their limb from limb and flung the pieces to the winds!

Ricken: But I did no such thing! Besides, that would have them worried about me in a whole other way... See the problem? I can't LIE, but if I write about how things really are, they'll worry. And if I write about how much I miss them, that only makes it worse...

[Robin]: How about just a few words to let them know you're all right?

Ricken: ...I don't know. Maybe I'll just hold off until I do something that makes them proud.

[Robin]: Well, if they could've heard you just now, they already would be.

■ RICKEN X AVATAR (FEMALE) [ROBIN] B

Ricken: Hmm...

[Robin]: Still haven't written a reply to your parents, have you?

Ricken: Yep. Stuck again. I can't think of the right words to say.

[Robin]: You could always just head back.

Ricken: Head back where? Home?

[Robin]: Why not? Stop by for a quick visit. Spend some time with your family. I'm not saying to drop everything and go tomorrow, but once things settle down.

Ricken: ...No. I can't go back yet.

[Robin]: Why not?

Ricken: I don't know how much you know about me, but I come from an old, respected house. And lately, my family home—and name—has fallen into serious disrepair. So this war is about more than saving the world, at least for me. It's about restoring my family name. And I can't go home until I've done it.

[Robin]: That's a lot to put on yourself, Ricken. Your parents are lucky to have you. Hard to imagine not a model son running around dismembering Risen and flinging—

Ricken: Stop with the dismembering already! What kind of monster do you think I am?!

[Robin]: Ha ha, I'm just teasing. Seriously, though, if you won't visit, you should write. Sparing your parents from worry is part of being a good son, after all.

Ricken: Yeah, I know you're right... Okay, I'll keep it basic. "Dear Mom and Dad, I hope you're well."

[Robin]: "Today I saved the life of my beloved, and the field red with the blood of my foes!"

Ricken: "Today I saved the..." ARRRGH! Will you NOT do that?!

[Robin]: I'm helping.

Ricken: YOU ARE NOT!

■ RICKEN X AVATAR (FEMALE) [ROBIN] A

Ricken: Hey, [Robin]. Would you mind sending this out with the other deliveries?

[Robin]: Letter to the family, eh? So did you finally figure out what to write?

Ricken: I just wrote the truth: that I miss them and hope to see them again soon.

[Robin]: No tales of glory? No brave words? ...No dismemberment?

Ricken: Hah! Not this time. I guess restoring the family name will have to wait a bit longer. I simply wrote that I've come a long way, but there's still more to be done. Not the greatest news in the world, but better than silence, I guess.

[Robin]: But it IS great news! I'm sure it'll put their minds at ease.

Ricken: By telling them how weak I still am?

[Robin]: No, by telling them you know your limits and you're working to overcome them. That's a very mature way of thinking. You should be proud.

Ricken: Heh heh! You really think so?

[Robin]: I guarantee it! You did great, Ricken. Now get over here!

Ricken: EWWW! Leggo! No noogies! Stop treating me like a kid! Didn't you JUST finish saying how mature I was?!

[Robin]: Ha ha! Sorry, it's just that hat and those cute wittle cheeks just begging to be pinc—

Ricken: Come on, knock it off!

■ RICKEN X AVATAR (FEMALE) [ROBIN] S

Ricken: Hey, [Robin]. Thanks again for your help with that letter home. I kinda got you something by way of thanks, so...here.

[Robin]: Aw, how sweet! A letter for me! Whoa, this is one heavy envelope... What'd you put in here?

Ricken: Open it and you'll see.

[Robin]: Rrrrr... Graaagh... Gods above, how much glue did you use here? Got it! ...Oh, look at that shiny stone. Ricken, it's beautiful.

Ricken: It's a precious stone found only on the slopes of the Ghoul's Teeth.

[Robin]: Gods, Ricken! You went to that fearsome place all alone? Its crags are filled with bandits and wild beasts of every stripe! Were you hurt? Don't lie to me now!

Ricken: Would you PLEASE stop treating me like a child?!

[Robin]: ...Oh...right. I'm sorry.

Ricken: I'm not a boy, [Robin]. I'm a grown man. And I need you to believe me when I say that.

[Robin]: But why, Ricken? Why is it so important what I think?

Ricken: Because...I'm in love with you. I don't want to be your kid or your little brother—I want to be your husband. So if I put that stone on a ring and offered it to you, would you accept?

[Robin]: ...Oh, Ricken. I know you're not a child anymore... I know because I've watched you grow into a remarkable young man. Just as I've watched you grow in my heart... So, yes, Ricken. Yes. Nothing would make me happier than to become your wife.

Ricken: R-really! Do you mean it?!

[Robin]: But no more taking ridiculous risks! I'll not have my husband cracking his head open just to prove a point. You hear me, young man?

Ricken: Of course, I...HEY!

[Confession]

Ricken: I wish I could throw my arms around you and never let go! ...Just...wait for me to get a little taller. Okay?

Maribelle

■ MARIBELLE X AVATAR (FEMALE) [ROBIN] C

[Robin]: Crepuscule... Crepuscule... What did that mean again?

Maribelle: Are you studying, [Robin]?

[Robin]: Oh, hello, Maribelle. Just reading up a bit.

Maribelle: Reading up, how lovely. I hadn't realized the lowborn read at all!

[Robin]: Did you just drop by to look down your nose at me, or was there something else?

Maribelle: A noble's nose engages in no such activities! I was sincerely impressed. If my turn of phrase offended, I apologize. Forgive me?

[Robin]: Er, all right. I take it back. But was there something you needed?

Maribelle: Yes. I had hoped to learn more about you.

[Robin]: Me? Why me? I'm not that interesting, you know.

Maribelle: Can you fault me for being curious about an amnesiac with a genius for strategy? You've also earned quite a bit of trust from our dear friend Lissa. It's only natural that I'd want to learn more about the stranger in our midst. I thought you might simply say that I hoped we could become...friends. Unless you object, of course.

[Robin]: No, I don't object, per se. But...weren't we already friends?

Maribelle: Oh, I'm pleased to hear you say that, [Robin]!

[Robin]: Heh! You really can be sweet sometimes, Maribelle. Well then, ask away. If I know the answer, I'm happy to tell it.

Maribelle: Oh, lovely! That's very kind. Well, then... Tell me about the quaint customs of the unwashed masses from whence you come? I'm especially interested in this "slang" of which you brutes seem so fond.

[Robin]: ...I take back what I said, and then I take back the take-back before that.

■ MARIBELLE X AVATAR (FEMALE) [ROBIN] B

Maribelle: A question about the material we covered yesterday, [Robin].

[Robin]: Ah, you mean about my lessons on the language of the great unwashed?

Maribelle: Precisely, yes. I immediately set about to practice what you'd taught me, but... Well, perhaps I spoke to looked askance, or avoided eye contact altogether. Others still contorted with glee, as if they were stifling laughter.

[Robin]: Wait, you used that slang? Out loud? In public?

Maribelle: If you hope to communicate with a person, you must first speak their language, no? And the quickest way to internalize new knowledge is to put it into practice!

[Robin]: Yeeees, both of those are technically true. But, Maribelle, when we talked, I... Look. The examples I taught you are reserved for intimate friends.

Maribelle: What?! You knew this and didn't tell me? Did you hope to ruin me?! Wait... So when I told Chrom he was "a right sweet bit'a fruit"...? You mean to tell me that was inappropriate?

[Robin]: I'm sorry! It was all in good fun! I never thought you'd actually—

Maribelle: One moment. If you taught me this slang, then you must consider us intimate friends?

[Robin]: Uh...

Maribelle: I'm afraid I had no idea! I'm flattered, [Robin], truly. In that case, I ought have begun my practice with you. Forgive me.

[Robin]: No, that's... I don't...

Maribelle: Awright then, pet? Everythin' luvverly jubberly, ain't it? 'Ave a bit a rabbit?

[Robin]: MARIBELLE! Stop! Please! I can literally hear everything you stand for screaming and dying in agony! Look, I'll clear things up with everyone. Okay? I'll take the blame. Just please, please, PLEASE promise you'll never talk like that again.

Maribelle: Well, I suppose if it's that important to you...

[Robin]: Thank you.

Maribelle: Hey, no skin off my arse, is it? I'll shut me north and south!

[Robin]: ...Wait a minute. I didn't teach you that. Damnation! Who has done this to you, Maribelle? Who?!

Maribelle: Hm-hm! I'm afraid THAT is my little secret...

■ MARIBELLE X AVATAR (FEMALE) [ROBIN] A

[Robin]: Er, Maribelle? I have an idea... Why don't we skip the slang lesson today? Instead, maybe you could teach me about the aristocratic life?

Maribelle: Any chance to educate my social inferiors is a chance I will take. Now then! What would you like to know?

[Robin]: Well, you hear people talk about a noble bearing, yes? What is that, exactly?

Maribelle: Well, I suppose it begins with learning to stand properly.

[Robin]: Am I not really standing now? Because it feels like I'm standing.

Maribelle: You have the posture of a damp noodle! The resolute promise of a soufflé. A noble stands... thusly. The spine forms a straight line. Pretend an invisible thread pulls your head ever skyward. ...Go on, give it a try.

[Robin]: Let's see. Straight spine... Invisible thread... Like this?

Maribelle: Why are you jutting your chin out?

[Robin]: It happens naturally when I force my head up.

Maribelle: A pauper's instinct! Cast it away!

[Robin]: Is this better?

Maribelle: Your shoulders are raised. Lower them and hold your chest high.

[Robin]: So like...this?

Maribelle: Yes! Just so! There, now. That wasn't so hard, was it? I say, you're quite the apt pupil, [Robin]. With enough practice, you could become a lady fit for the highest court! Well, I may exaggerate. Perhaps one of the more middling courts.

[Robin]: You think? Wow, I never—

Maribelle: Then it's settled! I shall make it my personal mission to shape you into a lady of high society. I'll instruct you until you're fit to consort with kings! ...Or at least a baron.

[Robin]: Er, you really don't have to—

Maribelle: Bup-bup-bup! Nothing is less noble than leaving a task half done! You needn't be shy. We're intimate friends, after all.

[Robin]: Wait... This is revenge for the slang incident, isn't it?

Maribelle: Less talking, more walking! ...ARISTOCRATIC walking, please! Then we will work on ballroom dance and how to properly wield a fork!

[Robin]: Heeeeelp meeeeeee!

Panne

■ PANNE X AVATAR (FEMALE) [ROBIN] C

[Robin]: Er, Panne?

Panne: What?

[Robin]: Would you tell me more about the taguel? I barely know a thing about them, and I thought... I mean, if you don't mind...

Panne: I do not.

[Robin]: ...Wait, really?

Panne: No, I do not mind. Why do you doubt me?

[Robin]: I don't know, I guess I just didn't imagine you saying yes so easily. I was all ready to argue my case. You kind of took the wind out of my sails.

Panne: Does it frighten you so, man-spawn? Or the fact I am taguel?

[Robin]: N-no, neither! Nothing like that. It's just... I thought you might not take kindly to me asking about your people. I know it was humans like me who killed them, after all.

Panne: Humans like you, yes. But not you. You do not bear the blame for what was done, so do not bear the guilt. Guilt creates distance. If you would learn of my people, cast it aside.

[Robin]: All right.

Panne: Mmm. At last you are calm. Your heart has slowed.

[Robin]: You can hear my heartbeat?

Panne: Lesson one—taguel have strong ears. A heart's beat always betrays its owner.

[Robin]: Heh. Remind me never to play cards against you... Oh, I have a meeting, but I would love to know more... Can we talk again soon?

Panne: Of course. It is nice to find someone who is curious about my people.

■ PANNE X AVATAR (FEMALE) [ROBIN] B

[Robin]: So, do all shape-shifters turn into rabbits, Panne?

Panne: No. There were others, far from here. Tribes of cat-wearers and bird-wearers.

[Robin]: Whoa, I would have loved to see that... I bet they were so cuddly and cute! Er...sorry. I probably shouldn't call a race of proud warriors "cute."

Panne: They were not cute. At least, not like the rabbit-wearers are cute. But then, what is? Nothing.

[Robin]: Heh heh, r-right. So, did you ever meet these other tribes yourself?

Panne: Long ago. How they fare now, I do not know. Perhaps they shared the same bloody fate as my own people...

[Robin]: I... I didn't mean to...

Panne: I am sorry. There is no call for you to share in my gloom, as well.

[Robin]: Oh... Um, well, what do you like to eat?

Panne: Taguel eat many things.

[Robin]: No, I mean, specifically. I'm on kitchen duty tonight—I'll cook whatever you want. It was my being nosey that made you sad, right? Let me cheer you back up!

Panne: You are...oddly kind.

[Robin]: So, let me guess... Carrot stew?

Panne: ...How did you know?

[Robin]: Ha ha, sorry! I know, just because you're a rabbit doesn't mean you... Wait, I was right?

■ PANNE X AVATAR (FEMALE) [ROBIN] A

Panne: *Sniff* Ah! Is that your famous carrot stew I smell? I hope you don't mind if I sneak a taste before dinner?

[Robin]: No, Panne, wait! That's not for—

Panne: Sluuuurp!

[Robin]: ...Oh dear. I'm SO sorry, Panne, but I messed up the recipe on that batch. Everybody said it tasted... off. Well, actually they said it tasted like last month's dishwater, but...

Panne: It seems perfectly fine to me.

[Robin]: ...You've got to be joking.

Panne: Taguel never joke about food. Nothing seems off here. It tastes exactly the same as every other time you have made it.

[Robin]: It does?! You mean, ALL the stews tasted like this to you? And that means...the Taguel taste buds must not work like ours. ...Or at all.

Panne: Would you mind if I had a bowl?

[Robin]: Hey, take the whole pot if you want! No one else will touch the stuff.

Panne: Many thanks. You really are too kind, [Robin].

[Robin]: Soup-er happy to hear you say that, Panne!

Gaius

■ GAIUS X AVATAR (FEMALE) [ROBIN] C

[Robin]: Gaius, I am SO sorry about earlier! I had no idea you were in the bath...

Gaius: Aw, no worries. At least, I hadn't taken off my smallclothes yet, eh? Er, but I did want to mention I'm usually in much better shape. You know, with the stress of this blasted war, I've been eatin' more sweets than usual. Usually I'm a real piece of eye candy. Belly like a washboard, glutes like a lumberja—

[Robin]: Okay, then! That's quite enough. I believe you... Er, but I did notice something else, and...it has me a little worried...

Gaius: WHAT?! You saw THAT?! Gods, how embarrassing... It's just...uh...some poison oak I got into the other day, I swe—

[Robin]: I'm talking about the tattoo on your arm. That's the one they use to mark convicted criminals, isn't it?

Gaius: Oh, that? Yeah, I got caught once doing a favor for a mate. Paid the price. But, uh, I'd appreciate it if you kept that little nugget under your hat, Bubbles.

[Robin]: ...Did you just call me Bubbles? Er, but don't worry. I won't tell any—

Gaius: You'll tell everyone, you say? So it's to be blackmail, is it? Fine then. I can understand taking an opportunity to line your pockets. You can have my portion of dinner tonight, okay? Will that slake your greed for now?!

[Robin]: Er, one helping of bear is already more than enough, thanks. Also, I'm not blackma—

Gaius: You drive a hard bargain, Bubbles! Very well. Take this custard pie!

[Robin]: ...No, thank you. I'm not—

Gaius: If you are looking for ransom, I can assure you I don't have any money. But what I do have are a very particular set of honey cakes...

[Robin]: Look, I don't want any treats from you, all right?! I'll keep your blasted secret!

Gaius: Whoa, easy there, Bubbles! Here, maybe a little chocolate will put you in a better mood...

■ GAIUS X AVATAR (FEMALE) [ROBIN] B

[Robin]: Gaius? I didn't know you ran a market stall...

Gaius: Oh, sure. I like to get out, meet the common folk, sell the odd trinket... Speaking of which, see anything you fancy? I've got silk smallclothes from exotic ports, genuine leather belts, top-quality figs...

[Robin]: Do you have any books? Strategy books, specifically. I'm hoping to expand my tactical knowledge to better serve the Shepherds. However, I can't find a single volume in these parts. It really is most strange...

Gaius: Strategy books, is it? Wait right there, Bubbles.

[Robin]: Huh? Where'd he go? ...Oh, you're back! That was fast.

Gaius: Take a gander at this lot, and tell me if any of 'em tickle your fancy!

[Robin]: By the lily... Gaius, this crate is FULL of books! Did you buy every tome in the market?!

Gaius: Sort of. Here's the yours. Every last one, my gift to you! But that makes you even more about the whole "wink-wink" thing!

[Robin]: Gods, but you are pigheaded. For the last time, Gaius, I am NOT blackmailing you! Now please, return these books. I can't take them in good conscience.

[Robin]: Oh...

■ GAIUS X AVATAR (FEMALE) [ROBIN] A

Gaius: Here, Bubbles. I got you something.

[Robin]: A pendant? ...Is this because of the one I saw in town that I liked? Er, thank you, Gaius, but I'm not sure I feel—

Gaius: Heck of a thing, too! Probably worth a big sack of gold down at the market.

[Robin]: Then I must refuse. I can't accept such an extravagant gift.

Gaius: All right, maybe I stretched the truth, just a little... It'd be worth a sack of gold IF they paid for sentimental value, see? ...'Cause I made it myself.

[Robin]: YOU made this? But, it's magnificent!

Gaius: Pleased you like it, Bubbles. Makes all the effort worthwhile.

[Robin]: But why did you—

Gaius: Oh, no particular reason! None at all! Just...one good turn and all that.

[Robin]: You're trying to bribe me again, aren't you?! I've already told you a hundred times, I'll keep your secret! I gave you my word, and that should be the end of it!

Gaius: Look, I trust you. Honest and truly. It's just that in my business, there's no such thing as a free lunch. Gal who says she's wanting payback down the line! Well, she's the first one wanting payback down the line!

[Robin]: ...Oh, very well. I was hoping it wouldn't come to this. I have something important to tell you.

Gaius: Important?

[Robin]: It's a secret. A very embarrassing one. You see... *whisper, whisper*

Gaius: BWAAA HA HA HA! And the chicken...?! Oh, you did NOT do that!

[Robin]: Ah, but I did. And now you are the only one who knows. So in return for you keeping it safe, I promise to safeguard YOUR secret. Do we have a deal?

Gaius: ...Heh, I see what you did there. And...I appreciate it. All right. Deal. ...But you have to keep the pendant! It's not a bribe, now. More like a... I don't know... A thank-you gift.

[Robin]: In that case, I accept.

■ GAIUS X AVATAR (FEMALE) [ROBIN] S

[Robin]: Gaius? When are you going to tell me what this is all about?

Gaius: Just come here, Bubbles. I've got something I want to show you.

[Robin]: What is it? Did you make another pendant?

Gaius: Nope. I made one better. ...Here.

[Robin]: Oh my goodness, Gaius! What a beautiful ring.

Gaius: Really? Phew! Glad I didn't screw it up. See, 'cause I was kind of hopin' you'd...wear it.

[Robin]: I...don't understand...

Gaius: Well, it's an engagement ring, see? And I'm offering it to you.

[Robin]: ...Oh gods. You're serious, aren't you?

Gaius: Never been more serious in my life! [Robin], you're the sweetest gal I've ever met. And I love you. So? Will you marry me, Bubbles?

[Robin]: Ha ha, well it's unlike you to ask a favor without offering something in return...

Gaius: Aw, come on, don't leave me hangin'! I'm seriously dyin' here!

[Robin]: So what do I get, then? A lifetime together with you? Always and forever?

Gaius: I...guess?

[Robin]: Is that asking too much?

Gaius: No way! That's a piece of cake! Right then, it's a deal. I promise to make you happy for the rest of your life.

[Robin]: Then my decision is a piece of cake, too. I've been smitten with you for ages, Gaius. Of course I'd be honored to be your wife.

Gaius: Aw, thanks, [Robin]! You've brought joy to this old brigand's heart! Now come here and give me some sugar, Bubbles.

[Robin]: Er, but, Gaius? One other condition: you have to stop calling me Bubbles.

[Confession]

Gaius: Baby, you're a river of chocolate in an ocean of cream. I'm gonna steal your heart on a daily basis.

Cordelia

■ CORDELIA X AVATAR (FEMALE) [ROBIN] C

[Robin]: Ow! I used the last of the salve yesterday, but this cut still stings... What to do, what to do...

Cordelia: You're not out of salve. I restocked your medical supplies this morning.

[Robin]: You did? Ah, that's great. Thank you, Cordelia. You never miss a detail, do you?

Cordelia: I just like to stay on top of things. By taking stock of everyone's equipment, I know when anything needs replacing.

[Robin]: Wait, you keep track of EVERYONE's equipment?! ...All in your head?

Cordelia: Of course. Imagine the chaos if our potions and equipment ran out at the same time.

[Robin]: ...Gods. I can certainly see why everyone calls you a genius.

Cordelia: Do not call me that!

[Robin]: Oh, I'm sorry... I meant no offense.

Cordelia: ...No, of course not. Please forgive me. It's just that...my superiors called me that from the moment I joined the knights. It was so very hard to bear. ...Little Lady Genius, they called me. They teased and taunted me...

[Robin]: Oh...

■ CORDELIA X AVATAR (FEMALE) [ROBIN] B

Cordelia: [Robin]! Look, I crafted a new javelin based on your feedback.

[Robin]: You MADE one?

Cordelia: Er, yes?

[Robin]: As in, you forged it yourself? You didn't assemble it...from a kit, or something?

Cordelia: No... I cut a sapling, fashioned a grip, and hammered the point in the forge. I suppose I could have waited around for the javelin fairy, but she's so unpredictable. Here, look. See the pattern on the shaft? It's my own design. ...Well? What do you think?

[Robin]: I think that I wasn't expecting you to go and fashion a whole javelin from scratch! You really ARE a genius!

Cordelia: I beg your pardon?

[Robin]: Oh, I... Sorry, I know you're sensitive about that word. I take it back. Anyway, I'm glad I was able to help. If there's anything else I can do...

Cordelia: Heh, [Robin], you are far too kind! Why, if I... N-no, wait. We can't be doing this. People will get the wrong idea!

[Robin]: Doing what? What wrong idea?

Cordelia: If you're so kind to me all the time, people will start to think...we're friends.

[Robin]: ...Oh. I thought you were going to say something else... Er, but why would that be so bad? We are friends...aren't we?

Cordelia: D-do you think so?! Truly?

[Robin]: Of course. Why not?

Cordelia: Oh, I'm sorry. I guess... I guess I grew accustomed to not having any. I was the youngest recruit in the pegasus knights, and my comrades were veterans. There was no one whom I could truly call my "friend."

[Robin]: That's...so very sad.

Cordelia: Oh, well as I said, I grew accustomed to it. Besides, I did have my pegasus to talk to. Even if the chats were a bit one sided...

[Robin]: Heh, I guess they would be...

■ CORDELIA X AVATAR (FEMALE) [ROBIN] A

Cordelia: [Robin]! Guess what? I showed my new javelin to everyone in camp. They were all so complimentary! Thank you again for the help.

[Robin]: Don't thank me! You're the one who went out and learned smithery. I'm just glad it all worked out. If only those pegasus knights could see you now!

Cordelia: Heh, perhaps they are looking on from the afterlife.

[Robin]: Er, the afterlife?

Cordelia: Yes, if you believe in such things. ...You do know the story, don't you? How my fellow knights gave their lives so I could escape and warn your party?

[Robin]: Gracious, no! I mean, I have heard some of them... I just... I didn't think those were the same knights who... I'm sorry. I didn't fully understand until this moment.

Cordelia: That's all right. I suppose how I put things is partly to blame.

[Robin]: So despite all the teasing, they loved you enough in the end to die for you?

Cordelia: I was surprised, too! It turns out they'd pretty much decided I was the future. The insults and so forth were just the usual hazing of a new recruit. *Sniff* My only regret is... I wish we'd had more time to get to know each other. I only learned...how much they loved me...in those last, awful moments...

[Robin]: Cordelia...

Cordelia: *Sniff* R-right, then. Enough self-pity. I don't want to try your patience. ...But I must say, it does feel good to get this off my chest.

[Robin]: I understand now why you don't like to be called a genius.

Cordelia: You do?

[Robin]: Remember how upset you got the first time I called you that? I thought it reminded you of a sarcastic insult, but in fact it was the opposite. When your comrades sacrificed themselves for you, you realized that they meant it.

Cordelia: You're rather clever yourself, working all that out on your own.

[Robin]: Not clever, no. Just blessed with the kind of insight close friends share. Because I AM a close friend now, and I'll always be here for you.

Cordelia: *Sniff* Oh, [Robin]. ...Th-thank you.

Gregor

■ GREGOR X AVATAR (FEMALE) [ROBIN] C

Gregor: Here, [Robin]. You will drink this, yes?

[Robin]: Hmm? What is it?

Gregor: Is special medicine Gregor drinks on hard journey! Tastes like bottom of old well, but is very good for you.

[Robin]: I don't need medicine, Gregor. I feel fine.

Gregor: You have no hurting throat? No hacking up of lung?

[Robin]: Well, now that you mention it, my throat does feel a little sore...

Gregor: In battle, Gregor hear you breathe. Is raspy like old dying donkey.

[Robin]: You must have a terrific sense of hearing to notice that over the din of combat.

Gregor: For sellsword like Gregor, health very important. Soldier must be strong, yes?

[Robin]: I daresay you're right. I don't pay as much attention to my health as I should. What kind of precautions do you take to avoid becoming ill?

Gregor: Gregor have three rules: gargle, wash hands, and take temperature!

[Robin]: Oh. That sounds easy enough. Any other tricks?

Gregor: Gregor may have one more thing, but is very secret!

[Robin]: Ah. Well, I wouldn't want you to reveal anything you're—

Gregor: You sleep in same bed as Gregor! Then we share body heat!

[Robin]: —not comfortable with... I beg your pardon?

Gregor: Body becomes very cold at night, yes? This keeps muscles limber!

[Robin]: An extra blanket will do just fine, thank you.

■ GREGOR X AVATAR (FEMALE) [ROBIN] B

[Robin]: Say, Gregor? I wanted to thank you for that medicine you gave me. I was feeling better after taking it...but I think it gave me strange dreams.

Gregor: Er...

[Robin]: Is Gregor maybe in these dreams?

Gregor: Er...

[Robin]: Ho ho ho! Is true! You dream of sharing bed with Gregor!

[Robin]: We weren't in a bed! We were flying through the air... Then we landed...on the sun, I think. And I rested my head on your knee. Gods, it was horrible.

Gregor: Do not be feeling special. Gregor have that effect on many people.

[Robin]: Since then, I haven't slept in days! Days! Look at my eyes! They're bloodshot!

Gregor: Some of greatest romances in history start with dreams like this.

[Robin]: It's not funny! It is most definitely not funny! I have ch-chills up my back even as we speak...

Gregor: Chills? Hmm... Here, [Robin]. Let Gregor look in eyes.

[Robin]: No! Stay away from me!

Gregor: You are strange person. Now make with the hushing!

[Robin]:

Gregor: Bloodshot eyes... Chills on spine... Strange dream... You had insect bite not long ago, yes?

[Robin]: Er, yes, actually. A great big millipede bit me on the ankle the other day, but...

Gregor: Oy, is so terrible! You suffer dangerous infection carried by large bug! We must render treatment with no delay. Gregor fear your life is at stake.

[Robin]: R-really? It's that serious?

■ GREGOR X AVATAR (FEMALE) [ROBIN] A

Gregor: Ah, [Robin]. How is recovery?

[Robin]: Good, thanks to you. The healers said if you hadn't caught the infection when you did, I'd have died. I owe you my life, Gregor.

Gregor: Oh ho ho! Sometimes batty old man knows thing or two, yes? You are clever young lass, but old man like Gregor can be teaching you many things. You listen to elders, and one day you might be smart like Gregor.

[Robin]: Heh, yes, I'll certainly pay closer attention from now on.

Gregor: That is water running under bridge. But...

[Robin]: What? Is something troubling you?

Gregor: You still have nightmare dream? Where you fly and put head on Gregor's knee?

[Robin]: Not anymore, thank the gods.

Gregor: Is good. ...Because Gregor has to charge performance fee for appearing in dream.

[Robin]: A performance fee? For a dream?! That's ridiculous!

Gregor: But if you say no more dream, then is okay. We call first one rehearsal. Gregor give steep discount. Now, you look after health so you see no more bad dreams, yes? If you get weak again, you can rest head on knee, no charge.

[Robin]: I assure you, I will be watching my health very carefully.

Gregor: You sound very with the motivation! Gregor believes you!

■ GREGOR X AVATAR (FEMALE) [ROBIN] S

Gregor: Oy, what is with long face like horsey? You have nightmare of Gregor again?

[Robin]: Actually, I haven't dreamed about you for a while, unfortunately.

Gregor: Well, is good news, yes? Why no making with the skipping of joy? ...Wait! You say "unfortunately." You miss dream starring old Gregor?

[Robin]: Oh gods, did I say that out loud?!

Gregor: Uh-oh. Now you red like ripe tomato! So you DO miss nighttime Gregor visit!

[Robin]: Well...yes, as a matter of fact. You haunt my dreams when I don't want it, but when I start to actually LIKE you? Poof! You disappear completely!

Gregor: Is true. Gregor is rude dream stalker. In penance, Gregor offer small trinket.

[Robin]: Trinket? But a ring? Gregor, this is...

Gregor: Is magic ring that allow Gregor to stay in dreams as long as you want. Only big condition— when you accept, spell can never be broken. What you say? Are you prepared for life with Handsome Gregor?

[Robin]: This... Is this a marriage proposal? Are you serious?

Gregor: No need ask question when you are knowing of answer. Handsome Gregor never joke about affairs of heart!

[Robin]: Gregor, I know this is hard for you, but I need you to speak as clearly as possible. Are you proposing?

Gregor: If you no need ring, is fine... Just throw in junk pile along with Gregor's broken heart!

[Robin]: N-no! I do want it! I gladly accept! With all my heart!

Gregor: Then Gregor be with you in dream and in real life, every day!

[Confession]

Gregor: Now you listen, Gregor promise to bring his beloved many happiness for as long as we both keep on with the living.

Nowi

■ NOWI X AVATAR (FEMALE) [ROBIN] C

Nowi: HIYAAA!

[Robin]: Yeowch!

Nowi: Argh! Sorry, [Robin]! Are you all right?

[Robin]: You mean, apart from this lump on my head? What is this you threw at me?

Nowi: That shiny rock that happens to be my most treasured possession. It took AGES to find.

[Robin]: If it's so precious, why are you tossing it around?

Nowi: I was trying to hit that big snake! Did you see it? It slithered away real fast.

[Robin]: ...So you're hunting game? With a rock?

Nowi: Exactly! I almost got him, too. ...Oh, look! There it is again! See?

[Robin]: Here, let me try.

Nowi: You! You think you can hit it?

[Robin]: Casting magic or hurling stones, it's all about focus and control. And you have to lead your target... Like...THIS!

Nowi: Oh, WOWZERS! Nailed it right in the head! That was great!

[Robin]: Well, I have my moments.

Nowi: How did you do it?! You've got to show me!

[Robin]: All right. First of all, you want to grip the stone like this...

Nowi: Okay...

■ NOWI X AVATAR (FEMALE) [ROBIN] B

Nowi: Hey, [Robin]! Look what I got!

[Robin]: My, that's a big snake! Did you catch it yourself?

Nowi: Yep! But only because of your rock-throwing lessons. So, and to thank you for all the help, I want you to have this...

[Robin]: But...this is your shiny rock. Your most treasured possession?

Nowi: Oh, I'm not THAT fond of it. Besides, I'll just find another one.

[Robin]: Well, that's...very generous of you. Thank you, Nowi.

Nowi: Say, [Robin]. You're a good teacher. Is there anything else you can show me?

[Robin]: Well, how about trying your hand at field cooking? You know, campfire cuisine? Frederick has just started teaching me the basics, so I'm not very good yet, but...

Nowi: That's perfect! We'll practice together and be gourmet chefs before you know it!

[Robin]: With that kind of enthusiasm, we just might, heh heh...

[Robin]: ...Well, it looks...edible? At least?

Nowi: At LEAST? I think it smells totally scrumptious!

[Robin]: The proof is in the flavor. Which, I don't know... Looks like it could fall anywhere between mud and toenails...

Nowi: [Robin], what ARE you mumbling about? Let's hurry up and eat already!

[Robin]: Er, right. H-here goes nothing. *Munch, munch*

Nowi: *Chomp, chomp* Hee hee! See? It's DELICIOUS! It came out just right!

[Robin]: It did, didn't it? Thank goodness Frederick is such a good teacher.

Nowi: No, YOU'RE a good student! I wish I could remember things as well as you. I've lived a thousand years, and what can I do? Nothing, that's what.

[Robin]: Don't say that. You've got time to learn all kinds of things. And of course I'll help, if you like.

Nowi: Aw, thanks, [Robin].

■ NOWI X AVATAR (FEMALE) [ROBIN] A

[Robin]: So you split the blade of grass, cup it in your hands like so, and blow... Ffffffvvvvvvvvvv-WWEEEEEEE!

Nowi: Wow! It's just like a flute!

[Robin]: Here, why don't you try?

Nowi: Er, okay. Here I go... Pfffffth... Thffffptht... Ah, that didn't sound like anything! Maybe I'm not puffing hard enough? If I turned into a dragon, I could blow—

[Robin]: Er, probably not a good idea. We don't want to start a wildfire.

Nowi: *Sigh* Yeah, I guess not.

[Robin]: Look, I'll help you practice until you've got it. Sound good?

Nowi: I guess. Though I still think if I just transformed...

[Robin]: Let's just try it my way, okay?

Nowi: Hey look, [Robin]! There's another giant snake!

[Robin]: So there is. And it's quite a bit bigger than the last one you caught... ...Er, Nowi? What are you doing?

Nowi: I'm gonna show you how well I've learned to throw! Ready? Here goes! HIYAAA!

[Robin]: Well done, Nowi! You hit him right between the eyes! That must be the biggest snake I've ever seen taken down by a single rock.

Nowi: Pretty impressive, huh?

[Robin]: The Shepherds will eat well tonight! ...If we can haul that thing back to camp.

Nowi: I can do it! Even a snake that size is no problem for a mighty dragon. Now I just have to transform and... Oh, no! Where's my dragonstone?!

[Robin]: Er, you didn't just use it to knock out that snake, did you?

Nowi: Oh, gosh. I think I did! *Sniff* Wh-what am I going to do?! I can't ever turn into a dragon again, and no one will get to eat snaaaaaake! WAAAAAAAAAH!

[Robin]: Easy, Nowi, easy. It's all right. We just have to search a little. I promise I won't leave until we've found it. All right?

Nowi: Gosh, you'd do that for me? [Robin], you're the best!

LIBRA X AVATAR (FEMALE) [ROBIN] C

Libra:

[Robin]: Oh, hello, Libra. What are you up to?

Libra: I'm drawing a picture.

[Robin]: Gracious, that's very good! Great shading, exquisite detail, and through it all, an air of melancholy... It's very like you.

Libra: Melancholy? Truly?

[Robin]: I don't mean that in a bad way! Actually, you should probably just ignore me... I know very little when it comes to fine art.

Libra: Well, to be honest, I don't know much about it either.

[Robin]: Really? But you're so talented!

Libra: I've been told my pictures are technically proficient, but lack artistic soul.

[Robin]: Poppycock! I mean look at this sketch—it's BURSTING with soul! I bet whoever told you that was simply jealous of your talent.

Libra: Well, I appreciate the sentiment. Here, you can have this if you like it so much.

[Robin]: Are you sure? You didn't draw it on commission or anything?

Libra: I don't ever do drawings on request. ...No exceptions.

[Robin]: Well, if it's not meant for anyone else, then yes, I'll gladly accept. Thank you.

LIBRA X AVATAR (FEMALE) [ROBIN] B

[Robin]: Tsk! I just can't get this color right.

Libra: Er, [Robin]? You have paint on your cheek. ...And your chin. ...AND behind your ear.

[Robin]: Oh, er, so I do. Whoops!

Libra: Are you trying your hand at painting?

[Robin]: Yes! Seeing your drawing has inspired me to take up the palette myself... But, I fear I'm wasting my time. Just look at this muddy slop! Clearly when the gods distributed artistic talent, I was in the outhouse.

Libra: The gods would have waited for you, I'm sure. But let's take a look... Oh...dear. Er, it's a portrait of Lissa, isn't it? You picked an odd color for her face... And the left eye is rather...oblong. Still, a fine first effort! We can't expect to be perfect straightaway.

[Robin]: ...It's a pegasus. And it's NOT my first try. It's my 100th.

Libra: Oh. ...Oh, dear.

[Robin]: You don't have to say anything, I can see it in your face. I should just give up.

Libra: N-no, I wouldn't go that far!

[Robin]: I would. Still, this little experiment helps me realize just how talented YOU are. I gaze on that picture you gave me every day, you know?

Libra: Not EVERY day, surely?

[Robin]: Each night before I sleep! It fills me with a wonderful sense of peace. I'm always worried it'll get damaged when we march, so I pack it very carefully.

Libra: You're the first person who's ever valued one of my works so highly. And though pride be a sin, I'm... pleased that you treasure it so.

LIBRA X AVATAR (FEMALE) [ROBIN] A

[Robin]: *Sigh*

Libra: What's wrong, [Robin]? You seem most upset.

[Robin]: I am, Libra. I am... That wonderful drawing you gave me was torn to shreds. It's ruined completely.

Libra: During the last battle, I assume? When we were suddenly forced to break camp?

[Robin]: Yes, exactly. I had no time to pack it away properly, and so... Oh, I miss it already...

Libra: Don't get upset, [Robin]. I can draw you another one.

[Robin]: But you said you never draw pictures by request. Remember?

Libra: For you, I will be delighted to make an exception!

[Robin]: Really? Oh, thank you! What will it be?!

Libra: Well, I haven't thought about it. What kind of picture would you like?

[Robin]: How about a self-portrait?

Libra: Er, you want to hang a picture of ME on your tent wall? The picture that you look at every night before sleeping?

[Robin]: Is that a problem?

Libra: Well, it's just that the last time I did a self-portrait, everyone thought it was a woman. Even after I specifically tried to play up my more manly features...

[Robin]: That...must have been embarrassing.

Libra: Well, not that it matters. It's hardly my fault if people can't see the blindingly obvious, is it?

[Robin]: Er, right. So, no self-portraits... How about a portrait of me, then? It can be a keepsake for when I get old, to remind me I was once young and beautiful!

Libra: A most challenging request, but I will pray that Naga guide my hand!

[Robin]: Er, someone less understanding could take that the wrong way, you know...

LIBRA X AVATAR (FEMALE) [ROBIN] S

Libra: Ah, [Robin]. I have completed the portrait you requested.

[Robin]: You have? Let me see it!

Libra: Here you are...

[Robin]: Oh! Gracious! Is that...ME?! You... You flatter me, Libra. It's too much... This person is so ravishing and glamorous, no one will imagine it's meant to be me.

Libra: Well, I was not after an exact likeness. I only hoped to capture a small fraction of the radiant beauty that suffuses you. Sadly, my humble skills were not up to the task of capturing perfection on the canvas. Perhaps such things are best left to the gods themselves.

[Robin]: Heh, now it's REALLY too much... Still, what a wonderful picture. I must give you something in return. What would you like, Libra?

Libra: I am a man of the gods; I desire no worldly goods. But, if you were to accept one more gift, I would consider the debt settled.

[Robin]: Er, I don't think I follow your math there.

Libra: This should make the equation clear.

[Robin]: A ring?! B-but... Are you... Are you proposing to me?

Libra: For some time now, I have found myself falling more and more in love with you...

[Robin]: Oh... I... I had no idea.

Libra: I apologize if I've put you in an awkward position. Of course, if you are not—

[Robin]: No, not at all! I'm thrilled, Libra! Because...I'm in love with you, too. That's why I was so upset when I lost the picture you gave me.

Libra: If you accept my proposal, I would paint you pictures for the rest of our days.

[Robin]: Well how could I turn down an offer like that? I'll be surrounded by beautiful art, and looked after by a beautiful partner.

Libra: Er, don't you mean "handsome" partner...? B-but don't mind me! I just feel so manly whenever I'm around you.

[Confession]

Libra: I am yours forever, my love. May the gods smile upon our union, and bring us joy in the years to come.

Tharja

THARJA X AVATAR (FEMALE) [ROBIN] C

Tharja:

[Robin]: Tharja? ...Are you following me?

Tharja: ...Maybe.

[Robin]: Maybe?! I've seen you hiding behind tents and wagons all week!

Tharja: Ah. Of course you'd notice, with our fates entwined so...

[Robin]: Sorry, what? Our...fates?

Tharja: Oh yes. I realized it the first moment we locked eyes. "She isn't like the others," I thought. "She's the one I've been seeking!"

[Robin]: Riiiiight. Well, um, thank you? ...I guess?

Tharja: That's why I've been watching your every... single...move. Yesterday you read two books and part of a third. You snacked on an apple. And last night, you turned over 12 times in your sleep. ...Well below your average.

[Robin]: You've been watching me sleep?!

Tharja: I thought you'd be grateful.

[Robin]: No, I think "disturbed" is more the word. You mean to tell me you've been following me every single day since we met?

Tharja: ...Yes.

[Robin]: I suddenly feel very ill.

Tharja: Don't worry. I'll take care of you. ...Veeery good care.

[Robin]: Coming from a normal friend, I'd probably be happy to hear that. But somehow when you say it, it's not quite so comforting...

Tharja: Is that what you want, [Robin]? Some-one..."normal"?

[Robin]: Well, I...suppose? That's to say—

Tharja: All I needed to hear.

[Robin]: Wait, Tharja! Stay here! ...Where I can see you! Oh gods, this will not end well...

THARJA X AVATAR (FEMALE) [ROBIN] B

Tharja: Why good day, [Robin]! How fare you? Enjoying this weather?

[Robin]: ...Tharja? What are you doing?

Tharja: What, me? Ho ho! Whatever do you mean? Just a normal greeting on a typical day. ...Why? Are you concerned for my welfare, my lady?

[Robin]: Um, well... I suppose, in a way.

Tharja: You ARE?! Why, how sweeeeet!

[Robin]: Actually, I'm more concerned about whatever you're planning for me.

Tharja: Of course I have a plan for you, silly-billy! Now close your eyes, and get ready for... A slice of liver-and-eel pie! That's your favorite, correct? I can give you the recipe, you know.

[Robin]: ...Are you SURE you're all right, Tharja? You didn't eat anything strange, did you? Miscast a hex? Hit your head on a rock?

Tharja: Oh ho ho, goodness me! Such an imagination you have, my lady. I don't know anything about anything strange, much less eat it! Just a typical day for a typical girl here.

[Robin]: This is about our conversation from before, isn't it?

Tharja: Don't be silly. Now have some pie!

[Robin]: Look, I don't want—MMPH! *Munch, munch, munch* ...Actually, that's delicious.

Tharja: Oh, huzzah! I've been working on the recipe every day after supper now.

[Robin]: "Normal practice"...? You mean you've been practicing being normal?

Tharja: Yes! And it worked! I'm perfectly normal now! Ho ho! My yes, so typically normally plain.

[Robin]: Do you realize that your "typical normal" is actually very, very unusual?

Tharja: Oh my, huzzah! Goodness, I simply must... something?

[Robin]: Tharja, I'm sorry about what I said before. You shouldn't have listened to me. I liked you more the way you were, so can you go back to being the old Tharja?

Tharja: Gracious, I... I have been practicing so diligently as of late, I'm not sure I can stop!

THARJA X AVATAR (FEMALE) [ROBIN] A

Tharja: (...Heh heh heh!)

[Robin]: I'm glad Tharja's acting like her old self again. Ah-although... I feel... Urk! Ch-chills up spine... G-goose bumps... C-can't trust sh-sh-shivers...

Tharja: [Robin]? ...You all right? [Robin], you're shaking like a leaf! You're drenched in sweat! Okay, Tharja, think. We need cold water and a spell to bring down the fever.

[Robin]: Nnnrgh...

Tharja: Hello.

[Robin]: Huh? Wh-what happened? Why am I lying here?

Tharja: You lost consciousness and collapsed. It was because of the fever.

[Robin]: Y-yes, I've been feeling unwell for a while. Probably been working too hard.

Tharja: I thought you might accuse me of putting a curse on you...

[Robin]: I'd never assume that! What kind of monster would curse their friend...

Tharja: ...Oh. Right. That would be crazy! Heh heh.

[Robin]: Anyway, thank you so much for taking care of me.

Tharja: Didn't you once say you wouldn't want me taking care of you?

[Robin]: Clearly, I was mistaken.

Tharja: You're just saying that because I helped you out.

[Robin]: No, it's true! In fact, I wonder if you wouldn't mind...staying... "Yaaaaaawn" Just...just for a while...

Tharja: Aw, how sweet. She's sleeping. Sleeping and... helpless. Hee hee hee hee!

Olivia

OLIVIA X AVATAR (FEMALE) [ROBIN] C

Olivia: 248... 249... 250! Phew, that's all of 'em! ...Still a long way to go, though.

[Robin]: What are you doing, Olivia?

Olivia: EEEEEEEEEEK!

[Robin]: Oh, I'm sorry! I didn't mean to startle you.

Olivia: Oh. It's okay, [Robin]. I didn't see you there.

[Robin]: Um, so if you don't mind me asking, what's in the bag there?

Olivia: Hm? Bag? What bag? Oooooooh, THIS bag! Er, it's nothing really. Just a few coins...

[Robin]: Keeping a secret stash, are you?

Olivia: It's money I've been saving out of my wages, I'll have you know! Sheesh. "Secret stash" indeed. You make it sound so sinister.

[Robin]: I'm sorry. I certainly didn't mean to imply anything untoward. I'm just impressed is all. It takes real dedication to save on a soldier's pay.

Olivia: Oh! Thank you, [Robin]. Such praise means quite a lot coming from you...

[Robin]: It does? Huh. I've never thought of myself as anything spec—

Olivia: Aaaaaaaaanyway, I've got to run. I'm on mess duty tonight. You know what they say, right? A hungry Shepherd is a big jerk!

[Robin]: Is that what they say? I had no idea. ...Ah! Olivia, wait! You dropped your secret stash!

Olivia: Will you PLEASE stop calling it that?! You make it sound like I stole it or something. People will get suspicious!

[Robin]: Well, whatever you want to call it, you're losing it as we speak! Look at all the coins rolling down the hill!

Olivia: ARRRGH! Why do coins have to be so darn round!

OLIVIA X AVATAR (FEMALE) [ROBIN] B

[Robin]: So, Olivia. How goes the saving?

Olivia: Pah-fectly whell, my good lady-dee! Now be a dear and fetch me some cav-iah?

[Robin]: Um, are you all right?

Olivia: Of course! I found a book that teaches how to talk like a noble, so I'm practicing.

[Robin]: Oh. I thought maybe a bee had stung your tongue...

Olivia: I did NOT sound like that! ...Or did I? Oh, gods, I DID! This stupid book is useless. Do you realize I've been talking like that all day? Gods, how embarrassing!

[Robin]: Oh, it wasn't as bad as all that. Just unexpected is all. I'm sure if you keep practicing you'll get the hang of it.

Olivia: You really think so?!

[Robin]: Er...sure. But listen, I wanted to ask something: What are you saving up for?

Olivia: You mean my big bag of loot? ...I want to build a theater.

[Robin]: A theater? You mean, with a stage and stands and seats and everything?

Olivia: YES! And fly lofts and trapdoors and a huge proscenium arch! A place where people from all walks of life can experience the wonder of dance.

[Robin]: When you say dance, are you referring to YOUR dancing?

Olivia: Well...kinda, yeah. Why? Does that sound egotistical? Because I—

[Robin]: Wonderful! I'll be first in line when it opens!

Olivia: Why, thank you, [Robin]. How kind of you!

[Robin]: But building a theater is quite an undertaking. It'd cost a fair bit of coin.

Olivia: I know, I know. I suppose it's all a bit of a pipe dream...

[Robin]: Say, I have an idea. Why don't we join forces and construct it ourselves?

Olivia: Oh, gosh, no! I don't even know which way to point a hammer.

[Robin]: Well, I might not look it, but I know a thing or two about carpentry. Come on, it'll be fun!

Olivia: Okaaay, but...you really think we can pull this off ourselves?

OLIVIA X AVATAR (FEMALE) [ROBIN] A

[Robin]: Phew! Finished at last!

Olivia: We did it. I still find it hard to believe, but we actually did it.

[Robin]: What do you think? Do you like it?

Olivia: It's...it's even more beautiful than I imagined! *sniff*

[Robin]: Good! It's nice to know that all that work wasn't in vain.

Olivia: ...There's just that one teeeeeeny-tiny issue with the size.

[Robin]: ...Ah.

Olivia: It's going to be difficult to dance in a theater that fits in the palm of my hand. ...Not that I'm complaining or anything.

[Robin]: Yes, but the perfect venue for a flea circus!

Olivia: I don't want a flea circus!

[Robin]: Heh, I know. In any case, as small as it is, it's still a theater that WE built. Now that we know how it's done, it should be a simple matter to scale everything up.

Olivia: You think so?

[Robin]: Absolutely! Always have a plan, I say.

Olivia: Well, if you think so, then I believe it! Besides, working with you is so much fun, it hardly feels like work at all. So, only...what? A few more decades? And we'll build a fabulous, human-size theater! ...Hmm. You sure it wouldn't just be easier to save up my money?

[Robin]: Now, now! You promised not to talk about that again, remember?

Olivia: Oh, right. Sorry. Well, I have a new, special dance I made to celebrate our new performance space! Would you... Um, would you like to see it? I mean, if you're busy, that's fine...

[Robin]: I can always make the time to watch one of your dances!

Olivia: Hee hee! Okay. I might be a bit rusty, but I'll do my best. I've been saving this for when the new theater was ready...

[Robin]: Ah, this IS fun, isn't it? The only thing better than having a dream, is making it come true with a friend!

Olivia: Thanks, [Robin]. I couldn't do it without you.

Cherche

CHERCHE X AVATAR (FEMALE) [ROBIN] C

Cherche: Oh, this one is cute! Er, then again, maybe not. Hmm, this one has some nice horns, but I think it's the wrong type for Minerva. Dear me, this is harder than I expected.

[Robin]: Cherche? What are you up to?

Cherche: Ah, perfect timing, [Robin]. I want to ask you something.

[Robin]: What about?

Cherche: Among your many friends, are there any particularly beautiful wyverns?

[Robin]: ...Did you just ask if I have good-looking wyvern friends?

Cherche: Well, it was worth a shot. I'm looking for a partner for Minerva. I must have searched through dozens of portraits and letters of introduction. And yet, not a single one has been up to Minerva's very exacting standards.

[Robin]: Minerva? That massive thing you ride into battle? I, er, didn't know that anyone offered match-making services for wyverns.

Cherche: No one does! That's what is making this so very difficult. I've been doing everything all on my own so far.

[Robin]: Impressive. You're breaking new ground in wyvern relations.

Cherche: It's a giant leap for mankind and wyvernkind alike, I'll wager. ...Want to pitch in?

[Robin]: Well, if you think I can help! Ha ha ha...ha? Wait... You were being serious?

Cherche: Did you hear that, Minerva? [Robin] is going to help us!

[Robin]: Oh, look how happy you've made Minerva!

[Robin]: That bloodcurdling sound was happiness?!

CHERCHE X AVATAR (FEMALE) [ROBIN] B

[Robin]: I've assembled an extensive dossier on prospective wyvern mates, Cherche. ...I can't believe I just said that.

Cherche: Oh, thank you! This is so exciting! Let's see what you have.

[Robin]: Here you go.

Cherche: Ah, you've included oil portraits of all the wyverns! What a nice touch. Hmm...no. ...Nope. ...Ugh, not a chance. ...No. ...Aaand, no. Um, [Robin]? Did you know that these are all female wyverns?

[Robin]: Er, right. Is that a problem?

Cherche: Minerva is a girl. ...Who likes boys.

[Robin]: He is? ...I m-mean, she is?!

Cherche: Yes, she is! ...It's perfectly obvious if you just bother to look.

[Robin]: (Why in blazes would I ever be looking at—)

Cherche: I'm sorry? I didn't quite catch that.

[Robin]: J-just scolding myself for making such an obvious blunder! Ha ha! ...Ha. Well, I guess I'll be starting over then.

Cherche: You can probably tell just by looking at her, but Minerva is VERY picky. So do make sure that you bring her only the most handsome candidates.

[Robin]: ...You do realize that I have no concept of what makes a wyvern handsome, right?

Cherche: The shape and length of his horns, the shine of his scales, and the length of his wings. Also consider overall musculature, roar volume, and fire-breath heat. ...Oh, and if he happens to be rich, so much the better.

[Robin]: Oh, you have GOT to be joking!

CHERCHE X AVATAR (FEMALE) [ROBIN] A

[Robin]: Cherche, I believe I've found the perfect wyvern for Minerva! Here, look at this... ...Well? What do you think? Not bad, eh?

Cherche: If this oil painting is accurate, he appears absolutely perfect! Look, Minerva! What do you think? Isn't he terribly handsome?

Cherche: Oh, she definitely likes him.

[Robin]: Thank heavens! I was just about at the end of my rope with all this wyvern business...

Cherche: Thank you, [Robin]. We both appreciate everything you've done for us. You are truly too kind.

[Robin]: Well, if I do succeed, I imagine my name will go down in the history books.

Cherche: As the first-ever chaperone for a wyvern blind date? Oh yes. I wager you'll be famous for centuries.

Henry

HENRY X AVATAR (FEMALE) [ROBIN] C

Henry:

[Robin]: Henry? What are you doing? ...Why are you all hunched over? Are you unwell? Is your stomach... Oh, gods, are you hurt?! Somebody, HELP! Henry's been—

Henry: Hey-o, [Robin]! What's all the ruckus?

[Robin]: Wait, you're...okay? You were all crouched down and quiet... I thought you were wracked with pain.

Henry: Nya ha ha! Nope! I'm completely fine.

[Robin]: Ah, well, that's a relief... But, then, what were you doing?

Henry: Guess I was having way too much fun playing with this to notice you come in...

[Robin]: What is it, some kind of—AAAAAAAAH!

Henry: Don't worry. It's perfectly safe! *poke, poke* See? Dead as a doornail.

[Robin]: An arm?! A disembodied Risen arm?! Ew... Did you bring it back from the battlefield?

Henry: Yep. I was interested in seeing what makes them tick. I thought I'd perform a little dissection and get some "inside" information. Hey, why don't you examine it with me? Maybe we can discover some new weakness!

[Robin]: Ugh! D-don't wave that thing in my face! I don't want it anywhere near me.

Henry: Suit yourself! Now where did I put that finger...?

HENRY X AVATAR (FEMALE) [ROBIN] B

Henry: Lah-di-da, do-di-doh, ♪ fee-fi-fo-fum, bom bom...♪

[Robin]: Henry, what are you drawing in the soil? A magic sigil? Do you mind me asking what it's for? I must say it looks rather sinister...

Henry: Aw, [Robin], you worry too much. It isn't sinister at all! Not one bit! I'm just going to use it to summon an army of Risen.

[Robin]: Wh-what?!

Henry: If I get it to work, we can have them all fight on our behalf! Then we can sip tea for the rest of the war and collect the accolades once it's over.

[Robin]: Well I understand the idea in theory. It could reduce casualties on our side... But there is one slight problem... Have you given any thought to how you'll control these soulless warriors?

Henry: Oh, they can't be controlled. You just let them loose to attack anything that moves. But we'll be safe so long as I draw the sigils far enough away from camp.

[Robin]: WE might be safe, but won't they turn on local villages, wreaking death and mayhem?

Henry: Yeah, probably. Would be surprising if they didn't, actually. Still, we'd win the battle.

[Robin]: Unacceptable. We cannot sacrifice innocent lives for the sake of victory.

Henry: See, now you're just not thinking logically. We've killed countless people in this war—what's a few more souls on the ledger?

[Robin]: Those deaths were necessary. We had to kill our foes or be killed ourselves. But killing the enemy isn't the same as sacrificing innocents for victory.

Henry: Seems like an arbitrary line to me... But all right. You're the tactician! No more unholy summoning sigils.

[Robin]: Good.

HENRY X AVATAR (FEMALE) [ROBIN] A

[Robin]: Henry, I wanted to congratulate you on that last battle.

Henry: Oh?

[Robin]: Yes. Especially when those Risen appeared out of nowhere. You placed the village at your back, even though it was tactically disadvantageous. By holding the line, you saved the lives of countless civilians.

Henry: Yeah, well, you said we shouldn't sacrifice innocents to win a battle.

[Robin]: I know what I said, but I was surprised you'd taken it to heart.

Henry: Heh, I just do what I'm told.

[Robin]: I didn't realize you were so obedient and... conscientious.

Henry: Heck, I always obey orders! Well, except for stupid ones like "don't fight the enemy." If someone tried to tell me that, I'd cut 'em in half and feed them to the crows!

[Robin]: I...see... Well! We wouldn't want that happening to me, eh? Ha ha! ...Ha.

Henry: Hey, you're looking a little pale and sweaty there. Everything okay?!

[Robin]: Oh, n-never mind that! I have another task for you. Would you help me organize my library of strategy books? I've accumulated so many recently, I just can't keep track of them.

Henry: You got it!

■ HENRY X AVATAR (FEMALE) [ROBIN] S

Henry: Hey, [Robin]. I'm done mending those tents! What should I do next?

[Robin]: Well, let's see. You've sorted my books, swept the floor, checked the weapons... I do believe that's absolutely everything. Thank you so much for the help.

Henry: Yeah, okay... But what should I do now?

[Robin]: Well, I guess you're free to go and do whatever you want.

Henry: Oh, really? In that case, I'll stay right here and hang out with you.

[Robin]: Um, you will?

Henry: It's fun being around you, [Robin]. And I especially love doing your chores.

[Robin]: Ha! Well, I enjoy your company, too, Henry.

Henry: ...But when I say it's "fun" being with you, I mean it's...kind of special.

[Robin]: Huh? I'm confused, Henry. It's not like you to be so oblique.

Henry: Nya ha! I know, right? What's got into me? Here, this is what I'm talking about...

[Robin]: You're giving me a ring? ...A very sinister-looking ring?

Henry: Oh, don't mind the skulls and snakes carved in it. It's not typical or anything. I could never curse anyone I liked as much as I like you... It's an engagement ring that I picked out special. I want us to get married!

[Robin]: This is...unexpected.

Henry: Nya ha! You didn't think I'd do something like this without someone ordering me, huh? But it's abso-lutely posi-lutely my own idea. So what do you say?

[Robin]: I accept, Henry. I accept wholeheartedly. You may not have cursed me, but I seem to have fallen under your spell...

Henry: Yes!

[Robin]: But you must promise me we'll be together forever.

Henry: Oh, you can count on me. I always do as I'm told!

[Confession]

Henry: I'll love you with every ounce of my blood, until I die. Ooh...when do you think that'll be?

 Lucina

■ LUCINA X AVATAR (FEMALE) [ROBIN] C

[Robin]: Phew! What a long day. So many chores, so little time...

Lucina: [Robin]!

[Robin]: Oh, hello, Lucina.

Lucina: What do you think you're up to?

[Robin]: I beg your pardon?

Lucina: Don't act all innocent! What are you doing poking around outside Father's tent?

[Robin]: ...Is that his tent?

Lucina: You know perfectly well it is. Now confess! You were trying to get close to him for some nefarious reason, weren't you?!

[Robin]: I think there's been a bit of a misunderstanding here... I was on my way back to my own tent and happened to pass by this way.

Lucina: You know all about just today! You're ALWAYS lurking near him, whenever the chance presents itself! It's almost as if the two of you are... lovers.

[Robin]: Lucina? I am Chrom's chief tactician, top aide, and his trusted military advisor. My duties demand that I be constantly at his side.

Lucina: Hmph. A reasonable enough cover story, I suppose... Are you saying you have no intention of seducing him?

[Robin]: The thought never crossed my mind.

Lucina: But you ARE with him all the time, yes? And he trusts you so much. It would be so easy to fall in love, even if you didn't mean to.

[Robin]: Our relationship is purely professional. Chrom is the general; I am the tactician.

Lucina: That's easy to say. And you might even believe it yourself...

[Robin]: You refuse to trust me, don't you? Very well. I have a proposal. Why don't you follow me for a while and watch everything that I do? Perhaps direct observation will eradicate your doubts.

Lucina: Very well. I'll do exactly that. I will be your shadow! Just watch and see.

■ LUCINA X AVATAR (FEMALE) [ROBIN] B

Lucina: Ah. There you are. I'll be shadowing you again today. Just so you are aware.

[Robin]: If this is the only way for me to win your trust... Then yes, I welcome your surveillance with open arms.

Lucina: Who knows what sultry designs you have in mind for my sweet father?

[Robin]: Lucina, I appreciate you wanting to keep the Chrom of this age safe from...harm. But aren't you being overly protective? You suspect even his closest allies?

Lucina: And how do I know you're a true ally? Because of your say-so?

[Robin]: Surely you can sense the trust and affection that we have for each other? Chrom and I would never risk our friendship for the sake of some romantic dalliance. When you're older, you'll learn that men and women can be just friends.

Lucina: Are you insinuating I'm naive?

[Robin]: I'm not insinuating anything. I'm flat out saying it. You're acting like a silly, jealous child.

Lucina: Jealous? Is that what you said? So you DO have designs on him! You admit it! And I'm getting in your way!

[Robin]: ARRRGH! Are you even listening?!

Lucina: Of course, I can understand why. Perhaps even forgive you. It's natural that you'd be attracted to such a gallant, wonderful man.

[Robin]: Chrom's nice, I suppose, but I've never thought of him as gallant. ...Or wonderful.

Lucina: What are you saying? You don't think he's gallant?! You think he's just NICE? But you're with him all the time! How can you be so blind to his incredible charms?! How dare you not be attracted to him! It's beyond insulting! If you don't start falling for him soon, my true anger will show its face!

[Robin]: Er, I thought you DIDN'T want me to fall in love with him.

Lucina: R-right! I do! ...But I don't. But... No, wait. I do. J-just stay away from him, harpy!

[Robin]: I'm honestly not sure which one of us is more confused...

■ LUCINA X AVATAR (FEMALE) [ROBIN] A

Lucina: Can we talk, [Robin]? I have something to say.

[Robin]: I can't wait to hear this.

Lucina: Well, it's about my father, as you probably guessed. I couldn't help noticing that you've been keeping your distance from him recently.

[Robin]: How could I not, after all the dire warnings you threw in my direction? I've been trying to keep contact to a minimum and only talk when necessary. I know it bothered you to see me with him, and I don't want to make you unhappy.

Lucina: Well, the thing is, I was talking to him and he brought it up with me. He was curious if I knew why you were suddenly trying to avoid him. He seemed a little upset, honestly.

[Robin]: Oh. I was hoping he wouldn't notice. Still, I assume you told him the reason?

Lucina: Of course not! If he found out I was driving his friends away, he'd... Um... In any case, it seems I should apologize. I'm sorry, [Robin].

[Robin]: Oh, it's all right... I know all of this must be a bit bewildering for you. I see how you'd want to keep him all for yourself. But you have to believe me when I tell you that Chrom and I are just friends. Admittedly, very good friends who share a special bond and a deep understanding... But no more than that, I promise. You have nothing to fear from me.

Lucina: I believe you.

[Robin]: Well, that's a relief! But I confess, it's been refreshing to talk to someone who holds nothing back. Will you promise to keep saying what's on your mind, no matter what?

Lucina: If that is your wish, I will do so. Honestly, I'm not sure I know any other way!

 Lucina (Mother/daughter)

Lucina's mother/daughter dialogue can be found on page 285.

 Say'ri

■ SAY'RI X AVATAR (FEMALE) [ROBIN] C

[Robin]: Say'ri? Hello? ...Er, I had a question for you.

Say'ri: I am in the tent, my lady. Enter and be welcome.

[Robin]: Finally! It feels like I've been looking for... Oh! I'm so sorry! I had no idea you were changing! I'll, er, just step outside.

Say'ri: Fie, [Robin]! We are both women, yes? And I've no shame in my body. ...But if it makes you uncomfortable, I shall dress. Give me but a moment.

[Robin]: Sorry to keep you waiting, my lady. Now, you had a question?

Say'ri: Well, I did, yes. ...But now I'm actually more interested in your smallclothes. Ah, wait, I assume that's what they were? Those bolts of white cloth?

Say'ri: Aye, you have the right of it. My culture has many unique customs—most-like our smallclothes differ as well.

[Robin]: But they're just strips of cotton wrapped around your chest and hips. It looks like they could fall off at any moment.

Say'ri: I'm honored that you are interested in the customs and culture of Chon'sin. Mayhap next time we have a moment, I could tell you more.

[Robin]: Well, certainly, thank you. I'm most interested...and it may even prove useful. Who knows what mysterious lands this campaign will end up taking us? A crash course on different cultures might be excellent preparation.

Say'ri: I shall be honored to serve as your guide to Chon'sin, [Robin].

■ SAY'RI X AVATAR (FEMALE) [ROBIN] B

[Robin]: Hello, Say'ri.

Say'ri: Ah, [Robin].

[Robin]: You have a moment? I was wondering if you might tell me more of Chon'sin.

Say'ri: Aye, gladly! What shall we speak on today? Perhaps you'd care to sample a cup of Chon'sin-style tea?

[Robin]: That doesn't look like any tea I've ever seen...

Say'ri: Aye, we use different leaves and different utensils, and even drink unlike you. Chon'sin takes tea very seriously. There are entire schools devoted to the art.

[Robin]: Goodness! That seems a bit excessive, doesn't it?

Say'ri: Perhaps, but to the devotees of Teaism, even a lifetime of study is not enough. Not to worry, though—I'm not one of them. Now permit me but the water...

[Robin]: ...

Say'ri: Take this with care. The cup is fearsome hot.

[Robin]: Ooh, thank you! This is exciting... Right, here goes... *slurp* PFFFFFFT! Bitter! Gods, it's bitter! Is it supposed to taste like this?

Say'ri: Aye and aye again. Once you grow used to it, anything else seems as water. It goes especially well with sweets and small cakes.

[Robin]: Can't you put sugar in it like we do with our tea?

Say'ri: You may do as you will, but in Chon'sin we drink it plain.

[Robin]: Your people have a truly hardy palate. Though I suppose if you grow up with it...

Say'ri: Am I to take it that you are not fond of our tea?

[Robin]: I just wasn't expecting it, is all. I've never tasted anything so bitter in my life! But it does have a pleasant aftertaste. Who knows? With a bit of practice...

Say'ri: I'm pleased you found the experience interesting, if not wholly pleasant. You must let me teach you more about my culture when time permits.

[Robin]: I'd like that very much.

■ SAY'RI X AVATAR (FEMALE) [ROBIN] A

[Robin]: Hello, Say'ri. Thank you again for that tea the other day. I was wondering if you'd care to share more about your country's customs?

Say'ri: Aye, my lady! Now, what could I talk about today? Something esoteric, perhaps... I know. I could tell you of our art... For Chon'sin artists, the most beautiful objects are the old and broken.

[Robin]: Aye and aye again. Something in our eye prefers the patina of age. 'Tis but a different aesthetic.

[Robin]: I've only ever thought of aesthetics to mean bright, beautiful things.

Say'ri: Then I shall attempt to explain my people's point of view. Something that's old and worn is infused with a certain beauty. A beauty of hard use, if it please you. Of decay and poverty.

[Robin]: Poverty? ...That's a bit difficult to wrap my head around.

Say'ri: It does require a new way of looking at things, but it can be done. In time, you'll appreciate the beauty of brown, the allure of rust, the smell of mold.

[Robin]: I think I prefer my art to be colorful and clean.

Say'ri: Aye, and to me, such things seem garish and dull, both at once. I much prefer the honest poverty of simple, understated pieces.

[Robin]: That's the second time you've used that word, "poverty."

Say'ri: The appreciation of poverty is an essential part of our culture. We often say that poverty teaches us what is truly important in life. Not status, or standing, or possessions, but a loving heart and positive spirit.

[Robin]: Mmm, a lesson we should all appreciate. People who become rich are so often spoiled by their wealth and luxury. They end up wanting more and more but can never be satisfied.

Say'ri: Aye! The Chon'sin interest in age and decay is a reminder of that very point. 'Tis a way to remonstrate with ourselves and appreciate what we already have.

[Robin]: What a wonderful way of looking at things... I suppose it explains a lot. I've always admired how poised and graceful you look when you fight. You seem...centered. As if the little things don't affect you. And now I understand why.

Say'ri: You honor me, my lady.

[Robin]: Heh, it's true though. I think we can all learn a lot from your country.

Say'ri: I'm pleased you've come to think so. Truly. I hope one day you'll come visit.

[Robin]: I'd like that very much.

Say'ri: Then we've one more reason to finish this war and restore peace to the world!

[Robin]: Yes we do.

 Basilio

■ BASILIO X AVATAR (FEMALE) [ROBIN] C

Basilio: Ah, [Robin]! You look radiant today!

[Robin]: Oh? And what prompted that unexpected dose of flattery?

Basilio: I've made it my custom to greet every lady I meet with a compliment.

[Robin]: Well, consider me complimented. ...Was there something else you wanted?

Basilio: I want to buy your services! Er, as a tactician, I mean.

[Robin]: Oh? Are you trying to pluck me from Chrom's employ?

Basilio: I wouldn't have used those words...but yes, that's exactly what I'm trying to do! You see, it's not fair to young Chrom, but my need is greater, and that's a fact.

[Robin]: Well, I appreciate your honesty, if nothing else.

Basilio: Pah! I'm no court dandy with time to play games of wit and words! So what's it to be, tactician? Give me your answer.

[Robin]: I'm flattered by the offer, Khan Basilio, but I must refuse. This war is far from over, and I vowed to stand with Chrom to the bitter end. I couldn't just abandon him on the whimsy of one of our allies.

Basilio: Ho! Speaking of games with whims... This is no whimsy of mine, dear lady. I make this offer fair and true.

[Robin]: Then I'd advise you to present the offer with more care. It's hard to take seriously when it comes out of the blue like this.

Basilio: Fair enough. But at least you'll be prepared for the next time I ask you. ...And I WILL ask again, [Robin]! Count on it!

[Robin]: Hmm, somehow I believe him...

■ BASILIO X AVATAR (FEMALE) [ROBIN] B

Basilio: Ah-hah, [Robin]. Just the brilliant tactician that I wanted to see!

[Robin]: This isn't about your proposition, is it? Because I told you—

Basilio: Shush! Say no more, not until you hear me out. I've brought proof of my sincerity! Ta-DAH!

[Robin]: Gracious... What a beautiful bouquet!

Basilio: Aye, but it's no more than you deserve. I've met a lot of women in my time... But never one as sharp and as willing—and able—to improve herself as you.

[Robin]: Er, well, I'm not sure I'm all that, haha... But is this really about offering me a job? Because it's starting to sound like a different kind of proposition altogether...

Basilio: Perish the thought, milady! I've got no ulterior motives—you have my word! I only want you to quit Chrom's employ and serve as my chief tactician.

[Robin]: Right. But I don't understand why. All three of us are in the same army, yes? If I stopped working

for Chrom and worked for you instead, what would change?

Basilio: ...Huh? Oh, er...well, sure. If you put it like that...I guess nothin' would change. Hmm. Maybe this brilliant scheme of mine ain't so brilliant after all... I'd best get back to the drawin' board and do some thinkin'... Till next time!

[Robin]: Basilio?! Basilio, wait! What should I do with all these flowers?

Basilio: Ah, I'm...not sure. Whatever one normally does with flowers? ...Eat them?

[Robin]: *Sigh*

■ BASILIO X AVATAR (FEMALE) [ROBIN] A

Basilio: Ah, so this is where you're hiding! Can you spare a moment for old Basilio?

[Robin]: Certainly, but if this is about—

Basilio: You becoming my chief tactician? That's exactly what it's about. Except I've been rethinking the offer an... Well, maybe "tactician" is the wrong word. What I need is a toady. Someone to track appointments, bring me tea—

[Robin]: A toady?!

Basilio: Well, all right, "assistant," if you prefer. I hear some use that term nowadays.

[Robin]: That might be the most insulting thing anyone has ever said to me! And even if I DID want to be your lackey, my loyalty remains with Chrom.

Basilio: ...You're dead set on staying his tactician, then? Is that it?

[Robin]: Yes, Basilio. That's it.

Basilio: Well, fair enough. I don't expect you to join me out of sympathy. Just do me one favor, will you? Think on my offer.

[Robin]: I'd have to be brain dead to consider being your assis—

Basilio: See, I'm the kind of man that doesn't let go once I've got a bone in my jaws.

[Robin]: It's a thin line between persistent and pig-headed, Basilio. *Sigh* You are loyal, though, and certainly dedicated, I'll give you that much.

Basilio: Har! Now THAT'S what I'm talking about! It's like you see right into my heart! I need you on my staff, [Robin]! Name your price! Whatever it takes!

[Robin]: Basilio? This conversation is over.

Basilio: Oh, come now, admit it: my stubborn attitude is all part of my abundant charm! And to prove it, I'll be seeing you again, and THEN you'll give me the answer I seek!

[Robin]: Heh heh, he certainly doesn't give up easily, does he...

■ BASILIO X AVATAR (FEMALE) [ROBIN] S

[Robin]: Hello, Basilio.

Basilio: Ah, [Robin].

[Robin]: I hope you're not here to pester me about being your toady.

Basilio: Hold on a moment, this time YOU were the one who chased ME down!

[Robin]: Oh, was I? Fancy that.

Basilio: ...

[Robin]: What's the matter, Basilio? ...You don't seem yourself.

Basilio: I've been thinking about my offer... And I've come to realize that I don't need you as my tactician OR assistant.

[Robin]: Wait, you don't? Er, I mean...good! Because I had no intention of accepting. What would be the point? I really just don't understand what you were thinking...

Basilio: Look, I've been beating around the bush for a while now, and I'm tired of it. I don't want you to work for me. I...want you to be my wife.

[Robin]: Dammit, Basilio! You turned you down on two job offers already, and... Wait, did you just say WIFE?

Basilio: By the seven hells, yes! My wife! Everything I offered before was me avoiding the guts of the matter. From the moment I clapped my eye on you, I've been yearning to make you mine!

[Robin]: I...have no idea what to say...

Basilio: Well, "yes" would be a fine start. Come on, [Robin]. Don't beat my big, brown heart.

[Robin]: Gods, but you can be quite charming when you put your mind to it... And in truth, I...have carried feelings for you for some time now...

Basilio: There, you see? Fate herself is practically demanding that we wed! And trust me, my lady—the men of Ferox know how to treat a lady right!

[Robin]: Well, I guess I'll just have to find out, won't I?

Basilio: Har! I'll start by laying out the biggest wedding feast Ferox has ever seen!

[Robin]: Heh ha, well, just take it easy with the mead, all right? We've all seen what happens when you let yourself go.

Basilio: Old Basilio will be the very model of manners and good breeding! Er, but I can have SOME mead, right? ...Maybe just a barrel or two?

[Confession]

Basilio: Just think of all the fun times we're gonna have! All the battles! Heh, I'm gonna make you proud!

 Flavia

■ FLAVIA X AVATAR (FEMALE) [ROBIN] C

Flavia: [Robin]! I want a word with you.

[Robin]: Oh, Khan Flavia. What can I do for you?

Flavia: I just wanted to say...that I am very much an admirer of yours. You are quick witted, bold, and decisive. Everything a superior tactician should be.

[Robin]: Oh, well...I'm honored by the compliment, Khan Flavia. Though in truth, I'm unaccustomed to such high praise...

Flavia: Please dispense with the humility. I find it terribly dull and, in your case, ill fitting. Besides, once this war is over, I want you to serve as my chief tactician.

[Robin]: ...Me?

Flavia: Regna Ferox sorely needs military talent of your caliber. At my side, you'd be worth a legion or more of battle-hardened fighters!

[Robin]: Milady, I...I don't know what to say. Might I have some time to think on it?

Flavia: Yes, of course. You mull it over, then return to me with an answer.

[Robin]: Th-thank you. I'll do that.

■ FLAVIA X AVATAR (FEMALE) [ROBIN] B

[Robin]: Hmm... But then, if they hit us here, our flank would be exposed. Unless...

Flavia: Ha! Look at you, [Robin]! Everyone else is resting, yet here you are, studying battle maps on your own. You're not only skilled, smart, and brave—you're hardworking and diligent, too!

[Robin]: Oh, I'm just doing my job.

Flavia: Were that we were all so dedicated. ...Ah, yes. I almost forgot. I brought you something from the town florist.

[Robin]: Goodness, they smell lovely. Thank you very much.

Flavia: I've been told that the fragrance of flowers soothes the soul and heals the flesh. You must remember to take a break sometimes and recover your strength. I don't want you keeling over before I've secured your services for myself!

[Robin]: Are you truly serious about hiring me to serve Regna Ferox?

Flavia: Of course I am! As a tactician, your judgment is supreme, and your talent both rare and true. Why do you think I have such love for you?!

[Robin]: ...Muh?

Flavia: In fact, I want you to join the royal family and help me aid the people of Regna Ferox!

[Robin]: Er, what do you mean by that?

Flavia: Is it not clear?

[Robin]: Well, it's just that...you're a woman. And I'm a woman. And I'm flattered, but I'm not really... I don't think...

Flavia: Is there better things to do than worry about a person's gender, [Robin]! I only care about talent, brains, and character. And as I keep saying, you have all of those qualities in spades.

[Robin]: This is really not what I was expecting you to... Er, so maybe... Um... I need to go.

Flavia: Damn and blast! What's gotten into that woman? I thought an orphan like her would leap at the chance to be my adopted sister!

■ FLAVIA X AVATAR (FEMALE) [ROBIN] A

Flavia: Ah, there you are, [Robin].

[Robin]: K-Khan Flavia!

Flavia: Well? Have you thought more about my proposal?

[Robin]: Oh, er, right. You mean the one about me going to Regna Ferox?

Flavia: And joining my family. Don't forget that bit.

[Robin]: Yes, about that. You see, I'm not entirely sure what it means. Because we're both women, and... I mean, not that there's anything wrong with that, but...

Flavia: Yes? And...? We're both women. That's no impediment as far as I'm concerned?

[Robin]: It is for me!

Flavia: Why? Isn't it more important that we hold love for each other? Any other details—

[Robin]: This is a bit more than a detail! Look, I'm just not ready to make such a drastic change. Besides, now is not the time to even consider such things, is it?

Flavia: Hmm... Then I take it you wouldn't consider coming to Regna Ferox anytime soon?

[Robin]: Well, with this war still raging, it's hard for me to think even a day in advance. Besides, Chrom deserves my undivided attention right now. He's earned that much.

Flavia: I'm disappointed, [Robin], though I understand your position.

[Robin]: I'm sorry. Truly I am. Um, but...I do hope we can continue to be friends?

Flavia: Oh, of course. ...Still I'd grown somewhat used to imagining our happy future. Adopting you into the royal family and finally having a sister of my own... Perhaps we could even have been bridesmaids at each other's weddings! But forgive me. You're right. This isn't the time for idle fantasies.

[Robin]: ...Sister?

Flavia: But if it's friendship you want, then friendship we shall have!

[Robin]: Wait. When you said you loved me, you meant as a SISTER?!

Flavia: Well, an adopted sister, yes. ...Didn't I make that clear?

[Robin]: No, you didn't! I thought that... Um... Well, never mind what I thought.

Flavia: Wait a second. You thought... You and me...? AHHH HA HA HA HA HA HA!

[Robin]: It's not my fault! The way you were talking, it just... Oh, gods, I'm so embarrassed...

Flavia: Blazes, girl, you're turning as red as Basilio after two barrels!

[Robin]: "Ahem" Annnyway... All right, then. I will consider your offer. The sister one, I mean. But not until this damnable war is won for good.

Flavia: Fair enough. But know this... I'm not the kind of woman who gives up easily. I yearn for you like a wolf yearns for the still-beating heart of the deer... And when the time comes, you will be my prey!

[Robin]: Er, you know...

Flavia: Yes, my lovely fawn. You shall be mine, now and forever!

[Robin]: You're doing it again!

Donnel

■ DONNEL X AVATAR (FEMALE) [ROBIN] C

Donnel: Nah, still no good. The hook's too big. Maybe if I... Naw, that ain't it neither!

[Robin]: Donnel? What are you trying to do?

Donnel: This dang fishin' hook I'm makin' just don't wanna work for me. See here? That's it. This is it! Ya try 'n' fish it; just slip right off soon as it starts fightin'.

[Robin]: Ah, yes. It needs a barb on the inside. Here, may I? ...There we go.

Donnel: Wow, thanks! I owe ya one, [Robin]. How'd ya know so much about fishin' hooks anyhow?

[Robin]: Oh, just something I read about at one time or another.

Donnel: Shoulda guessed. You always got yer nose in one dusty book or another. I just wish there was some way I could return the favor. Say, you know anythin' 'bout buildin' snares? I'm actually a pretty good trapper.

[Robin]: Not much, I'm afraid. Perhaps you'd teach me some basic traps sometime?

Donnel: Darn tootin' I will! We can start with a box trap. Ain't nothin' to it.

[Robin]: Sure, sounds great!

■ DONNEL X AVATAR (FEMALE) [ROBIN] B

[Robin]: Hey, Donny! You remember that box trap you helped me make? Well, I caught a boar! Just look at the size of this thing!

Donnel: It's near as big as this fish I caught thanks to yer tricky hook!

[Robin]: Goodness, I think we're going to have leftovers tonight.

Donnel: Heck, if we smoke that boar'a yours, we'll be set for a month.

[Robin]: Boar jerky? My mouth's watering just thinking about it... Oh, and speaking of, I was working on ways to improve that trap. I think I've got a better trigger figured out. You should come by and take a look.

Donnel: Swell! I got a new hook I wanted to show ya, anyhow.

[Robin]: Ha ha, listen to us! We're obsessed.

Donnel: Heh, ain't that the truth? We ain't even on larder duty!

[Robin]: We should be, the way we're stockpiling provisions.

Donnel: I wager the others'd think we're a right pair of greedyguts, way we's goin'.

[Robin]: Hmm... I suppose snarfing down boar isn't very ladylike, now that I think about it?

Donnel: Huh? Are ya japin' with me now? Yer the finest lady I ever met! Back in my village, ain't a single milkmaid could hold a candle to ya!

[Robin]: How kind of you to say, Donny. Do you really think—

Donnel: And ain't just you, neither! Every gal in this here army is a knockout. Yee-haw!

[Robin]: Oh. I...see.

■ DONNEL X AVATAR (FEMALE) [ROBIN] A

Donnel: Do you cook, Donny?

Donnel: Sure—if I ain't got a choice. You?

[Robin]: I've only poisoned myself twice!

Donnel: You say that like yer proud! But ain't much use to all this meat if we can't do nothin' with it.

[Robin]: Do you want to have a go? At cooking it, I mean? If the two of us put our heads together we could come up with something.

Donnel: No harm in tryin'.

[Robin]: Gah! The fish! You're burning it!

Donnel: And yer stew is boilin' over!

[Robin]: HOOOOOOT! Hot! Hot! Hot!

Donnel: You all right?!

[Robin]: Ow— Y-yes, I think so. It's just a little burn.

Donnel: Doing cool that, quick! Take this... Aw, horse apples! We're outta water! I'll go draw some. Don't move!

[Robin]: I got the water! Stick yer hand in there!

[Robin]: Ahhhhhhhhh...

Donnel: I reckon there WAS harm in us tryin' to cook.

[Robin]: Still, I'd say it was worth it. At least I got to learn something about you.

Donnel: And what's that?

[Robin]: You've got a cool head in a crisis. You were quick on your feet and kept it together. Thanks again for the water.

Donnel: Shucks. Ain't nothin' nobody else wouldn't a done...

[Robin]: Don't be so modest. You certainly... *sniff* *sniiiiff* Er, Donny? Is something burning?

Donnel: The fish! The fish is still on the goldurn fire!

[Robin]: I think the harm is tasting to outweigh the benefit now. Let's just throw some dirt over these cookfires and slink away. And perhaps we'll not mention this to anyone else, eh?

■ DONNEL X AVATAR (FEMALE) [ROBIN] S

Donnel: Gosh, [Robin]. That was one heckuva to-do the other day!

[Robin]: Indeed, that burned-fish odor lingered for days. Chrom was NOT happy about us stinking up the camp! ...Or the bears that followed the scent.

Donnel: Aw, crab apples. I sure am sorry. Reckon I shoulda been more careful.

[Robin]: No, it was my fault for burning my hand and making you fetch water. If anything, you kept a bad situation from getting any worse.

Donnel: Maybe. But I can't help thinkin' that if I was older and wiser and smarter... Well, maybe these kinda'a mishaps wouldn't keep happenin' to me.

[Robin]: I could say the exact same thing. We're both only halfway to wisdom.

Donnel: So if we're both halfway, maybe we'd get more wise if we done got together?

[Robin]: Got...together?

Donnel: I really hope ya don't think it forward of a simple country boy to be askin'... But I was hopin' ya'd do me the honor of acceptin' a present.

[Robin]: ...A ring?

Donnel: In my whole life, I never met no one who's as much fun to be with as you. So I'm thinkin' it sure would be nice to spend the rest of my life with ya!

[Robin]: Why, Donnel...

Donnel: Ya like my company and whatnot, don't ya, [Robin]?

[Robin]: Donnel, being with you is... It's like a nonstop festival ride.

Donnel: Then...?

[Robin]: Yes. I accept.

Donnel: Yeeeeee-haaaaaaw!

[Robin]: You'll do the cooking and laundry, and I'll be in charge of sleeping and eating.

Donnel: Huh? But...what about workin' together and gettin' wiser and all that?

[Robin]: It was just a joke, Donny.

Donnel: Haw haw! Good one, [Robin]! Aw, I KNEW this'd be fun!

[Confession]

Donnel: I love ya. I don't reckon I could live without'cha. Let's you n' me settle down on the farm!

■ ANNA

■ ANNA X AVATAR (FEMALE) [ROBIN] C

Anna: Oh, [Robin]! Just the lady I wanted to see!

[Robin]: Oh, hello, Anna. What can I do for you?

Anna: I have a proposition for you...

[Robin]: A proposition?

Anna: Yes! Just this morning, I got my hands on a stock of special skin cream. You just smooth it on, and the wear and tear of battle and travel disappear! Old, dry skin replaced by silky smoothness. It's the hard-travelin' girl's best friend! And today only, I can offer it to you at an insanely low price.

[Robin]: Er, I see. That's very kind, I suppose. But, to be honest, I don't use creams and lotions much. They're not really my thing.

Anna: But a girl's skin is her most important ally! Why, neglecting it is like abandoning a comrade on the battlefield! You're so pretty already—just think what a beauty you'll be with healthy, glowing skin!

[Robin]: Er, well, if you put it like that... I suppose I could try a little.

Anna: That's the spirit! ...Aaand here you go. One tub of Anna's Wonder Cream.

[Robin]: Heh, now you've gotten me all excited. I'll have to try a little later.

Anna: Great. You do that. ...Bye!

Anna: ...Wait a second? What's this? Oh, cripes! I gave her the wrong one! The stuff I gave her is the experimental formula that's still being tested on cows! ...Well, I gueeess it'll be all right? I mean, flame-tree resin is probably safe and effective on skin. ...Right? And since the sale's been made, I couldn't give her money back. ...Right? No, of course not. All sales are final!

■ ANNA X AVATAR (FEMALE) [ROBIN] B

[Robin]: Anna!

Anna: Oh, [Robin]! Did you need me for...something or other?

[Robin]: It's about that skin cream you sold me.

Anna: (...Oh no. She knows! She's going to want her money back, and I already spent—)

[Robin]: Anna, what are you mumbling about? Are you listening to me?

Anna: What? Oh, er, yes! Yes, I'm listening! ...So, how is the cream? I only ask because sometimes it, er, doesn't affect everyone...exactly the same.

[Robin]: Well, let me tell you, it works like a charm on me! My skin's been rosy pink and smooth as silk since I started using it.

Anna: ...For serious?

[Robin]: Oh yes. Can't you tell? Look at my face! I'm beaming! Thanks to you, I wake up every morning confident and ready for any challenge.

Anna: Oh, I'm so reliev— Er, I mean, pleased! I knew it would work! Ha ha...

[Robin]: Do let me know if you get any more in. I'm ready to buy a lifetime's supply!

Anna: Er, of course...

[Robin]: Great! See you soon!

Anna: ...Well, that was unexpected. If it's that amazing, I'm going to have to try some myself!

■ ANNA X AVATAR (FEMALE) [ROBIN] A

Anna: Er, [Robin]? You remember that skin cream I sold you recently? I, er, don't suppose you'd let me try some of it?

[Robin]: Don't tell me you've never used it yourself?

Anna: Well, the thing is, I had such a limited supply, and it was so popular... It, uh...sold out before I had a chance!

[Robin]: Why, Anna, I had no idea it was such a rare and valuable commodity.

Anna: Oh, it's fine. That's what business is all about, right? B-but after you told me how well it worked, I was thinking I ought to try it myself.

[Robin]: Well, there's no time like the present. I have the tub right here in my bag... Now just hold still while I smear it all over your face.

Anna: ...Gracious. It's very sticky, isn't it? It's almost like glue.

[Robin]: It always feels like that at first. But soon you'll find your skin tingling with health.

Anna: So, like, how long are we talking here? Not too long, I hope.

[Robin]: ...Anna? What's the matter?

Anna: I'm...not sure. Something feels strange. My skin is... It's... Oh gods, it's itchy! So itchy! ...And getting MUCH itchier!

[Robin]: ...uh?

Anna: Arrrgh! I can't stand it! It's like a hundred mosquito bites covered in tar! Wh-what's happening to me? How can I make it stop?!

[Robin]: Good heavens, Anna! Your face is swelling up like a balloon! Hold on! I'll fetch some water!

Anna: Does she know I sold her the wrong cream? Is this some kind of sick revenge plot? N-no, that wouldn't be her style. ...Or would it? Maybe her skin just reacts differently to the cream? *scratch, scratch* Argh! Such an apt punishment for my crimes! It must be the work of the gods! But I'm not going to let this little setback bring me down... *scratch* When life gives you lemons, you sell lemonade! *scratch* Then you sell the lemon rinds, and plant the seeds, and sell the lemon trees later on! *Scratch, scratch, scratch* Oh, gods! If only I had just sold her some lemonade! *scratch*

■ OWAIN

■ OWAIN X AVATAR (FEMALE) [ROBIN] C

Owain: Severiestus? ...Too complicated. Deus Dumbfoundus? ...Too long.

[Robin]: Owain? What are you doing?

Owain: Oh, 'tis the lady tactician! I sense your appearance is evidence of Fortune's work. Would milady for the nonce stop the sands of time, that o'er centuries have flowed?

[Robin]: ...I haven't the foggiest clue what you're saying.

Owain: Er, do you have a moment? We're like-minded souls, yes? I could use some advice.

[Robin]: Well, for starters, you should try speaking like a normal person.

Owain: Hark now! In my hand I hold my faithful friend, a shimmering sliver of silver steel. My weapon, my blade, my companion to death... It demands a sacred appellation!

[Robin]: Er, right... Are you saying you want help thinking up a name for your sword?

Owain: Ah, yes! Two souls united are we, words mere gilding to instinctive understanding.

[Robin]: ...Quite. But why do you need MY help? Aren't you the name guy around here?

Owain: Ah, but therein lies the rub, for I cannot conjure the proper agnomen. ...Not one that sounds cool, anyway.

[Robin]: Ah... Okay, I suppose I could try to come up with some ideas...

Owain: I'd be most grateful! My blade is like a brother to me... Ah, how I adore it!

[Robin]: Well, I'll just...give you two some privacy, then...

■ OWAIN X AVATAR (FEMALE) [ROBIN] B

Owain: Ah, 'tis the Titler! She who was chosen by fate to name my faithful blade!

[Robin]: ...Actually, I think you were the one who asked me.

Owain: Enough idle chitchat! Has inspiration struck? Prithee, do you have a name?

[Robin]: Actually, I was wondering if I might have a little more time with that.

Owain: Sooo...today is not the day my sword receives its sacred appellation? Oh, my poor, sweet sword. Yes, I, too, grieve at the insufferable delay... But we must remember the Titler cannot be rushed, no matter how tardy she may be.

[Robin]: If you can talk to the thing, why don't you just ask what it wants to be called?

Owain: Oh, wow. I never thought of... I mean, nay, woman, nay! You speak the impossible! It must be thee who proffers the name! A vow has been made and sealed in blood! Should we break it, great and horrible will be the curses that rain down upon us!

[Robin]: Look, could you at least give me a hint? What should it sound like?

Owain: Well, it should have strong, manly letters. Like V or D or G. ...And no Qs. It must be a forceful name that strikes fear into the hearts of evildoers everywhere!

[Robin]: Maybe you could give me a couple of examples? ...Please?

Owain: Well, er... Vermidog? Viseguard? Hmm... Oh! Oh, I got one! Cloverfinger!

[Robin]: Wow, those are all SO great! Why don't you just use one of those?

Owain: Ah! I know what you're doing! You seek to evade your responsibility as Titler! Yet remember that fate herself entrusted you with this sacred task! Now, speak, Titler! Give us your answer! What shall be... the NAME?!

[Robin]: Look, Owain. I'm really sorry about this, but nothing's coming to mind. What's the rush, anyway? If you ask me, I think it would make a lot more sense to wait for a bit.

Owain: Explain thyself! ...Er, thouself? ...Explain!

[Robin]: I think you should first spend more time using the blade. The better you two know each other, the easier it will be to find a good name.

Owain: By the gods, that's not a bad notion at all! Find the character, and thence the name! Perhaps this is what fate had in mind when she brought about that meeting 'twixt us!

■ OWAIN X AVATAR (FEMALE) [ROBIN] A

Owain: Aha! There she be! We've been seeking her, my partner and I, for we wish to offer our humble thanks.

[Robin]: "Partner"? ...You mean your sword?

Owain: After our fruitful dialogue, I was resolved to become better acquainted with my blade. Strange to tell, but since that day we've become a mighty force on the battlefield. 'Tis like the gods themselves are reaching down to guide every parry and blow!

[Robin]: Oh?

Owain: Yes! Why, just the other day, some fiend launched an arrow at my back. Instead of striking me, it glanced off the blade as I swung to strike another! Training has become easier, I learn new skills without effort, and my armor gleams. Plus, I found a four-leaf clover and got the end cut of the roast three days running! Everything's comin' up Owain!

[Robin]: I'm not sure what I have to do with you finding clovers and roast ox, but I'm pleased for you.

Owain: You couldn't give my sword a name, sure. But instead, you pointed the way to a deeper understanding of my faithful blade. And let's face it, that's MUCH more important than some silly moniker! I'll be sure to seek you out the next time I need advice on anything!

[Robin]: Well, I'm glad it...all worked out.

Owain: O fount of deepest understanding! O goddess of infallible wisdom!

[Robin]: Er, okay, Owain, you're welcome. Just keep your voice down a little?

■ OWAIN X AVATAR (FEMALE) [ROBIN] S

Owain: *Siiiigh*

[Robin]: Owain? What's the matter? You seem down.

Owain: I am. And the kicker is, I have no idea why...

[Robin]: It must be serious if you've stopped the lordly speechifying.

Owain: Yeah, I've given up on that. It was starting to irritate even me. In fact, lots of things are bothering me lately. Heck, I can barely eat! I've talked to the physicians, I've talked to the healers, and neither can help. They just said I must have picked up an infection or something.

[Robin]: That does sound quite serious. Here, let me feel your forehead...

[Robin]: Er, but I only wanted to see if you have a fever...

Owain: Yes, but you see, I worry that this illness somehow revolves around...you. When I think of you, I find enough strength coursing through me to lift a wyvern! But at the same time, my chest tightens and I can barely breathe!

[Robin]: That sounds...familiar.

Owain: You recognize the symptoms? Please, you have to tell me what disease I have!

[Robin]: Er, it's not a disease, exactly. Although it IS serious... Oh, this is embarrassing.

Owain: E-embarrassing?! I have an embarrassing illness?!

[Robin]: N-no, I don't mean that. It's just...not easy to talk about.

Owain: Oh, please, [Robin]! If you know something, you have to tell me!

[Robin]: You spend a lot of time thinking about me, don't you? I mean...inordinately.

Owain: Yeeeeees...

[Robin]: And when you do think about me, you feel that tightening in the chest, don't you? Doesn't that sound familiar? Isn't that what...love feels like?

Owain: By the mullet of Ike, I think you're right! Somehow, some way, I must have fallen in love with you! ...Zounds. I can see why you were embarrassed to tell me.

[Robin]: Of course I'm embarrassed! Fancy having to tell a man that he's in...love with me. I mean, what if I'd been wrong and you just laughed in my face? I'd have never lived it down!

Owain: I guess I did put you on the spot there, didn't I?

[Robin]: Well, I suppose it can't be helped. Youthful innocence is one of your many charms.

Owain: You...think I'm charming? Charming enough to...marry, maybe?

[Robin]: Hee hee. Maybe. Although if we're to be wed, you'll need to work on recognizing your own emotions. And no more talking like a noble with a thesaurus! Got it?!

Owain: Indeed, I have recei—er, yeah, got it!

[Confession]

Owain: You eluded my defenses and pierced my heart! It seems I've finally found...my weakness.

■ INIGO

■ INIGO X AVATAR (FEMALE) [ROBIN] C

Inigo: Ah, [Robin]. You're looking beautiful as always! Care to join me for tea?

[Robin]: Sorry, no time for anything so frivolous today.

Inigo: I'm deadly earnest, my lady! I assure you, there is no frivolity intended.

[Robin]: I'd be more apt to believe you if you hadn't already invited half the ladies in the army.

Inigo: Well, well. Is that how it is? My heartfelt invite, earnest as earnest can be, trampled under your sweet boot!

[Robin]: I don't think "earnest" means what you think it means. ...Especially between us.

Inigo: Then even more reason to talk over tea! We mustn't let these misunderstandings cloud our relationship and keep us apart.

[Robin]: ...You're incapable of taking anything seriously, aren't you? You know, you might have better luck with women if you cut down on the glib banter.

Inigo: Glib banter? Moi? Why, [Robin], you do me a grave injustice! What you see as glib is the unvarnished reverence of a heart that yearns for love! And, strange though it may sound, I find your grumpy cynicism alluring... We must talk like this again soon!

[Robin]:

■ INIGO X AVATAR (FEMALE) [ROBIN] B

Inigo: [Robin]! There you are! Were you afraid I'd forgotten our date? Well, put your mind at ease. Here I am!

[Robin]: Hello, Inigo. Did all the other ladies turn you down again?

Inigo: ...How did you know?

[Robin]: The only time you talk to me is when you've run out of other women. You're an incredibly easy man to read. You know that, right?

Inigo: *Sigh* Why are you so hostile to your poor, faithful friend, Inigo?

[Robin]: Please. Don't look at me with that hangdog expression. I'm sure you'll find another young lass who'll fall for your questionable charms.

Inigo: Of course I will! ...Won't! I meant, of course I won't! I need no other woman but you!

[Robin]:

Inigo: Er...

[Robin]:

Inigo: S-stop staring at me like that. It's making me uncomfortable. Besides, it...it won't work. I'm telling you the truth!

[Robin]: Oh, really? Look into my eyes, and tell me that again.

Inigo: I... I'm not lying. T-truly, I'm not... ARGH! Okay, you win! I'm lying! Damn it, [Robin]! I just can't get anything past you, can I?

[Robin]: The sooner you learn that, the better. When you see a woman, all you think of is how to seduce her. Everyone knows it.

Inigo: Waaait a minute... I see what's happening. You're jealous! I'm flattered, of course, but I must confess I'm also a bit disappointed. I didn't imagine a lady of your stature to succumb to the green-eyed monster.

[Robin]: Oh, for the love of... Nothing could be further from the truth!

Inigo: Oh, I think I touched a nerve.

[Robin]: Gods, but talking to you is an infuriating experience! Why don't you try doing something useful? Outside of battle, I mean. If you managed that even once, I might consider having tea with you. But as it is—

Inigo: Aha! Then we have a deal! ...And I'll be leaving now, before you can change your mind. Ta-ta!

[Robin]: Wait! Inigo! I was just... *Siiiiiigh*

■ INIGO X AVATAR (FEMALE) [ROBIN] A

Inigo: ...This is for you, just for being you. A little token of my gratitude.

[Robin]: ...Is that Inigo over there? What's he up to? Looks like he has a present for that soldier. Trying to seduce her, no doubt. *Sigh* The fool truly is incorrigible. So much wasted potential...

Inigo: Ah, [Robin]! Perfect timing! Here, I have a present for you, too. It's a salve I bought in town. The salesman said it has amazing healing and restorative powers.

[Robin]: Oh! That's actually really nice of you, Inig... ARGH! Wait, what am I doing?! I won't be wooed with gifts!

Inigo: Wait... You thought...? That I...? WAAA HA HA HAAA!

[Robin]: Why are you laughing?

Inigo: Ha ha ha ha! Ha ha! Hooooooo... S-sorry... Got to catch...breath... I'm not trying to buy your affections. Or anyone else's! The very idea!

[Robin]: Then what ARE you doing?

Inigo: I noticed that a lot of our soldiers are getting worn down with all this fighting. I thought I'd lift people's spirits with little pick-me-up presents.

[Robin]: Then why are you only giving it to the women?

Inigo: I'm not! I've been giving something to everyone.

[Robin]: Oh. I just assumed that... I mean... Yes, well. Sorry about that. I must say, it's a very clever idea. I didn't think you had it in you.

Inigo: I don't know if it's clever... I just like to make my friends happy is all. We all have to pitch in and help out however we can, right?

[Robin]: ...You are full of surprises today, Inigo.

Inigo: I know! I'm kind of surprised myself. ...Sooo, not so bad, am I?

[Robin]: Well, I thought you were pretty horrible before, so maybe not "so" bad, but...

Inigo: Heh, I'll take it! ...And I'll take my exit before you change your mind! Ta-ta!

[Robin]: Heh, yes, not SO bad, I suppose.

■ INIGO X AVATAR (FEMALE) [ROBIN] S

Inigo: Ah, [Robin]. Today your beauty shines more radiantly than ever!

[Robin]: Ah, Inigo. Today your idle flattery is as predictable as always.

Inigo: On the contrary! When it comes to wooing, I have been the very model of restraint.

[Robin]: Oh? How unlike you.

Inigo: Lately, I've only talked to women in order to strengthen our bonds as fellow soldiers. In truth, I hope to settle down and spend more time with the person I love.

[Robin]: What?! No... You have a... *ahem* I mean, who's the lucky lady?

Inigo: Who? Ha ha! Oh my, you're putting me on the spot here. I thought that you might have already guessed. ...Sensitive woman that you are.

[Robin]: I don't think I follow.

Inigo: Look, it's like this... The person I love more than anyone... Well, it's YOU!

[Robin]: Wait, what?! ME?! Where on earth is this coming from?

Inigo: I've felt like this for a long time... I just haven't had the courage to tell you. A man like me—a foolish, frivolous man—needs someone like you. Someone to tell me what's what. To show me the right path. To keep me in line...

[Robin]: Oh, good heavens.

Inigo: Then this confession is all in vain? You truly hate me?

[Robin]: I don't hate you, Inigo.

Inigo: Then...is there a chance we can be together?

[Robin]: Well...yes. Yes, there is. A good chance. But only if you promise that you'll stop trying to woo other women.

Inigo: ...Really? Do I have to? I mean, that's really asking a lot, considering I... Er, I mean, if it's what you REALLY want, I'll...do my best.

[Robin]: You'll what?!

Inigo: Ha ha! A jest, my lady, a jest! [Robin], I promise I will have eyes for no but you.

[Confession]

Inigo: I used to say this to all the ladies, but... You are truly the only one for me.

■ BRADY

■ BRADY X AVATAR (FEMALE) [ROBIN] C

Brady: *Pant, pant, wheeze* Need...air... HAAA... ngh...*sputter, pant* D-dammit...

[Robin]: What's the matter?

Brady: Ain't *pant* n-nothin' *pant* matter *wheeze*...

[Robin]: I thought you were out training with the rest of the troops?

Brady: Well duh, that's EXACTLY *cough* what I was doin'. So get off my back!

[Robin]: You overdid it, didn't you?

Brady: Sh-shut yer yapper!

[Robin]: Do you need a glass of water? Or maybe a damp towel would help?

Brady: N-no... I'm perfectly...*cough* fine. Dammit, gotta get back there...rest of 'em...learnin' stuff...gettin' ahead'a me... Gotta...train...more...*sniff*...

[Robin]: Er, Brady. Are you crying?

Brady: I SAID shut yer *sniff* yapper. I NEVER cry, yeah?!

[Robin]: I think you're being much too hard on yourself here, Brady. You have to understand, you're already an important part of this army. Look, here's a handkerchief. Why don't you blow your nose?

Brady: That isn't snot, it's tears! I don't need ya wipin' my nose like a sap, see?

[Robin]: But you never cry, yeah?

Brady: You ain't nearly as nice as everyone says you is.

[Robin]: I'm sorry. I know I shouldn't tease. But seriously, Brady. Are you really so desperate to get stronger?

Brady: Well, yeah. Of course I am. It's pretty much all I care about.

[Robin]: Then let me help you.

Brady: What, I'm supposed to just have you drill me? Teach me to fight better? You?

[Robin]: Basically, yes.

Brady: Yeah, well...I suppose that's...fine. Do what ya gotta do.

[Robin]: Then it's settled! Excellent...

■ BRADY X AVATAR (FEMALE) [ROBIN] B

[Robin]: Well, Brady. Ready to begin training? It's time we toughened you up.

Brady: Yeah, I guess. Where do we start?

[Robin]: First thing we need to do is work on your habits off the battlefield.

Brady: Huh? What's that got to do with fightin' and gettin' strong?

[Robin]: It has everything to do with it, actually. Your problem is a lack of stamina. We have to make sure the basics are covered before we get into combat.

Brady: Sounds like a buncha malarkey if ya ask me, but whatever.

[Robin]: Now, folks tell me that you're rather picky when it comes to food...

Brady: Yeah, I guess. Ain't everyone?

[Robin]: If you want to get stronger, you can't just eat the things you like. You need a balanced diet, with a full spectrum of nutrients and vitamins.

Brady: What, ya mean like equal parts beef AND pork...?

[Robin]: No, I mean meat, grains, fruits and veggies, and dairy. Oh, and no more late nights. A dissolute lifestyle leads to all kinds of health problems.

Brady: Fine, fine. So if I eat right and go to bed early, that'll make me strong?

[Robin]: It won't happen overnight, but little by little, you'll find your stamina improving.

Brady: Gettin' good at fightin' sure has a lot less fightin' than I thought. A bit borin', ain't it?

[Robin]: If you don't want to hear my advice, I so have other things I could be doing...

Brady: Oh, no, no! I ain't complainin'! I'll stick to yer program like glue.

■ BRADY X AVATAR (FEMALE) [ROBIN] A

[Robin]: Good, you're here. Let's get started, shall we? First, I have something for you.

Brady: What is it? A weight machine? A new practice sword? A fencin' dummy?

[Robin]: It's a bowl of my secret soup!

Brady: What the hey does soup have to do with buildin' my cannons?

[Robin]: It's a key part of the program. Now eat the whole bowl, please.

Brady: Soup ain't gonna do nothin' for nobody! ...Unless you put secret stuff in here, yeah?

[Robin]: Only if you consider carrots, turnips, leeks, and pig trotters "secret stuff."

Brady: Just regular soup, huh? All right. Down the hatch, I guess... *slurp* EEEEEEEEW! What in blazes?! This tastes horrible!

[Robin]: Oh, it's not that bad. ...There must be some reason you're still eating it, right?

Brady: "Slurp" It's ...kinda...addictive...even though...'slurp'...it ain't tastin' better.

[Robin]: You know why? Because it's full of nutrients that your body's been craving.

Brady: "Slurp" Yeah?

[Robin]: That's right. I analyzed your likes and dislikes to customize the recipe for you. It wasn't easy, either. I was up half the night working on it.

Brady: Well, ain't you a peach? 'sluuuuuurp'

[Robin]: My pleasure. If you want results, sometimes you just have to work hard. All I ask in return is that you finish all of it...and there we are. All done!

Brady: Oh, yeah. I couldn't stop eating it...

[Robin]: Well, Brady, I'm impressed. I'll make another batch right away. We'll fix your nutritional problems yet!

Brady: Heck, if eatin' that stuff will make me strong, I'll take a whole barrel!

■ BRADY X AVATAR (FEMALE) [ROBIN] S

[Robin]: I brought you more of my special soup, Brady.

Brady: Oh. Er, sure. All right.

[Robin]: What's the matter? You seem a little...off. Are you finally growing tired of the soup?

Brady: Naw, it ain't like that. I'm stronger than ever thanks to your daily doses of veggie goodness. I just got somethin' what needs sayin' to you, yeah?

[Robin]: Sounds serious.

Brady: It is. Life-'n'-death serious. See, I've come a long way this last little while, yeah? And it's all 'cause you been workin' so hard on my behalf.

[Robin]: Whatever you've accomplished is due to your own hard work, Brady. And what's more, you haven't been making a big show of how much you've learned. You just put your nose to the grindstone and got on with it. I've been very impressed.

Brady: Aw, [Robin]...

[Robin]: So what's wrong, Brady? What is this life-and-death matter you want to discuss?

Brady: Guess I should stop beating 'round the bush and just let fly, yeah? I wanna drink yer soup every day for the rest of my life!

[Robin]: I...I'm not sure I understand... Do you want the recipe?

Brady: It kinda struck me a few days ago, but I figured ya didn't feel the same. So I decided to just bite my tongue and play the cool cat, yeah? But when ya stand there and praise me like that, it kinda gives me hope again. I loves ya, [Robin]! I'm crazy about ya!

[Robin]: Oh, Brady...

Brady: I want us to be together all the time, from now until we're old and busted.

[Robin]: Well, this is a surprise... But such a happy one! It would be my great honor, Brady. I'll always be here to support you.

Brady: Aw, that's swell! But ya won't have to help me forever, ya know? One day, I'm gonna get so strong that I'll be lookin' after YOU!

[Robin]: Well, in the meantime, soup's on!

Brady: Now that's what I like to hear!

[Confession]

Brady: You make me wanna be stronger! Better! I swear to become a guy worthy of your love.

 Kjelle

■ KJELLE X AVATAR (FEMALE) [ROBIN] C

Kjelle: Torchlight glinting off polished steel... Imposing rows of fearsome visors... Ah, I never get tired of this sight.

[Robin]: Kjelle? What are you doing in here?

Kjelle: Ah, [Robin]. Greetings. I was just admiring the armory. Don't you think it's lovely seeing all our gear lined up in neat little rows?

[Robin]: I don't know that I've ever thought about it... Armor is an interest of yours, I take it?

Kjelle: An interest? To say the least! In truth, I absolutely ADORE armor! It's both battlefield tool and work of art... It grants a warrior might and majesty. It's one of the main reasons why I became a knight, in fact.

[Robin]: I suppose there is a certain something about a well-made suit of plate. Especially the elaborate models fashioned for nobles and royalty.

Kjelle: Ha! I should have guessed that you, of all people, would share my passion.

[Robin]: Er, yes, well... Perhaps not to the same degree.

Kjelle: I could help with that. I could tell you everything I know about armor. I could deepen your knowledge and help fuel the fires of your passion!

[Robin]: Oh. Yes, that's...very kind of you. Perhaps when we have more time.

Kjelle: Agreed then! Next chance we get, I'll treat you to my five-part lecture on chain mail. This is serious business, [Robin]. Just remember: you requested it!

[Robin]: ...Did I?

■ KJELLE X AVATAR (FEMALE) [ROBIN] B

Kjelle: Ha! There you are... I've been looking everywhere for you!

[Robin]: (Damn! She found me!) Er, I mean... Hello, Kjelle.

Kjelle: Ready for my discourse on armor?

[Robin]: Oh, right. See, the thing about that is... Well, to be completely honest... Look, I won't ever be as passionate as you about armor. I just won't. And I feel like I'd just be letting you down, so maybe it's best if we—

Kjelle: Nonsense! Give me enough time, and I guarantee to ignite your love for armor. If not as works of art, then as valuable equipment that keeps your soldiers safe. You're interested in being the best tactician you can be, right? Because if so, it's essential that you learn as much as you can about protective gear.

[Robin]: Er, well, yes. I suppose that is...a point.

Kjelle: No need to thank me, truly. What are friends for? And there're no better friends than those united in a common love of helm and shield!

[Robin]: I...can so very hardly wait.

Kjelle: Then let's begin! *ahem* I should probably start by listing all the things one can enjoy about armor. First, the smell: a wonderful bouquet of tangy metal and warm, rich leather.

[Robin]: See, you've lost me already, Kjelle. I think armor smells terrible. It's sweaty and gross, especially after we've been fighting for weeks.

Kjelle: Oh, [Robin], [Robin]... Why are you fighting this? There's no need to mask your feelings. Listen to your heart! Let it sing!

[Robin]: ...I honestly have no idea what you're talking about.

Kjelle: Moving on, then! What's next... Ah, yes! The sound of armor! Don't you just love it? CLINK-CLANK! CLINK-CLANK! *Siiiiigh* I could listen to it all day...

[Robin]: (...My instinct was to run when I saw her coming. Why didn't I run?) (*Sigh* Nothing for it now but to just stand here politely until she's done...)

■ KJELLE X AVATAR (FEMALE) [ROBIN] A

Kjelle: Ah, there you are, [Robin]. Are you ready for our next discussion on properly enjoying armor?

[Robin]: Kjelle, you don't enjoy armor. You LOVE armor. You're consumed by it! Infatuated! Maybe even obsessed!

Kjelle: Obsessed? Me?

[Robin]: Well, it's not necessarily a bad thing, of course... It's just...hard to talk with you about anything else and, er...

Kjelle: No, no. It's fine. I get it, [Robin]. I'm boring you, aren't I? I start talking about armor, and then I just won't shut up. Armor this and armor that and blah-dee blah-dee blaaah. You hate me now, don't you? You hate the very sight of me.

[Robin]: What?! What's that absurd! I...I enjoy your company very much. And I don't hate armor either, you know. You're just so serious about it! I mean, how did this happen? Where did this mad obsession even come from?

Kjelle: *Sigh* You want to know why I care about armor so much, [Robin]? ...It's because armor was my only friend.

[Robin]: I don't understand...?

Kjelle: In my future, humanity was on the verge of extinction. Risen roamed the land. My life depended on my armor. Long after my comrades and parents were dead and gone, it yet protected me. In the end, it was all I had left. It was constant. It never deserted me.

[Robin]:

Kjelle: It's thanks to my armor that I'm still alive today to talk about it. Do you see now? Armor isn't just gear. It's a friend that I owe my life.

[Robin]: But that was then... Now you have something better you can rely on.

Kjelle: ...Better armor, you mean?

[Robin]: No! Us, Kjelle! Your friends! Look around the camp. Don't you see how many people here care about you? When we all stand together, nothing can possibly harm you.

Kjelle: You make a convincing case, [Robin]. But I don't simply want to be protected... I want to protect my comrades in turn!

[Robin]: No one would ask any less of you, because we all feel the same. We all watch out for each other.

Kjelle: Now THAT'S the best kind of armor there is!

 Cynthia

■ CYNTHIA X AVATAR (FEMALE) [ROBIN] C

Cynthia: COME, FOE! TASTE THE STEELY TANG OF CYNTHIA'S DEADLY BLADE! ...Gah. "Steely tang"? I sound more like a culinary critic than a hero... I AM CYNTHIA! QUAKE IN YOUR SUPPLE CALFSKIN BOOTS, EVILDOERS! Hey, that's not half bad...

[Robin]: Cynthia? What's all the shouting about?

Cynthia: Oh, hello, [Robin]! Just practicing my opening line for when we go into battle.

[Robin]: You do that a lot, don't you? Talk to the enemy, I mean.

Cynthia: Of course! That's what heroes do! It's important to make the enemy understand how majestic and heroic I am.

[Robin]: Look, I love speeches and gallant poses as much as the next soldier. But doesn't that leave you exposed to a sudden strike from a foe?

Cynthia: Oh, no. That's against the rules! See, when heroes meet on the battlefield, everyone gets time to deliver their lines. If the foe knows anything about heroic derring-do, they'll wait their turn.

[Robin]: I don't think our foes give two figs about derring-do. You're far more likely to get a quick dagger between the ribs.

Cynthia: B-but war is civilized! It celebrates bravery and honor and all that good stuff. Otherwise, it's just a bloody mess. Otherwise, it's just random slaughter!

[Robin]: ...I'm sensing a steep learning curve ahead of us here.

Cynthia: Look, back in my future, the only foe we ever faced was the Risen. Now, when fighting brain-dead monsters, it's all about survival, niceties be damned. But I'm sure... I just assumed that here in the past, things would be more civilized. I mean, war can't ALWAYS be a horrific bloodbath... Can it?

[Robin]: Oh, Cynthia...

Cynthia: Well anyway, I should run. I need to practice my sword flourishes!

[Robin]: I can't decide if her attitude is admirable or pathetic.

■ CYNTHIA X AVATAR (FEMALE) [ROBIN] B

Cynthia: I AM CYNTHIA! YOUR BLOOD SHALL RUN THICK LIKE SWAMPLAND! ...Ew, no. That's a bit gruesome. I AM CYNTHIA! I FLOAT LIKE A LEAF AND STING LIKE A NETTLE! ...Eh. Too vegetarian.

Although it might lull the foe into a false sense of security...

[Robin]: Hello, Cynthia.

Cynthia: Oh, hi, [Robin]!

[Robin]: Practicing your battle lines again?

Cynthia: That's right! Because I still believe in the rules of heroic and gallant fighting.

[Robin]: Just remember, not everyone follows the rules, or even knows about them. Some people have even less honor than the Risen, in truth.

Cynthia: I know what the risks are. But I refuse to give up the idea of civilized combat.

[Robin]: Do you promise to at least look out for treachery?

Cynthia: Hey, stop worrying already! I can take care of myself. I'm a hero, remember? It's my job to rally and inspire our comrades.

[Robin]: We all know how brave you are, Cynthia. You don't have to take risks to prove it. What good is a hero if she's so foolhardy everyone has to worry about her safety?

Cynthia: I hadn't thought about it that way...

[Robin]: Well, perhaps you should. What say you at least consider toning it down a little? Okay?

Cynthia: ...Fiiine. I'll think about it. And sorry if I made you worry.

[Robin]: She's such a sweet girl, and so innocent. I just hope that doesn't prove her undoing...

■ CYNTHIA X AVATAR (FEMALE) [ROBIN] A

Cynthia: [Robin], can we talk?

[Robin]: Of course, Cynthia. What's on your mind?

Cynthia: Well, er, I've been thinking about what you told me...

[Robin]: You mean about the risks of your heroic posturing on the battlefield?

Cynthia: Right, exactly. But see, I still believe in all the chivalrous rules of combat. ...I really don't want to give up striking poses and delivering my battle lines. But I've decided that I'll be extra careful, and only do it when it's absolutely safe.

[Robin]: And how will you know that?

Cynthia: Well, if I'm facing a noble foe who knows the rules, I'll go ahead and do my thing. But if it's a monster or a smelly bandit, I'll just hit 'em in the face.

[Robin]: That sounds like a fair compromise. Thank you for considering my advice.

Cynthia: Well, it didn't seem fair not to, after you told me how worried you were. After all, a real hero is someone who can look after herself AND her friends. Imagine if a comrade was hurt because I was busy making the sun glint off my blade! If Chrom was gut-punched because I was yelling about my terrible might! If you were beheaded and quartered, then set aflame, all because I was—

[Robin]: Okay, okay, I think I have the idea.

 Severa

■ SEVERA X AVATAR (FEMALE) [ROBIN] C

[Robin]: *Slurp* Ah, yes. Perfect. Adding that dash of fenugreek did the trick.

Severa: What are you doing, [Robin]?

[Robin]: Oh, hello, Severa. I'm just putting the finishing touches on tonight's stew. It's my turn in the galley, you see.

Severa: It smells pretty okay... Are you, like, a professional cook or something?

[Robin]: Me? Oh, gracious no. It's nothing special. I just tossed a few things in the pot.

Severa: Pfft. False modesty is so overrated. I can tell by the smell alone that a lot of work went into that stew. *Sniiiff* Ahhh. All kinds of herbs and stuff. You musta cooked for hours.

[Robin]: You're very kind, but I really think I just got lucky today. Usually when I cook, it ends up tasting like mud. ...Or burned mud.

Severa: I TOLD you already, that stuff is totally overrated! Gawds!

[Robin]: I'm sorry?

Severa: I mean, really! You've made a success of something, so go ahead and celebrate! Pat yourself on the back! Tell everyone what a fantastic job you did! Soak up the praise! Otherwise, people forget you're being modest and start taking you at your word. And then when you do something really great, everyone treats it like a yawner. Before you know it, you're just boring old [Robin], and everyone ignores you!

Severa: And another thing! What in blazes are you doing fiddling around with soups, anyway? You're our TACTICIAN! You should be planning how not to get us killed! I don't want to die tomorrow because you're thinking about stupid soups!

[Robin]: Er, well. Normally I AM excused from roster duties, given how busy I—

Severa: I know, right?! So why are you HERE?! You should be in a war council with Chrom or planning our next march! You should secure provisions, check supplies, have our weapons repaired, blah blah blah blah. But NOOOOOO! You're flinging soup around like some innkeeper's lackey!

[Robin]: W-well, when you put it that way, I guess it doesn't make much sense... I just wanted to ensure folks were getting healthy food for the sake of morale.

Severa: MORALE?! Pffffft! We're fine. Oh, we all just LOVE it here. And we certainly don't need a daily serving of [Robin]'s Chef Surprise to help. GAWDS! It's like talking to an infant! I am SO out of here.

[Robin]: ...I'm honestly not sure if I should be flattered or insulted.

■ SEVERA X AVATAR (FEMALE) [ROBIN] B

Severa: Severa, can we talk?

Severa: [Robin]? Sure, if... No, wait! If you've got time to chat, you've got time to think up new strategies!

[Robin]: Yes, well, that's what I want to talk to you about... You told me I need to spend more time on strategizing and less on distractions.

Severa: Yeah, I KNOW I said that. So what? Are you gonna tell me how stupid I am?

[Robin]: Not in so many words. But I'd like to offer a counterargument, if I may. You see, when I cook for the troops, it's an opportunity to spend time with them. I can learn how they're feeling, exchange information and ideas, and so forth. This strengthens our bonds and makes us more effective out on the battlefield.

Severa: Huh? How so?

[Robin]: Well, the more you know about a comrade, the more you begin to trust each other. And that trust is the key to bringing out our innate strengths and abilities. So in the end, making friends is actually an important part of the tactician's job.

Severa: Yeah, whatever. I guess.

[Robin]: In any case, I wanted you to hear my reasoning, whether you agreed or not.

Severa: I SAID "whatever," didn't I? Gawds!

[Robin]: You just don't seem very satisfied. What are you thinking? Come now, you don't have to hold back. I'm all for exchanging ideas, remember?

Severa: It's just...when I saw you stirring that pot of delicious stew, I got so angry...

[Robin]: Yes, I noticed... But I still don't really understand why.

Severa: Because we're just about the same age and you're so much SMARTER than me! You're better at tactics and strategy and battle techniques and...everything! Everyone already thought you were amazing, and then you go make this amazing soup! I was just... I dunno. Jealous, I guess.

[Robin]: Severa, first off, I'm not nearly so perfect as you seem to think I am. And I wouldn't be half what I am today if it wasn't for the help of all my friends.

Severa: Gawds, and you're MODEST, too! It's so totally annoying.

[Robin]: Severa, are you sure it's really ME who's making you angry? Or does my skill set perhaps remind you of someone else?

Severa: Wha—?! How'd you... I mean... No, you're wrong!

[Robin]: You don't sound so sure...

Severa: Gawds! See what I mean about you being so darn clever? I...I don't want to talk about it. My mind's all weird. I need to think.

[Robin]: Of course. Take your time.

[Robin]: I think I might finally understand what that girl is coming from...

■ SEVERA X AVATAR (FEMALE) [ROBIN] A

Severa: [Robin]?

[Robin]: Yes, Severa? What can I do for you?

Severa: You remember when you asked if I was mad at you or...someone else?

[Robin]: Of course. But look, you don't have to talk about it if you don't want to.

Severa: No, it's all right. Kind of do. I'm thinking you might understand. I mean, you probably know this already, but you reminded me of...my mother.

[Robin]: Yes, I see...

Severa: It's just that you're both so clever and smart and good at everything you do! And then there's little old me. I haven't done squat.

[Robin]: But you don't hate your mother, do you?

Severa: No! Of course not! ...It's just that whenever I see her, I can't help thinking how wretched I am. She's strong, noble, articulate, beautiful, and admired by everyone and their horse. Oh! Oh! AND she's kind and considerate and not in the slightest bit vain! Do you realize how hard it is being the daughter of Her Royal Perfectness? I guess I should just get used to being pathetic, huh?

[Robin]: You have your own virtues, Severa. For one, you have a kind heart.

Severa: Pffft. Yeah, right.

[Robin]: Think about it. You were reluctant to talk about this on account of MY feelings.

Severa:

[Robin]: You know I have no memories of my parents or childhood... That's why you hesitated to complain about your own mother. Because you didn't want to inadvertently hurt my feelings. ...Am I right?

Severa: What? NO! Who could possibly think that far ahead?!

[Robin]: Heh. Who's being modest now, Severa?

Severa: Look, I'm serious. All that stuff about your parents never occurred to me.

[Robin]: Your eyes get so big and earnest when you're telling a lie. Did you know that?

Severa: ARRRGH!

[Robin]: You've got a heart of gold, Severa. ...I hope you'll allow me to be your friend.

Severa: All right, fine! FINE! You wanna think I planned all that? Go ahead. Just stop talking about how nice I am! It's so embarrassing... Gawds!

 Gerome

■ GEROME X AVATAR (FEMALE) [ROBIN] C

[Robin]: Hello, Gerome.

Gerome: [Robin].

[Robin]: What are you doing here all alone?

Gerome: I'm doing nothing in particular. As for being alone, that's my normal condition.

[Robin]: Um, please don't take this the wrong way, but... If you really want to be left alone, why do you wear such a conspicuous mask?

Gerome: The two are unrelated.

[Robin]: Are they now? Hmm...

Gerome: Why are you so obsessed with what I do, anyway?

[Robin]: Oh, I wouldn't say obsessed. More like...concerned. I just think you could do a better job of getting to know your comrades-in-arms.

Gerome: Why? I'm not like them. I don't share their convictions. I didn't travel back here to try and relive some lost golden age of peace.

[Robin]: Well, I don't think that's why any of you came back.

Gerome: Enough. I'm done talking about this. ...And with you. I'm trying not to associate with anyone from this era unless necessary in battle.

[Robin]: Fair enough. I'll leave you to it, then.

■ GEROME X AVATAR (FEMALE) [ROBIN] B

[Robin]: How are things, Gerome?

Gerome: I thought I was clear that I didn't wish to associate with others.

[Robin]: Supper is ready. Or are you eschewing food as well as company?

Gerome: ...I eat alone.

[Robin]: ...Don't you think meals are more enjoyable in the company of friends?

Gerome: Food is fuel for the body. Nothing more.

[Robin]: I disagree. Mealtime is much more than just filling some physical need. It's an opportunity to get to know your allies: learn their habits, their quirks. Such things can prove very useful when you step on the battlefield together.

Gerome: Bah. I've fought well enough without such knowledge until now. The pack doesn't need the lone wolf, and he doesn't need them.

[Robin]: I'm not so sure...but we can leave it there. Hold on a moment, and I'll bring your meal out here.

Gerome: Didn't I make myself clear? I don't need your help in this matter, or any matter. I'm capable of getting my own meal.

[Robin]: Good heavens, but you are a stubborn one. All right then. I'll leave you be. ...But I expect to see that plate clean. I won't have anyone wasting food. Not even the "lone wolf."

Gerome:

■ GEROME X AVATAR (FEMALE) [ROBIN] A

[Robin]: Hello, Gerome.

Gerome: What do you want, [Robin]?

[Robin]: Heh, you sound so pleased to see me! Am I interrupting your training?

Gerome: Yes. Whenever I'm alone, I work through a set of muscle-strengthening exercises. I'm always trying to make myself stronger.

[Robin]: Very admirable. Well, I don't want to get in your way. I'll leave you to it...

Gerome: You can remain if you like.

[Robin]: I thought you preferred to be alone.

Gerome: Most of the time this is true. But recently... Well, perhaps the idle chats you all engage in aren't a complete waste of time...

[Robin]: Oh? Are you saying you'd like to have one of those idle chats with me?

Gerome: That would be...acceptable.

[Robin]: Well, this IS a surprise!

Gerome: It's not like you would leave me alone anyway, am I right?

[Robin]: Heh, perhaps not.

Gerome: That's what I thought. So go on then. Talk.

[Robin]: Heh heh, right then. So, what do you think about...

■ GEROME X AVATAR (FEMALE) [ROBIN] S

[Robin]: Thank you so much for attending the war council yesterday, Gerome. You made some excellent suggestions.

Gerome: After our chats, I realized there's no point in going only to say nothing. I used to think councils were held so you could hear the sound of your own voices. But I was wrong. Exchanging views, deciding issues, getting to know your comrades... A lot of good happens around the great map table.

[Robin]: I like to think I had a part in your change of heart. And I'm even more thrilled that you're comfortable enough with me to say so!

Gerome: Just because I enjoy solitude doesn't mean I don't know how to be grateful.

[Robin]: You know, you're quite adorable when you let your guard down...

Gerome: Wh-what's that supposed to mean?

[Robin]: Heh heh, your neck is turning red... Are you blushing under that mask?

Gerome: H-how absurd!

[Robin]: Then you won't mind if I take it off and have a look.

Gerome: NO! Stay away from me!

[Robin]: Gracious, Gerome! What has gotten into you?

Gerome: ...Er, I'm not sure. I'm sorry, but I'm always...on edge when I talk to you. I get delirious and...light headed...

[Robin]: Oh?

Gerome: ...Blast. I might as well just come out and admit it. You see, [Robin]...

[Robin]: Gerome? Y-your mask! What are you doing?!

Gerome: There. Now I can look you in the eye and tell you exactly how I feel. I've always tried to be strong so I can fight alone on the battlefield. And I still want to be strong, but now it's for a different reason. ...I want to be strong for you.

[Robin]: For... For me?

Gerome: These feelings are...new to me. But I know they run deep. If you don't feel the same, I'd just ask that you say as much now.

[Robin]: Oh, Gerome! I care for you, too, so deeply...

Gerome: Music to my ears.

[Robin]: And to prove it, I'll make myself stronger so I can help you as well. Together we can build a better future for everyone!

Gerome: Yes, for everyone. My life of solitude ends today.

[Confession]

Gerome: From today on we'll hone our edges, together. We'll carve a path to happiness through whatever fate may bring.

 Morgan (male) (Mother/son)

■ MORGAN (MALE) X AVATAR (FEMALE) [ROBIN] (MOTHER/SON) C

Morgan (male): Oh, Mother! Over here! Come with me a minute!

[Robin]: What is it, Morgan?

Morgan (male): Oh, nothing. It's just... C'mon! I need to talk to you about something.

[Robin]: Well, I'm afraid I'm a bit busy at the moment. Can we talk later?

Morgan (male): H-here? Er, that's not really... I can just wait, thanks.

[Robin]: Are you sure it's nothing urgent?

Morgan (male): Um, no, it's... Ha ha! ...I'll be right back.

Morgan (male): Okay, all set! Now to lure Mother into that pitfall trap...

[Robin]: Phew, I'm back! Hey, let's take a walk, shall we? Right this way, Mother!

[Robin]: You're acting very strange, Morgan.

Morgan (male): (Allllmost... Just a couple more steps...)

[Robin]: ...Huh? A pitfall? Now that's a classic!

Morgan (male): Dang! How did you know?! I was super careful disguising it. It didn't look suspicious at all!

[Robin]: True, your work on the pit is first class. But your odd behavior made it obvious. Subterfuge and misdirection are half of any good trap, Morgan.

Morgan (male): Dang. I'll get you next time!

Morgan (male): By the way, as long as you're here, mind helping me fill this hole in? If someone fell in by accident, they could really hurt themselves.

[Robin]: Wait, how deep did you make it?!

■ MORGAN (MALE) X AVATAR (FEMALE) [ROBIN] (MOTHER/SON) B

[Robin]: Hmm... Now where did I put it...?

Morgan (male): Looking for that treatise on tactics, Mother? Blue cover? Fairly thick?

[Robin]: Yes. How did you... Waaait a minute.

Morgan (male): Yup! I hid it! Think you can find it?

[Robin]: Is that today's challenge, then?

Morgan (male): It's somewhere in camp—I'll tell you that. You have until sundown today! Though I could give you weeks, and you would never find my diabolical hiding—

[Robin]: Found it.

Morgan (male): WHAT?!

[Robin]: It's in that bag you're holding, isn't it?

Morgan (male): Hmph. ...Fine.

[Robin]: Guess I win this round.

Morgan (male): How did you figure it out so fast?

[Robin]: You know me well, Morgan. And that includes knowing how much that book means to me. I knew you'd never hide it anywhere it might be damaged or stolen. So it needed to be somewhere you could keep a close eye on it...yet still concealed.

Morgan (male): You read my entire thought process! ...And here I thought I was being so clever.

[Robin]: All right, that settles today's challenge. Now come take a seat.

Morgan (male): Huh?

[Robin]: Let's read that book together. You wanted to work on your strategic thinking, right?

Morgan (male): Right!

■ MORGAN (MALE) X AVATAR (FEMALE) [ROBIN] (MOTHER/SON) A

Morgan (male): I'd draw your forces out to this line, then strike with an ambush team from the woods.

[Robin]: Then I would move...here. Now you find yourself trapped in a pincer movement.

Morgan (male): Crud. You win again.

[Robin]: At least it was just pieces on a board. In real life, that would've cost lives. A tactician is responsible for their army's survival, and a single mistake can be fatal. But you cannot allow the pressure of that responsibility to stymie you. Running scenarios like this will help prepare you for anything.

Morgan (male): Thanks, Mother. I'll give some of your strategy tests another read-through. But know this—one of these days, I WILL outmaneuver you!

[Robin]: Okay, we'll see about that, kiddo. But you're welcome to try me anytime. I'm always happy to accept a challenge. All right then, we're done for today.

Morgan (male): Okay! See you tomorrow!

[Robin]: ...Phew, that was a close one. I was one step shy of getting completely wiped out. I hoped that to be an unattainable goal for a little longer so he would push himself. In actuality, I'M the one who needs a push. Better dust off a few of these books myself.

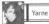 Yarne

■ YARNE X AVATAR (FEMALE) [ROBIN] C

[Robin]: Ha! Caught you at last. Let's see that furry mane of yours...

Yarne: HEY! Don't touch the hair, lady!

[Robin]: But it's so soft and fuzzy! I just can't help it.

Yarne: I told you...I'm ticklish...hee hee...behind... ha ha...the EARS! S-STOP STOP!

[Robin]: Oh, come on. Don't squirm so much. A little petting every now and then isn't going to kill you.

Yarne: I'm a proud taguel, not a blasted pet!

Yarne: No need to get all uptight about it.

[Robin]: See, that's exactly what I'm talking about. A little petting will calm you down.

Yarne: No! Absolutely not! Do you hear...

[Robin]: Er, [Robin]? Where'd she slip off to?

■ YARNE X AVATAR (FEMALE) [ROBIN] B

[Robin]: HA! Caught you again, Yarne!

Yarne: ARGH! NOT THE CUDDLING! PLEASE, ANYTHING BUT THAT!

[Robin]: Come on, don't act like you didn't just LET me creep up on you... Those great long ears of yours can hear me coming a mile away.

Yarne: I-I wasn't paying...attention.

[Robin]: Oh well. Petting time!

Yarne: ARRRRGH! S-S-S-STOP! AHH HA HA! P-PLEASE...TICKLES...HEE HEE HEE! ...Finally! Are you done? My fur is not a toy for you to play with, you know. It's a proud badge of my taguel heritage!

[Robin]: ...Oh wow. That gives me a great idea. What if there were a whole bunch of taguel lying around, like throw pillows on a bed... Imagine how much fun it would be to just flop onto them! So soft and fluffy!

Yarne: Yeah, well, you don't have a whole pile. You have me.

[Robin]: Oh, right. Sorry. That was a little insensitive, wasn't it?

Yarne: Just a smidge.

[Robin]: I can't imagine if we ever lost you... I'd never feel that fuzzy fur ever again.

Yarne: I should hope that's not the only reason you want to keep me around! Which reminds me, [Robin]. I have a favor to ask.

[Robin]: Of course. Ask away.

Yarne: I'm the last of the taguel, right? So it's essential that I keep myself alive. So when you set up battle formations, can you keep me somewhere safe? Say like, at the very, very back? You can do that, can't you?

[Robin]: Well...I suppose that's possible, sure. But is that what you really want?

Yarne: Oh, absolutely! Without a doubt! You're the only one who can save me. Look, you don't have to answer right away, but will you think it over?

[Robin]: ...All right. I'll consider it.

Yarne: Aw, thanks, [Robin]! I knew I could count on you.

■ YARNE X AVATAR (FEMALE) [ROBIN] A

Yarne: Hey, [Robin]! Have you an answer for me yet? You know, about my request to be kept waaaaay back from the front lines?

[Robin]: Yes, Yarne. I've given it some serious thought. However...

Yarne: W-wait, wait! Don't say a word! ...Do you hear that?

[Robin]: Hear what? The only thing I hear is the breeze and—

Yarne: SHHHHHHHH! Someone...is...coming...

[Robin]: What? Who?!

Yarne: ...Wait, no. Not someone. A whole LOT of someones! They have us surrounded!

[Robin]: Are they ours or...the enemy?

Yarne: I don't recognize any of the footfalls, and I'm sensing bloodlust! It's... it's an ambush!

[Robin]: Yarne, you have to get out of here! I'll hold them off! You run back to camp and get help!

Yarne: But, I can't! That is... I mean, what about...?

[Robin]: Stop blathering and go! NOW!

Yarne: B-but...! Erm...oh...ah... O-okay, I... ARGH, NO! I can't do it! I can't leave you here to die!

[Robin]: Yarne!

Yarne: I'LL stay here and fight them off... YOU run back to camp!

[Robin]: Out of the question! I'm not leaving you here!

Yarne: Well, I'm not leaving YOU here!

[Robin]: Well, I guess we're just stuck with each other, then, aren't we? It seems we have no choice but to fight them off together. But if we have a chance to both make a clean getaway, we should take it.

Yarne: S-sounds good, [Robin]. Together we can do it! ...Maybe?

[Robin]: We can and will. Now stay close. We'll punch through and get out of here!

■ YARNE X AVATAR (FEMALE) [ROBIN] S

[Robin]: Yarne? How is the wound?

Yarne: I'm all healed up.

[Robin]: That's good to hear. You truly were amazing back at the ambush. You practically took on their entire force single-handed! I've never seen anything like it, honestly. It was very impressive.

Yarne: Heh, yeah? Maybe a little bit.

[Robin]: It's funny to think how much you've changed since we first met. Do you remember when you were absolutely terrified of combat? Or how you asked me to deploy you away from the front lines? But look at what a dashing and brave soldier you are today!

Yarne: Well, if I look brave and, er, dashing, it's all thanks to you, [Robin]. I only fought like that to protect you... I'm not sure if that's bravery, exactly. By the way, forget about my request... I'll fight anywhere you need me.

[Robin]: Are you sure?

Yarne: Yep. I've decided that training harder serves everyone better than hiding away.

[Robin]: Good... Of course it's important we all protect ourselves... But we're strongest when we look out for each other as well.

Yarne: Exactly...which brings me to something...um... something I wanted to ask you. That is, I was wondering...if you'd like to look out for each other from here on out. See, because I don't think there's anything I can't do with you by my side!

[Robin]: Yarne... Do you mean...

Yarne: Of course, if you don't want to, that's okay. It's just that—

[Robin]: No, I do! I do, Yarne! I do...

Yarne: Y-you do?! Wooo-hooo!

[Confession]

Yarne: I love you! Let's repopulate my species! ...Uh, sorry. Was that awkward...?

 Laurent

■ LAURENT X AVATAR (FEMALE) [ROBIN] C

Laurent: [Robin].

[Robin]: Hello, Laurent. Can I help you?

Laurent: There is something I wanted to discuss with you.

[Robin]: Oh? Discuss away!

Laurent: [Robin], in your role as chief tactician, you always work alone. I was wondering if perhaps you might not be overburdened with your duties. Or if you might be in the need of a lieutenant. ...Such as myself.

[Robin]: A lieutenant? Well, er...

Laurent: Simply put, I would like to assist you in your work, [Robin]. If you are amenable, of course.

[Robin]: Well, that sounds very helpful. If I need anything, you'll be the first to know.

Laurent: Excellent. Please, do not hesitate to summon me at any time.

[Robin]: But you mustn't let this interfere with your other duties, all right?

Laurent: What do you mean?

[Robin]: We can't have you running ragged at two jobs, now can we?

Laurent: An astute observation. I shall bear my own mental health in mind. But do not forget to ask me for help whenever you need it.

[Robin]: Right. I won't. Thanks, Laurent.

■ LAURENT X AVATAR (FEMALE) [ROBIN] B

Laurent: [Robin]? Is there anything I might help you with today?

[Robin]: No, not really. I've got everything under control, thank you.

Laurent: Ah. A shame. Would you mind terribly if I watched you while you work?

[Robin]: Er, no, I suppose not.

Laurent: Thank you.

[Robin]: ...Right. Next I need to check our weapons and armor for wear...

Laurent:

[Robin]: Okaaay, looks good. Next, take stock of our rations...

Laurent:

[Robin]: Good! Okay, now what's next? ...Ah, yes. Formation drills for the front-line troops.

Laurent: [Robin]?

[Robin]: Yes? What is it, Laurent?

Laurent: You seem incredibly busy.

[Robin]: Oh, this is nothing. Just a normal day of checking tasks off my list...

Laurent: Is your every waking moment truly filled with a never-ending series of chores? Unacceptable. Now I'm more determined than ever to learn what you do.

[Robin]: Er, well, like I said, I don't mind you watching.

Laurent: Thank you, [Robin]. I shall see you again.

■ LAURENT X AVATAR (FEMALE) [ROBIN] A

Laurent: [Robin].

[Robin]: Hello, Laurent.

Laurent: Hard at work, I presume?

[Robin]: Yep. Just trying to get some of these chores done.

Laurent: You look exhausted, [Robin]. Drawn, haggard, and deathly pale.

[Robin]: Um, thanks? I guess I have been feeling a little worn down— Whoops!

Laurent: And now you can barely walk without stumbling. This simply MUST cease! You have worked yourself to the very brink of total exhaustion.

[Robin]: Oh, don't exaggerate, Laurent! I just slipped on a pebble.

Laurent: I'm not exaggerating. You're looking more Risen than human lately.

[Robin]: It's just that... I have so much to do. Everyone is counting on me.

Laurent: That's why you must trust your friends. ...And in me. Allow me to shoulder at least a share of your burden!

[Robin]: Laurent...

Laurent: I respect you tremendously, both as a tactician and a friend. But in this one area, I believe your judgment is suspect at best. You must face the facts and allow me to assist you with your work!

[Robin]: Well, if you feel THAT strongly about it, I suppose I can't really say no.

Laurent: Finally I wring a concession from you! Now promise me you won't work so hard.

[Robin]: All right, Laurent. I promise.

■ LAURENT X AVATAR (FEMALE) [ROBIN] S

Laurent: [Robin]. I'm finished here. Is there anything else I can do?

[Robin]: No, I think that's it. Looks like all our chores are done for the day.

Laurent: I'm glad I'm able to assist and ensure you didn't overwork yourself.

[Robin]: I'm glad, too... That scolding you gave me finally set me straight.

Laurent: I'm sorry if I spoke harshly. It was hardly my place.

[Robin]: It's okay. I know it was all out of friendly concern.

Laurent: That was certainly part of it, yes. I care for my friends and hope to keep them well. But, in your case, it...goes deeper. You are...more than just a friend to me.

[Robin]: What? ...What do you mean?

Laurent: In the beginning, I admired you solely as a tactician. My interest was professional. But as we've spent more time together, I've come to know you better... I see now what a wonderful woman you are as well... And that is why...I want to be with you. Forever. My dream is to be the man at your side from now until the end of days.

[Robin]: Oh, Laurent! Nothing would make me happier!

Laurent: Excelsior!

[Confession]

Laurent: You've been an object of fascination since I first saw you—one I would gladly spend my life investigating.

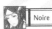 Noire

■ NOIRE X AVATAR (FEMALE) [ROBIN] C

Noire: [Robin].

[Robin]: Hello, Noire. What can I do for you?

Noire: Oh, nothing. I just wanted to get a good look at you up close.

[Robin]: Er, well, all right, I suppose. Can I ask what you're looking for?

Noire: It's just that...you're so wonderful and amazing! *Sigh* I wish YOU were my mother.

[Robin]: Noire! Tharja's a fine young woman, and I'm sure she was...er, will be a fine mother.

Noire: I don't know. She hardly seems like the paragon of caring motherhood.

[Robin]: Maybe you shouldn't hold her to such lofty standards. If you don't have an image of perfection, she'll seem a perfectly good candidate.

Noire: Yeah, maybe. But I still think you'd be LEAGUES better! Anyway, so I was wondering... Do you mind if I call you mom?

[Robin]: Um... Er... I don't...

Noire: You're going to say no, aren't you?

[Robin]: I just think it would be so...strange. People might get the wrong idea.

Noire: *Sniff*

[Robin]: Oh, for pity's sake, don't look at me with those woebegone eyes! Look, you can't call me mom, but if you want to hang around me, that's fine.

Noire: Really! Gosh, thanks SO much! I'll definitely start doing that!

[Robin]: Methinks there's more to this than she's letting on...

■ NOIRE X AVATAR (FEMALE) [ROBIN] B

Noire: H-hi, [Robin]. Do you mind if I stand close to you again?

[Robin]: No. I suppose not. But are you ever going to tell me what this whole mom thing is about?

Noire: It's just that you're so strong and kind and charismatic. You're a true leader, both on and off the battlefield. You have this kindly maternal aura that cocoons everyone who comes near. But you also have a calm, commanding presence that makes people feel safe. You're like a mother to this whole entire army, [Robin]!

[Robin]: Gracious! I don't think I've ever been paid such an extravagant compliment. But Noire, I'm still so young. I don't think I'm half the person you think I am.

Noire: You say you're young, but how can you know for sure? You have no memories at all, right? So who knows when you were born?

[Robin]: Huh. Well, I suppose I could be an old crone and just not know it. At least I'm aging well.

Noire: Besides, it doesn't matter if you're old! At least not to me. I still think you're a perfect mother.

[Robin]: Noire, what happened to Tharja in the future?

Noire: She died. Just like all the other mothers. Every last one of them.

[Robin]: Gods have mercy...

Noire: A lot of fathers died first because they were on the front lines. Then the Risen started picking off the rest of us one by one.

[Robin]: ...I see. That explains why you're seeking a new mother.

Noire: Yeah, I guess. Anyway, thanks for listening to me, [Robin]. I'd...better go now.

[Robin]: Oh, Noire...

■ NOIRE X AVATAR (FEMALE) [ROBIN] A

Noire: [Robin]. You're awake!

[Robin]: Huh? Noire? Was I sleeping? ...Wait, where am I?

Noire: You're in the nursing tent. You collapsed all of a sudden. The healers say you have thin blood or something.

[Robin]: Was it you who found and brought me here?

Noire: Yes. I haven't left your side since you arrived. I've spent a lot of time in this tent, so I kind of know how things work.

[Robin]: Thank you for taking care of me.

Noire: Aw, you don't need to thank me. It was an honor.

[Robin]: I've been working hard lately—perhaps the exhaustion is catching up to me. Still, I'll have to find a solution. I don't have the luxury of being ill!

Noire: Oh gods, I'm SO sorry! This is all my fault! It's because of me that you worked yourself to the point of collapse!

[Robin]: Er, actually you didn't have anything to do with—

Noire: Yes, I did! Don't try to deny it! It's because I told you that you were like our mother, isn't it? You have to take care of yourself, [Robin]. You can't take all of our burdens on your own shoulders!

[Robin]:

Noire: And if you ever need a shoulder to lean on, you can just come talk to me.

[Robin]: You really are a kind soul, Noire. I feel better already knowing that you're around to look after me.

Noire: Hee hee! Me too!

[Robin]: It's strange to have a whole camp full of my very own grown-up children. But it's a wonderful feeling to have so many people that care for me.

Noire: We DO care for you! ...Especially me.

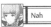 Nah

■ NAH X AVATAR (FEMALE) [ROBIN] C

[Robin]: HEY! Nah! What in blazes do you think you're doing?!

Nah: Oh hey, [Robin]. What's the trouble?

[Robin]: What's the TROUBLE? You! Turning into a dragon and crashing through the countryside!

Nah: Oh. That. ...Sorry.

[Robin]: Sorry isn't good enough!

Nah: Look, it's something I have to do.

[Robin]: And why, pray tell, is that?

Nah: Every now and then, I get this incredible urge to just...run amok. It's like a really horrible itch that HAS to be scratched. So I turn into a dragon and rampage for a bit. It's genetic or...something.

[Robin]: What about the people who get hurt on these little strolls of destruction?

Nah: Oh, gosh, I would never do that! Never! I always go somewhere nice and quiet where there's no one around. Then I just sort of unleash myself on trees and bushes and stuff. My record is thirty giant firs in a single rampage! Pretty impressive, huh?

[Robin]: Well, I...suppose that is impressive. But are you sure it's safe?

Nah: Er, like I might hurt myself on a sharp branch or something?

[Robin]: Something like that. ...Listen, Nah. You think I could watch the next time you do this?

Nah: Oh, sure. That would be no problem. In fact, it'd make it more fun!

[Robin]: Er, fun? Maybe this isn't such a good idea after all...

■ NAH X AVATAR (FEMALE) [ROBIN] B

Nah: *Yawn* What a great rampage... I'm going to sleep well tonight!

[Robin]: I don't think I've ever seen anything so terrifying in all my life... Dragons are ferocious beasts when they want to be!

Nah: I bet you're afraid I'm going smoosh somebody around here into jelly, huh?

[Robin]: Huh? Oh, n-no. Of course not. I'm sure it's quite safe...

Nah: Liar, liar, pantaloons aflame! Just remember, I only rampage if there's no one around. It's perfectly safe.

[Robin]: I'm sure you're right. Who could you hurt in such an isolated spot?

Nah: Exactly! I'm not an idiot, you know. I've been doing this for a while.

[Robin]: ...Still, it makes me wonder why you have such urges in the first place. I assumed it was something instinctual in your species... But there's no record of your mother ever doing it. In fact, I've never heard of any manakete engaging in such behavior!

Nah: Beats me. Hmm... The other manaketes have always been true-bloods, right? As far as I know, I'm the only half-human manakete that's ever lived.

[Robin]: You think it's something from your human side that compels you?

Nah: Hey, I dunno. I just work here. All I know is that I have to do it, whether we like it or not.

[Robin]: Well, if you don't mind, I'm going to keep coming on these little trips of yours.

Nah: Hey, it's your funeral. Kidding! I'm kidding. ...Ha ha?

■ NAH X AVATAR (FEMALE) [ROBIN] A

Nah: Hee hee! Oh, gods, that was fun! That was the best rampage EVER!

[Robin]: Here, Nah. Have some water.

Nah: Thanks!

[Robin]: Gracious, you certainly took it up another notch today. It's a good thing we're in such an isolated spot here.

Nah: Gods, yeah. Can you imagine me running amok in the middle of town?

[Robin]: A grim thought indeed. But listen, I have a theory about why you need to rampage. I think they're a way for your dragon side to get some exercise.

Nah: Hmm, yeah. Could be. Is exercise something you humans do a lot?

[Robin]: Most of us, yes. It's a great way to get rid of stress and blow off steam. And the healers say regular exercise is the key to good health.

Nah: Do you uproot trees?

[Robin]: Er, no, not usually. In fact, almost never.

Nah: Oh. That's too bad. Uprooting trees is my favorite bit. Oh, so the other day in the village I saw a lady screaming at her husband. She was chasing him around the square with this huge rolling pin. Then she went in the house, threw his stuff out of the window, and stomped on it. Was that exercise? 'Cause it sure looked like a good workout.

[Robin]: Er, no. That's something different. Although I wager she was blowing off steam...

Nah: Hmm. Well, it seems my exercise needs to be destructive. I can't stop until I've splintered some trees or torn up a swathe of undergrowth.

[Robin]: It's a good thing we have plenty of forest to spare.

Nah: Oh, and I feel much better running amok for here with me.

[Robin]: Because I can make sure that you don't destroy anything important?

Nah: Because forests are dark and scary and have lots of ghosts. But when you're around, I'm not scared one little bit!

[Robin]: Heh. Sometimes I forget there's a little girl inside that monstrous beast.

Nah: So you ARE going to keep coming out with me for your exercises, aren't you?

[Robin]: Of course. I've grown quite fond of them, and of you... You're like the little sister I never had...and I guess the big monster I never had, too!

Nah: YAAAAAAAAAY!

Tiki

■ TIKI X AVATAR (FEMALE) [ROBIN] C

Tiki: Zzzzzzz...

[Robin]: (Is that Tiki? Looks like she's asleep; I better keep my voice down. (What is she thinking anyway, taking a nap out here?)

Tiki: Phzzzzzzth...

[Robin]: (She's going to catch her death of cold. If only I had a cloak to put over her...)

Tiki: Zzzzzzzzz...

[Robin]: (When she's all curled up asleep like that, she almost looks like a normal human girl.)

Tiki: Zzzzzz... Oh, Bantu... This is...the first time...I've seen a town... Thank you...

[Robin]: (Ah, listen to that. She's talking in her sleep. Dreaming about ancient times, no doubt.) (Hmm. I wonder how old she is, exactly.) (Thousands of years at least, if she remembers the age of legends...)

Tiki: Zzzzzz... That is...a secret...

[Robin]: (Did she just answer me in her sleep?) (...Heh. No. A coincidence, surely. But there's an easy way to make sure.) (Tiki, where did you used to live?)

Tiki: Zzz... Long ago, I lived with a great mage...in a secret, hidden house... Then I was laid down to sleep...in the temple of the ice dragon...

[Robin]: (Gracious! She's actually answering my questions!) (Hmm. It's odd how little we actually know about our friend Tiki here.) (This might be a golden opportunity to find out more...)

Tiki: Zzzzzz... *snort*

[Robin]: (Heh heh, this should be VERY interesting indeed...)

Tiki: Zzzzzz... I sense...danger... Zzzzzzzzzzzzzz...

■ TIKI X AVATAR (FEMALE) [ROBIN] B

Tiki: Zzzzzz...

[Robin]: (Well, hello there... Tiki is snoozing again, eh?) (Perhaps you need to nap more than normal people when you're thousands of years old.) Anyway, nap time for Tiki means question time for me! Now then...) (Tiki, what happened after you slept at the ice dragon's temple?)

Tiki: Zzzzzz... N-no!

[Robin]: Hmm?

Tiki: P-please...don't seal me away. I want...to be free... Zzzzzz...

[Robin]: What's going on?

Tiki: ...I...will not...allow this... You're making...me... ANGRY!

[Robin]: T-Tiki?! What's happening? Are you all right?

Tiki: Zzzzzz...

[Robin]: Gracious, she sounded truly terrified... Tiki, are you all right?

Tiki: ...Yes...I'm all right...Mar-Mar...

[Robin]: ...Mar-Mar? (Oh, wait. She must be talking about the ancient hero Marth.) (Something terrible happened for her long ago, but King Marth came to the rescue?)

Tiki: Mar-Mar...

[Robin]: (Aw, look. Her face is lighting up like a child on her birthday! So cute!) (She must have loved the ancient king very much.)

Tiki: Mar-Mar...please don't...go. Don't...leave me.

[Robin]: (...Oh, dear. Another sad time.) (I guess I assumed that living as long as Tiki would be all fun and games.) (All that time to do and see the things you desire? To learn whatever you want?) (But she must have experienced countless hardships as well.) (She would've watched the people she loved the most age and die...) (How terrible. I hope her dreams have some happy memories as well.)

Tiki: Zzz... Thank you...[Robin].

[Robin]: You're welcome, Tiki.

■ TIKI X AVATAR (FEMALE) [ROBIN] A

Tiki: Zzzzzz...

[Robin]: (Snoozing again? I'll keep quiet, but maybe I could ask just one more question...)

Tiki: Zzzzzz...

[Robin]: (After all, there is something I've been DYING to find out...) (It sounds like Tiki really liked the King Marth of long ago...) (But did she LIKE him, like him? Curious minds must know!)

Tiki: Zzzzzz...

[Robin]: (I mean, it would be a shame to let such a chance go to waste...)

Tiki: *Snort* Zzzzzzz?

[Robin]: (Er, Tiki? Hello, can you hear me? I want you to listen very carefully.) (Remember when you told me about ancient King Marth and how he saved you?) (Well, I was wondering... Did you love him?)

Tiki:

[Robin]: Hello? (This is odd. Usually she answers right away.) Hey, Tiki? Can you hear me? I'm asking you a question. Were you in love with King Marth? Did you want to marry him? Come on, spit it out!

[Robin]: Tiki: Tiki...is not home.

[Robin]: Hey! What kind of dreamspeak is that?! I'm supposed to answer my question!

Tiki: *Snort* H-huh?! Wooza wozza?! What's going on?!

[Robin]: Aw, nuts. I woke her up.

Tiki: [Robin]? Is there an emergency? Is the camp under attack?

[Robin]: Er, well... I mean, that is to say... You were... moaning in your sleep. I thought you were having some terrible nightmare and decided to wake you up.

Tiki: Really? Thanks, [Robin]. ...I think it was a nightmare. I vaguely remember being hounded by some awful hag. She wouldn't stop pestering me with personal questions.

[Robin]: O-oh? F-f-fancy that! What a funny dream! Heh hah!

Tiki: *Yaaawn* But I'm still pretty sleepy. You don't mind if I doze off again, do you?

[Robin]: Oh. No. Of course not. Be my guest.

Tiki: Just another forty winks and I'll...be ready...for action... Zzzzzzz...

[Robin]: (Whew! I dodged an arrow there!) (I couldn't very well tell her I was asking such private questions in her sleep...)

Tiki: Zzz... *mumble*

[Robin]: (She's talking in her sleep again! Let me just bend down here so I can get a good—)

Tiki: WAAAAAAAAARGH!

[Robin]: WAAAAAAAAARGH!

Tiki: ...all right, and before you leave...fetch a cloak to...lay over me... It's a bit chilly...down here... Zzzzzzzzzz...

[Robin]: Oh! Uh, right. Of course! Whatever you say, Tiki!

Tiki: Hee hee... Zzzzzz...

Gangrel

■ GANGREL X AVATAR (FEMALE) [ROBIN] C

Gangrel: Busy as always, eh, tactician? Careful now... Keep that nose of yours so close to the grindstone and you're like to sand it off!

[Robin]: Someone has to pick up the slack around here. Especially for those with nothing better to do than waste time with pointless banter.

Gangrel: Ho ho, you've a sharp tongue, milady, but hear me out. You may find your impatience misplaced.

[Robin]: I really have things to do...

Gangrel: You see, something's been troubling me for a while now... What's a woman like you doing in the service of a man like Chrom?

[Robin]: What do you mean?

Gangrel: Oh, Chrom's a brave fellow, true, but he's chosen a hard road to travel. I'm not sure I see the attraction for someone of your...caliber. Seems like you could do better than collect crumbs from his table.

[Robin]: It is a hard road, no denying it, but it's the same we've always traveled. Through thick and thin we've stuck together. I see no reason to change that.

Gangrel: Noble words and well spoken! But I expect nothing less. I've had my eye on you ever since our first battle...

[Robin]: Is there a point to all this?

Gangrel: I've had my say. ...For today. Just think on it, will you?

[Robin]: ...Think on what?

■ GANGREL X AVATAR (FEMALE) [ROBIN] B

Gangrel: There she is! Busy as a honeybee and accomplishing twice as much, I warrant! Gwa ha ha!

[Robin]: Why are you following me around? If you're looking for trouble...

Gangrel: Of course not! I have no quarrel to pick with you.

[Robin]: Then what DO you want? Why do you keep pestering me so?

Gangrel: You're not one for reading between the lines, are you? Then I shall spell it out... I want you to leave Chrom and his gang, and serve as my tactician instead.

[Robin]: You're trying to RECRUIT me?

Gangrel: Of course! Why else would I keep chatting you up?

[Robin]: Heh, indeed, why else would you...

Gangrel: Well then? I would have your answer. Will you serve as tactician to Plegia?

[Robin]: I'm...honored, I suppose? But no. I'd never take a position there.

Gangrel: Why not? Plegia's as fine a realm as any in the land!

[Robin]: Yes, it is. And I'm the tactician who inflicted a humiliating defeat on her. What would your people say if I were given control of their army?

Gangrel: The people? You don't have to worry about them! They love their old king, you know. If I tell them you're the woman for the job, they'll welcome you with open arms! Perhaps even hold a parade in your honor...

[Robin]: So after this war is over, you intend to return to Plegia?

Gangrel: I suppose. Most likely? I haven't given it much thought, to be honest...

[Robin]: What? But if you don't return, you'll have no need for a tactician anyway. Perhaps you should decide your own future before we start discussing mine.

Gangrel: Hmm, I suppose you're right. What AM I going to do after this war...?

[Robin]: Let me know what you come up with. ...Or don't. That's fine, too.

■ GANGREL X AVATAR (FEMALE) [ROBIN] A

Gangrel: Well, that's enough for today. Besides, it's time for Gangrel's daily visit. Every day, just like clockwork, that one.

Gangrel: Greetings, [Robin]! Guess whooooooo? Here, I brought you a gift from the market. Made a trip especially for you.

[Robin]: Flowers? Er...thank you...I guess? An odd sort of gift, coming from you.

Gangrel: Gwee hee hee! I suppose it is, now that you mention it. Not quite my image, eh? Truth is, this is the first time I've ever tried this sort of thing. In the old days, I couldn't swing my arms without striking some sycophant or another. And I did, fairly often... Gwar hee hee... Simpering merchants, fawning corporals, women of all types and...backgrounds. Everyone was agreeable, whether I earned their friendship or not.

[Robin]: It was the throne they revered, not the man who sat in it.

Gangrel: Really? Why, how shocking...

[Robin]: Anyway, have you made a decision yet? About where you'll go after the war?

Gangrel: Not yet. I'm still considering all the possibilities... That cur Validar left Plegia little more than a smoking ruin... She's a shadow of her former self, and no denying.

[Robin]: Your realm has suffered greatly, it's true.

Gangrel: When this war's done, I'm not sure there'll be a nation to govern or people to serve. ...But then again, if it CAN be saved, the former king is just the man for the job!

[Robin]:

Gangrel: What's this? I don't hear you disagreeing? In fact, your face almost looks...hopeful? Has my rousing speech convinced you to quit Chrom and cast your lot with me?

[Robin]: What? No! ...Not at all. But...I am glad to see you taking things seriously, for once.

Gangrel: Of course I do, when it comes to Plegia! I hope you'll do the same, tactician.

■ GANGREL X AVATAR (FEMALE) [ROBIN] S

Gangrel: Ho, tactician! Your favorite former monarch is here again! So, what say you? Have you made a decision? Will you take me up on my offer?

[Robin]: Gangrel, I see that you've been making a genuine effort to change... So in return, I've been giving your proposal some serious thought.

Gangrel: Oh, it's an effort, all right! I'm not used to begging and wheedling. Back in the old days, when I saw something I wanted, I took it! No questions asked!

[Robin]: I suppose being a murderous despot does have its advantages... So what of your past deeds? Have you any regrets?

Gangrel: Without question... Power can be a great and terrible thing... At some point I began to live for it and only it. I forgot what normal life was. Now I'm just Gangrel, foot soldier. It's easy to renounce my old wicked ways. But what if I return to Plegia and end up on the throne once again? I'm still a flawed, weak man. I'll need someone to keep me in line. Someone like you, for example. You wouldn't let me stray, would you?

[Robin]: It sounds like you're looking for a babysitter...

Gangrel: Gwa ha, no, I'm looking for YOU, [Robin]! I want you at my side.

[Robin]: This is starting to sound like a different kind of proposal altogether...

Gangrel: What do you mean? Could I be any more clear in asking for your hand in marriage?! Er, one moment... Did I forget that part?

[Robin]: What?! You've only talked about hiring me as a tactician...

Gangrel: Tactician, wife—it's all the same! Who cares about the details! You and me, together forever! THAT'S my proposition to you!

[Robin]: ...That has to be the most ham-fisted marriage proposal I've ever heard. ...If I were to accept, I'd need proof you've changed—and will STAY changed.

Gangrel: I swear it up and down! I will jump through whatever hoops you deem fit! With you at my side, I'll want for nothing... I could never be tempted by power again. You'll make me a better person, my lady. Someone who rules justly. Someone who makes the world a better place. ...But I won't neglect your happiness, either. Don't you worry! I'll love you like no man has ever loved, even once you become a wizened old hag.

[Robin]: That's...almost romantic, in a way... But if you speak the truth, I'd...I'd be honored to share my life with you.

Gangrel: Y-you would?! TRULY?! Gwa ha hooooooooo! Yes! [Robin] and I are to wed! This calls for a feast! Slaughter all the livestock you can find!

[Robin]: Oh gods, no! No one is doing that. Besides, we have more important matters to attend to first. Ruling justly...? Making the world a better place...? Remember...?

Gangrel: Oh, er, yes. Of course. Building a future of peace and prosperity... THEN we slaughter everything for the greatest feast this world has ever seen! Gwar ha ha ha ha ha!

[Robin]: This is going to take a little work...

[Confession]

Gangrel: How in blazes did you get me to...love you? If you're trying to make a new man of me, it's...working.

Walhart

■ WALHART X AVATAR (FEMALE) [ROBIN] C

[Robin]: Ah, Walhart. So this is where you've been hiding.

Walhart:

[Robin]: I was actually hoping to ask for your advice. Is now a good time?

Walhart: Groveling ill suits you. Remember that you are my superior in this army. Now state your business, tactician. What advice do you seek?

[Robin]: We're expecting tough battles ahead, as you know. So I was wondering what your approach would be if you were in charge.

Walhart: I cannot help you in this. I had little need for battle plans and plots. Little need for the cunning trickery of the tactician... I won battles on the mettle of my soldiers and the strength of their beliefs.

[Robin]: So you rejected strategy entirely?

Walhart: I was the Conqueror! Master of all men. My domain stretched from sea to sea! I had no disdain for your strategy. I simply had no need of it.

[Robin]: So all was decided on the battlefield? Man-to-man and steel to steel?

Walhart: Yes. But clearly mine was the wrong way. For it is I who stand here as your servant—I who am tarred forever with the ignominy and shame of ultimate defeat.

[Robin]: Though we question your motives, there is no shame in losing a war. You fought bravely and well. Nobody thinks less of you in defeat.

Walhart: Fool! Of course they do! They think me weak, and they are certain! If a man demands respect at the end of a sword, he has none left when it shatters.

[Robin]: Walhart, you lost a single battle. That hardly makes you weak.

Walhart: It does in my world. But I know that Chrom believes differently, and he is the victor. The vanquished have no right to their own convictions—they must follow their masters.

[Robin]: But it's a healthy thing to have a mix of different beliefs, new ways of doing things... Even if we don't agree with them, learning about other ideas only makes us stronger. You must promise not to forsake your views. I could learn something from your views.

Walhart: You speak as a child that has captured a particularly interesting insect... But no matter. I shall indulge your whim. There are worse ways to pass the time.

■ WALHART X AVATAR (FEMALE) [ROBIN] B

[Robin]: There you are, Walhart. I was hoping we might talk more.

Walhart: Come again to shake the jar of your captive insect, have you?

[Robin]: Your words, not mine. I'm simply hoping you can tell me more about your views.

Walhart: I don't know what fascination they hold, but you should remember this... Chrom was the victor, and together you have the power to vanquish all. You don't need the delusions of the defeated to make you stronger.

[Robin]: That's where you're wrong, Walhart. It was a miracle that we prevailed. The slightest nudge of the scales, and the outcome would've been far different.

Walhart: Pah! There's no such thing as miracles. You won by cunning and might alone. And I lost because of my own weakness. A weakness exposed by you!

[Robin]: So you believe all victors to be powerful, and all defeated weak. Is this accurate?

Walhart: You have the right of it.

[Robin]: Furthermore, you assert that the weak are obliged to obey the powerful. Is this so?

Walhart: That, too, is my belief.

[Robin]: Then change it.

Walhart: Where there's life, there's a will. And where there's will, there is the power to change. And that is what I want you to do.

Walhart: Your words are wind. They mean nothing.

[Robin]: To live is to make mistakes. We've all sipped the bitter cup of defeat, but we live to drink another day. What matters is not how often we fail, but what we learn from those failures.

Walhart: Learn from FAILURE? The very idea... Yet, as it comes from my victorious rival, I am obliged to consider it. Very well, tactician. I shall meditate upon your words, and we will speak again.

[Robin]: That's all I ask.

■ WALHART X AVATAR (FEMALE) [ROBIN] A

Walhart: [Robin]. What are you doing here?

[Robin]: It's time I sorted my old tomes, so I've unpacked the entire library. I didn't realize how many books I've collected! Goodness me. Maybe I... shouldn't have...picked up so many... S-starting to lose...balance!

Walhart: ...Idiocy. Here.

[Robin]: Walhart? What are you doing?

Walhart: You were struggling under the load. I decided to assist.

[Robin]: Riiight. But you're holding me, not the books...?

Walhart: It seemed the quickest way to help. But if it displeases you... ...There. Safely on your own two feet again.

[Robin]: *Cough* Er, thank you.

Walhart: Why do you carry your own tomes? Surely such menial work could be assigned to the grunts. Or prisoners of war.

[Robin]: Er...I don't think I'm comfortable with that.

Walhart: You are an army of equals, yes? Menial tasks are shared by all? Then even the great Walhart should not be above such things? Or do you just pay lip service to "equality" while the hierarchy is alive and well?

[Robin]: Fine. You win. ...Walhart, I order you to carry my books.

Walhart: Gladly. ...Hmm? This trunk is hardly heavy at all! Bah. The tactician who brought down my army has the strength of a mewling kitten! 'Tis amusing to think such a brilliant warmonger can barely lift a box of papers.

[Robin]: It wasn't me who brought you down. It was the combined strength of our army. Measured one against one, I'd barely come up to your ankle. ...Figuratively speaking.

Walhart: Yet you have the power to marshal the collective strength of your fellow men. The people of this world could do far worse than to have you as supreme ruler. I wager you could bring the prosperity and peace they've long yearned for.

[Robin]: I didn't realize you cared so much about the lives of the smallfolk.

Walhart: It was my methods that were wrong, not my motives. ...It all fell apart once I began to worship might for its own sake. That wicked Grimleal fanatic whispering lies in my ear didn't help matters... The responsibility was all mine, but I can't help but think... What if I met you instead of Excellus? Perhaps I'd have seen the error of my ways. Perhaps I'd have become the benevolent monarch I first set out to be...

[Robin]: It's not too late. You still have the power to put things right. To improve the lives of all.

Walhart: I can scarce believe such folly.

[Robin]: Remember what I told you before? Where there's life, there's a will. And where there's will, there is the power to change.

Walhart: ...Very well. As you have spoken truth to me before, I shall trust you and your words.

[Robin]: It's all true. You'll see...

■ WALHART X AVATAR (FEMALE) [ROBIN] S

Walhart: Ah, here you are.

[Robin]: Walhart. What can I do for you?

Walhart: It's about what you said the other day. About life and will...and power to change.

[Robin]: Yes, I remember.

Walhart: I've been thinking about how I might change. About how I SHOULD change.

[Robin]: Go on...

Walhart: Since you and Chrom defeated me, I've learned a great deal. For example, about Emmeryn's vision for the world... It is a vision I would very much like to see come true.

[Robin]: That is...very surprising.

Walhart: I don't know rightly if this is what you meant by "change." But I know what my mission is now. I'm going to work for a future where Emmeryn's dream is a reality.

[Robin]: Why, that's wonderful, Walhart! It truly is.

Walhart: Then I know it is the right decision.

[Robin]: You know, Walhart, you used to be so intimidating and angry, but now look at you!

Walhart: Yes, I do come across that way...

[Robin]: Beneath all the bluster and menace, you have...dare I say it? A soft heart? ...Even as you were setting out on a path of conquest and subjugation.

Walhart: I sought to unite the world under my rule and thereby foster peace and happiness. But I chose the wrong path—one which led only to destruction and despair.

[Robin]: So start anew. Take what you've learned, and try again, but do it differently. Your goal hasn't changed. You just need to follow a new road to reach it.

Walhart: Where there's life, there's a will. And where there's a will...

[Robin]: Exactly!

Walhart: When I walk this new road, I would have you at my side to lend me strength.

[Robin]: You mean...as a tactician?

Walhart: No. As a partner in life. ...As my wife.

[Robin]: You're for real?!

Walhart: It can only be you. You must guide me on this new road, lest I stray from it again. And, more importantly, I've grown...very fond of you.

[Robin]: Oh.

Walhart: You do not have to give me an answer right away. Think upon it. I'm willing to wait for as long as it takes.

[Robin]: Actually, I don't need any time at all. We can walk that road together.

Walhart: Then the future is bright, indeed. For both of us, and the world!

[Confession]

Walhart: With you at my side, the path to glory shall be an easier one. Let us become as gods of strength and happiness!

Emmeryn

■ EMMERYN X AVATAR (FEMALE) [ROBIN] C

[Robin]: How are you feeling, Your Grace?

Emmeryn:

[Robin]: If something troubles or concerns you, you will tell me, won't you?

Emmeryn: There is nothing...troubling me.

[Robin]: Well, I'm pleased to hear that! But you must promise to let me know if anything changes.

Emmeryn: Very...well.

[Robin]: I still remember those events as clearly as if they happened yesterday. That heady time when we fought against the Plegian threat side by side.

Emmeryn:

[Robin]: You were a true inspiration to me. You know that? You strove so hard to avoid war and safeguard peace against all odds. And you persevered even when principles caused you and Chrom to clash.

Emmeryn:

[Robin]: But I know Chrom wants peace as badly as you. He shares your dream.

Emmeryn: I don't...understand.

[Robin]: It's okay, Your Grace. You're tired, and you've not recovered your memories. I doubt I'm making much sense.

Emmeryn: No, I...want to hear...it. Please...continue.

[Robin]: Er, that's it, really. I just wanted to know that we're doing what you wished. We're on the right road. I'm sure of it. The road that leads to peace.

Emmeryn: ...Peace...

[Robin]: Yes, that's right. We're making your dream come true.

Emmeryn: Do I...help or...hinder? This...shell of me?

Emmeryn: You help, of course!

Emmeryn: That...is...good.

[Robin]: So you mustn't give up on us OR yourself!

■ EMMERYN X AVATAR (FEMALE) [ROBIN] B

[Robin]: How do you feel today, Your Grace?

Emmeryn: Will you...talk to me...again? As you did...before?

[Robin]: If it pleases you. Perhaps I can tell you about Chrom. Would you like that?

Emmeryn: Chrom is...my...brother?

[Robin]: That's right. He took over the throne, after you... Er, after you left. He's become a fine ruler. A beacon of hope, for people all across the world. They trust him to bring about a future of peace and prosperity.

Emmeryn: Peace...and...prosperity...

[Robin]: We're not there yet, though. We're fighting a terrible war against frightening odds. But at least Chrom gives us hope, even in these desperate hours. I know you'll be proud of him when you finally see all he has done.

Emmeryn: Very...well...

[Robin]: Of course, once you've recovered, the first priority will be to reclaim your throne. You're still the exalt, after all.

Emmeryn: I am...exalt? I do not...understand...

[Robin]: No, of course you wouldn't. Not yet, anyway.

Emmeryn: Chrom is...ruler. Chrom is...exalt. He must... lead.

[Robin]: Well...if that were to be your wish, then of course it would be done.

Emmeryn:

[Robin]: But it's too early for that, now. When your memory has returned, then you can make a decision.

Emmeryn: Wh-why not...now?

[Robin]: Because... Well, because Chrom wants you back on the throne, that's why! The thought that you'll return gives him strength, to keep going.

Emmeryn: I...see. I shall...do as you say.

[Robin]: You just focus on recovering your memories, and I'll drop by whenever I can to help.

■ EMMERYN X AVATAR (FEMALE) [ROBIN] A

[Robin]: Your Grace. How are you today?

Emmeryn:

[Robin]: Your Grace? ...Emmeryn? Are you all right? Are you feeling unwell?

Emmeryn: I am...quite well. I have been...thinking.

[Robin]: You have?

Emmeryn: What...am I? Who...am I?

[Robin]: But... You're...

Emmeryn: So I am...told. But...with no memories...I cannot...lead. I cannot...inspire. I am...an empty shell. A burden... Of no use...to anyone.

[Robin]: Nothing could be further from the truth! Why have you started thinking like this? Was it something I said?

Emmeryn: You did...nothing...wrong.

[Robin]: No, I did. It was all that talk about Chrom being an inspiration to us, was it not? About his need for you to recover your memories and reclaim your rightful throne? I've been putting too much pressure on you... Of course you feel helpless. Oh, Your Grace! Please forgive me!

Emmeryn: Stop...blaming...yourself. You are...innocent.

[Robin]: But, Your Grace!

Emmeryn: I am...glad to...speak...to you...[Robin]. I am grateful...that you...come to me...like this... I...did not know...what I must...do... But now...I have...a goal. A reason...to live.

[Robin]:

Emmeryn: I am...most grateful...to you. I'm sorry...I am still...so weak...

[Robin]: You're growing stronger every day. I'm sorry if I ever made you doubt it.

Emmeryn: Don't...blame yourself. Just...promise me... that you...will help until...I am strong...

[Robin]: Of course I will, Emmeryn! I shall stay with you always, whether you recover your memories or not! A bond of friendship unites us now, and never shall it be broken.

Emmeryn: ...You...serve me...because...I am...exalt. It is...your...duty...

[Robin]: I serve you because you are my friend.

Emmeryn: [Robin]... Thank...you...

Yen'fay

■ YEN'FAY X AVATAR (FEMALE) [ROBIN] C

[Robin]: Oh! Hello, Yen'fay.

Yen'fay:

[Robin]: Why are you sitting on the floor? I almost stepped on you!

Yen'fay: I was meditating. It soothes the mind and brings the spirit into balance. Do you have need of me?

[Robin]: Well, er, we're all going to have some tea. I was wondering if you'd care to join us.

Yen'fay: Your invitation is...unexpected. However, I am a ghost from another world, and not fit for human company. A ghost who let his loved ones die. A ghost who lives in shame and ignominy.

[Robin]: That's a bit excessive, don't you think?

Yen'fay: The truth is cold and hard; self-deceit cannot blunt its edge. I am not worthy to be a part of this world's affairs, save in battle.

[Robin]: Surely your people would be thrilled to welcome the return of their leader?

Yen'fay: I am not the Yen'fay of this world. Chon'sin's ruler is dead.

[Robin]: Well, yes, I suppose that's true. It would be difficult for you to replace the real Yen'fay. His death is well known. But remember: WE need you, and those lethal skills of yours. That's something!

Yen'fay: I have nothing left to offer. I am a blade and nothing more. A blade who owes a debt to both you and Chrom. It is my obligation to give myself utterly in your service.

[Robin]: And we're grateful for it, Yen'fay. We could use more like you.

■ YEN'FAY X AVATAR (FEMALE) [ROBIN] B

[Robin]: Whoa, Yen'fay!

Yen'fay:

[Robin]: Gods, I almost stepped on you again! (...Wait, is he asleep?) (His eyes are shut tight...it—)

Yen'fay: I told you already—this is how I meditate.

[Robin]: Ah, yes, you did say that, didn't you? How silly of me to forget.

Yen'fay: When I meditate, I visualize both my foes and my allies in battle. I conjure up countless scenarios, and thus prepare to meet any eventuality.

[Robin]: Heh, and here it looks to all the world like you're just snoozing the day away...

Yen'fay: It is an ancient practice of my culture. It has no equivalent in your own. I am not surprised you find it difficult to comprehend.

[Robin]: Er, so when you imagine these scenes, do you see yourself fighting the foes?

Yen'fay: Yes. It is important to repeat basic moves over and over in your mind. This allows the body to move by instinct alone in the heat of battle.

[Robin]: I must say, it's reassuring to have someone so well prepared fighting on our side.

Yen'fay: My warrior's prowess is all I have left. If I am to be your blade, I must be sure my edge is honed to razor sharpness.

[Robin]: Er, indeed... Like I said—very reassuring. Just be careful not to wear yourself out.

Yen'fay: Your concern is unnecessary.

■ YEN'FAY X AVATAR (FEMALE) [ROBIN] A

[Robin]: (Ah, Yen'fay on the floor again... He sure does love his meditation.)

Yen'fay: ...Mmm? Ah, curse it! This is most embarrassing... I was supposed to be meditating, but I seem to have fallen asleep.

[Robin]: Don't tell me... Even the mighty Yen'fay gets tired sometimes?

Yen'fay:

[Robin]: Yen'fay? Is something wrong?

Yen'fay: I was dreaming...of my homeland.

[Robin]: Oh?

Yen'fay: I try not to think upon the past. Reminiscing does not help in war. My goal is to be an unthinking blade, without needs, memory, or regret.

[Robin]: But no matter how hard you try, you can't help but yearn for your homeland?

Yen'fay: Is it writ so clearly on my face? My training has been poor if I am betrayed so easily by emotion.

[Robin]: It's okay, Yen'fay. Longing for the home of your youth just makes you human. You're not just a blade that we send out to chop Risen in half, you know? You're a person. ...And a friend.

Yen'fay: You speak kindly, [Robin]. The people of Chon'sin are strong—they will rebuild with or without me. So when this war is done, and our nations again know the sweet blessing of peace... I must set out to discover a new path for myself.

[Robin]: A new path?

Yen'fay: I cannot return to my true home. And what use is a blade with no war to fight? I saw it in my dream. The future of this world has no place for the likes of me.

[Robin]: As long as the flame of life still burns inside you, you will have a role.

Yen'fay: You speak as a poet, [Robin].

[Robin]: I'm just telling the truth. You'll find what you're looking for, I know you will. After all, when this war is won, you'll have plenty of time to find your way.

Yen'fay: Thank you. Your encouragement... It carries a great deal of weight. You are the only person to whom I dare confess my...weaknesses. There is no one that I trust more in this world... ...My friend.

■ YEN'FAY X AVATAR (FEMALE) [ROBIN] S

Yen'fay: Ah, there you are.

[Robin]: Hello, Yen'fay.

Yen'fay: I have something important I wish to discuss with you.

[Robin]: Oh? What is it?

Yen'fay: It's about our talk...regarding my life after the war. Though this may be presumptuous, I would beg a boon of you.

[Robin]: I'd be delighted to help any way I can. What is it?

Yen'fay: When this war is done, I shall be wandering, without purpose... When that happens, I want you at my side.

[Robin]: I'm...not sure what you mean...?

Yen'fay: You have been so kind to me. Advising me. Helping me. On each occasion, you gave me the inner strength to persevere. I've begun to believe that with your help, I could have found my final home.

[Robin]: But, how...?

Yen'fay: In life, there are many paths we can follow and many choices to be made. It is far easier to find your way if you have someone you trust. Someone you trust. Someone you love... Or so I have come to believe, thanks to you.

[Robin]: Yen'fay, I'm... I'm so happy to hear you say that, you have no idea! I feel the same way...I never want to leave your side. Whatever happens. We will find our way, you and I, both. And we'll find it together.

Yen'fay: Yes, together...

[Confession]

Yen'fay: I claim to be no master in the arts of romance, but my love for you shall be challenged by none!

Aversa

■ AVERSA X AVATAR (FEMALE) [ROBIN] C

Aversa: ...Which concludes my report for today, my lord. You will return to your duties. If you require anything else, you have but to summon me.

[Robin]: ...Was that Aversa? What was she doing in Chrom's tent? Hey, Aversa! Hold a moment!

Aversa: Why, if it isn't the former tactician. What do you want with me, anyway?

[Robin]: Former? What do you mean by that?

Aversa: Just what I said. Oh, you've done a decent enough job as tactician, I'll give you... But I think we all agree it's time you took a break and let the professionals take over. Go put your feet up, and have a cup of tea. Chrom's little army is safe in my hands now.

[Robin]: You scheming witch! I'M the tactician. I always have been, and I always will be.

Aversa: Heh. Well, that's not really up to you, now is it? Chrom and his soldiers need the best, and the best happens to be me.

[Robin]: Are you saying you know more about running a battle than I do?

Aversa: Must I spell it out for you? When we faced off against each other, whose fingers got burned the most?

[Robin]: I'll grant you that you were a challenging foe, but it was I who claimed ultimate victory.

Aversa: Ah! I think I see the source of your confusion... Allow me to clarify. You think Chrom won BECAUSE of you, whereas, in fact, he won DESPITE you. Trust me. When I'm his tactician, this campaign will go much more smoothly.

[Robin]: You try and twist the words around your forked tongue, but the truth won't bend. I know what I've done, what I've achieved. Your lies don't change that.

Aversa: Well, well! The little weasel has some fire in her yet... Clearly she won't give up her playthings without a tantrum... Still, time and ability are on my side. I'll soon have your precious lot. Then Chrom will realize it's me that he wants! ME! Hoo ho ho hee hee heh!

[Robin]: ...I suppose I shouldn't be surprised by any of this, really.

■ AVERSA X AVATAR (FEMALE) [ROBIN] B

Aversa: Chrom? CHROM? ...Now where did he go? I was sure he was around here somewhere.

[Robin]: Hello, Aversa. Looking for Chrom? If you have a message, perhaps you can leave it with his tactician.

Aversa: When a lady needs to see her lord, there's no need to involve former staff. Especially when it's of a personal nature. Chrom and his NEW tactician have private business. ...So run along.

[Robin]: I see your fantasy life is as rich as ever. To think such a delusional fool would ever become tactician. Ha!

Aversa: Delusional? I think not. Chrom is a hot-blooded man, after all, and young besides. And when two young, passionate people are thrown together in such situations... Well, sparks can fly.

[Robin]: Two young people? You must be a dozen years older than him if you're a day.

Aversa: Why, you insolent little... Eight years! That's all I have on him! Eight!

[Robin]: It might as well be a century.

Aversa: Gya! If it wasn't for my impeccable social graces, I'd teach you some manners...

[Robin]: Hah! I'm sure an alley cat like yourself can do little more than scratch and hiss... But I won't be found brawling in the mud like a circus act. Strategists must set an example. ...Which you should know.

Aversa: You would lecture me on decorum? After your comment on my age? Very well. Since you refuse to see reason, you leave me no alternative... I challenge you to a duel!

[Robin]: A duel?! Pah! You truly see that as an appropriate way to decide who becomes tactician?

Aversa: Yes! My second will let you know the time and place. If you flee, or do not appear, I will win by default.

[Robin]: Wait, what?! Hold on! I didn't agree to anything!

■ AVERSA X AVATAR (FEMALE) [ROBIN] A

Aversa: So you've come for our duel. ...I must confess, I'm surprised.

[Robin]: This is absurd. We're supposed to be battling a common foe, not each other. But if it's a fight you want, then a fight you shall have.

Aversa: To the victor goes the spoils! Now, might shall decide what's right!

[Robin]: Come and get— ...Hold on. ...I can't help but feel like we're being watched. Are you certain we're the only ones out here?

Aversa: Of course I am. ...Unless you planted an ambush!

[Robin]: Why in blazes would I bring it up if they were my own men?!

Aversa: If they aren't yours... And they aren't mine... They must be... The enemy?!

[Robin]: Then your defeat will have to wait. We must join forces until we can get back to the camp. Agreed? Now let's move!

Aversa: And here I had such terrible things planned for you... *Sigh* Yes, we fight as allies for now. Let's go.

[Robin]: *Pant, pant, pant* We should be *pant* safe now... Enemy won't dare...come this close to camp...

Aversa: *Pant, pant* Th-thank the...gods... Not used *pant* to r-running...so fast...

[Robin]: ...Still, you...saved both our skins. If it wasn't for that trap you sprung, they would have been on us... Although... When'd you set that trap? Planning to cheat in our little duel?

Aversa: You're one to talk! Who was it that cut the escape route through the woods? You wanted to make sure you had a way out in case our fight didn't go your way.

[Robin]: You weren't complaining about it when we fled to safety, were you?

Aversa: ...Well, I may have been a LITTLE glad for it at the time.

[Robin]: If we didn't have each other, we'd both be in Risen stomachs right now.

Aversa: Who would have thought we'd make such an effective team? Perhaps... Perhaps you and I should try working together for a change.

[Robin]: Are you offering to help with tactical planning? Hmm... You would bring a lot of experience, at least...

Aversa: It's settled, then. We shall help each other. For now. But make no mistake. I'll be right behind you... And the first time you slip up...

[Robin]: You'll jump in and install yourself as Chrom's right-hand woman? Hah, got it. Don't worry, Aversa. I know EXACTLY how you think. But you know what? Sometimes the company of rivals can be a good thing.

Priam

■ PRIAM X AVATAR (FEMALE) [ROBIN] C

[Robin]: Hello, Priam. More swordplay?

Priam: Stay back—this is a real blade I'm training with! Hyeah! Ho! Hyuh!

[Robin]: Amazing! You cut the log into perfect thirds, all without touching a branch!

Priam: ...Did you need something?

[Robin]: We're about to drill some group formations. Care to join us?

Priam: I seek the strength of the single warrior, the indomitable king of steel. It is my goal to stand as the mightiest of all rivals on the battlefield. I have no need for parade-ground quadrilles.

[Robin]: I admire any soldier who wants to make themselves stronger... However, my duty is to build our fighting force into a cohesive and effective unit.

Priam: I've no desire to denigrate your work, so long as I may follow my own path.

[Robin]: Well, individual strength IS important... Perhaps I should train solo more often.

Priam: Anyone who dares step onto a battlefield needs to be physically ready.

[Robin]: Then perhaps you would be so kind as to provide me with some training?

Priam: You are asking to be my pupil?

[Robin]: Well, why not? Everyone says your martial prowess is second to none.

Priam: ...Very well. You may join my training sessions. I will provide occasional guidance.

[Robin]: Then I look forward to our first lesson, Master Priam.

■ PRIAM X AVATAR (FEMALE) [ROBIN] B

[Robin]: Master Priam, would you consent to some fencing lessons today?

Priam: Only if you stop this "Master" nonsense. Just Priam is fine.

[Robin]: Oh, and here I thought you'd like that... Very well, Priam—where do we start?

Priam: With your weapon. Unsheathe it. Admire it. See how it glints. A sword is not some crude implement to be waved about like a party favor. We must draw upon the ambient energies that infuse the air to guide the blade.

[Robin]: Ambient energies? Er, you're not talking about magic, are you?

Priam: No. I speak of something else. It is difficult to grasp at first, but as you train, you can feel this energy begin to flow. That is, IF you prepare your mind. You must remove all barriers to self-knowledge.

[Robin]: I will try. With everything I am, I will try.

Priam: Then you are ready for the first step.

■ PRIAM X AVATAR (FEMALE) [ROBIN] A

Priam: [Robin].

[Robin]: Hello, Priam.

Priam: I left some of my belongings here. You didn't happen to see them, did you?

[Robin]: Oh, I'm sorry! I forgot to tell you...

Priam: Tell me what?

[Robin]: I had a little spare time, so I thought I'd do your laundry for you.

Priam: My...laundry?

[Robin]: Yes, I washed all your soiled training gear. I also patched some of the larger holes. I hope you're not upset. Should I have asked first?

Priam: No, it's fine. But...why would you do such a thing?

[Robin]: Well, you've spent so much time teaching me about swordplay, I wanted some way to repay you. This was the best I could come up with.

Priam: I see. Still, it was unnecessary. I can wash my own clothes.

[Robin]: Hold on a second... Priam, are you blushing?

Priam: Me? Blush? Of course not! What foolishness! I am a warrior of the sword. Nothing can faze me. Nothing!

[Robin]: You're red as a tomato! Heh heh. I never thought I'd see the day.

Priam: S-silence! I'm not blushing. ...I must go. You... have my thanks. ...For the laundry.

[Robin]: Heh heh, had no idea he had such a sensitive side...

■ PRIAM X AVATAR (FEMALE) [ROBIN] S

Priam: [Robin], are you there?

[Robin]: Oh, hello, Priam. Are we due for another fencing lesson?

Priam: No. I wanted to...thank you again. ...For taking care of my clothing. This is for you... I bought it from a merchant in the last town.

[Robin]: Why, Priam, what an ornate ring! Er, hold on a moment. Are you asking me—

Priam: It has no special meaning, mind! It's just a token of gratitude. I'm no expert on women's accessories... I just picked something at random.

[Robin]: Well, you did quite well. I think it's lovely. Still, it must have cost a fortune. Isn't it a little extravagant for a thank-you gift?

Priam:

[Robin]: Priam?

Priam: Damn, but you are persistent... Very well. It's not just a thank-you gift. It's a token of my great... respect. I am a man who is dedicated to combat and the way of the sword. However, in recent weeks, it has been you who dominates my thoughts. And I...think I have fallen...in love.

[Robin]: ...Are you serious?

Priam: Of course I'm serious! Why would I joke about something like this?

[Robin]: But...how? When? Why?

Priam: Because in your heart, I've found a new way. You have been gentle and caring to me, yet still stronger than any steel. All my life, I have lived only for the blade. But now I want to live for you.

[Robin]: Oh, Priam. I just had to be sure your feelings were heartfelt! I feel the same way! I have for... It feels like such a long time.

Priam: Then you'll say yes? For true? Oh! Huzzah! HUZZAH!

[Robin]: Hee hee, why, Priam, I've never seen you so... emotional.

Priam: I would not normally allow myself such a...display. But when you follow the way of love, you must let your feelings sing. Anything else would be a grave disservice to the one you pledge your heart to.

[Robin]: Indeed, and poetically put. Perhaps for you, a pen truly would be mightier than a sword.

Priam: Well, let us not get carried away...

[Confession]

Priam: You give my strength new purpose—and meaning. I'll let the world burn before I see you hurt.

Chrom

Avatar (male)

The dialogue between Avatar (male) and Chrom can be found on page 218.

Avatar (female)

The dialogue between Avatar (female) and Chrom can be found on page 228.

Lissa

LISSA X CHROM C

Lissa: *Siiiiiigh*

Chrom: Well, that was a big one.

Lissa: Oh! Chrom!

Chrom: Something on your mind? Or are you just sighing for the sheer joy of it?

Lissa: Well, it's just... Do I... Do I seem like a princess to you?

Chrom: Er, how's that?

Lissa: I'm asking if I seem like a princess!

Chrom: If you aren't, you owe us some rent for your room in the castle...

Lissa: Oh, hardy har! That's not what I mean and you know it. I'm asking if you think I live up to my station.

Chrom: What brought this on?

Lissa: When I compare myself to you and Emmeryn, I...I feel like dead weight.

Chrom: What a stupid thing to say.

Lissa: Hey!

Chrom: Well? It's the truth. You're fine just how you are, Lissa. Give yourself a little credit. I'll see you later.

Lissa: What? Hey! Don't give me a lazy answer and then run away! I hope you trip and break your nose, jerkface! ...Okay, that last bit may not have been the most princess-like.

■ LISSA X CHROM B

Lissa: All right. The coast is clear.

Chrom: Lissa?

Lissa: Ack! B-brother! Hey there! How are...things... with the war?

Chrom: Where are you going?

Lissa: Oh, the weather's just SO lovely, so I thought I'd take a little stroll and—

Chrom: It's raining.

Lissa: IS IT? Oh, fiddle dee dee! It was sunny just a moment—

Chrom: It's been raining for three days.

Lissa: Urk.

Chrom: All right, fess up: Where do you keep running off to lately?

Lissa: Me? Run off? Ha ha! You're crazy, Chrom. Stop being crazy.

Chrom: [Robin] has also been asking about you. ...About how you knew so much regarding the enemy's formation in that last battle. Please don't tell me you've been scouting all by yourself, Lissa.

Lissa: ...So it'd be okay if I didn't tell you?

Chrom: You fool! What would you have done if they'd caught you?!

Lissa: I... I didn't... I don't know! I just knew I had to do something to help! It's my duty as princess to fight and—

Chrom: And what?! To become a high-ranking hostage?! To be tortured for information?! And gods, are you REALLY still on about this princess stuff?!

Lissa: You wouldn't understand! You don't know what it's like to be your and Emmeryn's little sister!

Chrom: ...Look. If you want a mission so badly, I'll give you one: Go ask everyone in camp how you can be a better princess.

Lissa: What?

Chrom: It doesn't have to be today, but do it. ...And yes, that's an order.

Lissa: Oh, for the... All right. Fine...

■ LISSA X CHROM A

Chrom: How goes the mission I gave you, Lissa?

Lissa: It's over. I talked to everyone. I asked them all how I could be a better princess, just like you asked.

Chrom: And what did they say?

Lissa: A dozen different things! One guy said I should be more calm and stop throwing tantrums. Another person said I should stop being so picky about what I eat, which was weird. Oh, and a certain someone told me to stick my pinky out when I drink tea. Ugh!

Chrom: And the most common response?

Lissa: What do you mean?

Chrom: Surely some people had the same advice, right? What did you hear the most?

Lissa: Um... Well, there were a whole lot of people who said "nothing."

Chrom: So there you have it.

Lissa: There I have what?

Chrom: I told you you're fine just as you are, didn't I? And the people agree!

Lissa: Yeah, but... I still don't feel like I'm contributing anything.

Chrom: When you approached people, how did they react? And I mean before you said anything, I'd bet good coin they all smiled at you. ...Right?

Lissa: What? No, they... Hmm... Yeah, I guess they did.

Chrom: You make people happy, Lissa. You motivate and inspire them just by your presence. I might instill confidence, but I don't make them happy. And neither would Emmeryn.

Lissa: You think so?

Chrom: I KNOW so. And believe me, that talent is more useful than you'd think. Everyone else knows it, too. That's why they told you not to change a thing. So if you won't trust my opinion, how about theirs? You're their princess, after all.

Lissa: Well, I mean... There I do, but...

Chrom: Then stop worrying! You're going to be a princess all your life. That's plenty of time to figure it out. Just be yourself and the rest will come naturally.

Lissa: ...Huh. That actually makes sense. Thanks, Chrom.

Frederick

■ FREDERICK X CHROM C

Frederick: I've completed my patrol of the encampment, milord. All appears to be in order. I found no

sign of the enemy nearby. I believe we are safe here for the night.

Chrom: Good to hear. Thank you, Frederick.

Frederick: While on my rounds, I took it upon myself to inspect our weaponry as well. I've placed any items that showed exceptional wear outside your pavilion. Be your choice to sell or repair them, sire, I recommend swift action.

Chrom: ...Oh. Well, you HAVE been busy... Your work ethic always impresses, Frederick. I almost feel lazy by comparison.

Frederick: Nonsense. I've done nothing more than my duty as a knight of Ylisse. Oh, and beg pardon, milord, but I noticed you often cause a ruckus when training. With that in mind, I reinforced the tents near any open areas you're like to use.

Chrom: Er, yes. I see. Sorry for the trouble.

Frederick: No trouble at all, milord. Happy to help. ...Also, with the nights growing colder, I procured blankets from a nearby village. I had an artisan create posters emblazoned with your noble image. Yes, that's best. Blue it is! Here you are, milord. And two sets of spares, just in case.

Chrom: Frederick, do you never tire?

Frederick: Of course not, milord. I am here to serve. Ah, and one final thing: I've taken measures to raise troop numbers and morale. I had an artisan create posters emblazoned with your noble image. My milord in a bold pose—mind you, a scale in one hand and a sword in the other. And at your feet, I scrawled our new recruiting motto: "Chrom Wants You!" I had them pinned inside each and every tent. Surely the troops would be thrilled to rally behind their common leader, milord.

Chrom: ...Wait. You did what?! In whose... You hung this pict... In EVERYONE'S tent?!

Frederick: No need for thanks, milord. Merely doing my duty. And that concludes my report. Rest well, sire!

Chrom: F-Frederick! Wait! We really need to... talk. ...Oh, gods. I've got to tear those posters down before anyone sees them!

■ FREDERICK X CHROM B

Frederick: My deepest apologies, milord. Had I known you'd run from tent to tent rending the posters, I never would have—

Chrom: Gods, I've never been so embarrassed in all my days! My sister nearly pulled a muscle laughing! Listen, Frederick. We need to talk. I know everything you do is for my sake, and I appreciate it. But it's... Well, at times, it's a little extreme. And other times it's damn near traumatic! I'm a grown man, Frederick, and I'm capable of taking care of myself.

Frederick: 'Tis not my place to doubt your capability, milord, but I've duties as a knight. If anything were to happen to you or Lissa, I couldn't... I don't know if I could stand it.

Chrom: But you do see the difference between being a knight and being a nanny?

Frederick: ...I'm sorry, milord, but I would risk your embarrassment rather than forsake my duty.

Chrom: ...Fine! Fine. Let's try this again. Let's pretend you're "milord," and I'm your loyal knight. Now, let's say you sneeze. Just one little sneeze... Suddenly I come dashing up to you with blanket and tea in hand! Or, let's imagine you make an off-hand remark about how fish sounds good... And I ride across two mountains to a freezing river to secure dinner! Or, heavens preserve us, let's suppose you look tired, or perhaps even yawn... So I bring a parade of increasingly arcane herbal cures to your tent for the next hour! How would that make you feel?

Frederick: Milord, I... I would be enraged, milord. And humiliated.

Chrom: You see? At some point, such assistance becomes a burden. I respect your sense of duty as a knight, but you must be sane about it! You waste so much time and energy on me and myself, and it saddens us. If you want to make us happy, take some time for yourself. Relax! Enjoy your life!

Frederick: ...I suppose, milord.

Chrom: *Sigh* If it was, I've no doubt you would obey without question. But that would defeat the point. It's not an order, Frederick. It's a request. ...From one friend to another.

Frederick: Milord... Very well. If it is your wish, I shall limit my actions to a bare minimum. I apologize for any trouble my efforts may have caused until now.

Chrom: Thanks for understanding. And for your dedication.

Frederick: It is my pleasure to serve, milord. Er, that is...within reason.

■ FREDERICK X CHROM A

Frederick: ...And that concludes today's report, milord.

Chrom: All right. Thank you, Frederick.

Frederick: *Sigh*

Chrom: Now there's something I never expected to hear. Is everything all right, Frederick?

Frederick: Oh! M-my apologies, sire! I did not mean for you to hear that.

Chrom: It's fine, but are you all right? You're not coming down with something, are you?

Frederick: Not at all, milord. I'm the picture of health.

Chrom: Then why have you seemed so exhausted lately? You looked pale as a sheet this morning! I thought a Risen had entered our camp. The other Shepherds are worried as well. Is something the matter?

Frederick: Milord, I apologize again. I'm just... You see... I feel I've been of no use to either you or Lissa of late...

Chrom: Hmm? What was that? You're mumbling.

Frederick: N-nothing, milord! It's nothing. Perhaps I simply need a bit of sleep.

Chrom: Then go rest! And if there's anything bothering you, come tell me straightaway. Oh, but before you go... Thank you for patching the holes in everyone's tents. I know mine is a lot more comfortable without that blasted draft.

Frederick: But milord, I... How did you know?

Chrom: Who else would fix a tiny detail like that after a long day of battle?! So again, my friend, thank you. From everyone. There are days I think this entire army would fall apart if not for you.

Frederick: Milord, I... I don't know what to say. Your praise is the highest honor!

Chrom: Ha ha! It's just the truth, Frederick. That's all. Now, if you'll excuse me, I need to go speak with [Robin].

Frederick: Yes, of course. [Robin]'s tent is...that way, wasn't it? I'll get started straightaway, milord!

Chrom: Get started... Just as you clearing the gravel?! Frederick, what in the world are you doing?!

Frederick: It wouldn't do to have you trip up and hurt yourself, sire! Surely you see... ...Ah! Are you worried you could trip over ME, then? Of course. Not to worry, sire! I have a plan that will let me clear the path well ahead of you.

Chrom: Um...Frederick?

Frederick: Is something amiss, milord? Ah, of course! The reeds are a hazard as well. I'll just pluck them here...

Chrom: That's...not what I was going to say.

Frederick: So careless of me, sire! I'll have the devils uprooted in just a moment!

Chrom: Oh, for the love of...

Frederick: All clear, sire! You can trod through camp without worry or delay!

Chrom: (Is this his idea of keeping things to a minimum?)

Chrom: Still, I suppose it keeps him happy.

Frederick: Mmm? Did you say something, milord?!

Chrom: Er...Frederick?! For the love of the gods! I have a meeting with [Robin].

Frederick: Oh, yes, of course [Robin] is now. Hello, [Robin]. Do pardon the intrusion.

Chrom: Frederick! We don't need you to... You can dust later! And actually, you don't need to dust [Robin] at all, Frederick! ...FREDERICK!

Sully

■ SULLY X CHROM C

Chrom: Hmm? Oh, hey, Sully.

Sully: Hello, Chrom.

Chrom: Are you here alone? I thought you'd be with Lissa and the rest of the women.

Sully: Why, so I can make dinner for all the brave men? Nuts to that. I'll tend the fire.

Chrom: That seems like a lot of hard work for one person.

Sully: Would you rather I cook? Or sew? No thanks. I hate all that crap.

Chrom: Huh. Well, I guess I understand. You don't seem much of a... Er...

Sully: What? A lady? Go ahead. Say it. No sweat off my thighs.

Chrom: Okay then! I guess everyone has their own special talents. Say, I can't really cook or sew either. I can at least help with the fire?

Sully: Har! You're all right, Chrom.

■ SULLY X CHROM B

Chrom: Oh, hey, Sully.

Sully: Hello, Chrom.

Chrom: Where are you taking all that equipment? Would you like some help?

Sully: Pfft! This is nothing. I'm just trying to clean up around this craphole.

Chrom: It seems like every time I see you, you're working like there's no tomorrow. Just try not to overdo it, all right? It's not worth it if you wear yourself out.

Sully: Wear myself out? Har! That's the point, Chrom. This is part of my training regimen.

Chrom: You're training to...clean a tent?

Sully: Gods, but you're dense. I'm training my MUSCLES! Lugging stuff builds pure strength a hell of a lot faster than sparring. Also helps with balance and coordination. You know. All that crap.

Chrom: Oh. I guess that makes sense. Plus the tent gets clean!

Sully: Yeah, I've always been efficient like that. Any chance to train is a chance I'll take.

Chrom: I bet you've built up some real strength. How about a little demonstration?

Sully: Har! Come at me, little man. Just don't start crying when I wipe the floor with you.

■ SULLY X CHROM A

Chrom: Gnya! Yah!

Sully: HURAAAAAGH! GRAAAAGH!

Chrom: "Huff, huff" Haaaa... I'm...impressed, Sully. ...Whew! There's more force behind your strikes than ever. It's like trying to fend off a bear.

Sully: "Huff, huff" Har... Thanks, Chrom. That means something, coming from you. Your defense is rock solid. It's like sparring with a damn wall. Guess you haven't been slacking either.

Chrom: I was always taught that the best shortcut is the one you never take. Nothing for it but to put in the hours.

Sully: Har! I remember that speech! Damn, that brings me back...

Chrom: You remember playing bandit king? How we used to wallop each other with sticks?

Sully: How much things have changed...and how much they haven't, har! But yeah, we played rough back then. Boys and girls alike. Remember how we used to sneak out of town to climb trees in the woods? Those were some damn good times.

Chrom: Yes, we've come a long way, Sully, and yet we're still evenly matched.

Sully: Damn straight! No way I'm letting some cheese-eating royal leave me in the dust. That's half the reason I train, you know? So you won't have the satisfaction.

Chrom: Sully? I hope you never change. You're the only woman I can still do this with. You know that?

Sully: That's because the other women decided to become a bunch of damn LADIES. Aw, hell. Some days I wonder if maybe I...

Chrom: Oh no you don't. You're perfect, just as you are. I wouldn't change a thing, at least. We can speak as equals. It's one small part of my past that's unchanged, and...it anchors me.

Sully: ...Are you messing with me? Well, hell, Chrom. If it works for you, I won't go changing for anybody else.

Chrom: Good. See that you don't. ...That's an order.

Sully: Pfft. Like I'd ever listen to you.

■ SULLY X CHROM S

Sully: Oh, Chrom! There you are.

Chrom: What is it, Sully? Are you ready for another round of sparring?

Sully: No. Not today, anyway.

Chrom: Oh, all right. So what did you need?

Sully: Look, you remember the other day when you said I was part of your past? You said anchor you, and um... What did you mean by that?

Chrom: Er, well, I suppose... Though I was seldom allowed in the castle kitchens growing up...

Sully: Ah, you're right. I don't know. I guess I just said what I was thinking without really... thinking. I don't want you to change for anyone, Sully. I want you to always be yourself. Sorry, I know that's pretty vague.

Sully: No, it's good enough. You just... You accept me for who I am.

Chrom: Yes, of course.

Sully: But that's only because you see me as the same damn tomboy you knew as a kid! Other girls all went and became LADIES, but good ol' Sully's still one of the guys!

Chrom: But I thought you liked being treated as one of the guys?

Sully: Gods bless it, no! I'm not! I'm a woman, too, dammit! Yeah, maybe I can't cook, or clean, and I burn all the laundry, but...

Chrom: Sully, what do you want to say?

Sully: Rragh! I'm just... I don't... I like you. You know? Like...that. Like a girl...likes a guy?

Chrom: ...Oh.

Sully: So, um, yeah. As a guy, do you think you might...feel the same? Maybe...forever?

Chrom: Are you... Are you proposing to me?

Sully: GAH! D-do you have to just come out and say it like that?! I've never asked anything like this before in my life, Chrom. You're killing me here!

Chrom: I just had to be sure we were thinking the same thing. The answer is yes, Sully. Yes!

Sully: What?!

Chrom: You're offering to be with me, right? I'd be lying if I didn't say you feel like one of the guys sometimes, but so what? That just means we're more similar than most couples. It's hardly a bad thing.

Sully: But I'm NOT a guy, you bastard! I'm asking you as a woman!

Chrom: I know! I get it! And I'm saying yes as a man.

Sully: R-really? Just like that?

Chrom: It's all right for a woman to have skill in battle, you know? And last I checked, there's no law requiring laundry skills in order to marry. I care about you a very great deal. I always have... I just hope you know what you're getting into. Carrying a nation on your shoulders is a massive responsibility. Half of that would fall on you. Are you sure it's a load you want to bear?

Sully: Are you joking? Have you seen my shoulders? Anyone gives you trouble, Chrom, you just send 'em over to me.

Chrom: Now that's the kind of rock-solid support a ruler needs! And so I pledge my support in return. For this day, and every day to come. ...Here. This is for you.

Sully: Holy crap! A signet ring from the royal house of Ylisse! I don't know, Chrom. It looks so...extravagant.

Chrom: My parents had it made for me when I was born. I've always kept it close, and I see no reason to change that now. The only difference is that it will now be attached to an even greater treasure.

Sully: Chrom, it's... It's beautiful. Thank you.

Chrom: Ha! Now I'm the one blushing. I suppose we'll have to get used to this. Good thing we have the rest of our lives.

Sully: I may be your anchor, but right now I could just fly away! I...I love you, Chrom. I think I always have.

Vaike

■ VAIKE X CHROM C

Chrom: All right, everyone! Let's pair off and try some one-on-one sparring.

Vaike: Oh-hoh! You ready to take on Teach, Chrom?

Chrom: Vaike, maybe we should find new partners. Just to keep things fresh.

Vaike: Pshaw! We're rivals. We have to fight! Ya can't turn your back on me! ...Plus, I was really close to beatin' ya last time. Really, REALLY close.

Chrom: Er, right. If you say so. But still, I think we should—

Vaike: No, it's fine. I know what you're doing. You're trying to psyche me out!

Chrom: Oh, come on! If we don't mix it up, we'll never keep ourselves sharp.

Vaike: ...Oh, I see. Not enough suspense for ya, is that it? Then let's spice it up with a little wager! Everything we own—winner takes all!

Chrom: ...Vaike? We're training for war. I can't very well gamble with the royal treasury.

Vaike: Fine, fine! No quid. But how about this... The loser has to sneak up behind Frederick and pull down his pantaloons!

Chrom: ...Are you mad? Frederick would chop us up like firewood! And then make a fire!

Vaike: What's this now? Is someone...chicken? Ba-KAWK bawk bawk bawk—

Chrom: Oh, ALL RIGHT! I'll spar with you! ...Just stop that ridiculous clucking.

Vaike: Har har! Yes! Now Chrom's got a full head of steam! Show ol' Teach what ya got!

■ VAIKE X CHROM B

Vaike: It's fightin' time, Chrom!

Chrom: Very well. But on one condition...

Vaike: Condition? It's not like you to ask for a handicap—

Chrom: Nothing of the sort, Vaike. It's just that... Well, Lissa was pretty upset after our last duel. Poor girl was crying her eyes out. She said we were taking our sparring much too seriously. She made me promise to go easy and fight safe so neither of us gets hurt.

Vaike: Har har har! Yeah, that last clash was a real doozy. Good times. Good times... But, uh, listen, Chrom. You're gonna have to explain this "fight safe" concept to me.

Chrom: I've been pondering that myself. Perhaps we could decide the winner...with a coin flip?

Vaike: Good gods, no! I don't want lady luck pickin' the winner. Not between us, anyway. ...Hey, I got it! What say you and me have a good old-fashioned cooking contest?! You make something, I make something, and we'll see who comes out on top.

Chrom: Er, well, I suppose... Though I was seldom allowed in the castle kitchens growing up...

Vaike: Ah, you're right. Cookin' against royalty'd be like spearin' fish in a barrel. If I can't beat ya with honor, I got no interest in beatin' ya.

Chrom: Hold on now! ...I didn't say no. I've roasted my share of campfire boar and have heard no complaints...

Vaike: Har har! Then a cook-off it is! Get ready to taste my victory!

■ VAIKE X CHROM A

Chrom: Ready for another duel, Vaike?

Vaike: Naw. I'm bored with beating ya. We should fight other people.

Chrom: Wait. When exactly did you beat me?

Vaike: Hel-LO?! Remember the cookin' contest? Ol' Teach won that fair and square!

Chrom: How do you figure? When you ate my dish, you fell backward off the chair and passed out. That made me the winner by knockout! ...Or are you denying you collapsed?

Vaike: Kn-knockout?! You almost killed me with that slop you called goulash! I spent a week scrubbing the taste off my tongue! ...Look! Itsh shtill hurtz!

Chrom: That doesn't say we had to make the BEST dish. You just said it was a cooking contest.

Vaike: B-but the whole point of a cooking contest is... Aw, forget it! Good gods, you really do hate losing, don't you?

Chrom: And you don't?

Vaike: ...Har har, yeah, I suppose you're right. We're birds of a feather, you and me. We love to compete. ...AND to win!

Chrom: Well then? Are you ready for your fellow bird to knock you out of the sky?

Vaike: Har! Bring it on, little man!

Sumia

■ SUMIA X CHROM C

Sumia: Oh! There you are!

Chrom: Hello, Sumia. Did you need something?

Sumia: Um, no. [Robin] is just looking for you.

Chrom: Oh, right. The strategy meeting. Poor [Robin] does love to... AAAAAARGH!

Sumia: Chrom! Are you all right?!

Chrom: Y-yes, I'm fine. I just tripped on a pebble. Gods, how embarrassing.

Sumia: It's because you're so exhausted! You've been working too hard lately.

Chrom: I'm fine, Sumia. And besides, we're all tired. Such endless fighting wears on everyone.

Sumia: Heh. There's no need to don a brave face for my sake. You carry twice the burden of anyone. It's only natural you're exhausted.

Chrom: Heh. It's hard to say so. But in truth, everyone looks to their commander for inspiration and strength. An army is only as stalwart as its leader. The instant I show weakness, we're through.

Sumia: It must be so hard for you...

Chrom: I'll...be fine. And please, don't speak of this conversation to anyone. All right?

Sumia: N-no! Of course not! I would never—

Chrom: Ha ha! At ease, Sumia. And stop worrying so much! It'll take more than a few battles to bring this soldier to his knees.

Sumia: I know! You're the greatest warrior I've ever... Huh. I just realized something.

Chrom: What is it?

Sumia: You trusted me with a secret! It's our first secret together!

Chrom: Um...yes, I suppose it is.

Sumia: Don't worry. My lips are sealed tighter than a bear trap. ...So long as you promise to take a nap before the strategy meeting!

Chrom: ...What?

Sumia: I'll just tell [Robin] that you've been delayed.

Chrom: And if I don't agree to your terms?

Sumia: Then I'll tell everyone the mighty Chrom was bested by a mere pebble!

Chrom: That sounds like blackmail... Still, I suppose a short nap couldn't hurt.

Sumia: Oooh, it's so thrilling to be able to help out like this! Anyway, I'll leave you to it. Sweet dreams!

Chrom: That girl has a strange knack for getting her way...

■ SUMIA X CHROM B

Sumia: Chrom? Where are you? Hel-LOOOOO?

Chrom: ...I'm right here, Sumia.

Sumia: Oh! There you are. Um, so...here. I baked you a pie.

Chrom: Really? Well, this is a surprise. ...Mmm! It smells amazing!

Sumia: You've been working so hard recently, I thought you must be tired... My mother used to bake me rhubarb-and-fiddlehead pie, and it always perked me up.

Chrom: Rhubarb and...fiddleheads? No mutton? Or goat? ...Or bear? I usually prefer a bit of meat in my pies.

Sumia: Absolutely not! Meat is the last thing you need when your body's worn out! A stick of rhubarb will clear your bowels and get you right as rain in no time. That's what my mother used to say anyway—and she was always right!

Chrom: Heh. Old Nurse Nan used to say the same when I was young.

Sumia: See? They can't both be wrong. Now eat your pie while I go clean your smallclothes. I see quite a pile forming on the far side of your cot there! ...Well? Go on! Don't mind me now—just eat your pie!

Chrom: Er, well, if you insist.

Sumia: Oh, I HATE rhubarb. But if Sumia thinks it'll make me feel better, I suppose I should force it down... Mmm? Hey, this isn't bad... In fact, it's delicious!

Chrom: ...Well, that was about the best pie I've ever had.

Sumia: ...Hel-LOOOO? Chrom? I'm baaaaack! Oh, have you finished already?

Chrom: I did, and it was amazing! Usually rhubarb makes me queasy, but not this time! What's your secret?

Sumia: Oh, nothing special. Just a bit of spice here and a pinch of herb there... You can make something taste like anything if you know the tricks.

Chrom: Well, Sumia, I'm more than impressed. You're a true wizard of the kitchen.

Sumia: Oh, I'm so glad you liked it. Now then! How about a cup of elderberry tea?

Chrom: Hold on! You made me a pie, so I should be making YOU tea. Just let me boil some water here...

Sumia: Oh, Chrom... This is too much. Really. Hee hee! I knew he'd love the pie! Especially since it took me 15 tries to get it right...

■ SUMIA X CHROM A

Sumia: Chrom! Hel-LOOOOOO?!

Chrom: Oh, hey, Sumia.

Sumia: Look! I baked you another pie.

Chrom: Sumia, you are too much. Where do you find all the time and energy for this?

Sumia: Oh, it's nothing. Really! Hardly any trouble at all. Except for finding veggies. ...and grinding flour. ...Oh, and kneading dough. But apart from THAT, it's easy as...well, pie! I like doing it. Really. Honest.

Chrom: Well, if you say so.

Sumia: Oh, I do say so! And today I made an extra big one so we can eat it together!

Chrom: A pie shared with friends is twice as tasty. Or so my old Nurse Nan said. ...Listen, Sumia. I'm... I'm sorry. About bringing you into all this, I mean. You deserve better than a battlefield, but right now that's where I need you.

Sumia: Oh, Chrom... It's an honor and a privilege to serve you. Besides, serving as a soldier isn't all bad. There are lots of things I like about it.

Chrom: Truly? Like what?

Sumia: Well, the horses are fun!

Chrom: You mean the pegasus? Er, pegasuses? ...Pegasi?

Sumia: Those too! I just love swooping through the sky—it's so exhilarating. But I like looking after them even more. Combing manes, brushing teeth...

Chrom: You do spend a lot of time in the stables, now that I think about it.

Sumia: I do hate that they have to fight. When I see them in the thick of battle... I want to win this war. It can't be helped. But, it makes my heart ache every time I see such a beautiful creature hurt.

Chrom: I don't know what to say, Sumia. Except to thank you again. Thank you for all the sacrifices you're making for my sake. I swear that I will do everything in my power to end this war quickly. And I promise to build a peace that will endure for generations.

Sumia: I know you will, Chrom. And I'm going to help you do it!

■ SUMIA X CHROM S

Chrom: Sumia?

Sumia: Oh, hello, Chrom.

Chrom: I...I was looking for you. Have you been here long?

Sumia: Actually, I'd just finished baking a pie. I was about to go...look for you.

Chrom: I don't deserve more of your pies, Sumia. You're being too kind to me.

Sumia: Hee hee! No, not at all. I LIKE looking after you!

Chrom: Not as much as looking after the pegasi, I wager.

Sumia: No, not as much as... Wait! NO! I MUCH prefer looking after you!

Chrom: Listen, Sumia. I was looking for you because...I have a favor to ask.

Sumia: You don't have to ask for favors. I'll do anything your heart desires.

Chrom: Er, see, I was hoping... If you were willing... Maybe you might do me the honor... Um...

Sumia: Do you want more pies? Because I'll bake until my hands fall off!

Chrom: P-pies? No, er, what I'm trying to say is... I'm thinking of the rest of our lives and...

Sumia: You want pies every day until you die? Well, that's a tall order, but if you—

Chrom: This is not about pies! Just listen!

Sumia: ...Muh?

Chrom: S-sorry, Sumia. This isn't how I thought... Oh, I'm ruining this whole thing! What I want to ask is...will you grant me the honor of...being my wife?

Sumia: Chrom?! Are you...proposing?

Chrom: Yes! You've done so much for me... Your kindness has warmed my heart. And somewhere between the fifth and sixth pie I thought to myself... "Chrom, you must marry this woman and stay together for the rest of her life!"

Sumia: I...I don't know what to say. But in truth, I've felt the same way since our very first pie...before that, even. I've known from the start that nothing made me happier than...being with you. But, I never dreamed... Not in a thousand... I mean, me? Marry royalty?!

Chrom: You shall be the finest royal bride the realm has ever seen! Er, that is...if you consent?

Sumia: Of COURSE I'll marry you!

Chrom: No words ever rang as sweet! But now we must make it official. Will you wear this for me?

Sumia: B-but this ring bears the crest of the royal family of Ylisse! Are you sure I'm allowed to have such a treasure?

Chrom: This was crafted to commemorate my birth, and later given to me by my father. Since my earliest days I have planned to bestow it to the woman I would marry. It is yours now. A symbol of our everlasting love and affection.

Sumia: Oh, Chrom, I'm...I'm so honored. I will treasure it all of my days.

Chrom: Then our future is sure to be filled with happiness and pies, both!

Sumia: Oh, yes! We shall have pies morning, noon, and night! ...Er, but would you mind terribly if we hired a cook?

Maribelle

■ MARIBELLE X CHROM C

Maribelle: Oh! Good day, milord.

Chrom: Hello, Maribelle. ...And just Chrom is fine, please.

Maribelle: A-are you here all alone? Goodness, but there's a chill in the air today! Would you care for a cup of tea?

Chrom: Well, I won't say no. ...Thank you. You're very kind.

Maribelle: Oh, please! For a noblewoman of Ylisse, serving royalty is a high honor!

Chrom: In times of peace, maybe. But this is war. Kings, nobles, and peasants alike are all just comrades-in-arms. So please, don't wear yourself out trying to look after me.

Maribelle: Yes, but—

Chrom: You've been fighting as hard as any of us. You must be exhausted.

Maribelle: Well... I confess I sometimes find myself wishing for a respite. But then I remind myself how much harder it must be for you! Heavy lies the crown and all that, yes? So it's my duty to help you however I can!

Chrom: Your dedication is appreciated, Maribelle. ...A bit extreme, maybe, but appreciated. Just promise to look after yourself as well. Will you do that? ...For me?

Maribelle: Your wish is my command, milord. But first let me bring you that tea!

Chrom: I'll take it. Thanks.

Maribelle: I so very much enjoy our time together... I pray we find opportunity to do it again.

Chrom: I hope so, too.

■ MARIBELLE X CHROM B

Maribelle: Tsk! The pool of suspects grows larger by the moment!

Chrom: Er, sorry. Who's a suspect now?

Maribelle: Oh, milord! I didn't see you there! I was just going over my...list.

Chrom: Uh-oh. This can't be good. What list is that?

Maribelle: I've been keeping track of men who may be getting too close to Lissa! My darling is a bewitching vixen, even if she doesn't realize the power of her charms. So when these lecherous men get too close, I drive them back from the ramparts!

Chrom: ...You aren't joking, are you. Why on earth would you do such a thing?!

Maribelle: Isn't it obvious? Lissa is your younger sister, and princess to the royal house of Ylisse! It falls upon me, her bosom friend and true companion, to save her from scallywags!

Chrom: Scallywags? Er, look, Maribelle. I think my sister can guard her own ramparts just fine.

Maribelle: Ha! Don't be so naive! It seems even great men are blind when it comes to matters of the heart!

Chrom: Hey! I am NOT blind! ...And you're being paranoid! There's no harm in Lissa having a few friends among her comrades-in-arms.

Maribelle: That they are comrades makes them more dangerous! Snakes in the den, says I! As such, I've put a strict screening process in place. Any man who would speak to Lissa must first be interviewed by me. Many times. AND provide supporting documentation, of course!

Chrom: ...Heh. I guess in a way it's reassuring to know that Lissa has you watching over her. Well then, I'll trust you to keep her safe for me.

Maribelle: Of course, milord! A woman of my position would offer no less!

■ MARIBELLE X CHROM A

Maribelle: Milord! I hope this day finds you well.

Chrom: As well as can be expected.

Maribelle: If there is anything I can do to ease your burden, you will let me know, won't you?

Chrom: Of course. Thank you, Maribelle. But you really need to stop exhausting yourself on my behalf. I don't deserve it.

Maribelle: Bite your tongue! Serving you is sheer delight! Why, I'd gladly lay down my life for you and Lissa.

Chrom: Well let's hope it never comes to that. I don't want anyone dying for my sake.

Maribelle: But on such a day, I would be first in line to thrust myself upon the enemy's pikes!

Chrom: That reminds me: I talked to some soldiers who saw you get captured by Plegia. They say that, as the Plegian army approached, you went out to meet them. That you parleyed with their captain, asking them to withdraw from Ylisse. And that the honorless curs responded by taking you hostage. Tell me the truth, Maribelle: Did you do this for me and Lissa?

Maribelle: ...I thought to protect you and Lissa from danger. That was my only goal. I know it was wrong of me to take such drastic action without consulting you. But you must believe me when I say—

Chrom: Enough, Maribelle. I believe you. But I need you to promise something. You must never take such a rash action again. Do you understand?

Maribelle: Yes, but—

Chrom: Just as you care for me and Lissa, so do we care about you. We would never forgive ourselves if you came to harm for our sake.

Maribelle: Y-you...are too kind, milord. I solemnly swear that I will never do such a foolish thing again.

Chrom: It wasn't foolish, Maribelle. It was brave and... noble. But if we don't fight as equals in this war, we have no hope of winning it. And if Lissa and I were to lose you... It would be a pain we couldn't bear.

Maribelle: I... Well, I... It won't happen again, milord. I swear it!

Chrom: We must stand shoulder to shoulder. Divided we fall, but together we rise!

■ MARIBELLE X CHROM S

Maribelle: Milord! I've brewed elderberry tea and buttered some crumpets. Won't you rest a spell?

Chrom: Well, since you've gone to all this trouble... Wait. Is this gooseberry jam? It was my favorite as a child! How did you know?

Maribelle: A little bird told me...

Chrom: A little bird named Lissa, I wager. Heh heh, that girl...

Maribelle: Oh, how I envy your sister... You have such affection for her... And you have spent a lifetime together... How I wish I could compare!

Chrom: Maribelle, what are you talking about? Lissa's my sister. You're my...friend.

Maribelle: Yes, but you are also royalty and... And you're surrounded by all these fine and noble women! All the time! Lissa and her friends... The court ladies... Oh, you must have such wonderful times! I feel so dreary and plain by compare.

Chrom: Wonderful times?! Hah! Royal court is dull as an anvil. It's my duty to attend, but that's all. ...And it's a loathsome duty at that.

Maribelle: B-but...beautiful admirers hang upon your every word! So how could there possibly be room in your life for... What I mean is... How will you ever find a place for me in your heart?

Chrom: Um, I'm sorry, did you just say...

Maribelle: ...Wait. Did I say that out loud? ...I said that out loud, didn't I? ...Loudly. OH, GODS! Chrom, PLEASE pretend you didn't hear that! I don't know what came over me! Curse this blasted battle fatigue! My mind must be on the moon! Oh, that the ground might open up and swallow this foolish creature!

Chrom: Maribelle! Get ahold of yourself.

Maribelle: Er... *ahem* Forgive me, milord. I... I don't know what came over me. ...Again.

Chrom: Listen, are you—

Maribelle: Would you mind terribly if we started over? I have something important to tell you, and it deserves a better beginning.

Chrom: Well, I think you already told me... Er, but please. Do go on.

Maribelle: Milord, I am...deeply and madly in love with you! I always have been so, even when we were but children. Yet I've never been able to confess this shameful secret. You were always surrounded by those fine court ladies, and I... Well, I felt so coarse and provincial! I was ashamed, and so kept my feelings hidden.

Chrom: I...see.

Maribelle: B-but now I just don't care anymore! I had to confess, and I'm glad I did. It's like a horrible weight has been lifted from my shoulders!

Chrom: You really should have told me earlier, Maribelle. Because the truth is... I feel the same for you.

Maribelle: T-truly? Oh, Chrom, don't jest with me! Not about this!

Chrom: I assure you, I am not jesting. I've loved you since we were young. Your poise, your consideration for others...

Maribelle: M-milord... Are you truly...

Chrom: Perhaps this will convince you of the sincerity of my feelings.

Maribelle: Oh, heavens. It's a ring! ...And it bears the crest of House Ylisse! Y-you would have me wear this treasure?

Chrom: My parents had it crafted to celebrate my birth. I've always kept it safe because I knew someday I would give it away. I would give it to the woman I wanted for a lifelong companion. ...For a wife. So yes. I want you to have it.

Maribelle: This is a dream come true. I'll never take it off!

Chrom: I wonder how Lissa is going to take this news?

Maribelle: Lissa? Oh thunder, she'll be more excited than anyone! "My big brother is FINALLY getting married," she'll say!

Chrom: Ha ha! You know, I think you're right.

Gaius

■ GAIUS X CHROM C

Chrom: Gaius, do you have a moment?

Gaius: What's up, Blue?

Chrom: ...Blue? Er, right. Well, you must have traveled a lot in your old line of work, yes?

Gaius: Sure did! Us thieves tend to outstay our welcome in a hurry.

Chrom: The reason I ask is that I've had little chance to see the world properly. I've journeyed on diplomatic business, but that's pretty much it. And frankly, one majestic court looks very much like another. I've often wondered what it would be like to roam the world free of royal burdens.

Gaius: Ha! You royals up in your pointy towers really don't have a clue! You think us commoners are free to just spend our days sauntering along! Think we pick daisies and gaze at tourist attractions and eat bonbons all day!

Chrom: Look, that's not what I was implying at all. ...And I think you know it.

Gaius: So what's the problem? Tired of silk pants and the undying adoration of the masses?

Chrom: I try to appreciate my situation, but being a royal can be incredibly...stifling. It's a comfortable prison, true, but a prison nonetheless.

Gaius: Sounds like a serious case of not being able to count your blessings.

Chrom: It's true—I'm never hungry, I've a hot bath and a warm bed, people leap to my aid... Perhaps you're right. What right have I to complain of such a life?

Gaius: Ya damn straight.

■ GAIUS X CHROM B

Gaius: Heya, Blue.

Chrom: You know, I really wish you wouldn't call me... Never mind. What can I do for you, Gaius?

Gaius: You got plans for the evening? After supper, I mean?

Chrom: I have to inspect the armory and make sure we're ready for the next battle.

Gaius: Booooooor-ing. What about tomorrow?

Chrom: Tomorrow I meet with the war council to discuss strategy and tactics.

Gaius: Man! It's all work and no play for our fair leader, isn't it?

Chrom: ...What exactly did you want, Gaius? If it's important, I'll carve out some time.

Gaius: Oh, it's not so important. ...Or maybe it IS!

Chrom: Would you please get to the point?

Gaius: Look, I got to thinking about what you said. You know, about not having freedom?

Chrom: Yes?

Gaius: Well, I thought I'd give you a taste of what it's like to be footloose and fancy-free!

Chrom: How do you propose to do that? I don't have time for a 'round-the-world tour.

Gaius: A single evening is all it'll take! ...You just tell me when you're ready.

■ GAIUS X CHROM A

Gaius: Finished your preparations? Ready to sample life outside the gilded cage?

Chrom: Preparations? I wasn't aware that—

Gaius: Aw, come on! You want to dress up a bit, don't you? ...I mean, I would.

Chrom: Look, I don't know what you're talking about. Where are we going anyway? How am I supposed to prepare when I have no idea what's going on?

Gaius: Seriously, Blue? Gods, if you royals aren't the most coddled set of... Look, we're going out to have fun. You know about fun, right? So try to wear something that doesn't look like it was stolen from a sarpa.

Chrom: Hey, I have a very keen fashion sense, thank you very much!

Gaius: ...Well, I suppose those clothes'll have to do, then. Come on, Blue. Quit your grumblin'. I'll explain on the way.

Chrom: B-but, wait!

Gaius: Ha ha ha! So... What'd you think?

Chrom: It was...interesting.

Gaius: Yeah, but was it FUN?!

Chrom: Well, I suppose so. I'd never seen a man juggle flaming hams before... And when those acrobats got into a knife fight...that was really something.

Gaius: I know, you're overwhelmed. It's a lot to take in. Still, we did what we set out to do.

Chrom: And what was that, exactly?

Gaius: To show you a slice of the real world!

Chrom: Ah, yes.

Gaius: So then? Still think you're trapped in a prison made of diamonds and baby tears? Today you wanted to experience something new, and that's exactly what we did! No one tried to stop you. No one asked for your autograph. Nothing stood in the way except your own royal reserve. King or traveling minstrel, the world is as narrow or wide as you make it.

Chrom: You're saying it's not duty that holds me back...but self-pity? Gods... I've been such a self-indulgent arse...

Gaius: Aw, don't be too hard on yourself, Blue. Those silk-clad shoulders carry a heavier burden than I'd be willing to bear. Just remember—attitude and outlook go a long way toward making your world.

Chrom: And you took me to that den of iniquity just to teach me that lesson?

Gaius: Naw. I like going there, but I can't afford it unless some sap foots the bill. But you be sure to let me know when you want to go again, all right?

Chrom: ...Maybe later.

Olivia

■ OLIVIA X CHROM C

Chrom: Hey, Olivia. What are you doing here all by yourself?

Olivia: Oh! Milord! C-Chrom! Sir! Sir Milord! ...Hello! Er, I l-like to come here for peace and quiet. ...To relax.

Chrom: Then I'm intruding. I'll leave you to your—

Olivia: NO! Er, I mean, it's all right. I don't mind. Really.

Chrom: Well, if you're sure you don't mind...

Olivia:

Chrom:

Olivia:

Chrom: Heh, not very talkative, are you? That's all right. I was never much one for—

Olivia: Oh, look at the time! Gotta go!

Chrom: Er, Olivia?

Chrom: ...Gods, I'm supposed to be leader of Ylisse and commander of the army. If I can't even talk to my soldiers properly, how am I going to rule my subjects? Or inspire people? Or forge alliances with other nations? But every time I try to talk to Olivia, it ends in this awkward silence... Well, no more. I'll find a way to break through if it kills me!

■ OLIVIA X CHROM B

Chrom: Ah, there's Olivia now... ...Right! Today I shall be charming and witty, and we will talk of this and that. I'll make her forget her painful shyness as we quickly become fast friends. Maybe a joke would lighten things up. Friendly ribbing always puts me at ease...

Chrom: Ha ha! Why, if it isn't Olivia! Ha ha! There by yourself again?

Olivia: EEK! Oh, milord! I mean, Chrom! Sir! I was just...practicing my dancing. ...Since I'm useless at fighting. I mean, what is it I do, you know? Dancing, that is. Not fighting. ...Yes. Well. Anyway.

Chrom: Ha ha! Oh, Olivia, what a wit you are! But you mustn't sell yourself short. If we were a poor dancer, I'd just kick you out of the Shepherds!

Olivia: Wait, what?! Oh my gosh, I'm so... I mean, I'll do my best! Please... I just—

Chrom: N-no! That was a joke! Just...joking! Ha ha ha ha! ...Ha? See, if you were ACTUALLY bad, I wouldn't joke about it. ...Right? Look, Olivia, we all think you're an excellent dancer. Honest. So please—there's no need to be so self-effacing all the time. All right?

Olivia: Y-you are very kind. But I'm so clumsy, and there's still much that I have to learn.

Chrom: You're doing it again.

Olivia: Oh! *gulp* S-sorry! I forgot—

Chrom: I do think it's great that you want to better yourself, though. I could take a page or two from your book when it comes to practicing swordplay!

Olivia: Oh, Chrom! Please! You're embarrassing me!

Chrom: But, I didn't mean to...

Olivia: Um...

Chrom: Er, Olivia? Is something wrong? You're... staring at me...

Olivia: I am?! Ah, SORRY! I mean... Um... I think I left the campfire burning! Gotta go!

Chrom: No, wait! Olivia!

Chrom: ...That girl is a puzzle. Still, we actually exchanged a few words today. I suppose that's progress.

■ OLIVIA X CHROM A

Chrom: Oh, hello, Olivia.

Olivia: Eeek! Chrom!

Chrom: Practicing again?

Olivia: I was just finishing, actually.

Chrom: Oh? I was hoping that you might show me what you've been working on.

Olivia: Y-you mean dance...in front of you? Ah ha ha! Hee hee! Hooooo... N-no. I couldn't possibly.

Chrom: But on the battlefield, you never hesitate to dance when called upon.

Olivia: Yes, but...well, that's...different. The setting... The atmosphere... There's no time to think about it, or worry about it... I just...do it.

Chrom: It amazes me that someone so shy could be such an amazing performer. Your dances are really quite wonderful. I don't know how you can't see it.

Olivia: Lord Basilio told me much the same thing. ...Albeit with different words. Something about charming the butt off a butterfly.

Chrom: Ha! That sounds like Basilio, all right. You and he go back a long way, right? How did you first meet?

Olivia: ...I owe him my honor and my freedom. Once, when I was with a traveling theater group, I caught the eye of a corrupt noble. He would have stolen me and forced me into marriage if not for Khan Basilio.

Chrom: Hah, and here I thought Basilio more likely to carry you off himself.

Olivia: Oh no, you have Basilio all wrong! He's not like that. Not really. He told me a khan doesn't need such tricks to find himself a partner ...Actually he was much cruder about it, but you get the idea.

Chrom: Let me guess: it was something about his "big brown arse"?

Olivia: Hee hee! I guess you DO know Basilio pretty well after all!

Chrom: Hey, look at that!

Olivia: What?! D-did I say something wrong? I did, didn't I?!

Chrom: No, I just... I don't think I'd ever heard you laugh before. At least not in a nervous way.

Olivia: Oh, geez. Did I really laugh?

Chrom: Yes...it was actually quite lovely.

Olivia: Oh, Chrom, you mustn't say that! Gods, I wish the ground would swallow me up right now!

Chrom: Well, I'm sorry if I embarrassed you. But I enjoyed seeing you today. I feel like we're finally really getting to know each other... I look forward to our next conversation.

Olivia: Oh, yes! Absolutely! Me, too!

Olivia: I can't believe Chrom and I can actually talk to each other like normal people! Gosh, I was SO terrified of him at first. But he's actually quite charming once you get to know him...

■ OLIVIA X CHROM S

Olivia: Hello, Chrom!

Chrom: Well, Olivia, this is a pleasant surprise. Usually I have to track you down.

Olivia: Well, you always make a point of talking to me, right? I thought it was time I repaid the favor.

Chrom: Ha! Well, I'm honored. I remember the days when you couldn't say more than two words at a time.

Olivia: I know! The old me wouldn't dream of just coming up to you and saying hello. In fact, sometimes, when I'd see you coming, I'd run and hide in a barrel!

Chrom: ...In a barrel? Er, yes. Well in any case, it seems that I'm very much in Basilio's debt. If not for him, we'd never have had the chance to become friends.

Olivia: Oh, don't even say that!

Chrom: To think I might have lived my whole life without knowing you...

Olivia: I know, I... I feel the same way. You even helped me be less shy around other people! 'Cause if I can talk to you, I can talk to ANYONE!

Chrom: ...Am I so terrifying?

Olivia: Oh, no! No, it's not like that! You're an important person, you know? A prince and our leader and all that? It's not like folks just walk up to you and start blabbing away.

Chrom: Hmm... I see your point.

Olivia: But it's all right, because I'm not scared of you at all anymore. Hee hee hee!

Chrom: I do so love that laugh.

Olivia: And I love seeing you relax instead of reading war books or whatever you do!

Chrom: Well then, perhaps you would like to see more of me.

Olivia: Oh... Yeah, sure! Why not?

Chrom: Then perhaps you'd like to see me...all the time?

Olivia: Well... I would have to eat and sleep at some point, but...

Chrom: ...But perhaps we can do that together as well, if... ...If we were married.

Olivia: Oh my gosh, WHAAAAAT?!

Chrom: Will you do me the honor, Olivia? Will you marry me?

Olivia: Hmm, let's see... Will I marry this smart, funny prince who's also super handsome? YES! Of course I will! Yes!

Chrom: Well now you're making ME blush... Here, then. I've been carrying this around and waiting for the right moment. Please take it as proof of my love for you.

Olivia: ...C-Chrom, this ring bears the crest of the royal house of Ylisse! This is priceless! I can't take it!

Chrom: My parents had it made on the occasion of my birth. They told me to give it to the woman that I would spend my life with. I'm only doing what it was designed for in the first place.

Olivia: Th-thank you, Chrom. I shall wear it proudly for the rest of my days.

Chrom: I've been waiting for this moment my whole life, Olivia. Today I'm the happiest man in all the realm!

Lucina (Father/daughter)

■ LUCINA X CHROM (FATHER/DAUGHTER) C

Lucina: Might I ask a lesson, Father? I would love to learn the sword from you.

Chrom: You're a master in your own right already. What could I possibly teach you? You're likely better served training alone where you can hone your own style.

Lucina: But I was hoping that you might... That we could...

Chrom: Hmm?

Lucina: ...I'm sorry. If it's a bother, I won't insist.

Chrom: I never said it was a bother. I just meant that with your level of skill, you'd be...

Lucina:

Chrom: ...Heh. Fine. Go fetch a pair of practice blades.

Lucina: Wonderful! I just so happen to have two right here...

Chrom: Well, someone's certainly prepared. Very well, let's begin.

Lucina: Yes, sir!

Chrom: Hnngh!

Lucina: Yaaah!

Chrom: Ngh...

Lucina: ...Urgh!

Chrom: ...Impressive as ever. I was certain I dodged that one, but you nicked my shoulder.

Lucina: ...You had me soundly beat. Had you not held back on that blow to my chest, I'd have a few shattered ribs. I was right to think you still have much to teach me. We'll have to make these lessons a habit.

Chrom: Wait, you didn't just... Did you throw that match just so we'd continue doing this?

Lucina: Why, Father... I would never!

Chrom: ...Devious. I see I'll have to keep a closer eye on you, heh.

■ LUCINA X CHROM (FATHER/DAUGHTER) B

Chrom: All right. That should do it for today's training. Let's stop here.

Lucina: Thank you, Father.

Chrom: It still feels so strange to hear you call me that...

Lucina: You don't like it?

Chrom: No, no. It's not that I dislike it. It's just...different, is all. I'm still wrestling with the reality that I have a child, and that that child is you.

Lucina: I see.

Chrom: Oh, but don't tell your mother. You know how she can be.

Lucina: Ha! It always seemed to me like you told her everything... In the future, I mean... You two were always so close.

Chrom: Oh, come now. You make us sound like a pair of fawning lovebirds. I'm sure we would never embarrass ourselves, especially at court...

Lucina: So you say, but your blushing face seems a little less certain! ...Heh. It feels good to share a secret. It's been too long. You were always sharing little tidbits with me in the future.

Chrom: Was the future me really so furtive? I don't think of myself as a man of secrets.

Lucina: Oh, they were just silly little things. Still, it gives me a thrill to hear them.

Chrom: So the future me wasn't so much furtive, but more of a hopelessly doting father?

Lucina: Well, there was one thing you never did tell me.

Chrom: Oh?

Lucina: ...How you and mother first met.

Chrom: That's...not the sort of story a daughter needs to hear.

Lucina: It's certainly one this daughter would LIKE to hear! Why don't we make a little wager? If I manage to defeat you, you'll tell me.

Chrom: ...I'm not so sure that's...

Lucina: That certain you'll lose, eh?

Chrom: Hmph! ...Very well. I accept.

Lucina: Then get ready, Father, because I'm serious about hearing this story!

Chrom: And I'm serious about not telling it—so likewise!

■ LUCINA X CHROM (FATHER/DAUGHTER) A

Lucina: I'm ready for today's training, Father.

Chrom: Before we begin, I have a question.

Lucina: Oh?

Chrom: It's something I'd been meaning to ask for some time now. Once this war is over, will you return to your own world?

Lucina: ...I don't know. I know it will be possible to cross the bounds of time again, my world itself may be lost. Naga said as much before we left.

Chrom: I see.

Lucina: But don't worry, Father. Once peace is returned, I'll leave you to your life.

Chrom: What? Why?

Lucina: I understand I don't belong in this time. I'll not have myself become a burden.

Chrom: Lucina! I never want to hear you say such a thing again!

Lucina: Father?

Chrom: I've told you before, you are no burden. You could never be a burden!

Lucina: But...

Chrom: I fear I'm not very adept at putting these sorts of things into words... But it's clear you need to hear something, so listen well.

Lucina: ...All right. I'm listening.

Chrom: Lucina...I am so very grateful for you. Grateful that you were born... That you grew into such a fine and noble woman... Grateful you withstood terrible hardship and risked all you knew to come here... I haven't the words to express how much it all means to me. None, save "thank you."

Lucina: Father...

Chrom: You're my daughter and my friend. You will always have a place at my side.

Lucina: Father, I... Th-thank... Oh, Father! *sob*

Chrom: Shhh, it's all right, Lucina. There, there, it's all right now. Daddy's here for you...

Inigo (Father/son)

Inigo's father/son dialogue can be found on page 293.

Brady (Father/son)

Brady's father/son dialogue can be found on page 297.

Kjelle (Father/daughter)

Kjelle's father/daughter dialogue can be found on page 299.

Cynthia (Father/daughter)

Cynthia's father/daughter dialogue can be found on page 303.

Morgan (male) (Father/son)

The Morgan (male) father/son dialogue can be found on page 309.

Lissa

Avatar (male)

The dialogue between Avatar (male) and Lissa can be found on page 218.

Avatar (female)

The dialogue between Avatar (female) and Lissa can be found on page 229.

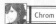
Chrom

The dialogue between Chrom and Lissa can be found on page 239.

Frederick

FREDERICK X LISSA C

Lissa: Huh. That's odd. I could have sworn he was over here some— Ah ha! There you are, Frederick! ...Geez, why the grumpy face?

Frederick: I fear this is the only face I have, milady. Was there something you needed?

Lissa: What are you doing back here?

Frederick: Inspecting the contents of our armory for worn or damaged equipment.

Lissa: Ooooo! Can I help?

Frederick: I cannot allow that. You could cut yourself, or accidentally—

Lissa: Do you think I'm an idiot?! Honestly, Frederick!

Frederick: I think you are a princess whom I am duty-bound to keep safe.

Lissa: Yeah, yeah, boooooooring...

Frederick: Was there something you needed from me?

Lissa: Oh, no. I mean, yes, but...I wanted to ask you a favor.

Frederick: How may I serve you?

Lissa: I want you to train me like you do the others. I'm tired of struggling to keep up with everyone. I wanna hold my own!

Frederick: A fine idea—it would be my pleasure to assist in your training. Though I must warn you, I am not a gentle teacher. Be certain you want this.

Lissa: Oh, I am!

FREDERICK X LISSA B

Frederick: Come, milady. It's time for your lessons. And don't bother trying to run away this time. I'll fetch my horse if need be.

Lissa: Guh... Me and my big mouth. Frederick, pleeeeease! My whole body's one big bruise after yesterday.

Frederick: A clear indication you need to train more. You're badly out of shape. Now come. You'll never get stronger by making excuses.

Lissa: I won't get any stronger if I die from training too hard, either! I need a break, Frederick. Do you know what a break is?

Frederick: I'm familiar with the concept, yes. But it's not something I engage in personally.

Lissa: How is that possible? People need to let off steam or they explode. It's very messy.

Frederick: I exist to serve and protect you and Chrom. That is my role as a knight. The oath I took did not include stipulations for time off.

Lissa: You know what? I think you just don't know HOW to relax.

Frederick:

Lissa: Wait! I thought I was joking... Was I right?! You don't know how to relax?!

Frederick: ...Enough talk. Adopt your stance. We'll practice dodging arrows.

Lissa: More like dodging questions.

Frederick:

Lissa: All right, fine. I can see this is going to take some doing. So how about this: in exchange for you making me stronger, I'll train you in the art of slacking off. You should feel honored. I'm the best slacker in all Ylisse!

Frederick: Milady, we really don't have time for—

Lissa: If we don't make the time to waste, you'll never learn to waste time!

Frederick: Wasting time learning how to better waste time seems a frightful waste of time indeed.

Lissa: Exactly! So let's get started.

Frederick: Perhaps this time I should be the one running away...

FREDERICK X LISSA A

Lissa: Come, Frederick. It's time for your lessons. And don't bother trying to hide this time. You're terrible at it, you know.

Frederick:

Lissa: Ah, there you are. Come on, didn't we have fun last time?!

Frederick: Doing what? Wandering about camp, bothering the others for no cause? Or do you mean when we laid in a field, aimlessly staring at clouds for hours?

Lissa: Both! It was amazing, right? Rejuvenating? Life changing?

Frederick: It was exhausting! In all my years of training and combat, I've never felt so tired!

Lissa: A clear indication you need to relax! You're too in shape, Frederick.

Frederick:

Lissa: ...Did you seriously not enjoy ANY of it?

Frederick: Well...I can't say it was...entirely unenjoyable... The time we spent exploring was a new and valuable experience.

Lissa: Oh, goody! I'm so happy to hear that.

Frederick: If you are happy, then I am happy, milady.

Lissa: Well then, let's get started! Those clouds aren't going to watch themselves!

Frederick: But we lazed about yesterday. I propose an alternating schedule. Even-numbered days, we train. Odd-numbered days, we...*ahem* Relax.

Lissa: Awww...

FREDERICK X LISSA S

Lissa: Hello, Frederick, I... Huh? Tee hee... What was that you just frantically put away? Are you...hiding something from me, Frederick? Tee hee hee...

Frederick: Me? I, er, no. Of course not, milady! Not I. ...Now, how may I help you?

Lissa: By showing me what you're hiding. Honestly, you're a terrible liar. It's that ring you "secretly" picked up last time we were goofing off in town, huh?

Frederick: ...Not so secretly, I see.

Lissa: Hee hee. Did you really think you could keep secrets from ME, after all these years?

Frederick: Then I suppose you know my intention in buying it... And that it's meant for you?

Lissa: Well, I was PRETTY sure, but it's never certain till it's certain, you know?

Frederick: ...Then I suppose it was a waste of time drafting twelve different ways of telling you. You always did know me so well.

Lissa: It seems like I trained you well, too! I'm so proud of you for wasting so much time! And of course I know you well, Frederick. How could I not? You were my first crush.

Frederick: Milady, I... I did not know.

Lissa: I know you didn't, even though I made it SO obvious, SO many times! Honestly, you can be hopelessly dense sometimes. But I guess it worked out in the end, because I got my dream, tee hee.

Frederick: And what dream was that?

Lissa: To marry my first love, obviously! It's kinda every girl's dream.

Frederick: I'm afraid I wouldn't know...

Lissa: But you must have a dream of your own, right? What's your dream, Frederick?

Frederick: To serve you, to protect you, and to make you happy, for as long as we both shall live.

Lissa: Hah, well, all right. I think I can let you do that. Twist my arm!

Frederick: Heh. Thank you, milady.

Lissa: Okay, you're going to HAVE to start calling me Lissa!

Frederick: V-very well...Lissa. Thank you.

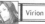
Virion

VIRION X LISSA C

Virion: There, all set. Now fly straight and true, my love.

Lissa: Virion?

Virion: Oh, horrors! I fear you've caught me in the act.

Lissa: In the act of...what, exactly? Groping pigeons?

Virion: Ha ha ha! Oh, my dear lady, no! ...Well, not today, at any rate.

Lissa: So then, what?

Virion: I have commended a letter to this bird's fair wing.

Lissa: Oh, it's a carrier pigeon! But wait, why do you care if I saw that?

Virion: Well, I'm something of a guest here, being foreign as I am. Protocol demands leave from a commander before carrying on any correspondence.

Lissa: You mean Chrom? I seriously doubt he'd mind you sending a few letters.

Virion: Perhaps you're right. But not everyone shares my brother's broad-mindedness. There are some around the camp who still don't fully trust me.

Lissa: So why not get Chrom's permission? If you're open about it, no one will have any cause for suspicion. ...Er, right? Here, I'll go ask him myself!

Virion: Lissa, wait! I don't... You shouldn't... Oh, dear. This won't end well.

VIRION X LISSA B

Lissa: Hey, Virion. I talked to Chrom; you're clear to send as many pigeons as you want.

Virion: ...With nary a question about the content of my letters? Fascinating. I commend Chrom's openness, but naivete is a troubling trait in a general.

Lissa: Pfft! He's not naive, silly. I just invented a little backstory for you. I told Chrom you're writing letters to your dear old ma and pa back home.

Virion: Aristocrats have neither "mas" nor "pas," milady! Such vulgar terms... But tell me—suppose I were actually a spy exposing secrets to the enemy? What would be made of your groundless stories then?

Lissa: Um, wait. Are you confessing to me? Because you don't seem like a spy.

Virion: Ha ha ha! Oh, this is truly too much. You and Chrom both, you're...

Lissa: What? Why are you laughing?

Virion: Apologies, dear girl. Your incandescent innocence simply caught me off guard.

Lissa: Watch it, fancy pants! It's "milady," not "girl." I won't stand here and be mocked!

Virion: Perish the thought, milady! I have only the deepest admiration for you. I'm envious, in fact. Men of my elevated station must suspect all who surround them. You and your brother are blessed to live free of such petty intrigues.

Lissa: You DO realize that as a princess I outrank you twenty times over. ...Right?

Virion: Oh, well...yes... *ahem* I suppose you would, wouldn't you? But then royalty has its own kind of shield from many of life's harsher realities. A fact lesser nobles such as myself know only too well! Caught between the huddled masses below and the royal houses above... O onerous fate! I accept my station ever know rest?!

Lissa: ...Nope. I still don't see how you have it harder than my brother.

Virion: Er... Yes, well it's a...nuanced thing. A casual observer might agree that leading an army is the greater burden. But to the trained eye, it's really quite clear that... You see, um...

Lissa: You have no idea what you're talking about, do you?

Virion: NO! I DON'T! OKAY?! Are you pleased to hear it?! I... *ahem* My apologies. What were we talking about?

Lissa: Your stupid carrier pigeons. Gods, even if you were a spy, it wouldn't matter. Your explanations would more likely confuse the enemy than help them! Anyway, you still haven't told me—what are your dumb letters about, anyway?

Virion: I'm afraid that's privileged information, my dear lady.

Lissa: What?! But after I... Ngaaah!

Virion: Ha ha! Ladies prefer a man with a bit of mystery, my dear Lissa. Though our exchange has been most valuable in its own right...

Lissa: What, you're happy you got to hide something from me?

Virion: No, I learned you trust me! A lady's faith is among the sweetest gifts she can bestow. This has all been ever so enlightening, my dear. You have my thanks.

Lissa: Bah, I still think you're full of it!

VIRION X LISSA A

Virion: Hmm, it should have returned by now...

Lissa: Waiting for one of your carrier pigeons, Virion?

Virion: D-don't be silly, milady! Just enjoying a bit of refined reflection as I bask in the westering sun's ruby light...

Lissa: Oh, sooo I guess you won't be needing this then?

Virion: My pigeon!

Lissa: It flew in through my window. I think the thunderstorm must have frightened the poor thing. Or maybe it just likes me. But since you don't need it, maybe I'll just keep—

Virion: Wait! I...suppose if it's afraid, the humane thing is to restore it to a familiar setting... Perhaps I should take it back. For its sake. Now give Virion the bird like a good lady.

Lissa: Geez, you're WELCOME!

Virion: There! The creature seems calmer already. ...But what's this? A reply tied to its leg?

Lissa: What does it say?

Virion: Mmm, as if you don't already know?

Lissa: What's THAT supposed to mean?

Virion: The bird flew in through your window, my dear. Would you really have me believe you didn't so much as peek at this missive?

Lissa: I didn't! It's the truth.

Virion: Are you daft, girl?! Why ever not?! You'll never hope for a better chance to learn the contents of my correspondence! Why, if I were hatching a plot...

Lissa: You're not hatching anything, birdbrain!

Virion: But...how can you be so sure?

Lissa: Because I am! Because you're Virion and...I trust you. If I'm going to hear about these secret letters, I want it to be from you. I'm not about to violate your privacy to satisfy my idle curiosity.

Virion: How...utterly bizarre. Alluring, yes, but bizarre.

Lissa: What's bizarre?!

Virion: Your trust. As I said before, a lady's faith is a heady thing. Oft too strong a brew for me in times past... But I fear I'm starting to acquire a taste for it.

Lissa: Care to boil that down for me, fancy pants?

Virion: Someday, this new taste may blossom into a full-blown addiction. And on that day, I shall tell you all about my letters.

Lissa: ...SOMEDAY?! Well, if you're going to be such a CHICKEN, I'll leave you to your PIGEON pal there! When you're ready to talk, you know where to find me. Hmph!

VIRION X LISSA S

Lissa: I heard you were looking for me, Virion?

Virion: Ah, there you are, my dear. Yes, there's something I was hoping to discuss. It shouldn't be long now. Just one... Ah ha! Perfect.

Lissa: Oh, it's your little carrier pigeon! ...Is it carrying a flower?

Virion: Indeed! A common enough specimen where I come from.

Lissa: It's beautiful. I don't think I've ever seen a blossom quite like it.

Virion: Now, we just take the stem...and wind it back around, through the leaves...

Lissa: Oh! You made it into a ring!

Virion: Just so. In the language of flowers, this particular blossom means "eternal love." It's frequently given out at weddings in my country.

Lissa: Eternal love... How wonderful.

Virion: Of course. ...And this as well.

Lissa: But wait, that's... This is... Virion, this is a real ring.

Virion: A humble gift for the woman whose trust has become my fondest addiction.

Lissa: Are you asking to...marry me?

Virion: If you would stoop so low to have me. Though naturally, if you object...

Lissa: No! Of course I don't object. It's just...

Virion: Just...what?

Lissa: What were all those damned letters about?!

Virion: Oh, yes. ...That.

Lissa: You said if a day like this ever came, you would tell me.

Virion: So I did. Very well—here. Read one for yourself.

Lissa: "My sweet Virion: I was overjoyed at your last letter. I hope the flower arrives intact!" "Your father and I are eager to meet her as soon as circumstances allow." Wait, this IS from your parents! So the story I told Chrom was...

Virion: Actually the truth, yes.

Lissa: You big jerk! You lectured me about spies and lying and...and...and everything!

Virion: I lectured you for telling groundless stories, my dear. A subtle but important difference. I never said your groundless story wasn't accurate.

Lissa: Unbelievable! ...But wait. I still don't understand. Why all the secrecy?

Virion: Because it's...well, embarrassing. A proud aristocrat, staking his life in a just and noble war, writing home to Mother?

Lissa: I think it's gallant! What greater reason to fight is there than love of family? In fact, when I told the story to Chrom, I thought how nice it'd be if it WAS true... Besides...I accept you, Virion, just the way you are. And, yes. I accept your proposal, too.

Virion: You'll wear the ring?

Lissa: Proudly. As a symbol of my trust in you, Virion. ...And our love.

Vaike

VAIKE X LISSA C

Vaike: Ogre's teeth! Where in blue blazes has Chrom gone to?! ...Say, Lissa! You ain't seen that brother of yours skulkin' around, have ya?

Lissa: If I had, I wouldn't tell YOU.

Vaike: Oh, come on! It's nothin' serious! Why ya gotta take his side all the time?

Lissa: Because he's my brother and I know you just want to hit him with something! Gods, you're like children, the both of you.

Vaike: I could try explainin' it, but ya wouldn't understand. It's a warrior thing.

Lissa: More like an idiot thing. You know, there ARE other ways to communicate! Besides bopping each other on the head with blunt axes, I mean.

Vaike: Look, Lissa. The Vaike doesn't hate your bro. Heck, I like him! Most of the time... But we've gotta fight! Fate made us rivals, and who are we to deny fate?

Lissa: Oh now, that is just absurd. So why, exactly, are you "rivals"?

Vaike: Huh? Well, you know. ...Stuff.

Lissa: No, I don't know! I think you have a grudge against Chrom, and I want to get to the bottom of it!

Vaike: A grudge? No way! I RESPECT the man! He's the greatest warrior in the realm! But if ya wanna be the very best, ya gotta beat the very best...

Lissa: Ah-ha!

Vaike: ...B-but don't go tellin' him I said that! If he knew I was praisin' him, I'd never hear the end of it every time we squared off!

Lissa: Tee hee, don't worry, Teach. I'll keep your little secret.

VAIKE X LISSA B

Lissa: Vaike? I asked Chrom about you, and do you know what he said? He said you're a great warrior and he's learning a lot from your duels.

Vaike: Bah! He's just trying to soften up ol' Teach.

Lissa: Er, but didn't you say pretty much the same thing about him the other day?

Vaike: Keep your voice down! I told ya, that's between you and me.

Lissa: Riiiight. How silly of me.

Vaike: Did ya know that Chrom once put on a disguise and came to my little town? Never let on 'bout who he was, even when my axe took a...dislikin' to him. I used to think royals were nothin' but puffed-up blowhards. Stick a pin in their silk-covered hides and whoosh! ...All the air runs out of 'em. But that brother of yours... He changed my mind.

Lissa: People are always reminding Chrom he's royalty. ...He tends to forget.

Vaike: I've dealt with a lot of fool ignorance since I joined the Shepherds. People are always askin' who I think I am, a commoner lording it with princes. I've had it from lowborn and highborn alike. ...But never Chrom. He doesn't care how lowborn I am, so long as I handle myself in a fight.

Lissa: Vaike, behind all the bluster, I think you may love Chrom more than any of us.

Vaike: Hey, don't go puttin' words in my mouth! And not a word of this to Chrom, either! ...'Specially that lovey-dovey part.

Lissa: My, so many secrets we're sharing these days, tee hee.

Vaike: One of these days, the Vaike needs to learn to keep his big yap shut.

Lissa: Oh, don't be silly. I'm actually tickled you trust me. But promise you'll try to get along with my brother, all right?

Vaike: All right. ...But AFTER I beat him!

VAIKE X LISSA A

Lissa: "Slurp chomp" So then Chrom, he... "chomp, chomp" "snort" So he said...

Vaike: Look, either you should eat or you should talk. ...Actually, just eat, would you?

Lissa: Okay, fine. ..."chomp, chomp" "slurp"

Vaike: You really think that brother of yours is the bee's knees, don't you?

Lissa: "Schnorf slurp" Look who's talking! "Crunch" "chomp"

Vaike: Cripes, why did I ever buy you that blasted mince pie in the first place...

Lissa: Blackmail, remember? You know I'm terrible at keeping secrets when I'm hungry.

Vaike: This is a fool bit of business, and no denyin'... Still, the more I hear your stories about Chrom, the more I admire him.

Lissa: I'm SO proud of him. He's done so much for our people...and for me. I feel like anything I've accomplished I owe to him in one way or another.

Vaike: Aw, what are you talkin' about? You expect ol' Teach to believe that?

Lissa: Oh, don't mind me. I'm just blabbering.

Vaike: Way I see it, you got lots to be proud of. I mean 'sides your brother.

Lissa: Do you really think so?

Vaike: As sure as my name is Vaike the Mighty! Ya never back down from a challenge, and you're not all snooty like most royal folk. You're nice, and kind, and as beautiful as a goddess! Gods strike me down if it ain't the truth! You got plenty to be proud of!

Lissa: Vaike, that's... Well, thank you. Even if it was a total exaggeration.

Vaike: No japin'! You're all that and more! There's just so much good in ya.

Lissa: Goodness... W-well, I suppose I could say the same of you, couldn't I? All that talk about fighting my brother? I know it's all just bluster. You don't want anyone to know what a kind, considerate, and wonderful man you are!

Vaike: Aw, shucks... You're gonna make the Vaike blush...

VAIKE X LISSA S

Vaike: Hey, Lissa? Ya seen Chrom around?

Lissa: You're not looking to duel him again, are you? Because I thought we—

Vaike: No, no! Not that! It's just... Well, it kinda concerns you, actually.

Lissa: Oh?

Vaike: See, I been thinkin' and... Well, I was wondering if... Aw, horsefeathers. I'm no good at this! So what I'm tryin' to say is... Would ya do me the honor of wearin' this?

Lissa: ...Is that...is that an engagement ring?!

Vaike: I had the town armorer craft it special. I know it ain't much, 'specially for a royal... But I ain't a rich man, and so this was really all I could—

Lissa: You know that if we wed, Chrom will be your brother in name, yes? That means no more talk of duels and rivals. Got it?

Vaike: Aw, nuts to that! I love ya, Lissa! I love ya so much it hurts! But Chrom and me are rivals, and it'll take more than a weddin' to change it!

Lissa: TRULY?! Gods, you are simply the most stubborn, willful...brave, and strong, and charming man I have ever known. Yes, Vaike. Yes! I accept!

Vaike: Aw, Lissa, you've made the Vaike's day! Week! Year! Lifetime!

Lissa: We should go tell my brother the good news. I'm sure he'll be surprised!

Vaike: That's why I was lookin' for him. ...Figured I should get his blessin'.

Lissa: Well, then. Shall we look together?

Vaike: Yeah, together! After you, Mrs. the Vaike!

Stahl

STAHL X LISSA C

Stahl: Ah, that's MUCH better!

Lissa: See, there's nothing a good healing staff can't fix!

Stahl: I'm sorry to have you use it for a simple stomachache. I thought I had more tonic in my bag, but every flask was empty.

Lissa: That's because you're always giving it to other people! By the way, what caused your tummy rumble in the first place?

Stahl: Stress! Lots and lots of stress! ...I'm searching for a special item, you see. And every time we arrive in a town, I think, "This is it! It must be here!" But I always end up disappointed.

Lissa: Ooooo! Sounds spicy! So what's the secret item, huh? Tell me, tell me!

Stahl: Wing scales from a rare giant butterfly. My brother wants them for a concoction. They're impossible to find in Ylisse, so he hoped I could buy some on our journey. I go to the market in every town we visit, but not a single merchant has had them.

Lissa: Aw, I see... Not quite as exciting as I was expecting... And I can't believe your dumb brother gave you errands in the middle of a war!

Stahl: I admit, his timing could have been better.

Lissa: You risk your life every day! You can't waste energy chasing butterfly whatevers!

Stahl: Heh, well, he IS my brother. How could I say no?

Lissa: *Sigh* You're far too nice to people, Stahl. You let them push you around. Oh, fine. I guess I'll try to help. What's the name of this stupid butterfly?

Stahl: Oh, gracious, no! I couldn't possibly involve you in this fool's errand!

Lissa: I just... I care too much for you! I just don't want to waste any more cures on your silly stomach! The sooner you

find the scales, the sooner I can worry about REAL problems!

Stahl: Well, if you really want to help...

Lissa: You just stand there smiling. Lissa is on the case!

STAHL X LISSA B

Stahl: The butterfly scales! At last! Oh, many thanks for your help, Lissa.

Lissa: Hey, no sweat. I had a little shopping errand of my own to do anyway. My brother wanted me to buy perfume for someone, but he wouldn't tell me who. He just said to buy something I liked, which isn't really much of a clue. He's so dense sometimes! I mean, what if his special lady friend has different tastes?!

Stahl: I don't suppose it matters so much, does it? It's the thought that counts after all. Besides, it's hard for a man to buy perfume on his own. I know from experience!

Lissa: There you go again, giving people the benefit of the doubt. Don't you think it's super annoying how both our brothers treat us like servants? I mean, here we both are running from market to market buying stuff for 'em!

Stahl: Heh! You have a point.

Lissa: Of course I do! ...And I don't mind so much, but it's super unfair for you. You're always helping other people, and you never get anything in return.

Stahl: Oh, but I do! I enjoy helping people and making things a little easier for them. As long as someone actually acknowledges my efforts now and then, that's enough.

Lissa: Aw, you are SUCH a sweetie! In that case, I'll watch you like a hawk and make sure no good deed goes unseen!

Stahl: Well in THAT case, I'll have to be sure I give you something to see!

STAHL X LISSA A

Stahl:

Lissa: What are you reading, Stahl?

Stahl: A letter from my brother. He's thanking me for the butterfly scales I sent.

Lissa: Ye gods, what dreadful penmanship! It's nothing at all like yours.

Stahl: Heh. My brother is a rugged, no-nonsense sort. He doesn't much care for calligraphy. But look here! He sent along more of his secret stomach tonic. This new recipe uses the butterfly scales. It's twice as effective as before!

Lissa: So the errand he sent you on was actually for your benefit?

Stahl: Apparently so! It's a good reminder—brothers don't always say and do the right thing... But in the end, or when it matters, they always have our interests in mind.

Lissa: Pffft! Not MY brother! I doubt he ever thinks of me at all! Unless it's to tell me that I'm childish and I should learn to grow up or whatever. He's too busy running a country and a war to worry about his little sister...

Stahl: I assure you, that is not the case! At all! Chrom cares for you very much. And who can blame him? If I had a charming sister like you, I'd never leave your side!

Lissa: Y-you think I'm charming?

Stahl: Of course! ...Er, is that strange?

Lissa: I'm...I'm just not used to accepting praise from such a...fine gentleman, is all. Thanks, Stahl. You made my day!

Stahl: Heh, well, I only spoke the truth.

STAHL X LISSA S

Lissa: Er, Stahl? Look what Chrom gave me.

Stahl: Isn't that the perfume he had you buy?

Lissa: He felt bad about missing my birthday, so he wanted to get something I really liked. Apparently I mentioned wanting a new perfume, and so...

Stahl: He sent you to buy your favorite kind. Ha! I told you brothers always pull through!

Lissa: Hee hee! Yeah, he really is the best brother a girl could have.

Stahl: Seeing you in such a happy mood, perhaps I should seize the opportunity...

Lissa: Opportunity? For what?

Stahl: Lissa, I have a confession to make.

Lissa: Ooh, a confession?! Scandalous! Okay, dish. Give me all the juicy details...

Stahl: I love you.

Lissa: ...What?!

Stahl: I know you're royalty, and I never felt I was worthy enough to court you. So I kept my feelings bottled up until I no longer had the strength to hide them... Th-that's why I decided to buy you this ring.

Lissa: Oh, Stahl, yes! Yes, of COURSE I'll marry you! I've loved you forever!

Stahl: Truly?!

Lissa: YES, you ninny! Here, let's see that ring.

Stahl: ...Ah, it fits you perfectly!

Lissa: Hee hee! It totally does, huh? I'm so glad you finally unbottled those feelings, tee hee!

Stahl: It's like a weight off my shoulders! I can't wait to tell my brother the good news.

Lissa: Oh, right! And I gotta tell Chrom! ...Oh, hey! You and him are gonna be brothers now! That's so weird.

Stahl: Heh, and so wonderful. Just like you, Lissa.

Kellam

KELLAM X LISSA C

Lissa: Tsk, my stupid brother can be so selfish sometimes! I spent AGES making this pie, and he didn't eat a bite! Oh well. I suppose I'll just have to eat the whole thing by my—

Kellam: I'll help.

Lissa: ARRRGH! KELLAM! Gods! D-don't sneak up on me like that!

Kellam: But...I've been standing right here since before you arrived.

Lissa: Oh... Well, yeah... I guess I should be sorry, then. So, what were you saying? You want some of this pie?

Kellam: Yes, please! I'm awful hungry... *Munch, munch* Mmm... Mmm? Murf...

Lissa: Well? How is it?

Kellam: *Cough* *hack* Haaaaaaa... Um, it's... Well, it certainly...exists...

Lissa: I know, right? I add an elixir to give it that extra kick. I mean, out of everyone here, he's trusting you to keep his little sis safe. That's pretty good for you!

Kellam: Actually, Lissa, perhaps you could try it once without the elixir...

Lissa: Really? Huh. Well, maybe next time. Hey, do you know a lot about cooking? You could taste-test more of my pies! I want to make a pie that not even jerkface Chrom can resist!

Kellam: Well...if you really need a guinea pig, I...guess I could help out... In these times of turmoil, we all have to make sacrifices for the greater good.

Lissa: ...Sacrifices?

Kellam: Er, well, that is... Sacrificing, uh...my diet!

KELLAM X LISSA B

Lissa: Kellam, it's ready! Kellam! Where are— Oh! There you are. Here it is, Kellam! A piping-hot pie fresh from Lissa's oven of surprises!

Kellam: ...Oh. Joy.

Lissa: I made an extra-big one this time, so eat as much as you like.

Kellam: *Shudder* Okay... L-let's see it... *Sniiiff*

Lissa: You see how the filling has a rainbow of colors in it?

Kellam: Golly, so it does...

Lissa: It's more savory than sweet. I plan to serve it as a dinner.

Kellam: Let me...just have a little sample first. Let's see...*chew* GURGH!

Lissa: Kellam?! Are you all right? Is that good heaving or bad heaving? Does the filling taste funny? I didn't mess it up again, did I...?

Kellam: L-Lissa, do you ever...taste the dishes yourself?

Lissa: Nooooo. Why? Should I?

Kellam: It's...a good thing...you gave this to me...first... Th-then...only one of us...need...know...the horror...

Lissa: K-Kellam?! Oh gods, he fainted! Kellam, can you hear me?! Stay away from the light! Gah! Where did I put my healing staff?!

KELLAM X LISSA A

Kellam: I haven't seen you baking any pies recently, Lissa. Don't tell me you've given up.

Lissa: But...aren't you angry at me?

Kellam: Angry? About what?

Lissa: Well, you know. When I almost killed you with my rainbow filling.

Kellam: Why would I be angry? It wasn't intentional. Er, it actually WASN'T intentional, right?

Lissa: Kellam, you are SO sweet! ...You know, I don't think I've ever seen you angry. Not even once.

Kellam: I've never seen the point of anger. It's not much fun for anyone. Whenever I feel myself getting mad, I hold it in until it fades away. Because it always does in the end.

Lissa: You know, Kellam. I'm going to have another go at making a pie. And this time it's going to be totally delicious, and you'll get the first taste!

Kellam: Um... That sounds...nice?

KELLAM X LISSA S

Lissa: ...Well? How was it?

Kellam: It was delicious. Honestly and truly!

Lissa: I know, right? I've been practicing SO much, and it finally paid off.

Kellam: If you serve this pie to Chrom, he'll eat every last crumb.

Lissa: Oh, I don't care about my dumb brother anymore. I just wanted to make a pie that YOU liked!

Kellam: I'd happily eat your cooking for the rest of my life, Lissa.

Lissa: For reals?

Kellam: Yes. And here's the proof...

Lissa: A ring?

Kellam: My mother made it. Pretty fancy, don't you think? She told me to give it to the woman I'd spend the rest of my life with. And I know you're royalty and all, but... Lissa, will you marry me?

Lissa: Oh my gosh, YES! Of course! ...Er, but you should know that cooking isn't the only thing I'm bad at. I can't sew. Or do laundry, really. And I'm not much for cleaning or yard work...

Kellam: Wait. You can't do any of those things? ...Really?

Lissa: Hey! You're SUPPOSED to say "Oh, it doesn't matter!"

Kellam: B-but that means I have to do absolutely... everything.

Lissa: Too late! I've got the ring, and I'm not giving it back!

Kellam: Oh dear.

Lissa: Anyway, don't worry. You've got plenty of time for all those chores! We're gonna be together for forever and ever and ever!

Lon'qu

LON'QU X LISSA C

Lissa: There you are, Lon'qu! I take it my brother talked to you?

Lon'qu: Er...

Lissa: Oh, stop it! Yes, I'm a girl, but it's your job to guard me! So no running away and being all weird. All right?

Lon'qu: Chrom said there was a plot on your life. Is this accurate?

Lissa: Yeah, I guess somebody wants my sweet little head on a platter. Don't ask me why!

Lon'qu: You're of royal blood. That's enough to make you a target. And any shadow could hide a knife, so we must prove we are never alone.

Lissa: My hero! I won't have to worry about a thing with you around! La la laaaa!

Lon'qu: Don't be careless! Keep your eyes open! Death could lurk in any nook or... *Sigh* Surely there is someone else better suited to this task.

Lissa: Yeah, but you were just lazing around catching butterflies all day, so Chrom—

Lon'qu: I just happened to be—

Lissa: J-just kidding, Lon'qu! K-kidding! I'm sure Chrom was impressed by your skill and charm and good looks! I mean, out of everyone here, he's trusting you to keep his little sis safe. That's a pretty huge honor, right?

Lon'qu: ...I suppose.

Lissa: Right! So come on, no more grumbling. Let's shake hands and make nice!

Lon'qu:

Lissa: Oh, fine. No handshaking. We can just...nod at each other. Sheesh! Do you really have such a problem with women?

Lon'qu: I find them...disconcerting. But it will not interfere with my duty.

Lissa: Hmm... Maybe as thanks for guarding me I'll go ahead and fix your little problem...

Lon'qu: ...Or maybe not?

Lissa: Fiiiiine! I'm going to train, then. You can...just stand there and look dour.

Lon'qu: That suits me just fine.

LON'QU X LISSA B

Lissa: It's about time the rain stopped, I thought it'd never—ooooooh! Look! A rainbow!

Lon'qu: Keep your distance. I can see it from here.

Lissa: Um, can you even GUARD me from that far away?

Lon'qu: I can close the distance in the blink of an eye.

Lissa: Seriously? I'm nowhere near that fast! Here, lemme see how long it takes me to—

Lon'qu: Enough! Stop trying to get closer!

Lissa: Hee hee! You're pretty sharp! ...But I'm just trying to be friendly. How are we supposed to be best buds if you're way over there?

Lon'qu: I'm close enough to protect you. ...And we are NOT "best buds."

Lissa: Geez, what a grump! Why even bother guarding me if that's how you feel?

Lon'qu: Because those are my orders...and morale would fall if anything happened to you.

Lissa: Oh, puh-leeeeease! No one would care if something happened to me. Someone stronger would just roll my corpse out of the way and take up the fight...

Lon'qu: ...Do you truly not see how your presence energizes the others? How your smile and demeanor put everyone at ease?

Lissa: R-really? Hee... Sooo, what about you, Lon'qu? ...Does my smile put you at ease?

Lon'qu: Perhaps. ...From a certain distance.

Lissa: Ugh, why do I even BOTHER?! I'll see you later, grump.

Lon'qu: Wait. I'll go with you.

Lissa: No you won't! I'm going to take a bath!

Lon'qu: But my orders... You'll be...

Lon'qu: Argh! Hmm, now that I think about it, there's been no sign of any attempts on her life. Either her would-be assailants are being extremely cautious... Or perhaps this is some sort of ruse? Are she and Chrom toying with me?

LON'QU X LISSA A

Lissa: The path's kinda bumpy here, Lon'qu. Should we hold hands?

Lon'qu: No.

Lissa: Honestly, you think you'd be used to me by now. And you're always so serious! It wouldn't kill you to smile once in a—

Lon'qu: Shhh!

Lissa: That is SO rude! Gods, I'm only trying to—

Lon'qu: Get behind me! Quickly! There's a— Hngh!

Lissa: N-no, Lon'qu! You're hurt! Please, you can't... Don't die!

Lon'qu: ...Ngh. It's just a single arrow. It won't kill me.

Lissa: Yeah, but any more of them could... And I...I think we're surrounded!

Lon'qu: I wager we've found your assassins. Stay close!

Lissa: R-right!

Lon'qu: ...That's the last of them.

Lissa: Here, hold still. Let me tend to your wounds.

Lon'qu: I'm fine. Are you hurt?

Lissa: No. Thanks to you.

Lon'qu: Good. That's...good.

Lissa: Lon'qu, you just... You saved my life.

Lon'qu: I followed orders. You should be safe now, but I'd better escort you to your tent, just to be certain.

Lissa: Um, Lon'qu?

Lon'qu: What?

Lissa: Now that you foiled the plot, I guess your bodyguard duty is over now... I suppose we're done walking together like this, huh?

Lon'qu: I see no reason to continue.

Lissa: Yeah, but... We were finally getting close. I'd be sad to lose that now.

Lon'qu: Do not lay this at my feet. I told you to keep your distance.

Lissa: Yeah, but...

Lon'qu: *Sigh* I...suppose...we could still chat. If you want. ...From time to time.

Lissa: You mean it?! Oh, yay! Thanks, Lon'qu!

Lon'qu: *Grumble, grumble*

LON'QU X LISSA S

Lissa: Heya, Lon'qu! I'm back for another chat!

Lon'qu: ...Not again.

Lissa: Yeesh, try to contain your excitement there. Oh, and be sure not to smile. Most boys would cut off a leg to have a cute girl drop by to visit.

Lon'qu: Would you have me paste on a fake grin whenever you grace me with your presence?

Lissa: Well, no... Actually, that would be really creepy, coming from you.

Lon'qu: Then this is what you get.

Lissa: All right, all right. You don't have to be so cold to me. I just miss you, you know! You were guarding me around the clock for so long, and now I barely see you. But I suppose you wouldn't understand how I feel, huh? I mean, you can't stand girls. All right, listen. If you don't want me here, just say so and I'll leave you in peace.

Lon'qu: I...like when you come to see me.

Lissa: Fine. Don't worry. I know where the door is. You don't have to... Wait, what'd you say? I must not have heard you right... Because it almost sounded like you said you liked having a girl come bother you.

Lon'qu: You heard me fine... And you are no bother. I... also miss the time we spent together.

Lissa: I...must be losing my mind.

Lon'qu: This may come as a surprise...but I have something for you.

Lissa: A ring? ...Is this a WEDDING ring? But wait, you hate women!

Lon'qu: I don't hate anyone. And as far as my issue with women, you...are the exception. I find myself thinking of nothing but you. My every moment is consumed with you. If you will allow it, I swear to be with you and protect you for the rest of your days.

Lissa: Oh, Lon'qu... Of COURSE I'll allow it! And I'll watch your back, too! But you have to be beside me always. No more distance!

Lon'qu: ...No more distance.

Ricken

RICKEN X LISSA C

Ricken: Hrmm...

Lissa: Uh-oh. You sound barfy, Ricken. Want me to run and get my staff?

Ricken: I'm all right. I just don't feel like I've been fighting at 100 percent lately.

Lissa: Aw, don't worry. Everybody has an off day. You wanna practice for a little bit?

Ricken: Practice how?

Lissa: You know? Spar with me! Maybe it'll get you past your little block.

Ricken: Oh, uh... No, thanks. It won't help.

Lissa: Oh, what? WHAT?! Do you think I can't spar with you? Is that it? I may not be my brother, but I can kick serious butt when the mood—

Ricken: NO! I said it won't help!

Lissa: ...Whoa.

Ricken: They're trying to kill us out there, Lissa. Kill. Us. And the only thing we can do is kill them first. ...We have to take the lives of people. My hands are shaking just talking about it. It's just so...terrible.

Lissa: I'm sorry, Ricken. I didn't mean to make light of everything.

Ricken: No, I know. I shouldn't have yelled. Sorry, Lissa.

Lissa: I had no idea things were eating away at you like this...

Ricken:

RICKEN X LISSA B

Ricken: What are you doing, Lissa?

Lissa: Combat training.

Ricken: ...What?

Lissa: I fight too, you know!

Ricken: Is this because of what I said before? You really don't have to do this.

Lissa: Yes, Ricken. I do. I can't expect other people to protect me all the time. We're at war. Unexpected things happen. I need to be ready to do what is necessary.

Ricken: But, Lissa, that's my job. Protecting you, I mean. Being on the front lines means being in danger, and... I don't want to see you get hurt.

Lissa: You think I don't feel the same about you? About Chrom? About everyone?

Ricken: No, but—

Lissa: You don't get to bear this alone, Ricken. It's totally unfair.

Ricken: Lissa, I only... You're right. I'm sorry. We're all in this together, no matter what.

RICKEN X LISSA A

Lissa: Heya, Ricken. Are you reading again? You're gonna go blind at this rate!

Ricken: I've got a lot to learn if I hope to be of use to Chrom in the future.

Lissa: But you're useful now!

Ricken: I'm talking about the far future. I'm hoping to someday be his royal advisor. He's my hero, you know? I want to be close to him and be someone he can rely on.

Lissa: Hee hee! Yeah, you want to be close, all right! When you first joined up, you followed him around like a baby duckling! So what is it about my brother that draws you to him? And don't say his rugged good looks, or I'll slug you!

Ricken: When I was young, the other kids used to terrorize me. One time, it got pretty bad... But Chrom jumped in and stopped it. I wasn't used to people being nice to me, so I figured there had to be a catch. Like maybe he was just showing off because he knew he could take the other kids?

Lissa: MY brother? Showing off? Hah! No, he would have done the same thing no matter who was bullying you.

Ricken: I found that out for myself when he saved me a second time. The kids chased me into the woods, but then a pack of wolves showed up. There must have been 20 of them... Chrom showed up just in time and ran them all off!

Lissa: Whoa. Guess I can see why he's your hero.

Ricken: That's not even the best part. He'd fought another wolf pack to reach us! After the other pack ran off, the next barely stand. That reminder he was human, too, made everything else all the more impressive. I remember wishing that I were that brave. I still do, I guess...

Lissa: I think you're plenty brave, Ricken. And I'm sure you'll be someone's hero someday!

Ricken: Thanks, Lissa. But for now, the best way for me to get there is to hit the books!

RICKEN X LISSA S

Ricken: Are you all right, Lissa? Any injuries from that last battle?

Lissa: Nope! I'm fit as a fiddle. ...Sweet of you to ask, though.

Ricken: Sure.

Lissa: You know, I think you're just as much of a hero as my brother. You've saved my neck more times than I can count, and I can count pretty high.

Ricken: Of course! You're Chrom's little sister. I'll keep you safe no matter what.

Lissa: ...Oh. Right.

Ricken: Er, I mean... Oh, that didn't come out right. Yes, you're his little sister. But you're also so much more... When you said you wouldn't let me bear the weight of fighting alone, I... It felt like a weight lifted off me. ...That's what I want to protect you.

Lissa: Aw, that's so sweet. I'm glad I could help.

Ricken: I've actually been thinking about this a lot and... See, I was wondering if... Well, here.

Lissa: A ring?

Ricken: It's a signet ring passed down within my family. I'd like to maybe...wear it? 'Cause I was thinking then I could just keep protecting you! ...You know? Forever?

Lissa: Hee hee! Now you want to stay close to Chrom AND me!

Ricken: N-no! It's not like that! I mean, yeah, I like him, but I LOVE you!

Lissa: Ricken. I was teasing!

Ricken: ...So is that a yes?

Lissa: Yes!

Maribelle

MARIBELLE X LISSA C

Lissa: This tea is soooo good!

Maribelle: Isn't it just divine, darling? The leaves are infused with a citrus aroma, so I was certain you'd like it.

Lissa: I like citrus.

Maribelle: In all the years we've shared tea, you only mention the flavor if it's a citrus blend. How funny that you didn't even know!

Lissa: That is funny! And a little embarrassing, I guess... You know me better than I know myself, Maribelle!

Maribelle: That's hardly a surprise, darling. I'm your best friend.

Lissa: Hee hee! I know! It's SO true. ...Wait a second. I don't know what kind of tea YOU like best!

Maribelle: Well now, that simply won't do at all. Why don't you take a guess?

Lissa: Hmmmm. Is it...rose tea?

Maribelle: Tsk! Such a common flavor.

Lissa: Tea with milk?

Maribelle: Ugh! Why not just drink from a mud puddle?!

Lissa: This is hard! Maybe if I knew more about tea... What other kinds are there?

Maribelle: Ah, well. I suppose I'll have to take pity and simply tell you. My favorite blend...

Lissa: Is...?

Maribelle: Black tea infused with the still-warm blood of an adult male grizzly bear.

Lissa: *PFFFFFFFFFFTTT!*

Maribelle: Lissa, what is wrong with you! What manner of lady spews tea?! It is simply not done!

Lissa: What's wrong with me? What's wrong with you?! Who would drink such a thing?!

Maribelle: No one, darling. It was only a jest. ...Now wipe your mouth, please.

Lissa: I actually believed you... All right, what's the real answer, then? What's your favorite tea?

Maribelle: Why, whichever ones you enjoy, darling. That way I get to appreciate both the beverage and your enjoyment of it! So if you ever find a blend you're especially fond of, just say the word.

Lissa: Um, all right. I will. Thanks. But I still kinda feel like that wasn't a real answer...

MARIBELLE X LISSA B

Maribelle: Phew... Today's battle must have been the fiercest yet! You're not hurt, are you, darling?

Lissa: No, I'm fine. What about you?

Maribelle: I also appear to have escaped injury, thank you.

Lissa: Good! That's...good.

Maribelle: Why, whatever is wrong, darling? ...Are you hurt after all?! Why, when I find the dastard responsible, I'll gouge out his—

Lissa: No, no! It's nothing like that. I'm just wondering how long this is going to continue. All the injuries... All the death... It's all just so awful. If I stop to think about it, I get too scared to move.

Maribelle: There's no need for fear! I will lay my life down for yours without hesitation.

Lissa: That doesn't help at all! I don't want YOU getting hurt either!

Maribelle: Don't worry, darling. I'm far too clever to allow that to happen.

Lissa: Yeah, but...didn't you get kidnapped by those guys from Plegia?

Maribelle: Th-that was... There were extenuating circumstances! In any case, my mind is quite made up. Keeping you safe is my utmost priority.

Lissa: I don't understand why you always put me first. Even when we have tea, we always drink the kind I like. You need to take care of yourself too, Maribelle. Don't deprive yourself of the things you enjoy, and don't you dare get hurt!

Maribelle: Oh, my darling Lissa... I appreciate that, I really do, but please don't let it trouble you. I AM doing what I enjoy, you see? All that I do, I do because I want to.

Lissa: That's not what I meant, and you know it!

Maribelle: Don't make that face, darling. It will give you the most terrible wrinkles later. You know what I think we both need? A nice warm bath. I feel as if I'm made of nothing but dust and sweat! Let's go to the bath.

Lissa: H-hey, wait! Maribelle!

■ MARIBELLE X LISSA A

Lissa: Maribelle! Maribelle, are you all right?! How bad is it? Let me see! Does it hurt?!

Maribelle: Darling, you're raving like a madwoman! ...Or, gods forbid, a lowborn.

Lissa: It's my fault! He was swinging for me, and you jumped in the way!

Maribelle: Yes, and here I stand, still right as rain! I told you, I'm far too clever to suffer harm at the hands of some barbarian.

Lissa: W-well, as long as you're all right... Thank you, Maribelle.

Maribelle: It's my pleasure, darling.

Lissa: But...Maribelle? Why are you so determined to protect me? Is it because of what things were like before you joined the Shepherds?

Maribelle: Wh-whatever makes you think—

Lissa: That's it. Isn't it?

Maribelle: *Sigh* I suppose there's no sense in denying it. As I'm sure you're aware, Lissa, I can sometimes be...difficult. I never had much in the way of friends. ...Never had any friends, in truth. The other children whispered about me... At court I was always alone... Until you. You were the only one willing to give me a chance. You...saved me, Lissa. And I swore to do the same.

Lissa: But that was years ago! I'd forgotten all about it until just now.

Maribelle: But I have never forgotten! How could I? I was alone in the dark, and you offered me your kindness. You shone as bright as the sun, Lissa, and burned twice as warm.

Lissa: But I didn't do anything special! I just... I just wanted to be friends.

Maribelle: With a pariah? With the butt of every malicious rumor and cruel jape?

Lissa: I didn't care what those jerks thought! I choose my own friends! And you're a wonderful person... You didn't deserve any of that.

Maribelle: Ha ha! Oh, my darling, you are the most incurably soft-hearted woman in all Ylisse. And that is precisely why I care for you and would defend you with my life.

Lissa: Aw, Maribelle... Thanks. But I don't want to be some fragile teacup that has to be protected at all times. From here on, I'll be jumping in front of axes for you, too! And the same goes for tea. Next time, we're drinking what YOU want to drink! Though I'm not sure where I'll find an adult male grizzly... But whatever! True friendship is a road that runs in two directions, right?

Maribelle: Ha ha! Yes, I suppose it is. ...I did mention the bear blood was only a jape, correct?

Gaius

■ GAIUS X LISSA C

Lissa: Now, this goes through here... Then I just loop this thread aaand... YEEEEOWCH!

Gaius: You all right there, Princess? What's going on?

Lissa: I'm TRYYYING to learn needlework! But I'm mostly just poking holes in my dumb finger.

Gaius: You should wash and dress those wounds, you know.

Lissa: Yeah, whatever. They're just pinpricks. ...See? Hardly bleeding at all.

Gaius: Small wounds can become infected as easy as large ones. Here, Princess. Let me take a look...

Lissa: Geez, fine! If you're going to be all stubborn about it... Just stop calling me Princess, all right? It almost sounds sarcastic when you say it.

Gaius: Just a friendly nickname, is all. I give 'em to everyone.

Lissa: Yeah, well, I bet you didn't give Chrom a nickname, did you? It's so unfair. He risks life and limb nearly every day. But me? Nooooo! People hover around me if I have so much as a sewing accident.

Gaius: If it makes you feel better, this is the worst sewing accident I've ever seen.

Lissa: Gods, you'd think I was made of glass or something. ...H-hey! Easy with the bandages there! My hand looks like a grapefruit!

Gaius: You pierced a vein, Princess. Lucky it wasn't worse.

Lissa: *Grumble, grumble*

Gaius: Aw, cheer up now. Lemme see what you're sewing there! ...Ooh. It's, uh... It looooks like... A three-legged ogre? No, wait. A whalefish eating a sailor?

Lissa: It's a kitty cat.

Gaius: A cat? Really? Er, maybe if I turn it this way...

Lissa: It's not done yet, okay?!

Gaius: Hmm... For a cat, why don't you lengthen this... And then a few stitches here...

Lissa: ...Holy cow, Gaius! That's amazing! I didn't know you could sew!

Gaius: I've always had nimble fingers. Useful skill in my trade.

Lissa: Well, um... Thanks. I guess.

Gaius: My pleasure. Though perhaps you might take up a safer hobby, hmm? Like, say, jousting...

■ GAIUS X LISSA B

Lissa: Wait, so I poke this through here, and loop it over...there?

Gaius: No, not quite. Here, let me show you. FIRST you loop, theeen...

Lissa: Oh, I see! That wasn't so hard! ...And look, it's finished! Ta-da!

Gaius: That's some nice work there, Princess. ...Although I think I did everything but that twisted blue bit up in the corner.

Lissa: Tee hee! Now that you mention it, you did help me an awful lot, didn't you? You know, if you keep helping me, I'm never going to learn.

Gaius: Is that so bad? I mean, you're a princess, right? If you need something sewn, you could always just ask the royal seamstress.

Lissa: That is TOTALLY not how I operate, mister! I refuse to become one of those lazy nobles who can't even butter their own crumpets! Not that I've learned to do most anything useful so far...

Gaius: Hey, don't be so hard on yourself, Princess. This stuff takes time.

Lissa: Yeah, maybe. It's just so frustrating when I can't do the simplest tasks on my own! Cooking, laundry... you name it...

Gaius: One thing at a time, Princess. Practice makes perfect.

Lissa: Practice makes perfect? Hmm... I've never heard that.

Gaius: It's a fun little saying, isn't it?

Lissa: Heck, yeah! And I'm gonna practice until my head falls off. All right, Gaius! I want to learn every skill that you know!

Gaius: Er, but I'm not really the teaching type—

Lissa: Oh, nonsense! Don't be modest! Teach me stuff! Pleeeeeease!

Gaius: Well, I suppose it's bad form to turn down a princess...

■ GAIUS X LISSA A

Gaius: GAAAAACK! Gods, Princess! How much salt did you put in this soup?!

Lissa: Just the one bag. Is that too much?

Gaius: Never mind. Let's focus on the positive. Your potatoes were...edible?

Lissa: You don't need to try and make me feel better, Gaius. The only reason the potatoes worked is because you remembered to take them out.

Gaius: Well, I suppose I did help a little...

Lissa: At this rate, I'd better find a husband who knows how to cook. I mean, would YOU marry a woman who can't even make a sandwich?

Gaius: What, me? Um... Well, I don't know. I never really thought abo—

Lissa: I knew it! You'd toss me out like a moldy sack of grain. All right, then! Tomorrow I want to learn how to open a jar. Deal?

Gaius: Look, Princess. You're very sweet, and I like you a lot. But are you sure we should be...you know. Seeing so much of each other?

Lissa: What do you mean?

Gaius: I'm a thief, and you're Chrom's sister. ...Tongues might start wagging is all.

Lissa: If anyone has a problem with that, I'll have their head on a pike!

Gaius: Sorry, I didn't mean—

Lissa: Tee hee. Just kidding. I wouldn't put anyone's head on a pike. But seriously, I'm not allowed to spend time with my friend? Come on! And I don't give a fig what a bunch of gossipy court ladies say about it!

Gaius: ...Oh. Well, all right, then.

Lissa: In fact, you can treat me just like any of your other friends! And that's an order!

Gaius: Well for one thing, my other friends don't issue orders...

■ GAIUS X LISSA S

Lissa: Guess who?!

Gaius: WAAAH!

Lissa: Oh, sorry! Did I startle you?

Gaius: Oh, er... N-not really, no...

Lissa: Heh, well isn't that sweet. It sure SEEMED like it. Especially when you jumped and went "WAAAH!"

Gaius: Look, you shouldn't sneak behind people and cover their eyes like that!

Lissa: Hee hee! I thought you'd be used to it by now.

Gaius: Sometimes I think you could stand to be a bit more princess-like...

Lissa: Bah! I'll remember you said that the next time I'm out on the battlefield healing you! Well, now you're going to feel super guilty when I show you the gift I brought!

Gaius: ...Needlepoint. Lissa, did you make this?

Lissa: Hee hee! I've totally been practicing! Can you tell?

Gaius: This looks like a cat. But a REAL cat! Not one of your..."unique" ones.

Lissa: See? I wouldn't make such a bad wife!

Gaius: I've never thought you would.

Lissa: Why Gaius, you old charmer...

Gaius: ...Er, when you bat your eyelashes at me like that... People might get the wrong idea.

Lissa: No they wouldn't... Because they would be right.

Gaius: They would? ...Lissa, I have a question to ask you... You're the sweetest girl I've ever met... If you think I'm worthy, I...I...

Lissa: You're gonna marry me right now, and that's totally an order!

Gaius: Oh... Well, that certainly was easier than I expected...

Lissa: Yaaaaaaay! I KNEW that needlepoint would do the trick!

Gregor

■ GREGOR X LISSA C

Lissa: EEEEEK!

Gregor: Oy! What is matter?!

Lissa: Ohmigosh! Look at that huge bug!

Gregor: Is just oversized millipede, yes? No cause to be panicking. You shriek like sun is plummeting into earth—you make Gregor choke on tea!

Lissa: Oh gods, look at it. Urgh... Plus it might be poisonous!

Gregor: Very well. Gregor take bug outside for sake of delicate princess.

Lissa: H-hey! I am not delicate! ...But thanks.

Gregor: You are brave girl, yes? Face many enemies on field of battle! Yet shriek like scaredy-cat wits when small insect appears in tent.

Lissa: I know, I know. It's a thing, all right? I can't stand bugs.

Gregor: Hmmm... Is just small insects? Or do you fear and hate other things?

Lissa: Hmm... Well, I don't like snakes, obviously. Or frogs or newts. Any amphibian, really. Spicy food makes me break out in a rash, but I'm not scared of it, per se. But yeah, bugs that's about it. Oh, and except for the dark. ...Long nails kind of creep me out, too. Especially if they're all dirty! Oh, and lemons. Don't even

get me going on lemons. But the worst are ghosts! Oh, they are just absolutely terrible... ...Yeah, so I guess that's everything. Oh, wait! Certain kinds of sausage—

Gregor: Oy, Gregor is sorry he even ask!

Lissa: It's weird. I can fight and all that stuff, but when it comes to other things... *Sigh* You must think I'm kinda pathetic.

Gregor: No, no. Everyone have fears, yes? You just have few more than usual.

Lissa: You think so?

Gregor: And beside, in Gregor's opinion, is charming in strange way.

Lissa: Aw, thanks, Gregor.

■ GREGOR X LISSA B

Lissa: So where are we going, Gregor? You know I'm afraid of heights, right? Oh, and bandits. ...And the dark.

Gregor: There may be some dark involved, but is all worth it in end.

Lissa: Um...okay. But if you try anything weird, I'll scream for my brother!

Gregor: Gregor not buffoon! Gregor never put sister of valued employer in danger.

Lissa: Well, that's good. But seriously, where are you taking me?

Gregor: Shhh! Can you hear from deep below ground? Sound of groans and moans?

Lissa: Ohmigosh, are those...GHOSTS?! EEEEEEEEK!

Gregor: Quiet!

Lissa: ...Eep.

Gregor: Do not scream in loud panicky voice. Is going to get us in big trouble.

Lissa: Wh-why are you making me do this?!

Gregor: If you summon courage and overcome greatest fear, other fears go away.

Lissa: So you want to frighten me out of my wits in some haunted hellhole? ARE YOU OUT OF YOUR MIND?!

Gregor: ...Er, no. Is just idea Gregor read in book. Sorry. You do not tell Chrom, yes?

Lissa: He'd probably be pretty mad, huh?

Gregor: Please, do not tell! Gregor need job! Gregor is intending no harm to Lissa.

Lissa: Oh, it's fine, Gregor. I'm not telling Chrom. ...Besides, it was actually kind of exciting! Hee hee!

Gregor: Thank you. Gregor is having many debts, yes? If he lose steady income—oy!

■ GREGOR X LISSA A

Lissa: Nnnn...nnnn...nnggg... Just...close...fingers... and... Gaaaaaah!

Gregor: Oy, again with the yelling...

Lissa: I did it, Gregor! Look! I actually managed to pick up one of those horrid millipedes!

Gregor: Yes, yes, Gregor is seeing. No need to be waving so close to his face.

Lissa: Can you believe it? I am so amazing. This is the first bug I've touched! Ever!

Gregor: Good! You start with little insect, and from here overcome bigger fears. Even longest and hardest journey begins with small baby steps, yes?

Lissa: You think I can do it? You think I can overcome all my fears?

Gregor: Gregor have no doubt! Soon you will be afraid of nothing. Not even ghost!

Lissa: Gosh!

Gregor: You write down all things you fear, yes? Make very big list. Then, whenever you conquer fear, you can be ticking off from list.

Lissa: That's...an excellent idea!

Gregor: Yes, Gregor is having many good ideas. And now he prepare special supper for you.

Lissa: Oh?

Gregor: Yes, we celebrate day that Lissa conquests first fear! Come now. Eat while is very hot.

Lissa: Wait, you have it ready and waiting? But how did you know I'd succeed? Don't tell me you just had faith...

Gregor: Gregor always have faith. Besides, if you fail, he just eat special meal all by himself.

Lissa: Oh, heh hah! Well, thank you, Gregor. This is very thoughtful!

Gregor: Now, make with the eating!

■ GREGOR X LISSA S

Lissa: Gregor, I need your help. Can you please look at this?

Gregor: Eh? Is massive stack of paper. Is hundreds of pages long!

Lissa: I know, right? It's my list of things that I'm afraid of.

Gregor: ...Oy.

Lissa: See, I knew you'd react like that! The list is too big, isn't it?

Gregor: Is...bigger than Gregor is expecting, true...

Lissa: I don't know. I feel like giving up.

Gregor: Yes. You give up!

Lissa: H-hey! You're supposed to encourage me.

Gregor: Gregor is doing that exactly! But in slightly different way, yes? Lissa is never getting through list alone. But Gregor can help if he is around. Around...all the time, yes? Always by your side?

Lissa: Er...

Gregor: That way is more efficient! Otherwise, you are never finishing list.

Lissa: But won't it be super boring if you follow me around everywhere?

Gregor: No! Is greatest honor and pleasure. In fact, Gregor is thinking long about this. Is why Gregor buying you very large ring.

Lissa: Goodness! That really is a large ring!

Gregor: Yes, yes. If Gregor is husband, he can be helping Lissa with fears more easily.

Lissa: Hey, yeah! But you'd have to promise to deal with the big bugs, all right? ...Oh, and any lemons we encounter! I mean that literally and figuratively.

Gregor: Gregor makes solemn oath.

Libra

■ LIBRA X LISSA C

Lissa: Hey, Libra! Come test your courage with me!

Libra: I beg your pardon? Is fighting this war not a sufficient test?

Lissa: It's a training exercise [Robin] dreamed up a while back. It's supposed to "hone our ability to adapt to unexpected conditions." I know, blah blah blah, right? But let's do it anyway!

Libra: Well, it certainly sounds like a worthy cause... I'd be happy to help!

Lissa: Yay! Okay, so now the two of us have to pair up and find [Robin].

Libra: Just the two of us?

Lissa: Yup, those are the rules. We all pair up and search for [Robin].

Libra: Might I ask why you thought to choose me as your partner?

Lissa: Because you're a PRIEST! ...Duh! If we meet any ghosts out on the trail, you can zap 'em with prayer magic!

Libra: There is no such thing as "zapping with prayer magic"! What's more, I doubt this training exercise involves the souls of the depar—

Lissa: Blaaaah dee blah dee blah! Now come on! Let's get moving!

Libra: Y-you needn't pull, Lissa! I'm coming!

■ LIBRA X LISSA B

Lissa: Hey, so I never noticed during that training exercise, but you're REALLY pretty! Your skin is perfect! Your hair is perfect! It's soooo not fair!

Libra: Not...fair?

Lissa: AND you're tall and sweet and you even SMELL nice! You're a one-man show of everything I wish I had, but don't.

Libra: You have a host of traits I lack as well, Lissa.

Lissa: Name one! ...Or more, if you want.

Libra: You're extremely expressive. You treat every person you meet fairly and equally. Your cheery disposition spreads to all those around you. You are ever true to yourself. I would gladly trade any element of my appearance for that beauty in your heart.

Lissa: Oh, I...

Libra: Something the matter, milady?

Lissa: It's EMBARRASSING! I expected a little buttering up, not the whole crock!

Libra: Heh, my apologies. I just find it so easy to talk with you. Another of your finer traits, now that I think about it.

Lissa: Hey, you smiled! That's a rare treat.

Libra: Is it?

Lissa: Yeah!

Libra: And you noticed? Have you been...watching me?

Lissa: ...I guess I have, now that you mention it. I wonder why?

Libra: Heh, well, if you find an answer, I would be eager to hear it.

Lissa: Lemme get back to ya on that one!

■ LIBRA X LISSA A

Lissa: Libra! Libra!

Libra: Lissa? What has you in such a state?

Lissa: I figured it out! I know why I've been watching you all the time!

Libra: Oh?

Lissa: It's because you're like a ghost!

Libra: Um...pardon?

Lissa: Is that weird? I thought it was weird. But I think lots of stuff is weird, so—

Libra: What do you mean?

Lissa: I first noticed it when we were together for that training exercise. There are times when you seem kinda like a vision...or a mirage. I mean, someone so tall and beautiful would normally be the center of all attention! But with you I almost feel like you might up and vanish if I even take my eyes off you. Anyway, so, um, yeah. That's it. ...Sorry. I know it probably sounds pretty crazy.

Libra: Perhaps, but somehow... I'm actually quite flattered.

Lissa: So how do you see me, huh? Come on, fair's fair and all!

Libra: You? You are positively bursting with life! The very opposite of myself.

Lissa: Oh, that's not true at all! You may give off a ghostly feel, but you're the liveliest alive person I know!

Libra: Well, I'm quite certain that's the first time that's ever been said about me...

■ LIBRA X LISSA S

Lissa: Libra! ...Libra, are you there?

Libra: Yes. No cause for alarm, Lissa. This ghost hasn't disappeared yet.

Lissa: Aw, c'mon, you know I didn't mean that in a bad way!

Libra: Heh heh, I know, I know. And you know I said I'm not going anywhere.

Lissa: Yeah, but that's not enough. I still worry all the time... Welp! I guess the only answer is to stay by your side forever!

Libra: ...Lissa?

Lissa: Huh? Oh. OH! I said that out loud, didn't I...

Libra: Indeed, and I'm so happy you did... I feel the same, Lissa. ...I always have.

Lissa: Er, you do? You have?!

Libra: Yes, and I always will... If you will have me?

Lissa: But... Y-you don't mean...

Libra: Will you accept this, Lissa?

Lissa: A ring.

Libra: Nay, a promise. A promise to stay with each other, as long as we draw breath. Stand vigil and keep me grounded, Lissa. Keep me tied to this place, and to you.

Lissa: Oh my gosh, YES! I'll stay at your side until the sun stops rising!

Libra: I don't think I've ever felt so alive as I do now, in this moment, with you.

Henry

■ HENRY X LISSA C

Lissa: *Yaaawn*

Henry: You getting enough sleep, Lissa? You look pretty bushed.

Lissa: No, not nearly enough! I'm exhausted!

Henry: If you don't rest up before a battle, you might find yourself resting up in a grave.

Lissa: I know, it's just... I keep lying in bed thinking about fighting the next fight. And then I think about Emm, and about... Argh! It's all too much! I'm sick of all this stupid grief and mourning! And I'm tired of people dying! I don't even want our ENEMIES to die anymore, Henry. I'm just...tired.

Henry: That does seem like a problem. War is killing and death, ya know? Keeping the people you care about alive means making the other guy dead.

Lissa: My head knows that, but my heart is still having a hard time. I wish I was as tough as you, Henry. These sleepless nights are killing me...

Henry: Well then, lemme help you! Give me a little time and I'll have you sleeping like a baby.

Lissa: Oh, wow. I'd give anything for one night of pure, dreamless sleep.

Henry: Nya ha ha! Just leave it to ol' Henry!

■ HENRY X LISSA B

Henry: So, did you get over your insomnia, Lissa?

Lissa: Yep! As soon as I close my eyes, I'm out like a candle. I don't know what changed, but I'm super glad it did!

Henry: Nya ha ha! Just a little touch of Henry's Super Sleepy-Time Magic! ...The nonlethal version.

Lissa: Really? That was you? Aw, thank you, Henry.

Henry: Always happy to lend a helping curse!

Lissa: I suppose it WOULD be a curse, huh? That can't be healthy, long term... And what do you have to do to set it up? Some kind of weird ceremony?

Henry: Oh, it's not so much trouble, really... Hardest part is probably finding fresh sacrifices every time.

Lissa: ...Sacrifices?

Henry: Yup! I usually just use birds or something.

Lissa: STOP! You can't go robbing poor little birdies of their lives for something like this! I'd rather go sleepless than live with that sort of guilt!

Henry: First you don't want any allies or enemies to die, and now BIRDIES are off the table? ...You're a strange one, Lissa.

Lissa: I'M the strange one?! You're one to talk! Look, I'll find a solution on my own, no cute creature deaths required! So no more curses! Got it?!

Henry: As you please!

■ HENRY X LISSA A

Henry: Wow. You look pretty wobbly there, Lissa. Still having trouble in slumberland?

Lissa: *Yaaawn* Yes! And the more I worry over it, the worse it gets.

Henry: You're suuuuuure you don't want me to grant you a little curse or two? You'll run yourself ragged at this rate. You need your rest!

Lissa: Thanks anyway, Henry. It really is sweet of you to keep offering.

Henry: Nya ha ha! Me? Sweet? That's a new one. Besides, you're the one who's always concerned about people dying and stuff. I don't know how you do it, honestly. I couldn't go a week!

Lissa: Heh heh, thanks. You're making me blush... Or... maybe just...dizzy?

Henry: Ack! Lissa!

Lissa: S-sorry. Kind of lost my balance there... Thanks for catching me, Henry.

Henry: Easy peasy. Any time.

Lissa: Mmm... You're so warm. It's nice... Relaxing... Zzzzzzz...

Henry: Um, Lissa? Nya ha! Guess I'm not going anywhere for a little while. You're pretty warm, yourself. Now I'm... *yaaawn* I'm getting all sleepy, too...

■ HENRY X LISSA S

Henry: Hey, Henry?

Henry: Hey-o! Need your human pillow again?

Lissa: Tee hee! If you don't mind?

Henry: Course I don't!

Lissa: Mmm... You're always so warm and cozy... Thanks for putting up with this all the time.

Henry: Hey, it feels pretty nice for me, too. Any excuse to be closer to you...

Lissa: W-wait, are you saying...

Henry: I am! Let's get married! Nya ha ha!

Lissa: But...

Henry: What, you don't want to? I thought we were both on the same page here!

Lissa: N-no! It's not that I don't want to! I mean, I really care about you... It's just... I turn around, you tossed it out there so casually. You didn't even ask! Maybe you could set the mood first?

Henry: I'm not much of a mood guy, I'm afraid, unless we're talking gruesome bloodshed... Well, how about this: I did get you a ring! Will that work?

Lissa: Aww... That'll work just fine.

Henry: All right! Here you go, then...

Lissa: Oh, thank you, Henry. I look forward to a lifetime's worth of sweet dreams with you!

Henry: I feel like I'm dreamin' already, nya ha!

Donnel

■ DONNEL X LISSA C

Lissa: Ah ha! I've been looking for you, Donny.

Donnel: Huh? Did you need me for something, Yer Gracefulship?

Lissa: No titles! We've talked about this before. I want you to think of me as an older sister.

Donnel: I know, Yer Worshipful...er, Miss Lissa. But it just feels so darn weird!

Lissa: Well, get used to it. You're one of a precious few allies younger than me, you know? I have to milk this! Anyway, feel free to come ask for my help aaaaaany-time!

Donnel: But yer the princess of Ylisse, Miss Lissa!

Lissa: Then consider it a royal order. ...And drop the "miss" stuff!

Donnel: Y-yes, ma'am!

Lissa: ...Well, I suppose that'll do for now. Hee, this is great! I always wanted a little brother to order around!

Donnel: Gosh! I'm honored, I guess.

Lissa: Now, what can your big sis do for you? Anything at all, just say the word.

Donnel: Er... I'm frightful sorry to dash your hopes'n all, but I can't think a nothin' right now. L-lemme work on it. Bye!

Lissa: Wha? Hey! Get back here!

■ DONNEL X LISSA B

Lissa: Looks like it's the two of us on provisioning duty today! What should we hunt for? Mushrooms? Wild herbs? Ooh, maybe berries?

Donnel: That all sounds tasty, but fightin' a war takes stouter stuff'n that. I vote for game!

Lissa: So, er, meat. From animals. Riiight... Guess we need to hunt some, then. Er, let's see...

Donnel: Don't fret it none. I laid a half dozen traps yesterday just in case. Just follow me, Lissa!

Lissa: Whoa, look! Two rabbits and a boar! The traps really worked!

Donnel: Good thing, too. Now I ain't gotta worry 'bout you wanderin' around in the woods.

Lissa: I'm amazed, Donny. Where'd you learn how to hunt like this?

Donnel: From my pa, at first. Past that, I just kinda picked it up on my own.

Lissa: Wow. No matter where you are, you'll never lack for food.

Donnel: From yer lips to Naga's ears! 'Sides, I couldn't see my dream through if I weren't able to get on anywheres.

Lissa: What dream is that?

Donnel: To travel the world lookin' for the secret to this stone my pa gave me. Was his dream, too, back before... Well, when he was still alive. ...So I'm fixin' to do it for him.

Lissa: That's wonderful, Donny. You make me want to really knuckle down and buckle down on my own dream.

Donnel: You got a dream, Lissa?

Lissa: Hey! Why do you sound so surprised?

Donnel: Wh-what?! Naw, I didn't mean it that way at all!

Lissa: My dream is to become a true lady like my sister, Emmeryn.

Donnel: Well, I reckon you'll get there eventually.

Lissa: ...Eventually?

Donnel: Er, real soon, I mean! Like tomorrow! I knows ya will! Gosh, I can see it now. I bet you'll be the prettiest lady o 'em all! Wearin' big dresses and dancin' at them fancy balls...

Lissa: You really think so?

Donnel: Heck, I know so! Prettiest lady in the whole dang world, see if you ain't!

Lissa: Heh heh. Thanks, Donny.

■ DONNEL X LISSA A

Lissa: Settle down and take a seat. Professor Lissa is now instructing.

Donnel: Er, if I'm gonna be learnin', I'd rather it was Sir Chrom teachin' me to fight proper. I don't mean no offense, Lissa, but—

Lissa: Tut tut! No talking! ...And it's PROFESSOR Lissa! All right now, class. Open your texts to page 84.

Donnel: Er, beggin' your pardon, Professor, but that constellation's the Wyvern, not the Dragon.

Lissa: ...What?

Donnel: Yes, ma'am. And that bright star ain't Arthentine, it's Tryffin.

Lissa: Rgh, fine! This astronomy lesson is OVER! Just... read the book quietly to yourself!

Donnel: Aw, Lissa! Wait, I didn't... Dang it all. Why'd I have to go openin' my fool mouth?

Lissa: That little know-it-all! Pigs'll fly before I offer to teach HIM again! ...Gyaaaaaah! Oh, darn it! I twisted my ankle! Aw, why did I have to storm off so far from camp? I...I could die out here! I'm gonna be eaten by a bear or a lumberjack or something!

Donnel: Lissa? Miss Lissa, can you hear me? Where are ya, Lissa?

Lissa: D-Donny?! Over here! I'm here, Donny!

Donnel: Oh, thank goodness. I was worried ya... Huh? What's up with yer leg, Lissa?

Lissa: I sort of...twisted my ankle.

Donnel: Lemme have a look at that... Pig slop! There ain't no "sort of" about it. Ya done sprained it bad. Here, hop on m'back.

Lissa: What? You don't have to...

Donnel: Just hurry up and climb on! ...Er, please. There's talk a bandits showin' up all over these parts, so we best skedaddle.

Lissa: A-all right.

Donnel: ...Hup! All right, you hang on now! I'll have us back in two shakes.

Lissa: S-say, Donny? Were you out looking for me this whole time? ...I'm so sorry. I make a pretty terrible older sister.

Donnel: Aw, that ain't true at all, Lissa. I'm just happy ya care about me. Yer always so nice to me and all...

Lissa: Heh... I'd say the same thing for you, Donny.

■ DONNEL X LISSA S

Donnel:

Lissa: What are you up to, Donny? And what is that? A ring?

Donnel: Gah! L-Lissa... This, uh... I was just...

Lissa: Wait, is that what I think it is?

Donnel: ...Y-yes, ma'am, I reckon it is.

Lissa: You can't!

Donnel: Huh...?

Lissa: Y-you're... You're not ready!

Donnel: ...Too soon, eh?

Lissa: I mean, sure, you're more reliable than I'd thought... And more knowledgeable, and less wet, and able to survive on your own in the world... Wait, maybe you ARE ready... No, no, no! What am I saying?! A thousand times no!

Donnel: Yeah, all right. I reckon yer just lookin' out for me. 'Sides, it's crazy to think a farm boy like me could be with a princess...

Lissa: Wait, what? Donny, who are you talking to?

Donnel: I'm sorry, Lissa. You were a little bit nice to me and I went and got the wrong idea. Won't mention it ever again, though, don't ya worry. I'll just be goin' now...

Lissa: Hey, wait! You were planning to give that to ME?

Donnel: ...Yeah?

Lissa: Augh, stupid Donny! Stupid, stupid, stupid, stupid, STUPID!

Donnel: Awww! C'mon now, I done said I was sorry...

Lissa: How can you just give up so easily?! I never said I WOULDN'T accept!

Donnel: Huh? Then...

Lissa: Donny, I would love to marry you!

Donnel: Er, are ya sure? I'm just a big ol' pig slopper from the sticks...

Lissa: I know.

Donnel: So if ya get hitched to me, you'll be givin' up on bein' a high-class society lady. No more big dresses or fancy balls or them masks what make ya look like a cat... It'd just about kill me to take yer dreams away from ya.

Lissa: Hee hee! This isn't the most convincing proposal, Donny. Besides, none of that stopped me from getting that ring for me, did it?

Donnel: Well, no, but...

Lissa: You're not taking anything away from me. You're just giving me a new dream.

Donnel: ...Yeah?

Lissa: Yes. A dream of starting a happy family with you.

Donnel: Golly, Lissa.

Lissa: And I can become a true lady anywhere! ...Even on a pig farm. It isn't about clothes or dances. It's a matter of character, integrity, and grace. I intend to have all of that. A true lady, a happy wife, and a good mother... And I couldn't be any of those things without you. So, will you help me?

Donnel: Yee-haw! Ya bet yer life I will! Oh, I swear I'll make ya the happiest girl in the world!

Lissa: You already have, Donny.

Owain (Mother/son)

■ OWAIN X LISSA C

Owain: There's something I need to know, Mother.

Lissa: And what's that?

Owain: The name of your weapon.

Lissa: My weapon? Why?

Owain: What manner of son would I be not to know the name which guards his mother? Teach me so I may whisper its sobriquet in prayer and keep you ever safe.

Lissa: Oh, you meant THAT sort of name.

Owain: ...Hmm?

Lissa: That Holy Slayer, Saintly Dragon blah-blah kinda stuff you're always talking about. I was wondering if you really didn't know the word "staff"! Hee hee!

Owain: ...I'm pretty sure I should be offended by both of those statements. But yes, that sort of name! What is it?

Lissa: It doesn't have one.

Owain: You've granted it no name?!

Lissa: Right. I mean, why bother?

Owain: MOTHER! A name confers a soul unto an inanimate object and grants it power! It transforms a mere tool into a divine instrument possessed of limitless potential!

Lissa: See? There's the blah-blah stuff I was talking about... *Sigh* I'll give it some thought, all right? But right now I've got to be going. Bye!

Owain: W-wait, Mother. I'd braced for an insufficiently astonishing name, but this is worse than I feared! This may require drastic measures for her own good...

■ OWAIN X LISSA B

Owain: Ah, there you are!

Lissa: Were you looking for me, honey?

Owain: Here, have a look at these.

Lissa: Wowzers! This is quite a list! Okay, lemme see... "Gryphonsbane Edge," "Fell Ballista," "Staff of Deep Hurting." ...Owain, this list goes on for 20 pages!

Owain: Twenty-six. And if you don't find one you like, I can always whip up more.

Lissa: Choose them for what? What am I even looking at here?

Owain: Names! ...Er, for your armament.

Lissa: What? Don't you think these are a little overblown for a run-of-the-mill weapon?

Owain: There's nothing run of the mill about it! At the point that it's YOU wielding it, a weapon deserves a name no less grand!

Lissa: Hmm, yeah, I think I'll pass. These just aren't me.

Owain: But without a name, your weapon will forever remain some mundane object! How can I rely on a mere tool to keep you safe in the heat of battle?

Lissa: AWWW!

Owain: Wh-what? What did I say?

Lissa: Oh, Owain, you sweet boy! Let Mama give you a hug!

Owain: Waugh! L-let go! You're choking me!

Lissa: Aww, I had it wrong this whole time. You were just worried about me, weren't you? That's my boy! You are just the sweetest son in the world! *smooch*

Owain: S-still...choking...

Lissa: All right, Owain, I'll do it! I'll think up a name!

Owain: But I've already come up with a whole list here...

Lissa: Whoops! I almost forgot that Chrom asked me to come see him. You be good now, honey! And thanks again!

Owain: Mother, wait! Honestly, she never listens. It's like she's off in her own little fantasy world! Hard to believe we're related...

■ OWAIN X LISSA A

Lissa: Owain!

Owain: Yes, Mother?

Lissa: I've got it! I picked one!

Owain: One...what?

Lissa: A name! For my weapon!

Owain: Ah, right! Well, let's hear it! No doubt it joins your quiet grace with your fiery strength and iron resolve!

Lissa: Owain?

Owain: Yes?

Lissa: No, that's the name. ...Owain.

Owain: Mother, that's MY name.

Lissa: I know, silly! It's the name of that which I value most in the whole wide world! What better name could there be?

Owain: Yes, but won't that get a little... I don't know, confusing? I just don't think it's a great idea.

Lissa: Awww...

Owain: If you would draw out your weapon's full potential, its name needs more...oomph.

Lissa: I think Owain has PLENTY of oomph! It's got oomph up to HERE! It's... Wait a minute! Are you saying you don't like your name?!

Owain: No, no, I'm not saying that at all...

Lissa: *Sniff* F-fine, then! Fine! Just tear my heart out and stomp on it, why don't you? Imagine, a son rejecting the name his mom poured her heart and soul into choosing!

Owain: No, Mother, would you PLEASE just listen?

Lissa: Well, fine, then. Call yourself whatever you like. I'll get THIS Owain to protect me. THIS Owain will never turn on me. THIS Owain will never leave my side! Even if it snaps in half!

Owain: AUGH, STOP! Don't even TALK about a weapon named after me breaking! Look, I'll protect you, okay? I promise. Now just, PLEASE stop!

Lissa: You will?! Oh, that's so sweet, honey! C'mere, you!

Owain: Gah, just p-please stop...hugging too tight... C-can't...breathe...

Lissa: All right, well, if you insist, I'll stop trying to name my weapon, then. Tee hee. There's no need, now that I have you to protect me! Isn't that right, dear?

Owain: Why do I feel like I've just been had...?

Lissa: I would never dream of it, sweetheart. And I promise I'll be right there to rescue you when you're in trouble, too. We don't need fancy names or divine power, Son, we just need each other.

Morgan (female) (Mother/daughter)

The Morgan (female) mother/daughter dialogue can be found on page 312.

Frederick

Avatar (male)

The dialogue between Avatar (male) and Frederick can be found on page 218.

Avatar (female)

The dialogue between Avatar (female) and Frederick can be found on page 229.

Chrom

The dialogue between Chrom and Frederick can be found on page 239.

Lissa

The dialogue between Lissa and Frederick can be found on page 242.

Virion

■ VIRION X FREDERICK C

Frederick: That's quite the handsome blade you carry, Virion.

Virion: Ah, you've a discerning eye, Frederick. Yes, it is rather nice, isn't it? Elegant... Sophisticated... A perfect match for its owner! Why, it's almost—

Frederick: The hilt bears the sigil of House Claive.

Virion: Yes, but you interrupted me.

Frederick: Apologies. ...But it's been troubling me for some time now. Just how is it you came to hold a dagger from one of Ylisse's high noble houses?

Virion: I enjoyed a brief but fruitful collaboration with the Claives once upon a time. Well, specifically with one young and VERY beautiful Claive... She gave me this blade as a token of our everlasting...friendship.

Frederick: I see. And when exactly did you find the time to foster such a bond?

Virion: Ah, my dear naive Frederick. Not all bonds take equal time to form, you know! Some are forged in a

lifetime, while others spring to life in a moment. ...Others still take but one very good night.

Frederick:

Virion: Oh, please! Spare me the pious air... But...is that yet a hint of...envy I see as well? Ha! Well, permit me to explain... It is my avocation to grant noble ladies a brief respite from their dreary lives. And I know of no better way to do so than by romance's sweet perfume. But I always acted the gentleman! No harm befell their honor or reputation.

Frederick: Oh, that was never my concern. Ylisse's noble houses are built of sturdier stuff than one dandy's escapades can shake.

Virion: Tell me, sir... Do you always smile so as you twist the blade in a fellow's gut? No... You wondered at the history of my blade, and now curiosity is slaked. If that's quite all, this dandy shall leave you to savor your unshakable honor.

Frederick: ...Avocation, he says. Heh. Quite the hobby. Yet I fear he's made many other powerful allies through such trysts. Dandy or no, the man is sly. Methinks he merits watching...

■ VIRION X FREDERICK B

Frederick: He's gone, Virion.

Virion: I-is he, then? Phew! That's a relief. My apologies for the bother. To think that poor fool would trudge all this way for a mere handful of coins.

Frederick: One would need hands of freakish size indeed to cradle that much gold. Pray tell, how does a fellow even begin to create such a vast amount of debt?

Virion: My dear sir, there are a thousand ways. ...Preferably all accomplished at once.

Frederick: I'll ask no more. Besides, there's another matter I'm more curious about.

Virion: Indeed?

Frederick: Before he left, that man offered to finance our efforts here. ...I declined.

Virion: Mmm, yes. Probably for the best.

Frederick: This doesn't strike you as odd? I just saw a man track down his debtor only to offer his companions additional coin. In what world is that not madness?

Virion: It seems perfectly logical to me. Should something untoward happen before I repay him, the debt dies with me. It's well within his interests to ensure I survive this bloody mess.

Frederick: You racked up a debt so large it ties his welfare to yours...? I've not the capacity to determine if such actions are genius or madness. You're cunning fit to shame a fox, Virion.

Virion: Ha ha! Oh, you flatter me, sir! ...But do go on.

Frederick: Mark my words, fox! If your skulking about ever comes to be a burden on Chrom—

Virion: Yes, yes, you'll have my skin for a stole. I'm well aware. I happen to be fond of my skin, so I give my word no ill shall come from my deeds.

Frederick: Keep your word and you'll keep your skin.

■ VIRION X FREDERICK A

Frederick: Virion.

Virion: Ah, Frederick. And what deeply personal matter will you be prying into today, mmm?

Frederick: Perhaps we could talk about a large anonymous donation we just received? I've no doubt you played a part in that. ...And in truth, we badly needed it. Permit me to offer my thanks, and Chrom's in his stead.

Virion: You are quite welcome. I was confident a clever fellow like you would catch on! I doubted Chrom would have accepted if I came with the help of Ylisse in too open. Especially considering the...less-than-immaculate origin of the goods.

Frederick: Hence the anonymous donation.

Virion: Rather genius, wouldn't you say? Elegant! Sophisticated! A perfect match for—

Frederick: But no one will ever know it was you.

Virion: Yes, but you're interrupting again. We've had this chat, Frederick! Ah, well. I suppose there's a kind of rustic charm to your enthusiasm.

Frederick: ...My apologies. But I can't help think that giving so much without recompense is unlike you.

Virion: You wound me, sir! And besides, I haven't come up empty handed. I said I was confident you'd catch on, Frederick, and I meant it. So now you are in my debt.

Frederick: Ah, there's the rub! And just what would you ask of me in return?

Virion: When the fighting is over, peace will return to my land. And I plan to enlist the help of Ylisse in rebuilding it. I suspect Chrom would agree without my resorting to such tricks, but... Well, a clever man takes no chances. With you there to convince him, I'd say the matter is settled, mmm?

Frederick: Unbelievable. You're already planning beyond this campaign.

Virion: You'd do well to do the same! Chrom boasts an archer of my caliber and a warrior of yours among his ranks... The man could scarcely lose if he tried.

Frederick: A taste of the same flattery you use on the noble ladies, no doubt. Still, we have no choice but to give our all. That much is true. Let's pray our combined efforts are enough.

Virion: I'm perfectly confident in my portion of the bargain, Frederick. Just see that you hold up your end!

Frederick: I was about to say the same.

Sully

■ SULLY X FREDERICK C

Sully: There you are, Frederick! I thought you might be up for a little sparring.

Frederick: Certainly, Sully. ...All right, you may strike whenever you are ready.

Sully: Get ready for a whuppin'!

Frederick: The hilt bears the sigil of House Claive.

Sully: Hiiiiii-YA!

Frederick: Mmm... Good technique and excellent form, however, it is now my turn...

Sully: Gah!

Frederick: Are you all right?

Sully: Oh, yeah! Just peachy! Thanks! Er, think I'm going to yield, though. ...

Frederick: Is something the matter?

Sully: Just wondering how you beat me so easily, is all.

Frederick: I would hardly call such a match "easy."

Sully: Yeah, but I never lose to anybody!

Frederick: Sometimes these things are a simple matter of chance.

Sully: Hmm... Well, thanks for the practice. I'll let you know once I've honed my edge a bit.

Frederick: I look forward to it.

■ SULLY X FREDERICK B

Frederick: You weren't your usual self in that last fight, Sully. If something is troubling you, I'm happy to hear it.

Sully: I can't figure out how the hell you beat me when we sparred! That's what's wrong!

Frederick: Good heavens. That was days ago... Is there really any need to compete? We fight for the same cause.

Sully: Yeah, but it... I don't know. It was as if I KNEW we were going to beat me. I've never had that feeling with anyone else. ...Never.

Frederick: When you first joined the Shepherds, I was the one who taught you. Perhaps that has something to do with it.

Sully: Ha! I remember... I came in thinking I could mop the floor with all of you. And I might have until you showed up! You didn't look like much back then, but you beat the crap out of me.

Frederick: I wouldn't say I beat the..."ahem" Yes, well. I suppose it was a rite of passage of sorts.

Sully: I didn't sleep for days after that... I was just so damn angry.

Frederick: Perhaps this is the cause of your current consternation. When master and student first fight, the student naturally stands no chance. The perception that one's teacher is unbeatable can be difficult to shake.

Sully: So I can't beat you now because you beat the crap out of me when I was 15?

Frederick: It doesn't sound quite so honorable when you say it in that manner...

■ SULLY X FREDERICK A

Sully: Did you see me out there today, Frederick?

Frederick: Truly impressive work! It seems you've made a breakthrough.

Sully: It's thanks to what you said before. I've always felt like I needed to be better than everyone, you know? If there was one person better than me at anything, I considered it a failing. And when I couldn't beat you, I let it get into my head in a big way.

Frederick: There is a certain strength in such a mindset, methinks.

Sully: I admit, it made me strong back then. But now it's just holding me back. I didn't train all these years to beat you. I've trained to be someone you can rely on as an equal.

Frederick: And you have grown into a fine soldier. I fear nothing when you are by my side.

Sully: When I stopped to really see how I felt, it was pretty obvious. Anyway, it's all thanks to your teaching. So...thanks.

Frederick: You are a student no more, Sully, but a master in your own right. From this day on, we fight as equals.

Sully: You're damn right we do!

■ SULLY X FREDERICK S

Sully: Hmm...

Frederick: Something on your mind, Sully?

Sully: Just thinking about why I couldn't beat you the last time we sparred.

Frederick: I thought you'd already found your answer.

Sully: Yeah, I thought so too, but... Well, now I'm not so sure. See, I don't think it's because you were my teacher.

Frederick: No? Then what is it?

Sully: When I'm around you, I get...clumsy. I can't focus like I need to. I'd never felt that way with anybody else before, so I didn't know what it was. But it's not because you taught me. ...It's because...I love you.

Frederick:

Sully: I know that's big news to dump on you out of nowhere. But I can't move forward until I deal with all this crap. So, um... What do you think?

Frederick: In truth, I also wondered if that might have something to do with it. And so I prepared this gift for just such an occasion.

Sully: ...Oh, Frederick! It's a ring with my name on it!

Frederick: I'd planned to give it to you once this war was over.

Sully: I just can't believe it! I mean, me? Really? But I'm so...

Frederick: Strong? Brave? Intelligent? Yes, Sully. You are all of that and more.

Sully: Okay, my heart is pretty much just sunbeams and puppies right now. And I never say cute crap like that, so you KNOW it's serious!

Frederick: I feel the same...albeit with perhaps less flair for the dramatic. Sully, my love, will you be my sunbeam?

Sully: Only if you'll be my puppy!

Frederick: That was embarrassing.

Sully: Er, yeah. It was... Let's go spar!

Miriel

■ MIRIEL X FREDERICK C

Soldier: Hiyuuurgh!

Frederick: HMPH!

Soldier: Gah! H-how did you block that?!

Frederick: You are not using your strength wisely. Too much wasted movement. Go and practice what I taught you.

Soldier: Sir! Thank you, sir!

Frederick: Ah...

Miriel: Frederick.

Frederick: Miriel. What brings you here?

Miriel: Fascinating... I was convinced that young lad had you dead to rights. But when his blow was about to land, you parried with the merest flick of your arm.

Such a feat would seem to defy all natural laws. What is your secret? To what forbidden dark arts are you privy?

Frederick: If you saw my arm move, then your eye is sharper than most. When my master-at-arms first showed me the technique, I did not see as much.

Miriel: A woman of science is first and foremost an observer.

Frederick: Ah! And a keen eye is a fine weapon. But I don't think you came here to discuss swordplay.

Miriel: On that count, you are wrong. I want you to teach me that move.

Frederick: It is no easy trick to learn.

Miriel: I am a patient woman.

Frederick: Very well. Shall we begin?

■ MIRIEL X FREDERICK B

Frederick: Hold the lance motionless, as a heron hunting a fish. The tip cannot waver.

Miriel: ...Yes.

Frederick: HYAAAR!

Miriel: Ah!

Frederick: Good. The lance did not move at all. You have a steady hand and strong nerve.

Miriel: You moved so fast I had no time to react. I would have thought that impossible. ...And look! You cleaved the lance in twain with naught but a blunt wooden staff. Yet my hands felt no impact. It's as if the lance split of its own accord.

Frederick: 'Tis the result of many factors: speed, muscle control, and the flow of power. These same skills allowed me to throw that young soldier earlier.

Miriel: How can you possibly compute all those factors in such a short time?

Frederick: A soldier does not...compute. A soldier acts on instinct and training.

Miriel: Instinct? But man is a rational animal, gifted with a keen mind.

Frederick: Minds are a hindrance in the brief moment between life and death. You can use intelligence before a battle and during training... But in combat, you must let instinct rule. You must learn how to FEEL!

Miriel: This is a most remarkable ability.

Frederick: With hard work and training, anyone can do the same.

Miriel: Even I?

Frederick: Of course! A keen observer such as yourself will learn faster than most. I might even wager that you are better equipped than I for such things.

Miriel: That is most encouraging.

Frederick: I have some special exercises that may help you develop your instincts. Perhaps you would allow me to show you. ...That is, if you are free.

Miriel: I can always free for the pursuit of knowledge.

■ MIRIEL X FREDERICK A

Miriel: Frederick, are you certain I need to continue this training?

Frederick: Does some aspect of it concern you?

Miriel: To be honest, I'm coming to doubt the efficacy of your methods. I've collected flowers, fished in the river, and been chased by bees. Shall I paint with our fingers next? Or perhaps bake pies crafted from loam?

Frederick: Of course not! Our next lesson involves spending the night around a campfire. Doing so will nurture your instincts by exposing you to different stimuli.

Miriel: I believe I've experienced quite enough stimuli already. Surely I'm in touch with my instinctive side by now?

Frederick: You don't want to do the campfire? But I was so looking forward to it... I even collected crowberries and honeycombs for roasting.

Miriel: I believe I'm ready for more advanced studies. I ken now how you performed that trick, and I'm more instinctive as well. My current problem, however, is one of detachment.

Frederick: I'm not entirely sure I understand, milady.

Miriel: I have been fighting alongside Chrom for some time now. And I consider my fellow Shepherds to be most stalwart comrades. But even after all our shared hardships, I don't feel true friendship. I want to experience this connection. ...Specifically, with you. If what you say is true, feelings of friendship will make me stronger in battle.

Frederick: W-well, if you think it would help... Er, of course. I'd happily be your friend.

Miriel: Thank you, Frederick.

■ MIRIEL X FREDERICK S

Frederick: Miriel? How go your observations on the nature of friendship?

Miriel: Well enough, I suppose. But there has been an unexpected obstacle.

Frederick: Do tell.

Miriel: My heightened feelings have created an emotion akin to avarice. I mean by this, I want to spend all your time with me and no other. Indeed, when I see you with certain people, I grow almost...enraged. Tell me: Is this a normal reaction when friendship blossoms between two people?

Frederick: I see... Miriel, do these feelings of "avarice" occur when I speak to a man?

Miriel: ...Interesting. They do not.

Frederick: But if I speak to a woman?

Miriel: I wish to pull out her hair in the manner of an angry cat.

Frederick: Oh. Well, I'm afraid this might be a symptom of something quite serious.

Miriel: And yet you are smiling. Why?

Frederick: Because, my good lady, I have just the medicine to cure what ails you.

Miriel: A ring? What manner of talisman is this? I pray I'm not meant to swallow it.

Frederick: No. You place it on your finger.

Miriel: This treatment is oddly similar to a marriage ritual I once read about.

Frederick: As always, your keen eyes miss nothing. ...I am proposing to you.

Miriel: Fascinating... I suppose I must assess my feelings before giving you an answer.

Frederick: Er, that is...customary, yes. But unless I'm mistaken, I think you have strong feelings for me. Friendship between men and women often turns to love. And when love blooms, so does its wicked twin, jealousy.

Miriel: ...Jealousy.

Frederick: I know this because I suffer from the same curse! Seeing you in conversation with other men is like a dagger in my heart.

Miriel: And this ring is the only cure?

Frederick: The only cure I'm willing to try.

Miriel: I see... I... I do believe I love you, Frederick.

Frederick: If you were to marry me, Miriel, I promise to give you joy every day of your life.

Miriel: Then marry you I shall!

Sumia

■ SUMIA X FREDERICK C

Sumia: Frederick! What are you doing up so early?

Frederick: Good morning, Sumia. I'm inspecting everyone's weapons and armor to ensure all is ready for battle.

Sumia: But it's not even dawn yet! Don't you ever sleep?

Frederick: I have sworn to serve Chrom and the Shepherds to the best of my ability. As commander, Chrom bears a burden far heavier than any of ours. It would ill behoove me to neglect any opportunity to lessen that load.

Sumia: He's fortunate to have you. Imagine getting up this early just to check gear!

Frederick: I did not stir this morn simply to satisfy myself as to our battle readiness. I also exercised, performed a number of weapon drills, and patrolled the camp. I then stoked the fire, readied the makings for morning tea, and consumed one egg.

Sumia: Er...

Frederick: Oh, and I scared off a noisy flock of birds nesting too near milord's tent. Then, with no other pressing task, I took the time to inspect our equipment.

Sumia: Good heavens.

Frederick: Apologies, my lady. You must find my prattle to be terribly dull. I have often been criticized for what some consider an excess of zeal. Such devotion appears to make my comrades uneasy.

Sumia: Well, I think it's wonderful!

Frederick: ...You do?

Sumia: Absolutely! You're an inspiration, Frederick. There's no other word for it. Look at all you do for Chrom! It makes me wish I was more like you. I'm so sick of being the girl whose main contribution is falling on her face! I know we all need levity in these times, but I would still prefer to do more.

Frederick: I don't know what to say. You're the first person who has ever considered what I'm trying to do. Perhaps we should join our causes to each other. We could be the grease that keeps the Shepherds running smoothly.

Sumia: Now THAT is a splendid idea!

■ SUMIA X FREDERICK B

Sumia: I'm so sorry, Frederick!

Frederick: I-it's quite all right, milady. I suppose it is a bit complicated the first time.

Sumia: But I can't believe I got lost patrolling the camp. So embarrassing! And I don't know HOW I managed to drop that potion. That...expensive potion. Although you did agree the broom was worn out before it broke, so that's probably... Oh gosh, and the fire! I'm SO SORRY about the fire! You have a spare tent, right?

Frederick: Yes, well, look on the bright side: You did a splendid job pulling weeds. I don't see a single straggler in this entire camp!

Sumia: Well, I always liked making little chains and bracelets out of flowers!

Frederick: ...Er, you did just pluck weeds, yes? Not the flowers from the flowerbeds?

Sumia: Flower...beds? Oh, HORSE PLOP! It's true! All I'm good for is falling on my face! I'm going to go back to bed and pull the covers over my head.

Frederick: Please, milady, no! You mustn't give up.

Sumia: B-but...

Frederick: The most important part of any battle is that you give your all. Everything you did today was out of consideration for your fellow Shepherds. And if the results were less than optimal? Well, it's not the worst thing in the world. So long as you strive to help people, success will eventually find its way to you.

Sumia: Oh, Frederick! If you really think so, then I promise not to give up! Perhaps I could make little flower necklaces for everyone!

Frederick: ...Please don't.

■ SUMIA X FREDERICK A

Frederick: Hmm... What to do, what to do...

Sumia: Hello, Frederick. Is something wrong?

Frederick: Ah, Sumia. Yes, something IS wrong! This horse escaped the paddock during the night. I managed to catch it by the bridle, but the foul beast refuses to be led back!

Sumia: Oh, is that all? Here, let me try.

Frederick: No, milady, it's too dangerous! The brute is practically frothing at the mouth!

Sumia: Oh, don't be silly... There, what a nice horsey. Shhhhhh... Auntie Sumia won't hurt you, I promise. But if you stay out here, the wolves might get you. Let's go back to your friends.

Frederick: By the nine heavens! It's moving!

Sumia: We'll be fine, Frederick. I'll make sure this brave guy gets back safe.

Frederick: You have a gift, milady. I thought the creature would die on this very spot.

Sumia: Oh, he just needed some encouragement is all. It's kind of like how you aid and motivate Chrom! Humans and horses both need friends to lean on sometimes.

Frederick: Still, you performed a great service, and I am in your debt.

Sumia: Oh, really, it's not a big—

Frederick: Do not be modest, milady! I might have wrestled that beast all day without you!

Sumia: Yes, possibly. Except, well, the thing is... See, last night, I fed the horses. And you know the latch on the gate? The one you're supposed to close? Weeell, there's a teensy-tinesy possibility I might have left it... kind of...open.

Frederick: By the gods! So it was you who let this demon beast free!

■ SUMIA X FREDERICK S

Sumia: Frederick! I've been meaning to thank you! You're the one who polished my armor to such a lovely sheen, right?

Frederick: I...wasn't sure you noticed.

Sumia: Of course I noticed! My plate and weapons have never looked so good... Why, I glittered like a lighthouse on my ride today! ...I actually felt pretty.

Frederick: You are always beautiful to me, Sumia. In truth, I've eyes for no one else.

Sumia: Hee hee! Not even Chrom?

Frederick: 'Tis no laughing matter, milady. I serve Chrom because I have sworn to do so. He is my lord and master. But when in your presence, I cannot tear my eyes from you. I am captivated! True, at first it was because I feared you might blunder into a nearby tree... But soon I found myself gazing at you whenever the opportunity permitted.

Sumia: Oh, Frederick...

Frederick: Please, milady. Would you do me the honor of accepting this gift?

Sumia: ...This is the most beautiful ring I've ever seen, Frederick. Does it mean what I think it means?

Frederick: My heart is yours, milady. Now and forever, if you would only but claim it.

Sumia: But why? I'm so inept at everything! Weeding, fire starting, wagon repair...

Frederick: None of that matters, so long as you are by my side!

Sumia: I just can't imagine... Gods, this ring is so shiny. You must have polished it for days. Frederick, this is the nicest thing that anyone has ever done for me...

Frederick: You deserve it and more. Were that I could, I would present you with the moon herself.

Sumia: I don't want the moon, Frederick. I just want you! So yes! Yes and yes and yes again! You've made me the happiest woman alive!

Maribelle

■ MARIBELLE X FREDERICK C

Maribelle: Hmm...

Frederick: Ah, Maribelle. I hope you are well.

Maribelle: Yes, thank you, Frederick. It's good that you're here; I wanted to talk to you. Is it true what they say? That you're a professionally trained steward?

Frederick: A steward? Gracious, no. I wouldn't have a clue about such work. I am a knight, milady.

Maribelle: Oh? That's not what I heard. But I suppose rumors have a way of... Are you doing?

Frederick: I am laying out Princess Lissa's garments for the morrow.

Maribelle: ...That seems like something a steward might do.

Frederick: I suppose. But I only do so if I have spare time after...killing and such.

Maribelle: And what will you do after you finish laying out these garments?

Frederick: I shall check on the dinner preparations and then plan tomorrow's menu.

Maribelle: You ARE a steward!

Frederick: My good lady, while some of my duties may resemble those of a steward, I assure you—

Maribelle: I have spent a lifetime in noble houses, and you, sir, are a steward! Serving tea? Dusting china? Polishing the good silver? You are most definitely a—

Frederick: I AM NOT A STEWARD! ...I just like things to be neat and tidy.

Maribelle: Well, you're terribly good at it. So perhaps you would come to my manor and instruct my staff?

Frederick: Milady, I don't think—

Maribelle: Frankly, it's impossible to get good help these days! Our head steward is so old, and he's off with the gout nearly every other day. Now, we don't want to work the poor man to death—just think of the scandal! But a house can't maintain itself, and what will we do when he kicks the bucket?

Frederick: ...Your sympathy is touching.

Maribelle: Eventually yes, we'll have to put our poor old steward out to pasture. But I would consider it a personal favor if you trained our young staff in the interim. I'm sure there are so many things you could teach them! ...This is just until we have a new man in place, of course.

Frederick: Milady, for the last time, I am a knight! I am not, nor have I ever been, a ste—

Maribelle: Fine! Then just show them how to tidy up or whatever it is you do around here! You teach recruits how to fight, yes? This is the same, except you fight filth.

Frederick: Well, yes. It's true that I help instruct the younger Shepherds... But they are the best and brightest of the realm, and I merely offer advice.

Maribelle: Oh, good heavens. You couldn't POSSIBLY make this any more complicated! Fine then. Why don't YOU teach ME so I can teach THEM?

Frederick: Teach...you, milady?

Maribelle: I'm nothing if not the best and bright! So, yes. You shall teach me tidiness. And once I've learned your secrets, I can put our manor back to order myself!

Frederick: Well, I suppose that is acceptable...

■ MARIBELLE X FREDERICK B

Frederick: Ahem! Maribelle? Milady? It's morning. Time to wake up.

Maribelle: Unnngh...m-morning? Already? Wait one second! Where's the sun? It's pitch black outside!

Frederick: A steward's day begins before dawn. And unless I'm mistaken, you expressed a desire to study the arts of stewardship.

Maribelle: Ugh, yes, I did say that, didn't I? At least, I think I did...

Frederick: Good. Then let us begin with our morning duties. A steward must prepare tea for the lords and ladies before they awaken.

Maribelle: "YAAAAAAWN" I'm SOOO tired... But I suppose I can manage to boil a— Oh, blast! The stupid kettle fell over!

Frederick: Then please boil the water again. And this time, do so carefully. Now, as you have wasted a pot of your master's finest tea, what do you say?

Maribelle: Really, now! This is simply... Oh, all right! I'm sorry for spilling the stupid tea and blah blah whatever.

Frederick: UNACCEPTABLE! ...Now then. Try it again, this time like you mean it.

Maribelle: "Grumble, grumble" Oh, dearest Lord Frederick, please forgive my clumsiness! It shall never happen again! (...Because next time I'll spill it on your stupid head.)

Frederick: I shall assume your mumbling was all aboveboard. Now then! We must prepare the silverware. Today you are in charge of spoons.

Maribelle: ...Who does he think he is, making me polish cutlery? I'm a LADY! I ought to polish that face of his and cram it up his... Here you are, milord! All done, milord! Does the shininess please milord?

Frederick: UNACCEPTABLE! I want to see my reflection on the surface. ...Start again.

Maribelle: GRRRRRRRRR!

■ MARIBELLE X FREDERICK A

Frederick: Ah, Maribelle! Up early, I see.

Maribelle: You know, once you get used to it, this early morning lark isn't so bad.

Frederick: Excellent. Shall we proceed with our training, then? First you must boil the tea, and then I have a chest of silverware that needs polishing.

Maribelle: Wait, Frederick! Let me take that.

Frederick: Excuse me?

Maribelle: It's just... I'm worried about the foot you hurt in battle the other day. You should be trying to rest.

Frederick: Well, I concede the injury is troubling me somewhat... Frankly, I'm flattered you noticed. No one else has.

Maribelle: It's thanks to the steward training you've been kind enough to give me. I spot details like that all the time now. ...Well then, milord? Tea?

Frederick: My, but this tea is excellent! Are you using a new leaf?

Maribelle: It's a special vulnerary concoction for your foot. I spoke to the apothecary last night, and he said it came highly recommended.

Frederick: Why, Maribelle...

Maribelle: Y-yes?

Frederick: You have taken my lessons to heart and understand the true spirit of service!

Maribelle: Do you think so?

Frederick: I may not be a steward, but I constantly strive to be a better knight. Consideration for others... Willingness to assist any in need... I expect, of course, of the spirit of service that is at the core of chivalry.

Maribelle: I never made the connection...

Frederick: Weaponry and horsemanship can be taught to any capable of swinging a blade. But the spirit of chivalry comes from within! Maribelle, you have shown that you understand what it means to serve others.

Maribelle: Frederick, I'm...honored that you think so. I'm going to keep up my training and never forget your lessons!

Frederick: Good! Nothing pleases me more than inspiring a love of service!

Maribelle: Oh, you WILL continue to give me lessons, won't you, Frederick?

Frederick: If that is your wish, milady.

■ MARIBELLE X FREDERICK S

Frederick: How do you find it?

Maribelle: It's delicious, Frederick! You do make a wonderful cup of elderberry tea.

Frederick: And yet it hardly compares to your own brew, Maribelle.

Maribelle: Frederick, dear. I've been thinking... When this beastly war is over, are you sure you won't consider coming to the manor?

Frederick: B-but we had an arrangement. You were to teach your domestic staff...

Maribelle: Yes, I know. But the more I think about it, the more I realize it simply MUST be you. ...Please? Not even for a short while? Because then we could... Well, you see... We could be together more often.

Frederick: Together as servant and lady? No. I must refuse.

Maribelle: Do you hate me, Frederick? ...Am I so awful to look upon?

Frederick: In truth, I have grown...very fond of you. More, perhaps, than you suspect.

Maribelle: Wh-what do you mean?

Frederick: So fond, in fact, that I would be willing to join your household on one condition... That you take me as your husband! Maribelle, my love! Will you do me the honor?

Maribelle: Is that a ring? For ME?! Gods, it's beautiful!

Frederick: The stone is modest, but I polished it until it shone as radiant as you, milady. Won't you please accept it?

Maribelle: Oh, Frederick... Of COURSE I will!

Panne

■ PANNE X FREDERICK C

Frederick: Great paladin's helm! What manner of beast is that? Ah, hold. It's only Panne. ...But why is she prowling about in beast form? And why is she charging me?! BACK, FOUL BEAST! BACK, LEST MY SWORD TASTE YOUR—

Panne: *Pant, pant* F-finally! You are a hard one to catch, man-spawn.

Frederick: Why did you chase me down in beast form? I feared you were planning to eat me. Did I scare you?

Panne: Running on four legs is much faster. ...Did I scare you?

Frederick: A knight does not know fear. ...This was more like surprise. Why do you ask?

Panne: Lies! I hear your heart race even now! You were scared as a newborn pup. It is all right. You do not need to pretend for my sake. I have grown used to fear and ignorance from your kind.

Frederick: You mistake me, good lady. I hold no fear of the taguel. Behold what is in front of your eyes: are we not conversing as equals?

Panne: If this is true, then why were you scared?

Frederick: When I was but a young boy, I lived in a small village in the hills. One day I wandered into the forest, where I was set upon by a mountain wolf. My wounds were most grievous...many in the village doubted I would survive. When you came running, you reminded me of the beast that attacked me and... I apologize, good lady. I did not mean to offend with my actions.

Panne: I'm sorry, Frederick. I had no intention to remind you of such things. Would you prefer if I avoided you on the field of battle?

Frederick: That is unnecessary. When in combat—

Panne: The enemy is before you and you lose all fear, yes? Spoken like a warrior.

Frederick: Yes. Although if you could avoid moving, that might help.

Panne: Yes, well I am sure I cou—wait, what?!

■ PANNE X FREDERICK B

Panne: All right, Frederick. I'm in animal form. Now, how is it if I stand over here? I'm quite a long way from you.

Frederick: Yes. That's fine.

Panne: Good. Now, if I come a little closer...

Frederick: Y-yes, that's fine. ...I think.

Panne: And if I move a little closer still...

Frederick: BEGONE, FOUL SHE-WITCH!

Panne: Ah. This appears to be the point where fear enters your veins.

Frederick: S-so it would seem. ...Er, and apologies once again. That reminds me: The other day you came to ask me a question. What was it?

Panne: Mmm... I do not remember.

Frederick: Blast. My craven reaction is the reason I cannot recall.

Panne: It cannot be important if I forgot so easily. But I have a new question: What will you do with this fear of yours? Will you live in terror of animals for the rest of your days?

Frederick: If I knew of some way to cure it, good lady, I would not hesitate to do so.

Panne: Perhaps I can help.

Frederick: T-truly?

Panne: Your friends accepted me into their warren, and one good deed deserves another.

Frederick: That is a very kind gesture. ...Very well. I accept whatever aid you may provide.

Panne: I hope you are prepared.

■ PANNE X FREDERICK A

Panne: All right, let's try this yet again. Now, if I stand here...

Frederick: NOT ONE STEP CLOSER, FOUL NETHER CREATURE!

Panne: I think we might be stuck.

Frederick: I'm so very sorry. It's better than before, but I can't seem conquer this last bit.

Panne: Perhaps it's time to take your treatment to the next level.

Frederick: I'm not sure I approve of—

Panne: The next and final level.

Frederick: I DEFINITELY do not approve of—

Panne: GRAAAAAAAAAGH!

Frederick: "Groan" Y-you...leapt upon me...

Panne: I had grown bored of walking around in the distance while you cursed my name. How are you feeling? Aren't you afraid?

Frederick: Strangely, no. I'm not afraid at all. Gods, I've never noticed how soft and beautiful your fur is.

Panne: Good. All cured.

Frederick: Yes, yes, of course. No more fear for... Oh, look at these floppy ears! They're so cute!

Panne: OWCH! Do NOT yank on my ears, man-spawn!

Frederick: Er, yes. Dreadfully sorry, my good lady.

■ PANNE X FREDERICK S

Frederick: Panne, might I have a word?

Panne: What is it?

Frederick: I no longer fear your animal form, and for this I owe you a great debt.

Panne: Is this the part where you no longer need my services? Where you return me back to my rabbit hutch with an affectionate pat on the head?

Frederick: My good lady! You mustn't say such a thing, even in jest. I am deeply, deeply indebted to you. And what's more I...brought you this.

Panne: Is this... Oh ho, it IS! It's a ring! Is this the man-spawn ritual where you ask me to be your mate and spit on all others?

Frederick: Er, we usually speak of it in more poetic terms, but...yes. It is. I am so very pleased to be with you, Panne! Would you honor me by becoming my wife?

Panne: Your wife? Ha! I remember when you cowered at the sight of me! Perhaps I am moving up in the world. Oh, enough, Frederick. Do not make that sad face at me. I have grown fond of you for...some reason. And I would be proud to be your mate.

Frederick: Together we have conquered fear! What could possibly stop us?!

Panne: Heh, indeed. First, a bunny. Next, the world!

Cordelia

■ CORDELIA X FREDERICK C

Cordelia: The supplies have been unloaded, and everything is accounted for, sir.

Frederick: Ah, good work. Thank you. Next, may I ask you to—

Cordelia: Inspect the worn weapons and scrolls? Already done, sir. Oh, but I did have a number of questions regarding the layout of the camp.

Frederick:

Cordelia: Frederick?

Frederick: I was just thinking how little you have changed from when I knew you in Ylisse. Back when you served the royal pegasus knights. Always working harder than everyone and finding some task that needs doing... Phila once confessed to me that she'd have been lost without your help. I'm convinced it was her intention to eventually name you her successor.

Cordelia: Ph-Phila said that?!

Frederick: I envied her, in truth. I've often wished that I possessed a successor of your caliber.

Cordelia: Come now, Frederick, sir! You go too far. People will get the wrong impression if they overhear such flattery.

Frederick: The wrong impression? ...Ah, yes. I see. Apologies, milady. I'm afraid I'm not as sensitive as you to how such things can be perceived.

Cordelia: Of course not. Sometimes it feels as if every man only wishes to woo me...

Frederick: Indeed, the stories of your colorful past certainly do precede you.

Cordelia: Er, stories? What stories? ...Frederick, what stories?!

CORDELIA X FREDERICK B

Frederick: Might I have a word, milady?

Cordelia: Ah, Frederick. Of course. What is it? Why are you so fidgety? Wait, is this about your inexperience in matters of the heart again? Aha! You've come to me for love advice, haven't you?!

Frederick: Er, n-no, milady! I assure you, my intentions are entirely innocent. I was hoping you'd show the new recruits how well you handle a spear.

Cordelia: ...I suppose I could. But what would be the point? A common soldier is never going to be capable of wielding a spear the way I do.

Frederick: No. But at the very least, I want them to experience your legendary skills firsthand. Then they'll understand that your skills are born of effort, and not a matter of luck.

Cordelia: ...Luck? But why would they think that in the first place?

Frederick: Well, you see... Er, how shall I put it? For mere military mortals such as our new recruits and myself... Well, your martial genius places you on an entirely different plane. So far above us, in fact, that it's difficult to understand how skilled you really are.

Cordelia: Laying it on a bit thick, aren't you?

Frederick: I'm quite sincere. It must be very difficult having talent of your sort. It must be frustrating to be so constantly misunderstood and underappreciated. For our army's morale, I think it's important that our new recruits understand this.

Cordelia:

Frederick: I know it's an onerous request. You have every right to refuse.

Cordelia: Oh, no. I'll do it. In fact, I'm delighted you asked...

Frederick: You are?

Cordelia: I've always felt...apart from the rest of society. Like I'm in a different world. And when I'd complain about this or that, no one would take me seriously. People would say, "Oh, you're a genius. What do you have to complain about?" You're the first to realize that... Well, it's not easy being me.

Frederick: Well, I am pleased that milady is pleased!

Cordelia: So! Now that we've settled that, tell me all about your love life!

Frederick: Heh, er...perhaps later? ...Much, much later?

CORDELIA X FREDERICK A

Cordelia: Frederick!

Frederick: Milady, you seem giddy with excitement... Did something fortunate occur?

Cordelia: Not yet, but it's about to.

Frederick: Oh? I'm pleased to hear that.

Cordelia: You're always willing to help me, aren't you? If I ask a favor?

Frederick: If it is in my power to do so.

Cordelia: Great! Then put your boots on. We're going out.

Frederick: Do we need to secure more supplies?

Cordelia: Oh, no. This is going to be MUCH more interesting than some shopping trip.

Frederick: You say that with such an ominous bent! I'm starting to feel rather apprehensive. (...Wait. Could it be that I inadvertently insulted her the other day?) (Is she so angry at me that she is plotting to exact revenge?) (Ye gods! She's going to lure me to some dark place and stick a spear in my back!)

Cordelia: Frederick, what ARE you mumbling about? I want us to talk about your love life! I know you so want to pour your heart out, but you're afraid to take the first step. So you and I are going to a nice, quiet spot to see if we can't sort it all out.

Frederick: Er, what?

Cordelia: I've already picked out a place with absolutely no chance of being disturbed. Oh, and I made sandwiches too!

Frederick: Ah, Cordelia. Even with all your preparation, you still make one fatal mistake. You failed to account for the possibility that I might refuse your invitation!

Cordelia: No, I didn't. I assumed that if you refused, I'd have to eat all the sandwiches myself. So I made only my very favorite kinds—chutney, blue cheese, and pickled beets.

Frederick: I...see. Then I concede that your preparations are flawless. I think I have little choice but to gird myself and submit to this, at least. But only on one condition: you must first tell ME of YOUR love life.

Cordelia: Hold on to your helm, Frederick! I've got LOTS to say!

CORDELIA X FREDERICK S

Cordelia: Frederick! When ARE we going to discuss your love life?!

Frederick: Didn't we do that already?

Cordelia: We had that meeting in the gazebo, but you never really said anything!

Frederick: Perhaps because I was unable to get a word in edgewi—

Cordelia: Are you saying I talked the entire time?!

Frederick: Do you even recall our conversation? If, indeed, it can be called that? You spent two hours describing in vivid detail your unrequited passion for Chrom. You also sobbed repeatedly and kept asking me "Why, Frederick? Why?!" Then you devoured all the sandwiches and ran off with the picnic hamper.

Cordelia: Er, yes. Thank you for...reminding me. But I assure you, our next conversation will not be nearly so shameful! This time it will be all about you. You'll have my undivided attention for the whole day, if that's what it takes.

Frederick: Heh. Is this a solemn vow?

Cordelia: Absolutely!

Frederick: In that case, I shall begin my confession immediately...

Cordelia: Goody!

Frederick: *Ahem* Time to get down to brass tacks. No beating about the bush, so to speak... The truth is... *ahem* Yes, quite. Well, the truth is... I am in love with you.

Cordelia: Huh?! ...Is this a jape? It is, isn't it? A silly jape! I bet there's a pack of jesters waiting behind that tree to surprise me!

Frederick: No jape, milady. Not for me.

Cordelia: Oh. But...I thought... I mean... All this time I was asking... I had no idea your love troubles had anything to do with ME!

Frederick: Yes, and I know your heart belongs to Chrom. But even so, I will not give up. I have no desire to speak ill of Chrom, for I am his man in all things. But, Cordelia, I would never give you cause to weep so bitterly as you have for him. I would devote my whole existence to ensuring your happiness.

Cordelia: Why, Frederick... When you say something like that, I know that you're telling the truth. B-because it's how I feel, too. Day in and day out. I have those very same thoughts. ...Except they're for Chrom.

Frederick: And just as you love Chrom with all your heart, so do I love you with mine. Here. Let this be the proof.

Cordelia: ...An engagement ring?

Frederick: It doesn't matter that right now your heart belongs to another. It's enough for me to hope that someday you'll put it in yourself to love me. Will you marry me, Cordelia?

Cordelia: Oh, Frederick! This is... Yes, I will marry you!

Frederick: You will?!

Cordelia: I know that Chrom will never love me. ...I think I've always known it. And frankly, I've grown weary of unrequited love. Just the thought of giving it up is like a weight falling from my shoulders. Oh, Frederick, thank you for making me face reality at last! If I promise to love only you, will you make me the happiest woman in the world?

Frederick: I swear it, milady.

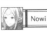 Nowi

NOWI X FREDERICK C

Frederick: Ah, Nowi.

Nowi: Eeek!

Nowi: Wh—?! No, wait!

Nowi: Yes? What is it?

Frederick: Why did you attempt to flee, milady? Have I done something to anger you?

Nowi: Last night, I had a nightmare about my basket of fruit being stolen...

Frederick: Ah. Yes, I see how such a thing might be... Er, except I don't. Why did that make you want to run away?

Nowi: Because YOU were the thief, and I didn't want to lose any more fruit!

Frederick: This is unfortunate. I hate to think I wronged you—dream or otherwise. Perhaps it would clear the air if I offered you my ration of fruit this evening? And I only ask one small thing in return.

Nowi: For extra fruit, I'll do anything!

Frederick: Well then, I was hoping we might spend more time together.

Nowi: ...Yeah, no. That's not worth fruit. Plus you're not really my type.

Frederick: Milady! I did NOT mean it as a proposal! What a dishonorable idea! ...I want you to show me your dragon side.

Nowi: Huh? But why?

Frederick: Opportunities to spar with a dragon are few and far between. To get even a taste of dragon combat would be a most valuable experience!

Nowi: Won't you be all scared and stuff?

Frederick: That is why I need your help. Fear of the unknown is the fear most dangerous.

Nowi: I'm not sure about this.

Frederick: ...You'd have two rations of fruit?

Nowi: Oh, right! I almost forgot! Okay, sure!

NOWI X FREDERICK B

Nowi: Frederick, are you all right?

Frederick: *Groan* Y-yes, milady... Completely fine... Such a small burn... I c-can hardly feel it. If I just ignore it, it will heal. Eventually...

Nowi: Are you scared? I burned off an awful lot of hair. What if it grows back all weird?

Frederick: Oh. D-does it appear grievous?

Nowi: Well, it's kind of all frizzy and spiky and sticking out. Hee hee! It's actually pretty funny! Hee hee hee!

Frederick: Then we had best stop for now and give my body a chance to recover. This has been a very educational experience, thanks to you. I must return to my training while the pain of the wounds remains fresh in my mind.

Nowi:

Frederick: Are you all right, Nowi? Are you injured?

Nowi: I'm just thinking how stupid you are! Getting yourself all hurt like that, with no one to look after you properly!

Frederick: I must put myself through such trials if I am to protect everyone.

Nowi: But why do you insist on doing it by yourself! You can ask for help!

Frederick: What are you driving at, milady?

Nowi: You said you were going to return to training, right? Meaning, on your own? But that'll make you lonely. I should know. Before I came here, I was all alone, too. It makes me sad to see you working and training so hard with no one around you.

Frederick: Milady, you have a kind and gentle heart. But I couldn't possibly be lonely when those like you are thinking about my welfare.

Nowi: So you don't feel lonely at all?

Frederick: Not a bit. So once my wounds have healed, perhaps we can spar once again?

Nowi: Sure. That'll be fun!

NOWI X FREDERICK A

Frederick: Nowi, are you free? I was hoping we might have another sparring session.

Nowi: But we just had a fight yesterday! AND the day before that!

Frederick: Yes, but I am so close to anticipating when you unleash a breath attack.

Nowi: Oh, okay. If you want to play THAT much... Why are you always so obsessed about getting better at fighting?

Frederick: I must be strong so I can protect Chrom and our allies. This war demands no less. Also, the more I learn, the more I can pass on to the other Shepherds. This will reduce battlefield casualties and increase the odds of eventual victory.

Nowi: And it'll make you the biggest hero ever!

Frederick: Unlikely. And in any case, I do not do this for praise or glory. My only aim is to save as many of my comrades as possible survive this war.

Nowi: I love being praised more than ANYTHING! Don't you care about the glory even just a little bit?

Frederick: I am but human, milady—any praise that comes my way is highly appreciated. But approbation and glory cannot by themselves be your goal.

Nowi: Gosh, you're just like a real knight! But SOMEONE has to tell you how great you are—and it might as well be me! So, er... Well done, Frederick! Good job! You're the best knight ever!

Frederick: Heh. Why, thank you, Nowi. You remind me of my mother.

Nowi: Well, don't forget, I AM like several centuries older than you!

Frederick: Yes, of course. I often forget that you are a wise, mature woman.

Nowi: Tee hee hee! Now you're praising ME! And you do it ever so well!

Frederick: I only speak the truth.

Nowi: In fact, you're so good at it, I think we should spend more time sparring.

Frederick: It would be my pleasure!

NOWI X FREDERICK S

Nowi: Frederick! Let's practice some more. I'll turn into a dragon for you!

Frederick: Now this is unusual—normally, it is I who challenges you to battle. Has something piqued your interest in our training sessions?

Nowi: Not really. I just decided that you and me should practice together more often. See, when you try hard, I always remember to always try hard too, and you know how hard you work. Even if no one else appreciates all your hard work, I want to make sure I do. And, another thing. When you take a day off, I want to take a day off with you! Then we can keep each other company, and neither of us will ever be alone. We'll get stronger, we'll be able to help out Chrom more, and it'll be fun!

Frederick: But then we would be spending nearly every waking moment together.

Nowi: ...You don't hate me, do you? Please say you don't! Because I don't hate you! In fact, I really, really, REALLY like you!

Frederick: I like you, too, Nowi.

Nowi: No! I don't mean that kind of like. I mean, I LIKE YOU like you.

Frederick: ...Ah.

Nowi: I love how you're always working so hard for others, even when you're tired. Plus I love how you're always thinking of ways to protect people. It makes ME want to protect YOU! So, um, do you like me? Like, as a woman and all that? 'Cause I want you to like me like I do for you, I...I want you to tell me. Please. Frederick! Don't keep me in suspense!

Frederick: After such a forthright confession, it would ill behoove me not to answer in kind. In truth, I was planning to do this when I was better prepared... ...But, Nowi, I have in fact fallen in love with you. We have spent so much time together lately, and I came to realize... Well, that you are the most important person in my life.

Nowi: YAAAAAAAAAY! So I suppose we should get married now, right?

Frederick: If you will do me the great honor. But unfortunately, I have not yet picked out a suitable ring for you. I shall go to the jeweler in town and order one immediately.

Nowi: Oh, wait! Before you go, let's have another fight!

Frederick: Well, I suppose there is always time for just one more...

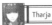 Tharja

THARJA X FREDERICK C

Frederick: This exercise really works the stomach muscles. Ready? Just 300 this time! 299...298...297...

[Robin]: Going...to...die...

Tharja: That's some dedication, [Robin].

Frederick: That's enough for today. Remember to hydrate and eat your hardtack. Diiiis-MISSED!

Tharja: What a taskmaster. I thought he'd never finish. Look at [Robin] and those fools... I hope they realize (he/she) belongs to me. I suppose I could curse them all. ...Gods, that would take forever. It would be easier to just curse [Robin]. A stink spell, perhaps? It caused people to pass out and retch, I'd have all to myself! ...Except that would smell like an outhouse. Hmm... Maybe a different plan...

Frederick: Come at last, eh, Tharja? I fear you missed the session.

Tharja: Oh. ...Darn.

Frederick: We did look for you, but it's important that we keep to schedule. In the end, I had to start Freder-

ick's Fanatical Fitness Hour without you. But seeing as you're here, I suppose I can work in a private session.

Tharja: Um... Actually, that's not... Oh dear gods...

Frederick: Next up, biceps! I should warn you, this may burn a little bit. Aaand ONE! Aaaaaand TWO! AAAAAAND THREE!

Tharja: *Pant, pant* Wh-what's...happening to me... Vision...fading... Blackness...everywhere...

Frederick: ...I say, Tharja. You appear to be unwell. Let's pick this up again tomorrow. Get a night's rest and eat some beans.

Tharja: *Huff, huff* T-tomorrow... You're...joking... Why...want..."huff" torture me...?

Frederick: A sound body leads to a sound mind. You're just a little out of shape is all. See you tomorrow at dawn.

Tharja: ...I'm...a dark mage... "huff" Don't need biceps...the size...of beer barrels...

THARJA X FREDERICK B

Frederick: Tharja! A word, if you please?

Tharja: I don't, actually.

Frederick: Why did you not keep our appointment at the training ground?

Tharja: We had an appointment?

Frederick: Don't play the fool with me! *sniff* I waited the entire day and most of the evening hoping you would show! That training ground is chilly at night, and I seem to have caught a cold. *sniff*

Tharja: Oh? I thought you'd be far too healthy to catch a cold.

Frederick: Erm, well...

Tharja: Tsk, don't feel bad. Cursed colds are harder on everyone.

Frederick: What?! You deliberately gave me a cold?!

Tharja: Hee. You seem angry.

Frederick: A-angry? Of COURSE I'm angry!

Tharja: Well, you should be. I'm very wicked. If I were you, I'd avoid me completely.

Frederick: You know why you did this, don't you? Weak physical conditioning! Your unsound body has resulted in a most unsound mind!

Tharja: I don't like where this is going...

Frederick: AAAAAACHOOOOOOOOO! ...Ah, better. My cold has gone. I'm so fit, one good sneeze gets rid of all my symptoms.

Tharja: Er, that makes no sense.

Frederick: Now that I am recovered, we shall continue your training. Here, tomorrow. At dawn. And this time, you WILL come. Do I make myself clear?

Tharja: Yes, we'll see about that. Hmm... I lied about the curse, but even so, how did he shake a cold so quickly? Heh... Maybe next time I WILL cast a hex.

THARJA X FREDERICK A

Frederick: Ah, Tharja, I've been waiting for you. Finally ready to build a healthy body?

Tharja: No. The reason I'm here is... Is to check THIS!

Frederick: Argh! Wh-what are you doi... OUCH! Unhand me, woman!

Tharja: There! I knew it. You suffered a deep wound in the last battle.

Frederick: I didn't think anyone saw that...

Tharja: It happened because I cursed you.

Frederick: What?! We are allies! Why do you insist on plaguing me with dark magic?

Tharja: It wasn't supposed to be harmful. It only made me invisible to you. It was the only way I could think of to avoid your insane training. But somehow, you still sensed that I was in danger and shielded me from the blow. Even though you were cursed. Even though there was no way you should have seen me?

Frederick: Ah. This explains a great deal. I was unable to shake the persistent feeling that you were somewhere nearby. I feared that I was losing my mind, to tell the truth.

Tharja: You can tell Chrom if you want. He'll probably want to hang me by my thumbs or...something.

Frederick: The Shepherds do not engage in torture! Especially not with our stalwart comrades. In any case, it was not your fault. I should never have exposed myself to the hex. My guard slipped. The responsibility is mine.

Tharja: Gods, but you're a trusting fool. Is there any sin you won't forgive?

Frederick: You will not mind if I take that as a compliment?

Tharja: Take it however you want. Now let me take a look at that wound. *Grumble* For someone who cares so much about health...

Frederick: Tharja, do I detect a note of affection in your voice?

Tharja: I'm only looking after you because [Robin] likes you.

Frederick: Ah. Then I'd best recover soon... For sake, of course, heh.

THARJA X FREDERICK S

Tharja: Has your wound healed?

Frederick: Good as new, thanks to you.

Tharja: Well then...Yes?

Frederick: Yes, what?

Tharja: You're fully cured. No need to see me anymore. So why are you still here?

Frederick: I wanted to make absolutely certain that you'll come to the next training session.

Tharja: I've promised you five times already! Surely that's enough. Look, what do you really want? If you're not going to leave, I will.

Frederick: N-no, please! Wait! I had something else to ask!

Tharja: *Sigh* What is it?

Frederick: You didn't cast another curse on me recently, did you?

Tharja: Why?

Frederick: Because lately, a powerful...emotion has taken root in my heart. That wouldn't be the result of some evil hex, now would it?

Tharja: Not from me.

Frederick: In that case, the passion I'm feeling must come from within. Which makes this the perfect time to present this...

Tharja: ...This better not be a cursed ring.

Frederick: How can a love so powerful ever be called a curse?

Tharja: Love...? Wait, are you proposing?!

Frederick: Indeed I am.

Tharja: ...Are you mad?

Frederick: If I were a poet, I could use sweet words to explain how my love came to be... But alas, I am not. I can only tell you what I know in my heart. I love you, Tharja. I want you at my side for all of my days.

Tharja: That's...really sweet, actually.

Frederick: Then will you accept my ring?

Tharja: On one condition...

Frederick: Name it!

Tharja: We do the life's journey without the exercises. I don't care about a sound body, and I don't WANT a sound mind. Mages need to stay a little crazy, or we lose our edge...

Frederick: Agreed. No more exercising for you, and no more curses for me!

Tharja:"Sigh" Oh, fine.

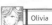 Olivia

OLIVIA X FREDERICK C

Olivia: Er, Frederick?

Frederick: Yes, milady? How may I be of service?

Olivia: Well, see, I was wondering... And this may be an odd question, but... Well, what do you think of me?

Frederick: Think of you, milady? *Ahem* Well, you are flexible of limb and move with an economy of motion. You have the qualities of a superior fencer. I would recommend a light rapier to start.

Olivia: No, I'm not talking about being a soldier. What I mean is... What do you think of me as a woman?

Frederick: Do I find you attractive? Is that your meaning?

Olivia: I suppose so, yes.

Frederick: Hmm... A difficult question, if I may speak bluntly. I'd not thought of you in such terms before, and so cannot provide a meaningful answer.

Olivia: Oh. That's just what he said...

Frederick: Who?

Olivia: Khan Basilio. He never takes me seriously, no matter what I do. I guess I have no appeal for older men. My dance teacher once told me I had to learn how to captivate everyone. Otherwise, no one would believe my performance.

Frederick: So your interest was professional rather than personal. I see... While I'm sure you are blessed with many charms, they are sadly lost upon me. I'm sorry I could not be more encouraging. Now, if you will excuse me...

Olivia: Er, yes. Thanks, I guess.

OLIVIA X FREDERICK B

Frederick: Might I have a word, milady?

Olivia: What is it?

Frederick: I wanted to return to our conversation from the other day. I took it upon myself to ask some fellow soldiers whether they found you attractive. Almost to a man, they asserted that you are extremely charming! Many also commented most heartily on some of your...other features. Furthermore, most of the respondents are older than you, in some cases very much so. In conclusion, therefore, I think we can safely say that you possess wide appeal.

Olivia: ...Wait. How many people did you ask?

Frederick: Well, let's see. I spoke with all the Shepherds, so that should be... Oh, and I also queried those farmers in the last village we passed... Ah, and the beggars at the side of the road! Mustn't forget them. So that means—

Olivia: AAAAAAUUUUUUUGGGGGGH!

Frederick: Er, milady? Are you not pleased by these most favorable results?

Olivia: FREDERICK! Everyone's going to think that I asked YOU to ask THEM!

Frederick: ...I had not considered that.

Olivia: Oh, gods... I have to leave. I have to run away right now...

Frederick: W-wait, milady! I am so terribly sorry! Please allow me to make amends. Perhaps I could travel with you whenever you go out in public. Then you can simply hide behind my person whenever someone approaches.

Olivia: ...This is the worst day ever.

OLIVIA X FREDERICK A

Olivia: I'm really surprised how easy it is to hide behind you, Frederick. I don't think anyone has seen me in the camp for days!

Frederick: I am delighted to be of service, milady. For one such as I, whose life is devoted to such endeavors, it is no small matter.

Olivia: So, um, you don't mind that I'm hiding behind you all the time?

Frederick: Quite the opposite. I am happy to perform my duty.

Olivia: Oh, goody! Thank you, Frederick!

Frederick: I must say, milady, having spent so much time with you recently, I... Well, I am starting to see why the others found you so charming.

Olivia: Y-you are?

Frederick: Yes, I am.

Olivia: Erm, I don't suppose you could tell me exactly what you like about me?

Frederick: Please, milady! Do not stare at me with those beseeching eyes!

Olivia: Some details would be nice, Frederick. ...You know. For professional reasons.

Frederick: I see. May I have time to put it into words? My feelings on the subject are still... vague.

Olivia: Okay. But just don't take too long!

OLIVIA X FREDERICK S

Olivia: Ha! I finally cornered you! Have you been trying to avoid me? You know you cannot hide forever!

Frederick: A-avoid you, milady?! Perish the thought! Nothing was further from my mind.

Olivia: So why haven't I seen you around camp in forever? Hmmm?

Frederick: I've been busy with...preparations. For example, I had this made.

Olivia: A ring? But why did... Wait, there's something on it... "To Olivia, with all my love." Frederick?! I don't understand.

Frederick: I am not a man accustomed to speaking of affairs of the heart, so I shall be brief. This ring is meant as an expression of the great love and affection I feel for you. You would do me a great honor if you were to accept it.

Olivia: ...You want to marry me?!

Frederick: That is my intent, yes.

Olivia: Oh, how did you know?! Oh my gosh, yes! Yes, yes, yes! I've been crazy about you forever!

Frederick: I hereby swear that I will lay down my life in order to protect you!

Olivia: Well, that's...a bit harsh, but I like the sentiment, I guess. Oh, thank you, Frederick. You gallant, wonderful man! I'm so excited we're getting married! It's like a dream come true!

Frederick: For both of us, Olivia. For both of us!

Cherche

■ CHERCHE X FREDERICK C

Cherche: HIYAH! YAH!

Frederick: Excellent technique.

Cherche: A true gentleman would announce himself rather than skulk about in the shadows.

Frederick: My sincere apologies, milady. I was loath to interrupt. Especially when I was being treated to such a virtuoso display of skill.

Cherche: Heh. 'Tis an honor to be praised by such a renowned and accomplished soldier.

Frederick: The technique you just used—is it commonly practiced in Valm?

Cherche: No, actually. It is part of a secret art passed down within my family.

Frederick: Then I've wronged you more than I thought, for I had no intention of pilfering secrets. Pray forgive my accidental insolence, milady.

Cherche: Don't apologize, please. I don't mind sharing our traditions with allies. In fact, I can teach it to you if you're interested.

Frederick: I do not wish to impose.

Cherche: We fight for the same cause. It's in my interest to help you. Who knows? One day, you might use it to save your life in battle.

Frederick: In that case, then yes. Thank you. I would like to learn what you know.

Cherche: When shall we begin?

■ CHERCHE X FREDERICK B

Frederick: Cherche, I want to thank you for teaching me your family's fighting art.

Cherche: I hope you'll find it useful.

Frederick: I'd like to return the favor if I could.

Cherche: Perhaps in the next battle, you can fight alongside me so I might observe you.

Frederick: That hardly seems a sufficient reward for your services. I was taught that a lady of your standing should expect gifts of gold or silk.

Cherche: Do I strike you as the sort to be satisfied with trinkets? Why, if I didn't know better, I'd say you'd taken advice from Virion!

Frederick: Ha! I'd be dead in the grave before I'd take counsel from that ill-behaved scallywa... Er, that is, from Virion! From LORD Virion, a fine and outstanding member of—

Cherche: Oh, shush. I know what Virion is like. Yes, he was once my liege, but he lost his domains and is no longer a lord. I'm my own woman now. I can go my separate way whenever I choose.

Frederick: And yet, you do not.

Cherche: Strange, isn't it?

■ CHERCHE X FREDERICK A

Frederick: Ah, Cherche. Perfect timing. Do you know where I might find Virion?

Cherche: No. And I wouldn't bother trying to look for him, either. Knowing him, he's off whispering sweet nonsense into some poor maid's ear.

Frederick: But we are to be marching soon! Will he be ready in time?

Cherche: Oh, probably. I'm getting his equipment ready as we speak.

Frederick: That is very loyal of you, especially considering what a cad he is. I think you could teach me a thing or two about serving one's lord!

Cherche: I told you, he is no longer my lord. And besides, you are the very paragon of loyal and chivalrous knighthood. None compare to you when it comes to the knightly virtues.

Frederick: You are too kind. Yet when I see how devoted you are, it humbles me somehow.

Cherche: How so?

Frederick: Hear me, Cherche. For a knight, loyalty is the primary virtue. But to what—or to whom—should it be directed?

Cherche: To the realm, I suppose. Your liege lord's domain.

Frederick: And if that realm is destroyed?

Cherche: Well, er...

Frederick: The knight's vow of loyalty still holds, but it is directed not to the land. Nor is it to a castle, or to a town, or any particular place. The vow is to the people who make up the realm. As a knight, you owe fealty to Virion and the smallfolk of his domain. You understand that act accordingly. It is an honor to fight alongside you.

Cherche: Well, well! High praise indeed, coming from the famous Frederick! But in all seriousness, thank you. And may I say, it is an honor to fight in the same army as you.

Frederick: Then that we may fight bravely, and until victory!

Cherche: Shoulder to shoulder!

■ CHERCHE X FREDERICK S

Cherche: Frederick? In the last battle, you went too far trying to protect me. You almost let that Risen have a bite of your hide!

Frederick: I-I was merely careless! My training must have been insufficient!

Cherche: Normally, you'd dispatch such a foe without a thought, but you were distracted. Distracted, I say, by what was happening to me...

Frederick: I apologize for the error, milady. If a knight is to defend his charge, he must be able to see every threat and danger.

Cherche: I'm not your charge, and I'm asking you to forget me and worry about yourself!

Frederick: I cannot, milady.

Cherche: And why not?

Frederick: Because you are as important to me as any prince or lord.

Cherche: Is this some kind of jest?

Frederick: I fear I do not joke, milady. I never did develop a skill for it. For how can a man as wretched as I find room in his heart for humor?

Cherche: Oh, don't be so melodramatic.

Frederick: Listen to me, Cherche.

Cherche: ...Yes?

Frederick: When we first came to know each other, it was as fellow knights and comrades. But as we fought, the bonds of friendship drew us closer together. So close, in fact, that I find myself thinking about you night and day. Cherche...will you do me the honor of accepting this?

Cherche: An engagement ring?

Frederick: A vow of love and loyalty, until death takes me from you.

Cherche: Why, Frederick! This is so gallant! ...Of course I accept!

Frederick: Splendid! Then I shall live and die a happy man!

Cherche: Oh, enough with the talk of dying. You're under MY protection now. ...Oh, and Minerva, of course!

Henry

■ HENRY X FREDERICK C

Frederick: HENRY! CAN YOU HEAR ME?!

Henry: Oh, hey, Frederick! What's up?

Frederick: You were absent at today's training session!

Henry: Training session? First I've heard of it!

Frederick: Surely you recall Chrom reminding everyone in his address to the troops yesterday?

Henry: Ooooooooooooh, THAT training session! It must have slipped my mind.

Frederick: Then you weren't absent due to injury or illness?

Henry: I WISH I had an awesome illness, but no. I'm right as rain.

Frederick: That's good to hear. However, I'm quite disappointed you missed the session. Being prepared for battle is a matter of life and death.

Henry: Aw, don't worry about me, Frederick. I'm not going to die so easily!

Frederick: What makes you, out of all your comrades, so uniquely immune to war's perils?

Henry: Oh, you know. Stuff and things.

Frederick: I do not know! Training is essential for all soldiers, and that includes you!

Henry: Okay, fine! Geez, careful not to twist your smallclothes there...

Frederick: H-Henry? Where are you going? I'm not finished with you yet!

Henry: I'm going to the training ground! Want to join me?

Frederick: Me?

Henry: Nya ha ha! Just kidding!

Frederick: About going to train? Or inviting me along?

Henry: Hmm... You know, I'm not even sure myself. Welp, see you around!

Frederick: Henry, wait! Are you going to train or not? It's a matter of life and death!

Frederick: Bah! What an aggravating young man!

■ HENRY X FREDERICK B

Frederick: HIYARGH! GARH!

Henry: Working up quite a sweat there, eh, Frederick?

Frederick: Ah. Hello, Henry. Have you come to train at long last?

Henry: Oh, no! Just to watch.

Frederick: Such an attitude ill serves a Shepherd. Come, let us train together.

Henry: Why did you spend so much time training, anyway? It looks exhausting!

Frederick: Because I want to! Should anything can happen on the battlefield. I do not want my dying thought to be "if only I had trained a little harder."

Henry: Ha! Your dying thought will be about blood! ...Or maybe ichor.

Frederick: Enough chitchat! Fetch a wooden shield, and take some swings at me.

Henry: No need. I'm not going to die anyway. But good luck with that!

Frederick: HALT! You shall not escape my watchful gaze today!

Henry: Whoa, easy there, Frederick! You're bruising my arm! ...Oooo, look at the colors!

Frederick: Enough dillydallying! Let's train! One, two... together! HIYARGH! GARH!

Henry: ...Aw, man. I knew I shouldn't have come here.

Frederick: What did you say?!

Henry: Oh, nothing. But I suppose a bit of practice won't hurt.

■ HENRY X FREDERICK A

Frederick: Ah, Henry. Have you come to join me in training again?

Henry: Yeah, I was kinda bored, so why not?

Frederick: You feign nonchalance, yet you attended every one of our training sessions recently.

Henry: Yeah, I know. It's funny, but I'm actually starting to enjoy it! ...Sort of.

Frederick: Listen close, Henry. I have something I would tell you...

Henry: Yes?

Frederick: *Sniff* Wh-when you say that, it fills my heart with happiness!

Henry: H-hey, Frederick! Easy with the bear hugs! These little bones might snap like... Oh, whoa! Are you CRYING?!

Frederick: Tears of joy, my young friend! For at last you are a devoted and committed soldier!

Henry: I always WAS!

Frederick: Continue this hard work, and you will win the respect and praise of everyone in the army.

Henry: You really think people notice what I do around here? 'Cause I doubt it. I mean, what kind of things do they say about me anyway?

Frederick: I'm sure if we were to ask Chrom, he'd say you his most trusted lieutenant. You are the hope of the future and the greatest prospect this army has.

Henry: Nya ha ha! If you lay it on any thicker, I'll be smothered to death! But I'm not training to make myself look good in front of my comrades, you know?

Frederick: Then why, pray tell?

Henry: Well, because the more I practice, the more stuff I'm able to do. I like being good at lots of things.

Frederick: And that's sufficient motivation to put yourself through this torture?

Henry: It's no torture! It's fun! Now I can sneak up behind foes really easily, and my curses work better, too.

Frederick: I-I see. I'm glad you enjoy it...when I find it so...difficult.

Henry: I can't believe anyone ever complains about training. What's so hard about it?

Frederick: Perhaps if you train enough, you will learn the meaning of work and self-sacrifice. Come then! Let us grow strong together!

Henry: Hey, sure! I've got nothing else going on today!

Owain (Father/son)

Owain's father/son dialogue can be found on page 289.

Inigo (Father/son)

Inigo's father/son dialogue can be found on page 293.

Brady (Father/son)

Brady's father/son dialogue can be found on page 297.

Kjelle (Father/daughter)

Kjelle's father/daughter dialogue can be found on page 299.

Cynthia (Father/daughter)

Cynthia's father/daughter dialogue can be found on page 303.

Severa (Father/daughter)

Severa's father/daughter dialogue can be found on page 305.

Gerome (Father/son)

Gerome's father/son dialogue can be found on page 307.

Morgan (male) (Father/son)

The Morgan (male) father/son dialogue can be found on page 309.

Yarne (Father/son)

Yarne's father/son dialogue can be found on page 314.

Laurent (Father/son)

Laurent's father/son dialogue can be found on page 316.

Noire (Father/daughter)

Noire's father/daughter dialogue can be found on page 317.

Nah (Father/daughter)

Nah's father/daughter dialogue can be found on page 318.

Virion

Avatar (male)

The dialogue between Avatar (male) and Virion can be found on page 218.

Avatar (female)

The dialogue between Avatar (female) and Virion can be found on page 229.

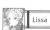
Lissa

The dialogue between Lissa and Virion can be found on page 242.

Frederick

The dialogue between Frederick and Virion can be found on page 245.

Sully

■ SULLY X VIRION C

Sully: Hrah! Yaaaaah!

Virion: Ah, most fortuitous fortune! It is none other than my dearly beloved Sully! Your floating, so like a butterfly. Your stinging, so like the bee! Why, it's positively—

Sully: You got a point, Ruffles?

Virion: None save the point of my heart's compass, which strains ever toward Sully.

Sully: That sounds like a no. So get lost. I'm trying to train here.

Virion: So cold! I feel a chill coming on. I'll surely catch my death if you don't spare a few warm words, milady... Come now! All this training for war... All this angry grunting... It's unbecoming of a lady so measured.

Sully: Pfft. A pretty girl can stab a guy as easy as an ugly one. But she still needs to practice. ...So clear out!

Virion: No doubt the poets would write of your grace in combat. "Stabulous," they'd say! But there is no need for such exertions. Not when you've a man to protect you!

Sully: I've yet to see a man up to that task.

Virion: Milady, you wound me. Such a man stands before you at this very moment!

Sully: Wait, are you talking about...you? AAAAH HA HA HA HA! Oh, you're a funny guy, Ruffles. I'll give you that.

Virion: ...I wasn't joking.

Sully: Do you have any idea how many people try to kill me on a daily basis? It'd take a certified hero just to keep up, let alone "protect" me.

Virion: And I vow to be just such a hero!

Sully: Ruffles, I'd hire a wet nurse AND her kid as protectors before I'd consider you.

Virion: Is it proof of milady desires, is it? So be it! I shall gladly furnish such! Watch closely our next battle. I'll display such heroism as makes for legend and song!

Sully: Oh, this should be good.

■ SULLY X VIRION B

Sully: Hey, Ruffles. I saw you in that battle.

Virion: Then you've seen the fearsome beast that lurks within this lover's tender bosom! I only pray it did not frighten you, gentle lady. And I trust it proved that I am the hero fated to keep you safe!

Sully: Was it also fate that you chickened out of that duel?

Virion: That was common sense and nothing more! What reason had I to accept?

Sully: Running from a duel is hardly heroic...

Virion: At the very least I am that man's hero! By turning down his offer I spared his life.

Sully: I think we have a different idea about what the word "hero" means.

Virion: You wound me, milady! I assure you, I am no craven. Had that cur but glanced at you, no force in this world would have stayed my hand.

Sully: Pfft. You've always got some clever answer ready... Talking to you is like dancing. It's exhausting and sweaty and I hate it.

Virion: I speak only the truth, milady. Whether or not you believe me is your prerogative.

Sully: Great. Then I don't believe you.

Virion: Y-you might at least have paused a moment to consider before—

Sully: Har! Easy, Ruffles. I'm just teasing. Sure, you fled the duel, but you actually looked passable the rest of the time. Looks like you're still in the running to be Mr. Hero. I'm looking forward to next time.

Virion: All shall gaze upon my might and tremble, milady! This I swear!

■ SULLY X VIRION A

Virion: Ah, Sully...hmm? Why are you looking at me so? ...Is there something on my face?

Sully: I'm the wrong person to ask. I've been seeing things lately.

Virion: And yet, your beautiful eyes appear as clear and sharp as ever. Tell me of these visions, milady, that I might proffer some support.

Sully: You fought a duel, you damned fool! What's more, you WON! And you beat back the others who had trouble fighting as a unit! If that isn't seeing things, I don't know what is.

Virion: Are you truly so surprised at that, milady? I told you before that I would accept a duel only a reason.

Sully: And what was this reason?

Virion: That man had to be stopped. Had I let him escape, he might have turned his wrath upon neighboring villages.

Sully: So you risked your neck for a handful of strangers?

Virion: I fought to defend the defenseless. No true nobleman would do less. But nor would he ever meaningless battles like a blood-mad savage in search of glory. Ugh... The very thought disgusts me.

Sully: So...is that why you wanted to defend me?

Virion: Exactly! You, my dear, are a lady fair. A paragon of grace and beauty. Any fellow who would call himself a gentleman would defend such a creature.

Sully: Don't call me a creature, you flowery snot! And I can defend my own damn self. Although... Well... I guess I don't mind if you call me a lady. But only because I've seen you show a bit of courage on the battlefield. If not for that, I'd send you off half the "gentleman" you claim to be.

Virion: Then you accept me as a hero worthy of protecting you?

Sully: Let's not get crazy now, Ruffles. I just promoted you from lousy craven to decent guy. That's all. ...And I suppose you can watch my back in a brawl.

Virion: Aye, and soon you'll trust your tender heart to my love's fearsome embrace!

Sully: ...Okay, you're still clearly insane. But if there must be a dangerous madman about, I'm glad he's on my side.

■ SULLY X VIRION S

Sully: ...Virion.

Virion: Sully! What a prize, that these eyes might gaze once more upon your beauty.

Sully:

Virion: Goodness, milady. Your countenance is so very...intense. I should think a lesser man might burst into flames on the spot.

Sully:

Virion: "Ahem" Is it getting hot here? ...I should be very relieved if you would only respond.

Sully:

Virion: ...Enough! I yield, milady! Nothing is so daunting as a woman's silence.

Sully: Ha! I KNEW it! It's all well and good for you to pester others, whether they want it or not. But turn the tables and you change your damn tune! You can't handle the attention!

Virion: This was a...test? Rather beneath a lady of your bearing, I must say.

Sully: I can't get a word in edgewise with you if I play fair. I doubt anyone can with that sharpened tongue of yours. Besides, I needed to know at least one of your weaknesses beforehand.

Virion: Er, before...what, pray tell? Delving into the character of your future husband before you wed him? Heh heh...

Sully: Yep.

Virion: Because frankly, I don't see wh—WHAT?! H-hold a moment... Are you serious?

Sully: Deadly so.

Virion: Well, th-this is an honor to be sure, but I'm not... I haven't prepared myself!

Sully: Ha ha... Adding prone to ambush to that list of weaknesses...

Virion: You have me at a loss, milady.

Sully: Oh? Where has your famous wit run off to? If ever a moment called for poetry... I'm a lady, right? Paragon of grace and beauty. Don't leave me dangling here...

Virion: N-no, of course, I... *ahem!* I hereby swear to leave none of milady's desires unmet, even at the cost of my life. It would be this humble man's great joy to accept your gracious offer.

Sully: Well, I suppose that works. ...Barely. That really the best you've got, Ruffles?

Virion: ...B-but, I...

Sully: Har har! Only jesting! That'll work just fine for me. Let's go ring shopping. I've got the place picked out already. Let's move. ...And no lagging behind!

Virion: Y-yes, milady...

Sully: I can't hear you!

Virion: Yes, milady! Coming, milady!

Miriel

■ MIRIEL X VIRION C

Miriel: Virion.

Virion: Ah, my sweet... Er, Miriel, is it? How can I be of service?

Miriel: I wonder if I might ask you a favor.

Virion: For you, milady, I would gladly walk to the ends of the earth over hot coals and—

Miriel: I am studying prognostication, and need you to further explain the art.

Virion: You mean fortune-telling? Well, color me surprised! I assumed someone of your intellectual bent had little time for superstitions.

Miriel: Within the camp, your fortunes have a reputation for being especially accurate. Even if they are mere shibboleth, such oracles can foster hope in a people. This is a legitimate, and possibly fruitful, area of study.

Virion: Hmm. Well, if you say so. But I must tell you this... There's a lot more to fortune-telling than staring at entrails or poking at tea leaves! Please, my dear, I urge you reconsider this request. The path is long and difficult, and I do not wish to subject you to such an ordeal.

Miriel: You claimed you would stride across hot coals for me. Was that a falsehood?

Virion: Not a falsehood, no! More of a...er...rhetorical flourish!

Miriel: So you are refusing my request? How fascinating. I thought my femininity sufficient to ensnare your cooperation. Well. If you will not proffer aid, would you at least tell me my fortune?

Virion: Now THAT, milady, is more easily done! To be honest, I'm more than a little flattered that you're interested.

Miriel: Excellent!

Virion: Now, let's see what tomorrow has in store for you...

Miriel: Must you hold my palm while you work? I would very much like to take notes.

Virion: Hmmm...hmm. Aye, yes, yes, I see...WATER! Buckets of it! You are...drenched... Be careful... Something valuable... Damaged by water—

Miriel: Water is vague. Can you be more specific. Do you refer to a nearby lake or stream? Perhaps rain? Condensation? A fogbank? Though in gaseous form, fog is actually—

Virion: Milady, please! A fortune is not a textbook! I saw water! That is all. Where it came from, I cannot say.

Miriel: Such answers will be laughed out of any credible journal. But no matter. We shall see tomorrow if your augury bears fruit.

Virion: So we will, milady. So we will...

■ SULLY X VIRION B

Miriel: Hello, Virion. I've prepared a full report on our earlier experiment.

Virion: ...Experiment? Are you talking about my fortune-telling? The one where I told you to beware of water?

Miriel: Yes. And contrary to my initial hypothesis, your prediction was most accurate. I was caught in a sudden cloudburst and became soaked to the skin.

Virion: You don't say? That's amazing! Fantastic! Ha ha!

Miriel: I beg your pardon?

Virion: Er, what I mean to say is...I trust you were all right?

Miriel: It was fortunate that I'd left my books back in my tent. The squall's fury would have reduced them to illegible wads of pulp.

Virion: Ah, if only I was there to protect you from the tempest with my cloak!

Miriel: You have further piqued my interest in this esoterica. Will you not teach me even the basics of your art? I cannot hope to study what I do not comprehend on a base level.

Virion: Ah, my sweet Miriel. On this alone must I refuse you!

Miriel: A shame. Peer review is an important tenant of any scientific endeavor.

Virion: Er, yes! So then! Anyway! ...If that's everything?

Miriel: I am finished here, yes. Now I must speak with Chrom about your gift for forewarning. The battlefield applications of such a talent are numerous. We could anticipate ambushes, find weak points, avoid tactical errors...

Virion: N-no! Miriel, I must draw the line!

Miriel: I do not understand.

Virion: Er, well... I can't really say, exactly.

Miriel: But with prescience, the outcome of any battle would no longer be subject to

Virion: STOP! *Ahem* Very well, very well... ...Listen, how about this?

Miriel: Yes?

Virion: I'll teach you how to tell fortunes, but you must promise not to go to Chrom.

Miriel: ...I find your proposition acceptable.

Virion: And it will take some time so we can start. I must prepare...lesson plans, and, uh, so on. So let me get ready, and we'll start the next time we meet. Agreed?

Miriel: Agreed.

Virion: Good heavens, that was close. But NOW what do I do?

SULLY X VIRION A

Miriel: Ah, Virion. THERE you are.

Virion: Eeek! I must beat a retreat! Virion, AWAY!

Miriel: Not so fast!

Virion: M-milady! You're...gripping my arm...so very... hard! Owww...

Miriel: If you don't restrict you, you will simply run away again. Now then. Do you recall a promise to teach me fortune-telling?

Virion: Erm, let me see... You know, I'm not sure I do...

Miriel: I have not seen you since we forged our earlier understanding. You take meals in your tent and practice archery in the dead of night. I can only theorize from this behavior that you are attempting to avoid me.

Virion: No! Of course not! I've just been...busy. Busy, busy bee! Buzz buzz! I scoff at the mere SUGGESTION that I might try to avoid you, milady.

Miriel: Your answer is less than plausible. But regardless, here you are. You will teach me what I want to know, or I will go to Chrom. You've had ample time to prepare a standard lesson plan.

Virion: M-milady is nothing if not incredibly, frustratingly persistent... But are you sure about this? You may be... disappointed with what you discover.

Miriel: What do you mean?

Virion: Well, it's only that... You see... Fortune-telling has nothing to do with seeing the future. It's about seeing the emotions of the questioner, and manipulating them.

Miriel: Fascinating. Please, tell me more.

Virion: Let me think... How can I put it? It's like an exercise in persuasion. I simply tell the person something that is likely to happen, yes? And then I convince them it is an omen meant only for them!

Miriel: And you choose a vague, common event, such as any interaction with water. That way, when it occurs, the person will establish a link back to your augury. They are so preoccupied with seeing their experiences as special, they never notice. I see... So when you told me my fortune, in a way you were merely appealing to my ego.

Virion: People will believe the moon is made of cheese if you just turn their heads right. Really, that's all there is to it. ...I hope you're not too disappointed?

Miriel: Not at all. On the contrary, in fact.

Virion: Oh?

Miriel: Though my scientific mind had doubt, a small part of me believed your claims. You clearly have great insight into the human psyche.

Virion: Er, well...

Miriel: This opens up a whole new field of very promising study. You must teach me everything you know. Verbal tricks, persuasive skills, all of it. I will record your findings and study them at length later.

Virion: A-all right. I'll do it. Just s-stop... gripping... my arm!

SULLY X VIRION S

Miriel: Virion? Your last fortune did not come to pass as you said it would. Either your skills have become dulled, or you are losing the gift of persuasion.

Virion: Though it pains me to disagree with milady, I believe the fortune was accurate.

Miriel: I subjected your prediction to rigorous scientific analysis. No such event occurred.

Virion: Are you quite sure?

Miriel: You said, and I quote... "You will meet a charming rogue who is madly in love with you." The specificity of the prediction is what made it so unusual. Previously, your portents were of ordinary events dressed up in mysterious language.

Virion: Yes, true. But this particular prognostication is special.

Miriel: In what way?

Virion: As you say, my fortunes are spun with words intended to provoke emotion. Like a puppeteer, I pull on heartstrings and make them dance to my tune.

Miriel: A crude comparison, but do continue...

Virion: Sometimes the person resists, and words are not enough. Then deeds must accompany the words, to lend them weight and conviction.

Miriel: And to what manner of deed are you referring?

Virion: Well, take this, for example.

Miriel: That is a ring.

Virion: I bought it a little while ago with the intention of presenting it...to you. I hope you will accept it?

Miriel: ...I see. The fortune you spoke earlier was in reference to this very moment.

Virion: Yes. I confess it was all part of an elaborate stratagem. I wanted there to be no doubt in your mind of my intentions. For I love you, Miriel! I cannot abide one more day without you at my side!

Miriel: ...Fascinating.

Virion: Please, my lovely, answer me true... Will you marry me, sweet Miriel?

Miriel: Your argument for wedlock lacks even the most basic of persuasive elements. ...And yet, I find myself oddly enticed...

Virion: I cannot always tell with your manner of speaking... Are you saying yes?

Miriel: I have...feelings for you. True feelings. A most unexpected development...

Virion: You know what this means, don't you? My fortune was completely accurate! ...I don't think that's ever happened before.

Miriel: Your causational approach to this problem leaves open many troubling—

Virion: Er, yes! Right! Well, let's hurry off and find a minister then, shall we?

Miriel: Agreed.

 Maribelle

MARIBELLE X VIRION C

Maribelle: Virion?

Virion: Ah, milady! 'Tis a pleasure to be in the company of one so beautiful. Your eyes—

Maribelle: Charmed, I'm sure. But flattery so freely given quickly loses its luster. If you insist on calling yourself a noble, you must take care what you say and do. Your words and deeds reflect not only upon yourself, but all men of breeding.

Virion: Then, fair lady, you must tell me the best way to polish my noble reputation... Perhaps we can have a first lesson tonight over dinner? Just the two of us, mmm?

Maribelle: Absolutely not! I can't be seen consorting with a rogue such as yourself!

Virion: You wound me, milady! Harsh words for one whose love for you is deeper than the sea.

Maribelle: Don't play me for a fool, cad. You've more love for that frilly shirt than for me.

Virion: She wounds me yet again! What will it take to prove my sincerity, dear lady?

Maribelle: Can I tell you this: honey-coated words alone will not be enough.

Virion: Then by my deeds I shall win you, and the bards will sing of our love!

Maribelle: Any singer who utters even a word will have a quick answer from my parasol!

MARIBELLE X VIRION B

Virion: And so we find ourselves come to this...

Maribelle: Is something troubling you, Virion? You stand as if you have the weight of the world on your shoulders.

Virion: You see to the core of me, my lady. I'd thought to hide my troubles from you. But 'tis true: I bear a terrible weight that threatens to crush me with every step. And your kind, loving eyes have spied it at first blush!

Maribelle: Er...

Virion: I find that war makes people ever so eager to whine. Don't you agree? "I can't march another step!" "Why must we carry all these spare bows?!" And so on. I had to engage in a full retreat just to give my poor ears a rest.

Maribelle: Is THAT why you wouldn't advance with the rest of us during the previous fighting? What madness! What's wrong with you, Virion?! The fact I have even a moment's concern for your welfare boggles the mind.

Virion: B-but...did you see the way I came running onto the battlefield at the end? It was magnificent! Why, our foes all but fled in terror at the sight of me!

Maribelle: Was this before or after you let yourself get surrounded? Before or after you panicked and forced Chrom to rescue you?

Virion: All part of the plan! By playing the decoy, I lured the enemy into our snare. They don't call me Virion the Cunning for nothing, you know.

Maribelle: You are the most dishonest and silly man I've ever had the misfortune to meet. You call yourself a nobleman? You take meals with your scullery maids when no noble is looking. You, sir, are an embarrassment to men of good breeding everywhere.

Virion: Enough! It's one thing to consider me superficial, but dishonest? Silly? Milady's ravishing beauty hides a tongue that cuts too deep. But alas, it's not the first time I've been hurt by words so ill considered.

Maribelle: I'm... I'm sorry, Virion. I should not have spoken so harshly.

Virion: W-would you excuse me for a while? I have some thinking to do.

Maribelle: Wait! Don't go! I didn't mean what I said! ...Er, at least not all of it!

MARIBELLE X VIRION A

Maribelle: Hello, Virion. I've not seen much of you as of late... Are you keeping well?

Virion: Well enough. Busy with noble deeds and so forth. ...Keeping up the good work.

Maribelle: Er, Virion, about before...

Virion: I should go, milady. Forgive me.

Maribelle: Oh, yes. Yes, of course. It's just that... Well, you haven't been yourself recently. You seem tired. I rather miss my lively old Virion.

Virion: Milady, when you called me dishonest, it gave me pause. Am I a credit to nobility? Do I bring honor to house and peer? Can I yet be better? I am unused to thinking on such things, and my ponderings gave me a terrific headache. I've barely had a bite to eat and grow ever thinner by the day. If I think any harder, I fear I shall simply waste away.

Maribelle: Hah!

Virion: Scorn does not become you, milady.

Maribelle: My apologies. But I promise, I'm not mocking your plight. I just find this ever so amusing. For you see, you have already proven me wrong and don't even realize it.

Virion: Hmm? You have me at a disadvantage, sweet lady.

Maribelle: I said you were superficial and dishonest. A blight on all who hold good blood. But here you stand, anguishing about whether you are worthy or not. That alone proves your worth!

Virion: ...For true? A great relief if you feel so. Now I think...I must away to...the inn...

Maribelle: Virion? Virion! H-help! Someone! Virion has collapsed!

Virion: F-forgive me. I haven't eaten a morsel all day, and I suddenly felt quite dizzy.

Maribelle: I fainted because you were hungry?! I thought you'd suffered a mortal wound!

Virion: Perhaps if I had some salted pork... And bread... And an apple or two...

Maribelle: You are a remarkable man, in every sense of the word. Well, instead of lunching at the inn, perhaps you might dine with me today? I recently took down a fat boar that would be perfect for a turnip stew.

Virion: I would be honored, milady.

MARIBELLE X VIRION S

Virion: Ah, sweetest Maribelle.

Maribelle: Virion?

Virion: I want to thank you again for that wonderful stew the other day.

Maribelle: Oh, but the pleasure was mine. After all, we are friends now, aren't we? And I did so enjoy listening to your stories. Especially the one about getting lost in your own castle. I know the exact feeling!

Virion: It seems we have much in common, being fellow members of the nobility. Perhaps when next we share a pot of stew, we might speak of more romantic things?

Maribelle: There you go again with your wild japes... And just when I was starting to form a more favorable impression. I DO hope you're not going to disappoint me again.

Virion: It is no jest, milady, I assure you. ...And perhaps this will prove my sincerity.

Maribelle: Is...that a ring? Why would you offer me a ring?

Virion: I have always been your most fervent admirer, milady. I spoke true when I said my love is deeper than the sea. When you doubted me, it sent me into a raving fit of...introspection. And so ever since, I have struggled for a way to prove my sincerity.

Maribelle: You thought yourself into unconsciousness for...me? Oh, Virion, that is so GALLANT!

Virion: Yes, I suppose it is rather, isn't it? I mean, now that you mention it. And the gods saw fit to answer my prayer in part, for now we are friends. But it is not enough... I would be more than just a friend. I would be your companion—nay, your husband!

Maribelle: Oh... Will you ever give me peace if I refuse you? Heh... No. I don't think you will... Very well, gallant Virion. I accept your ring.

Virion: T-truly?!

Maribelle: You should know by now that I always mean what I say. But if we are to wed, you must pledge to put my happiness above all else. Agreed?

Virion: With every fiber of my being I agree! I shall think of nothing but! And when this hateful war is over, I shall welcome you to my home! Our celebration feast shall be the envy of nobles throughout the land!

Maribelle: Oh, I think not! Surely you know you must marry into MY house. We have no male heirs, and my father will insist on adopting my husband.

Virion: Y-you mean... We would have to live with your parents?! Er, th-that is to say... If milady so wishes... then of course I would be...honored? Ah ha ha! Ha ha. Haaaaa...

 Panne

PANNE X VIRION C

Panne: There is rain, but the sun shines still. ...Strange.

Virion: It's called a sun shower, my dear lady. Quite beautiful, in its own way.

Panne: That was not a question, man-spawn. And do not speak to me without cause.

Virion: And here I thought that was a natural entrée into civilized conversation. Ah, well. I've met many a lovely lady who built up high walls around her. ...And I've surmounted them all.

Panne: Perhaps I will stuff and mount you in my warren! If it is your aim to provoke me, I accept. Let us fight and be done with it. Choose your weapon!

Virion: A duel? How romantic! Then my weapon, sweet lady, shall be words. I am a far better poet than I am a warrior anyway.

Panne: As you wish.

Virion: Your graciousness, my dear, is without peer. Now by all means, after you.

Panne: I know of you, you lecherous worm. Your transgressions are legend. You turned tail and left vassals to die so that you might pursue mates! The very sight of you causes bile to rise in your throat. I curse your name!

Virion: ...Perhaps I ought to have picked daggers after all.

Panne: Alas, I have spoken. Take your turn, poet.

PANNE X VIRION B

Panne: ...You.

Virion: M-milady? My, my. I hadn't thought to see YOU start a conversation with ME. Perhaps this time we'll have a hailstorm.

Panne: You said you were no warrior. But in the last battle, you matched me trophy for trophy. You speak lies.

Virion: I said only that words were my forte, sweet lady. I never said I couldn't fight. Though I would never claim to be any sort of true warrior. Not after failing to protect the ones I cared for.

Panne: Why did you run, man-spawn? Why did you abandon your warren? You had a duty to your fellows.

Virion: I planned to offer myself up in exchange for the safety of my people. ...My men balked. They chose to fight and die rather than have me over. Not only did I fail to ransom their safety, I was also the reason they kept on fighting.

Panne: So you showed your belly and ran to remove any reason for resistance?

Virion: That was my thinking, yes. I don't expect my people share that view. To them, I am as you say—a craven. All the sweet words in all the worlds can offer no defense to that claim.

Panne: ...I withdraw my words from earlier. You are no craven. You know how it feels to lose kin and kind. In that, we are the same.

Virion: We are most certainly not!

Panne: I do not understand.

Virion: My people yet live and wait for me. It is my duty—and my dream—to save them. But you had even that stolen from you. I would not think to claim our losses equal.

Panne: Hmph. Is that pity, man-spawn?

Virion: Mere pity would be an insult to a wound so deep as yours, milady. I can but pray that your heart does not succumb to the scars that cover it.

Panne: Your prayers mean nothing, but I accept your words.

PANNE X VIRION A

Panne:

Virion: And what do you see in the moon's reflection this evening, dear lady?

Panne: What do you want, poet?

Virion: I hear taguel hold that souls of the departed return to the moon.

Panne: You hear true. That is why taguel do not look directly upon her holy face.

Virion: Fascinating. But to your question, I was wondering if you might assist me with...this.

Panne: That smell... Blackberry wine?

Virion: Indeed! And now, I propose a toast to the moon. What do you say?

Panne: I am surprised to find a human who understands such tastes.

Virion: Oh, we man-spawn are full of surprises. So you'll join me, then?

Panne: All right. ...So. What will you do when the fighting has ended?

Virion: Return to my own war, naturally. My people are still suffering.

Panne: Ah, yes. Your...dream, was it? Perhaps I will help you make this dream into reality.

Virion: Th-that's very... Thank you, my lady. ...Heh.

Panne: Why do you giggle? It is revolting!

Virion: Revolting? I've been accused of many things, milady, but never that! I am simply happy at the prospect of sparing my people further suffering. And, I must say, pleasantly surprised to hear an offer of assistance from you. Perhaps our bond is stronger than I know, mmm?

Panne: Or the wine.

Virion: Then let us drink another toast to the peace yet to come.

PANNE X VIRION S

Virion: Ah, my sweet Panne.

Panne: ...Yes?

Virion: I have something for you, if you would be so good as to accept.

Panne: A bit early for wine, no? Perhaps we should... This is a ring. Explain yourself!

Virion: I would swear an oath of eternal love to you, milady.

Panne: You are drunk.

Virion: Aye, lady! Drunk on your beauteous... No. This is no time for idle flattery. Your offer to help me see my dream realized was generous beyond belief. You want me to have a dream of your own. A gleam of hope to guide you.

Panne: And you think you can offer that?

Virion: I will do so or die trying.

Panne: Your death cannot possibly help me to... Huh? What's this? Another sun shower?

Virion: Amazing! The very skies above urge us on!

Panne: Only you would see rain as a good omen.

Virion: But it is, my sweet! 'Twas this very rain which presided over our first meeting. Our love has moved the heavens. The moon herself weeps for joy!

Panne: You are mad. ...But it is amusing. Very well, poet. I accept your ring.

Virion: I shall never fail you, my love. I swear it by the moon and rain.

Cordelia

CORDELIA X VIRION C

Cordelia: Say, Virion... Do you have a moment?

Virion: My dear Cordelia! For you, I have all the moments in the world.

Cordelia: Er, yes, well... I just have a question.

Virion: Ask away! I count myself an expert in music, astrology, cuisine, art, and more besides! How might humble Virion assist the lovely and talented Cordelia? She whose wisdom and knowledge are sung by bards throughout all of Ylisse!

Cordelia: Actually, that's somewhat related to what I wanted to discuss. See, the truth is... Um—

Virion: Tsk! It is most unlike my good lady Cordelia to speak with such hesitation. Gallant Virion cannot help but shed a tear of pity at such a plight. Mayha—

Cordelia: Will you PLEASE stop interrupting and let me finish?! Gods, this is awkward enough as it is...

Virion: Apologies... It seems your presence reduces me to blathering like a lovesick schoolboy. However, leaving my verbal disruptions aside, you still seem a bit lost for words. Perhaps I can rescue you from your traumatic tongue-tied trial? For in my boundless perspicacity, I believe I have identified your trouble!

Cordelia: ...Go on.

Virion: Indeed! Yes, well. *ahem* Here goes... You are lovely, but firm and single minded, which leads you to treat others harshly. You regret this flaw with all of your being, and wish to reform your character. ...Well? Has Virion once again struck the bull's-eye?

Cordelia: That's... That's exactly what I was thinking. ...How did you know?

Virion: Do not ask the gods why they bring sunshine to the land, dear Cordelia. Milady's sweet words carry easily on the wind, if you only lend an attentive ear.

Cordelia: You've been spying on me?! How dare you, sir!

Virion: Well, "spying" is overstating it a bit, don't you think? I merely overheard...

Cordelia: Well, I... Hmmm... Do you see? This is what I'm talking about. I mean, you shouldn't eavesdrop on me, but I shouldn't have said that, either.

Virion: There are those who mewl criticisms wrapped in soft silks, it's true... But rest assured, many of us prefer the honest and forthright approach.

Cordelia: Oh, this is hopeless...

Virion: Wait, milady! Virion has yet to impart all of his sage and sapient advice!

CORDELIA X VIRION B

Virion: Ah, Cordelia. I cannot help but notice you seem troubled as of late.

Cordelia: Oh? I feel fine. Have you noticed a problem on the battlefield?

Virion: Your fighting is impeccable as always! But your brow seems creased with worry... Our cares always find a way of rising to the surface, mmm? And your beautiful visage cannot help but mirror the turmoil in your heart.

Cordelia: Or you've been eavesdropping again.

Virion: Never! For sharp-eyed Virion, milady's anguish is writ large on her features.

Cordelia: Well, maybe there is something... But that is all I'll say. And make that to yourself! I don't want anyone else knowing I am troubled.

Virion: And whyever not?

Cordelia: Because then they might start to pity me. And I hate pity! It makes me feel like I've...lost.

Virion: Lost? Ha! How very like milady to frame it in terms of competition. But...dare I ask, why are you willing to let me know this?

Cordelia: Because you're flippant and fancy-free... You take everything in your stride. My blunt manner never seems to phase you in the least.

Virion: Ho ho! Say no more, milady... Virion has heard this speech before. A prelude to a confession of love! Milady, I am most grateful—

Cordelia: It has nothing to do with love!

Virion: Aaaaah... Y-yes, then. Just so... *ahem* In any case, perhaps sometime we might discuss the source of your troubles... Such a beautiful face is ill served by the sombre shadow that clouds it!

Cordelia: ...Perhaps. Sometime. But no more of this "love" talk, understand?!

CORDELIA X VIRION A

Cordelia: Virion, well met.

Virion: Cordelia! How my heart leaps when I set eyes upon your perfect visage.

Cordelia: Heh, laying it on thick, as always... I was hoping we could talk.

Virion: My ears await the sounds of your gentle voice...

Cordelia: I wanted to thank you, actually.

Virion: Oh?

Cordelia: I've been feeling much better recently. I snapped out of my glum mood.

Virion: That is wonderful news! But why do you thank me?

Cordelia: Because you were so patient with me, listening to my grumbling... What's more, by talking to you I was able to sort out my own feelings. I had no call to be so gloomy. Not when others suffer far worse than I. If there are things about me that I don't like, I should just fix them.

Virion: 'Tis true that when we share our troubles, we are halfway to ending them. I'm delighted to have played a role in returning a joyful glow to your cheeks!

Cordelia: I'm just amazed that talking to you helped lighten the burden... I guess I just thought such things... I don't know. Made me weak?

Virion: There is no weakness in honesty!

Cordelia: Well, thank you again, Virion. I'm truly grateful for all your help.

Virion: Ah, and so the seeds of your love for me have finally taken root, blossoming in—

Cordelia: WRONG!

CORDELIA X VIRION S

Cordelia: Yaaaaaawn

Virion: Ah, someone slept well!

Cordelia: ...Yes? What are you staring at, Virion? Do you mind, sir?!

Virion: Shhh, let me look into your eyes... Alas, no. Nothing. Such a pity.

Cordelia: You're starting to concern me here, Virion. Explain yourself.

Virion: I'd hoped that such a mighty yawn might cause a tear or two to well in your eyes.

Cordelia: And that would be interesting...why?

Virion: What could be more beautiful than a single tear glistening on milady's snowy cheek?

Cordelia: Virion... Flattery is more potent when it's not spread across every girl in camp.

Virion: Why, you wound me! Milady mistakes the pure motives of her humble servant!

Cordelia: Oh, really? Come now, Virion. I'm many things, but not an idiot. I see you sidling up to the maids and whispering sweet lies in their ears... Are so many damsels truly in distress that you must attend to them all?

Virion: Ah ha! Then the green-eyed monster has finally taken your heart... You DO love me!

Cordelia:

Virion: ...Isn't this the point where milady flies into a feverish denial? Mmm?

Cordelia: I won't deny what's true... B-but, that is not... I don't mean... Argh! I don't know what I mean!

Virion: Ah, but the words have been spoken, and Virion has taken them into his heart!

Cordelia: It's just that—

Virion: Here, milady. A gift from me to you. I have long held it in the deep hope that such a moment might arise.

Cordelia: A...ring?

Virion: A ring that proves the sincerity of my love. Sweet Cordelia, will you marry me?

Cordelia: I... Well, I...

Virion: I know that you once yearned for another man. Perhaps you still do. But on this front I cannot compete. For our brave leader is more deserving of your affections than I.

Cordelia: ...H-how did you know?

Virion: I am ever watchful of you and have learned to read your joys and sorrows. And I sensed that the scales of your affections tipped away from Chrom.

Cordelia: Yes, and toward you... Oh, Virion, I had no idea that you were paying so close attention...

Virion: Now you do. And thus am I so emboldened to propose, with all my hopes that you will accept!

Cordelia: How could I say no to a man who knows me so very well?

Virion: You need never carry your burdens alone ever again, my sweet. From now on we share them, as we share everything: together.

Nowi

■ NOWI X VIRION C

Nowi: Ouch! I really scraped my hands when I slipped back there...

Virion: I hear a fair maiden in need of medical aid! Shall Virion tend the wound?

Nowi: Oh, could you?

Virion: But of course! A dab of ointment, a small, clean bandage... There! Danger has been thwarted thanks to my speedy and skilled treatment.

Nowi: Aw, thanks!

Virion: No need for thanks, sweet Nowi.

Nowi: Hey, so I've noticed that you keep calling me "sweet." Don't you think it's a little belittling or whatever?

Virion: If I have offended, you have my apologies. 'Tis but a habit of mine. Pray, do you not like it?

Nowi: No, pray! I do not!

Virion: Then I shall endeavor to correct myself with all due haste! A nobleman must take care how he addresses others, you know. Especially one as distinguished as you!

Nowi: What's so special about me?

Virion: Why, you are over a thousand years old! You lived in the time of my great ancestors. You are practically immortal. Divine, even! It ill behooves me to disrespect you.

Nowi: Okay, knock it off! You're making me sound like some old lady.

Virion: Nonsense, Nowi my sweet! You are charming, young, and beauty itself!

Nowi: You really think I'm beautiful?

Virion: Let the gods strike me down if it is not so! You see? No lightning strikes. No fire ants nibble at my drawers.

Nowi: Wow. You really ARE good at this whole philandering thing.

Virion: Ph-ph-philandering?! Where did you hear such a vulgar word?!

Nowi: Um, that's what everyone says about you. ...Seriously. Everyone. Even Chrom. Didn't you know?

Virion: I most certainly did not!

■ NOWI X VIRION B

Nowi: I'm SOOOOOO hungry! When do we EEEAT?!

Virion: An empty stomach will not do. I, Virion, shall bring hither victuals.

Nowi: Er, Virion?! Where did you go?! VIIIIIRIIIIIOON?! Oh! There you are.

Virion: Apologies for the delay, sweet Nowi. I have collected some lovely fresh lettuces.

Nowi: Um, that's nice, but...I hate vegetables.

Virion: Ah! How foolish of me, offering plants to a dragon! I shall sally forth and find a fatted calf with all haste!

Nowi: Wait, Virion! Look, if you want to help, I'd rather you just...kept me company. If we played a game or whatever, that would help keep my mind off the hunger.

Virion: Very well. What would you like to play? Chess? Tiddlywinks? Naughts and crosses? I also know checkers, blind man's bluff, king of the bean, field bowling, falconing—

Nowi: I wanna play duck duck dragon!

Virion: Duck duck...dragon? Well, I say. I'm not familiar with that game.

Nowi: It's easy! I turn into a dragon and chase you while spewing white-hot fire. And if I catch you, I totally win!

Virion: That sounds dreadful!

Nowi: So, let's start, okay? I'll count to....um...one million, and you go hide.

Virion: One million? Do you realize how long that will take?

Nowi: OOOOOONE... TWOOOOOO... THREEEEEEE.

Virion: My life is flashing in front of my eyes! ...Very, very slowly. Well, I'll not wait for her to finish. Virion, AWAY!

■ NOWI X VIRION A

Nowi: Hee hee hee! Today was so much fun! I LOVE duck duck dragon!

Virion: Insofar as a terrifying brush with death can be fun, then yes...

Nowi: What? I didn't quite catch that.

Virion: Er, I was muttering myself about how much I enjoy these games of ours!

Nowi: I know, right? Playing games is pretty much my favorite thing ever. But no one ever wants to play with me! It's crazy!

Virion: I can't imagine why no one else is clamoring to join in...

Nowi: But now I have you, and we can play duck duck dragon over and over again!

Virion: Over and...over? Dear gods, I don't think my poor heart can take it. And yet I cannot bring myself to wipe that smile of joy from her face...

Nowi: Virion? You're doing that thing again. The one where you mumble to yourself?

Virion: I am? My apologies. I was just thinking about how sad I'll be when we stop playing.

Nowi: I KNEW you liked duck duck dragon!

Virion: Er...

Nowi: You know, you really should have told me sooner. It's not even dark yet! That means we have time for ONE MORE ROUND! OOOOOOONE... TWOOOOOO... THREEEEEEE.

Virion: No, Nowi! I beg of you, no! I cannot abide the remorseless tick of death's grim clock!

Nowi: Geez, what's with the wailing, Virion? I can barely hear myself count.

Virion: Um, never Nowi? Do you know any games aside from duck duck dragon? I'm concerned we might, er, waste all your dragonstones! ...Yes, that's it.

Nowi: Aw, don't worry. Now that I know how much you like it, I'll make the sacrifice! Okay, so where was I? FOOOUR... FIIIIIVE...

Virion: NOW she decides to take my feelings into consideration?! ...Still, if she is willing to give up things for my sake, then I must do the same for her. I shall take part in her game, even if it means the death of me! Virion, AWAY!

Nowi: SEEEEEEEEVEN... EEEEEEEEEIGHT...

■ NOWI X VIRION S

Nowi:

Virion: Why the scowl, sweet Nowi? Do you not feel like playing duck duck dragon?

Nowi: No. I don't.

Virion: But I thought it was your favorite game and that you would never tire of it! I'm willing to have a match right now, if you like. My singed hindquarters have nearly healed from the last match! Or perhaps you have thought of some other game, perhaps?

Nowi: I want to get married.

Virion: Playing house is a bit beneath a 1,000-year-old woman, but if you like, I'm all for it. Shall I take on the role of minister? I deliver a crackling good sermon!

Nowi: No! I want to marry YOU!

Virion: Yes, but then who will play the minister? I suppose we could ask Frederick, although it would be a terribly dull affair...

Nowi: Do I really have to spell this out? I don't want to PLAY marriage, Virion! I want to BE MARRIED! ...TO YOU!

Virion: Y-you want... Wait, to me? Are you serious?

Nowi: Yes, yes, and YES!

Virion: Right then! I see! ...No, wait. I'm still confused. You, Nowi, wish to marry me? ...Virion?

Nowi: AAAAAARRRRRRRGGGGGGGH! Yes, you dunderhead! Why do you think I've been chasing you all over the place?!

Virion: B-but that was a game! And one I spent in a state of mortal terror.

Nowi: *Sniff* D-do you hate me, Virion? Is that it? Do you th-think I'm...ugly? *Sniff* B-b-because I... I couldn't take that! Waaaaaaaaaaaaaaah!

Virion: Good gracious, no! You're lovely! Oh, please do stop crying!

Nowi: Oh, yay! That means you love me! For a moment there, I thought you might turn me down.

Virion: Er...

Nowi: Aw, Virion. I've liked you since the first moment we met! Everyone treats me so seriously because... Well, you know. 'Cause I'm really old. But you're fun and funny and silly and it's just great! I don't ever want to lose that feeling.

Virion: Oh, sweet Nowi. It is true that the times I've spent with you haven't been...entirely unpleasant. And your confession of love makes me realize how truly fond of you I've become. So let us marry, fair Nowi. Not as a game, but for true.

Nowi: So you ARE saying yes?! Oh, I'm so excited! We have to go buy a ring right away! That's the rule, right?

Virion: We shall buy a magnificent ring fit for a true noblewoman.

Nowi: Yay! I can't wait!

Libra

■ LIBRA X VIRION C

Libra: It's remarkable how much rubbish an army on the march leaves behind! I'd best pitch in and help clean up.... Ungh! This is heavier than it looks! *Gasp* It suddenly feels lighter! But how?!

Virion: Such slender, delicate arms are ill suited to this kind of work!

Libra: ...Virion?

Virion: Please! Allow gentle Virion to carry this! I think there's a pillow over there that needs moving if you want to help.

Libra: Oh. Yes, well, thank you, Virion.

Virion: Think nothing of it, milady! A woman of your beauty shouldn't be reduced to hauling trash.

Libra:

Virion: What's the matter, sweet Libra? Did I say something wrong?

Libra: I'm a man.

Virion: Ha ha ha! Not only are you beautiful, you have wit to... Erm, to match? Yes? Hmm... Except now I look more closely at your face... *gulp*

Libra: It's all right. It happens a lot. I'm sorry I was cross.

Virion: You had every right to be cross, good sir! Ah ha ha! Oh, my. How could I, Virion, make such an error? Me! VIRION! Oh my stars.

Libra: Are you all right?

Virion: N-nothing! It's just that...your eyes...so very shiny and pretty... Like two pools...of...something...

Libra: Can we just get back to work?

■ LIBRA X VIRION B

Libra: Virion? What happened to you? Your left cheek is red and swollen. Did someone strike you?

Virion: What, this? It's nothing! Just a memento from the trenches of love's battlefield. You see, I spied a pretty lass walking down the road, and asked her if she was a woman. Ha ha! You should have heard the sound of her palm upon my cheek! Yes, well, one can't be too sure about these things, can one? Ah ha! Ha. ...Yes.

Libra: How...unfortunate.

Virion: Damnation, Libra! I've been like this ever since I mistook you! When I approach a woman, I'm frozen by the fear of committing another blunder! You have thrown gallant Virion off his game, and the world suffers as a result!

Libra: Er, I'm sorry?

Virion: When I look at your soft, milky skin and glowing, lustrous locks of hair... Well, it occurs to me that you must come from a very coddled background! Perhaps one of the finer noble houses? Royalty, even? Pray, tell me, good la-sir! Ha ha! Most good and noble sir! What is your lineage?

Libra: Sorry, Virion. I'm not from a noble house. In fact, I was born to poor, humble parents who neglected me as a child. I only escaped their cruelty when I found the faith.

Virion: Extraordinary! You're no tame rose gently cultivated in a well-tended garden... But a wild bloom that struggled out of barren soil with petals reaching for the sky! As well as being profoundly beautiful, you're also tough and tenacious!

Libra: Please, sir. Such praise makes me uncomfortable. I am but a humble servant of the gods.

Virion: Oh my! Look how your milky cheeks blush when I compliment you! It's so... Er... Yes! Right then! Good to see you again, old chum!

Libra: Virion? You are a very strange man.

Virion: (That I could possess only a tenth of his beauty... It's enchanting!)

■ LIBRA X VIRION A

Libra: I suppose I'd best get started.

Virion: Ho, Libra! That's a mighty pile of lumber you have there!

Libra: Yes, it is. The temple nearby is short of firewood, so I thought to do a little log splitting.

Virion: You mustn't ruin those perfect hands! Here, let me help.

Libra: No, please. I've got this.

Virion: No no, I insist! As one friend to the other! Now let's get chopping.

Virion: *Pant, pant* L-Libra? S-stop chopping... I implore you... M-my arms... So...tired and...rubbery...

Libra: What are you talking about? We're barely halfway done.

Virion: H-halfway?! I've been...swinging that...that infernal axe...for hours... Or has it been days? I know not... M-my mind is...confused... Visions of logs... piled before me... A mighty tower...reaching to the sky... Which, when I look around me, isn't very far from the truth! What army of madmen collected this uncountable mass of dead trees?

Libra: I did.

Virion: Y-you gathered ALL these by yourself? B-but how?

Libra: I picked them up and carried them. It's simple, really. Here, are you done resting? This bundle needs to go over there.

Virion: Er, very well, if you insis—OOF! I-it's heavier...*-grunt*...than it l-looks... J-just...got...to...h-hang on...a little...bit...longer... OH, BLAST!

Libra: Virion, look out!

Virion: Hm? I...I'm still alive...? I remember toppling backward with that massive weight in my arms...

Libra: It's all right. I caught hold of you just in time.

Virion: Libra! You saved me!

Libra: It would appear so. Are you unharmed?

Virion: Er, yes. I think so.

Libra: Good. Now perhaps we should take that rest after all. Forgive me. I shouldn't have pushed you to work so hard.

Virion: Hmm... From this angle, Libra looks quite different. Very manly, in fact. That big brow... Those massive knuckles...

Libra: Sorry? Did you say something?

Virion: Who, me? Oh, er, no. Nothing of import, my good man! Er, friend. Man...friend. *Ahem* Anyway, you are a stout comrade, Libra, and I thank you for saving me.

Libra: Hah! Think nothing of it, Virion. I consider you a trusted friend as well.

Tharja

■ THARJA X VIRION C

Tharja:

Virion:

Tharja: Oh, how nice. I was just going to ask for a volunteer from the audience. Tit for tat... Become a CAT!

Virion: Meow!

Tharja: Oh my. That was fast. Let's try another one, shall we? Jeepers creepers... Close those PEEPERS!

Virion: Zzzzzzzzzzz.

Tharja: This guy's a walking curse magnet. I've never seen anything like it.

Virion: *Snore* You are...so beautiful... *snort* Please... marry me... Zzzzz.

Tharja: Oh, that's quite enough of that. Spiders and flies... Open your EYES!

Virion: Whu—? Huh?! What?! Where am I?! Oh, alas! It was but a vivid dream. I've never slept so soundly in my life. Such a pity I awoke at that moment. There I was on the verge of saying yes. We would have exchanged sweet nothings, and then, under the light of the moon—

Tharja: *Ahem*

Virion: Ah, greetings! ...Tharja, I believe? How may I be of service this fine day?

Tharja: Service, eh? That's not a bad idea at all. Oh, you're going to be perfect.

Virion: Aha ha ha! Oh, my good lady, you flatter me! Though I must admit, you're not the first woman to tell me such a thing. However, you ARE the most lovely! Perhaps I'm still dreaming, mmm?

Tharja: Enough chatter. You've got chores to do. Sputter and spidge... Build me a BRIDGE!

Virion: As you command, milady! Virion, AWAY!

Tharja: Oh, I'm going to like him a LOT. Eee hee hee!

■ THARJA X VIRION B

Tharja: Dasher and derricks... Remodel the barracks!

Virion: As you wish, milady! Virion, AWAY!

Tharja: Flower and beast... Cook the whole camp a feast!

Virion: It shall be done, milady! Virion, AWAY!

Tharja: Hmm... What should I make him do next?

Virion: I shall do anything you ask.

Tharja: Did you say something?

Virion: I said, "I shall do anything you ask." You don't even have to rhyme.

Tharja: ...Wait. Have you been awake this whole time?

Virion: Of course.

Tharja: That's impossible. A victim of a curse enters a trance state with no memory or awareness of his actions.

Virion: A curse? Is that what you're trying to do? Tsk! You should have told me before. Those little hex doo-dads never work on me.

Tharja: But you've been doing everything I demand without hesitation! Are you playing me for a fool? Because that would make me...angry.

Virion: Not at all! I simply find it impossible to say no to a beautiful woman.

Tharja: What if I told you to... Oh, I don't know. Pluck out your own eye? Or sacrifice your life?

Virion: If necessary, I would do either one without hesitation. Ooh! Then I could wear a fine diamond eye patch.

Tharja: If necessary?! What does that mean? You're evading the question. Or you're lying.

Virion: I never tell a falsehood to a lady, even in jest. In time, you will come to see the sincerity of gallant Virion's heart.

Tharja: Hmph...

■ THARJA X VIRION A

Tharja: You are a fool.

Virion: An unfair accusation, on its face. But it does harbor a grain of truth. In the presence of a lady so fine, it ill behooves me to appear so slovenly.

Tharja: I'm not talking about your wardrobe! I'm talking about what you did.

Virion: Perhaps if milady were to tell me what I did, I might better explain why I did it.

Tharja: In our last battle, you threw yourself in front of a blow that was meant for me.

Virion: Don't you remember our talk?

Tharja: When you said you would give up your life if it were...necessary?

Virion: Exactly! Well, there was also a bit about eyeball plucking, but that's beside the point.

Tharja: You are immune to my curses, which means you chose to take the blow in my place. What I fail to understand is why.

Virion: Once, in the not-too-distant past, I was responsible for the lives of many people. Yet when that dastard Walhart attacked, I was unable to fulfill my solemn duty. Those who were overrun, and those who had placed their trust in me were...cut down. In response, I swore to devote my life to the service of others. The dead are gone, but if I save others in their name, they will not have died in vain. It is...the proper thing to do.

Tharja: That makes no sense.

Virion: Plainspoken and blunt, as always. I do like that in a woman!

Tharja: You are... Hmm... How do I put this?

Virion: A gentleman of impeccable manners? A dashing rogue of countenance fair?

Tharja: An idiot who bleeds on my behalf. I hate it when people bleed for me. I'd rather they bleed BECAUSE of me.

Virion: Are you SURE you didn't mean to say the dashing rogue one? Because I think—

Tharja: Enough with your japes! Now be quiet while I tend to those wounds. Otherwise, I might be tempted to stitch your mouth while I'm at it.

■ THARJA X VIRION S

Virion: Sweet Tharja. I wanted to thank you for your gentle nursing the other day. In gratitude, I brought you a small token of my goodwill. I wonder if you would do me the honor of accepting it?

Tharja: This is a ring. ...A fancy ring. I smell a rat.

Virion: No rats, my sweet! Only common sense. If I am ready to give my life for you, I must be at your side night and day. Otherwise, I might miss my chance were it to come.

Tharja: So. If someone else asked you to give your life for theirs, would you do it? You'd make offer open to strangers and village idiots alike, or am I a special case?

Virion: I have found myself pondering that question of late. But no, Tharja. I will sacrifice myself for no one save you.

Tharja: Why?

Virion: When love blossoms in a man's heart, must he explain himself? But if you were to press me, I would say I have fallen for your gentle kindness.

Tharja: You must be thinking of someone else.

Virion: Oh? The bridge you had me build was so that children could cross the stream in safety. The barrack repairs kept the soldiers dry, and my feast filled their rumbling bellies. You could have used me in any way possible, and yet you chose to benefit others. What is that, if not kindness? I would be honored to serve your life in service of such an extraordinary woman!

Tharja: I don't want you to exchange your life for mine.

Virion: You would deny me the inestimable honor?

Tharja: Don't worry. I have a different plan for you. I want you to live, Virion. So promise me.

Virion: B-but that is no proper oath for a gallant warrior such as I!

Tharja: Nevertheless, it is what I desire. And if you want to marry me, you'll do it.

Virion: ...So be it. As milady commands, I pledge to defend your life. But I also swear to never risk my own life in service of this task! ...Good heavens. These are the strangest wedding vows ever!

Olivia

■ OLIVIA X VIRION C

Olivia: Tra-la-la-la-LAAAAAA! ♪

Virion: Oh ho!

Olivia: Eek! Wh-who's there?!

Virion: My apologies, fair maiden. I had no wish to startle you.

Olivia: Virion? Oh, thank goodness it's only you.

Virion: Goodness, indeed! It appears the young maiden trusts me as a friend. Although, speaking as a man of passion, I am unsure if this pleases me or not.

Olivia: What do you mean?

Virion: Ah, it is no matter. Now please! Tell me more of your intoxicating promenade! I find it strange that you are performing a dance for two all by your lonesome.

Olivia: You're familiar with this dance?

Virion: I have, on many occasions, taken the gentleman's part.

Olivia: Erm, I don't suppose you'd care to show me the steps? I m-mean, if it's no trouble! I'm trying to learn it, you see, but it would be SO much easier with a partner!

Virion: Virion has never refused a plea from a damsel in need, and he shall not begin now! I will teach you that I know. I will teach you...EVERYTHING!

Olivia: Oh! That's great!

■ OLIVIA X VIRION B

Virion: And STEP and STEP aaand...BACK!

Olivia: L-like that?

Virion: Ah, it brings a tear to my eye. You have captured it perfectly!

Olivia: Well, it's all thanks to my kind and patient teacher!

Virion: A lady should be handled like a baby bird. Gently...and yet ever mindful that at any moment she could fly away!

Olivia: No one would care if I flew away...

Virion: My lady Olivia appears to be unaware of her many talents and charms!

Olivia: Oh, stop it, Virion. You're just saying that because I happen to be standing here.

Virion: That they are hidden behind that gawky exterior makes them all the more beguiling!

Olivia: Okay, maybe don't stop.

Virion: This is why your dances inspire so many of us on the battlefield. But, if I may be so bold, a little more confidence would not be entirely remiss.

Olivia: Th-thank you for your honesty, Virion. I appreciate the praise. Even if it's just idle flattery, it makes me want to try harder.

Virion: Idle flattery?! My lady, you wound me! I speak as one possessed by beauty.

Olivia: You see, now I KNOW you're lying! You say the exact same things to all the girls.

Virion: Perhaps. But it is never a lie!

Olivia: Er, right. But if EVERYONE is as beautiful as you claim, doesn't that mean—

Virion: *Ahem!* That's enough chitchat for today! We must continue our lesson.

Olivia: Yes, of course. Ready when you are!

■ OLIVIA X VIRION A

Olivia: Tra-la-la-la-LAAAAAA! ♪

Virion: Ah, if it isn't my little dancing bird. Practicing solo again, are we?

Olivia: Oh, hello, Virion. I was just rehearsing the steps for this new dance. It's very...ardent.

Virion: Yet you find it difficult to do so alone. Am I correct?

Olivia: Er, well, yes, actually. How did you know?

Virion: Tsk-tsk. I am your teacher! I know these things. Well then! I shall simply have to instruct you... personally.

Olivia: W-well, that would be fine, except...

Virion: Yeeeeeeeees?

Olivia: Well, it's just that you're so very good! Far better than me, actually. I have two left feet! No, two left HANDS where my feet should be! So when you're close, I...I get so nervous.

Virion: So you prefer to dance alone, then? This is your solution?

Olivia: Er, yes...

Virion: Very well. As you are a lady fair, I shall respect your wishes. HOWEVER! As you dance, I shall be dancing right along with you. There is no need for hand-holding or the exchange of sultry glances! I can instruct you perfectly well from across the room.

Olivia: W-would you mind?

Virion: Ha ha! My dear lady, I have done far worse in the name of far less. Shall we begin? And a one, and a two...

Olivia: Hee hee! You're right! It's SO much better when you have a partner! Even if the partner is spinning across the room...

Virion: 'Tis a dance meant for two, my lady. That is the only way to do it justice.

Olivia: Oh, Virion! I'm so glad I asked for your help!

Virion: You are not the first to utter such a sentiment.

Olivia: Thanks to you, I've perfected yet another dance. I'm starting to believe I might have some talent after all.

Virion: I'm pleased that the knowledge granted by my noble pedigree could be put to use.

Olivia: *Siiigh* He's soooo dreamy...

Virion: Pardon? Did you say something?

Olivia: What? Who, me? Oh, gosh no! Um, but... Do you think I could maybe have another lesson soon?

OLIVIA X VIRION S

Olivia: *Sigh*

Virion: Tsk! Such a world-weary and forlorn sigh ill suits my young protégé!

Olivia: S-sorry!

Virion: I might be able to help, if only you would share with me the nature of your sorrow. In my time, I have lifted cares from the shoulders of many a mournful maid.

Olivia: N-no. Please, Virion. Just leave me alone.

Virion: It breaks my heart to see a woman in such desperation... Especially one whom I love with all of my being.

Olivia: Oh, stop it. Just stop. You don't love me. You're just saying things again.

Virion: You do not believe me?

Olivia: Ha! I wager you say that to every girl you see! Love probably strikes you three times before breakfast.

Virion: There you are wrong! I have never said it to anyone, ever.

Olivia: T-truly?

Virion: Truly, my dear.

Olivia: B-but you're always asking girls to marry you.

Virion: I admit, I am quite fond of proposing to... Well, most anyone I meet. But I have told none that I loved them with all my heart.

Olivia: I don't know...

Virion: Olivia, tell me! Do you feel for me as strongly as I feel for you?

Olivia: *Sniff* O-of course, you foolish man! I've loved you from the moment we met!

Virion: Then perhaps you will accept this gift as proof of my affections?

Olivia: It's...a ring. For me?

Virion: Look how beautiful it is upon your finger! Like a butterfly in the moonlight it sparkles!

Olivia: It DOES look beautiful...

Virion: At last, I have made you smile. Would you care to dance together to celebrate this wonderful moment?

Olivia: Oh, Virion! Of course!

Cherche

■ CHERCHE X VIRION C

Cherche: Virion? I've been searching for you. It's time for our training session.

Virion: Is it that hour already? Well then, prepare your sparring gear and—

Cherche: Already done. I'm ready if you are.

Virion: Ha ha! Of course you are! I always said you were my most dedicated vassal.

Cherche: Your flattery's wasted on me.

Virion: Flattery? Surely you know by now that gallant Virion always speaks from the heart! If I had not been so cruelly robbed of my domains, you would still—

Cherche: But you DID lose your lands, so there's no point discussing what might have been. This is reality, where we face each other on the training ground as equals.

Virion: Ah, reality. I have come to loathe that place of late. You know that when my lands were stripped, your bonds of vassalage were ended, yes? You have no obligation to train me as you do. You are free to serve whomever you choose.

Cherche: I am aware of that. But I never served you because of your land holdings.

Virion: You didn't? Oh ho ho! Then was it, perchance, for love?

Cherche: One more comment like that and I'll have Minerva eat you.

Virion: *Gulp* My deepest apologies, milady! My lips are hereby sealed!

■ CHERCHE X VIRION B

Virion: *Sigh*

Cherche: Is something the matter?

Virion: Ah, my sweet Cherche. As always, you see directly into Virion's heart. You come upon me lovelorn and lonely, spurned by a fair lady with a sharp tongue.

Cherche: Do you mean me? Oh goodness! It's not often someone calls me fair. But seriously, what troubles you? Are you still crestfallen about how Walhart so rudely seized your lands?

Virion: Enough! That was a tragedy, and many of my people died. I'll not have you speak so lightly of it.

Cherche: That was not my intent, Virion. I know that many suffered under Walhart's cruel heel. But I also know that, short of the dead, you have suffered more than any of us.

Virion: Loyal Cherche, your kind words fill my heart with courage and hope! Could it be that you have fallen helplessly in love with your gallant Virion?!

Cherche: Hah!

Virion: Ah, sweet nostalgia. It's been so long since last I heard that derisive snicker.

Cherche: I do not jest, Virion. The deed has been done, and you could not have stopped it. It's time you looked to the future and stopped blaming yourself for the past.

Virion: I did not think it would be so hard to forgive myself...

Cherche: Behind your carefree facade, you've always been terribly uncompromising. But you must promise that you won't surrender to hopelessness and despair.

Virion: Then I shall promise it, but only because you ask. But in return, you must promise me something, sweet Cherche. If the day comes when you must choose between loyalty to me or your own path... I want you to do whatever is best for you and give no thought to me. Agreed?

Cherche: Why, Virion, what a serious speech! But it's hardly necessary. I had no intention of taking you into account when making such choices.

Virion: W-well, good... Yes, good. Exactly as I would have it. Though I suppose you could think about me a LITTLE bit! If you...wanted to.

Cherche: Now, now. Don't give it another thought. ...I certainly won't.

■ CHERCHE X VIRION A

Virion: I wish I knew what was happening to our homeland right now.

Cherche: The sooner we win this cursed war, the sooner we'll be able to find out.

Virion: Tell me, Cherche, what do you intend to do when this war is over?

Cherche: Return home and help rebuild the domains of House Virion. I assume your plan is much the same?

Virion: Yes, of course. My domains shall have great need of me.

Cherche: Are you sure you can handle going back? That broken landscape will have many painful memories carved into it.

Virion: True. But it is also filled with many joyous memories as well. ...Many of which involve you. You'll scoff, but the happiest moments of my life have been spent in your company.

Cherche: Come, Virion. You know I'm not one of your dizzy maids who falls for that flattery.

Virion: Why is it that when I speak from the heart, no one believes me? Is this the price I must pay for my flippant yet debonair charm?

Cherche: I think we just know each other too well to speak of such emotional matters.

Virion: Hmm... Perhaps you are right.

■ CHERCHE X VIRION S

Cherche: Time for you to go, Virion.

Virion: Alas! Am I to be shooed away so soon?

Cherche: You're practically nodding off. I don't want to sit here and listen to you snore.

Virion: Yes, I'm afraid I haven't been sleeping well recently. My cot is cold, and I've no one to share it.

Cherche: Have you tried seducing a lonely kitchen wench?

Virion: Do you think I can find happiness with just any random lass? I have standards, dear!

Cherche: There are as many maids as stars in the sky. There must be SOMEONE out there.

Virion: Yes, and you know full well who it is.

Cherche: Oh, Virion. We talked about this before. We're too close to each other.

Virion: Yes, we are close. Closer perhaps than any two people have ever been! I can no more imagine being without you than being without air or water! How can another woman be anything but a shadow of what you are to me?

Cherche: Now you're just practicing lines for your next conquest.

Virion: You, of all people, should know when I'm being sincere.

Cherche: Yes. I suppose I do.

Virion: And though I fear I know your answer, I have one final card to play. ...I have brought you something.

Cherche: Is that what I think it is?

Virion: If you think it's an engagement ring, then yes. It is indeed. Do you believe me now?

Cherche: I suppose I must.

Virion: Then what is your answer? Will you accept?

Cherche: Heh. I think I have to. Who else would agree to be YOUR wife? I warn you though: once we tie the knot, your days of maids are over. Stray from me but once, and I'll have you to Minerva as a snack.

Virion: Nothing will be further from my mind! ...Well, the maid part. I'm always quite concerned about your little pet.

Cherche: Did you hear that, my sweet Minerva? You must ensure he keeps his promise.

Virion: Er, can we please save the threats? This is meant to be a happy moment!

Cherche: Just doing my due diligence, love!

Owain (Father/son)

Inigo (Father/son)

Inigo's father/son dialogue can be found on page 293.

Brady (Father/son)

Brady's father/son dialogue can be found on page 297.

Kjelle (Father/daughter)

Kjelle's father/daughter dialogue can be found on page 299.

Severa (Father/daughter)

Severa's father/daughter dialogue can be found on page 305.

Gerome (Father/son)

Gerome's father/son dialogue can be found on page 307.

Morgan (male) (Father/son)

The Morgan (male) father/son dialogue can be found on page 309.

Yarne (Father/son)

Yarne's father/son dialogue can be found on page 314.

Laurent (Father/son)

Laurent's father/son dialogue can be found on page 316.

Noire (Father/daughter)

Noire's father/daughter dialogue can be found on page 317.

Nah (Father/daughter)

Nah's father/daughter dialogue can be found on page 318.

Sully

Avatar (male)

The dialogue between Avatar (male) and Sully can be found on page 218.

Avatar (female)

The dialogue between Avatar (female) and Sully can be found on page 229.

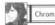
Chrom

The dialogue between Chrom and Sully can be found on page 240.

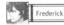
Frederick

The dialogue between Frederick and Sully can be found on page 245.

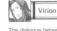
Virion

The dialogue between Virion and Sully can be found on page 248.

Vaike

■ VAIKE X SULLY C

Vaike: Mm-MMM! Now that smells like a slice of heaven. Whatcha eatin' there?

Sully: Bogsberry and cabbage pie, with the best cream of treacle in all of Ylisse.

Vaike: A shiny copper coin says it was baked by them lady friends that were followin' ya!

Sully: Keep your coin. They gave it to me before we left to keep me warm on the journey.

Vaike: Gremlin's tail! The Vaike's never had a gaggle of maidens bake HIM a pie! How'd ya do it?! What's your secret?! ...Er, not that I'm jealous or nothin'.

Sully: I suppose I'm just charming like that. Why, you need advice?

Vaike: Har har! Ol' Teach don't need advice on that score! I mean, sure, no one's ever bothered to bake me a tasty pie... But I knew a milkmaid once who gave me an apple—and it only had one worm in it!

Sully: Well, good for you.

Vaike: 'Sides, I'm more of a man's man, ya know? And men don't usually go for pie bakin'. I'd rather eat a donkey's hindquarters than a pie baked by one o' my mates! Har har! Still, I'd give anything to have lasses offering me their pies all the time. ...Maybe it's the horse? Ladies do love the horses...

Sully: An idiot on a horse is still an idiot.

Vaike: What's that supposed to mean? Hey, wait a sec, Sully. You're a woman. ...Er, right? Got some tips for the Vaike? What do YOU admire in a man?

Sully: He has to be better than me. Someone I can respect.

Vaike: Better? ...You mean better looking?

Sully: I mean better at important things! Smarter, stronger, faster with blade and lance...

Vaike: Well, maybe you should take me on. I'm pretty tough, ya know.

Sully: If you think fighting me will attract women, you're an even bigger fool than I thought... ...Eh, but why not? It's been days since I've dished out a good thrashing, heh heh.

■ VAIKE X SULLY B

Vaike: C'mon, Sully. Help ol' Teach out here. Why can't I ever win the girl? I got devilish good looks, the strength of an eagle, and the charm of a fancy noble!

Sully: Well, one of those is true. ...Sort of. I suppose you can handle a lance, even if I'm better with a sword. Our match was pretty damn even until you decided we should arm wrestle. So, yes. I'll admit that you're strong. ...Not bright, mind you, but strong.

Vaike: 98... 99... 100! Er, sorry. What was that last bit? Hard to hear you over these bicep curls... Ya gotta help me out here, Sully. Ya just gotta! Look at these arms! Just look at 'em! I mean, what else does a lady want?

Sully: Gods be damned, but you are thick. How about being kind? Or thoughtful?!

Vaike: Er, what would a girl want that stuff for?

Sully: ...Look. If you ask me, I'd want a man with ideals. One who wants to better himself. If I'm going to spend the rest of my life with someone, I have to respect him.

Vaike: Har! That's me up and down! Heck, I joined the Shepherds 'cause of my ideals.

Sully: Now that you mention it, you never did tell me why you're fighting for Chrom? So? Out with it. What made you sign up?

Vaike: I wanted to be the greatest warrior in all the realm!

Sully: No, idiot. I'm asking why you wanted to be a great warrior in the first place.

Vaike: Well, it's a bit of a tale, but you need more Teach-talk that bad, eh? Well, all right... I grew up poor in this podunk little village where I was famous for never losin' a fight. Local kids latched on to me, and before I knew it, I had my own little gang. Course, we were just a bunch of ne'er-do-wells as far as the adults were concerned.

Sully: What a surprise...

Vaike: So one day, Emmeryn herself came to our corner of the world, and she said... "I seek to bring prosperity and equality to all the people of Ylisse!" Well, that struck a nerve. Soon as I heard it, I knew what my mission was.

Sully: To forsake your misspent youth, join the Shepherds, and fight for social justice?

Vaike: Er, yeah, that! That was it exactly! What you just said! Okay, maybe not the EXACT same words I used, but...

Sully: ...Vaike? You may not be such a complete moron after all. You might even, dare I say it? ...Deserve some respect?

Vaike: That's the Vaike! Man of your dreams, right here, reporting for d—

Sully: No, I stand corrected. No respect warranted. None, whatsoever.

Vaike: Awwwwww!

■ VAIKE X SULLY A

Vaike: Hey-ho, Sully! Just the gal I was hopin' to see. Got a question for ya.

Sully: What is it? I'm busy.

Vaike: Why did YOU sign up for the Shepherds? I told ya my story, remember? Now you gotta tell me yours. Fair's fair!

Sully: My story's dull... I joined so I could become a knight.

Vaike: Aw, come on! You're havin' me on!

Sully: You got a problem?

Vaike: No, it's just... See, I thought ya already were a knight.

Sully: Oh, I have armor and arms, but have yet to undergo the formal ceremony...

Vaike: Ah, I see. So you're gonna sever yourself in glory here with us Shepherds... Maybe catch Chrom's eye and earn yourself a knighthood?

Sully: Not quite. I was born into a long line of knights. My house and all that crap. This title will be mine by inheritance when the time comes. I could spend my life eating grapes from a damn silver bowl and still be called "sir"!

Vaike: Er, so then why—

Sully: Because there's no honor in accepting something you haven't earned! A knight shouldn't just be lucky enough to be born to some damn noble! A knight has duties. ...Responsibilities. "A knight is brave and true, aids all in need, and defends the weak from evil." I can't uphold that oath without honing my skills. Suffering hardship. All that. How can I know courage if I don't face bloody death a bunch of times? I'll fight for the Shepherds until I've damn well EARNED the title of knight!

Vaike: Criven's horn, that's a rousing speech!

Sully: Oh please, I'm not trying to... It just means a lot to me is all. I don't get a chance to talk about it much. I'm sorry if I bored you.

Vaike: ...Bored?! Har har! Ain't NOTHIN' boring about you, Sully. In fact, the Vaike hasn't been this excited since the exalt came to visit my li'l ol' town!

Sully: ...Really?

Vaike: Cross my heart and hope to... Okay, well, just cross my heart. 'Cause I realized something, Sully: you and me should duel more often! You wanna be a knight among knights, and I wanna be a warrior's warrior. Seems we could help each other out!

Sully: Hmm... Don't expect me to go easy on you. It'll hurt. ...Maybe a lot.

Vaike: Har har! Bring it on! The Vaike can take it!

■ VAIKE X SULLY S

Vaike: Heya, Sully.

Sully: Oh. Hello, Vaike.

Vaike: So I was just thinkin', and I... Look, are you fallin' for me?

Sully: WHAT?! ...Where in the hell did you get that idea?!

Vaike: Well, it's just that you've been actin' different around me. You wouldn't, like, I thought maybe that was the reason. But if I'm wrong, then I'm wrong...

Sully: Well, I... I never said you were WRONG, exactly... Er, that is... Well...yes. Yes, I suppose I am... maybe...starting to fall for you...a little... But I still don't like you a lot!

Vaike: That's good enough for the Vaike! 'Cause truth be told, I'm startin' to take a shine to you, too.

Sully: Whatever happens...you should know... I won't be doing any damn housework!

Vaike: Har har! Not exactly what I was expecting to hear, but okay. I mean, duh, I'd be the biggest fool in all of Ylisse if I expected that! I'm a simple man, but I like being with you. I feel like I can trust ya with my troubles. And I guess that's why I'm thinkin' ya might... make a good...wife.

Sully: Thinking back, I never would have thought... I mean this is all so unexpected, it's just... Oh, hell with it! Why not? Let's get married!

Vaike: Now hold on! I'm the man here, and that means I'm the one doin' the askin'!

Sully: Pfft! Too late, knucklehead.

Vaike: Aw, this whole thing's a mess! I spent all day plannin' it out, too.

Even bought this blasted ring...

Sully: Well?! Are you going to give me the ring or stand here like a damn fool?!

Vaike: Yeah, all right... Here, catch!

Sully: Oop! Got it! ...Oh Vaike, this is... It's gorgeous.

Vaike: Only the best for Mrs. the Vaike!

Stahl

■ STAHL X SULLY C

Stahl: Thanks for training with me today. That was a great session.

Sully: Ha! Giving up so soon? What a wimp!

Stahl: Er, what?

Sully: How can you call yourself a knight if you crap out so soon? The legendary knights who served Marth would never give up so easily.

Stahl: You mean Cain and Abel? The "Bull" and the "Panther" from the old stories?

Sully: That's the kind of strength we need to win this war. And it's the kind of strength I aspire to.

Stahl: Well, sure. I mean, who wouldn't want to be a hero of legend and song? I just don't think I have it in me. I'm more of a...mellow type.

Sully: Ha! Then take that attitude over to the kitchen, ya damn scullery maid. I plan to run circles around those rusty old legends.

Stahl: Heh! You're something else. But perhaps I could stand to be a little more forceful in my training.

Sully: Damn right! I won't stop until I'm built like the Bull!

Stahl: Ha ha! I'm sure you'll... Wait, you're the Bull in this scenario?

Sully: You got a problem with that?

Stahl: No, no! No, that's...just fine. I guess that makes me the Panther, huh? Yeesh. I've got my work cut out for me...

■ STAHL X SULLY B

Stahl: ...Enough! I yield!

Sully: Oh, come on. You're better than this! Now you're just letting me win.

Stahl: No one LETS you win anything, Sully. You take victories by force.

Sully: Pfft. That's your excuse?

Stahl: Hey, you know what I like.

Sully: You lack confidence because you don't know yourself well enough. Here, shake my hand. ...Go on! Shake the damn thing!

Stahl: Er, all right.

Sully: Well? What do you feel? Tell me how my hand and yours are different.

Stahl: Well, yours is smaller than I would have thought. ...And really soft! It's kind of nice, actually.

Sully: You're getting distracted. Focus on the first thing you said. You're bigger than me, and you've got more muscle. Also, you're a better rider. So explain why it is that I keep kicking your arse all over the battlefield.

Stahl: I don't know! I guess you just project this... aura. Like you're going to eat me for breakfast, you know?

Sully: All in your head! Change your attitude, and you'll be a better fighter overnight.

Stahl: You really think so? Hmm... Wait! Now you're just pushing me around in a different way.

Sully: Except that I'm right. And if you're smart, you'll listen to me. So what do you say? Another round?

Stahl: You're on. And I'm standing my ground this time!

■ STAHL X SULLY A

Sully: Oof! ...Yeah, I'll feel that one tomorrow.

Stahl: Heh heh! Stahl the Panther strikes again! Still, I think I finally understand what you were getting at. The right attitude really does make a difference.

Sully: Well, don't think you'll ever be better than me. Because you won't.

Stahl: Ha! I wouldn't dare suggest it.

Sully: But you know the others expect you to show me up someday.

Stahl: ...Huh?

Sully: It's okay. I'm used to it.

Stahl: ...Er, Sully? Is everything all right? You're getting weird on me.

Sully: It's just... People look at me and all they see is a damn woman!

Stahl: Um, okay? Not sure where this is coming from, but if I implied—

Sully: Not you, idiot. You treat me as an equal, and I've always respected that. I just worry that... Well, what happens if you do surpass me someday? People won't think it's because of hard work or skill or any of that. It'll just be another damn man beating a woman to the finish line again.

Stahl: Now who's being wishy-washy?

Sully: Hey! Don't you lecture me, chump! I'll kick you right in the—

Stahl: Ha ha! Now that's the Sully I know. A mighty Bull in the making! ...Or is it a mewling Sheep? We'd better go another around and find out.

Sully: Oh, I am so going to hand you your lunch in a second. Come on, tough guy! Show me what you're really made of!

Stahl: Eep! M-maybe this was a bad idea...

■ STAHL X SULLY S

Sully: *Pant, pant* All right! Enough... I...I yield. *Wheeze* Gods, Stahl. You're a damn beast today.

Stahl: *Pant* It's all thanks to your training, Sully.

Sully: No one made you strong. You were tough to begin with.

Stahl: So does this mark the end of Sully's reign of terror?

Sully: For today. But there's always tomorrow.

Stahl: I knew you weren't going to give up quietly. You've always worked harder and aspired higher than anyone. You're amazing.

Sully: Yeah, well, I never could've done it without you around. It's easy to keep on the path when you've got someone walking beside you. You're about the best training partner I've ever had.

Stahl: Um, yeah. Well, maybe I could be more than just a...training partner?

Sully: Wait, what are you... Stahl, are you giving me this?

Stahl: Yeah. It's a...wedding ring. I'm still more Mouse than Panther most days. But with you at my side, I can become the man and knight I aspire to be. And I want to be there to spur you along, too. ...Not that you need it.

Sully: That's a pretty bold offer, Mr. Mouse.

Stahl: Yeah, I may look confident, but I'm about to soil my good pair of trousers. If it weren't for you, I'd never be able to ask something like this. You're my courage, Sully.

Sully: That's actually very sweet. ...You know what? I accept. We've got a long ways to go, but I'd have no other traveling companion. It's you and me to the end, Stahl.

Stahl: Then here's to the new Bull and Panther!

Miriel

■ MIRIEL X SULLY C

Sully: Miriel! Just the girl I wanted to see.

Miriel: Greetings and salutations, Sully. Are you in need of assistance?

Sully: You're an egghead, right? You like researching and investigating things?

Miriel: Why, yes. Unlocking the mysteries and wonders of the natural world gives me—

Sully: Yeah, yeah, whatever. Look, I have a favor to ask.

Miriel: ...You wish me to develop a new weapon? Something of that ilk?

Sully: Naw, nothing like that. I want you to study ME!

Miriel: You? Well, that would be most unusual... I confess, I have never considered you as a possible field of research, but...

Sully: Yeah, well, maybe it's time you consider it. You might have noticed that I'm not like other women, right?

Miriel: If you are speaking of your martial prowess, then yes, it is a known quantity.

Sully: Er, yeah! Right! That! ...And some other stuff, too. Look, I just want to figure out what's so different about me. I mean, I TRY to fit in, I really do, but something sets me apart.

Miriel: I see. You wish me to observe your social interactions and verbal communications. In this way, I might see behavioral signifiers that differentiate you from the group norm.

Sully: That is probably exactly what I'm saying! ...I think.

Miriel: I need time to prepare my queries and form a control group. Is this acceptable?

Sully: Er, sure. Whatever you just said. Whatever it takes.

■ MIRIEL X SULLY B

Sully: Hey-ho, Miriel! How's the research project going?

Miriel: I have many such projects underway, but I assume you refer to your personality study. Since we talked, I have been observing you with fierce scientific rigor.

Sully: Wait, really? I didn't even notice.

Miriel: If the subject is aware of the observation, the results would be compromised. It was vital that I observe you in your natural habitat.

Sully: Oh yeah? ...So? Any conclusions?

Miriel: During the observation phase, two main points came to my attention.

Sully: ...Well what the hell are they already?!

Miriel: The first is your language. The second is your general bearing.

Sully: You mean the way I walk and talk and crap like that?

Miriel: Your clothing and armor are unexceptional and fit within Shepherd social norms. However, your use of language—especially vulgarity—is quite irregular. Also, you tend to carry yourself in a very aggressive manner.

Sully: O-kay.

Miriel: If you wish to fit in with others, I would recommend change in these two areas.

Sully: Aw, come on! That's horse plop!

Miriel: I assure you my conclusions were reached via scientifically proven methods.

Sully: I've had people tell me this before! "You have to do this!" "You gotta act like that!" It never works! I pretend for a week or so and then just give it up. Who says we all have to act the same, anyway? Who made all these damn rules?

Miriel: I believe they are based on social mores as opposed to actual law.

Sully: Well, hell... I'm gonna have to think on this one for a bit. Thanks for doing the observation stuff. Hope I didn't waste your time.

Miriel: Not at all. It was quite fascinating.

■ MIRIEL X SULLY A

Miriel: Ah, Sully. Might I have a moment?

Sully: What's up, Miriel?

Miriel: Have you considered enacting my suggestions from our recent conversation?

Sully: You mean about the way I speak and behave and all that? Yeah, I've thought about it plenty, but I still don't know what to do...

Miriel: I wonder then if you might care to participate in a small experiment?

Sully: It doesn't involve rats, does it? Can't stand those things...

Miriel: Nothing so crude, I promise. First, I am going to ignite this pile of dry twigs...

Sully: Oh-kay. And?

Miriel: Now then. Suppose you need to extinguish this fire. How would you do it? You are allowed to use anything you see around you.

Sully: Er, I guess I'd use that bucket of water.

Miriel: You would pour water on the fire?

Sully: Yeah, sure. Water on fire, fire goes out. Right?

Miriel: Very well. Please go ahead.

Sully: Ha! See you in hell, fire! WHOA! That made the fire twice as big! What the heck did you do?!

Miriel: The fluid in the bucket is a substance commonly known as "kindling water." It is a mysterious liquid that emerges from the ground near distant mountains.

Sully: Kindling water?

Miriel: Just now, you made the assumption that water always douses fire. However, you failed to consider that there may be different kinds of water. It may also interest you to know that people who live near kindling water find it useful.

Sully: ...I get it. It's different than regular water, but still useful to some folks. And people who are different may still have useful roles to play.

Miriel: Precisely. My research indicates that you should be happy just the way you are.

Sully: Heh. Thanks for the pep talk, Miriel. I feel better already. Although, I do still have one question...

Miriel: Yes?

Sully: How the hell are you planning on putting out this fire?!

Kellam

■ KELLAM X SULLY C

Sully: Kellam? Hey, Kellam!

Kellam: ...Yes?

Sully: I've got a bone to pick with you, pip-squeak! Chrom tells me that in our last battle you were secretly combat. No more tangles! watching my back!

Kellam: Um, I wasn't trying to keep it a secret, Sully. I was just fighting alongside—

Sully: Well knock it the hell off! I'M the one who does the protectin' around here, got it?! I don't need some tiny man in a huge suit of armor watching me.

Kellam: B-b-but...

Sully: You think I need extra protection? That it? You think I'm frail and weak? You think you can be my gallant knight in shiny, oversized armor?

Kellam: I wasn't giving you special treatment, honest! I just like protecting people!

Sully: I'll say this once, pip-squeak: don't ever pull that crap again! Are we clear now? 'Cause if we are, I'm done. I've got better things to do than yell at you, tiny man.

Kellam: O-of course you do! I mean... Um, well, bye.

■ KELLAM X SULLY B

Sully: Kellam? ...KELLAM!

Kellam: ...Yes?

Sully: Oh, there you are. ...Yep. Looks like I was right. You did injure your arm.

Kellam: Oh, gosh. Did you notice? I didn't think anyone—

Sully: Of course I noticed, you tiny idiot! You got hurt trying to protect me again! Didn't I tell you the other day I didn't need your damn help?

Kellam: B-but, that guy was about to cut your head off! I just can't stand by and watch friends be cut down. It's not in my nature.

Sully: Oh, aren't we gallant. Pffft! I had that guy in the bag. And besides, it doesn't do any good if you get killed in someone else's place.

Kellam: Y-you're probably right.

Sully: Now give me your arm, and let me take a gander at this wound.

Kellam: Oh, it's all right. Really! Barely a scratch, in fact.

Sully: Quit your griping, and get over here so I can put a damn bandage on!

Kellam: R-right away, ma'am!

Sully: Gods, what a fool. You'd probably leap into the noose if I hung myself, huh?

Kellam: I wager I would!

Sully: And here I thought you were a meek little mouse. When it comes to looking after folk, you're as stubborn as a damn ox!

■ KELLAM X SULLY A

Sully: Kellam?

Kellam: ...R-right here, Sully. L-look, don't hit me! I know I helped you out again, but I didn't mean to! Honest!

Sully: Actually, I came to thank you. I was outmanned that time. Had you not stepped in...

Kellam: What? Are you saying—

Sully: Yes, all right? Yes. You win. You can watch my back. Gods, I've never met a more stubborn man in all my life!

Kellam: Everyone needs help sometimes, Sully. I mean, we all fight for the same cause. It makes no sense to stand alone, no matter how strong you are.

Sully: Heh. So you want to serve as everyone's shield, huh? Well, that's a hard role for one man. How about I help you out?

Kellam: Help me out?

Sully: If you're watching everyone else's back, someone's got to cover yours, right? You can be the shield of the Shepherds, and I'll be the shield of YOU!

Kellam: Er, I suppose so. But...

Sully: What? You don't like the idea of someone helping you out? Well, tough beans!

Kellam: Well, all right. Thanks, Sully.

■ KELLAM X SULLY S

Sully: Hey, Sully. I wanted to thank you for watching my back in that last battle.

Sully: No sweat, pip-squeak. Reckon I owed you for one damn favor or another. ...Funny. I can't even imagine how I fought back when I didn't have you around. It feels good knowing someone's looking out for you.

Kellam: I know! I feel so much stronger when you're out there.

Sully: But it's even more than that, Kellam. The way you want to help everyone else... You make me want to be a better person.

Kellam: Um, well, funny you say that... See, the thing is... I'm more interested in protecting you than anyone else.

Sully: Oh?

Kellam: I like you, Sully. In fact, I REALLY like you. So I was thinking maybe we could...get married?

Sully: Married?!

Kellam: Yeah, married! Look, I went out and got you a ring and everything!

Sully: ...I'm not much of a lady, you know. Not sure I'd be much of a wife.

Kellam: I think you'd be great!

Sully: I, uh... Look, this kind of crap isn't easy for me, but...I like you, Kellam. I've never really felt this way about anyone before.

Kellam: So then...yes?

Sully: All right, pip-squeak. Let's do it. I'll watch your back, you watch mine, and together we'll be unbeatable!

Sumia

■ SUMIA X SULLY C

Sumia: There. Doesn't that feel better? Your mane is alllll combed. No more tangles! Who's a good pegasus? Huh? Who's a good wittle pegasus?

Sully: Are you talking to that thing again?

Sumia: Oh, hi, Sully.

Sully: You're spoiling the animal. She's practically died and gone to horse heaven.

Sumia: She does look happy, doesn't she?

Sully: Ah, well. She's seen you safe through some terrible battles, so I suppose she earned it.

Sumia: You're quite fond of your horse, too, aren't you, Sully?

Sully: Hell yes, I'm proud! He's got smarts and guts! What more could a woman want?

Sumia: Hee hee! When you talk about him, you sound like a proud mother.

Sully: Eh, I'm not the maternal type.

Sumia: Even so, it's obvious how fond you two are of each other. Whenever you praise him, he snorts ever so happily!

Sully: You noticed that? ...Huh. Most folks just assume he's some mindless beast.

Sumia: Oh it's so nice to have someone to talk to about this sort of thing... Do you have a minute to talk more? Chat about pegasi and the like? ...I mean, if you don't mind? I know you're very busy. ...I don't mean to intrude.

Sully: Pfft! Intrude? I could talk horses till the cows come home!

Sumia: Oh, wonderful! Let me just put on some tea and we can—

Sully: Hold it right there, girlie! You just combed that horse top to bottom. You deserve a rest. You relax and put your feet up! I'll make the tea this time.

Sumia: Oh! Um, all right.

Sully: I'll be right back!

Sumia: Hee hee, I've never seen Sully look so excited about anything!

■ SUMIA X SULLY B

Sully: I spiced the tea with crowberry extract and a dash of mustard. Do you like it?

Sumia: It's wonderful! Thank you, Sully. Did I tell you I bought this tea from a traveling merchant? It's a rare blend.

Sully: Har! You don't see many merchants selling tea in these troubled times.

Sumia: But troubled times are when people need a nice cup of tea most! That's what the merchant said, anyway, and I'm inclined to agree with him.

Sully: Works for me! Let's forget about war for a bit and just have a nice chat.

Sumia: Oh yes, let's! That would be so nice! Um... So... What should we talk about? I told you everything I know about horses. I guess we could have some... girl talk?

Sully: Oooo! Does little Sumia want to confess her forbidden love?

Sumia: S-Sully! Shhhhhh! Someone might hear you!

Sully: Har har! I saw right through you on that one! C'mon, we're both women of the world, right? We know which way the wind blows. And what are friends for if not to hear confession of a sultry midnight passion?!

Sumia: Well it's hardly... Eh, all right, then. But you have to go first!

Sully: M-me?! But I... I mean I don't... Dammit, Sumia! That's hardly fair!

Sumia: Hee hee! You're funny when you're flustered.

Sully: W-well, it doesn't matter anyway. My love life's duller than a sack of flour.

Sumia: Hey, you're so shy all of a sudden! You weren't like this when we were talking about pegasi.

Sully: Yeah, but that's a HORSE! I can talk about horses all damn day. Love's just so... Er, you know? Lovey.

Sumia: ...Would you rather talk about horses some more, Sully?

Sully: Hell yes!

■ SUMIA X SULLY A

Sully: Huh. When you put 'em side by side, there's hardly any difference at all... If not for the wings, pegasi and horses would look exactly the same.

Sumia: They even eat the same food! Maybe they're cousins of one sort or another.

Sully: It's just odd. How the hell did pegasi end up with wings?

Sumia: I've always wondered how the horses lost theirs.

Sully: Har! I never thought of it that way! In either case, they're strange animals. Although I guess you can say that about almost anything. Dragons... People...

Sumia: I think that every creature is weird and wonderful in its own way! ...Except cows. Cows just annoy me.

Sully: When I was a kid, I was taught that the gods made all the world's creatures. So then I asked who made the gods! ...Har! That shut 'em up right quick.

Sumia: Oh, I do so hate ponderous questions like that. They only serve to remind me how little we know about anything.

Sully: Yeah, I know how you feel. We make up all these stories and legends to explain crap we don't understand... But they usually make even less sense than just saying "we don't know"!

Sumia: That's how we end up fighting wars over ideas. Because no one knows who's right.

Sully: I guess war is inevitable when everyone has their own version of the truth.

Sumia: I'd like to think that one day we can live in a world that won't know war.

Sully: Know what? I think that day's coming. ...And maybe sooner than you think.

Sumia: That would give us more time to drink tea!

Sully: And talk about horses!

Sumia: Hee hee! Yes, of course.

Lon'qu

■ LON'QU X SULLY C

Sully: Those were some impressive moves on the battlefield today, Lon'qu.

Lon'qu: Ngh...

Sully: Your fighting is so fluid, yet so crisp. It's amazing to watch. I'd love to see how my own moves stack up someday.

Lon'qu: I refuse.

Sully: Har! Scared?

Lon'qu: No. I simply have no interest in fighting you.

Sully: The hell does that mean? You think you got me beat before we even start?

Lon'qu:

Sully: You don't know thing one about me! Not until we've crossed blades.

Lon'qu: You are a woman.

Sully: ...Oh, that does it. Draw! Draw and defend your life!

Lon'qu: Stop!

Sully: Make me!

Lon'qu:That would have hit me.

Sully: Then it's a good thing you parried. Let's see if you're as quick next time.

■ LON'QU X SULLY B

Sully: Come on, Lon'qu. Let's spar!

Lon'qu: We did. You won.

Sully: Pfft. That? I've seen you fight, and that wasn't half what you're capable of. It doesn't count if you win when the other guy's not even trying.

Lon'qu: Half is all I can offer someone like you.

Sully: Oh, what? Can't fight a woman? Afraid I'll break a nail? I expect this crap from a lot of people, Lon'qu, but not you!

Lon'qu: I mean no insult. The fault is mine alone. I have an...aversion to women. A crippling, involuntary reflex. You're a true warrior, and skilled. But I cannot fight you.

Sully: Is this some childhood-trauma thing? Did a girl take your lunch money?

Lon'qu: Something like that.

Sully: Well, I won't pry. Everybody's got their secrets. ...Wait. Does this happen to you on the battlefield, too?

Lon'qu: I manage to suppress it in instinctual, life-and-death situations.

Sully: So if your neck were on the line, you'd be able to fight. That makes sense... HAAAAAA!

Lon'qu: Are you mad, woman?!

Sully: Going for the kill would be the easy fix, but that isn't really an option here. But I figured if I turned up the intensity, I might be able to trigger a survival reflex. Now pretend I'm about to kill you!

Lon'qu: You ARE mad!

■ LON'QU X SULLY A

Sully: Hey, Lon'qu. What's new?

Lon'qu: Nothing. Would you like to spar?

Sully: Finally stopped seeing me as a woman, eh? It usually doesn't take guys this long.

Lon'qu: No. Nothing has changed in that regard. Over the course of sparring, I've just...gotten used to you.

Sully: I guess anyone would after staring me down for that many rounds. Does this mean the gloves can finally come off?

Lon'qu: Indeed. I am sorry for the long delay. I owe you a debt that I intend to repay with steel.

Sully: Oh, you ARE feisty today! Let's begin.

Lon'qu: ...Hyaaa!

■ LON'QU X SULLY S

Sully: Damn my hide! You're like fighting with a hurricane! I almost miss the days when you were still hung up on women.

Lon'qu: My aversion isn't gone, but you've proven that it can be quelled. You have made me stronger. I'd accepted my weakness, but you carved it from me by force. And through our matches, you pared me down to expose a better man.

Sully: Fighting you has made me a better warrior as well. And a better woman.

Lon'qu: This is forward of me, but I have very little experience with such things, so... This ring is for you, if you're of a mind to have it.

Sully: I'd be honored, Lon'qu.

Lon'qu: With your help, I know I can grow stronger still. That I can become a worthy partner.

Sully: Har! This from the guy who just wiped the floor with me! Well then? What are you waiting for?

Lon'qu: I don't understand.

Sully: With all that emotional stuff sorted, I feel like a fight!

Lon'qu: ...Heh. As you wish!

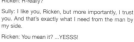

Ricken

■ RICKEN X SULLY C

Ricken: Well, I think that should do it. Wait, is this even the right page? Er, Sully? You should probably stand back. This might explode.

Sully: Whoa, check out all the vials! What are you cooking up?

Ricken: Medicine.

Sully: You must have one hell of a cold.

Ricken: Not that kind of medicine. It's a potion to hasten the rate of an organism's growth.

Sully: There's a medicine for that? Huh. So, uh, what are you using it on?

Ricken: Me.

Sully: Is that safe?

Ricken: ...Er, completely?

Sully: Are you asking me, or telling me? Look, why do you even need something like that anyway?

Ricken: I'm tired of being dead weight. I need to grow up in a hurry.

Sully: Ha! Growing up isn't about size, and it sure as hell ain't about age. Not to mention how awkward things would get if you were suddenly 40...

Ricken: I guess, but...

Sully: Look, you think I got strong with potions and weird magic? It took time and effort. You'll grow just fine without dabbling in the exotic arts.

Ricken: Thanks, Sully. I guess I'll pour this out.

Sully: Just keep it away from me.

Ricken: It's meant to be used on plants, anyway. Heh. What if I'd grown leaves?

Sully: Pour the damn thing out already!

■ RICKEN X SULLY B

Ricken: Ooh, Sully! I just read about a crazy new potion!

Sully: I thought I told you to quit messing around with that stuff! ...Yeah, okay, I'll bite. What's it do?

Ricken: It turns a woman into a man!

Sully: And you came running to me with this why?

Ricken: Well, I figured you'd be first in line.

Sully: If anyone else had said that to me, I'd make them eat their own guts. Look, Ricken. I'm fine as I am. I'm not looking to switch sides.

Ricken: But I heard you say before you hated not being taken seriously because you're a girl.

Sully: Right, but the problem isn't me. It's that other folks are small minded. It's a stupid way to think, and I aim to prove it. I'll outfight every man on the field, but there's no point if I don't do it as me. Understand, Ricken?

Ricken: Wow, Sully. I wish I could think like you. I'd rather be anything besides myself. Anyway... Sorry. I didn't mean any offense.

Sully: No worries. I know you meant well, even if you came across like a dolt.

Ricken: Ha ha ha! Yeah, I know.

■ RICKEN X SULLY A

Sully: What sort of recipe are you looking for this time, Ricken? Chrom isn't going to turn into a slug or something, is he?

Ricken: Ha ha! No, this is just my journal. I'm through making weird potions, so you can stop worrying.

Sully: Har! So you mean I won't get to see you sprout leaves?

Ricken: Okay, enough! I get it! Potions are a tool, not an answer.

Sully: Hey, that's pretty good. You're starting to sound all grown up. ...Wait, have you gotten taller?

Ricken: Er, I dunno. I don't really see myself, you know?

Sully: Come here...

Ricken: Er—

Sully: Yup. You've definitely grown an inch or so. At this rate, you'll be taller than me soon.

Ricken: YESSS! ...Er, I mean, height isn't as important as keeping people safe in the field.

Sully: Har! Nice save!

■ RICKEN X SULLY S

Sully: Thanks for the support out there, Ricken. That could have gotten ugly.

Ricken: Glad to help!

Sully: You've become a real powerhouse. You're every bit a full-fledged Shepherd. I feel like I could take on anything with you at my side.

Ricken: ...I'd rather be at your side than at your back.

Sully: My...side?

Ricken: I mean, as an equal! I mean, not while we're fighting. I mean... Here.

Sully: This is a ring, Ricken.

Ricken: You said I was a full-fledged Shepherd? Well, I'm also a full-fledged man. I love you, Sully. Marry me!

Sully: That is really damn direct, you know that? But I suppose that's one thing I appreciate about you.

Ricken: R-really?

Sully: I like you, Ricken, but more importantly, I trust you. And that's exactly what I need from the man by my side.

Ricken: You mean it? ...YESSS!

Gaius

■ GAIUS X SULLY C

Sully: Hey, hold up. I want a word with you, Chuckles.

Gaius: Meeeeeee?

Sully: Didn't I see you near my tent this morning? Kicking the pegs and lifting the tarp?

Gaius: Oh, was that your tent? Yeah, I was admiring the handiwork. I always appreciate well-made canvas.

Sully: So listen, I'm missing a gemstone from my baggage. Now I want you to close your eyes and think very, VERY hard. Did you see any dodgy characters skulking around the area? Thieves or the like?

Gaius: Hmm... Nope, can't say I did. But if I had, rest assured I'd introduce them to the sharp end of my dagger.

Sully: All right. But if you DO see something, you'll let me know. ...Right? Aaaaaanything at all. Aaaaaanyone suspicious.

Gaius: Yes, of course I will.

Sully: Something wrong, Chuckles? You look like you just swallowed an eel.

Gaius: You know—and I really hate to say this—but I'm starting to think you suspect me.

Sully: You damn well better not be accusing me of mistrusting a fellow Shepherd!

Gaius: Whoa, hold on! I was just thinking out loud! Put the sword away, if you please. It's not a completely unreasonable assumption given my...profession.

Sully: If a thief doesn't want to be suspected, he should stop skulking around like a thief...

■ GAIUS X SULLY B

Sully: Hey, Chuckles. I've been looking for you.

Gaius: Hello, Sully. Slap some whipple upside the head lately?

Sully: Not yet, but the day is still young. So, um, I found my missing jewel. It turned up in a magpie's nest. Stupid

thing must have flown into my tent and taken the first shiny bit it saw.

Gaius: Well, I'm glad that case is all tied up with a big bow.

Sully: So, listen. I owe you an apology. I left the tent flap open after all. And the first thing I did was come looking for you. Anyway...sorry.

Gaius: All water under the bridge. And, uh... Well, maybe I was wrong to take umbrage at your questions. I mean, I AM a thief. Taking things is kind of in the job description.

Sully: I've always prided myself on judging people fairly and without prejudice. But as soon as I saw my gem was missing, you were the first person I thought of.

Gaius: Well, it's not like Chrom or Lissa would be ransacking your things, now is it? Suspicion and a lack of honor are just all part of the thieving game.

Sully: "Honor is of the body; hone the body, and honor shall grow strong."

Gaius: I'm sorry, what was that?

Sully: It's a portion of the knight's code. The one I strive to follow every day. Basically, if you work your butt off, you can train both body and honor. So if you're worried about honor, don't be. I'll train the shiftiness right out of you.

Gaius: I don't know. Exercise is more of a knight thing. We thieves need our downtime.

Sully: You'll have plenty of downtime in the grave, Chuckles. We start tomorrow. At dawn. In the training yard. Oh, and maybe bring a bucket or something to puke in.

Gaius: Oh dear.

GAIUS X SULLY A

Sully: I told you to drop and give me 50, maggot! But it looks like you just dropped!

Gaius: *Pant, pant* Can't...we...take...a break? I'm feeling...dizzy. Wine. I need...wine and bread. And some... cheese...

Sully: What's that, maggot? I can't heeear you! Now get up. Warm-ups are finished—it's time to start training for real!

Gaius: Oh, for the love of all that's holy! Please, have mercy... Urk... A-all right. I'm up. Wobbling, but up. What's...next?

Sully: Good, Gaius. Very good.

Gaius: Wh-what?

Sully: I pushed you as hard as I knew how, but you still haven't given up. Everyone else who attempted my training had run home to Mommy at this point.

Gaius: If I knew running away was an option, I would have fled long ago.

Sully: Heh. You're just saying that. I can see it in your eyes that you're ready for more!

Gaius: The only thing I'm ready for is death's sweet embrace... Although now that I have my breath back, perhaps I could do another round. Truth be told, this exercise has a way of lifting a man's spirits.

Sully: Oh? Did they need lifting?

Gaius: I often brood about my misspent youth, when I was but a mere bandit. Mayhap there's something to this "good for the body, good for the soul" flapdoodle. Though more likely, I'm just too tired to think clearly.

Sully: Or maybe my training is actually taking effect. This is great, Gaius. Look how much you're learning! Tomorrow we meet an hour before dawn—we have a lot to get through.

Gaius: Argh. Please tell me that today was not just a primer for the horror to come... (I can't believe I'm actually starting to enjoy this madwoman's company.)

Sully: Stop mumbling, maggot! You've still got 23 laps to go!

Gaius: Right!

GAIUS X SULLY S

Gaius: *Gasp* *pant* W-well, Sully...? Can we...call it a day...?

Sully: What...*pant*...are you talking about... We're...just getting started...

Gaius: Except...you're sounding...a wee bit...pooped yourself...*pant*

Sully: No, you're..."wheeze"...imagining it...

Gaius: *Cough, cough* Ungh... This is... ridiculous... Wh-why can't I breathe...? Sully...I've...got something...important to ask you...but...

Sully: Important...? Like...what?

Gaius: Th-the thing is... I can't ask while we're...wheezing like a pair of asthmatic bellows.

Sully: I-it's okay... I always..."gasp" have important conversations...like this.

Gaius: If...if you insist... Here...this is *pant* for you... Sorry... Can't lift it...

Sully: It's...a ring?

Gaius: *Gasp* Yeah... I want you to...marry me...

Sully: What? Wh-why...me...?

Gaius: B-being...with you..."wheeze" gives me strength...to face...the horrible past... Long explanation... More complicated... Can't...get into it...now...

Sully: "Wheeze"

Gaius: *Pant* I know...this is...out of the blue and all, but...

Sully: I...accept.

Gaius: Eh? *cough* *splutter* Y-you do?

Sully: You're...the first...to survive my training...this far. I think...there's no limit...to how far we can..."pant" go together...

Gaius: S-sorry about...the proposal... Wanted...candles...and harp music...

Sully: N-no...it's...it's perfect... *splutter*

Gaius: How...so...?

Sully: N-normally...I can't "pant" things like...pride and shame... tie our tongues... But...now that we're at death's door... we can speak...from the heart.

Gaius: Hah ha— "gasp" *splutter* You might be...right...

Sully: I know I'm right...

Gaius: I... I think I'm...starting to get my breath back.

Sully: Whew... Yeah, so am I. Soooooon...

Gaius: Yeaaaaah...

Sully: Ready for another 10 laps?

Gaius: Sounds great!

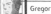

Gregor

GREGOR X SULLY C

Sully: Hey, Gregor.

Gregor: Is sad times when youngsters address elders without proper title! Sully should be calling Gregor "sir"! He is old, yes? Is only polite.

Sully: Whatever. Listen, I hear you have a fighting style that's fearsomely effective. That true?

Gregor: Many brave men will testify to Gregor's skill with blade. Is too bad all are being dead! Ho ho ho! Oh, Gregor love that joke.

Sully: Great. Then what say you and I have a duel?

Gregor: Mmm... What you pay Gregor?

Sully: You want to be paid for fencing practice? We're allies, you old coot. You should be helping me for free!

Gregor: Gregor is sellsword who swings swell sword! Dinner must get on table somehow, yes?

Sully: I'll put you on the table, old man! Never mind. Fine. But if I pay you, I get to set some conditions.

Gregor: Conditions?

Sully: You say you're a top fighter, but how do I really know that? You might curl into a ball at the first sign of trouble, and then I'm out good coin! So here's the deal: I only pay if you manage to teach me something new.

Gregor: Beautiful lady is driving for hard bargain. She is craving coin-back guarantee! But Gregor accepts, so long as he sets condition of his own... Loser must obey one request from winner! Even if humiliating! We have deal, yes? Or are you like the cat who is scared?

Sully: Deal. I'm tired of men like you underestimating women like me!

Gregor: Oy, but you are wrong... Gregor underestimate no one. Especially not muscle-bound lady with great chip on shoulder.

Sully: Then this should be interesting.

GREGOR X SULLY B

Sully: Hello, Gregor.

Gregor:

Sully: Oh, for the love of— Hello, "Sir Gregor."

Gregor: Oh, hello, Sully. Gregor not seeing you there.

Sully: I want another duel with you. A serious one. No holds barred! I've been training hard since our last skirmish, and I think I'm ready.

Gregor: Training hard? Is sounding like bad news for Gregor!

Sully: We spent so much time arguing over terms the other day that I lost the damn fight. Then you were supposed to come up with a humiliating punishment, but you didn't. Just making me call you "sir" isn't enough motivation. I need more! So come on! Get off your butt and duel me for your very honor!

Gregor: Oy, we are having place to ourselves, yes? Why speak of fighting and honor? Gregor thinks this is good time to whisper sweet nothings into ears. But, if talking with swords is better, okay. Kiss of steel is also sweet sound to Gregor. But when you lose, Gregor make you do very, very, very humiliating something.

Sully: Let's go!

GREGOR X SULLY A

Sully: Gregor.

Gregor: Oy, Sullykins.

Sully: Stop calling me that.

Gregor: Ho ho! You no like name Sullykins? But name suits you. Very ladylike.

Sully: There's nothing ladylike about it, you flea-ridden old goat!

Gregor: You wound Gregor. When comrades fight together, they give pet name, yes? Is sign of friendship and respect, yes? "Hail, Sullykins, brave and faithful ally!" Come, Gregor and Sullykins are friends. No need to make with the blushings.

Sully: I'm not...blushing.

Gregor: But newfangled name is not only reason Sullykins is embarrassed! You know real reason, yes? Sully secretly in love with Gregor!

Sully: You say that again, and I'll shove my sword so—

Gregor: Ho ho ho! Gregor likes woman with steam-filled head! Maybe he teases you more.

Sully: And maybe I'll turn you into a doormat!

Gregor: Oy, Sullykins, You draw your sword and challenge Gregor to do battle?

Sully: You have insulted me and my honor for the last damn time!

Gregor: And if Sully loses? Then what?

Sully: Then that life and honor are yours to do with as you will.

Gregor: Gregor accepts terms from Sullykins! Is ready when she is...

GREGOR X SULLY S

Sully: Gregor? I wanted to ask you something about our duel last week.

Gregor: If you want to dispute results, Gregor have nothing to say.

Sully: No. I accept that you're better. ...For now, at least. But I can't accept the punishment you gave me for losing. I lost a duel fair and true, yet you refuse to claim the damn prize. Now name your terms so we can be done with this and I can sleep at night!

Gregor: Gregor is no longer interested in competition with woman like you.

Sully: What the hell does that mean?!

Gregor: Gregor fights with you many times. Gregor wins many times. Is enough.

Sully: I already admitted you won! So if you're gonna refuse just because I'm a woman—

Gregor: Is not because you are woman. Is because you are Sully.

Sully: Oh, so now what does THAT mean?!

Gregor: Gregor cannot fight woman who he is loving so madly. So instead of beating you with sword, he buys you lovely gift instead.

Sully: ...Is that a ring?

Gregor: Gregor is wanting to marry you, yes?

Sully: I don't understand. ...Why me?

Gregor: Because you are fine woman. Strong and brave and proud! Gregor is long time admiring Sullykins from afar.

Sully:

Gregor: Gregor knows he is old man with many scars and fattened belly. So is okay if you say no. But do not be saying so because of duels! That, Gregor's poor heart could not take.

Sully: I wouldn't say no because of that. ...And actually, Gregor...

Gregor: Wait... Gregor is confused. Is meaning Sully says yes?

Sully: I've learned a lot from you, Gregor. About fencing and swordsmanship, sure. But also honor and respect. I think we could make a pretty damn fine team if we married.

Gregor: Oh, words of joyfulness! Gregor will do his happy dance!

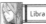

Libra

LIBRA X SULLY C

Sully: Hoofprints? This far out? Hmm... It seems they continue for some distance.

Sully: Looking for something, Libra? I can help you want.

Libra: Ah, Sully. You are very kind. And what's more, you've helped already. For it seems you are responsible for the far-ranging hoofprints.

Sully: You mean my HORSE is responsible, right? Anyway, sounds like you've got time on your hands. Mind if we talk for a bit?

Libra: I'm afraid I haven't much of interest to say, but I'm more than happy to listen.

Sully: With all the newcomers we're taking on, the camp's gotten pretty busy. It's hard to get any privacy, huh? I imagine it must be doubly hard for a woman like you.

Libra: I'm a man.

Sully: Oh. Right. Er, yeah. Of course. Well, this is pretty damn awkward.

Libra: Please. It's not an unfamiliar situation for me. Though I must say, your question is somewhat perplexing. Aren't you capable of supplying a woman's perspective yourself?

Sully: Well, yeah, sure. But...you know. I'm not exactly GIRLY. But...Gods, that came out wrong. Er, look. I'll just ask someone else. Thanks for your time, though!

Libra: Of course.

LIBRA X SULLY B

Sully: Do you have a moment, Libra?

Libra: Yes, of course. What is it?

Sully: Look, I'm sorry as hell that—

Libra: Is this about the other day? Please, Sully. You already—

Sully: Er, no. I'm actually apologizing in advance for what I'm about to ask.

Libra: That's...ominous.

Sully: I really hope you won't take this the wrong way, but I wanted to know... How do you feel about looking so... pretty? I mean...like pretty?

Libra: Oh. That is...not what I was expecting you to ask. But, well... I don't know that I take that as an insult one way or the other. There isn't much I can do about the way I look, after all. Yes, being mistaken for a woman can pose some minor difficulties. Especially in bath houses. Or taverns. Or, um, anywhere, actually. But why do you ask?

Sully: Well, see, I'm not exactly the girly type, you know? I ask people to treat me the same as a man, and I don't let anything limit me as a knight. But talking to you the other day got me thinking that... I don't know. Maybe it's just time I accepted myself more for who and what I am.

Libra: I fear I make a poor model for this question, Sully. You'd be better served by any number of others in our camp.

Sully: What makes you say that?

Libra: A man of the cloth should be a beacon of hope. A light in the darkness. He ought never let his smile falter, nor forget to treat all with warmth and respect. At the very least, that is the sort of man I aspire to be.

Sully: That's exactly the sort of man you ARE, Libra.

Libra: So you say. And yet, I cannot help but feel I am merely skilled at playing such a figure. I worry that my entire person is an act. A hollow shell.

Sully: Libra...

Libra: I apologize. It was not my intent to burden you with my idle ramblings. Pray, forget it.

LIBRA X SULLY A

Sully: Do you have a dream, Libra? Any grand goal in life?

Libra: Hmm... I suppose it would be to see the world at peace once more.

Sully: Har! I figured you'd say something along those lines. You know, it's okay to want something for yourself once in a while.

Libra: To see happiness in others brings me equal amounts of joy.

Sully: Yeah, I'm sure that's true. But sometimes you still have to think of JUST you. It's like you're actively trying to deny yourself pleasure or happiness. I just wonder why sometimes, is all.

Libra: I wonder why it is you would trouble yourself so over a humble man like me.

Sully: Maybe I'm just a nosy jerk. Ever think of that? Or maybe... Well, I dunno. I just like you, I guess.

Libra: Oh?

Sully: It's like you and me are kindred spirits in a way. The tomboy to end all tomboys, and the most beautiful man in the land!

Libra: Heh. Opposites though we are, we share quite a bit. I feel a closeness to you as well.

Sully: What do you say? You and me, partners for the long haul?

Libra: I would be honored.

LIBRA X SULLY S

Libra: Might I have a moment?

Sully: Uh, Libra! S-sure! What's up?

Libra: Are you feeling well? You look flustered.

Sully: Oh, I'm fine. I just remembered what I said the other day. I guess I'm kind of embarrassed. To listen to me run my mouth off, you'd think I was professing my love.

Libra: ...Then you weren't?

Sully: Of course not!

Libra: Well, it appears to be my turn to feel ashamed. I fear I mistook your words. How vain I must have been to go so far as to procure this...

Sully: Oh, damn. You got me a ring.

Libra: I am terribly sorry. I was so thrilled to hear when we saw one another as kindred spirits, and just... I'll dispose of this. Please think no more of it.

Sully: W-wait! It'd be a shame to waste it! I mean, it's so... Um... I accept, Libra.

Libra: This is not the sort of item I would have you accept out of pity. For a thing so small, it bears more weight than I would trouble anyone to bear.

Sully: Well, I'm pretty good at lifting heavy stuff.

Libra: But...

Sully: I'm not doing this out of pity, you damn fool! I'm doing it because I like you. ...And I want to live my life with you.

Libra: Then I will give it gladly!

Henry

HENRY X SULLY C

Henry: Hi, Sully! Need something?

Sully: Just wanted to chat, if you have a second. I'm still not completely sure how we wound up with a Plegian mage in our camp. Er, but don't get me wrong! I'm happy you're slinging spells from our side.

Henry: Happy to help! Just point me at the enemy, and I'll curse 'em to gooey bits. Pchew pchew pchew! Nya ha ha!

Sully: ...Right. You specialize in that dark-magic stuff, don't you? So, what's the deal? Can you really take an enemy out with just a curse?

Henry: Yep! Sure can. Just takes a liiiittle bit of time and planning. What about you? Ever curse anybody?

Sully: A knight is honor bound to face her enemy in fair and honest combat. I would never resort to such dirty, underhanded means! Hmm... But the enemy might... Say, Henry? I got a favor to ask. I need you to slap a curse on me sometime. No big deal, whatever's easiest.

Henry: Absolutely! I'll need a pound of flesh, seven fingernails, and your left kidney. Nya ha ha! I jest. A single hair will do just fine.

Sully: "Pluck" Here ya go.

Henry: Yay! I'll start working on this little guy so we can get you all cursed up.

Sully: You're awfully sunny for a dark mage.

HENRY X SULLY B

Sully: Mnnngh... Ch-chest...burning! F-fever...rising! C-can't...breathe!

Henry: Oh-ho, oh, oh. It looks like sooomeone got cursed! Yaaay!

Sully: Hngh... H-Henry?

Henry: Nya ha ha! One tailor-made curse, just as requested. I finally got one to take. And it was no easy task, you big overachiever, you!

Sully: C-call it off... P-please...

Henry: What, already?

Sully: Grkk... HURRY!

Henry: You got it. "Mumble, mumble" "hiss" ...All done!

Sully: "Cough" Whew... It felt like I was dying.

Henry: That's 'cause you WERE! ...You totally still had five or six solid minutes left, though.

Sully: The curse was fatal?!

Henry: Well, it wasn't going to be at first, but it turns out you've got buckets of willpower. Like I said, none of the little ones took. So I had to bump the stakes up a teensy bit. Hope ya don't mind!

Sully: You're crazy! But I'm even crazier for having asked for the damn thing... So wait a second. What do you mean about the first curses not taking? Does that have to do with strength or willpower or something?

Henry: Yep yep! That's it, all right. I can curse till I'm blue in the face, but if their will's stronger than mine? Pbbt.

Sully: Which means that you were eventually able to overcome my will. ...Thanks, Henry. I think I've got more training to do than I thought.

Henry: Aw, don't fret! You're the toughest nut I ever cracked, and I've cracked a lot. Hey, you wanna go again? I've got the cutest little death altar all set up...

Sully: I'll let you know.

HENRY X SULLY A

Sully: Hyaaa! ...HAH!

Henry: "Grunt" Yeow!

Sully: Oh, crap! Henry! Sorry about that! I didn't mean to hit you. Are you hurt? I just didn't see you there.

Henry: Aw, shucks. Just a little elbow to the face! No harm done. No sense crying over a bloody nose. Nya ha ha! ...Ooh, blood.

Sully: You know, I can't remember seeing you get upset. Not even a little.

Henry: I can't remember BEING upset. Folks here are so nice, and even bad guys are pretty great when they splatter. When life gives you lemons, use 'em to ward off scurvy. That's what I say!

Sully: No anger, no frustration, an unusually upbeat attitude... I'm starting to see how you beat me in the willpower department. I've got all kinds of anger and frustration flying around. It's tough to keep 'em in check.

Henry: Aw, you're going to make me blush. I'm nothing special.

Sully: I think it's your humility that I envy the most, actually. I feel like I'm always in a desperate struggle against my own pride.

Henry: Yeah, but you're a knight, right? You kind of HAVE to be prideful. You've got goals and focus and honor and stuff. Can't have that without pride. I think that's super great, myself. I've never had anything like that.

Sully: ...Heh. Thanks, Henry.

HENRY X SULLY S

Sully: Grrrah! ...YAH!

Sully: Training again? I'll keep my distance this time.

Henry: I've got a long ways to go if I hope to stave off your curses.

Sully: Does building an iron body make your will stronger too?

Henry: Well, it appears to be the plan.

Sully: Ability honed through training gives me confidence, which in turn grants willpower. At least, that's the plan.

Henry: Sounds like a good one to me!

Sully: You know, it was really shaken up when you were able to curse me. At first I thought I was just bitter, but I'm not sure anymore. I think there's another reason you always overwhelm me...

Henry: Nya ha ha! Guess you'd better do a few more reps than, huh?

Sully: Ha! An iron will won't help with this.

Henry: Aw, Sully. You're getting mushy on me, aren't you?

Sully: No, it's just... Well, yes, actually. Kind of. Look, you're always cheerful and confident, and that appeals to me. All right?

Henry: Oh, wow! That's great. Because I think you're pretty special, too. So is now a good time to skip on down to the market for a ring?

Sully:

Henry: Hey, tomorrow works if that's better. Wait, did I say something wrong?

Sully: Is there NOTHING that can faze you? I just proposed, and you didn't even flinch. I'll have to train harder than I thought if I want to get the drop on you.

Henry: The fighting kind of training, or the looooove kind?

Sully: Oh, your eyes are gonna bug out when you see what I've got planned.

Henry: Really? I made a pegasus knight's eyes do that once. I drew pictures! Wanna see?

Donnel

DONNEL X SULLY C

Donnel: Rraaagh!

Soldier: I yield! I yield! M-mercy!

Donnel: She's just like one of them knights out'a the stories Ma used to tell! I'm jealous somethin' fierce...

Sully: I'm not LIKE a knight, kid. I AM a knight.

Donnel: Urk! Ya heard me then, did ya?

Sully: Half the camp hears your every thought! You're not exactly subtle.

Donnel: B-beggin' your pardon, Sir Ma'am! I didn't mean nothin' by it. So, uh, do ya think maybe you could tell me what bein' a knight's like?

Sully: As long as you promise to stop calling me "Sir Ma'am." Why are you asking, anyway? Thinking of becoming a knight?

Donnel: Oh, gosh, no! It's just that knights and such in the stuff's a legend to me. Ain't never seen one back on the farm, and now here you are, and... Well, I reckon I'm curious, is all.

Sully: Curious to see how close I am to your storybook version?

Donnel: I ain't tryin' to impose on ya. If it's a big ol' hassle, just say so.

Sully: It's fine. Come find me at dinner. We can talk there.

Donnel: Thank you, Sir Ma... Er, Sully! That's mighty kind of ya!

DONNEL X SULLY B

Donnel: Thanks again for before, Sully. Mighty kind of ya to take the time.

Sully: What, our chat about knights? I'm just glad someone actually cares.

Donnel: Ya mean that? 'Cause I'd sure love to hear more, if ya don't mind none.

Sully: Oh, come on. It couldn't have been that interesting.

Donnel: I reckon not to you, but it's a whole new world to me!

Sully: Hmm... All right, then. Let's barter.

Donnel: Barter? Ah, shucks, Sully. I ain't got nothin' to offer. 'Less you wanna take an IOU on a couple'a piglets.

Sully: I don't want your livestock, Donny. I want your stories.

Donnel: You want me to tell ya 'bout life back on the pig farm? Well, it ain't like I mind talkin', but farm life's dull as rocks.

Sully: To you? Sure. But to me, it's probably going to be fascinating. I grew up in a damn castle, remember? I'm curious how you farm folk live.

Donnel: Well, I reckon I owe ya a tale or two. What say I come find ya at dinner?

Sully: Heh. You know, that sounds great.

Donnel: Hey! Ya sound just like me!

DONNEL X SULLY A

Sully: Heya, Donny. Thanks for the wild stories the other night.

Donnel: Ya mean like the one 'bout the greased-pig run? Why, sure! Farmin' ain't as glamorous as knigh-tin', but I 'spose we have our laughs.

Sully: I'd never have guessed how much fun I missed out on as a city girl.

Donnel: I wouldn't be too eager to trade lives if I was you.

Sully: Hmm?

Donnel: Well, I hate to spoil the fun, but there's lots on the farm that ain't a hoot. Stories I told only covered the good times. There's plenty that ruin a day's crop. Flood, drought, raiders... Plus, we lose pigs to sickness darn near every season. Yessir, the farmin' life's a hard one, and no denyin'.

Sully: I'm sure you're right, but knighthood's no bed of roses, either. Sure, it's glamorous, but there's politics and backstabbing behind the scenes. And you've got to follow the orders you're given, even when they're stupid. Believe me, farmers aren't the only ones with troubles.

Donnel: So you was just cherry-pickin' the good stories too, eh?

Sully: Maybe we should sit down and swap horror stories next time.

Donnel: I don't much go in for scary talk. Ain't got the stomach for it.

Sully: No, not literal horror stories. ...Just the less-happy ones. You can't understand someone's world until you know both sides of it.

Donnel: I reckon yer right about that... All right, then. It's a deal!

DONNEL X SULLY S

Sully: Hey, Donny. You up for another story session?

Donnel: Well, sure, but... Do ya really wanna hear more'a me flappin' my gums? Ain't I keepin' ya from other things? ...From other people?

Sully: You aren't keeping me from a damn thing. Look, if you're tired of our little chats, just say so.

Donnel: It ain't like that at all, Sully! Heck, I like talkin' to you more'n about anything.

Sully: Then get to it! I'm always interested in what you have to say.

Donnel: Oh gosh! Is she sayin'... Wait, she ain't sayin' she's INTERESTED interested, right?

Sully: Er, Donny? You're mumbling like a madman again.

Donnel: But she ain't said she AIN'T either... Hmm, but no...

Sully: Hey! Mumbles! If you've got something to say, then out with it!

Donnel: Gah, fine! Here! Take it!

Sully: ...Is this a ring?

Donnel: Oh gosh, Sully! Marry me, please!

Sully:

Donnel: Aw, heck. This ain't how I wanted it to go, but I was fixin' to burst if I didn't ask ya! I told ya my whole life's story, the good and the bad, and ya listened to it all. I knows yer a knight and a beautiful lady and I'm just a grubby ol' pig farmer. But ya listened, and ya cared, and darn it all if that don't make me love ya.

Sully: Pig farming's not so grubby.

Donnel: Ya wouldn't say that after muckin' stalls for ten years.

Sully: But it's honest. I know the work is hard, your village is poor, and times are lean. ...But I'll take the smelliest sty over the festering rot you find in court society. There's a beauty to farm life. That much is clear, listening to your stories. And I think I might like to give it a try.

Donnel: Then... Will ya...?

Sully: Yes, Donny. Once this war is over, I'll experience farm life, firsthand.

Donnel: Yee-haw! I feel like I'm dreamin'! Someone pinch ol' Donny!

 Lucina (Mother/daughter)

Lucina's mother/daughter dialogue can be found on page 285.

 Kjelle (Mother/daughter)

KJELLE X SULLY (MOTHER/DAUGHTER) C

Sully: Phew... That's enough for today.

Kjelle: Yes, ma'am!

Sully: You're good, kid. Good enough to keep me on my toes.

Kjelle: I learned from my mother.

Sully: What, you mean me? Er, I mean, future me? Dammit! I can't wrap my head around all this time-travel business!

Kjelle: You fight just like the mother I knew. ...Which makes sense, I suppose.

Sully: That explains why you're so hard to beat. You know all my moves. Although, wait. There's one thing I don't understand...

Kjelle: What's that?

Sully: You're not great on horseback, are you? How'd that happen? I'd think I would've taught you better.

Kjelle: But you never taught me to ride.

Sully: What? Why not? Did you guys lack to eat all the horses or something?

Kjelle: We had horses. But what we lacked was talent. Or more specifically, I lacked it, You said I was a lost cause, so I wound up teaching myself. ...Poorly.

Sully: Huh.

Kjelle: So yeah, come to think of it, now's your chance.

Sully: Oh? My chance for what?

Kjelle: To teach me how to ride! I mean, it IS your fault I don't already know.

Sully: MY fault? How is it MY fault? I haven't done anything! I haven't even HAD you yet!

Kjelle: But you will! So come on, what do you say? Please?

Sully: ...Oh, fine. You're so damn intent on learning, we'll work it into the regimen.

Kjelle: Perfect! Thanks, Mother.

KJELLE X SULLY (MOTHER/DAUGHTER) B

Sully: All right. That's it for today's training.

Kjelle: Yes, ma'am! Thank you, ma'am! So? Am I any better on horseback? Maybe just a little?

Sully: ...What do you think?

Kjelle: Not...really? Maybe I really don't have the talent for it.

Sully: Talent is an excuse! You lack practice, not talent.

Kjelle: No... You're right. I'm sorry. I guess I just got frustrated.

Sully: Still, there IS something strange here...

Kjelle: How your own daughter could be such a poor rider?

Sully: No, not that. The fact that future me told you anything different than what I just told you myself.

Kjelle: That it's a matter of talent, you mean?

Sully: Yeah. I hate that word, "talent." Always have. So why would I ever say you lacked it?

Kjelle: Well, to be fair, you never used the word "talent". I believe your exact words were "you're not suited for riding." But it's basically the same thing.

Sully: Hmm... Well I'm sure I wouldn't say it without some reason...

Kjelle: Uh-oh. Does that mean you're going to stop teaching me again?

Sully: I'm no damn quitter! We'll finish what we started or die trying.

Kjelle: Whew! Thanks!

Sully: Still, there's something funny about all of this...

KJELLE X SULLY (MOTHER/DAUGHTER) A

Sully: You have a minute, Kjelle?

Kjelle: Did you need me, Mother?

Sully: Well, I think I figured out why I didn't teach you how to ride in the future.

Kjelle: Oh no! Does this mean you're going to stop giving me lessons?

Sully: Just listen: it takes a special talent to navigate a mount atop a battlefield. You see the be-all, end-all of combat. Everyone has their own unique skill set. I think I probably wanted you to find your own way to fight.

Kjelle: But why? Riding is a crucial skill.

Sully: Because I'm your mother.

Kjelle: What?

Sully: One tiny slipup can cost a warrior her life out in the field. And if I saw a risk, no matter how small, I'd want to nip it in the bud.

Kjelle: But...you're teaching me now.

Sully: Well, uh... Look, maybe it took a little bit for the whole maternal thing to sink in. I agreed to teach you without really thinking about it. I acted like I was training a peer more than raising my daughter. ...Make sense?

Kjelle: So your thinking has changed?

Sully: Damn right it has! Spending all this time together, I feel a lot more...motherly. I think that's why I can see future me was coming from. I would've been older than you, and worried about what you'd do when I was gone.

Kjelle: So you discouraged my riding since you wouldn't always be there to protect me? ...Huh. In other words, you did what you did because you cared about me.

Sully: It's just a guess. I mean, I can't very well ask future me about it, right?

Kjelle: I suppose that means the end of my lessons. *sigh* It was fun while it lasted. I still think I'd be more effective on horseback, but I guess it's not meant to be.

Sully: Now just a damn minute—who said anything about giving up?

Kjelle: What? But you just... Aren't you saying you agree with why you stopped teaching me?

Sully: Yeah, maybe, if I was future me! But I'm NOW ME! We're practically the same age here! We can fight side by side for the rest of our lives, girly.

Kjelle: Then you'll keep training me?

Sully: Course I will! I'm sure I'd understand... Er, will understand... Er, whatever! And given we're both so young and fit, there's no excuse not to train hard! Hope you're ready to sweat...

Kjelle: ...J-just try to be a LITTLE gentle, would you?

Sully: I CAN'T HEAR YOU! LET'S GO, LET'S GO! MOVE IT!

Kjelle: Y-yes, ma'am!

 Morgan (female) (Mother/daughter)

The Morgan (female) mother/daughter dialogue can be found on page 312.

 Vaike

 Avatar (male)

The dialogue between Avatar (male) and Vaike can be found on page 219.

 Avatar (female)

The dialogue between Avatar (female) and Vaike can be found on page 230.

 Chrom

The dialogue between Chrom and Vaike can be found on page 240.

 Lissa

The dialogue between Lissa and Vaike can be found on page 242.

 Sully

The dialogue between Sully and Vaike can be found on page 251.

 Miriel

MIRIEL X VAIKE C

Vaike: HIYAARGH! HIYUUUP! GWAAAAAAR!

Miriel: Would you be so kind as to put an end to your caterwauling? I'm trying to read, but I can't hear myself think over your incessant grunting.

Vaike: Har har! You gotta give it all when ya train, or it's just a waste of time.

Miriel: ...Hmm. Yes, I suppose that makes sense. The explosive release of air from the lungs generates power in peripheral muscles.

Vaike: Who's over periwinkle mussels now?

Miriel: And rapid spin attacks create centripetal force that increases overall power. Fascinating! I imagine you used complex calculus to optimize your methods?

Vaike: Lady? From what you just said I understood "fascinating," and that's about it.

Miriel: Surely you developed these skills of yours by calculating the forces involved?

Vaike: I don't need a buncha math mumbo jumbo. I do it all by instinct!

Miriel: Irrational means have yet taken you to a rational technique... Fascinating. Perhaps this "instinct" of which you speak bears further investigation.

Vaike: Fightin' a war ain't rational, lady. Just watch me in the next battle.

Miriel: Very well. I shall do just that.

MIRIEL X VAIKE B

Miriel: Ah, Vaike.

Vaike: Heya, Miriel! So did you watch me fight or what?

Miriel: Indeed. I observed that your battle shouts enhanced the effectiveness of your blows. Often the foe would briefly let down his guard, granting you a momentary opening. I had not realized the impact war cries would have on the psychology of an enemy.

Vaike: Yeah, yeah. But what about me? What about the Vaike?!

Miriel: I observed the details of your moves, but not from the perspective of the foe. Perhaps an analogy would be helpful here... So if we were to assume that you are a planet, and the enemy is the sun—

Vaike: Hey, wait. I wanna be the sun!

Miriel: But the sun does not travel around planets. Rather, planets spin around the sun. Or so it was postulated in my mother's book. It has yet to be proven...

Vaike: You sure it's not your head spinnin'? I don't see this ground going anyplace.

Miriel: Alas, we cannot sense this motion, making the theory intuitively difficult.

Vaike: All right, sure. The ground's spinnin'. Just like when I swing my weapon, yeah?

Miriel: Yes. This generates the centripetal force we discussed the other day. I'm glad we had this conversation. It has helped clarify my thoughts on the subject. Would you mind terribly if we continued our discussions for research purposes?

Vaike: You mean chat as friends? Er, well, sure. After all, we have so much in...uh, common?

MIRIEL X VAIKE A

Vaike: Face it, lady—you've got more brains in your big toe than I have in my whole noggin. So why me? You must have egghead pals who are into this century-petal-force stuff.

Miriel: Yes, but you possess in abundance something that I do not—instinct. I learn a great deal from our conversations. They are most rewarding.

Vaike: Well, I suppose I like talkin' to you, too. Not that I understand half of whatcha say... Speakin' of which, what's that giant brain of yours thinkin' about today?

Miriel: Bonds.

Vaike: ...Bonds?

Miriel: There is nothing so complex and deserving of study as the human heart. And additionally, the bonds of friendship that arise unbidden between acquaintances. Whence do these bonds of friendship occur? How do they change us? Mold us?

Vaike: Are ya askin' me? 'Cause I'd say stuff like that just...happens. It's like...when you fight alongside someone, you start to trust 'em and like 'em better. Take us, for example. You and I are startin' to see each other more. Right? I think of you as a friend, and you think of me the same way. ...Er, right?

Miriel: I certainly find you an interesting subject for observation.

Vaike: Er, yeah... That's not really what I meant. *Sigh* For someone so smart, you sure can be pretty slow sometimes... Okay, how about this: Why don't you and I go out together?

Miriel: Go out? Where? And to what end?

Vaike: We could walk around town, maybe drop by the alehouse for a pint and some cheese? It's how folks strengthen their bonds. That's what you're interested in, right?

Miriel: I fail to see how meandering about town will impact our relationship. But I am ever willing to experiment. Perhaps your instincts will teach me something new.

Vaike: So...that's a yes, right? You'll go with me?

Miriel: Yes, by all means—take me to this alehouse of yours.

MIRIEL X VAIKE S

Vaike: Hello, Miriel.

Miriel: Ah, Vaike! My friend! Hello, friend.

Vaike: Er, you don't have to call me "friend" all the time. We can just take it as a given. The best thing about friends is bein' comfortable around each other.

Miriel: Ah, I see. I must confess, informality does not come...naturally to me.

Vaike: Aw, Miriel. Is that a blush?! Don't tell me you're gettin' shy on me now!

Miriel: Shy? Of course not. I have never— That is to say... Perhaps. Only a little.

Vaike: Heh, you sure you're feelin' all right? I've never seen ya be tongue-tied before.

Miriel: N-no, it's just... Ever since we visited the alehouse, I haven't eaten well. I assumed the fault lied with the buzzard-and-kidney pie, but...it's something else. When I think of you, I feel a...tightness. Here, in my chest. Is this friendship?

Vaike: Um... Actually, what you're feelin' is a lot more serious than friendship.

Miriel: Blast! It IS a malady. I knew it! Is it fatal? Is there a cure? Oh, I must be ill if I'm asking you of all people for advice...

Vaike: *Ahem* Proooobably could have phrased that better. ...But never mind. I think what you're feelin'...is love! You've fallen here, I have feelings for you, too. Real feelings... So yeah, I'm on board for your research, but no foolin'... I want to make you my wife! Let's get hitched!

Miriel: Do you speak of a connubial relationship? A blessed sacrament? Marriage? Well, yes. I suppose that would be an enthralling, zesty experience.

Vaike: ...You know what? I'm just gonna assume that means yes! So what do ya say? Let's blow this place and go find a ring!

Miriel: Ah, the ring. Is it a talisman that evokes the bonds of love? Or merely a symbol of the husband's right to his wife's person and property?

Vaike: ...It's just a bloomin' ring! It means I promise to be your husband and honor you and blah blah blah. It just makes it all official-like.

Miriel: Wouldn't a sealed and witnessed contract be more appropriate?

Vaike: Hah! It's just what you do, all right? If ya get married, you gotta have a ring!

Miriel: ...Fascinating.

 Lon'qu

LON'QU X VAIKE C

Vaike: Spinnin' backslash, comin' at ya! HI-YAAAAAARGH!

Lon'qu: ...Hya!

Vaike: Sweet ogre pie, that was well evaded! You're a quick little bugger.

Lon'qu: Idiot! You nearly removed my head.

Vaike: Now, now, don't get your smallclothes in a twist. I was just testin' ya, is all.

Lon'qu: Testing me?

Vaike: That's right. And you'll be pleased to know, you've met—nay, exceeded expectations! You can be my squire and pupil, and I'll see if I can't make a real warrior outta ya.

Lon'qu: I'm going to assume this is just an elaborate joke.

Vaike: C'mon, whaddya say? You can be my right-hand man!

Lon'qu: ...Gods, he's serious. I have no desire to be your pupil, fool!

Vaike: Sure ya do! Everyone does! No need to play hard to get.

Lon'qu: Such persistence! ...Very well. If you defeat me, I'll consider it.

Vaike: But you haven't had any trainin' yet! It wouldn't be fair.

Lon'qu: Where I'm from, strength is the only law that matters.

Vaike: Well, I guess that's simple enough. All right, then! Are ya ready?

Lon'qu: Always.

LON'QU X VAIKE B

Vaike: So this is where you're hidin', Lon'qu! You and me need to have another fight!

Lon'qu: I will give you as many as it takes.

Vaike: Don't get cocky on me now! I've been practicin' since the last one. This time I'll thump ya good, and then you'll have to be my squire!

Lon'qu: I have no doubt you have become stronger and more adept. But I have not been sitting idly by. I, too, have grown stronger.

Vaike: Really? Oh. Well, damn. So how about this? Let's have you stop trainin' for, say, three days. That'll give me a chance to catch up and make it a fair fight!

Lon'qu: If strength is the only law, then tell me why I would do such a thing.

Vaike: Well, because...I have a dream. And I need someone like you to make it come true.

Lon'qu: ...A dream?

Vaike: Why, yes! Glad ya asked! See, what I wanna do is—

Lon'qu: Enough! I care only for two things: the strength of your arm and the mettle of your blade.

Vaike: Sooo, that's a yes then?

Lon'qu: If it's a fight you want, then a fight you shall have! Begin!

LON'QU X VAIKE A

Vaike: Lon'qu! This time I'm ready for ya, and no mistake!

Lon'qu: After your last showing, I thought you'd be finished with duels. How many times must I defeat you before you admit failure?

Vaike: I ain't a man who gives up a dream because of a setback! ...Or, uh, two.

Lon'qu: Surely there are other candidates to be your protégé? Perhaps you can even defeat some of them.

Vaike: Graaagh! No, no, and none other! It has to be you, and none other! It isn't just your skill with the blade. It's the way ya fight in battle. You've got fire in ya! A warrior's passion!

Lon'qu: I don't—

Vaike: I need that passion to fuel my dream. That's the only way it'll come true.

Lon'qu: You seem to possess more than enough passion yourself.

Vaike: See, that's EXACTLY my point! We birds of a feather gotta stand together! I light the fuse, you provide the fuel, and then we kick heinie all over!

Lon'qu: Perhaps you have a point.

Vaike: Of course I do!

Lon'qu: But we must be equals. I refuse to function as either pupil or squire.

Vaike: Partners, eh? Sounds good to me!

Lon'qu: Then why don't you say so sooner? BEFORE we had all those fights?!

Vaike: I dunno. Guess it never occurred to me. Anyway, ya wanna hear my dream?

Lon'qu: No. So long as you can hold your own in combat, I shall be satisfied. Until the next battle...partner.

Vaike: W-wait! I gotta tell ya my dream! How can we be partners if I don't?

 Maribelle

MARIBELLE X VAIKE C

Maribelle: *Sigh*

Vaike: Uh-oh. Something troublin' ya there, Maribelle? Cares got ya down? You can tell ol' Teach all about it!

Maribelle: Oh, hello, Vaike...

Vaike: ...Wait, what? No fancy zinger? No swipes at your old friend Vaike? That ain't it at all! This must be some serious troubles, eh?

Maribelle:

Vaike: Aw, come on, Maribelle. What is it?

Maribelle: Vaike? Am I a...snob?

Vaike: ...Is THAT what you're worried about? That kinda talk never seemed to bother you before. Why now?

Maribelle: So I AM a snob! Oh, I knew it! I've been thinking a lot about myself and my behavior lately. And you know what? I'm a snob! A sad, inexcusable woman who is proud and vain beyond her station...

Vaike: Whoa, hold on now! Don't be hasty. I mean, sure, when ya first got here, ya wouldn't even look at us normal folk—

Maribelle: Yes, but you were all SO uncouth! What with the stench of the slum about you.

Vaike: Now, see, there it is again. And just when I was startin' to think better of ya.

Maribelle: Better of...me?

Vaike: Today's the first time I've ever heard ya even consider you might be wrong. Dummy that I am, I thought for a moment ya might be changin' your ways... But I guess a tigress don't slip her stripes so easily, huh?

Maribelle: Pah! I hardly think it is YOUR place to criticize ME, miscreant!

Vaike: Yeesh! The tigress kept her claws, too!

MARIBELLE X VAIKE B

Maribelle: Whoa, look at them two fat, juicy apples! Luck is smilin' on ol' Teach today!

Vaike: Well, sure. What can I do ya for?

Maribelle: I was told that Chrom wagered his dessert on some game with you and lost. This simply will not do. Gambling in such times is beyond shameful!

Vaike: If there's shame in winning an apple fair and square, it's that it don't happen more often!

Maribelle: Regardless. Hand it over, but it simply is not done. Hand over the ill-gotten fruit.

Vaike: If ya want this apple, you'll have to earn it like I did—by rollin' the dice!

Maribelle: You wish me to gamble to show you that gambling is wrong? I believe you are missing the point...

Vaike: Well, all right. If you're too hoity-toity to toss dice with ol' Teach, then...

Maribelle: I am NOT hoipy toipy... Hatty totty... Oh, FINE. Just give me the dice.

Vaike: Har har! That's the spirit! But first, ya gotta say what YOU'RE wagering.

Maribelle: Oh, whatever. It does not matter. Whatever you like.

Vaike: Oh? Whatever I want, I can have of you?

Maribelle: Virtue and right always prevail in the end. I've no doubt how this contest will turn out.

Vaike: ...You ain't gambled much before, have ya?

MARIBELLE X VAIKE A

Vaike: Er, Maribelle? Milady? Would you mind givin' this to Chrom?

Maribelle: An apple? But I lost our bet...

Vaike: Right, and that's why ya had to join me for a drink in a common alehouse. Our wager's settled. This is just me havin' a change of heart. This apple's fresh. I got it yesterday. Paid for it with honest coin and everything.

Maribelle: Then am I to assume you have renounced your gambling ways?

Vaike: Well, I wouldn't go so far as to say that. Tomorrow's another day, eh?

Maribelle: Fair enough. Still, I must admit...it was quite interesting to dine with the masses. And I ended up with an apple as well... Perhaps by losing, I actually won out!

Vaike: Heh, you really didn't mind slumming it down with us common filth, eh?

Maribelle: It was an absolutely fascinating experience! All the smallfolk are each so very different... I didn't even mind the smell, after a time.

Vaike: Yeah, it didn't exactly go like I planned... I thought I'd teach ya a lesson about how people look down your nose at 'em. But after ten minutes you had 'em all charmed. They loved you like a sister! Maybe you ain't such a snob after all.

Maribelle: Perhaps not, tee hee. Oh but you simply MUST take me there again sometime. Do promise me, Vaike!

Vaike: Uh...sure? I guess?

Maribelle: Splendid! It's a date. Now I must find Chrom and deliver his apple.

Vaike: ...The Vaike ain't wrong often, but maybe this time...I guess I must be? Maybe I misjudged that woman...

MARIBELLE X VAIKE S

Maribelle: ...Checkmate.

Vaike: Aw, donkey ears! Not again! These damn noble games are stickin' not needles in my brain!

Maribelle: Please. Tantrums are so unbecoming. ...Elderberry tea?

Maribelle: Oh, er, sorry. ...Uh, milady. Tea would be...lovely.

Maribelle: Now don't gulp it down like a drowning fish! Sip gently... Let the palate savor it... You did say you wanted to acquire noble manners, correct?

Vaike: Somethin' like that, yeah. I figured if I can get along with commoners, I can learn to like nobles.

Maribelle: Your commitment is admirable. Now, what shall we

have you do next? Hmmm...

Vaike: Hey, what about—

Maribelle: Tsk! I won our last wager, remember? Next we do whatever I say.

Vaike: Ya know, for someone so against it, you sure got fond of gambling quick!

Maribelle: This isn't gambling! It only counts if one wagers money or valuables... Speaking of which, perhaps you'd care to show me that thing you've been hiding?

Vaike: Wh-what? You mean this old thing? Aw, it's just—

Maribelle: It's a ring, is it not?

Vaike: Yeah, it's a ring. I ordered it special. Actually, it's... It's f-for you. ...Milady. It's...an engagement ring... You've got a sharp tongue, sure, but things are never dull when you're around... And old Teach just hates it when things are dull! ...So I was thinkin' maybe—

Maribelle: *Ahem* Vaike, I have decided how you can settle your debt from our last wager.

Vaike: ...Yeah?

Maribelle: Give me that ring, and make me the happiest woman in all of the realm! You may have lost the bet, but you have won my heart.

Vaike: Aw gladly, milady, gladly! ...Wait, you're saying you'll marry me, right?

Panne

■ PANNE X VAIKE C

Vaike: Panne! Ya got a sec?

Panne: Leave me be, human.

Vaike: Nope, sorry. Can't do it. We need to talk about your battle strategy. I don't like ya runnin' off and fightin' the enemy on your own.

Panne: If you desire the glory of the kill, you will have to move faster.

Vaike: This ain't about glory! When ya charge ahead like that, it puts us all in danger. We can't keep up, and then our formations start to break down.

Panne: I'll not be told when and where to fight by ignorant man-spawn! If my fighting style troubles you, you should look the other way.

Vaike: Pshaw! Not likely! Even if I wanted to, you're always in the thick of the action.

Panne: Man-spawn usually find it easy to ignore the existence of a taguel.

Vaike: Har! Like you beasts are any better. You wish all us humans would up and vanish, and ya don't mind sayin' so!

Panne: Why, you—

Vaike: Aw, don't try to deny it! We both know it's true.

Panne: Enough! If you wish me to follow you as an obedient whelp, I shall oblige. It should prove amusing watching you blunder around the vanguard.

Vaike: ...YOU? Bwa ha ha ha ha!

Vaike: ...Well, that could've gone better.

■ PANNE X VAIKE B

Vaike: Hey, Panne.

Panne: What now? Are you here to give me more unwanted battle advice? Don't worry, man-spawn. I'm staying as close to you as a mother is to her child.

Vaike: Yeah, I know. And I appreciate it. Buuut... Maybe it'd be better if ya moved a little closer to the front lines. Fightin' at the rear ain't your style.

Panne: First you tell me to stay behind, and now you order me to advance? It's obvious what your real desire is: you want us fighting shoulder to shoulder. I refuse. I don't trust you man-spawn one bit. This taguel fights alone.

Vaike: All right, I admit it. Ya got me. But I think we make a good team, and I wanted to keep ya close.

Panne: You humans are beyond trust.

Vaike: Look, I ain't the smartest guy in the room, and I don't know much about taguel folk. But I know about YOU. You're brave and straightforward and honest, and I like that. I reckon ya got more honor than most humans I've known put together. Back in the slum where I grew up, trust earned ya a blade in the back. So you're smart not to trust our lot. ...Leastwise that's how I see it.

Panne: Then why would I trust YOU?

Vaike: 'Cause there's a difference between trustin' a human and trustin' a friend. We Shepherds all look after each other. ...Or ain't ya noticed?

Panne: I had sensed a...fellowship. Almost like a pack.

Vaike: Anyway, just think it over, Panne. I've done enough preachin' for one day.

Panne: Such a strange man...

■ PANNE X VAIKE A

Panne: Vaike?

Vaike: Hold on. YOU wanna talk to ME? Ain't that a kick in the teeth! But before ya start, I gotta apologize for all my blather the other day.

Panne: No apology is necessary. For somereason, I... enjoy talking with you. But I enjoy fighting with you even more. I have learned much at your side.

Vaike: Har! They don't call me Teach for nothin'! And in truth, I appreciate the backup.

Panne: You should be more careful about diving into the midst of the foe.

Vaike: Har har! A tiger can't change his spots. Crazy Vaike, they used to call me!

Panne: Heh.

Vaike: Well slap my side and call me a drum. You CAN laugh! You should do it more often, ya know? It makes your whole face light up.

Panne: Now you mock me! I know I must seem strange and...ugly in your eyes.

Vaike: Ogre's teeth! Have you gone daft?! Taguel and humans both got beauty to spare! ...And maybe even a little ugly, too.

Panne: How can you be so blind to the gulf that exists between our races?

Vaike: I just see a woman who likes to imagine walls where there ain't none. Human, taguel, pixie, or troll: if yer loyal and true, we can be friends.

Panne: I wish I could believe that.

■ PANNE X VAIKE S

Vaike: Is it my imagination, or have we been seein' a lot of each other recently?

Panne: It is not your imagination. Whenever I have the opportunity, I stay somehow by your side. I am...comfortable with you somehow. It is a most extraordinary feeling.

Vaike: Ya actually like bein' with me? 'Cause I like havin' you around, too.

Panne: You remember our last talk? How you made me...laugh?

Vaike: Yeah, sure.

Panne: That was the first time I'd laughed since the massacre when I lost my tribe. Sometimes I wondered if I would ever laugh again.

Vaike: Har har! You just stick with me! Ol' Teach is always good for a laugh. ...Aw, heck. I was meanin' to save this, but I suppose now's as good a time as any.

Panne: A...ring? This is for me?

Vaike: Yeah, well, I was thinkin' that you and me might kinda sorta...you know, get married? I know it's forward as all heck, but I think you and me make a really good team. You can keep me outta trouble, and I can help ya be happy again! ...Maybe?

Panne: You realize what you are saying, yes? A life with me will not be easy.

Vaike: You're talkin' to Crazy Vaike, remember? There ain't nothin' I can't handle!

Panne: Well, then... This Crazy Vaike sounds like a human I could trust. So yes. I accept your ring with all my heart. Thank you!

Cordelia

■ CORDELIA X VAIKE C

Vaike: Chrom! Hey, CHROOOOOOM! Come out, come out, wherever you are!

Cordelia: Vaike.

Vaike: Ah HA! Found ya!

Cordelia: Do I look like Chrom, you oaf?! I wish you'd stop chasing him around.

Vaike: I ain't chasin' no one. We're archrivals! Our paths are destined to cross.

Cordelia: Destiny doesn't need your help, and Chrom doesn't need a rival. Stop bothering him. Let the man concentrate on winning this war.

Vaike: Bothering him?! He loves sparrin' with ol' Teach! Ain't turned me down yet.

Cordelia: That's because you corner him and refuse to go away until he agrees. Hear me, Vaike. If you hold any love for Chrom, you will let this go.

Vaike: Hmm... The Vaike is starting to think this ain't about Chrom at all—it's about YOU!

Cordelia: Oh, for the love of... Fine then. If it's a duel you want, I will accept your challenge.

Vaike: ...YOU? Bwa ha ha ha ha!

Cordelia: That's right. If you want to fight Chrom, you have go through me first.

Vaike: Oh, I get it—you think you can weaken me so I'll lose when I take on Chrom after? Hah! I could take the two of you with both hands tied behind my back! Let's go, sister!

■ CORDELIA X VAIKE B

Vaike: GYAAA! I almost had Chrom that time... I was so close!

Cordelia: No matter how often you lose, you never give up, do you? It's almost...admirable. But why do you insist on using an axe? Chrom has the advantage with his sword.

Vaike: Pshaw! I don't need no fancy weapon-match-up mumbo jumbo. If I start thinkin' on the battlefield, I'm done for! I stick with what I know: instinct, brute strength, and the stupidity to keep fightin'!

Cordelia: Do you really want to beat Chrom?

Vaike: What do you think?!

Cordelia: I've been watching you fight. You have the ability and talent, no doubt. But it's obvious you never learned the basics. Too pigheaded, I'm guessing...

Vaike: Hey, who you callin' a pig?! I wash all the time!

Cordelia: There are better ways to fight than swinging the axe wildly around your head. If you like, I can show you some techniques.

Vaike: You really think you can help me beat Chrom?

Cordelia: I can give you the tools. It's up to you to make them work.

Vaike: Well, I got nothin' to lose. Let's do it!

Cordelia: I should warn you, though... I don't go easy on my students.

Vaike: Well I should warn you: you ain't never had a student like the Vaike!

■ CORDELIA X VAIKE A

Cordelia: Phew. Let's take a breather.

Vaike: *Pant, pant* S-s-so soon...? B-but I can... keep...going...

Cordelia: Bold words...if we ignore the fact that you can barely gasp them out. Rest and recovery are important parts of training. So now, we rest.

Vaike: *Wheeze* Well, if...if you insist... I'll...just sit here...on the ground. Blistering bulls... I'm damn near dead...

Cordelia: I must say, Vaike, you've impressed me. I didn't expect you to learn so much in such a short period of time.

Vaike: Me either! I never had much patience for learnin' the basics... But you make it kinda fun. I'm pickin' up stuff I'd never learn alone. Hmm... I guess my way isn't always the best way after all.

Cordelia: Why, how very unlike the Vaike to recognize that.

Vaike: Takes a real man to admit when he's wrong! ...Or consider it, I guess.

Cordelia: In any case, I'm very pleased with your progress.

Vaike: There is one thing that's botherin' me though...

Cordelia: What's that?

Vaike: Well, you know how me and Chrom are archrivals of destiny and all... By teaching me, aren't you helpin' to take him down in a way?

Cordelia: By making you stronger, I help Chrom to grow strong as well. Only by being challenged can we hope to better ourselves.

Vaike: Hmm... Yeah, I guess that makes sense.

Cordelia: The Shepherds need everyone at their best, and that includes you. So your training is actually for the benefit of everyone.

Vaike: Gads! When it comes to usin' yer noggin, you could give [Robin] a run!

Cordelia: That's only because you never use your own head that we all seem so intelligent.

Vaike: Hey, now wait just one—

Cordelia: Looks like someone has his wind back! Shall we get back to work, then?

Vaike: Yes, ma'am!

■ CORDELIA X VAIKE S

Cordelia: Remember: this is REAL training. I won't be going easy on you.

Vaike: Gimme everything you got! The Vaike's gotta defeat Chrom!

Cordelia: Har har, yes! Didja see that?! I won a round against Chrom! I mean, he won one, too, so I guess it's technically a draw. But still!

Cordelia: I did see—it was quite the spectacle. Both of you fought to your limits.

Vaike: The sword's not my first choice, but I SWORE I'd win one eventually! 'Sides, I reckon beatin' Chrom was the only way to cut through your heart's defenses...

Cordelia: ...What are you talking about?

Vaike: Maybe it's time you stop waitin' on Chrom. There's others just as worthy.

Cordelia: I...I have no idea what you are talking about! And furthermore—

Vaike: And when I say "worthy," I'm talkin' about the Vaike, natch! What say ya turn some'a that single-minded devotion my way?

Cordelia: B-but, I'm still not sure I properly understand...

Vaike: You've got passion, and I got passion! I'm thinkin' we can fan each other's fires and really set things ablaze! ...Here, I want ya to have this.

Cordelia: ...This is a ring. Vaike, are you...proposing?

Vaike: It's custom made, ya know? Had it crafted a while ago. I was hopin' I might knock Chrom outta your heart. And, well...I guess I'm still hoping. What do you say? I got a chance or what?

Cordelia: I, er... Well... What I want to say is... Yes, Vaike. Yes.

Vaike: Truly? You'll marry me?! Gods blow me down if this ain't the best day of the Vaike's whole life!

Cordelia: Well the Cordelia feels the exact same way, hee hee...

Nowi

■ NOWI X VAIKE C

Nowi: *Sniffle*

Vaike: Hey! What's all the snifflin' about?

Nowi: Oh, n-nothing...

Vaike: Ha! You can't fool the Vaike! I'm a master of psych... Er, psik... Ya know. Mind stuff!

Nowi: I had a frightening dream.

Vaike: A nightmare, eh? What about? Beasts? Ghouls? Snaggletooth witches?

Nowi: I was all alone. Everyone had left me. Even Chrom and [Robin].

Vaike: Well, that's a daft dream! Chrom and [Robin] would never do that. Heck, no Shepherd would do that!

Nowi: But in a hundred years you will. You'll all be gone.

Vaike: Oh. Well, I guess so, yeah.

Nowi: Then I WILL be alone! Waaaaaaaaaaaaah!

Vaike: Look, ya can't go weepin' over what might happen a hundred years from now! Ya gotta live in the present and have fun while ya still can.

Nowi: That's easier said than done.

Vaike: If you've got time to brood about future centuries, you've got time to have fun. In fact, let's play a game right now! How about Headless Soldier?

Nowi: Yaaay!

■ NOWI X VAIKE B

Nowi: Okay, I think I've got it this time... PLTHTHTH... PSZZZTHTHTH...

Vaike: BWA HA HA! That's the worst whistlin' I've ever heard! Here, let me show ya again...

Nowi: No! I've almost got it. Listen... PLSHTHTHTHT... *splutter*

Vaike: Ya sound like a camel that swallowed bagpipes. But you're lucky. You got all the time in the world to practice.

Nowi: Lucky? Ha! I don't see what's so great about it.

Vaike: Gallopin' geldings, what I wouldn't give for an extra century or two! Then I know I could make my dream come true!

Nowi: Dream? What dream?

Vaike: To become the greatest warrior in the land and help the children of my old slum town. I want to improve their lot so they can help pull up folks around 'em. By the time I'm done, I'll have made life better for EVERYONE!

Nowi: Oh! What a wonderful dream!

Vaike: I was inspired by the exalt. She made a speech in my town once, see? But the thing is, I don't have enough time to make it all happen. If I had a few extra decades, I might be able to make everyone's life...

Nowi: Hey, I have an idea! If you die before you fulfill your dream, I could take over! With the two of us together, I know we could make it come true.

Vaike: Really? You'd do that for Ol' Teach?!

■ NOWI X VAIKE A

Nowi: *Siiiiigh*

Vaike: Aw, come on! You're too young and pretty to be mopin' like this!

Nowi: Vaike, I'm older than you. ...MUCH older.

Vaike: Yeah, I know. But you're still a kid at heart, right? Anyway, what's the matter? Another scary dream?

Nowi: The thing is, Vaike, I really like you. And that makes me sad. *Sniff* Because it means I'm gonna miss you when you're gone!

Vaike: Hey, don't bury me yet! And besides, you'll be helpin' me with my dream. It's like havin' me right there!

Nowi: I promised to do that, and I will. But it's going to be so awful and sad...and...lonely without you. And then everyone else is gonna go away and...and... WAAAAAAAAAAAH!

Vaike: H-hey now! Don't start cryin', Nowi! I ain't goin' nowhere.

Nowi: P-promise? *sniff*

Vaike: I guarantee it! So wipe away those tears, and let's start enjoyin' the day!

Nowi: Th-thanks, Vaike. I feel better.

Vaike: Har har! That's more like it!

■ NOWI X VAIKE S

Nowi: Hey, Vaike? Is it really true that you'll never leave me?

Vaike: This again? Look, Nowi! I promised, didn't I? How many times are ya gonna ask the same question?!

Nowi: I'm sorry. But I can't help thinking it's a promise you won't be able to keep.

Vaike: All right, all right! One more time. I vow to never leave you—cross my heart!

Nowi: Oh, thank you, Vaike! As long as YOU'RE with me, I'll never be lonely!

Vaike: My company's that good?

Nowi: It sure is!

Vaike: Well then, uh... Maybe you'd do me the honor of acceptin' this.

Nowi: Oh, a ring! How pretty!

Vaike: Now you don't have to ask if I'm leavin' again. This proves I'll stay.

Nowi: It...proves it?

Vaike: That's right. It means I'll be your friend and stay by your side forever.

Nowi: But what about—

Vaike: Yes, even after I'm worm food! All ya have to do is close your eyes, twist this ring, and imagine me. Next thing you know, I'll be standin'

right next to ya! So stop worryin', all right?

Nowi: Th-thank you, Vaike. You have...no idea what this means to me... *sniff*

Vaike: Aww, don't start cryin' again!

Tharja

■ THARJA X VAIKE C

[Robin]: Hello, Tharja.

Tharja: Oh, [Robin]! *siiiiigh*

Vaike: HEEEEEEY, THARJA! Whatcha up to, sister?!

Tharja: Nothing you'd be concerned with. ...Or understand.

Vaike: Hah! That's where you're wrong. When some creepy mage is followin' a friend around, Teach MAKES it his concern!

Tharja: I'm not going to hurt [Robin]. I just find (him/her) fascinating. You on the other hand...

Vaike: Hey, that [Robin]'s a handsome (lad/lass), and no denyin'. Soft, silky hair... (Strong, bulging/Round, shapely) —

Tharja: Gods, you men are all the same. Completely obsessed with appearances. My attraction to [Robin] is something I experience on a higher plane. It's a meeting of the minds.

Vaike: Well, maybe you and me could meet minds! Folks say the Vaike is pretty spiritual.

Tharja: You'd need to have a mind before I could consider meeting it.

Vaike: Aw, come on! Gimme a chance! I'm all about meetin' stuff!

Tharja: I'd have a better chance conversing with a donkey. ...Now go away before I decide to stab you.

Vaike: Monkey dung! What's that? [Robin] chump got that I don't? Well, I'm gonna find out, or my name ain't the one and only Vaike!

■ THARJA X VAIKE B

Tharja: It was so very nice to see [Robin] today. Hee. I think I'll just sit here for a bit and bask in the glow of—

Vaike: HEY-OOOOOO, THARJA!

Tharja: ...Or perhaps I'll end my day by killing a man. What do you want, you great sack of suet? Are you spying on me again?

Vaike: Nope! Well, I mean, I WAS for a while, but I trust ya now. I had to make sure you weren't up to any witchy business with my pal, [Robin].

Tharja: If I catch you spying on me again, I'll turn you into a toad.

Vaike: Hey now! Ain't no need for those kinda threats!

Tharja: I don't make threats. I make promises. Besides, isn't that what you want?

Vaike: Turnin' into a toad? Are ya batty?!

Tharja: Nothing is more intimate than having a hex cast upon you. The spell creates a bond between the mage and victim—a resonance of souls. You WERE eager to connect with me on this level, were you not? And besides, being a toad might increase your intellectual capacity.

Vaike: Sweet, crispy goat haunch! I barely understand a thing you say! But ol' Teach thinks bein' soul mate to a fine gal like you might be preeetty sweet.

Tharja: You'd have better luck being a soul mate with the gunk beneath your fingernails.

Vaike: Waaait. Are you implyin' I'm stupid? 'Cause if you are, you're WRONG!

Tharja: Evidence suggests otherwise.

Vaike: Oh, he does, does he?! Well, I'm gonna find this Evidence fella and give him what for!

■ THARJA X VAIKE A

Vaike: Oh ho! Now THIS is a surprise.

Tharja: Shouldn't you be off eating dinner with the others? I hear they're having lamb. You can throw the bones on the ground and everything.

Vaike: Yeah, well, shouldn't YOU be havin' dinner, too?! Whatcha doin' out here all alone?

Tharja: Nothing that concerns you.

Vaike: Look, you can't brush me off that easily. Teach knows why you're here, see? You're thinkin' about the battle today, yeah? About how some folks got hurt? Don't go blamin' yourself for that, now. You did all ya could.

Tharja: ...I should have done more.

Vaike: Look, you're a creepy lady and all, but ya still shouldn't be so focused on the dead. I mean, there's plenty of livin' around here still, right? So why not focus on them? Here, I brought ya figs and part of a pie. Thought ya could use a meal.

Tharja: You planned this?

Vaike: ...Huh?

Tharja: You didn't just pass here by accident. You knew I was upset and followed me!

Vaike: Look, if ya keep askin' questions, this pie's gonna get cold.

Tharja: ...Perhaps I stand corrected.

Vaike: About what?

Tharja: I thought you lacked the ability to understand my mind. I may have been wrong.

Vaike: Didja say that? I totally forgot. Now dig in!

■ THARJA X VAIKE S

Tharja: One bat wing... A dash of pig tail... And then...

Vaike: HEEEEEEY, THARJA!

Tharja: I hope this ain't dinner yer makin'! Bwa ha ha ha! ...Er, no, seriously. Whatcha up to?

Tharja: I'm brewing a potion for a spell.

Vaike: Har! What is it? Fireballs? The Vaike loves fireballs!

Tharja: I'd rather not say.

Vaike: Why not? Ya gonna cast it on me? Bwa ha ha ha!

Tharja:

Vaike: Hey, wait! You ARE gonna cast it on me?! N-now look, sister! Ol' Teach told ya he don't wanna be no toad!

Tharja: It's not a toad, I promise. ...Ah, there we are. Done. All right, Vaike. Drink.

Vaike: Heck no!

Tharja: You need to trust me, Vaike. This potion is special. It will allow me to capture your heart.

Vaike: Wait, it's a LOVE potion? Har har! I coulda saved ya the bat wings! Before ya go pourin' stuff down my throat, take a look at this.

Tharja: This looks like a ring.

Vaike: See? Ya don't need spells or magic or whatnot to get my heart. Ya already got it!

Tharja: Very well. I accept your proposal.

Vaike: Aw, see? That's just swell! So, uh, maybe you'll just pour out that potion there, eh?

Olivia

■ OLIVIA X VAIKE C

Vaike: ...Huh?

Olivia: *Sob*

Vaike: What's wrong there, Olivia? Whatcha cryin' about?

Olivia: The scent on the wind.

Vaike: *Sniff* ...Huh? Wind smells fine to me! What's wrong with it?

Olivia: It's the fragrance of change—of the passing of the seasons. I cannot help but weep.

Vaike: It's the what now?

Olivia: Oh, no! Did I say that out loud?! Oh, I'm so EMBARRASSED! D-don't look at me!

Vaike: Er, yeah. I'm gettin' increasingly confused by this conversation.

Olivia: Why do these kinds of things ALWAYS happen to me?!

Vaike: You mean sniffin' the air and breakin' into uncontrollable sobs?

Olivia: Stars on a cloudless night... A single strawberry on a plate... A flock of birds soaring across the blue skies... Such beauty strikes my heart and overcomes me with emotion!

Vaike: Just sounds like yer cryin' over a buncha weird stuff, if ya ask me. But hey, we all got our problems, right?

Olivia: Yes...I suppose so.

Vaike: Er, so these mooning fits of yours don't happen on the battlefield, right?

Olivia: Oh, no! In combat, I remain totally focused at all times.

Vaike: See then? Ya got nothin' to worry about! Still, ya might wanna avoid sniffin' the air with other folks around. People think you're weird.

Olivia: Er, yes. I'll try to keep that in mind. I'm sorry for putting you to trouble.

Vaike: You ain't gotta apologize to ol' Teach! Just keep yer chin up, all right?

Olivia: Oh, yes. Of course. I'm sorry I'm not more cheer—

Vaike: Ogre's teeth, lady! Stop apologizin'!

Olivia: S-sorry...

■ OLIVIA X VAIKE B

Vaike:

Olivia: Oh, I'm SO sorry, Vaike!

Vaike: Lemme guess: ya saw a wildflower at the bottom of the cliff and got all weepy. And THEN ya nearly fell off the dang thing 'cause ya couldn't see. That the gist of it?

Olivia: Th-that's about it, yes. If you hadn't come along...

Vaike: You'd have plummeted to your death. I know. Listen, why are you like this?

Olivia: I don't know! I just... *sniff*

Vaike: You're like one'a them long-haired weirdos that bangs gongs in the street.

Olivia: *Sniff* I'm sorry.

Vaike: Gads, you do like to apologize, don't ya? I really wish you'd knock it off.

Olivia: S-sorry...

Vaike: Look, stop it. Try to say somethin' else for a change, all right? Like "Oh, Vaike, yer so wonderful!" or...somethin'.

Olivia: Er, well... That is...

Vaike: C'mon, you don't have to be so shy! You're talkin' to the Vaike here!

Olivia: Th-thank you.

Vaike: Hmmmmmm?

Olivia: For...you know. Saving me. Just now.

Vaike: Oh, that. Har har! That ain't nothin'.

Olivia: Oh, gosh. That wasn't a very good thank you, was it? I'm so sorr—

Vaike: DON'T say it! It was great! Perfect! No need for any more apologizin'!

Olivia: Oh, you must forgiv— Er, I mean...all right.

OLIVIA X VAIKE A

Olivia: Oh, er, Vaike?

Vaike: Yep?

Olivia: I...wanted to say something about earlier. When I almost fell off the cliff.

Vaike: Just so long as ya don't go apologizin' again!

Olivia: Oh, no. Actually, what I wanted to say was... Vaike, I think you're wonderful.

Vaike: Huh?

Olivia: Oh, GODS! Did I say the wrong thing?! I did, didn't I? Oh, I'm just going—

Vaike: No, it was fine! I just...wasn't expectin' it, is all. And while I agree about the wonderful bit, what's it got to do with the cliff?

Olivia: Well, er, it's just that when we spoke afterward, you told me... That is... See, you asked me to say that you're wonderful. So I thought about it, and—

Vaike: That was AGES ago!

Olivia: Er, so?

Vaike: Look, Olivia. Ya can't just go savin' up compliments for whenever. If somebody does somethin' great like savin' yer life, ya tell 'em right away! Not weeks later when everyone's forgotten about it!

Olivia: Oh. Sorry.

Vaike:

Olivia: But you DID save my life. So now I have to find some way to repay you.

Vaike: Well, there is ooone thing you could do for me, I s'pose. Wanna hear it?

Olivia: Oh, yes! Please, I'd love to!

Vaike: No more apologizin' to me. Ever.

Olivia: Er...

Vaike: "Sorry this" and "sorry that" makes it impossible to have a proper chat. And, frankly, I was kinda hopin' we could sit down and talk sometime!

Olivia: Oh? I-I see... Then I'll try...

OLIVIA X VAIKE S

Vaike: Say, Olivia? You got a sec? I was hopin' we could chat.

Olivia: Of course, Vaike. What is it?

Vaike: Well, I was just thinkin'... Ever since ya stopped with the apologizin', we've been havin' some great times! Don't ya think?

Olivia: Oh, er...yes... I suppose... I mean, I like talking to you! ...I think. Mostly.

Vaike: Right! And 'cause it's all goin' so swimmingly, I thought I'd give ya this. If ya take it, we'll be able to keep talkin' till we're old and batty!

Olivia: ...Oh my gosh, Vaike. Is this a ring?

Vaike: Oh, and uh... You know our little rule? Well, consider it something for when you—

Olivia: What do you mean?

Vaike: I mean, ya can apologize to me right now if... ya know. If ya need to. Otherwise it'd be hard for ya to turn me down and all. I mean, if that were— Hey, are you backin' away from me?

Olivia: Oh, gods, I'm SO embarrassed, I have to... I have to...

Vaike: Hey, it ain't like I do this every day or anythin', sister!

Vaike: Mopin' monkeys, she just took off! She's a funny one, that girl. Hope she comes back soon. The Vaike don't wanna stand here all day like a chump... Yup. Aaanytime would be great. Just any old time now.

Olivia: ...Er, Vaike?

Vaike: There she is!

Olivia: Um, that was... I mean... I shouldn't have run off like that.

Vaike: It's all right. You can say it. I told ya, apologies'll be accepted.

Olivia: No. That's the thing... You don't have to lift the rule. ...See?

Vaike: ...You're wearin' it? You're wearin' the ring?!

Olivia: I think it suits me.

Vaike: Course it does! I ordered it all special for you!

Olivia: I'm very honored, Vaike. Er, Vaike?

Vaike: Yep?

Olivia: I...I love you.

Vaike: Holy ogre toes! Why didn't ya say so before now?!

Olivia: Because I'm...bad at communicating...

Vaike: Look, I tell ya what. You marry me, and I'll be the talkin' for the both of us. Sound like a plan?

Olivia: It certainly does!

Cherche

CHERCHE X VAIKE C

Vaike: Egads, lady! That STINGS!

Cherche: Hush. That's how you know it's working.

Vaike: Your bedside manner could do with a bit of work.

Cherche: You're the one who tried to fight my poor wyvern, Minerva, with your bare hands! If I hadn't come along when I did—

Vaike: If you hadn't come along, I woulda won! I was just linin' up my finishin' blow.

Cherche: Is this when you were curled on the ground with your hands over your head? Or when you were running amok like a sad, headless chicken?

Vaike: H-hey! How long were you watchin' ol' Teach, anyway?

Cherche: Oh, look. Another cut.

Vaike: YEEEEEE-OWCH!

Cherche: Hee hee! Now, the next time you fancy wrestling a wyvern, don't expect me to save you. Stay away from the stables unless you want to serve as Minerva's supper.

Vaike: Bah! That dumb lizard just got lucky. Next time I'll show her who's number one!

Cherche: ...Number one in her feed bowl, perhaps.

CHERCHE X VAIKE B

Cherche: Vaike? What are you doing to Minerva?

Vaike: Huh? Me? With Minerva? Well, I, uh... Oh, you mean THIS Minerva! ...Yeah, I ain't doin' nothin'.

Cherche: Then why are you crouched in the mud while she stands over you and drools? Down, Minerva! Down! ...That's a good wyvern. You know she's playing with you! I haven't seen her this excited since the time she brought down that wild griffon.

Vaike: Yeah, well, ya know how it is. Mutual respect grows when ya fight with folks and...all that. Ain't that right, Minerva? Har har har!

Cherche: Are you saying you've learned to communicate with my Minerva? This is really quite amazing. She's actually taken a shine to you!

Vaike: Yeah, but you're still number one in her book.

Cherche: Oh, I'm glad you two are getting along.

Cherche: Just don't get TOO friendly with her. She's MY wyvern, remember?

Vaike: Wh-what?! Har har! No! Ol' Teach wouldn't dream of it.

Cherche: ...Now will you please clamber out of the mud and come over here? You've picked up a few more scratches from your latest play session.

Vaike: You ain't gonna use more of that stingy stuff, are ya?

Cherche: We'll see...

CHERCHE X VAIKE A

Cherche: So? How was your first experience riding on the back of a wyvern?

Vaike: It was amazin'! Everybody looks so tiny from up there!

Cherche: I'm astonished she trusts you enough to let you ride on her back. You two have truly formed a special bond.

Vaike: Well, I've been feedin' her and givin' her water and cleanin' out her stable, so...

Cherche: Is that so? Why, thank you, Vaike.

Vaike: Aw, it's my pleasure! Anythin' to help out a friend, right? ...Heh. I used to think wyverns were hideous lookin', but Minerva's just a big ol' puppy!

Cherche: It's true—they really are the most adorable creatures around! We've been together for over 10 years, and she's more beautiful than ever.

Vaike: Wait a second! You were ridin' Minerva back when you were a kid?! How's that possible? And where'd ya get her, anyway?

Cherche: I met her when I wandered into Wyvern Valley.

Vaike: Blisterin' behemoths! You entered that chasm of horror ALONE?! As a KID?!

Cherche: I wanted to have an adventure. Minerva was just a baby then, with the cutest round eyes!

Vaike: That's...kind of amazin'. Okay, so you brought her home, right? What then? Didja fight duels to get to know each other or what?

Cherche: Not exactly. I was training to be a cleric at the time and used a very heavy staff. Whenever she misbehaved, I'd just bonk her on the head. Soon she was meek as a bunny, and I was riding her to school.

Vaike: That musta been a handful for your teachers...

Cherche: Ever since then, Minerva and I have been simply inseparable. Oh, I forgot—I also apologized for bonking her on the head.

Vaike: Beautiful, smart, funny, AND kind! You are some woman, Cherche!

Cherche: Sir, you should know that flattery will get you nowhere with me.

Vaike: It ain't flattery! It's the truth! Seriously. Ol' Teach ain't bright enough to think up flattery on the spot like that.

CHERCHE X VAIKE S

Vaike: Heya, Cherche.

Cherche: Oh, hello, Vaike. Are you here to see Minerva?

Vaike: Nope. I'm here to see you. Actually, uh... I've kinda been usin' Minerva as an excuse for a while now. I just like bein' around ya, ya know? You're smart, and funny, and...I dunno. I like it.

Cherche: So you made friends with Minerva in order to get closer to me?

Vaike: I wasn't tryin' to deceive ya or nothin'! I just couldn't think of a better plan.

Cherche: How delightful!

Vaike: Look, I... I kinda got ya somethin'. Ordered it special and everythin'. It's a ring. See, I was hopin' ya might... I dunno. Marry me?

Cherche: Why, that's very sweet, Vaike. But what about Minerva?

Vaike: Oh, she'd be part of the family, too!

Cherche: Are you sure you want the responsibility? Feed costs alone are a tremendous burden. You can't just let her fly around and pick up random animals off the hillsides.

Vaike: Oh, that ain't good. I've been lettin' her roast wild boars and stuff. But, uh, sure! If you want it, I'll buy her the finest wyvern chow around!

Cherche: Oh, and we'll need a house that has room for all three of us.

Vaike: Gods' beards! That's a huge house! I suppose I'll have to build it... But, uh, can it maybe wait until after the war?

Cherche: That should be fine. Oh, wait! Another thing...

Vaike: Monkey meat, there's MORE?! Listen, I don't mind—

Cherche: Ah. I see. Hee hee hee! I'm just joking, Vaike. ...About everything. As long as you promise to be kind to Minerva, that's all of us needs.

Vaike: Well, that's a relief! I thought you were gonna make a pauper out of the Vaike! So will ya marry me, then?

Cherche: How could I possibly turn you down? Of course I will!

Vaike: Aw, man! You just made me the happiest man in the realm! I can't wait to see Chrom's face when I tell him I'VE got the prettiest girl!

Cherche: Oh, Vaike. Minerva will be so pleased that you said that about her!

Vaike: I wasn't talkin' about the wyvern...

Owain (Father/son)

Owain's father/son dialogue can be found on page 289.

Inigo (Father/son)

Inigo's father/son dialogue can be found on page 293.

Brady (Father/son)

Brady's father/son dialogue can be found on page 297.

Kjelle (Father/daughter)

Kjelle's father/daughter dialogue can be found on page 299.

Severa (Father/daughter)

Severa's father/daughter dialogue can be found on page 305.

Gerome (Father/son)

Gerome's father/son dialogue can be found on page 307.

Morgan (male) (Father/son)

The Morgan (male) father/son dialogue can be found on page 309.

Yarne (Father/son)

Yarne's father/son dialogue can be found on page 314.

Laurent (Father/son)

Laurent's father/son dialogue can be found on page 316.

Noire (Father/daughter)

Noire's father/daughter dialogue can be found on page 317.

Nah (Father/daughter)

Nah's father/daughter dialogue can be found on page 318.

Stahl

Avatar (male)

The dialogue between Avatar (male) and Stahl can be found on page 219.

Avatar (female)

The dialogue between Avatar (female) and Stahl can be found on page 230.

Lissa

The dialogue between Lissa and Stahl can be found on page 242.

Sully

The dialogue between Sully and Stahl can be found on page 251.

Miriel

MIRIEL X STAHL C

Stahl: ...Ninety-eight...ninety-nine...one hundred! Phew...

Miriel: Why do you repeat that same motion over and over again?

Stahl: Have you never heard of shadow fencing?

Miriel: I assume it entails performing sword strikes and parries with an imaginary opponent. Is the point of the exercise pure kinetic stimulation, or is there more to achieve?

Stahl: Well, by making moves second nature, you can perform them better and faster.

Miriel: Interesting. So the goal is to remember the moves in your muscles, not your mind. I think this process warrants further study. Would you mind terribly much if I observe?

Stahl: In theory, no. But I've just finished for the day and I'm exhausted...

Miriel: Ah. I see. That is disappointing. ...Most TERRIBLY disappointing.

Stahl: B-but if you really want, I suppose I could run through a few more drills...

Miriel: I believe two hundred repetitions would be sufficient to establish a baseline.

Stahl: T-two hundred?! Good gods, I don't have the energy for that!

Miriel: ...Most TERRIBLY disappointing.

Stahl:

Miriel: Well, I suppose I can find another, more lucrative field of study. Perhaps I will just...observe this rock. Yes, that should suffice. Hmm... It's round. And smooth. Wait! ...No, it's still round.

Stahl: ARGH! All right, all right. I'll do it. Just stop making me feel bad. *Sigh* Here we go. One...two... th-three...

Miriel: Excellent.

MIRIEL X STAHL B

Stahl: H-here's...the finish line...at last... *pant, pant* *wheeze*

Miriel: Hmm... You circumnavigated the camp ten times, and your total time was... Fascinating!

Stahl: M-Miriel... *pant* Every day...you grow more like a demon...sent to torture me... Have you observed *wheeze* enough running now? Can I please stop?

Miriel: I see no harm in taking a short break.

Stahl: Phew... Thank goodness... So...what *pant* did you learn?

Miriel: As you may know, I have been observing everyone's training, and not just yours. And in every measure of performance, you come out at the exact median.

Stahl: I do?

Miriel: Be it arm strength, running, stamina, or anything else, you are perfectly average. If I didn't know better, I'd say that your methodology was flawed. It's something of a scientific miracle that you can be so completely unoutstanding.

Stahl: Yes, well. That's just the sort of man I am!

Miriel: You are aware of your ordinariness?

Stahl: Yeah, I've always tended to be more or less like everyone else. I do about the average amount of training everyone else does, but...you know. Meh.

Miriel: Yet it is remarkable that you are able to precisely hit EVERY statistical mean. You must allow me to investigate further. And to do that, I need more data.

Stahl: D-do you mean...?

Miriel: Yes. Your break is over. Ten more laps around the camp, please!

Stahl: She IS a demon!

MIRIEL X STAHL A

Stahl: Ninety-eight...ninety-nine...one hundred! Phew. All done!

Miriel: Fascinating. I've now directly observed the results of your repetition drills. Compared with the first time I watched you, your movements are smoother and faster.

Stahl: That's because you keep making me do them over and over again. But I wager I'm still only as good as half the people in camp, right?

Miriel: Yes. That's an extraordinary result.

Stahl: Extraordinary? But I've always been Sir Average! Why would that change?

Miriel: Because in recent days, all of your skills and statistics have improved dramatically. And yet, you remain in the very center of my graph. See? At the top of this bell curve.

Stahl: Wait, wait. So while I got better, everyone else ALSO got the exact amount better?

Miriel: Everyone in the army is aware that you are the most average soldier. Therefore, when they see you improve, they feel compelled to improve as well. In this way, they are able to avoid falling below the expected mean.

Stahl: I see... So it's not just a matter of me adapting to everyone around me... It's about THEM seeing ME and adapting to THAT. Wow, thanks, Miriel! I'm way more influential than I ever imagined!

Miriel: I'm simply grateful for the chance to observe such a fascinating phenomenon. I hope you will allow me to continue my analysis and experiments?

Stahl: Of course. For as long as you like!

Miriel: Excellent.

MIRIEL X STAHL S

Stahl: Aaaaaand...finish line. *pant, pant* Heh heh. After this, everyone'll have to work REAL hard to keep me average!

Miriel: Stahl, you are blessed with a most remarkable skill.

Stahl: You mean, a most average skill, don't you?

Miriel: The ability to be ordinary at everything is, in fact, most extraordinary.

Stahl: Er, well, I suppose that makes sense in a totally nonsensical kind of way. But listen, I found something else about me that isn't average.

Miriel: You have piqued my curiosity. Please, edify!

Stahl: This is difficult to put into words. ...Er, especially to you. But let me try. The other thing I'm not average at is... being in love with you. Because without a doubt, I love you more than anyone else in the world!

Miriel: Is this a jape? Some manner of revenge for my making you exercise?

Stahl: No jape, milady. The honest truth. And I have this ring to prove it.

Miriel: In other words, you wish to be my lifelong partner. Is that correct?

Stahl: It means I want to be your husband! I admit, I used to hate all the running you made me do. But now I live for it. I can't wait to get out there and jog or chop wood or whatnot! I like that you're always watching and making notes, and I want that to continue.

Miriel: And I, for my part, am anxious to continue my observations. And more importantly, I also harbor some measure of affection toward you. Therefore, I shall accept both your ring and your proposal.

Stahl: I guarantee that when it comes to marital bliss, we won't be average!

Miriel: Interesting. For the first time ever, you strive to be above average in something.

Stahl: That's right. And I know I can do it—because I love you, Miriel.

Miriel: Ah, yes. Quite. Thank you. I...um...also find you agreeable.

Kellam

KELLAM X STAHL C

Kellam: Er, Stahl?

Stahl: WAH! Gracious me, Kellam! How long have you been lurking there?

Kellam: I don't know. 20 minutes or so? They said you were looking for me, and—

Stahl: 20 minutes?! Good heavens, Kellam. Next time, clear your throat or something. Anyway, yes. I have a question for you.

Kellam: Sure. How can I help?

Stahl: I'm just wondering... How do you feel when you're engaged with a foe?

Kellam: When I'm engaged with a foe? Well, pretty normal, I guess... Why do you ask?

Stahl: Hmm... You see, the thing is—in battle, I often feel unsettled and nervous. I worry that I may be letting my colleagues down out in the field. You, on the other hand, always appear perfectly unflappable in combat.

Kellam: I may LOOK unflappable, but inside I'm really quite nervous... Even scared, sometimes. Why, I remember this one time—

Stahl: Lies! I don't believe that for a second. Whenever I look at you, you're poised, calm, and in total control.

Kellam: ...Wait. You SEE me? On the battlefield? No one EVER notices me out there. I tend to blend in, you see...

Stahl: Yes, yes, we all know about your little issue. But what I want to discuss—

Kellam: Gosh, though. If I'm not invisible, I'd better be more careful out there! This has been a big help, talking to you. Thanks so much!

Stahl: Oh, you're perfectly wel— Hey, wait a second! I was the one looking for help here!

Stahl: Huh? Where'd he go? Well, all right, then. If that oaf can be cool and collected, I can be too! I'll have to work twice as hard at it...

KELLAM X STAHL B

Kellam: Hey, Stahl?

Stahl: Ah, there you are, Kellam! I was searching high and low for you.

Kellam: Yeah, sometimes the sun glints off my armor and makes me hard to spot. And sometimes people just don't look hard enough...

Stahl: Listen, do you remember our discussion from the other day?

Kellam: About how I feel on the battlefield?

Stahl: Right! I said you were unflappable and you said it wasn't true and so on and so forth.

Kellam: Well, the thing is, I don't think I quite got my point across. I'm not just nervous out there, Kellam. I'm actually rather terrified! I even carry an extra fauld just in case— Well, just in case.

Kellam: Yes, but you see—

Stahl: But I have a plan! I'm going to study your behavior and become just like you! I must know everything— your preparation, your training, AND your daily routine.

Kellam: But, how will you—

Stahl: By watching and observing! By engaging you in the most meticulous study one man has ever done to another!

Kellam: Er, that might be a bit of a problem.

Stahl: Dastard! Would you prefer I quake in terror on the battlefield?

Kellam: Well, no. But if you want to watch me, you have to be able to SEE me. And most people have a hard time doing that.

Stahl: Hmm...

Kellam: Maybe you should follow someone else around. Frederick is pretty brave.

Stahl: No. It must be you, and no other! And if you're that hard to spot, I'll just have to practice finding you!

Kellam: I don't understand why it has to be me, Stahl.

Stahl: Because we are the same, you and I! Meek and unassertive, yet clever! Why, if not for my devilish good looks, we could be brothers!

Kellam: Um, okay?

Stahl: Of all the Shepherds, you are the most suitable model for me to follow. So, Kellam! Prepare to be watched!

Kellam: I have a bad feeling about this...

KELLAM X STAHL A

Stahl: Ahoy, Kellam!

Kellam: Oh, you saw me first! That's a change.

Stahl: Ha ha! I have been practicing, my good man! I've honed my powers of observation to a razor-like sharpness! I can now find you from a distance of five armlengths away.

Kellam: Gosh, you were serious, weren't you? About trying to learn from me?

Stahl: Of course I was serious. And what's more, I believe I have met with success! I have seen, for example, that you laugh and cry, just like everyone else. But it's very subtle—you don't wear your emotions on that enormous metal sleeve.

Kellam: Well, I AM human, you know.

Stahl: And what's more, I noticed that you act quite differently on the battlefield. I see now your tension and nervousness, and that is a great relief to me!

Kellam: ...Relief?

Stahl: Relief that I'm not the only one who feels so when faced with certain death!

Kellam: But, I told you that in the very beginn—

Stahl: Now, here's the REAL difference between me and you... You accept your fear, and yet you are its master! Like a dog in the hunt, you unleash to bring forth terrible, slathering death!

Kellam: I don't...understand what you're saying.

Stahl: Well, thanks to your example, I'm now more confident than ever. You've been a great help, Kellam. I hope I haven't been too much of a nuisance! Ha ha!

Kellam: Er, no. On the contrary... I feel better about myself now.

Stahl: Oh?

Kellam: You're just about the first person who's taken any notice of me. ...Or cared. Frankly, it's been a real shot in the arm.

Stahl: Oh! Well then, how delightful!

Maribelle

MARIBELLE X STAHL C

Stahl: Maribelle, about that favor I asked you earlier...

Maribelle: Zzzzz... Oh, I do declare... My stars and garters... Frankly, my dear Chrom, I don't... Zzzzz...

Stahl: Um, Maribelle?

Maribelle: Huh?! Wha—?! W-where am I?! ...Is that you, Stahl?

Stahl: You've been studying too much, Maribelle. You need to take a break. You can't even keep your eyes open anymore.

Maribelle: Quite frankly, sir, my rest is... *yawn* Oh, pardon me! But I mean to say that it's none of your concern, and I'm quite all right.

Stahl: It's not all right! I just caught you sleeping on your feet! Are you feeling dizzy? Feverish? Any sudden chills?

Maribelle: I told you, I'm fine! ...I had a spot of indigestion earlier, but that's all.

Stahl: Then I insist you try my special tonic. It works wonders on stomach ailments.

Maribelle: Well, if you insist. Thank you. Th-this should keep me going...for a few more days...

Stahl: Now, now. You need to sleep properly, too.

Maribelle: Yes...I love thatsszzzzzz...

Stahl: Er. Maribelle? ...Maribelle?

MARIBELLE X STAHL B

Maribelle: Ah, Stahl. I wanted to thank you for your concern the other day. That tonic did wonders for my indigestion.

Stahl: I'm delighted it helped.

Maribelle: In fact, I was wondering if you might have another dose or two to spare...

Stahl: Are you planning to stay up all night again? Because if so—

Maribelle: If you don't want to give me any, say so and stop wasting my time!

Stahl: Eep! N-No, that's not— Er, here. Have as much as you like.

Maribelle: *Ahem* Thank you. You are too kind.

Stahl: I know it's not my concern, but please do take care of yourself, milady.

Maribelle: ...Oh, very well. I suppose you deserve some manner of explanation. For a long time now, my dream has been to join the royal judiciary. A fool's dream it seems, now that I know how much I must read and memorize...

Stahl: Yeesh! That sounds like a challenge. I envy your courage and dedication. Er, but is there any way I might help make your dream come true?

Maribelle: I suppose I could think of something. But why on earth would you care?

Stahl: Because I have no dreams of my own and want to live vicariously through yours? Er, but more seriously, you're my friend! I just want to help if I can.

Maribelle: Well, I have found myself on the hunt for certain legal documents...

Stahl: It would be an honor.

Maribelle: Excellent! And in return for your help, I shall help you discover a dream of your own.

Stahl: Oh, that's all right. I don't have—

Maribelle: You shared your tonic, and now you are helping me with my studies. It behooves a woman of my station to return favors promptly.

Stahl: But...living vicariously!

Maribelle: We said we are friends, did you not, sir? And what do friends do for each other?

Stahl: *Sigh* They help each other...

MARIBELLE X STAHL A

Stahl: I found the documents you were looking for.

Maribelle: Well, I'll be! Thank you so very much for the kind assistance. By the by, I've drawn up a list of proposals for YOUR dream.

Stahl: Oh. I thought perhaps you might have...forgotten.

Maribelle: Right then! Don't think. Just give me the first answer that comes to mind... Would you rather rise in Chrom's army, or run the family apothecary?

Stahl: Hmm... Both sound quite enticing, truth be told.

Maribelle: Come now, sir! A true gentleman must have an opinion about such matters!

Stahl: Well, I've thought about it a lot. An awful lot, in fact. And I realized we have no idea how this world will turn out after the war. So perhaps I should see what is best for my friends before I decide. I've never been very good at working hard for my own benefit. If I'm not helping someone, I just can't seem to get interested.

Maribelle: Then there is nothing I can do to assist you.

Stahl: ...Huh. I expected you to tell me to get ahold of myself or something.

Maribelle: If you hadn't actually bothered to think about it, I would have been livid. But you've already chosen a path. You want to do what's best for those close to you. And once you discover a way, I'm sure you'll do your very best to make it happen. That IS a dream, Stahl. One that demands both courage and industry!

Stahl: Heh. I may not be much for grand causes, but I do like helping people out.

Maribelle: A bit overly humble for my tastes, but there's no doubting your honesty.

Stahl: Thank you! ...I think. In any case, right now my job is to help you and Chrom. So, what else can I do for you? Any more documents that need finding?

Maribelle: Yes, but they can wait for a while. Why don't we both have a refreshing cup of elderberry tea? I haven't had a nice chitchat in ever so long!

Stahl: It would be my pleasure!

MARIBELLE X STAHL S

Stahl: Maribelle, weren't you looking for this book?

Maribelle: Why, yes. How did you know?

Stahl: I've spent a lot of time with you lately. It's all kind of second nature. Like right now, I'd wager that you want a hot cup of elderberry tea.

Maribelle: Well, now that you mention it, it is about time for a little break. You are getting very good at anticipating my every need! Since you started helping, I haven't once had to stay up all night. And I do believe you have a special genius for making people's lives easier!

Stahl: I enjoy making people from all walks of life happy, Maribelle. Although there is one person who I like making happier more than any other... And that's you, Maribelle.

Maribelle: Why, Stahl... I do believe that is a...

Stahl: If you haven't noticed, I've become completely smitten with you. Whether carrying books or copying obscure scrolls, my heart leaps for joy at every task. And that's why I want to be your husband.

Maribelle: Are you sure? It would mean a lot of hard work...

Stahl: Hard work? Pshaw! If it's done in your service, it would be a joy!

Maribelle: Why, Stahl, you certainly know how to sweep a lady off her feet... Very well. I would be honored to wear your ring.

Stahl: Then from now on, my dream shall be YOUR dream!

[Panne]

PANNE X STAHL C

Stahl: Er, Panne? Sorry to intrude, but it's time for supper.

Panne: I will eat on my own terms. Now leave me.

Stahl: But I prepared your very own dish! I think you'll love it. It's got—

Panne: Did I ask for special treatment, man-spawn?

Stahl: Er, no. But I know that you taguel don't eat the same kinds of food we humans do. And since Lissa's making some kind of weird stew tonight, I thought... Um... Well, you know. I just thought maybe we could...you know? Spend some time together?

Panne:

Stahl: ...Right then. Okay. I'll just set these potatoes right here and go back—

Panne: Taguel cannot eat potatoes. They make us sick to our stomachs.

Stahl: Oh, I'm sorry. I had no idea.

Panne: That is because I never told you. There are more important things to worry about in war than the state of my insides.

Stahl: If you say so.

Panne: ...Man-spawn, wait. It took courage to speak the truth to me. I will not forget it.

Stahl: Oh, not at all. I should be thanking you!

Panne: Why would you thank me? Are all humans this odd? Or are you special?

PANNE X STAHL B

Stahl: Panne! I'm so glad you're here.

Panne: What do you want?

Stahl: Here, taste this for me.

Panne: I don't want to taste any—MURPH!

Stahl: See, if I come up with a dish you like, you can join us in the mess tent! It took me a few tries, but I think I've finally made something really—

Panne: Blech! Ptooie! Idiot man-spawn! I told you I cannot digest potatoes!

Stahl: B-but I sliced them really thin! I used Chrom's sword and everything.

Panne: I am leaving. Possibly to vomit. Do not follow me!

Stahl: No, wait! I have another dish to try.

Panne: *Sniff* It smells appalling.

Stahl: Yeah, but there are no potatoes in it. Just cottage cheese. ...Er, and squid.

Panne: I am still leaving.

Stahl: Wait, wait! I've got one more! This one's the best, I promise! It's a carrot dumpling wrapped in a flaky pastry crust.

Panne: I suppose if it gets the potato taste out of my mouth...

Munch, munch

Stahl: ...Well?

Panne: ...Unpleasant.

Stahl: Damn. I thought for sure I had it.

Panne: ...However, it IS edible.

Stahl: Hey, I can live with that! So does that mean...

Panne: Very well. I suppose I might occasionally join the others in the mess tent if you made this.

Stahl: Th-that's wonderful! I'll make a huge batch so I can freeze some for later. Thank you, Panne!

Panne: You're thanking me again? You truly are a strange human.

PANNE X STAHL A

Panne: Why are you hovering around me while I eat?

Stahl: I'm trying to see what other kinds of food you like. You can't keep eating nothing but dumplings. You'll get scurvy!

Panne: Then sit down and join me! Do not hover like a jackal.

Stahl: Oh, er, thank you. That's very kind! Hmm... What's this red thing?

Panne: Firefruit. Its juice can make human skin blister and itch for days on end.

Stahl: *Munch, munch* Hey, that's pretty good! ...Wait, what did you say about your eyes? Oh, gods! It's on my fingers! ...And in my EYES! Aaaiiieeeeee!

Stahl: Urrrgh...

Panne: Hello? Stahl? Are you dead? ...Nod if you are not dead.

Stahl: N-no, I'm fine. Just a...little light headed is all.

Panne: You cannot enjoy the meal properly when you're in such a state.

Stahl: Er, Panne? Maybe I just fainted, but were you licking my face just now?

Panne: Yes. It is the way we taguel clean each other. Is that a problem?

Stahl: Er, no! I mean, I'm glad you saved my eyesight and all, but... It's just a little odd to be licked by a beautiful woman.

Panne: I have no idea what you are talking about, strange man. Here, try this fruit instead. It should be safe for human skin.

Stahl: Um, there are bite marks in this. Is that normal, or were you eating it?

Panne: Do you refuse to take it just because it's been in my mouth?

Stahl: Gracious, no! N-not at all! Ha ha! Ha. Why should I care? So, er...here goes... *crunch, crunch*

PANNE X STAHL S

Stahl: It was good to see you at supper again, Panne.

Panne: Well, none of the food was especially repugnant to me.

Stahl: I know! It's because we tried so hard to come up with a menu everyone could enjoy. Funnily enough, the dishes you suggested were the most popular.

Panne: You changed the whole menu for the sake of me?

Stahl: If that's what it took to get you to join us at mealtimes, no one minded at all. And, you know. It gave me a reason to spend more time with you!

Panne: Hah.

Stahl: Did I say something funny?

Panne: I only sat close because I was afraid you'd get firefruit juice in your eye again.

Stahl: Right. But I didn't mean tonight. I mean, not exactly. We've grown somewhat comfortable around each other, right?

Panne: ...Oddly enough, I do not mind it.

Stahl: Y-you don't? That's great!

Panne: You are genuinely excited about it, aren't you? You are a strange man.

Stahl: It seems like you've grown more forgiving and tolerant of humans.

Panne: Not all of them, man-spawn. Just you.

Stahl: Er, well, in that case, I was thinking you might... take this ring?

Panne: Is it valuable?

Stahl: No! I mean, yes! ...That's not the point! I want us to marry and begin a new era in taguel-human relations.

Panne: You wish to marry me for diplomatic purposes?

Stahl: I'm in love with you, Panne! Hopelessly in love! I want us to spend the rest of our lives together.

Panne: Ah. I see. Very well, Stahl. I accept.

Stahl: Really? Oh, thank you, Panne. We'll have the greatest wedding ever! And no potatoes will be invited!

Panne: Heh. This time I suppose I should be thanking you. ...Thank you, Stahl.

[Cordelia]

CORDELIA X STAHL C

Cordelia: Hello, Stahl.

Stahl: I was drawn here by the sound of sweet music. Was it you playing?

Cordelia: You are kind to say so. But in truth, I'm quite out of practice.

Stahl: What? No, you play beautifully! And one of my favorite Ylissean folk songs, to boot!

Cordelia: It's been so long since I last played. When I saw this harp at the local market, I just couldn't resist.

Stahl: I remember how you entranced the court by playing at Chrom's birthday ceremony. Those were some good times... Say, why don't you put on an encore performance? It'd be huge for morale!

Cordelia: Oh, that court concert was a long time ago. I don't even remember the music. Although I suppose I could muddle through if I had the score in front of me.

Stahl: Wait, you were just playing from memory? That's even more impressive!

Cordelia: Please, Stahl, I'm serious. Stop trying to flatter me. Compared to Phila, I'm just a clumsy amateur.

Stahl: Well, sure. But Phila was the best I've seen. She could have joined the royal orchestra.

Cordelia: I always dreamed that one day I might be as skilled as her. It's silly, I know.

Stahl: Hey, never say never! Especially when you're so abundantly talented!

Cordelia: Stop it, seriously! See, now I'm just getting embarrassed... Er, oh, hey! Would you look at that? It's chore time. ...Gotta go!

Stahl: That Cordelia... She's never satisfied with being second best in anything. I'm going to have to step up my game if I ever hope to compete with that!

CORDELIA X STAHL B

Stahl: Tickling the old strings again, are we?

Cordelia: Why, hello, Stahl. Yes, I was— Um, is that a harp?

Stahl: Yep! Just bought it down at the market. Oh, and I got some sheet music, too.

Cordelia: Heh. Sounds like someone is itching to play a duet!

Stahl: Well, at some point, sure. But right now I can barely make noise on this thing. I was hoping you might be my teacher instead of my duet partner.

Cordelia: Well, I've never taught before, but I'd be happy to help.

Stahl: I'm going to practice like a madman until I'm good enough to play with you. I'll practice until my fingers are bloody and raw! I'll practice until my eyes—

Cordelia: Well, it's...good to have a goal.

Stahl: Hey! I'm just trying to be as dedicated to things as you are, Cordelia.

Cordelia: Heh. Perhaps I have been TOO dedicated... Speaking of which, I think we should start your lesson. Now, watch carefully as I pluck the first few bars of this song...

Stahl: You have my undivided attention.

Cordelia: Er, won't your eyes dry out if you keep them open so wide? Er, right, then. Never mind. Let me begin...

Stahl: Wow, you played that note so beautifully...

Cordelia: Huh? No, I didn't!

Stahl: No, no! The tone was lovely!

Cordelia: Stahl, it's just one note. Will you please let me finish?

Stahl: Er, yes. Right. Sorry. Go ahead.

Cordelia: ...Look, I don't think I'm quite ready for teaching. Give me some time to work out a lesson plan, okay? I don't want to do this until I'm sure my methods are...sound.

Stahl: But, Cordelia. Gods, she's more of a perfectionist than I thought. This is going to be tough.

CORDELIA X STAHL A

Cordelia: Stahl, I'm sorry about the other day. When I was supposed to teach you— ...Err, that song. Yes, the song you're playing...right now. Goodness, Stahl, you're doing very well! Where did you learn that?

Stahl: When I saw how passionate you were about a single note, I knew I had to practice. I'm still kind of murdering it, but I think it's getting better...

Cordelia: I wouldn't say murder! ...Maybe more like assault.

Stahl: I knew I had to work twice as hard as you if I wanted to play that duet. So I've been practicing every waking moment—even in the latrines!

Cordelia: Oh! Um, yes, that is...quite dedicated. By the by, I've never heard that song played with the faster tempo you employed. I rather like it! Such a nice twist on an old classic.

Stahl: Yeah, it's just an idea that struck me as I was studying the notes.

Cordelia: How very astute of you.

Stahl: I think it was more blind luck than astuteness, but thanks.

Cordelia: Stahl? There are many in this camp who play the harp better than I. Why have you settled on me for this duet and concert idea?

Stahl: Because you don't just... You make the harp sing! You can do anything, Cordelia. You have a natural gift. I wish I could be more like you!

Cordelia: I'm not sure that being naturally gifted at something is always a good thing.

Stahl: Muh?

Cordelia: Well, if you don't have talent, it takes a lot of time and effort to acquire a new skill. And through that process, you learn things that more naturally talented people miss. Like your discovery of the faster tempo.

Stahl: Hmm... I suppose so.

Cordelia: And that persistence leads to you becoming just as good as anyone else. To be honest, there are times when I've thought I'd rather be more like you!

Stahl: Hah! Well, we can't BOTH be right!

Cordelia: This isn't about right or wrong. It's just two ways of looking at the same problem. ...In any case, your practice has paid off, and I name you my equal in the harp. We should play that duet soon.

Stahl: It would be my honor!

CORDELIA X STAHL S

Cordelia: Phew...

Stahl: That was wonderful.

Cordelia: It was, wasn't it? We played in exquisite harmony and every note was perfect. I'd love to put on a performance for everyone in the camp!

Stahl: And I, as well! Cordelia, playing as well as a duet has made me realize something... I think you and I should spend more time together.

Cordelia: I'm not sure how that follows...

Stahl: What if I were to offer you this ring? Would that make my meaning clear?

Cordelia: Stahl!

Stahl: Look, I'll understand if your heart belongs to another man... I've known for a long time now that you've had eyes for Chrom. But I can't keep my secret any longer.

Cordelia: You...know about Chrom?

Stahl: Sure. Ever since that birthday bash. The song you played for Chrom was so full of love, it was like declaring it to the world. But I thought that if I tried hard enough, it might be able to someday win your heart. So, er, right... I'll just hold on to this ring in case that day ever comes.

Cordelia: Why can't I have it now?

Stahl: ...What?

Cordelia: You don't need to take Chrom's place. You already have.

Stahl: I...have?

Cordelia: I've never been happier than when we played together just now. I want to be able to know that joy each and every day.

Stahl: Then I shall wake you with the sounds of my harp every morning for the rest of your life!

Cordelia: Wonderful! But, er...EVERY morning?

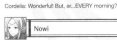
[Nowi]

NOWI X STAHL C

Stahl: Hmm? I hear the chirping of a bird. And it's very close indeed.

Nowi: Heya, Stahl! Just the man I wanted to see. Can you spare some of that healing tonic you're always carrying around?

Stahl: What do you want it for?

Nowi: This little bird hurt a wing, and I want to help him out.

Stahl: I'm not sure my tonic works on birds. ...It's mainly for diarrhea.

Nowi: Ew, THAT'S not going to help. Hmm... Wait, I know! A healing staff should do the trick!

Stahl: Nowi, I know you just want to help, but healing staves are very valuable. I'm not sure we can spare one for a bird, regardless of how cute it is.

Nowi: What? So we just let it DIE because Chrom might get a boo-boo?

Stahl: Well, Chrom. Or me. ...Er, or anyone, really.

Nowi: Ugh! How could you be so cruel! Waaaaaah!

Stahl: ...Gods, maybe she's right. This war is turning me into a heartless brute. Nowi, wait. I'm sorry. You're right. Let's call Lissa and have her help this poor little critter.

Nowi: *Sniff* R-really? You'll do that? Thanks, Stahl...

NOWI X STAHL B

Stahl: Hey, Nowi. I brought some fresh bandages.

Nowi: Thanks, Stahl. The bird is feeling much better now!

Stahl: I'm not surprised, with how you've been looking after him.

Nowi: Yeah, but I'm tired of calling him "the bird." I think he needs a name. What do you think of Janaff?

Stahl: Er...

Nowi: That totally sounds like a bird, right? I thought of it myself, by the way.

Stahl: I'm just not sure it's the best idea to give him a name. It'll just make it that much harder when it comes time to part company.

Nowi: But we're not going to part company! Me and Janaff will be friends forever.

Stahl: Okay, now you're just being absurd. First of all, how are you going to look after him in the middle of battle? And second, what are you going to feed him? We're low on food as it is.

Nowi: I'll find a way! I'll be like his mother and take extra good care of him! So can I keep him? Pleeeeeeeeease?

Stahl: Oh, for the love of... Fine. I'll talk to Chrom. Maybe you and I can look after him together.

Nowi: Yay! Thanks, Stahl!

NOWI X STAHL A

Stahl: Janaff seems to be full of beans today.

Nowi: Yeah, we just got back from a flight around the camp. It was lots of fun!

Stahl: Well, I'm glad you found a friend. Perhaps now it... Hmm? What's that shadow?

Nowi: Oh my gosh! Look at that huge flock of birds!

Stahl: Janaff seems awfully excited, Nowi. I think maybe he wants to join them.

Nowi: What? No he doesn't! Liar! He's MY friend!

Stahl: The flock keeps circling us like they're waiting for something... Nowi, I think Janaff's friends and family have come to take him home.

Nowi: No! I'M his family now! I'm his mother! I'm going to turn into a dragon and chase those stupid birds away!

Stahl: You can't do that, Nowi.

Nowi: But... But...!

Stahl: What do you think Janaff would want? ...I mean, besides more worms. Do you really want to keep him from his true family? From his friends?

Nowi: Oh, fiiine. I know you're right, but it's still sad and unfair. I'm s-sorry, Janaff. I shouldn't have tried to hold you against your will. *sniff* You can...*sob* go... *sniffle* If you really...want to...

Stahl: Wow! Look how fast he flew into the flock! He looks happy, doesn't he? He's doing little somersaults in the air. Farewell, Janaff! May all your meals be huge grubs and the like!

Nowi: *Sniff* Bye, Janaff. I hope you have fun...with all your friends...

Stahl: ...And he's gone.

Nowi: *Siiiiiigh*

Stahl: You did the right thing, Nowi.

Nowi: H-he was my best friend ever... *sniff* Oh gods, I miss him so much! Waaaaaaaaaaah! Ja-naaaaaaaaaff!

Stahl: Hey. Easy there, Nowi. We don't want you to pull something...

NOWI X STAHL S

Stahl: Nowi?

Nowi: Hee hee. Hi, Stahl.

Stahl: What are you up to? You're looking inordinately cheery.

Nowi: Last night, I had a dream where I was flying through the sky with Janaff! He visited me in my dream to tell me he was doing okay.

Stahl: Hey, that's great! He must have really cared for you.

Nowi: By the way, why are you here? Do you want something?

Stahl: Um, yes, actually. I've been thinking about this lately. Ever since you released Janaff, I mean. Seeing you make such a huge sacrifice for the happiness of someone else... Well, it kind of made me realize that I have feelings for you. So, um, I got you this ring. ...If you'll take it.

Nowi: Does this mean you want to get married?

Stahl: Oh, good. You know about this, then. I was afraid I'd have to explain and... Well, yes, Nowi. I want to get married.

Nowi: And if we marry, that makes us family, right?

Stahl: It sure does. You and me and all the little birds we can adopt.

Nowi: Never mind birds! I wanna be a mom and have dozens of children!

Stahl: Er, dozens?

Nowi: Oh, okay. Maybe just one dozen. Anyway, can I have the ring now?

Stahl: R-right. Of course.

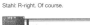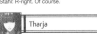
[Tharja]

THARJA X STAHL C

Stahl: Hey there, Tharja. Catch!

Tharja: ...A fig? And what do you want me to do with this?

Stahl: Just thought you might be hungry. You barely touched your lunch, and you're pretty scrawny, yeah? Figured a nice juicy fig might hit the spot.

Tharja: You were spying on me in the mess tent?

Stahl: Well, I'd hardly call it "spying"... I mean, it's a public place, isn't it? Anyway, I just noticed you weren't pushing beans around with a fork.

Tharja: Oh. Well, all right then. Very thoughtful of you.

Stahl: I actually have a whole bag. I could leave 'em right here if you—

Tharja: One is enough.

Stahl: Right. Got it. Well, I guess I'd better, um... Yeah. Just let me know if I can do anything else for you, all right?

Tharja: I am suspicious of this unbidden kindness.

Stahl: Sorry, what was that?

Tharja: Nothing, nothing... You know, in my home, it is customary for new friends to exchange locks of hair. Perhaps you would give me a strand or two from your head.

Stahl: Huh? Oh, well, sure, I guess. I mean, if it's a custom...

Tharja: Thank you. You have been most helpful... Eee hee hee...

■ THARJA X STAHL B

Stahl: Hey, Tharja. You have a moment? I was wondering about that hair-custom thing. Because I've been asking around, and no one else has ever heard of it.

Tharja: You mean that nonsense about friends exchanging bits of hair?

Stahl: Er, nonsense?

Tharja: Hee! I'm a dark mage. You know what people like me do with locks of hair, right?

Stahl: Hey, wait a second... Y-you're not gonna put a hex on me?

Tharja: Oh, don't look so put out about it. It's really a tiny little thing. It just forces you to speak the truth to me... Or else die in a horribly painful manner.

Stahl: What?! But that's so...mean.

Tharja: Now, speak! Why are you so kind to me? Answer with truth, or else!

Stahl: *Gulp* I was... I mean, I was just kind of...um... concerned.

Tharja: You thought I might be a Plegian spy? Yes, I figured as much. But you should know I never liked that dastard Gangrel. What kind of king would sacrifice his realm to suit his own twisted goals? It's a travesty he ever took the throne.

Stahl: No, that's not what—

Tharja: I have been loyal to Chrom from the very beginning. Not that I imagine any of you sad sacks will believe me.

Stahl: That's not what I meant when I said I was concerned, Tharja.

Tharja: Oh, this should be interesting. So what exactly did you mean?

Stahl: Look, you always seem to be sitting off on your own without any friends. I thought you might be lonely. That's all.

Tharja: If I wanted friends, I would conjure them forth from the black abyss!

Stahl: Rrr...right. Got it. I'll just be...walking...over here now.

Tharja: Oh, stop. You don't have to go. I'm just surprised that you are what you claim to be. That's all.

■ THARJA X STAHL A

Stahl: Hey, Tharja. Whatcha doing with that big crystal orb?

Tharja: Divination.

Stahl: Soooo, is that some kind of hex or what?

Tharja: Divination is the art of seeing into the future. Right now I'm trying to see who is going to win our next battle.

Stahl: N-no! Don't do that!

Tharja: ...Come again?

Stahl: If you see victory for us, we might get complacent and lose. And if you see defeat, we'll give up before we've even started. Don't you see? No good can come of what you're doing.

Tharja: I suppose that's one way to look at it. I thought you'd be more confident.

Stahl: Oh, no. I go into every battle expecting to get my lunch handed to me.

Tharja: How inspiring.

Stahl: But don't worry! You're my special friend! I'll die before I let anything happen to you!

Tharja: ...What?

Stahl: Oh gods. Did I really just say "special friend"? I meant "stalwart ally." That's it! That's all.

Tharja: That's weird.

Stahl: Ugh... Well, you're the one who put that stupid truth spell on me. I can't help it if everything I say comes out in shades of pink.

Tharja: Hmm. I'd forgotten about that.

Stahl: Still, it's funny. Having to speak the truth is almost...relaxing, in a way.

Tharja: That's the first time one of my victims has thanked me ever... Still, if you are so eager to be friends, perhaps it wouldn't be so terrible.

Stahl: Really? You mean it? My heart bounds like a thousand fluffy kittens! Uh, do you think you could remove this hex now?

■ THARJA X STAHL S

Stahl: Ha! Hya! Eeeya! ...Nope. Still not right.

Tharja: You'll get it eventually.

Stahl: Yeah, but when? I need to hone my skills if I want to serve Chrom and the others. Plus you'll never like me if I don't get strong and powerful.

Tharja: ...Like you?

Stahl: I mean, you're always strong and tough and scary, right? Well, I'm not. I'm just some guy who floats through life on a breeze. So if I don't get stronger, I'm never... you know. Gonna have a chance.

Tharja: Bashing a practice dummy to smithereens will not improve my opinion of you.

Stahl: Yeah, but it couldn't hurt, right?

Tharja: You're missing the point. Your modesty and flightiness ARE your strengths. They are also...oddly charming.

Stahl: Wait, really? They are?

Tharja: Yes, I suppose. Though gods help me if I understand why.

Stahl: Oh, Tharja! Marry me!

Tharja: Is this some kind of joke?

Stahl: I love you! I hunger for you with the passion of ten thousand dying suns! I can't breathe around you. I... *wheeze* *gasp* Look, I even went out and got a ring and everything. ...Please say yes.

Tharja: For someone so mild mannered, you can be quite forceful... Very well. I accept.

Stahl: Really?! WOO! Tharja, this is the best day of my entire life! And you know that's true because I'd die a horrible death if I lied to you.

Tharja: Actually, I removed that curse some time ago.

Stahl: You removed... Wait, what?!

Tharja: Oh, yes. You had the power to hold your tongue all along.

Stahl: Really? ...REALLY really? I think all the kittens in my heart just died of shame...

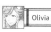 Olivia

■ OLIVIA X STAHL C

Stahl: Say, Olivia? Could I trouble you for—

Olivia: Aah!

Stahl: Um, sorry. Did I startle you?

Olivia: N-no, you were just...so close.

Stahl: Er, but I'm...way over here. Funny, I tend to think of myself as one of the less-imposing Shepherds.

Olivia: I'm sorry. It's just that when people look at me, I get...nervous.

Stahl: Is that so? I have just the thing. Wait here!

Olivia: Um, Stahl? Where did you—

Stahl: Here we are!

Olivia: A letter?

Stahl: I wrote my request down. That way you don't have to talk to me.

Olivia: Oh! Right. Well then, let me see... Oh, you want a needle and thread? Sure! Shall I bring them by your tent later?

Stahl: Just drop 'em by the front flap. That way you won't have to worry about another conversation.

Olivia: Outside your tent, then. Got it. Th-thank you. I'm sorry.

Stahl: Hey, you're the one doing me a favor! This is the least I can do.

■ OLIVIA X STAHL B

Stahl: I'll just leave the letter here, Olivia. No rush.

Olivia: I'll be sure to read it. And sorry again.

Stahl: I've told you, it's no trouble at all. Though it might be nice to have a leisurely conversation at some point. Anyway, so long as it's nothing personal, I'm not worried.

Olivia: Oh, n-no! It's like this with everyone until I get used to being around them. I'm just...not good with strangers.

Stahl: I see. So you can't talk to strangers, but you can talk to friends?

Olivia: U-usually...

Stahl: All right. In that case... *AHEM* Bwa ha ha! Aye, lass! Bring me some meat and mead! Let's rumble!

Olivia: Er...what?

Stahl: Well, since you've known Basilio for so long, I thought I could act like him. You know? To make you feel more at ease?

Olivia: THAT was your Basilio impression?!

Stahl: It sounded a lot better in my head.

Olivia: Wow, that was seriously terrible! But you know what? Seeing something that embarrassing has made me less embarrassed!

Stahl: Well then, I guess it was worth it. Next time I'll try to come up with a plan that lets me retain a shred of dignity.

Olivia: Hee hee. I'm looking forward to it.

■ OLIVIA X STAHL A

Stahl: You seem calm today, Olivia. Perhaps you've gotten used to me?

Olivia: It seems so, doesn't it! I'm sorry it took so much time and effort.

Stahl: Hey, no apologizing! Everything worked out in the end, right?

Olivia: I still can't believe you did impressions of everyone I know AND my entire family!

Stahl: I can't believe how bad I am at doing impressions.

Olivia: Basilio was the best of the bunch. ...Which is terrifying.

Stahl: Heh heh heh...

Olivia: Hee hee!

Stahl: Pffffaaah ha ha ha ha! Man, that was so bad...

Olivia: Hee hee hee! You have a gift for making people laugh, Stahl. You're a comedic genius!

Stahl: Heh. Funny looking, maybe. I dunno about my future on stage, though.

Olivia: I wish I had your talent. It would be nice to make people smile in these dark times. All I do is wind up making them uncomfortable...

Stahl: Not when you're dancing! That's some motivational stuff right there. It makes me feel alive somehow. It gives me the courage to continue.

Olivia: You...really think so?

Stahl: Hey, I'm a genius, remember? So can the negativity!

Olivia: I think that may be the kindest thing anyone's ever said to me, Stahl. I'm so glad we're friends.

Stahl: The pleasure's all mine.

■ OLIVIA X STAHL S

Stahl: Hello, Olivia.

Olivia: Hey, Stahl! Did you need something?

Stahl: I have something to give you.

Olivia: ...A letter? I think we've moved past the letter stage now, Stahl.

Stahl: I know, but this time I'M feeling shy.

Olivia: Uh-oh. Did I say something to make you uncomfortable?

Stahl: No, no. You're perfect. It's just... Look, just open it. Please?

Olivia: Well, all right.

Stahl:

Olivia: Er, Stahl? The envelope is completely... Oops! Something just fell out! ...Is that a ring?

Stahl: It's for you.

Olivia: Oh! Then you...

Stahl: I...I love you, Olivia. And I want to be with you as your husband, if you'll have me.

Olivia: Er, I'm... I don't...

Stahl: You don't have to answer right now. Take some time and think it over.

Olivia: N-no, that won't be necessary. I know my answer. I was surprised you would marry me. But I guess if we're both a bit bashful about this, it's a good sign. So yes, Stahl. I'd love to marry you.

Stahl: Oh, Olivia! Thank you! I swear I'll make you happy!

Olivia: Hee! You already have.

 Cherche

■ CHERCHE X STAHL C

Stahl: Phew... Another load done. Just one more basket and... Hmm... Now whose cloak is this?

Cherche: Hello, Stahl. I see it's your turn for laundry duty today.

Stahl: Oh, hey, Cherche. Say, do you know whose cloak this is? It has the most delightful smell!

Cherche: Oh, that's mine. I sprinkle it with a special fragrance I find soothing. It helps me get a good night's rest, even when we're camped in the wilds.

Stahl: *Sniff* Gods, it's like nothing I've ever smelled before!

Cherche: It smells of home to me. It's quite common back where I come from.

Stahl: It's interesting how things vary from place to place. Smells, fashions, art, manners...

Cherche: Before the empire swallowed up all of Valm, the land was split into small, unique realms. You can still see these differences today as you move from town to town.

Stahl: Someday I'm going to buy you an ale and have you tell me all about it! But, um, what about the cloak? Won't all the smell run out if I wash it?

Cherche: That's fine. I'll just add more fragrance when you're done.

Stahl: Then laundered it shall be!

Cherche: You know, people in some areas of Valm have unusual ways of washing clothes. If you're interested, we can do the laundry together and I'll show you some tricks.

Stahl: Milady, I will ALWAYS take free assistance on laundry day. Plus you can tell me more about Valm as we work!

Cherche: And in return, you can tell me some things about Ylisse. Er, and speaking of manners and customs, it is... Um... Well, in my land, it's considered very bad form to go sniffing a lady's cloak.

Stahl: Then why do you make it smell so good? It's like a trap!

Cherche: Heh. I suppose it is, at that.

■ CHERCHE X STAHL B

Stahl: Tents? ...Check. Stew meat? ...Check. Firewood? ...Uh-oh. Low on firewood.

Cherche: Is something the matter?

Stahl: Oh, hey, Cherche. No, nothing's the matter, per se.

Cherche: Is that so? You look worried. Furrowed brow and all that.

Stahl: Oh, you can just ignore that. My brow furrows pretty easily.

Cherche: Being naturally frowny must cause many a misunderstanding, hah! Or perhaps it just makes people feel more solicitous toward you...

Stahl: Hah! I'd never thought of it as an advantage before.

Cherche: You know, it seems like every time I see you, you're engaged in another chore.

Stahl: I volunteer a lot. I just enjoy keeping things... tidy, I guess. Plus, you don't want some of these axe slingers going anywhere near your laundry...

Cherche: Well, I think it's very admirable. Perhaps you could use a hand?

Stahl: Well, I WAS just about to head out to collect more firewood.

Perhaps you'd care to accompany me to the forest? I can use your talents if we stumble across any fell beasts.

Cherche: Back in my village, an invitation to collect firewood indicates romantic interest. Something to do with firewood igniting the flames of passion in the girl's heart...

Stahl: Wha—?! G-good gracious, truly? I... I meant no offense. I swear! ...Also, that is a really weird thing I'm just saying.

Cherche: Heh heh. Oh, it's quite all right. How were you to know? In any case, I'll help out, and you can tell me more about the culture of Ylisse.

Stahl: Sounds like a plan.

■ CHERCHE X STAHL A

Cherche: Here, Stahl. This is for you.

Stahl: Oh, what a beautiful handkerchief! Thank you. ...Did you make it?

Cherche: I wanted to give you something in return for all your stories of Ylisse. I'm not an expert at needlework, but it's the thought that matters, right?

Stahl: I think it's great! I'd buy this in a store!

Cherche: That's very kind of you to say. You've taught me so much about the culture of Ylisse that I'm quite anxious to visit. In fact, when this war is over, I'm planning to tour its most famous sights.

Stahl: That's funny, because when peace comes, I've decided to visit YOUR homeland. I want to help reunite families and rebuild their towns and villages.

Cherche: You have a generous heart, but that really should be my job. Besides, your duty is to the reconstruction of Ylisse, is it not?

Stahl: Yes, but I have to at least visit Valm. I mean, we DID collect firewood together.

Cherche: Hah!

Stahl: No, but seriously. I consider you a good friend, Cherche. And since our last talk, I've been studying the customs of your country. This handkerchief is a gift given from one friend to another, is it not? So forget Ylisse! There are plenty who can rebuild better than I. Instead, I shall work to rebuild the country of my dear, close friend, Cherche!

Cherche: Why, Stahl, that's very sweet of you. But, I think you made a mistake. The gift of a handkerchief is only significant when exchanged between women. From a woman to a man, it has no meaning at all. ...Well, other than a more carefully?

Cherche: It's quite all right. I'm flattered you thought to read about my country at all. Besides, who cares if you don't know all the ins and outs of my culture? You're pleased to be my friend, and that's all that matters. I would be happy to call you the same.

Stahl: I'd like that very much.

Cherche: Friendship is the best way to build bridges between cultures, don't you think?

Stahl: Absolutely!

■ CHERCHE X STAHL S

Stahl: Cherche, do you have a moment?

Cherche: Yes, what's on your mind?

Stahl: I wanted to apologize again for not knowing about the handkerchief thing.

Cherche: Don't be silly! What's a little mistake between friends anyway?

Stahl: We have become good friends, haven't we?

Cherche: You sound almost...dissatisfied about that. Or is that your naturally furrowed brow?

Stahl: I think you have the right of it, Cherche. Dissatisfaction, I mean.

Cherche: What are you saying?

Stahl: Cherche, when I'm with you, I want something more than friendship. I misinterpreted your gift last time, but this time there can be no mistake. So...here.

Cherche: You're giving me a ring?

Stahl: It's an Ylissean custom. It means I want to marry you.

Cherche: I know. We have the same custom in Valm.

Stahl: Great. Then my intention should be crystal clear! I love you, Cherche, and friendship just isn't enough anymore. I want us to be man and wife, and maybe even raise a family together. I want your home to be my home, and I want to help rebuild your country. What do you say, Cherche? Shall we build a future together?

Cherche: You look worried again.

Stahl: Er, I was going for a more of an earnest and beseeching kind of thing...

Cherche: Yes, I see it now. A pleading look, especially around the eyes. Are you sure you want to abandon Ylisse and throw in your lot with Valm? When your ardor cools and reality sets in, you may well regret your decision.

Stahl: The ring symbolizes a lifelong oath. I shall not break it.

Cherche: Then I must make a promise, too. Stahl, I will love you and honor you for the rest of my life.

Stahl: Y-you will? Oh, thank you, Cherche! You won't regret this!

Cherche: I know. Because if you break your oath, I will have Minerva devour you whole.

Stahl: Oh, my! Is that another one of Valm's customs? Never fear, my love. I assure you—that is certainly not going to be necessary!

Cherche: Good! Then we're agreed.

 Donnel

■ DONNEL X STAHL C

Donnel: Mmm... Hmm... Aw, pig plop! This is all mumbo jumbo to me!

Stahl: Are you trying to read that magic scroll? Good gods, Donny. Here now, take a break and have a soothing cup of nettle tea. It's a little bitter, but it'll settle your nerves if you can keep it down.

Donnel: Thang ya kindly, Stahl.

Stahl: Think nothing of it. And once you're calm, THEN start thinking about what kind of soldier you want to be.

Donnel: How'd ya know that's what I was doin'? I ain't said nothin' about it to ya.

Stahl: This morning you were picking locks, then you were practicing archery. Now I find you attempting to decipher a scroll to "smite thine enemies with fire". Either you're incredibly bored, or you aren't satisfied with your current role.

Donnel: Welp, I s'pose the cat's outta the bag now... Hey, Stahl. Yer pretty clever. What do ya reckon I should do?

Stahl: Well, I don't know anything about tomes or magic staves... But I'm a keen student of weapons, especially sharp ones. You could do what I did and watch the experienced sellswords and knights.

Donnel: And then I could watch what weapon might work best fer me! Gosh, that's a dilly of an idea!

Stahl: But remember, it's not enough to just pick a weapon you like. You need training and— Did he just leave? Good heavens, he's an eager one, isn't he?

■ DONNEL X STAHL B

Donnel: Howdy, Stahl! Just the gentleman I was hopin' to run into.

Stahl: Do you have a question?

Donnel: Could you...go over yonder? ...No, just a little bit farther.

Stahl: Are you trying to make me fall into that pit trap you dug?

Donnel: Aw, donkey bottoms! I ain't never gonna get the hang of this.

Stahl: Easy, Donny. Don't look so glum. You still have time to learn.

Donnel: But I done tried so many different things, and I'm useless at all of 'em! I just wanna find one thing I'm better at than everyone else. Thought it might be booby traps, but shuck my corn if that's the case now...

Stahl: Trying to be better than everyone is an ambitious goal that few ever achieve. Take me for example. Average strength, skills, and looks. Nothing stands out. Compared to everyone else in the Shepherds, I'm as dull as can be.

Donnel: Aw, Stahl, that ain't true! ...Well, maybe it's a bit true.

Stahl: The point is, Donny, I still have a role. We can't all be the best at something, but we CAN all provide a unique blend of skills.

Donnel: Sure we're the best...at bein' ourselves? Reckon that ain't much of anythin'.

Stahl: Just keep practicing what you know, and take care of yourself on the battlefield. Talents will come to light when you least expect them.

Donnel: Well, if ya say so...

■ DONNEL X STAHL A

Stahl: With every battle, the enemy grows more numerous and deadly.

Donnel: Ain't that the truth! Sure am glad we got [Robin] plottin' strategy for us. (He's/She's) awful good at gettin' the most outta this here army.

Stahl: Ah, so you've noticed.

Donnel: We just gotta carry out orders as best we can.

Stahl: And the battle is not won by those who are best at one thing, is it? It takes all of us working in unison to achieve victory. Of course, you may have the time to hone and improve our skills... But in the end, how we fight as a group determines if we shall prevail.

Donnel: Gosh, Stahl! When you put it like that, it makes me sound pretty important.

Stahl: That's because you are! Now then, I think it's time for our midday meal. Shall we go to— ...Waaah!

Donnel: Yee-haw! Looks like I'm better at trap settin' than you are at trap spottin'! Gosh, but you sure looked funny when that fake floor collapsed under yer feet!

Stahl: Yes, that was...very clever. Now get me out of here!

 Owain (Father/son)

Owain's father/son dialogue can be found on page 289.

 Inigo (Father/son)

Inigo's father/son dialogue can be found on page 293.

Brady (Father/son)

Brady's father/son dialogue can be found on page 297.

 Kjelle (Father/daughter)

Kjelle's father/daughter dialogue can be found on page 299.

 Severa (Father/daughter)

Severa's father/daughter dialogue can be found on page 305.

 Gerome (Father/son)

Gerome's father/son dialogue can be found on page 307.

 Morgan (male) (Father/son)

The Morgan (male) father/son dialogue can be found on page 309.

 Yarne (Father/son)

Yarne's father/son dialogue can be found on page 314.

Laurent (Father/son)

Laurent's father/son dialogue can be found on page 316.

 Noire (Father/daughter)

Noire's father/daughter dialogue can be found on page 317.

Nah (Father/daughter)

Nah's father/daughter dialogue can be found on page 318.

Miriel

Avatar (male)

The dialogue between Avatar (male) and Miriel can be found on page 219.

Avatar (female)

The dialogue between Avatar (female) and Miriel can be found on page 230.

 Frederick

The dialogue between Frederick and Miriel can be found on page 245.

 Virion

The dialogue between Virion and Miriel can be found on page 248.

Sully

The dialogue between Sully and Miriel can be found on page 252.

Vaike

The dialogue between Vaike and Miriel can be found on page 254.

Stahl

The dialogue between Stahl and Miriel can be found on page 256.

Kellam

■ KELLAM X MIRIEL C

Miriel:

Kellam: Miriel? Why are you gritting your teeth and staring at me like that?

Miriel: Because the moment I avert my eyes, I lose sight of you. Even when you don't attempt to hide, you simply disappear into thin air. It is a most perplexing puzzle.

Kellam: It's true that I blend into the background sometimes...

Miriel: But it makes no logical sense. That suit of armor you wear reflects sunlight like a mirror. Not to mention the novel nature of its oversizedness.

Kellam: I think I just lack presence is all.

Miriel: By which you mean you are unassertive, laconic, and a man of few words? There must be more to it than that. Science abhors an incomplete explanation. Hmm... Hmmmmm...

Kellam: Um, can you stop staring at me like that? It's creeping me out a little.

Miriel: But you are such a fascinating subject for observation. Think of all we can learn from you! If I were able to study you somehow...

Kellam: I think I'm going to go now...

Miriel: ...Fascinating.

■ KELLAM X MIRIEL B

Kellam: M-Miriel? Why are you clutching my arm?

Miriel: So I can keep track of you without having to stare unblinking for all hours of the day. This makes it easier for me to carry out my observations.

Kellam: Oh. Okay. Because see, it's just that... Well, I find it a little embarrassing.

Miriel: Do go on.

Kellam: I–I'm not used to talking to people when they're standing so close.

Miriel: That's perfectly all right. Neither am I.

Kellam: ...Is this all some kind of joke?

Miriel: When it comes to my research, I am incapable of jocularity.

Kellam: Oh. I see.

Miriel: Right then! I have set up a few atmospheric measuring devices on the table to the right. If you would be so good as to walk that way while you depart, I shall...

Kellam: Depart?

Miriel: Vanish. Evaporate. Dematerialize. Just walk off like you always do.

Kellam: All right, here goes...

Miriel: And there he goes, right on cue. ...Simply fascinating.

■ KELLAM X MIRIEL A

Miriel: Thank you for your assistance the other day.

Kellam: Are you going to observe me again?

Miriel: Do you find it discommodious?

Kellam: I don't understand what that means, but your observation makes me nervous. Still, if you need me to keep doing it, I'll help however I can.

Miriel: Then let us proceed. Please disappear...NOW!

Kellam: Um...

Miriel: Yes? Is something the matter? Do your thing! Amscray! Begone!

Kellam: I am. It's not working.

Miriel: ...Now THAT is fascinating!

Kellam: How so?

Miriel: Well, this is just a provisional theory... But perhaps your ability stems from a reluctance to impose yourself on others. You withdraw from people's consciousness, and hence from their senses as well.

Kellam: Nope. I don't understand that either. Is it why you can see me now?

Miriel: A bond has formed between us, making you a larger presence in my conscious mind. Our familiarity means that my senses are better able to detect your presence.

Kellam: So are you saying you and me are becoming friends?

Miriel: Well, I used the word in its broader sense. More like companions. ...Or pack mates. We have spent considerable time together, so certain attachments naturally develop.

Kellam: Oh. That's nice, I guess.

Miriel: We must spend more time together.

Kellam: R-really?

Miriel: Yes. I would like to hold your arm for a little longer.

Kellam: Um, okay...

■ KELLAM X MIRIEL S

Miriel: I must say, Kellam, you are a very forbearing and patient young man. Not many people would put up with being a test subject for so long.

Kellam: Oh, I don't mind. This way I get to hear all your interesting theories. In fact, I'm so used to you clinging to my arm, I get lonely when you're not there.

Miriel: Interesting. I have experienced these feelings of loneliness as well. Clearly, the bonds of friendship between us are growing ever stronger. It would be most intriguing to see where this relationship takes us.

Kellam: Well, maybe we can. ...I have a gift for you.

Miriel: Is it an astrolabe? A microscope? Perhaps a new orrery? Ah, I see. It is a ring.

Kellam: It's handmade and one of a kind. If you accept it, we can be married.

Miriel: This new line of research would take years to complete. And I have so many other avenues of study to pursue... But yet, when you presented the ring, I felt a certain amount of...elation. How fond is it of me that you are willing to be my test subject for life?

Kellam: If that's what it takes? Absolutely!

Lon'qu

■ LON'QU X MIRIEL C

Miriel: The moon is illuminated by the sun? A most curious claim. And yet...

Lon'qu: Hey.

Miriel: The sun's light dims and is extinguished as it falls below the horizon. How, then, can—

Lon'qu: Hey! Watch OUT.

Miriel: Ack!

Lon'qu: Do you have a death wish, woman? You nearly walked off a cliff! ...Gods. I grabbed a woman's arm.

Miriel: Apologies. I was lost in my reading.

Lon'qu: Maybe sit down next time if you aim to stay alive.

Miriel: My heart is racing. An autonomic response to danger, I assume? Very interesting. I must make a note of this...

Lon'qu: Just close the book.

Miriel: I am conducting a thought experiment and would prefer not to interrupt it.

Lon'qu: You'd be interrupted permanently if I hadn't stopped you. Don't let it happen again.

Miriel: Assuming the sun does somehow continue to shine from beyond the horizon... Bah. It's no use. My focus is lost.

■ LON'QU X MIRIEL B

Lon'qu: I told you not to let this happen again!

Miriel: You did.

Lon'qu: So why is this your seventh brush with death in a week? The falling rocks and being swept off by the river I can perhaps understand... But you just stepped in front of a cart! A cart full of...of very loud minstrels!

Miriel: Yes. But I saw you coming as well.

Lon'qu: And you just assumed I'd save you?

Miriel: That was my hypothesis, yes. The first few instances were accidents, but they raised a curious question. Was my attendant increase in heart rate purely the result of proximal danger?

Lon'qu: Say that in words a human can understand.

Miriel: A second situational cause could be postulated: proximity to you. Perhaps contact with someone unfamiliar was the cause of my momentary excitation. The only way to be sure was to collect data, which entailed replicating the experiment.

Lon'qu: So you had to keep trying to die so I could keep saving you? What if I'd been too slow?

Miriel: An incisive criticism. My methodology failed to prepare for that contingency.

Lon'qu: For a smart woman, you sure are dumb. So understand this—that was the last time I'm pulling you out of the fire! I'm uncomfortable enough around women as it is. I don't need you making it worse.

Miriel: A categorical aversion to women? Curious. Does this extend to, say, a female cat?

Lon'qu: What? No. Cats all look the same to me.

Miriel: What about primates? Statues of women? Perhaps a female cadaver?

Lon'qu: I'm pretending you stopped at statues.

Miriel: Is your reflex physical, or psychological? This merits a most rigorous investigation!

Lon'qu: I'm starting to wish I'd let those minstrels run you down...

■ LON'QU X MIRIEL A

Lon'qu: All right! Why did you do it?!

Miriel: Your question is far too vague for—

Lon'qu: You filled my tent with statues of women! And most of them had no arms!

Miriel: Ah, yes. That. Your question was ambiguous, Lon'qu. Specificity is paramount in any inquiry. Regardless, the statues were an experiment to learn the extent of your aversion reflex. And now I may collect the results! So then, how did you react to the statues?

Lon'qu: By smashing them.

Miriel: I see. So an inanimate likeness DOES trigger your reflex.

Lon'qu: No, that's not the—

Miriel: Thank you for your cooperation. We can proceed to the next test once I've procured sufficient female monkeys to—

Lon'qu: For the love of all the gods, no! You don't get it.

Miriel: I have made an error in my calculations?

Lon'qu: I didn't get rid of the statues because they looked like women. There was barely enough room in my tent to stand! Plus I didn't want people to think I had...issues.

Miriel: Ah! I see your point. A man who claims to be constitutionally averse to women with a tent full of statues? You might indeed be the subject of scrutiny, to say nothing of salacious rumor.

Lon'qu: Assuming those words mean what I think they mean, yes. That's exactly.

Miriel: This was an oversight in my methodology. I apologize. We'll repeat the experiment in a secluded location.

Lon'qu: No, we won't.

Miriel: My heart is racing at the prospect of clean, reliable data!

Lon'qu: I said forget it!

■ LON'QU X MIRIEL S

Lon'qu: ...Hello, Miriel.

Miriel: Curious. How did you know it was me?

Lon'qu: After enduring your "experiments" day in and day out, I've come to expect you. Also, you have a fairly unique presence.

Miriel: A presence, you say? How ambiguous. With what sensory organ do you detect it? We would have to disable them one at a time to be certain.

Lon'qu: Just... Look, forget I said anything. What are you here to test this time?

Miriel: I've observed a new phenomenon. Over the course of our joint research, I have come to crave further contact with you. I've yet to ascertain the cause and extent of this addiction, however.

Lon'qu: I...have a theory.

Miriel: A hypothesis, Lon'qu. Not a theory. A theory is a measurable extension of... I apologize. I interrupted you. Please continue.

Lon'qu: I think what you feel is the same as what I feel for you.

Miriel: Then you've cultivated an immunity to women as a result of our experiments?

Lon'qu: Not an immunity. Just an exception.

Miriel: Fascinating. And a relief! It seems a shame to lose such a rare affliction. In any case, this calls for further inquiry.

Lon'qu: Heh. I thought you'd say as much. That's why I got you this.

Miriel: It appears to be a ring.

Lon'qu: That's because it is a ring. Wear this, and our addictions will be sated. You'll also never lack for a test subject.

Miriel: Are these properties magical in nature? Most intriguing...

Lon'qu: I'm asking you to marry me, idiot!

Miriel: Ah, I see! Fascinating.

Lon'qu: That's...not really an answer.

Miriel: Apologies. I appear to be flush with a host of new and unfamiliar feelings. Each one is more intriguing than the next! I'm not sure how to express them properly.

Lon'qu: Most people smile.

Miriel: ...Is this satisfactory?

Lon'qu: Actually that's a bit creepy... But... You know what? We'll work on it.

Ricken

■ RICKEN X MIRIEL C

Ricken: Hyaaa! Wind! Nrrraaaagh! Elwind! Hnnnnnngh! Fire! Whew... That's good for now.

Miriel:

Ricken: You're awfully quiet over there, Miriel. Come to think of it, I don't think I've ever seen you practicing spells. So, I guess you just read and think? A lot?

Miriel: Vigorous thought suits me. There is less grunting.

Ricken: But don't you want to actually try out the stuff you're learning?

Miriel: The testing of hypotheses through experimentation is of paramount import.

Ricken: Um, Miriel? What did you just grab? Why are you staring at a glass of water?

Miriel: I've immersed two distinct metals in this solution. Now to apply a charge... THUNDER!

Ricken: Gah!

Miriel: Success! How pleasant.

Ricken: Whoa! They both look like the same metal now. How'd you do that?

Miriel: It's merely a thin coating of particles freed from the sample by the spell's energy.

Ricken: I have absolutely no idea what that means, but it's still amazing! So does that have some kind of combat use or something?

Miriel: None whatsoever.

Ricken: Oh! That's...kind of weird.

■ RICKEN X MIRIEL B

Miriel: Administer the spell to the charcoal, if you please.

Ricken: Got it. ...Hyaaa!

Miriel:

Ricken: Whoa.

Miriel: ...And success! How nice.

Ricken: Wait, hold on! Why did it glow like that? And why was it that color?

Miriel: This is another byproduct of the spell's magical energy.

Ricken: Sooo, I don't suppose this has any combat applications either?

Miriel: Absolutely none.

Ricken: And since the thunderbolt already glows, why bother with the coal at all?

Miriel: Practical use is not my concern. I conduct experiments to uncover natural truths.

Ricken: Gee, I never really stopped to think about anything like that. So, what's the next experiment? Anything I can help with?

Miriel: I welcome your assistance, but as I said, it is likely to be of dubious use at best.

Ricken: Aw, that doesn't matter. Let me help! This is real cutting-edge stuff. I mean, maybe you'll find some amazing use for it after all. Plus we're tossing lightning bolts around, and that's fun!

Miriel: Heh. It is good to see one so young enjoying science. Let us proceed.

Ricken: Yes, ma'am!

■ RICKEN X MIRIEL A

Miriel: And...begin.

Ricken: Nrrraaagh!

Miriel: ...Curious. As hypothesized, the same tome yields different results based on the user.

Ricken: Well, yeah. That's because you're a stronger mage than me.

Miriel: But what is magical prowess, specifically? What factors determine its development?

Ricken: Well, it's... I mean, it's like that one thing where mages... Hmph. You know? I've never even stopped to think it through.

Miriel: A complex, multicausational phenomenon to be sure, but a fascinating line of inquiry.

Ricken: You're always asking questions other people haven't even thought of. Where do you come up with this stuff?

Miriel: My research is based predominately on the writings of my mother. To her final day, she documented every phenomenon and natural law she observed. Some called them the ravings of a madwoman, but I saw crystalline insight.

Ricken: And now you want to prove her right! We're not that different, you know? I'm fighting for my family's name, too. We used to be an old noble house, but times have been hard lately. It's up to me to come home a war hero and rebuild our reputation! So if there's anything I can do to help, just say the word.

Miriel: Likewise.

■ RICKEN X MIRIEL S

Miriel: I believe we've made satisfactory progress. Let us conclude here for the day.

Ricken: Sure! So are things quicker with an assistant, or am I mostly in the way?

Miriel: You've improved efficiency considerably and enabled an entirely new methodology. Your help is appreciated.

Ricken: Hee hee! That's great. But actually, I'd like to help in all your experiments from now on, if that's okay.

Miriel: In perpetuity? That would be a great help indeed.

Ricken: Well then... Um... Here.

Miriel: A ring? How curious. Are you proposing we melt it down to ascertain its composition?

Ricken: I'm proposing you marry me! Then we could work side by forever. And that's important because...I think I've fallen in love with you.

Miriel: Most fascinating. Your words acted as an aural cue causing a suffusion of warmth to permeate my chest. This demands further exploration. I shall need your help for more experiment.

Ricken: I'd love to!

Miriel: I hypothesize this will be a highly educational partnership.

Gaius

■ GAIUS X MIRIEL C

Gaius: Hey, a pack of cards! Don't tell me there was a game on and I didn't get invited. Crivens, I haven't dealt in quite some time. *shuffle* Heh heh. I guess old Gaius Nimble Fingers can still tickle the deck when he wants.

Miriel: What was that?

Gaius: Wargh! Don't sneak up on folk like that! Cripes, I darn near bit my tongue... Anyway, I was just fiddling with these cards. Used to be quite the player back in the day. That is, until one fateful evening... The evening I wagered and lost the finest crowberry tart I ever saw. The horrific memory haunts me to this day, and ever since, I've sworn off gamb—

Miriel: I was not inquiring about your own personal failings. I wanted to know how you made that card vanish into the ether.

Gaius: What card?

Miriel: The card that was in your hand a moment ago. The one with a regent's image. I saw it clearly, but now it is nowhere to be found.

Gaius: Oh, that? Heh heh. Just a little trick I learned on my travels. See? The card's in my right hand... Then I flip it like so... Presto! It's in my left!

Miriel: Fascinating! You seem to have mastered the legendary art of teleportation!

Gaius: What? Er, no, it's just sleight of hand. Anyone can do it with enough practice.

Miriel: ...Sleight of hand? I am not familiar with that particular discipline.

Gaius: It's all about deceiving the eye and fooling the senses. For example... Ta-daaaaa! I just made a card appear out of nowhere. ...Or so it seems. But I was actually just hiding it in my sleeve.

Miriel: Ah, I see. What an amusing hobby. Do you have any other tricks? I would be interested to see more.

Gaius: Interested enough to give me, say, three peach pastries in exchange?

■ GAIUS X MIRIEL B

Miriel: Gaius, I would like to observe more of this sleight of hand of yours.

Gaius: Sorry, Specs. You saw every trick I know. Besides, I don't want to do more, anyway.

Miriel: ...Specs? Ah yes, a reference to my eyewear. How very amusing. But why do you not wish to demonstrate more of your talent? It is quite singular.

Gaius: Because you see right through my tricks. It spoils the fun! Ah, Gaius! You have placed the card inside your codpiece!" "I say, Gaius! That coin can be located behind your third knuckle!" It's seriously demotivating.

Miriel: I admit that I would be a difficult person to fool in this regard. Years of training have honed my powers of observation into a sharply pointed rapier.

Gaius: Er, wait. You actually practice looking at stuff?

Miriel: Of course. It is an invaluable tool for any serious practitioner of science. The first lesson of observation is that you cannot trust your perceptions. Sensory impressions are mere constructs and easily distorted by preconceptions.

Gaius: Sooooo, folks see what they want to see, but you taught yourself not to?

Miriel: The human mind can accomplish anything if one is sufficiently diligent.

Gaius: Got it. That explains why I can't fool you. Well then, maybe it's time to get serious.

Miriel: Please explain.

Gaius: Well, I've been holding one back. In fact, I wasn't going to show you... But as you've won every round so far, I reckon it's time to play my trump card.

Miriel: I did not realize we were engaged in a competition.

Gaius: Look, Specs, whenever you figure out one of my tricks, that means I lose. And if I lose, I have to give you my pastries. But that's just honorable. So if you can't figure it out...

You have to buy me a treacle pie from the best baker in town. Deal? All right, here goes!

Miriel: It had not occurred to me that you might consider the pastries some form of wager... But very well, then. I accept. Show me your trick.

■ GAIUS X MIRIEL A

Miriel: Dear me, Gaius. You look very low today.

Gaius: If you're here to gloat, get on with it and then leave me alone. I'm out of tricks, Specs. I got nothing. Zero. Zilch. Nada. Ix-nay. I don't even have any more sweets to wager.

Miriel: Truly? You are completely out? I'd thought you to have a secret stash.

Gaius: Raided it last night. Cleaned it out in an eyeblink, I did. I've never been this long without sugar! I think I'm having heart palpitations.

Miriel: You misunderstand. I was speaking not of sweets, but of card tricks.

Gaius: Oh. Well, you bled me dry on those, too.

Miriel: Interesting. Perhaps then you could think up some new ones.

Gaius: Oh, yeah, sure. I'll just reach down and pull 'em out of my... Look, why are you so interested in my card tricks, anyway? It's not like I ever manage to fool you.

Miriel: It is a difficult reason to put into words, but I shall attempt it. I found our competition to be stimulating. Almost thrilling, in point of fact. My senses were heightened like never before. It was a truly zesty experience!

Gaius: Oh? You seemed pretty bored to me.

Miriel: I assure you, I was not. Your enthusiasm for the game was quite infectious. My skin tingled, my heart raced, and I noted a dozen other signs of excitement besides.

Gaius: So there IS a bit of passion behind that logical exterior of yours.

Miriel: That would be a fair proposition, yes.

Gaius: Oh, yeah. That passion just comes shining through... Tell you what, Specs... If you like playing that much, I'll try to conjure up some more tricks. All right? I may just have a couple of ideas...

■ GAIUS X MIRIEL S

Gaius: Hey, Specs. I've got one. ...A new trick, that is. Care to play?

Miriel: There is nothing I would rather do at this moment.

Gaius: So, I have a white handkerchief here, yes? Just a normal, everyday item. Now if you would be so kind, please drape it over your hand.

Miriel: Like this?

Gaius: Good. Now I'll just lift it off and...

Miriel: Interesting. You have caused a ring to appear in the palm of my hand.

Gaius: Do you know why it's there?

Miriel: Because a ring is small and easy to conceal, thus lending the trick credence?

Gaius: Uh, no. That's not what I— I don't mean HOW it got there. I mean WHY.

Miriel: Ah, I think I understand your meaning now.

Gaius: Well, let me tell you the "why" first. Because... these last few weeks have been the most fun I've ever had. I'm serious, Miriel. Even when I lost pastries, I was just happy to be near you. Maybe it's the competition, or maybe it's just that you're beautiful. I'm not sure. But anyway, I was thinking maybe you might feel the same way, and so...

Miriel: You need not explain more.

Gaius: But I haven't finished my speech yet.

Miriel: I am most fascinated by this zest for competition you claim to have developed. ...And the comment about beauty did not hurt your cause either. At any rate, I believe ours to be a relationship worthy of further study. A marriage contract would suit my purposes very much indeed.

Gaius: Th-that's great. I mean, really! Fantastic!

Miriel: Now, Gaius...

Gaius: Yes, dear?

Miriel: Will you show me how you managed to place the ring on the palm of my hand?

Gaius: This better not be the only reason you said yes...

Gregor

■ GREGOR X MIRIEL C

Gregor: Miriel! You want sit down with Gregor? Enjoy tasty cup of elderberry tea?

Miriel: I am curious as to why you are constantly inviting females to consume tea.

Gregor: Gregor is man, yes? He enjoys company of lovely maidens. What more is to tell?

Miriel: Would you say women possess some attractive force which draws you to them?

Gregor: Oy, yes, Miriel is very attractive! That is why Gregor offers tea.

Miriel: That's not what I meant, but I suppose it's the best I'll get from a layperson. So then, what aspects make a woman attractive? Can you define them? I would very much like to quantify this phenomenon if at all possible.

Gregor: You are using many large words. Gregor is... very confused.

Miriel: It's simple: there must be rules governing attractive force and how it operates. If you are able to define the parameters, it should be possible to re-create them.

Gregor: But every man is liking different thing, yes? Gregor speak for no one but Gregor.

Miriel: Ah. So you claim it is impossible to arrive at a universal definition of attraction? But that would imply that there are contradictions in human nature.

Gregor: Gregor is surprised brain does not ooze out of Miriel's ears.

Miriel: Such a thing is highly improbable. At any rate, my life is devoted to meticulous research and rigorous scientific study.

Gregor: Is sounding like barrel of monkey laughs.

Miriel: Now, I believe you were offering me tea? Elderberry was it?

Gregor: A-actually, Gregor suddenly busy! Urgent chore at...somewhere else!

Miriel: Ah. Well, next time, perhaps.

GREGOR X MIRIEL B

Gregor: Hmm... Interesting. Gregor never thinks of that...

Miriel:

Gregor: Ho ho! That makes you think.

Miriel: Am I no longer interesting to you? As a female companion, I mean?

Gregor: Porridge and pierogi! Why are you sneaking up on Gregor?!

Miriel: The other day, you told me that a man such as yourself is drawn to attractive women. I was conducting an experiment to ascertain the existence of consistent rules. However, if I no longer possess such a quality, then the control group is flawed.

Gregor: Gregor still thinks Miriel have likely deadly siren! But, today, Gregor is being engrossed in very fascinating book. Gregor is embarrassed. Ignoring presence of beautiful woman is very shameful.

Miriel: And what is this folio that was able to engage your attention so thoroughly?

Gregor: Gregor finds it lying on ground at edge of camp. Is very, very fascinating. Gregor is not knowing of these rules and laws governing natural phenomenon. But this book makes it fascinating subject. Time flies by for Gregor!

Miriel: Ah. I have been looking for that book, actually. It belongs to me. My late mother wrote it.

Gregor: Oy! Ten thousand apologies to you from the tongue of Gregor, dear lady! Gregor did not intend to steal precious book from dead mother.

Miriel: Quite all right. You couldn't have known.

Gregor: No, is big problem! Gregor scribble many notes in margins of pages...

Miriel: My mother would be pleased that you found her work so fascinating. And as for me, I'm grateful that you found it. I thought it lost forever.

GREGOR X MIRIEL A

Miriel: Er, Gregor? May I have a word? Do you recall writing notes in the margin of the treatise my mother wrote?

Gregor: You are upset because Gregor scribble nonsense things in book, yes?

Miriel: No, not at all. It's just that some of your comments were most...curious. I was hoping you might have time to edify me on a couple of them. As a simple matter of scientific discourse only. Peer to peer, as it were.

Gregor: Er, Gregor is confused. Did his comments not make sense?

Miriel: Perhaps in this situation a concrete example would be helpful. See, here you deleted the phrase "that which helps establish the theory"...

and replaced it with a single word: "experience."

Gregor: Oh, yes, Gregor remembers that. Er, Miriel is not liking this edit?

Miriel: No, on the contrary. I've been pondering this passage for some time in the belief it should be improved. But you have struck upon the missing link and dramatically improved the work, entire. I did not suspect you were in possession of such scholastic ability.

Gregor: Oh ho! Is true. Gregor never go to class. Gregor is graduate from school of life!

Miriel: I am unfamiliar with this institution. Are they accredited?

Gregor: You want to know secret of life study? ...Do nothing. Is exactly what Gregor does.

Miriel: I'm afraid I do not properly understand...

Gregor: Gregor does nothing special. Gregor learns by watching life. Knowledge is natural. Like bird learning to fly or cat coughing up ball of fur.

Miriel: How utterly fascinating...

Gregor: Most people run like chicken with no head. Always thinking of next urgent task. But if you go slow and watch everything, you can be smart like Gregor!

Miriel: Well, then. Food for thought. Thank you very much, Gregor.

Gregor: Come back anytime! Gregor always ready to share knowledge with peers!

GREGOR X MIRIEL S

Gregor: Ah, Miriel. You have nose stuck in book again?

Miriel: I've been thinking a great deal about our discussion the other day. I find it difficult to approbate the idea that one can learn without active study. Examining phenomena, research, postulating proofs—surely these things matter!

Gregor: Gregor not saying books and sciencey things not important... Gregor just thinking there other ways of learning, yes?

Miriel: No, I'm sorry. The idea just seems wholly without merit.

Gregor: Hmm. Okay, Gregor makes example. How is scientist defining love?

Miriel: Love?

Gregor: Yes, you know? When two people are liking each other and want to make with the—

Miriel: I am aware of the concept, Gregor, thank you. And as to your query, I would start by confirming observable behavior. Then, the culturally determined rituals in which persons in love engage.

Gregor: Like the holding of hands, yes? Or the making of adorable kissing faces? ...Or the giving of presents? Like this?

Miriel: ...Ah, a ring. Yes, this is a concrete example of the ritual to which I referred. The male of the species presents this as an indication of his desire to mate. This would indeed constitute evidence of the existence of love.

Gregor: Tell Gregor: can scientist Miriel explain what she is feeling right now?

Miriel: Well, I have an elevated pulse, sweaty hands, and a nervous energy about me. I cannot, however, explain the reason for these sudden...thrilling phenomena. Tsk! This will not do! I must remain dispassionate and analyze the facts.

Gregor: You see? This is being exactly Gregor's point. You do not allow experience to teach you. Everything analyzed like math problem. You must be silencing giant brain and listening to heart instead, yes? All new experiences and discoveries is coming from heart!

Miriel: I have never considered such a plan. But perhaps if I follow your advice, I will find a new world waiting to be discovered.

Gregor: Listen to Gregor. Human heart is too wonderful to be understanding by stuffy theory. You must crawl inside and live inside like small burrowing land mammal. Take Gregor's hand. Gregor can show how. We go on wonderful journey, together!

Miriel: Is this possible? Dare I throw aside logic and embrace the wiles of emotion? Very well, Gregor. I will accompany you on this journey of the heart!

Gregor: Ha ha! ...Gregor assume that mean yes?

Libra

LIBRA X MIRIEL C

Old Villager: Thank you, Libra. I feel your words have parted the dark clouds about my heart.

Libra: It gladdens me to hear that, my child.

Miriel:

Old Villager: The parables you've shared have lent my life a sense of direction. I feel hope rekindled in my breast. I cannot begin to thank you.

Libra: Your path will hold its share of hardship, but I pray you keep that hope alive.

Miriel:

Libra: Hmm? Oh, Miriel. What are you doing here?

Miriel: Observing.

Libra: That conversation just now? I fear it's hardly anything so grand as to merit study. I merely shared the teachings of Ylisse to those villagers eager to listen.

Miriel: And were they receptive?

Libra: I believe that faith will find a home in them. Such teachings offer a guide to life and are a steadfast beacon in these dark times. I pray it will also sustain them in the lean days ahead.

Miriel: If the teachings bear such salubrious effect, why not share them with greater numbers?

Libra: Naturally, were it possible, I would share them with everyone! Er, but why do you bring this up?

Miriel: By my observations, your methodology is highly inefficient. It vexes me.

Libra: Inefficient?

Miriel: Indeed. Assembling an audience, selecting the venue, promulgating the message... A scientific approach to these factors would yield a far more efficient modus.

Libra: Perhaps, but that isn't—

Miriel: Possible? Poppycock. Anything is possible. Given a thorough analysis of the germane phenomena, a sound theory will emerge. However, in the absence of empirical data, you might dismiss it as idle speculation. Therefore I must prove it through a physical implementation.

Libra: So what do you mean?

Miriel: I will show that it can be done. However, I fear I am unfit to preach the teachings of Ylisse. In this capacity, I would enlist your aid. I will furnish the mechanism, you the words. Now, if you'll excuse me, I must begin planning posthaste.

Libra: W-wait, Miriel! ...Oh dear.

LIBRA X MIRIEL B

Miriel: I have the results from our previous discussion.

Libra: Ah, yes. Your method to spread my teachings to a broader audience.

Miriel: Precisely. A unified fundamental theory has emerged from my investigation. First, the venue must be of sufficient capacity and easily accessed. Before speaking, the event must be made public knowledge among nearby villages. During the gathering itself, wind magic is to be employed to amplify your voice. Now then. For the next—

Libra: H-hold on just a moment, Miriel.

Miriel: Is something amiss?

Libra: Your plan is to gather a large crowd and speak to all of them at once?

Miriel: Quite. In so doing, you mitigate effort and time requirements by the greatest margin.

Libra: Yes, but I can't address individual people in such a crowd.

Miriel: Nor ought you. Speaking the same words to followers one by one is hideously inefficient. Gathering them and addressing the lot in one fell stroke is a far superior plan.

Libra: Superior in time and effort spent, perhaps, but—

Miriel: The plan will succeed. Further peer review is wholly unnecessary.

Libra: ...Very well. If you're that certain, we should try it.

Miriel: I will make manifest the eminence of my methodology!

LIBRA X MIRIEL A

Miriel: The theory is sound, and yet...

Libra: Is something wrong, Miriel?

Miriel: My data shows attendance is waning at your religious gatherings. The logs clearly indicate more people came to the initial meetings than come now.

Libra: Yes, I'd noticed as well.

Miriel: But my modus is theoretically sound. I've just revisited all my assumptions, and they withstand the strictest scrutiny. Yet data cannot lie.

Libra: Well, perhaps your ideas failed to account for a critical element.

Miriel: Such as?

Libra: The human heart. Oh, don't get me wrong—your methods get the words to more ears than ever. But the message stops at the ears, I fear, and does not travel to the heart.

Miriel: A defect in amplification, then?

Libra: Um... Not exactly, no. Every individual listens to the teachings of Ylisse for different reasons. If I limit my sermons to truths that apply equally to all, they fall short. Only by showing the relevance to each person's life can I truly reach them.

Miriel: A logical postulation. Perhaps I was indeed myopic in my designs. You certain from the start that my method would fail?

Libra: I thought offering salvation to a mob would be... difficult, yes.

Miriel: Then why did you consent to the mass gatherings? Or was I simply too heedless and stubborn to hear your objections?

Libra: A bit, perhaps. But mostly, I thought your plan might yield a different sort of benefit.

Miriel: And did it?

Libra: Indeed it did! You've given me the opportunity to meet more people than I ever could have alone!

Miriel: Curious.

Libra: I had grown rigid in my methods, Miriel—a lesson I hope you will take to heart. Your work was a success in terms of meeting converts, but it was only a step. And so I must continue the work that we started on a more personal level.

Miriel: There is merit in what you say.

Libra: I'm thrilled to hear it. Now, if you'll excuse me, I'd best head off to have some of those conversations.

Miriel: I hope you will permit me to offer my continued assistance as well.

LIBRA X MIRIEL S

Miriel: Another successful gathering today?

Libra: Absolutely. I can't thank you enough for all your help of late, Miriel.

Miriel: I am glad to be of service. And this has proven a most fruitful area of personal study as well.

Libra: Oh? What have you learned?

Miriel: That any system-built theory is only as efficacious as the dedication of the user. This is a known scientific truth, but one I had yet to learn so viscerally.

Libra: The parables hold similar words. ...Albeit smaller ones.

Miriel: This endeavor has sparked a curiosity in me to better understand the human heart. This will help transport my theories from the realm of abstraction into the tangible.

Libra: Perhaps you might begin by examining the contents of my heart?

Miriel: I had not planned to do so.

Libra: Then perhaps offering you this will spark your curiosity.

Miriel: ...Ah. A ring. Inductive extrapolation suggests this is a proposal of marriage.

Libra: Look into your own heart, Miriel. What do you find?

Miriel: Wonderment and joy in equal parts. Or so it would seem.

Libra: And do the contents of your heart move you to accept this ring?

Miriel: The sum of its contents provide an unequivocally affirmative response. Still, it is most curious. These sensations are demonstrably real, but hardly logical.

Libra: A fine subject for further investigation. I'll have to make sure you never lack for future data!

Cherche

CHERCHE X MIRIEL C

Cherche: That's your claws trimmed. Now spread your wings so I can wash underneath... That's it. Good girl, Minerva!

Miriel: ...?

Cherche: Oh, hello, Miriel. How long have you been standing there staring at Minerva? You seem utterly entranced. Do you like wyverns?

Miriel: No. Not at all.

Cherche: Oh, all right... You don't have to be so blunt about it, you know.

Miriel: ...My apologies. I was absorbed in my observations and forgot others desire a modicum of tact. That wyvern you have there seems to comprehend human speech.

Cherche: She's a very smart girl.

Miriel: I've read reports which claimed that ancient dragons possess the power of language. However, I'd not heard that living wyverns were capable of such feats.

Cherche: Well, sounds like you've stumbled upon the discovery of the century, then!

Miriel: Perhaps. Although it will still need to be peer-reviewed before publication. Will you allow me to continue observing the creature and further expand my thesis?

Cherche: Sure, we wouldn't mind that. Would we, Minerva? She says that would be fine. ...She also likes your hat.

Miriel: Fascinating.

CHERCHE X MIRIEL B

Miriel: Now, Minerva. What's this?

Cherche: ...She says it's an apple. Did I tell you she loves apples? Her favorite snacks are live goats, but apples run a close second.

Miriel: I see. Tell me, Minerva, how old are you now?

Cherche: ...She says she just turned 20.

Miriel: Interesting.

Cherche: So, what do you say, Miriel? Ready to go public with the discovery of the century?

Miriel: I'm afraid I will have to rewrite my entire thesis based on new information.

Cherche: Oh? How so?

Miriel: It is clear the subject, Minerva, does in fact respond to human language. However, there is no causational evidence that she understands the words themselves. It is also evident that you and the beast share a special and unique bond. Most-like this connection enables a mutual grasp of thoughts, emotions, and intent. In conclusion, there is but one rational explanation for Minerva's apparent skill. The answer lies with you, rather than the wyvern.

Cherche: With...me?

Miriel: You are the only person able to engage in this direct communication. Other humans can no more talk to Minerva than to a squid or squirrel. Rather than a talking wyvern, I believe I've discovered a human that speaks wyvern.

Cherche: That's not so special. Many humans say they can communicate with their pets.

Miriel: Hmm... I had not considered it in such a light. Clearly more investigation is warranted.

CHERCHE X MIRIEL A

Miriel: Hmm. It appears that Cherche is absent today.

Miriel: Two decibels louder and you would have caused permanent hearing loss, Minerva. I assume you are expressing displeasure caused from hunger, yes? I have an apple here in my sleeve. Would you like it? Could you please release my arm from your jaws before it is torn off?

Miriel: Curious.

Cherche: Hee hee...

Miriel: I fail to see the humor in the situation. Were I a barrister, I could take you for all you were worth.

Cherche: I'm sorry. I was just thinking how nice it is that you two became friends.

Miriel: Friends? Do you think so?

Cherche: How did you know she was hungry otherwise?

Miriel: It was a logical assumption. ...Wait. No, it was not. Fascinating. Perhaps I am acquiring your knowledge of wyvernspeak.

Cherche: Nope. It just means that when you get to know a wyvern, you start to understand her.

Miriel: I'd not considered that such a thing might be possible for the layperson.

Cherche: Apparently so.

Miriel: How utterly fascinating! I must now expand my investigation to include myself as a subject. That is, if you will allow me to continue to interact with Minerva? In fact, I hope you will be my partner in what is becoming a fruitful field of inquiry!

Cherche: Well, it's not just up to me.

Miriel: Ah, of course. ...Minerva, will you continue to help in my research?

Miriel: I believe that was affirmative.

Cherche: It certainly was!

Henry

HENRY X MIRIEL C

Miriel: Many thanks for your fortuitous assistance the other day.

Henry: Nya ha ha! No problem. But talk about your strange days! When I saw that big snake on your hat, I thought he was a pet.

Miriel: The shade under the tree was pleasant, and my book terribly absorbing. Therefore, I failed to notice when the creature undulated down to my position.

Henry: Good thing I came along when I did, or he'd have chomped your face but good.

Miriel: An ophidian of that size is not capable of "chomping a face." However, I am curious how you managed to dispatch the creature. You did not clasp it in your hand, nor cast any spell I could fathom.

Henry: It was a curse. If I'd used a tome spell, you'd have been in the line of fire, too.

Miriel: A curse? Ah, yes. Dark thaumaturgy not based on this world's elemental forms. I would like to study this skillset further, if I may.

Henry: Why? Do you have someone you want to curse?

Miriel: I'm interested in how such hexes are conjured and the theory behind them.

Henry: You always have to know exactly how things work, huh? Want a demonstration? I could turn [Robin] into a toad or something.

Miriel: No. The experiment is not of such import that our comrades need be imperiled.

Henry: But it wouldn't be forever! Just a few days at the most.

Miriel: If we were suddenly called to battle, a toad tactician would be most disadvantageous.

Henry: Oh yeah. I hadn't thought about that. Well, maybe I could cast a different kind of hex.

Miriel: So long as the risk is within acceptable parameters.

HENRY X MIRIEL B

Henry: I'm sorry, Miriel. But I can't show you any more curses.

Miriel: How disappointing. My research is nearly ready for peer review.

Henry: Yeah, well, [Robin] got mad at me. said I'm not allowed to randomly curse people anymore. Pfft.

Miriel: Fortunately, I've already collected enough data to posit a tentative theory of hexing.

Henry: You have? That's great! I cast hexes all the time, and I've never come up with ONE theory about them.

Miriel: Hex casting is the art of unleashing magic through a series of movements. It is the ritual itself that grants efficacy, rather than tomes or staves.

Henry: Yeah, well, sure. I just never thought it was all that exciting.

Miriel: Even more fascinating is the extent of your own thaumaturgic energy. If my calculations are correct, you are able to release huge quantities of magical force.

Henry: Nya ha ha! Oh, stop it, Miriel! You'll make me blush. Although it's pretty much true. When it comes to hexing folks, I'm the master. Why, this one time at mage camp, I killed 100 people with one curse!

Miriel: I am not privy to the subject of this "mage camp." And when exactly did this catastrophe take place?

Henry: Er, I don't remember when. ...Or where exactly. But it totally could have happened.

Miriel: In any case, I am most anxious to investigate the extent of your powers. Will you permit me to carry out additional tests and observations?

Henry: Sure! You can watch me in action for as long as you like.

HENRY X MIRIEL A

Henry: *Sigh* Aw, dang it. Failed again! This is harder than I thought.

Miriel: You seem vexed, Henry. Is something amiss?

Henry: Well, you know that town we passed through a few days ago? I saw a pregnant lady on the main street with a load of cheese and fruit in her arms. She looked pretty tired and worn out, so I stopped to help her carry her wares.

Miriel: I am told parturiency can indeed be a most trying experience.

Henry: Right?! Anyway, the more I thought about it, the more I realized pregnancy is dumb. So I'm planning to help the mothers of the world by inventing a special curse. I'm gonna create a hex that conjures new kids right out of thin air!

Miriel: Fascinating.

Henry: So if the curse is going to work, I need a ritual that can generate new life force. But I can't find even one. Who knew it would be so hard, when killing is so easy?

Miriel: The process of creating life is imbued with mystery and wonder. Many wise sages have tried to fathom the secret without success.

Henry: Gosh. If you and the old wise men don't know how it's done, what hope do I have?

Miriel: I would say the odds are remote indeed. Still, with so much as yet unknown, it may prove an intriguing field of study.

Henry: Say, if you're as curious as me, why don't we study it together?

Miriel: A most meritorious suggestion.

HENRY X MIRIEL S

Henry: Hello, Miriel. How's your research into the whole life-creation thing coming along?

Miriel: Poorly. It appears this is one mystery that will not easily surrender its secrets.

Henry: Yeah, I haven't had much luck myself. Except for one idea...

Miriel: Please, enlighten me.

Henry: Chrom married a woman and had a child, right? So, I was thinking you and me could marry and and...you know, see what happens.

Miriel: Fascinating... By experiencing the creation of life firsthand, we might learn to replicate it. That kind of immersion research could lend itself to a substantial breakthrough. But are you truly willing to engage in such a long-term endeavor?

Henry: Sure! I think you're the bee's knees!

Miriel: I find that term difficult to quantify.

Henry: Well, how's this? I'm completely smitten with you. Research or not, I know I want to spend my life with you. So how about it? Do you feel the same way?

Miriel: I have noticed clammy skin and increased heart palpitations in your presence of late.

Henry: That sounds like a yes to me! ...Oh, and here. Take this.

Miriel: Ah. A ring.

Henry: If you wear it, it means we're promised to each other forever and ever!

Miriel: ...Fascinating. The palpitations have returned.

Henry: Well, if you're happy, then I'm thrilled! And even if our experiment with creating life doesn't pan out, I'm okay with that.

Miriel: I see no reason to abandon the research simply because of an espousal.

Donnel

DONNEL X MIRIEL C

Donnel: Say, Miriel? Do ya have a minute?

Miriel:

Donnel: Er, Miriel?

Miriel:

Donnel: Hey! Miriel!

Miriel: Gwaugh?! What is it? Why are you shouting?

Donnel: I tried gettin' yer attention, but you was off in yer own world.

Miriel: Yes. When I read, I often immerse myself in it to the exclusion of all else.

Donnel: Seems like yer always readin', Miriel.

Miriel: I strive to utilize my time efficaciously. What free time I have, I spend reading.

Donnel: I reckon ya must'a studied a whole bunch by now, huh?

Miriel: I cannot say whether the breadth of my scholarship constitutes a "bunch." But I have studied more than the average person, that much is incontrovertible.

Donnel: In that case, I got a favor I wanna ask ya for... Miriel, will ya teach me?

Miriel: Teach you what?

Donnel: Er, I dunno. Math and science and all that kinda stuff, I guess.

Miriel: Why?

Donnel: Well, if I learn my subjects now, I'll be able to help my village when the war's done. We got no school back home, so there ain't no one what knows about book learnin'.

Miriel: I can instruct you in the basic theories of the usual courses. You may, however, find none of it to be of immediate practical use.

Donnel: Shucks, so long as I know the theory, I can always think up ways to use it.

Miriel: Are you literate?

Donnel: Ol' Goatkeep Gran knew her letters. She taught me how to read all right.

Miriel: I cannot instruct you beyond the bounds of my own ken, but I will attempt the basics.

Donnel: Well, much obliged then, Miriel!

Miriel: Be forewarned—I am not easy on my pupils.

Donnel: I wouldn't want ya to be!

DONNEL X MIRIEL B

Miriel: ...Let us conclude today's lesson here.

Donnel: Whew! Good. I'm beat.

Miriel: Unsurprising. We covered material of exceptional complexity today. But that is not to say these lessons have been entirely free of surprises.

Donnel: Oh? Like what?

Miriel: For one, the voracity with which you attack your studies is remarkable. I acceded to your request for tutelage with the expectation you would lose interest. Yet here you are, having already mastered some of the more difficult concepts.

Donnel: Aw, shucks. I'm barely keepin' up! And I ain't sure I got a perfect grasp of it, neither.

Miriel: Even an imperfect grasp, in conjunction with a diligent attitude, is sufficient to advance. Often a nuanced, intuitive understanding is something that develops organically.

Donnel: Er, if you say so, Miriel.

Miriel: Given this rate of acquisition, you might...

Donnel: Hmm? You say somethin'?

Miriel: Nothing of import. Now then, class is dismissed. Be certain to review the material before our next lesson.

Donnel: Yes, ma'am!

DONNEL X MIRIEL A

Miriel: I finished grading your examination.

Donnel: How'd I do?

Miriel: A perfect score. Exemplary work.

Donnel: Yee-haw!

Miriel: That concludes a canvass of the primary precepts of academic study. My lessons end here.

Donnel: They do? Gosh, I think I'm gonna miss 'em.

Miriel: But there is no end to learning. From today hence, you will be navigating the sea of knowledge by your own sextant.

Donnel: All by m'self, huh?

Miriel: Worry not. To extrapolate from the present data, you possess considerable aptitude. Continue to apply yourself, and you will find ample success in any academic pursuits.

Donnel: But I'd still rather be sailin' them seas with you, Miriel.

Miriel: I must recommend against such a joint venture.

Donnel: Why do ya say that?

Miriel: Empirical data shows that no previous attempt at such a partnership has survived. I have not always been without colleagues interested in collaborative investigation... Yet, ultimately, none were ever able to sustain the arrangement.

Donnel: Well, why not?

Miriel: According to them, I exhibit a tendency to press onward to new territory alone. Even I am aware that I tend to lose sight of all else when immersed in thought. As such, continuing my studies alone is the only natural conclusion.

Donnel: That ain't true at all!

Miriel: Hmm?

Donnel: It's their own fault for not keepin' up! Just 'cause they got lazy don't mean you should have to study alone forever.

Miriel: That is a fascinating theory.

Donnel: Let me join ya, Miriel. I'll do all I can to keep up! You said yourself I been makin' progress faster'n you thought!

Miriel: To use a metaphor, the path ahead is steeper still, and the footing unsure. There will be times I am unable to point the way. Are you certain you want this?

Donnel: Well all that sailin' talk had me nervous, but I'm a mountain boy. Climbin'? Now THAT I can do!

DONNEL X MIRIEL S

Donnel: Your studies been goin' well lately, Miriel?

Miriel: Quite smoothly, yes. Thanks to you. Many a time, you've provided the clue to surmount a current stumbling block. As the conventional wisdom goes, two heads appear empirically superior to one.

Donnel: Oh. That's real nice. So, um... I wanted to talk at ya about that today.

Miriel: About having two heads? You know that scientifically, this is highly improbable. ...Ah. Or perhaps you're finding it difficult to pursue studies in conjunction with me?

Donnel: Naw, it ain't that! It's the opposite, actually.

Miriel: Go on.

Donnel: I want us to be more conjuncted! Er, I wanna conjunct different... Shoot! Here! I wanna give ya this!

Miriel: A ring.

Donnel: It's a weddin' ring. I was hopin' ya might consent to be m'wife. I wanna keep explorin' things with ya as long as I live!

Miriel: I see no requisite for marriage in pursuing a joint exploration of academic studies.

Donnel: Well, no, I reckon not. So does that mean ya won't?

Miriel: However, accepting this ring would enable a host of other exploratory pursuits. And each of them could be undertaken as a collaboration with you... I can scarce think of a more exhilarating prospect.

Donnel: Um, could ya please just say yes or no?

Miriel: ...Very well. I accept. A broad array of new frontiers now lie open before us.

Donnel: And we got the rest of our lives to explore 'em together!

Morgan (female) (Mother/daughter)

The Morgan (female) mother/daughter dialogue can be found on page 312.

Laurent (Mother/son)

LAURENT X MIRIEL (MOTHER/SON) C

Laurent: Ahh, I see. How very fascinating... This era is so fortunate to have its texts still intact. It is a scholar's dream. And I shall need to read more still if I hope to catch up with Mother.

Miriel:

Laurent: Mother? What is that bottle you're carrying? ...Is that liquor?

Miriel: Indeed. "Breath of Dragons." A Feroxi spirit. Extremely potent.

Laurent: But it's not even midday. I would not have taken you for a heavy drinker.

Miriel: This sample was not procured to imbibe. It was intended for this...

Laurent: F-fire?!

Miriel: Mmm, yes. Just as I'd heard. Potations of sufficient strength and purity burn quickly. But why the blue flame? ...Fascinating. This demands further inquiry.

Laurent: You never cease to amaze, Mother. You're embarking on a new ground. Uncovering new truths about the world! I'll never catch up by merely reading about

the discoveries of others. Please allow me to join you in your observations.

Miriel: Certainly. Between us, we will lay the mechanisms of this phenomenon bare.

LAURENT X MIRIEL (MOTHER/SON) B

Miriel: Place copper within a flame, and the flame burns green... Truly a fascinating spectacle no matter how many times I observe it.

Laurent: And proof that other substances beyond liquor can change a flame's color.

Miriel: Precisely. Now, to return to the blue flames of our initial sample. Provided it is of sufficient potency, any spirit will burn with the same hue. Perhaps it is the inebriating power within the liquor that yields the azure tone?

Laurent: Pardon, but an observation, Mother: A metal plate melts at different rates when placed over blue and red flames. Is it possible the heat of the flame bears some influence?

Miriel: Hmm... I see. A line of questioning I had not considered. It may be the case, therefore, that liquor combusts at a lower temperature. This merits further investigation.

Laurent: Heh heh...

Miriel: ...Is something amusing?

Laurent: You seem happy, is all. At present, I have yet to muster conclusive evidence that I am your son... But working like this—being able to assist you—makes me happy as well.

Miriel: True, no unassailable case has been made as to our relation. You may not be my son. But you've more than proven you are my colleague in the pursuit of truth.

Laurent: Even without a blood link, we still share a bond between us. That may just be a greater reward than the truths we seek.

Miriel: Many a worthy truth was found in the course of pursuing entirely different phenomena.

LAURENT X MIRIEL (MOTHER/SON) A

Laurent: Mother, might I ask your opinion on a new creation?

Miriel: That? A round parcel, tightly bound... What is it?

Laurent: A derivative product of the new discoveries you made in colored flames. They made for such a striking sight, I was moved to explore possible applications. I've packed substances that produce flames of green, blue, and yellow inside. If detonated in midair, it should yield a dazzling display of color.

Miriel: I cannot imagine such an experiment would elucidate any hidden truths.

Laurent: I will admit it lacks in practical uses...

Miriel: ...But it would surely illuminate the sky in a breathtaking manner.

Laurent: That was the intent, yes. On the next clear night, I thought we might assemble the camp and give it a test.

Miriel: Just as critical as the quantity of knowledge one amasses is how one employs it. Your imagination is something that I lack. I greatly envy such dynamism. Laurent, will you permit me to assist you in this experiment?

Laurent: I would be honored, Mother!

Kellam

Avatar (male)

The dialogue between Avatar (male) and Kellam can be found on page 219.

Avatar (female)

The dialogue between Avatar (female) and Kellam can be found on page 230.

Lissa

The dialogue between Lissa and Kellam can be found on page 243.

Sully

The dialogue between Sully and Kellam can be found on page 252.

Stahl

The dialogue between Stahl and Kellam can be found on page 256.

Miriel

The dialogue between Miriel and Kellam can be found on page 259.

Maribelle

MARIBELLE X KELLAM C

Maribelle: YEOWCH! Oh, for the love of all that is shiny and rich and wonderful... All right, who left this massive suit of armor in the middle of everything?!

Kellam: Um, actually...

Maribelle: Eeeeek! Good heavens, Kellam, will you please stop sneaking around like that?!

Kellam: I wasn't sneaking. I didn't leave my armor laying around. I'm actually still wearing it.

Maribelle: Yes, yes, yes. I should have known you were somewhere inside all that steel plate. Speaking of which, I've been meaning to ask you about that. Why is it that you wear such a ridiculously enormous suit of armor? Is it a hand-me-down? Was your mother hoping you'd grow into it?

Kellam: I suppose it is a smidge bigger than the standard... But I don't see much need to go changing things now. It protects me well enough, and I'm plenty agile in a fight.

Maribelle: But you do realize you don't have to wear it ALL the time, right? For heaven's sake, I've seen you wearing it at a wedding!

Kellam: Well, I happen to like it. It's my most comfy outfit.

Maribelle: Codswallop! Comfort has no place in fashion! You should listen to me and try going without it every now and then.

Kellam: I'll think about it.

Maribelle: H-hey, come back here, you oversized kipper can! I'm not finished with you! ...Tsk. Too late. He disappeared. How DOES he do that?

MARIBELLE X KELLAM B

Maribelle: Kellam? Keeellaaam! Come out, come out, wherever you are!

Kellam: You called?

Maribelle: Here, I got these for you.

Kellam: Gosh, what nice clothes! They look expensive.

Maribelle: Well, you didn't expect I'd hand over a pile of rags, did you? Now normally these would be FAR too fine for a commoner such as yourself. But considering the circumstances, I thought you deserved something decent.

Kellam: That's mighty kind of you, milady. But I really like my armor and—

Maribelle: I HOPE you aren't about to say that your silly armor is better than these silks.

Kellam: I-it's just that I think I'd prefer to stay as I am, if it's all the same to you.

Maribelle: Oh, tosh-bosh! Why be so stubborn?

Kellam: When I first joined the Shepherds, I was terrified I wouldn't be able to fight. I thought I'd be useless in battle and end up being left behind and forgotten. Truth be told, I was really close to quitting and just going home. Not that anyone would have noticed...

Maribelle:

Kellam: But just when things were at their lowest, this armor arrived from home. The whole village had pitched in to make it because they were so proud of me. Imagine! The first boy to make it out, and now serving the prince no less!

Maribelle: I didn't realize your story was so...inspiring.

Kellam: This armor reminded me of the hopes and dreams of the people back home. And even if they got my size wrong, I'm going to keep wearing it!

Maribelle: Yes, well... Perhaps I was wrong to chastise you without knowing the circumstances. I pray we can put this little incident behind us?

Kellam: Oh, of course, Maribelle. I know you were just worried about me.

MARIBELLE X KELLAM A

Kellam: Say, Maribelle? I wanted to thank you for your help on the battlefield. If you hadn't covered my back, I wouldn't have been able to protect everyone else.

Maribelle: Not at all. Truth be told, it's a great comfort having you at my side. You pop up out of nowhere when I'm most in need, then melt away into the shadows. You're like one of those faithful sidekicks in the stories Mother used to read.

Kellam: Um, but I was standing right beside you the entire—

Maribelle: Yes, well, whatever. In any case, I'm developing a much better opinion of you. It's so inspiring to see a poor indigent like yourself help his village folk.

Kellam: Inspiring? Me? Oh no, milady. I'm just a simple farmer trying to do his best.

Maribelle: In the future, when this beastly war is over, I hope to become a judge advocate. I would be the first woman to ever hold such a post, so it will not be easy. However, I have no intention of giving up, no matter how hard the fight may be.

Kellam: That sure is brave of you! I couldn't do anything like that!

Maribelle: Oh, really? I don't know about that. I think you do it every single day. If anyone has foresworn the easy path and chosen the hard road, it's you.

Kellam: Oh, I don't know. I think I just like protecting folk...

MARIBELLE X KELLAM S

Kellam: Maribelle?

Maribelle: Yes?

Kellam: This is kind of sudden, but I was thinking about your dream for life after the war. Anyway, I was thinking I might be able to help you if I was...around.

Maribelle: How odd that you would say such a thing! I have been entertaining the same thoughts. In truth, I've grown rather fond of having you at my side.

Kellam: Oh, I'm so glad you think that way!

Maribelle: You'll make a fine butler with a little training! Maybe a valet in the worst case. We've been lacking one of those ever since poor Mr. Yates went off to prison...

Kellam: Um... N-no. That's not... I don't want to work for you.

Maribelle: Work for me? My darling, the servants in my house are like family! You get all the major feast days off, and we even switch places on the solstice!

Kellam: I want to MARRY you, consarnit! That's why I got you this ring!

Maribelle: ...Oh my dear good heavens.

Kellam: I know you'd be marrying below your station and all, but I don't care. If you want money or crowns or whatever, then you can go find some other man. But if you want a man who'll love you to the end of his days, then take me.

Maribelle: *Ahem!* Yes, well, when you put it that way... I suppose we could make the titles work. Name you a lesser duke or something.

Kellam: So is that a yes?

Maribelle: Yes, Kellam. I will be your wife. But you are NOT wearing armor to our wedding!

Panne

PANNE X KELLAM C

Kellam: Panne, aren't you going to join us for some sparring?

Panne: No.

Kellam: Can you not find a partner? Because I'm free if you'd like to—

Panne: When I fight, it is to the death. I am not interested in playing at war.

Kellam: Yes, but we—

Panne: Have you forgotten who I am, man-spawn? I am a taguel. In beast form, I cannot hold back until my thirst for blood is slaked. If you don't mind having your throat torn out, then let us spar by all means.

Kellam: Oh, I don't know. I think I'd be all right.

Panne: Hah. And why is that?

Kellam: Well, this massive suit of armor I trundle around in is pretty much impregnable.

Panne: Do not be so confident, iron man. If you fight me, I will grant no quarter. Do not expect me to stop until your guts are on the ground.

I cannot be held responsible for the consequences.

Kellam: Oh, erm... Well, all right. That's fair, I suppose. But maybe you could stop right before the guts part?

PANNE X KELLAM B

Kellam: Hello, Panne. Looks like you decided to turn out for additional sparring.

Panne: I have come to challenge you.

Kellam: Uh, really? Because you sort of destroyed me in our first match.

Panne: You are still alive. This in itself is a victory for you.

Kellam: I thought I was going to die... Does that count?

Panne: It does not! This time, I shall remove your heart with my teeth.

Kellam: Er, do you mind if I ask you a question first?

Panne: If you must.

Kellam: Just before you deliver the finishing blow, you leap left and right. Why is that?

Panne: It confuse the defender and trick him into lowering his front guard.

Kellam: That makes sense. [Robin] was wondering about it, too. After we're finished, I'll have to go tell (him/her). (He/She) will be very interested.

Panne: I have revealed one of my secrets. Now you must respond in kind. How is it that you were able to fend off my initial strike?

Kellam: Well, I turn left to take it here... Then I use the spear shaft like so...

Panne: I see. Sometimes you man-spawn are cleverer than you look. Well, then. Enough talk. Are you ready to die?

Kellam: Not really?

Panne: Come, come! Show some enthusiasm! Have you no pride as a warrior? You're a worthy foe capable of besting me, else I wouldn't deign to fight you.

Kellam: Th-thank you very much.

Panne: Don't thank me, fool! Where is your pride?

PANNE X KELLAM A

Kellam: *Groan* Ow, ow, owww... Whole...body... hurts...

Panne: Just stay still. And don't get up. I put a salve on the deepest cuts. Hopefully it works on humans, too.

Kellam: Ungh... I guess you...won again... C-congratulations...

Panne: Tsk... I know that you weren't interested in winning our mock battle. As we fought, a crowd of man-spawn gathered to watch and study my techniques. And later, many of them shared their skills and secrets with me. That was your true purpose, wasn't it? To trick me into fraternizing with others.

Kellam: When I first joined the Shepherds, I was all alone, too— ...Oh dear, that claw mark looks infected. OW! ...Yep, that's infected. Anyway, then Chrom invited me to spar and started introducing me to people.

Panne: And you thought to do the same for me at the risk of your own life and limb? You're a bigger fool than I thought.

Kellam: Zzzzzhhzzz...

Panne: He's fallen asleep... Just as well. It will help him to heal faster. You are a fool, man-spawn. But you have courage.

PANNE X KELLAM S

Panne: Are you not going to spar today?

Kellam: How do you keep managing to find me? No one else can.

Panne: I track you by your scent. You stand out like a bull in a cake shop.

Kellam: Oh. ...Do I smell that bad?

Panne: It is nothing special—all you humans smell unpleasant to me. Still, I'm sorry you won't be there today. Fighting you is one of my few pleasures.

Kellam: I know. I like it too. Especially when we have tea afterward.

Panne: I didn't realize you liked my tea so much. Most humans think it tastes like medicine.

Kellam: Er, well, the tea is actually wretched. But what I like is the talking part. You're so passionate and self-assured! I get excited just watching you.

Panne: I confess that I also enjoy our chats. You have a soothing way about you. It is like rubbing my back against an old, familiar tree.

Kellam: Gosh, that's just like me. I mean, when I'm with you. Um, so here. I have something for you. It's...it's a ring that I made.

Panne: Oh? I am aware of this tradition.

Kellam: You are?

Panne: The human male gives a shiny bauble to a female as his right to wed. We taguel usually decide such things through mortal combat.

Kellam: Well, um, I don't really want to fight you so I can marry you.

Panne: Nor do I. You'd likely not survive the ordeal. Here, then. Give it to me.

Kellam: W-wait. You accept?

Panne: Of course. I know you love me. I can smell it from miles away.

Kellam: Wow, that's great! (I really need to wash this armor at some point...)

Cordelia

CORDELIA X KELLAM C

Cordelia: ...Good. It seems that I have gone undetected.

Kellam: Oh, hey, Cordelia. What are you doing?

Cordelia: K-Kellam?! How long have you been there? ...Gods, isn't it impossible to do anything in secret with this guy hovering around.

Kellam: Sorry, did you say something? I didn't mean to interrupt your training.

Cordelia: Ah, it's fine. Don't worry about it. It's my fault I got caught.

Kellam: Practicing your stealth moves, eh? Are you planning some sort of covert op?

Cordelia: A good warrior should never neglect the chance to practice ALL her skills. You never know when they might come in handy.

Kellam: Wow, Cordelia. You're so dedicated.

Cordelia: Yes, but when it comes to stealth, you have us all beat.

Kellam: Yes, but I don't know if that counts. It's not like I practice or anything. People just seem to... overlook me.

Cordelia: Oh, come now. There must be SOMETHING special that you do!

Kellam: Not really. I just kind of stand here and fade into the background. Anyway, I'd better be on my way. Good luck with your training.

Cordelia: Maybe I should talk to him more about— How does he DO that?! You'd think that armor would be a big clanking giveaway...

CORDELIA X KELLAM B

Cordelia: *Pant* O-okay, I think I did it...

Kellam: Hello, Cordelia. Are you practicing your stealth moves again?

Cordelia: Kellam, there you are! Listen, I think I've got the hang of it now. I just circled the whole camp without being spotted by anyone!

Kellam: Really? Oh, well done! That must have been hard.

Cordelia: But here's the thing: I made a count of everyone, and I never found you.

Kellam: That's because I was on guard duty patrolling the camp's perimeter.

Cordelia: What?! B-but I was sneaking AROUND the perimeter! I didn't see you anywhere! Are you sure you weren't taking a nap in one of the tents? I won't tell.

Kellam: No, I was on the perimeter. I even saw when you hid behind that raspberry bush.

Cordelia: Wait. You SAW me circling the camp? Then I didn't... Then I wasn't... Oh, blast it all!

Kellam: Aw, don't be glum. It's hard to be stealthy when you stand out as much as you do.

Cordelia: You think I stand out?

Kellam: Well, I mean, you're just so pretty, and you have that long hair, and—

Cordelia: That's it. I'm getting a haircut.

Kellam: Oh, no! Please don't do that!

Cordelia: I'm just joking, Kellam. Don't worry. But... thanks for the compliment.

Kellam: Oh, um... You're welcome.

CORDELIA X KELLAM A

Kellam: Hmm... I haven't seen Cordelia all day. I wonder if she's practicing her stealth moves again?

Cordelia: Correct!

Kellam: GYAAAH! How long have you been there?!

Cordelia: Yes! Nailed it! I finally managed to sneak up and catch you unawares! Gods, but that took forever.

Kellam: Congratulations!

Cordelia: Well, I still can't just disappear at will like you can.

Kellam: I find it helps to turn sideways. But sometimes I just stand there.

Cordelia: I'll never have that skill, no matter how much I practice.

Kellam: Why are you so worried about stealth? You have lots of other skills.

Cordelia: Oh, I have lots of skills, all right. But I haven't mastered any of them. I wish there was ONE thing I could be better at than anyone else!

Kellam: Aw, I bet there is. Just let me think... Oh, I know! You're better at being able to do more things than anyone else!

Cordelia: That's...not quite what I had in mind.

Kellam: But it's an amazing skill! You learn new things nearly every day, right? That means you're the best at being average at everything!

Cordelia: Um...okay? I suppose that IS something to be proud of, huh?

CORDELIA X KELLAM S

Kellam: *Pant, pant* Okay. This time I won't blink for 17 minutes. Ready... Gwwwaaarrrrrffff!

Cordelia: That's quite a workout, Kellam.

Kellam: My eyes! They burn! ...Oh! Hi, Cordelia. I'm practicing the exercises you used to see me.

Cordelia: I never expected that I'd be teaching them to you one day! But I kind of like it. It's fun to have a secret training partner.

Kellam: I think it's fun that someone actually talks to me. Which is why I went out and made you this ring.

Cordelia: Oh, Kellam, it's beautiful! Did you really craft this?

Kellam: Yep. It's probably not worth much, but there's only one like it in the whole world.

Cordelia: I didn't know you could make jewelry!

Kellam: Well, I can't. But I tried my very best. It took a lot of trial and error, but...

Cordelia: You did all that for me?

Kellam: I...I really like you, Cordelia. More than anyone! Not to mention, you can actually see me. So, I got to thinking, and, um... Well, I'd really like you to accept this, and...you know, be mine.

Cordelia: Oh, dear. Kellam, I'm so sorry. I don't know how to say this...

Kellam: Uh-oh.

Cordelia: Just kidding. YES! Yes, yes, and yes! I accept your proposal!

Kellam: R-really?! Oh gosh, that's great! I kinda thought you'd turn me down.

Cordelia: Now why would I do that?

Kellam: Oh, you know. Because I'm kind of a wet leaf of lettuce...

Cordelia: You'll have to ditch that attitude if you want to be MY husband, mister!

Kellam: R-right! You got it!

Nowi

■ NOWI X KELLAM C

Nowi: Hmm? What's this piece of paper doing on the ground?

Kellam: Um, that's mine.

Nowi: Really? Let's see what it says... "Dear everyone. How are you?"

Kellam: Hey, that's private! Don't read it!

Nowi: Oh, it's a letter! Did you write this?

Kellam: It's for my family back home. My parents and brothers. I just want to let them know I'm okay.

Nowi: You have brothers?

Kellam: Oh, sure. Five of 'em. We grew up in a pretty lively house.

Nowi: *Sniff* I wish I had brothers and sisters. It's so boring when you're all alone...

Kellam: Gosh, that must be rough... But, uh, please don't cry. You know, I always wanted a sister... So if you want, maybe you could pretend that I'm your brother!

Nowi: That's a great idea! From now on, I'll be your big sister!

Kellam: Oh, right. You're older than me. I always forget that.

Nowi: Okay, Little Brother, let's play a game! I get to pick because I'm the oldest.

Kellam: Um...okay?

■ NOWI X KELLAM B

Nowi: Keeellaaaaaam! It's time to play hide-and-seek!

Kellam: Actually, you might not want to play that game with me.

Nowi: Don't you try to wriggle out of it. Your big sister orders you to play!

Kellam: Well, if you insist...

Nowi: I'm going to count to a million, so you run off and hide somewhere.

Kellam: A m-million?! Well, okay...

Nowi: OOONE... TWOOO... THREEEEEE...

Kellam: I was afraid this might happen. I'm hungry and it's almost dark. She must've gone home by now... I'll give it five more minutes, and then I'll come out and head for supper.

Nowi: Ah-HAH! Gotcha!

Kellam: Gah?! You were still looking?

Nowi: Well, I HAD to find you, right? Otherwise you'd have been waiting forever! Sitting in a bush... All alone... Not a single friend to talk to... But don't worry about that, Little Brother! I'll NEVER leave you alone!

Kellam: ...Never?

Nowi: Okay, your turn! Now you have to find me!

Kellam: Um, Nowi? It's dark, and I'm hungry, so maybe we can—

Nowi: Hey! Your older sister commands it!

■ NOWI X KELLAM A

Kellam: Found you, Nowi!

Nowi: Aww! Not again! Why are you so good at this stupid game?!

Kellam: Oh, I've had a lot of practice.

Nowi: But how do you hide so well? You have to teach me! Pleeease?!

Kellam: Aw, shucks, Nowi. I can't teach you, because I don't know. It just...happens. Our family was real poor, see? So my brothers and I had to share everything. But I was a mean kid who hated sharing, so we'd always get into fights. Eventually my family got tired of my selfishness and started ignoring me. Well, I got mad and they stayed mad, and now... Well, it's like I'm just not there.

Nowi: Oh, Kellam... That's the saddest thing I've ever heard in my life!

Kellam: It is?

Nowi: You may have a family, but really you're all alone like me!

Kellam: Well, I suppose so. In a way.

Nowi: Well, never mind all that. I'm your sister now, and I KNOW you exist! So no more hiding from me, all right? ...Unless we're playing.

Kellam: Heh heh. This sister thing ain't half bad!

■ NOWI X KELLAM S

Nowi: What are you doing, Kellam? You look so serious.

Kellam: Er, hello, Nowi. I'm just...polishing this ring.

Nowi: Wow, it's so shiny!

Kellam: My parents gave it to me when I first left for the capital. I'm supposed to give it to someone who I want to bring into the family.

Nowi: You mean like your big sister?

Kellam: Well...

Nowi: Oh, I'm just kidding. I know an engagement ring when I see one.

Kellam:

Nowi: ...Well? Are you going to give it to me or not?!

Kellam: Wh-what?! Well, I was planning on making more of a deal out of it. I mean, with some music or maybe a big cake or...something? ...Here. Do you accept?

Nowi: Yay! Of course I do!

Tharja

■ THARJA X KELLAM C

Tharja: Now where did I put that...

Kellam: Looking for something?

Tharja: ...! The last person who snuck up on me like that isn't a person anymore. How do you stay so quiet? Is it a spell of some kind?

Kellam: Um, no. Not that I know of, anyway.

Tharja: Right. Well, nice talking to you, quiet man. Now if you'll excuse me, I have a letter to mail.

Kellam: Oh! I'm here to mail a letter, too. Can I give you a hand?

Tharja: ...I know how to mail a letter. I just hope the postmen are still going to Plegia.

Kellam: Hmm. I imagine they would, but it's hard to say for certain. Why Plegia? Is that where your family lives?

Tharja: Yes.

Kellam: I suppose you're worried about them, huh? I worry about mine a lot.

Tharja: I come from a family of powerful mages. They can usually take care of themselves. But times like these... Well, who knows?

Kellam: A family of spell casters? Oh, wow. I bet they're safe as houses!

Tharja: I hope so...

■ THARJA X KELLAM B

Kellam: Say, Tharja?

Tharja: Agh! What did I say about sneaking up on me like that? Next time, I'll turn you into a newt.

Kellam: I wasn't sneaking, honest! That's just how I walk. Anyway, I just came to give you this. It arrived in the morning post.

Tharja: A letter? For me? Give it here.

Kellam:

Tharja: Oh, good.

Kellam: Is it your family? Are they all right?

Tharja: ...Are you still here?

Kellam: I was just anxious to know the news.

Tharja: Why do you care about my family? It's kind of creepy. But if you must know, it's from my parents and everyone is just fine. ...And your family?

Kellam: Um, nothing yet. I've been coming home every morning, but...yeah. My eldest brother has a wife, and they usually answer right away. But this time, I don't know...

Tharja: I can check for you. ...I mean, if you want.

Kellam: How?

Tharja: I'm a mage, quiet man. There's not much we can't do.

Kellam: Gosh, would you really? That would be a load off my mind!

Tharja: Sure. Now, tell me about this brother of yours, and omit no detail. If I'm missing important information, the spell might go...horribly wrong.

Kellam: *Gulp* Um... D-does that happen a lot?

■ THARJA X KELLAM A

Kellam: Hey, Tharja?

Tharja: Argh! ...That's it. Newt time for you.

Kellam: I'm sorry! I tried to not startle you! I clanked two pots together and everything! P-please don't turn me into a newt...

Tharja: Oh, all right. I'll give you another chance. Anyway, I assume this means you heard from your brother?

Kellam: That's right! He was in the refugee camp, just like you said. His letter says he and his family evacuated to avoid the fighting. I'd still be looking for him if it wasn't for you.

Tharja: Don't worry about it.

Kellam: Also, it sounds like he and his wife had a little baby boy. Which makes me an uncle, I suppose.

Tharja: Hee. That's good news.

Kellam: Um...

Tharja: What?

Kellam: N-nothing. I've just never seen you smile before. It's nice, is all.

Tharja: Maybe I'll turn you into that newt after all...

■ THARJA X KELLAM S

Tharja: Kellam?

Kellam: Gah! Y-you scared me! How did you see me?

Tharja: Heh. At last, revenge for all the times you crept up on me... I just had to modify a little invisibility spell I've been working on.

Kellam: Gosh. It must be handy being able to use magic like that.

Tharja: Here. I brought you something.

Kellam: What is it?

Tharja: It's a charm. It protects the wearer from misfortune and bad luck. I made a big pile and had some spares. I thought you could give it to your nephew.

Kellam: Aww, thanks! My brother and his wife will be so excited! You've been so nice to me, Tharja. I don't know how to repay you.

Tharja: I had some left over. That's all. Don't freak out.

Kellam: So actually, I have something for you, too. It's... Well, here.

Tharja: ...A ring? Did you win this at a carnival or something?

Kellam: I like you, Tharja. You're smart, and pretty, and you've been good to me and mine. Anyway, I've been thinking that maybe you and me could...be together?

Tharja: You are so very strange, quiet man. And I suppose I'm not exactly the harvest-festival queen myself.

Kellam: Don't say that! You're perfect!

Tharja: Now I know there's something wrong with you. But all right. Let's get married and make a strange life for the both of us.

Kellam: Wonderful! I can't wait to tell my brother the good news!

Olivia

■ OLIVIA X KELLAM C

Olivia: Um, excuse me. Do you have a second? I need some advice...

Kellam: What, me? S-sure, I suppose.

Olivia: It's just that I've been feeling, well...useless lately.

Kellam: That's crazy talk! Your dancing is an inspiration to us all!

Olivia: There must be SOMETHING I can do besides flail my arms about...

Kellam: Hmm... Well, can you cook?

Olivia: I mean, my grandmother taught me how to bake cakes and other desserts... Would that really be helpful?

Kellam: Are you kidding? Everyone LOVES dessert! It's the best meal of the day.

Olivia: Hmm, I suppose I could give it a shot. Let's see... I'll need honey and raisins... Oh, and a whole lot of butter!

Kellam: Mmm... I'm drooling already!

Olivia: Hee hee. You're pretty smart for a tree, you know that? Thanks for listening!

Kellam: Oh. She was...talking to the tree. Guess she didn't notice me there. Er, well, good luck all the same, Olivia!

■ OLIVIA X KELLAM B

Olivia: Oh, Mr. Tree was wonderful! Everyone loved my cakes!

Kellam: Um, I'm not a tree...

Olivia: But the strangest thing happened! See, I couldn't find any honey... But right when I was about to give up, a big jar appeared in my bag! Some gallant stranger must have helped me in my hour of need! *siiigh*

Kellam: Happy to help, Olivia. I just... I... Uh-oh... WAAAAAA-CHOO!

Olivia: K-Kellam?!

Kellam: Stupid pollen! It's just been so out of control these past... Oh. Um, hello, Olivia.

Olivia: Goodness, you scared me! Where did you come from? Oh, wait. You dropped something.

Kellam: Wait, you don't have to—

Olivia: ...Honey? Kellam, was that you?

Kellam: S-sorry. I'll be on my way.

Olivia: Wait, Kellam! ...Thank you.

Kellam: N-no! Thank you! The cakes were delicious.

Olivia: Then I'll have to make more right away. You mind if I take this honey?

Kellam: It's all yours.

■ OLIVIA X KELLAM A

Olivia: Kellam? Keeeeellam... HEY, KELLAM!

Kellam: I'm right here.

Olivia: Oh, there you are! I've been calling your name all over camp!

Kellam: Do you need more honey?

Olivia: No, not today. I just... Here. This is for you.

Kellam: Oh, it looks like a little star. What is it?

Olivia: It's called rock candy. I thought you could eat it while you march.

Kellam: What a good idea! I'm sure everyone will appreciate the boost.

Olivia: No, they... It's not for them. I made it for you.

Kellam: Just for me?

Olivia: J-just you.

Kellam: That's very kind, Olivia. Thank you. I can't wait to try it.

Olivia: I hope you like it.

Kellam: If there's, um...anything else I can ever help with, just say so.

Olivia: I will. Thank you.

■ OLIVIA X KELLAM S

Olivia:

Kellam: Hello, Olivia.

Olivia: WAAAH! Hee hee... You caught me again. I was going to slip this flower into your bag.

Kellam: Heh. It's tough to slip past me undetected. I'm kind of an expert, after all.

Olivia: You're always sneaking ingredients and little treats into my things, Kellam. It's not fair that I can't do the same...

Kellam: Speaking of which... Um... Have you checked your purse today?

Olivia: ...Oh, you're right, there's a little pouch! You rascal. I can't imagine what— Kellam? This is a ring.

Kellam: It's nothing fancy, but my mother made it, and it's very special to me. She said I should give it to the woman I love, and so... Um... Olivia, will you marry me?

Olivia:

Kellam: Oh... S-sorry, forget I—

Olivia: NO! I m-mean, not no! I mean yes, Kellam. Yes, of course. It's just... I'm just overcome, is all. I feel... Happy. So very, very happy. ...Thank you, Kellam.

Kellam: I love you, Olivia. I have since the very first moment I saw you.

Olivia: Ooh... That makes me all...wobbly inside. D-don't look at me!

Kellam: Anytime you start feeling shy, I'll just disappear into the woodwork. That's part of what makes us such a great pair.

Olivia: No you don't! This is my weird problem, and I'm going to fix it. So I'm going to need you to help me.

Kellam: We have the rest of our lives to work it out, Olivia.

Olivia: Yes, we do, don't we... Oh, Kellam, I'm so happy!

Cherche

■ CHERCHE X KELLAM C

Cherche: Let's see... Yes, that's everything. Time to saddle up and head out!

Kellam: Cherche, wait! Before you go—I wonder if you could take these trousers to the tailor? They need patching.

Cherche: You mean this little tear? I can patch that myself.

Kellam: Oh, but would you mind?

Cherche: Ha! I wouldn't have mentioned it if I wasn't offering, Kellam.

Kellam: Wow, thanks. I'm terrible at sewing. Last time, I nearly took my eye out with a needle.

Cherche: Well, I'm sure there are plenty of other things you can do well.

Kellam: I guess. But I was always jealous of folks who knew how to stitch their own clothes.

Cherche: I'm surprised a cute young lad like you didn't have a girl to do it for him.

Kellam: *Gulp* C-cute?!

Cherche: Surely you know how ridiculously adorable that armor of yours is. The village girls must have fawned all over you!

Kellam: My armor is...adorable?!

Cherche: Anyway, I must be off. Don't want to be late for the market!

Kellam: Wait a second! What's this about my armor?!

■ CHERCHE X KELLAM B

Cherche: Oh, look. It's the boy in the adorable armor.

Kellam: That's not what people call me, is it?

Cherche: No, but in my opinion, it's the perfect name for you.

Kellam: Oh. Well, um, thanks, I guess. Anyway, I brought my trousers.

Cherche: Let me see... Oh, that's nothing. I'll have it fixed in a jiffy.

Kellam: Thanks so much. Sorry again to ask you to do it.

Cherche: I don't mind at all. Oh, but while I'm at it, why don't I spruce up your armor, too?

Kellam: Spruce it up?

Cherche: Sure! A couple changes here and there would make it look really convincing! Say a few steel spikes on the shoulders? You'd look just like a real barbarian!

Kellam: Land sakes, no!

Cherche: Not even if they're long and pointy?

Kellam: Especially if they're long and pointy!

■ CHERCHE X KELLAM A

Kellam: Cherche, why don't you let me go to the market today?

Cherche: Really? Why?

Kellam: You're not well. I can tell. I've been watching you all day.

Cherche: Well, I was trying not to let it show, but I AM feeling a bit under the weather... Are you sure you don't mind?

Kellam: Of course not! Golly, Cherche, you're always so nice to me. It's the least I can do.

Cherche: You know, Kellam, I've been thinking we should spend more time together. That is, if you wouldn't mind.

Kellam: You and me?

Cherche: Maybe this fever is making me a bit dizzy and foolish... But I can't help thinking how nice it would be if we were a bit closer. Something about you and that adorable armor makes me feel...safe.

Kellam: I'd love to spend more time together! Heck, I owe you for the trousers.

Cherche: Great. Then a bit closer we shall be!

■ CHERCHE X KELLAM S

Kellam: Cherche? I have something I want to give you.

Cherche: Do you need more mending done?

Kellam: No, I, uh... Well, I made you this ring.

Cherche: Why, Kellam!

Kellam: Did I do something wrong? I know it's not the best ring ever, but we can change it if you—

Cherche: No! It's absolutely lovely! The ring is not the issue. But Kellam, you have to understand: I'm a knight, and always will be. Cast your lot with me, and you'll never know peace and quiet again.

Kellam: Just being in your presence gives me all the peace I need. Since we've become close, I hardly mind the rigors of travel or the turmoil of war. Heck, I don't care if rocks fall on my head, as long as you're with me! Well, not WITH me. I mean, I don't want rocks falling on YOUR head. A-anyway, will you take the ring?

Cherche: Oh, Kellam. Of course I will. Let us be partners-in-arms forever!

Donnel

■ DONNEL X KELLAM C

Kellam: *Cough*

Donnel: WAH! Gosh, Kellam, you 'bout near killed me just now! Where the heck'd ya come from?!

Kellam: You're planting bilberry bushes, aren't you? They're my favorite crop. You know, if you mix the soil with clover and pig dung, the berries get extra juicy.

Donnel: Shuck my corn! I never knew you was a farmer!

Kellam: Well, my father tilled the soil, but my brothers and I helped out in the fields. If you want, I could help you out, too.

Donnel: That's a mighty kind offer, Kellam! I'd surely 'preciate it! I'm plantin' the bushes in pots so's I can move 'em about, but there's just so many... Folks think berry pickin's a doddle, but they're dead wrong.

Kellam: It's been a while since I mucked around in the soil. Truth is, I kind of miss it.

Donnel: Well, I'm much obliged. You mind startin' on them pots in the stores tent?

Kellam: Goodness, that's an awful lot of bilberry bushes! There must be...hundreds.

Donnel: Seein' as how they're so popular, I wanted to make sure I had enough for everyone.

Kellam: *Sigh* Welp, guess I'd better get to work...

■ DONNEL X KELLAM B

Donnel: What'n blazes am I gonna do now?

Kellam: What's wrong, Donnel?

Donnel: It's my plants. They ain't exactly thrivin'. Look how droopy and yeller they are! Sure wish I knew why it was. S'pose that's what I get for tryin'.

Kellam: But why would only these plants here be affected? Those others seem fine.

Donnel: A'yup. It's a real head-scratcher. *scratch, scratch* Gosh darn it! I water 'em every day and talk to 'em each evenin'! Heck, I even tried singin'!

Kellam: Perhaps they're not getting enough nutrients? A problem with the soil?

Donnel: Well, now that you mention it... When we all rushed out to meet the last attack, some'a them pots got knocked over. I figured 'em as fast I could an' grabbed some earth to replace the soil what spilled.

Kellam: Ah! Perhaps the earth you added doesn't suit the plants?

Donnel: But how am I gonna replace it? If what you say is right, then the dirt 'round these parts ain't no good.

Kellam: Well, we could skim a bit of the good soil from each of the healthy pots. There must be hundreds of them in the stores, so there's plenty to go around.

Donnel: Say now... That might just work! You're as clever as an old fox, Kellam!

Kellam: Oh, I'm no smarter than the next man. I just spend a lot of time alone. It gives me plenty of opportunities to think.

Donnel: Donkey dung! I'd wager you're the cleverest fella in all the Shepherds!

Kellam: That's kind of you to say, but I very much doubt it.

Donnel: I got a copper coin what says you is!

■ DONNEL X KELLAM A

Kellam: Hello, Donnel. I heard through the grapevine that the bilberries ripened. Have you been serving them to everyone in camp?

Donnel: With brown sugar and cream! Everyone loves 'em! I thought I had loads and loads, but everyone gobbled 'em up so fast... Land sakes! They was gone 'fore I knew it!

Kellam: Well, that's great!

Donnel: They made me promise to serve more once I had a new crop. You think them bushes there are ready? The berries are kinda red.

Kellam: Well, hold on. Let me try one. ...Ptooie! Sorry, Donny. These boys need another few weeks at least.

Donnel: All right then. S'pose I should cool my heels for a spell. I'm mighty glad I spoke to Kellam the Genius before collectin' 'em!

Kellam: I told you, I'm not that clever. I just happen to—

Donnel: I wish I had half yer brains! Remember them plants what was all droopy and dyin'? Well, I changed the soil like you said and got me a bumper crop! I wager coppers to pebbles your pa and ma miss havin' you around the farm.

Kellam: Most days, they didn't know I was there. They never asked my opinion or anything.

Donnel: Well, that's about the dumbest darn thing I ever done heard!

Kellam: Gee, Donny. You're the first person who's ever appreciated my advice.

Donnel: Who wouldn't 'preciate it? You got brains oozin' out yer ears! Say, you'll stick around to teach me more stuff, right?

Kellam: Well, sure. I'll try to help however I can. But... isn't it strange I'm teaching you about farming and not fighting?

Donnel: Heck no! I'm already plannin' for the peace to come! When these troubles are over, honest folk are gonna return to their farms. We need to be ready so we can bring life back to this here land!

Kellam: Perhaps when the time comes, I could help with that.

Donnel: You'd do that for me? Gosh, thanks, Kellam!

Kellam: Then it's a deal. First, we finish this war...

Donnel: Then we plant enough bilberries to make pies for everyone!

Owain's father/son dialogue can be found on page 289.

Inigo's father/son dialogue can be found on page 293.

Brady's father/son dialogue can be found on page 297.

Kjelle's father/daughter dialogue can be found on page 299.

Severa's father/daughter dialogue can be found on page 305.

Gerome's father/son dialogue can be found on page 307.

The Morgan (male) father/son dialogue can be found on page 309.

Yarne's father/son dialogue can be found on page 314.

Laurent's father/son dialogue can be found on page 316.

Noire (Father/daughter)

Noire's father/daughter dialogue can be found on page 317.

Nah (Father/daughter)

Nah's father/daughter dialogue can be found on page 318.

Sumia

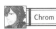

Avatar (male)

The dialogue between Avatar (male) and Sumia can be found on page 220.

Avatar (female)

The dialogue between Avatar (female) and Sumia can be found on page 231.

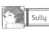

Chrom

The dialogue between Chrom and Sumia can be found on page 240.

Frederick

The dialogue between Frederick and Sumia can be found on page 246.

Sully

The dialogue between Sully and Sumia can be found on page 252.

Gaius

■ GAIUS X SUMIA C

Sumia: Oh, there you are, Gaius!

Gaius: Easy... Eeeeeasy... Alllmost theeeere.

Sumia: Gaius? Gaaaaaaius! HEY! GAIUS!

Gaius: SHHHHH! Quiet down! Can't you see I'm busy here?!

Sumia: Oh, sorry...

Gaius: Aw, horse plop. It flew away.

Sumia: Huh? What flew away? Hey, what are you doing, anyway?

Gaius: I'm bee watching. Or at least, I was.

Sumia: Oh, I didn't know you liked insects!

Gaius: I don't. I was just trying to figure out where that little fellow lives.

Sumia: You mean its hive? Ah-hah! NOW I get it!

Gaius: ...What do you get?

Sumia: You're looking for bee larvae!

Gaius: Ugh, gross. No!

Sumia: They're considered a great delicacy among fine society back at the capital. You know, I always suspected you had a sophisticated palate...

Gaius: I have NO idea what you're blathering about, Stumbles.

Sumia: Hey! You should let me help you find some bee larvae! I mean, since I scared your little bee friend away and all.

Gaius: Uh...wow, look at the time! I gotta fly.

Sumia: Oh. All right. But you MUST tell me when you go out again, all right? I insist! Bye, Gaius!

Gaius: ...Bee larvae? Crivens, I'll never understand these fancy city folk. Welp, no honey for me today. Maybe I'll try again tomorrow...

■ GAIUS X SUMIA B

Gaius: Heh heh. There's bound to be a hive around here somewhere. Plus, this meadow of tall flowers should hide me from that oddball noblewoman.

Sumia: Hey, Gaius!

Gaius: Oh, come on! Really?

Sumia: Hee hee. Isn't this field sooo pretty? Now, let me guess... You're here to hunt bee larvae, right? Ha ha! I KNEW it! In that case, I'm here to help!

Gaius: Look, Stumbles, I don't want to be rude or anything, but I'd rather get hide from—

Sumia: What kind of flowers do bees like most? The little purple ones? Those are pretty!

Gaius: Hey! Hello? I'm trying to insult you here!

Sumia: Ooh ooh ooh oooh! Look, Gaius! A bee, a bee!

Gaius: Huh? Wh-where?!

Sumia: There! It's flying toward the forest beyond the meadow.

Gaius: You're right. I'll bet a custard pie there's a beehive somewhere in those trees...

Gaius: Right, I'm going to check it out. You stay here and weave flower bracelets or— Huh? Where'd she go?

Sumia: Oh, Gaaaius! Yoo-hoo! I've found the beehive! Now, I just... "grunt" have to... "grunt" pull it off this branch...

Gaius: What in the... Are you mad, woman?! You can't just go grabbing beehives!

Sumia: EEEEK! Bees! Bees! Oh gods, they're everywhere!

Gaius: I warned you, you daft— Um, what are you doing? H-hey! Don't run TOWARD me!

Sumia: Here's your beehive, Gaius—catch! Sorry, gotta run! See you later!

Gaius: Good heavens, she's fast. But what am I supposed to do with— Gah! BEES! Thousands of them! Aaaaaaaaargh!

■ GAIUS X SUMIA A

Gaius: Ouch! Ow ow ow ow ow... I didn't know it was possible to get stung this much. ...And live, I mean.

Sumia: Oh, I'm so sorry, Gaius. I know I'm feeling that it was partly my fault. I mean, I'm the one who took the honey, and then gave it to you.

Gaius: Don't worry about it. You got what I was looking for.

Sumia: The bee larvae?

Gaius: No, not bee larvae! Who eats that, anyway? I wanted that sweet, sweet honey. Look at that golden, syrupy shine... Mmmmmm...

Sumia: Oh. Well, I suppose honey is good. It's no bee larvae, but... Say, do you mind if I just try a little bit? Maybe just a quick tast—OW!

Gaius: Your arm bothering you there? Here, lemme look.

Sumia: *Sniff* I-if you insist...

Gaius: Your elbow's swollen up like a turnip! Were you stung or something?

Sumia: Y-yes, but... I didn't want to mention it because you had all those stings. And you seemed so happy about the honey, s-so I didn't want to spoil it...

Gaius: This kid's braver and more thoughtful than I realized.

Sumia: Sorry, what was that?

Gaius: Listen, Stumbles, do you like sweets? Cakes? Candies? That sort of thing?

Sumia: Oh, of course! Especially the pretty ones.

Gaius: Well then, maybe you should have this.

Sumia: B-but, that's your honey! You worked so hard for it!

Gaius: Hey, you saw the bee, found the hive, AND collected it. I just ran for my life. Seems to me this belongs to you as much as anyone.

Sumia: Oh, Gaius.

Gaius: You know, all this time I thought you were just another strange noble. But I was wrong. I'd be honored to call you a friend.

Sumia: "My friend, Gaius..." Hee hee. It DOES have a pleasant ring to it, doesn't it? Oh, you know what we should do, now that we're friends? Collect more honey!

Gaius: Er... no thanks. I think my honey-hunting days are done...

■ GAIUS X SUMIA S

Sumia: Hello, Gaius.

Gaius: Sumia! Just the girl I wanted to see. I've got something for you.

Sumia: Oh, isn't that funny? I have something for you, too.

Gaius: You don't say?

Sumia: I used that honey you gave me to bake a crowberry cake. It's the first time I've baked with honey, so if it tastes awful, just let me know.

Gaius: You made me...cake? Out of honey...? That's the nicest thing anyone... Oh gods, it looks so gooood... Mmmmrrraaaaagggghhh... ...Er, yes. Right. Lemme just set the cake down for a second. Listen, Sumia. I need to tell you something.

Sumia: Hee hee. That's so crazy! Because I have something to tell YOU!

Gaius: Yeah, okay, that's great. But listen, before we get into that—

Sumia: I love you, Gaius! Um, was that too sudden?

Gaius: Uhhhhh...

Sumia: I'm sorry! But ever since I realized it, I've been dying to tell you!

Gaius: I wish you'd waited.

Sumia: You...do?

Gaius: Look, when we started this conversation, I told you I had something for you, right? Well, you kind of took the starch out of my muffin, but...

Sumia: Oh my gosh, Gaius, it's a ring! Does this mean...?

Gaius: I'm kind of in love with you, too, Sumia. And I thought maybe you might like to be my wife. In fact, I'll do all the cooking if you keep making those cakes.

Sumia: Oh, Gaius! YES! Er, but it actually took me 23 tries to get that last cake right.

Gaius: It did? ...Well, never mind, then. I'll bake the cakes, too.

Sumia: But we'll still be able to collect honey together, right?!

Gaius: Er, you know what? You just sit back and let me take care of everything...

Cordelia

■ CORDELIA X SUMIA C

Sumia: I'll be safe... I'll be dead... I'll be safe... I'll be dead...

Cordelia: Sumia, what are you doing?

Sumia: Oh, just seeing how I'll get on in the next battle.

Cordelia: ...By pulling petals off a flower?

Sumia: Yes. ...Why? Is that strange?

Cordelia: Well, no stranger than any other attempt to foretell the future, I suppose. I don't put much stock in horoscopes. Fate is what you make it, I always say.

Sumia: I wish I was strong as you, Cordelia.

Cordelia: How so?

Sumia: You have so much confidence in yourself you actually think you can control even fate. I'm just thrilled if I can walk through camp without tripping on a stool.

Cordelia: Our only limits are the ones we place on ourselves.

Sumia: But...

Cordelia: In fact, it's time you got rid of yours. First rule: no more flower fortunes.

Sumia: What?! But how will I—

Cordelia: Second rule: no questions! You don't need some weed to tell you what to do, Sumia. You control your own destiny. Trust me in this.

Sumia: Er, okay...

■ CORDELIA X SUMIA B

Sumia: Oh! H-hi, Cordelia. How are you doing?

Cordelia: Oh! H-hi, Cordelia! I'm great! Wonderful, actually! Thanks for asking!

Cordelia: ...What's the matter?

Sumia: The matter? Ha ha ha! Oh, you and your matter!

Cordelia: ...You're hiding something behind your back.

Sumia: Hm? Hiding something? Oh, no, I don't think so. I just like to streeeeetch my arms like this... Ahhh...

Cordelia: You're doing flower fortunes again, aren't you?

Sumia: N-no! That's insane! You're talking like an insane person!

Cordelia: Then show me.

Sumia: Show you what? I don't have anythi—

Cordelia: SUMIA!

Sumia: Okay! Here! Take it!

Cordelia: You promised you'd stop this nonsense, remember?

Sumia: No, I didn't promise anything! You just ordered me to! You don't understand, Cordelia! I NEED my fortunes!

Cordelia: Why?

Sumia: Because they give me hope, and that inspires me to do my best.

Cordelia: But what if you get a bad fortune?

Sumia: Oh, I just keep trying until a good one pops up again!

Cordelia: *Sigh* Well...if they're that important to you...

Sumia: Oh, but they are! You'll see! I'll show you how much they help.

Cordelia: I still disapprove of such superstitious nonsense, but if you insist...

Sumia: Yay! Thanks, Cordelia! You won't regret it!

■ CORDELIA X SUMIA A

Cordelia: You've been looking strong and confident these past few days, Sumia.

Sumia: It's all because of my flower fortunes. I told you they helped!

Cordelia: Yes, I suppose I'm going to have to just accept them. Still, I wish I understood why they held such sway over you.

Sumia: Remember when you said I had to stop? Well, I did—for a bit, at least. But the whole time, I felt confused and...adrift.

Cordelia: Why?

Sumia: Do you know how scary it is to go through life without knowing what'll happen next?

Cordelia: Er, actually, that's pretty much the human condition.

Sumia: Not if you use fortunes!

Cordelia: You know fortunes are random, right? They have zero basis in fact.

Sumia: You're missing the point! They don't have to be right!

Cordelia: They don't?

Sumia: If the fortune is good, you work hard to keep things the same so it won't change. And if it's a bad fortune, then you work hard to change things so you can avoid it! Either way, you end up working to make the future how you want it.

Cordelia: That is...the most sensible nonsense I have ever heard.

Sumia: The fortunes motivate me to keep doing my very best!

Cordelia: Hmm... I think I see now. I saw fortune-telling as a way to avoid taking responsibility for your future. But the way you use it is the exact opposite...

Sumia: Exactly! The funny thing is, I never even realized it until you made me quit. So even if your advice was completely terrible, it was still useful in the end!

Cordelia: Er, you're welcome. ...I think. The important thing is that you have your confidence back. As for me, I'll stick with making my own future.

Sumia: Oh yeah? I've got another flower here... Wanna hear how this future will turn out?

Henry

■ HENRY X SUMIA C

Sumia: Oh no, oh no... What do I do now?

Henry: Hey-o, Sumia! What's shaking? I heard some almighty smash over here!

Sumia: I was carrying this huge stack of bowls, and I tripped on...well, something, and—

Henry: Nya ha ha! Look at all the smashed crockery! That's hilarious!

Sumia: Ugh! What am I going to do? How is everyone going to eat? I can't just pour the soup in a trough and make them share! Or maybe I could...?

Henry: Hey, no need for the soup buffet. I can fix the bowls.

Sumia: Really? But how?

Henry: I'm a mage! I just wave my wand and mutter a little incantation... Humina humina humina... Presto! The busted bowls are busted no more!

Sumia: Holy snap! That's amazing!

Henry: Yeah, it's just a temporary hex, unfortunately. Tomorrow they'll be in pieces again. But at least folks won't have to eat out of their hats tonight.

Sumia: N-no, that's fine! This gives me time to buy new ones tomorrow. It's funny, I used to think magic was all scary and weird, but I guess not.

Henry: Oh, it can! This spell can certainly be used for evil. All it does is reverse time. See, so if something bad happens to someone and you cast it on them... They have to experience that same tragedy over and over again! Nya ha!

Sumia: Oh, that sounds horrible!

Henry: I know, right? It is! Nya ha ha!

■ HENRY X SUMIA B

Sumia: Thank you again for the help with the bowls, Henry.

Henry: No problem! Us dark mages love to help others.

Sumia: It was just like you said—those fixed bowls ended up falling apart again.

Henry: Yeah... Even crockery cannot escape the blood-soaked hand of fate.

Sumia: Um, gross? Anyway, I think it's great you use hexes to help people instead of... Well, whatever nasty thing you could be doing.

Henry: Nya ha! Yeah, it feels pretty great to be able to help to others.

Sumia: You know, you could do all kinds of things with that reverse-time spell. Like, revive dead crops, or mend broken arrows during battle, or...whatever!

Henry: Saaay, I could, couldn't I? I like the way you think, Sumia! Those are some hex-cellent ideas!

Sumia: Gosh, do you really think so? I don't normally have good ideas. Most of them are awful, to be honest. I'm not a magic genius like you.

Henry: Would you maybe want to try your hand at a little...dark magic?

Sumia: Well, I have always kind of wondered what it would be like...

Henry: Say no more! Er, give me a little time to get things ready. Next time we meet, you'll be flinging spells like a pro!

Sumia: You'll do that for me?

Henry: Of course! I always wanted to ride a pegasus, after all.

Sumia: Waaait. What kind of hex are you planning here?

Henry: Nya ha ha! You'll see!

■ HENRY X SUMIA A

Henry: H-Henry! Wh-what's happening? What have you done to me?!

Sumia: Isn't it obvious? You're me, and I'm you! Clever curse, eh?

Henry: AAAAAARGH!

Sumia: Whoa! Careful with my vocal chords! Besides, you're the one who wanted to cast spells, right?

Henry: This is NOT what I had in mind!

Sumia: Well, you're about as magic as an old sock, so this was the only way. And while you cast some hexes, I'm going to ride your pegasus all over camp! Whoo hoo! I'm gonna swoop down on people and drop stuff on their heads!

Henry: B-but, wh-what if you fall off?! You might hurt me!

Sumia: Pfft! You fall on your face 10 times a day! This body is made of rubber.

Henry: Okay, but what about YOUR body? It seems pretty flimsy, to be honest. What if I trip into a ditch and snap this little chicken legs of yours?

Sumia: Well, if you're THAT worried about it, I guess we can switch back...

Henry: I think that would be for the best. I'm sorry to disappoint you.

Sumia: Hey, no worries! This bodice is kind of freaking me out anyway. Okay, here goes... KA-BLAMMMO!

Henry: ...There. All better.

Sumia: ...That was...weird.

Henry: You didn't get to spin any dark magic, though. Aren't you disappointed?

Sumia: No. It was a bad idea in the first place. What if I cursed you by mistake? What if I'd turned your guts into pudding or whatever it is you dark mages do?

Henry: That would have been awesome! But still, I'm glad you're worried about me.

Sumia: You're a good friend, Henry. Of course I'm worried.

Henry: Aw, thanks, Sumia. Next time, I'll make sure to look out for you.

Sumia: We're not going to switch bodies again, are we?

Henry: Of course we are! I haven't had a chance to ride your pegasus yet!

■ HENRY X SUMIA S

Sumia: Well? How did you enjoy your first pegasus ride?

Henry: Ohmigosh! First it was like...WOOOO! And then we were like...PSHAAAW! It was totally fantastic! Thanks for loaning me your body.

Sumia: I'm happy I could help.

Henry: Er, but when I was borrowing your body, I noticed something...funny.

Sumia: Funny...?

Henry: Your heart was racing constantly! I felt giddy and dizzy at the same time. I think you should see a healer soon. What if you have a murmur?

Sumia: Um, actually, Henry, what I have can't be fixed by a healer.

Henry: Oh, and I also noticed it gets a lot worse when you're around me. Now, it could be a systemic cardiovascular issue, but I'm thinking—

Sumia: It's not that. Think hard, and I believe you'll figure it out.

Henry: Oh, wow... I get it now. We have the exact same ailment!

Sumia: We do?

Henry: I think you're amazing, Sumia, and when you're around, my heart goes nuts. So...it sounds like maybe you've got the same thing going on, right?

Sumia: I know it's a bit odd, but I think I've fallen in love with you, Henry.

Henry: Great! That means I didn't waste my money buying you that ring!

Sumia: Ring? Oh my goodness! How did that get on my finger?

Henry: I bought it when I took over your body. It made the fitting a breeze!

Sumia: You wanted to borrow my body so you could check my ring size?! B-but the jeweler might think I'm a pathetic spinster buying her own ring!

Henry: Oh, yeah. He definitely thinks that. Anyway, do you like it?

Sumia: Of course I do, Henry. It's beautiful. You've cast the best hex of all... And I couldn't be happier!

Lucina (Mother/daughter)

Lucina's mother/daughter dialogue can be found on page 285.

Cynthia (Mother/daughter)

■ CYNTHIA X SUMIA (MOTHER/DAUGHTER) C

Sumia: We're mother and daughter, and yet we're almost the same age... Kind of a weird feeling, huh? Still, I'm sure we can be friends.

Cynthia: Friends? But that won't do at all! You're still my superior. In battle, you mustn't hesitate to issue me orders just like any other soldier.

Sumia: But you're NOT just like any other soldier, are you? No, we shall be friends, and you'll speak to me as an equal.

Cynthia: Truly? You won't think me too forward? You won't be insulted?

Sumia: Of course not.

Cynthia: That's a relief! See, I told myself, if there's one person I mustn't annoy, it's Mother!

Sumia: ...Am I really so intimidating?

Cynthia: ...Well, in my time, you're a true legend. The most famed pegasus knight of all! There are so many stories of your heroic and terrible deeds. Like when you smashed through the enemy lines to rescue a stricken Chrom!

Sumia: Er...did I do that?

Cynthia: Or the time you argued with Chrom and slapped him in the face!

Sumia: Gods above, I sound like a madwoman!

Cynthia: Or the time you went into a blood frenzy and downed friend and foe alike!

Sumia: I downed FRIENDS?! That's not heroic at all!

Cynthia: The point is, I was raised on such stories, and they gave me strength and inspiration.

Sumia: ...I guess I'm going to need to be more selective about which historians I talk to.

■ CYNTHIA X SUMIA (MOTHER/DAUGHTER) B

Cynthia: Did you see me, Mother? Did you see how I handled that lance?

Sumia: Oh, of course I did. I was very impressed.

Cynthia: Oooh, what an honor—the seal of approval from the great Sumia herself! Does this mean you'd be willing to help me join the pegasus knights?

Sumia: Is that what you want, Cynthia?

Cynthia: Yes! In my future, the knights had long since disappeared into legend. But I always dreamed of joining them! Swooping through the broad blue skies... Skewering foes with a bloody lance... Cynthia, hero of the pegasus knights!

Sumia: Well, I'm not responsible for recruiting, as you well know. However, if Phila were here, I'm quite sure she'd turn you down.

Cynthia: Wait, WHAT?! But why?! You just said I was really good with the lance!

Sumia: Lance skills alone are not what make the pegasus knights so formidable.

Cynthia: You mean I have to be good with a sword, too? Ooh, or maybe magic?

Sumia: If you wish to know the answer, bathe in the waters of the spring.

Cynthia: But the spring is...really, really cold. Couldn't we just do flower fortunes?

Sumia: No. Now go as I say and go to the spring. You'll find your answer there. You'll have to think long and hard, though. It won't come easy.

Cynthia: Why won't she just tell me instead of making me take a freezing-cold bath? *Sigh* Well, if it's not a lance or a sword or magic spells, then... Ah, wait! The axe! Maybe it's all about the axe! ...No, that can't be it. Man, this is a real puzzle...

■ CYNTHIA X SUMIA (MOTHER/DAUGHTER) A

Sumia: Well, Cynthia? Have you found your answer yet?

Cynthia: Yep. After you posed the question, I thought and thought and thought... But I couldn't think of anything, so I did what you said and bathed in the spring. That's when I noticed my poor pegasus was as dirty as a farm hog! I'd been so busy making MYSELF look grand, I neglected my darling mount!

Sumia: Ah, good. You understand at last. A knight's pegasus isn't some beast of burden or a farmer's mule. She is a partner and ally, and must be cared for as much as a knight cares for herself. ...A lesson which I can see you've learned. Your mount is looking radiant today.

Cynthia: Oh, yes! I've started washing and brushing her every day now. I want her to look as fine and proud as your pegasus, Mom!

Sumia: Hee hee! Now that will be a challenge. Don't get your hopes up! ...By the by, Cynthia, I had something I wanted to ask.

Cynthia: Yes? What is it?

Sumia: Our two pegasi seem so similar, don't you think? So similar, in fact, that I'm wondering...

Cynthia: Yep! My pegasus is the very same one that you used to ride. When my mother was killed back in my time, my pegasus made its way back to me.

Sumia: I see...

Cynthia: She told me what Mother said just before she died... "Please, return to Cynthia. Look after her and protect her." She—well, you—sent your pegasus to me so I'd have something to remember you by. All of which makes me feel TOTALLY worse for not taking better care of her! She's been my stalwart friend and ally ever since, but I don't even deserve her!

Sumia: Now, now, Cynthia. That's not true. You made a mistake, but you recognize that now. You have lots of time to make it up to her and strengthen the bonds of trust. After all, you're not the only one who ever neglected her pegasus...

Cynthia: Y-you used to forget to wash her, too?

Sumia: Wash her? Heavens, there were times I forgot to FEED her! Once I even tried to pluck out some wing feathers to make myself a fancy hat.

Cynthia: Good grief!

Sumia: My point is, you still deserve to be her friend, even if you forget to wash her. She loves you far too much to desert you for that. I've seen how happy she looks, swooping across the sky with you on her back.

Cynthia: Truly? I'm so relieved to hear it... Oh, Mother, I can't thank you enough. You've taught me so many things that I didn't have a chance to ask before. You really are everything the legends say! Well, maybe a bit more clumsy, but...

Morgan (female) (Mother/daughter)

The Morgan (female) mother/daughter dialogue can be found on page 312.

Lon'qu

Avatar (male)

The dialogue between Avatar (male) and Lon'qu can be found on page 220.

Avatar (female)

The dialogue between Avatar (female) and Lon'qu can be found on page 231.

Lissa

The dialogue between Lissa and Lon'qu can be found on page 243.

Sully

The dialogue between Sully and Lon'qu can be found on page 252.

Vaike

The dialogue between Vaike and Lon'qu can be found on page 254.

Miriel

The dialogue between Miriel and Lon'qu can be found on page 259.

Maribelle

■ MARIBELLE X LON'QU C

Maribelle: Lon'qu! Just what do you think you were doing in that battle yesterday?

Lon'qu: Stabbing people.

Maribelle: I was REFERRING to your insistence on charging off faster than I can follow! It's lovely that you're so eager to bathe in blood, but I must insist you match my pace.

Lon'qu: Leave me, woman.

Maribelle: Ha! Spoken like a true cad! I've heard tell of your little "issue" with women, but you'll just have to get over it.

Lon'qu: This is no problem of yours. If I bleed, it is due to my own weakness. Each cut is a lesson. Each scar a reminder.

Maribelle: Oh, and just think how much you'll learn when you die in a heap on the battlefield! It's my job to keep your blood inside you, and that requires cooperation.

Lon'qu: I can patch my own wounds. Now leave me!

Maribelle: I will not! Now you just sit right there and—I say! Get back here this instant!

■ MARIBELLE X LON'QU B

Maribelle: Ah ha! There you are!

Lon'qu: Ugh.

Maribelle: You nearly lost your sword arm yesterday, Lon'qu! Are you aware of this? A little girl could probably wrest that sword from your weak grip. A true warrior's pride won't be worth a whit if you can't lift a blade!

Lon'qu: I've intensified my training so that such a thing won't happen again. Now stop following me.

Maribelle: Not so fast!

Lon'qu: That's my arm. You're touching my arm. ...Please stop touching my arm.

Maribelle: Not until you furnish me with a reason for this suicidal stubbornness!

Lon'qu: Enough! I yield! Just remove your paw from me.

Maribelle: PAW?! Why, you inbred, foul-tempered, lowborn gutter rat! Are you truly so averse to women that you must insult them at every turn?

Lon'qu: I...do not function well around them. The closer they get, the worse it is. I beg of you, keep your distance.

Maribelle: So that's the reason you've been running off whenever I try to heal you!

Lon'qu: I mean no offense, though I know it is taken. It would be best if you simply accepted it.

Maribelle: Absolutely not.

Lon'qu: Why not?

Maribelle: Because it's unacceptable! You always speak of growing stronger, yet here's a glaring weakness to correct. At this rate, a little girl could simply walk up and kill you with a spoon. I won't have you risking your life over such a foolish thing.

Lon'qu:

Maribelle: I know it's not my place, but I think—

Lon'qu: No. You are not wrong. This is a weakness I must correct.

Maribelle: I can ask no more, Lon'qu.

■ MARIBELLE X LON'QU A

Maribelle: You put on quite an impressive show today, Lon'qu.

Lon'qu: Hmph.

Maribelle: I would have been in a terrible bind had you not been close by to defend me. Though you would have been in a similar fix had I not healed you afterward. Regardless, it was quite chivalrous of you. And proof you've overcome your problem! This is a celebratory day indeed. Perhaps you'll join me for a cup of—

Lon'qu: TOO CLOSE! Er, I mean... Please step back.

Maribelle: I'm sorry, did you just shriek at me like some kind of ill-mannered lout?

Lon'qu: My problem is not gone. It's better in combat, but... At times like this, I can't... I can't. I'm sorry.

Maribelle: I see.

Lon'qu: Go on. Laugh at the craven.

Maribelle: I'll do no such thing! I owe you all the more knowing you defended me despite the discomfort. I should dearly like to help you work through this issue.

Lon'qu: I don't see how.

Maribelle: Oh, there has to be SOME way. Hmm, perhaps it's best to have you jump in headfirst. I could bring you to an establishment where a pack of lovely ladies wait on you!

Lon'qu: Pass. ...Wait. How would you know about such a place?

Maribelle: Rude! A woman must have her secrets.

Lon'qu: Perhaps there is another way. A normal way.

Maribelle: Quite right! And I won't rest until I've come up with it, my dear. Anything for a friend, I always say.

Lon'qu: Are we friends?

Maribelle: Would you disagree?

Lon'qu: Most friends stand closer than twenty paces from one another. But yes. I would like to be friends.

Maribelle: Good, because it's a done deal regardless.

■ MARIBELLE X LON'QU S

Maribelle: Whenever you're ready, Lon'qu.

Lon'qu: R-right...

Maribelle: You're almost there. Stay focused.

Lon'qu: ...Ngh!

Maribelle: Excellent! You finally managed to touch me. And with almost no simpering to boot. Mmm, your hand runs cool.

Lon'qu: Your cheek is...warm.

Maribelle: Let's break for today, yes? Steadily decreasing the distance day by day seems to be working.

Lon'qu: I expected you to fill a tiger pit with women and push me in.

Maribelle: Gentlemen have likened me to many things before, Lon'qu, but never a sharp spike. Besides, you asked for a "normal" method. I think this one is quite reasonable.

Lon'qu: It is. But we've been at it for so long, and I've only just managed to touch your cheek. I have taken so much of your time.

Maribelle: Oh, posh! It's no bother at all! ...Still, I suppose you have a point. Perhaps we ought to make arrangements for the long term, mmm?

Lon'qu: Meaning...?

Maribelle: Well, I could continue to train you indefinitely if we were married.

Lon'qu: You have no obligation to do that.

Maribelle: Gods, but you can be dreadfully dense at times. Do you think I would propose marriage out of a sense of obligation?

Lon'qu: Er, no.

Maribelle: So then! We've now established how I feel about you, albeit somewhat painfully... Perhaps you would return the favor.

Lon'qu: I...feel something for you as well, though I do not have the words for it. I yearn to keep you safe in my arms until the breath leaves my body. And yet, I can barely touch you. It is shameful. I have no right to ask your hand.

Maribelle: Well, Lon'qu, there's no hurry. We have the rest of our lives! And YOU, my dear, are a catch worth waiting for.

Lon'qu: Perhaps we could practice one more time. I would very much like to hold your hand as we walk to town. We will need a ring, after all.

Maribelle: With you, my dear, I would walk anywhere. Now, get those cold hands over here!

Panne

■ PANNE X LON'QU C

Panne: *Pant* I should be safe now... There's no way he could track me out—

Lon'qu: Hold.

Panne: Gah! You are no ordinary man... Enough of this game. Tell me what you want and leave me be!

Lon'qu: Do not come near me!

Panne: Stay away from YOU? What do you think I've been trying to do all day, you ignorant man-spawn?

Lon'qu: I found this bag. It's full of weeds...or something.

Panne: That's my bag.

Lon'qu: I know. You dropped it near the camp.

Panne: Is that why you chased me over hill and dale? Why didn't you just tell me?

Lon'qu: Yes, well. When I saw your face, I became paralyzed with fear. And then you fled before I had a chance to explain.

Panne: Bah. This is insulting.

Lon'qu: Wait—don't forget your weeds!

Panne: I don't want them, or the bag. They are yours now.

Lon'qu: Blast. What am I supposed to do with these? Hmm. I wonder if they taste good? *nibble* Blegh! ...A poor idea.

■ PANNE X LON'QU B

Panne: You again.

Lon'qu: I want to return your bag of weeds. I'm tired of carrying it around all the time.

Panne: Idiot human. Why didn't you just throw it away? *Sigh* Never mind. Here. Give it to me.

Lon'qu: Don't come any closer! I'll toss the bag that way, and you can pick it up.

Panne: Do you hate my kind so much?

Lon'qu: It is not your kind I mind. It is your gender.

Panne: And why would you, a human skilled in swordplay, possibly fear all females?

Lon'qu: I have my reasons. I am haunted by nightmares, tormented memories from my past. When I approach a woman, she has the taguel or human, I am gripped by an icy fear.

Panne: Then I am not the only one plagued with terrible memories.

Lon'qu: I do not like to speak of it. If others knew I still suffered from childhood nightmares, they would think me weak.

Panne: ...Throw me the bag.

Lon'qu: Here.

Panne: Thank you. Now wait right there.

Lon'qu: What are you doing?

Panne: I'm making a special brew using the herbs I collected. ...Here.

Lon'qu: *Sniff* It smells vile. And there are twigs floating in it.

Panne: Just drink it down.

Lon'qu: Are you sure it's safe for humans?

Panne: Drink it or don't. I care not.

Lon'qu: Very well. *glug, glug* *Splutter* Bleeech! Urgh! It tastes even worse than it smells!

Panne: Yes. But you will find it helps with your nightmares.

Lon'qu: Gods, that was awful. I hope this isn't some kind of elaborate practical joke.

■ PANNE X LON'QU A

Lon'qu: Hello, Panne.

Panne: You look cheerful. I assume this to mean the potion did its deed. This is good. I was unsure it would work on humans.

Lon'qu: Your brew did more than cure me of my nightmares... Since I drank that draught, I've been having the most wonderful dreams.

Panne: The effect will wear off soon. Wait while I brew another mug.

Lon'qu: Thank you.

Panne: ...Done. I'll just leave it here and back away.

Lon'qu: Right. Down the hatch. ...Urgh. The taste does not improve with exposure. But if it means no more nightmares, I'll drink a barrel and ask for more.

Panne:

Lon'qu: Tell me, Panne. Why do you help me? I know you've little love for humans.

Panne: Well, I'd already given you the herbs. I didn't want them to go to waste.

Lon'qu: And why did you collect them in the first place? Were they for you? Are you also haunted by nightmares?

Panne: I often dream of the night man-spawn razed my village and murdered my kin. Just before she died, my mother told me that I mustn't hate all humans. She said there were good men as well as wicked, and I was never to forget it.

Lon'qu: But why did you make the potion for me?

Panne: I told you. I didn't want the herbs to go to waste.

Lon'qu: ...You have a good heart.

Panne: You know nothing about me.

■ PANNE X LON'QU S

Panne: Here for another dose of Panne's potion? Sit there while I make it.

Lon'qu: Actually, I thought I'd offer my own brew—elderberry and tea leaves from Ferox. There's no better tea in all the lands.

Panne: If you are so confident, I suppose I must have some... *Slurp* Why, this IS good...

Lon'qu: You know, it's funny...

Panne: What is?

Lon'qu: Whenever I talk to you, a warm and...fuzzy feeling comes over me. I'd assumed that it was because of your potion. But I have the same feeling right now, and I haven't touched a drop.

Panne: Now that you mention it, I feel the same way.

Lon'qu: There's no medicine in that brew. Just Ferox's finest tea leaves.

Panne: And it certainly is delicious. I could drink this every day.

Lon'qu: If we were to spend more time together, I would make you a cup every morning.

Panne: Are you implying what I think you are, human?

Lon'qu: Taguel or human—it matters not to me. You are just the woman I love.

Panne: Things have changed since we first met. Remember how afraid you were?

Lon'qu: I do. But I'm not anymore. Panne, will you accept this ring?

Panne: Ah, a bribe to spice the proposal. Such a typical human custom. But I know you speak from the heart, and so I accept. You're the first human I've known who makes me forget about the past... And for that, I shall be eternally yours.

Cordelia

■ CORDELIA X LON'QU C

Cordelia: Lon'qu, we're about to hold the war council. It's time to return to camp.

Lon'qu: Very well. ...Er, may I ask you something?

Cordelia: Of course.

Lon'qu: Why did you come to my assistance in our most recent battle?

Cordelia: Well, you were beset by foes and looked as if you needed the help.

Lon'qu: I see. You are not wrong in this. I would like to settle the debt quickly. Is there anything you need?

Cordelia: It's hardly a debt, Lon'qu. We're on the same side. But I can see you're serious, so let me see... I'd love to get some fencing lessons, but I suppose that's not possible. I mean, what with your crippling phobia of standing near women.

Lon'qu: Er...

Cordelia: By the way, does this phobia mean you can't help me on the battlefield, either?

Lon'qu: No. In the heat of battle, I am able to overcome my...inclinations.

Cordelia: Well, that's a relief. I'd hate to think you'd stand there while some brigand ran me through.

Lon'qu: If you ever require assistance, you need only say the word.

Cordelia: I'll keep that in mind!

■ CORDELIA X LON'QU B

Lon'qu: What has happened to my oaken practice sword?

Cordelia: Oh, I replaced the blade. The old one had a split in it.

Lon'qu: How diligent of you.

Cordelia: No one had checked the training equipment since the start of this campaign. I took it upon myself to sort though the wooden blades, shields, and dummies.

Lon'qu: I see.

Cordelia: Er, Lon'qu? Did you know that sweat is pouring down your face?

Lon'qu: Yes, of course. I was just finishing my leg-strengthening drills.

Cordelia: Well, it's good timing, because I have a fresh pile of towels from the laundry. I'll leave one here for you.

Lon'qu:

Cordelia: Right then! To the sound of thunderous gratitude, I'll go and prepare supper. You like cabbage stew, don't you?

Lon'qu: It is my favorite dish. Are you the one who keeps preparing it at every meal?

Cordelia: Oh, so you DID notice! Yes, that's me. I like to keep morale up by serving little treats now and then. Anyway, see you at supper!

Lon'qu: You help people even when they don't know it? ...Wait. Let someone else cook tonight. It's time for your first fencing lesson.

Cordelia: Er, but what about the whole pathological fear of women thing?

Lon'qu: I shall instruct you from a distance. Now tell me what you wish to learn.

Cordelia: Why, that's downright gentlemanly of you.

■ CORDELIA X LON'QU A

Cordelia: Hmm? Someone tidied up all the practice equipment. Also, the laundry's been brought in, and supper's on the boil. What manner of witchcraft is this?!

Lon'qu: I did these things.

Cordelia: You?!

Lon'qu: Yes. I discovered a problem during our fencing lesson. You are too worried about everything else going on in this camp. This means you are incapable of the proper focus required for fencing. I have removed the distractions so that you might concentrate properly.

Cordelia: Oh, er. Right. I see.

Lon'qu: Ungh.

Cordelia: Lon'qu? What's happening? What are you doing? You just went pale!

Lon'qu: I am steeling myself for our next session. It is a complicated procedure that cannot be shouted from a distance. I must...approach you...and hold your arm...to show you how...to perform the action...

Cordelia: Gracious, Lon'qu! If it's so stressful, we can skip the lesson.

Lon'qu: N-no! I owe you...a debt... Just...watch well. I don't want...to do this again.

Cordelia: You have my undivided attention!

■ CORDELIA X LON'QU S

Cordelia: Hi-yah! Gwaah!

Lon'qu: Interesting. You adapted my moves and wrought them into something new. The result is a new fencing art entirely of your own devising.

Cordelia: It's going to be incredibly useful in the battles to come. And I couldn't have done it without your help, Lon'qu.

Lon'qu: Who do you intend to protect with this new skill of yours?

Cordelia: Why, my comrades, of course. Everyone in this army.

Lon'qu: You lie. I have watched you in battle. You have eyes for only one man. You are in love with Chrom.

Cordelia: I did love him, once. For the longest time...

Lon'qu: You speak as if that was in the past. Has your heart changed?

Cordelia: Actually, yes. It has. Now you tell me something, Lon'qu. Why do you care about my heart?

Lon'qu: Er...

Cordelia: No, wait. I'm not finished yet. You've given me help and fencing lessons under the guise of repaying a debt. But I told you you owed me nothing. So what is the real reason?

Lon'qu: That was the reason. ...At least in the beginning.

Cordelia: You overcame your phobia of me while performing countless menial chores... I would know your reason for this, sir.

Lon'qu: I am not a man who...expresses himself well with words. Perhaps this gift will tell you what you want to know.

Cordelia: Let me see— Ah, a ring! Oh, and what a nice big stone! So many carats... Wow...

Lon'qu: Put that loupe away! If you don't want the ring, discard it and we will speak no more of this.

Cordelia: I don't want to throw it away, Lon'qu! I want to WEAR it.

Lon'qu: You do? Then...?

Cordelia: Yes, Lon'qu. I've fallen in love with you as well. And I'd be happy to marry you.

Lon'qu: Even in my wildest dreams I dared not hope that you'd say yes.

Cordelia: Heh. Yes, and you're stuck with me now, I fear. But don't worry. I think we're going to be very happy together!

Gregor

■ GREGOR X LON'QU C

Lon'qu:

Gregor: Oy, Lon'qu. Why are you having furrowed brow and narrow eyes? Gregor is ally and friend, not foe.

Lon'qu: I know all about you, Gregor. Basilio told me. He says you are the only sellsword to ever match him in single combat.

Gregor: Oy, that is from distant past. Gregor barely remember those times.

Lon'qu: I have also heard that you were once a candidate to become khan of Regna Ferox.

Gregor: Ho ho! You send Gregor on trip to memory street. He was forgetting that!

Lon'qu: So, the stories are true? In that case, I challenge you to a duel!

Gregor: Do not wave sword in Gregor's face. Edge is seeming very sharp.

Lon'qu: I wish to fight using real weapons. A true duel for true stakes!

Gregor: You forget Gregor is sellsword and professional. Gregor is not unsheathing sword unless someone is paying him much gold.

Lon'qu: Craven. Have you no pride? Or do you fear the wrath of Basilio?

Gregor: Gregor is fearing no man. But he also does not fight without clink of coin. Besides, you waste your time, yes? A fight with me will not make you strong.

Lon'qu:

Gregor: Enough. Gregor and Lon'qu are comrade-in-arms, yes? No more talk of fighting.

Lon'qu: Damn him...

■ GREGOR X LON'QU B

Lon'qu: Here, Gregor. Catch.

Gregor: Oh? Is little bag of coins. You give Gregor pocket money?

Lon'qu: You said a sellsword never fights unless it's for money, right? Well, there's your money. I now order you to fight me for true.

Gregor: Oy, you know how to persuade Gregor. Jingly coins is like music in his ears. But please, tell Gregor why you are wanting to fight him so badly. You are thinking is first stage of defeating Basilio, yes?

Lon'qu: When I paid your fee, I don't remember asking you to prattle on like a hen.

Gregor: Oy, this one is strict paymaster. Okay, we fight. But first, conditions! We are being comrades in same army, so no fighting "until death." "Until death" makes many people very sad. Especially ladies.

Lon'qu: We will stop when one of us yields or overwhelming victory is assured.

Gregor: Agreed. Now, when we are beginning?

Lon'qu: No time like the present...

Gregor: Ho! ...Okay. Gregor win.

Lon'qu: What?

Gregor: Oh? You do not notice? Look at chest. See? Gregor's sword is already poised to thrust.

Lon'qu: H-how did you—

Gregor: Ah, yes. Gregor sees chink in armor. Here, at throat.

Lon'qu: Mngh!

Gregor: Don't move. If sneezing even tiny bit, sword goes into neck. Very messy. This counts as "overwhelming victory assurance," yes?

Lon'qu: Damn you... You only won through trickery!

Gregor: Is no trick. Is speed! Is also why Basilio so much stronger than Lon'qu.

Lon'qu: Curse you...

Gregor: Lon'qu is young fool now, but Gregor sees much potential. You will learn.

■ GREGOR X LON'QU A

Lon'qu: Gregor...

Gregor: Lon'qu wants another duel, yes?

Lon'qu: No. I came to apologize. I concede that you beat me fairly in our duel. You are right. I am both young and a fool. I need more battle experience. It's the only way I will gain the wisdom required to anticipate your sly moves.

Gregor: Ho ho! Of course, and knowing is half of battle! You are needing those things, yes? But also you are needing to learn how to handle sword.

Lon'qu: Are you implying—

Gregor: Do not make Gregor repeat self. You need spend time with Gregor so he can be teaching sword skills.

Lon'qu: I thought sellswords only fight for money.

Gregor: Gregor say that once. But in recent days, he is starting to change thinking. Gregor is feeling loyalty to Shepherds, and wants to helping in all ways.

Lon'qu: Then I demand you teach me everything you know!

Gregor: You have angry passion of young man. But Gregor is liking that! You remind him of young Gregor when he was being very hotheaded! Let us make with the training, then. Gregor whip you into shape!

Nowi

■ NOWI X LON'QU C

Nowi: Lon'qu! Play with me!

Lon'qu: No.

Nowi: Oh, come on, please? It's boring playing by myself. Aren't you soooo booooored?

Lon'qu: I like being alone. Go ask someone else.

Nowi: I was going to, but they all look super busy.

Lon'qu: Are you saying I don't? Because I am busy. Very busy indeed.

Nowi: *Sniff* *sniffle*

Lon'qu: Your tears have no effect on me! Besides... everyone knows I have a crippling fear of women. ...And yet, why do I not feel that fear around her? I must learn why!

Nowi: *Sniffle* Wh-what did you say? I can't hear because I'm CRYING!

Lon'qu: Nothing of importance. However... I have decided that I will play with you—but only for a short time.

Nowi: Yippee! You're the best!

Lon'qu: Yes, yes. Stop hopping around. Now what game do you want to play?

Nowi: Erm...er...thinking hard...er... Oh, I know! Let's play house!

Lon'qu: I do not know that game. But it does not sound like something I'd enjoy.

Nowi: It'll be fun! You get to play Dad!

Lon'qu: *Sigh* If you insist. But only for a short while!

Nowi: Great! And I'll be Mummy!

Lon'qu: Is that it for the rules, then? ...I was hoping dice were involved.

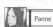
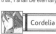
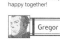
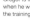

NOWI X LON'QU B

Nowi: Lon'qu, let's play!

Lon'qu: I've already played with you once. Surely it is someone else's turn.

Nowi: Yeah, but that game is still going! Plus no one can play Dad but you. And if you don't play with me, well, I guess I'll just have to—

Lon'qu: Put that dragonstone away, you little extortionist. You don't scare me. However, I will play one more time.

Nowi: Works for me!

Lon'qu: It is not entirely unpleasant, after all. With you I do not feel that icy grip of fear...

Nowi: Hee hee! Well, duh! Who'd ever be afraid of me when I'm not in dragon form?

Lon'qu: Enough talk! Begin the playing of house! But know that this is my last time.

Nowi: Sure, whatever.

Lon'qu: Now, where were we? I was just about to leave and go work in the fields...

Nowi: Here's your breakfast, dear! Eat it all! You need to keep your strength up!

Lon'qu: Munch, munch. Ah. That was delicious. Now, I am off to work. Fare thee well.

Nowi: See you tonight!

Lon'qu: Now I shall pretend to engage in agriculture. Chop, chop, shovel!

Nowi:

Lon'qu: Nowi? Why are you just standing there?

Nowi: Well, er, I'm at home, right? So when Dad goes off to work, what does Mummy do? *Sniff* Oh, how sad! I don't know! I don't know anything about families!

Lon'qu: Nowi, come here.

Nowi: Why?

Lon'qu: You cannot simply stand there all day. Let's work the fields together.

Nowi: Oh, yay! I like working in the fields! Chop, chop, chop!

NOWI X LON'QU A

Nowi: Here you are, dear husband! I've made your supper.

Lon'qu: Munch, munch, munch. Chew. Swallow. Blech! This food is terrible!

Nowi: Eek! Dad's angry!

Lon'qu: Of course I am! How do you expect me to eat this pig swill?!

Nowi: It's all we can afford on your pathetic salary! Maybe you should pull your thumb out and start providing for this family! That's it! You're sleeping in the stables tonight!

Lon'qu: Very well. I shall attempt to earn more.

Nowi: Lon'qu! You're doing it wrong! You're supposed to argue back!

Lon'qu: Are you sure this is the correct way to play house? It seems to me we should be doing things other than arguing all the time.

Nowi: Nope! This is totally the right way to play. Remember when I told you I didn't know what families actually do at home? Well, I went into town and spied on one of the families who live there.

Lon'qu: And this is how they acted?

Nowi: Yep! All the time! This game is totally based on reality!

Lon'qu: Do you think it's possible that the family you observed was not...typical?

Nowi: I dunno. Maybe. So what should a typical family do then?

Lon'qu: How should I know?

Nowi: Well if you don't know, then why can't we just play it my way? I'm going back to the game now. So, er, where was I? Oh, right... You're a lousy provider, husband! Oh, why didn't I marry the blacksmith?

Lon'qu: *Sigh*

Nowi: Come on, put some effort into it! It's a boring argument if you just sit and sigh.

Lon'qu: I don't like this family you invented! Here, I have an idea. Why don't you go to town and spy on a few more families? Then we can compare them all and choose our favorite family to copy.

Nowi: I guess I could do that... But only if you come with me!

Lon'qu: If it stops you from berating me, I shall do as you ask.

Nowi: Yay! I bet no one's better at sneaking around people's houses than us!

Lon'qu: ...What is that supposed to mean?

NOWI X LON'QU S

Lon'qu: Good-bye, sweet wife. I'm off to work in the fields.

Nowi: Have a good day, dear husband! Now, what do I do first again? Cleaning, right? Then lunch, then chop firewood. Hee hee! I'm so busy!

Lon'qu: Don't forget to draw water from the well.

Nowi: Oh, right. Thanks for the reminder! I never realized just how many things a typical mother has to do in a day. It's hard to keep track of everything.

Lon'qu: Don't worry. The more we play, the better you'll get at it.

Nowi: You mean we're going to keep playing? So you finally admit you like playing house?

Lon'qu: I do. As a matter of fact... Here.

Nowi: Gosh, what a beautiful ring! But, wait—this is real! Isn't this terribly extravagant for a game?

Lon'qu: This is a game no longer, Nowi. I want us to be a real family. And so I must offer you a real ring.

Nowi: What kind of family? Like brother and sister or something?

Lon'qu: No, silly. I want to be your husband.

Nowi: Gosh! You mean we won't have to pretend anymore? We could have our own real-life family? Oh, Lon'qu—tell me I'm not dreaming!

Lon'qu: Like you, I have been alone for a very long time. I find this new life agreeable, and I wouldn't want to share it with anyone but you.

Nowi: This is going to be MUCH more exciting than that stupid pretend game!

Tharja

THARJA X LON'QU C

Tharja: Tonight we're holding a war council. Don't be late.

Lon'qu: Is Lissa hosting again? Maybe she'll make more of those little honey cakes. Oh, hold on. You've got a bug stuck in your hair...

Lon'qu: Don't come any closer!

Tharja: Well, if I repulse you THAT much...

Lon'qu: You are not special. I feel the same way about all women.

Tharja: Well, that makes it all better. Hmm... I wonder if someone cast a curse to make you fear women?

Lon'qu: I think not.

Tharja: Then why are you so afraid of us?

Lon'qu: Something at the core of my nature has always made me...uneasy around you.

Tharja: Yeah, still sounds like a curse to me. I wonder who cast it?

Lon'qu:

Tharja: You want me to fix it?

Lon'qu: What?

Tharja: It must be hard turning into a gibbering idiot whenever you meet a woman.

Lon'qu: You have the power to rid me of this fear?

Tharja: Someone's iiiiiinterested...

Lon'qu: I am not.

Tharja: Sure, whatever. When you change your mind, you know where to find me.

Lon'qu:

THARJA X LON'QU B

Tharja: Lon'qu.

Lon'qu: I'm not going to move across the room, if that's what you want.

Lon'qu:

Tharja: Okay, I have better things to do than watch you stand there with your mouth agape. You want me to dispel your fear, right?

Lon'qu: Can you truly release me from this crippling aversion to your kind?

Tharja: Only if you promise to never refer to women as "your kind" again. Also, I need to know exactly where this fear comes from.

Lon'qu: ...All of it?

Tharja: Unless I know the true nature of what ails you, I cannot destroy it.

Lon'qu: Every night, I am plagued by a dream. A dream of true events. Of a young girl who lost her life because of me. She was an ordinary village girl who lived on the outskirts of town. We became friends despite the fact that I was an impoverished youth from the slums. In time, she began to steal away from her parents to see me. Love flowered between us. But then...

Tharja: Go on.

Lon'qu: I'm sorry. This is...difficult for me. One day we went into the fields to picnic and spend time by the river. ...The bandits were so fast. So many. I fought them with all that I had, but she still... They...

Tharja: I'm sorry, Lon'qu.

Lon'qu: From that day on, the presence of a woman has filled me with fear. A woman died because of my failings. I would not let it happen again. And though that day is long past, I relive it every night...

Tharja: It is not unusual for powerful incidents to grip our hearts for many years after. You aren't cursed by mortal means, Lon'qu—the memory IS the curse.

Lon'qu: Can you help me?

Tharja: Perhaps. But it will take time. I must learn about you, this girl, and your youth spent in the slums. If I am to break the curse, I must know everything there is to know about you.

Lon'qu: If that is what it takes...

THARJA X LON'QU A

Tharja: Lon'qu? I'm ready to perform the ritual.

Lon'qu: Do you avow that this ritual will cleanse my soul and finally grant me peace?

Tharja: Yes. It will erase everything and give you a fresh start.

Lon'qu: Good.

Tharja: However, the curse has been with you for years, and its roots reach deep. The only way to eradicate it is to uproot it along with all your childhood memories.

Lon'qu: You mean, I will forget everything? My life in the slums? The times I spent with...her?

Tharja: Every last bit. But these memories torment you, right? You should be pleased to lose them.

Lon'qu: No. I cannot go through with this.

Tharja: Hey, I spent hours collecting bat wings! You can't back out now!

Lon'qu: Even as I told you my story, I realized how important the memories are to me. My life on the streets? Her death? These experiences make me strong. If I lose the memories, what happens to the lessons I learned from them? I fear that they, too, will be lost.

Tharja: ...Seriously, do you have any idea how many bat wings I had to collect?

Lon'qu: I have confidence a woman of your ilk have another use for them. Even so, I'm very grateful for your help.

Tharja: Okay, don't thank me. That just feels weird.

Lon'qu: Then I shall think of some other way to pay you back.

THARJA X LON'QU S

Lon'qu: Tharja.

Tharja: Oh, Lon'qu. How are you planning to waste my time today?

Lon'qu: Nnngh...

Tharja: Are you...forcing yourself to stand closer to me? Don't tell me you let someone else erase your memories?

Lon'qu: This is...my own doing. I can overcome this fear...through tyranny...of will...

Lon'qu: Well, charmed, I'm sure. But at this rate, it's going to take years to cure yourself. Why don't you let me help?

Lon'qu: No. I don't want to rely on magic or tricks...

Tharja: Not with a curse, idiot. ...I mean you can practice on me. We could be friends. Companions, even. Be there for each other in times of trouble. If we were together day and night, you'd have to overcome your fear.

Lon'qu: What do you mean?

Tharja: Sometimes, I swear you're about three arrows short of a quiver. Here. I'll use small words, okay? Let's. Get. Married. You see, if you're not up for it, that's okay, too. It'll give me more time to follow [Robin] around.

Lon'qu: Your proposal might have worked better without that last bit. Even so... Marriage has long seemed like a distant dream to me. However, there is a strength and grace about you that I find appealing. You are the first to look so deep into my heart and accept what you saw there. With you at my side, I might finally free myself of the painful past.

Tharja: To be honest, I was expecting you to throw up or something.

Lon'qu: I fear making friends with any woman, lest ill fortune strike them down. But you are frighteningly fierce. I wager you can look after yourself.

Tharja: It's true. People who mess with me tend to get turned inside out.

Lon'qu: I find this thought oddly comforting.

Tharja: All right, then. We'll get married and see if we can't make you normal again.

Lon'qu: And as proof of my dedication, I offer you this ring.

Tharja: ...Wait. You had this ready the whole time? Oh, you are a sly dog, Lon'qu.

Olivia

OLIVIA X LON'QU C

Lon'qu: Hiii-YA! *Crash* ...Hmph. Another failure.

Olivia: Oh, that's too bad.

Lon'qu: Olivia? Have you been watching me?

Olivia: Oh, sorry. I hope I wasn't intruding. It's just that Khan Basilio used to practice that same move.

Lon'qu: It is a trick that I have yet to master. But one day I shall! When Basilio slices the water jar open, not a drop is spilled.

Olivia: I know! It's crazy, huh? Somehow, he slices through it so cleanly that the flask doesn't shatter.

Lon'qu: I have power, accuracy, speed... What am I lacking?

Olivia: Not that I'm an expert, but I don't think power has anything to do with it. When Basilio does it, he barely even swings his blade.

Lon'qu: You have observed him this closely?

Olivia: Well, er, yes. I suppose so.

Lon'qu: Then watch me as I attempt the trick again. Tell me if you see what I do wrong. But please—do not stand so close as I work.

Olivia: Oh, um, okay...

OLIVIA X LON'QU B

Lon'qu: Hiii-YA! *Crash* Damnation! Again I fail. The flask shatters under the blow every time...

Olivia: Hey, Lon'qu? Perhaps you should take a break. Dinner's almost over.

Lon'qu: Stay, woman! Not one step closer!

Olivia: Eeek! Sorry! I didn't mean to... Wait, do I make you nervous?

Lon'qu: Anyway, I am not hungry. You may give my portion to someone else.

Olivia: I don't know if that's a good idea. You need to keep your energy up. Although, I guess if anyone can skip meals, it's you. Basilio did say he never knew anyone with more self-discipline.

Lon'qu: ...Basilio said this to you directly?

Olivia: Well, yeah. He talks about you all the time, actually. Always saying you're a genius with the blade and his true rival and blah blah blah. He talks about you to anyone within earshot. We're all bored of it, honestly.

Lon'qu: I did not know Basilio felt thus.

Olivia: You look pleased.

Lon'qu: Wh-what? *cough* No, n-not at all. I care not what he thinks of me. ...Perhaps I will eat after all. Excuse me.

Olivia: Hee hee. He can't fool me! That stern facade of his COMPLETELY fell away. He was blushing like a tomato!

OLIVIA X LON'QU A

Lon'qu: ...Curses. Will I never do this?!

Olivia: Oooh, you were SO close that time!

Lon'qu: You call that close? I call it pathetic. I've yet to strike a flask without it shattering into a million pieces!

Olivia: Well, sure. But—

Lon'qu: Bah. I'll never be a match for Basilio, let alone his better...

Olivia: Have you forgotten what Basilio said?

Lon'qu: That I'm a genius? His greatest rival? Empty words, designed only to flatter. I have talent, but I lack the true heart of a warrior. THAT is his meaning!

Olivia: That's not true at all! You WILL become his rival someday. You mustn't give up, Lon'qu!

Lon'qu: I understand now why I cannot cleave the flask. I have speed and power, but my heart is weak and irresolute. Without courage and conviction of purpose, my blade wavers and shatters the flask.

Olivia: Um, okay?

Lon'qu: Yet, even though I know this, I am powerless to cure myself. Especially in your presence!

Olivia: Hey, I've got an idea!

Lon'qu: Wh-what are you doing?! Release me! Release my hand, I say!

Olivia: Breathe, Lon'qu. Let the tension flow from your body... I know you can do it, Lon'qu! I believe in you!

Lon'qu: O-Olivia...

Olivia: No one is more resolute in purpose than you. You just have to believe.

Lon'qu: V-very well... Just let go of me!

Olivia: Oh, gosh! Sorry! I didn't mean to be so...um... sweaty. Yikes, this is embarrassing. I left a big red handprint on your wrist. Um, does it hurt?

Lon'qu: It does not hurt, but the experience was nonetheless terrible. However, I hear what you say, and I shall not give up.

Olivia: That's the spirit! I believe in you, Lon'qu! I know you'll make Basilio proud!

Lon'qu: We shall see.

OLIVIA X LON'QU S

Olivia:

Lon'qu: Hiiiyaaargh!

Olivia: Huh? Did you miss it?

Lon'qu: ...Look again.

Olivia: Oh my gosh, Lon'qu! You did it!

Lon'qu: At last, I have succeeded.

Olivia: I'm so proud of you!

Lon'qu:

Olivia: Whoops—sorry! I guess I kinda grabbed your hand there, huh? I know you don't like being touched, but I just got so excited and—

Lon'qu: I don't mind. ...With you.

Olivia: Y-you don't?! Oh, sheesh. This is SO embarrassing!

Lon'qu: Hm? But you're the one who grasped MY hand.

Olivia: Eh, right. I know, but... Look, it's complicated.

Lon'qu: In any case, I must thank you for helping me to master this skill. I could not have done it without you, Olivia. You make me stronger. And that is why I would like to offer you this...

Olivia: Wow, what a pretty ring! Wait. Does this mean...

Lon'qu: I would like us to marry.

Olivia: I thought you didn't like women?

Lon'qu: *Cough* Er, I don't... As a rule. But you are no ordinary woman, Olivia. When I'm with you, I feel no embarrassment. I do not tremble, or grow tongue-tied, or—

Olivia: You don't actually dislike women at all, do you? You just get nervous around us!

Lon'qu: Are you saying I'm scared? Of women? Absurd! Because I'm not. Well, mostly not. ...Well, perhaps.

Olivia: Hee hee... I would never have guessed! Hee hee hee hee!

Lon'qu: Why are you laughing?

Olivia: Don't you see? This means we're exactly the same! We both get embarrassed, and we both have a hard time around people! We're going to get along PERFECTLY!

Lon'qu: D-does that mean...you accept my proposal?

Olivia: Do you even need to ask? I've liked you for ages, Lon'qu!

Lon'qu: I am delighted to hear that. I hereby vow to never leave your side... I dedicate my sword to protecting you.

Olivia: And I promise to stay by your side as well for the rest of my life!

Cherche

CHERCHE X LON'QU C

Cherche: Say, Lon'qu?

Lon'qu: What?

Cherche: This might be a strange question, but... Did you grow up in the slums? Living in the streets?

Lon'qu: I have no idea what you're talking about.

Cherche: Oh. Then it must have been a different Lon'qu.

Lon'qu: Must have been.

Cherche: But you did know a young girl called Ke'ri, didn't you?

Lon'qu: Where did you hear that name?!

Cherche: Ah ha! It was you that they told me about!

Lon'qu: Who is they? What is the meaning of all this?!

Cherche: I met Ke'ri's parents. A while back, when I was in Regna Ferox with Minerva. I saved them from a pack of bandits outside the town. They told me that their daughter had been killed by the very same outlaws. Later I heard a young boy named Lon'qu was with her at the time. ...And that he fought like a demon in a vain attempt to protect her. Naturally, when I was introduced to you, I started thinking—

Lon'qu: I fought, yes. But in the end, it was she who died protecting me. Her mother and father hated me. They blamed me for her death. I was a homeless boy from the slums, and I stole their only daughter.

Cherche: Actually, about that—

Lon'qu: Enough. I cannot bear to speak of it. I would like to be alone now.

Cherche: Wait, Lon'qu! There's more to the tale than you know...

CHERCHE X LON'QU B

Cherche: Lon'qu?

Lon'qu: You again. Begone!

Cherche: We have to talk. There's more to the story of Ke'ri and her parents.

Lon'qu: Even so, I have no wish to hear it. If there is any mercy in your heart, you will leave the matter be.

Cherche: You will want to hear this.

Lon'qu: I think not!

Cherche: Her parents did not hate you, Lon'qu. They were grateful to you. It's true that when Ke'ri was killed, they blamed you for her death. But then they learned how desperately you tried to save her. And when you vanished from the slum, they knew that it was their fault.

Lon'qu:

Cherche: Soon after Ke'ri died, they found her diary. They discovered what a good friend she had been to her.

Lon'qu:

Cherche: Your friendship made her happy, and that, in turn, made them happy. So they don't hate you. Not anymore. And I know they would want you to know that.

Lon'qu: Thank you for delivering the message.

Cherche: It's my pleasure.

Lon'qu: It is...good to be forgiven. And yet, I doubt this wound can ever truly heal.

Cherche: *Sigh*

CHERCHE X LON'QU A

Cherche: You look to have the weight of the world on your shoulders, Lon'qu.

Lon'qu: I am the same as always.

Cherche: I know you better than that. You're distracted by something...I mean, Minerva is right behind you and you haven't even noticed!

Lon'qu: Agh! Wh-what fool's game are you playing?!

Cherche: Heh. Well, that woke you up a little. Listen, Lon'qu. I dredged up a past you wanted to forget, and I'm sorry.

Lon'qu: Do not apologize. You were right to talk to me, and I'm glad to know the truth. When you spoke of her parents' forgiveness, I thought it would only bring more pain. But, since then, the nightmares that plague me have become...fewer.

Cherche: Nightmares?

Lon'qu: Many a night have I been forced to relive the moment she died protecting me. Ke'ri died because she was my friend. Never again shall I repeat that mistake. I vowed that I would let no one get close enough to be hurt by me again.

Cherche: ...So this is why you fear to have contact with women.

Lon'qu: My nightmares will never fade completely, nor will my fear of friendship and love. But for the first time, I can imagine a future that might be different. Thank you, Cherche.

Cherche: I only told you what I knew. ...But perhaps, if you would allow, we can try to cure the remaining hurt together? For a start, we could go for a ride on Minerva. Perhaps even bring a picnic—

Lon'qu: I am...not ready.

Cherche: Oh. Yes, of course not.

Lon'qu: But, if you can think of something else that might help...

Cherche: I will let you know.

CHERCHE X LON'QU S

Cherche: All right, here we go. Let me know the moment you start to feel queasy.

Lon'qu: I am ready.

Cherche: Hmm... I'm not sure the best place to start. Where does one touch a deadly swordsman who does not want to be touched? What do you think, Minerva?

Lon'qu: Please just get on with it.

Cherche: Now, Lon'qu, don't be so impatient. Minerva and I are discussing the best place to begin your aversion therapy. I bet the head would be very scary for you. ...Huh? Lon'qu? What are you doing with my hand?

Lon'qu: We'll be standing here all day if I don't take the initiative. Does it displease you when I hold your hand like this?

Cherche: No, not at all. But you're the one we should be worried about. Are you feeling all right?

Lon'qu: At first it was difficult, but now it feels almost... peaceful. I don't think I could do this with any other woman but you.

Cherche: Well, this is progress.

Lon'qu: Tell me, Cherche. Why do you help me? What have I done to deserve it?

Cherche: Can't I do it out of the goodness of my own heart?

Lon'qu: Few in this world would ever be so decent. Cherche, I want you to have this.

Cherche: A ring? Does this mean...

Lon'qu: You have healed the wounds in my heart and replaced them with love. For the first time, I can see a future in which I am not alone. Will you join me in this adventure? Will you marry me?

Cherche: Gladly!

Lon'qu: I was afraid you'd say no.

Cherche: And I was afraid you'd never ask! Right, Minerva?

Cherche: ...Oh. She says that if you let me down, she'll bite your limbs off.

Lon'qu: Don't worry. I shall not give Minerva any reason to turn on me.

Owain (Father/son)

Owain's father/son dialogue can be found on page 289.

Inigo (Father/son)

Inigo's father/son dialogue can be found on page 293.

Brady (Father/son)

Brady's father/son dialogue can be found on page 297.

Kjelle (Father/daughter)

Kjelle's father/daughter dialogue can be found on page 299.

Severa (Father/daughter)

Severa's father/daughter dialogue can be found on page 305.

Gerome (Father/son)

Gerome's father/son dialogue can be found on page 307.

Morgan (male) (Father/son)

The Morgan (male) father/son dialogue can be found on page 309.

Yarne (Father/son)

Yarne's father/son dialogue can be found on page 314.

Laurent (Father/son)

Laurent's father/son dialogue can be found on page 316.

Noire (Father/daughter)

Noire's father/daughter dialogue can be found on page 317.

Nah (Father/daughter)

Nah's father/daughter dialogue can be found on page 318.

Ricken

Avatar (male)

The dialogue between Avatar (male) and Ricken can be found on page 220.

Avatar (female)

The dialogue between Avatar (female) and Ricken can be found on page 231.

Lissa

The dialogue between Lissa and Ricken can be found on page 243.

Sully

The dialogue between Sully and Ricken can be found on page 252.

Miriel

The dialogue between Miriel and Ricken can be found on page 259.

Maribelle

■ MARIBELLE X RICKEN C

Maribelle: The tea is ready, Ricken.

Ricken: ...Mmm, that's good. Thanks, Maribelle.

Maribelle: It's the least I can do after you saved me from those Plegian scoundrels, dear boy. A single cup of tea will scarce repay the debt I owe you!

Ricken: Aw, you don't owe me.

Maribelle: Ha! Without you, tea would be leaking from sword holes on every side of me! This debt must be paid, especially as we're both members of Ylisse's old high house. We may not be as close now as in ages past, but we're peers nonetheless. If I can ever be of help, you need but ask.

Ricken: Th-that's...

Maribelle: Whatever is the matter, dear?

Ricken: I'm just surprised to hear you say so, is all.

Maribelle: Come now! You saved my life! Surely you don't think me the sort to forget a debt?

Ricken: No, not that! The part about our houses. My house isn't like it used to be. ...Actually, we're dead broke.

Maribelle: Ah, yes. That. Well, the recent financial struggles of your house are hardly—

Ricken: I was just surprised to hear you call us peers. That's all. Plus, look at me! I'm hardly an aristocrat.

Maribelle: And what else could you be, mmm? A noble's honor isn't measured by size of purse, but quality of character. And anyone who would risk his life for another has a noble spirit indeed! Your family is every bit an equal to mine, and hang those who say differently!

Ricken: Heh... Thanks, Maribelle.

■ MARIBELLE X RICKEN B

Maribelle: Oh, Ricken, dear? Let me see your leg.

Ricken: Wh-what? Why would you want to—

Maribelle: Ricken!

Ricken: Urk! Y-yes, ma'am.

Maribelle: Heavens, look at this wound! Small wonder you're gimping about like the village drunk! Why didn't you say something about this?

Ricken: What, this? Ha ha! Oh, this is nothing! Just a...flesh wound.

Maribelle: And what if this "flesh wound" were to get infected? Mmm? What then? You must stop taking unnecessary risks! ...Such as fighting at all.

Ricken: What?! What's THAT supposed to mean?

Maribelle: Putting someone you saved into the line of fire is the worst kind of cowardice. Yes, you saved me, but you could have died a hundred times along the way! Well, never again! I shall demand Chrom find a way to spare you further combat. I should have done this sooner, dear boy. Oh, I hope you can forgive me—

Ricken: Don't you dare! ...And don't call me a boy! I can handle myself in a fight, Maribelle. You should know that better than anyone.

Maribelle: Now see here! I have no doubts on your abilities, least of all me. But I would be devastated beyond comfort if anything happened to you.

Ricken: I have this power for better or worse, and I know how to fight. Don't ask me to sit by while my friends, my family, and my country are in danger.

Maribelle: I suppose if you're truly certain, it's not my place to stop you. I only ask that you don't stop from striving to keep you safe. TELL me when you're

hurt, Ricken! Let me use my gifts for you as well. You'll keep no one safe by playing the stoic.

Ricken: All right.

■ MARIBELLE X RICKEN A

Maribelle: This war grows more intense with each passing battle.

Ricken: I'm exhausted as well, but if we give up now, all of Ylisse will suffer. We can't let that happen.

Maribelle: Ricken, I owe you an apology for my words from the other day. I understand the situation as well as any of us, and I was wrong to imply otherwise.

Ricken: You weren't wrong. ...Not totally, anyway. I AM young, and I DID hide an injury. I'm trying to be more careful. I really am.

Maribelle: Good. You tell me the moment you get even a scratch, are we clear?

Ricken: You may not believe this, but I have no desire to suffer a terrible wound.

Maribelle: Yes, well. So long as that's understood. By the by, I procured a delicious blend of tea in town the other day. If we both manage to survive the coming battle, I promise to share it with you.

Ricken: Ha! That sounds delicious! Just make sure you're careful too, all right? I'm not the only person on the battlefield that people care about.

Maribelle: You've become quite the noble young man, Ricken.

■ MARIBELLE X RICKEN S

Maribelle: Ricken...

Ricken: Oh, is it teatime already?

Maribelle: Er, not quite. I've actually come to you with something of a proposal. You see, I would like to help with the restoration of your family's fortune.

Ricken: That's really kind, but not necessary. It's not like we eat crumbs off the floor. And while your coin might repair the house, our name would still be sullied. We have to do this ourselves.

Maribelle: Well, yes, naturally. But...

Ricken: Although, I've been thinking. I know this may sound odd, but... I have a proposal of my own.

Maribelle: Oh?

Ricken: I want you to have this.

Maribelle: ...This is a signet ring. It bears your house crest. I cannot accept this. Such a token is best reserved for your future wife.

Ricken: Yes. I know.

Maribelle: Oh, moldy caviar! How could I have been so daft? It seems you and I are proposing the same thing.

Ricken: Wait, you WANT to get married? I thought you'd say I was far too—

Maribelle: Of course! As you say, a family's name can only be restored from within.

Ricken: I don't give a whit for my name, Maribelle! I'll only marry you if...if you love me.

Maribelle: I believe that I do, yes. It seemed a bit... Well, unusual, I suppose, so I thought if I covered it somehow...

Ricken: You made up the thing about my family name because you were embarrassed?

Maribelle: Perish the thought, Ricken! I'm deeply concerned for your family's honor. Besides, do you think me the sort who would marry a man she didn't love?

Ricken: Oh, Maribelle! I've been in love with you since the moment we met! I'll make you happy! I swear it!

Maribelle: R-really? From the moment we met?

Ricken: I nearly went mad when I heard you'd been taken captive! Chrom tried to stop me from going, but I wouldn't hear of it!

Maribelle: I don't know what to say... You've become a man with strength equal to the passion of his convictions. And now I'll have the pleasure of sharing tea with that man for the rest of my life.

Ricken: Then prepare the kettle, my love!

Panne

■ PANNE X RICKEN C

Ricken: Hey, Panne. Panne? Panne? ...Hey! Panne!

Panne: Stop shouting, you cretinous whelp. My ears are highly sensitive.

Ricken: Oh, gosh! Sorry! I thought you couldn't hear me.

Panne: I was trying to ignore you.

Ricken: Why? Didn't you realize it was me? I bet you thought I was someone else.

Panne: I have no interest in associating with you.

Ricken: Hey, why not? Because I have, like, a hundred questions for you! Like, can you see in the dark? And how sharp are your claws? Oh, and what—

Panne: Keep testing me, and you'll learn firsthand how sharp my claws are.

Ricken: Look, can we be friends? If we were friends, you'd have to talk to me, right? Yeah, you would! So I'm just gonna stick to you like glue!

Panne: ...You bizarre child appears to be utterly without fear. Very well. You may tag along with me. ...If you dare!

Ricken: H-hey! You're not allowed to change into a monster!

■ PANNE X RICKEN B

Ricken: Hey, Panne!

Panne: Curses, the whelp.

Ricken: Phew, that's a relief. I looked for ages, but I couldn't find you anywhere.

Panne: I was hiding. From you.

Ricken: Sheesh. Why are you so mean to me? What did I ever do to you?

Panne: Nothing yet. But you will. In time, you'll learn hate and contempt just like all the others of your kind.

Ricken: No I won't. I'll always be your friend.

Panne: You say that now, but humans change.

Ricken: I used to be bullied, too. You know what it feels like. In my hometown, the local noblefolk always picked on my family. We were nobles, too, but we'd fallen on hard times. The other families really hated us for that.

Panne:

Panne: Ricken, I know you and the taguel had it way worse than I ever did. But my father said we had to keep our pride or else the bullies would win. And if there's one thing I hate, it's bullies.

Ricken: So you used to be young and foolish, too? Hard to imagine!

Panne: Your family problems have nothing to do with me.

Ricken: Er, yeah. I suppose not.

Panne: And frankly, I'm tired of you following me around like a lovesick puppy. But if that's what you really want to do, then fine. I give permission.

Ricken: R-really?

Panne: Don't think this makes us friends. Follow me at a distance. ...And quietly.

Ricken: Brilliant! Thanks, Panne! Okay, I've got a few questions...

Panne: *Sigh* This whelp only hears what he wants to hear.

■ PANNE X RICKEN A

Ricken: Say, Panne. I heard taguel can turn into all kinds of animals. So what else can you become besides a big bunny?

Panne:

Ricken: Hey, Panne? Did you hear me? I asked what other animal—

Panne: You just won't take stony silence for an answer, will you? I've seen some taguel who became lions, and others who turned into wolves.

Ricken: No way! That's great! I bet they were really strong!

Panne: A long time ago, my mother used to tell me the tale of a certain tribal leader... This was back when taguel ruled the land and lived in an earthly paradise. Before humans changed and our way of life was wiped out forever.

Ricken: *Sniff, sniff* Waaaaaah!

Panne: Why are you crying?

Ricken: I'm sorry. It's just...I feel so bad for you... You and the taguel lost so much! You'd have been so much better off if it wasn't for us humans.

Panne: I... I have never seen a man-spawn cry for our sake... Tsk. Here, here. Wipe away the tears and cheer up.

Ricken: *Sniff*

■ PANNE X RICKEN S

Panne: Ricken.

Ricken: Oh, wow! You actually said my name! Thanks, Panne! This is such an honor!

Panne: Are you being sarcastic? I can't tell. And are you sure I've never said your name?

Ricken: Yep, this is the first time! So what can I do for you?

Panne: I was thinking about the other day, when you cried over my story. I am very worried.

Ricken: Worried? About what?

Panne: You are a young man in possession of a naive innocence that will one day vanish. And when that happens, I fear that one of us is going to get hurt. I think we need to stop spending so much time together.

Ricken: No, don't say that! Not when I just bought you this...

Panne: Is this a ring?

Ricken: I really like you, Panne. I want us to swear to be each other's friend, forever and ever.

Panne: This crest on the ring—does it symbolize the pact?

Ricken: It's my family crest. My father said I'm supposed to... Well, I'm supposed to give the ring to the person I want to marry.

Panne: Marriage? I have heard of this human custom. Are you sure about this? I am a taguel, after all.

Ricken: Of course I'm sure!

Panne: All right, Ricken, you've convinced me. We shall be friends for life.

Ricken: Yes! This is the best day ever! You won't regret this, Panne!

Cordelia

■ CORDELIA X RICKEN C

Cordelia: Ricken, how are you feeling? Are your little legs tired from all the marching?

Ricken: Hey, I'm not a child, you know.

Cordelia: Apologies. I didn't mean to imply that you were a child. I'm just worried you might be overdoing it. There's no shame in admitting you need the rest—we all get tired sometimes.

Ricken: Not you! You're always full of beans! I've never heard you complain once. I don't know how you keep going all the time without stopping...

Cordelia: It would take a lot more marching than this to wear me out, I assure you.

Ricken: Ha! I know. I could march all day!

Cordelia: Then why are your legs still quivering like pudding?

Ricken: M-my legs are NOT quivering like pudding!

Cordelia: Ricken, you can barely stand. If the enemy were to fall upon us now, you'd be dead. Listen, when we set off again, I want you to ride in one of the convoy wagons. You might even have time for a quick nap. You could use one.

Ricken: Hey, I don't need a nap! I'm not a—

Cordelia: Once you're feeling better, I need your help with some camp chores. But you're no good to me right now. So sleep. And that's an order!

Ricken: Fiiiine. Sheesh.

Cordelia: Goodness. THAT was difficult...

■ CORDELIA X RICKEN B

Ricken: Er, Cordelia? Thanks for before. I have to admit, I was pretty beat from all that marching.

Cordelia: Are you feeling better now?

Ricken: Much better! I was being so stubborn. That was dumb. You know, you sure do spend a lot of time worrying about everyone else, Cordelia.

Cordelia: I like to think that's my most important role here. You see, in the past, I used to be too much, and got myself into trouble as a result. At that time, it was Chrom who stepped in and rescued me from myself. If

it hadn't been for him, I don't know what would have happened...

Ricken: So you used to be young and foolish, too? Hard to imagine!

Cordelia: We all were. But now that I'm older and wiser, it's my turn to help others.

Ricken: Yeah! And now that I'M older and wiser, I'm gonna help people out as well. First thing I'll do is go around camp and remind everyone not to be pigheaded!

Cordelia: Everyone? Including me?

Ricken: Okay, okay. Maybe not EVERYBODY...

■ CORDELIA X RICKEN A

Cordelia: Ricken, you've been busy lately, haven't you?

Ricken: Yep! I've been working my fingers to the bone.

Cordelia: You really have grown into a reliable young man! Color me impressed.

Ricken: Heh. That's the first time you've ever called me a man.

Cordelia: Do you mind?

Ricken: Only if it's just idle compliments. ...Which that probably was.

Cordelia: A man grown, and a clever one to boot! Clearly, I must work on my flattery.

Ricken: I knew it!

Cordelia: Don't be upset, Ricken. You've come a long way in a short time. You're far ahead of most people twice your age.

Ricken: I just wish people would treat me like the man I am, you know? I mean, I know I'm younger than most folks here, and smaller, but still...

Cordelia: Respect is earned in time, Ricken. Try to force it, and you'll end up passed out from exhaustion on a baggage wagon.

Ricken: Yeah, I know...

Cordelia: Still, if you're determined to improve yourself, that's half the battle.

Ricken: It is? Great!

Cordelia: Keep working at it, and someday you'll be more powerful than me!

Ricken: Hey! I told you to stop with the idle flattery!

■ CORDELIA X RICKEN S

Ricken: Hey, Cordelia? Can we talk?

Cordelia: Of course, Ricken. What's on your mind?

Ricken: I was wondering what kind of person I am to you. I mean, how do you see me? Do you still think I'm some ignorant kid who can't be trusted to wash his own ears?

Cordelia: Why do you ask?

Ricken: Well, er... I was kind of hoping you'd accept this gift.

Cordelia: ...A ring?

Ricken: It has my family's crest on it, right there. It's our most treasured heirloom.

Cordelia: And you want to give it to me?

Ricken: Listen, I know that you're smitten with Chrom. Heck, everyone does! But I like you far more than he ever will. Or could, for that matter! So I was thinking that perhaps we could get...you know, married?

Cordelia: Wow, I...I wasn't expecting anything like this. I don't know what to say. Honestly, I've always thought of you as something of a kid brother.

Ricken: Well, I'm not your brother, Cordelia. I'm nearly a grown man. And I'm asking you to look at me as the man who's fallen in love with you.

Cordelia: You still seem young to me, Ricken. But when I look to the future...

Ricken: Yes?

Cordelia: I see you becoming something amazing. My equal, my partner, and my champion.

Ricken: Does this mean...?

Cordelia: Yes. I accept your ring.

Ricken: Yippee! We're going to get married! I can't wait for the ceremony!

Cordelia: But wait we must. There'll be no ceremony until you come of age.

Ricken: Oh, all right. But meanwhile, I'll do all I can to be the man you dreamed of. Plus, you'll be around to make sure I become something amazing!

Cordelia: Of course. Although I'm starting to wonder if I have anything left to teach you. You've already made me proud, Ricken. I'm looking forward to our future!

Gregor

■ GREGOR X RICKEN C

Ricken: Gregor! Heeeeey, Gregor!

Gregor: Is no need for bellowing like crazy person. Gregor is old, but ears still hearing fine.

Ricken: So, okay. I need you to tell me everything you remember about the last battle. I was way at the back behind the fighters, so I couldn't see anything at the front line.

Gregor: Hmm... Why you want to know? Ricken is writing history of battles?

Ricken: Exactly!

Gregor: Gregor not minding to answer questions, but why do you do this thing?

Ricken: If we keep detailed records, we can learn from them and do better the next time.

Gregor: Is serious boy, yes? Gregor like that. Okay, Gregor helps. In last battle, Gregor fought on front line. At his side was—

Ricken: Er, actually, you can skip the stuff you did. I don't need that. I just need to know about Chrom. This history's about him and me.

Gregor: Ho ho! Ricken has hero worship for big manly Chrom, eh?

Ricken: Hero worship? Ha! All Chrom does is treat me like a child. My plan is to keep a detailed record of all the stuff the two of us do in battle. He'll have no choice but to recognize me as a full-blown Shepherd soldier. Anyway! Can we get back to my questions?

Gregor: Gregor wishes he were Chrom so, too, have party of fawning flunkies...

■ GREGOR X RICKEN B

Ricken: Hey, Gregor! I've got another question!

Gregor: Again, Gregor has sensitive ears. Screaming like wild beast is not needed. Now let Gregor guess—you want to know how Chrom did in fight today, yes? Gregor expected more questions, so he watches Chrom with eye like hawk. Go on then, make with the asking.

Ricken: Actually, I don't want to ask about Chrom. I want to ask about you!

Gregor: Oy? Why this, now?

Ricken: Because I was behind you when you were fighting in the thick of the action. You were totally amazing! I've never seen anyone fight like that before.

Gregor: Oh ho! You must never pay attention to Gregor on battlefield before, yes?

Ricken: Yeah, I figured you were too old to be interesting.

Gregor: Ah, yes. Gregor is enjoying brutal honesty of small children...

Ricken: Hey, I'm not a child, I'm a grown man! Anyway, in the last battle, I watched almost everything you did. I mean, I didn't want to at first, but you were so quick and strong. I didn't think those moves were possible for such an old man.

Gregor: Gregor will take compliment. Even if you are not wanting to look at "old man" in beginning.

Ricken: Aw, come on, I didn't mean to say it quite like that.

Gregor: Is okay. Gregor is having very thick skins. So, what about questions?

Ricken: Oh, right. Okay, so first of all...

■ GREGOR X RICKEN A

Gregor: Greetings, little Ricken.

Ricken: Hey, Gregor. Hang on one second, okay? I'm just finishing up the latest chapter.

Gregor: Still writing your history of battles? Gregor is thinking you had given up to it.

Ricken: I haven't missed a single one since I started keeping records! Someday I'll become Chrom's right-hand man, and I'm going to need this book.

Gregor: Gregor is not knowing you are having such great ambitions. To be speaking of which, lately you not asking Gregor many questions about battle.

Ricken: Yeah, sorry. Did you miss me?

Gregor: Ho! Gregor misses you like fly stuck in tent buzzing round and round.

Ricken: Hee hee! I guess I was kind of a pest earlier, huh? But the more I wrote, the better I got at seeing what went on at the front lines.

Gregor: Gregor hopes you provide good support instead of just watching battle.

Ricken: Oh, sheesh, of course I was still doing my job! I mean, if I didn't, I'd never get to be Chrom's right-hand man.

Gregor: Yes. More time you spend in battle, more become better at seeing whole situation. But is so unusual one so young is acquiring such veteran skill. You have great talent.

Ricken: Aw, thanks, Gregor. So hey, do you want to read my history? There's an awful lot of stuff in there about you.

Gregor: Oh ho ho! If Gregor is star, book will sell like cakes on fire!

Nowi

■ NOWI X RICKEN C

Chrom: Fortunately no one got hurt, but you MUST be more careful in the future.

Ricken: I'm so sorry! It won't happen again—I promise! I just didn't think the flames would spread so fast.

Chrom: Now is not the time to discuss it. Come by my tent first thing in the morning and you can explain yourself then.

Ricken: Y-yes, sir.

Ricken: *Sigh*

Nowi: I'm sorry, Ricken. I didn't mean to fall asleep, honest. But I couldn't keep my eyes open.

Ricken: Geez, Nowi! You have to promise to stop taking that dragonstone to bed! I don't want to wake up to the smell of burning tents again.

Nowi: B-but, I can't get to sleep if I'm not holding on to it...

Ricken: Look, what if I read you a book instead? Would that help you sleep?

Nowi: Ooh. That ought to work!

Ricken: Fine. ...Now let's keep this dragonstone accident our little secret, okay?

Nowi: Okay! Thanks, Ricken!

■ NOWI X RICKEN B

Nowi: Ricken, are you still angry?

Ricken: No. I guess not.

Nowi: Oh, that's good. Because I've never seen you so angry! ...It was kind of scary.

Ricken: Yeah. I'm sorry I shouted like that. I just sort of...snapped.

Nowi: What did those townspeople do to set you off like that?

Ricken: They were saying bad things about Chrom. It really made my blood boil! Don't they realize how much he's sacrificed and risked so they can live in peace?

Nowi: It's not very fair, is it?

Ricken: No. But I was wrong to be so angry. There are ungrateful fools everywhere. I can't afford to lose my temper whenever someone says something dumb.

Nowi: I don't blame you one bit! Especially when I think how much you adore Chrom. If someone said bad things about a person I liked, I'd probably just eat 'em.

Ricken: You think so?

Nowi: Definitely! You're the kind of person who wants to protect people. ...Just like me.

Ricken: I do my best!

Nowi: Well, anyway. It looks like we have another secret, don't we?

Ricken: Er, right. If you can avoid telling anyone about this, I'd be really grateful.

Nowi: Hee hee! No problem. After all, you're holding on to a secret for me, too!

Ricken: Geez! Let's hope we won't need to keep any more!

NOWI X RICKEN A

Ricken: That wedding was so fun! I'm glad we got to go.

Nowi: Yep. It seemed like the whole village was celebrating!

Ricken: Even though they didn't really know who we were, they gave us so much food. It was like a harvest festival.

Nowi: A harvest festival? I haven't been to one of those in ages! Oh, I love festivals! People are laughing, and dancing, and eating tasty food!

Ricken: You like it when you're surrounded by lots of people, don't you?

Nowi: When I was young, which is a REALLY long time ago, I had no one to talk to. Sometimes, it got so lonely I thought I was the only person in the world. That's why whenever I see a partygoing on, I just HAVE to join in.

Ricken: You don't get lonely now, though, do you?

Nowi: Oh, no! Now I have lots of friends, and there's always someone to talk to! Like you! And [Robin]! And all the other nice people in the army! But...

Ricken: But what?

Nowi: But someday, everyone is going to leave and go their separate ways, aren't they? And when that happens, I'll be alone again, just like before.

Ricken: No way! I'm not going to let that happen! In fact, when the war finishes, why don't we go on a tour of all the festivals we can find?

Nowi: Like, all around the whole world?

Ricken: Yeah! We'll invite the others and travel to every last corner of the map! Every single day would be a new festival with music and candied apples for all!

Nowi: Oh my gosh! We could try to see every festival in the world! Promise me, Ricken! Promise you'll take me on this tour!

Ricken: It's a promise!

NOWI X RICKEN S

Nowi: Hey, Ricken. Let's play a game!

Ricken: Sure! How about a guessing game? For example, see if you can tell what I have for you in this bag.

Nowi: I love guessing games!

Ricken: Here, then. You can put your hand inside, but you're not allowed to peek!

Nowi: Hmm... It's hard...and round...and small... Is it a dragonstone?

Ricken: Nope. Besides, you have one of those. Can you tell anything else about it?

Nowi: Wait, yes! It's got a hole in the middle... Oh! It's a donut! I love donuts! No, wait. It's not a donut. It's metal... Um, is it a ring?

Ricken: That's right! Here, you can look now.

Nowi: Hey, I know what this is! It's just like the one the lady was wearing at the wedding!

Ricken: This is my most prized heirloom. See this here? It's my family crest. And the reason I brought it today is because I wanted to...give it to you.

Nowi: A-are you asking me to marry you?

Ricken: Yes! I really like you, Nowi, and I want you to be my wife.

Nowi: B-but, you're going to get older and older and I'll hardly change! And then—

Ricken: It doesn't matter how we look! It's what's in our hearts that counts. Do you think you could still love me when I'm a wizened old man?

Nowi: Of course I could! I promise I will! I'll never stop loving you, ever!

Ricken: Good! Because I certainly won't stop loving you!

Nowi: Yaaaay! I'm never going to be lonely again!

 Tharja

THARJA X RICKEN C

Ricken: Say, Tharja? You can...you know...do magic and stuff, right?

Tharja: Yes. I can do magic and...stuff.

Ricken: Cool! So, um, can you maybe teach me how to cast a curse?

Tharja: Did someone steal your lunch money?

Ricken: Oh, jeepers, no! I just like learning new skills is all.

Tharja: Curses and hexes are no simple matter. ...But perhaps you possess the talent.

Ricken: Oh, I do! I'm sure I do! So you'll teach me then?

Tharja: No.

Ricken: What? Oh, come on!

Tharja: Casting hexes is not a hobby to be picked up on a whim.

Ricken: I know! This is serious business! Super-deadly serious business! I'm trying to get as strong as possible so I can be a key part of Chrom's army. I'm studying fencing, wyvern riding, and even butter sculpting! ...You know. Just in case.

Tharja: Hexes and curses are a different animal. A wild, untamable beast. Now forget we had this conversation, and go practice your butter sculpture.

Ricken: Well, phooey. I was hoping she'd just say yes. But no worries! She's going to learn that Ricken never ever gives up!

THARJA X RICKEN B

Tharja: ...Are you still following me? Shoo.

Ricken: I'll stick to you like an ant on honey until you teach me how to cast curses.

Tharja: Maybe the first lesson will be me casting one on you.

Ricken: Seriously? That'd be great! Just let me gird my loins here... Okay! Ready when you are.

Tharja: ...Gods, but you are persistent. *sigh* Fine.

Ricken: Really? You'll teach me?

Tharja: ...No. But I'll tell you why I CAN'T teach you. My own powers are not fully developed, so I'm in no position to instruct anyone.

Ricken: Oh. ...Wait, really?

Tharja: Just because I'm a powerful dark mage doesn't mean my training is complete. I have many hexes yet to learn, and even the ones I know don't always work.

Ricken: When it comes to cursing, you're awfully conscientious.

Tharja: The hexing arts are a capricious master, and I do not like mistakes.

Ricken: But if you're afraid of slipping up, how can you learn new things? Everyone knows the best way to learn is to just do it and see what happens.

Tharja: That seems like a rather dangerous attitude for a mage. Although... Hmmm... Actually might be fun... All right. I'm going to start experimenting with new and unknown magic. I'll go out to the woods alone and cast every curse and hex I've ever heard of! ...Hee.

Ricken: Hey, wait! This was all my idea. You have to let me come!

Tharja: ...I'll think about it.

THARJA X RICKEN A

Tharja: Do you have the materials I asked you to prepare?

Ricken: Yep, all here! I'm ready to get cursing!

Tharja: Then you can begin. But make sure to follow my orders exactly.

Ricken: I will. ...Oh, wait.

Tharja: Yes?

Ricken: You haven't told me who I'm supposed to cast it on yet.

Tharja: You can try it on me.

Ricken: ...Er, are you sure?

Tharja: It's the quickest and easiest way to determine if you did it correctly. And I'm not sure these other chumps would appreciate being test subjects.

Ricken: No, I guess not. Okay, here goes... Hyaaa! ...So how do you feel? Did it work?

Tharja: Huh. It would appear that I'm cursed. That's very good for a first attempt.

Ricken: Hurray!

Tharja: ...Hurray! Oh! I see you chose a happiness-contagion hex. How sweet of me.

Ricken: I was actually kind of surprised someone invented nice curses. I thought they were all scary and cruel and just turned people into weasels.

Tharja: Don't be fooled by the name. Curses are a kind of magic that

gives life to dreams. Whether it is a dream of joy or horror depends very much on the victim.

Ricken: People are all wrong about you, Tharja. You're actually really nice! I mean, even though you seem creepy, you let me practice on you. Maybe you should show more of that side instead of the doom and gloom. I mean, your smile is pretty, you know? You should show it more.

Tharja: I like the way I am.

Ricken: Well, okay. I guess. Seems like a waste though...

Tharja: Life would be dull if everyone was happy and polite. Also, don't tell anyone about this. I have an image to maintain.

Ricken: Okay, Tharja! It'll be our secret! So does this mean you're going to teach me more curses?

Tharja: Maybe some simple ones.

Ricken: Aw, can't I learn them all?

Tharja: Let's start small.

THARJA X RICKEN S

Tharja: You really are good at this. I see you've already mastered the basic hexes.

Ricken: Thanks to you!

Tharja: Keep your thanks. Our lessons have helped me learn more about my art. Working with you has helped focus my thinking.

Ricken: Sooo, the more you teach me, the better you're going to be?

Tharja: I suppose. But you really don't need me to continue your studies. You've got plenty of talent without me mucking around in there. As long as you're curious and dedicated, you'll be fine.

Ricken: But I only learned so fast because you're such a good teacher! I want you to show me more creepy spells and teach me how to sneer and stuff!

Tharja: ...Teach you how to sneer?

Ricken: A-actually, I think we can learn a lot from each other, you know? So, um, I kind of got you this...

Tharja: That looks expensive.

Ricken: It's a family heirloom. I was told to give this ring to the woman I marry. I'm going to be of age soon, and when that happens, I want you to be my wife!

Tharja: ...We do make a pretty good team, don't we? If I can just convince you to be a little more evil... ...Heh.

Ricken: So that's a yes, right? Um, is that a yes?

 Olivia

OLIVIA X RICKEN C

Ricken: Oh, cool. That's very interesting...

Olivia: Hello, Ricken. That sounds like quite the book you're reading.

Ricken: Hee hee hee! Oh, NOW I get it!

Olivia: *Ahem* Er, Ricken?

Ricken: Aaaaaah! Okay, okay, riiight... That makes perfect sense...

Olivia: Gyaaaaaah!

Ricken: Jeepers, Olivia! What's the deal? You scared me out of my skin!

Olivia: I-I'm sorry! I just... Gosh, it's not like I yell like that. How embarrassing.

Ricken: Okay, well, I'm paying attention now. So what do you want?

Olivia: Er, nothing important, actually. You just seemed so absorbed

in that book of yours. I wanted to say how much I admired your dedication to learning.

Ricken: Oh! Uh...right. Heh heh.

Olivia: So, then! What fascinating subject are you studying today?

Ricken: Actually, I'm not learning anything. This is a book of stories.

Olivia: Oh? Like fairy tales?

Ricken: More like ancient myths and legends. The one I'm reading now is about a prince who falls in love with a forest maiden.

Olivia: It's a love story? Oh, wow. Those are my favorite kind.

Ricken: You, uh... You want to read it together?

Olivia: Oh, I'd LOVE to! Here, let me sit down next to you...

Ricken: Whoa! Space-bubble violation! I thought you were the shy type.

Olivia: Oh, I don't mind as long as you don't. Now come on, turn the page!

Ricken: Er, oookay. But why do you have that strange look in your eyes?

OLIVIA X RICKEN B

Ricken: C-c-crikey, this story is giving me the hee-bie-jeebies!

Olivia:

Ricken: WAAARGH! Hooo! That was a scary bit!

Olivia: "Yaaaawn"

Ricken: Um, aren't you scared? Not even a little tiny bit? Not even when Shanty Pete left his hook on the side of the carriage?

Olivia: Er, no. Not really.

Ricken: Wow. I thought you'd be shaking and telling me to close the book.

Olivia: "Shrug" I dunno. I've heard much scarier stories.

Ricken: Scarier than THIS one? "gulp" But, wait. I didn't think you were much of a reader.

Olivia: It's true. Books are too heavy to carry when you travel as much as I do. The stories I know are all spoken tales.

Ricken: So you just keep all your stories in your head?

Olivia: Exactly!

Ricken: I'm impressed! Not only can you dance, you have an amazing memory, too!

Olivia: Stop it. You're embarrassing me!

Ricken: Listen, for our next story, why don't you tell me one of yours?

Olivia: ...I'm not sure that's a good idea. I'm not a very good storyteller. I probably won't do it justice... B-but if you REALLY insist, I suppose I could tell you the scariest story I know.

Ricken: Y-you're getting that weird look in your eyes again...

OLIVIA X RICKEN A

Ricken: Hey, Olivia! You have to finish the story you were telling!

Olivia: I didn't realize that you liked it so much!

Ricken: Are you kidding? I was totally into it! Besides, when you're telling it, you really look like you're enjoying yourself. Your enthusiasm is infectious!

Olivia: It's the performer's blood in me, I suppose. I simply love having a rapt audience! There's nothing better than putting a smile on someone's face.

Ricken: You get a kick out of making other people happy? Man, you're awesome!

Olivia: R-really? Wow, no one has ever... Anyway, you wanted to hear the rest of the story, right? I'll keep going, but you have to promise me something... If anything scares you, stop me right away!

Ricken: Huh? But then I won't know how it—

Olivia: If you don't, I can offer no assurances about what might happen...in the night. There. I have warned you once. I will say no more on the subject. Mwa ha ha ha ha...

Ricken: W-wait, is the story THAT scary?! Come on, really?!

Olivia: Well... BOO!

Ricken: AAAAAAAAAARGGH!

Olivia: Hee hee. I'm sorry, Ricken. I was just setting the mood. It's a little trick that Khan Basilio taught me. Did you like it? ...Ricken? What's wrong? You're shaking like a leaf.

Ricken: It's just s-s-so scary, I don't know if... Oh, gosh... Look at me...

Olivia: Pfft... Hee hee... Heh heh ha ha ha! Oh man, you really freaked me out there, huh?

Olivia: Hee hee! I really did get you, didn't I? You were terrified! Anyway, shall we get on with the story? We left off at the haunted castle...

Ricken: Yep, I can't wait! Go on, get to it! You really are a great entertainer, Olivia!

OLIVIA X RICKEN S

Olivia: ...So, after overcoming many tribulations, the little cow concluded her thrilling journey.

Ricken: Uh-huh? And then?!

Olivia: Safe at last, it grew a thick pelt of wool...and turned into a sheep! ...The end.

Ricken: Hah! No WAY! Is that really how it ends?! That is SO awesome! Ha ha ha!

Olivia: I like it, too. Of all the stories I know, it's probably the silliest.

Ricken: Hee hee hee... Oh man, Olivia. You sure know how to spin a yarn! When I'm with you, I'm pretty much laughing the whole time!

Olivia: R-really? Well, that's very kind of you to say.

Ricken: Wouldn't it be great if we could stay together forever?

Olivia: Hee hee. That would be great, wouldn't it? So anyway, do you want to hear another story?

Ricken: N-no, Olivia. I don't think you understand.

Olivia: Hmm?

Ricken: Here. Th-this is for you.

Olivia: Ricken, is this a...ring?

Ricken: I...I really like you, Olivia! You're smart, and cute, and just about the funniest person I've ever met! So what do you say? Do you want to get married?

Olivia: Oh my gosh, Ricken! YES!

Ricken: REALLY?

Olivia: The truth is, Ricken, I've grown very fond of you. You enjoy my stories like no one else... And you scream like a girl when I scare you, which is awesome!

Ricken: Ha ha! You've started saying awesome! Thanks, Olivia. You won't regret this.

Olivia: Hee hee. Of course, Ricken. And thank you, too. I'm looking forward to spending an awesome life together!

 Cherche

CHERCHE X RICKEN C

Ricken: Hey, Cherche! Can I ask you for a big, humongous favor?

Cherche: Well, you can ask, but I can't make any promises.

Ricken: Can I pet your wyvern?

Cherche: What?

Ricken: Aw, nuts. I can't, right? I knew it...

Cherche: Hold now. I was just surprised, is all. You can pet her as much as you like. Minerva IS very cute. I'm surprised more people don't ask to play with her.

Ricken: Cute? More like utterly terrifying!

Cherche: Terrifying! MY Minerva?!

Ricken: Er, uh, right! Cute it is, then! ...Also totally scary.

Cherche: Well. I suppose she is a little bit scary. But you still want to pet her anyway?

Ricken: Yep! I love animals. I'm like a monster whisperer or something. I've never touched a wyvern before, but I bet we'll be best friends anyway. In fact, I think I have the makings of a first-class wyvern rider!

Cherche: Oh, do you now?

Ricken: Yep! For a monster whisperer like me, riding a wyvern should be easy as pie!

Cherche: Ah, the arrogance of youth...

CHERCHE X RICKEN B

Ricken: Thanks for letting me play with Minerva again today.

Cherche: Yes, she seems to be growing used to your visits.

Ricken: Yeah. I think I'm ready to get my own wyvern and become a wyvern rider! I mean, Minerva loves me, so I'm sure other wyverns would go crazy for me too!

Cherche: I'm going to be blunt because I want to save you future disappointment. If I wasn't around to calm Minerva, she likely would have eaten you by now.

Ricken: Soooo, what you're saying is, we're NOT forming a bond and becoming best pals?

Cherche: No, I'm afraid not. Why are you so fixated on becoming a wyvern rider anyway?

Ricken: I dunno. I guess because I feel kind of useless in battle. I mean, I can use magic and stuff, but that's all I'm really good at. So I thought that maybe riding a wyvern would make me...more helpful.

Cherche: I understand you want to be an important part of the army. But the way to do that is to specialize in one particular area. Do you dislike your magic studies and training?

Ricken: No, I love it!

Cherche: Well, there's your answer. You should strive to be the greatest mage you can be! If you love what you do, you're already halfway to mastering it.

Ricken: Yeah, I guess you're probably right. Thanks for the advice, Cherche!

CHERCHE X RICKEN A

Ricken: Hey, Cherche. Do you mind if I try touching Minerva again?

Cherche: Of course. In fact, I probably don't even need to be there this time. She's taken quite a shine to you.

Ricken: Really? That's great! Maybe I won't ever be a wyvern rider, but at least I'll have a wyvern friend!

Cherche: And while we're on the subject, I'm sorry I spoke so negatively about our prospects.

Ricken: Hey, it's always better to hear the truth and make your peace, right? I have to learn how to be stronger and more powerful so I can help everyone. Can't very well do that if I waste all my time chasing stupid dreams!

Cherche: I don't think it's stupid, Ricken. Just a tad unrealistic.

Ricken: My ultimate goal is to become Chrom's right-hand man and most trusted ally. His stalwart aide and the mightiest arrow in his quiver! Then maybe people will start looking up to me and my family.

Cherche: Do people disparage your family? But, I thought you were...

Ricken: What, a noble? Sure. We've got fancy shields and a castle and all that. It's just that in recent years we've fallen on hard times, moneywise.

Cherche: So all your efforts at self-improvement are to uphold the honor of your house? ...Perhaps I haven't given you enough credit, Ricken.

Ricken: Aw, shucks. It's not like I've actually done anything yet.

CHERCHE X RICKEN S

Cherche: Ricken? I made you a new hat. Would you like to try it on?

Ricken: You made duds just for me?

Cherche: Well, you're always trying so hard to do your best, I thought you deserved a reward.

Ricken: Wow, thanks so much, Cherche! No one's ever done anything like this for me before!

Cherche: Well, I'm glad you're pleased.

Ricken: So, um, I have something for you, too.

Cherche: Oh? This is a surprise.

Ricken: Yeah, so, um...here.

Cherche: What a beautiful ring! But—

Ricken: It's my most treasured heirloom. It's been in our family for generations.

Cherche: Ricken, I can't possibly accept such a precious gift.

Ricken: No, you don't understand. It has to stay in the family forever. ...Forever.

Cherche: Oh, heavens.

Ricken: Wait, lemme guess. You're going to laugh now, right?

Cherche: Of course not. Such a serious proposal demands a serious reply. Do you realize that marrying me involves...different responsibilities?

Ricken: Oh, I know. And I promise that I'll look after you AND Minerva. My best years are still ahead of me, you know?

Cherche: I've no doubt you will go on to do many amazing things, Ricken. And Minerva and I would very much like to be a part of it.

Ricken: So does that mean you'll say yes?

Cherche: You have grown into a fine man, Ricken. And we will have a spectacular wedding!

 Henry

HENRY X RICKEN C

Ricken: Hi, Henry! Thanks so much for coming to my rescue the other day.

Henry: Sure! It's what I do.

Ricken: Having a mighty mage like you in our ranks makes me feel a lot safer. Good thing for us you aren't fighting for the other side.

Henry: Well, I used to work for Gangrel, so if you hadn't defeated him, who knows? You and I might have been squaring up on the ol' battlefield. Nya ha ha!

Ricken: I didn't know you were with the Plegian army!

Henry: Oh? I thought word had gotten around. Yeah, Gangrel was toppled before I got the chance to fight any real battles. A shame, too. It would've been fun to face off against the Shepherds!

Ricken: But we're the good guys...

Henry: Oh, Chrom and Frederick are nice soldiers and all, but I wager I could take them both!

Ricken: H-Henry! That's treason!

Henry: Is not.

Ricken: W-well even if it isn't, people might get the wrong idea. They'll start thinking you ARE an enemy, and then we'll end up fighting for real.

Henry: Neat! We could see whose magic is stronger.

Ricken: HENRY! You're my ally! I don't want to fight you. Besides, if we were mortal foes, we wouldn't be able to talk like this.

Henry: Weeell, I guess it's kinda fun being on the same side as you... All right. I guess I'll stick with the Shepherds—for now, at least.

Ricken: I should hope so!

HENRY X RICKEN B

Ricken: Hey, Henry?

Henry: What?

Ricken: Remember a while ago, when you told me that you served under Gangrel? It made me wonder... Have we fought against anyone you knew?

Henry: Yeah, sure! You've cut down a few of my former comrades. You interested in who they were? Lemme see if I can recall... Well, there's Vasto. I liked him! Always ready with a joke or quip.

Ricken: That guy?! He tried to stop us when we headed east that one time.

Henry: He was really excited about that posting—it was his first major command. Ha! He used to talk about his mother all the time. "Best knitter in Plegia," he'd say!

Ricken: Oh. That's...nice.

Henry: Then there was Mustafa. He always gave me a bag of peaches whenever I visited. He said I reminded him of his son and that I should consider myself part of his family.

Ricken:

Henry: Oh! And Campari used to make little birdhouses for homeless—

Ricken: Actually, Henry? I don't think I want to know about your comrades after all.

Henry: Aw! I thought you were interested.

Ricken: I was, but now everyone seems more... normal than I expected. They're not maniacs or monsters. They're just like us, except they're dead.

Henry: Yep. Dead as driftwood, they are. And it was you Shepherds who killed 'em! Their friends and families are probably still crying their eyes out.

Ricken:

Henry: What's wrong?

Ricken: Henry, it's my job to kill Plegian soldiers... So I have to believe they deserve to die. But now you've reminded me that they aren't faceless blobs with axes. They have friends, and families, and... H-how am I going to fight them if I know that? What if I hesitate?

Henry: You're weird. I don't see the problem here at all.

Ricken: No, it's all right, Henry. It was my fault for asking.

HENRY X RICKEN A

Ricken: Henry, can I ask you a question?

Henry: Judging by your expression, I'd say it's a serious one. Nya ha ha!

Ricken: Er... Do you remember when we talked about the Plegian soldiers we've killed? And how some of them used to be my comrades and friends? Don't you...resent you?

Henry: Resent you? Shucks no. What good would that do?

Ricken: Um, none, I suppose. It wouldn't be good for anyone, you included.

Henry: Exactly! So I decided not to.

Ricken: But how can you just brush it off like that? If I were cut down in battle tomorrow, would you just shrug and carry on?

Henry: No! I'd be very sad and angry. And I'd find out who did it, hunt them down, and exact bloody revenge! ...Oh yes. There would be blood.

Ricken: But you just said you don't resent us and there's no point in holding grudges.

Henry: Oh yeah. I DID say that! I wonder what the difference is...

Ricken: Er, are you asking me?

Henry: When I was with Plegia, I didn't think much about this kind of thing. Maybe because in that army, I didn't have real friends like I do here.

Ricken: Do you think of me as a friend?

Henry: I guess, sure. Honestly, I'm not much good with touchy-feely stuff. You know what I'd rather talk about? The next battle!

Ricken: I suppose it wouldn't be bad to plan a little strategy. In the end, victory is the only thing that can justify all this death...

Owain (Father/son)

Owain's father/son dialogue can be found on page 289.

Inigo (Father/son)

Inigo's father/son dialogue can be found on page 293.

Brady (Father/son)

Brady's father/son dialogue can be found on page 297.

Kjelle (Father/daughter)

Kjelle's father/daughter dialogue can be found on page 299.

Severa (Father/daughter)

Severa's father/daughter dialogue can be found on page 305.

Gerome (Father/son)

Gerome's father/son dialogue can be found on page 307.

Morgan (male) (Father/son)

The Morgan (male) father/son dialogue can be found on page 309.

Yarne (Father/son)

Yarne's father/son dialogue can be found on page 314.

Laurent (Father/son)

Laurent's father/son dialogue can be found on page 316.

Noire (Father/daughter)

Noire's father/daughter dialogue can be found on page 317.

Nah (Father/daughter)

Nah's father/daughter dialogue can be found on page 318.

Maribelle

Avatar (male)

The dialogue between Avatar (male) and Maribelle can be found on page 220.

Avatar (female)

The dialogue between Avatar (female) and Maribelle can be found on page 231.

Chrom

The dialogue between Chrom and Maribelle can be found on page 241.

Lissa

The dialogue between Lissa and Maribelle can be found on page 243.

Frederick

The dialogue between Frederick and Maribelle can be found on page 246.

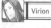
Virion

The dialogue between Virion and Maribelle can be found on page 249.

Vaike

The dialogue between Vaike and Maribelle can be found on page 254.

Stahl

The dialogue between Stahl and Maribelle can be found on page 256.

Kellam

The dialogue between Kellam and Maribelle can be found on page 261.

Lon'qu

The dialogue between Lon'qu and Maribelle can be found on page 264.

Ricken

The dialogue between Ricken and Maribelle can be found on page 266.

Gaius

■ GAIUS X MARIBELLE C
Maribelle: Now see here, Gaius. What do you think you're playing at, hovering around me like a persistent fly? It disturbs me to see your leering visage, particularly when I'm in the midst of battle.

Gaius: I'm sorry, Twinkles. I just thought... Well, if I can atone for what I did, then maybe—

Maribelle: Maybe what? I might FORGIVE you? We might become oh-such-good friends? You broke into the royal treasury with the intent of stealing from the realm. And then you did it AGAIN!

Gaius: Look, I know I did wrong, and I feel lousy about it. Gods strike me down if I don't.

Maribelle: Ha! You must be a stone idiot if you think I'll believe a thing you have to say! Or have you forgotten the first time you were caught raiding the treasury? You claimed my FATHER was behind it! My poor, decent, innocent father! He was hauled in front of the magistrate and almost put to death because of you!

Gaius: Actually, the thing about that is... L-look, I said some things I'm not proud of in an attempt to avoid the noose. But I'm a changed man now, and if you'll just let me, I'm sure I can—

Maribelle: Oh, enough. If I want a dog and pony show, I shall attend a carnival.

Gaius: No tricks, Twinkles. I speak from the heart on this one.

Maribelle: The blackened heart of a brigand is hardly worth listening to!

■ GAIUS X MARIBELLE B
Gaius: Thanks for the help, Twinkles. You saved my bacon out there.

Maribelle: It's my job to heal stricken comrades. ...Even you.

Gaius: Yeah, but I'm the guy who brought false charges against your father. No one would have said boo if you let me just bleed to death.

Maribelle: I needed you alive, unfortunately. There is something I must ask you.

Gaius: I'll answer if I can.

Maribelle: I was rereading transcripts of my father's trial, and something struck me as...strange. Tell me, and speak the truth: Where exactly did you first hear my father's name?

Gaius: Well, er...

Maribelle: My father is a rich and powerful man, but rather unknown outside the nobility. Which begs the question... Why did you choose to accuse him? How did you even know to do so? I can think of only one reason, but I would hear it from your lips... Did someone threaten you, Gaius? Did they force you to name my father?

Gaius: They said... They said I had to do it or else they were going to...

Maribelle: Kill you?

Gaius: No, Twinkles. Not me.

Maribelle: Then who? Who was threatened?

Gaius: Look, it doesn't matter now. Bloke told me to name your father and I did. End of story.

Maribelle: And who was this scoundrel who had such a terrifying hold over you?

Gaius: You're not going to let this go, are you? All right. I suppose I should start at the beginning...

■ GAIUS X MARIBELLE A
Maribelle: I am in your debt, Gaius.

Gaius: You are?

Maribelle: Yes. I wrote down everything you told me and sent it to my father. Now he will be able to turn the tables on the dastards who plotted against him.

Gaius: Well, I... I hope it works out for him.

Maribelle: If it does, it will be thanks to your willingness to tell the truth. So again, thank you.

Gaius: Don't thank me, Twinkles. I don't deserve it. It was a cowardly thing I did, and a day doesn't go by that I haven't regretted it. I even sent a letter after the trial, but too little, too late, I reckon.

Maribelle: Wait, what was you? That letter rescued my father from the headsman's axe!

Gaius: I'm pleased to hear it. But I should have done more.

Maribelle: Gaius, you saved my father's life! Admittedly, your actions put him in danger in the first place... But still! You wrote that letter knowing the schemers would try to hunt you down!

Gaius: That wasn't a worry. I'm pretty good at running away from things.

Maribelle: I've been very unfair toward you, Gaius. I spoke before I knew all the facts.

Gaius: Hey, I'm the one who broke into your royal treasury. ...Twice.

Maribelle: Thief you may be, but you are more honest than half the so-called nobles I know. But, there is still one thing you haven't told me. Who did the plotters threaten to secured your testimony, who did they threaten? It must be someone important to you.

Gaius: Nope. I'd never met her. Never saw her, in fact. All I knew is that she was a young girl who didn't deserve to die. Even if it meant sending her father off to swing.

Maribelle: Oh...

Gaius: What is wrong, Maribelle? You tell Gregor.

Wait, that went wrong. You had to come to my rescue! Again!

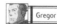
Gregor

■ GREGOR X MARIBELLE C
Maribelle: Hold, you overgrown lummox! I would have a word with you.

Gregor: Creasing the forehead and squinting eyes is wasting such beautiful face.

Maribelle: Beautiful? Why, goodness me... Argh! Do not try to change the subject, you silver-tongued weasel! I've a most serious matter to discuss with you.

Gregor: Gregor is listening.

Maribelle: You took a loaf of bread from the pantry again, didn't you?

Gregor: Yes. Food portions Gregor receives is not enough to maintain mighty physique. If Gregor is fainting from hunger, Shepherd ladies will be plunging into despair, no?

Maribelle: Good heavens, but you are a self-deluded nitwit.

Gregor: Is true! It happening all the time.

Maribelle: Are all lowborn sellswords truly this inane, or is it just you?

Gregor: Eh? Gregor is not catching that last part. You must say again.

Maribelle: Listen to me, fool. The Shepherds have strict rules about such things. Food is rationed for a reason. You can't just go willy-nilly breaking... Sir! *ahem* ...Are you listening to me?!

Gregor: O-of course! Gregor is hearing pretty lady! Do not be rule breaking near Willy, yes?

Maribelle: A lack of discipline leads to disorder, and disorder leads to wickedness. Innocuous though they may seem, your acts could cause the ruin of our whole army.

Gregor: But Gregor is only taking tiny loaf of bread...

Maribelle: You think I'm exaggerating, don't you? One small crack is all it takes to bring down the dam that holds back chaos.

Gregor: Gregor is thinking Maribelle is carried away with this vivid imaginings.

Maribelle: I am a woman of fair mind and breeding. I believe in what is right and proper. And I cannot abide rogues who flaunt the rules that make us strong.

Gregor: Enough! Gregor is making many apologies for bread, yes? From now on, Gregor obey all rules and be model of good behavior.

Maribelle: Yet another empty promise. We have nothing further to discuss. I bid you good day.

Gregor: She is pretty like rose, but her tongue is sharp like thorn.

■ GREGOR X MARIBELLE B
Maribelle: Gregor! Just what do you think you were doing in that last battle?

Gregor: Gregor was making with the killing. Why? Is problem with that, too?

Maribelle: You charged ahead without waiting for your allies.

Gregor: But we are achieving great victory, yes? So all is being well if ends okay.

Maribelle: If everyone thought the same, where would this army be? Discipline would collapse, and we'd be nothing but a disorganized mob.

Gregor: But Gregor did charging ahead for sake of noble Maribelle.

Maribelle: Er, did you?

Gregor: Gregor spies foes hidden in thicket, yes? They wait to ambush most beautiful fighter. So Gregor gallantly leaps into fray to be defending the Lady Maribelle.

Maribelle: Well, that...certainly does a long way toward explaining your actions. When you saw me exposed to mortal threat, you had no choice but to hurl yourself—

Gregor: Oh no! Gregor is doing the same for any pretty girl! Not just Maribelle.

Maribelle: Ah. *ahem* Y-yes, of course. I knew that. In any case, I forgive you. However, we still have rules, and they must not be broken for any reason.

Gregor: Gregor is understanding! ...Actually, no. Gregor is very much confused.

■ GREGOR X MARIBELLE A
Gregor: Oy, Maribelle? Hellooooo? Where are you?

Maribelle: *Sigh* Oh, Gregor...

Gregor: What is matter with Maribelle? Is like heavy weight is being placed on shoulders.

Maribelle: And tell me, how do I normally look?

Gregor: Beautiful, like flower in sunshine. But today, beautiful flower is wilting. What troubles beauty? ...so that gods weep from jealousy and despair!

Maribelle: Oh...

Gregor: Ah, yes. Gregor is most gallant, no?

Maribelle: This simply will not do!

Gregor: No?

Maribelle: Even if I wanted to be rescued by you, which, to be honest, was the case—

Gregor: Oh no!

Maribelle: I cannot allow myself to rely on someone who continuously breaks our army's rules. It must not and will not happen henceforth!

Gregor: Er, yes. About that. Gregor is sorry he is stealing many pies from kitchen. ...And that he takes lock of Chrom's hair to sell to local gossip leaflet.

Maribelle: *Sigh*

Gregor: Do not sigh! Gregor is actually much better than before, yes? Is because Maribelle is scolding Gregor so much that he tries hard to follow rules. Is making Gregor better soldier and allows him to be helping comrades, no? He is just not perfect yet. These things, they take time.

Maribelle: So it's thanks to my efforts that you're able to lend me aid?

Gregor: Yes, you are understanding Gregor!

Maribelle: Well, I suppose that makes sense. All right, then. I'll continue to allow you to aid me on the battlefield. And you will continue to work on obeying the rules. Are we agreed?

Gregor: Muchly in the agreeing!

■ GREGOR X MARIBELLE S
Gregor: Hmmm...

Maribelle: Oh, gracious me! It's a miracle!

Gregor: What is miracle?

Maribelle: You are! Lest I'm mistaken, you appear to be thinking! And intently at that. What terrible aberration of nature has allowed for such a freak phenomenon?

Gregor: Is true. Gregor is having very serious thoughts. Before world sees ending, Gregor wants to give this present to Maribelle.

Maribelle: What in the world is it... A ring?

Gregor: Gregor is wanting to marry Maribelle. Today, Gregor makes solemn promise: Maribelle will not regret a life with Gregor!

Maribelle: ...Is this another of your frivolous impulses?

Gregor: Gregor is never more serious in whole life.

Maribelle: Well, you obviously went to a lot of trouble to procure such an..."ahem" ornate ring.

Gregor: You like ring, yes?

Maribelle: ...I think it's dreadful.

Gregor: Oy...

Maribelle: However. I am delighted by your proposal! It would be my great honor—and yours! Perhaps if we marry I will be able to teach you about good taste... As well as how to follow the rules!

Gregor: First rule Gregor follow: he must do happy dance with new bride-to-be!

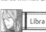
Libra

■ LIBRA X MARIBELLE C
Maribelle: Good day, sir. Here to offer up a prayer?

Libra: Indeed. And yourself?

Maribelle: I make it a part of each morning.

Libra: A commendable endeavor. Might I join you?

Maribelle: But of course.

Libra: Come to think of it, I fear I haven't yet properly thanked you.

Maribelle: Oh? Whatever for?

Libra: Forgotten, have you? It was an all-too-common happening for me, I'm afraid. I was approached by a pack of drunkards who had taken me for a woman. I suspect they still feel the sting of the tongue-lashing you gave them now. Not to further endanger my masculinity, but you were my knight in shining armor.

Maribelle: Ahh, yes. I recall it now. I was given quite the dressing-down myself back at camp! A number of others thought it rash of me.

Libra: Well I, for one, am a grateful recipient of your just and decisive valor. You have my thanks.

Maribelle: I acted mostly to quell my own indignation at those boors, I assure you. But if I was of some small service to you as well, so much the better. Your words help bolster the strength of my convictions.

Libra: Then you are most welcome!

■ LIBRA X MARIBELLE B
Maribelle: Hmm... A difficult quandary, to be sure.

Libra: Is something on your mind, Maribelle? I can hear the gears in your head turning from here.

Maribelle: I've been reading a chronicle of court cases as a part of my studies of late. The decision in one such case has left me quite conflicted.

Libra: Might I ask what manner of trial it was that has you so vexed?

Maribelle: A child cast out by her parents was driven by hunger to steal from an aristocrat.

Libra: Orphan or not, it seems a clear enough matter. Regardless of the reason, all crimes against a noble house are capital offenses.

Maribelle: This is not a matter of inviting the local squalor to a dinner party, sir! All must be equal in the eyes of the law, else we cannot claim them fair.

Libra: All, you say? Even the unwanted children of lowborn parents?

Maribelle: Naturally.

Libra: I must confess, I never thought to hear someone espouse such views.

Maribelle: Have I said anything so shocking?

Libra: Quite the contrary. Your words are warm and fair. I feel proud to have met so pure a person. Redeemed, even.

■ LIBRA X MARIBELLE A
Maribelle: I've made up my mind, Libra. When this war is won, I shall start another.

Libra: A war, Maribelle?

Maribelle: Indeed. I aim to fight for the rights of all citizens as a minister of the law!

Libra: Someone of your elevated station would fight on behalf of the meager masses?

Maribelle: Of course. I'll start in Ylisse, then take the fight to Ferox, Plegia, and everywhere else. I'll fight each battle until none suffer under the burden of an unequal body of law.

Libra: Bending other kingdoms to your will is no mean task, even with an army at your back. To do so with diplomacy alone is a monumental undertaking, Maribelle.

Maribelle: I'm well aware of the madness of it, but my mind is set firm.

Libra: Why would you take up such a colossal burden of your own free will?

Maribelle: Because of your words, Libra. The joy and the pride they stirred in me. You thanked me for something that ought to be a given, and you said you felt redeemed. If my efforts could bring redemption to more people, no burden is too great.

Libra: I merely spoke my mind. I never thought to impart such grand or weighty meaning.

Maribelle: Yet your words changed my life just the same. And for that, you have my thanks.

■ LIBRA X MARIBELLE S
Libra: Maribelle, about what you said before... You're certain that is the life you desire?

Maribelle: I never back down once I've set my mind on something.

Libra: That's impressively stubborn.

Maribelle: Yes, and utterly uncharming. I'm well aware.

Libra: That stubborn lack of charm is just another part of your considerable charm.

Maribelle: My, my. You've a gift for flattery.

Libra: I assure you, I'm entirely sincere.

Maribelle: Libra...?

Libra: Oh, Maribelle... Will you marry me?

Maribelle: You can't talk me out of my mad crusade, so you'd keep me locked up at home?!

Libra: Perish the thought! I wish to fight your crusade with you.

Maribelle: If that's a jest, I'm not laughing. And if it isn't, I'm laughing even less!

Libra: More's the pity, as your laugh is music to my ears! But if it's any aid in convincing you of my sincerity, I procured this.

Maribelle: That ring... It's beautiful.

Libra: Will you do me the honor of accepting it?

Maribelle: ...This marks a second time your words have changed the course of my life.

Libra: A change for the better, one hopes?

Maribelle: No doubt. If you would promise yourself to me, I would be thrilled to do the same.

Libra: I am yours until my last breath.

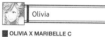
Olivia

■ OLIVIA X MARIBELLE C
Olivia: ONE and TWO and THREE... One more pirouette aaaaaand... Hold for applause! Yay, Olivia! Woooo! Standing ovation! Olivia's the best! Marry me, Olivia!

Maribelle: You dance rather well.

Olivia: Eeeek! Maribelle! How long have you been standing there?!

Maribelle: From the beginning, darling. I didn't mean to spy. But your dance was so wonderful! I just couldn't bring myself to interrupt.

Olivia: Oh, er, gosh. Thanks. I mean, I'm still working on the rough bits, so... Oh, gods, this is SO embarrassing.

Maribelle: Ha! Save the false modesty for your social betters, my dear. A working-class girl like you needs confidence above all else.

Olivia: Er, right... Okay. Thanks, I think?

Maribelle: Good heavens. Are all lowborn folk this skeptical? How can you be so bold one minute and such a quivering mess the next?

Olivia: Wh-what do you mean?

Maribelle: When you dance, you're so...daring! You stand tall and proud, completely unafraid to meet the watcher's eye. You exhibit great strength and dignity.

Olivia: Oh...b-b-but... Argh, stop it! This is so embarrassing!

Maribelle: And yet when you stop, you become this jabbering, bashful mess of insecurities. I want to see more of Olivia the Bold and less of Olivia the Mouse! Got it?!

Olivia: Oh, er. Yes, I'm sure you're right... I guess. But—

Maribelle: Ugh. Very well. If you won't do it yourself, I'll just have to aid you. You'll grow a backbone if I have to drag you there kicking and screaming!

Olivia: B-backbone?

Maribelle: Pluck! Grit! Dignity! Resolve! Pick any noun you like! Hmm... I'll have to think about the best way to whip you into shape. This may take a bit. I'll let you know when the first lesson is ready.

Olivia: I don't like the sound of this...

■ OLIVIA X MARIBELLE B
Maribelle: Olivia!

Olivia: Eeeek! M-Maribelle?!

Maribelle: Heavens! You're as twitchy as a single count in a room full of unwed dowagers!

Olivia: Oh, I know. I'm sorry...

Maribelle: Well, I suppose it's partly my fault. I do walk with dainty, stealthy steps. But never mind that. On to business! Your first lesson is about to begin.

Olivia: Oh, already? That was quick. So, er, what do I have to do?

Maribelle: I want you to initiate a conversation with a gentleman.

Olivia: Pfft! Is that all? That'll be easy! I talk to my fellow soldiers all the ti—

Maribelle: I said a gentleman! Not some knuckle-dragging oaf from the sticks! I want you to go to town,

approach the first NOBLE you see, and make his acquaintance.

Olivia: Huh?! N-no way! I can't talk to a stranger!

Maribelle: What you think you can or can't do is irrelevant. You simply must do it. I know it seems like I'm pushing you into the deep end, but it's a proven method. It's called shock therapy, and it's the latest thing in all the finest courts.

Olivia: B-b-b-but...

Maribelle: Oh, stop with the pathetic stuttering! Look, this is no picnic for me, either. I did a lot of research for your sake. Are you going to waste all my efforts? You DO want a backbone, don't you?

Olivia: W-well, I guess it wouldn't be so bad...if you came with me?

Maribelle: Darling, of course I shall accompany you! How else will I know if the deed is done? And this being your first time, a little moral support might be beneficial. So! As soon as you are ready, we shall set out for town.

Olivia: I c-can't believe she's making me do this... *gulp*

■ OLIVIA X MARIBELLE A

Maribelle: Well, it seems you made friends with a gentleman.

Olivia: Yes, and he bought us all that tea! Plus those diamond-tipped canes. I don't know. I felt a bit guilty.

Maribelle: Tsk! Such things are a small price to pay for the company of two charming beauties!

Olivia: But boy, Chrom sure was angry when he found out, wasn't he? He said the Shepherds shouldn't be picking up strangers all over town.

Maribelle: I TOLD him we could handle any scallywags that came along, but he wouldn't listen. He said the sight of Shepherds brawling in the streets would hurt his cause. As if I'd gouge out someone's eyes like a common gutter rat! Honestly... Oh, well. I'm sorry, Olivia. Perhaps this was a fool's errand after all.

Olivia: Oh, gosh, no! Don't apologize! You were only trying to help.

Maribelle: Actually, there's one other thing I should apologize for.

Olivia: Oh?

Maribelle: Remember the shock therapy idea? The one that led to all this? Well, apparently this is an exercise meant for...gentlemen only.

Olivia: So all those lines you made me say were...

Maribelle: Completely inappropriate for women of our station, yes. ...Especially the wolf whistles. ...And the bit about his legs "going all the way up."

Olivia: Heh. Ha ha. Ha ha ha ha!

Maribelle: What's so funny?

Olivia: It's just that we were SO serious! We spent all that time memorizing lines! And it was completely inappropriate! Ha ha ha! How embarrassing...

Maribelle: It WAS rather embarrassing, wasn't it?

Olivia: Well, your methods were wrong, but your lesson still worked. Plus now I have this really nice cane! Say, maybe we should sneak into town and meet another noble! Chrom won't have to—

Maribelle: Olivia!

Olivia: Hee hee! I'm just joking. Besides, I'd rather hang out with you than some stuffy noble gentleman. So then, would YOU care to join me for tea, O fairest of nobles? Methinks heaven should count its angels, for there is one standing in front of me! Those pantaloons must be made of mirrors, for I can see myse—

Maribelle: ...That's enough, Olivia. It's time you started forgetting those lines. Still, I DO enjoy tea. And it would be churlish of me to refuse your invitation. Yes, then. Let us enjoy a cup of tea as newfound friends!

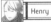
Henry

■ HENRY X MARIBELLE C

Maribelle: I am so weary of this gods-forsaken war. Every time we turn around, Risen are tearing some poor village apart. Ah, I fear this will all get darker before we finally spy the dawn. And yet, look at this flower still finding a way to bloom amidst the devastation. *Sniff* It brings a tear to the eye to see such a fragile struggle to the light. What a good flower you are. Stay strong now, little one.

Henry: Hi there, Maribelle! You all right?

Maribelle: ACK! Henry?! H-how long have you been standing there?

Henry: I, dunno! Since before you launched into that soliloquy, anyway.

Maribelle: Eavesdropping is a shameful habit, sir. And on a lady, no less! Were you birthed in a barn?

Henry: Aw, but it's fun listening to you mumble! You say all kinds of crazy stuff. I really liked the last bit where you started chatting with the flower.

Maribelle: I was NOT chatting with the... flower. I was remarking on the... That is to say... Oh, what's the use? You've caught me in the act, and that's that. Go on, then! Point and laugh. Take this chance to mock your social betters.

Henry: Mock you? Why? I do the same thing all the time. ...Hmm? What's that, flower? *mumble, mumble* ...Ooh! Okay, I'll tell her.

Maribelle: What in the WORLD are you doing?

Henry: Talking to the flower. She says she's very grateful that you spoke to her. Also, she says she'll stay strong as long as you do, too.

Maribelle: I appreciate the gesture, sir, but you don't have to feign madness for my sake.

Henry: I'm not feigning anything. I'm just really in touch with the natural world. I can talk to any living thing you want. Trees. Flowers. Maggots. Ooooooh... Maaaggots...

Maribelle: That is a remarkable talent, if a shade disturbing.

■ HENRY X MARIBELLE B

Henry: Hi, Maribelle. You look like a cat ate your favorite canary.

Maribelle: *Sniff* It's a fate far worse, I fear. My flower friend has withered and died.

Henry: Aww, guess it hasn't rained around here for weeks now, huh?

Maribelle: Henry, can you still...talk to her?

Henry: Nope! Only living stuff.

Maribelle: Yes, of course. How silly of me. She's dead, never to bloom again... It truly makes a woman think. Someday, on the battlefield, such could be my fate.

Henry: Basically. I mean, flowers die, people die... That's just how the world works.

Maribelle: Even so, the idea that I could be gone tomorrow? Or in the hour? Ghastly! We try to ignore the ever-present threat of death, but it's always there. And when you finally think about it, it's a black yawning pit of utter terror!

Henry: Meh, not to me. Everyone kicks the bucket at some point, so why fret?

Maribelle: Perhaps it's not so much death I fear as the pain of dying.

Henry: See, now that I can understand. But get this—I've got a special curse ready, see? Been working on it for a while now. If you're mortally wounded, it kills you off before you suffer any pain! Just...poof. Off ya go!

Maribelle: I see. And is this something you could perhaps cast on me?

Henry: Sure, yeah. Heck, I can do it right now if you say the word. Then you'll never have to fear the old boneyard again!

Maribelle: I declare, Henry, you have the strangest ways of putting people's minds at ease. And yet, I'm rather tempted to accept your offer.

■ HENRY X MARIBELLE A

Maribelle: Henry, do you have a moment?

Henry: What is it?

Maribelle: I've been watching you in our recent battles, and I noticed something...odd. No matter how fierce the fight becomes, you always have a smile on your face.

Henry: Yep. I love fighting! Pshew! Pshew!

Maribelle: But as a mage, you go into battle with little armor and are often the first one targeted. You could be injured or killed in an eyeblink, and yet still you smile!

Henry: It's 'cause I'm not scared, Maribelle. Fighting is actually pretty simple. I just have to kill the other guy before he has a chance to kill me.

Maribelle: Henry, sometimes I find it very difficult to understand you.

Henry: Yeah, most animals are supposed to fear death and stuff.

Maribelle: Animals.

Henry: But I'll tell you one thing—there's no reason to be sad about death. Everyone in this army is going to croak sooner or later—it's just a matter of when. And at the end of it all, we'll be reunited again on the other side.

Maribelle: You think so?

Henry: ...Oh, wait! Holy crows! I just had a really weird thought. That means all the foes we kill are gonna be over there, too. Aw, rats. I'm gonna have to kill them all over again!

■ HENRY X MARIBELLE S

Maribelle: Henry, weren't you injured in the last battle?

Henry: Who, me? No, I don't think so. Didn't see any blood, at least. And believe me, I always look reeeally closely.

Maribelle: That's good to hear. The part about being unharmed, at least.

Henry: Why the sudden concern?

Maribelle: Remember when you told me that you're not afraid of dying? Well, I've been watching you in battle, and I see no idle boast! But the more I watch, the more concerned I become. I fear you may throw your life away on some rash act and that I might...lose you.

Henry: It's a definite possibility! We're fighting a war, after all.

Maribelle: Do not make light of my fears! I couldn't bear to lose you because—

Henry: Because then I couldn't cast that curse that lets you die without pain?

Maribelle: No! It's not about that! I mean, yes, I WOULD miss that, but it's not the reason.

Henry: Okay. So what is? Oh, wait! Lemme guess! You worry I wouldn't finish my toenail collection?

Maribelle: It's because I'm in love with you, you idiot man!

Henry: Huh?!

Maribelle: Oh, my stars and garters. Did I really say that out loud?

Henry: Yeah, you said it out loud. Loudly! But don't be embarrassed, Maribelle. I think you're swell, too.

Maribelle: Oh, Henry. Is this true?

Henry: Yep! I want to be your knight in shining armor. ...Blood-red shining armor! In fact, I'm hoping that we can spend the rest of our lives together. Which I guess is another way of saying that we should get married. Yay! ...Wait. Aw, heck. I don't even have a ring ready or anything.

Maribelle: The ring can wait, silly. The answer is still yes.

Donnel

■ DONNEL X MARIBELLE C

Maribelle: What careless lout elected to leave their belongings here?!

Donnel: Gosh, I'm sorry! That's my pack!

Maribelle: Well, I would ask that you be more careful in the future. In cases of emergency, this corridor is the escape route for the entire camp.

Donnel: I didn't know that, Maribelle. I'm real sorry. We didn't have anythin' like that back on the farm.

Maribelle: Very well, then. I shall take it upon myself to instruct you.

Donnel: Huh?

Maribelle: We shall begin with the laws of Ylisse and the code of organizational regulations. You may borrow this book for now. I expect you to learn its contents front to back!

Donnel: Th-that's an awful thick tome, ain't it?

Maribelle: Justice is a weighty matter.

Donnel: And you want I should memorize this whole thing, ma'am?

Maribelle: Diligence is the noblest of the virtues, Donnel! Education elevates us from the beasts of the field. Oh, and that volume was a gift from my father. I ask that you handle it with utmost care.

Donnel: O-oh, yes, ma'am! I'll be real careful!

■ DONNEL X MARIBELLE B

Maribelle: Good day, Donnel. How fare your pursuits in the learned arts?

Donnel: Great! In fact, I got it all good'n learned, so you can have this here book back.

Maribelle: Preposterous! Even I haven't yet committed the entire code to memory!

Donnel: I wouldn't lie to ya, ma'am! I just always been good at memorizin' stuff. Ma used to say it was 'cause my head was so empty, there was plenty'a room.

Maribelle: Then I suppose you won't object to my asking you a few questions... First, from chapter one: What crimes fall under the auspices of Article IV, Section 3?

Donnel: ...And he shall be sentenced to no fewer'n one or greater'n ten years' imprisonment. ...'Lessun he give the goat back, that is.

Maribelle: Correct AND verbatim! ...Well, except for the awkward grammar. Have you really got the entire legal code memorized?

Donnel: Yes, ma'am! Spent every bit of free time I had on it, I did!

Maribelle: All on this one book?

Donnel: You said it was important to ya, so it'd be rude for me to sit on it! 'Sides, it's mighty nice of ya to teach me, so I owe it to ya to do my part.

Maribelle: I must confess, Donnel, I did not expect you to take to the task with such zeal. I fear I have underestimated you, and for that I apologize. I see now that you are a diamond in the rough. ...Very rough, it's true, but a diamond nonetheless! I shall make it my cause to see you polished into a sparkling paragon of a gentleman!

Donnel: Oh, I, dunno, ma'am. I ain't never been one for fancy clothes and silverware. Plus don't gentlemen all wear masks and dance in circles and stuff?

Maribelle: This is not up for discussion! Now come with me!

■ DONNEL X MARIBELLE A

Maribelle: Hold the waist firm. Now, one step right and two steps left. Ouch!

Donnel: Gosh, I'm real sorry, ma'am! I don't mean to keep doin' that.

Maribelle: It seems that your good memory does not extend past books. Much to the chagrin of my aching foot.

Donnel: It ain't just that I don't know the moves. But when I'm dancin' with you, Maribelle, I get...flustered, I guess.

Maribelle: Have you no decency, Donnel? A true gentleman always keeps his feelings in check! Now you have me feeling self-conscious as well...

Donnel: I'm tryin' just as hard as I can, but I think any fella'd get distracted. You're all pretty 'n' lovely 'n' beautiful, Maribelle, and I'm just a smelly old—

Maribelle: I don't mean to be inappropriate or nothin', Maribelle. But I know you don't want to hear junk like that from a pig slopper like me.

Maribelle: That's not true. ...Well, not precisely. You're earnest and dedicated in all you undertake, Donnel, and I respect that.

Donnel: You do?

Maribelle: Yes. And now that we're finished praising one another, shall we return to our lesson?

Donnel: Oh. So you sayin' all that was just another part of "high society learnin'"?

Maribelle: No, I spoke frankly airing one's thoughts and feelings can be a sad...liberating thing.

Donnel: Now that's the real lesson!

Maribelle: Oh no, I'm not finished yet! With me, now, Donnel! One, two, three... One, two, three...

■ DONNEL X MARIBELLE S

Donnel: S-say, Miss Maribelle? I reckon I want ya to have this.

Donnel: If you think a ring with a fake stone will win me over, you're outta yer... Er, yer mad!

Donnel: The stone ain't real, but there's nothin' fake 'bout the way I love ya! Try again when you ain't such a hick... Er, once ya make somethin' of yerself!

Donnel: Aw, horsefeathers! What'n the heck am I doin' here? Maribelle'd never say yes to a darn pig slopper like me!

Maribelle: *Ahem*

Donnel: M-M-Maribelle?! How long have... Did ya...?

Maribelle: Your portrayal of me is quite the princess. I can't say I'm flattered.

Donnel: N-no, that... I didn't...

Maribelle: Let me see that ring.

Donnel: H-here, ma'am.

Maribelle: ...It's truly lovely. And you would give this to me?

Donnel: The stone ain't... I mean, it's a fake.

Maribelle: I'm not the sort to base her reply to a proposal on the ring's worth, Donny.

Donnel: Then does that mean yer gonna accept it?

Maribelle: Will you ask me again? Properly, and to my face?

Donnel: Course I will! *ahem* Miss Maribelle, will you do me the honor of bein' my wife?

Maribelle: Master Donnel, I would be delighted.

Donnel: Aw, shucks!

Maribelle: Donnel? One does not end a proposal by saying "aw, shucks."

Lucina (Mother/daughter)

Lucina's mother/daughter dialogue can be found on page 285.

Lucina's mother/daughter dialogue can be found on page 285.

Brady (Mother/son)

■ BRADY X MARIBELLE (MOTHER/SON) C

Maribelle: Now, repeat after me: "My name is Brady. Pleased to make your acquaintance."

Brady:

Maribelle: Did you hear me? "My name is Brady. Pleased to make your acquaintance."

Brady: ...The name's Brady. Pleased to make your acquaintance.

Maribelle: "My name IS," Brady. Not "The name's." Now, "My mother's name is Maribelle." ...Go ahead, darling. Try it.

Brady: My ma... Er, my mother... Aw, nuts, Ma! Yer crazy if you think I'm puttin' up with this crap!

Maribelle: Don't you dare walk out on me, young man!

Brady: Ma, we're at war here. Ya know? With killin' and all that malarkey? If you wanna teach me something, teach me some tricks with a staff.

Maribelle: I'll teach nothing of the sort to a boor who scoffs at the value of proper language!

Brady: Why not?

Maribelle: A person's words reflect their character.

Brady: So anyone who speaks a little rough is some kinda knuckle dragger? Ain't that a little simplistic?

Maribelle: Unrefined language shows a lack of concern for how one comes across to others. It demonstrates a lack of respect and is ample cause to judge someone.

Brady: Why ya always gotta be so hardheaded about everything?

Maribelle: Better a hard head than a brain made of mush! I'd sooner choose my words carefully than speak rashly and regret it.

Brady: Sounds like somebody screwed up in the past, yeah? Who'd ya piss off?

Maribelle: Really, must your EVERY phrase be vulgar! It should be "WHOM did you piss off," Brady. ...Go on, repeat it for yourself.

Brady: Uh, something tells me that still ain't entirely proper speech.

■ BRADY X MARIBELLE (MOTHER/SON) B

Brady: Huh... Never knew that...

Maribelle: Good day, Brady. What are you reading?

Brady: Oh! N-nothing, Ma.

Maribelle: Don't tell me it's something salacious!

Brady: What?! No! I don't even know what that word means!

Maribelle: Give here this minute! Let me see... "Proper Diction: A Beginner's Guide"?

Brady: ...Happy now? I was gonna surprise ya after I learned how to talk all pretty.

Maribelle: Brady, you...

Brady: Anyway, what of it?! I'm only doin' it what to get ya off my case!

Maribelle: Brady, this book is designed for children seven years or younger...

Brady: WHAT?! It's that tough!

Maribelle: I never imagined things were this grim...

Brady: L-look, I just wanted to review the basics, yeah? If you always harpin' on the basics!

Maribelle: Yes, they're paramount, naturally. But still... Chapter one: "Your Friend, the Noun" ...This is honestly where you're starting?

Brady: H-hey, get off my case! I don't need this! I talk just fine anyway, yeah? Forget all this! I'm a make like pants and split!

Maribelle: Goodness. Just what manner of education will my future self offer that poor boy?

■ BRADY X MARIBELLE (MOTHER/SON) A

Brady: Indeed, I discussed the matter a fortnight past with [Robin]. Was I remiss in notifying you?

Maribelle: Brady?! The voice is yours, but the words...

Brady: I completed my reading of "Proper Diction: A Master's Guide" yesterday evening.

Maribelle: Yes, I heard from many people. ...Frankly, the entire camp is terrified.

Brady: I can only hope my more eloquent locution better conforms to your ideal son, Mother. Now, in further news of the day, I feel that we must allow for... "Gaaaaaasp"

Maribelle: Are you all right?! What is it?!

Brady: How do you breathe, Ma?! Talkin' like that damn near suffocated me! I seriously thought I might pass out.

Maribelle:

Brady: I mean, uh, speaking in that manner nearly caused me to be overcome? ...From lack of respiration?

Maribelle: Nice try, darling.

Brady: Aw, horse apples! Ain't no good, Ma. The words just don't fit in my mouth. I feel like I'm gonna chomp my own tongue off here.

Maribelle: Brady, I'm just so very pleased you even bothered to make the effort. But it's time I stopped foisting my ideals on other people. You can think and act responsibly without thinking and acting like me.

Brady: You're creepin' me out here, Ma. What's with the sudden about-face?

Maribelle: That's just it: YOUR sudden about-face creeped ME out.

Brady: Right?! ...Wait, hey! Did you just call me creepy?

Maribelle: Hmm, did I?

Brady: I only did all that speakin' junk 'cause ya kept tellin' me to.

Maribelle: I know, sweetheart. And I'm so very proud of my little honey bear.

Brady: Gah, okay, stop! You're welcome, so just stop!

Maribelle: Ah! Seems I've discovered another way to motivate you... Boo-Boo-Bear.

Brady: No more, Ma! I'm beggin' ya!

Morgan (female) (Mother/daughter)

The Morgan (female) mother/daughter dialogue can be found on page 312.

The Morgan (female) mother/daughter dialogue can be found on page 312.

Panne

Avatar (male)

The dialogue between Avatar (male) and Panne can be found on page 220.

The dialogue between Avatar (male) and Panne can be found on page 220.

Avatar (female)

The dialogue between Avatar (female) and Panne can be found on page 231.

The dialogue between Avatar (female) and Panne can be found on page 231.

Frederick

The dialogue between Frederick and Panne can be found on page 246.

The dialogue between Frederick and Panne can be found on page 246.

Virion

The dialogue between Virion and Panne can be found on page 249.

The dialogue between Virion and Panne can be found on page 249.

Vaike

The dialogue between Vaike and Panne can be found on page 255.

The dialogue between Vaike and Panne can be found on page 255.

Stahl

The dialogue between Stahl and Panne can be found on page 257.

The dialogue between Stahl and Panne can be found on page 257.

Kellam

The dialogue between Kellam and Panne can be found on page 261.

The dialogue between Kellam and Panne can be found on page 261.

Lon'qu

The dialogue between Lon'qu and Panne can be found on page 264.

The dialogue between Lon'qu and Panne can be found on page 264.

Ricken

The dialogue between Ricken and Panne can be found on page 266.

The dialogue between Ricken and Panne can be found on page 266.

Gaius

■ GAIUS X PANNE C

Gaius: "Sigh" One pot of honey, and that's it. This is barely going to last three days, and I just ate my last candied fig this morning...

Panne: Gaius?

Gaius: That you, Panne? What can I do you for?

Panne: What are you doing here? I rarely see you man-spawn clambering on sheer cliffs.

Gaius: I was collecting hon— Er, that is to say, I'm here on a...mission. Yeah, that's right. A very important and dangerous mission.

Panne: Oh.

Gaius: I can tell you're impressed, Whiskers. Don't try to hide it. You're thinking, "Crivens, this must be a brave and agile man, to be—"

Panne: Your dexterity would be below average among the taguel. And do not call me Whiskers.

Gaius: Below average, eh?

Panne: I admit, when I saw you at a distance, I thought you might be one of my kin. Perhaps a particularly clumsy friend who managed to hide among these rocks. But it was a fool's hope.

Gaius: Yikes. When you say that, I feel kind of bad for clambering around up here.

Panne: It is all right. You did not know.

Gaius: But uh, before you go...

Panne: Yes?

Gaius: ...You know a good way of getting down from here?

Panne:

■ GAIUS X PANNE B

Gaius: Heya, Whiskers. Thanks for getting me out of that tight spot the other day.

Panne: I never imagined I would one day be forced to carry a human down a cliff. I hope the experience will not be repeated. I found it disagreeable and humiliating.

Gaius: I thought we looked pretty dashing with me on your back. Like a Panne knight! ...You get it? See, instead of "pegasus," I said "Panne," so—

Panne: I am not a beast of burden, idiot!

Gaius: Crivens, you're a snippy one, aren't you? Maybe you need some sugar. Here, have one of my candied figs. It'll settle that temper of yours.

Panne: I do not usually eat sweets.

Gaius: No wonder you're always mopin' around. A berry tart keeps me whistling no matter how hard the going.

Panne: Do these sweets of yours serve as emergency rations?

Gaius: Any moment I'm not eating sugar is an emergency, Whiskers.

Panne: "Nibble" ...Ah, yes, very sweet. In emergencies, we taguel sometimes eat a similar-tasting fruit. But it is even sweeter than this candied confection.

Gaius: Sweeter than candy? What-what's it called? Where can I get it? Ya gotta tell me, Whiskers!

Panne: Are you that interested in our culture?

Gaius: Oh, er...yeah! Of course. Absolutely obsessed, in fact! ...So this fruit of yours where can I find it?

Panne: You're standing below a tree right now.

Gaius: Wh-what?! A candy tree?! Mmmmuuuurr-rgghhh... Now I just gotta climb my way... Wait, up THERE?!

Panne: If you refer to the single, solitary tree at the very top of this cliff, then yes.

Gaius: Well, crap.

Panne: What are you doing, man-spawn? You know you can't get down again! I won't help if you get stuck. You'll have to stay there for the rest of your days! Gods take this half-wit. He's stuck again...

GAIUS X PANNE A

Panne: Enough. Stop pestering me!

Gaius: I'm sorry, Whiskers, I am. But ever since you told me about that candy tree, I can't get it out of my head!

Panne: It is not a candy tree—it is a fruit tree. And I'm tired of playing Panne knight!

Gaius: Hey, you just said Panne kni—

Panne: Are you listening to me?

Gaius: Er, yes.

Panne: Good. Anyway, you could at least pretend to be interested in the culture of my people. It would make me happier than you could possibly know.

Gaius: Wait, you KNEW I was just after the fruit? You saw through my cunning sham?

Panne: It was easy. You said as much when you were climbing toward the tree. You tend to talk to yourself a lot, man-spawn.

Gaius: Yeah, but I was so far away! How did you hear me?

Panne: Taguel ears are far more sensitive than your own.

Gaius: Crivens... I wager you overhear all kinds of secrets.

Panne: Not really. Our hearing is so sensitive, we pick up every little sound. Often the one thing we WANT to hear is drowned out by background clamor.

Gaius: Interesting. Tell me something else I don't know about the taguel.

Panne: Why? I've told you all there is to know about our sweet fruit tree.

Gaius: No, not that. I mean, about how you live and your culture and all that. I'm interested, Whiskers. Really.

Panne: You're not just saying this to place butter on me?

Gaius: Actually, the saying is... You know what? Never mind.

GAIUS X PANNE S

Gaius: Here, I've finished the ring. What do you think?

Panne: Very good. You have captured the style of taguel ornamentation perfectly. You're quite skilled with your hands. Did you ever think of being a jeweler?

Gaius: Hah! With your endorsement, I reckon I could make a go of it! Now tell me again about your high holy feast. How did that go again?

Panne: Aren't you bored of discussing the taguel, Gaius? We've done little else for weeks.

Gaius: Panne, you never bore me.

Panne: Oh? Well, I am glad.

Gaius: When you talk about your people, your whole face lights up. It's the exact opposite of that time you had to carry me down the cliff.

Panne: I considered leaving you there. ...Or killing you.

Gaius: Listen, Panne. I've been thinking that maybe we could spend more time together. See, among us man-spawn, a ring like this usually symbolizes a promise. And, if the lady does a man the honor of wearing it, then—

Panne: Then I would be your property? Is that it? Do you wish to employ me as a pack mule to haul you to and fro your candy tree?

Gaius: What? No, no. That's not why. The honest truth is... Well, it's... You see, the thing is...

Panne: Gaius, I understand. And my answer is yes. I will wear your ring.

Gaius: You will? Truly?! Oh, Panne, this is the sweetest day of my life!

Panne: Coming from you, Gaius, that is high praise indeed.

Cordelia

CORDELIA X PANNE C

Cordelia: Er, Panne?

Panne:

Cordelia: What are you doing to my pegasus?

Panne: So this steed belongs to you?

Cordelia: Yes, she does.

Panne: You are lucky. She is a wise and faithful creature.

Cordelia: Thank you. But how do you know she's wise?

Panne: We talked.

Cordelia: Oh, yes. Of course. You talked to her and... Wait, you can TALK to my pegasus? Like, with words?

Panne: Is that strange?

Cordelia: Er, no, I suppose not. Just a bit surprising is all. We knights can communicate with our steeds, but it's not so...direct.

Panne: I am no knight. I am a taguel. But enough talk. Take good care of this animal, understood?

Cordelia: See you...later? Er, maybe? Right then, back to business. Hmm? What's this green stuff smeared around the cut? A healing salve... So that's what she was doing! Well, we must remember to thank Panne the next time she drops by!

CORDELIA X PANNE B

Cordelia: Panne, I wanted to thank you for the other day.

Panne: I did nothing.

Cordelia: You treated my wounded pegasus, right? You gave her a healing salve?

Panne: ...No.

Cordelia: Oh, I see. Well, whoever put it on, the medicine was very effective.

Panne: It is a secret taguel recipe far stronger than your man-spawn cures. ...Er, not that I would know.

Cordelia: Ah ha! So it WAS you!

Panne: I had hoped to treat the wound surreptitiously.

Cordelia: Well, we're both very grateful. Thank you, Panne.

Panne: I do not deserve your gratitude. After I treated your creature, I... I made her an offer.

Cordelia: What kind of offer?

Panne: I offered to free her so she would not be subjected to the dangers of war. This fighting has nothing to do with her or her kind. It seems cruel to make her struggle alongside us. But she told me she wanted to help, and could never desert you.

Cordelia: My pegasus said that?

Panne: The creature is very faithful. That is why you must take care of her.

Cordelia: Y-yes, of course! I'll do everything I can to make sure she isn't hurt again.

Panne: Do all in your power and more. I would not like to see such a magnificent beast come to harm.

Cordelia: Nor would I, Panne.

CORDELIA X PANNE A

Cordelia: Well, what did you think? How was your first ride on the back of a pegasus?

Panne: Interesting. And frightening. The ground was very far away. But it was also...thrilling.

Cordelia: I'm glad you enjoyed it! We had to do something to thank you for the salve.

Panne: Still you talk of the salve... I told you, you owe me nothing.

Cordelia: All right. But if you do want to go on another ride, just let us know. My pegasus has grown ever so fond of you, and she loves to frolic in the sky!

Panne: Thank you. Both of you.

Cordelia: Not at all!

Panne: When you two fly, you move as if you were a single creature. How can you humans forge such strong bonds, yet still fight such terrible wars?

Cordelia: That's a good question. And I don't know the answer. But I do know that we fight this war to build a better, peaceful future. If I didn't believe that, I'd drop my weapons and walk away right now.

Panne: I believe that you would. And in truth, the same hope drives me to fight. The hope for a world where taguel and human can at last live in harmony.

Cordelia: Oh, Panne...

Panne: Did I say something strange?

Cordelia: No, of course not! It's just that... To hear you say that makes me happier than you could know. But haven't you noticed? Humans and taguel ARE living in peace together! Two of them are right here, giggling like schoolgirls on the back of a pegasus!

Panne: It seems we have made a friendship, just as you did with your pegasus. Perhaps I am at the point where I can name you my true friend.

Cordelia: I couldn't have put it better myself. We ARE true friends! And that means I'll always be here to watch your back.

Panne: And I yours!

Gregor

GREGOR X PANNE C

Panne: *Gasp* Wh-what's happening to the sun? Everything is growing dark!

Gregor: Oy?

Panne: Whaaa-...aaa... No! Ancestors help me...

Gregor: What is being wrong? Panne is shaking like dry leaf in wind.

Panne: D-darkness...consuming all...

Gregor: Is just eclipse! Sun is only hiding behind moon for small time. It is coming back, Gregor swears. Do not make with the worrying.

Panne: T-truly?

Gregor: Panne has never heard of eclipse?

Panne: I've been in hiding for most of my life. There is much I do not know.

Gregor: Oy, you must have been poor and lonely girl, yes?

Panne: Do not offer me pity. I will not accept it.

Gregor: You are funny woman, saying so to Gregor while cuddling in his strong arms!

Panne: Cuddling...? In your arms...? Aaargh! When did you grab me, man-spawn?! I should eat your heart for this insult!

Gregor: Please, do not be doing this! Gregor is needing his heart! And it was you who is jumping into Gregor's arms like frightened rabbit, yes?

Panne: Er, yes, well, it must have been...this "eclipse."

Gregor: Is no problem! Gregor always in mood for friendly cuddle.

GREGOR X PANNE B

Gregor: Hello, Panne.

Panne:

Gregor: Oy, Panne! Is only Gregor!

Panne: Yes? What is it, then? Have your say and leave.

Gregor: Why so cold to good friend Gregor?

Panne: None of your business.

Gregor: Aaah, Gregor is knowing why! Panne is ashamed, yes?

Panne: Wh-why would I be ashamed? I simply do not wish to see you.

Gregor: So now you hate Gregor with passion of maniac? All right! Gregor knows when he is being unwanted like trash.

Panne: No! ...Er, don't go.

Gregor: Yeees?

Panne: I don't hate you. And I want to... To thank you for helping me.

Gregor: Ah, you see! Now we are having conversation like grown adult. Maybe you will let Gregor pet fuzzy ears then, yes?

Panne: Are you making fun of me?

Gregor: Ho ho! Gregor is thinking you have many commitment issues. Is lucky thing he is expert in such matters.

Panne: I have no idea what you're blathering about.

Gregor: Gregor saw you trembling like little bunny when eclipse came, yes? So Gregor thinks, "Little bunny is needing much care and protection!" Panne spent much time hiding from man, yes? She knows little of us. So then, she must open heart to Gregor! Let him be guide to world of mankind.

Panne: Hah. I think I would be more comfortable back in hiding...

GREGOR X PANNE A

Panne: Gregor, just what were you doing in that last battle?

Gregor: Is Gregor's sworn duty to protect you. What else can Gregor be doing? You are Gregor's devoted pupil. Gregor is masterful and wise teacher. Gregor cannot stand in idleness while noble pupil is skewered into rabbit meats.

Panne: So you thought to throw yourself in front of an onrushing cavalry, yes? You're lucky you're still alive.

Gregor: You have worry for master Gregor, yes? You are noticing his wound of gapingness?

Panne: Master Gregor can stick his head in a dragon's maw for all I care.

Gregor: Argh! Gregor's wound! The stitches, they tear open!

Panne: What? Where? Are you bleeding? Quickly, let me see! ...Hm? No, everything looks fine. Bandages in place and—

Gregor: Oh ho ho ho! Gregor makes jape!

Panne: Do that again and I'll give you more real wounds to worry about!

Gregor: Yes, yes! Is perfect! Now do again with more anger.

Panne: ...What?

Gregor: Panne must learn to express feeling more. Is first step to intimacy. Holding anger inside and never learning to forgive? Very bad. Is reason why Panne has few friends.

Panne: ...I have no idea what you are talking about.

Gregor: Is, how to say, baby steps, yes? You will learn like good bunny. Until then, Gregor protect you.

Panne:

GREGOR X PANNE S

Gregor: Panne! Helloo? ...Where is favorite pupil?

Panne: *Pant, pant*

Gregor: Ah-ha! Gregor finds you.

Panne: How did you—

Gregor: Why does Panne hide from Gregor? Do you hate him so?

Panne: You act like a reckless fool when you're near me. I don't want to see you hurt.

Gregor: Ho ho! You worry about old man too much. Gregor knows well how to protect self.

Panne: I don't need you hovering around trying to defend me all the time.

Gregor: But is not about what you need. Is about what Gregor need. If Gregor gives you one good reason, will you let him protect you?

Panne: Well, it had better be very good.

Gregor: Gregor is wanting to marry you.

Panne: Are you... ...Is this another of your japes?

Gregor: Gregor never joke about love! ...Well, not this time. Here, see?

Panne: A ring?

Gregor: You know what ring mean for human, yes? Now you know, is no joke. Is love.

Panne: Waaaaaaaaaaaaaaargh!

Gregor: Oy! Why do you make with the screaming and the crying and the noises?!

Panne: I am releasing pain and anger from my heart. It is what you told me to do if I was to make friends with anyone.

Gregor: Ah, yes. Gregor is remembering now. So, what is result? How does Panne feel?

Panne: I am not sure... I am feeling many strange things. Joy? Contentment? Even...hope? I have not felt this way in so long a time.

Gregor: Gregor is delighted! His heart is swelling to burstiness!

Panne: But you don't get to protect me all the time. Understand? We're going to protect each other.

Gregor: Very good! Now you come, little bunny! Jump into Gregor's arms!

Libra

LIBRA X PANNE C

Libra: Might I beg a moment of your time?

Panne: You get one moment. State your business, priest.

Libra: I wanted to thank you.

Panne: You owe me nothing.

Libra: But I do. You saved Lady Emmeryn from assassination. As an Ylissean citizen and a man of the cloth, I owe you my gratitude.

Panne: I saved no one. Emmeryn lived only long enough to fall into the next snare.

Libra: You were there, then. When she... Ah, I fear we both witnessed it.

Panne:

Libra: I see that what happened to her pains you even now. I, too, still grieve. I cannot help but feel that I failed her somehow.

Panne: What, then? You would have the two of us sit around licking each other's wounds?

Libra: No, I merely thought to—

Panne: You are human. I am taguel. Linger near me and you'll be viewed with suspicion by your kind.

Libra: You're worried for my reputation? That's very gallant.

Panne: Watch your words, man-spawn, lest you get yourself hurt.

Libra: My apologies...

LIBRA X PANNE B

Libra: Hello, Panne.

Panne: What now, priest?

Libra: I apologize for disturbing you, but there's something I need to ask. Why did you come to the exalt's aid?

Panne: Can you not believe a taguel would help a human?

Libra: Apologies. That isn't what I meant. Had you even met her before?

Panne: No. The night of the assassination attempt was the first I saw her. I knew neither her face nor her name. All I knew is she was descended of the first exalt.

Libra: Your debt was to a man who died over a thousand years ago?

Panne: It is the debt of all the taguel. We are told the story as kits. In his time, the taguel were slaves to humans. Kept as labor—or even pets—we were treated worse than livestock. The slightest resistance would earn a swift execution, to serve as an example.

Libra: I've never heard of such cruelty.

Panne: Humans are quick to forget history. ...Or re-write it. But the first exalt had the strength and courage to end the horror. He stood up for the taguel, though it earned him the ire of his fellow humans. "We are all the same," he said. "Equal beings. No difference separates human and taguel."

Libra:

Panne: It was a platitude then, as now. But in that platitude, my kind found salvation. Liberation and equality took time, but in those words we found dignity. And so we teach our young of the debt we owe him. Should any exalt ever need our aid, we will give it regardless of cost.

Libra: I see.

Panne: Despite our history, I never hated mankind. The exalt proved our race's worth. Until man-spawn slaughtered my people and put my warren to ruin, that is.

Libra: Panne, I haven't the words to tell you—

Panne: I've spoken all of mine as well, and wasted both of our time.

Libra: Not at all! You've allowed me to better understand who you are, Panne. And convinced me you are someone I would dearly love to know still better. I thank you for sharing your story with me.

Panne: Hmph.

LIBRA X PANNE A

Libra: Panne, I just had a word with Chrom. I hear you were involved in an altercation with some of the other soldiers.

Panne: I don't see how that's your concern.

Libra: Isn't it, though? The next time you find yourself in a situation like this, please, let me know. You needn't sully your hands for my sake. I can express my own displeasure.

Panne: ...You heard, then?

Libra: Indeed. A little bird told me the cause of your scuffle. Apparently you intervened when someone began telling off-color jokes about me?

Panne: Hmph. Perhaps I was just in the mood to hit someone that day.

Libra: You always insist on hiding your kindness and denying your compassion. I would dearly love to see you embrace these traits more openly.

Panne: I didn't ask your opinion. Speaking with you made me feel better. And hearing those soldiers angered me. That is all. Now we're even.

Libra: You amaze me, Panne. The light within you shines so brilliantly. Never losing its purity of character or allowing the world to dim its luster... I thank the gods and the exalt for granting me the chance to bask within its glow.

Panne: You're mad. And a terrible flatterer.

Libra: Apologies. Have I embarrassed you?

Panne: ...Hmph.

LIBRA X PANNE S

Libra: Panne. There is a matter of import that I would discuss with you. Might I—

Panne: Speak your business.

Libra: Very well. I would like to ask only that you listen and give me a fair chance. ...And that you accept this ring.

Panne:

Libra:

Panne:

Libra: Er, Panne? I thank you for accepting the ring, but, um... Have you nothing to say?

Panne: You asked me to listen.

Libra: Of all the times to start doing as you're asked...

Panne: Come again?

Libra: N-never mind. I retract my prior request for listening. Please, speak your mind. Be frank.

Panne: I feel like leaping across a mountain range.

Libra: ...Is it safe to assume that means you're happy?

Panne: That's not it. Something greater. I suspect this is...bliss.

Libra: Well, I'm blissful to hear it! And relieved...

Libra: Greed, I fear. I succumbed to my baser inclinations. When presented with your brilliant light, I knew I had to have it all to myself.

Panne: That's quite the desire, to have driven a man of the cloth to fall from grace. Perhaps I should be the one thanking your gods and your exalt.

Libra: Mostly I feel like thanking you, Panne.

Olivia

OLIVIA X PANNE C

Olivia: Um, hey, Panne...?

Panne: What do you want, man-spawn?

Olivia: Oh, er, sorry! I didn't mean... N-never mind! Bye!

Panne: Wait.

Panne: You must have wanted something, or you wouldn't have approached me.

Olivia: Erm...

Olivia: Well! Out with it! What is your complaint?

Olivia: C-complaint?! Oh gosh, no! I don't have a complaint!

Panne: Then state your business. Quickly.

Olivia: I...er...was...just wondering... That is to say... Well, it's a bit silly, but... What do you think of me?

Panne: I do not think of you.

Olivia: Oh! R-right. Yeah, I suppose that was kind of a strange question. It's just that I feel so useless most of the time, so...

Panne: You are not.

Olivia: You really think so? Because—

Panne: You do not trust me? You think I am lying?

Olivia: Oh gosh, no!

Panne: I find your search for reassurance puzzling. If you are here, then clearly you are needed. If you were useless, Chrom would have left you by the side of the road somewhere.

Olivia: I...guess?

Panne: Are you perhaps laying the groundwork for a future failure?

Olivia: What? No! I would never do anything like that...

Panne: ...Wouldn't you?

OLIVIA X PANNE B

Panne: I'd like to thank you, man-spa— Er, Olivia. Your dancing was of great assistance.

Olivia: Oh, truly? I'm so glad I could be of assistance!

Panne: I hope you will continue to do so in the future.

Olivia: Well, I'll try, but I'm just so use!— Argh, I almost did it again!

Panne: Did what again?

Olivia: Make excuses for myself in case I mess up...

Panne: Ah. You're referring to my accusation from the last time we spoke. Pay it no mind. It was unfounded.

Olivia: No, wait. See, the thing is, you were right. I do try to make excuses for myself. I wish I knew how to be strong and confident like you... Um, can you tell me your secret? Can you make me more like you?

Panne: Is this what you wanted to ask the last time you approached me?

Olivia: Yes, actually.

Panne: You make a difficult request. I know not from whence my strength springs. I am a taguel and you are not. It may be that I cannot teach you anything.

Olivia: Maybe so, but I still want to try!

Panne: Very well. Give me some time to think upon the problem.

OLIVIA X PANNE A

Olivia: Olivia. Do you remember our talk about learning how to be strong?

Panne: Of course! Actually, I've been wondering when we could start my lessons.

Panne: I have thought deeply on the problem, and I may have an answer. But it is the answer of a taguel. It may not suit you.

Olivia: I'm willing to try anything!

Panne: I began by thinking about what sets humans and taguel apart. The difference is that humans are fundamentally irrational creatures.

Olivia: Irrational?

Panne: Yes. You humans always attempt the impossible while ignoring the possible. This is, as I said, irrational. It is not, however, a failing. Chrom, for example, chases an impossible task, and yet it is a noble cause. I think this is one of the greatest strengths of your species.

Olivia: Um, wait. So I should be...more irrational?

Panne: Yes.

Olivia: O...kay?

Panne: It's actually quite rational. For you to be irrational, I mean.

Olivia: Okay, stop it.

Panne: Listen, Olivia. Can you tell me what is possible or impossible? I speak here of the future.

Olivia: Er, well...

Panne: You see? You do not know. None of us, human or taguel, know this. But you decide that nothing is possible and give up trying to achieve anything.

Olivia: Hmm...

Panne: This is your first assignment: you must learn your own limits. You need to discover what it is you're capable of.

Olivia: Okay, got it. Learn my limits... Discover my capabilities...

Panne: The only way to know your limits is to push yourself to them. At least, that is what a taguel would do. It won't be easy, but if you apply yourself...

Olivia: Oh, I will! I'm going to apply myself like treacle on bread! Just you wait! Thanks so much for the advice, Panne. Maybe we could talk again sometime?

Panne: I would be glad to. We're in this together, now.

Olivia: Yay! Just knowing you're a part of this makes me feel like I can do anything!

Henry

HENRY X PANNE C

Panne: Nnh? Wha—? Who is...? G-get off me, man-spawn! Wake up!

Henry: Mmm? Oh, hey! Mornin'!

Panne: Do not "morning" me, Plegian curse slinger. Get away at once!

Henry: Hey, I've got a name, you know. It's Henry.

Panne: I have no use for the name of a filthy Grimleal craven.

Henry: That's not very neighborly, now is it? What difference does one's religion make? I just want to be friends!

Panne: I will have no dealings with your ilk! Your lot killed the exalt in cold blood. You stole Emmeryn from her people.

Henry: Hey, I haven't killed a single exalt! And besides, I tried to save her. I was the one who told you the exalt was going to be killed, remember?

Panne: I remember. You made quite a spectacle of yourself in the process.

Henry: Yeah, well, I knew I had to do something!

Panne: What reason would you have to spare the exalt's life?

Henry: Ylisse is weak enough as it is. If the exalt were assassinated, I worried they'd lose the war in a week! That would have been a terrible waste of a perfectly fun war.

Panne: THAT was your reason?!

Henry: Not that it made much difference in the end. Whoops! Nya ha ha.

Panne: Bah! You are strange and unpleasant. Do not speak to me again.

■ HENRY X PANNE B

Henry: Hey, Panne!

Panne: Keep your distance, Plegian viper.

Henry: Aww, did you forget my name again? It's Henry! Hey, so are you bad with names because you're a half-beast?

Panne: Are you eager for me to kill you, boy?

Henry: Aw, that's sweet of you to offer, but no thanks! And I meant it as a compliment!

Panne: What part of "half-beast" is a compliment?!

Henry: Er, the beast half, I guess. I love animals! I wish I could be one. Even a half one would be okay with me.

Panne: For what possible reason?

Henry: My parents abandoned me in the woods when I was little. So it was mostly the nice animals there who raised me. I still love their smell. It relaxes me in a totally nostalgic sort of way.

Panne: I suppose that explains the odd feral air about you. ...As much it pains me to say so, I find your scent acceptable.

Henry: Nya ha! Yay!

Panne: But understand this—I have no intention of forgiving what your Grimleal have done.

Henry: So if I went out and killed them all, could we be friends?

Panne: Are you mad? Have you no sense of fealty to your warren?

Henry: Eh, not really. I'd kill pretty much whoever you want me to, Panne.

Panne: You are a child tearing wings from flies, and nothing more. You have no idea what the taguel have gone through. What horrors Plegia has wrought. ...Still, perhaps you are simply too young or stupid to know better.

Henry: I'm not that young, and I don't think I'm stupid. But hey, who knows, right? Still, I'd like to know more about you, Panne! Can I stick with you?

Panne: Only if you can keep up.

■ HENRY X PANNE A

Panne: When I said you could follow me, I didn't mean indefinitely. Just how long do you intend to keep this up?

Henry: I was thinking indefinitely, actually. Why, you do not want me around?

Panne: Of course not. I hate humans. I've always hated humans.

Henry: Oh, riiight. That. Hey, tell ya what. In that case, howzabout I curse Chrom to death?

Panne: Are you mad?

Henry: Everyone would panic, and the war would escalate more and more. Humans all over would suffer like never before, and blammo! Panne's happy!

Panne: I do not wish for any of that! It would dishonor the memory of Emmeryn. No future can be built upon hate, and random human suffering buys me no joy.

Henry: Geez, Panne. What WILL convince you to let me stick around? You remind me of the fuzzy animals that raised me, and they all died, and now I... Come on, Panne. Please don't abandon me like my parents did. I'll do anything you want. A-n-y-t-h-i-n-g! Enemies? Gone! Rivals? Kaput!

Panne: I don't doubt that. The lives of others mean nothing to you. You have so much to learn, Henry. And if I am the only one capable of teaching it, then so be it. I won't abandon you.

Henry: Woo-hoo!

■ HENRY X PANNE S

Panne: Lesson one: everyone in this camp is an ally to be cherished.

Henry: Could you be a bit more specific?

Panne: Hmm... Treat them the same as you would the animals that raised you.

Henry: But you hate humans.

Panne: I've come to learn some humans aren't so bad. For example, I don't hate anyone here.

Henry: All right. If you say so, I'll play nice.

Panne: Good. Coexist with humans long enough, and I'm sure you'll find your humanity. ...Heh. To think the day would come when I'd encourage someone to be MORE human.

Henry: Hey, Panne! Will you take this?

Panne: Hmm? What is it?

Henry: It's a wedding ring! It's a promise that you'll always stay with someone. I don't ever want to be alone again, but I need a promise. So, um, please? Please be my family!

Panne: ...I think I finally understand why I was never able to really get mad at you.

Henry: Oh?

Panne: We're too alike, you and I. We both lost our families and lived alone too long. But no more. I accept your ring. From now on, we are each other's family.

Henry: Great! It's a promise! Thanks, Panne!

Donnel

■ DONNEL X PANNE C

Panne: Hngh! ...Hmm? A hunter's trap?

Donnel: Er, that's—

Panne: Is this your doing?

Donnel: Gosh, I'm sorry, Panne! I never dreamed I'd snare me a person! I've been doing this for years, but yer the first human bein' I ever caught.

Panne: I am no human. I am a taguel!

Donnel: S-sorry!

Panne: Caught in a trap. How embarrassing... Hmm... Still, it is remarkably well made.

Donnel: I grew up in the mountains, and our little pig farm couldn't feed us all. If we wanted to eat, we had to hunt.

Panne: So your survival skills bested mine. That is your claim?

Donnel: I-in real sorry! I didn't mean no offense. I didn't mean none'a this... I'll stop trappin' if ya promise not to eat me!

Panne: You needn't stop, man-spawn. The problem is easily solved. I need only to keep a sharper lookout for your human traps.

Donnel: Y-yer sure ya don't mind, then?

Panne: I welcome the challenge.

■ DONNEL X PANNE B

Panne:

Donnel: Hey there, Panne. Whatcha doin' way out here? You be careful now. I got traps set up all 'round these parts.

Panne:

Donnel: Oh. Looks like ya...already found that out...

Panne: What was your first clue?

Donnel: Oh, gosh, I'm so sorry! I'll have ya outta there in two shakes! There, all free. ...Oh, pig slop! Yer ankle's all swollen up! Gah, I feel just awful... Ya need any help?

Panne: My wound is inconsequential. I care more about this trap... After the last time, I was extremely careful. Yet here I am, snared like a common beast. Why am I the only one to fall for this? I cannot accept this.

Donnel: Well, every animal's got its own unique way of goin' about its business. Some of it's instinct, some's reflex. So if ya use that knowledge to design a trap...

Panne: This is the result.

Donnel: Yup. Take this one here. There's a dozen other traps you passed before it. Bet you noticed all'a them, right? Well, yer s'posed to. They're decoys. I set them boys up to guide the animal into this here real trap.

Panne: So I was led here by instinct? That is your claim?

Donnel: A'yup. Somethin' like that.

Panne: I never thought to find an apex predator among the humans of the camp. You've left my pride in tatters, man-spawn.

Donnel: Gosh, I'm real sorry 'bout that.

Panne: Your apology serves no purpose. Only a duel can restore my honor. Set another trap, human. This time I will see through it.

Donnel: Are ya sure 'bout that? I don't know if I—

Panne: If you decline, I will challenge you to hand-to-hand combat! And if I sense you have not set the trap with all your skill, I will challenge you again. If you wish to go unscathed, you had best set your trap very carefully indeed.

Donnel: I wanna go home...

■ DONNEL X PANNE A

Panne: Gyah! How is this possible?!

Donnel: S-sorry, Panne!

Panne: How did I walk into ANOTHER trap? And a pitfall, no less! Is there any greater cliche?

Donnel: Well, this time I was designin' the trap to catch YOU! ...On purpose, I mean. I been watchin' ya pretty close, so that determined the trap I set.

Panne: I'm well aware you were watching me. That is why I intentionally took unnatural and misleading actions.

Donnel: None of that really matters, though. Instincts're what I'm after. If ya know what a critter does when they ain't thinkin', they're good as caught.

Panne: You claim to know my actions better than I do?

Donnel: Er, I guess so. ...Sorry 'bout that.

Panne: Now that ain't hardly fair to say! I just know more about trappin' is all. I can think of a dozen things yer better at than me, easy!

Panne: Is that your idea of pity?

Donnel: Ain't no one needs to pity you, Panne. Just speakin' the plain truth.

Panne: ...I allowed myself to blind me. This was a valuable lesson, Donny. You have my thanks. I'm certain this war will provide ample opportunity to see who is more shrewd. Our rivalry will ensure we never grow bored.

Donnel: Gosh, I'm honored ya see me that way.

Panne: Just don't expect things to continue to be so one-sided. I will win the next round!

Donnel: Well, I ain't goin' easy on ya! You'll have to earn it!

Panne: I would have it no other way.

■ DONNEL X PANNE S

Panne: Explain yourself.

Donnel: Explain what?

Panne: Explain why I'm standing at the bottom of a pitfall trap!

Donnel: Well, 'cause I set it and you fell in.

Panne: Yes, but why did you set it? Our next challenge isn't till next week! And was there a necessity to make it deeper than I am?

Donnel: Hey, I'm lowerin' you a rope, ain't I?

Panne: ...Next question. What is this tied to the end of the rope?

Donnel: It's a ring. Carved it m'self, out of wood. ...I thought ya might like that.

Panne: And WHY is there a ring tied to the end of this rope?

Donnel: 'Cause I want ya to marry me!

Panne: And you thought to ask me while I was in a pit?!

Donnel: I reckoned this was the only way I could get ya to sit still and lemme ask!

Panne: ...Most women would not respond well to being dropped into a hole.

Donnel: I'm real sorry 'bout that, but we both know ya ain't "most women." Now maybe it won't

the smartest thing to do, but I had to tell ya. Yer the first person I met where I saw to their core and still found 'em beautiful. 'Cept for my ma, of course. But she don't count.

Panne: My heart burns for revenge against the humans who slaughtered my kin. There is no beauty in such anger.

Donnel: Your anger ain't the real heart of you, Panne. Not by a country mile! 'Sides, it's them rotten humans' own dang fault ya hate 'em! I want 'em to face justice just as much as you do.

Panne: You...do?

Donnel: Cross my heart and hope to spit! ...But honestly, I don't expect ya to say yes to me. I truly don't. I just wanted a chance to say my piece.

Panne: It is an...interesting offer. We can continue discussing it once I'm out of this pit.

Donnel: Yeah, all rig—Ah! Waaaugh!

Panne: Some hunter you are! You've fallen into your own trap!

Donnel: You yanked on the rope harder'n I was expectin'!

Panne: *Sigh* ...Pick that up.

Donnel: Huh?

Panne: The ring. As long as you're here, you might as well put it on me.

Donnel: Wha—?

Panne: Do you wish to be my mate or not?

Donnel: Yer darn shootin' I do! ...Aw, look at that. Perfect fit.

Panne: I suppose finger size was something you took note of while you were watching me?

Donnel: Maybe I just got lucky. But, uh, if ya don't mind me askin', why'd ya say yes?

Panne: Do I need a reason?

Donnel: You don't need a darn thing, Panne! I'd be happy to be here with ya forever!

Panne: If we stay here just the two of us, we will starve to death.

Donnel: Long as it's with you, I don't know as I'd really mind.

Panne: You are sweet. ...Which may come in handy in a week or two.

 Morgan (female) (Mother/daughter)

The Morgan (female) mother/daughter dialogue can be found on page 312.

 Yarne (Mother/son)

■ YARNE X PANNE (MOTHER/SON) C

Panne: Yarne.

Yarne: Gyah! I... Wh-what do you want?!

Panne: Are you trying to avoid me?

Yarne: Wh-what? Me? Avoid YOU? Gosh, no! It's just I... I...just had an urgent errand I was going to attend to.

Panne: What kind of errand? Collecting provisions? Perhaps I could accompany you.

Yarne: Um, yeah, I don't know... It's just...

Panne: Is there a problem?

Yarne: No...not exactly.

Panne: Pah. Enough of this prevarication. We are kin, yes?

Yarne: Of course. But—

Panne: But what?

Yarne: The mother in my future died when I was still young. Before I could remember. I don't know what it's like to...have a mother. Especially a taguel mother.

Panne: Neither do I. I have no idea how taguel mothers and children interact with each other. My friends and kin were taken from me by humans when I was still an infant.

Yarne: So...you have no idea how you're supposed to act either?

Panne: I do not, but does it matter? We can forge a new tradition of what it means to be a taguel mother and son.

Yarne: Hey, that's a great idea! We'll learn how to be a family together...

■ YARNE X PANNE (MOTHER/SON) B

Panne: Sleep tonight and good night. ♪ You are thy mother's delight. ♪

Yarne: Erm, Mother? I know you're just trying to imitate human mothers, but...I don't think it's working.

Panne: Well, that's a relief. I was feeling very foolish. I thought perhaps human customs might be similar enough to work for taguel. But it seems perhaps I was mistaken...

Yarne: (...Which is why I was saying we should find our own way...)

Panne: Did you say something?

Yarne: N-no! Nothing at all. Er, you don't have to glare at me like that. It's not my fault the lullaby didn't work.

Panne: Was I glaring? I didn't mean to. I must try to remember that you're more timid than a taguel.

Yarne: I'm not timid! ...Well, perhaps I am. Just a little bit. But who wouldn't be in my situation? I'm one of the last surviving taguel! If I die, it could mean the end of our race!

Panne: So it's not battle that you fear, but rather the role you've taken on.

Yarne: Yes. I'm proud of my ancestry—of the taguel blood you passed on to me. I don't want to be known as the fool who allowed his race to die.

Panne:

Yarne: But after meeting you here in this world, I want to do more than just survive... There's something else about being taguel. Something I feel in every hair of my being... It's something I can't quite put into words, but maybe when I can, it will help guide us. Until then, I think we should stop trying to imitate humans. Let's try things our own way and do what comes natural. What feels right. It may take a while, but I think we'll find the answers we want eventually.

Panne: Well said. ...Very well, then. We shall try it your way.

turkey leg I see sticking out of your pocket?! Heavens, Gaius! Don't you care about your appearance at all?

Gaius: Well, as long as it's not slowing me down on the battlefield, right? I'm not some fancywaist who needs to strut about like a peacock.

Cordelia: Well, perhaps you should consider it regardless.

Gaius: All right, all right. Message received. I'll put on some new clothes, mother.

Cordelia: Don't forget to comb your hair. And wash those old clothes in vinegar, or you'll never get the smell out.

Gaius: ...I'm going now.

Cordelia: Once washed, if you want to reduce the wrinkles, take a willow reed and...

Gaius: Hey! Don't walk away when I'm talking about laundry!

■ CORDELIA X GAIUS B

Cordelia: Gaius! Isn't that the same outfit you were wearing yesterday?

Gaius: Yeah, but it was CLEAN yesterday. One extra day won't kill me, right?

Cordelia: And have you combed your hair?

Gaius: Er, no. But I DID dunk my head in a watering trough a couple of nights ago. Why do you care so much, anyway?

Cordelia: Because.

Gaius: Er, because why?

Cordelia: By the way, don't think you can run off again in the middle of our conversation. I have my pegasus saddled and waiting, and we WILL hunt you down.

Gaius: Crivens. Are all of your chats this happy and carefree, or am I a special case?

Cordelia: No, just you. Now come over here and let me trim that hair.

Gaius: I suppose I'm not getting out of this, am I? All right, do your worst. But you still haven't explained why you're so obsessed with my grooming.

Cordelia: Because you are one of Chrom's staunchest and most valuable allies. *Snip* Turn your head a little, please... Thaaaank you.

Gaius: Staunch ally, eh? I like the sound of that. All right. Message received. I'll dress like a dandy so as not to make Chrom look bad. Oh, and I like the sides short, if you'd be so kind.

Cordelia: *Snip* Already on it. Oh, and before I forget, use this soap when you launder your clothes. You have stains dating back to the dark ages, but this should get them out.

Gaius: I'll wash them so bright, it'll hurt your eyes to look at me...

Cordelia: We'll see.

Gaius: Hey, now. How about showing a bit of trust for your staunch ally?

Cordelia: Trust is earned, my dear Gaius. Especially when it comes to laundry.

■ CORDELIA X GAIUS A

Cordelia: Oh, Gaius... What a sight you are!

Gaius: Huh? Aw, now what?! I combed my hair as soon as I got up, and these clothes are fresh out of the stream!

Cordelia: You look very presentable.

Gaius: So if my hair is fixed, and my clothes are clean, what's the problem? You must be here, Cordelia.

Cordelia: Oh, no, you misunderstand me. What I mean is, you look so smart and serious. You look like a grown man.

Gaius: Oh. Uh...yeah. Guess I'll take that as a compliment. Although, I actually do appreciate the help, even if I didn't at first.

Cordelia: Really? You're actually grateful?

Gaius: Yeah, and to prove it, I bought you this ribbon down at the market. You know. For those days you don't have time for a proper hair wash.

Cordelia: Oh, er, thank you. I suppose I have been neglecting my own appearance somewhat.

Gaius: It's because you're too busy worrying about how everyone else is doing! But don't worry. Now that I'm cock of the walk, I can help out once in a while.

Cordelia: Er, yes. I suppose—

Gaius: It'd be a shame for a beautiful woman like yourself to look less than her best.

Cordelia: I see all that cleaning didn't scrub the silver from your tongue...

■ CORDELIA X GAIUS S

Gaius: Er, Cordelia? Do you have a moment?

Cordelia: Yes. What can I do for you?

Gaius: ...Hey, you're wearing my ribbon!

Cordelia: Hee hee. You noticed?

Gaius: Sure. Although you always look beautiful to me, with or without it.

Cordelia: You can be very charming when you put your mind to it, Gaius.

Gaius: Only to you, Cordelia. Anyway, I was wondering if you have time to give me a trim.

Cordelia: Again? But I just gave you one the other day.

Gaius: Sure, but don't you think it's getting a bit shaggy? Look here, over my ears...

Cordelia: Well, I suppose there are a few stray strands here and there...

Gaius: Hmm...

Cordelia: Um, why are you clutching my hand?

Gaius: Just checking the size for this...riiight...here.

Cordelia: Oh, what a lovely ring! Did you make it yourself?

Gaius: Yeah, but I wasn't sure about your size. Glad to see it fits. See, because now that I'm all cleaned up, I thought you might want to...be with me?

Cordelia: Is this a proposal, Gaius?

Gaius: Look, I'm no Chrom, and I won't pretend to be and convince you otherwise. But I couldn't live with myself if I didn't at least try to win you over. So what do you say, Cordelia? Will you marry me?

Cordelia: How very sly of you to slip the ring on before I had a chance to argue. But it IS very beautiful... I would hate to take it off again.

Gaius: I'll take a yes out of laziness. I'm not picky.

 Gaius

 Avatar (male)

The dialogue between Avatar (male) and Gaius can be found on page 221.

 Avatar (female)

The dialogue between Avatar (female) and Gaius can be found on page 232.

 Chrom

The dialogue between Chrom and Gaius can be found on page 241.

 Lissa

The dialogue between Lissa and Gaius can be found on page 244.

 Sully

The dialogue between Sully and Gaius can be found on page 252.

 Miriel

The dialogue between Miriel and Gaius can be found on page 259.

 Sumia

The dialogue between Sumia and Gaius can be found on page 263.

 Maribelle

The dialogue between Maribelle and Gaius can be found on page 268.

 Panne

The dialogue between Panne and Gaius can be found on page 269.

 Cordelia

■ CORDELIA X GAIUS C

Cordelia: Ah, Gaius. Weren't you wearing those exact same clothes yesterday?

Gaius: That a problem?

Cordelia: And unless I'm very much mistaken, you also wore them the day before that.

Gaius: Yeah, well, this is my favorite outfit. Why are you so interested in my attire? You fancy me or something?

Cordelia: I'm simply trying to offer a piece of friendly advice here. Perhaps you don't realize that your body can smell like the floor of a tavern. That shirt is covered in honey, and the less said of your pantaloons the better.

Gaius: Oh. Actually, uh, I hadn't noticed.

Cordelia: Not to mention your hair needs a trim and you have crumbs stuck to your face. ...And is that a

Cordelia: Then yes, Gaius. I would be thrilled to be your wife.

Gaius: Sweet! This'll save me a load in barber's fees. Ha ha. Kidding! ...Just kidding, dear. You won't regret this, Cordelia.

Nowi

■ NOWI X GAIUS C

Nowi: Hey, Gaius! Who did you vote for?

Gaius: Huh? Vote? I don't know what—

Nowi: Don't play dumb with me! I saw all you men standing around earlier! You were voting on who's the best-looking girl in the Shepherds, right?

Gaius: Oh, that. Yes, there may have been a bit of ranking going on. I'm not interested in that nonsense.

Nowi: Yeah, but you still haven't told me who you voted for!

Gaius: Yes, I did. I told you that I left. I didn't vote for anyone. While those fools were haggling, I went to the mess hall and stole their desserts. THAT'S what I call interesting.

Nowi: Okay, okay. You're not into that sort of thing. Good for you. But still, you must have a favorite type, right? I mean, every guy does! So, like, do you prefer older women? Blondes? Tall? Short? Chubby?

Gaius: Egads, but you're a persistent little creature. All right. I prefer older women. Satisfied? Now will you please stop talking so I can eat Chrom's dessert?

Nowi: Oh, what a coincidence! I'm older, so I must be your type!

Gaius: Huh? But... Oh, yeah. You're older than me. I always forget that. But most older women have a certain gravitas that you...lack.

Nowi: Hey, I'm over 1,000 years old! We don't come much older than that, you know.

Gaius: I'm not debating your actual age, kid. I'm just saying that... Well, the appeal of a mature woman is in her confidence and poise.

Nowi: Poise?

Gaius: You know, how you carry yourself. A poised woman has class and bearing, but still knows exactly what she wants.

Nowi: That? Oh, I've got poise, mister! Thousands of years' worth of it! I can't BELIEVE you don't think I have poise! I am SO mad at you right now! Ugh! The nerve, I swear...

Gaius: Right. Let me explain this again...

■ NOWI X GAIUS B

Nowi: Oh, Gaius! Yoo-hoo!

Gaius: Hey there, kid. How's the dragon business treating— *Sniff* *sniiiff* Oh, sweet flaming onions... What's that horrific stink?

Nowi: I put some perfume on! I think it gives me more poise.

Gaius: How much did you use? My eyes are burning up...

Nowi: Well, the whole bottle, of course. What did you expect?

Gaius: Er... If I say you have lots and lots of poise now, will you go wash that off? *cough*

Nowi: Really?! So I'm your type now? Being older and poised and everything?

Gaius: Um...sure. Absolutely and without hesitation. *hack, hack* *cough*

Nowi: Hee hee. Sounds like someone is in looooove with me.

Gaius: Not likely.

Nowi: Rude! ...Also, why not?

Gaius: Look, I don't actually care about older women, all right? I just made that up on the spot so you'd leave me alone.

Nowi: ...Oh. Fine then. No, that's fine. Let's start over, then. And this time, give me a serious answer. If I match the answer, it means you're totally in love with me and I win!

Gaius: Oh, for the love of... Fine. I like women who are broad minded and tolerant of others. Which you aren't. So you lose.

Nowi: ...Broad-minded and taller than others? What's height got to do with it?

Gaius: No, that's not what... Gods, this is like discussing literature with a horse. Tolerant, Nowi. Tolerant. T-O-L-E-R-A-N-T. Someone who's kind, warm, and willing to embrace different cultures and ideas.

Nowi: Oh, I get it. Hey, if I turn into a dragon, I can embrace you AND keep you warm!

Gaius: Um...please don't? I like my bones to be solid and nonliquefied.

Nowi: Gods, you are SUCH a hard man to please... Just tell me what I can do, okay? And use normal-person words!

Gaius: Ugh. I'm no good with kids. Even kids that are a thousand years old...

Nowi: Come on, Gaius! I'm waaaiitiiiing.

■ NOWI X GAIUS A

Nowi: So, Gaius. Besides being seven feet tall, what else do you look for in a woman? Come on, don't be shy. You can tell me! We're besties now, right?

Gaius: Listen, kid, how much longer are you going to follow me around? Wait a second. I have an idea. Heh heh heh... Hey, Nowi. What would you say to a deliciously sweet candied fig?

Nowi: Oooh, I LOVE sweets! Gimme!

Gaius: All right. I'll give you this one if you go stand waaaaay over there.

Nowi: Okay!

Gaius: Great. So here's the fig... Now you go do what you promised. Go on, off with you.

Nowi: Bye!

Gaius: Finally... Peace and quiet at last. I'll just settle down here and—

Nowi: Hey, Gaius!

Gaius: Gya! What are you doing here, kid? You promised to stay away! ...Um, what's this for?

Nowi: It's a flower! I picked it for you. You know? To say thanks! Hope you like it, Gaius! See you around!

Gaius: Huh. Here I was about to chase her away with the flat of my sword... And all she wanted was to

thank me and then run off again. I'm going to need more figs.

■ NOWI X GAIUS S

Nowi: Thanks for the candied fig, Gaius. It was deeeeeee-lish!

Gaius: I'm glad you liked it.

Nowi: Me too!

Gaius: Hey, did you ever find out who was voted most beautiful woman?

Nowi: Oh, that? Meh, I don't care.

Gaius: Huh? B-but you followed me around for weeks trying to find out! What about all those absurd questions you peppered me with?

Nowi: Well, that's because I wanted to know what YOU liked in a woman.

Gaius: Why do you care so much, anyway?

Nowi: Well, you know. Because...I like you. And I want you to like me, too!

Gaius: You...like me?

Nowi: Yeah! I mean, you pretend to be all grumpy all the time, but you're actually very nice. I mean, look at all the candied figs you made for me! You're always doing stuff like that. Slaving away on behalf of others.

Gaius: Er...

Nowi: I know I don't have a lot of poise, and I'm actually kind of short... But I know if I try really hard, I'll eventually become the kind of woman you like. So that's what I'm gonna do. Even if it takes a hundred years!

Gaius: Cripes. I'll be pushing up daisies by that point!

Nowi: Oh, no—you're right. I hadn't thought about that... *Sniff* Then...I guess...I'll never be good enough...for you... I'll b-be alone and...and... *sniff* Waaaaaaaaah!

Gaius: Hey, come on, stop the blubbering. Oh gods, please stop... Listen, Nowi. I know how you feel. And the thing is...I think I like you, too. I can't believe it, but it's true.

Nowi: B-b-but...what about the poise stuff? And being tolerant? And mature?

Gaius: Sometimes things that seem important actually aren't. You know?

Nowi: Really? So does this mean...um... You want to get married?

Gaius: You know what? Sure. Why not? Let's get hitched and see what happens.

Nowi: Yay! Till death do us part! ...Well, until you die, anyway.

Libra

■ LIBRA X GAIUS C

Gaius: Hmm? What's this fancy little doll doing here?

Libra: Excuse me, sir. I believe that is mine. I must have dropped it earlier.

Gaius: Righto, then. Here you go! So what is that little doodad, anyway? A graven image of one of your gods?

Libra: Oh, no. It's just a toy doll, really. The children at the orphanage have been asking me for toys. They wanted something they could hold at night—to help them sleep, you see.

Gaius: You sewed a doll for a pack of whelps you barely know? I think there's a special place for you in heaven, Padre!

Libra: Oh, it's not so bad. It only takes me a few hours to construct each one. And to be frank, such honest labor scarcely feels like work at all.

Gaius: Some days, you just getting out of bed is labor enough for me... Say, though. You ever considered giving the little moppets sweets as well?

Libra: Sweets?

Gaius: You know, sugary stuff. Pastries and whatnot? Kids love 'em.

Libra: Oh, I see. No, I had no such plans. The thought never occurred to me. But perhaps it is something to keep in mind for the next visit. Thank you, Gaius. I'm glad this chat wasn't a complete waste of time.

Gaius: Er... Me, too? Although... Hmm.

Libra: Yes? Something on your mind?

Gaius: Well, I'm just thinking... I mean, let's say you make enough sweets for an entire orphanage. That's going to be a LOT of sweets, right? Massive piles of 'em. So maybe you might put aside a couple for, say, the man who gave you the idea? I mean, it's only fair, right?

Libra: ...You're asking me to steal sweets from orphans?

■ LIBRA X GAIUS B

Libra: O gods, hear my plea and partake—

Gaius: Hey there, Padre. Having a little chat with the management, are we?

Libra: I was praying, if that's what you mean. Perhaps you would care to join me? A good soul cleansing can do wonders for one's mood.

Gaius: I've never been much for talking to the blokes upstairs, you know? Still, what can it hurt just this once? So, um, how's this work? I can ask for anything I want, or what?

Libra: Well, it is true that many people pray to receive things for themselves. But originally, prayers were not used to beseech the gods for favors. Rather, they were used to give thanks for blessings already received.

Gaius: Blessings, eh? So I could say thanks for candied figs and honey cakes? Oh, and fruit pies, too?

Libra: Er, yes. I suppose so. If they are something you feel profoundly grateful for.

Gaius: Profoundly doesn't begin to cover it. ...So, er, do I kneel or what? Is there a bench involved somehow?

Libra: It is customary to bend the knee in supplication, yes. Now then...

Gaius:

Libra:

Gaius: O ye gods, thanks a billion for all thine abundantly sweet and tasty goodness.

Libra: Dear gods, thank you for watching over us, and protecting our friends and comrades.

Gaius: What? Thou art jealous, O mighty gods? Jealous and angry, you say? Then send thou's terrible fruit pies to me, that I might use them to smite thine foes!

Libra: ...?

Gaius: I also love jellied pears, O vengeful ones! And those biscuits with goo in the middle!

Libra: Gaius, your demands for sweets hover ever closer to blasphemy...

Gaius: O furious and insane gods! Send me ten—nay, TWENTY of your finest cakes!

Libra: He's not listening to a word I say. Gaius? GAI-US!

Gaius: ...Huh? Hey there, Padre. What's with the shouting?

Libra: I was shouting because you were completely ignoring me! That wasn't a prayer—it was a market list! The gods are not scullery maids who deliver treacle tarts on demand!

Gaius: Oh. Right, yeah...sure. Sorry. Get carried away. I'll start over, then. *Ahem* O most horrifying and fattened gods, thou art most tricksy in thine ways...

Gaius: D-dear gods, please send not lightning to strike down this heretic... He knows not what he does!

Gaius: I will deliver unto thee my first-born son, if only you make donuts rain down upon—

Libra: GAAAIUS!

Gaius: ...Whoops. Sorry.

■ LIBRA X GAIUS A

Libra: O gods, I thank you for this most blessed of days.

Gaius:

Libra: You're desperately trying not to think of sweets, aren't you?

Gaius: ...Maybe.

Libra: Your trembling lip, your sweaty brow, your uncontrollable drooling... These are all the signs of a man fighting great temptation.

Gaius: Not so, Padre. Ha ha! Who's religious now? I was just praying that I'd be unharmed in the next battle.

Libra: Oh? That's actually quite sensible. Perhaps I was being unfair. I thought for sure you were dreaming about swimming in syrup or some nonsense. But why now, if I may? You usually have such a cavalier attitude toward battle.

Gaius: Well, in that last battle we fought, I had me a pretty close shave. If I'd been a split-second slower, my head would have been bouncing across the field. It made me think. You never know when your number's going to be up, you know? And it got me thinking maybe I should take these prayers a bit more seriously.

Libra: Coming face-to-face with one's own mortality can have that effect.

Gaius: But why should the gods pay an old sinner like me any mind? It's not like I've ever done anything to earn their appreciation.

Libra: In the eyes of the gods, we are all innocent, if only we open our hearts to them.

Gaius: Yeah, that's easy for you to say, Padre. I bet you've never once strayed from the straight and narrow.

Libra: Oh, if it were only so... I am as much a sinner as anyone.

Gaius: You? Lord Squeaky Clean? I find that hard to believe.

Libra: Think about how many people have died because of me.

Gaius: Huh?

Libra: Every time I survive a battle, it means others have died in my place. And when I pray for safety in a fight, it is the same as praying for my foe's death.

Gaius: Wow. Never thought of that. ...Wait, so I've been praying for other people to die, too?! Crivens! I'm a terrible person!

Libra: Not terrible. Just human. Every soldier who prays for deliverance has done the same.

Gaius: This religion stuff is complicated.

Libra: Yet, we should still pray. We shall pray for ourselves, and each other, and for our allies and comrades. Even though in doing so, we are praying for the death of strangers.

Gaius: O gods...

Tharja

■ THARJA X GAIUS C

Tharja: You.

Gaius: Me?

Tharja: Yes, you. You're a thief, right? Skilled at pilfering and all that? I've got a little job for you.

Gaius: I'm listening...

Tharja: I want you to bring me a strand of [Robin]'s hair.

Gaius: That's...unbelievably creepy. What do you need (his/her) hair for?

Tharja: Hee hee...

Gaius: Um, yeah. I don't usually take sinister chuckles as an answer. Sorry, kid. Go find someone else to help with your weird hobbies.

Tharja: This is not a negotiable request.

Gaius: Oh? And what are you going to do about it, Sunshine? Curse me?

Tharja: Heh.

Gaius: Heh. Ain't a hexer alive that's managed to put a curse on Gaius the Nimble! Go on, Sunshine. Do your worst.

Tharja: You are making a terrible mistake...

Gaius: Ooh! So scaaary! Do you see me shaking here?

■ THARJA X GAIUS B

Gaius: Hey there, Sunshine.

Tharja:

Gaius: Look, I know I'm unbelievably sexy, but you don't have to stare so hard.

Tharja: Don't you feel...different?

Gaius: What do you mean?

Tharja: I cursed you. Some time ago, in fact.

Gaius: Nope! I'm right as rain.

Tharja: Impossible. My frog eyes were fresh... My newt tail was still twitching... Ah, wait. Maybe that's it.

Gaius: You figure something out there?

Tharja: I must have added the wrong herbs to my cauldron. Instead of cursing you, I've just enhanced your stamina and lifted your mood... Damn and blast!

Gaius: Yep. That's a real bummer right there. But now that you mention it, I have been feeling pretty frisky today. It's like all my cares have melted away! So the good news is, your little spell actually works.

Tharja: That's very encouraging. Now, let's see... If I simply recast the spell like so... And replace the lambswort with a pinch of wyvern saliva...

Gaius: *Yawn* You are still trying to curse me?

Tharja: Hee hee... Thanks to you, I'm one step closer to perfecting the ultimate curse.

Gaius: Right. Well, Sunshine, you just let me know when you get that— Huh. She's gone. That's a bit disconcerting... Anyway, let's see if Lissa has any more of those little cakes!

■ THARJA X GAIUS A

Tharja:

Gaius: Hey there, Sunshine. Curse anyone lately?

Tharja: Look at me carefully. Do you feel...different?

Gaius: You mean aside from the pale woman staring into my eyes like a lunatic? Nope. All aces over here.

Tharja: Blast and damnation!

Gaius: Maybe you should consider a new line of work there, Sunshine. What was this curse supposed to do, anyway? Turn me into a toad?

Tharja: It was meant to help you see my good side.

Gaius: Wait, what? Are you trying to make me fall for you?

Tharja: It's just an experiment, fool! I have to test it somehow.

Gaius: Guinea pig, eh? I gotta say, I'm a little surprised.

Tharja: About what?

Gaius: I didn't realize you fancied me! I mean, I know I'm a charming devil and all, but—

Tharja: A hard fall in love with a kraken. And besides, love brewed in a cauldron isn't real. If I ever decided to look for love, I would insist on an unsullied version. ...Although, I'm not above using a potion or two to get the boulder rolling.

Gaius: Oh, fair maiden... I never imagined you were such a romantic!

Tharja: Don't be sarcastic.

Gaius: No, I'm serious. Knowing that actually makes you much more attractive. I've always had a soft spot for bad girls, and they don't come much badder than you.

Tharja: ...Perhaps my spell is working after all.

Gaius: You're a fool! A blind, stupid fool! Your radiant hair! Your stunning eyes!

Tharja: All right, then. Experiment complete. Now you stay there while I go mix up an antidote.

Gaius: No, don't do it! I don't want to be cured!

■ THARJA X GAIUS S

Gaius: Um, Tharja? Why are you following me around?

Tharja: I want to make sure the antidote continues to work.

Gaius: Oh, right. That. Um, ha ha ha! Of course it worked! Of...course. ...Er, it DID work, right?

Tharja: You are completely free of any spell, curse, or hex.

Gaius: Huh. 'Cause you see, there's one liiittle problem with that... I still find you incredibly attractive, and I think I'm in love with you.

Tharja: Wow... Okay, that IS a problem.

Gaius: There's only one cure for this condition. You must accept...this.

Tharja: ...A ring?

Gaius: I had to be sure it wasn't your magic that made me fall for you.

Tharja:

Gaius: Okay, look. You want the truth? I've been interested in you for a while. Long before you ever tried casting a spell, anyway. I just really want to chat you up that didn't end with you hurling fireballs at me.

Tharja: ...In that case, I accept.

Gaius: What? You do?

Tharja: You are a sarcastic and coarse man, but there is something...interesting about you. Plus, you let me test spells on you. That has to count for something.

Gaius: Glad to be of service. But, um, you're not STILL going to use me as your guinea pig, are you?

Tharja: Not unless you disappoint me. ...You WON'T disappoint me, right?

Gaius: Not after that, I won't!

Olivia

■ OLIVIA X GAIUS C

Gaius: Hey, baby.

Olivia: Ah! Gaius, isn't it? What can I do for you?

Gaius: I was wondering if you might give this a little taste test for me.

Olivia: Is that a frosted fruit pie? Sure, give it here!

Gaius: Well?

Olivia: *Cough* G-gracious! It's so sweet... *hack* *cough* Also, the crust is oddly...soggy. No crunch or texture at all. *cough*

Gaius: Oh...yeah, huh? Shoot.

Olivia: If I were you, I'd march over to the baker and demand a refund!

Gaius: ...I made this.

Olivia: Oh my gosh! I'm so sorry! I didn't realize...

Gaius: No sweat. Wouldn't be the first time I went overboard with the sugar.

Olivia: Oh, Gaius, I'm SO sorry...

Gaius: Like I said, don't worry about—

Olivia: Sorry, sorry, SORRY! ARGH! Can you forgive me? Please?!

Gaius: Holy crap, lady! What's gotten into you?

Olivia: *Sniff* I didn't know it was YOUR pie! I said such rude and horrid things! I just... When I think about the look on your face, I... Oh, dear...

Gaius: Hey, enough already. Seriously, you have GOT to get control of yourself here. So my pie was awful. Olivia: ...Oh. R-right.

Gaius: Look, would you be willing to try one of my pies again? It'd be nice to get a comparison taste test.

Olivia: W-well, if you think it will help.

■ OLIVIA X GAIUS B

Gaius: Hey, babe. You got a second?

Olivia: Of course. What do you need?

Gaius: I whipped up another pie. Went easy on the ol' sugar pile this time, too. Anyway, you mind letting me know if it cuts the mustard?

Olivia: Well, sure. Why not? Hand it over!

Gaius: Well? How is it?

Olivia: ...You know what? It's not bad.

Gaius: You're not just saying that to make me feel better, are you?

Olivia: Absolutely not! Besides, you'd know. I'm a truly terrible liar.

Gaius: Well, all right then! Glad you like it.

Olivia: Say, Gaius? Why do you ask ME to taste your pies? There are tons of people in camp who'd be happy for a free bite.

Gaius: It's 'cause you're a dancer. See, the way I see it, you've got a sensitive soul. The Shepherds are a stout bunch and great if you need to throw down. But most of those clods couldn't tell a turnip from a sirloin. I think I saw Chrom eating an unpeeled orange the other day. No kidding!

Olivia: Hee hee! That sounds about right!

Gaius: See? You know what I'm talking about.

Olivia: You're trouble, mister. Saying such mean things about our fellow Shepherds.

Gaius: Even if they're true?

Olivia: Especially if they're true! Hee hee hee! Oh, but who am I to laugh? I'm useless at everything.

Gaius: That's so wrong. I don't even know how to respond. So you never said it. Anyway, I'm still working on my recipe, so I'll be needing your services again.

Olivia: O-of course! Anytime.

■ OLIVIA X GAIUS A

Olivia: Hello, Gaius! Do you have another pie for me?

Gaius: You bet I do, baby! Now strap yourself in, and get ready to ride the flavor stallion!

Olivia: Oh my goodness! I don't know if— Er, well, all right. Gimme that!

Gaius: ...Well?

Olivia: *Horf, snarf, chomp, munch* Oh gods... So good... Soooooo gooooood...

Gaius: We have a winner! Ding ding ding!

Olivia: I wish there was more! But say, Gaius. Doesn't it get exhausting? Making pies all the time, I mean. Just gathering all the ingredients alone must be a full-time occupation.

Gaius: You got that right. Even basic stuff is rare in times like these.

Olivia: Then why do you do it?

Gaius: I dunno. I guess I just like pie. Although there's a challenge to it that I find kind of fun, too. And it's always nice to see fellow fighters' eyes light up when I bring 'em a snack.

Olivia: Hmm...

Gaius: You're humming. What's going on?

Olivia: Gaius, I don't think you're being completely honest.

Gaius: Huh? Honest Gaius is what they used to call me back in school! ...Well, that and Booger Brain. But mostly it was Honest Gaius.

Olivia: Hmm... I suppose we'll see, won't we? But if you make another pie, you have to promise to bring it to me! All right?

Gaius: What the lady wants, the lady gets!

■ OLIVIA X GAIUS S

Gaius: So, Olivia. How's the pie today?

Olivia: *Munch, munch* Can't talk. Eating.

Gaius: The tension is killing me!

Olivia: ...It's DELICIOUS!

Gaius: Truly?

Olivia: Gaius, that pie was pastry perfection. Don't change a thing.

Gaius: Well then, maybe you should have another slice.

Olivia: Don't mind if I do! *munch, munch* ...OW! The heck? I just bit something really hard! Wait a minute. Gaius, there's a RING in this pie!

Gaius: I know.

Olivia: Wait, that is so unsanitary!

Gaius: It is? Oh. Um, yeah. Guess I didn't quite think about it like that. See, because I was hoping to use it to propose to you.

Olivia: Wait, what?

Gaius: You liked my pies so much I just kept baking more. And before I knew it, I was thinking about you the entire time. So, what do you say? Will you be my wife?

Olivia: I must confess, Gaius, I've enjoyed our little meetings a great deal.

Gaius: ...That mean you're into me or not?

Olivia: Yes, Gaius. I'd be honored to be your wife.

Gaius: Sweet. I hope you're ready for a lifetime of delicious fruit pies!

Olivia: Oh, you know I am!

Cherche

■ CHERCHE X GAIUS C

Cherche: Hello, Gaius. Where are you sneaking off to?

Gaius: Just taking a quick stroll around the perimeter. I want to make sure there aren't any enemies sneaking up on us.

Cherche: Such diligence should help us all sleep easier at night.

Gaius: Heh, first time a lady's ever said THAT to me. ...Still, thanks.

Cherche: Of course. You're a seasoned rogue and a man of the world. I envy your experience. I honestly believe you are one of the most important cogs in the Shepherd machine!

Gaius: Never been called a cog before, either. But thanks again.

Cherche: Which is why I want to put that worldly experience and wisdom to better use.

Gaius: ...Yep. Right on schedule.

Cherche: What do you mean?

Gaius: You don't butter up a guy like that unless you want something.

Cherche: My, but you ARE a sharp one. ...And I mean that sincerely. Well, I might as well get on with it. I've been hearing rumors about you.

Gaius: Oh? Do tell.

Cherche: I hear you're planning to sneak away from camp and abandon the Shepherds.

Gaius: I see. So you came all the way out here to see if I'd do a runner.

Cherche: I had to know if the rumors were true.

Gaius: Look, the next time you have a question about my motivations, just ask. I like a compliment as much as the next guy, but we could've saved a lot of time here.

Cherche: You're not angry?

Gaius: All part of being a thief. If I got burned every time someone spied on me, I wouldn't last a week.

Cherche: I see. Well, in the future, I shall be certain not to let you discover me.

Gaius: Wouldn't it be easier to just stop spying on me?

Cherche: Hee hee. I'm not too sure about that...

CHERCHE X GAIUS B

Gaius: Where'd you get that, Cherche?

Cherche: This spear? I purchased it from a traveling smith the other day.

Gaius: You mean One-Eyed Mort? Ha! I'd steer clear of that trickster. I've seen theater troupes that wouldn't use the gear he sells.

Cherche: Now that you mention it, it is rather crudely constructed. I suspect I'll need a replacement in the not-too-distant future.

Gaius: Tell you what. Why don't I lend you mine for a spell, and I'll try to fix that one up.

Cherche: You can use a forge?

Gaius: I've been around the block a time or two.

Cherche: Thank you. You really are a most useful man to have around.

Gaius: Hey, you're the one who has to hold the front line in battle. If your weapon falls apart, who'll save me from being poked full of holes?

Cherche: So your helping me is just enlightened self-interest?

Gaius: Nothing more, nothing less.

Cherche: You'd like to think that, wouldn't you? And yet, I wager that beneath your gruff exterior hides a heart of gold!

Gaius: Look, just give me the spear.

Cherche: I look forward to seeing your handiwork.

Gaius: And I look forward to showing it to you.

CHERCHE X GAIUS A

Cherche: Gaius, would you mind taking a look at my armor?

Gaius: ...Whoa. Did you take on a whole company in this stuff or what? A fix like this is out of my league, sorry to say. Better take it to a professional and see what he says.

Cherche: Oh. Well, thank you anyway.

Gaius: You impress me, Cherche. I mean it. Very few people have the courage to throw themselves into battle like you.

Cherche: I'd not call it courage so much as simple self-preservation. Truth be told, I hate all this fighting.

Gaius: Yet you're always in the thick of it.

Cherche: This war has scattered my family and friends. Driven them from their homes. Unless we see this through, none of us will ever go home again.

Gaius: Is that what you're fighting for? To be reunited with friends and family?

Cherche: If we lose, I might never see them again, and I can't bear that prospect. So as long as I still have strength to bear a weapon, I shall stand and fight.

Gaius: People all have their reasons, don't they?

Cherche: And what of you, Gaius? You seem a pragmatic man above all else. Am I safe in assuming you fight for survival in place of a greater cause?

Gaius: More or less.

Cherche: It's more than reason enough, Gaius. Never let anyone tell you otherwise. Now, if you will excuse me, I have to find that armorer.

Gaius: ...You know, I USED to think it was reason enough. Cherche has family waiting for her. She has a home to go back to. And if she dies, a whole lot of folks are going to feel it... Well, cripes. I guess I know what I gotta do...

CHERCHE X GAIUS S

Gaius: That last scrap was touch and go for a while, huh?

Cherche: For you, perhaps. You were so intent on protecting me, you almost got killed. I thought you were fighting to survive. What inspired this newfound recklessness?

Gaius: Oh, don't worry. I'm not going to start indulging in pointless heroics. But I've got a new mission now, see? I just... I want to make sure you make it home.

Cherche: It's wonderful to have such a stalwart champion, but I'm loath to see you hurt. If you can stop hurling yourself in front of blows meant for me, I'd appreciate it.

Gaius: I'll try to be a shade more careful. How's that?

Cherche: I don't understand, Gaius. Why the sudden interest in my welfare? I'd always assumed thieves didn't go much in for altruism.

Gaius: It's not altruism if you care about the person.

Cherche: What do you mean?

Gaius: It means... Well, it's like... Look, I don't know. I'm not much good at giving fancy speeches. Maybe this'll explain things better.

Cherche: ...A ring? Gaius, did you craft this?

Gaius: Yeah, I did. See, I just... I thought I could protect you better if we were married. I know us thieves have a poor record when it comes to honesty, right? But this is from the heart, Cherche. I'm all in for you, if you'll have me.

Cherche: I... I believe you, Gaius. You've repaired my weapons, acted as my shield, and fought bravely by my side. How could I say no?

Gaius: Now that's what a sly dog like me likes to hear!

Cherche: I must say, it's pleasant to have such a frank conversation with you.

Gaius: Well, we could have done this earlier if you weren't so intent on spying on me.

Cherche: Yes. I believe I owe you an apology for that.

Gaius: Already forgiven.

 Owain (Father/son)

Owain's father/son dialogue can be found on page 289.

 Inigo (Father/son)

Inigo's father/son dialogue can be found on page 293.

 Brady (Father/son)

Brady's father/son dialogue can be found on page 297.

 Kjelle (Father/daughter)

Kjelle's father/daughter dialogue can be found on page 299.

 Cynthia (Father/daughter)

Cynthia's father/daughter dialogue can be found on page 303.

 Severa (Father/daughter)

Severa's father/daughter dialogue can be found on page 305.

 Gerome (Father/son)

Gerome's father/son dialogue can be found on page 307.

 Morgan (male) (Father/son)

Morgan's (male) father/son dialogue can be found on page 309.

 Yarne (Father/son)

Yarne's father/son dialogue can be found on page 314.

 Laurent (Father/son)

Laurent's father/son dialogue can be found on page 316.

 Noire (Father/daughter)

Noire's father/daughter dialogue can be found on page 317.

 Nah (Father/daughter)

Nah's father/daughter dialogue can be found on page 318.

Cordelia

 Avatar (male)

The dialogue between Avatar (male) and Cordelia can be found on page 221.

 Avatar (female)

The dialogue between Avatar (female) and Cordelia can be found on page 232.

 Frederick

The dialogue between Frederick and Cordelia can be found on page 246.

 Virion

The dialogue between Virion and Cordelia can be found on page 249.

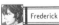 Vaike

The dialogue between Vaike and Cordelia can be found on page 255.

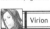 Stahl

The dialogue between Stahl and Cordelia can be found on page 257.

 Kellam

The dialogue between Kellam and Cordelia can be found on page 261.

 Sumia

The dialogue between Sumia and Cordelia can be found on page 263.

 Lon'qu

The dialogue between Lon'qu and Cordelia can be found on page 264.

 Ricken

The dialogue between Ricken and Cordelia can be found on page 266.

 Panne

The dialogue between Panne and Cordelia can be found on page 270.

 Gaius

The dialogue between Gaius and Cordelia can be found on page 271.

 Gregor

GREGOR X CORDELIA C

Cordelia: *Sigh* Oh, how can I ever make him love me?

Gregor: The sound of lovelorn sigh sends shivers down spine of Gregor!

Cordelia: Eek! G-Gregor! What are you doing lurking in the shadows?

Gregor: To be prepared is big part of battle. Is true in war. And love! If we were love-fighting, this first skirmish go to Gregor.

Cordelia: A brazen statement for one you have barely even met! And what does sneaking up on people have to do with love?

Gregor: Is good that Cordelia want to learn! Gregor will enlighten. On battlefield of love, to be adored is to have high ground. Surprise attack can lay groundwork for great success.

Cordelia: Aren't you taking this "love as war" metaphor a little far?

Gregor: Surprise attack leaves heart's fortress unmanned, yes? Then gates can be knocked over with battering ram of charm! Heart is then defenseless for final assault.

Cordelia: ...I see. You've clearly given this a great deal of thought.

Gregor: Gregor more clever than he looks. Now you can also be victor in love!

Cordelia: Yes, sir!

Gregor: Hmm... Gregor hope he not just bite off more than he can be chewing...

GREGOR X CORDELIA B

Cordelia: Gregor? Hello? Are you there, Gregor?

Gregor: Oy, why you having long face like horsey just died? Did surprise assault on fortress of love meet with horrible failure?

Cordelia: H-how did you know?

Gregor: Gregor is already telling you! He is very wise in matters of love.

Cordelia: So what am I doing wrong?

Gregor: To make other person love you is easier saying than doing, yes?

Cordelia: Especially if you're a boring stick-in-the-mud like me...

Gregor: No, no, love is coming to everyone, sooner or later. Just need practice, yes?

Cordelia: Yeah, and apparently need a lot of practice. I tried the surprise attack you talked about earlier, and he just got mad. I probably shouldn't have leapt out of the bushes in a Risen mask...

Gregor: Is not concern! Even best plan is failing if pieces on board are wrong type, no?

Cordelia: Oh, forget it. I'm going to go curl up with a pint of figgy pudding...

Gregor: Never surrender! Cordelia can win battle! This is Gregor's guarantee. You are beautiful and charming, yes? Maybe attack was overwhelming. Is like sending armored knight to smoosh fly buzzing in kitchen. Instead of smooshy fly, you are getting only pile of broken crockery.

Cordelia: Oh, this is all so confusing. You have to help me! Please!

Gregor: Ho ho! Gregor shows how to navigate stormy seas of love to safe harbor.

Cordelia: Thank you, Gregor. I don't know what I'd do without you.

GREGOR X CORDELIA A

Gregor: There! Gregor outdo himself, no? Cordelia is looking like perfection!

Cordelia: Er, yes. Gregor, I appreciate all your help with this. I really do... I mean, who even knew you could sew or apply makeup? But, um, I'm not sure any of this is going to strike at the real problem...

Gregor: Eh?

Cordelia: Shouldn't we have just found out more about the man and what he likes?

Gregor: No, is crazy talk! You are like tulip bulb in flower-patch, yes? Tulip is only needing water and manure to grow into lovely flower. Tulip does not ask gardener what color she should be, yes? Tulip just grows!

Cordelia: I'm really starting to lose my grip on your analogies, Gregor.

Gregor: Gregor knows his way can be very confusing sometimes. But Cordelia have passion and beauty! He knows she can succeed.

Cordelia: ...Wow. You're quite skilled at pep talks, I'll grant you that. Just be careful you don't get my head too big, or I might just float off!

Gregor: Woman so charming as you should for sure have huge swollen head! Gregor says you are perfection, and he never wrong about such things. Now go claim victory, yes? Do this for Gregor.

Gregor: Woman, sir! I won't let you down.

Gregor: Ah, Gregor... You have let fair woman take your heart while you not looking. *Sigh* Ah, well. Gregor must soldier on...

GREGOR X CORDELIA S

Cordelia: Oh, Gregor!

Gregor: Cordelia! You must tell Gregor: how did his soldier do on love's battlefield?

Cordelia: A-actually, there's nothing to report. I haven't done anything yet.

Gregor: Did Gregor not give you enormous confidence boost?

Cordelia: *Sigh* I know. You've done everything you can, and now it's up to me.

Gregor: That is spirit!

Cordelia: Well, anyway. Here goes nothing...

Gregor: I am wishing much luck to you!

Cordelia: Thank you. Now... Erm... *Cough* I...think I've fallen in love with you...

Gregor: Ho ho! Is very good! Is exactly how you do it! Not even Gregor can resist charm!

Cordelia: I was hoping we might see more of each other...and perhaps even get married?

Gregor: Oy! Is so cruel to practice this on Gregor! Cordelia must save proposal for real deal!

Cordelia: I have been. That was it.

Gregor:Oy. THIS is real deal? You propose to Gregor?!

Cordelia: I propose to Gregor.

Gregor: Then maybe you chase like lovesick puppy all this time was Gregor?

Cordelia: Not at first, no. But the more time I spent with you, the more I knew I'd been wrong.

Gregor: Gregor is confused, yes? All this...very not expected.

Cordelia: You think I'm charming, right?

Gregor: Like newborn baby napping in litter of tiny kittens!

Cordelia: And you think I'm pretty, right?

Gregor: Like sun over field of flowers on a cloudy-less spring day!

Cordelia: And you like me. Right?

Gregor: Oh yes. Gregor likes Cordelia very much.

Cordelia: Then I think you have your answer.

Gregor: Yes, is right! Gregor and Cordelia should make with the hitching!

Cordelia: Oh, good! Then I think you owe me a ring.

Gregor: Gregor have old sock of coins under bed. He buys Cordelia finest ring in land!

Cordelia: Then Cordelia and Gregor become so very much happy, yes? Hee hee.

 Libra

LIBRA X CORDELIA C

Cordelia: *Grunt* Oomph! These crates...are heavy...

Libra: Cordelia?

Cordelia: Gyah?! Oh gods, look out! *CRAAAAAASH*

Libra: Oh, I am SO sorry! I startled you, didn't I?

Cordelia: N-no, not at all! I just tripped over this pebble here... It's my fault for carrying too much at once. I couldn't see where I was going.

Libra: Are you unharmed?

Cordelia: Yes, thanks. Just a bruised toe.

Libra: Well, that's good news at least. Here, why don't you let me help you?

Cordelia: They're very heavy...

Libra: Not a problem. One...two... Oomph! Now then. Where would you like them?

Cordelia: Well, if it's not too much trouble, I was taking them down this way.

Libra: Lead on, milady!

Cordelia: Is here all right?

Libra: Yes, perfect. Thank you. You've been such a help!

Libra: 'Twas my pleasure. But do you always haul such heavy crates by yourself?

Cordelia: Well, I hate to bother anyone else, and if I can do it myself, why not?

Libra: That simply won't do. Next time, you must call for me so I can help! I won't take no for an answer.

Cordelia: Oh, well, if you're going to be that insistent about it, then sure!

LIBRA X CORDELIA B

Cordelia: *Grunt* Oomph!

Libra: Cordelia, let me help you!

Cordelia: Ah, Libra. Thank you. They ARE rather heavy.

Libra: Every time I see you, you're hard at work on one chore or another.

Cordelia: In such times of strife, it seems almost immoral to sit around and do nothing.

Libra: The gods do frown on sloth, it's true. But they also dislike stubborn pride. You mustn't overdo it, Cordelia. You've been rather ashen of late.

Cordelia: It's true I haven't been sleeping well. Whenever I close my eyes, I can't help thinking horrible thoughts about the war.

Libra: That is a troublesome thought. Are you eating three square meals?

Cordelia: Er, sort of?

Libra: Unacceptable.

Cordelia: No, I'm fine.

Libra: Cordelia, put those crates down, and return to your billet right away.

Cordelia: But—

Libra: No buts!

Cordelia: ...But I can't leave you to do all this by yourself!

Libra: That was a but! ...And ironic, coming from you. Who is the woman who insists on doing every job herself? Do you feel too foolish or proud to ask for help?

Cordelia: Er...me?

Libra: Yes, you, Cordelia, you have to learn to look after yourself. Now get something to eat and lie down! I'll be over later with a concoction.

Cordelia: Oh, if you insist...

LIBRA X CORDELIA A

Libra: Cordelia!

Libra: ...Blast! He found me. Er, hello, Libra!

Libra: Are you all right? I heard from Lissa that you had a fainting fit.

Cordelia: Just a little one. And I didn't say anything because I didn't want you to worry.

Libra: This is not the time to be fretting about MY feelings. How are you feeling now?

Cordelia: Oh, I'm fine. I even saw a physician, if that makes you feel better. She said I just need to get more rest and drink lots of tea.

Libra: Well, that's good to hear.

Cordelia: ...And I AM sorry.

Libra: What about?

Cordelia: For not listening to you. For not taking it easy like you told me.

Libra: It is not me who you should be apologizing to.

Cordelia: Who, then?

Libra: Why, to yourself, of course! You're the one who has to suffer all the exhaustion and pain!

Cordelia: I just can't help it! I see a job, and then another, and then another... Libra, would you maybe stay with me and scold me if I try to do too much?

Libra: I'm afraid scolding isn't in my nature. I'm more of the forgiveness type. What I can do, however, is offer my support and words of wisdom. Some gentle reminders to let you know you're trying to do the impossible.

Cordelia: I'd be grateful if you would!

LIBRA X CORDELIA S

Cordelia: *Grunt* Oomph! This...is...a heavy one...

Libra: Cordelia! What are you doing? You're supposed to be recovering!

Cordelia: Oh, hello, Libra. Yes, I'm feeling much better now!

Libra: Your problem is that you're incapable of not doing anything for five minutes...

Cordelia: You might be right, at that.

Libra: Oh, Cordelia. I can't take my eyes off you for more than a minute, can I? Is there any way to get you to relax?

Cordelia: Well, I suppose you could just follow me around nonstop!

Libra: ...Yes. That is indeed the only solution. You're going to have to let me be with you day and night.

Cordelia: What?! That's absurd!

Libra:

Cordelia: Er, what I mean is...that would be sort of...odd... Unless we were married, of course. But you don't mean that! ...Or do you?

Libra: Perhaps this ring will make my intentions clear.

Cordelia: ...Oh.

Libra: There are whispers in camp that Chrom rules supreme in your heart. But even so, I could never forgive myself if I did not tell you how I truly felt. So as doomed and foolish as my entreaty may be, I must ask—will you marry me?

Cordelia: It isn't foolish, Libra. Or doomed, either.

Libra: It isn't?

Cordelia: Libra, no one has ever worried as much about my welfare as you have. You try to stop me working too hard... You rush to my aid when I collapse... I've been thinking how nice it would be if you were always there for me. So nice, in fact, that I will gladly accept your ring!

Libra: Oh, Cordelia! You have made me so very happy!

Cordelia: Do you swear to look after me, make me tea, and lug crates until death do us part?

Libra: I do so swear!

 Henry

HENRY X CORDELIA C

Cordelia: There. It took a while, but it's finished at last!

Henry: Hey-o, Cordelia! Whatcha makin' there? Is that a scarf?

Cordelia: Yes. Who knows when we might be called upon to battle in frigid conditions!

Henry: Neat! Plegia's all hot and sunny, so there's not much call for scarves. Hey, so I'm no expert, but isn't that more of a man's scarf?

Cordelia: Er, well, the scarf is actually an item that can be worn by either... Um... It's not for me. It's a present.

Henry: Oooh, lucky guy! I wish someone would make ME a nice cozy scarf!

Cordelia: Well, heh. Well, you can have this one, if you like it that much.

Henry: Huh? But what about the special fella you were gonna give it to? I don't want an angry boyfriend pounding on my tent flap in the dead of night!

Cordelia: Well, now that I think about it, the gift probably isn't such a good idea.

Henry: Aw, but it's so beautifully made! I'm sure he'd love it.

Cordelia: Yes, but I doubt his wife would.

Henry: Oooooooooooooooooooooooooh. Say, what if the wife was dead? Could you give it to him then?

Cordelia: Henry, that's terrible! Never say that again! And in any case, it's a moot point, because I'm giving it to you. ...Thank you, Henry.

Henry: What a weirdo. Why'd you thank ME for taking HER present?!

■ HENRY X CORDELIA B

Henry: Hey, Cordelia! Thanks again for the sweet scarf!

Cordelia: Not at all. I'm glad you like it. *siiiiigh*

Henry: Uh-oh. Looks like someone's got a case of the bloody Mondays...

Cordelia: Ew! ...And I'm fine, really. Just indulging in a little self-pity.

Henry: That's kind of like making yourself sad on purpose, isn't it? You want help? 'Cause I've got a curse that'll REALLY make you miserab—

Cordelia: No, thank you! ...I was just moping about the married man I've fallen for. Still, I've no one else to blame but myself, so I have no right to grumble.

Henry: That's for sure!

Cordelia: Henry, sometimes you are honest and straightforward to a fault. You know, I wish I could just decide to stop liking someone.

Henry: I've got a curse for that, too! One little chant will take your heartache away.

Cordelia: Truly?

Henry: Sure! Just tell me who you're yearning for, and I'll pluck the love out like a weed! You'll feel much better, I promise.

Cordelia: I appreciate the offer, and it IS tempting... But I have to say no.

Henry: Why?

Cordelia: No matter how much it pains me, I don't want this love to go away.

Henry: Huh. So you ARE making yourself sad deliberately!

Cordelia: I know, Henry. I know...

■ HENRY X CORDELIA A

Henry: Yikes, I think my arms have gone numb from carrying so much stuff!

Cordelia: I appreciate your help. I had no idea I'd bought so much until it was too late. It was very good of you to come and escort me around the market.

Henry: So, now that we've been shopping, how's the lovesick heart? Better?

Cordelia: What do you mean?

Henry: I asked Lissa for advice, and she told me to take you on a big shopping trip. She said a few hours trying on dresses and armor would fix that broken heart, pronto!

Cordelia: So this was all a plot to make me feel better, was it? Well, I would never have believed it, but I DO feel better. Thank you.

Henry: Great! So now that we know shopping works, let's go to the market again!

Cordelia: Er, but we were just there.

Henry: I can go back and forth all day if that's what it takes! Plus, they had this eyeball in a jar that I wanted to—

Cordelia: Henry, you're very kind, but I think you've done enough for one day.

Henry: Then how about some comfort food? Fruit pies and cream? Candy apples? Macaroni and cheese with fried boar crisps and crumbled horse—

Cordelia: Definitely not! I have to stay in fighting shape. Anyway, it wasn't the shopping that made me feel better—it was being with you.

Henry: What, really?

Cordelia: Just knowing that you care enough to help is comfort in itself. We could have done anything and you would have lifted my spirits.

Henry: I don't really get all this "feelings" stuff, but if you say so. Er, but if you're REALLY grateful, you could join me for a fruit pie...

Cordelia: Oh, all right. ...But just the one!

■ HENRY X CORDELIA S

Henry: *Pant* A-avast, fiend! Prepare to wear your guts for garters! *Pant, pant* It's n-no good... I can't even lift the thing...

Cordelia: Henry, what in the world are you doing with that battle axe?

Henry: I'm practicing how to look more manly! I figured you might like me better if I was a little bigger and tougher.

Cordelia: Is this another of your schemes to make me feel better?

Henry: Nya ha! No, it's a scheme to make you fall in love with me.

Cordelia: It's a... Wait, what?

Henry: I know I'm not as tough or brave or handsome as Chrom, but maybe—

Cordelia: D-did you just say Chrom?

Henry: Well, that's the guy you're always pining for, isn't it? That's what Lissa said, anyway. Was she wrong?

Cordelia: *Sigh* No, she wasn't. Oh, this is so embarrassing! I didn't want anyone to know.

Henry: Aw, it's okay. I'm just gonna work hard so you end up liking me instead!

Cordelia: Henry, you don't have to impress me by trying to be more like Chrom. There's plenty of things about you that I already like. ...In fact, I've found myself thinking about you more than Chrom lately.

Henry: Really?

Cordelia: You've been so kind and thoughtful and considerate toward me. I'm ashamed I didn't realize you were falling in love with me before my eyes!

Henry: Well, if you REALLY feel bad about it, you could accept this ring...

Cordelia: Oh, Henry! I'll gladly accept it! No one knows how to make me happy quite like you...

Donnel

■ DONNEL X CORDELIA C

Donnel: The sun is gold, them clouds is white! ♪ Land's far below, 'cause I'm in flight! ♪

Cordelia: I never thought to hear that song sung by a simple villager.

Donnel: Hey, Cordelia! Reckon ya know that song too, huh?

Cordelia: Any pegasus knight worth her wings knows that one, Donnel. But I had always thought it was nearly unknown outside the order.

Donnel: A lady visited my village—donkey's years ago, it was—and taught me the words. I confess I don't really get what it's about, exactly... But it's a rousin' tune what makes me think of bravery and valiant derrin'-do!

Cordelia: Well, it IS about bravery. It celebrates the exploits of one of history's greatest pegasus knights.

Donnel: Well, ain't that somethin'?

Cordelia: Yes. She lived back in the legendary times of the first exalt of Ylisse. She was his greatest knight and his most stalwart defender. She watched over him like the sun itself, swooping down to dispatch foes. The slow, heavy knights feared her aerial dance most of all. At night they huddled together and told tales of a death-dealing lance from the sky.

Donnel: Gosh! Reckon I'm a fan all confused.

Cordelia: Oh, she was. But she was more than just a warrior. She had the courage of a demon, yes, but the heart of an angel. They say the people loved her even more than she loved the exalt. In fact, for every foe she defeated, she won two more to her side with her charisma.

Donnel: Golly! Tough as a badger, but charmin' as an old fox! Reckon I can see why they wrote such a fine song for her.

Cordelia: They built statues, too—one of which still stands in the Ylissean capital. I could take you there to see it after the war, if you would like.

Donnel: Ya bet yer gold teeth I would! It's a date, Cordelia!

■ DONNEL X CORDELIA B

Donnel: Cordelia, I was hopin' ya might spin me more yarns 'bout that pegasus knight.

Cordelia: Heh. Seems like I piqued your curiosity.

Donnel: Piqued it and pricked it, too! I think I'm fallin' in love with her!

Cordelia: Well, keep this under your hat, but it's long been my dream to become just like her. I'm truly delighted that you're as interested in her life as I am! ...Although needless to say, I'm nowhere close to realizing my dream. They'd probably laugh me out of the Shepherds if they knew.

Donnel: She must'a been mighty special if a gal as amazin' as you can't measure up.

Cordelia: Oh, I'm not amazing, Donnel. I'm actually a very ordinary knight and woman.

Donnel: Aw, donkey dung! You're amazin' in more ways than I could ever count!

Cordelia: Stop that. You shouldn't try to flatter me—charming though it may be.

Donnel: I ain't flatterin' ya, Cordelia! Cross my heart and hope to spit! And to prove it, I'm gonna start listin' 10 ways you're amazin' every day!

Cordelia: Er, every day?

Donnel: Yep! Monday to Sunday, no days off!

Cordelia: Well, this should be amusing. I wonder how long you'll last.

Donnel: Oh, just you wait. I can do this for ages!

■ DONNEL X CORDELIA A

Donnel: Welp, let's see... Beautiful, kind, strong, wise... Um, beautiful...

Cordelia: You said beautiful twice. Not to mention, you've listed all those other things before as well.

Donnel: W-wait! I ain't done yet! Mmm...thinkin' hard... Mmmmmnn... Ya got a huge nose!

Cordelia: ...That's not a compliment.

Donnel: It ain't?

Cordelia: Look, just admit that you've run out of good things to say about me. I'm still impressed you managed to keep it going for so long. I'm starting to think that perhaps I AM a little bit amazing!

Donnel: I told ya that already! Loads'a times! Fact is, the more I get to know ya, the more amazin' I think ya are.

Cordelia: Well, I've never been quite so flattered in my life, that's for sure. ...And as a little thank-you gift, I made you this.

Donnel: What is it? A letter?

Cordelia: We've been spending a lot of time together, and I've grown to know you quite well. So I drew up my own list, for you.

Donnel: Gosh! That's a lot of writin'! ...Them's all my good points?

Cordelia: Oh, no. Those are your faults.

Donnel: ...Oh. Ain't quite what I was expectin', but... Hmmm... Yup. Okay, I see... Yikes, there's a second page... And a third!?

Cordelia: Flattery is all well and good, but we must know our faults if we want to grow. So I made this list to help you, and I want you to do the same for me. Then I can fix my weaknesses and make myself a new pegasus knight of legend!

Donnel: Well, if that's what ya want, I reckon I'll give it my best. But I've gotta warn ya, it ain't gonna be easy findin' fault with you!

■ DONNEL X CORDELIA S

Donnel: *Cough* Er, Cordelia?

Cordelia: Yes, Donnel. What is it?

Donnel: It's about that list ya asked me to make. The one about yer bad points? Well, I, er...thought up a couple'a things.

Cordelia: Excellent! Come then, show them to me. ...Ah, yes, good. You have quite a lot.

Donnel: Yeah, but actually... That ain't why I wanted to talk at ya.

Cordelia: Oh?

Donnel: What I'm really here for is to give ya this here ring.

Cordelia: Oh. What's it for?

Donnel: Well, I guess I'm hopin' you'll wear it. I've been spendin' a lot of time thinkin' about ya. Both good points and bad. And frankly, I ain't had much time lately to do anythin' else.

Cordelia: ...Ah. I think I understand now. This is an engagement ring, isn't it?

Donnel: Yep.

Cordelia: Well, what a coincidence. I've got one for you, too.

Donnel: Ya do?

Cordelia: Let me just grab it right... Oof! ...Here.

Donnel: Creepin' carrots, this is heavy! How much paper ya use in this stack?

Cordelia: I've spent a great deal of time listing your good and bad points. That's my final report.

Donnel: Gosh! Ya came up with way more stuff than the last time... S'pose I got a whole mess'a things to fix this time, huh?

Cordelia: Quite a few, yes. I don't believe in sugarcoating the truth, as you know.

Donnel: Aw, horse pucky! What'n the heck was I thinkin'? I ain't just some dumb farm boy what tried to marry a pegasus knight!

Cordelia: Oh, dear. It seems I missed one of your faults. Here, give me that. I'll just write it in on the last page... "Comes to hasty conclusions."

Cordelia: Oh, I already have "easily confused." It's back on page 19. But anyway, what makes you think I'm turning down your proposal?

Donnel: Ain't it obvious? Look at this huge list of stuff about me what needs fixin'!

Cordelia: When you were thinking of my faults and strengths, you fell in love with me. ...Right? Well, I think the same thing happened to me when I was making your lists.

Donnel: And you started likin' me in spite a all...THIS?

Cordelia: I did indeed. And so, Donnel, yes. I accept your proposal.

Donnel: Yeeeeee-haw!

Cordelia: Of course, once we're married, we'll likely have to expand these lists a great deal. Getting to know you will be an adventure— I'll have to remember to sharpen my quill!

Donnel: Er, yeah. An adventure! ...Definitely. Ha ha... yeargh.

Severa (Mother/daughter)

■ SEVERA X CORDELIA (MOTHER/DAUGHTER) C

Cordelia: So, tell me about the future, Severa.

Severa: Why do you care? It's a different future. None of it will even happen here.

Cordelia: Well, maybe not exactly, but parts of it might. ...Right?

Severa: How should I know? Gawds!

Cordelia: ...Are you upset about something?

Severa: No, I'm NOT upset. Stop prying, Mother.

Cordelia: I suppose it was the frown and furrowed brow that threw me off...

Severa: It's your fault for dredging up memories of the future. I don't want any of it to happen again, and I don't want to think about it! Is that ALL RIGHT with you?

Cordelia: ...I'm sorry, dear. I never stopped to think about how hard it must have been for you. It was thoughtless of me. ...Forgive me?

Severa: Fine. As long as you learned your lesson...

Cordelia: Well then, let's talk about something else, shall we?

Severa: I don't have anything to say to you...

Cordelia: No? Well, I have a mountain of questions for you! Come now. Indulge your mother, just for a little while?

Severa: Ugh. All right, all right.

Cordelia: Wonderful. Thank you, dear.

Severa: Though if you REALLY want to thank me, you'd give me your dessert at dinner...

Cordelia: ...All right, it's a deal.

■ SEVERA X CORDELIA (MOTHER/DAUGHTER) B

Cordelia: Here you are, then. My dessert is yours once again.

Severa: ...Thanks. So, what do you want to know today?

Cordelia: Hmm, I know there was something I wanted to ask you.... Ah, that's it. Why didn't you choose to be a pegasus knight?

Severa: Ugh, because I'd sooner drink boiling tar than follow in your footsteps.

Cordelia: ...That's just a bit harsh, isn't it?

Severa: If you want harsh, try living in the shadow of someone who's perfect at everything. Trust me, it's a NIGHTMARE. Everyone loves you and respects you and thinks you're pretty and smart and strong. I'm just a big pile of dog food...

Cordelia: Ah ha ha, that's quite a list of compliments! I'm flattered, Severa.

Severa: Hey, I'm just repeating what everybody ELSE says. I never said any of that!

Cordelia: Oh? ...Then what DO you think of me? What sort of mother was I?

Severa: Perfect, of cour— Er... *AHEM* I mean, you were a coldhearted, selfish brute who abandoned your only daughter!

Cordelia: Severa, I...I'm so sorry. *sniff*

Severa: H-hey... No fair crying... I didn't mean it. Of course I didn't mean it... You were kind and pretty and strong and perfect... All right?! Are you happy now...?

Cordelia: Ah... I'm sorry, dear, but yes. I am. It warms my heart to hear you say that.

Severa: Whatever. We're done here!

Cordelia: ...My, she is quick when she wants to be. Quicker than me, that's for certain. But she doesn't need to know I became a pegasus knight because I'm a lousy runner...

■ SEVERA X CORDELIA (MOTHER/DAUGHTER) A

Cordelia: Oh, darn the luck... No dessert with today's rations, I'm afraid.

Severa: None?

Cordelia: Looks like I don't get my Severa time today.

Severa: Well...I SUPPOSE I could make an exception. Just for today, if you insist.

Cordelia: Oh, I insist.

Severa: *Sigh* Fiiiiine. What do we have to talk about this time?

Cordelia: How about today we make a promise?

Severa: Booooring...

Cordelia: A promise for the two of us as we build a new future together... A promise that, no matter what, we'll never part with another sad farewell.

Severa: ...What if you break your promise?

Cordelia: No "ifs" this time. This one is absolute.

Severa: ...Absolutely absolute?

Cordelia: Absolutely.

Severa: Well, I guess that's okay. ...I guess I can trust you now...

Cordelia: Of course you can, dear! ...Er, but didn't you trust me before?

Severa: I've WANTED to for, like, ever! ...I wanted to tell you everything. But then I thought about losing you again and it... I can't do it... I can't be alone again! I WON'T!

Cordelia: And so you kept your distance. Aw, my poor girl...

Severa: I'm sorry, Mother... I'm so sorry! I didn't want to be cold, but I knew once I let you in, there was no going back.

Cordelia: I'm so very glad you have. Thank you, Severa. You followed your feelings, but there's nothing to fear now. You can trust me with anything, and I'll do the same in return. Deal?

Severa: Ah, Mom! I love you so much!

Morgan (female) (Mother/daughter)

The Morgan (female) mother/daughter dialogue can be found on page 312.

Gregor

Avatar (male)

The dialogue between Avatar (male) and Gregor can be found on page 221.

Avatar (female)

The dialogue between Avatar (female) and Gregor can be found on page 232.

Lissa

The dialogue between Lissa and Gregor can be found on page 244.

Sully

The dialogue between Sully and Gregor can be found on page 253.

Miriel

The dialogue between Miriel and Gregor can be found on page 259.

Lon'qu

The dialogue between Lon'qu and Gregor can be found on page 264.

Ricken

The dialogue between Ricken and Gregor can be found on page 266.

Maribelle

The dialogue between Maribelle and Gregor can be found on page 268.

Panne

The dialogue between Panne and Gregor can be found on page 270.

Cordelia

The dialogue between Cordelia and Gregor can be found on page 273.

Nowi

■ NOWI X GREGOR C

Nowi: Heya, gramps!

Gregor: "Gramps"? What is this "gramps"? If Gregor is "gramps," then little girl is great-great-great-great-granny.

Nowi: So you know how old I am, huh? Weird. Most people can't stop talking about how young I look.

Gregor: Is just, how you say, flatulence? No, wait. ...Flippery? ...Flatness? ...Gregor does not remember. Is that word when people say lies to make other person feel better.

Nowi: No idea what you're talking about. Anyway, I have something to ask you.

Gregor: If you want borrow money, answer is no. Gregor is poor like beggar.

Nowi: Yes, I know that. That's why I want to give you something.

Gregor: You give Gregor shiny gold coin?

Nowi: No, Chrom doesn't let me have money. I always end up losing it.

Gregor: Agreed. Gregor too is sooner trusting senile squirrel with life savings!

Nowi: Hey, for your information, I happen to be quite smart! But I don't care about money. Us manaketes don't use it much.

Gregor: Ah, is very good! Money is root of all evil. So then, what you give Gregor?

Nowi: I knitted you a big, wooly sweater! See? It's got shoulder pads built in!

Gregor: ...Now this looks like "gramps" clothing. Also, Gregor is no good in sweater. Is too hot, yes?

Nowi: Yeah, but this one is really light. It really breathes! I lined it with manakete scales!

Gregor: Scale of manakete? Gregor is stunned. How are you finding such priceless artifacts?

Nowi: See? I thought you'd be impressed. I just had some lying around, so don't worry about it.

Gregor: Then Gregor accepts wonderful gift with much gratitude!

Nowi: Hee hee! Glad you like it.

■ NOWI X GREGOR B

Gregor: Nowi, you have time, yes? We can speak?

Nowi: What's up, Gregs?

Gregor: Gregor's name is Gregor! ...But at least you are not calling him gramps.

Nowi: All right, so? What is it?

Gregor: You remember sweater you give to Gregor? Is very fine sweater. Best ever! Is helping to deflect dangerous blows in last battle. Gives Gregor peace of mind.

Nowi: Oh, goody! I'm glad you like it.

Gregor: Gregor is...not exactly say he is liking it.

Nowi: No? I kind of think you were.

Gregor: When Nowi makes sweater, how many scales is she using?

Nowi: Oh, I don't know. A few?

Gregor: Gregor not knowing this "few." Meaning is more than two, yes?

Nowi: Um, yeah. Definitely more than two.

Gregor: Now Gregor knows where you get scales. They come from Nowi's own body. But this must be hurting terribly, yes? And missing scales means no armor for you, but is very foolhardy!

Nowi: But I just wanted to—

Gregor: Since you lose armor, we have new rule: you stay close to Gregor in battles.

Nowi: I think I can handle that!

■ NOWI X GREGOR A

Gregor: Nowi, in past days, you and Gregor are fighting many times side by side.

Nowi: I know, it's so fun! I'm doing my very best to protect you.

Gregor: No, is backward! Gregor protecting you! ...Ah, but never minding now. When allies fight together, bonds grow strong and become more powerful, yes? So Gregor thinks we should train together, becoming unbeatable force!

Nowi: What? Now? 'Cause see, I kinda promised to eat with Chrom and some friends. And I thought maybe you might want to come along? Pleeease?

Gregor: First we do training, then maybe we can do the visiting friends. You know saying? "Youth must work like dog to make future better!"

Nowi: ...Actually, I've never heard that one. Besides, I'm hardly a youth. You know that.

Gregor: Ah, yes. Gregor is sometimes forgetting you are old crone. Okay then, meddling Gregor will leave Nowi alone to her fun...

Nowi: Gregor, wait! Don't be upset.

Gregor: No! Gregor is old fool who is only thinking about self. Gregor tries to help you be stronger, but already you are smarter than Gregor.

Nowi: Oh, Gregor... You know, now that I think about it, I do want that special training!

Gregor: Oy, this is worse! You agree just to make old man not be feeling like sad sack!

Nowi: No! Look, you spend all this time worrying about me, so I should listen to your advice. I'm really grateful for the offer, okay? Honest! So let's train together.

Gregor: ...Nowi not pitying Gregor, yes? You swear on mother's grave?

Nowi: Really, I can't wait to train! It's such a great idea!

Gregor: Well, if you are insisting!

■ NOWI X GREGOR S

Gregor: Bond-building training is complete! Now we are like unbeatable team!

Nowi: So now we can relax and have some fun, right?

Gregor: Ah. You are remembering that?

Nowi: Don't tell me you're going to back out! You promised!

Gregor: Gregor remembers. Is man of his word, yes?

Nowi: Good! Then let's go play!

Gregor: Before the romping and the frolicking, Gregor has gift to bestow...

Nowi: Oh, what a beautiful ring!

Gregor: Ring is symbol of solemn vow. Gregor is wishing to spend life with Nowi. Er, you will...accept?

Nowi: You mean we can play and hang out every day from now on? Gimme!

Gregor: No, no. Not play. Gregor is mangling language once more. Ring is sacred vow, yes? Is meaning that we—

Nowi: Oh, silly Gregor. Of course I know what it means. I'm 1,000 years old, remember? You love me and want to get married, right? So just come out and say it.

Gregor: But...is difficult. Gregor is...very shy man.

Nowi: So are you sure you love me? Because, if you don't—

Gregor: No, no! Gregor's heart is true! He seeks solemn bond as man and wife! Okay, then! Gregor proves this to you! *cough* *ahem* ...Gregor love you, Nowi.

Nowi: That wasn't so hard, now was it? And I accept! But you have to promise to live as long as you can, okay?

Gregor: Ho ho! Gregor will be doing his best!

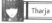

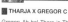

Tharja

■ THARJA X GREGOR C

Gregor: Ah-ha! There is Tharja is needing to ask question. Is all right, yes?

Tharja: I'm busy.

Gregor: Ah! You are not wanting to be seen talking to old man like Gregor.

Tharja: Age has nothing to do with it. I'm just not interested in talking.

Gregor: Oy, little girl have tongue like snake. Very full of evil. Tharja could pretend to not liking old-man smell at least. Then Gregor is less insulted.

Tharja: You could smell like roses and fresh-cut grass. It wouldn't matter.

Gregor: Why are you hating friendly Gregor?

Tharja: I said I didn't want to talk to you. ...So why are you still talking?

Gregor: Old man like Gregor only hears what he wants. Very useful skill in life, yes?

Tharja: ...Is that true?

Gregor: Oy, NOW evil girl is expressing interested-ness in Gregor!

Tharja: Because that would explain why my curses never work on you.

Gregor: Oh no! Why are you trying to cast evil hex on poor Gregor?!

Tharja: What does it matter? The damned spell didn't work anyway.

Gregor: Ah-ha! This is why you are being so rude. Gregor is immune to your witchery! I make you look like...how you say? Fool? Amateur? This sort of thing?

Tharja: Go ahead and mock me, old man. I'll have my revenge, just you wait...

Gregor: Wait, evil girl! Gregor is still having long list of questions to ask!

■ THARJA X GREGOR B

Gregor: Oy, why is evil girl still not talking? Gregor is nice guy! Laugh like bowl of jelly!

Tharja: ...I should inflict a permanent silence curse on you, old man.

Gregor: Ho ho! Evil girl's spells not work on Gregor! Are you remembering this?

Tharja: I have...never been...this angry...in my en-tire life!

Gregor: You should forget with all the anger and the making of the clenched fists. Gregor only want to chat. Make with the small speech, yes?

Tharja: You want to be friends with me? Then prove your loyalty. Give me nail clippings and a lock of hair so I can cast a spell that sticks.

Gregor: If Gregor agrees to your unholy terms, you must answer question, yes? Most times Gregor only wants to know if evil girl have dinner plans. But, not today.

Tharja: ...You get one question.

Gregor: Oh, this is too bad. Gregor have long list. But he will narrow down... Does evil girl know mag-ic spell that can, how you say, bring back dead?

Tharja: Seriously? That's your question? It's almost as bad as "can you make me immortal?" Ugggh!

Gregor: So then, you cannot do this?

Tharja: No, Gregor. I can't. No one can. Now if you want to TALK to the dead, that's something I could maybe arrange.

Gregor: Is for truly? Oh yes, that would be more than enough! Please, you must help Gregor talk to dead person!

Tharja: It's not easy, you know. It takes a lot of work, and a LOT of preparation.

Gregor: Please, you must do this! Gregor gives you soul in exchange, yes?

Tharja: ...Really, now?

Gregor: Cross Gregor's heart and hope to die!

Tharja: Well, if you're that desperate, maybe I can do something...

Gregor: Then Gregor is being always in your debt.

■ THARJA X GREGOR A

Gregor: Tharja! You finish researching spell, yes? Read all tomes? Collect bat wing? Please say yes. Gregor is very much wanting to talk to dead person!

Tharja: I am ready. Now then... Whose soul do you wish to summon?

Gregor: Gregor's brother. His name is Gregor.

Tharja: ...You have the same name?

Gregor: When he died, Gregor took Gregor's name. Is fitting tribute, no?

Tharja: ...Oh, gods. That's why the curses never worked! The brother whose name you took must have died with unfinished business. If he clings to this world, the name would still belong to him.

Gregor: And that make spooky magic not work right, yes?

Tharja: A curse won't stick if you don't know the true name of the intended target.

Gregor: You want to know Gregor's real name now, yes? So you can charm him?

Tharja: Later. Right now, we need to focus on your brother. Imagine his face... Imagine his voice... Now... Talk to him.

Gregor: Hello? Gregor? Yoo-hoo! Are you hearing?

Tharja: (Brother... Is that you...?)

Gregor: Oy, is sounding just like him! Tharja is sum-moning soul of brother!

Tharja: (My brother...)

Gregor: Oh, Brother! I am so sorry you die because of bad thing I did! If you bear grudge, tell me now. I atone for injustice!

Tharja: (I bear no grudge against you... You did all you could to save me...) (You must not feel guilty... I am proud of you...)

Gregor: Oh, Gregor! I try to save you, but bandits were so many!

Tharja: (You must forgive yourself, Brother.) (For-give...)

Gregor: *Sniff* Oy, G-Gregor...

Tharja: Well? Did you say what you had to say?

Gregor: Y-yes. All thanks to Tharja. Gregor's broth-er was taken by bandits, and he could not save him. Gregor had large hole in heart, but now hole has been filled in. Gregor have no more regrets. You can take soul or whatever you want.

Tharja: I'm...a little tired. Perhaps next time.

Gregor: Gregor brings soul next time we meet. You take then, yes?

■ THARJA X GREGOR S

Gregor: Gregor must thank Tharja again. You did him great favor! Brother hears apology and forgives Gre-gor. Now he is like new man!

Tharja: Yeah? Well that makes one of us who's happy.

Gregor: Oy, but Gregor says thank you many times over. Why are you giving him that evil glare of fury?

Tharja: Ever since I hosted the soul of your brother, something has been...wrong with me. I can't stop thinking about you. It's...incredibly annoying.

Gregor: Ah... You fall in love with Gregor? Is okay. He sees same thing before. But, is good. Gregor likes you, too. That is why he is bringing you present!

Tharja: ...This is a ring.

Gregor: Look on inside. Is having Gregor's name carved in! If you accept, then we carve your name next to Gregor's. Together forever!

Tharja: ...You intend to continue using the name of your brother?

Gregor: Thanks to you, I know he forgives Gregor for unfortunate and violent death. So now Gregor bears his name with pride! ...He also very used to it by now.

Tharja: Well, it's as much yours as your brother's, I suppose. ...Hmm. Maybe now some of my curses will actually stick.

Gregor: For you, Gregor do anything. Even if it turns him into toad.

Tharja: I don't think that will be necessary. Besides, I've got a better idea... Heh heh...

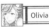
Olivia

■ OLIVIA X GREGOR C

Olivia: Um, excuse me. Gregor? I have your dinner if you're hungry.

Gregor: Gregor is very big man, yes? And big man is always hungry! So, it was your turn to make with the cooking, eh?

Olivia: Yes, I'm on chef duty today. It's actually my first time, so if you don't like the food, just...let me know.

Gregor: Gregor shall sample and give report. *sluuuuurp*

Olivia: W-well?

Gregor: This is tastiest liver stew Gregor has eaten in whole life!

Olivia: Oh! You recognize it? N-not many people out-side of Regna Ferox know this dish. ...Er, or like it, for that matter.

Gregor: Gregor is sellsword. He serve many masters and travel to countless lands. Ah! Is good for the re-minding! Gregor has large bag of secret spice. ...Here. He put in stew and you taste.

Olivia: Um, okay... *slurp* Oh, it's twice as good! And you only added that tiny bit!

Gregor: Gregor's spice can turn this bowl of gruel into feast fit for king!

Olivia: It's amazing what a tiny pinch of seasoning can do for a meal. So, um... Would you be willing to share some with me? ...Pleeease?

Gregor: Many regrets, but Gregor is out of spice. He can make more, but it takes time, yes?

Olivia: Perhaps I can help? I mean, I could gather the ingredients or something?

Gregor: This is happy idea! When you finish cooking meals for local oafs, you come find Gregor, yes?

Olivia: I'll do that!

■ OLIVIA X GREGOR B

Gregor: Today is okay, yes? You join Gregor on trip into woods?

Olivia: You mean to gather ingredients, right? For your secret spice blend?

Gregor: Yes. We must go deep into woods, so Gregor is thinking we pack lunch.

Olivia: Oh, all right. I can make sandwiches if you want.

Gregor: No, no, Gregor not let girl with small hands do all the work! Come. Gregor will help with the making of sandwiches.

Olivia: All right...

Gregor: Good. Thanks to you, we now have picnic hamper full of tastiness!

Olivia: You're being kind—I'm sorry I wasn't much help. I'm so terrible at making sandwiches...

Gregor: Gregor is being...confused. Perhaps he not hear your language so well? Olivia is sad, yes? Is thinking she bumbles about in kitchen like drunk bear? But Olivia is fine cook. When is her day in mess hall, Gregor salivate with excitement!

Olivia: Really?! Oh my gosh, I never... I mean, people don't usually tell me that.

Gregor: Then people are idiots. You listen to Gregor and learn truth. Olivia is tasty cook and lovely dancer. Gregor think she would make fine wife.

Olivia: Oh, stop that, you're embarrassing me! I'm none of those things.

Gregor: But is true! Sellsword know how to see true value in people, yes? And Gregor is master of sells-words! Gregor never make mistake.

Olivia: Oh stop it, Gregor! I know you're just saying these things to be nice. But, um... Thank you.

Gregor: You are being most welcome.

■ OLIVIA X GREGOR A

Olivia: Gregor! There you are.

Gregor: What is wrong? You look to be making with the yelling at any moment.

Olivia: Gregor, let me look at your back. I think you may be injured.

Gregor: Why are you thinking so?

Olivia: Because you're limping around like a two-legged mule!

Gregor: You have been spying on Gregor's move-ments...

Olivia: I'm a dancer, Gregor. I always notice how peo-ple are moving around.

Gregor: Ah, well. You have taken cat out of bag. Gre-gor may be tiny bit injured.

Olivia: See? Now lift up your shirt and let me take a look at... Eek! Gregor, look at—

Gregor: Ha! Is nothing! One time Gregor's leg fall off and he sew it back on. But if pretty lady with small hands want to nurse Gregor, he will not complain.

Olivia: Oh my goodness. It's hard to look at. Okay, so just hold still. This might sting a little bit...

Gregor: Ho ho! Gregor... He feels nothing!

Olivia: Gregor is going to feel something if he doesn't hold still!

Gregor: ...Ahhh, is good. Gregor is feeling better al-ready.

Olivia: Listen, I want you to go talk to one of the heal-ers, all right? Just to make sure you don't get gan-grene or something.

Gregor: For old man like Gregor, being nursed by beautiful woman is best medicine of all.

Olivia: Hop to it, mister!

■ OLIVIA X GREGOR S

Gregor: Oy, Olivia! Gregor have big surprise for you today.

Olivia: Oh? What is it?

Gregor: Is small pouch of secret spice blend! Just as Gregor promised.

Olivia: Oh, thank you, Gregor! This is going to be so... Um, wait. There's something hard in here. Oh! It's a ring! You must have dropped this in here when you were grinding.

Gregor: Is...how you say? No problem? Gregor is giv-ing you ring, yes?

Olivia: Gregor, this is huge. It must have been so ex-pensive! I can't take it.

Gregor: Okay, okay! Gregor is not putting in pouch by accident. He does this on purpose. Is all part of sneaky and elaborate plan. Gregor goes to dangerous places and collects many rare spices. Then he can give you expensive ring in unexpected and charming manner.

Olivia: Dangerous places... Wait, is that how you hurt your back?

Gregor: Olivia not need to know! ...Is embarrassing story anyway. Involve slippery rock and angry squirrel.

Olivia: Oh, I'm so sorry... You went to so much trouble on my account...

Gregor: Gregor not sorry! Gregor will face army of angry squirrels for you. You are first woman Gregor truly loves, and now is time for the proving. So what does Olivia say? You accept ring and proposal of marriage, yes?

Olivia: I... I don't know, Gregor. It's all so sudden.

Gregor: Hmm... This is not answer Gregor is hoping for.

Olivia: I'm sorry, it's just... My mind is whirling in a thousand directions at once!

Gregor: Then you have answer.

Olivia: I do?

Gregor: Your mind is spinning because of the happi-ness, yes? So if you marry Gregor, you can be happy forever!

Olivia: Hmm... You know, you just might have some-thing there... All right! Let's do it! Let's get married!

Gregor: Oy, Gregor feel huge pain in chest when you bat eyelashes like that!

Olivia: I'm sorry, I'll try not to... Oh, wait. That's a good thing, isn't it?

Gregor: Is very good thing!

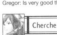
Cherche

■ CHERCHE X GREGOR C

Cherche: Gregor, I wouldn't stand there if I were you. Minerva is coming through.

Gregor: Oy! If there is one thing Gregor knows, is not to get in way of mighty wyvern! But if lovely lady want to bowl Gregor over, is totally being fine with him.

Cherche: Careful, my amorous friend. A knock from me will set your head spinning just the same.

Gregor: Gregor's head always spinning in your pres-ence!

Cherche: Heh... How would you like to take a trip somewhere that'll really make you dizzy?

Gregor: Gregor would know more...

Cherche: Join me for a ride on Minerva, into the open skies!

Gregor: You mean, go up? Up into sky? Beautiful lady is crazy, no?

Cherche: Offer's still open... Going once... Going twice...

Gregor: Never in Gregor's life has he said no to beau-tiful woman. But this time...

Cherche: Don't tell me you're afraid of heights.

Gregor: Gregor is young boy, he is stuck in top of tall tree for three days and nights.

Cherche: Ah, that must have been quite the uncom-fortable experience.

Gregor: Father say, "Gregor, you must stay in tree!" He was very strict man.

Cherche: Why, that's terrible! You poor little—

Gregor: Stop! Gregor accept no pity from beautiful lady.

Cherche: ...Oh. Well, all right, then.

■ CHERCHE X GREGOR B

Cherche: Phew. Well done, Minerva.

Gregor: Cherche is fighting bravely too, yes?

Cherche: As did you, Gregor. You were very impres-sive out there. Hmm? What's the matter, Minerva?

Gregor: Ho ho ho! Yes, Minerva! You also brave and strong.

Cherche: Wait, you can understand her?

Gregor: Gregor knows about wyverns. Once long ago, he visit place called Wyvern Valley. Was for business. ...But not so good. Gregor not like to make men cry.

Cherche: What kind of business?

Gregor: Gregor ordered to collect claws from dead wyverns, yes? But Gregor is with wicked men. They turn mission into wyvern-hunting party. Soon, we come across mother wyvern trying to protect baby. ...Mother not make it.

Cherche: I see.

Cherche: Minerva! What in the world has gotten into you?!

Gregor: What is happening? Why she act so crazy now?!

Cherche: I don't know! I've not heard her cry out like this since she was a baby.

Gregor: ...Wait. Gregor remembers this cry. Is sound-ing like baby wyvern in valley.

Cherche: ...Oh. I...I see. Gregor, would you mind leav-ing us alone for a while?

Gregor: Yes, Gregor melt into shadows like piece of butter.

Cherche: Now, Minerva. What is it you want to tell me? *Gasp*...Are you sure?

■ CHERCHE X GREGOR A

Cherche: Gregor? You're going to catch a cold sleep-ing out here.

Gregor: Zzz... No, no... Gregor eat enough... Well, maybe one more pierogi... *Snort* Eh? Wha—? ...Oh, hello, Cherche. And Minerva! Why you come see Gregor?

Cherche: We wanted to talk to you. Is now a good time?

Gregor: For you, any time is good. But is Minerva sure she is wanting to talk to Gregor?

Cherche: Oh, it's so sweet you take her feelings into consideration. You know, Minerva, you're right. He's just like you said.

Gregor: Callous and heartless?

Cherche: Minerva told me all about what happened in Wyvern Valley. About how you turned against your fellow sellswords and fought them off. You saved her life, Gregor. If it wasn't for you, I wouldn't be with her today. We both owe you a great deal.

Gregor: Gregor knows what feeling is to see parents killed before own two eyes.

Cherche: What are you talking about?

Gregor: Gregor's parents were hard, but they were all he have. But one day... Well, it does not matter. Gregor could not let same thing happen to Minerva.

Cherche: That's why you stepped in and turned against your comrades.

Gregor: Gregor always do duty for employer. But that not duty. Was bad murder. Gregor could not do. Never.

Cherche: *Sniff* Oh, Gregor. How can we ever thank you?

Gregor: Stop. No crying, please. Gregor have soft spot for weeping ladies. Save tears of gratitude for when Gregor really deserves them.

Cherche: But, you do deserve them! And much more, besides...

Gregor: Oy...

■ CHERCHE X GREGOR S

Cherche: Here, Gregor. I mended your clothes. Now it's almost time for supper. What do you fancy this evening?

Gregor: Oy, Cherche. Is no need pamper Gregor like he is king! You already say thanks for Minerva many, many times. So Gregor say you are welcome, and then we are even, yes?

Cherche: I'm not doing this for Minerva's sake. What put that idea into your head? She's perfectly capable of paying you back herself.

Gregor: Then why you always so nice to Gregor?

Cherche: Gregor, how long will you make me wait? I can't be much more obvious...

Gregor: Ho ho! When it comes to women, Gregor is genius of hint-spotting. Gregor is trying to overcome big challenge first, but he cannot wait. Here! Is ring for you. You will marry Gregor, yes?

Cherche: Oh, Gregor! Yes! I accept with all my heart! ...Er, but what's this "big challenge" that kept me waiting?

Gregor: If Gregor marry Cherche, then maybe he have to fly in the sky sometime, yes? So before we marry, Gregor must overcome terror of high places.

Cherche: Yes, that is important, isn't it? Well then, what do you say? Shall we go for a little ride?

Cherche: Oh, look! Minerva's getting excited.

Gregor: If gods want Gregor to fly, they give him wings for arms! Or big balloon head! ...B-but if Gregor squeeze eyes tight and be with Cherche...is maybe not so bad!

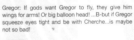
Owain (Father/son)

Owain's father/son dialogue can be found on page 289.

Inigo (Father/son)

Inigo's father/son dialogue can be found on page 293.

Brady (Father/son)

Brady's father/son dialogue can be found on page 297.

Kjelle (Father/daughter)

Kjelle's father/daughter dialogue can be found on page 299.

Severa (Father/daughter)

Severa's father/daughter dialogue can be found on page 305.

Gerome (Father/son)

Gerome's father/son dialogue can be found on page 307.

Morgan (male) (Father/son)

The Morgan (male) father/son dialogue can be found on page 309.

Yarne (Father/son)

Yarne's father/son dialogue can be found on page 314.

Laurent (Father/son)

Laurent's father/son dialogue can be found on page 316.

Noir (Father/daughter)

Noire's father/daughter dialogue can be found on page 317.

Nah (Father/daughter)

Nah's father/daughter dialogue can be found on page 318.

Nowi

Avatar (male)

The dialogue between Avatar (male) and Nowi can be found on page 221.

Avatar (female)

The dialogue between Avatar (female) and Nowi can be found on page 232.

Frederick

The dialogue between Frederick and Nowi can be found on page 247.

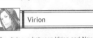
Virion

The dialogue between Virion and Nowi can be found on page 250.

Vaike

The dialogue between Vaike and Nowi can be found on page 255.

Stahl

The dialogue between Stahl and Nowi can be found on page 257.

Kellam

The dialogue between Kellam and Nowi can be found on page 262.

Lon'qu

The dialogue between Lon'qu and Nowi can be found on page 264.

Ricken

The dialogue between Ricken and Nowi can be found on page 266.

Gaius

The dialogue between Gaius and Nowi can be found on page 272.

Gregor

The dialogue between Gregor and Nowi can be found on page 274.

Libra

■ LIBRA X NOWI C

Nowi: Libra, give me a piggyback ride!

Libra: Ah! Careful there, Nowi! I didn't see you coming.

Nowi: Hey, what's this scar, Libra? Here on the back of your neck?

Libra: Don't touch it!

Nowi: Eep! S-sorry! Does it hurt?

Libra: N-no, it doesn't hurt. Not there, anyway. The wound is long healed...

Nowi: So why aren't I allowed to touch it?

Libra: Because it might reopen a deeper wound that yet causes me pain.

Nowi: Like...inside your neck?

Libra: I'm speaking of a wound of the heart.

Nowi: Ooooooooh! I get it! ...Wait, so your heart hurts? Why?

Libra: When I was a child, I was raised far from the home of my parents. ...In truth, I was abandoned by them.

Nowi: Oh no, that's terrible! Why would your mother and father do that?

Libra: Perhaps they hated me. Perhaps they had a better reason. I do not know. When they left me at that place, I began to howl most piteously. I clung to my mother so desperately I had to be forced off... Which is when I sustained the scar you see now.

Nowi: *Sniff* That's so sad!

Libra: I'm sorry. I didn't mean to upset you. And it's long in the past now.

Nowi: Well, I don't care! I'm going to make you feel better!

Libra: How will you do that?

Nowi: Just like a cramp—I'm going to rub your heart until the pain goes away! So, er... Where do you humans keep your hearts, anyway?

Libra: I've spent years avoiding what lies within mine... I'm not entirely sure if I could find it again if I tried.

Nowi: Okay, fine. Then I'll help. We'll find out where your heart is hiding and get rid of the pain together!

■ LIBRA X NOWI B

Nowi: How about here?

Libra: Hee hee! S-stop it! M-my backbone is very-...t-t-ticklish!

Nowi: Dang! This is harder than I thought... How about here? Is this your heart?

Libra: Ah ha ha! Now you're...t-tickling my ear!

Nowi: How about here?

Libra: Ah ha ha ha ha ha ha! N-not my s-sides! P-please!

Nowi: Libra, we won't get anywhere if you don't start taking this seriously!

Libra: Hooo... I-I'm trying, Nowi. I just had no idea that I was so ticklish.

Nowi: I'm just touching you! I'm hardly even moving my fingers!

Libra: I suppose it's because I'm not used to it. I've spent so much of my life trying to avoid simple human contact. Now the slightest touch makes my nervous system go into convulsions.

Nowi: But why do you avoid touching people? Don't you like hugs even?

Libra: I suppose it's because I lost the ability to trust people and so...feared them instead.

Nowi: Hmm. I can understand that. I mean, I was afraid of humans, too.

Libra: But you aren't anymore?

Nowi: Nope! Well, maybe a little bit. But not as much as before. I mean, I know there's lots of scary humans around, but there's lots of nice ones, too.

Libra: I envy you. Fear still holds me in its grip, no matter how I try to overcome it.

Nowi: Why don't I help you? For a start, I could introduce you to the nice people in camp.

Libra: Well, I suppose I'm willing to try if you are...

■ LIBRA X NOWI A

Libra: Er, Nowi? How much longer are we going to traipse through the camp?

Nowi: There are still loads and loads of nice people you haven't met yet!

Libra: Yes, but I'm worried we might be making a nuisance of ourselves.

Nowi: Don't be silly! People love it when you visit their tents unannounced!

Libra: I wonder.

Nowi: Trust me! Plus, the faster we find that heart of yours, the faster you'll make friends.

Libra: Yes, that would be wonderful. If it were to truly happen...

Nowi: Okay, whatever next? ...Oh, right! We haven't visited the storehouse yet.

Libra: The storehouse?

Nowi: Yeah, it's almost supper time. People'll be running in and out fetching ingredients.

Libra: You are much more familiar with the goings-on of the camp than I imagined.

Nowi: You didn't know stuff like that?

Libra: I'm afraid I've never paid much mind to how our meals are made.

Nowi: So you just slurp up your rations without a single thought for the folk in the kitchens?

Libra: To my shame, yes. I'm very selfish, aren't I? *Sigh* It appears I have a great deal more to learn from you than I realized!

Nowi: From me, of all people? Gosh.

Libra: Yes, you are really quite remarkable. I'm lucky to have you as my teacher!

Nowi: Hee hee! I like being remarkable!

■ LIBRA X NOWI S

Nowi: Phew! I'm exhausted, Libra.

Libra: Me, too. I had no idea it would take so long to meet everyone in camp.

Nowi: I told you there were a lot of nice people!

Libra: I'm ashamed I never realized it before. Thank you, Nowi.

Nowi: Hee hee! I'm just glad you met everyone and liked them all! So, how about it? Have you found your heart yet?

Libra: I'm not sure...

Nowi: Will it still hurt if I touch your scar?

Libra: ...I honestly don't know. Would you...care to try?

Nowi: Sure. Here goes...

Libra:

Nowi: Well?

Libra: It's...slightly ticklish.

Nowi: But it doesn't hurt anywhere?

Libra: ...No. In fact, quite the opposite. It's like a... warm and tender feeling.

Nowi: Where are you feeling it?

Libra: Right here...in my chest.

Nowi: The same place it used to hurt?

Libra: Yes... Yes, exactly!

Nowi: Well, then, I think we've found your heart!

Libra: How remarkable.

Nowi: Are you glad?

Libra: Of course. I'm...overjoyed.

Nowi: Hehe. That's good! 'Cause when you're happy, I'm happy, too.

Libra: Nowi, what would you say to us spending even more time together?

Nowi: I'd say that would be amazingly awesome, that's what! I was going to ask you the same thing since the last few weeks have been such fun.

Libra: In that case, perhaps you would do me an even greater honor? I'd like to give you this ring as proof of my love for you.

Nowi: Oh, Libra... You mean, like...as your wife?

Libra: Yes. I do believe that's exactly what I mean.

Nowi: Of course I will! This is the happiest day of my life!

Libra: If this fluttering in my chest is any indication, then it's mine, too, Nowi.

Tharja

■ THARJA X NOWI C

Nowi: Huh? Is that you, Tharja? What are you doing?

Tharja: ...Strange. I cannot read through the shell that cloaks your mind.

Nowi: Dragons don't have shells, silly! They have scales and talons and stuff.

Tharja: Speaking of talons, I need some of your nail clippings. Just a sliver or two from the ends will suffice.

Nowi: Um...what for?

Tharja: Manakete talons are used in dark-mage divinations. I want to see what the future holds between me and [Robin].

Nowi: Oh my gosh, you can tell fortunes? That's amazing! Okay, wait. ...Oof! Here's a bag of all my toenail clippings! ...Yes, I saved them. Don't ask why. Long story. Slightly gross. But! If you take these, I get to ask the first fortune. Deal?

Tharja: *Yawn* I suppose you want me to find you your true love, yes?

Nowi: What? No! Don't you dare poke around in my love life! No, I want you to find out about my mom and dad. Like, where they are, and if they're safe, and all that. Can you do it?

Tharja: ...Yes. Give me your clippings, and I shall begin the preparations.

■ THARJA X NOWI B

Nowi: Hey, Tharja!

Tharja: ...Oh. You.

Nowi: So did you do it? Did you find out about my mom and dad?

Tharja: ...Yes.

Nowi: So what's the story? Don't hold out on me. Spill those beans!

Tharja: Your mother and father are both...doing well. They worry about you all the time and can't wait to see you again.

Nowi: Oh, that's great! So where are they? I have to go see them.

Tharja: They are far, far away, Nowi. Too far for you to ever reach them.

Nowi: Pfft! Yeah, right. If they're beyond the oceans, I can fly to them. If they're in the deepest forest, I can walk to them. I'm kind of immortal, you know? I've got plenty of time.

Tharja: Ten thousand years would not be enough. Just be content knowing they're well.

Nowi: ...What aren't you telling me?

Tharja:

Nowi: Tharja, just tell me the truth. I'm a grown woman. I can take it.

Tharja: I could not locate your parents. And this means...

Nowi: That they've gone to a land so far away neither of us has ever heard of it?

Tharja: Um... Well, yes. I suppose it COULD mean that...

Nowi: Aw, what a shame. I suppose I won't be seeing them anytime soon, huh? Well, thanks anyway.

Tharja: You're, uh, welcome...

■ THARJA X NOWI A

Nowi: *Sniff* Mom... Dad... *sob*

Tharja: Nowi?

Nowi: H-huh? Oh... Tharja.

Tharja: You've figured it out, haven't you? About your parents.

Nowi: What do you mean? Do you have more news?

Tharja: Stop it, Nowi. You don't have to pretend. I can tell you've been crying. And I know why.

Nowi: I don't cry! I'm really strong! *sniff* Besides, nothing bad has happened. Mom and Dad are just... far away. So I don't have any reason to cry. ...Look, I'm fine, all right?

Tharja: All right. You weren't crying. I was clearly mistaken. ...Oh, I almost forgot. I decided to look into your future the other day.

Nowi: You did?

Tharja: You survive the war, and you end up living a very happy life. Every day is full of laughter, and you're never lonely again.

Nowi: Well, that sounds just like now! I have you, and all the Shepherds, and every day is super fun!

Tharja: And it's only going to get better. ...So dry those tears.

Nowi: Hmph. What tears? I'm strong, remember?

Tharja: So you are, Nowi... So you are.

Cherche

■ CHERCHE X NOWI C

Nowi: Hee hee! Yaaaaaay, Minerva! One more time! One more time!

Cherche: I'm glad you and Minerva are having so much fun together, Nowi. But maybe it's time to stop wrestling and give Minerva a break. Minerva is powerful, yes, but she's a formidable foe yourself in dragon form.

Nowi: Oh, right. Sorry, Minerva! Did I tire you out?

Cherche: Poor Nowi. You still want to play, don't you?

Nowi: It's okay, I don't mind. Well, I mind a little, but if Minerva is pooped, I'll just have to be patient.

Cherche: Perhaps I could take the place of Minerva.

Nowi: Are you crazy? I'm a dragon! I'll smoosh you into a paste!

Cherche: Oh, I don't know about that. I once bested Minerva, after all.

Nowi: What, really?

Cherche: Really. So you don't have to worry about scratching me with those claws, young lady.

Nowi: Hee hee! All right, then! Here I come!

■ CHERCHE X NOWI B

Nowi: How's this? I'm not doing it too hard, am I?

Cherche: No, that's just perfect. Mmm, I had no idea you were so good at back massages.

Nowi: When you're as old as I am, you pick up lots of stuff. Anyway, I'm still really sorry I hit you so hard with my tail. I didn't think you'd go flying like that!

Cherche: A little to the left, please... Ahhhhh, that's it. And don't worry. This isn't the first time a dragon smacked me.

Nowi: You know what I think? I think you made up that story about fighting Minerva. You just said that so I wouldn't feel bad about playing with you.

Cherche: Are you accusing me of spreading falsehoods, Nowi?

Nowi: What? No! ...Well, maybe a little bit. ...Okay, lift your head and turn.

Cherche: Oooooh, that feels good... Oh, and see the burn scar on my shoulder? Minerva did that when I captured her.

Nowi: Wow! You got hit by dragon fire and survived?!

Cherche: The thing is, when I first met Minerva, she was very weak. After that first puff, her fire was barely enough to singe my hair. If she'd been fully healthy, our fight would've turned out very differently.

Nowi: Hee hee. And after that first time, you grew to trust each other, huh? Gosh, you're so lucky to have a friend like Minerva. I'm super jealous!

Cherche: She's a good girl to have around, that's for sure.

■ CHERCHE X NOWI A

Cherche: Nowi? Nowi, are you all right?!

Nowi: Unnngh, no. But it's okay. ...D-did I lose?

Cherche: I'm so sorry! I thought you'd turn into a dragon before I could land my blow.

Nowi: Last time I was a dragon, I hit you so hard you flew into a tree. I didn't want that to happen again.

Cherche: That's very kind of you, Nowi.

But I don't want to hurt you, either. So next time, you make sure you enter dragon form. Do you hear me?

Nowi: Aw, it's fine. It hardly hurt at all! Plus sometimes I... I mean, I kind of like NOT being a dragon.

Cherche: Well then, maybe we could play a different game.

Nowi: Oh, sure! Like what?

Cherche: How about drawing pictures? That should be safe enough.

Nowi: Naw, that sounds boring. How about hide-and-seek?

Cherche: You don't like drawing pictures?

Nowi: I guess so, but then Minerva wouldn't be able to join in. Hide-and-seek is much better—all three of us can play!

Cherche: Then hide-and-seek it shall be.

Nowi: Great! I am SO going to win!

Henry

■ HENRY X NOWI C

Nowi: Whew! I've been playing all day and I'm pooped! What cute little kids!

Henry: I've seen them around. They're from one of the villages near the camp. But what do you mean, "cute little kids"? Aren't you a kid, too?

Nowi: No! I'm an adult woman who's more than a thousand years older than you!

Henry: Oh, right! Nya ha ha! Sorry, short stuff!

Nowi: H-hey! Do you always speak to your elders like that?

Henry: Nope! Just you. After all, how many "elders" do you know who play hide-and-seek as much as you?

Nowi: What's wrong with hide-and-seek? It's fun! ...In fact, you should join us next time.

Henry: Okay!

Nowi: Wait, really? Oh, that's so exciting! I've asked just about everyone in camp, but they always turn me down.

Henry: It's 'cause you're always so full of energy. "One more time, one more time, pleeease!" Most people just can't keep up with that kind of raw enthusiasm!

Nowi: I know, right? It's so annoying how quickly some people tire out. I mean, ten hours? Come on! That's like a warm-up! Do you know I haven't found a single playmate since I joined this dumb army? ...Until now, that is! Hee hee! We're going to play games from dawn to dusk!

Henry: I know how you feel! Ya know, I don't tell many people this, but I was kind of abandoned when I was young. My family ignored me completely, and I didn't have any playmates. But it was fine, because I learned to amuse myself! Oh, and make friends with animals.

Nowi: Then we're exactly the same! But now we have each other, right?

Henry: Nya ha ha! You know it!

■ HENRY X NOWI B

Henry: Jeepers! I don't think I've ever seen a gaggle of children run away so fast!

Nowi: ...I think I goofed up.

Henry: Well, yeah! How did you think they'd react to a dragon appearing in their midst?

Nowi: I just wanted to give them a ride on my back! I mean, everyone likes flying, right? *Sigh* They were absolutely terrified, huh? I suppose they won't play with us again.

Henry: Yep! They're probably quivering in fear under their beds and crying like babies! But no worries! There'll be more victim—er, that is, village kids—at our next camp.

Nowi: Kids are really stupid! Why didn't they see me in dragon form? And doesn't everyone want to play with a dragon? I mean, come on... Flying in the sky... Exchanging fire breath... Listening to my blood-curdling roars...

Henry: If they exchanged fire breath with you, they'd end up as little clumps of charcoal.

Nowi: *Sigh* I wish I had some manakete friends. That would be more fun.

Henry: Well, I can't promise anything, but I might be able to conjure one up for you.

Nowi: You could?

Henry: Sure! I'll need to make some preparations first, though. Might take some time.

Nowi: Oh, that's fine! Everyone knows I'm the best at being patient.

■ HENRY X NOWI A

Henry: Ta-daaah! What do you think?

Nowi: Wow! It's a dragon!

Henry: Pretty little thing, isn't she? Now you'll have someone to breathe fire with!

Nowi: I-is she a manakete like me? Where in the world did you find her?! Hello, dragon. My name is Nowi! It's super nice to meet— Huh? My hand just...went right through her like she wasn't there...

Henry: Right. You can't actually touch her. My magic is good, but not THAT good!

Nowi: You mean...she's an illusion?

Henry: Yep! So, what do you think? Do you like her?

Nowi: No! She's stupid!

Henry: Hey! I spent a lot of time and effort on this, you know!

Nowi: I want a real friend! Someone I can laugh with and talk with and cry with! I'm going to look super dumb exchanging jokes with a mute astral projection!

Henry: Aw, nuts. I thought you'd really love her.

Nowi: I know you're just trying to help, Henry, but this isn't going to work.

Henry: No problem! I'll come up with a better idea, that's all. Easy peasy. And as soon as I do, you'll be the first to know!

Nowi: Aw, you're such a good friend, Henry. Thank you!

Henry: Nya ha ha! No sweat!

■ HENRY X NOWI S

Henry: Hey, Nowi. I've finally conjured up a plan that'll solve your problem.

Nowi: You mean about finding me a manakete friend?

Henry: Yep. And unlike the hologram, this will be a real live, talking, laughing dragon. The only catch is it's going to take time. ...Lots and lots of time.

Nowi: Aw, I don't care. Didn't I tell you I'm really good at being patient?

Henry: Okay. So first of all, you have to accept this.

Nowi: It's a ring...? What's this for?

Henry: Because you and I are going to get married! Chrom did that and he ended up with that cute little daughter. So my plan is, we'll get married and have a bunch of children. They're going to be part manakete, what with you being the mom and all. And then once they grow up, BAM! Manakete playmates for life!

Nowi: Gosh, Henry! That's ingenious! Why didn't I think of that? Hee hee! So I suppose this means we're going to be husband and wife?

Henry: Sure does! A lifetime of fun and games, coming right up!

Donnel

■ DONNEL X NOWI C

Nowi: Hey, can I see that rock?

Donnel: Huh?

Nowi: Ker...FLING!

Donnel: Horse apples! What'd ya go and do that for?!

Nowi: Yay! I got it!

Donnel: H-hey! Hold up a minute!

Nowi: Check it out, Donny! I bagged a pheasant!

Donnel: *Huff* *pant* Forget yer bird, Nowi! The stone! Where's my stone?

Nowi: What, this one?

Donnel: Aw, there she is! Whew...

Nowi: Oh, sorry. Was it important?

Donnel: More than anythin' I own. It's my one real treasure. ...It belonged to my pa.

Nowi: O-oh my gosh, Donny! *sniff* I'm s-sorry! I didn't know! I... Waaaaaaaah!

Donnel: Tho, now! No need to start bawlin'! I ain't mad! ...Least not anymore.

Nowi: *Sniff* ...Y-you're not?

Donnel: Naw. Ain't no harm done.

Nowi: H-here. You should take this pheasant. I'll even roast it for you! I'm not sure what temperature to put my breath at, but I figure about 10,000 degr—

Donnel: Gah, wait, wait! I'll just build a fire! This ain't the time nor the place to go turnin' into a dragon, Nowi.

Nowi: ...But I like turning into a dragon.

Donnel: Look, we got us plenty of dry wood. Just sit back, and I'll have us a fire goin' in two shakes of a pig's tail.

Nowi: Okay. Thanks, Donny!

Donnel: Gosh, but that was close...

■ DONNEL X NOWI B

Nowi: Hey, Donny. You still have that stone from before?

Donnel: You mean my pa's stone? Course I do.

Nowi: Can I see it? I promise not to throw it! Pleee-ase? ...Oooh, it's so pretty. Is that why it's your most favorite treasure?

Donnel: Looks ain't got nothin' to do with it. The stone's part of a promise with my pa.

Nowi: A promise?

Donnel: He gave it to me back 'fore he died. He always loved rocks and stones and such, but this was his favorite. He said it had a kinda power in it, all hidden away. That it was greater than it looked. Reckon I don't quite understand all that, but it's what he believed. So I promised him one day I'd figure it out and release that hidden power!

Nowi: Wow. I'm jealous.

Donnel: Of my stone? But you got one what turns ya into a dragon!

Nowi: No, of your promise with your father! I never knew my father. Never got to talk to him...

Donnel: I'm real sorry to hear that.

Nowi: Oh, but I do remember where I was born!

Donnel: Oh yeah? Where's that?

Nowi: I... I forget!

Donnel: Huh? But ya just said—

Nowi: No, I do remember, but just not right now. Next time I have it, I'll tell you!

Donnel: Er, I don't quite understand all that, but I guess I'll look forward to it.

Nowi: Hee hee, let's play! You're the most fun to play with around here!

Donnel: Aw, shucks, Nowi! I think yer a real hoot, too!

■ DONNEL X NOWI A

Nowi: Hey, Donny! I remembered where I was born!

Donnel: Aw, yeah? Where at?

Nowi: It's all the way left from here!

Donnel: What, ya mean west?

Nowi: No, left! Across the ocean and way to the left!

Donnel: I ain't sure I follow. You don't know any landmarks or nothin'?

Nowi: No, not really. I was kidnapped right after I was born.

Donnel: Oh, gosh! That's terrible!

Nowi: It's my dream to go back to my homeland someday.

Donnel: Oh yeah?

Nowi: I mean, maybe I've got friends and family there, right?!

Donnel: Well, if I find it first, I reckon I'll be sure to come runnin' and tell ya!

Nowi: You promise? Yay! Oh, oh! And if I find it, I'll come tell you, too!

Donnel: Now that there's a square deal!

Nowi: Yeah! I'm really hungry!

Donnel: ...I sure do have trouble keepin' up with ya sometimes, Nowi. But if yer tummy's a'rumblin', I set me a trap a couple days ago. Wanna go see if we caught anythin'? If we got us a rabbit, I'll fix ya a Donny Special!

Nowi: Yaaay! You're the bestest, Donny!

■ DONNEL X NOWI S

Donnel: Hey, Nowi. So, I was thinkin'... We both got things we're lookin' for, right?

Nowi: Right!

Donnel: Well, why don't we look for 'em together?

Nowi: Oh, that's a great idea! Here, let's promise! Pinky swear!

Donnel: Er, I was thinkin' of somethin' a mite different than a pinky swear...

Nowi: ...Thumb swear?

Donnel: I reckon this one's gonna need yer ring finger...

Nowi: Oh... I see! Donnel, are you saying what I think you're saying? Because—

Donnel: Sure am. It's a marriage promise.

Nowi: Hee hee, I knew it! People forget I've been around the block a few thousand times.

Donnel: Well, now it's finally time to take things to the next level. Let's have yer hand, then.

Nowi: Here...

Donnel: Yee-haw! It's a perfect fit!

Nowi: Yaaay! We did it!

Donnel: Now we're promised to each other.

Nowi: No take-backs!

Donnel: Don't ya go and worry 'bout that. I'm gonna live out my life at yer side.

Nowi: Thanks, Donny! You're the best!

Donnel: Aw, I'm so happy, I'm gonna dance a jig! Yeeeeeeeee-haaaaaaw!

Morgan (female) (Mother/daughter)

The Morgan (female) mother/daughter dialogue can be found on page 312.

Nah (Mother/daughter)

■ NAH X NOWI (MOTHER/DAUGHTER) C

Nowi: Nah, look, look! See all the pretty flowers?! Let's go pick some and make flower necklaces! It'll be fun! SO much fun!

Nah: You go. As you can see, I'm busy right now.

Nowi: What is that, some kind of picture book? Let me see... Oh, boo! It's full of writing!

Nah: It's a book on the use of dragonstones in battle. I found it in the baggage train.

Nowi: Is it fun? Because it looks like the opposite of fun.

Nah: Of course it isn't "fun." But it's vital that I study these kinds of things.

Nowi: This army would be WAY better if we didn't have to do so much boring stuff.

Nah: Doubtless. But it's our duty to learn all the arcane secrets of our dragonstones. We have inherited a unique, and truly powerful, ability. We must cultivate and master it so that we can better serve our allies in battle.

Nowi: Ew. Do you always use such big words? I'm not used to thinking so hard! Why don't we run out to the woods and play a game before our brains melt?

Nah: Mother, you need to take this more seriously. We're in the midst of a war!

Nowi: I KNOW, silly. But thinking about it all the time isn't going to help me! The tougher things get, the more I laugh, and the easier we laugh, too. I think that's kind of my job here. To keep everyone smiling.

Nah: Wait. You think your role in this army is to play all the time?

Nowi: Exactamundo! So what do you say? Let's go play!

Nah: *Sigh* Well you certainly are good at your "job," I'll give you that...

(Cross-references to other pages appear inline below with each portrait entry.)

■ NAH X NOWI (MOTHER/DAUGHTER) B

Nah: Oh, darn. It's not here, either. Where can it be?

Nowi:

Nah: Oh, hello, Mother. Have you seen my dragonstone anywhere?

Nowi: D-dragonstone? Er, NO! Not a clue! I have no idea. Nope. None whatsoever.

Nah: ...You're a terrible liar.

Nowi: B-but I'm NOT lying! Ha ha. Ah ha...ha?

Nah: *Sigh* All right, Mother. What did you do with it?

Nowi: Nothing! ...I, er, just decided to look after it, is all.

Nah: Give it back! Honestly, how am I supposed to train without it?

Nowi: Oh, training, schmaining! Let's have some fun instead.

Nah: I don't want to have fun. I want to get stronger. If I don't, I'll never help win this war or earn my place in this army.

Nowi: Er...

Nah: If I'm not helping people, then what's the point of even having me around? No real human wants to be friends with a half person who can't look after herself.

Nowi: Is that what you're worried about? But I'M here—and I'm a manakete! You don't have to prove something to the humans to be here with us. Manakete, taguel, human—everyone in this army is equal and in it together!

Nah: You truly believe that?

Nowi: I do. And more importantly, you're still very young for a manakete. You can't overuse the dragonstone. It's far too powerful for one of your age.

Nah: It's true that after a day of training I tend to feel terribly weak...

Nowi: I'm going to give it back to you, but I don't want to see you hurting yourself. You must promise me to only use it during actual battle. Do you hear me?

Nah: All right, Mother. I swear to use it more responsibly from now on.

■ NAH X NOWI (MOTHER/DAUGHTER) A

Nowi: Nah! Nah! Come on, Nah! I'm over here!

Nah: *Pant, pant* I don't think... I can run...*pant*... any more...

Nowi: Tsk. Well, I suppose we can rest for a while if you REALLY have to.

Nah: D-don't you think we've...played enough? Maybe we could...study a bit...

Nowi: BOOOOOORING!

Nah: Mother, you do realize we're in the middle of a cataclysmic war, yes? The fate of the entire world depends on whether or not we emerge victorious.

Nowi: I know! That's why we have to get stronger and always be ready to fight.

Nah: Which means we must study—

Nowi: Nah, when it comes to thinking or studying, I leave that to Chrom and [Robin]. I trust them to do their egghead jobs, and they trust me to fight.

Nah: Yes, but training and studying...that's how we grow stronger.

Nowi: You DO know that training isn't the only way to make yourself strong, don't you?

Nah: But how else... Wait. Are these games how you practice for battle?

Nowi: Well, it tired YOU out, didn't it? The more you play, the stronger you get!

Nah: ...It appears I might have underestimated you, Mother. From now on, I'm going to trust you more. ...AND start playing a lot more seriously!

Nowi: "Playing seriously"? Oh Nah, that is SO like you!

Libra

Avatar (male)

The dialogue between Avatar (male) and Libra can be found on page 221.

Avatar (female)

The dialogue between Avatar (female) and Libra can be found on page 233.

Lissa
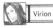

The dialogue between Lissa and Libra can be found on page 244.

Virion
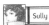

The dialogue between Virion and Libra can be found on page 250.

Sully
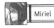

The dialogue between Sully and Libra can be found on page 253.

Miriel
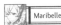

The dialogue between Miriel and Libra can be found on page 260.

Maribelle
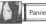

The dialogue between Maribelle and Libra can be found on page 268.

Panne

The dialogue between Panne and Libra can be found on page 270.

Gaius
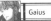

The dialogue between Gaius and Libra can be found on page 272.

Cordelia
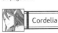

The dialogue between Cordelia and Libra can be found on page 273.

Nowi
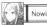

The dialogue between Nowi and Libra can be found on page 275.

Tharja
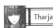

■ THARJA X LIBRA C

Tharja: Spoonful of frog's wart... One lizard tail... Cockscomb of a coal-black rooster...

Libra: What are you doing, Tharja?

Tharja: Trying to invent a spell that can change memories.

Libra: Is such a thing even possible?

Tharja: Well, I'll never know if you stand there and bother me, will I?

Libra: Ah, of course. I'll leave you to it. Er, but before I go, can I ask you one thing?

Tharja: Make it snappy.

Libra: How are you going to determine if the experiment is a success?

Tharja: I'll cast the hex on someone and see what happens. Same as always.

Libra: In that case, I would like to volunteer to be your test subject.

Tharja: Oh? A priest wants to sacrifice himself for the greater good? Shocker.

Libra: Unfortunately, my motives are largely selfish.

Tharja: Sure, whatever. I accept anyway. Just don't blame me if it all goes horribly wrong.

Libra: Er, is that a possibility?

Tharja: No curse is without danger. There's always a risk of harm—to body AND to soul.

Libra: I see. Then, I shall prepare for the worst, but hope for the best.

Tharja: Pray to whatever gods you believe in, Priest. ...This is going to be fun.

■ THARJA X LIBRA B

Tharja: I shall now attempt to cast the memory-transformation spell...

Libra: Ready when you are.

Tharja: We should act on a memory that won't affect your ability to fight in battle.

Libra: Something from my childhood would probably work best. For example—

Tharja: Hey! I'm calling the shots here. But, er, just for fun... If you could choose a new memory, what would it be?

Libra: I'd like to remember a time spent with doting parents in a warm, loving home. Could you conjure such a memory?

Tharja: That sounds positively nauseating. But who am I to criticize? Think hard about the scene... Visualize it in your mind's eye...

Libra: Ah! I can see it now!

Tharja: All right...here goes... ...Nmmm...mmm...nn-ngh... ...What? This cannot be.

Libra: Is something wrong?

Tharja: ...Er, no! No, no. Nothing at all. There, done. The hex is cast. Do you feel different?

Libra: Um, no, not really.

Tharja: Huh. Well, I guess it didn't work.

Libra: Maybe I'm the problem.

Tharja: No. It failed because I don't yet have the talent and knowledge. Er, but Libra. When I cast the hex, I saw... Well, I saw a terrible darkness in you. What was that?

Libra: ...Ah. I see. I tried to hide it from you, but it appears I failed. My hope was that your hex would extinguish it before you knew of it.

Tharja: So that's why you volunteered to be my guinea pig.

Libra: As I said, my motives were selfish. I'm sorry for using you like this.

Tharja: No skin off my back. But now I'm very interested in all that darkness festering inside you... If I could tap into it, it could power some truly intense hexes.

Libra: In that case, would you like to continue experimenting on me?

Tharja: Doesn't it scare you to go delving into that dark place?

Libra: I am beyond fear, dear Tharja. Nothing can terrify me.

Tharja: A lot of dark mages would take such a boast as a challenge.

Libra: Heh heh. Perhaps I'm not beyond fear after all.

■ THARJA X LIBRA A

Tharja: I...I saw it. I saw everything. I know what lies in the dark depths of your heart.

Libra: Then you know my most secret of secrets... That my parents believed I was possessed by demons and abandoned me. And you know the terrible price this inflicted on my soul.

Tharja: You were alone and loved by no one. An urchin, wretched and friendless. Until you found the faith and became a priest, your only memories are pain. ...I don't know how you manage to survive with such a burden.

Libra: Nor do I. But, strangely, now that you know of it, the burden has grown lighter. It's as if the very act of your witnessing my sorrows has blunted their power.

Tharja: When hearts and minds come together, they sometimes change each other. It's like a spell of sorts—if one side is transformed, the other is, too.

Libra: Perhaps your magical hex somehow dispelled my darkness.

Tharja: Doubtful. I didn't cast anything of the sort. In any case, I can no longer use you as a test subject.

Libra: Why not?

Tharja: Because I have nothing further to learn from you. Once you know someone's secret pain, curses become a bit too easy.

Libra: That is unfortunate. I'd hoped I could help you more. Well, if you ever think of something else I might do, will you tell me?

Tharja: Maybe you should just focus on being happy for a bit, you know? Now you can face life without all that pain dragging you down.

Libra: Yes... Hmm. Thank you, Tharja. I shall do just that!

■ THARJA X LIBRA S

Libra: Tharja? Might I have a word?

Tharja: What is it?

Libra: I wonder if you wouldn't mind looking into my heart once more.

Tharja: Why?

Libra: It will be easier for you to look than for me to tell you.

Tharja: You know, you priests can be very pushy when you want to be. Maybe this time I'll do more than look. Did you consider that? Maybe this time I'll plant a seed of terror in your soul.

Libra: Anytime you're ready.

Tharja: Wow, someone's serious today. All right, don't move...

Libra: I won't.

Tharja: Wh-what is... I don't understand.

Libra: You looked into my heart, didn't you? You saw the feelings I have for you.

Tharja: Why did you make me do this?

Libra: When hearts touch, they affect each other. Much like a curse does, or so you said.

Tharja: I maybe said...something like that.

Libra: So how do you feel? Any change in your heart? Any new yearnings or feelings?

Tharja: You seek to put a hex on MY heart? Y-you're a priest! How dare you!

Libra: Well, you started it.

Tharja: I most certainly did not.

Libra: The love I feel must have grown naturally from my own heart. And how is it YOU feel, Tharja? Because while priests can do many things, casting hexes is not one of them.

Tharja: Liar! You're lying! You have to be! O-otherwise...

Libra: Otherwise we have fallen in love with each other naturally.

Tharja: Are you sure this isn't a trick?

Libra: Love has no value if it is won by deception.

Tharja: Then I guess I have no choice but to believe my heart.

Libra: So if I were to offer this ring and propose marriage, would you accept?

Tharja: You had a ring all ready? That's rather bold, Libra.

Libra: Such fateful moments come but rarely in our lives. I did not want this one to pass me by.

Tharja: It's strange, but you seem completely different from the man whom I first met.

Libra: Different in a good way, I hope?

Tharja: ...Yes. Different in a very good way. And now you'll be the second-most important person in my life. ...After [Robin].

Libra: Um, well, I...suppose I can live with that?

Olivia

■ OLIVIA X LIBRA C

Libra: In Naga's name, we sing...

Olivia: Oh! How lovely...

Libra: Oh, excuse me. Olivia, isn't it? Can I help you with something?

Olivia: Oh, er, no. I was just passing by and saw you and well... Sorry to intrude.

Libra: Not at all. I was just finishing.

Olivia: I'm sorry, but were you dancing just now?

Libra: I was, or at least I was attempting to. A professional like yourself must have gotten a good chuckle out of it.

Olivia: No! Quite the opposite. I've just... I've never seen a dance like that before. The way you clutched at your chest and looked skyward was... Well, it was kind of amazing, to be honest.

Libra: It is a devotional dance meant to serve as a prayer to the gods. I am at best a clumsy dancer, so I do not do it justice. However, it is a ritual that all the faithful learn at some point.

Olivia: It was beautiful. Truly it was.

Libra: To be praised by one of such divine talent is no small honor.

Olivia: Er, would you mind terribly if I watched you again sometime? I mean, as long as it isn't blasphemous or something.

Libra: You would be welcome. Such praise is meant to be shared with all.

Olivia: Oh, yay! Thank you!

■ OLIVIA X LIBRA B

Olivia: La de dum... La de dum de doooo...

Libra: Goodness...

Olivia: Oh, Libra! I didn't see you there.

Libra: Very impressive, Olivia. But who taught you the movements of our sacred devotional dance? As far as I know, the only time you saw it performed was when you watched me.

Olivia: I usually only need to see a dance once to be able to learn it. But this one is different. It's like I'm going through the motions.

Libra: To truly perform the devotional dance, you must understand its subtext.

Olivia: Um, could you maybe explain it to me... if you have the time?

Libra: It would be my pleasure. Now, this initial arm movement...

Olivia: Okay. And in this bit you're offering thanks for the blessing of rain?

Libra: Yes. As you raise both arms, you lift the prayer from the ground to the heavens.

Olivia: Got it.

Libra: ...Well, I believe that is everything. Do you have any questions?

Olivia: No, thank you. You explained everything perfectly!

Libra: I'm glad to be of service.

Olivia: You're really good at this, you know? You should be a priest or something!

Libra: Actually...

■ OLIVIA X LIBRA A

Olivia: Aaand ONE and TWO and...

Libra:

Olivia: Oh, hello, Libra. What do you think? Am I getting better?

Libra: *Sniff*

Olivia: Libra? Are you all right? You're not crying, are you?!

Libra: ...Do forgive me, my dear. *sniff* *sniffle*

Olivia: What's the matter?

Libra: ...I'm sorry, I don't think I've wept like this in years. Your dance has freed my heart from a prison of ice!

Olivia: Gosh, really? Was I that good?

Libra: I thought the gods themselves had descended to dance in your person!

Olivia: Uh, wow! That's high praise.

Libra: It is no easy thing to lift prayers to the gods. Yet your dance was flawless.

Olivia: Well, er, thanks! But, of course, I couldn't have done it without you. I mean, you're such a good teacher, and you made everything so clear.

Libra: No, it is you who has taught me with your magnificent dance. I am the one who is grateful!

Olivia: Well, if that's the case, you're welcome to come watch. I mean, if you want.

Libra: Thank you. I shall do that.

■ OLIVIA X LIBRA S

Libra: Though it sits in my palm before me, I cannot believe I have taken this step...

Olivia: Hi, Libra!

Libra: Ah! Olivia! ...What did you see?!

Olivia: Um, you standing there? A couple of trees, maybe?

Libra: You didn't see anything in my hand?

Olivia: Um, no? ...Geez, you're acting really weird right now. Anyway, I came by to give you this. As thanks for the dancing lessons.

Libra: ...A crown of flowers? Why, it's beautiful! Did you make it yourself?

Olivia: Yep! It took a while, but it was the least I could do. Here...

Libra: Thank you.

Olivia: So...okay then! Guess I'll be going now.

Libra: Olivia, wait.

Olivia: Huh?

Libra: I also have a gift for you, Olivia. Would you accept this small token?

Olivia: Oh, look! It's a ring! ...Gosh, this is really pretty.

Libra: This is more than a mere trinket, Olivia. It is a symbol of my love. I wish to spend the rest of my life with you.

Olivia: Oh, Libra! That's wonderful! I'd love to get married!

Libra: Your words bring joy to my heart.

Olivia: Yes! And we have your sacred dance to thank for it!

Cherche

■ CHERCHE X LIBRA C

Libra: I say... Was that the lonesome cry of a wyvern? Heavens, I do believe it's getting closer. ...Yes, there it is. My, look at all those razor-sharp teeth.

Cherche: Minerva, stop that howling! We've heard quite enough already. I'm sorry if she startled you, Libra. ...Although, you don't seem very startled, actually.

Libra: Oh, it hardly bothers me. I've had plenty of past opportunities to grow used to it.

Cherche: You must be a seasoned adventurer, to be so complacent about wyverns!

Libra: Well, not wyverns specifically. But I have tangled with the occasional fell beast. Tell me, though. Is it not difficult to teach a wyvern to heel?

Cherche: Well, Minerva is not my servant, Libra. She's family. If she obeys me, it's because she chooses to do so.

Libra: A wyvern treated as family?

Cherche: Is that so strange?

Libra: Well, I don't mean to judge you, milady. But frankly, yes. It does seem a bit strange. I didn't even think it possible to forge bonds between such disparate races. But I am glad to see it. Such open thinking embodies the word of the Ylissean faith.

Cherche: Oh, now you're just flattering me.

Libra: Flattery is a sin, milady. I would not dream of using it. But you have inspired me to follow your wonderful example. I, too, shall seek out a member of another species and attempt to befriend it!

Cherche: ...I hope he knows what he's doing.

■ CHERCHE X LIBRA B

Libra: You and I shall be wonderful friends, even if you don't speak human speech! What does such a trifle matter when we are building a bridge between our very hearts?

Cherche: Libra? Are you speaking to that mole?

Libra: We are establishing a connection, milady. A meeting of the minds, if you will.

Cherche: Going well, is it?

Libra: Difficult to say. I have no way to tell what the creature is actually thinking. I don't suppose you would have any advice in this arena?

Cherche: Not much, I'm afraid. Minerva is very good at making her feelings known. Whereas you are essentially talking to a furry beanbag.

Libra: *Sigh* This is harder than it looks...

Cherche: Well, if you like, you could try making friends with Minerva. You'd like that, wouldn't you, girl?

Libra: Gods save us! She sounds enraged!

Cherche: Oh no, that was her happy howl. Enraged is more...snippy. She's taken quite a liking to you. Not many can look at her without trembling in fear.

Libra: I appreciate the vote of confidence.

Cherche: See? You two are friends already, and you haven't even started yet!

Libra: Well, if you're sure Minerva would not mind...

Cherche: Not at all. And I'll be happy to offer advice and such whenever you need it. ...Or if she tries to eat you. But I doubt that'll happen.

Libra: I should hope not!

■ CHERCHE X LIBRA A

Libra: Hello, Minerva. How are you? Splendid weather, isn't it?

Libra: Ha ha. Yes, yes indeed. Cloudless skies? A dry southerly wind? It's a perfect day for an airborne tour!

Cherche: You two are as thick as thieves, aren't you!

Libra: Ah, hello, Cherche. And yes, I feel we have established a true heart-to-heart connection. It's all thanks to you.

Cherche: Heh. I fear this is all your doing. You spend so much time with her, Minerva has grown very fond of you.

Libra: To think that I've become close friends with a member of another species... But no... I mustn't think like that.

Cherche: Like what?

Libra: I fight the instinctive urge to place individuals into categories. We are all fellow creatures in the eyes of the gods. I never truly understood this until my contact with Minerva.

Cherche: I bet she noticed the change in your thinking. She's a very wise wyvern.

Libra: Indeed! I am starting to learn the truth of that. And if you don't mind my saying, I think you are very wise as well.

Cherche: I've learned a lot from Minerva, I imagine.

Libra: I do envy your relationship. I would love to be so close to her. I must continue to devote myself to building trust and friendship.

Cherche: I'm sure you'll succeed if you put your mind to it!

■ CHERCHE X LIBRA S

Libra: Hmm... That's Minerva. But something sounds wrong. ...Minerva, what is it? What happened?

Libra: ...What? It's Cherche?! She's not feeling well? Understood. I'll come right away!

Libra: Cherche!

Cherche: Hello, Libra. What are you doing here?

Libra: Minerva came to me in a panic. She said you were ill.

Cherche: Really? She said that?

Libra: Please, Cherche, what is the matter? Shall I summon a doctor?

Cherche: A doctor will not help, I'm afraid. I suffer from an ailment of the heart.

Libra: Ah. Then I believe I understand, then. ...You are in love with me.

Cherche: That's... Um... I had actually expected this to be somewhat more couched in metaphor... But yes, Libra. I am.

Libra: I see.

Cherche: I'm sorry. I didn't mean to spring it on you so suddenly, but I couldn't—

Libra: Do not apologize. Your words bring joy to my heart.

Cherche: They do?

Libra: Absolutely! I would not lie to you about such a thing. I confess, in bouts of wild optimism, I prayed this day might come. And yet, I am a man poor in worldly goods, and do not have a ring to offer you.

Cherche: I don't need a ring, Libra. You just have to promise to love me forever!

Libra: Then I pledge, on bended knee, my eternal love! ...And promise to buy a ring later.

Owain (Father/son)

Owain's father/son dialogue can be found on page 289.

Inigo (Father/son)

Inigo's father/son dialogue can be found on page 293.

Brady (Father/son)

Brady's father/son dialogue can be found on page 297.

Kjelle (Father/daughter)
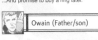

Kjelle's father/daughter dialogue can be found on page 299.

Severa (Father/daughter)

Severa's father/daughter dialogue can be found on page 305.

Gerome (Father/son)

Gerome's father/son dialogue can be found on page 307.

Morgan (male) (Father/son)

The Morgan (male) father/son dialogue can be found on page 309.

Yarne (Father/son)

Yarne's father/son dialogue can be found on page 314.

Laurent (Father/son)

Laurent's father/son dialogue can be found on page 316.

Noire (Father/daughter)

Noire's father/daughter dialogue can be found on page 317.

Nah (Father/daughter)

Nah's father/daughter dialogue can be found on page 318.

Tharja

Avatar (male)

The dialogue between Avatar (male) and Tharja can be found on page 222.

Avatar (female)

The dialogue between Avatar (female) and Tharja can be found on page 233.

Frederick

The dialogue between Frederick and Tharja can be found on page 247.

Virion

The dialogue between Virion and Tharja can be found on page 250.

Vaike

The dialogue between Vaike and Tharja can be found on page 255.

Stahl

The dialogue between Stahl and Tharja can be found on page 257.

Kellam

The dialogue between Kellam and Tharja can be found on page 262.

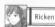

Lon'qu

The dialogue between Lon'qu and Tharja can be found on page 265.

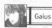

Ricken

The dialogue between Ricken and Tharja can be found on page 267.

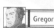

Gaius

The dialogue between Gaius and Tharja can be found on page 272.

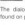

Gregor

The dialogue between Gregor and Tharja can be found on page 274.

Nowi

The dialogue between Nowi and Tharja can be found on page 276.

Libra

The dialogue between Libra and Tharja can be found on page 277.

Henry

HENRY X THARJA C

Tharja: I know you.

Henry: You do?

Tharja: When I still fought for Plegia, we heard all sorts of stories about you. A silver-haired youth with a knowledge of curses and an extraordinary gift for magic. A man guarded by fierce crows so that very few had seen the true extent of his powers.

Henry: Oh wow! Now that's a reputation! Yeah, crows have always had a thing for me, I guess. Dunno why.

Tharja: Perhaps you'd be willing to teach a trick or two to a fellow dark mage?

Henry: Sure! You want me to cast a death curse on someone?

Tharja: Someone in camp? Mmm... No. That could be problematic.

Henry: Hee hee! Yeah, I guess. Too bad, though. See, 'cause I've got one that makes blood come out your—

Tharja: Thank you, I get the picture. What's with the smiling, anyway? No one's going to trust you if you're grinning like the village idiot.

Henry: Hee hee! Smiling? This is how I always look.

Tharja: Hardly reassuring. Tell me what you're plotting and I may yet spare you.

Henry: Sorry! Nothing sinister over here. I'm just a hale and hearty mage.

Tharja: Ugh... Hale? Hearty? Have you no respect for our ancient profession? We're supposed to be harbingers of pestilence and famine and doom!

Henry: Mm... I love doom.

HENRY X THARJA B

Henry: Hello, Tharja!

Henry: Heey! Did you just put a curse on me?

Tharja: Yes. Now, if you do not speak the truth, you will DIE! Answer me clearly and without hesitation. Are you a foreign spy?

Henry: Nope! Not me! Although I do own a cloak and a couple daggers.

Tharja: Who do you serve? Ylisse or Plegia?

Henry: Aw, I don't get into politics. I just want to toss fireballs at bad guys.

Tharja: Interesting. That's the same reason I joined up.

Henry: Really? Hey, would you maybe tell me all about it?

Tharja: I'm doing the interrogating here. Now then, one final question... Do you vow to never cause harm to [Robin], no matter what?

Henry: No problem!

Tharja: ...How strange. My magic ensures that you are telling the truth, but I find your heart difficult to read. It seems devoid of human emotion. What's inside that head of yours? What are you thinking?

Henry: Right now, I'm thinking about you. And about how you must really really REALLY like [Robin]!

Tharja: Mind your own business, little man.

Henry: Is that why you're always following (him/her) around?

Tharja: I wouldn't expect someone like you to understand affairs of the heart. In any case, you may go. I have no further use for you.

Henry: Hey! You forgot to remove the curse! Oh, well. I suppose it'll fizzle out eventually. La la la...

HENRY X THARJA A

Tharja: Here you are.

Henry: Yep! Here I am!

Tharja: I have a rather urgent problem, and I need your help.

Henry: Do you need a death curse? Please say you need a death curse.

Tharja: No death curses! It appears that I, myself, am victim of a curse from an unknown assailant. I have tried to remove it, but the magic is too powerful. I'm hoping that if we combine our might, we may be able to—

Henry: Hecka-necka, jimma-jamma, woozle-wazzle! Aaand presto! Curse dispelled! Actually not dispelled. I tossed it back at the original sender. Hee hee!

Tharja: That's impossible. By the gods! It IS gone.

Henry: Yeah, dispelling curses is kind of my speciality. Right now, whoever cast that curse must be in one confused pickle! Too bad we can't be there to see it. That would be swell!

Tharja: With that kind of power, you could have easily deflected my earlier curse...

Henry: Oh yeah. I guess so, huh? Although you didn't really need to put a truth curse on me, you know? I don't have anything to hide, and I've never told a lie in my life.

Tharja: Aha! At last you reveal the source of your power. You disarm your foes with terrifying honesty and sincerity!

Henry: Well, usually I disarm foes by removing their arms. But your way sounds impressive, too!

Tharja: It's not a compliment.

Henry: Hee hee! I know!

Tharja: Stop being so blasted cheerful, or I'll... I'll twist your tongue in knots!

Henry: Oh, you can try to cast a hex on me...if you dare!

Tharja: Don't think you're the only one who can deflect curses!

Henry: Wizard fight! Wizard fight! Yaaaaaay!

HENRY X THARJA S

Henry: Hey, Tharja! Look at these flowers I found! Aren't they pretty?

Tharja: Er, yes. Sure. I suppose they are.

Henry: Aw. You're just saying that. You don't think they're pretty at all! Poor little flowers—after they went to all that trouble to bloom and everything.

Tharja: Are you actually talking to them? That's more than a little creepy. If you don't cease at once, I'll cast a hex and turn them into dry sticks.

Henry: Tharja, would you like that better? Would you prefer these poor flowers to be twigs?

Tharja: Stop! Must I sound as if I'm being rude to your ridiculous bouquet?

Henry: I don't mean to! It's just that if you wanted a bundle of twigs, I'd be happy to oblige.

Tharja: Wait, what are you—

Henry: PRESTO! ...There you go.

Tharja: You were so pleased with those flowers, yet you destroyed them just like that...

Henry: Nya ha! Oh, I don't care—as long as you're happy, that's all that matters.

Tharja: Wh-where is this going?

Henry: Tharja, I'm head over heels for you! In fact, I'd rip my heels clean off if it would put a devious grin on your face! Heck, I'll destroy this whole army if that's what you want. ...Do you want that?

Tharja: Ugh, of course I don't. Do you think I'm completely insane?

Henry: No, I was just using it as an example. So anyway, you want to get hitched?

Tharja: Egads, you do know how to sweep a girl off her feet, don't you? And yet... If you promise to protect [Robin], I just might consider it. If we both fall into some mortal peril, you need to save [Robin] first. Is that clear? You must be ready to sacrifice me for (his/her) sake. If you can bring yourself to promise me that, then yes, I will marry you and—

Henry: Is that all? Easy peasy! No problem what-so-EVER!

Tharja: Good. ...I think.

Henry: This is great. I thought you'd make the conditions really, really onerous. Hold and I'd think twice about the idea. But you didn't! So, anyway. I'd better go down to the smith and get a ring made.

Tharja: You know, he may actually, truly be crazy... I mean, what kind of proposal was that? Still, it's not like I'm the most normal person around either. Who knows? Perhaps it's the perfect match...

Donnel

DONNEL X THARJA C

Tharja: You there. Boy. Do you know where I can find a newt's eye?

Donnel: Yes ma'am! I've seen tons of them slimy critters up in yonder stream. Hold and I'll fetch ya one!

Tharja: You there. Boy. Where can I get the tail of a snow-white sow?

Donnel: Fresh out, I'm 'fraid. But I can run ask the camp butcher if ya like!

Tharja: That dunderhead wouldn't possibly have such a thing...

Donnel: Well, I suppose I could hop down the valley and check the local swineherd. I reckon one'a them pigs'll have a white tail!

Tharja: You there. Boy. Bring me a bat.

Donnel: Shucks, they mostly live in caves down by the ol' fishin'. Er, beg pardon, ma'am, but...did you just order me to go fetch a bat?

Tharja: Yes, I did. Sometime today, please.

Donnel: Well, all right then! I'll just toodle on down to the caves and flush one out!

Tharja: ...I can't imagine why that hayseed keeps following my orders. I haven't even had a chance to place a curse of servitude on him yet...

DONNEL X THARJA B

Donnel: Howdy, ma'am! I got them two venomous black snakes you been lookin' fer!

Tharja: Yes, thank you. Just throw them in the usual place.

Donnel: You got it!

Donnel: Well? Aren't you going to ask me?

Tharja: Ask ya what, ma'am?

Donnel: Tsk. Don't play coy. The favor, obviously.

Tharja: I reckon I don't quite follow.

Donnel: You want me to use my magic powers to do something for you, right? For weeks, you've been running hither and yon, collecting specimens. At first it was just amusing, but you've actually proved to be quite helpful. So then? Name your price. What do you want in return?

Tharja: Well, I imagine I'd like ya to do nothin', ma'am.

Tharja: I don't understand.

Donnel: I don't want nothin' in particular, so I'm askin' ya to do nothin'.

Tharja: Surely you must have some reason for helping me.

Donnel: Gosh, ma'am. That's just how we do things back in my village. If a mage was settin' about to cast a curse, see, we was all duty bound to pitch in. Just like we all help build the barns and mend the fences and clear the pastures!

Tharja: Wait. You used to help mages cast curses? Cast curses...on you?!

Donnel: That's what curses are all about, right? Usin' dark arts fer the greater good? By helpin' you, I reckon I'm helpin' everyone in the Shepherds. Ain't that right? Gosh, maybe THAT should be my favor! I should ask ya to cast more nice magic!

Tharja: I don't know who taught you about curses, but that's not how they work.

Donnel: It ain't?

Tharja: Gods, it's a wonder your village is still standing... But all right... I'll see if I can find a way to cast some, er, "nice" magic. And in the meantime, you can keep collecting specimens.

Donnel: Yee-haw! It's a dilly of a deal!

Tharja: I think this is going to be a very useful arrangement. ...Particularly for me.

DONNEL X THARJA A

Donnel: Tharja, your hexes sure are powerful! Everyone's feelin' on top'a the world!

Tharja: Hmm...

Donnel: The cold what was goin' 'round done threw us all for a loop. I didn't know what we was gonna do till ya cast yer hex and fixed us up!

Tharja: Snuffing out a sniffle is a fairly simple matter, actually. You just have to direct the curse at the cold instead of the person.

Donnel: Well, you sure done impressed me! There's just one thing I don't get... Why don't ya want me tellin' no one it was you what cured them ailments?

Tharja: People might get the wrong idea.

Donnel: Whatcha mean?

Tharja: They might think I did it for some kind of... common good... Or out of the goodness of my heart. *shudder* I only did it to thank you for the help you've given me. If people think I've gone soft, I'm finished as a dark mage...

Donnel: Well, either way, the result's the same.

Tharja: Yes, well. If you need some disease cured again, you know where I am. However, I want something of you in return.

Donnel: Don't worry! I'll keep on collectin' all them creepy crawlies for ya!

Tharja: ...Heh heh. You really are quite useful.

DONNEL X THARJA S

Donnel: Heya, Tharja. I've went'n collected all them things ya wanted.

Tharja: ...Ah, good. Then I have everything I need for my next spell. Just stand still please...

Donnel: Erm, Tharja. Is it all right if I ask ya a lil' question?

Tharja: That depends.

Donnel: What was that spell you just cast? Usually ya tell me what yer fixin' to do, but not today.

Tharja: I was making this.

Donnel: Dancin' donkeys! That there's a fine ring!

Tharja: ...It's for you.

Donnel: Fer me?!

Tharja: I made another one just like it for myself.

Donnel: Well shucks, this is startin' to sound like yer fixin' to get us hitched!

Tharja: Well, yes, as far as society at large is concerned, we would be wed. However, in practice, I want you to be more like my...personal servant. I consulted a few books; this seemed the easiest way to secure cooperation.

Donnel: Books? Yer dark-magic tomes talk about weddin's?

Tharja: Well, what became weddings, what... You'd be surprised how many social rituals have come out of the dark arts. In this case, an exchange of rings forging an unbreakable bond. It symbolizes a solemn pact that two people will stay together until death.

Donnel: Gosh! Sounds like someone's in love with ol' Donny!

Tharja: That...would be another way to put it, yes. In any case, I would like your answer. Will you join with me?

Donnel: If you promise to love me all my life, then we got a deal! Collectin' bats and watchin' you cast hexes is excitin' as all get-out! I wouldn't mind doin' nothin' but fer the rest of my days!

Tharja: Excellent! Then it's settled. Now put that ring on like a good boy... And become mine FOREVER! Eee hee hee...

Morgan (female) (Mother/daughter)

The Morgan (female) mother/daughter dialogue can be found on page 312.

Noire (Mother/daughter)

NOIRE X THARJA (MOTHER/DAUGHTER) C

Tharja: You there.

Noire: Eep?! M-Mother! Did you need something?

Tharja: What were you doing in that last battle? Were you trying to distract me?

Noire: I... Did I? I'm sorry, I didn't intend to, I swear.

Tharja: You mirrored my every movement! It was like some bizarre curse.

Noire: Oh. That. Well, you see—

Tharja: Don't care. Doesn't matter. Just stop.

Noire: N-no, wait! It was force of habit!

Tharja: What...habit?

Noire: In the future, you were always too wrapped up in your research to teach me things. N-not that I blame you! I know you had your reasons... You were consumed with avenging Father, so you never had time to waste on me. But I wanted to help you, so I...I taught myself magic and dark arts by following your example.

Tharja: And that became a habit?

Noire: Er, well, yeah. I guess.

Tharja: Hmm.

Noire: O-oh! But if it's a distraction, I'll stop! I promise! So, um, it'd be really nice if maybe you didn't...put any weird curses on me?

Tharja: I see... Hmm... I'm thinking this could have its uses... Heh... Meh heh heh heh...

Noire: Eeeek!

NOIRE X THARJA (MOTHER/DAUGHTER) B

Tharja: Why doesn't it work?! We're performing the rites in perfect sync!

Noire: Hmm... Still no use, then.

Tharja: "Still"?

Noire: Well, I've... I've never managed to actually place a hex on anyone... I can use dark magic in combat just fine. But the sorts of hexes you deal in, Mother—they've always been beyond me somehow.

Tharja: That makes no sense. You're able to mirror my actions perfectly.

Noire: True, but I can only mimic the form. Not the substance.

Tharja: It still doesn't make sense. But then again, none of this does. Why wouldn't my future self have taught you how to properly curse people? If I was swallowed up in research, I'd never turn away a useful assistant...

Noire: I'm not sure. I was pretty young.

Tharja: Hardly a problem. I was instructed in the dark arts from infancy. Even my umbilical cord was cut with a curse.

Noire: Ew, gross! What kind of weirdo curses a newborn baby?!

Tharja: Meh heh heh... Well, no matter. That just means it falls on me to shape you into something useful. Oh, and I shall teach you... Whether you wish it or not. Heh... Meh heh heh.

Noire: I'm s-scared, Mother... But I'll try to...do my best.

Tharja: Hmm, yes. Yes, you will...

NOIRE X THARJA (MOTHER/DAUGHTER) A

Noire: I've assembled the last of the implements for the rite, Mother. I'm finally going to learn to cast hexes. I'll make a useful assistant yet, just watch!

Tharja:

Noire: Er, Mother?

Tharja: ...I've changed my mind. There will be no rite tonight.

Noire: What? But—

Tharja: I won't be teaching you the dark arts. Now put those implements away.

Noire: But why? Wh-what did I do? Do I lack the talent? Am I in your way?

Tharja: You have a frightening amount of talent. Your innate magical potential is vast. Even that talisman I made turned you into an entirely different person! One couldn't hope for a greater vessel to shape into a curse slinger. ...And you could never be in my way.

Noire: Then why?

Tharja: ...I think I've come to understand the motives of my future self.

Noire: What?

Tharja: I don't want you dealing in hexes. The dark arts carry with them tremendous risks. My future self knew as much...

Noire: You think that she was worried for my safety? That...she loved me?

Tharja: Can't say. Not about her, at least... But I love you, if that helps.

Noire: Mother...

Tharja: Just don't expect me to say it often! ...Or maybe ever again. And just because hexes are off the table doesn't mean I have nothing to teach you. There are more ways than hexing to skin a cat. ...Or other things. Heh. So pay attention, and try to follow along.

Noire: Oh yes, ma'am!

Olivia

Avatar (male)

The dialogue between Avatar (male) and Olivia can be found on page 222.

Avatar (female)

The dialogue between Avatar (female) and Olivia can be found on page 233.

Chrom

The dialogue between Chrom and Olivia can be found on page 241.

Frederick

The dialogue between Frederick and Olivia can be found on page 247.

Virion

The dialogue between Virion and Olivia can be found on page 250.

Vaike

The dialogue between Vaike and Olivia can be found on page 255.

Stahl

The dialogue between Stahl and Olivia can be found on page 258.

Kellam

The dialogue between Kellam and Olivia can be found on page 262.

Lon'qu

The dialogue between Lon'qu and Olivia can be found on page 265.

Ricken

The dialogue between Ricken and Olivia can be found on page 267.

Maribelle

The dialogue between Maribelle and Olivia can be found on page 268.

Panne

The dialogue between Panne and Olivia can be found on page 270.

Gaius

The dialogue between Gaius and Olivia can be found on page 272.

Gregor

The dialogue between Gregor and Olivia can be found on page 275.

Libra

The dialogue between Libra and Olivia can be found on page 277.

 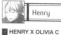

Henry

HENRY X OLIVIA C

Henry: ...Aw, poor little doggy. The silly mutt stepped in a hole and hurt its leg.

Olivia: DON'T TOUCH THAT DOG!

Henry: Huh? What the hey?

Olivia: I know you! You're that creepy kid who likes blood and magic and...blood magic! You stay away from that poor little doggy!

Henry: But this dog is hurt. See, his leg has this—

Olivia: N-no! Stop! I'll take care of him and nurse him back to health!

Henry: Huh? Oh, okay, sure! We can take care of him together!

Olivia: T-together? Waaait a second. Aren't you going to sacrifice him to your dark god or something?

Henry: You're a crazy lady. Why would I do that? I love doggies! I want to save his life! Right, boy? Who's a good boy? Aren't you glad the crazy lady wants to help us? Yes you are!

Olivia: Hey! How am I crazy! You're the one who's obsessed with blood.

Henry: Hey, that's a medical condition! Show some respect!

Olivia: Oh, never mind. Right now, we have a dog that needs looking after. Will you run and get me some bandages?

Henry: You got it, crazy lady!

■ HENRY X OLIVIA B

Olivia: Um, Henry? What are those red stains on your clothes?

Henry: Oh, will you look at that? It's blood! ...Wonder where it came from? *Lick* ...Oh, hey! It's MY blood! Nya ha! I must have been wounded in battle! Oh man, good times.

Olivia: GROSS! ...And also really creepy. And why are you laughing about it?! That wound needs to be dressed immediately!

Henry: You wanna help? It's kind of out of the way, so I can't reach it.

Olivia: ...Oh, gods, look how deep this is! How could you not notice?

Henry: Oh, I've got a high pain threshold. It's a genetic thing. Nerve damage. I've had a lot worse than this!

Olivia: You've had WORSE? Where? And how?!

Henry: When I was a kid, my parents put me in this exclusive wizard school. Well, as you can imagine, some of the experiments got a biiit out of hand. Once, I almost set my face on fire! Nya ha! Those were the days...

Olivia: Your teachers were negligent. Why didn't your parents pull you out of there?

Henry: Meh, my parents didn't care what I did as long as I wasn't expelled. Heck, the whole reason they sent me to wizard school was to get rid of me. But hey, no worries! I turned out fine!

Olivia: I see now... Your cheerful demeanor is just a mask you use to hide your pain. You use it as cover to tamp down your deep-seated resentment and anger.

Henry: That's what all my psychiatrists said. But nope! Not true. I'm just a happy guy.

Olivia: No, no... You can't fool me. I've never seen a real smile from you, you know! I can tell a faker when I see one. Shhh... It's all okay now. You never need to visit that terrible school again. Now come on, let down your guard. Show me the real Henry!

Henry: Wow. You really ARE a crazy lady!

Olivia: I am not crazy! I'm trying to help, so you could at least be patient! *Sigh* All right, your wound is bandaged. But this isn't over, you hear? I want you to come see me again so I can help you get over these emotional issues.

Henry: Hey, sure. I got time.

■ HENRY X OLIVIA A

Olivia: Now, when you feel sad, you pull your face like so...

Henry: You mean like thiiiis?

Olivia: No, down! The corners of your mouth are supposed to go DOWN! *Sigh* I'm starting to think that you're incapable of changing your expression. Look, Henry. Life is like dancing... You can't just mimic the moves. You have to FEEL them!

Henry: Nya ha! You compare everything to dancing. It's hilarious!

Olivia: I don't think this is a laughing matter. I'm trying to help you, you know!

Henry: Look, crazy lady. I like you. I really do. But you have GOT to let this go. I smile because I'm happy, all right? There's nothing more to it.

Olivia: N-no. That just can't be possible. *Gasp* Ungh...urg...!

Henry: Hey, are you okay there? You're making funny noises.

Olivia: M-my chest...suddenly...feels tight... C-can't breathe... It h-hurts...

Henry: Aw, jenkies! You've been cursed! I'd know those symptoms anywhere.

Olivia: *Pant* Henry...please. You have to get...out of here...

Henry: What? Oh come on, that's crazy talk. You're gonna die here in a second. Now you just sit there while I figure this out... Hmm, let's see... *Mutter, mutter, mutter* KA-BLAMMO! So long, curse! See ya in hell!

Olivia:

Henry: Olivia? H-hey, Olivia. ...You being crazy again, Olivia?! Aw, come on, Olivia! You can't die now! NOOOO! OLIVIAAAAAA! Come back to me, Olivia! Stay out of the light! STAY OUT OF THE LIIIIIGHT!

Olivia: S-stop crying. I'm...I'm all right.

Henry: ...Huh? Aw, thank goodness! I was worried there for a sec.

Olivia: Well, at least I finally got to see a different expression on your face...

Henry: Did you? ...I totally didn't notice.

Olivia: Thank you, Henry. You saved my life.

■ HENRY X OLIVIA S

Olivia: Henry, I want to thank you for your help the other day.

Henry: Aw, don't worry about it. Really, I should have recognized the symptoms faster. But don't worry! I'm gonna find who did it and make sure they never curse you again. Oh, yes. There will be blood.

Olivia: Eek! I'm just glad you're on our side!

Henry: Well, I'm glad I'm on YOUR side!

Olivia: You do have a very nice smile, Henry. Even if it is a little creepy sometimes.

Henry: Aw, hamburgers. Really?

Olivia: Absolutely! And what's more, I was wrong to have ever doubted its sincerity! I think I'm done giving you lessons.

Henry: Hey, I like your lessons! And I like YOU! In fact... I wanna be with you all the time!

Olivia: Henry?

Henry: You don't think I went to all those frowning lessons because I wanted to frown, do you? Heck no! I went because I wanted to see you and be with you! So let's get hitched! What do you say? I've got a blood-magic spell all ready!

Olivia: Wh-what?! Um, but, H-Henry, I don't...

Henry: Ha! Just kiddin'. I bought you a ring. Here, see? It's huge and everything.

Olivia: ...Oh my goodness. That IS huge! You are a very odd man, Henry, and yet I find myself strangely attracted to you. So, yes. All right. Let's get married.

Henry: Awesome! You won't regret this, Olivia. I promise!

Olivia: Oh, this might just be the happiest day of my life!

Henry: Nya ha! Just hearing that makes me even happier than before!

Olivia: Hee hee. I didn't think that was possible...

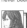

Donnel

■ DONNEL X OLIVIA C

Donnel: The swan princess done lost her love, ♪ and now her luck is buuuuusted! ♪

Olivia: She looks so sad beside the lake, ♪ her wedding ring a'rusted ♪

Donnel: Yikes! You done scared me, ma'am!

Olivia: Oh, did I? Gosh, I'm sorry. I didn't mean to startle you. But that's one of my favorite ballads, and I couldn't help but join in!

Donnel: Eh? You know that song?

Olivia: Oh, yes! All dancers dream of the day when they might perform as the white swan.

Donnel: It's a sad song somethin' fierce, and I always get to feelin' low when I sing it. Just the way that poor white swan princess is out lamentin' her black swan prince. She sets out to journey 'round the world, hopin' to meet him one more time. But while she's gone, the evil swans wreck her home and put her realm to the torch! That's why she gets to cryin' out by that pond in the song, most-like.

Olivia: But, Donnel, it doesn't end there. Don't you know the other verses?

Donnel: ...It don't end with that line about brewin' up tea?

Olivia: No, that's just the end of the middle act! Here's the rest... The moon sees the princess sadly sipping her tea and takes pity on her. He calls out to the black swan prince and tells him how the princess suffers. When the prince hears this, he summons his allies and chases the wicked swans away. Then prince and princess are reunited in the smoldering ruins of her palace! There they embrace tenderly while the princess smiles softly up at the moon.

Donnel: Well pluck my feathers and feed me grits! That ain't a sad song at all!

Olivia: No, it's not.

Donnel: Gosh, thanks for settin' me straight, ma'am. I reckon I like it even more now!

Olivia: Oh, you're very welcome!

■ DONNEL X OLIVIA B

Donnel: Say, Olivia? I've been a'ponderin' that swan princess from the song. You wanna know what I think? I reckon it really is a sad story.

Olivia: Oh? How so?

Donnel: The princess's whole kingdom was burned up, but they never got put right.

Olivia: Well, it's true the song doesn't mention rebuilding...

Donnel: So even if the white swan hitches up with her true love, her home's still rubble. I don't see how she can be properly happy like that. I surely don't.

Olivia: I'd...never thought of that.

Donnel: Right? It ain't no cheerful ditty at all—it's one'a them funeral dirges!

Olivia: And if that's so, it casts her final act in an entirely different light...

Donnel: Olivia? You chewin' on straw there? Whatcha mumblin' about?

Olivia: Oh, sorry. I was just thinking about the choreography for that song. There was one point that always puzzled me, but I think you've given me the answer.

Donnel: I did?

Olivia: In the choreography, the princess smiles at the moon when they embrace. But the movements are slow and sad, full of loss. I never understood how she could be so sorrowful in the midst of an embrace. But now I think I get it.

Donnel: She's happy for herself, but still thinkin' 'bout her home bein' all busted up.

Olivia: Yes, exactly. Thank you, Donnel. This has been an eye-opening talk! I might be able to add a whole new dimension to this dance.

Donnel: Gosh! I'd pay anythin' to see that!

Olivia: Er, well, I need much more practice. I'm not much of a dancer...

Donnel: Well, you get to rehearsin' and lemme know when yer ready to go!

■ DONNEL X OLIVIA A

Olivia: Donnel? Do you mind coming over here for a second?

Donnel: What's up, Olivia?

Olivia: Er, well... I was hoping that you might want to watch me dance.

Donnel: Jumpin' jacksnakes! You're all done practicin'? Show me! Show me!

Olivia: Yes, but I can't dance without music. Would you be so kind as to sing?

Donnel: Aw, sure! But I only know the words partway.

Olivia: That's all right. I'll sing as I dance, in the sections you don't know.

Donnel: Okeydokey. Ready? Here goes nothin'! The moon was smilin' gently down... ♪

Olivia: And now at last, the two embrace ♪ and in his arms the swan does sigh... ♪

Donnel: Up she looks, with smile so wide, ♪ to gaze at the moon in the sky. ♪

Donnel:

Olivia: Er, Donnel? ...Hello? Did you like it?

Donnel: Aw, shucks, Olivia! That's the purdiest thing I ever seen in m'whole darn life! *Sniff* Gosh... Aw, shucks...

Olivia: *Sniff* Donnel? You're crying!

Donnel: *Sniffle* So are you...

Olivia: *Sniffle* Heh ... I guess I am. I got so caught up in the dance, I actually became the white swan!

Donnel: I know! I'd a'sworn you were the princess herself!

Olivia: Oh, well now... It wasn't THAT good...

Donnel: I reckon I could watch you dance all day! ...Don't suppose ya would, though.

Olivia: I might be up for one more...

■ DONNEL X OLIVIA S

Donnel:

Olivia: Donnel?

Donnel:

Olivia: Donnel!

Donnel: What in tarnation? ...Oh, hi, Olivia.

Olivia: Is something wrong? You're just sitting here like a stunned toad. W-was my dance that bad?

Donnel: Jeepers, no... I couldn't tear my eyes away, you were so beautiful.

Olivia: T-truly?

Donnel: It's like I was hypnotized or somethin'. Hope I ain't gettin' sick...

Olivia: Oh dear...

Donnel: I just get so weepy when I imagine you as the white swan. It's almost like I'm the black swan and I've fallen in... Er... Which is by way of sayin' I went'n bought ya this.

Olivia: Is that...a ring?

Donnel: Now, I know I'm no prince or black swan. ...More of an odd duck, I s'pose. And I know a grubby old ring like this won't make a princess smile at the moon, but—

Olivia: Donnel, any gift from you has the power to make this princess smile.

Donnel: So does that mean...?

Olivia: I think it's time for me to dance again. Except, in this performance, I won't be dancing for the black swan prince.

Donnel: N-no?

Olivia: No. This time I'm dancing for you. For you... my love...

Donnel: Aw, gosh! I'm gonna sing that song like it ain't never been sung 'fore!

Lucina (Mother/daughter)

Lucina's mother/daughter dialogue can be found on page 285.

Inigo (Mother/son)

■ INIGO X OLIVIA (MOTHER/SON) C

Olivia: Inigo? It's the middle of the night. Where are you going?

Inigo: Oh, Mother! Er, well, I was just off to...chat up the ladies! You know me! Ha ha!

Olivia: Nonsense. The only thing out there at this hour are Risen. Now, may I have the truth?

Inigo: Er, I... I'm... I just wanted to...

Olivia: Practice your dancing?

Inigo: ...How did you know?

Olivia: Someone said they spotted you dancing in the woods a few nights back. I thought you might be making a habit of it.

Inigo: They SAW that?! B-but, I made sure to stay behind that big tree the whole time! Argh, that's so embarrassing! ...And I bet they were horrified.

Olivia: Quite the opposite. They said it was a breathtaking sight. Apparently they lost track of the time just standing there, mesmerized.

Inigo: That's even MORE embarrassing! I'm not good with praise, you know? I'm used to rejection! And wait, lost track of the time? How long were they watching?! Ugh, I give up... I'll never be able to practice in peace again. This is going to haunt me to the grave! The GRAVE, I tell you!

Olivia: Well, what if we practiced together? Finding secret, out-of-the-way spots to practice is something of a talent of mine. Besides, it's too dangerous to let you charge off into the woods alone at night.

Inigo: Together? What, with YOU?! Wouldn't you be humiliated trying out incomplete dances with someone watching?

Olivia: Not if that someone were you! You're my son, Inigo! So what do you say? It would be just the two of us.

Inigo: Er, that's really sweet, but... I'm sorry, Mother.

Olivia: Hmm? Why not? Still too embarrassing?

Inigo: No, it's not that. Well, it IS, but... It's more than that.

Olivia: What do you mean?

Inigo: L-look, I'm sorry, but I can't. I just can't! I'm going back to my tent. Good night, Mother!

Olivia: Inigo, wait!

■ INIGO X OLIVIA (MOTHER/SON) B

Inigo: Sigh... Let me guess. You're in one today?

Olivia: Eep! I-Inigo?! Er, what a coincidence!

Inigo: Yes, you just happened to find yourself hiding in a barrel. What ARE the chances? Mother, PLEASE stop trying to spy on me while I practice! You've climbed trees, hidden under bridges, painted yourself in ridiculous camouflage... The time you jumped out by that waterfall nearly gave me a heart attack!

Olivia: But I want to see you dance! Random people from the camp keep coming across you and raving about it! I'm your mother, and I haven't seen you dance even once! How is that fair?!

Inigo: I'm sorry, but being able to move people with my dance is mortifying. I'm as shy as you are. You HAVE to know how I feel. ...Don't you?

Olivia: Oh... W-well, if you're so shy, why do you spend each day hitting on every girl you find?!

Inigo: Heh, you of all people should know the answer to that one. After all, you're the reason I developed this flirting habit in the first place!

Olivia: What?! I most certainly am not!

Inigo: Yes you are! When I was little, I was even more shy than you are now. I came to you in tears asking how to be more comfortable around people. And you said the fastest way for a man to practice bravery was to talk to women!

Olivia: ...Oh, gods. What in the world was my future self thinking?

Inigo: I believe you said it was advice a good friend once gave you. Anyway, I gave it a try, and it worked! ...Surprisingly enough.

Olivia: And then it became a habit?

Inigo: Apparently so. But whatever you want to call it, I owe it all to you.

Olivia: I'm sorry...

Inigo: What? Why? Don't apologize. If I want to help people with my dancing, I need to become as alluring as possible. If I can't talk my way into a date or five, I know I've still got a long ways to go. Flirting is another part of my training. ...With its own benefits, naturally. So, really, I'm thankful.

Olivia: W-well, I suppose as long as it's helped you...

Inigo: It has, and it does! So you don't need to worry about me so much, okay? Now, come on. It's nearly time for supper.

Olivia: It's such a relief to hear he has good reasons for all that skirt chasing. Hee hee! Though I'd love to see a girl's face when he says his mother sent him... But wait—I still didn't get to see him dance today! I lugged this barrel in here and everything. ...Ugh, how embarrassing.

■ INIGO X OLIVIA (MOTHER/SON) A

Inigo: ...Nice. Those were some damned fine moves, if I do say so myself.

Olivia: Yes, a brilliant performance!

Inigo: Gah?!

Olivia: Though your spins still lack the strength of your convictions. Stop holding back! Oh, and extend your focus through those very tips of your fingers. That will help through those tricky transition points.

Inigo: All right, where were you hiding today, Mother?

Olivia: Nowhere! I swear! Though I thank the gods for the chance to finally see you dance. The latter half was a bit of a departure, but I recognize the routine. It's my favorite. ...Er, did I teach you that in the future?

Inigo:

Olivia: Inigo?

Inigo: Yes. It was the last dance you taught me. That's why the second half is different. ...You died before we got that far.

Olivia: ...Oh.

Inigo: Ever since I've been working so hard to develop an amazing version to show you... Not much point, if you're going to spoil the surprise by peeking before it's done.

Olivia: I'm so sorry! I didn't know! Oh, I feel just awful...

Inigo: Don't. It's fine... To tell you the truth, I really wanted to hear your thoughts. I always used to practice beside your grave. I'd try to imagine what you'd say as you watched me. What I could fix... I'd picture how you'd tell me to speed up, or praise me when I got it right. I could hear it all in my head as I danced. But I just wanted to hear it aloud... Anyway, that's why I'm... I'm just glad. *sniff*

Olivia: Ah! No, don't cry! It's all right! The me in the future might have left, but I swear, this me is here to stay. We can dance together, or see the world, or anything! I'll do anything to make you happy, my darling boy!

Inigo:Thanks, Mom.

Olivia: It's my pleasure.

Inigo: Sorry I've been so weird about letting you watch me dance... Er, but would you teach me the real second half of that routine sometime?

Olivia: Of course!

Morgan (female) (Mother/daughter)

The Morgan (female) mother/daughter dialogue can be found on page 312.

Cherche

Avatar (male)

The dialogue between Avatar (male) and Cherche can be found on page 222.

Avatar (female)

The dialogue between Avatar (female) and Cherche can be found on page 233.

Frederick

The dialogue between Frederick and Cherche can be found on page 248.

Virion

The dialogue between Virion and Cherche can be found on page 251.

Vaike

The dialogue between Vaike and Cherche can be found on page 256.

Stahl

The dialogue between Stahl and Cherche can be found on page 258.

Miriel

The dialogue between Miriel and Cherche can be found on page 260.

Kellam

The dialogue between Kellam and Cherche can be found on page 262.

Lon'qu

The dialogue between Lon'qu and Cherche can be found on page 265.

Ricken

The dialogue between Ricken and Cherche can be found on page 267.

Gaius

The dialogue between Gaius and Cherche can be found on page 272.

Gregor

The dialogue between Gregor and Cherche can be found on page 275.

Nowi

The dialogue between Nowi and Cherche can be found on page 276.

Libra

The dialogue between Libra and Cherche can be found on page 277.

Henry

■ HENRY X CHERCHE C

Cherche: Oh, hello, Henry. Have you come by to pet Minerva?

Henry: Sure have! She's as cute as a button, that one. ...Well, if buttons were cute. We had wyverns in Plegia, you know, and also the occasional fell beast. But we didn't have a single wyvern that was as pretty as Minerva.

Cherche: You're very astute. Not many humans realize how beautiful she is. They think wyverns all look the same, but people like you and I know better!

Henry: Yeah, it's sad that some folk can't tell the difference from one animal to the next. I mean, pegasi, wyverns, dogs, birds... They're all as different as you and me!

Cherche: You must really love animals.

Henry: Yep! I make four-legged friends wherever I go! And even some two-legged ones. I'm also pals with a three-legged bear, but that's a story for another time.

Cherche: I only hope you and I can become such fast friends one day. Now, why don't you slowly approach Minerva and try scratching her ear?

Henry: All right, here goes! Hey there, Miss Wyvern! I'm Henry. Nice to meetcha!

Henry: Yowza! Sh-she tried to bite me! Look, I'm bleeding! Mmm, blood...

Cherche: Minerva! What's gotten into you?!

■ HENRY X CHERCHE B

Cherche: Henry, I'm sorry about the other day, when Minerva almost...bit your hand off. She was terribly excited about something, but I'm not sure what.

Henry: Aw, it's fine. I bet I just give off some kind of animal aura. Or maybe she thought I was a big ham? I do smell kind of ham-like.

Cherche: In any case, I gave her a stern talking to. I don't think it'll happen again. I hope you won't hold it against her, and that you're still willing to be friends.

Henry: Are you kidding? Of course! Minerva and I are going to be besties for sure!

Cherche: I know everyone is fond of Minerva, but you seem especially attracted to her.

Henry: Well, when I was young, my best friend in the entire world was a giant wolf. My parents ignored me most of the time, you see, so that wolf became my whole family. Then one day she came to visit me, and some hunters in the village... They shot her full of arrows. Killed her on the spot.

Cherche: Th-that's terrible!

Henry: But they paid... They paid in BLOOD. Er, but yes. None of my magic could bring my beautiful wolf friend back. So I guess that's why I hang out with you and Minerva. 'Cause it reminds me.

Cherche: We can never replace your wolf, but Minerva and I would be glad to be friends with you. In fact, we were just about to go and fly a patrol around the camp. If you have nothing else to do, you're more than welcome to join us.

Henry: You mean, you'd let me ride on Minerva's back?! In the SKY?! Holy horsefeathers, yes! Please let me come!

Cherche: Great. This will be lots of fun!

■ HENRY X CHERCHE A

Henry: Cherche? Do you mind if I pet Minerva a little bit?

Cherche: Of course not. I was wondering if you were going to come by today.

Henry: I know I'm here a lot, but I always feel safe and happy when I'm with Minerva.

Cherche: ...So now that you're here, Henry, I hope you'll let me ask you something. You're always smiling

and laughing and acting as if you hadn't a care in the world. Yet, you never seem to make friends with people or allow them to get close. ...Even me.

Henry: What? You think so? Nya ha ha! I'm not like that at all!

Cherche: There you go with that laugh again. It just sounds so hollow... I wonder if it's even possible for someone to be your true friend?

Henry: Sheesh, Cherche. It's not like that! We're already friends! Anyway, I'm glad we had that chat, but are we going on patrol today? I want to fly on Minerva's back again!

Cherche: ...No. Not today. I think it's best if you don't see her for a while.

Henry: Wha—?!

Cherche: I'm very happy that you like Minerva and you two get along so well. But I think you need to spend more time with human friends—namely, me. So I'm going to carry out my patrol on foot, and you're coming with me.

Henry: Huh. Well, all right. If that's what you want, it's fine by me!

Cherche: Good. Let's go, shall we?

Henry: Forwaaaaaard, march!

■ HENRY X CHERCHE S

Henry: Welcome back, Cherche! How was today's patrol?

Cherche: Uneventful. Did you come out here to meet me?

Henry: I figured the old dogs would be barking, so I brought a homemade bunion salve.

Cherche: Why, thank you, Henry! But how did you know?

Henry: We've been on so many patrols together, I've memorized your whole routine. After this, you'll put a cold towel on your head and drink a cup of hot elderberry tea.

Cherche: It's quite remarkable how much more attention you pay to other people now.

Henry: Nya ha ha! Yeah, I know. And it's all thanks to you!

Cherche: In any case, I'm pleased that we've become good friends.

Henry: Actually...being friends is nice and everything, but I want more. We spend so much time together, I'm thinking we should make it official.

Cherche: Er, make what official?

Henry: Aw, come on. You've been around the carousel before. You know what I mean! So here. This is for you.

Cherche: ...A ring? Henry, are you—?

Henry: You've been really good to me, Cherche. More than just a good friend. Going on patrols together is fun and all, but I want to see you ALL the time. So, I was thinking we could, you know...get hitched. What do you think?

Cherche: Goodness, Henry, but this is sudden. However...I have found myself... thinking about you a lot lately. Ever since we met, I've wanted to know the real man behind that jolly facade. And this would be a chance to do just that. Very well, Henry. I accept your proposal.

Henry: Fantastic! This is great, Cherche! You and me are gonna be a family!

Cherche: ...I think you're forgetting someone.

Henry: Who, Chrom? Well, I guess he can be involved somehow, but that seems... Oh, you mean Minerva! Nya ha ha! I almost forgot! Yeah, of course! Minerva'll be a part of the family, too!

Cherche: ...Was your first thought really CHROM?!

Donnel

■ DONNEL X CHERCHE C

Donnel: You mind if I ask ya a question here, Cherche?

Cherche: Go ahead.

Donnel: I hear there's a girl in Valm what can whup a wyvern in a fight. That true?

Cherche: I assume you mean a human girl? If so, I doubt it. I've certainly never heard of such an extraordinary person.

Donnel: Haw! Yeah, I figured it was just some fool spinnin' tales.

Cherche: Who told you this, anyway?

Donnel: Some old merchant what claimed he'd been travelin' back and forth to Valm. He used to visit our village to sell goodies. Tonics what make ya taller and the like. It was quite a tale he told, though. 'Bout the wyvern girl, I mean. 'Parently, she wandered into Wyvern Valley when she was only nine! She whupped up on a wyvern there and then rode the poor fella all the way home. Haw, guess that tale's worth as much as the dang tonic he sold me! I mean, what sad excuse for a wyvern would go and get tamed by a little girl?

Cherche: Minerva? What's the matter?

Donnel: Don't reckon it was somethin' I said, do ya?

Cherche: I can't imagine what it might— Minerva, stop that at once! You mustn't eat poor Donnel!

Donnel: YEE-IKES! Yer beast is crazy, lady! I'm gonna make like a chicken and fly!

Cherche: Minerva! Bad wyvern! What has gotten into you?!

■ DONNEL X CHERCHE B

Cherche: Er, Donnel. About our last conversation... I think I know who the girl in that story might have been.

Donnel: Huh? But I thought we decided it was a load of horse pucky.

Cherche: Yes, except... Well, all the events in the story happened to me.

Donnel: You?!

Cherche: Yes. I believe the old man's story is about the first time I met little Minerva. Heh. I never thought the tale would be recounted across the land!

Donnel: So you's the legendary wyvern-subjugatin' gal?

Cherche: You sound disappointed. Not what you were expecting?

Donnel: Gosh, no! I'm thrilled to bits! Even got the goose bumps on my arm!

Cherche: So you have.

Donnel: I don't reckon you'd mind if I maybe hung out with ya for a spell? ...Wouldja?

Cherche: Why?

Donnel: 'Cause if I watch ya, I could try'n learn how to be as famous as you! Whuppin' wyverns, tamin' wild beasts... Why, gals'll be swoonin' at my feet!

Cherche: Well, I'm not sure. We'll have to see what Minerva thinks. ...Well, girl?

Cherche: ...You have her permission.

Donnel: Yee-haw! This'll be swell!

Cherche: You don't mind being so close to Minerva, do you? She rarely leaves your side.

Donnel: Well, I've worked with livestock 'fore, so I reckon I can get used to it.

■ DONNEL X CHERCHE A

Donnel: Cherche, I've done yer laundry and finished yer mendin'!

Cherche: Thank you, Donny. Also, it's feeding time for Minerva. Would you mind seeing to her?

Donnel: Okeydoke!

Donnel: ...Hey there, girl! How ya doin'? Gosh, look at all a'them teeth. You sure are a fierce one! I can't believe you really let a little nine-year-old put a whuppin' on you...

Cherche: Oh, gotcha. You're busy eatin'. I'll leave ya to it.

Cherche: Heh. You two are getting along famously now.

Donnel: I made sure to do just how you did, and she cozied right on up to me. Not to mention, I've learned cookin', and cleanin', and how to use a needle!

Cherche: But you'd rather know how I defeated the wyvern than learn household chores, right?

Donnel: See, I been thinkin' about that. You don't treat her anythin' like a regular ol' horse. I reckon you two are more like old friends than master and servant. I sure do envy it. I was never that friendly with my mule back on the farm. Don't s'pose you'd tell me how you managed to earn her trust?

Cherche: Through the same bonds of friendship that made you part of our little group. You notice how close you've gotten to Minerva? Do you notice how close you've gotten to me?

Donnel: Aw, shucks. But yer so pretty and kind, and I'm just a big lug from the sticks. ...Ya really think we're becomin' friends?

Cherche: Oh, I know we are.

Donnel: Gosh, how excitin'! Donnel Tinhead, friends with the famous wyvern subduer!

Cherche: And the wyvern, too...

■ DONNEL X CHERCHE S

Donnel: Hey-ho, hey-ho... *pant, pant* Just...a bit farther...

Cherche: Goodness, what an enormous metal ring! It must weigh half a ton! Why don't you ask Minerva to help you lug it?

Donnel: That's the thing...it's a present FOR Minerva... *pant* A surprise, like! Reckon I better take a break... 'fore I hurt my back... *Thunk* Phew! That's better.

Cherche: Did you say this is a present for Minerva?

Donnel: I'm givin' it to her as a symbol of the friendship what growed between us!

Cherche: Donnel, this is a bit upsetting... Minerva gets a present, but I don't?

Donnel: Actually, I got one for you, too. ...Ain't quite as big, obviously. But givin' a lady a ring is a mighty big thing, so I was frettin' somethin' fierce! What if ya don't like it? What if ya turn me down?

Cherche: I'm just relieved you're not asking my wyvern to marry you!

Donnel: Lordy, Cherche! That ain't never gonna happen. There's only one gal for me!

Cherche: ...Well, it is a lovely ring, Donnel. Do you mind if I put it on?

Donnel: N-no. Course not.

Cherche: ...It's a perfect fit.

Donnel: G-gosh! Seein' that on your finger makes me happier'n I been my whole life!

Cherche: And so am I. But I don't think it's fair we keep all this joy to ourselves, do you? Let's go and find Minerva and hand over her present.

Donnel: You got it!

Gerome (Mother/son)

■ GEROME X CHERCHE (MOTHER/SON) C

Gerome: Minerva, you look so sad and woebegone. I suppose it's my fault, isn't it? If it wasn't for me, you'd be living a life of tranquility in Wyvern Valley.

Cherche: I'm sorry that I've dragged you into yet another terrible war.

Gerome: ...Hmm? What's that? That's not why you're sad?

Gerome: ...Ah, yes. I understand completely. Your original mistress is alive in this time, and you pine for her hand on the reins.

Cherche: ...That's not it, either.

Gerome: Ch-Cherche?!

Cherche: Minerva is worried about you. Don't you see that forlorn look in her eyes?

Gerome: Minerva, is that true?

Cherche: I sense a powerful bond of trust and friendship between you.

Gerome: Heh. It seems you've done a fine job of looking after each other.

Gerome: We must not be that close if I can't even understand what she's trying to tell me... Come, Minerva. Let's go.

Cherche: Tsk. So impatient...

■ GEROME X CHERCHE (MOTHER/SON) B

Cherche: Gerome, might I have a word?

Gerome: If you must.

Cherche: What is this attitude of yours? Must you always turn a cold shoulder to me?

Gerome: I did not pass through time to make bosom companions on the other side. And I especially did not come here to make friends with you.

Cherche: Yes, charming and pleasant as ever... Well, I actually came here to talk about Minerva, not us. I have a request.

Gerome: What is it?

Cherche: You handle the reins superbly... I was hoping you'd teach me what you know.

Gerome: I have nothing to teach you. I just sit in the saddle and follow Minerva's lead.

Cherche: Oh, hogwash. I've seen how you two swoop and dance in the sky. Plus you handle the lance with such verve! A skilled rider like yourself has a great deal to teach me.

Gerome: How skilled could I be to still fall victim to the cruel whims of fate? ...How skilled could I be when I was unable to protect those I loved?

Cherche: Sometimes, no matter how strong you are, you cannot change destiny on your own. But you know that, don't you? That's why you've taken up arms in our cause.

Gerome: ...Yes, it's true. By joining you, I hope to accomplish what I could not alone.

Cherche: Then you must teach me. If not for my sake, then for your own cause.

Gerome: I...I cannot deny there is a truth to your words. Very well...

■ GEROME X CHERCHE (MOTHER/SON) A

Cherche: Thank you for your time, Gerome. Training is always better with a partner. Especially one as skilled as you.

Gerome: I learned much from you as well, Cherche. Your aerial tactics are second to none.

Cherche: Did you call me Cherche then, too? Back in your own time, I mean.

Gerome: It...matters not.

Cherche: Who DID you inherit this surliness from? Was it me or your father?

Gerome: You would know better than me. My parents were gone long before I could build any meaningful memories.

Cherche: I...I didn't know that.

Gerome: They spent their time helping smallfolk in one corner of the land or another. I waited for them, of course. Waited for the day that they might come home to me. ...But only Minerva returned.

Cherche: ...I'm so very sorry.

Gerome: People everywhere grieved for the heroes and honored their noble sacrifice. But I didn't want heroes. I wanted a father and a mother.

Cherche: I swear to you, Gerome, that won't happen this time. I'll never leave you.

Gerome: I know. After all, that's why I'm here—to change fate so you won't have to. This time, I'll make sure you survive. This time, we'll be together...

Morgan (female) (Mother/daughter)

The Morgan (female) mother/daughter dialogue can be found on page 312.

Henry

Avatar (male)

The dialogue between Avatar (male) and Henry can be found on page 222.

Avatar (female)

The dialogue between Avatar (female) and Henry can be found on page 233.

Lissa

The dialogue between Lissa and Henry can be found on page 244.

Frederick

The dialogue between Frederick and Henry can be found on page 248.

Sully

The dialogue between Virion and Henry can be found on page 253.

Miriel

The dialogue between Miriel and Henry can be found on page 260.

Sumia

The dialogue between Sumia and Henry can be found on page 263.

Ricken

The dialogue between Ricken and Henry can be found on page 267.

Maribelle

The dialogue between Maribelle and Henry can be found on page 269.

Panne

The dialogue between Panne and Henry can be found on page 270.

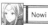

Cordelia

The dialogue between Cordelia and Henry can be found on page 273.

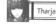

Nowi

The dialogue between Nowi and Henry can be found on page 276.

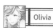

Tharja

The dialogue between Tharja and Henry can be found on page 278.

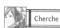

Olivia

The dialogue between Olivia and Henry can be found on page 278.

Cherche

The dialogue between Cherche and Henry can be found on page 279.

Owain (Father/son)

Owain's father/son dialogue can be found on page 289.

Inigo (Father/son)

Inigo's father/son dialogue can be found on page 293.

Brady (Father/son)

Brady's father/son dialogue can be found on page 297.

Kjelle (Father/daughter)

Kjelle's father/daughter dialogue can be found on page 299.

Cynthia (Father/daughter)

Cynthia's father/daughter dialogue can be found on page 303.

Severa (Father/daughter)

Severa's father/daughter dialogue can be found on page 305.

Gerome (Father/son)

Gerome's father/son dialogue can be found on page 307.

Morgan (male) (Father/son)

The Morgan (male) father/son dialogue can be found on page 309.

Yarne (Father/son)

Yarne's father/son dialogue can be found on page 314.

Laurent (Father/son)

Laurent's father/son dialogue can be found on page 316.

Noire (Father/daughter)

Noire's father/daughter dialogue can be found on page 317.

Nah (Father/daughter)

Nah's father/daughter dialogue can be found on page 318.

Lucina

Avatar (male)

The dialogue between Avatar (male) and Lucina can be found on page 223.

Avatar (female)

The dialogue between Avatar (female) and Lucina can be found on page 234.

Chrom (Father/daughter)

The dialogue between Chrom and Lucina can be found on page 241.

Owain

■ OWAIN X LUCINA C

Owain: Hey, Lucina.

Lucina: Greetings, Owain. How does the day find you?

Owain: Good, good! Just thought I'd drop in for a visit.

Lucina: That's kind of you. But... Why are you speaking so strangely today? That is, so strangely...normal. You're typically much more, er, colorful. Making up stories and yelling and the like. Are you feeling all right?

Owain: Y-yeah, I'm fine. It's just... You're a princess, Lucina. I figured it wasn't exactly appropriate for addressing royals. Plus, Mom would tan my hide if she ever found out.

Lucina: Lissa would object to you spinning yarns for royalty?

Owain: Not just royalty! Anybody! She gets really upset whenever I do it. Heh, actually, I suppose most everyone does. They think I'm a bit batty.

Lucina: Do they now? That's a shame. Personally, I find it quite intriguing.

Owain: What, really?

Lucina: It's no simple feat to speak as you do when fantasy grips your mind. Inventing weapon names and such requires a rich vocabulary and quick thinking. And of course your stories demand a particularly active imagination.

Owain: I guess they do, don't they? Thanks Lucina.

Lucina: Perhaps you might even consider demonstrating how you do it sometime? I've oft been told that my manner of speech is somewhat...formal. If I could learn to adopt your tone, it might prove useful to my own.

Owain: Heh, you sound like you're asking me to teach you a foreign language. Hmm... I'm not sure if this would be such a good idea...

Lucina: And if I were to pledge never to speak of it to Lissa?

Owain: ...Then so be it! Prepare yourself, young Lucina! Your destiny cometh! Hee hee, aw I can't wait.

Lucina: I look forward to it as well.

■ OWAIN X LUCINA B

Owain: What are you working on, Lucina?

Lucina: Falchion hasn't been at full strength lately, so I'm examining the blade for damage.

Owain: Falchion troubles, eh? Leave it to me!

Lucina: Oh...all right. Thank you.

Owain: No blade nicks... No obvious flaws... Aha! Here's your problem!

Lucina: You've found something? Excellent! Can it be rectified?

Owain: Aw, this is easy. I've even got the tools I need with me. I'll take care of it right now.

Lucina: Wonderful. Thank you, Owain! Could I perhaps ask you to speak in your fanciful manner as you work? It would be good practice for my efforts to adjust my own tone.

Owain: Heh! All right. I'll speak, and you can practice translating... Hark! Your partner fang resists the remorseless arrow of time! It is infused with the breath of gods and the passion of ages. Should a thousand thousand years pass, it shall never know the red sleep!

Lucina: Sword troubles... Falchion's blade will never dull or rust no matter how much time passes.

Owain: But where fang meets sinew, Falchion remains a mortal work. Even genius cannot hope to stop the turning of the great wheel! And so it is reborn with each generation; transformed, but ever the same in spirit.

Lucina: Hmm... But parts of the sword other than the blade DO wear out over time. The guard and pommel have been replaced over the years, changing its appearance. But it remains Falchion still.

Owain: Perfect! That was exactly right. You're amazing, Lucina.

Lucina: I suppose I did a fair job for a first try. But you are the amazing one, Owain. To discover all that about a sword from a single glance is a fearsome talent indeed!

Owain: Eh, taking care of weapons is a bit of a hobby of mine. Oh, hold on... Aaaaaand we're done! Here you go.

Lucina: Thank you again.

Owain: My pleasure. Just let me know if there's anything else I can do.

Lucina: Perhaps I will take you up on that.

■ OWAIN X LUCINA A

Owain: Hey there!

Lucina: Hello, Owain.

Owain: How's the sword treating you? Any better?

Lucina: Absolutely! I can really feel the difference. Never hath I spied Pointy Demonspanker shine so brightly!

Owain: Pointy... Wait, did you say Demonspanker? But that's Falchion! Treasure of the royal house of Ylisse! ...Er, right?

Lucina: It was. But as it has been reborn so many times, I thought to change its name. I tried to think of what you would call it. I pray my efforts are adequate.

Owain: *Giggle* Hmm, uh... Heh heh, so... No, I mean, it's a fine name. But, well... The cause to give one's blade a fitting name is a noble one, Lucina. HOWEVER! You committed a grave sin!

Lucina: I did?!

Owain: To name a weapon is to imbue it with a soul. To change Falchion's name is to insult the spirit it's borne for millennia!

Lucina: I...did not consider that.

Owain: In your commendable haste to make the sword more dear to your own heart... I fear you've stripped the very soul from your weapon! Though your intentions were laudable, this slight must be undone.

Lucina: Yes, of course. I see now how thoughtless it was of me. ...Pray forgive me, Falchion.

Owain: It is done. The blade's rightful name is restored. But do not forget the love that spurred you to this brief folly. Keep it with you always. And if you find yourself in need of maintenance, simply call out my name! Heh... I mean, just in case... *giggle* Pointy Demonspanker needs it... Pffffft! Bwa ha ha ha!

Lucina: I'm starting to suspect you didn't truly think it was such a fine name...

■ OWAIN X LUCINA S

Owain: Might I beg a moment, Lucina?

Lucina: Hmm? Certainly, Owain. You're awfully formal today...

Owain: There's something I'd like you to have.

Lucina: Oh?

Owain: Here.

Lucina: ...A sheath?

Owain: It should fit Falchion.

Lucina: A thoughtful gesture, Owain, but Falchion already has a sheath.

Owain: Yes, I know. And it's as old and worn as the pommel I fixed the other day. I thought maybe it was time to retire it.

Lucina: You're always so thoughtful, Owain. Thank you. You do too much for me...

Owain: Please, it's my pleasure. Plus, it's good for the sword... Because I was thinking it could serve as my proxy.

Lucina: How do you mean?

Owain: There's no telling what the war holds for us. I probably won't always be there to fight at your side when you need me. But your sheath will always be there. If it can aid you in my stead, I'll rest easier.

Lucina: Owain...

Owain: I've been trying to think of ways I can help out for a while now, you know. And the other day, you said you were impressed by my way with weapons. So I figured this might be a way I could...show you how I feel.

Lucina: That's really beautiful, Owain. I'm certain it will serve me well.

Owain: You accept it then?

Lucina: Of course, Owain. And with you, this sheath, and Falchion at my side, I have nothing to fear!

Owain: Yesss! Oh, I'm so glad I got up the nerve to give it to you!

Lucina: From this day forth, we're partners. So no more holding back. Feel free to speak in your normal, abnormal way.

Owain: You got it! ...Wait, abnormal?

Lucina: I didn't say that. Well, no, I SAID it, but I didn't... I'm sorry, Owain. But it's the fact that it's strange that makes it so fascinating!

 Inigo

INIGO X LUCINA C

Inigo: Lucina! Wait! Hold up one second. ...Aw, what, no smile for old Inigo? There's a shocker.

Lucina: I beg your pardon?

Inigo: It's just you're always so darn grim. Don't get me wrong, a determined woman certainly has her charms! But all day, every day is a bit much, don't you think? It's bringing people down.

Lucina: Then the others have complained of my attitude as well?

Inigo: Well, no. I mean, not everyone... But some people! Er, well, one... Okay, me. Look, I just figured I'd point it out before it became a huge problem.

Lucina: I see.

Inigo: Fretting is contagious! If you keep it up, you'll have the whole camp infected.

Lucina: You think I'm contagious?

Inigo: In a way, yeah! ...A little, I guess. You're a leader, you know? We all look up to you.

Lucina: You make a fair case.

Inigo: Yeah? So smile a little! Even if you have to fake it. It's not hard, you know. You just raise your cheeks like this! Here...

Lucina: Gah! Ret go uh mah FAFE!

Inigo: See there, Lucina? That's the cheeriest I've ever seen you. I think I feel a new infection coming on!

Lucina: You'll freel more an dat if you don unhand muh!

Inigo: Ha ha, mercy, my lady! I'll leave you alone! But get practicing. Next time I drop by, I expect you to be smiling like a pro!

Lucina: ...Would he honestly have me grinning about all day like a madwoman? Bah. He always did seem a bit off...

INIGO X LUCINA B

Lucina: Another village wiped out by the Risen. Another step toward a dark future...

Inigo: Tsk tsk tsk. Such a grim countenance...

Lucina: Oh, it's you.

Inigo: Looks like someone forgot her daily smiling practice!

Lucina: Now is hardly the time!

Inigo: Now is PRECISELY the time! In dark times like this, you just have to keep grinning until you feel happy.

Lucina: A village was butchered, Inigo! Men and women, slaughtered! Would you have me charge into battle with a grin on my face? Laugh as my steel pierces flesh?! There are times when a person has no business smiling!

Inigo: Gods, but you ARE grave... All right, then. It looks like drastic measures are in order.

Lucina: Wh-what are you... Get your hands away from—

Inigo: Tickle tickle tickle!

Lucina: S-stop that! Stop...AH HA HA! I-Inig... AH HA HA! Stop! Stop! Stop that this instant! Stop before I cut off your hands!

Inigo: Well? Feel any happier?

Lucina: I feel annoyed! I told you, I'm not in the mood for such folly. Now leave me be.

Inigo: Hm, so tickling is off limits, then? Perhaps it's time for a little—

Lucina: NO! Do not attempt anything! Do not even speak! JUST! BE! QUIET!

Inigo:

Lucina: ...Thank you.

Inigo:

Lucina: Inigo, what are you... What is that...some kind of strange new dance? ...What is wrong with your face? Are you in pain...?

Inigo: Ha ha! I'm fine, Lucina. It's called miming! That was my "man trapped in a box." Entertaining, no? And entirely silent! Mother taught me that one. She said she uses it quite often.

Lucina: That isn't what I meant when I told you to be quiet!

Inigo: Well how else am I supposed to help you practice?

Lucina: ENOUGH, Inigo! What must I do to convince you to leave me in peace? Unlike you, my head is not filled with rainbows and sunshine. I carry sense enough to realize the dire straits we find ourselves in. I have no desire to smile right now, and even less to fake one! If you're too dense to understand that, I don't know how to help you!

Inigo: ...All right, Lucina, all right. I'm sorry. I didn't mean to... ...I'll see you later.

Lucina: Blast. I shouldn't have lost my temper. I know he meant well...

INIGO X LUCINA A

Lucina: Perhaps I should apologize to Inigo... He works on my nerves sometimes... but I know he means well. I suppose he'd tell me to just smile and forget about it.

Inigo: ...Hey, Lucina.

Lucina: Inigo, I—

Inigo: No, don't worry! Just passing through. I won't bother you, I promise.

Lucina: Inigo, I actually wanted to apologize for before... I meant what I said, but my delivery was quite harsh... I appreciate your desire for mirth, but I just don't think this is the time. If you can agree to stop asking me to smile, I pledge to never yell at you again.

Inigo: Sure. No problem. Sometimes I forget that everyone's head isn't stuffed with rainbows.

Lucina: Inigo, I didn't—

Inigo: Don't worry about it. Consider it dropped. I'll stop bothering you now.

Lucina: Inigo, wait...

Inigo: Hmm?

Lucina: I'm sorry. I just thought... It looked like you were crying.

Inigo: What, me? Ha ha! No, I'm not crying. I'm pretty sure I was smiling?

Lucina: Yes, I suppose. Still, for a moment it looked like... Well, I looked at your face, and it just made my heart drop.

Inigo: Oh, wow. Um...I'm sorry? I certainly didn't mean to make you upset.

Lucina: No, don't apologize! It is I who needs to make amends. I was unable to understand your thinking when you expressed it in words. But when I saw your face just now, it all became clear to me. We influence the emotions of those around us...and a smile is a powerful thing.

Inigo: That's it exactly, Lucina! And yours counts for double!

Lucina: Heh. Thank you, Inigo.

Inigo: By the gods! Finally, she smiles! ...Now was that so bad?

Lucina: It's...easier than I thought.

Inigo: You're a natural!

Lucina: Perhaps you will see more of this in the future. I shall dedicate myself to lifting the spirits of all those around me.

Inigo: Well, if you ever need help, you only have to ask!

INIGO X LUCINA S

Lucina: May we speak a moment, Inigo?

Inigo: So much for the new, cheerier Lucina...

Lucina: Even the new me cannot muster a smile today.

Inigo: What, did something happen? Is everyone all right?

Lucina: No, our friends are all fine, so far as I know. That said, there hasn't been anything I'd call happy news, either.

Inigo: Okay, seriously. What's going on? You're acting awfully strange today.

Lucina: It's about to get...stranger.

Inigo: You're scaring me, Lucina.

Lucina: When I became so upset at your insistence that I smile before... Do you remember that?

Inigo: Of course. I record everything any girl says to me, insults and all.

Lucina: Well, I realize now that wasn't the only reason I was so angry... I was angry because you were making me happy, and I didn't think I could afford such feelings at a time like this...

Inigo: Oh?

Lucina: I've been such a stern person to you, and I don't deserve your kindness... But the truth is, I... ...I think I am in love with you.

Inigo: ...What?

Lucina: Would you stay with me, Inigo? Would you be the sword at my side?

Inigo: I... ...Yes, Lucina. Yes! If you'll have me.

Lucina: Truly?! For good and all?!

Inigo: Lucina, I've been in love with you since the moment we met! But you're Yllisean royalty... I guess I never thought I was worthy. Besides, I figured Chrom would murder me if I tried anything!

Lucina: You were worried about Father?! Ha ha ha! I can just picture him receiving you at the castle, broadsword across his lap! Ha ha!

Inigo: There's that smile again!

Lucina: I can't help it! Imagine Father chopping you into bloody bits!

Inigo: I'm glad you're laughing and all, but maybe next we'll work on your sense of humor...

Inigo: Ha ha... Ha? Um...ha? Don't worry, love. You'll always come first in my book!

Lucina: There shouldn't be a book at all! I catch you looking at another woman and it will be ME chopping you into bloody bits!

Inigo: There's that odd sense of humor again? Heh, good one, Lucina... Er, Lucina?

 Inigo (Brother/sister)

INIGO X LUCINA (BROTHER/SISTER) C

Inigo: This place is a mess! I really should straighten up more...often... Is that a...AAAAAAAAUGH!

Lucina: Gods, I've never seen Inigo run so fast! Are we under attack?!

Lucina: Inigo! What happened back there? ...Are you all right?!

Inigo: L-Lucinaaa!

Lucina: Breathe, Inigo. Calm down and tell me what happened. You have nothing to fear now that I'm here.

Inigo: B-b-bug! A bug!

Lucina: ...A bug? ...As in...an insect?

Inigo: As in a huge, freakish nightmare, with gross, hairy legs... It's HORRIBLE!

Lucina: You're telling me all of your screaming and flailing was over an INSECT? *sigh* I thought the Risen had come. You could have sent the camp into a panic.

Inigo: AAAAAH! It's back! And it can fly?! S-stay away! Don't come near meee!

Lucina: Come now, I don't see what all the fuss i—EEEEEEK!

Inigo: See? SEE?! It's the stuff of nightmares! Now hurry up and kill it! Kill it with fire magic or something!

Lucina: Oh, no—I'm not going near that thing! It's HUGE!

Inigo: WHAT?! What happened to having nothing to fear now that you're here? How are you gonna save the future if you can't even smoosh one stupid bug?

Lucina: Those two things are not related in the slightest. And how do YOU plan to impress girls if you're scared of a bug?

Inigo: I'd sooner die loveless and alone than touch that thing! Look, you're the older one! You do it! Father told you to protect your little brother, didn't he?

Lucina: Er, well, I suppose he did... *sigh* All right, I'll... do something about it.

Inigo: I knew I could depend on you, Luce! Three cheers for the once and future exalt!

Lucina: ...You're a royal too, you know? It wouldn't kill you to show a bit more spine.

Inigo: Hey, now's your chance! It just crawled into a corner behind that shelf!

Lucina: It's too dark. I can't see it...

Inigo: You should light up Falchion. Then once you spot it, ker-STAB!

Lucina: Falchion isn't some common pitchfork, Inigo! It's a blade of legend!

Inigo: Ah ha ha, all right, all right. I'm sorry I...

Inigo: AHHHHH! It's flying again! It's flying!

Lucina: As formidable a foe as it may be, I won't allow it to set a single hairy leg on you!

Inigo: Go, Lucina, go! GET HIM!

Chrom: What in the name of...? What are you two doing in here?!

Lucina: F-Father?

Inigo: Father!

Chrom: Honestly, you two. All that commotion over a silly insect? What were you thinking?!

Inigo: Sorry...

Lucina: I'm sorry, Father...

Chrom: Just see that it never happens again.

Inigo: Figures he would be the one to get it. He's unshakable.

Lucina: It's true. Although he was a lot less calm when it came to scolding us...

Inigo: Aw, are you still down about that? I actually had a lot of fun. I can't remember the last time it's ever getting in trouble like that before. It felt like... I don't know, like we were a normal family for a second there.

Lucina: Heh. I confess, it did have its moments...

INIGO X LUCINA (BROTHER/SISTER) B

Lucina: Inigo.

Inigo: Mmm?

Lucina: You know what I'm about to say, don't you?

Inigo: Um... Be sure to wash Falchion after I'm done cutting this apple?

Lucina: DON'T use Falchion to cut apples in the first place, you dolt!

Inigo: Eep! S-sorry! I'm sorry!

Lucina: You had best be more than just sorry... That sword is a national treasure of Yllisse and a memento of my father. Would you use the last earthly remembrance of your dead father to cut FRUIT?! You've shamed the weapon that built your very homeland!

Inigo: Well, you've seen for yourself how big the apple is. And with no other knives around... B-besides, I've barely ever touched the thing before. I dunno, I...I got curious.

Lucina:

Inigo: So, um, a-are you... Yeah, you're mad.

Lucina: You've never held Falchion before?

Inigo: Not really, no. In the future, you always kept it by your side. And since we've been back here, I've maybe moved it from tent to tent once or twice.

Lucina: Then we don't know if you have the potential to wield it.

Inigo: It's a special person to use it?

Lucina: I see there is much you do not know. This blade was forged with Naga's power and steeped in the exalt's bloodline. Only a select few are able to wield it, even among the Yllisean royal house.

Inigo: Gods, talk about picky. Er, though I'm not surprised you're one of them, Lucina.

Lucina: You may well be another, Inigo. I'm mortified we've come this far without ever putting it to the test.

Inigo: That'd be pretty amazing if I really could wield it. Cutting down foes with a mystical sword! You couldn't KEEP the girls away!

Lucina: Mostly I'm ashamed I never stopped to consider it. If you are, in fact, among Falchion's chosen, that is knowledge we will need. There may come a time when it proves necessary for you to take it up.

Inigo: What, like if you're busy?

Lucina: Like if I'm dead, Inigo. Having someone able to wield it even after I'm gone would be a considerable asset. We must use any means at our disposal to ensure the future is saved. Now let's go put it to the test.

Inigo:

Inigo: Inigo?

Inigo: Aw, forget it. There's no way the sword would choose someone like me.

Lucina: You don't know that until you try. You yourself just said you wished you were able to wield it. So let's—

Inigo: I said NO! I'm not doing it! Don't make me... Don't make me practice for your death, Lucina!

Lucina: ...I understand how you feel, but we must be practical about this. We cannot afford to lose this war. No matter what happens or who dies.

Inigo: You think I don't know that?! But it's not... It's just not that simple for me, all right? What, are you planning to leave me, too? First my parents and now you?

Lucina: Not by choice, Inigo. Never by choice. ...But there are no guarantees in war.

Inigo: And that's supposed to make me feel better?! If it means you dying, I don't want anything to do with Falchion! And if you make me try, I'll only use it to chop up more apples, so there! This is pointless. I'm leaving.

Lucina: Inigo... He sure is stuck on this whole apple business...

INIGO X LUCINA (BROTHER/SISTER) A

Inigo: Lucina, is this, uh... Do you have a minute?

Lucina: What's wrong, Inigo? Why the serious face?

Inigo: I want to help me see whether or not I can wield Falchion.

Lucina: Huh? You were so dead set against it. What changed?

Inigo: I did, I suppose. I thought about everything you said... About how we need to win this war by any means necessary. I was running away from that truth and from my duty as a child of the exalted bloodline. But like you said, we need to be practical about this. ...So will you help me?

Lucina: Of course. I'll make the necessary preparations immediately.

Lucina: All right. I want you to strike at that log as if it were the enemy. If you lack the potential to wield Falchion, its blade will be dull as a stone. You will scarce knock the bark off your target. However, if you are among the blade's chosen, the log will be cleft in two.

Inigo:

Lucina: Here. Take Falchion.

Inigo: All right... Here we go...

Inigo: Hey, wait. What am I going to do if this DOES work? ...No. I'll worry about that later. No more doubts. This is a part of my duty... Here I go! Rr-rAAAGH!Huh? I didn't feel anything.

Lucina: ...The log is unscathed. I'm sorry, Inigo. It seems you've not been chosen to wield Falchion.

Inigo:

Lucina: Don't take it too hard. This doesn't change who you are. You're still my brother, a son of Chrom, and a prince of Yllisse. Don't let this—

Inigo: Pffft. Heh heh ha ha ha!

Lucina: ...Inigo?!

Inigo: Ah ha ha ha, s-sorry, it's just... I was so worked up, I... I totally missed! I missed the log! Ah ha ha, hilarious!

Lucina: ...Heh. Heh heh. *ahem* Do try to be serious, Brother. You're making me laugh... *Sigh* I suppose we both got a little too wrapped up in this whole Falchion matter. It wound up souring the air between us, almost as if we'd been quarreling. I far preferred that night we got in trouble for the giant bug.

Inigo: Oh, me too! ...Though at least this helped me firm up my resolve. Not doing this won't let me out of fear that the people I love might die is just...cowardice. If something should happen to you, I swear to keep fighting to the bitter end. But I still have no intention of letting that happen. The pain is too much to imagine. So let me protect you. It's the least your brother can do!

Lucina: I fear I, too, was running. I was afraid to make you a promise. No more. I swear to be here, and now, that this war will not claim me. I refuse to leave you all alone, Brother, nor allow any harm to come to you. We will survive this together. We will forge a future of our own making.

Inigo: It's a promise!

Lucina: So it was sworn on Falchion. ...Oh, blast! I completely forgot that I'm on cooking duty tonight. Sorry, but I must be going.

Inigo: Ah, wait! Lucina, you forgot Falchion! ...So much for not leaving me all alone. Ah, well. Guess it's just you and me, Falchy. How's about one more swing for the road, seeing as I'll likely never touch you again? Hrrngh... YAAAAH!Yup. Not a scratch. You just better do a damned good job of looking after my sister, you got that? If Lucina dies, you're getting demoted to royal fruit knife. Don't think I won't do it! ...All right, well, better get you back to her.

Chrom: ...Hmm? What's this log? Was someone training? Hmm, split perfectly in two. I've never seen such a clean cut before...

 Brady

BRADY X LUCINA C

Lucina: Hello, Brady.

Brady: ...Nnngh? Oh, uh, hey... *cough*

Lucina: Oh, dear. Are you not feeling well?

Brady: Whatcha talkin' about? Just look at me!

Lucina: Er... Truth be told, you look at least as ill as you sound.

Brady: Aw, stop your worryin'! It's just a little cold! *Cough* *hack* *wheeeeze*

Lucina: Brady, if you're ill, you should be resting.

Brady: I'm fine! I just need a... Need a... Hommina... Hoomina... Ahhhhgkbh-CHOOOO!

Lucina: There, do you see? You can barely speak without producing a bizarre sneeze.

Brady: Q-quiet, you! It ain't a... Ahhhhhgkbh-CHOOO! ...Ain't nothin' "bizarre" about it.

Lucina: I have the perfect thing for a cold. Allow me to fetch it for you.

Brady: Keep it! S-save it for yourself. Look, just leave me to dribble in peace, yeah?

Lucina: Well, please be sure to go easy until you're better, yes?

Brady: Enough already! Make like an ox cart and... uh...haul off! Don't want you catching the dreaded red, too.

Lucina: Well, if you're certain you don't need any help. Take care, Brady.

Brady: Gah... Nice going, tough guy! Why ya gotta make everyone all worried...?

BRADY X LUCINA B

Lucina: Yah! Haah! Rrraaagh!

Brady: Yeesh, does that gal ever get tired? She's been swinging that sword for hours!

Lucina: Hyaaah! ...Ngh?!

Brady: Muh?

Lucina: Lucina! What happened? What's wrong?!

Lucina: Oh... B-Brady. Nothing. My hand slipped and I dropped my sword. ...It's fine.

Brady: Fine? Ain't nothing fine about it! Now gimme a look at that arm!

Lucina: H-hey! Brady, what are you...?!

Brady: And your neck, too.Yup. Figured as much. You're running yourself ragged. More practice. You need forty winks, and you need it yesterday!

Lucina: What are you talking about? I'm not tired, and I certainly don't have time for a nap.

Brady: Maybe you should stop worryin' about us chumps and listen to your body! You go out on the battlefield like this, and you'll get yourself killed!

Lucina: Just what do you mean by that? How can you—

Brady: Hey! Experienced priest here, remember'? I may be hopeless myself, but I can tell a thing or two about other people's health. Now hold still...

Lucina: B-Brady, I don't...

Brady: Body feel sluggish today? Heavier than normal?

Lucina: How could you possibly—

Brady: Swollen neck. Your muscles are inflamed.

Lucina: How would my neck make me feel heavier?

Brady: Neck's the only road what leads between the brain and the body. Every signal's gotta pass through it, and inflammation slows traffic down. Even just a little exertion can wipe ya out like an old rag.

Lucina: Is there a solution?

Brady: I told ya! Get your keister in bed! And stick a cool, moist cloth under your neck while you sleep. When you get up, give your neck a gentle stretch. Roll your head around. Massage it.

Lucina: All right. I'll give that a try... Thank you, Brady.

Brady: No rushing, either! And actually sleep, for the love a clams'! ...Gone already. Typical.

BRADY X LUCINA A

Lucina: Brady...

Brady: That's my name!

Lucina: I'm a little late in this, but thank you for your help before. I did as you said, and I feel completely recovered! In fact, it may just be in my head, but I actually feel lighter on my feet than ever.

Brady: Well, don't go pushing yourself, twinkle toes. You only get one body.

Lucina: I'll be careful. Meanwhile, I fear you're looking as sallow as ever.

Brady: Hey, this is my natural color! And quit yer worryin' about me! We're done here! Git!

Lucina: Not yet, we aren't! It's my turn to aid you. You didn't let me help you at all when you came down with that cold. I won't be denied the chance again! I WILL help you, Brady.

Brady: You can start by lettin' go! Gya! Getcha stinkin' paws off a me!

Lucina: Struggling is...futile! Hurk! I can...outgrapple you!

Brady: Waugh! What part of helping me involves a submission hold?!

Lucina: The part where you refuse to submit! Now, submit! Give your body over to me!

Brady: D-don't go sayin' crap like that where folks can hear ya—OUCH! Agh! Uncle! Uncle!

Lucina: Believe it or not, I'm quite the masseuse.

Brady: GAAH?! My neck! My back! Ngh! ...Oh god, I heard somethin' snap!

Lucina: Does that hurt? I hadn't even begun to apply any real pressure. ...I think someone might be exaggerating.

Brady: I think someone might have his shoulder dislocated! Please stop! Owww!

Lucina: ...Oh. Sorry. I didn't realize.

Brady: Yeesh! Feels like I just ran through a gauntlet or two...

Lucina: How very strange... Everyone else I've done this for has needed at least that much pressure to feel it.

Brady: Well, I guess I'm just one'a the gods' special little critters. Next time be a bit more gentle, will ya?

Lucina: I'll be more careful. I promise.

Brady: Good. And, uh, thanks, I guess. ...For the thought, anyway.

BRADY X LUCINA S

Brady: Lucina! Have you heard?

Lucina: Heard what?

Lucina: Oh! Oh, no, you clearly... Yes, well, um... It seems that... People seem to think we're a couple.

Brady: Whaaat? ...How?!

Lucina: Rumors that we're together are flying all around camp.

Brady: Yeah, but WHY?! Who started 'em? And what for? Oh, man, whoever it was, they're about to enter a world'a pain!

Lucina: I don't know that it's any one person. Perhaps it just spread on its own. We've been fairly close as of late. Wrestling, massages...that sort of thing. Out of context, I suppose they could have appeared as intimate behaviors.

Brady: ...A WORLD'A PAIN! Gah! How can you be so calm when ya say junk like that?!

Lucina: S-sorry! I didn't realize I oughtn't...

Brady: Course whoever saw us just HAD to view it in the most scandalous way possible!

Lucina: Quite the misunderstanding, yes.

Brady: Anybody with half a brain would know I'm way too big a weakling to be with you!

Lucina: ...Th-that's not true at all! Thanks to all your advice, my body's never been in better condition. I...I really appreciate that.

Brady: Oh yeah?

Lucina:

Brady: Enough to act on some crazy rumors?

Lucina: I'm sorry?

Brady: No, I... I mean, only if you wanted, but... I dunno. If they're already sayin' it... I mean, why not, right?

Lucina: Why not...be a couple, you mean?

Brady: Y-yeah! Or goin' steady, or whatever ya wanna call it. Like being with ya, Lucina. Even when ya just about broke my dang back, heh heh. So if everybody else is gonna set the stage for us, why waste the opportunity?

Lucina: I always felt that your kindness kept my spark alive amidst all this darkness... If you'll have me, Brady, I'd be honored.

Brady: Hey, same here. So... Sure, I guess? Let's do it.

Lucina: It's a bit ticklish, putting all this into words, isn't it? Heh, am I blushing as red as you?

Brady: Gah! I didn't even realize till now! I must look a damn tomater!

Brady (Brother/sister)

BRADY X LUCINA (BROTHER/SISTER) C

Brady: Ugh, this place is a mess! I really should straighten up more...often... Is that... AAAAAAAAAUGH!

Lucina: Gods, I've never seen Brady run so fast! Are we under attack?!

Lucina: Brady! What happened back there? ...Are you all right?!

Brady: L-Lucinaaa!

Lucina: Breathe, Brady. Calm down and tell me what happened. You have nothing to fear now that I'm here.

Brady: B-b-bug! A bug!

Lucina: ...A bug? ...As in...an insect?

Brady: As in a huge, freakish nightmare, with gross, hairy legs... It's HORRIBLE!

Lucina: You're telling me all of your screaming and flailing was over an INSECT? *sigh* I thought the Risen had come. You could have sent the camp into a panic.

Brady: AAAAH! It's back! And it can fly?! S-stay away! Don't come near meee!

Lucina: Come now, I don't see what all the fuss i— EEEEEK!

Brady: See? Ya SEE?! It's the stuff of nightmares! Now hurry up and kill it with fire magic or whatever you!

Lucina: Oh, no—I'm not going near that thing! It's HUGE!

Brady: WHAT?! What happened to having nothing to fear now that you're here? How ya gonna save the future if you can't even smoosh one stupid bug?

Lucina: Those two things are not related in the slightest. And how a tough guy like you possibly be scared of an insect?

Brady: I'd sooner die a craven that touch that vile thing! Look, you're the older one! You do it! Pop told you to protect your little brother, didn't he?

Lucina: Er, well, I suppose he did... *sigh* All right, I'll... do something about it.

Brady: I knew I could depend on ya, Luce! Hip hip huzzah and all that malarkey.

Lucina: ...You're a royal, too, you know? It wouldn't kill you to show a bit more spine.

Brady: Hey, now's your chance! It just crawled into a corner behind that shelf!

Lucina: It's too dark. I can't see it...

Brady: You should light up Falchion. Then once ya spot it, ker-STAB!

Lucina: Falchion isn't some common pitchfork, Brady! It's a blade of legend!

Brady: Hmph. Fine, be stingy with the thing. See if I...

Brady: AHHHH! It's flying again! Look out!

Lucina: As formidable a foe as it may be, I won't allow it to set a single hairy leg on you!

Brady: Go, Lucina, go! GET HIM!

Chrom: What in the name of...? What are you two doing in here?!

Lucina: F-Father?

Brady: Pop

Chrom: Honestly, you two. All that commotion over a silly insect? What were you thinking?!

Brady: Sorry, Pop.

Lucina: I'm sorry, Father...

Chrom: Just see that it never happens again.

Brady: Figures he'd be the one to smoosh it. He's unshakable.

Lucina: It's true. Although he was a lot less calm when it came to scolding us...

Brady: Hah. Ya still worried about that? I actually had a lotta fun. Can't remember the two of us ever getting in trouble like that before. It's like... I dunno. Felt like we was just a normal family for a second there.

Lucina: Heh. I confess, it did have its moments...

BRADY X LUCINA (BROTHER/SISTER) B

Lucina: ...Brady.

Brady: Mmm?

Lucina: You know what I'm about to say, don't you?

Brady: Um... Be sure to wash Falchion after I'm done cutting this apple?

Lucina: DON'T use Falchion to cut apples in the first place, you dolt!

Brady: Eep! D-don't get so bent outta shape! I'm sorry!

Lucina: You had best be more than just sorry... That sword is a national treasure of Ylisse and a final memento of my father. Would you use the last earthly re-

membrance of your dead father to cut FRUIT?! You've shamed the weapon that built your very homeland!

Brady: Well, you've seen how big the apple is. And I don't see no other knives around... B-besides, I've barely ever touched the thing before. ...I got curious, yeah?

Lucina:

Brady: So, um, a-are ya... Yeah, you're mad.

Lucina: You've never held Falchion before?

Brady: Not really, no. In the future, ya kept it right by your side. And since we been back here, I maybe moved it from tent to tent a couple times.

Lucina: Then we don't know if you have the potential to wield it.

Brady: What, it takes a special cat to use it?

Lucina: I see there is much you do not know. This blade was forged with Naga's power and steeped in the exalt's bloodline. Only a select few are able to wield it, even among the Ylissean royal house.

Brady: Yeesh, talk about picky. Er, though I ain't surprised you're one of 'em, Lucina.

Lucina: You may well be another, Brady. I'm mortified we've come this far without ever putting it to the test.

Brady: It'd be the cat's pajamas if I really could wield that sucker. Cutting down foes with a mystical sword? Now THAT'S aces! I'd be just like Pop!

Lucina: Mostly I've imagined I never stopped to consider it. If you are, in fact, among Falchion's chosen, that is knowledge we need. There may come a time when it proves necessary for you to take it up.

Brady: What, like if you're busy?

Lucina: Like if I'm dead, Brady. Having someone able to wield it even after I'm gone would be a considerable asset. We must use any means at our disposal to ensure the future is saved. Now let's go put it to the test.

Brady:

Lucina: Brady?

Brady: Aw, forget it. Ain't no way the sword could choose a mope like me.

Lucina: You don't know that until you try. You yourself just said you wished you were able to wield it. So let's—

Brady: I said NO! I'm not doing it! Don't make me... Don't make me practice for your death, Lucina!

Lucina: ...I understand how you feel, but we must be practical about this. We cannot afford to lose this war. No matter what happens or who dies.

Brady: Ya think I don't know that?! But it ain't... It just ain't that simple for me, all right? What, you planning to leave me, too? First my folks and now you?

Lucina: Not by choice, Brady. Never by choice. ...But there are no guarantees in war.

Brady: And that's supposed to make me feel better?! If it means ya dying, I don't want anything to do with Falchion! And if you make me try, I'll just use it to chop up more apples, so there! This is pointless. I'm leaving.

Lucina: Brady... He sure is stuck on this whole apple business.....

BRADY X LUCINA (BROTHER/SISTER) A

Brady: Lucina, is this, uh... Do you have a minute?

Lucina: What's wrong, Brady? Why the serious face?

Brady: I want ya to help me see whether or not I can wield Falchion.

Lucina: Huh? You were so dead set against it. What changed?

Brady: I did, I guess. I thought about everything ya said. About how we need to win this war by any means necessary. I was running away from that and from my duty as a child of exalted blood. But like ya said, we need to be practical about this. ...So will ya help me?

Lucina: Of course. I'll make the necessary preparations immediately.

Lucina: All right. I want you to strike at that log as if it were the enemy. If you lack the potential to wield Falchion, its blade will be dull as a stone. You will scarce knock the bark off your target. However, if you are among the blade's chosen, the log will be cleft in two.

Brady:

Lucina: Here. Take Falchion.

Brady: All right... Here goes nothin'...

Brady: Damn. What am I gonna do if this DOES work? ...No. I'll worry about that later. No more doubts. This is part of my duty... Here I go! RrrAAAGH! Huh? I didn't feel nothin'.

Lucina: ...The log is unscathed. I'm sorry, Brady. It seems you've not been chosen to wield Falchion.

Brady:

Lucina: Don't take it too hard. This doesn't change who you are. You're still my brother, a son of Chrom, and a prince of Ylisse. Don't let this—

Brady: ...Pfft. Heh heh ha ha ha!

Lucina: Brady?!

Brady: Ah ha ha ha, s-sorry, it's just... I was so worked up, I... I totally missed! I missed the log! Ah ha ha! What a riot!

Lucina: ...Heh. Heh heh. *ahem* Do try to be serious, Brother. You're making me laugh... *Sigh* I suppose we both got a little too wrapped up in this whole Falchion matter. It wound up souring the air between us, almost as if we'd been quarreling. I far preferred that night we got in trouble for the giant bug...

Brady: Heh, same here. ...Though at least this helped me firm up my resolve. Not doing that I can outta fear the people I love might die is just...cowardice. If something should happen to ya, I swear to keep fighting to the bitter end. But I still got no intention of letting that happen. The pain would be...too much. So lemme protect ya. It's the least your brother can do!

Lucina: I, too, was running. I was afraid to make you a promise. But no more. I swear to you, here and now, that this war will not claim me. I refuse to leave you all alone, Brother, nor allow any harm to come to you. We will survive this together. We will forge a future of our own making.

Brady: It's a promise!

Lucina: So it is sworn on Falchion. ...Oh, blast! I completely forgot that I'm on cooking duty tonight. Sorry, but I must be going.

Brady: Ah, wait! Lucina, ya forgot Falchion! ...So much for not leavin' me, yeah? Guess it's just you and me, Falchy. How's about one more swing for the road, seeing as I'll likely never touch ya again? Hrrngh... YAAAAH! Yup. Not a scratch. Ya just better do

a damned good job of looking after my sister, yeah? If Lucina dies, you're getting demoted to royal fruit knife. Don't think I won't do it! ...All right. Let's get ya back to her.

Chrom: ...Hmm? What's this log? Was someone training? Hmm, split perfectly in two. I've never seen such a clean cut before...

KJELLE X LUCINA C

Kjelle: Ah! There she is. Are you free, Lucina?

Lucina: Hello, Kjelle. What did you need?

Kjelle: A sympathetic ear. I've been challenging everyone in camp to sparring matches. ...What a pathetic lot! None of them can even land a blow on me... It's a bit of a disappointment.

Lucina: Is that really a surprise? I suspect very few are a fair match for you in a duel.

Kjelle: You flatter me. Hmmm... I bet you would offer more of a challenge! Heh, in fact you'd likely wipe the floor with my corpse!

Lucina: I hardly think that's the case.

Kjelle: Trust me, I can tell. You're strong. In fact, I bet the two of us could win this war all by ourselves.

Lucina: Isn't that a bit excessive, isn't it?

Kjelle: Big armies are inefficient. They take too long to react, and they lack agility. Surely you've heard tales of the ancient days, before the Hero-King Marth? They say one of his ancestors fought back a great evil single-handedly! Perhaps we'd do well to take a lesson from him—form an elite band of fighters.

Lucina: I'll grant you that small forces do have their advantages.

Kjelle: Big organizations mean bureaucracy and bloat. Besides, half of any larger army is just cannon fodder.

Lucina: I'll not think of any of our men as sacrificial lambs, and neither would Chrom, Kjelle. Still, it's true that uniting a large group of people under a single cause is difficult. More so than I had imagined... And I agree it's important to hone one's abilities as an individual.

Kjelle: Ha! I knew you'd understand! We're a matched pair after all.

Lucina: I do feel, however, that your views are too extreme.

Kjelle: We'll crush them all! Slash them to bi— Er, sorry. Did you say something?

Lucina: I rest my case.

KJELLE X LUCINA B

Kjelle: Hey, Lucina. Are you hungry? I thought the two of us might have lunch.

Lucina: I would enjoy dining with you, Kjelle, but why just the two of us?

Kjelle: Because it's no fun eating with a bunch of puny weaklings. I'd rather dine with you.

Lucina: ...Everyone in this camp is equally our ally, are they not?

Kjelle: Sure, but some are more equal than others. Especially when it comes to fighting! ...What, you don't want to eat with me? Is that it?

Lucina: Please do not mistake my meaning. We've known each other since we were children—I consider you a close friend.

Kjelle: Thanks, Lucina! I feel the same.

Lucina: Then, as my friend, perhaps you'll indulge me by inviting the others to join us?

Kjelle: *Sigh* Fine. Just don't be surprised when they surrender to a bowl of pudding. Shall we then?

Lucina: Yes. And thank you, Kjelle.

KJELLE X LUCINA A

Kjelle: Hey, Lucina! Free for dinner tonight?

Lucina: I'm sorry. I promised my father I would dine with him this evening.

Kjelle: Heh. Not much I can do if ol' Chrom wants to see you, huh? He's got me beat.

Lucina: Beat at what?

Kjelle: Well, he's about the strongest man in this army, isn't he? I don't see much of a chance of beating him in single combat, so I'll cede this round.

Lucina: ...Just how do you imagine social affairs work?

Kjelle: If someone's stronger than me, they get my respect. And if they're weaker than me, I don't waste my time. That's all I'm saying.

Lucina: Confidence and a competitive spirit are healthy traits in any warrior. But you take it too far, Kjelle. I worry that you isolate yourself...

Kjelle: What's wrong with appreciating strength? You're strong, and I respect that about you. It drew me to you, and now we're friends. Isn't that a good thing?

Lucina: ...Why would I?

Lucina: We're not gladiators fighting for coin, Kjelle. We're at war! Yes, we ought push ourselves to grow as individuals, but in the end we are a team! We must join together as a whole, each of us supporting the other. That is the only way this war will be won.

Kjelle: I understand your thinking, but... Gods, just thinking about those weaklings makes my stomach churn! I seem them rolling around the battlefield, mewling like kittens and... Ugh!

Lucina: Then let us do it your way. I challenge you to a duel!

Kjelle: Er, what?

Lucina: If you beat me, I will acknowledge your philosophy as the truth. Should you wish it, the two of us can leave this army and form our own force. But if I win, you must swear to acknowledge your allies as equals. Strong and weak, warrior and healer alike. We face the enemy as one! United we stand, divided—

Kjelle: Okay, enough! I yield! ...You win.

Lucina: ...Huh?

Kjelle: I know better than to fight you when you have that look in your eye! ...Plus, your speech had my stomach churning even more than the weaklings.

Lucina: Then you'll do as I've asked?

Kjelle: Indeed. I'm sorry, Lucina. I know at times my ego can be difficult to deal with. I may be strong,

but I am very aware I'm not strong enough to win a war alone.

Lucina: I'm pleased to hear it.

Kjelle: I still think strength is important! That's not changing. But maybe it's time I started being more... inclusive?

Lucina: Oh? What did you have in mind?

Kjelle: Yes, I'll train the rest of this sorry lot until they meet my standards!

Lucina: Excellent! I'm sure the others will be thrilled to have your help in training.

Kjelle: We'll get a tougher fighting force, and I won't have to look at weaklings all day! It's a win-win arrangement!

Lucina: Assuming everyone is able to keep up with your training.

Kjelle: As you said, we're all equals. No exceptions, no special treatment! It's time these Shepherds were truly run through their paces! Now, a daily 10-mile run would be a good start. Then perhaps...100 log-lifts? 200?

Lucina: Perhaps this wasn't such a grand idea after all...

KJELLE X LUCINA (SISTERS) C

Kjelle: This place is a mess. I really should straighten up more...often... Is that a...AAAAAAAAUGH!

Lucina: Gods, I've never seen Kjelle run so fast! Are we under attack?

Lucina: Kjelle! What happened back there? ...Are you all right?!

Kjelle: L-Lucinaaa!

Lucina: Breathe, Kjelle. Calm down and tell me what happened. You have nothing to fear now that I'm here.

Kjelle: B-b-bug! A bug!

Lucina: ...A bug? ...As in...an insect?

Kjelle: As in a huge, horrid nightmare, with repulsive, hairy legs... It's TERRIBLE!

Lucina: You're telling me all of your screaming and flailing was over an INSECT? *sigh* I thought the Risen had come. You could have sent the camp into a panic.

Kjelle: AAAAAH! It's back! And it can fly?! S-stay back! Don't come close, fiend!

Lucina: Come now, I don't see what all the fuss i— EEEEEK!

Kjelle: See? SEE?! It's the stuff of nightmares! Now hurry up and kill it! Kill it with fire magic or what have you!

Lucina: Oh, no—I'm not going near that thing! It's HUGE!

Kjelle: WHAT?! What happened to having nothing to fear now that you're here? How do you plan to save the future if you can't even fell one wretched insect?

Lucina: Those two things are not related in the slightest. And what good is all your training if you're scared of a bug?

Kjelle: I've not trained for the horrors that come with touching something like that! Look, you're the older one! You do it! Father told you to protect your little sister, didn't he?

Lucina: Er, well, I suppose she did... *sigh* All right, I'll... do something about it.

Kjelle: I knew I could depend on you, Lucina! Three cheers for the once and future exalt!

Lucina: ...You're a royal, too, you know? It wouldn't kill you to show a bit more spine.

Kjelle: Hey, now's your chance! It just crawled into a corner behind that shelf!

Lucina: It's too dark. I can't see it...

Kjelle: You'd best light up Falchion. Then once you spot it, strike!

Lucina: Falchion isn't some common pitchfork, Kjelle! It's a blade of legend!

Kjelle: All right, all right. At ease, Lucina. I'm sorry I...

Kjelle: AHHHHH! It's airborne again! Take cover!

Lucina: As formidable a foe as it may be, I won't allow it to set a single hairy leg on you!

Kjelle: Go, Lucina, go! GET HIM!

Chrom: What in the name of...? What are you two doing in here?!

Lucina: F-Father?

Kjelle: Father!

Chrom: Honestly, you two. All that commotion over a silly insect? What were you thinking?!

Kjelle: Sorry.

Lucina: I'm sorry, Father...

Chrom: Just see that it never happens again.

Kjelle: Of course he would be the one to get it. He's unshakable.

Lucina: It's true. Although he was a lot less calm when it came to scolding us...

Kjelle: Hey, are you still down about that? I actually had a lot of fun. I can't remember the two of us ever getting in trouble like that before. It felt like... I don't know, like we were a normal family for a second there.

Lucina: Heh. I confess, it did have its moments...

KJELLE X LUCINA (SISTERS) B

Lucina: ...Kjelle.

Kjelle: Mmm?

Lucina: You know what I'm about to say, don't you?

Kjelle: ...Be sure to wash Falchion after I'm finished cutting this apple?

Lucina: DON'T use Falchion to cut apples in the first place, you dolt!

Kjelle: Eep! S-sorry! I'm sorry!

Lucina: You had best be more than just sorry... That sword is a national treasure of Ylisse and a final memento of my father. Would you use the last earthly remembrance of my dead father to cut FRUIT?! You've shamed the weapon that built your very homeland!

Kjelle: Well, you've seen for yourself how big the apple is. And with no other knives around... B-besides, I've never really touched the sword before. ...I suppose I got curious.

Lucina:

but I am very aware I'm not strong enough to win a war alone.

Lucina: I'm pleased to hear it.

Kjelle: So, a-are you... Yes, you're angry.

Lucina: You've never held Falchion before?

Kjelle: Not really, no. In the future, you always kept it by your side. And since we've been back here, I've maybe moved it from tent to tent once or twice.

Lucina: Then we don't know if you have the potential to wield it.

Kjelle: Wait, it takes a special person to use it?

Lucina: I see there is much you do not know. This blade was forged with Naga's power and steeped in the exalt's bloodline. Only a select few are able to wield it, even among the Ylissean royal house.

Kjelle: Huh. Quite particular, I see... Though I'm not surprised you're one of them, Lucina.

Lucina: You may well be another, Kjelle. I'm mortified we've come this far without ever putting it to the test.

Kjelle: Well, it would be quite an honor to wield such a divine weapon. A powerful warrior with a mystical sword... It's the stuff dreams are made of!

Lucina: Mostly I'm ashamed I never stopped to consider it. If you are, in fact, among Falchion's chosen, that is knowledge we need. There may come a time when it proves necessary for you to take it up.

Kjelle: Like...if you're too busy?

Lucina: Like if I'm dead, Kjelle. Having someone able to wield it even after I'm gone would be a considerable asset. We must use any means at our disposal to ensure the future is saved. Now let's go put it to the test.

Kjelle:

Lucina: Kjelle?

Kjelle: Forget it. There's no way the sword would choose someone like me.

Lucina: You don't know that until you try. You yourself just said you wished you were able to wield it. So let's—

Kjelle: I said NO! I'm not doing it! Don't make me... Don't make me practice for your death, Lucina!

Lucina: ...I understand how you feel, but we must be practical about this. We cannot afford to lose this war. No matter what happens or who dies.

Kjelle: You think I don't know that?! But it's not... It's just not that simple for me, all right? What, are you planning to leave me, too? First my parents and now you?

Lucina: Not by choice, Kjelle. Never by choice. ...But there are no guarantees in war.

Kjelle: And that's supposed to make me feel better?! If it means you dying, I don't want anything to do with Falchion! And if you make me try, I'll...I'll just use it to chop up more apples! Hmph! This is pointless. I'm leaving.

Lucina: Kjelle... She sure is stuck on this whole apple business...

KJELLE X LUCINA (SISTERS) A

Kjelle: Lucina, is this, uh... Do you have a minute?

Lucina: What's wrong, Kjelle? Why the serious face?

Kjelle: I want you to help me see whether or not I can wield Falchion.

Lucina: Huh? You were so dead set against it. What changed?

Kjelle: I did, I suppose. I thought about everything you said... About how we need to win this war by any means necessary. I was running away from that truth and from my duty as a child of the exalted bloodline. But like you said, we need to be practical about this. ...So will you help me?

Lucina: Of course. I'll make the necessary preparations immediately.

Lucina: All right. I want you to strike at that log as if it were the enemy. If you lack the potential to wield Falchion, its blade will be dull as a stone. You will scarce knock the bark off your target. However, if you are among the blade's chosen, the log will be cleft in two.

Kjelle:

Kjelle: Here. Take Falchion.

Kjelle: All right... Here we go...

Kjelle: Hey, wait. What am I going to do if this DOES work? ...No. I'll worry about that later. No more doubts. This is a part of my duty... Here I go! Rr-rAAAGH! Huh? I didn't feel anything.

Lucina: ...The log is unscathed. I'm sorry, Kjelle. It seems you've not been chosen to wield Falchion.

Kjelle:

Lucina: Don't take it too hard. This doesn't change who you are. You're still my sister, a daughter of Chrom, and a princess of Ylisse. Don't let this—

Kjelle: ...Pffft. Heh heh ha ha ha!

Lucina: Kjelle?!

Kjelle: Ah ha ha ha, I'm s-sorry, it's just... I was so worked up, I... I completely missed! I missed the log! Ah ha ha! How embarrassing!

Lucina: ...Heh. Heh heh. *ahem* Do try to be serious, Sister. You're making me laugh... *Sigh* I suppose we both got a little too wrapped up in this whole Falchion matter. It wound up souring the air between us, almost as if we'd been quarreling. I far preferred that night we got in trouble for the giant bug...

Kjelle: Oh, me too! ...Though at least this helped me firm up my resolve. Not doing what I can out of fear that the people I love might die is just...cowardice. If something should happen to you, I swear to keep fighting to the bitter end. But I still have no intention of letting that happen. The pain would be too much to imagine. So let me protect you. It's the least your sister can do!

Lucina: I fear, too, was running. I was afraid to make you a promise. But no more. I swear to you, here and now, that this war will not claim me. I refuse to leave you all alone, Sister, nor allow any harm to come to you. We will survive this together. We will forge a future of our own making.

Kjelle: It's a promise!

Lucina: So it is sworn on Falchion. ...Oh, blast! I completely forgot that I'm on cooking duty tonight. Sorry, but I must be going.

Kjelle: Ah, wait! Lucina, you forgot Falchion! ...So much for not leaving me so alone. Guess it's just you and me, sword. How's about one more swing for the road, seeing as I'll likely never touch you again? Hrrngh... YAAAAH! Heh. No scratch. You'd just better do a decent good job of looking after my sister, understand? If Lucina dies, you're getting demoted to royal fruit knife. Don't think I won't do it! ...All right. I'd better get you back to her.

Chrom: ...Hmm? What's this log? Was someone training? Hmm, split perfectly in two. I've never seen such a clean cut before...

■ CYNTHIA X LUCINA C

Cynthia: There you are, Lucina! I've been looking for you!

Lucina: Did you need something, Cynthia?

Cynthia: I wanted to ask you a little favor.

Lucina: If it's within my power, I am happy to assist.

Cynthia: I want you to buddy up with me!

Lucina: Buddy...up?

Cynthia: If we put our heads together, we could come up with some killer team attacks! Like the Dual Grim Fandango! Or the Twin Butt-Kick of Doom!

Lucina: I'm afraid such techniques aren't my style. I try not to attract undue attention on the battlefield, as a rule.

Cynthia: But nailing a really flamboyant move would be a guaranteed morale booster!

Lucina: Whose morale would be boosted, exactly?

Cynthia: All of us! I mean, this is YOU we're talking about. You're Lucina! Daughter of the big cheese! EVERYONE wants to see you kick heinie!

Lucina: You really think morale would be boosted if I "nailed a flamboyant move"?

Cynthia: I'm shocked you even have to ask! You're like a shining ray of hope for us. Both as Chrom's kid AND a fighter! And with such a heroic role comes a responsibility to inspire your allies. A single word or action from you could turn the tide of an entire battle!

Lucina: I suppose that does make a certain amount of sense...

Cynthia: Which is EXACTLY why we need to get cracking on those moves!

Lucina: ...Very well. If doing so will help to cheer on the others, I'll begrudge no effort. I must admit this is a bit outside my purview, but I will try my best.

Cynthia: This is gonna be GREAT! Okay, so leave everything to me. I'll come up with all your poses and victory lines and all that!

Lucina: Poses and...victory lines?

■ CYNTHIA X LUCINA B

Cynthia: I hope you came prepared, Lucina. Today, we create our killer team moves!

Lucina: I shall do my best.

Cynthia: Hey, you need to loosen up! This isn't math class or whatever. You just need to remember the three As: aesthetics, appearances, and acrobatics!

Lucina: I believe aesthetics and appearances are the same thing.

Cynthia: Yes! Which is why it's DOUBLY important you start worrying about them!

Lucina: ...What exactly would you have me do?

Cynthia: Okay, so first of all, you have to start waving Falchion around a lot more. You know how it sometimes lights up, right? We can NOT use that. It's too awesome!

Lucina: I cannot make my blade shine at will, Cynthia. Furthermore, I'm not sure it's appropriate to use Falchion as a prop in this pageantry.

Cynthia: I TOLD you, this is to raise your allies' morale!

Lucina: Are we conjuring mystical light purely for dramatic effect? ...Then it's pageantry.

Cynthia: You maybe say that because you're still feeling bashful. But it's part of a leader's job to stand up and make inspiring moves, right? Chrom does it all the time. Do you think he lets a little embarrassment get in his way? This is the same thing, except with boring ol' words replaced by glowing swords!

Lucina: ...It still feels like I'm being badgered into this. Which is why it's so frustrating that what you say holds to a curious sort of logic.

Cynthia: Okay, so I'm gonna pretend that's a compliment and just get on with things. Anyway, here's a diagram of the first maneuver I came up with.

Lucina: So then... We both jump into a full spin... We cross paths in midair... You shout "Shooting Stars!" as I begin to swirl my hair in a figure-eight pattern... ...And we're to do all this in actual combat?!

Cynthia: Yup! So we'd better start practicing!

Lucina: I stand corrected. This isn't pageantry—it's a sideshow from a traveling circus.

■ CYNTHIA X LUCINA A

Lucina: Er... C-come forth...light of justice?

Cynthia: You're not selling it! What happened to the bold warrior-goddess Lucina I know? You're fearless in combat—how can you be afraid of a few lines of dialogue?!

Lucina: I'm sorry. It's just... It IS rather embarrassing.

Cynthia: Only because you're not putting your heart into it! If you really belt it out, you'll be surprised how convincing it sounds! It's called "method acting," and it's all the rage among theater folk nowadays.

Lucina: You'd say so...

Cynthia: Trust me, I've been doing this all my life. Now, did you rehearse—er, train for the part where you land and Falchion glows? The timing is really key here. Fwoomp, THEN zing! It's got to be perfect.

Lucina: It's proved even more difficult than I thought, I'm afraid. Forgive me.

Cynthia: Yeah, but the glowing sword thing is kind of central to this move. ...Riiiight?

Lucina: But it's not as though the light serves any actual purpose in the attack.

Cynthia: You know, maybe it's that defeatist attitude that's keeping Falchion from lighting up!

Lucina: I'll thank you to avoid such accusations.

Cynthia: Okay, then think of it like this...

Lucina: *Sigh* Yes...?

Cynthia: My mother used to tell me a story as a girl. One set in the age of the great King Marth. There were three sisters who were pegasus knights, and unrivaled in battle or destiny!

Lucina: It sounds like a typical enough cradle tale so far...

Cynthia: When faced with a great challenge, they joined three as one for their Triangle Attack! By harnessing their combined strength, they were able to slay any enemy!

Lucina: Any foe?

Cynthia: They say even the most fearsome foe fell before the Triangle Attack! And every team attack since has been an attempt to recapture that awesome power!

Lucina: Hmm... Well, if it truly holds such practical potential, it does seem worth mastering...

Cynthia: And I'm nothing if not practical, right? Now, back to making your sword glow!

Lucina: Right, then. Maybe this won't be such a waste of time after all!

Cynthia: I knew you'd come around eventually! Now, the first step is getting to a point where you can make Falchion glow at will.

Lucina: If that's what it takes to arrive at a powerful new attack, I shall spare no effort!

Cynthia: Listen to you! I don't know about the others, but MY morale is through the roof! This is so key-y! The only thing we're missing now is some epic music! We are the best...team...ever! Dum dah duuuuuum!

Lucina: Come forth, light of justice!

Cynthia: Again! More intensity!

Lucina: COME FORTH, LIGHT OF JUSTICE!

■ CYNTHIA X LUCINA (SISTERS) C

Cynthia: This place is a mess! I really should straighten up more...often... Is that a...AAAAAAAAUGH!

Lucina: Gods, I've never seen Cynthia run so fast! Are we under attack?!

Lucina: Cynthia! What happened back there? ...Are you all right?!

Cynthia: L-Lucinaaa!

Lucina: Breathe, Cynthia. Calm down and tell me what happened. You have nothing to fear now that I'm here.

Cynthia: B-b-bug! A bug!

Lucina: ...A bug? ...As in...an insect?

Cynthia: As in a huge, freakish nightmare, with gross, hairy legs... It's HORRIBLE!

Lucina: You're telling me all of your screaming and flailing was over an INSECT? *sigh* I thought the Risen had come. You could have sent the camp into a panic.

Cynthia: AAAAAH! It's back! And it can fly?! S-stay away! Don't come near meee!

Lucina: Come now, I don't see what all the fuss i— EEEEEEEK!

Cynthia: See?! SEE?! It's the stuff of nightmares! Now hurry up and kill it! Kill it with fire magic or something!

Lucina: Oh, no—I'm not going near that thing! It's HUGE!

Cynthia: WHAT?! What happened to having nothing to fear now that you're here? How are you gonna save the future if you can't even smoosh one stupid bug?

Lucina: Those two things are not related in the slightest. And how do YOU plan to be a big hero if you're scared of a bug?

Cynthia: I'd sooner die a craven than touch that horrid thing! Look, you're the older one! You do it! Father told you to protect your sister, didn't he?

Lucina: Er, well, I suppose he did... *sigh* All right, I'll... do something about it.

Cynthia: I knew I could depend on you, Lucy! Three cheers for the once and future exalt!

Lucina: ...You're a royal, you know? It wouldn't kill you to show a bit more spine.

Cynthia: Hey, now's your chance! It just crawled into a corner behind that shelf!

Lucina: It's too dark. I can't see it...

Cynthia: You should light up Falchion. Then once you spot it, ker-STAB!

Lucina: Falchion isn't some common pitchfork, Cynthia! It's a blade of legend!

Cynthia: All right, all right! Sheesh... I'm sorry I...

Cynthia: AHHHHH!! It's flying again! It's flying!

Lucina: As formidable a foe as it may be, I won't allow it to set a single hairy leg on you!

Cynthia: Go, Lucina, go! GET HIM!

Chrom: What in the name of...? What are you two doing in here?!

Lucina: F-Father!

Cynthia: Father!

Chrom: Honestly, you two. All that commotion over a silly insect? What were you thinking?!

Cynthia: Sorry...

Lucina: I'm sorry, Father...

Chrom: Just see that it never happens again.

Cynthia: Figures he would be the one to get it. He's unshakable.

Lucina: It's true. Although he was a lot less calm when it came to scolding us...

Cynthia: Aw, are you still down about that? I actually had a lot of fun. I can't remember the two of us ever getting in trouble like that before. It felt like... I don't know, like we were a normal family for a second there.

Lucina: Heh. I confess, it did have its moments...

■ CYNTHIA X LUCINA (SISTERS) B

Lucina: ...Cynthia.

Cynthia: Mmm?

Lucina: You know what I'm about to say, don't you?

Cynthia: Um... Be sure to wash Falchion after I'm done cutting apples with it?

Lucina: DON'T use Falchion to cut apples in the first place, you dolt!

Cynthia: Eep! S-sorry! I'm sorry!

Lucina: You had best be more than just sorry... That sword is a national treasure of Ylisse and a final memento of my father! Would you use the last earthly remembrance of your dead father to cut FRUIT?! You've shamed the legacy that built your entire bloodline!

Cynthia: Well, you've seen for yourself how big the apple is. And with other knives around... B-besides, I've barely ever touched the blade before. I dunno, I...I got curious.

Lucina:

Cynthia: So, um, a-are you... Yeah, you're mad.

Lucina: You've never held Falchion before?

Cynthia: Not really, no. In the future, you always kept it by your side. And since we've been back here, I've maybe moved it from tent to tent once or twice.

Lucina: Then we don't know if you have the potential to wield it...

Cynthia: Wait, it takes a special person to use it?

Lucina: I see there is much you do not know. This blade was forged with Naga's power and steeped in the exalt's bloodline. Only a select few are able to wield it, even among the Ylissean royal house.

Cynthia: Yeesh, talk about picky. But I'm not surprised you're one of them, Lucina.

Lucina: You may well be another, Cynthia. I'm mortified we've come this far without ever putting it to the test.

Cynthia: Mostly I'm ashamed I never stopped to consider it. If you are, in fact, among Falchion's chosen, that is knowledge we need. There may come a time when it proves necessary for you to take it up.

Cynthia: What, like if you're busy?

Lucina: Like if I'm dead, Cynthia. Having someone able to wield it even after I'm gone would be a considerable asset. We must use any means at our disposal to ensure the future is saved. Now let's go put it to the test.

Cynthia:

Lucina: Cynthia?

Cynthia: Aw, forget it. There's no way the sword would choose someone like me.

Lucina: You don't know that until you try. You yourself just said you wished you were able to wield it. So let's—

Cynthia: I said NO! I'm not doing it! Don't make me... Don't make me practice for your death, Lucina!

Lucina: ...I understand how you feel, but we must be practical about this. We cannot afford to lose this war. No matter what happens or who dies.

Cynthia: You think I don't know that?! But it's not... It's just not that simple for me, all right? What, are you planning to leave me, too? First my parents and now you?

Lucina: Not by choice, Cynthia. Never by choice. ...But there are no guarantees in war.

Cynthia: And that's supposed to make me feel better?! If it means you dying, I don't want anything to do with Falchion! And if you make me try, I'll only use it to chop up more apples, so there! This is pointless. I'm leaving.

Lucina: Cynthia... She sure is stuck on this whole apple business...

■ CYNTHIA X LUCINA (SISTERS) A

Cynthia: Lucina, is this, uh... Do you have a minute?

Lucina: What's wrong, Cynthia? Why the serious face?

Cynthia: I want you to help me see whether or not I can wield Falchion.

Lucina: Huh? You were so dead set against it. What changed?

Cynthia: I did, I suppose. I thought about everything you said... About how we need to win this war by any means necessary. I was running away from that truth and from my duty as a child of the exalted bloodline. But like you said, we need to be practical about this. ...So will you help me?

Lucina: Of course. I'll make the necessary preparations immediately.

Lucina: All right. I want you to strike at that log as if it were the enemy. If you lack the potential to wield Falchion, its blade will be dull as a stone. You will scarce knock the bark off your target. However, if you are among the blade's chosen, the log will be cleft in two.

Cynthia:

Lucina: Here. Take Falchion.

Cynthia: All right... Here we go...

Cynthia: Hey, wait. What am I going to do if this DOES work? ...No. I'll worry about that later. No more doubts. This is a part of my duty... Here I go! RrrAAAGH!Huh? I didn't feel anything.

Lucina: ...The log is untouched. I'm sorry, Cynthia. It seems you've not been chosen to wield Falchion.

Cynthia:

Lucina: Don't take it too hard. This doesn't change who you are. You're still my sister, a daughter of Chrom, and a princess of Ylisse. Don't let this—

Cynthia: ...Pffft. Heh heh ha ha ha!

Lucina: Cynthia?!

Cynthia: Ah ha ha ha, s-sorry, it's just... I was so worked up, I... I totally missed! I missed the log! Ah ha ha, what a riot!

Lucina: ...Heh. Heh heh. *ahem* Do try to be serious, Sister. You're making me laugh... *Sigh* I suppose we both got a little too wrapped up in this whole Falchion matter. It wound up souring the air between us, almost as if we'd been quarreling. I far preferred that night we got in trouble for the giant bug...

Cynthia: Oh, me too! ...Though at least this helped me firm up my resolve. Not doing what I can out of fear that the people I love might die is just...cowardice. If something should happen to you, I swear to keep fighting to the bitter end. But I still have no intention of letting that happen. The pain is too much to imagine. So let me protect you. It's the least your sister can do!

Lucina: I fear I, too, was running. I was afraid to make you a promise. But no more. I swear to you, here and now, that this war will not claim me. I refuse to leave you all alone, Sister, nor allow any harm to come to you. We will survive this together. We will forge a future of our own making.

Cynthia: It's a promise!

Lucina: So it is sworn on Falchion. ...Oh, blast! I completely forgot that I'm on cooking duty tonight. Sorry, but I must be going.

Cynthia: Ah, wait! Lucina, you forgot Falchion! ...So much for not leaving me alone. Guess it's just you and me, Falchy. How's about one more swing for the road, seeing as I'll likely never touch you again? Hrrngh... YAAAAH! ...Yup. Once again, total whiff! You just better do a damned good job of looking after my sister, you got that? If Lucina dies, you're getting demoted to royal fruit knife. Don't think I won't do it! ...All right, well, better get you back to her.

Chrom: ...Hmm? What's this log? Was someone training? Hmm, split perfectly in two. I've never seen such a clean cut before...

■ GEROME X LUCINA C

Lucina: Gerome?

Gerome: Ah, Lucina.

Lucina: I'm not intruding, am I? I don't want to disturb your rest.

Gerome: It's fine. What do you want?

Lucina: Well, nothing, really. I just came to say thank you.

Gerome: For what?

Lucina: You gave me your mask, remember? You said there might come a time where I would need to conceal my identity...

Gerome: Ah. Yes. I remember.

Lucina: Well, it was very prescient of you! The mask proved most useful. So again, thank you.

Gerome: Think nothing of it.

■ GEROME X LUCINA B

Lucina: *Sigh*

Gerome: Something wrong, Lucina?

Lucina: Oh, hello, Gerome...

Gerome: What's the matter?

Lucina: I've lost my pendant.

Gerome: Oh? What manner of pendant?

Lucina: It's carved with the likeness of my mother. It's very precious to me.

Gerome: ...Where was the last place you saw it?

Lucina: I took it off while I was cleaning the supply tent. I didn't want it getting scratched.

Gerome: I suppose you've already searched there?

Lucina: Many times.

Gerome: Then we should retrace your steps and see if we can't find it.

Lucina: You'll help me look?

Gerome: It's important to you, isn't it?

Lucina: Yes, very much so. I simply... Thank you, Gerome.

Gerome: Thank me when we find it.

■ GEROME X LUCINA A

Lucina: Ah, Gerome. Perfect timing.

Gerome: Oh? What for?

Lucina: We're holding a war council, and I was hoping you might attend.

Gerome: Sorry. I'm not much for group activity.

Lucina: A pity. We could benefit from your calm, measured opinions. You have a keen mind for combat as well... Regardless, I will not force you.

Gerome: I am sorry if I disappoint you. But I know my own limitations. I am not one for plans or speeches. I am a wolf that deals only in death.

Lucina: Then we have something in common.

Gerome: We do not. You are a leader who can inspire with both words and deeds. Though we fight alongside each other in the field, we play different roles.

Lucina: You sell yourself short, sir.

Gerome: The right tool for the right job. Isn't that what they say? You provide the inspiration and strategy. I will cut down any who dare oppose us.

Lucina: There is a certain wisdom to what you say.

Gerome: Don't sound so surprised... Now, I have some swords to sharpen, and I think you have a council to attend.

Lucina: Farewell, Gerome. I shall look for you on the battlefield.

Gerome: You needn't look far—I will stand beside you, as always.

■ GEROME X LUCINA S

Gerome: Lucina? I need to speak with you.

Lucina: What is it?

Gerome: I...regret refusing your invitation to the war council. I am sorry.

Lucina: You owe me no apologies, Gerome. I understand your thinking... "The right tool for the right job." We must all strive to perform our roles as best we can.

Gerome: I know I said that, but I was mistaken.

Lucina: ...You were?

Gerome: I want to help you in any way I can, Lucina.

Lucina: I... Thank you, Gerome.

Gerome: I have admired you for many long years. I would gladly die for you. But when you asked me to help in an unfamiliar way, I chose the craven's path. I hope you can forgive me.

Lucina: Fine, you are forgiven! Then can we now please stop with this absurd apology! You've been my most stalwart companion ever since childhood, Gerome. And if anyone else named you craven, I would cut them down on the spot!

Gerome: ...Thank you, Lucina.

Lucina: Lone wolf you may be, but there is no one I rely upon more in a battle. Besides, what you've shown here is as inspiring as any speech or grand tact—

Gerome: Lucina, enough!

Lucina: I beg your pardon?

Gerome: I am no poet, Lucina, to woo you with honeyed words. I am a blunt measure of a man, so I know no other way to say this... ...I love you.

Lucina: Oh, Gerome...

Gerome: If truth be told, I've felt this way since I first laid eyes on you. But only after all these years have I finally found the courage to tell you.

Lucina: But I have felt the same, Gerome, for so long! Did you never sense it?

Gerome: You mean...we've both had this feeling? And since long ago?

Lucina: Heh, I guess neither of us is regarded as one to display our emotions.

Gerome: Then I regret our past, but we have our present and the future. Together.

Lucina: We shall fight, and live, side by side from now until we draw our final breath.

■ MORGAN (MALE) X LUCINA C

Morgan (male): Ah, perfect! There you are!

Lucina: Hmm? What are you hiding behind your back, Morgan?

Morgan (male): Ta-dah! It's for you!

Lucina: Ah! What lovely flowers! Thank you. But what is the occasion?

Morgan (male): Kids were picking 'em in the village we just passed through. They gave some to me, so that's your cut.

Lucina: I don't think I've ever seen such vibrant colors...

Morgan (male): Wonderful, isn't it? Even in the throes of war, the flowers still bloom. Just think what it will look like once the world is at peace! Fields awash in color!

Lucina: ...Heh.

Morgan (male): Hmm?

Lucina: I've not known anyone so optimistic in all my days. I'm a bit envious, honestly.

Morgan (male): Why? Is something on your mind? Some worry eating at you?

Lucina: Not a specific concern, so much as a grim memory that refuses me peace. ...I apologize. I have no place to complain when you've lost your entire memory. You must carry your own set of those woes, do you not? Living in a strange time, without a firm grasp on who you are?

Morgan (male): Ehh, it's not so bad as you might think. True, it can leave you feeling a bit...untethered, maybe? Afloat? But that's just another word for free... Every experience is brand new! The smell of the air, the color of those flowers—it's all so fresh and intense!

Lucina: Hmm... I'll say it again: I envy you. I arrived in this era with a heart blackened by painful memories.

Morgan (male): But your father's alive in this time, isn't he?

Lucina: Yes, and I consider it a blessing that I've had the chance to see him again. Morgan, I... If you'll excuse me.

■ MORGAN (MALE) X LUCINA B

Morgan (male): Da da daaaa doo dee dum... ♪ Perfect! I've got my melody nailed down.

Lucina: What are you doing, Morgan? What's all that humming about?

Morgan (male): You heard that, did you? So you recall the flowers I gave you? The ones from that village? Well, in return for the flowers, I sang the kids a song I wrote! They really seemed to enjoy it, so I thought maybe I'd try my hand at writing more. Perhaps I can sing for the camp if I get good enough!

Lucina: I'm sure they would welcome the distraction from fighting and marching and...fighting. I think it's a lovely idea.

Morgan (male): Yeah? Well, all right then! Guess I'd better get cracking!

Lucina: You really are always full of energy, aren't you? How do you manage to act so cheery all the time?

Morgan (male): It's not an act. I just do whatever comes naturally. And it's like I said before—when you can't remember anything, everything's brand new! There's so much out there to discover, I don't have time to get depressed!

Lucina: I'm certain I wouldn't be half so happy were I in your situation. I think your sunny disposition must be some fundamental part of your nature. I think it's wonderful.

Morgan (male): Hmm... I couldn't say. But isn't being in this era a pretty good deal for you, too? All I've heard of our era are tales of death and starvation and a whole lot of bad stuff.

Lucina: It was a terrible place, yes. Which means all the more hangs in the balance of our success or failure. If we lose, this world will become the awful future we escaped. ...The very idea haunts my nights.

Morgan (male): Well, that won't do at all! A warrior needs her sleep! You're a brilliant fighter and leader, but you can't shine from inside a gloomy cloud.

Lucina: ...You're right, of course. I'm sorry, Morgan. I certainly don't want to spread my dark cloud over others.

Morgan (male): Think nothing of it. I'm always happy to help find a silver lining!

■ MORGAN (MALE) X LUCINA A

Lucina: The future can be changed... It MUST be changed! I believe that with all that I am, and yet the nightmares persist. What I wouldn't give for some of Morgan's optimism...

Morgan (male): Did I hear my name?

Lucina: GAH?! M-Morgan! How long have you been there?!

Morgan (male): I just showed up, actually! It's time for dinner. We're all waiting for you.

Lucina: I'm not hungry.

Morgan (male): Uh-oh. Not feeling well? Maybe you should lie down.

Lucina: It's an ailment of the heart, I'm afraid.

Morgan (male): Did something happen? If you feel like sharing, I'm happy to listen.

Lucina: Morgan, do you... Do you truly believe the future can be changed? That we can overwrite our apocalyptic end with a happier one?

Morgan (male): Of course we can!

Lucina: How can you be so certain?

Morgan (male): Because my mother's that certain.

Lucina: [Robin]?

Morgan (male): She's amazing, my mother... My life's dream is to follow in her footsteps, actually... Anyway, as long as she's on the problem, we're in good hands. I don't know many things about this time or this world, but I know I have faith in Mom.

Lucina: I see... My own father, too, is fighting with all he has to win a better future. The ties between them are powerful indeed. Heh, so powerful I'm surprised they never "tied" the knot.

Morgan (male): Ha ha! There, you made a joke! ...A bit weak, but hey, it's a start! So, feeling a bit better now?

Lucina: I am, actually. Thank you, Morgan.

MORGAN (MALE) X LUCINA S

Lucina: Morgan, I... Might I have a word?

Morgan (male): Sure. Does this have to do with what we talked about last time?

Lucina: I suppose so. What you said has given me great comfort... I think I've seen the last of my nightmares.

Morgan (male): Lucina, that's fantastic! When you feel cheery, we ALL feel cheery!

Lucina: Morgan... There's something I'd like to say to you. ...Something important.

Morgan (male): Oh? ...What is it?

Lucina: I don't get nightmares now because... I'm too busy dreaming of you. And even when awake, I find you're in all my thoughts... I feel as if I never really knew what hope was before I met you.

Morgan (male): ...Wow. Lucina...I...

Lucina: Will you stay with me, Morgan? From now until the end of all?

Morgan (male): Sure, all right!

Lucina: "Sure, all right"? Th-that's not... Do you understand what I'm asking, Morgan?

Morgan (male): I think so. You're in love with me, right?

Lucina: Y-yes...

Morgan (male): And I'm in love with you! And we'll stick together, come what may. Right?

Lucina: W-wait. You're in love with ME? Why didn't you just say so?!

 Morgan (male) (Brother/sister)

MORGAN (MALE) X LUCINA (BROTHER/SISTER) C

Morgan (male): This place is a mess! I really should straighten up more...often... Is that a... AAAAAAAAAUGH!

Lucina: Gods, I've never seen Morgan run so fast! Are we under attack?!

Lucina: Morgan! What happened back there? ...Are you all right?!

Lucina: L-Lucinaaa!

Lucina: Breathe, Morgan. Calm down and tell me what happened. You have nothing to fear now that I'm here.

Morgan (male): R-r-roach! It's...

Lucina: ...A roach? ...As in...a bug?

Morgan (male): Not a bug! I love bugs! ...A roach! A huge, freakish nightmare one, with gross, hairy legs! It's HORRIBLE!

Lucina: You're telling me all of your screaming and flailing was over a COCKROACH? *sigh* I thought the Risen had come. You could have sent the camp into a panic.

Morgan (male): AAAAAH! It's back! And it can fly?! S-stay away! Don't come near meee!

Lucina: Come now, I don't see what all the fuss i— EEEEEEK!

Morgan (male): See? SEE?! It's the stuff of nightmares! Now hurry up and kill it! Kill it with fire magic or something!

Lucina: Oh, no—I'm not going near that thing! It's HUGE!

Morgan (male): WHAT?! What happened to having nothing to fear now that you're here? How are you gonna win this war if you can't even smoosh one stupid roach?

Lucina: Those two things are not related in the slightest. And YOU want to be a tactician, right? So figure out how to kill it!

Morgan (male): What's to figure out?! Who plans out strategies for killing insects?! Look, you're the older one! You do it! Father told you to protect your little brother, didn't he?

Lucina: Er, well, I suppose he did... *sigh* All right, I'll... do something about it.

Morgan (male): Fantastic! Thanks, Lucina! Three cheers for the once and future exalt!

Lucina: ...You're a royal, too, you know? It wouldn't kill you to show a bit more spine.

Morgan (male): Hey, now's your chance! It just crawled into a corner behind that shelf!

Lucina: It's too dark. I can't see it...

Morgan (male): You should light up Falchion. Then once you spot it, ker-STAB!

Lucina: Falchion isn't some common pitchfork, Morgan! It's a blade of legend!

Morgan (male): Ah ha ha, all right, all right. I'm sorry I...

Morgan (male): AHHHHH! It's flying again! It's flying!

Lucina: As formidable a foe as it may be, I won't allow it to set a single hairy leg on you!

Morgan (male): Go, Lucina, go! GET HIM!

Chrom: What in the name of...? What are you two doing in here?!

Lucina: F-Father?

Morgan (male): Father!

Chrom: Honestly, you two. All that commotion over a silly insect? What were you thinking?!

Morgan (male):

Lucina: I'm sorry, Father...

Chrom: Just see that it never happens again.

Morgan (male): Figures he would be the one to get it. He's unshakable.

Lucina: It's true. Although he was a lot less calm when it came to scolding us...

Morgan (male): Aw, are you still down about that? I actually rather enjoyed it. I can't remember the two of us ever getting in trouble like that before. It felt...strangely familiar somehow. Kind of a happy, nostalgic feeling.

Lucina: Heh. I confess, it did have its moments...

MORGAN (MALE) X LUCINA (BROTHER/SISTER) B

Lucina: ...Morgan.

Morgan (male): Mmm?

Lucina: You know what I'm about to say, don't you?

Morgan (male): Um... Be sure to wash Falchion after I'm done cutting this apple?

Lucina: DON'T use Falchion to cut apples in the first place, you dolt!

Morgan (male): Eep! S-sorry! I'm sorry!

Lucina: You had best be more than just sorry... That sword is a national treasure of Ylisse and a final memento of my father... A prince's sword used to cut FRUIT?! You've shamed the weapon and hurt your very homeland!

Morgan (male): Well, you've seen for yourself how big the apple is. And with no other knives around... B-besides, I've barely ever touched the thing before. I dunno, I...I got curious.

Lucina:

Morgan (male): So, um, a-are you...? Yeah, you're mad.

Lucina: You've never held Falchion before?

Morgan (male): Not really, no. In the future, you always kept it by your side. Since we've been back here, I've maybe moved it from tent to tent once or twice.

Lucina: Then we don't know if you have the potential to wield it.

Morgan (male): Wait, it takes a special person to use it?

Lucina: I see there is much you do not know. This blade was forged with Naga's power and steeped in the exalt's bloodline. Only a select few are able to wield it, even among the Ylissean royal house.

Morgan (male): Huh. Well, I've never fought with it before—at least as far as I can remember. I suppose that means in the future I came from, I wasn't deemed worthy.

Lucina: That's not necessarily true, Morgan. I never did give you a chance to try it before I traveled back here. Honestly, I'm mortified we've come this far without ever putting it to the test.

Morgan (male): I have to admit, it'd be pretty amazing if I really could wield it. A brilliant tactician wielding a legendary sword... Mother would be so proud!

Lucina: Mostly I'm ashamed I never stopped to consider. If you are, in fact, among Falchion's chosen, that is knowledge we need. There may come a time when it proves necessary for you to take it up.

Morgan (male): What, like if you're busy?

Lucina: Like if I'm dead, Morgan. Having someone able to wield it even after I've traveled would be a considerable asset. We must use any means at our disposal to ensure the future is saved. Now let's go put it to the test.

Morgan (male):

Lucina: Morgan?

Morgan (male): Aw, forget it. There's no way the sword would choose someone like me.

Lucina: You don't know that until you try. You yourself just said you wished you were able to wield it. So let's—

Morgan (male): I said NO! I'm not doing it! Don't make me... Don't make me practice for your death, Lucina!

Lucina: ...I understand how you feel, but we must be practical about this. We cannot afford to lose this war. No matter what happens or who dies.

Morgan (male): You think I don't know that?! But it's not... It's just not that simple, all right? Think of all that Mother's losing to ensure that future! Would you betray that?

Lucina: Not by choice, Morgan. Never by choice. ...But there are no guarantees in war.

Morgan (male): And that's supposed to make me feel better?! If it means you dying, I don't want anything to do with Falchion! And if you make me try, I'll only use it to chop up more apples, so there! This is pointless. I'm leaving.

Lucina: Morgan... He sure is stuck on this whole apple business...

MORGAN (MALE) X LUCINA (BROTHER/SISTER) A

Morgan (male): Lucina, is this, uh... Do you have a minute?

Lucina: What's wrong, Morgan? Why the serious face?

Morgan (male): I want you to help me see whether or not I can wield Falchion.

Lucina: Huh? You were so dead set against it. What changed?

Morgan (male): I did, I suppose. I thought about everything you said... About how we need to win this war by any means necessary. I was running away from that truth and from my duty to become a master tactician. But like you said, we need to be practical about this. ...So will you help me?

Lucina: Of course. I'll make the necessary preparations immediately.

Lucina: All right. I want you to strike at that log as if it were the enemy. If you lack the potential to wield Falchion, its blade will be dull as a stone. You will scarce knock the bark off your target. However, if you are among the blade's chosen, the log will be cleft in two.

Morgan (male):

Lucina: Here. Take Falchion.

Morgan (male): All right... Here we go...

Morgan (male): Hey, wait. What am I going to do if this DOES work? ...No. I'll worry about that later. No more doubts. This is a part of my duty...

Here I go! RrrAAAGH!Huh? I didn't feel anything.

Lucina: ...The log is unscathed. I'm sorry, Morgan. It seems you've not been chosen to wield Falchion.

Morgan (male):

Lucina: Don't take it too hard. This doesn't change who you are. You're still my brother, a son of Chrom, and a prince of Ylisse. Don't let this—

Morgan (male): ...Pffft. Heh heh ha ha ha!

Lucina: Morgan?!

Morgan (male): Ah ha ha ha, s-sorry, it's just... I was so worked up, I... I totally missed! I missed the log! Ah ha ha, hilarious!

Lucina: ...Heh. Heh heh. *ahem* Do try to be serious, Brother. You know we both got a little too wrapped up in this whole Falchion matter. It wound up spurring this argument between us, almost as if we'd been quarrelling. I far preferred that night we got in trouble for the giant bug...

Morgan (male): Oh, me too! ...Though at least this helped me firm up my resolve. Not doing what I can out of fear that the people I love might die is just...cowardice. If something should happen to you, I swear to keep fighting to the bitter end. But I still have no intention of letting that happen. The pain is too much to imagine. So let me protect you!

Lucina: I fear I, too, was running. I was afraid to make you a promise. But no more. I swear to you, here and now, that this war will not claim you. I refuse to leave you all alone, Brother, nor allow any harm to come to you. We will survive this together. We will forge a future of our own making.

Morgan (male): It's a promise!

Lucina: So it is sworn on Falchion. ...Oh, blast! I completely forgot that I'm cooking duty tonight. Sorry, but I must be going.

Morgan (male): Ah, wait! Lucina, you forgot Falchion! ...So much for not leaving me all alone. Guess it's just you and me, Falchy. How's about one more swing for the road, seeing as I'll likely never touch you again? Hrrngh... YAAAAH!Yup. Not a scratch. You just better do a damned good job of looking after my sister, you got that? If Lucina dies, you're getting demoted to royal fruit knife. Don't think I won't do it! ...All right, well, better get you back to her.

Chrom: ...Hmm? What's this log? Was someone training? Hmm, split perfectly in two. I've never seen such a clean cut before.

 Morgan (female) (Mother/daughter)

The Morgan (female) mother/daughter dialogue can be found on page 312.

 Yarne

YARNE X LUCINA C

Yarne: ...Pulse? Check. ...Arms? Check. ...Legs? Check! Whew! Looks like I'm all here. Ugh. Why do I keep fighting if I'm going to be such a coward about it?!

Lucina: Yarne? Is something wrong? You look upset.

Yarne: Oh, hey. No, I'm fine. I was just, uh... Reflecting on the horrors of war.

Lucina: I often do the same. Thinking how everyone is suffering each day we let it continue... Farmers are slain in their fields, merchants are robbed, children become orphans...

Yarne: Actually, I meant the part where everybody's trying to kill me. My life's worth no more than the next guy's. I know that, but... It's still a lot of pressure being the last of an entire race.

Lucina: I can only imagine.

Yarne: Don't get me wrong... I'm scared, but I still want to help. I'll keep fighting. I just...really don't... want to, is all. ...Heh. Pretty sad, I know.

Lucina: So be it.

Yarne: Er, so be what, exactly?

Lucina: I will cover your back. From now, you need only worry about foes in front of you.

Yarne: What?

Lucina: I swear to keep you safe. That way, perhaps you can fight without fear.

Yarne: Lucina, everyone else is out there fighting on their own. I feel terrible asking, but... That would be such a great relief! ...Thank you.

Lucina: I'm happy to do all I can to ease an ally's mind. Thank you for opening up to me. I'm honored by your trust.

Yarne: Not at all!

Lucina: I should be going. I'll see you, Yarne.

Yarne: Oh, what am I doing?! Gods, why not just ask her to babysit you, you big coward?! This is a new low, even for me...

YARNE X LUCINA B

Yarne: ...Ow! For a shallow cut, my arm sure doesn't want to heal up... Still really hurts, too. I knew I saw someone behind that tree, but nooo! I had to go charge in like an idiot... Ah, well. I'm still alive, and the arm'll heal. I'll count my blessings.

Lucina: Might I have a minute, Yarne?

Yarne: Sure. What is it?

Lucina: I wanted to see how you're recovering.

Yarne: What, this? I'm fine, thanks. I'm sorry you had to see me fall for such an obvious ambush. I was doing so well, too. But you know me! It's not a battle if I don't screw up.

Lucina: That's not true at all... But I'm just glad you weren't more seriously injured. I promised I would watch your back, and now... I am so, so sorry, Yarne.

Yarne: What?! No! Don't apologize. We're at war! Nicks and scratches are bound to happen!

Lucina: Still...

Yarne: It's very kind of you, Lucina, but I'm the one who needs to shape up, not you. Heh, next time I'll show 'em this rabbit's no easy prey! Give 'em the ol' taguel one-two!

Lucina: Just, please...

Yarne: Hmm?

Lucina: Please be careful. Don't do anything rash. In the last battle, it almost seemed like you were trying to protect me...? I'd be twice the fool if you get hurt trying to keep me safe while I try to keep you safe!

Yarne: Well, I can't just sit back and let you do all the work. And I can't keep you all to myself. The others need your help, too. Plus, I want to keep you safe as much as you want to keep me safe. We're friends!

Lucina: No, of course. That's all true, but...

Yarne: Believe me, I'm not eager to get hurt either. I'll do my best to stay out of trouble.

Lucina: And I'll do my best to keep trouble away from you.

YARNE X LUCINA A

Yarne: Are you all right?!

Lucina: Yarne?

Yarne: Holy carrots, your leg! Did you get that trying to protect me?

Lucina: No, I was just a bit careless. I, er...let my attention slip for a moment, and they were quick with a blade. That's all. It's mostly healed, besides. You needn't worry yourself over it.

Yarne: You're a terrible liar, you know that? After my arm got hurt, you've been guarding me nonstop. It's obvious. What happened to our promise not to do anything crazy, hmm?

Lucina: Er, I didn't... Don't be mad.

Yarne: I'm not mad at you, but I'm furious with myself!

Lucina: Yarne, no! Don't be. It really was careless. It's no one's fault but my own.

Yarne: ...Heh. Ha ha ha!

Lucina: Is...something funny?

Yarne: It's just... The two of us, taking hits for each other. Then we both protest that it's all our fault and that the other shouldn't feel guilty. I don't know, it just struck me as funny. We're some pair, you and me.

Lucina: Heh, I suppose it IS a little silly. But a part of me thinks that's the way it should be for allies.

Yarne: You think?

Lucina: Sure. Helping each other... Making sacrifices... Accepting responsibility for our failings and helping each other learn from them... That sounds like the ideal ally to me.

Yarne: When you put it like that, it does. I guess we're doing pretty well.

Lucina: Very well, I should think! You can continue to count on me to watch your back!

Yarne: And on me to watch yours!

YARNE X LUCINA S

Lucina: Hm? What is it? Everything all right? You're all worked up.

Yarne: I've just been so impressed with your performance in combat lately! I had to come and tell you!

Lucina: You're a whole different person out there! It's amazing to witness.

Yarne: Aw, you're exaggerating. But I'm glad. So, um... If I've been doing so well, do I get a reward?

Lucina: Hah! Of course, you name it! If it's within my power, it's yours.

Yarne: W-will you be my girl?!

Lucina: ...What?

Yarne: I always hated being a coward and a burden on everyone else. I wanted to change, but... It wasn't until we started watching out for each other that I learned how. You taught me what real strength is, and I learn more from you every day... But I've got a long way to go, and that's where you come in...

Yarne: I love you, Lucina! You make me a better taguel, on the field and off. I want to be with you always...

Lucina: ...I would like that very much, Yarne.

Yarne: You would? Really?!

Lucina: It's true that when we first met, you were quick to run and hide. But watching you conquer your fear has been an inspiration to me.

Yarne: Huh—

Lucina: Seeing you grow has filled me with pride, as much as if it were my own improvement. I want to keep sharing in your life, and I want to share in mine. So yes, Yarne ...I love you, too.

Yarne: Ha! After hearing that, I feel like I just grew about a hundred times stronger! With you by my side, I'll become a real warrior yet!

 Laurent

LAURENT X LUCINA C

Laurent: A moment, Lucina, if you please.

Lucina: Hmm? What is it, Laurent?

Laurent: Might I take a look at your left leg?

Lucina: ...What's this about?

Laurent: If my suspicions are correct, you have been injured.

Lucina: But... How did you know? I didn't tell anyone. ...They would have just worried needlessly.

Laurent: You're favoring your right slightly when you walk. I knew something was amiss.

Lucina: I'm impressed by your attention to detail.

Laurent: I consider it my role to monitor this army's condition and aid in its preservation. I ask that you seek prompt and thorough treatment for your leg. The desire to spare your allies worry is noble, but misguided. Hobbling yourself with a poorly healed leg will cause far greater woe than the truth.

Lucina: ...I shall have it looked at and be sure to give it proper time to heal.

Laurent: I wish you a swift recovery.

Lucina: Ever the voice of reason... I should learn from his example.

LAURENT X LUCINA B

Lucina: Rgh... Strange...

Laurent: Is something amiss, Lucina? You have an air of consternation.

Lucina: Oh, hello, Laurent. I've been practicing my sword form, but something feels off.

Laurent: In what way?

Lucina: The force behind each swing feels weak.

Laurent: Well, I fear your grasp of swordplay far exceeds my own... But I do understand something of forces. Might I ask you to demonstrate?

Lucina: If you think it might help. On three, yes? One... two... HAAAH!

Laurent: Ah! I think I've got it.

Lucina: Already?!

Laurent: I suspect you've begun taking shallower steps due to your erstwhile leg injury. A common phenomenon among the recently recovered, I've found. Add another half step's length to your lunge, and you're like to find your old form.

Lucina: I see. I'll give it a try. One... Two... RAAH! Ah! Yes, that's it exactly! Laurent, you're brilliant! I'm in your debt again. Such a talent almost defies all measure.

Laurent: Not at all.

Lucina: You really do keep such a keen eye on all of us. On behalf of the whole camp, it is most deeply appreciated.

Laurent: You are too kind. Perspicacity and analysis are the only things I have to offer. If you ever find yourself in need of either, I am at your humble service.

Lucina: I'm sure I'll have need of your talents again soon!

LAURENT X LUCINA A

Laurent: Lucina? Might I have a moment?

Laurent: Yes, of course.

Lucina: Lately, I've been hearing some disquieting talk. People are saying that the quality of your work has...faltered, as of late.

Laurent: What?

Lucina: Mind you, it's hardly fair to complain. We all rely on you too much as it is. And I, for one, am confident that there are no grounds for the accusation. However, as your friend, I thought I did want you to know.

Laurent: ...I see. Yes, well, thank you for alerting me.

Lucina: There's no truth to it, is there? I'll find the source of this baseless rumor and make them—

Laurent: N-no! Er, please, say nothing. I fear they have the right of it. Of late, I find myself...distracted.

Lucina: If something weighs on your mind, I'd be happy to lend an ear.

Laurent: Hmm... How to put it?

Lucina: No need to hold back, Laurent. You can speak plainly to me about anything. Well, as plainly as you ever speak... You owe me at least that much after all the help you've given me.

Laurent: ...Very well then. I fear I've lost sight of myself and the role that I serve. As I was making my rounds, helping the others in their training, I had a thought... What if all my efforts were nothing more than idle ego? Everyone in this army possesses tremendous skill and physical aptitude. Who am I to tell them how to go about their training? Or take care of their health? I worry that I serve only my own pride with these foolish endeavors.

Lucina: That's absurd, Laurent! I, of all people, know how helpful you truly are!

Laurent: Lucina...

Lucina: The only person here you could stand to spend more time helping is yourself.

Laurent: Er, myself?

Lucina: Yes! Work on learning to give yourself more credit. If you're unsure how, I'll show you.

Laurent: At the risk of sounding rude, you hardly seem the most qualified teacher. If there's anyone who is harder on themselves than I, it is you.

Lucina: Hah! Well, that just might be true! I'd be absolutely no help at all, eh heh...

Laurent: Perhaps the two of us can work on improving together?

Lucina: Heh, a fine idea. It's a deal!

LAURENT X LUCINA S

Lucina: Are you free, Laurent?

Laurent: L-Lucina!

Lucina: I thought we might join minds to think up some new ideas for...

Lucina: Um, Laurent? Is something wrong? You seem unwilling to meet my gaze.

Laurent: A-apologies, milady!

Lucina: You're acting very strange. Whatever is the matter?

Laurent: No, I merely, er... It's just that...

Lucina: If something is on your mind, perhaps I might help find an answer. I've told you before, you can always speak frankly to me.

Laurent: ...Very well then. When I spoke to you before about my distracted state, I mentioned my doubts. Was I really helping others, and so on. You recall this conversation, yes? Well, I fear it was...a half-truth.

Lucina: Oh?

Laurent: I was not worried about whether I was fit to support the army... I was worried I was unfit to support you. Thoughts of how I might better aid you, and you alone consumed me! That was my true distraction from watching over the others.

Lucina: Laurent, what exactly are you saying?

Laurent: You're Chrom's daughter, and in your veins runs the blood of exalts and heroes...So how could a common man such as I ever be worthy of you?

Lucina: That's ridiculous! Birth has nothing to do with talent or ability!

Laurent: I want to serve as your support, but how can I believe it's possible? And without such belief, nothing matters. I am but a twig floating in a stream.

Lucina: So that's the full reason, is it?

Laurent: I am in love with you, Lucina. I can say it no plainer.

Lucina: ...Oh.

Lucina: I know I'm a fool to harbor a love far beyond my station, and yet—

Lucina: Laurent, please—have you ever heard me talk about station before? I don't give a whit for your parentage. I care about what's in your heart. ...And in truth, I feel much the same about you.

Laurent: You... You do?

Lucina: I do, and have for quite some time.

Laurent: Th-this is wonderful! Stupendous! For once, I don't know what to say...

Lucina: I want to support you as you have me. Together...forever.

Laurent: As do I. It's only right two souls derelict in caring for themselves find each other!

Tiki

TIKI X LUCINA C

Lucina: Tiki! How does the day find you?

Tiki: Perfectly well, Lucina. Why do you ask?

Lucina: I just wanted to say, if there's anything I can help with, please let me know.

Tiki: Very kind of you. But I'm fine for the moment.

Lucina: Ah, of course. Sorry to disturb you. It's just... Well, IF you ever need help, I want to be there first!

Tiki: I'm very grateful for your concern, Lucina. Truly I am. But remember that you are an important part of this army. Your first duty must be to your fellow soldiers. ...Especially as you once dared take the great name of Marth as your own.

Lucina: That was perhaps...rash of me. You knew him, didn't you? The great King Marth? What was he like?

Tiki: ...You did not investigate this before you took his name?

Lucina: Only the legends. I called myself Marth to feel closer to him. I always yearned to know what he was really like—the man behind the deeds.

Tiki: Your enthusiasm seems sincere enough. Very well, I will tell you about him. ...But not today. Perhaps the next time we meet.

Lucina: Oh, thank you, Tiki! I would hear all there is to tell!

■ TIKI X LUCINA B

Lucina: Greetings, Tiki.

Tiki: And greetings to you, Lucina.

Lucina: I was hoping that today you might be able to tell me about King Marth.

Tiki: You are certainly persistent in your curiosity...

Lucina: It's more than idle curiosity. I should know more of the man whose name I once took as my own. Who was the real Marth? Are the stories of his deeds true? What was he like?

Tiki: One thing I can tell you is that he treasured his friends like no one else I've known. He was kind, considerate, and calm. And despite his station, quick with a smile.

Lucina: Really?!

Tiki: You sound surprised...

Lucina: I just didn't expect the mighty King Marth to be so...er, nice.

Tiki: And how DID you imagine him?

Lucina: The Marth of history led the liberators and smashed the power of evil dragons. He must've been a fierce, unforgiving man who struck fear in friend and foe alike! How could he not have been, when he was forced to wage such a terrible war?

Tiki: ...I suppose he was unforgiving—at least when it came to himself. He never stopped looking for a way to lead the world to peace. And every victim and sacrifice on that path haunted him...

Lucina: It sounds much like our own quest. There must be so much to be learned from him...

Tiki: His journey was dogged by setbacks and troubles. People did not understand his motives. He was deserted, and even betrayed. How he suffered! The struggles he faced would have crushed a lesser man. But they just made Marth stronger. That is why he became the Hero-King.

Lucina: He achieved the impossible, just as we must. No matter how steep or dangerous our path becomes, we will prevail! ...We must.

Tiki: Remember that Marth was an ordinary man long before he became legend. That's why he knew he couldn't do it alone. And why he needed the help of allies.

Lucina: The hero of legend had help?

Tiki: Of course he did! Behind every great man stands a host of friends and comrades. You want to win a war? Then you must learn to inspire warriors and win their trust.

Lucina: THAT'S why he was kind and considerate! He needed the best to stand by him.

Tiki: Yes, and the best loved him for it. Lucina, you can do it, too. You remind me of him. You inspire trust and even love among your comrades. As long as you never give up, I have no doubt you will honor the name of Marth.

Lucina: You honor me... Thank you, Tiki.

■ TIKI X LUCINA A

Lucina: HIYARGH! YAH! Unnngh...GAH!

Tiki: Working on your fencing, I see.

Lucina: I was just finishing my drills.

Tiki: I saw you helping out earlier, serving the soldiers their meals.

Lucina: I had some free time, so I thought I'd pitch in.

Tiki: And before that, you were helping unload the wagons...

Lucina: Well, I'm stronger than I look. Those crates are no problem for me.

Tiki: And before that, you went to market to purchase supplies. Honestly, it's hard to find a job or chore you're not helping out with. It's a fine thing you're doing, trying to build bonds of friendship and trust. But it will all be in vain if you work yourself into the sickbed.

Lucina: Oh, I'm fine. Truly. I can handle it.

Tiki: ...You're trying to emulate King Marth, aren't you? By winning the trust of the other soldiers, you hope to become a great leader.

Lucina: What? No! Not at all... Th-this is just how I am. Besides, I doubt legendary warriors wasted time cooking stews and going shopping...

Tiki: (...She builds trust and wins allies without even thinking about it...) (Could she truly be...?!)

Lucina: I beg your pardon, Tiki? Were you saying something?

Tiki: Apologies. I was lost in thought. But, Lucina, I must tell you something. Taking the name of Marth was a fateful decision of great import.

Lucina: How so?

Tiki: I cannot be sure of your intention in taking the name... But few dare compare themselves to a legend...and this set you on a path. The name evokes envy and hope in others, and burdens you with their expectations. Like it or not, you carry that weight now. The only question is—will it crush you?

Lucina: I never realized...

Tiki: Can you carry the hopes and dreams—the demands of so many?

Lucina: I...don't know. I know I can't ever be like the real Marth. No one can. But I realized on our quest today, and people have started to look to me... Then I shall never rest until every friend has achieved their dream!

Tiki: Good. You know the nature of your task—this is the key to victory.

Lucina: I have you to thank for opening my eyes. I won't let you or anyone down.

Tiki: I believe you mean this. But remember your allies when you face your greatest challenges! A true hero knows when to admit she cannot go it alone.

Lucina: I will take your words to heart. We will all win this war, together.

Tiki: Spoken as Marth might have himself...

Mother

■ MOTHER X LUCINA C

Lucina: Mother, guess what? I found a wonderful dress in the town market.

[Robin]: Oh?

Sully: Oh yeah?

Sumia: Oh?

Maribelle: Oh, do go on!

Olivia: Oh?

Lucina: It was gorgeous! I thought it'd be just perfect for you, so I bought it. I was thinking you could try a different style for once.

[Robin]: Why, Lucina! What a lovely surprise! Now let me get a look at this gorgeous... Er...dress? Oh dear. I've never seen so many...unusual colors and shapes in one piece of clothing.

Sully: Aw, hell. I suppose I might be ready to wear a gorgeous... Er...dress? Oh boy. I've never seen so many...unusual colors and shapes in one piece of clothing.

Sumia: Why, Lucina! What a lovely surprise! Now let me get a look at this gorgeous... Er...dress? Oh dear. I've never seen so many...unusual colors and shapes in one piece of clothing.

Maribelle: Why, Lucina! What a lovely surprise! Now let me get a look at this gorgeous... Er... dress? Oh dear. I've never seen so many...unusual colors and shapes in one piece of clothing.

Olivia: Why, Lucina! What a lovely surprise! Now let me get a look at this gorgeous... Er...dress? Oh dear. I've never seen so many...unusual colors and shapes in one piece of clothing.

Lucina: I know! It's very modern. See all the giant pink polka dots? If you look carefully, you'll see that each one is a portrait of Emmeryn herself! I wager each Father sees you in this, he'll just scream with delight!

[Robin]: (I bet he'll scream, all right...)

Sully: (Oh, he'll scream, all right...)

Sumia: (I bet he'll scream, all right...)

Maribelle: (I bet he'll scream, all right...)

Olivia: (I bet he'll scream, all right...)

Lucina: Pardon, Mother? I didn't catch that.

[Robin]: I'm sorry, Lucina. It's just that... Well, this isn't exactly my...style. I'm very grateful for the thought, but...I don't think I can wear it.

Sully: Sorry, Lucina. It's just... Well, this isn't exactly my...style. I'm really grateful for the thought, but...I don't think I can wear it.

Sumia: I'm sorry, Lucina. It's just that... Well, this isn't exactly my...style. I'm very grateful for the thought, but...I don't think I can wear it.

Maribelle: I'm sorry, Lucina. It's just that... Well, this isn't exactly my...style. I'm very grateful for the thought, but...I don't think I can wear it.

Olivia: I'm sorry, Lucina. It's just that... Well, this isn't exactly my...style. I'm very grateful for the thought, but...I don't think I can wear it.

Lucina: Oh? I was sure you would like it... Well, perhaps next time I go to market, you could come and pick something yourself. I know it seems frivolous in times like these. But in the blighted future I come from, I often fantasized of such simple pleasures.

[Robin]: Why, Lucina. What a considerate daughter you've grown up to be. I'd be delighted to go to market with you. ...Delighted and honored.

Sully: Heh, you really are something, Lucina. I'd be delighted to go to market with you. Delighted and honored.

Sumia: Why, Lucina. What a considerate daughter you've grown up to be. I'd be delighted to go to market with you. ...Delighted and honored.

Maribelle: Why, Lucina. What a classy, well-bred daughter you've grown up to be. I'd be delighted to go to market with you. ...Delighted and honored.

Olivia: Why, Lucina. What a considerate daughter you've grown up to be. I'd be delighted to go to market with you. ...Delighted and honored.

Lucina: Wonderful! And when we go, I'll wear the new dress!

[Robin]: (Oh, gods, no...)

Sully: (Oh, gods, no...)

Sumia: (Oh, gods, no...)

Maribelle: (Oh, gods, no...)

Olivia: (Oh, gods, no...)

Lucina: Pardon, Mother?

■ MOTHER X LUCINA B

Lucina: Everyone in this town is so stylish. I wager we'll find you the perfect dress here.

[Robin]: Er, yes. Just so long as it's not TOO stylish. Frankly, dear, you have much more...flamboyant taste in clothes than I do.

Sully: Er, yeah. Just so long as it's not TOO stylish. Frankly, you've got much more...flamboyant taste in clothes than me.

Sumia: Er, yes. Just so long as it's not TOO stylish. Frankly, dear, you have much more...flamboyant taste in clothes than I do.

Maribelle: Er, yes. Just so long as it's not TOO stylish. Frankly, dear, you have much more...flamboyant taste in clothes than I do.

Olivia: Er, yes. Just so long as it's not TOO stylish. Frankly, dear, you have much more...flamboyant taste in clothes than I do.

Lucina: I favor the tasteful and understated. For example, what about this one?

[Robin]: G-gracious! I don't think I've ever seen such a...shimmery magenta.

Sully: Good gods! I don't think I've ever seen such a...shimmery magenta. Pass.

Sumia: G-gracious! I don't think I've ever seen such a...shimmery magenta.

Maribelle: G-gracious! I don't think I've ever seen such a...shimmery magenta.

Olivia: G-gracious! I don't think I've ever seen such a...shimmery magenta.

Lucina: Hmm. I suppose it IS a little bright. Well, what about this one?

[Robin]: Oh, my... That's very lacy. ...In fact, it's nothing BUT lace. Lucina, I can see right through it!

Sully: Wow, that sure is lacy. ...In fact, it's nothing BUT lace. Lucina, I can see right through that thing!

Sumia: Oh, my... That's very lacy. ...In fact, it's nothing BUT lace. Lucina, I can see right through it!

Maribelle: Oh, my... That's very lacy. ...In fact, it's nothing BUT lace. Lucina, I can see right through it!

Olivia: Oh, my... That's very lacy. ...In fact, it's nothing BUT lace. Lucina, I can see right through it!

Lucina: Oh, all right. Well...how about this one, then?

[Robin]: Well, it's a nice color, I grant you. But I'm not sure about the whole octopus motif...

Sully: Well, the color's all right, but I'm not sure about the octopus motif...

Sumia: Well, it's a nice color, at least. But I'm not sure about the whole octopus motif...

Maribelle: Well, it's a nice color, I grant you. But I'm not sure about the whole octopus motif...

Olivia: Well, it's certainly a nice color. But I'm not sure about the whole octopus motif...

Lucina: Oh. I thought you liked octopi. ...This is not going well, is it? Why don't I come back another day and pick out something nice for you?

[Robin]: Er, well, I'm not sure if that's a good idea, but...all right. Let's try it.

Sully: Er, well, I'm not sure if that's a good idea, but... all right. Let's try it.

Sumia: Er, well, I'm not sure if that's a good idea, but... all right. Let's try it.

Maribelle: Er, well, I'm not sure if that's a good idea, but...all right. Let's try it.

Olivia: Er, well, I'm not sure if that's a good idea, but... all right. Let's try it.

Lucina: Wonderful! Then I shall not rest until I find you the PERFECT dress. Something that you will truly, truly adore!

[Robin]: Oh, yes, I'm sure you... Hmm? Oh, look at this...

Sully: Oh yeah, I'm sure you... Hmm? Hey, look at this...

Sumia: Oh, yes, I'm sure you... Hmm? Oh, look at this...

Maribelle: Oh, yes, I'm sure you... Hmm? Oh, look at this...

Olivia: Oh, yes, I'm sure you... Hmm? Oh, look at this...

Lucina: Which one? ...The baby garment?

[Robin]: Oh, isn't it just adorable? Look at the tiny little bows, too! ...Well, enough shopping for today. We should really be getting back to camp.

Sully: Man, is that cute or what? It's even got one of those tiny little bows. ...Anyway, enough shopping for today. We should really be getting back to camp.

Sumia: Oh, isn't it just adorable? Look at the tiny little bows, too! ...Well, enough shopping for today. We should really be getting back to camp.

Maribelle: Oh, isn't it just adorable? Look at the tiny little bow, too! ...Well, enough shopping for today. We should really be getting back to camp.

Olivia: Oh, isn't it just adorable? Look at the tiny little bows, too! ...Well, enough shopping for today. We should really be getting back to camp.

Lucina:

[Robin]: ...Hmm.

Sully: ...Hmm.

Sumia: ...Hmm.

Maribelle: ...Hmm.

Olivia: ...Hmm.

■ MOTHER X LUCINA A

Lucina: Well, Mother, I've done it. I've found your ideal outfit. I just know you'll love it!

[Robin]: Oh, goodness. I didn't think you'd find anything quite so quickly... But...I'm sure it will be just fine. I can hardly wait to try it on! Ha ha...ha.

Sully: Oh, wow. I didn't think you'd find anything quite so...quickly. I'm sure it'll be fine. I can hardly wait to try it on! Ha ha...ha.

Sumia: Oh, goodness. I didn't think you'd find anything quite so quickly... But...I'm sure it will be just fine. I can hardly wait to try it on! Ha ha...ha.

Maribelle: Oh, goodness. I didn't think you'd find anything quite so quickly... But...I'm sure it will be just fine. I can hardly wait to try it on! Ha ha...ha.

Olivia: Oh, goodness. I didn't think you'd find anything quite so quickly... But...I'm sure it will be just fine. I can hardly wait to try it on! Ha ha...ha.

Lucina: And I can't wait to see how it fits! Are you ready? TA-DAAAH!

[Robin]: ...Huh? It's...tiny. Almost like... Lucina, these are baby clothes.

Sully: ...Huh? It's tiny. Almost like... Lucina, these are baby clothes.

Sumia: ...Huh? It's...tiny. Almost like... Lucina, these are baby clothes.

Maribelle: ...Huh? It's...tiny. Almost like... Lucina, these are baby clothes.

Olivia: ...Huh? It's...tiny. Almost like... Lucina, these are baby clothes.

Lucina: Yes! I saw you admiring them in the shop when we visited the market together. I didn't understand why, until I realized you must've been thinking of your daughter. The one you have in this era, I mean. Your REAL daughter.

[Robin]:

Sully:

Sumia:

Maribelle:

Olivia:

Lucina: You could send it to her back at the castle. I'm sure she must miss you.

[Robin]: Why, Lucina...

Sully: Lucina...

Sumia: Why, Lucina...

Maribelle: Why, Lucina...

Olivia: Why, Lucina...

Lucina: I've been so happy here, despite having to fight this war. Being able to see my mother again has been a dream come true. I don't want to wake up and remember that you have a different life in this world.

[Robin]:

Sully:

Sumia:

Maribelle:

Olivia:

Lucina: Whenever I think of your little girl, I can't help but feel...jealous. I know it's ridiculous to envy myself, but I can't help it.

[Robin]: Oh, Lucina...don't be silly! I've thought of you as my daughter from the moment we were reunited! Believe me when I say I love you just the same as I love that child at the castle.

Sully: Oh, hell... Don't be silly! I've thought of you as my daughter from the moment we were reunited! Believe me, I love you just the same as I love that child at the castle.

Sumia: Oh, Lucina...don't be silly! I've thought of you as my daughter from the moment we were reunited! Believe me when I say I love you just the same as I love that child at the castle.

Maribelle: Oh, Lucina...don't be absurd! I've thought of you as my daughter from the moment we were reunited! Believe me when I say I love you just the same as I love that child at the castle.

Olivia: Oh, Lucina...don't be silly! I've thought of you as my daughter from the moment we were reunited! Believe me when I say I love you just the same as I love that child at the castle.

Lucina: ...Honestly?

[Robin]: Yes! You are a true daughter to me. I want to give you happy memories to make up for those you lost in your future world. And I know your father feels the same way.

Sully: Of course! You're a true daughter to me. I want to give you happy memories to make up for those you lost in your future world. And I know your father feels the same way.

Sumia: Yes! You're a true daughter to me. I want to give you happy memories to make up for those you lost in your future world. And I know your father feels the same way.

Maribelle: Yes! You're a true daughter to me. I want to give you happy memories to make up for those you lost in your future world. And I know your father feels the same way.

Olivia: Yes! You are a true daughter to me. I want to give you happy memories to make up for those you lost in your future world. And I know your father feels the same way.

Lucina: If anyone knows how he feels, I imagine it would be you...

[Robin]: Of course! Your father and I are alike in so many ways... We're both parents to the world's most wonderful daughter, for one.

Sully: Of course! Your father and I are alike in lots of ways... We're both parents to the best damn daughter in the world, for one.

Sumia: Of course! Your father and I are alike in so many ways... We're both parents to the world's most wonderful daughter, for one.

Maribelle: Of course! Your father and I are alike in numerous ways... We're both parents to the world's most wonderful daughter, for one.

Olivia: Of course! Your father and I are alike in so many ways... We're both parents to the world's most wonderful daughter, for one.

Lucina: ...Thank you, Mother. For everything.

Say'ri

Avatar (male)

The dialogue between Avatar (male) and Say'ri can be found on page 223.

Avatar (female)

The dialogue between Avatar (female) and Say'ri can be found on page 234.

Tiki

■ TIKI X SAY'RI C

Say'ri: My lady!

Tiki: Ah, Say'ri. Good day.

Say'ri: You fought the last battle masterfully, my lady. Truly, your power is beyond my ken.

Tiki: You're very kind. Though I must say, it has left me rather tired.

Say'ri: Then pray do not waste your words on me. Go now and rest.

Tiki: Yes, I... Hmm, I fear I...may not have much choice...

Say'ri: My lady?

Tiki: My power has returned, but... Still, I...

Say'ri: M-My lady! No! Alarm! Call forth a healer at once! The Voice is fallen!

Tiki: ...Zzzzzzzzz.

Say'ri: Fallen...asleep? My lady? My lady, can you hear me?

Tiki: Mmm... Five more years...

Say'ri: Fie! I pray the war will be long since over by then. Though p'raps it would be for the best to permit her sleep through it. 'Twould be selfishness itself to drag her with us in such frail condition.

Tiki: I'm not so fragile as all that.

Say'ri: Ah! You're awake.

Tiki: I am here of my own will. I wish to stay and be of use, Say'ri.

Say'ri: On the contrary, my lady! I ask that you do not leave my side. The risks are simply too great for you to wander hill and dale alone.

Tiki: Ah, Say'ri, always so serious! It is sweet of you to fret so. Very well. I give you my word.

Say'ri: And my thanks in return.

■ TIKI X SAY'RI B

Say'ri: My lady! Where are you?! Please, by Naga's mercy, respond!

Tiki: Ah, Say'ri. Splendid! Your timing is perfect. Some lovely villagers just shared some of their apples with me. Will you have one?

Say'ri: Apples?! Nay, I shan't!

Tiki: Suit yourself, though I see no cause to shout.

Say'ri: I've cause aplenty, my lady! Just how many times does this make?! You swore your word you'd not leave the camp without me at your side!

Tiki: Did I now? ...And you're certain the word I swore was "yes"?

Say'ri: Fie! You can't honestly have forgotten?

Tiki: I fear I have. Pray, forgive me. I am a being unlike you humans.

Say'ri: Being the Voice does not give you a license for falsehood!

Tiki: Thbbbbt!

Say'ri: My lady, I have no words. You are acting as a child! What would the people think if they saw you thus?

Tiki: Like I am, you mean? I care not! Let them think what they will.

Say'ri: The Voice is a rarefied and exalted being, sacred unto all. I fear dwelling amongst us lowly mortals is corrupting that sublime character.

Tiki: That's preposterous. And if my sublimeness precludes me from being around humans, I say good riddance!

Say'ri: My lady, please!

Tiki: Do you want an apple or not?

Say'ri: I speak of larger things than fruit, my lady! ...But I will concede your words do bear a ring of truth. If you see fit to gift me an apple, I shall humbly accept.

Tiki: Splendid! Now open wiiiide...

Say'ri: You can't possibly...?! If the people witnessed such a vulgar display, 'twould be the end of—Hr—rmph?!

Tiki: Delicious, isn't it?!

■ TIKI X SAY'RI A

Say'ri: The day draws ever nearer, my lady.

Tiki: What day?

Say'ri: The war's end. The day peace returns to the land. The day we might return home for good and all.

Tiki: Yes. With luck, it will come. But I fear the road we walk is paved with the bones of good people. ...Of innocents lost.

Say'ri: Aye and aye again.

Tiki: And poor Yen'fay among them. Do you grieve for him still?

Say'ri: 'Twould be false to say the sadness does not haunt me. But my brother met the end himself and chose. I've come to accept it as unavoidable. What's done is done.

Tiki: Liar.

Say'ri: M-My lady?!

Tiki: Lay down your stoic mask. I know the pain tears at you still. If you are in pain, tell me that you hurt! Let me in, Say'ri.

Say'ri: ...What would you have me say?

Tiki: Not that what's done is done! Not that you can forget so easily! Was your bond so feeble that a few weeks marching might erase him from your heart? Forget? Erase him from my

heart?! 'Twould be easier to erase the heart entire! He was my brother. ...My only flesh and blood.

Tiki: ...Forgive me, milady. I would retract those words, if possible. It was not my hope to deepen the wound.

Say'ri: My lady, please... Just...

Tiki: But I was desperate to hear the contents of your heart. To hear you speak frankly. I wanted you to tell me everything, Say'ri.

Say'ri: But why? Why me?

Tiki: Because I very dearly want to be your friend.

Say'ri: My...friend?

Tiki: Long have you stood at my side, Say'ri. Always faithfully, but never as a friend. Only as guard, disciple, and servant. I find it terribly lonesome. I think you are a beautiful person, Say'ri, and I would call you an equal. ...A friend.

Say'ri: I fear my lifetime is but a few short days compared to yours. Would you still have me, knowing that I cannot stay for long?

Tiki: Without a moment's hesitation. I am used to loss. Do not deprive me from the joy of ever HAVING.

Say'ri: ...As my lady wishes. Flighty, heedless, and exasperating as you may sometimes be...I like you a great deal as well. So equals it is from this day hence.

Tiki: Equals, from this day hence. ...And thank you, Say'ri.

 Morgan (female) (Mother/daughter)

The Morgan (female) mother/daughter dialogue can be found on page 312.

Basilio

 Avatar (male)

The dialogue between Avatar (male) and Basilio can be found on page 223.

 Avatar (female)

The dialogue between Avatar (female) and Basilio can be found on page 234.

 Flavia

■ FLAVIA X BASILIO C

Basilio: Oh ho! Who is this lovely young woman? Perhaps she's seeking companionship? ...Is what I was thinking before I recognized it was you, Flavia! Bwa ha!

Flavia: Yes, and I thought, "Who is this sad, crusty old man? Perhaps he is lost and confused?" Before I heard the tired buffoonery and recognized it was you, Basilio.

Basilio: Old man? Old? Hah! Bald and grizzled on the outside, yes, but inside beats the heart of a man half my age!

Flavia: That act may work on the others, but I know you too well, oaf... Isn't it time you dropped the charade and started acting your age?

Basilio: Oh, damn it all... *sigh* I suppose you've got a point... I'm old enough to grandfather half the whelps in this army.

Flavia: Did you know the youngsters have taken to calling you "gramps"?

Basilio: Why, the arrogant little... In my day, we had RESPECT for our elders... I doubt these young pups would dare face this "gramps" in a battle arena, I wager!

Flavia: Assuming you can still find your way there. Memory is the first to go, you know?

Basilio: You're no spring chicken yourself, woman! ...That is, assuming you ARE a woman. I doubt anyone's ever managed to prize you out of that armor long enough to find out.

Flavia: ...Speaking of equipment, have I shown you my new sword? I'm told it's sharp enough to slice through mail. Perhaps it's time I tested it...on YOU!

Basilio: Gar, have a care where you swing that thing! You'll cut an ear off! I came here to consult with a fellow leader, not to be threatened by a mad witch!

Flavia: "Consult with a fellow leader"? YOU? Ah ha ha ha! That's rich!

Basilio: Ogre's teeth, why do I even bother? I give up! Good-BYE!

Flavia: Heh, oh wait, Basilio. I'll stop, I promise! ...Basilio? Hmm, how curious... I wonder if he truly had something to discuss?

FLAVIA X BASILIO B

Basilio: You have a moment, Flavia?

Flavia: When it comes to you, oaf, I NEVER have a moment.

Basilio: Ah yes, too busy sharpening that razor wit along with your swords, I'm sure... But perhaps this'll warm that icy heart of yours: fine mead from the old country. Have a drink, and let's talk a bit...

Flavia: ...Mead? Well, well, Basilio. If I didn't know better I'd say you were up to something...

Basilio: Look, do you want some or—

Flavia: Yes. Pour me a mug—a large mug, mind—and you can have your talk.

Basilio: Take care not to spill it, now... This blasted stuff cost me a fair bit of coin. Now then, what I wanted to ask you... *ahem* Just between the two of us, eh? There are plenty of good men in this army of Chrom's, wouldn't you agree? So, er, have you...taken a shine to anyone?

Flavia: Gods preserve us. What are you up to, oaf? I smell a trap... If you think I'm going to list my crushes like a giddy schoolgirl, then you—

Basilio: Must you question everything, woman?! It's just idle banter, nothing more. Here, have another mug of mead... Tasty, isn't it? Now, come... You can tell old Basilio. My only aim here is to know you better.

Flavia: Hmm, you couldn't ply me with mead in any case. I can drink you under the table. Fine then... I suppose Chrom is an upstanding man, in his way.

Basilio: Hmph. Not exactly a barrel of laughs, is he? Always has his nose buried in those maps... Not to mention that hair! All bit much, don't you think? Over-compensating, I'd say.

Flavia: Your turn then. What lady do you fancy?

Basilio: Me? Well, er... I suppose that Lucina lass isn't half bad.

Flavia: What?! She's half your age!

Basilio: Ha! That's ripe coming from you! You're old enough to be Chrom's mother!

Flavia: ...I told you about my new sword, didn't I, oaf? It's sharp enough to shave with...

Basilio: *Gulp*

Flavia: See? Feel the edge on your neck there? Look how those whiskers just fall away...

Basilio: T-take it easy, Flavia. J-just put that sword down and we can—

Flavia: Keep talking? Yes, why don't we. I believe you were saying something about my age?

Basilio: Ur, yes, o-only how young and vibrant you look these da—

Flavia: Enough, you simpering simpleton! Get out of my sight! ...And leave the mead.

Basilio: But...it's my last bottle...

Flavia: And you're on my last nerve! Now go, or your next shave will be with death!

Basilio: Curse you, woman! I shall have revenge, or my name's not Basilio the Brave!

Flavia: Heh, first time I've ever heard the name, at least...

■ FLAVIA X BASILIO A

Basilio: Ah, the siren returns... I knew you couldn't resist the old Basilio charm for long.

Flavia: That's it, I'm leaving...

Basilio: Wait! Don't go... 'Twas only a jest. I'd still like to talk. We had fun last time, eh? ...At least until you drew your sword. Truth is, I was hoping we could speak about the future of Regna Ferox.

Flavia: You're not in charge anymore, oaf. You had your day in the sun. I'm the ruler now, and any decisions to be made will be mine alone.

Basilio: Aye, I grant that I've neither rights nor responsi-bilities—the power is yours. But I thought that as the former ruler, I might be able to offer advice and support.

Flavia: Pah, I can only imagine the counsel you would offer... Well then? Out with it. What is your sage advice, o wise bald one?

Basilio: Regna Ferox is a cold land, and the chill cuts deep. Once the war's over, you might consider moving some subjects to a more pleasant—

Flavia: Move people OUT of the kingdom? But that would only serve to weaken us!

Basilio: Indeed, in these times of strife and conflict it would be a foolish—nay, reckless act. But once peace comes, why not give the injured and the elderly a chance to rest?

Flavia: Hmm... I suppose it could make for a good boost to morale...

Basilio: You see? I've lots more notions where that came from, too. I'm full of them! A well-traveled man like myself has the experience to think around corners. You can gain loads of new ideas by studying other cultures and customs. Rulers should always visit other nations before taking the reins of their own land... At least, that's how this old Basilio sees it.

Flavia: You speak wisdom, Basilio... *Ahem* Which frankly is completely out of character.

Basilio: Hah! You raised your shield again, but I caught a glimpse of your true feelings! Be it to do with romance, mead, or matters of state, you enjoy my company! Admit it!

Flavia: Yes, well... I won't deny that time spent with you can sometimes be...interesting. Still, that doesn't change the fact that I now sit upon the throne! Whether I choose to take your advice or not is entirely up to me.

Basilio: Heh, I'd have it no other way, O mighty Khan Regnant.

Flavia: Well then, I look forward to hearing your other ideas when the time comes.

Basilio: We have a date, then. Though first, there's a little war that needs finishing.

Flavia: Yes, but even before that, this mead needs finishing! I saved your last bottle!

 Morgan (male) (Father/son)

The Morgan (male) father/son dialogue can be found on page 309.

Flavia

 Avatar (male)

The dialogue between Avatar (male) and Flavia can be found on page 223.

 Avatar (female)

The dialogue between Avatar (female) and Flavia can be found on page 234.

 Basilio

The dialogue between Basilio and Flavia can be found on page 286.

 Morgan (female) (Mother/daughter)

The Morgan (female) mother/daughter dialogue can be found on page 312.

Donnel

 Avatar (male)

The dialogue between Avatar (male) and Donnel can be found on page 224.

 Avatar (female)

The dialogue between Avatar (female) and Donnel can be found on page 234.

 Lissa

The dialogue between Lissa and Donnel can be found on page 245.

 Sully

The dialogue between Sully and Donnel can be found on page 253.

 Stahl

The dialogue between Stahl and Donnel can be found on page 258.

 Miriel

The dialogue between Miriel and Donnel can be found on page 260.

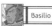 Kellam

The dialogue between Kellam and Donnel can be found on page 262.

 Maribelle

The dialogue between Maribelle and Donnel can be found on page 269.

 Panne

The dialogue between Panne and Donnel can be found on page 271.

 Cordelia

The dialogue between Cordelia and Donnel can be found on page 274.

 Nowi

The dialogue between Nowi and Donnel can be found on page 276.

 Tharja

The dialogue between Tharja and Donnel can be found on page 278.

 Olivia

The dialogue between Olivia and Donnel can be found on page 279.

 Cherche

The dialogue between Cherche and Donnel can be found on page 280.

 Owain (Father/son)

Owain's father/son dialogue can be found on page 289.

 Inigo (Father/son)

Inigo's father/son dialogue can be found on page 293.

 Brady (Father/son)

Brady's father/son dialogue can be found on page 297.

 Kjelle (Father/daughter)

Kjelle's father/daughter dialogue can be found on page 299.

 Severa (Father/daughter)

Severa's father/daughter dialogue can be found on page 305.

 Gerome (Father/son)

Gerome's father/son dialogue can be found on page 307.

 Morgan (male) (Father/son)

Morgan's (male) father/son dialogue can be found on page 309.

 Yarne (Father/son)

Yarne's father/son dialogue can be found on page 314.

 Laurent (Father/son)

Laurent's father/son dialogue can be found on page 316.

 Noire (Father/daughter)

Noire's father/daughter dialogue can be found on page 317.

 Nah (Father/daughter)

Nah's father/daughter dialogue can be found on page 318.

Anna

 Avatar (male)

The dialogue between Avatar (male) and Anna can be found on page 224.

 Avatar (female)

The dialogue between Avatar (female) and Anna can be found on page 235.

 Tiki

■ TIKI X ANNA C

Anna: Hmmmmmmm... I see...

Tiki: Hmm?

Anna: Interesting... Veeery interesting.

Tiki: Is there aught I might aid you with, my lady? You've been circling 'round my person for some time now.

Anna: Apologies, O exalted one! I'm just basking in the glow of the divine dragon's oracle.

Tiki: I am unused to such...rapt attention. You stare at me as one might an exotic creature in a menagerie.

Anna: I would call anyone who's been alive for millennia exotic! Wouldn't you?

Tiki: My life span should not preclude you from treating me as an ally or friend. For I came here in that capacity, and not as that of oracle.

Anna: Then can I get your autograph as a token of our new friendship?

Tiki: My...autograph?

Anna: Yeah, it's easy! All you have to do is write down your own name.

Tiki: I suppose I might grant such a request.

Anna: Really? Yay! Here, this should be enough to get you started.

Heave...HO!

Tiki: By the gods! I've never seen such a mountain of paper! You didn't mention needing more than a single...autograph.

Anna: Yeah, but I never said I didn't, either! Come on, be a sport! Pleeease?

Tiki: Well, I suppose I did give my word.

Anna: Woo! You're the best, Tiki! I have nothing but the deepest admiration for ya! ...Heh heh heh.

Tiki: ...Business? Strange. The word stirs memories of a merchant I knew long ago. And yet, with un-countable years behind me, memory is oft a kind of fog through which—

Anna: Hey, come on, now! Less talking, more signing! Chop-chop!

Tiki:

■ TIKI X ANNA B

Anna: Wheee-ha! Business is booming! Thank goodness for pious patrons! The question now is how to keep this growth up... Methinks it's time to stoke the flames of prophet fever! Wheee hee hee hee!

Tiki: I o'erheard you speaking of the prophets just now. Is this the explanation for your most blissful demeanor?

Anna: T-Tiki?! Uh...no! I didn't say "prophets." I said... um..."profits"! And I'm just happy because the last few battles have gone so well! Tee hee! Haaaa...

Tiki: Your mirth is well founded, and yet we can ill afford complacency. This war is still far from ended. And we mustn't forget that our victories come at the cost of others' lives. Though our causes differ, they still have families, hopes, dreams, and fears.

Anna: ...Except for the Risen. Those guys are just creepy. Oh, wait! I've got a great idea!

Tiki: Speak it, then.

Anna: You should give a speech praising the virtues of peace and brotherhood! What good is a Voice if she's muted, eh? Let's put those vocal cords to use!

Tiki: I'm not so arrogant as to think it's my station to lecture others. I'm merely a woman who has lived longer than most.

Anna: Yeah, but being all super old gives you wisdom and stuff! You can do a good thing here! The audience would be moved by your words. You could remind them why they fight—to achieve lasting peace for friend AND foe.

Tiki: Perhaps there is wisdom in what you say...

Anna: Do it for their sake! Even just once!

Tiki: ...Your passion has convinced me. I shall attempt to gather my thoughts into words.

Anna: Perfect! I knew I could count on you! We'll call it "Talkin' with Tiki"! Attendance could be in the thousands, so we'll need a big venue... And space for a commemorative gift shop at every exit! Tee hee hee!

Tiki: Anna, I do not wish for this to become an event of such magnitude. I don't even know what I plan to say yet.

Anna: Oh, don't worry. I'll have my people whip up a script for you! Ooh! And we can have a VIP meet and greet after the speech! It'll be huge! Teeee hee hee hee!

Tiki: Gods give me strength...

■ TIKI X ANNA A

Anna: Wow, nobody draws a crowd like Tiki. Talk about star power! I've known kings who would kill for that kind of adoring public! The speech was a sellout AND I unloaded my entire stock of Tiki memorabilia. Somebody pinch me! I must be dreaming!

Tiki: I volunteer for that duty.

Anna: Tiki?! Ha ha... You're as quiet and sneaky as ever! Hee hee! ...Hee? Wh-what's up with the scary face?

Tiki: Is there aught you would like to tell me, Anna?

Anna: You mean other than...um...how AWESOME you are?!

Tiki: I hear you charged admission to my speech on the unending power of good. Additionally, it seems you are hawking my signature like a common market trinket.

Anna: W-well, common market trinkets usually don't sell for 50 gold a pop! ...Look, come on! There was DEMAND, Tiki! The people just want to be a part of you! You get to spread your message, they get hope for the future, and I get a little coin! ...Er, or a lot of coin.

Tiki: If your actions were so altruistic, there was no need to hide them from me. Yet even now, I see the shame of your deeds writ large upon your face.

Anna: But wait! Wait! I didn't do it for my own personal gain, I swear!

Tiki: Such deceit only compounds your folly.

Anna: T-Tiki? Wh-why are you pulling out a Dragonstone?!

Tiki: To teach you that deceiving an oracle bears a hefty price. Now still your lying tongue and prepare to be eaten.

Anna: Aaaah, WAIT! You've got me all wrong! I, uh... I'm donating the proceeds! Yeah, that's it! To charities! Shanty Pete's Orphanage gets some, and so does, um...the Widows of Gangrel! Oh, and I'm giving a big hunk to People for the Ethical Treatment of Wyverns!

Tiki: ...You were planning to give your profits away?

Anna: Of course! What sort of greedy monster do you take me for? That's rhetorical, by the way, so don't actually answer.

Tiki: I have doubts as to this tale. Were you truly planning nothing more?

Anna: Wh-what, you mean like an unauthorized Tiki tell-all biography? Or, uh, selling locks of your hair and small bits of your clothing? Ha ha! O-of course not! Why, I'd never even consider such...things.

Tiki: Very well. I shall forgive you this once. But any events in the future will be open to all regardless of status or wealth. And you will give me every coin you have so far earned in my name. I shall see if I can't return them to their former owners personally.

Anna: Oh, come on! You're killing me here!

Tiki: You are free, of course, to decline. In which case you may pursue a new career opportunity in food services.

Anna: Here! Take it! Take the money!

Tiki: I am so glad you understand.

Anna: I understand you're a job-killing socialist...

Tiki: What was that?

Anna: N-nothing! Pleasure doing business!

Tiki: You know, Anna, a saleswoman like you could achieve true greatness. You should consider that the next time avarice tempts you.

Anna: Oh, I will, Tiki. You can count on it.

Anna: Wheeew! That was close! ...Now then. Time to earn back some of that sweet, sweet gold!

 Morgan (female) (Mother/daughter)

The Morgan (female) mother/daughter dialogue can be found on page 312.

Owain

 Avatar (male)

The dialogue between Avatar (male) and Owain can be found on page 224.

 Avatar (female)

The dialogue between Avatar (female) and Tharja can be found on page 235.

 Lissa (Mother/son)

Owain's mother/son dialogue with Lissa can be found on page 245.

 Lucina

The dialogue between Lucina and Owain can be found on page 280.

Inigo

■ INIGO X OWAIN C

Owain: Shadow DRAAAAAGON!

Inigo: Ah! If it isn't Owain.

Owain: Radiant DAAAAAAAAWN!

Inigo: And how are you today?

Owain: Busy! ...Which I would have thought was obvious.

Inigo: Ah, I'm sorry. Perhaps I'll come back when you're done playing.

Owain: Hey! This is serious!

Inigo: Seriously...childish? Seriously...embarrassing?

Owain: Seriously none of your business! Now leave me alone. ...Seriously.

Inigo: Sigh.

Owain: Okay, just stop. You're not even sighing. You're just saying the word "sigh." Maybe that's why all those girls keep turning you down.

Inigo: You're guaranteed to lose 100% of the jousts you never attend, my friend. Perhaps you should name your next move "Eternal Chastity."

INIGO X OWAIN B

Owain: Sure, why not? I've got the perfect teacher for it right in front of me!

Inigo: Why, you little—!

Owain: What, you want to go? Come on, chump! Have at me! My Shinon Strike will wipe the floor with you!

Inigo: Few things in life would give me greater satisfaction than to knock you on your rear. ...But one of us has to be the adult here. And it's obviously not going to be you.

Owain: Yeah, that's right. Walk away. You just keep right on walking. ...Jerk.

■ **INIGO X OWAIN B**

Owain: Eliwood's...RAAAAAAAAAGE!

Inigo: Oh, look. The little boy is playing with his dolls again.

Owain: Do you see a doll here? No, you don't! That's 'cause this is serious business. I'm honing my psyche so I can grapple with nefarious beasts of the night.

Inigo: Well, at least you'll be grappling with something tonight.

Owain: Oh, real mature. Now is there a point to this visit, or are you just— H-HEY! Don't read that!

Inigo: ...Is this your diary? It's filled with bad drawings of heroes and their weapons.

Owain: Don't! The Manual of Justice is more than your mortal eyes can handle!

Inigo: Oh, that's just adorable! You even named the book and everything! Now let's see what we've got... "Page 1: Owain. When danger nears, his sword hand twitches and his eyes turn red." ...Oh, come now. Really?

Owain: Give it baaaaaaaack!

Inigo: "Every ally hurt within a hundred paces adds a power multiplier..." "At +5, a special move is unlocked that can fell the enemy boss in one hit." Well, that IS impressive. I'm surprised you even need us around, frankly.

Owain: Why are you doing this to me? We're supposed to be allies!

Inigo: Let's jump ahead here, shall we? Hmm... How about... "Page 15: The Awesome Catalogue of Ultimate Techniques!" "The Axe of Dorcas... The Laguz Leap... Oh, you drew flames around this name! Does that affect the pronunciation?

Owain: Either stop reading or just stick a sword in me and be done with it.

Inigo: Oh, please. You're overreacting. Besides, genius of this ilk must be shared. I'll say this: your bizarre fantasy world is certainly...robust. You go all out on everything, Owain. And in a way, I respect that.

Owain: ...R-really? This isn't just a way for you to make fun of me again? Heh heh. Maybe there's hope for you yet.

Inigo: Yeah, see? Like this right here... "Page 27: Weapon Names—D through F." What's that about?

Owain: Well, um... I guess it's kind of a mental-warfare type of thing. A sword is just a hunk of metal, you know? But a sword with a name is an ally! So I came up with lots of possible names in case someone ever needs a suggestion.

Inigo: See? That's actually interesting.

Owain: Are you sure you're not still making fun of me?

Inigo: No, it really is interesting. ...A little bit. Not a lot.

Owain: Really?! Awesome! Wait right there! I'll get you a quill and paper, and we can get started right away!

Inigo: Get me...started? Um...

Owain: Oh, and cancel your dinner plans, because this is gonna take a while. But spending weeks on minutia is half the fun, right?! Ha ha ha!

Inigo: Wait, Owain! I never... What have I gotten myself into now?

■ **INIGO X OWAIN A**

Owain: Well? Have you come up with a name for that sword yet?

Inigo: I'm still not sure where to start. ...Or WHY to start, honestly.

Owain: Come on! A fine sword like that practically shouts its name at you! Just listen! Shhhh... Liiiisten...

Inigo:Nope. Apparently I don't speak sword. Help me out here, Owain. What does it say to you?

Owain: Hmm... This sword wants to be named... Flameclaw Wyvernborn the Foe-Slayer!

Inigo: That's very...long. Okay, then. What about this spear?

Owain: Ha! I already named that one. That's the Skyfire Lightning-Slicer!

Inigo: Um...you don't really slice things with a spear, Owain.

Owain: Skyfire Lightning-Poker!

Inigo: All...right then.

Owain: Left speechless, huh? I can't blame you.

Inigo: Remind me again how this is mental warfare and not just you being yourself to your fullest?

Owain: You'll understand once I carve the name into the weapon. Here, watch... Impressive, right?!

Inigo: Strangely enough, yes. It does look better.

Owain: A weapon with a strong name makes the wielder feel stronger, too! It fills you with confidence on the field of battle and lets you fight to your fullest!

Inigo: That kind of makes sense. ...Which scares me.

Owain: So let's get you started. Think of a good name, and then carve it into your blade!

Inigo: All right, I will!

Owain: All done?

Inigo: It's...a masterpiece!

Owain: Ha ha! That's the spirit! Let's have a look.

Inigo: Mmm, what do you think? A vast improvement over your ridiculous names, I think you'll agree.

Owain: Inigo, these are just the names of girls who spurned your advances. ...Gods, there must be two hundred names on this thing!

Inigo: Mental warfare, my friend. With no room for names, I HAVE to succeed!

Owain: Yeah, but you carved out half the metal! The sword's totally worthless now!

Inigo: Oh... Whoops.

Brady

■ **BRADY X OWAIN C**

Owain: Halt?! Who goes there?!

Brady: Halt? You're the one who just walked in. I ain't goin' nowheres.

Owain: A fine parry, sirrah. And yet, here you stand in garb most strange. Speak, fiend! What nefarious plot are you hatching here?!

Brady: What, ya mean here in the kitchen? Dressed like a chef?

Owain: A surcoat and crown of purest white... What strange rituals are—

Brady: It's an apron and a chef's hat, idiot! I'm cookin' dinner! Even you can't be that dense. Now quit wasting my time.

Owain: Cooking? You? Dinner?! Ha! I'd sooner believe a cavalier riding a pegasus over the moon!

Brady: Aw, I ain't got time for this malarkey! Look, tonight's my turn, all right? Now make like some eggs and beat it! You're gonna ruin the flavor.

Owain: I will not be deceived by such deceits! What manner of madman would allow you a turn at cooking for the camp?!

Brady: I'm a fine cook, all right! I learned from my dear ol' ma! So just... *sniff* G-get off my back!

Owain: Whoa...um, are you crying?

Brady: N-no! *sniff* ...And you're slipping out of character.

Owain: Brady, you are totally crying!

Brady: L-leave me alone! I was just cuttin' up taters, all right?!

Owain: Don't you mean onions? I don't think there's anything in potatoes that—

Brady: I JUST FELT BAD FOR 'EM, OKAY?! Now make like my pants and split!

Owain: Fine, fine. I'm going.

■ **BRADY X OWAIN B**

Owain: Alas, Brady! We meet again! ...Um, Brady?

Brady: What idiot left this helmet here?! Welp, too bad for them, 'cause I'm gonna punt it from here to kingdo—OOOOW! Ffffffffffffff!!

Owain: Do you hiss at me, sir? And what was that sound of a moment ago?! It was as the splintering of a mighty shield! The felling of a towering tree!

Brady: Hnnnnnnngh...

Owain: Oh ho! I see you hunched and shivering! Do you tremble in my presence, sir?!

Brady: N-no, you...idiot... Just...go away...

Owain: Why do you reach for your foot? Grasping for a hidden dagger, perhaps? What are you doing, fiend? I'll not be taken unawares! Give it here!

Brady: No no no no no—OOOOOOW! DON'T TOUCH THAT!

Owain: Okay, really. What's wrong?

Brady: You're...falling out of...character again *sniff*

Owain: Wait, are you crying again?

Brady: *Sniff* N-no, of course not. You got rocks in your brain! I...I just broke my toe... *sniff* *sniffle* ALL RIGHT, I'M CRYIN'! I'M SENTIMENTAL, OKAY?!

Owain: Y'know, I don't think tears of pain count as being sentimental, Brady...

Brady: Just...go away...

Owain: All right, hold on. I'll go find you a healer.

■ **BRADY X OWAIN A**

Owain: Ho, Brady of the Moistened Eyes, what business have you here?!

Brady: *Sob* Sh-shut up! L-leave me... *Sniff* Just leamme aloooone!

Owain: Man, are you crying already?! This is a new record.

Brady: I'm... *sob* I AIN'T CRYIN'! *sniff* *sniffle*

Owain: Actually no. You appear to be bawling. What happened this time, old friend?

Brady: Whaddya mean "this time"?! Ya make it sound like it's an everyday thing!

Owain: At this point, it kind of is... And why are you here, anyway? Weren't you joining the others on their training run?

Brady: I did! I just couldn't keep up after the first ten minutes, all right?! Wanna make somethin' of it?!

Owain: Ah, I see! That explains why you're such a sweaty mess. ...It doesn't explain the tears, though.

Brady: I told ya! I'm sentimental!

Owain: You're sentimental about being out of shape?

Brady: Yes, all right?! Now mind yer beeswax and leave me alone!

Owain: Um, Brady? Do you even know what "sentimental" means?

Brady: Course I do! Whaddya think I am, some kinda limp noodle?

Owain: Yes, well, you see, it's just that... You keep using it wrong. Sentimentality is when someone gets emotional over memories or moving events.

Brady: So like... If I saw a litter of newborn kittens and couldn't stop cryin' for hours?

Owain: Exactly! That's being sentimental! ...And a little weird, if we're being completely hon—

Brady: I... *choke* Hnngh!

Owain: Mordecai's claws! Are you still out of breath from running? If you feel like you're going to be sick, just turn your head and—

Brady: *Sob* I'm fine! I just... When I pictured those tiny kitties lyin' there all blind and mewling... *hic*

Owain: Right... So basically you are sentimental. But you're also a huge crybaby, too.

Brady: D-don't tell the others about this! If you do, I'll take yer lunch money!

Owain: Heh, you put up a tough front, but you're just a huge softy inside. I don't think Brady of the Moistened Eyes is ready to join the Justice Cabal... But still, I'm glad we're friends.

Brady: ...That mean you won't tell no one?

Owain: Heh. If it's that important to you, your secret's safe with me. Call me sentimental!

Kjelle

■ **KJELLE X OWAIN C**

Owain: Well, if it isn't my old nemesis, Kjelle!

Kjelle: What do you want, Owain?

Owain: Long have we vied for the title of strongest, bound by fate and our unbending wills. But I will not rest until I've put a stop to your nefarious deeds for good!

Kjelle: Really, I have no time for this. Do you need something? If not, I'm going to go.

Owain: Ugh, come on! Work with me here! Put some feeling in it! I know you hate men, but would it kill you to show a little effort?

Kjelle: I don't hate men. I hate idiots. ...A class you fall right into, coincidentally. Even the way you talk makes me angry. Half the time I have no idea what you're saying. It's always stories and sound effects and...posturing.

Owain: Which is why I'm speaking normally right now.

Kjelle: And yet I still can't see your point. Now go away.

Owain: What if I offer to help clean your gear? Come on, it'll be fun.

Kjelle: I can take care of my own things.

Owain: Fine then! Just...fine! I don't need this! I can go anywhere and be insulted!

Kjelle:

■ **KJELLE X OWAIN B**

Owain: You bear an ominous mien, nemesis! Your face is as a rose-lit dawn wreathed in storm clouds of ebon black!

Kjelle:

Owain: Where is it that calls you hence? What dark purpose spurs you on?! Is it the path of the fallen you walk, or the road to redemption?

Kjelle: I'm going to the storehouse because my things are there. And what's this about my mien, huh? Was that because I'm a woman? Don't you dare penning heartsy-fartsy stuff about how lovely I am. If you have to go writing poems about me, they damned well better be war epics!

Owain: Geez, all right! Tough crowd... Look, let's try this again. I'd prefer if you didn't speak at—

Kjelle: I'd prefer if you didn't speak at—

Owain: Hey, Kjelle. You off to the storehouse to grab some gear?

Kjelle: ...Why?

Owain: Lemme give you a hand!

Kjelle: Please don't.

Owain: Aw, come on. I can do a lot more than just name weapons, you know. I'm one of the best maintenance people in this whole camp. So just gimme a chance. Come on! C'mon, c'mon, c'mon, c—

Kjelle: "Sigh"...I suppose it's better than leaving you idle to work mischief elsewhere.

Owain: Great! I mean, extremely condescending, but the end result? Still great.

Kjelle: Less talking, more walking. I'm eager to see these...talents of yours.

Owain: Brace yourself! I don't want you dying of shock at how impressed you'll be!

■ **KJELLE X OWAIN A**

Owain: Cavalier armor. Medium weight class. Combines significant defense with impressive mobility.

Kjelle:

Owain: This one's an archer's jerkin. It boasts unrivaled ease of motion but lacks any real stopping power.

Kjelle: Do you really need to narrate?

Owain: It's important to keep the characteristics of the equipment in mind while working on it.

Kjelle: I suppose I should be happy you're not just goofing around. Still, it would help if you kept your thoughts inside your head.

Owain: Words are important. Our armor and weapons are partners in this war. Granting them a voice elevates them from hunks of iron to something more. It breathes into them a soul, transforming mere tools into implements of divine will!

Kjelle:

Owain: Take this breastplate. I hear it whisper to me... "I am the Argent Lion Mail," it says. "Behold my regal, silvery form! Behold!" Kjelle, are you beholding? Kjelle? ...Hey, where'd you go? She just...disappeared... That's...kind of amazing.

Kjelle:

Owain: Gah! What dark sorcery is this?! A lone knight's armor moves of its own accord! Be at peace, ghostly visitor!

Kjelle: It just never ends with you, does it?

Owain: Voices from beyond the grave! Begone, foul wraith!

Kjelle: It's me, you babbling buffoon! And if you say "A ghost ate Kjelle," I'm going to stab you in the eye.

Owain: Kjelle? What are you doing in there? Is that suit...comfortable? It hides you completely.

Kjelle: Am I...that much of a bother?

Owain: ...Also, this was the suit of armor I wore in my first battle. I put it back on from time to time. It...calms me.

Kjelle: No! No names. And even if it were to be named, it would be by anyone but you!

Owain: Hey! ...Wh-why not?

Kjelle: Because I said so! Now get sorting!

Owain: Yes, ma'am.

■ **KJELLE X OWAIN S**

Owain: Hey, Kjelle! You want me to take care of this helmet, or... Heh...should've known. She's gone again. I'm doing her a favor, and she leaves all the work to me? This is gratitude for you? Sometimes I don't know what to do with that girl. She obviously loves this old set of armor. Why won't she give the poor thing a name? It doesn't even have to be a good one. It's the spirit of the thing that counts. I'm probably wasting my time here, but I can't bear the thought of Kjelle

being hurt. But if I can't be there to keep her safe, I can at least make sure her gear is! Hold her close, armor. Protect all of your shiny, steely, plated goodness. Tell her all the things that I dare not. Tell her how much I...love her.

Kjelle: You what?!

Owain: K-Kjelle?! Is that you? But I don't see you anywhere. Where did that... Aaaaaah!

Kjelle: ...I'm here. In my armor.

Owain: But I thought you'd left! Why are you hiding in there while I'm out here doing all the work?!

Kjelle: I wanted to make sure you wouldn't slack off if I wasn't around to watch you.

Owain: Look, I don't need a babysitter! Not about this. I take armor and weapons very seriously, thank you.

Kjelle: Oh, will you forget the blasted armor for one second? ...Go back to the part where you said you loved me.

Owain: Argh! Y-you heard that?!

Kjelle: ...Yes. So?

Owain: Look, I didn't... I mean, I do, but... I was gonna tell you at some point! Urgh. Just stab me and get it over with.

Kjelle: Why would I stab the man who loves me?

Owain: Because you hate me? Because you have a big dumb boyfriend who's going to fold me into a pretzel? I bet his name's Troy. Or Steve. ...Or Chaz or something.

Kjelle: I don't hate you, Owain. I actually find you oddly charming. I mean, I could do without the goofy names and the yelling... But now I see some sense in the madness. You've got heart. And lots of it, apparently.

Owain: So, um, does that mean you'll...

Kjelle: I'd love to have you by my side, Owain. In battle or out of it.

Owain: My steel is yours, Kjelle. By my twitching sword hand, I swear to protect you for all time!

Cynthia

■ **CYNTHIA X OWAIN C**

Owain: Ho! Cynthia!

Cynthia: Oh, hi! Did you need something, Owain?

Owain: Nothing so grand. I just hadn't seen you for a while. I miss my Justice Cabal companion!

Cynthia: Ha! I remember when we used to play Justice Cabal as kids! Remember how I always played at being Beano the Barbarian Queen? Hee hee!

Owain: Ha ha! I never did understand where you got that name! Good times... So, uh, what're you up to now?

Cynthia: That's classified information, mister.

Owain: Aw, come on. You can tell me. I'm in the Justice Cabal!

Cynthia: Okay, fine. But this is just between us! So I'm trying to plan a dramatic entrance for our next battle. Something...heroic.

Owain: Well, if you're going to be a hero, there's only one real option... Wait until your friends are on the brink of defeat, then swoop in and smite the enemy! There's nothing more heroic than a good comeback.

Cynthia: That's terrible! I can't do that!

Owain: Why not? A hero always shows up at the last minute. It's in the job description.

Cynthia: No, it's not! A real hero is there the whole time, tirelessly defending her allies!

Owain: Noooo, I'm pretty sure a hero has to show up and save everyone at the very end. ...Huh. Weird. We always agreed on this kind of stuff before.

Cynthia: Maybe that's what happens when you grow up?

■ **CYNTHIA X OWAIN B**

Cynthia: Hey, Owain. Do you remember what we talked about before?

Owain: The perfect heroic entrance? Sure!

Cynthia: Well, I've been thinking about what you said, and it still feels wrong. You want me to wait and appear at the end, but what if someone needs me? What if they get hurt? Or...worse?

Owain: That's the whole point! You come swooping in just before anyone gets hurt.

Cynthia: But what if you're too late?

Owain: Just don't let it happen. Situational analysis is a basic part of heroism.

Cynthia: Mmm, it's still a risk. I think I'd rather just be there from the beginning.

Owain: Yeah, but you know what? Even if the worst DOES happen, I'd still be heroic! I'd slowly walk up to the crumpled body of my comrade... I'd stoop low and gently brush their bloody and matted hair from their face... And I'd—

Cynthia: Yes? Yes?

Owain: BY THE GODS, I SHALL AVENGE YOU! And then, clutching their lifeless form tight, I'd burst into flames!

Cynthia: You'd what?!

Owain: I'd become death incarnate! Friend and foe alike fall before my rampage! Driven mad by grief, I am an unstoppable engine of blind rage and destruction!

Cynthia: Geez, Owain! Have you gone batty?! And a hero should protect people, not go on crazy rampages!

Owain: By the time I regain my senses, it is already too late... A ravaged land stretches before me, its soil stained red with blood. I stand in silence, alone, with only the horror of my thoughts for company...

Cynthia: Owain? Hey, Owain! Snap out of it!

■ **CYNTHIA X OWAIN ?**

Cynthia: So! You wanna hear how the story ends?

Cynthia: You mean the one where you go crazy with grief and kill everyone? I'm not sure I wanna hear how that one ends, honestly...

Cynthia: It's not going crazy! ...It's me entering Avenger Mode. AAAAAANYWAY... I fall into Avenger Mode again and again, always regretting it, but powerless to resist. The stench of blood never leaves my crimson-stained hands.

Owain: Cynthia, I've been meaning to tell you there's nothing heroic about this story.

Owain: But then a heroine appears to stop my tortured onslaught! It's...Cynthia! Cue the harps and bells!

Cynthia: Hey! I want no part of this!

Owain: Cynthia sees that I will stop at nothing to end my mad reign of terror! And end it she does, though she pays the ultimate price...

Cynthia: Wait—I DIE?!

Owain: Your selfless sacrifice teaches me to quell my rage and control Avenger Mode. With that lesson forever in my heart, I become an inexorable force for justice. ...And that's the origin of Owain Dark, Avenging Avenger of Justice!

Cynthia: Wait a second! Go back to the part where you kill me!

Owain: Ah ha ha! Sorry, Cynthia. I got carried away by my own awesomeness! Man...maybe I should write novels. You know, once the war is over.

Cynthia: Just make sure I stay alive long enough to read them, all right?

■ **CYNTHIA X OWAIN S**

Owain: Cynthia?

Cynthia: Hey, Owain. You need something?

Owain: Remember when we were talking about what makes a hero?

Cynthia: Sure. You become the Dark Justice Avenger or whatever, and I take a dirt nap.

Owain: No, not that. I mean when we were talking about making a heroic entrance.

Cynthia: Yeah, what about it?

Owain: Did you ever come up with anything yourself?

Cynthia: I'm going to charge headlong into the fray while shouting something awesome! Like, "Mine is the blade that shall cleave the dark in twain!" Or...you know. Something.

Owain: Nice! I'm thinking now I'll do the same! But maybe say something like... "I am peaceful by nature, but all who threaten my friends will know pain!" You know. Just to keep with the whole Avenging Avenger angle.

Cynthia: Wait, hold on. You'd do the same thing? You'd charge headlong into the fray?

Owain: Well, the dialogue is a lot different, but yeah. I'm going to charge in.

Cynthia: ...Really? What changed your mind?

Owain: I've been thinking about this a lot since you brought it up, you know? I mean, why did we dream about becoming heroes in the first place?

Cynthia: Probably because we heard all the stories about our parents.

Owain: Right! And now that I'm here, I have a chance to keep them safe. I can't do that if I hang back and wait, so I'm going to follow your lead. ...Heh. It's still fun coming up with that story, though.

Cynthia: I know. It reminded me of when we were kids. I miss those days.

Owain: Yeah, me too... Say, Cynthia? You know, maybe we could... Um, if you wanted... I mean...

Cynthia: Hmm?

Owain: Do you want to get together, Cynthia?

Cynthia: Huh? But we're already together!Oh. Oh! You mean TOGETHER together!

Owain: Well...yeah. I mean, I like you more than anyone I know and... I think about—

Cynthia: I don't know, Owain. I never... I never thought about it quite like that. It wouldn't be boring, that's for sure.

Owain: So is that a yes?

Cynthia: ...Yeah! Let's do it! But one condition: no more sacrificing me in your stories. Got it?

Owain: By the mighty axe of Hector, I swear it will be so! We shall be legends fit to rival even our parents!

Cynthia: Legends or no, as long as we're together every step of the way!

Severa

■ **SEVERA X OWAIN C**

Owain: Let's see what we've got here... Hmm... Nice form... Elegant curve to the blade... I dub thee...Sword of the Swan! Hmm... This axe is nice and heavy, but with that bit on the end... I dub thee...Head Smoosher Plus One!

Severa: Are you talking to that axe?

Owain: No, that would be silly! I'm just naming our latest shipment of weapons.

Severa: Doesn't that seem a bit childish?

Owain: Ooh! I still haven't named your weapon!

Severa: Pfft! It doesn't need a name.

Owain: Of course it does! A name can be a very powerful thing! It makes a weapon your partner instead of a simple tool! Plus, you'll never confuse it with anyone else's!

Severa: Did your mother sew your name into your smallclothes or something?

Owain: Well, here let me see it. It'll just take a second!

Severa: No! Keep your grubby mitts off!

Owain: Geez, all right, all right. No need to be rude.

■ **SEVERA X OWAIN B**

Owain: Severa? Hey, Severa!

Severa: Oh, brother. What is it now?

Owain: I was going to help you name your—

Severa: I thought I made myself quite clear. My weapon does not need a name.

Owain: Oh no, you were very clear on that point. That's not what I was going to say. I think you should name your special moves!

Severa: Did you really just say "special moves"?

Owain: Like "something-something...SWORD!" or "whatever...THRUST!" and stuff. Come on, it's easy. I'll help you out!

Severa: I wasn't aware you had moves at all, let alone special ones.

Owain: Of course! I'm at 45 and counting. Just a few more, and I'll hit an even 50! Pretty impressive, huh?

Severa: And you shout these names out loud while on the battlefield?

Owain: That's kind of the point. It strikes fear in the enemy's heart!

Severa: Or it just makes them easier to kill when they're doubled over laughing.

Owain: ...Something tells me I'm not convincing you.

Severa: Listen, Owain. Ridiculous names and insane shouting is cute when you're six. But you're a grown man now! It's gone from embarrassing to just plain...creepy.

Owain: Oh yeah? Well, I've got a name for the move you're pulling right now! Grumpy...BLAST!

Severa: What if a real man decides to stab you while you're shouting? Hmm? You're left gurgling on your own blood while we find ourselves one fighter short! Go on! Ask anyone in camp! They all think you're ridiculous.

Owain: You think... Do they really...?

Severa: Yes, they really! So I'm sorry if I don't have time to indulge your weird little hobby! Now drop it!

■ SEVERA X OWAIN A

Severa: Owain? Hey, Owain! OWAAAAAIN! ...Hey! You! Have you seen Owain?

Blue Army Soldier: Last I saw, he was in some tent, curled up in a corner muttering to himself.

Severa: Oh, for the love of... Chrom just called an all-hands meeting. What does that man-child think he's doing?!

Severa: Ugh, could he make this place any darker? Is he really even in there...?

Owain:

Severa: O-Owain! What are you still doing here? Chrom called a meeting! And why are you clutching your knees and rocking in the corner? Talk about creepy!

Owain: I am creepy.

Severa: Hey, I was only stating the truth, weirdo. Okay, what is it. Did something happen? What's wrong with you?

Owain: Nothing happened. I'm just a creepy creep who creeps around with his weird hobbies.

Severa: Are you still upset over what I said before?!

Owain: No, I'm not upset. You were just stating the truth.

Severa: Ugh, okay! I'm sorry! I went too far and now you're sad and blah blah blah. There. We are good, now? Now come on. Chrom is waiting for us.

Owain: What would Chrom want with a creepy creep like me?

Severa: That's ENOUGH, mister!

Owain: Muh...?

Severa: Ugh... I can't believe you're actually going to make me say this... Since when did you let reality get in the way of your happy little fantasy world? You don't care what other people say. You walk your own path and whistle loudly! Deluded confidence and blind faith have always been your greatest strengths.

Owain: You...really think so?

Severa: I know so. So don't let a little criticism slow you down. Mine especially. Everyone knows I'm a huge jerk anyway, so just shrug it off and keep going.

Owain: You're... *sniff* Severa, you're...

Severa: I'm...what?

Owain: RRAAAAAAAAAAAUGH!

Severa: ...Oh, gods. It finally happened. The weirdo has snapped.

Owain: Severa, you're right! This isn't me! I never listen to what anyone says. Half the time I don't even know they're talking. Thank you, Severa. I feel a lot better! Now come on, I'll race you to Chrom's!

Severa: Wh-what?! No, I won't race you! Come back, Owain! *Sigh* ...What an idiot. Still, I'm glad he's better. A sad Owain is just...sad.

■ SEVERA X OWAIN S

Owain: Hey, Severa. Sorry again for before.

Severa: Are we still talking about that? Forget it.

Owain: No, really! Some of the things you said struck a chord in me. You helped me remember who I am and who I want to be.

Severa: Owain, I... Look, I should be the one apologizing.

Owain: Why? I understand why you got mad at me.

Severa: Not that!

Owain: What, then?

Severa: Here, just...look at my weapon.

Owain: This is... Hey, you inscribed a name in the handle! I thought you'd never! Wait...this looks really old and weathered. Which means you'd already... Ah ha ha! You're terrible! You gave me all that grief after you'd done the same thing? I guess that explains why you wouldn't let me see it before.

Severa: Look closer, you goof! ...Read it.

Owain: I'm confused, Severa. This is...my name.

Severa: I know. That's why I was too embarrassed to tell you.

Owain: You named your weapon after me? But... why? And how long ago?

Severa: Because you've always been nice to me, even when I wasn't. Because you're a person I've always been able to trust, no matter what. And because... I don't know. I guess I just...like you. I always have. I'm Owain... I'm always about saying and saying such terrible things to you... I didn't mean to, honest. These things just...pop out of me for some reason! *Sniff* *sob*

Owain: H-hey, don't cry!

Severa: Waaaaaaaaaah!

Owain: Hey, come on! I think you're great! I mean, you named your weapon after me and everything, right? So come on. No more crying. I'm honored to be at your side.

Severa: You...you mean it? *sniff* Like...REALLY at my side?

Owain: Are you kidding? You're GORGEOUS! I'd cut off my sword hand just to be with you for an hour! Um...sorry. Did I say too much there?

Severa: ...No, Owain. It was just right.

■ MORGAN (MALE) X OWAIN C

Owain: Ah ha! I've found you, Morgan!

Morgan (male): What? What's wrong? Has something happened?

Owain: Aye, the second I saw you, something happened! I knew you for my one and only rival!

Morgan (male): Beg your pardon?

Owain: My soul sensed your powerful aura, and at once realized our cosmic incongruity!

Morgan (male): Wow, I...must not have noticed.

Owain: You are the only one who could ever stand as my equal in battle. Now...ANSWER MY CALL!

Morgan (male): I'm still not sure what you're talking about, but you sound absolutely convinced. And to be honest, I find myself...intrigued. Even though it makes no earthly sense. I can't see how any self-respecting warrior could turn away such fiery passion.

Owain: Just so, my eternal ally-versary!

Morgan (male): Yes, it's so clear to me now. So obvious! Truly, we were fated to clash as rivals!

Owain: The gauntlet is thrown! Let our extremely protracted duel to the death begin! But let us not, in our haste for glory, forget to observe the one sacred rule of combat! ...When I'm shouting a move name, you have to wait for me to finish. I shall extend the same courtesy to you, as a fellow brother of the Justice Cabal.

Morgan (male): I agree to your terms, mortal foe! ...Though I doubt the enemies I've encountered would be quite so patient.

Owain: I fear the scum you've faced are berserkers, their honor lost to blood madness!

Morgan (male): I never knew...

Owain: Now, let us begin... Have at you, sir!

Morgan (male): Face me if you dare!

■ MORGAN (MALE) X OWAIN B

Owain: Come, my ordained ally-versary! Let our battle cries rend the very heavens above!

Morgan (male): May the song of our crossing blades echo unto eternity!

Owain: I shall be the first to strike! Radiaaant... DAAAAAAAAAWN!

Morgan (male): Too slow! I parry with ease!

Owain: Y-you do?!

Morgan (male): Is that all you've got, fiend?!

Owain: Impossible! How could he have defeated my ultimate special move?!

Morgan (male): Ha ha! My turn! Flamingo... PUUUUUUUNCH!

Owain: I don't even need to dodge such a pathetic fireball. I deflect it back at you! KA-PWING!

Morgan (male): Waugh?!

Owain: Heh heh. Child's play.

Morgan (male): But...how?! How did he return my arcane magic?!

Owain: It seems we're at a stalemate, my rival. Till next the fated hour is tolled!

Morgan (male): I'll not let you off so easy next time! I swear it! I SWEEEEEEEEAR!

Owain:

Morgan (male):

Owain: Ah ha ha ha ha!

Morgan (male): Ha ha ha ha ha ha!

Owain: That. Was. AMAZING!

Morgan (male): Oh my gosh, right?! You were great, Owain!

Owain: Hardly! For being new to this, you nearly blew me away!

Morgan (male): Please, you're too modest. I'm nowhere near as good as you. I'm surprised how much fun it is to think this stuff up on the fly.

Owain: And it only gets better from here! So...same time next week?

Morgan (male): Sure! I can't wait!

■ MORGAN (MALE) X OWAIN A

Owain: The bell tolls for thee, Morgan. The fated hour is upon us. I ready my true ultimate move...

Morgan (male): Actually, can you hold that thought for just a minute, Owain?

Owain: Craven! You would flee from this sacred duel?!

Morgan (male): No, no, I'm all set to go. I just thought I'd go invite some of the others, too.

Owain: The...others?

Morgan (male): Sure! Games like these are best in groups. The more the merrier, right?

Owain: ...A game? A GAME?! You dare insult the sacred affairs of the fated hour?! You dare compare our battle to the capering of fools upon a gilded stage?!

Morgan (male): No! I have nothing but respect for it! It always picks me up on slow days.

Owain: That is so not the point, Morgan!

Morgan (male): It isn't? I don't understand.

Owain: Oh, forget it. Just...forget it. And besides, the others wouldn't come anyway. They all treat me like an idiot when I make up moves.

Morgan (male): I've certainly never heard anyone say anything.

Owain: Trust me. They think I'm just a big kid. That's why I chose you as my rival. You take me seriously!

Morgan (male): Owain, I'm sorry. I didn't mean any disrespect by it.

Owain: No, it's fine. I know I'm pathetic. Just forget I said anything, all right?

Morgan (male): I don't think so.

Owain: What? Why not?

Morgan (male): Because it makes me happy to hear you speak from the heart. We may be eternal rivals, but we're friends first and last. You can tell me anything!

Owain: You... You mean that?

Morgan (male): Of course! If I can withstand your Nephenee's Lance attack, I think I can handle your feelings.

Owain: I still call no fair on that. I totally had you.

Morgan (male): Ha ha! You're dreaming. You've always been a dreamer, Owain. Everybody loves that about you. And they respect you for marching to the beat of your own drum.

Owain: I guess so.

Morgan (male): Well, I know so, friend. So have some confidence!

Owain: All right. I will! Thanks, Morgan. So, uh... Do you think we could still...

Morgan (male): The code of the Justice Cabal demands no less. Our rivalry is undying! Now help me come up with some new moves!

Owain: You got it!

The Morgan (male) father/son dialogue can be found on page 309.

■ MORGAN (FEMALE) X OWAIN C

Owain: *Huff* Ah ha! Found you, Morgan! *huff, huff*

Morgan (female): Sorry, were you looking for me? And what's got you so out of breath? Has something happened?

Owain: Aye, it has! The second I first saw you, something wondrous happened! A charge coursed through my body with the electrifying force of summer lightning!

Morgan (female): Er, what?

Owain: Though you wear a different face, I knew you for my fated ally! Across a thousand thousand lives we have shared the fortunes of war!

Morgan (female): ...I'm afraid I'm still not following.

Owain: You and I are partners, bound tight by the red string of fate since time immemorial. If we join forces once more in this life, no foe could hope to stop us!

Morgan (female): Ha ha ha!

Owain: Wh-what's so funny?

Morgan (female): You are! That was amazing. Is it from a play, or did you write it yourself?

Owain: I wrote it myse— Uh, no! I mean, I didn't write it at all! I'm saying it because I mean it!

Morgan (female): But how could you possibly know we were partners in a previous life?

Owain: My sixth sense bespoke it to my third eye.

Morgan (female): Ha ha ha! Oh gods, that's brilliant! You really have a gift for this, Owain.

Owain: But I'm not... This isn't just...

Morgan (female): Hee hee! Okay, okay. So if we WERE fated partners, can you prove it?

Owain: Of course! Name your challenge!

Morgan (female): No incarnation of me would ever settle for a partner who couldn't cook.

Owain: ...As in food?

Morgan (female): There is something wonderful about one person preparing food for another. It shows they care, and in turn gives the other person strength.

Owain: So be it! I shall cook a meal fit to dispel any doubts of our star-linked fates!

Morgan (female): Hee hee! I can't wait!

■ MORGAN (FEMALE) X OWAIN B

Owain: Prepare yourself, Morgan! My culinary masterpiece is complete!

Morgan (female): Oh, wow. That looks great!

Owain: It does, doesn't it? Though I still haven't come up with a fitting name for it—

Morgan (female): Okay, here goes! *horf* *slurp* *munch* *chomp*

Owain: Um...I wasn't finished...presenting it.

Morgan (female): Urp! Oh gods, that was incredible...

Owain: Ha! I eat recipes like that for breakfast! ...Metaphorically, I mean. Now, are you ready to acknowledge me as your true and rightful partner in battle?

Morgan (female): I'd say you passed round one with flying colors!

Owain: ...There's more than one round?

Morgan (female): Yeah, of course! We have to be sure about this kind of thing, you know? Now, if we're going to swear sacred oaths, we'll need a symbol of our promise.

Owain: We will?

Morgan (female): Something strong and timeless. Something...valuable. Aha! Gemstones! We must swear loyalty on a pair of gargantuan gemstones!

Owain: ...S-so be it! I'll scour the land for the two finest gems in existence!

Morgan (female): Great! I'll be waiting!

■ MORGAN (FEMALE) X OWAIN A

Owain: Morgan! I've got them!

Morgan (female): Got what?

Owain: Gemstones! The symbols of our oath! ...The ones you made me find?

Morgan (female): Really? I asked you to do that? ...Huh. Well, I'll just have to trust you. Remembering stuff isn't my strong suit.

Owain: You're killing me, Morgan. Anyway, here. Feast your eyes on THESE!

Morgan (female): Holy smokes! Look how black that one is!

Owain: This onyx was hewn from the abyssal darkness of the underworld itself! I was forced to battle a horde of fire-breathing—

Morgan (female): Ooooh! This one's such a pretty green!

Owain: Er, uh... Y-yes! Yes, it certainly is! The vessel for all of Mother Nature's power, found sleeping in a cradle of earth! I swam through miles of shark-infested waters just to—

Morgan (female): Sooooo pretty...

Owain: Yes, quite pretty. So will you now acknowledge me as your fated partner?

Morgan (female): I will indeed! You've shown the depths of your dedication in no uncertain terms. I pronounce us partners in battle forever! ...Sorry to make you jump through hoops.

Owain: 'Twas nothing! May our partnership bring peace to the land and glory to us both!

Morgan (female): Sooo... What do we do as partners? I mean, do we stand next to each other when we fight, or...what?

Owain: Naturally, we... Er, I mean, we'll... Actually, I hadn't thought that far ahead.

Morgan (female): Ah ha ha ha! You really are too much. Always sprinting ahead, whether you know where you're going or not!

Owain: No matter. We've got all of this lifetime to figure it out! In the meantime, here's to us, partner!

Morgan (female): Hee hee! To us!

■ MORGAN (FEMALE) X OWAIN S

Morgan (female): Um, say, Owain?

Owain: What's wrong? You sound upset. Speak, O fated companion! Spill your breast unto me!

Morgan (female): Oh, wow. Is that how that phrase goes. Anyway, um, it's about before. ...When I was testing you?

Owain: That business? What of it?

Morgan (female): Yeah, so, that wasn't really about cooking or gems or anything. I wanted to see how important I was to you. I'm sorry for being dishonest.

Owain: All part of the partner-vetting process! Think no more on it.

Morgan (female): But there's still one thing I really want that you haven't given to me. Maybe you could...think about what that might be?

Owain: What you really want, huh? Hmm... Wait, is this round three?

Morgan (female): It's the final round.

Owain: All right, give me a second here. Hmmmmm...

Morgan (female): Well? Have you figured it out?

Owain: Is it...a pony?

Morgan (female): Um, n-no. It's not a pony.

Owain: Oh. I thought all girls loved ponies. ...Because I'd certainly get you a pony! I'd get you anything you wanted!

Morgan (female): Really?

Owain: I'd do anything for the woman I love! I didn't...mean to...say that out loud.

Morgan (female): Owain!

Owain: Well, as long as I've spilled those beans, I might as well dump the rest of 'em out. That whole partner thing was a ruse. I just wanted to spend time with you.

Morgan (female): Oh, Owain! THAT'S the answer I've been looking for!

Owain: Wait...it is?

Morgan (female): All I ever wanted was to know how you felt. To hear you say those words! But all I could ever get from you were home-cooked meals and expensive jewels.

Owain: Does that mean you...

Morgan (female): Yes, you silly man, I love you! I've loved you for so long. Be my partner, Owain. Not just in battle, but in life.

Owain: I swear to be at your side, in war and in peace, for as long as I live!

Morgan (female): I'll hold you to that—because I swear the same!

■ MORGAN (FEMALE) X OWAIN (BROTHER/SISTER) C

Morgan (female): Let's see here... Birthday? May 5th. Favorite colors? Blue and purple. Favorite food? Probably bear meat...

Owain: What are you mumbling about over there, Morgan?

Morgan (female): Least favorite food? Veggies, apparently. Don't seem to mind them now, though...

Owain: Morgan!

Morgan (female): Oh! Owain?! Guess I was pretty out of it to miss my own brother paying a visit! Did you need something?

Owain: Just wondering what you were chanting over there... You practicing some all-powerful new magic incantations or something?

Morgan (female): Nope! Just going back over my notes on what you told me about myself. I was hoping they'd hold some clue that might help spark my memory. Heh. It's kind of crazy how much you know about me, huh? Like, I really once got five nosebleeds in the same day? I have no memory of that at all. At ALL! Ha ha ha! I can just imagine...

Owain: Well, you're still as cheerful, that's for sure. And as talkative as ever...

Morgan (female): I am? I mean, I was?! Hmm, now that you mention it, that does sound...right, somehow. ...Heh. Everything just feels funny. Even you being my brother hasn't really clicked.

Owain: If you think it's strange for you, imagine how I feel! My kid sister starts talking to me like a stranger, asking questions about herself... I had no idea how to even interact with you. It was pretty rough, but I got used to it.

Morgan (female): Heh, yeah... Sorry about that. But that's just another reason why I'm working hard to get my memories back. Once I do, nobody will have to feel weird or awkward around me again. Pretty noble, huh? I'm such a sweet, selfless girl!

Owain: Heh, and no doubles as well... In any case, I'm happy to help you get those memories back however I can. Someday soon I bet we'll be able to laugh about all the old times—now included!

Morgan (female): Heh, right!

■ MORGAN (FEMALE) X OWAIN (BROTHER/SISTER) B

Owain: Whew! Another long day of combat... I'm bushed. Think I'll hit the hay...ly? Is someone passed out over there? Wait, is that Morgan?!

Morgan (female): Nn...nngh.

Owain: Morgan! By my twitching sword hand, what's happened to you?

Morgan (female): ...Wha—?! Owain! Wh-what am I doing here? Was I asleep?! I don't even remember feeling tired... Oh, right! I was bashing that huge tome against my head when I blacked out. That explains why my face hurts so bad...

Owain: Bashing your... Morgan, why in the WORLD would you do that?! Wait, were you trying to get your memories back?

Morgan (female): Well, yeah! Obviously. If you ever saw me bludgeoning myself just for fun, I hope you'd put a stop to it.

Owain: I'll stop you even if it's NOT just for fun, nitwit! Look, I know you want your memories back, but please... Don't do anything reckless.

Morgan (female): ...But I want to be able to talk with you about old times again.

Owain: I know, Morgan, and I want that, too. But more than that, I want you safe. I may just be another stranger to you, but to me, you're my family. In the future, with Mother and Father gone, it was just the two of us. You're all I had, Morgan... I don't know what I'd do if anything happened to you.

Morgan (female): All right. I'm sorry, Owain.

Owain: Just as long as you understand.

Morgan (female): ...Heh, that felt really sibling just now. Don't you think? Me messing up and you scolding me felt...I don't know, it felt really plausible! Maybe if you keep it up, I'll remember something!

Owain: You really think so?

Morgan (female): Yeah! Oh yeah, this will totally work! So go on, keep yelling! C'mon, scream at your amnesiac sister, Owain!

Owain: I... I'm not really comfortable with—

Morgan (female): Hey, why don't you use the tome, too? Come on, don't hold back. Really wallop me with that thing! Maybe the simultaneous physical and mental shock will jar some memories loose! It's gotta be twice as effective as either one by itself, right? That's just basic science.

Owain: Good night, Morgan...

■ MORGAN (FEMALE) X OWAIN (BROTHER/SISTER) A

Owain: Hey, Morgan. I'm headed into town. Want to come along?

Morgan (female): I'd love to! Is there something in particular you need?

Owain: I might pick up a couple of things, yeah. But mostly I think there's something YOU need.

Morgan (female): It doesn't have to do with getting my memories back, does it?

Owain: The opposite, really. Maybe there's no need to worry about your memories.

Morgan (female): That...makes no sense.

Owain: I'll be honest—it does hurt to know you've forgotten me. But...maybe it's better to build new memories than to worry about old ones.

Morgan (female): What do you mean?

Owain: I've been thinking about this a lot. Why you might have lost your memories, I mean. And I'm wondering if you didn't have some awful memory you couldn't bear to keep. ...I know I've got a few. I see a lot of faces, you know? People we couldn't save...

Morgan (female): I'm sorry you have to bear those dreadful memories, Owain...

Owain: Look, this is just a theory, and even if it's true, it's not like you did it consciously. But I do think that getting your memories back might not necessarily be a good thing.

Morgan (female): Hmm... I understand, and believe me, I appreciate the thought... But I want to remember things, no matter how painful they are. Because I'm sure there'll be plenty of great memories mixed with the bad ones. And the truth, whatever it is... I really want to have that back, you know?

Owain: Well, if you're sure, then I'm happy to help.

Morgan (female): That's really kind of you, Owain, but do you truly realize what you're saying? I mean, it could be years before I remember anything. Or decades. Heck, there's a decent chance I may never get my memories back at all. I don't want to drag you into something that could last forever.

Owain: I'm already stuck with you forever, you goof. I'm your brother! And memories or no, we are united by our shared blood—the blood of heroes! Neither you nor any foul villain could ever hope to keep us apart!

Morgan (female): Owain, I... *sniff* Thank you! I'll do everything I can!

Owain: Then start by coming with me into town.

Morgan (female): Huh? But you said that doesn't have to do with getting my memories back.

Owain: Hey, there's no rule that says you can't have a little fun while you try. And there's certainly no rule against making some happy new memories, either. You're young! Live a little! There'll be plenty of time to worry later.

Morgan (female): Right... You're right! Thanks, Brother!

■ NOIRE X OWAIN C

Noire: Hnnnnrrrggghhh!

Owain: Whoa, Noire! That's an awful big load you've got. What are you up to?

Noire: Eep! ...O-oh! Hello, Owain. I'm just bringing some ingredients back from the market.

Owain: Geez, they look heavy. Here, lemme help you.

Noire: Um, but...are you sure?

Owain: Sure, I'm sure! Just drop 'em there, and let your white knight take over!

Noire: I'm sorry for the trouble. Thank you.

Owain: I'm a lone wolf by nature, but the call of an innocent in distress still—

Owain: By the red hair of Eliwood! This really is heavy! Is all this stuff for tonight's dinner?

Noire: No, not exactly. I thought I'd try my hand at confections.

Owain: Ah! And what do you have to confess? Go on now, you can tell old Owain!

Noire: Er, no. "Confections." Baked sweets. Little cakes and the like. So I've got flour, milk, eggs, honey, and a few random fruits.

Owain: Wow, I didn't know you were such an amazing cook!

Noire: Um, well, I haven't cooked anything yet. Actually, this is my first attempt. But maybe you might...try it? I mean...if you...what?

Owain: I'd love to! My sword hand is always hungry for confections!

Noire: Um. "Confections." It's pronounced— N-never mind. Thanks, Owain. I'll try not to let you down.

Owain: Hey, Noire! I'm here to put some cake in my belly!

Noire: Eep! O-Owain! Hello...

Owain: Whoa, it smells amazing in here! It's making my mouth water.

Noire: I hope it's all right. Some of these proportions are a bit tricky.

Owain: I'll let my stomach be the final arbiter of quality here. Give me that! *Horf, snorf, chomp* By the juggled axe of Kieran! This is amazing!

Noire: R-really? Oh, I'm so glad...

Owain: It's like a lightning bolt of flavor from a fluffy nimbus of perfect texture! Is this your mother's recipe? Because it tastes like magic!

Noire: I'd always wanted to try it, but... Well, we never had the ingredients.

Owain: Ha! Tell me about it! I spent most of my time in the future eating bugs. So what do you call this delicious morsel, anyway?

Noire: I...I don't know. The recipe never mentioned a name.

Owain: Then I must give it one!

Noire: Er... You will?

Owain: Sure! If you don't know it, I doubt anybody does, so I may as well give it a new one!

Noire: I... I suppose that's okay.

Owain: A harmonious clash of sweet and bitter rise up through a field of earthen brown... A single whole, when sliced, shows two tiers joined by love... It's coming to me... Brace yourself! It's...coming...to...me...! Behold! The Garden of Eternal Devotion!

Noire: That's... That's beautiful, Owain! You're a poet! You just poemed!

Owain: I did? I mean, um... Ha ha ha! Of course I did!

Noire: Oh, there are so many cakes I'd like to have you try! But even here in the past, this stupid war makes it hard to find ingredients.

Owain: Ha! Never fear, my dear chef! I'm sure we'll figure something out.

Noire: Um, so if I do...will you name it again? L-like before? I mean, like a poem?

Owain: S-sure, why not?!

NOIRE X OWAIN A

Owain: Hey, Noire!

Noire: Eep! H-hello, Owain...

Owain: Any chance you could whip up another cake? I'm craving something sweet.

Noire: Oh, I'm so sorry! But I'm all out of ingredients.

Owain: Ah... I figured as much.

Noire: I really am sorry...

Owain: Don't apologize! It's just one more reason for me to fight for peace!

Noire: I...I was looking forward to hearing your poems again.

Owain: You're really stuck on that, huh?

Noire: Eep! S-sorry! I didn't mean to—

Owain: Heh, you sure are jumpy. Anyway, if you could make any cake you wanted, what would it be? The last one tasted like chocolate, but there have to be other kinds.

Noire: Well, there are sweet breads you eat with jam and butter... Um, and then spongy cakes that you put berries on... All kinds, really. I don't know which one I'd like to try.

Owain: Oof, I shouldn't have asked... I'm drooling just hearing about them!

Noire: S-say, Owain...?

Owain: Hm?

Noire: Could describing them be enough to come up with a name? I mean, um... Could you maybe poem a cake that didn't exist yet?

Owain: Sorry, no can do. The engine of inspiration is sparked by frosting on the palate. It's like the flavor shakes the words out of my very soul!

Noire: Oh. ...Then I'll just have to try doubly hard to find ingredients.

Owain: Just don't do anything crazy, all right? I don't want you robbing an old lady's larder or something.

Noire: I won't do...that.

Owain: I don't want to know!

NOIRE X OWAIN S

Noire: O-Owain! I made another cake!

Owain: You did? Can I have a bite? Please? Pretty please?!

Noire: Of course! I...I made it for you.

Owain: Ooh, now this looks great! Don't blink or you'll miss this disappearing act! *Horf, norf, snarf, chomp, shlurp* ...BRAAAAAAAAAP! Oh, gods. I feel it! ...I feel inspiration! Get ready! Here it comes!

Noire: I've never been so alive in my life!

Owain: The flavors swirl like veining in the marble walls of a giant cakey cathedral! A symphony of scent scintillates the space with notes of supple spice! Citrus-tinged light shines forth as if through a stained-glass window! Here...it...COOOOOMES... The High Temple of Austere Majesty!

Noire: A...t-temple? My cake is a temple?

Owain: And at its altar, a prince and princess exchange their wedding vows!

Noire: A royal wedding?! Oh my goodness.

Owain: Oh, Noire! I cannot bear the thought of life without your sweet cakes! Marry me, Noire! Marry me!

Noire: Heh... Heh heh heh... Mwah ha ha ha ha ha! BLOOD AND THUNDER!

Owain: Gah! L-look! I'm sorry! You can say no if you want! It's totally fine!

Noire: YOU STOLE IT!

Owain: I stole wh-what?!

Noire: YOU STOLE MY PLAN! The cake was but a way to butter you up before asking the same question! And now you have o'erstepped your bounds and ruined my plan! INSOLENCE!

Owain: B-but wait! We both get what we want! Who cares who asks whom first?!

Noire:Oh. R-right. Yes, of course. I'm terribly sorry. I shouldn't have yelled, Owain. I was just a bit... overcome.

Owain: Hey, I know how it goes. I have trouble reining it in sometimes, too. Maybe that's another reason why we'd be good for each other? ...Maybe?

Noire: Oh, Owain! I am so very fond of you! I love how you chew with your mouth open! I love how you name your utensils! I love it all!

Owain: Now you're making ME feel a little overcome!

Noire: Hee hee!

 Nah

NAH X OWAIN C

Owain: Hey, Nah. What are you up to?

Nah: Judging from the book in my hands, I'd say it's rather obvious.

Owain: Yeah, but there's a whole stack of books next to you, too. Are you planning to read them all?

Nah: There were hardly any books in the future we came from. It's nice to have this much variety.

Owain: Yeah, I guess. But reading seems kinda...

I don't know. Old and boring? I mean, in manakete years, you're still pretty young, right?

Nah: I don't understand. What do you think I should do instead?

Owain: Play? Have fun? Run around in circles?

Nah: You do realize we're at war, right? This isn't the time for games.

Owain: Well, it still seems like you're trying to grow up too fast.

Nah: All right, fine! You think up a game, and maybe I'll play it!

Owain: Fine then! Maybe I will!

Nah: Good! You do that! You know where to find me.

NAH X OWAIN B

Owain: Nah!

Nah: What is it, Owain?

Owain: I thought up the perfect game for you!

Nah: I suppose asking you to let me read in peace is out of the question? Oh, all right. Let's hear it.

Owain: "What's That Breath Attack?" Great, right? I'm thinking you could easily come up with a hundred types!

Nah: A hundred?! Are you mad? Owain, I can't produce a hundred different kinds of breath!

Owain: No, no, no! You don't do it for REAL! You IMAGINE them! Just think about what would be a totally awesome attack! Here, I'll get you started. Ready... Seeeet... FIERY ICY DEATH STRIKE!

Nah: Wait...so it's on fire AND made of ice? Is that even possible?

Owain: It doesn't matter if it's possible! That's not the point! Okay, let's try again. Ready... Seeeeet... SUPER DINOSAUR DEATH GORE-NADO!

Nah: What does that even mean?

Owain: Nah, please! You're doing it again! I told you, you don't have to actually do it. You don't even have to understand it!

Nah: I don't understand. Why am I thinking up names for impossible things?

Owain: Because it's fun! Sheesh! If this were about doing real work, it wouldn't be fun at all.

Nah: ...I don't get it.

Owain: Wow, Nah. You may look young, but I think you're actually an old crank.

Nah: Maybe some of us can't afford to remain children forever...

Owain: Hm? What was that?

Nah: Nothing.

Owain: Well, don't worry. I'll put my thinking cap on and come up with another game!

NAH X OWAIN A

Owain: Hey, Nah! I'm back for another round of fun!

Nah: Are we still doing this? Because I think— Gyaaaaaah!

Owain: What do you think? How's the view from up on my shoulders?

Nah: Eek! D-don't drop me! J-just set me back down! Gently!

Owain: I figured if make-believe wasn't your thing, something more physical might be the trick. So? Are you having fun yet? I bet the world looks pretty different from up there, huh?

Nah: I dunno. I see things from at least twice this height in dragon form.

Owain: ...Oh. Right. I forgot about that. I'll just, uh... Let you down, then.

Nah: Thank you. ...Oof! You know, Owain, you can stop thinking of ways to waste time like this. I don't need fun or games or entertainment. I want a world at peace, and nothing more.

Owain: But play is important! I mean, even if you aren't really a kid! What sort of peaceful world are we making if it's all business all the time? We've got to lead by example, Nah, and that means living happy lives.

Nah: I don't disagree, Owain. In fact, it's kind of noble. But I just don't like horsing around. I prefer to read. ...Quietly.

Owain: Sorry. I guess I just assumed. But hey, if you ever get the urge to horse around, you know where to find me!

Nah: Why are you so fixated on this?

Owain: I've always been good with kids, you know? So I thought maybe if I did the same sorts of things with you...

Nah: Owain, look. You're really nice, and really sweet, but you need to understand... I'm not a kid. Okay? I know that's hard for you to get, but try. All right?

Owain: Ha ha! Okay, Nah, I will! I mean, um... I will, ma'am!

NAH X OWAIN S

Nah:

Owain: Hey, Nah. What are you doing here?

Nah: Waiting for you.

Owain: Lying in ambush, huh? Well, you got me! Wait, is this a game? Are you playing hide-and-seek?

Nah: No more games, Owain.

Owain: Er, right... Sorry, I forgot. I didn't mean to treat you like... I mean, it's just... Sorry. Did you need something?

Nah: Stop treating me like a child, Owain.

Owain: I know! I know. I'm sorry.

Nah: Because I'm not, you know. I'm a woman.

Owain: Yeah, I know, I just—

Nah: And when you treat me like a child, it makes me uncomfortable. Because... Because I have very unchildlike feelings for you. I want to be with you as an adult. I want you to see me as an equal.

Owain: Wait? You do? Seriously? ...Holy cow. I mean, don't get me wrong! I think it's great! It's just... Well, I dunno. Why me?

Nah: I've never known anyone as kind as you. Even in the future, amid all that despair, you were always so cheery and selfless. You drive me up the wall with your...exuberance. But your heart is always in the right place. Your heart is beautiful, Owain.

Owain: I don't know what to say... Wait, what am I saying? Yes I do! If you're willing to put up with me, I can certainly learn how to treat you right! From today on, I'm your guy!

Nah: And I'm your girl!

Owain: Woo! So...what do you want to do now? Think up new move names?

Nah: ...How is that any different from before?

Owain: Ha ha, I'm kidding! Kidding! It was a joke! Yeeeargh...

 Father

FATHER X OWAIN C

A foul sense hangs in the air... My sword arm throbs dully! Hngh?! Wh-what's this? Blood...raging! ...A different sort of blood rage than usual!

[Robin]: Owain? Is everything all right?

Frederick: Owain? Is everything all right?

Virion: Owain? Is everything all right?

Vaike: Owain? Everything all right?

Stahl: Owain? Is everything all right?

Kellam: Owain? Is everything all right?

Lon'qu: Owain. Is everything all right?

Ricken: Owain? Is everything all right?

Gaius: Owain? Is everything all right?

Gregor: Er, everything is all right, no?

Libra: Owain? Is everything all right?

Henry: Hey-o, Owain! Everything all right?

Donnel: What's goin' on, Owain? Everythin' all right?

Owain: STAY BACK, FATHER! You mustn't come any closer!

[Robin]: Why? Did you catch something? Do you think you're contagious?

Frederick: Why? Did you catch something? Do you think you're contagious?

Virion: Why? Did you catch something? Do you think you're contagious?

Vaike: Why? Did ya catch somethin'? You think you're contagious?

Stahl: Why? Did you catch something? Do you think you're contagious?

Kellam: Why? Did you catch something? Do you think you're contagious?

Lon'qu: Did you catch something? Do you think you're contagious?

Ricken: Why? Did you catch something? Do you think you're contagious?

Gaius: Why? Did you catch something? Do you think you're contagious?

Gregor: Why? Are you contagious? You have terrible disease?

Libra: Why? Did you catch something? Do you think you're contagious?

Henry: Why? Did you catch something? ...Ooo, are you CONTAGIOUS?!

Donnel: Gosh! Did ya catch somethin'? Ya think yer contagious?

Owain: The blood of heroes that courses through my veins hungers for fresh prey! If you draw within striking range in my present state, I cannot guarantee safety! I beg of you, stay back! Do not force me to topple my own father!

[Robin]: ...Er, I'm confused. Are you under someone else's control? Did someone curse you?

Frederick: ...I'm confused. Are you under someone else's control? Did someone curse you?

Virion: ...I fear I'm confused. Are you under someone else's control? Did someone curse you?

Vaike: ...Er, I'm confused. Are you under someone else's control? Wait, did someone curse ya?

Stahl: ...Er, I'm confused. Are you under someone else's control? Did someone curse you?

Kellam: ...Er, I'm confused. Are you under someone else's control? Did someone curse you?

Lon'qu: ...I'm confused. Are you under someone else's control? Did someone curse you?

Ricken: ...Er, I'm confused. Are you under someone else's control? Did someone curse you?

Gaius: ...Er, I'm confused. Are you under someone else's control? Did someone curse you?

Gregor: Gregor is confused. Are you under control of evil spirit? Did someone make with the cursing of you?

Libra: ...Er, I'm confused. Are you under someone else's control? Did someone curse you?

Henry: ...Er, I'm confused. Are you under someone else's control? I'm not detecting a curse, sooo...

Donnel: ...I'm a mite confused. Are ya under someone else's control? Did some witch go and curse ya?

Owain: Aye, the curse of my bloodline's uncontrollable power! IT GNAWS AT MY SOOOOOOUL! Hnngh... D-down! Down, I command thee! Be calm, sword arm! Stay, raging blood!

[Robin]: All right, Son, just stay where you are—I'll get your mother!

Frederick: All right, Son, just stay where you are—I'll get your mother!

Virion: All right, Son, just stay where you are—I'll get your mother!

Vaike: All right, Son, just stay where you are—I'll get your mother!

Stahl: All right, Son, just stay where you are—I'll get your mother!

Kellam: All right, Son, just stay where you are—I'll get your mother!

Lon'qu: All right, just stay where you are. I'll go get your mother.

Ricken: All right, Son, just stay where you are—I'll get your mother!

Gaius: All right, Son, just stay where you are—I'll get your mother!

Gregor: Gya! Stay put, boy! Gregor go and fetch mother!

Libra: All right, Son, just stay where you are—I'll get your mother!

Henry: Well, if it's not a curse, there isn't much I can do about it. I guess I'll go get your mother!

Donnel: Hold on, Son! Stay where ya are! I'll run and fetch yer ma!

Owain: Wait, MOTHER?! Er... Heh... That's not...strictly necessary. This pain is nothing to a man like me!

Owain: Given a moment, I'm sure it will abate! I've weathered far worse than... Er, Father? ...ACK! Did he actually go to get Mother?! Suddenly I don't feel so well...

FATHER X OWAIN B

Owain: Um... You're not still upset, are you?

[Robin]: Of course I'm upset! You started moaning and shouting out of the blue! Your mother and I were terrified! *Sigh* Look, I AM relieved you're all right. But what was all that about, anyway? Some kind of scripted stage acting?

Frederick: Of course I'm upset! You started moaning and shouting out of the blue! Your mother and I were terrified. *Sigh* Listen. I'm relieved you're all right. But what was all that about, anyway? Some kind of scripted stage acting?

Virion: Of course I am upset! You started moaning and shouting out of the blue! Your mother and I were terrified! *Sigh* Look, I AM relieved you're all right. But what was all that about, anyway? Some kind of scripted stage acting?

Vaike: Of course I'm upset! You started moanin' and shoutin' out ofthe blue! Your mother and I were terrified! *Sigh* Look, I AM relieved you're all right. But what was all that about, anyway? Some kind of scripted stage actin'?

Stahl: Of course I'm upset! You started moaning and shouting out of the blue! Your mother and I were terrified! *Sigh* Look, I AM relieved you're all right. But what was all that about, anyway? Some kind of scripted stage acting?

Kellam: Of course I'm upset! You started moaning and shouting out of the blue! Your mother and I were terrified! *Sigh* Look, I relieved you're all right. But what was all that about, anyway? Some kind of scripted stage acting?

Lon'qu: Of course I'm upset! You started moaning and shouting out of the blue. Your mother and I were terrified. *Sigh* Look, I AM relieved you're all right. But what was all that about? Some kind of scripted stage acting?

Ricken: Of course I'm upset! You started moaning and shouting out of the blue! Your mother and I were terrified! *Sigh* Look, I AM relieved you're all right. But what was all that about, anyway? Some kind of scripted stage acting?

Gaius: Of course I'm upset! You started moaning and shouting out of the blue! Your mother and I were terrified! *Sigh* Look, I AM relieved you're all right. But what was all that about, anyway? Some kind of scripted stage acting?

Gregor: Of course Gregor upset! You make with the moaning and the shouting out of blue! Your mother and Gregor very scared! *Sigh* Look, Gregor is glad you are safe, but why you yell like madman? Some kind of...scripted stage acting?

Libra: Of course I'm upset! You started moaning and shouting out of the blue! Your mother and I were terrified! *Sigh* Look, I AM relieved you're all right. But what was all that about, anyway? Some kind of scripted stage acting?

Henry: Ha ha! Of course not! Though when you started shouting out of the blue, your mother and I were worried. What was all that about, anyway? Some kind of scripted stage acting?

Donnel: Course I'm upset! You started moanin' and shoutin' out of the blue! Yer ma and I were terrified! *Sigh* Look, I AM glad yer all right. But what in blazes was that about, anyhow? Some kinda scripted theater show?

Owain: I don't script anything! I'll have you know, it's entirely improv— Er... I mean, it's authentic! I'm the chosen scion of warrior heroes across tide and time!

[Robin]: And you're not ashamed to spout those lines? ...That makes one of us.

Frederick: And you're not ashamed to spout such nonsense? ...That makes one of us.

Virion: And you're not ashamed to spout those lines? ...That makes one of us.

Vaike: And you ain't ashamed to spout that stuff? ...The Vaike is confused.

Stahl: And you're not ashamed to spout those lines? ...That makes one of us.

Kellam: And you're not ashamed to spout those lines? ...That makes one of us.

Lon'qu: And you're not ashamed to say these things out loud...?

Ricken: And you're not ashamed to spout those lines? ...That makes one of us.

Gaius: And you're not ashamed to spout those lines? ...That makes one of us.

Gregor: Ugh. And you speak such lines without feeling ashamed? Gregor not understand this.

Libra: And you're not ashamed to spout those lines? ...That makes one of us.

Henry: And you're not ashamed to spout those lines? ...That makes one of us.

Donnel: And you ain't ashamed to spout those lines? That makes one of us...

Owain: Ashamed? Ha! Far from it! Though I suppose I can't blame you for not understanding my bleeding-edge aesthetic. After all, you are the product of an earlier, simpler time...

[Robin]: Well, a future where everyone talks like you sounds a bit— ...OWAIN, GET DOWN!

Frederick: Perhaps. But a future where everyone speaks like you sounds a bit— ...OWAIN, GET DOWN!

Virion: Well, a future where everyone speaks like you sounds rather— ...OWAIN, GET DOWN!

Vaike: Heh. Well, a future where people talk like you makes the Vaike— ...OWAIN, GET DOWN!

Stahl: Well, a future where everyone talks like you sounds a bit— ...OWAIN, GET DOWN!

Kellam: I dunno... A future where everyone talks like you sounds a bit— ...OWAIN, WATCH OUT!

Lon'qu: ...Hmph. Well, a future where everyone talks like you sounds— ...OWAIN, NOW! NOW!

Ricken: Well, a future where everyone talks like you sounds a bit— ...OWAIN, GET DOWN!

Gaius: Well, a future where everyone talks like you sounds a bit— ...OWAIN, LOOK OUT!

Gregor: Well, future where people talk like Owain make Gregor feel— ...OWAIN! LOOKING OUT!

Libra: Well, a future where everyone talks like you sounds a bit— ...OWAIN, LOOK OUT!

Henry: Geez. Well, a future where everyone talks like you sounds to me like— ...OWAIN, GET DOWN!

Donnel: Well, a future where folks all talk like you sure sounds— ...OWAIN, HIT THE HAY!

Owain: What?!

[Robin]: ...Grah!

Frederick: ...Grah!

Virion: ...Grah!

Vaike: ...Grah!

Stahl: ...Grah!

Kellam: ...Grah!

Lon'qu: ...Grah!

Ricken: ...Grah!

Gaius: ...Grah!

Gregor: ...Grah!

Libra: ...Grah!

Henry: ...Whoopsie!

Donnel: ...Aw, pig slop!

Owain: Your shoulder! Father, you're hit!

[Robin]: Nngh... Archers...in the trees... They fired on you... But I'd never let them hurt my son... We're outnumbered... We have to get out of here! Now GO!

Frederick: Nngh... Archers...in the trees... They fired on you... But I'd never let them hurt my son... We're outnumbered... We have to get out of here! Now GO!

Virion: Nngh... Archers...in the trees... They fired on you... Those cowards! But I'd never let them hurt my son... We're outnumbered... We have to get out of here! Now GO!

Vaike: Nngh... Archers...in the trees... Those cowards, they fired on you... No one fires at the Son of Vaike... But we're outnumbered... We gotta get outta here, ya hear? Now GO!

Stahl: Nngh... Archers...in the trees... They fired on you... But I'd never let them hurt my son... We're outnumbered... We have to get out of here! Now GO!

Kellam: Nngh... Archers...in the trees... They fired on you... But I'd never let them hurt my son... We're outnumbered... We have to get out of here! Now GO!

Lon'qu: Nngh... Archers...in the trees... We're outnumbered... We have to get out of here! Now GO!

Ricken: Nngh... Archers...in the trees... They fired on you... But I'd never let them hurt my son... We're outnumbered... We have to get out of here! Now GO!

Gaius: Nngh... Archers...in the trees... They fired on you... Those...craven dastards... We're outnumbered... We have to get out of here! Now GO!

Gregor: Nngh... Archers...in the trees... They try to kill you... But Gregor never let them hurt son... We are outnumbered... We must be getting out of here! Now GO!

Libra: Nngh... Archers...in the trees... Thank the gods they missed you... We're outnumbered... We have to get out of here! Now GO!

Henry: Nngh... Archers...in the trees... They fired on you... But I'd never let them hurt my son... Go on, Owain—I'll take care of this! You just get out of here. Now GO!

Donnel: Nngh... Archers...in the trees... They fired on ya... But I'd never let them hurt my boy... We're outnumbered... We gotta skedaddle! Now GIT!

Owain: R-right!

[Robin]: We lost them... We should be safe here.

Frederick: We lost them... We should be safe here.

Virion: We lost them, heh, that was some quick thinking, if I do say so myself...

Vaike: Whew... We lost 'em. The Vaike's legs always come through in a pinch, huh!

Stahl: We lost them... We should be safe here.

Kellam: We lost them... We should be safe here.

Lon'qu: We lost them... We should be safe here.

Ricken: We lost them... We should be safe here.

Gaius: We lost them... We should be safe here.

Gregor: We finally lost them... We should be safe here.

Libra: We lost them... We should be safe here.

Henry: Well, that took care of that! Nya ha! Are you all right?

Donnel: Whew! We lost 'em... I reckon we're safe here.

Owain: Gods, not again...

[Robin]: Hmm?

Frederick: Hmm?

Virion: Hmm?

Vaike: Huh?

Stahl: Hmm?

Kellam: Hmm?

Lon'qu: Hmm?

Ricken: Hmm?

Gaius: Hmm?

Gregor: Hmm?

Libra: Hmm?

Henry: Hmm?

Donnel: Hmm?

Owain: Why?! Why did you take that arrow for me?! You could have died! This is how it happens, you know! This is exactly... Er...

[Robin]: This is how what happens?

Frederick: This is how what happens?

Virion: This is how what happens?

Vaike: This is how what happens?

Stahl: This is how what happens?

Kellam: This is how what happens?

Lon'qu: This is how what happens?

Ricken: This is how what happens?

Gaius: This how what happens?

Gregor: This how what happens?

Libra: This is how what happens?

Henry: This is how what happens?

Donnel: This is how what happens?

Owain: *Sob* Oh, Father... *sniff*

[Robin]: Owain? Owain, are you crying? What's wrong?

Frederick: Owain? Owain, are you crying? What's wrong?

Virion: Owain? Owain, are you crying? What's wrong?

Vaike: Owain? Owain, are you cryin'? What's the matter?

Stahl: Owain? Owain, are you crying? What's wrong?

Kellam: Owain? Owain, are you crying? What's wrong?

Lon'qu: Owain...are you crying? What's wrong?

Ricken: Owain? Owain, are you crying? What's wrong?

Gaius: Owain? Owain, are you crying? What's wrong?

Gregor: Owain? Owain, you are crying, yes? What is happened? Is something wrong?

Libra: Owain, are you crying? What's wrong?

Henry: Hey, are you crying? What's wrong?

Donnel: Owain? Owain, are ya cryin'? What's wrong?

Owain: I... *sigh* No, nothing. Nothing is wrong. It was...just more improv, all right? Just forget I said anything. More importantly, we need to get that shoulder looked at. I'll get Mother.

[Robin]: A-all right. I'll be here.

Frederick: A-all right. I'll be here.

Virion: A-all right. I'll be here.

Vaike: A-all right. I'll be waitin'.

Stahl: A-all right. I'll be here.

Kellam: A-all right. I'll be here.

Lon'qu:

Ricken: A-all right. I'll be here.

Gaius: A-all right. I'll be here.

Gregor: All right. Gregor will be here.

Libra: A-all right. I'll be here.

Henry: Aw, it's not that bad! I'm barely bleeding! Mmm... Bloood...

Donnel: A-all right, then. I'll be here.

■ FATHER X OWAIN A

Owain: Father, how's the shoulder?

[Robin]: Fine, thank you. Nearly healed. It wasn't much of a wound to begin with, fortunately.

Frederick: Fine, thank you. Nearly healed. It wasn't much of a wound to begin with, fortunately.

Virion: Nearly healed, thank you. It wasn't much of a wound to begin with, fortunately.

Vaike: Aw, I'm nearly healed up. Wasn't much of a wound to begin with, I guess.

Stahl: Fine, thank you. Nearly healed. It wasn't much of a wound to begin with, fortunately.

Kellam: Fine, thank you. Nearly healed. It wasn't much of a wound to begin with, fortunately.

Lon'qu: Fine, thanks. Nearly healed. It wasn't much of a wound to begin with.

Ricken: Fine, thank you. Nearly healed. It wasn't much of a wound to begin with, fortunately.

Gaius: Fine, thanks. Nothing a little sugar wasn't able to patch right up.

Gregor: Ha! It was just minor scratch. See? All healed.

Libra: Fine, thank you. It wasn't much of a wound to begin with, thank the gods.

Henry: Fine, thanks. Nearly healed. It wasn't much of a wound to begin with, fortunately.

Donnel: Fine, thanks! Darn near healed, I reckon. Wasn't much of a wound to begin with.

Owain: Good. I don't know what I'd do if...if I got you killed again.

[Robin]: Ah, so that's what this was about... I die protecting you in the future?

Frederick: Ah, so that's what this was about... I die protecting you in the future?

Virion: Ah, so that's what this was about... I die protecting you in the future?

Vaike: Ah, so that's what this was about... I die protectin' ya in the future?

Stahl: Ah, so that's what this was about... I die protecting you in the future?

Kellam: Ah, so that's what this was about... I die protecting you in the future?

Lon'qu: Is that what this was about? I die protecting you in the future?

Ricken: Ah, so that's what this was about... I die protecting you in the future?

Gaius: Ah, so that's what this was about... I die protecting you in the future?

Gregor: Is that what this about? Gregor protecting you in horrible future?

Libra: Ah, so that's what this was about... I die protecting you in the future?

Henry: Ah, I get it now. So I die protecting you in the future, is that it?

Donnel: So that's what this was about... I die protectin' ya in the future, don't I?

Owain: It was a Risen attack... You saved me but were gravely wounded in the process... We were separated in the chaos of battle... I never saw you again.

[Robin]: Well, if I did die protecting you, then at least I died with no regrets.

Frederick: At least it sounds like I died with no regrets.

Virion: At least it sounds like I died without regret.

Vaike: Ha! Sounds like a suitable death for ol' Teach!

Stahl: At least it sounds like I died with no regrets.

Kellam: At least it sounds like I died with no regrets.

Lon'qu: At least I died with no regrets.

Ricken: At least it sounds like I died with no regrets.

Gaius: At least it sounds like I died with no regrets.

Gregor: At least it sound like Gregor die with no regrets.

Libra: At least it sounds like I died with no regrets.

Henry: At least it sounds like I died with no regrets.

Donnel: Well, least I died with no regrets.

Owain: So yes, that's why when I saw you took a hit for me, I...I lost control. All those feelings of guilt and shame returned. I just couldn't stand it.

[Robin]: I'm sorry to have dredged up those painful memories, Owain. But more than that, I'm sorry I left you by yourself in the future...

Frederick: I'm sorry to have dredged up those painful memories, Owain. But more than that, I'm sorry I left you by yourself in the future...

Virion: I'm sorry to have dredged up those painful memories, Owain. But more than that, I'm sorry I left you by yourself in the future...

Vaike: Well, sorry that I dredged up those painful memories, Owain. But more than that, I'm sorry I left ya by yourself in the future...

Stahl: I'm sorry to have dredged up those painful memories, Owain. But more than that, I'm sorry I left you by yourself in the future...

Kellam: I'm sorry to have dredged up those painful memories, Owain. But more than that, I'm sorry I left you by yourself in the future...

Lon'qu: I'm sorry to have dredged up those painful memories, Owain. But more than that, I'm sorry I left you by yourself in the future...

Ricken: I'm sorry to have dredged up those painful memories, Owain. But more than that, I'm sorry I left you by yourself in the future...

Gaius: I'm sorry to have dredged up those painful memories, Owain. But more than that, I'm sorry I left you by yourself in the future...

Gregor: Gregor so sorry to dredge up all those painful memories. But more than that, Gregor sorry he left you all alone in future...

Libra: I'm sorry to have dredged up those painful memories, Owain. But more than that, I'm sorry I left you by yourself in the future...

Henry: Aw, I'm sorry to have dredged up those painful memories, Owain. But more than that, I'm sorry I left you by yourself in the future...

Donnel: I'm awfully sorry to go dredgin' up those painful memories, Owain. But more'n that, I'm sorry I left ya all by yourself in the future...

Owain: Father, no! You never left me! I never felt alone—not once! You and Mother were always with me because you were WITHIN me! I'm the scion of a heroine who gave me life and a hero who gave his life to save mine.

[Robin]: Wait. So all this talk about having the blood of heroes in you... You were talking about your mother and me? Owain, that's so— ...Wait a second. Why does OUR blood rage and boil at the drop of a hat? Lissa and I really don't seem the type to have such unruly fluids...

Frederick: Wait. So all this talk about having the blood of heroes in you... You were talking about your mother and me? Owain, that's so— ...Wait a second. Why does OUR blood rage and boil at the drop of a hat? Lissa and I really don't seem the type to have such unruly fluids...

Vaike: Wait. So all this talk about havin' the blood of heroes in you... You were talkin' about your mother and me? Owain, that's so— ...Wait a sec. Why does OUR blood rage and boil at the drop of a hat? Lissa and I really don't seem the type to have such unruly fluids...

Stahl: Wait. So all this talk about having the blood of heroes in you... You were talking about your mother and me? Owain, that's so— ...Wait a second. Why does OUR blood rage and boil at the drop of a hat? Lissa and I really don't seem the type to have such unruly fluids...

Kellam: Wait. So all this talk about having the blood of heroes in you... You were talking about your mother and me? Owain, that's so— ...Wait a second. Why does OUR blood rage and boil at the drop of a hat? Lissa and I really don't seem the type to have such unruly fluids...

Lon'qu: Wait. So all this talk about having the blood of heroes in you... You were talking about your mother and me? Owain, that's so— ...Wait a second. Why does OUR blood rage and boil at the drop of a hat? Lissa and I really don't seem the type to have such unruly fluids...

Ricken: Wait. So all this talk about having the blood of heroes in you... You were talking about your mother and me? Owain, that's so— ...Wait a second. Why does OUR blood rage and boil at the drop of a hat? Lissa and I really don't seem the type to have such unruly fluids...

Gaius: Wait. So all this talk about having the blood of heroes in you... You were talking about your mother and me? Owain, that's so— ...Wait a second. Why does OUR blood rage and boil at the drop of a hat? Lissa and I really don't seem the type to have such unruly fluids...

Gregor: Wait. So all this talk about having blood of heroes in you... You talking of mother and Gregor? Owain, Gregor is very touch— ...Wait. Why does OUR blood rage and boil at dropping of the hat? Lissa and Gregor not type to have such unruly fluids...

Libra: Wait. So all this talk about having the blood of heroes in you... You were talking about your mother and me? Owain, that's so— ...Wait a second. Why does OUR blood rage and boil at the drop of a hat? Lissa and I really don't seem the type to have such unruly fluids...

Henry: Wait. So all this talk about having the blood of heroes in you... You were talking about your mother and me? Owain, that's so— ...Wait a second. Why does OUR blood rage and boil at the drop of a hat? Lissa and I really don't seem the type to have such unruly fluids...

Donnel: Wait. So all this talk about havin' the blood of heroes in ya... You were talkin' about your ma and me? Owain, that's so— ...Hold on a sec. Why does OUR blood rage and boil at the drop of a sickle? Lissa and I sure been the type to have such unruly fluids...

Owain: Well, yes, the part about my blood raging may have been for...dramatic effect.

[Robin]: ...Wait, WHAT?

Frederick: ...I beg your pardon?

Virion: ...Wait, WHAT?

Vaike: ...Wait, WHAT?

Stahl: ...Wait, WHAT?

Kellam: ...Wait, WHAT?

Lon'qu: ...WHAT?

Ricken: ...Wait, WHAT?

Gaius: ...Wait, WHAT?

Gregor: ...Wait, WHAT?

Libra: ...Pray come again?

Henry: ...Er, what?

Donnel: ...How's that again?

Owain: But the point is that I'm more proud of my bloodline than anything in the world. When I remember I'm your son, I feel unstoppable. Like I could do anything! And I didn't come all this way to have you die on me again! Do you understand? From now on, we fight injustice together!

[Robin]: ...Thank you, Owain. But you're more than just my legacy. You've done plenty in your own right. Your mother and I are so proud of everything you've become...

Frederick: ...Thank you, Owain. But you're more than just my legacy. You've done plenty in your own right. Your mother and I are so proud of everything you've become...

Virion: ...Thank you, Owain. But you're more than just my legacy. You've done plenty in your own right. Your mother and I are so proud of everything you've become...

Vaike: ...Heh. Thanks, Owain. But more than just the Vaike's legacy, ya know. You've done plenty in your own right, and your mother and I are proud of ya for it.

Stahl: ...Thank you, Owain. But you're more than just my legacy. You've done plenty in your own right. Your mother and I are so proud of everything you've become...

Kellam: ...Thank you, Owain. But you're more than just my legacy. You've done plenty in your own right. Your mother and I are so proud of everything you've become...

Lon'qu: ...Thanks, Owain. You're more than just my legacy, you know. You've done plenty in your own right. Your mother and I are proud of everything you've become...

Ricken: ...Thank you, Owain. But you're more than just my legacy. You've done plenty in your own right. Your mother and I are so proud of everything you've become...

Gaius: ...Thank you, Owain. But you're more than just my legacy. You've done plenty in your own right. Your mother and I are so proud of everything you've become...

Gregor: ...Many thanks, Owain. But you carry more than just Gregor's blood! You done many good things. Gregor and the Lissa are so very proud of everything you become.

Libra: ...Thank you, Owain. But you're more than just my legacy. You've done plenty in your own right. Your mother and I are so proud of everything you've become...

Henry: Ha! Thanks, Owain. But you're more than just my legacy. Your mother and I are proud of everything you've become...

Donnel: ...Thank ya kindly, Owain. But ya carry on more'n just our blood. Ya done plenty in your own right. Lissa and me are right proud of everythin' you've become.

Owain: Aw, thanks! But... Hnngh... This sensation. B-blood...boiling once again... The fiery pride in your bosom has sparked the tinder of my soul and set me ablaze!

[Robin]: Heh. Well, it's good to hear you're back to your old self, at least...

Frederick: Heh. Well, it's good to hear you're back to your old self, at least...

Virion: Heh. Well, it's good to hear you're back to your old self, at least...

Vaike: Hah! Well, I'm glad to hear you're back to your old self, at least.

Stahl: Heh. Well, it's good to hear you're back to your old self, at least...

Kellam: Heh. Well, it's good to hear you're back to your old self, at least...

Lon'qu: Heh. It's good to see you're back to your old self, at least...

Ricken: Heh. Well, it's good to hear you're back to your old self, at least...

Gaius: Heh. Well, it's good to hear you're back to your old self, at least...

Gregor: Heh. Well, it nice to see son is back to usual wacky self, at least...

Libra: Heh. Well, it's good to hear you're back to your old self, at least...

Henry: Heh. Well, it's good to hear you're back to your old self, at least. Now let's talk some more about this blood of yours...

Donnel: Heh. Well, I reckon it's nice to see ya gettin' back to yer usual self at least...

Inigo

Avatar (male)

The dialogue between Avatar (male) and Inigo can be found on page 224.

Avatar (female)

The dialogue between Avatar (female) and Inigo can be found on page 235.

Olivia (Mother/son)

The dialogue between Olivia and Inigo can be found on page 279.

Lucina

The dialogue between Lucina and Inigo can be found on page 281.

Lucina (Brother/sister)

The dialogue between Lucina and Inigo (brother/sister) can be found on page 281.

Owain

The dialogue between Owain and Inigo can be found on page 286.

Brady

■ BRADY X INIGO C

Inigo: Another day, another rejection. Honestly, this is just getting silly. How long will it take womankind to realize my many, many charms?! Mm? What's that? Someone's hunched over the side of the road... I hope he's all ri— Brady?

Brady: Aw, I know it was hard. But you made it, little buddy!

Inigo: Everything all right, Brady?

Brady: GAH! I-Inigo?! D-don't startle me like that!

Inigo: Sorry! I just saw you and wanted... Wait, are you crying?

Brady: N-no! Of course I ain't cryin'! Why would I be cryin'?!

Inigo: ...Then who came and cried on your face?

Brady: No one! I mean... Um... Sh-shut up! What are you doing here, anyway?!

Inigo: I'm just wandering the hillside pondering the futility of love. ...So really. Why are you crying?

Brady: None'a yer beeswax!

Inigo: Tell me! ...Or I'll tell everyone I saw big, tough Brady bawling his eyes out.

Brady: Blackmail! ...Oh, fine. I saw this tiny flower bloomin' by the roadside and I got a little misty. You happy now?

Inigo: PAAAH HA HA HA HA HA HA! Hoooo! I'm sorry. I just... I never figured you for the sentimental type.

Brady: Yeah, yeah. Laugh it up, why don't ya. Just don't go tellin' no one, y'hear?

Inigo: My lips are sealed. ...Provided you do me one little favor.

Brady: Ugh. What?

Inigo: ...no. It's nothing difficult—I promise. We can talk about it next time. I'll be in touch! Ta-ta!

Brady: ...Ugh. Why'd it have to be him?

■ BRADY X INIGO B

Brady: NO STINKING WAY! I AIN'T DOIN' IT!

Inigo: Aw, come on! Don't be such a wet blanket, Brady! All you have to do is walk next to me next time I hit the town. It couldn't be easier!

Brady: Next time you go hit on girls, you mean! I don't wanna get dragged into your sad little world, pal!

Inigo: There's nothing sad about it! We'll talk to some girls, have a nice cup of tea, and everyone walks away whistling.

Brady: I'd sooner drink poison! Go ask someone else!

Inigo: Well, all right. I'm sure one of the others would be willing to be my wingman. We can exchange a good laugh at how sad you were the other day...

Brady: Y-you rotten little weasel! I'll kill ya! And I was NOT sad! I just had a lot of somethin' in my eye!

Inigo: Poetic license. Now, come on. It's just this one time.

Brady: Ugh... Fine. But just this once! I don't get why you want me, anyway. I'm a real square, ya know.

Inigo: And that's why you're PERFECT!

Brady: Haw?

Inigo: I just need you to stand there looking glum and sullen. Meanwhile, I'll be impressing the ladies with my smooooth moves.

Brady: Wait! You just want me to make you look good by comparison!

Inigo: Genius, isn't it?

Brady: NO, IT AIN'T! Did you really expect me to say yes to this?!

Inigo: I'm not expecting you to say anything, actually. Your outdated slang would likely send all the pretty girls running for cover... Unless you think you actually CAN flirt with the ladies. Mmm?

Brady: I-I don't say that! I just... I don't... Aw, horse-feathers! Fine. I'll go. But just this once, hear? Then never, EVER again!

Inigo: Thanks, Brady. See you tonight!

Brady: Gah, this is gonna be humiliatin'!

■ BRADY X INIGO A

Brady: Wh-whyyy?! *sniff* Hooow?! Tell me... Tell me it's all a bad dream! *Sniiiff* Waaaaaah!

Inigo: Gods, pull yourself together, man! You've been sobbin' for an hour.

Brady: You don't know what it's LIKE! You...you just don't know.

Inigo: If you don't stop, I'm gonna tell everyone to come enjoy the show. Believe me, it's a very temptin' idea.

Brady: I don't care! Everything was going fine until you ruined it, ruiner! This is all your fault!

Inigo: It's my fault you started runnin' your mouth about me? My fault you told a pack of strangers about how you saw me crying?! I'm the one who should be yelling at YOU, twerp!

Brady: ...Heh. Heh heh heh... Ah ha ha ha ha ha!

Inigo: This cat's gone loco...

Brady: No, you're right. You're right! That's what started it. I just don't understand why it made the ladies fall all over you! ...And start ignoring me, I might add!

Inigo: The heck should I know?! They came at me so fast, I could barely follow what they were saying. Somethin' about a thug with a heart'a gold. Then that other gal went off 'bout how dreamy sensitive men are.

Inigo: How is sobbing over a flower dreamy?!

Brady: Don't ask me, pal. First time anybody's ever said anything like that to me. I always thought bein' a crybaby was... Ya know. Shameful.

Inigo: Oh, nice. Rub salt in the wound. You think I'm not ashamed enough already? Then fine, go ahead and laugh! Laugh at the big, fat crybaby! And of course, now that I'm sobbing, there isn't a woman to be found!

Brady: Brother? You have GOT to let this go. So you're bad at picking up dames. Who cares?!

Inigo: Easy for you to say. They were fawning over you! Well, good for you, Mr. Popular. I'm reeeeeal happy for you.

Brady: I should redecorate your face with my fist for all this nonsense. But ya know what? Now I know that bein' sentimental ain't all bad. A huge load's been lifted from me today, and I guess I got you to thank for it.

Inigo: So you got to play dreamboat AND were cured of a lifelong trauma? I'd say someone owes me big.

Brady: Maybe. But I ain't doin' this again!

Inigo: Damn right you're not! I don't want you anywhere near me next time!

Brady: Heh. Maybe we're more alike than I thought.

Inigo: Hardly! And don't think I'm not still furious with you!

Brady: Aw, boo hoo hoo. Quit bein' such a Melvin!

Kjelle

■ KJELLE X INIGO C

Kjelle: Hya! Grah! Hiyaaah!

Inigo: How goes the training, Kjelle? Your form is as lovely as ever. ...If you know what I mean.

Kjelle: *Huff, huff...* What do you want, Inigo?

Inigo: You could use a break from training. What say you and me go have some fun?

Kjelle: I'm afraid to ask what your idea of fun entails.

Inigo: Madam, you wound me! A chaste cup of tea was all I had in mind. Perhaps some cake. Eating sweets is a proven pick-me-up, and you owe it to your exhausted body!

Kjelle: Pass. Now if you're done talking, I have a training regimen to get back to. ...As should you.

Inigo: Ouch! That hurts. All work and no play makes Kjelle a dull...um...Kjelle. If you don't blow off steam every once in a while, you'll explode!

Kjelle: Training isn't stressful. It's fun. ...Listening to you is stressful.

Inigo: Oh, come on! It'll be a blast! I'll even let you pick out the cake. My favorite is lemon with chocolate frosting, but you can get—

Kjelle: Go. Away. Now.

Inigo: Fine. Fiiiiine! I'll just go eat cake by myself, then. But I'll be back tomorrow! Just you wait!

Kjelle: ...I wonder if Chrom would mind if I stabbed him?

KJELLE X INIGO B

Inigo: Heeey, Kjelle! Ready to go? I've got the whole day planned!

Kjelle: My day is already planned. I'm training. Now go away.

Inigo: Sorry, no can do! Persistence is my greatest strength, you know.

Kjelle: It's pronounced "tragic flaw."

Inigo: Ah ha! I see your wit is as sharp as a tack!

Kjelle: That wasn't a joke.

Inigo: One day, my sweet, my ceaseless dedication will win you over.

Kjelle: ...You really are unbelievable.

Inigo: Are you all right? You look tired. Can I get you something? Perhaps a slice of cherry cake with those little frosting flowers would—

Kjelle: Oh, for the love of— FINE. Fine, fine, fine, fine. I'll go out with you on one condition.

Inigo: Ooh, progress! ...What's the condition?

Kjelle: You have to fight me for it. Land one blow past my guard, and you can take me to whatever cake shop you like. I'll even let you pick the weapon.

Inigo: Er... Um... Right. But you see, that's not really... fair. You're the strongest person I know... And that's including Chrom!

Kjelle: Okay, then. Get lost.

Inigo: N-no, wait! I'll do it! I'll fight you! I told you that persistence is my greatest strength! Although right now I wish strength was my greatest strength... Anyway, the sword was my first love, so let us do battle with that!

Kjelle: Sure. It's your funeral.

Inigo: *Gulp* I mean... um... Ha ha! Don't be surprised when I dance circles around you!

Kjelle: Anytime, twinkle toes. I've been waiting for a chance to pound you into dust. This is going to be fun. ...Heh. Heh heh heh. Ha ha. AAAH HA HA HA!

Inigo: Eep! Kjelle, I d-didn't know you had an evil side! W-well, at least you seem to be enjoying yourself for a change... Ha ha...ha?

KJELLE X INIGO A

Inigo: I hope you're ready, Kjelle! Today's the day. I can feel it!

Kjelle: What, again? How many times does this make?

Inigo: To be honest, I've lost track. ...Ten? A dozen, maybe?

Kjelle: I stopped counting at thirty. A normal person would have given up by now.

Inigo: Aw, thanks, Kjelle!

Kjelle: That wasn't a compliment! Why are you still here? What motivation could possibly drive you this far? It's truly baffling. And a little scary.

Inigo: I want to go out with you! That's all. I think it'd be fun. I know I'd have fun, and I want you to have fun, too. Maybe you'd even smile once in a while.

Kjelle: ...That's it?

Inigo: Isn't that what I said from the beginning? What other reason would there be?

Kjelle: Avenging your pride? Honing your skills? Dementia? There must be SOMETHING! No one would suffer this many thrashings for a date.

Inigo: Um...I don't know what else to say. I guess a date with you is worth a few bruises. Besides, you always have a huge grin on your face when we're fighting. So it's kind of like we're on a date already! ...Except for the beatings.

Kjelle: Ugh. Forget I asked.

Inigo: Already forgotten! Now let's get down to business. ...En garde!

Kjelle: You're on, lover boy.

KJELLE X INIGO S

Kjelle:

Inigo: What's wrong? You look so serious.

Kjelle: No, I was just...thinking.

Inigo: You sure? You're not getting sick on you? Maybe we should put off today's match.

Kjelle: No, I'm fine. Really. And we don't need to fight a match today. ...You already got me.

Inigo: I'm confused. Because last time we fought, you almost broke my face.

Kjelle: No, Inigo. You broke something. ...The wall around my heart.

Inigo: I think I'd remember that. I pay close attention to your...heart...area.

Kjelle: Gods, you're an idiot. It's a metaphor! It means your stupid persistence finally won out. And even though your sword didn't touch me, I count this as a win for you. So go on. You pick the spot and let's have some fun.

Inigo: You mean it?! Really?! Oh, wow, Kjelle, you will NOT regret this!

Kjelle: None of this makes any sense. I mean, it never did. You're such a huge flirt, I figured you'd take off when I shot you down. I even hit you in the face with a sword, but you just got up and kept trying. I guess in the end I found it kind of...charming.

Inigo: Now that you've learned that resistance is futile, care to ask me one more favor?

Kjelle: Sure, why not?

Inigo: I, uh... I don't actually want just one date...

Kjelle: Well, aren't we confident!

Inigo: The more we fought, the more it became clear to me... I...I can't get enough of you! I want to spend every single day with you!

Kjelle: Every single...day?

Inigo: Well, you know. There might be the odd overseas mission or something. But otherwise, yes! Every single day! So...what do you think?

Kjelle: Have you been plotting this the whole time?

Inigo: You said it yourself—that's a lot of beatings to suffer for just one date.

Kjelle: I don't understand. Why me?

Inigo: I think it's your smile, honestly. After watching you grin like a maniac every time we fought, something clicked. Now, this could be the head trauma talking. I won't rule it out. But I so enjoyed our time together and I... I think I love you.

Kjelle: Oh, wow... Um... I think... I mean, I might also...

Inigo: Yes?

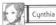

Cynthia

CYNTHIA X INIGO C

Inigo: *Sigh*

Cynthia: What's wrong, Inigo? No, wait! Lemme guess. You got shot down by another pretty girl, huh?

Inigo: Actually, she was GORGEOUS! And for such a beautiful young creature, she certainly packed a mean left hook... And some ice.

Cynthia: With all the practice you get, you'd think you'd have better luck hitting on women.

Inigo: Ha ha, very funny. I'm thoroughly amused. You just wait. I know what went wrong. I'll nail it next time for sure!

Cynthia: That's the spirit! Buck up, little camper! You're no fun when you're all mopey.

Inigo: Someone's bound to pick up on my rugged charm and roguish good looks eventually. I just have to hang in there until then.

Cynthia: Now you're talkin'! Wooooo! (Talkin' a bunch of nonsense.)

Inigo: Sorry, did you say something?

Cynthia: Who, me? Not this girl, no sir-ee. Nuh-uh. Nothin'. Anyway, I'm glad you're feeling better. You just stay there and practice smiling while I find you some ice.

CYNTHIA X INIGO B

Inigo: Ugh, my ears are still ringing... I'll grant that the kick to the shins was warranted, but she didn't have to yell!

Cynthia: Wheeew! This is the heaviest batch yet! ...Oh, hey, Inigo. How goes it? Any luck with the laaadies?

Inigo: Does this look like the leg of a lucky man, Cynthia?

Cynthia: Ouch. That's quite the bruise there. ...Well, we all have our off days. Or our off...every day.

Inigo: I don't need you to twist the knife! Just let me lick my wounds in private.

Cynthia: Aw, I'm sorry, Inigo! I didn't mean it like that, I promise.

Inigo: Enough. Let's talk about you for a change. What's all that you're carrying?

Cynthia: Um...cake, mostly. I think? These girls in town just started giving me gifts, but I haven't had time to look.

Inigo: Girls? Cake? Gifts? Girls? Town? ...GIRLS?!

Cynthia: It was so weird! I was just walking along when they started running up to me! Kept wishing me luck and saying I was their idol or something. I dunno.

Inigo: Oh, right, sure. You dunno. Cakes and girls just fell out of the clear blue sky. ...DO YOU HAVE ANY IDEA HOW JEALOUS I AM RIGHT NOW?!

Cynthia: Hee hee! Well, it does feel pretty good. I won't lie.

Inigo: I guess I can see why girls like you. What with that dashing heroine thing you've got going on.

Cynthia: I guess? I'm not really sure.

Inigo: All those girls...fawning over you... I'd give anything to have that happen to me.

Cynthia: Aw, don't get all weepy on me again. You gotta knuckle down and man up! Here, eat some cake. You'll feel better.

Inigo: ...Mmmrph! Thanks, Cynthia. I still feel pathetic, but I appreciate the sentiment.

Cynthia: Yay! Now get some sugar in you and climb back up on that love horse!

CYNTHIA X INIGO A

Cynthia: Phew, I think this haul sets a new record! If I eat all this by myself, I'll explode...

Cynthia: Hello, Inigo.

Cynthia: Ah, Inigo! Off to woo the ladies again?

Inigo: On my way back, actually. ...Don't ask how it went. That's quite the gift basket you've got. Accosted by another pack of feral fans?

Cynthia: What can I say? They love me. You want some more cake?

Inigo: I'm not really in the mood, thanks. ...Now, tell me. What's your secret? How are you so irresistible to girls? I like to think I'm rather charming, and my looks are nothing to sneeze at...

Cynthia: Maybe they smell the desperation. Why does it matter so much to you?

Inigo: What do you mean?

Cynthia: I mean, why do you feel a need to flirt so much? Would it kill you not to have a throng of screaming girls pining for you?

Inigo: I don't— Hmm... It's not a...logical thing that draws me to the ladies. It's more instinct.

Cynthia: Instinct, huh? Well, I can't speak for other girls, Inigo, but I find you pretty entertaining. You've been a good friend since we were young, and I like you a lot. Plus I know you've got a good heart, despite all the...leering. So that's gotta count for something!

Inigo: I appreciate that, but I—

Cynthia: I'm not the only one, you know. Lots of folks here like you! So maybe don't let a chicken walk on your lip every time a girl turns you down, eh?

Inigo: Don't let a chicken...? No, you're right. Thank you. No more moping, I promise.

Cynthia: Good! Now let's have that smile!

Inigo: You always knew how to drag it out of me. And now I've got to put it to use! There's got to be a lonely beauty around here somewhere!

Cynthia: Go get her, tiger!

CYNTHIA X INIGO S

Inigo: Hey, Cynthia. You, uh... You got a minute?

Cynthia: You're all quiet. What's wrong? Are you sick or something?

Inigo: Sorry, I just... I wanted to ask... You remember a little while ago, when you said you liked me? You mean that you like me because we've been friends since we were kids, right?

Cynthia: Um, kind of, yeah. But I mean... Wait, what's this about?

Inigo: I keep thinking about it. ...What you said, I mean. I think that... Um... I think I'm in love with you, Cynthia. And not just flirty one-time love. This is...real.

Cynthia: ...What?!

Inigo: I know it's probably impossible to take me seriously, given my record. But I had to tell you anyway, because... I want to spend the rest of my life with you. I want us to get old and gray together.

Cynthia:

Inigo: Heh... It's all right. I figured as much. Who could fall for the guy who's always whining about striking out with other girls?

Cynthia: Um... I could...

Inigo: Yes, I understand. No hard— Wait, what?

Cynthia: I've liked you since forever, Inigo. Ever since we were kids. And it always tears me up to see you sad. That's why I always cheer you on when...you know. Girls?

Inigo: R-really?

Cynthia: I mean, yeah, it made me super mad to watch you hit on every girl but me... But me being mad is still better than you being sad. At least, I think so.

Inigo: Cynthia, I'm so sorry... I was such a fool! I had no idea I was doing that to you this whole time. Oh, how could I not have seen it?!

Cynthia: Hee hee! Then here's to the start of a new future together!

Inigo: A future where the two of us are happy forever!

Cynthia: A future where you don't talk to any girl but me!

Inigo: No, of course... ...Not?

Cynthia: Was there a question mark at the end of that sentence, Inigo?

Inigo: Um...no?

Cynthia: There! You just did it again! And why are you backing away from me?!

Inigo: I, uh... Natural...self-preservation...reflex?

Cynthia: Inigo! You get back here THIS INSTANT!

Inigo: Sorry, my love! You'll always be my number one! But there are so many other lovely numbers out there!

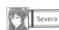

Severa

SEVERA X INIGO C

Inigo: Hel-lo, Severa! Looking good, lass!

Severa:

Inigo: Oh ho! There's nothing hotter than a cold shoulder!

Severa: You're an idiot. You think anything with a skirt looks good. Your compliments have lost all meaning.

Inigo: Ah! Her melodious voice rings out at last! Now if I can just get a smile, I can die happy!

Severa: You can die quickly if you don't shut up! Now stop wasting your breath. I'm not the sort of floozy to swoon over a cowpile of trite flattery.

Inigo: Aw, come on! Saying someone looks good is just like saying hi!

Severa: Do you say Chrom "looks good" when you see him? Or Frederick? No! You don't! It's just girls! Gods, this is... Look, I don't have time to deal with your weird sexist world. Later.

Inigo: S-Severa! Darling! Wait!

Inigo: Aaaaand she's gone. Geez. You'd think a lady could take a compliment.

SEVERA X INIGO B

Inigo: Hel-lo, Severa! You're looking darling as ever!

Severa: Are you deaf or just an idiot? ...Wait, don't tell me. I know.

Inigo: I'm simply incapable of speaking anything but the truth!

Severa: What must it be like to live in your head? Are there happy ponies in there? It's really something how utterly delusional your optimism is. If I didn't hate you so much, I might even be impressed.

Inigo: Huzzah! I got a heavily qualified and slightly sarcastic compliment from Severa!

Severa: You are a truly staggering creature... Why on earth do you insist on coming around and saying that I... That I "look good"?

Inigo: Um, because you look good?

Severa: ARE YOU MAKING FUN OF ME?! This camp is full of good-looking girls who will giggle and tee-hee all night long. I clearly despise you. So why chase me around?

Inigo: You're selling yourself short, Severa. I think the ice-queen bit is charming! The higher the hurdle has to leap, the more satisfying it feels once you're over it!

Severa: I am NOT a hurdle, jerk!

Inigo: W-wait! Th-that's not what I meant! Look, I'm serious. Honestly, I am. I wouldn't mess with your emotions.

Severa: Your idea of serious is pretty far out there, Inigo.

Inigo: ...Whatever could you mean?

Severa: Ugh! Enough! None of this matters. I have things to do. N-now just...leave me alone!

Inigo: I knew it!

Severa: Wh-what?!

Inigo: You put on a good show, but I know under all those thorns you're a total sweetie. And I'm going to stick around until I get to see the real you! ...Er, this is the part where you smile. It's a terrible waste to see such a pretty face scowling all the time.

Severa: You're obviously as blind as you are crazy. Now will you PLEASE just go away?!

Inigo: ...Huh? I can't go away if you go away first! Heeey! Severa! Wait up!

SEVERA X INIGO A

Inigo: Sorry to keep you waiting, Severa. An errand came up that has me running a bit behind schedule today.

Severa: I...I wasn't waiting for you, Inigo.

Inigo: Ah ha ha! Suuure you weren't!

Severa: Gya! You are simply DELUSIONAL! ...Also, you are running late today. You always bother me at the same time every day. I can set a clock to it.

Inigo: That's because I was getting...THIS! It's a present! To team up with you? ...Come on, open it! Come on, come ooon!

Severa: You got me a...present?

Inigo: I sure did! You never seemed to believe me when I said you looked good. So I thought this ring might help you feel more...I dunno. Pretty?

Severa: You...really want me to have this?

Inigo: Well, yeah! I picked it out for you! Go on, try it on.

Severa: This is stupid. I don't see why... A-all right. But just to see how... There. It's on.

Inigo: Say, it really brings out your eyes! I think you look adorable! Of course, I DO have a talent for this sort of thing.

Severa: F-flattery will get you nowhere, Inigo! Now take this back!

Inigo: But...it looks good on you.

Severa: ...It's bulky and garish and would just get in the way. Kind of like the person who gave it to me!

Inigo: Oh. I...I see...

Severa: Still, I suppose it means your words are more than idle flattery. Thank you. Now good-bye!

Inigo: ...There she goes again. But at least I got a smile this time! ...Oh, Inigo, you sly dog, you!

SEVERA X INIGO S

Severa: Say, Inigo... You have a second?

Inigo: Of course, Severa. Is everything all right? It's a little odd having you be the one to approach me.

Severa: Sh-shut up!

Inigo: Sorry! I didn't mean anything by it. Sooooo... What do you need?

Severa: I was thinking about something you said before. About how under the thorns I was sweet, and that you were waiting around to see it.

Inigo: That's the plan.

Severa: See, at the time, I assumed it was... Well, I thought it was more idle flattery. Like everything else you say. But that's not what I... I mean, I see now that... Look, I'll accept your ring. But not as a present.

Inigo: What?

Severa: I mean, assuming you haven't already given it to some other floozy. ...WELL?! Do you have it or not?!

Inigo: O-of course! It's right here! I've been carrying it next to my heart in case you...changed your mind.

Severa: R-really?

Inigo: I'm still not sure I follow everything you were saying, but you want it now...right?

Severa: Right. But not as a present!

Inigo: Severa, I'm not taking your money.

Severa: No, you idiot! I mean it's not JUST a present. It's a...promise. ...about us.

Inigo: Oh, NOW I get it! Sure, okay!

Severa: OKAY?!

Inigo: No! Not like that! I mean... Look, I was just nervous! I thought you were going to shut me down. But now I know that you actually... Here. Quick. Take the ring! Now you and I will be together forever!

Severa: ...What's going on here? You accept? Just like that? No blustering about how you aren't ready to commit? No fool talk about how it's not me, it's you? ...None of that? You're just going to...marry me? Like that? Poof? How can you be so CASUAL about it?!

Inigo: I told you my goal was to see the real you, and here she is! Why would I turn her away after waiting all this time?

Severa: ...Gods, I'm an idiot. I had a whole speech worked out and everything.

Inigo: Sorry to deviate from the script! ...But I'm very happy with the conclusion. Come, Severa! Our love will have a true storybook ending!

Severa: ...I can't believe I'm actually falling for these cornball lines. What's wrong with me?!

Inigo: Um, are we back to the ice queen already? Ah, well. Good thing I love her as much as the sweetie patootie!

Severa: Okay, now you need to stop talking. And I hope you love the ice queen, because you're stuck with her now! The rest of your life is a VERY long time, you know!

Inigo: I understand, Your Highness!

Gerome

GEROME X INIGO C

Inigo: Hey, Gerome. How's it going?

Gerome:

Inigo: What's with the silent treatment? Nothing? Not even a monosyllabic reply? Grunt once if you can hear me.

Gerome:

Inigo: Look, you're already hard enough to read thanks to that silly mask. The least you could do is respond when someone says hello.

Gerome: No, it isn't.

Inigo: What isn't?

Gerome: It isn't the least I can do. The least I can do is nothing. And I've no intention of whiling away my valuable hours with a vapid male floozy.

Inigo: Yowch. What did I ever do to you? Aside from that time I stepped on your wyvern's tail, which was SO an accident. Oh, wait. There's also the time I left all that butter in your tent. Did you get the butter scorpions cleared out yet? Those guys can be nasty. Wait, I know what this is about! You're mad because I voted you Most Likely to Go Bald at dinner last week.

Gerome:

Inigo: Not that either, eh? Hmm... Well, I'm fresh out of ideas.

Gerome: I'm surprised to see you think at all. ...Now good-bye.

Inigo: Hey, hey, whoa! Wait! Don't you think that's a little harsh? I haven't—

Inigo: Okay, then. See ya around, Gerome! Someday... Boy, that guy has NO sense of camaraderie. We're fighting a war here! You think he'd at least try to get along...

GEROME X INIGO B

Inigo: Heeey, Gerome! Roamin' Gerome! The paaale rider!

Gerome:

Inigo: I've got something to say to you, buddy!

Gerome: I don't care.

Inigo: Well, you may as well start walking, because I'm going to say it anyway: What's with the whole aloof bit, huh? Think you're too good for us?

Gerome: I have no interest in fraternizing. ...Least of all with you.

Inigo: Look, nobody's asking you to be a social butterfly like Lissa. But we're your allies, you know? You could at least try to be a little bit friendly! ...Even with me.

Gerome: "Allies"? ...Do you expect me to rely on you in combat? To team up with you? Your only expertise is in flirting, and you still manage to fail spectacularly. I'll take my chances alone.

Inigo: Argh! That does it, mister. You're coming with me!

Gerome: I am most certainly— N-now see here! Unhand me!

Inigo: Hope you didn't have any plans, 'cause if you did, they just got canceled!

Gerome: Where are you taking me?!

Inigo: Gerome, my friend? You and I are going to find some ladies!

Gerome: WE ARE DOING NO SUCH THING!

Inigo: Oh, yes we are! We're going to find some lovelies and be each other's wingman. Now stop moaning and start walking!

Gerome: Fate stalks my every step, fool! I've no time for such lunacy!

Inigo: Look, if you're afraid that I'll get all the girls, you can just say so. I mean, it's okay. Every party has a lonely guy stewing on the sidelines.

Gerome: I fear nothing but the cold hand of death!

Inigo: Great! Then let's get going! Okay, so the first thing you need is an opening line. Maybe something like... "Do you like tea? Because we like 'U'!" ...See, it's an alphabet joke. Girls love puns. It's a known fact.

Gerome: Idiot! There is no "we" here, and I want no part of this!

Inigo: Oh, wait! Or you could say... "Hey, baby. Ever ridden a wyvern before?" ...Oh, that's good. I may have to start riding wyverns so I can use that line.

Gerome: Let go of me this instant!

Inigo: Come on, gramps! Pick up the pace! Those ladies won't hit on themselves!

Gerome: S-stop! Put me down! Put me dooooown!

GEROME X INIGO A

Inigo:

Gerome:

Inigo: "Ooh, Gerome! You're so mysterious!" "Your mask is sooo dreamy, Gerome!" You were supposed to be my wingman! Not my competition!

Gerome:

Inigo: ...Say, Gerome?

Gerome: ...What is it?

Inigo: Your mask is falling off there, buddy.

Gerome: The strap is broken. A woman damaged it while she was...reaching for me.

Inigo: And I suppose the same woman tore those holes in your clothes?

Gerome: She did not want me to leave. She was... stronger than she looked. I've never been so manhandled.

Inigo: I WANT TO BE MANHANDLED! This makes FOUR TIMES I've taken you out and had the ladies completely ignore me. How does this keep happening? Huh?!

Gerome: I wish I knew. I find your flirtatious lifestyle to be utterly exhausting.

Inigo: Oh, boo hoo! Poor you! Quit gloating.

Gerome: I'm not gloating.

Inigo: So says the guy who had a band of women sing love songs outside his tent last night. I bet you feel preeetty special.

Gerome: Actually, I feel exhausted. They sang until dawn.

Inigo: Why do girls always go for the jerks? Huh? Never a nice guy like me! Well, fine. You get your wish. I'm never going out with you again!

Gerome: Thank the gods.

Inigo: *Sniff*

Gerome: Um...Inigo?

Inigo: *Whimper* *sniff*

Gerome: Are you...crying?

Inigo: Shut up! You don't know what it's like! I try SO HARD, and then you come along with a mask and some muscles and...and... Waaaaaaaaaaah!

Gerome: Um... Come now. Stop, stop. That... Stop crying this instant! This is making me very uncomfortable! Oh, for the love of... Fine. I'm sorry. There, all right? You're not a failure because you, uh... You taught me how to... Teamwork, yes? That was the point of all this? Well, you taught me teamwork.

Inigo: *Sniff* ...I d-did?

Gerome: You did. And now I owe you one. ...Or perhaps half of one.

Inigo: You...you mean it? I mean...well...I guess as long as you learned something, it was worth it. Just don't go getting cocky on me, now! I'll get twice as many ladies as you next time!

Gerome: Next...time?

Inigo: Oh, yeah! So keep that schedule open!

Gerome: Ha ha! ...Ha? ...Yeargh. And I thought keeping a wyvern content was difficult...

Inigo: Mmm? You say something?

Gerome: No. (Ah, well. At least he's feeling better now...)

The Morgan (male) father/son dialogue can be found on page 309.

Morgan (male) (Father/son)

Morgan (female)

■ MORGAN (FEMALE) X INIGO C

Inigo: Hey, Morgan. You busy?

Morgan (female): Oh, hi, Inigo! Not really. What's going on?

Inigo: I thought we might grab a cup of tea.

Morgan (female): Tea? Hmm.

Inigo: It doesn't have to be for long! I thought maybe talking might stimulate your brain. Maybe jog your memory a bit?

Morgan (female): I suppose that's possible, now that you mention it. In that case, we should ask everyone to come! More people means more topics!

Inigo: Er...right. But it seems like they're all...um...busy. So maybe just the two of us should go.

Morgan (female): I don't remember anyone saying they were particularly busy...

Inigo: Oh! Well, um...crap.

Morgan (female): Wait, were you flirting just now? Was I just hit on?!

Inigo: Wh-what? No! Of course not! I have nothing but the most platonic respects for you, Morgan! I'll, uh... Right then! Perhaps another time.

Morgan (female): Giving up already? That's a little surprising.

Inigo: Knowing when to make your exit is part of being a dashing gentleman.

Morgan (female): Well, I think being a gracious loser is an admirable trait!

Inigo: Oh, this isn't a loss. It's just a time-out in a much larger game!

Morgan (female): Your philandering is quite deplorable, but high marks on your attitude!

Inigo: Yes, I think high marks are— Wait, what was that first part?

■ MORGAN (FEMALE) X INIGO B

Morgan (female): Oh, there you are, Inigo.

Inigo: Hmm? Oh. Hi, Morgan.

Morgan (female): What's wrong? You look like you're wilting. Ooh, let me guess! You hit on a pretty girl, and she shot you down?

Inigo: Ha! Everyone thinks they know Inigo. Well, they don't know squat! ...But, yes. That's what happened. Honestly, all I want is one lousy cup of tea! Is that really so much to ask?

Morgan (female): That doesn't sound like the Inigo I know. What happened to "this game isn't over!" or whatever it was you said?

Inigo: The beginning turned into a middle, which became an end. Now it's a loss.

Morgan (female): Ouch. This really has you down, huh? ...Oh, all right. You can win this one.

Inigo: Huh? How do you mean?

Morgan (female): I'll go out with you.

Inigo: ...I suppose this is the part where mummers burst out of the bushes and laugh at me?

Morgan (female): No joke, Inigo! I'll give you a date, but on one condition... I don't remember anything about food, and I'd like to learn about new cuisines. So let's skip tea and jump straight to the main course! Buy me dinner.

Inigo: You're on! Where do you want to go? Within reason, of course! Ha ha!

Morgan (female): Hmm... Why not tell me how much you have, and I'll pick the best spot you can afford!

Inigo: Er... That sounds expensive...

Morgan (female): Ooh, I'm so excited!

Inigo: Oh dear...

■ MORGAN (FEMALE) X INIGO A

Inigo:

Morgan (female): Hi, Inigo! How goes the philandering? Did our dinner date help turn your luck around?

Inigo: Oh, yes. It turned me around a full 360 degrees!

Morgan (female): Oh, that's great! ...Wait, no it isn't. That's not great at all!

Inigo: Ha! That isn't the half of it. I only WISH I'd come full circle to when we went out.

Morgan (female): What happened?

Inigo: A girl agreed to join me for tea, and I was on cloud nine!

Morgan (female): Buuuuut?

Inigo: But she spiked my drink and robbed me blind while I was out cold! She even took the shirt off my back! ...Left the pants, though.

Morgan (female): Oooh. That's not good at all.

Inigo: The joke's on her. My purse was nearly empty after taking you out. But now I've gone from poor to flat broke. I guess it's dirt soup for Inigo tonight...

Morgan (female): Wow. I don't know what to say.

Inigo: I've always done my best for the ladies of the world. I'm even fighting a war for them! But now...

Morgan (female): Wait. You're fighting a war to impress girls?

Inigo: *Ahem* ...But now that my love has been so cruelly abused, I don't know if I can ever—

Morgan (female): You're fighting a war to impress GIRLS?!

Inigo: Can we get past that already?

Morgan (female): No, actually... I don't think I can! ...Still, I'm sure that woman didn't become a thief because she wanted to. So perhaps THAT should be your reason for fighting this terrible world. We need to bring hope back to the world and make it a place for honest folk again!

Inigo: I suppose you're right.

Morgan (female): Come on, Inigo. I'll buy dinner. I owe you a meal anyway.

Inigo: ...Truly?

Morgan (female): I know, I know. Quite an honor for you to be taken out by a lady. And a first for you, I'd imagine.

Inigo: I'll pretend I didn't hear the last part. ...But thanks, Morgan. That's sweet. All right then! I hereby forgive all the cruel ladies of this world! The war for your hearts rages on, and Inigo shall return to the fray!

Morgan (female): Now THAT'S the Inigo we ladies know and occasionally manage to tolerate!

■ MORGAN (FEMALE) X INIGO S

Morgan (female): Ah, here you are.

Inigo: Sorry, were you looking for me?

Morgan (female): It's your lucky day! I've come to help you flirt with the ladies!

Inigo: Wait, what? What does that even mean?

Morgan (female): Remember when that lady tricked you, then drugged you, then robbed you?

Inigo: Er, yes, thank you.

Morgan (female): Well, from now on, I'm going to hide in the bushes whenever you're on a date. And if anyone tries any funny business, I'll jump out and give 'em what for! Now, come on! I'm ready for action!

Inigo: That's sweet and...a little creepy, actually. But I don't need a chaperone.

Morgan (female): Aw, why not?

Inigo: Because I'm done flirting with other ladies. ...It's more fun flirting with you.

Morgan (female): Aw, and here I was all excited to watch you get shot down up close...

Inigo: ...Wait, that's your reason?! HEY, WAIT! Why did you just assume I'd get shot down?!

Morgan (female): Come on, it's not too late to change your mind! Let's go philander! C'moooon!

Inigo: No! You're going to sit here and talk with me, and you're going to enjoy it!

Morgan (female): BOOOOORING.

Inigo: Are you even listening to me? Do you understand what I'm saying?

Morgan (female): ...All I understand is that you're a big fun-burglar.

Inigo: Damn it, Morgan! I'm in love with you!

Morgan (female): ...For seriously?

Inigo: Yes, for seriously!

Morgan (female): Wait! I...I don't... Y-you can't just spring this on me out of the blue! It's not fair! Buuuuut... I suppose I... I mean... Weeeeeeell... ...Aw, sure! Why the heck not?!

Inigo: You came around quick.

Morgan (female): Who knows? Maybe being with you will be more fun than seeing you fall on your face.

Inigo: Well then, we have the rest of our lives to test that theory.

Morgan (female): And I say we start with the finest dinner in town! I'll have the golden lobster, please!

Morgan (female) (Brother/sister)

■ MORGAN (FEMALE) X INIGO (BROTHER/SISTER) C

Morgan (female): Let's see here... Birthday? May 5th... Favorite colors? Blue and purple... Favorite food? Probably bear meat...

Inigo: What are you mumbling about over there, Morgan?

Morgan (female): Least favorite food? Veggies, apparently. Don't seem to mind them now, though...

Inigo: Morgan!

Morgan (female): Oh! Inigo?! Guess I was pretty out of it to miss my own brother paying a visit! Did you need something?

Inigo: Just wondering what you were chanting over there... You practicing some new magic incantations or something?

Morgan (female): Nope! Just going back over my notes on what you told me about myself. I was hoping they'd hold some clue that might help spark my memory. Heh. It's kind of crazy how much you know about me, huh? Like, I really once got five nosebleeds in the same day? I have no memory of that at all. AT ALL! Ha ha ha! I can just imagine...

Inigo: Well, you're still as cheerful, that's for sure. And as talkative as ever...

Morgan (female): I am? I mean, I was?! Hmm, now that you mention it, that does sound...right, somehow. ...Heh. Everything still feels funny. Even you being my brother hasn't really clicked.

Inigo: If you think it's strange for you, imagine how I feel... My kid sister starts talking to me as a stranger, asking questions about herself... I had no idea how to even interact with you. It was pretty rough, but I got used to it.

Morgan (female): Heh, yeah... Sorry about that. But that's just another reason why I'm working hard to get my memories back. Once I do, nobody will have to feel weird or awkward around me again. Pretty noble, huh? I'm such a sweet, selfless girl!

Inigo: Heh, and so humble as well... In any case, I'm happy to help you get those memories back however I can. Someday soon I bet we'll be able to laugh about all the old times... included!

Morgan (female): Heh, right!

■ MORGAN (FEMALE) X INIGO (BROTHER/SISTER) B

Inigo: Whew! Another long day of combat... I'm bushed. Think I'll hit the hay ear...ly? Is someone passed out over there? Wait, is that Morgan?!

Morgan (female): Nn...nngh...

Inigo: Morgan! Morgan, are you all right?! What happened?!

Morgan (female): ...Wha—?! Inigo! Wh-what am I doing here? Was I asleep? It doesn't even remember feeling tired... Oh, right! I was bashing that huge tome against my head when I blacked out. That explains why my face hurts so bad...

Inigo: Bashing your... Morgan, why in the WORLD would you do that?! Wait, were you trying to get your memories back?

Morgan (female): Well, yeah! Obviously. For fun, I hope you'd put a stop to it...

Inigo: If you stop you even if it's NOT just for fun, you nitwit! Look, I know you want your memories back, but please... Don't do anything reckless.

Morgan (female): ...But I want to be able to talk with you about old times again.

Inigo: I know, Morgan, and I want that, too. But more than that, I want you safe. I may just be another stranger to you, but to me, you're family. In the future, with Mother and Father gone, it was just the two of us. You're all I had, Morgan... I don't know what I'd do if anything happened to you.

Morgan (female): All right. I'm sorry, Inigo.

Inigo: Just as long as you understand.

Morgan (female): ...Heh, that felt really siblingy just now. Don't you think? Me messing up and you scolding me felt... I don't know, it felt really plausible! Maybe if you keep it up, I'll remember something!

Inigo: You...really think so?

Morgan (female): Yeah! Oh yeah, this will totally work! So go on, keep yelling! C'mon, scream at your amnesiac sister, Inigo!

Inigo: I... I'm not really comfortable with—

Morgan (female): Hey, why don't you use the tome, too? Come on, don't hold back. Really wallop me with that thing! Maybe the simultaneous physical and mental shock will jar some memories loose! It's gotta be twice as effective as either one by itself, right? That's just basic science.

Inigo: Good night, Morgan...

■ MORGAN (FEMALE) X INIGO (BROTHER/SISTER) A

Inigo: Hey, Morgan. I'm headed into town. Want to come along?

Morgan (female): I'd love to! Is there something in particular you need?

Inigo: I might pick up a couple of things, yeah. But mostly I think there's something YOU need.

Morgan (female): It doesn't have to do with getting my memories back, does it?

Inigo: The opposite, really. There's maybe no need to worry about your memories.

Morgan (female): That...makes no sense.

Inigo: I'll be honest—it often hurts to know you've forgotten me. But...maybe it's better to build new memories than to worry about old ones.

Morgan (female): What do you mean?

Inigo: I've been thinking about this a lot. Why you might have lost your memories, I mean. And I'm wondering if you didn't have some awful memory you couldn't bear to keep. ...I know I've got a few. I see a lot of faces, you know? People we couldn't save...

Morgan (female): I'm sorry you have to bear those dreadful memories, Inigo...

Inigo: Look, this is just a theory, and even if it's true, it's not like you did it consciously. But I do think that getting your memories back might not necessarily be a good thing.

Morgan (female): Hmm... I understand, and believe me, I appreciate the thought... But I want to remember things, no matter how painful they are. Because I'm sure there'll be plenty of great memories mixed with the bad ones. And the truth, whatever it is... I really want to have that back, you know?

Inigo: Well, if you're sure, then I'm happy to help.

Morgan (female): That's really kind of you, Inigo, but do you truly realize what you're saying? I mean, it could be years before I remember anything. Or decades. Heck, there's a chance I may never get my memories back at all. I don't want to drag you into something that could last forever.

Inigo: I'm already stuck with you forever, you goof. I'm your brother! You're family—memories or no. You couldn't keep me away.

Morgan (female): Inigo, I... *sniff* Thank you! I'll do everything I can!

Inigo: Then start by coming with me into town.

Morgan (female): Huh? But you said that doesn't have to do with getting my memories back.

Inigo: Hey, there's no rule that says you can't have a little fun while you try. And there's certainly no rule against making some happy new memories, either. You're young! Live a little! There'll be plenty of time to worry later.

Morgan (female): Right... You're right! Thanks, Brother!

Noire

■ NOIRE X INIGO C

Inigo: Aaah! S-somebody help! Heeelp! N-Noire's gonna kill me!

Noire: Dum de dum de do...

Inigo: *Huff, huff...* N-Noire! Come on, put the bow down! It's all fun and games until someone loses an... AAAIEEEE!

Noire: Don't worry. Of all the weapons I use, I'm best with a bow. So it's very unlikely I'll hit you.

Inigo: Oh, is that so? Well, you know what? THAT DOESN'T HELP! And I was actually making headway with that girl until you started firing at her! ...Yes, well, you've had your fun. Now go away and let me get back to mine.

Noire: Oh, but I am my mother's daughter, you know...

Inigo: And what does Tharja have to do with any of this?

Noire: When it comes to chasing our prey, we never tire. It's in our blood. You might say I'm a bit...obsessive about stuff like this. So you aren't going to lose me. No, sir. Noooooo, sir.

Inigo: ...Someone help me! Please! Anyone!

Noire: Actually, that raises a different question. Why are you running in the first place? I promised not to hit you, remember? I...I promised. *sniff*

Inigo: Wait. Why are YOU going to cry? I'm the one being hunted!

Noire: *Sniff* D-don't you trust me?

Inigo: My faith in your bow skills is REALLY not the issue here...

Noire: Then what's the problem? I'm just doing what I was asked. Just keeping the hyenas at bay.

Inigo: Hyenas? Hey, wait a second! Who asked you to do that?!

Noire: SILENCE, FOOL! I SHALL BROOK NO FURTHER QUESTIONS! Now stand veeery still.

Inigo: Wait! Stop! Just think of all the ladies who will be deprived of—Aaaaugh! Help meeeee!

■ NOIRE X INIGO B

Inigo: Hmm... Back to the market today, perhaps? I saw a couple of ladies ripe for—

Noire: What are you up to, Inigo?

Inigo: EEEEEEK!

Noire: Heading out to pick something up at the market? Or some...ONE?

Inigo: Who, me? Ha ha! N-no, I would never go chasing girls! ...Yet. ...Today, I mean.

Noire: Well, if you're heading out, I'd better get ready as well. Hum de dum de dooo...

Inigo: Um, Noire? Why are you nocking an arrow?

Noire: Oh, don't worry about me! Just pretend I'm not here.

Inigo: That's kind of difficult when you're pointing an arrow at me.

Noire: I won't hit you, silly! I'm just keeping the hyenas at bay. Those are my...orders.

Inigo: From WHO, for crying out loud?!

Noire: Um... I... Oh, I'm sorry, Inigo. But I promised not to tell you. ...Though I must say, they chose the right woman for the job. For I am my mother's daughter! Eeeee hee hee hee!

Inigo: I really wish you'd stop saying that. And what's all this about hyenas?

Noire: I told you not to worry about it.

Inigo: Yes, and that is a piece of advice that I'm planning to ignore. Seriously, would you please just explain what's going on here?!

Noire:

Inigo: I haven't seen so much as a stray dog around here, let alone a hyena.

Noire: STILL YOUR CHATTERING TONGUE, LEST I REMOVE IT!

Inigo: Eeeeeeeek!

Noire: Inigo! Inigo, wait! Don't run! It's really hard to miss you when you're running around like that!

Inigo: Heeeeeelp meeeeeeee!

Noire: INSOLENT FOOL! RETURN TO ME AT ONCE!

■ NOIRE X INIGO A

Noire: Inigooo! Where are yooooooou?! You can run, but you can't hide... Hmm... Probably off chasing skirts again. I just hope there's no repeat of last time.

Inigo: What happened last time?

Noire: EEEEEEK!

Inigo: Ha! Doesn't feel good to be snuck up on, now does it? I figured turnabout was fair play, so I staged this little ambush.

Noire: Th-that's terrible! You're terrible! *sniff* *sniffle*

Inigo: Oh, come on! Stop that... It was the girls, wasn't it? Your "hyenas"? Every poor, defenseless girl I talk to runs off screaming in a hail of arrows!

Noire: I had to make sure you weren't tricked again. Those were... Those were Chrom's orders.

Inigo: Wait, CHROM told you to do this?!

Noire: Well, kind of. I mean, he let me work out the details, but... Look, none of this would have happened if you hadn't been tricked last time!

Inigo: Last... I was tricked? I don't...

Noire: Remember the lady thief you invited to tea? The one who stole half our gear? When Chrom heard about that, he asked me to start keeping an eye on you.

Inigo: I...see.

Noire: You're too trusting, Inigo. Chrom is worried it may shorten your life span.

Inigo: You make me sound totally hopeless. I'm not some easy mark just asking to get taken in. It was just one lady thief! Oh, well...and that girl cutpurse. The one with the glass eye. Ah, and then there was that band of female arsonists... But that still isn't a reason to open fire on me.

Noire: ...I was just worried about you. We all worry about you.

Inigo: Heh... I forgot all about that stuff, actually. Guess I thought everyone else did, too.

Noire: IMPUDENT FOOL!

Inigo: Gaaaaah!

Noire: You offer apologies, but do you truly grasp the gravity of your crimes?! You've been a burden on the commander and a waste of my precious time! I ask again—does your repentance match the scale of your misdeeds?! SPEAK NOW! SPEAK, LEST I PERMIT MY ARROW TO SPEAK FOR YOU!

Inigo: Good gods, y-yes! Yes, ma'am! I'm sorry! Honestly, I had no idea people paid that much attention to me...

Noire: BLOOD AND THUNDER!

Inigo: Ack! S-sorry, sorry, sorry! I promise I'll be more careful!

Noire: ...Wonderful. Then I'll be going, now. We worry because we care, Inigo—so just take care of yourself, okay?

Inigo: Phew... I thought I was a dead man. I'm just glad she put the bow down before she lost it there...

■ NOIRE X INIGO S

Inigo: There you are. I was looking for you.

Noire: Did you need something?

Inigo: A cup of tea. With you. Interested?

Noire: Wh-why? What's going on?

Inigo: It's not very ladylike to fib, you know.

Noire: I don't know what you're talking about.

Inigo: Your little bit about being "ordered" to keep the hyenas at bay.

Noire: I didn't lie! Those were my orders!

Inigo: But you weren't quite telling the truth, either, hmm? Something tells me you wanted to be one of those hyenas.

Noire: ...How did you know?

Inigo: Ha! Let's just say I have a gift for reading women.

Noire: I was the only one you never flirted with... ...You even flirted with a sign in front of the baker's shop one day! I left...left out, you know? And hurt. And...kind of... *mumble, mumble*

Inigo: Sorry, what was that last one?

Noire: I FELT ANGRY! Blood and thunder, mortal! My emotions are not to be trifled with! NOW FLIRT WITH ME!

Inigo: Um... I'm not sure I can really...do that right now...

Noire: A gift for reading women? Ha! What a joke. You've got a gift for MIS-reading women! That's why you always get turned down. *Sniff* I just... I just wanted a chance to turn you down too...

Inigo: Look, Noire? The reason I didn't flirt with you is because you're kind of...scary. I didn't want to set you off and wind up as an oversized pincushion for your arrows...

Noire: Oh. I...I see. I-it's not like I... *sniff* Like I get mad on purpose... I can't...h-h-help it! Waaaaaaaah!

Inigo: Cripes! D-don't cry! I mean, yes, I was a jerk, but you fired about a hundred arrows at me... What do you say we call it even and start over? Huh?

Noire: But I... *hic* I had to, or...the hyenas...

Inigo: I know, and I appreciate what you were trying to do. Listen. I was worried about making you angry. That's no lie. But I also thought you were...different. Kind of ethereal, if that makes sense. Like something mortal hands weren't meant to touch. Anyway, that's why I always hesitated. But I'm done hesitating. I'm going to ask what I've been wanting to ask you all along... Will you marry me?

Noire: Wh-what?! Isn't that a bit sudden?!

Inigo: I'm tired of beating around the bush with you. This is all I've ever wanted!

Noire: I don't... I'm... I'm flattered, but it's just so unexpected!

Inigo: Hah! You're adorable when you blush and fly into a panic.

Noire: If...if we do this, you have to stop flirting with other girls.

Inigo: Well, sure, that's, uh... Sure.

Noire: Saying "sure" twice makes it feel less sure.

Inigo: Well, it's hard to feel sure when you're pointing a bow at me!

Noire: ...I'd hoped you had learned your lesson by now.

Inigo: Wait. "Learned my lesson"? So that whole bit about hyenas WAS just a lie!

Noire: Oh, it was no lie. For I have a slavering scavenger in my sights right now...

Inigo: Wait, ME?!

Noire: Eee hee hee! Time to silence that philandering cackle for good!

Inigo: Aaaaah! Have mercy! I repent! I repeeent!

Nah

■ NAH X INIGO C

Nah: Hello, Inigo.

Inigo: Oh, hello, Nah!

Nah: Off pursuing females again?

Inigo: That's rather crass, don't you think? I'm simply a man who appreciates beauty! And frankly, I'd settle for a nice chat over a cup of tea.

Nah: I hear you normally settle for being punched in the face.

Inigo: Once! That happened ONE time! ...Er, in the recent past. Say, how do you know about that, anyway?

Nah: Word of the shameless spreads quickly. Everyone in town knows you're an indiscriminate flirt.

Inigo: I'll have you know, I'm very discriminating! ...I only approach ladies who seem likely to say yes.

Nah: What about the woman who dislocated your shoulder? Did she look promising?

Inigo: You're dredging up a lot of painful memories here, Nah...

Nah: Did it never occur to you that women might find what you're doing insulting? It's little wonder some get violent when they learn they're just one among hundreds.

Inigo: Every lady is one in a million to me! And they all seemed perfectly happy while we were on the date.

Nah: That isn't the point!

Inigo: I'm sorry, Nah, but I can debate the fine arts of love with you no longer. The day is young, and there are many ladies to meet. Ta-ta!

Nah: What? But I'm not done lecturing you yet! Inigo! Get back here this instant!

■ NAH X INIGO B

Inigo: *Sigh* ...She didn't have to yell like that. A simple no would have sufficed. Ah, well. Plenty of fish in the sea.

Nah: Still haven't learned your lesson, I see.

Inigo: No one has ever won a woman's heart through capitulation!

Nah: Or creepiness. How do you not surrender after being turned down this many times?

Inigo: It's who I am. Flirting is in my blood! I'm constitutionally incapable of NOT talking to beautiful women.

Nah: Ugh. I'm wasting my breath trying to convince you with words. I suppose I'll just have to eat you and be done with it.

Inigo: Ha ha! Ha! Oh, what a wit! What a razor-sharp... um...wit. You know, I really wish you wouldn't tell jokes with a straight face like that.

Nah: Honestly, I don't see why you need to ask women out at all. You're handsome enough. If you kept your mouth shut, they'd come to you.

Inigo: Who would even know to look for me if I didn't put myself out there?

Nah: Well, me, for one. I imagine I could find you tolerable if you stopped talking.

Inigo: Ah, the sweet naivete of youth! You're too young to be worrying about other people's affairs of the heart, Nah. I'm sure you'll find someone perfect once you're older. Now why don't you run along and see if Uncle Chrom will read you a bedtime story?

Nah: ...Get back here, you idiot! Manaketes just grow slowly! I'm the same age as you!

■ NAH X INIGO A

Nah: Might I have a word, Inigo?

Inigo: Hmm? Oh, of course, Nah. What is it?

Nah: I've been thinking about what you said before.

Inigo: What did I say?

Nah: That I was too young to be worrying about other people's affairs of the heart.

Inigo: Ah, yes. That. Look, I've apologized several times. And you DO look very young...

Nah: Exactly. Which is what got me thinking. If I were bigger, you wouldn't treat me like a child anymore, correct?

Inigo: Is this a trick? This seems like a trick. But, well... No, I suppose I wouldn't. But the point's moot, isn't it? It's not like you can grow overnight.

Nah: Oh, I don't even need a night, Inigo. I can do it right here.

Inigo: Damn, it WAS a trick! I knew it!

Nah: On your mark, get set... GROOOOOOW!

Inigo: W-wait, Nah! Nah! L-let's not be hasty... AAAIIIEEEEEE!!

Inigo: I... I just saw my life flash before my eyes... I saw the faces of a thousand girls, dressed in black. They...wept for me.

Nah: Oh, please. You're exaggerating.

Inigo: Am I?! You weren't five paces away when you transformed! I thought I was going to be trampled to death by a giant dragon!

Nah: NOW will you stop saying that I'm young?

Inigo: Y-yes, ma'am! Of course, ma'am!

Nah: Ha ha, good! You're lucky I'm in a good mood today. I'll let you off with a warning.

Inigo: ...Oh, gods. I was almost dragon chow!

◼ NAH X INIGO S

Nah: How are you today, Inigo?

Inigo: Gah! I'm fine, ma'am! My, but you're looking old and wrinkly today!

Nah: No female-chasing for you this afternoon?

Inigo: Nope! Nuh-uh! Not me!

Nah: Finally grew out of it, eh?

Inigo: I got the feeling that continuing to flirt might be... harmful to my life span.

Nah: Well, I suppose it's only natural the stress of all those rejections would take their toll.

Inigo: I'm worried less about stress than I am about some dragon eating... Er, you know what? Never mind.

Nah: Well, I'm proud of you regardless. Now we just need to pick a date for the wedding!

Inigo: ...Wedding? Whose wedding?

Nah: Ours, silly! You have quite the knack for getting into trouble when you aren't supervised. So I've decided to be your lifetime chaperone!

Inigo: You WHAT?!

Nah: Well, we already established that I'm old enough for you.

Inigo: Yes, but that hardly means that we should be MARRIED!

Nah: Hee hee! I understand. You're still shocked a catch like me agreed to look after you.

Inigo: I'm shocked about a LOT of things at the moment! Er, I don't have a veto about this, do I?

Nah: Now why on earth would you want to... ...Waaait a minute! You're not thinking of cheating on your new wife, are you?! Bad husband! That's a BAD husband! I suppose I'll have to eat you after all!

Inigo: You REALLY have to stop joking around with that whole eating thing! ...Er, joking around, yes? ...Joking? ...Ha ha ha? R-right, then! I'm done with ladies forever! Just call me Mister Faithful!

Nah: Good. And remember, if you break your promise to me... Chomp, chomp!

Inigo: *Gulp* R-right. Chomp...chomp. One question, though...

Nah: What's that?

Inigo: Does inviting a girl out to tea count as cheating?

Nah:

Inigo: I mean, it's just tea, right? Nothing wrong with a cup, right?

Nah: CHOMP, CHOMP!

Inigo: Aaaaaah! H-help! Heeeeeelp! My fiancée's gonna eat meeeeee!

Father

◼ FATHER X INIGO C

Inigo: Ugh, Father! That gorgeous girl was just about to say yes to a date! JUST about to! Did you really have to drag me off like that?!

[Robin]: We have a battle to prepare for, Inigo. Everyone else is ready to march. If you're mad, be mad at yourself for losing track of time.

Chrom: We have a battle to prepare for, Inigo. Everyone else is ready to march. If you're mad, be mad at yourself for losing track of time.

Frederick: We have a battle to prepare for, Inigo. Everyone else is ready to march. If you're mad, be mad at yourself for losing track of time.

Virion: Hunting the fairer sex is indeed a noble pursuit, as I know better than most... But we have a battle to prepare for, Inigo. Everyone else is ready to march. If you're mad, be mad at yourself for losing track of time.

Vaike: We've got a battle to prepare for, Inigo. Everyone else is ready to march. If you're mad, be mad at yourself for losing track of time.

Stahl: We have a battle to prepare for, Inigo. Everyone else is ready to march. If you're mad, be mad at yourself for losing track of time.

Kellam: We have a battle to prepare for, Inigo. Everyone else is ready to march. If you're mad, be mad at yourself for losing track of time.

Lon'qu: We have a battle to prepare for, Inigo. Everyone else is ready to march. If you're mad, be mad at yourself for losing track of time.

Ricken: We have a battle to prepare for, Inigo. Everyone else is ready to march. If you're mad, be mad at yourself for losing track of time.

Gaius: We have a battle to prepare for, Inigo. Everyone else is ready to march. If you're mad, be mad at yourself for losing track of time.

Gregor: We have battle to prepare for! Everyone else ready to march. If you are mad, be mad at self for losing track of time, yes?

Libra: We have a battle to prepare for, Inigo. Everyone else is ready to march. If you're mad, be mad at yourself for losing track of time.

Henry: It's time for a bloody battle, ha ha! Come on, let's get marching! If you're mad, be mad at yourself for losing track of time.

Donnel: We gots us a battle to prepare for, Inigo. Everyone else is fixed to march. If yer mad, be mad at yerself for losin' track of time.

Inigo: Oh, heh heh heh... Whoops... All right, time to go trounce some enemies and find a village lass to reward my efforts!

[Robin]:

Chrom:

Frederick:

Virion:

Vaike:

Stahl:

Kellam:

Lon'qu:

Ricken:

Gaius:

Gregor:

Libra:

Henry:

Donnel:

Inigo: You're staring, Father. Is there something on my face?

[Robin]: No. I just... I was wondering if you were like this in the future as well.

Chrom: No. I just... I was wondering if you were like this in the future as well.

Frederick: No. I was just wondering if you were like this in the future as well.

Virion: No. I just... I was wondering if you were like this in the future as well.

Vaike: No. I was just wonderin' if you were like this in the future, too.

Stahl: No. I just... I was wondering if you were like this in the future as well.

Kellam: No. I just... I was wondering if you were like this in the future as well.

Lon'qu: No. I just wondering if you were like this in the future as well.

Ricken: No. I just... I was wondering if you were like this in the future as well.

Gaius: No. I just... I was wondering if you were like this in the future as well.

Gregor: Gregor just wonder if Inigo is like this even in future.

Libra: No. I just... I was wondering if you were like this in the future as well.

Henry: Just wondering if you were like this in the future, too.

Donnel: Nah. I just got to wonderin' if you was like this in the future, too.

Inigo: Depends on what you mean by "like this," I suppose.

[Robin]: For someone who came from an apocalyptic hellscape, you're awfully carefree. Seems like you haven't a care in the world past whose bed you'll be sharing tonight. Lucina's so driven and serious... It's strange you don't have any of that purpose.

Chrom: For someone who came from an apocalyptic hellscape, you're awfully carefree. Seems like you haven't a care in the world past whose bed you'll be sharing tonight. Lucina's so driven and serious... It's strange you don't have any of that purpose.

Frederick: For someone who came from an apocalyptic hellscape, you're awfully carefree. It seems like you haven't a care in the world past whose bed you'll be sharing tonight. Lucina's so driven and serious... It's strange you don't have any of that purpose.

Virion: For someone who came from an apocalyptic hellscape, you're awfully carefree. Seems like you haven't a care in the world past whose bed you'll be sharing tonight. Lucina's so driven and serious... It's strange you don't have any of that purpose.

Vaike: For someone who came from an apocalyptic hellscape, you're awfully carefree. Seems like you haven't a care in the world past whose bed you'll be sharing tonight. Lucina's so driven and serious... It's strange you don't have any of that purpose.

Stahl: For someone who came from an apocalyptic hellscape, you're awfully carefree. Seems like you haven't a care in the world past whose bed you'll be sharing tonight. Lucina's so driven and serious... It's strange you don't have any of that purpose.

Kellam: For someone who came from an apocalyptic hellscape, you're awfully carefree. Seems like you haven't a care in the world past whose bed you'll be sharing tonight. Lucina's so driven and serious... It's strange you don't have any of that purpose.

Lon'qu: For someone who came from an apocalyptic hellscape, you're awfully carefree. Seems like you haven't a care in the world past whose bed you'll be sharing tonight. Lucina's so driven and serious... It's strange you don't have any of that purpose.

Ricken: For someone who came from an apocalyptic hellscape, you're awfully carefree. Seems like you haven't a care in the world past whose bed you'll be sharing tonight. Lucina's so driven and serious... It's strange you don't have any of that purpose.

Gaius: For someone who came from an apocalyptic hellscape, you're awfully carefree... Seems like you haven't a care in the world past whose bed you'll be sharing tonight. Lucina's so driven and serious... It's strange you don't have any of that purpose.

Gregor: For having come from apocalyptic hellscape devoid of hope, you are quite carefree. You worry only about whose bed you share tonight, yes? Lucina is real fighter! Worried for others! ...Is shame you not have that purpose.

Libra: For someone who came from an apocalyptic hellscape, you're awfully carefree. Seems like you haven't a care in the world past whose bed you'll be sharing tonight. Lucina's so driven and serious... It's strange you don't have any of that purpose.

Henry: For someone who came from an apocalyptic hellscape, you're awfully carefree! Seems like you'll be

sharing tonight. You don't seem to have much in the way of passion or drive. ...You know?

Donnel: For someone who hails from an apocalyptic hellscape, ya sure are carefree. Seems like you ain't got a care in the world past whose bed you'll be sharin'. Lucina's so driven and serious... It's strange you ain't got none of that purpose.

Inigo: No purpose?! I'll have you know I'm EXTREMELY driven!

[Robin]: Is that so?

Chrom: Oh, is that the case?

Frederick: Is that so?

Virion: Are you, now?

Vaike: Is that so? The Vaike is listening...

Stahl: Is that so?

Kellam: Is that really true?

Lon'qu: Really.

Ricken: Oh, is that the case?

Gaius: Oh, is that the case?

Gregor: Oh? Is true?

Libra: Oh, is that so?

Henry: You are, huh?

Donnel: Oh, ya are, are ya?

Inigo: Indeed! I will not rest until every woman in the realm swoons at just hearing my name!

[Robin]: ...Your purpose in life is to be popular with girls?! You literally traveled across time...to be popular with girls?!

Chrom: ...Your purpose in life is to be popular with girls? You literally traveled across time...to be popular with girls?!

Frederick: ...Your purpose in life is to be popular with girls? You literally traveled across time...to be popular with girls?!

Virion: ...Your purpose in life is to be popular with women? You literally traveled across time...to be popular with women?!

Vaike: ...Your purpose in life is to be popular with girls? You literally traveled across time...to be popular with girls?!

Stahl: ...Your purpose in life is to be popular with girls? You literally traveled across time...to be popular with girls?!

Kellam: ...Your purpose in life is to be popular with girls? You literally traveled across time...to be popular with girls?!

Lon'qu: ...Your purpose in life is to be popular with girls? You literally traveled across time...to be popular with girls?!

Ricken: ...Your purpose in life is to be popular with girls? You literally traveled across time...to be popular with girls?!

Gaius: ...Your purpose in life is to be popular with girls? You literally traveled across time...to be popular with girls?!

Gregor: Inigo's purpose in life is to be popular with girl? You travel all the way across time...just to be popular with lady?

Libra: ...Your purpose in life is to be popular with girls? You literally traveled across time...to be popular with girls?!

Henry: ...Your purpose in life is to be popular with girls? You literally traveled across time...to be popular with girls?!

Donnel: Yer purpose in life is to be popular with the ladies? You literally jumped through time... just to be popular with some ladies?!

Inigo: To be popular with ALL girls. Genius, I know. But stop, Father. You're making me blush.

[Robin]: I... I don't even know what to say.

Chrom: I... I don't even know what to say.

Frederick: I... I don't even know what to say.

Virion: I am...speechless...

Vaike: I'm at a loss for words!

Stahl: I... I don't even know what to say.

Kellam: I'm not sure what to say...

Lon'qu: I... I don't even know what to say.

Ricken: I... I don't even know what to say.

Gaius: I... I don't even know what to say.

Gregor: Gregor at loss for words...

Libra: I... I don't even know what to say.

Henry: That's a little weird, even for me.

Donnel: I'm more than a mite disturbed, Son.

Inigo: What? It never bothered you when Mother would blush in front of you!

[Robin]: No, that's not what... Where do I even begin? Suddenly I'm feeling very tired... I'm going on ahead.

Chrom: No, that's not what... Where do I even begin? Suddenly I'm feeling very tired... I'm going on ahead.

Frederick: No, that's not what... Where do I even begin? Suddenly I'm feeling very tired... I'm going on ahead.

Virion: It's as if you only inherited one aspect of my... Ahh, never mind. Suddenly I'm feeling very tired... I'm going on ahead.

Vaike: No, that ain't the... Ahh, never mind. Talkin' with you is exhausting. I'm goin' on ahead.

Stahl: No, that's not what... Where do I even begin? Suddenly I'm feeling very tired... I'm going on ahead.

Kellam: No, that's not what... Where do I even begin? Suddenly I'm feeling very tired... I'm going on ahead.

Lon'qu: No, that's not what... Where do I even begin? Suddenly I'm feeling exhausted... I'm going on ahead.

Ricken: No, that's not what... Where do I even begin? Suddenly I'm feeling very tired... I'm going on ahead.

Gaius: No, that's not what... Where do I even begin?

Gregor: No, that is not... Oy! Where does Gregor even begin? Suddenly Gregor feeling very tired... He go on ahead, yes?

Libra: No, that's not what... Where do I even begin? Suddenly I'm feeling very tired... I'm going on ahead.

Henry: That's because she's your mother. Am I going to have to curse you? Oops! There's the warning trumpet. Time for us to mosey!

Donnel: No, that's not what... Where do I even start? Ah, horsefeathers! Yakkin' with you plumb tuckers me out. I'm goin' on ahead.

Inigo:Not a care in the world, huh? Not a thought in my head, he means! For being such a softy with everyone else, he sure doesn't pull any punches with me...

◼ FATHER X INIGO B

Inigo: Ow! This one's pretty bad. I can't go back to camp like this...

[Robin]: Something wrong, Inigo? Everyone else has already headed back.

Chrom: Something wrong, Inigo? Everyone else has already headed back.

Frederick: Something wrong, Inigo? Everyone else has already headed back.

Virion: Something wrong, Inigo? Everyone else has already headed back.

Vaike: Somethin' wrong, Inigo? Everyone else has already headed back.

Stahl: Something wrong, Inigo? Everyone else has already headed back.

Kellam: Something wrong, Inigo? Everyone else has already headed back.

Lon'qu: Something wrong, Inigo? Everyone else has already headed back.

Ricken: Something wrong, Inigo? Everyone else has already headed back.

Gaius: Something wrong, Inigo? Everyone else has already headed back.

Gregor: Something is wrong? Everyone else has made with the heading back.

Libra: Something wrong, Inigo? Everyone else has already headed back.

Henry: Something wrong, Inigo? Everyone else has already headed back.

Donnel: Somethin' wrong, Inigo? Everyone else's already headed on back.

Inigo: F-Father?! Er, I just...thought I saw a cute milkmaid at the edge of the battlefield!

[Robin]: ...You're a worse liar than your mother. It's obvious your leg is wounded.

Chrom: ...You're a worse liar than your mother. It's obvious your leg is wounded.

Frederick: ...You're a worse liar than your mother. It's obvious your leg is wounded.

Virion: ...You're a worse liar than your mother. It's obvious your leg is wounded.

Vaike: Hah! You're a worse liar than your mother! It's obvious your leg is wounded.

Stahl: ...You're a worse liar than your mother. It's obvious your leg is wounded.

Kellam: ...You're a worse liar than your mother. It's obvious your leg is wounded.

Lon'qu: ...You're a worse liar than your mother. It's obvious your leg is wounded.

Ricken: ...You're a worse liar than your mother. It's obvious your leg is wounded.

Gaius: ...You're a worse liar than your mother. It's obvious your leg is wounded.

Gregor: You are worse liar than mother! Is obvious your leg is wounded...

Libra: ...Lying is a sin, my son. It's obvious your leg is wounded.

Henry: ...You're a worse liar than your mother. I can smell the blood on you!

Donnel: ...Yer a worse liar than your ma! It's obvious that there leg is sore.

Inigo: It's fine, it's—GYAAAH! Ow! Ow, ow ow! No, don't touch it! Don't touch it!

[Robin]: This is a serious injury, Inigo! Why didn't you say something?

Chrom: This is a serious injury, Inigo! Why didn't you say something?

Frederick: This is a serious injury, Inigo! Why didn't you say something?

Virion: This is a serious injury, Inigo! Why didn't you say something?

Vaike: This is a serious injury, Inigo! Why didn't ya say somethin'?

Stahl: This is a serious injury, Inigo! Why didn't you say something?

Kellam: This is a serious injury, Inigo! Why didn't you say something?

Lon'qu: This is a serious injury, Inigo! Why didn't you say something?

Ricken: This is a serious injury, Inigo! Why didn't you say something?

Gaius: This is a serious injury, Inigo! Why didn't you say something?

Gregor: Is serious injury, Inigo! Why you no mention it earlier?

Libra: This is a serious injury, Inigo! Why didn't you say something?

Henry: Wowzers, this is a serious injury! Why didn't you say something?

Donnel: This is a serious injury, Son! Why didn't ya say somethin' earlier?

Inigo: What, and ruin my reputation? The ladies want Inigo the Invincible.

[Robin]: Gods, ENOUGH, Inigo!

Chrom: Gods, ENOUGH, Inigo!

Frederick: That is ENOUGH!

Virion: That is ENOUGH, Inigo!

Vaike: All right, that's ENOUGH!

Stahl: Gods, ENOUGH, Inigo!

Kellam: Gods, ENOUGH, Inigo!

Lon'qu: Gods, ENOUGH, Inigo!

Ricken: Gods, ENOUGH, Inigo!

Gaius: Gods, ENOUGH, Inigo!

Gregor: ENOUGH!

Libra: Oh, Inigo! ENOUGH!

Henry: Oh, come on!

Donnel: Dagnabbit, that's ENOUGH!

Inigo: ...Father?

[Robin]: You can barely walk, and you're still thinking about girls?! Be serious for once! Really, why did you travel back from the future? Lucina fights so hard, but you... Honestly, I'm disappointed. You have no idea what it means to be at war.

Chrom: You can barely walk, and you're still thinking about girls?! Be serious for once! Really, why did you travel back from the future? Lucina fights so hard, but you... Honestly, I'm disappointed. You have no idea what it means to be at war.

Frederick: You can barely walk, and you're still thinking about girls?! Be serious for once! Really, why did you travel back from the future? Lucina fights so hard, but you... Honestly, I'm disappointed. You have no idea what it means to be at war.

Virion: You can barely walk, and you're still thinking about girls?! Be serious for once! Really, why did you travel back from the future? Lucina fights so hard, but you... Honestly, I'm disappointed. You have no idea what it means to be at war.

Vaike: You can barely walk, and you're still thinkin' about girls?! Be serious for once! Really, why did you travel back from the future? Lucina fights so hard, but you... Honestly, I'm disappointed. You got no idea what it means to be at war.

Stahl: You can barely walk, and you're still thinking about girls?! Be serious for once! Really, why did you travel back from the future? Lucina fights so hard, but you... Honestly, I'm disappointed. You have no idea what it means to be at war.

Kellam: You can barely walk, and you're still thinking about girls?! Be serious for once! Really, why did you travel back from the future? Lucina fights so hard, but you... Honestly, I'm disappointed. You have no idea what it means to be at war.

Lon'qu: You can barely walk, and you're still thinking about girls?! Be serious for once! Really, why did you travel back from the future? Lucina fights so hard, but you... Honestly, I'm disappointed. You have no idea what it means to be at war.

Ricken: You can barely walk, and you're still thinking about girls?! Be serious for once! Really, why did you travel back from the future? Lucina fights so hard, but you... Honestly, I'm disappointed. You have no idea what it means to be at war.

Gaius: You can barely walk, and you're still thinking about girls?! Be serious for once! Really, why did you travel back from the future? Lucina fights so hard, but you... Honestly, I'm disappointed. You have no idea what it means to be at war.

Gregor: You can barely walk, and still you think about girl?! Be serious for once! Why you travel back from future, Son? Lucina fights so hard, but you? ...Gregor is disappointed. Son has no idea what it mean to be at war.

Libra: You can barely walk, and you're still thinking about girls?! Be serious for once! Really, why did you travel back from the future? Lucina fights so hard, but you... Honestly, I'm disappointed. You have no idea what it means to be at war.

Henry: You can barely walk, and you're still thinking about girls?! It's like you traveled back from the future just to fool around or something. Honestly, I'm disappointed. I thought you'd be better than that.

Donnel: You can barely walk, and yer still thinkin' 'bout girls?! Be serious fer once! Really, why'd ya travel back here from the future? Lucina fights tooth 'n nail, but you... I'm plumb disappointed. You got no idea what it means to be at war.

Inigo: You don't know a damned thing! You're the one who's clueless, Father!

[Robin]: Wh-what?

Chrom: Wh-what?

Frederick: Wh-what?

Virion: Wh-what?

Vaike: Wh-what?

Stahl: Wh-what?

Kellam: Wh-what?

Lon'qu: Wh-what?

Ricken: Wh-what?

Gaius: Wh-what?

Gregor: Gregor is confused.

Libra: Wh-what?

Henry: Muh?

Donnel: Hey now!

Inigo: Do you think I'd be out here if I were ONLY after girls? Out here fighting every day, wondering if this is the time I don't make it home?

[Robin]: Inigo, I didn't—

Chrom: Inigo, I didn't—

Frederick: Inigo, I didn't—

Virion: Inigo, I did not—

Vaike: Inigo, I didn't—

Stahl: Inigo, I didn't—

Kellam: Inigo, I didn't—

Lon'qu: Inigo, I didn't—

Ricken: Inigo, I didn't—

Gaius: Inigo, I didn't—

Gregor: Er, that was not—

Libra: Inigo, I didn't—

Henry: Hey, I didn't—
Donnel: Son, I didn't—

Inigo: You may think me a dandy and a fool, but a lot of people depended on me in the future. Every day, I was out there fighting Risen and risking my life. With everyone looking to me to be strong, I had no choice. I HAD to be invincible. I couldn't complain or show any weakness. Not with everyone else struggling in that damn war-torn wasteland... Even with you and Mother gone, I had to pretend I was fine. That I wasn't hurting. I had to fight every day of my sorry life and wear a smile while I did it!

[Robin]:
Chrom:
Frederick:
Virion:
Vaike:
Stahl:
Kellam:
Lon'qu:
Ricken:
Gaius:
Gregor:
Libra:
Henry:
Donnel:

Inigo: ...You said I looked like I didn't have a care in the world! Well, I'm sorry to tell you, but that's not the case at all. I smile and joke around because I don't want to show the world any weakness... If that disappoints you...then I guess you'll just have to be disappointed.

[Robin]: Inigo, listen..
Chrom: Inigo, listen...
Frederick: Inigo, listen...
Virion: Inigo, listen...
Vaike: Inigo, listen...
Stahl: Inigo, listen...
Kellam: Inigo, listen...
Lon'qu: Inigo...
Ricken: Inigo, listen...
Gaius: Inigo, listen...
Gregor: Inigo, wait. Gregor did not—
Libra: Inigo, listen...
Henry: Inigo, listen...
Donnel: Son, listen...

Inigo: That said, I do appreciate the concern... I'll get the leg looked at.

[Robin]: I... I had no idea...
Chrom: I... I had no idea...
Frederick: I..., I had no idea...
Virion: I..., I had no idea...
Vaike: I... I had no idea...
Stahl: I... I had no idea...
Kellam: I... I had no idea...
Lon'qu:
Ricken: I... I had no idea...
Gaius:
Gregor: Gregor had no idea...
Libra: I... I had no idea...
Henry:
Donnel: Aw, shucks. I had no idea...

■ FATHER X INIGO A

[Robin]: Inigo? I wanted to speak with you.
Chrom: Inigo? I wanted to speak with you.
Frederick: Inigo? I wanted to speak with you.
Virion: Inigo? I wanted to speak with you.
Vaike: Inigo? I wanted to speak with you.
Stahl: Inigo? I wanted to speak with you.
Kellam: Inigo? I wanted to speak with you.
Lon'qu: Inigo. I wanted to speak with you.
Ricken: Inigo? I wanted to speak with you.
Gaius: Inigo? I wanted to speak with you.
Gregor: Inigo? Gregor wish to speak with you.
Libra: Inigo? I wanted to speak with you.
Henry: Hey, Inigo! Got a second?
Donnel: Inigo? Reckon I could speak at ya for a spell?

Inigo: Hey, Father! Here, have a look! My leg's all healed, see?

[Robin]: That's good, Son.
Chrom: That's good, Son.
Frederick: That's good, Son.
Virion: That's good, Son.
Vaike: Heck, that's great!
Stahl: That's good, Son.
Kellam: That's good, Son.
Lon'qu: That's good, Son.
Ricken: That's good, Son.
Gaius: That's good, Son.
Gregor: Ah, is good, yes? Very good.
Libra: That's good, Son.
Henry: That's great!
Donnel: That's good, Son.

Inigo: Thanks for making me get it looked at. ...And...I'm sorry to have worried you.

[Robin]: No, I'M sorry. For what I said. It was...insensitive... You've been fighting with all you've got. I had no right to criticize you.
Chrom: No, I'M sorry. For what I said. It was...insensitive... You've been fighting with all you've got. I had no right to criticize you.
Frederick: No, I'm sorry. For what I said. It was...insensitive... You've been fighting with all your might. I had no right to criticize you.
Virion: No, I'M sorry. For what I said. It was insensitive of me. You've been fighting with all you've got. I had no right to criticize you.
Vaike: No, I'm sorry! For what I said. It was...insensitive... You've been fightin' with all you've got. I got no right to criticize you.
Stahl: No, I'M sorry. For what I said. It was...insensitive... You've been fighting with all you've got. I had no right to criticize you.
Kellam: No, I'm sorry. For what I said. It was...insensitive... You've been fighting with all you've got. I had no right to criticize you.
Lon'qu: No, I'M sorry. For what I said. It was insensitive. You've been fighting with all you've got. I had no right to criticize you.
Ricken: No, I'M sorry. For what I said. It was...insensitive... You've been fighting with all you've got. I had no right to criticize you.
Gaius: No, I'M sorry. For what I said. It was...insensitive... You've been fighting with all you've got. I had no right to criticize you.
Gregor: No! Gregor is one who is sorry. He was... insensitive... You fight with strength of many men. Gregor have no right to criticize.
Libra: No, I'm sorry. For what I said. It was...insensitive... You've been fighting with all you've got. I had no right to criticize you.
Henry: Nah, I'M sorry. For what I said. It was pretty insensitive of me. You've been fighting with all you've got. I shouldn't have criticized you.
Donnel: No, I'M sorry. For what I said. It was right rude of me. You been fighting with all ya got. I got no right to criticize.

Inigo: Pfft, you still thinking about that? Ancient history. Plus...it was my fault, too.

[Robin]: Still...
Chrom: Still...
Frederick: Still...
Virion: Still...
Vaike: Still...
Stahl: Still...
Kellam: Still...
Lon'qu: Still...
Ricken: Still...
Gaius: Still...
Gregor: Still...
Libra: Still...
Henry: Still...
Donnel: Still...

Inigo: Seriously, it's fine! Cheer up!

[Robin]: Huh?
Chrom: Huh?
Frederick: Hmm?
Virion: Huh?
Vaike: Huh?
Stahl: Huh?
Kellam: Huh?
Lon'qu: ...?
Ricken: Huh?
Gaius: Huh?
Gregor: Hmm?
Libra: Huh?
Henry: Huh?
Donnel: Huh?

Inigo: You always seem so gloomy lately. Let's see a smile for once!

[Robin]: Ah ha ha! Stop that! S-stop! It really tickles! Ha ha ha!
Chrom: Ah ha ha! Stop that! S-stop! It really tickles! Ha ha ha!
Frederick: Ah ha ha! Stop that! S-stop! That tickles! Ha ha ha!
Virion: Ah ha ha! Stop that! S-stop! It really tickles! Ha ha ha!
Vaike: Ah ha ha! Stop that! S-stop! It really tickles! Ha ha ha!
Stahl: Ah ha ha! Stop that! S-stop! It really tickles! Ha ha ha!
Kellam: Ah ha ha! Stop that! S-stop! It really tickles! Ha ha ha!
Lon'qu: Ah ha ha! Stop that! S-stop! It...tickles...! Ha ha!
Ricken: Ah ha ha! Stop that! S-stop! It really tickles! Ha ha ha!
Gaius: Ah ha ha! Stop that! S-stop! It really tickles! Ha ha ha!
Gregor: Ah ha ha! Stop that! S-stop! Do not tickle Gregor! Ha ha!
Libra: Ah ha ha! Stop that! S-stop! It really tickles! Ha ha ha!
Henry: Ah ha ha! Stop that! S-stop! Don't grab my cheeks! Ha ha!
Donnel: Aw haw haw! Stop that! S-stop! It tickles somethin' fierce! Haw haw!

Inigo: Ha ha, there it is! That's better! I didn't come all this way to watch you mope around, you know?

tend to be. If something's wrong, come to me. We'll figure it out together.

[Robin]: ...That was why you came back? To make me happy?
Chrom: ...That was why you came back? To make me happy?
Frederick: ...That was why you came back? To make me happy?
Virion: ...That was why you came back? To make me happy?
Vaike: ...That was why you came back? To make the Vaike happy?
Stahl: ...That was why you came back? To make me happy?
Kellam: ...That was why you came back? To make me happy?
Lon'qu: ...That was why you came back? To make me happy?
Ricken: ...That was why you came back? To make me happy?
Gaius: ...That was why you came back? To make me happy?
Gregor: ...Wait, that was purpose for coming back? To make Gregor happy?
Libra: ...That was why you came back? To make me happy?
Henry: ...THAT was why you came back? To make me HAPPY?!
Donnel: ...That's why you came back?To make me happy?

Inigo: Well...yeah. You, and me, and everybody. The whole world, I guess. Anyway, I suppose I'm okay telling you that now.

[Robin]: You can tell me anything.
Chrom: You can tell me anything.
Frederick: You can tell me anything.
Virion: You can tell me anything.
Vaike: Hell, you can tell me anything!
Stahl: You can tell me anything.
Kellam: You can tell me anything.
Lon'qu: You can tell me anything.
Ricken: You can tell me anything.
Gaius: You can tell me anything.
Gregor: You can tell Gregor anything.
Libra: You can tell me anything.
Henry: Aw, you can tell me anything.
Donnel: Shucks, you can tell me anythin'.

Inigo: You say that now, but I don't want to hear any complaints once I get going! I may be all smiles on the outside, but I'm actually pretty sensitive. And pessimistic. ...Oh, and I cry at the drop of a hat. Whenever a girl turns me down, I'm a complete mess for days.

[Robin]: Ha! You can stop kidding now, Inigo. I'm already smiling.
Chrom: Ha! You can stop kidding now, Inigo. I'm already smiling.
Frederick: Ha. You can stop kidding now, Inigo. I'm already smiling.
Virion: Ha. You can stop kidding now, Inigo. I am already smiling.
Vaike: Ha! You can stop kiddin' now, Inigo. I'm already smilin'.
Stahl: Ha. You can stop kidding now, Inigo. I'm already smiling.
Kellam: Ha. You can stop kidding now, Inigo. I'm already smiling.
Lon'qu: Heh. You can stop kidding now, Inigo. I'm already smiling.
Ricken: Ha. You can stop kidding now, Inigo. I'm already smiling.
Gaius: Ha. You can stop kidding now, Inigo. I'm already smiling.
Gregor: Ho ho! You can stop kidding now. Gregor side hurt already, yes?
Libra: Ha. You can stop kidding now, Inigo. I'm already smiling.
Henry: Ha. You can stop kidding now, Inigo. I'm already smiling.
Donnel: Haw! You can stop kiddin' now, Inigo. I'm already smilin'.

Inigo: Oh, I'm not kidding... All the stuff about the girls—it was never part of the act.

[Robin]: Well, that's fine...in moderation, of course. You're a strong man, Inigo, and I couldn't be prouder of you. But no one is invincible, and you shouldn't pretend to be. If something's wrong, come to me. We'll figure it out together.

Chrom: Well, that's fine...in moderation, of course. You're a strong man, Inigo, and I couldn't be prouder of you. But no one is invincible, and you shouldn't pretend to be. If something's wrong, come to me. We'll figure it out together.

Frederick: That's fine...in moderation, of course. You're a strong man, Inigo, and I couldn't be prouder of you. But no one is invincible, and you shouldn't pretend to be. If something's wrong, come to me. We'll figure it out together.

Virion: Well, that's fine...in moderation, of course. Heaven knows, I can relate... You're a strong man, Inigo, and I couldn't be prouder of you. But no one is invincible, and you shouldn't pretend to be. If something's wrong, come to me. We'll figure it out together.

Vaike: Hey, the Vaike loves the ladies, so I can't hold it against ya. You're a strong man, Inigo, and I couldn't be prouder of ya. But no one is invincible, and ya shouldn't pretend to be. If somethin's wrong, come to me. We'll figure it out together.

Stahl: Well, that's fine...in moderation, of course. You're a strong man, Inigo, and I couldn't be prouder of you. But no one is invincible, and you shouldn't pretend to be. If something's wrong, come to me. We'll figure it out together.

Kellam: Well, that's fine...in moderation, of course. You're a strong man, Inigo, and I couldn't be prouder of you. But no one is invincible, and you shouldn't pre-

tend to be. If something's wrong, come to me. We'll figure it out together.

Lon'qu: Well, that's fine...in moderation, of course. You're a strong man, Inigo, and I couldn't be prouder of you. But no one is invincible, and you shouldn't pretend to be. If something's wrong, come to me. We'll figure it out together.

Ricken: Well, that's fine...in moderation, of course. You're a strong man, Inigo, and I couldn't be prouder of you. But no one is invincible, and you shouldn't pretend to be. If something's wrong, come to me. We'll figure it out together.

Gaius: Well, that's fine...in moderation, of course. You're a strong man, Inigo, and I couldn't be prouder of you. But no one is invincible, and you shouldn't pretend to be. If something's wrong, come to me. We'll figure it out together.

Gregor: That fine...in moderation, of course. You are strong lad, Inigo, and Gregor is very proud of you. But no one is invincible, and you shouldn't pretend to be, yes? If something wrong, you come to Gregor. We figure it out together.

Libra: Well, that's fine...in moderation, of course. You're a strong man, Inigo, and I couldn't be prouder of you. But no one is invincible, and you shouldn't pretend to be. If something's wrong, come to me. We'll figure it out together.

Henry: Well, that's fine...in moderation, of course. You're a strong man, Inigo, and I couldn't be prouder of you. But no one is invincible, and you shouldn't pretend to be. If something's wrong, come to me! We'll figure it out together.

Donnel: I reckon that's fine...in moderation, of course. Yer a right strong feller, Inigo, and I couldn't be prouder of you. But no one's invincible, and you shouldn't pretend to be. If somethin's wrong, come jaw at me! We'll work it out together.

Inigo: Father... I knew you loved me, but... Oh, thank you!

[Robin]: Waugh! N-neck! Inigo, my neck! Too tight! C-can't breathe!
Chrom: Waugh! N-neck! Inigo, my neck! Too tight! C-can't breathe!
Frederick: Waugh! N-neck! Inigo, my neck! Too tight! C-can't breathe!
Virion: Waugh! N-neck! Inigo, my neck! Too tight! C-can't breathe!
Vaike: Waugh! N-neck! Inigo, my neck! Too tight! C-can't breathe!
Stahl: Waugh! N-neck! Inigo, my neck! Too tight! C-can't breathe!
Kellam: Waugh! N-neck! Inigo, my neck! Too tight! C-can't breathe!
Lon'qu: Waugh! N-neck! Inigo, my neck! Too tight! C-can't breathe!
Ricken: Waugh! N-neck! Inigo, my neck! Too tight! C-can't breathe!
Gaius: Waugh! N-neck! Inigo, my neck! Too tight! C-can't breathe!
Gregor: Waugh! N-neck! Gregor's neck! Too tight! C-can't breathe!
Libra: Waugh! N-neck! Inigo, my neck! Too tight! C-can't breathe!
Henry: Waugh! N-neck! Inigo, my neck! Too tight! C-can't breathe!
Donnel: Waugh! N-neck! Inigo, my neck! Too tight! C-can't breathe!

Inigo: I-it's your own fault! I don't think you've ever said anything like that to me before! And listen—the same goes for you. Whatever the problem, I'll help. I'll be damned if I'm going to lose you twice.

[Robin]: And I'll be damned if I'm ever going to lose such a wonderful son.
Chrom: And I'll be damned if I'm ever going to lose such a wonderful son.
Frederick: And I'll be damned if I'm ever going to lose such a wonderful son.
Virion: And I'll be damned if I'm ever going to lose such a wonderful son.
Vaike: And I'll be damned if I'm ever gonna lose such a wonderful son!
Stahl: And I'll be damned if I'm ever going to lose such a wonderful son.
Kellam: And I'll be damned if I'm ever going to lose such a wonderful son.
Lon'qu: And I'll be damned if I'm ever going to lose you, period.
Ricken: And I'll be damned if I'm ever going to lose such a wonderful son.
Gaius: And I'll be damned if I'm ever going to lose such a wonderful son.
Gregor: And Gregor be damned as well to lose such wonderful son!
Libra: Thank you, Inigo. May Naga watch over us both.
Henry: You got it, Son. ...And thanks.
Donnel: And I'll be damned if I'm ever gonna lose such a wonderful son.

Brady

Avatar (male)

The dialogue between Avatar (male) and Brady can be found on page 224.

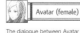

Avatar (female)

The dialogue between Avatar (female) and Brady can be found on page 235.

Maribelle (Mother/son)

Brady's mother/son dialogue with Maribelle can be found on page 269.

Lucina

The dialogue between Lucina and Brady can be found on page 281.

Lucina (Brother/sister)

The dialogue between Lucina and Brady (brother/sister) can be found on page 282.

Owain

The dialogue between Owain and Brady can be found on page 287.

Inigo

The dialogue between Inigo and Brady can be found on page 290.

Kjelle

■ KJELLE X BRADY C

Brady:
Kjelle: Oh, hey.
Brady: H-hey, Kjelle. How's tricks?
Kjelle: Tricks are fine, thanks.
Brady: Training again, are ya? Wish I could be like that.
Kjelle: Then quit talking and grab some weights! That's how I've done it—one day at a time, every day of my life.
Brady: Yeah, I remember ya as a kid! Always running around with some pointy stick.
Kjelle: No one gets strong without putting in the time. You've got to sweat for it.
Brady: I'd settle for being half as strong as you. A third, even! Maybe then I could stop doubting myself all the time... How long do you think it'd take for a guy to hit your level, eh? Couple'a weeks or what?
Kjelle: Depends on the guy. Natural talent goes a long way toward speeding things along.
Brady: But ya think anyone can get there eventually, yeah? I mean, if they really bust hump?
Kjelle: Anyone.
Brady: Then ya gotta train me, Kjelle! Ya just gotta!
Kjelle: No.
Brady: What?! How can you say no? I'm pleadin' with ya here!
Kjelle: I'm busy enough with my own training. I don't have the time to waste on you. Besides, you're frail. If you snapped in two an hour into my training regimen, we'd be short a healer.
Brady: ...Guess there ain't much I can say to that number. Too weak even to get less weak... Gah, look at me! What a Melvin!
Kjelle: Hey, don't let it get you down. ...Or just let it get you down somewhere else. I'm busy.
Brady: Yeesh. No harsh truth a total lack of sympathy can't make worse.

■ KJELLE X BRADY B

Kjelle: Wait. You're back here asking me to train you AGAIN?
Brady: I'll ask as many times as it takes! Please, Kjelle! Ya just gotta!
Kjelle: Doesn't matter how many times you ask. My answer isn't changing.
Brady: Come on, Kjelle! I'm beggin' ya! I could be somebody! I could be a champ!
Kjelle: Look, it's nothing personal. I'm just very aware of how harsh I am when it comes to training. I don't want your puny healer's blood on my hands.
Brady: I can take it! Whatever it is, I'll do it. Ya just gotta believe me!
Kjelle: That totally unfounded bravado of yours is oddly charming, but it's going to kill you. There are times when the spirit is willing, but the flesh is floppy and hopeless.
Brady: Says who? I ain't hopeless! You said yourself that any chump can get there if they stick to it! I'm ready to sweat for it! I'm ASKING to sweat for it! Come on, Kjelle. I'm beggin' here.
Kjelle: What's with this fixation on toughening up all of a sudden? Is this really just a confidence thing?
Brady: I told ya, I wanna finally stop doubting myself all the time. I want to feel like I'm helping you cats out there in the field!
Kjelle: You do know that you can train on your own, too, right? You don't need my help. ...Oh, fine. I give up. I'll do it.
Brady: Ya will?
Kjelle: The only bigger waste of my time than training you is listening to you beg. As long as you don't mind me continuing my own training while you do yours, I'm game.
Brady: That's a dilly of a deal!
Kjelle: BUT! If we do this, we do it my way. I'm going to rebuild you from scratch. ...And it's going to hurt. A lot. Are you sure you're up for it?
Brady: You got it, Kjelle! I'll give them exercises what for!

■ KJELLE X BRADY A

Kjelle: We begin today. Are you ready?
Brady: Just tell me what to do and it's done!
Kjelle: First, run over to there and back.
Brady: Er, over...where? Ain't nothin' but open field from here to the horizon.
Kjelle: Yes, I know. I want you to run until you reach the horizon.
Brady: Er, wait. Don't the horizon move around depending on where ya stand?
Kjelle: Look, just run until you can't see me anymore, all right?
And if I can see you when you turn around, you have to start over!
Brady: Clear day like today, I can see halfway to forever! You expect me to run that?!

Kjelle: We can't start the fun stuff until you've built up some endurance. All right, off you go. Five laps.

Brady: ...This dame's crazy! It'll be dark before I'm done!

Kjelle: I heard that! ...And no one's forcing you. If you don't like it, quit.

Brady: Fine! I'm goin', I'm goin'!

Brady: *Pant* *huff*... I...I lost my lunch about a dozen times, but I did it!

Kjelle: Good. Next we'll have you do squats while carrying one of those sandbags.

Brady: *Huff* *pant* Ya mean this thing? It weighs more than I do! And don't I get a break first?

Kjelle: Winded already? This is still just the warm-up.

Brady: Ya gotta be kiddin'! I'm dying here!

Kjelle: Then quit.

Brady: Rrrgh, no. I'm fine! Great! I could do this all day, dammit!

Kjelle: Better. For today, just do a thousand reps. We'll raise that by a hundred a day.

Brady: I... I don't even know what to cry about anymore... It's all just... I don't even...

Brady: Ooooooone...thousand! I...did it... I'm...finally done... Now...I can...die in peace.

Kjelle: How many deaths does that make today? Honestly, where do you find the time? Next is push-ups. One thousand. ...While holding the sandbag.

Brady: What does that even mean?!

KJELLE X BRADY S

Brady: *Gasp* *pant*... D-dying... I'm dying!

Kjelle: Did I say you could stop? Every time you say you're dying, I'm adding a hundred squats. That's eight hundred for today. ...so far.

Brady: Kjelle... Please... Just ten—no, five minutes! If I don't take a break, I'm gonna cease to be alive in a very literal sense!

Kjelle: ...Five minutes.

Brady: Thank you, thank you, thank you!

Kjelle: And this is still just endurance training! I'd say combat training is a stretch.

Brady: H-hey, hold on! Look, I may not be the quickest cat around, but ya can't just back out on me!

Kjelle: Who said anything about backing out? I'm in this for the long haul. Even if you try to change your mind.

Brady: ...You're a sadist.

Kjelle: An impressed sadist, though. To tell you the truth, I didn't think you'd stick it out. And seeing you vomit like that makes me want to train all the harder.

Brady: ...Dammit.

Kjelle: Huh?

Brady: How am I ever supposed to get stronger than you if you keep upping your pace? How am I ever supposed to make you love me if I can't... Um... Er...

Kjelle: I beg your pardon?

Brady: Look, it's obvious you'd never go for some string bean what's weaker than you. But just gimme time! I'll turn into someone who can match ya yet!

Kjelle:

Brady: Aaaah, for the love'a clams, tell me it ain't too late to take all that back! I ain't gonna open my big yapper again, I swear! So please just forget what I said.

Kjelle: You think I didn't know?

Brady: What?! Since when?

Kjelle: People don't work as hard as you did for no reason. For all your whining, you always did what I told you, and you never missed a day. Add in the fact that you insisted I be the one to train you, and it's pretty obvious.

Brady: Dammit, I'm so stupid! Way to go there, Brady! Muckin' up the works as usual!

Kjelle: Oh, I don't know. I think it's charming... And you're right.

Brady: I am? Wait, about what?

Kjelle: That you don't exactly qualify as you are right now. But you've got talent and guts and time. ...And an excellent coach. I said I'd rebuild you from scratch, right? May as well make you into my perfect man! And then, on the day you best me, we'll become the world's strongest couple!

Brady: Heh, all right! I can dig a challenge like that!

Kjelle: Good! By the way, your five minutes are up. Get back to work!

Brady: Hey, that don't count! We was talkin', not restin'!

Cynthia

CYNTHIA X BRADY C

Cynthia: Hmm... No, that can't be it...

Brady: You all right there, Cynthia?

Cynthia: Hmm? Oh! Yes, sorry, Brady. It's just the strangest thing's been happening lately.

Brady: Oh yeah?

Cynthia: Someone keeps coming to my aid in battle.

Brady: That don't sound so strange. We all help each other out, yeah?

Cynthia: Yes, but this is...different. If I'm hurt, a vulnerary will drop out of the sky in front of me! Or an enemy will be thundering toward me and get knocked off their horse by a rock!

Brady: Y-yeah, that's...strange, all right. Never heard that one before...

Cynthia: I know, right?! I'm going to track down whoever is doing it during the next battle.

Brady: No, don't! I mean, uh, don't you think that's kind of unnecessary? They're helping you, right? Maybe they just wanna be... I dunno... All anonymous-like?

Cynthia: Hmm... You're right in that many heroes prefer to operate in secret...

Brady: Don't do it... Don't do it...

Cynthia: What's that? I can't quite make out what you're mumbling over there.

Brady: Me? H-heck, I ain't sayin' nothin'! ...I'm just tired. ...That was a yawn. 'Sides, how are you going to track down your hero with no clues? And even if you find 'em, what then? You know what you say about gift horses.

CYNTHIA X BRADY B

Brady: Heya, Cynthia.

Cynthia: Oh. Hello.

Brady: Something wrong? You're usually...louder.

Cynthia: Remember what I told you before? About my secret protector?

Brady: Er, someone's been helping you out in combat and whatnot, right?

Cynthia: Well, ever since then, they've been awfully clever about covering their tracks.

Brady: Y-yeah? How do you mean?

Cynthia: Well, they always show up just when I'm in danger, right? And I figured that was the perfect time to catch a glimpse! So lately, whenever I was in trouble, I started looking around wildly!

Brady: That seems like a really terrible idea...

Cynthia: So in the last battle, I look over my shoulder and see a huge wall of smoke... And then, while I'm watching, a stone comes flying out and hits my enemy! My protector is using smoke screens! That is SO COOL!

Brady: Yeah, that's... That's wild. Ha ha...ha.

Cynthia: It's like they're just hell-bent on remaining anonymous.

Brady: Certainly sounds like it...

Cynthia: But why the need for secrecy if we're both fighting for the same side? Honestly, the more they hide, the more I want to discover who it is!

Brady: Like I said, as long as they're helpin', it don't really matter, right?

Cynthia: Of course it matters, silly. I need to know who to thank!

Brady: But what if they ain't lookin' to be thanked?

Cynthia: Every hero should be recognized for outstanding heroic deeds! That's item four of the Justice Cabal code.

Brady: I, uh... I ain't familiar with that one.

Cynthia: All right then. Next time I see smoke, I'm going to charge right into it!

Brady: You got rocks in your head! What if it's just a fire?!

CYNTHIA X BRADY A

Cynthia: Ooh, Brady!

Brady: Wh-what? Didja find somethin' out?

Cynthia: Yes! ...Wait, how did you know? And why do you look so suspicious?

Brady: H-hey! I can't help it! I was born with this ugly mug, all right?

Cynthia: Ha ha! Sorry, I didn't mean any offense.

Brady: So, what did you find out?

Cynthia: Oh, right! Remember my phantom helper out on the battlefield?

Brady: The one with the smoke screen?

Cynthia: It was Lissa!

Brady: ...Oh. Really?

Cynthia: ...That's it? I thought you'd be shocked. I mean, she's not exactly a likely suspect.

Brady: No, I... I guess she's not.

Cynthia: I asked her why, and she said it was because I'm a danger to myself! Can you believe that? Talk about rude! And who is she to talk? She's so spacey, she could outstare a statue!

Brady: You're a matched pair that way. Makes sense you'd help each other out.

Cynthia: Hey! Don't you start, too!

Brady: Sorry! Sorry...

Cynthia: Mostly I'm just glad the mystery is solved. It's been plaguing me for ages!

Brady: Er, but it's only been happening for a week or two at the most...

Cynthia: Oh, shoot! I forgot I promised to help with the supply run! Gotta dash! Bye!

Brady: Er, see you later! ...Cynthia.

Brady: And she thinks Lissa's the spacey one? Oh man, that's fresh! ...Well, at least she bought the ruse. Looks like I owe Lissa a dinner.

CYNTHIA X BRADY S

Cynthia: Brady?

Brady: What's wrong, Cynthia?

Cynthia: I owe you an apology.

Brady: What? Why?

Cynthia: Lissa told me. ...The truth, I mean.

Brady: ...She did what?! Th-then you—

Cynthia: Know that it was really you helping me all those times? Yes, I know.

Brady: I told her not to say anything! Why'd she have to open her big yap?!

Cynthia: It's not her fault, really! I started quizzing her about all her secret hero moves, and she just cracked.

Brady: Ya see? She did open her yapper, then! Ooh, I'm gonna have me a few words with that stool pigeon!

Cynthia: Honestly, it's your fault for picking her. I mean, she's not exactly the type to take secrets to the grave, is she?

Brady: ...Yeah...maybe not.

Cynthia: So I just want to know why, Brady. Why be my anonymous savior?

Brady: Aw, horse pucky. I ain't nobody's savior. I just couldn't stand to watch you chargin' around all reckless and stuff. You always gotta go get hurt, and I couldn't bear to see it. You're like a little sister to me, Cynthia. Ya know?

Cynthia: ...A sister? Oh, that's unfortunate. See, because...I don't think of you as a brother.

Brady: Um... Yeah, well, ya know what? Just forget I ever said—

Cynthia: I was glad when I heard it was you. I like you, Brady...a lot. Like...a lot a lot. Knowing that the man I

like had been watching over me made me... Well, it made me really happy.

Brady: I'm sorry, Cynthia. I...

Cynthia: No, I'M sorry! I didn't mean to... I dunno. Say all that, I guess.

Brady: Ah, nuts, Cynthia! All that sister stuff was a bunch of hooey! I'm crazy for ya. Always have been! That's why I shadowed ya. I mean, sure, I wanted to keep you safe... But mostly I just wanted to be near ya, and I didn't have the guts to say it.

Cynthia: Oh, this is the best day ever! I get the real answer to the mystery, PLUS the guy I like!

Brady: Heh, it's a pretty good day for me, too.

Severa

SEVERA X BRADY C

Severa: *Sigh*

Brady: Something got ya down, Severa?

Severa: No. I'm just...sticking out.

Brady: What, like flashin' a little leg or somethin'?

Severa: No, you pervert! I mean socially! ...You and I don't fit in with the others.

Brady: Get outta' here. Ya think?

Severa: Everyone else in this camp is so happy and bubbly and nice! Ugh! Gag me with a spade!

Brady: Hey, yeah! Plus they all act like they're best chums!

Severa: Chums? Ugh, gag me again! Anyway, between us, one cynic to another, I think we should team up.

Brady: What did you have in mind?

Severa: I'm thinking that we'll start a totally exclusive club and leave them out of it! Severa and Brady's S&B Society has a nice ring to it, hmm?

Brady: The heck is an S&B Society supposed to be?

Severa: Isn't it obvious? It's a play on our initials.

Brady: I get that part, ya mope! Now what's it really mean?

Severa: It means... Um... Snark & Bark Society! It's totally our personalities! ...Plus the word "society." We need a sophisticated word like that to make everyone else all jealous.

Brady: This is starting to sound like a big pain in the keister.

Severa: Ugh, rude! And crude! Gods! Look, if you want to be that way, then you can be all cynical on your own. Or you can join my awesome society and have cynical backup whenever!

Brady: I got an uneasy feeling about this, but...well fine.

Severa: Then it's decided! Our contrarian collaboration officially begins today!

Brady: Just try not to make me regret this, yeah?

SEVERA X BRADY B

Severa: Oh, Brady!

Brady: What's wrong?

Severa: I'm so glad you're here! It's an emergency!

Brady: Are we under attack?!

Severa: Worse! I'm building the official S&B Society tent, and we're out of materials! Oh, it's just awful!

Brady: Just use one of the spare tents! We got plenty.

Severa: Ugh, no way! Our noble organization deserves better than plain, ugly canvas!

Brady: So whaddya want me to do about it?

Severa: Well, maybe we can start off with a spare after all...

Brady: Uh, what changed from a second ago when that was unacceptable?

Severa: Duh! Embellishments! We'll take a drab old tent and transform it into a palace. We'll need silks, and colorful lanterns, and fine, gilded tassels! Oh, and maybe some of those little hangy-bead thingies for the door!

Brady: You want all that on a stupid tent for two people?

Severa: It's not a stupid tent, and we are not just two people! We are the S&B Society!

Brady: This plan's startin' to rub my fur the wrong way...

Severa: I don't care about your fur, which you don't even have anyway! Here's your list. Go fetch everything on it, and then come back for more orders.

Brady: List? Let's see... Jumping jesters! I'll have to go to a big city to find half this stuff! Look at these quantities! Twenty tapestries? Thirty-five diamond-tipped canes? ...Forty-five golden bricks?! Oh, come on! You can't even buy gold bricks! I think I need a drink....

Severa: Ooh! Thank you for reminding me. We'll be needing a nice set of teacups as well. Oh, and since I handled all the planning, you don't mind footing the bill, right?

Brady: You're dreaming, lady! We're splittin' the cost at the very least!

Severa: Hey, we voted on this, remember? I am the society president and CEO! ...You are the treasurer.

Brady: Being treasurer doesn't mean you pay for everything out of pocket!

Severa: Um, I think I know what a treasurer does, Brady. Gods! Hmm... Okay, so we'll also need some shelves for books and such...

Brady: Hey! ...Are you even listening to me? Fine, I'll see what I can get from the local markets. But you're paying me back for half! You hear me, ya mooch?

Severa: Sure, sure. Off you go.

Brady: I knew this was a bad idea.

SEVERA X BRADY A

Brady: Hey, Severa!

Severa: Greetings, Society Member Number Two. Are we done with today's procurement run?

Brady: Stop callin' me that! ...And yeah, all done. Still don't see why I always line the ones what's buyin' junk. I mean, what've you been doin' this whole time, aside from loungin' around?

Severa: I've been very busy, I'll have you know! I've been assembling everything you bought into decorations for the tent. ...See?

Brady: ...Actually, that doesn't look terrible. Although it's all a bit...gaudy, isn't it?

Severa: No, it isn't! It's elegant and sophisticated! We are a SOCIETY, after all. If not for the gold, silk, and lanterns, it'd lack panache. We have a name to live up to! If it all happens to be a hair over the top, it will just make people all the more jealous!

Brady: A hair? This thing is a full wig shop over the top, Severa. I can barely see in here! All the gold leaf is blinding me!

Severa: Well, get over it! Gods, I don't see why you always have to complain.

Brady: Said the contrarian to her partner in a contrarian society! Look, I've already spent way more time and money on this than I thought I would...

Severa: Would you stop your grumbling already? ...Ooh! Brady, those teacups are darling! I didn't know you had an eye for those.

Brady: Well, you know...

Severa: Or did you just have the seller choose them for you?

Brady: Urk...

Severa: Oh, please. Don't try to deny it. I can read you like a book. Anyway, back to sewing! It won't be long now. I know it's difficult, but try to contain your excitement.

Brady: Stubborn as a mule, as always... Still, if this makes her happy, I...guess I can do it.

Severa: What was that, Number Two?

Brady: I didn't say nothin'!

SEVERA X BRADY S

Severa: Brady! *sob* It's t-t-terrible! Waaah!

Brady: What in the... Augh! Come on, let go! You're crushin' my ribs!

Severa: B-but it's... *sniff* It's gone! *sob*

Brady: Calm down! Sheesh... Now, what's gone? What happened?

Severa: Y-you remember a few days ago? When that storm came through?

Brady: Yeah, that was wild. Thought my tent was gonna up and fly away.

Severa: It did fly away, you moron! The S&B Society tent blew away, and now I can't find it!

Brady: What? There was half a ton of decorations on that thing! How'd something that gaudy ever get off the ground?

Severa: Gaudy?! It was elegant and sophisticated!

Brady: R-right! ...Course it was. But hey, that's a shame. I know ya worked real hard on it.

Severa: A shame? No, it's a tragedy! It's the worst thing that's ever happened in the history of everything!

Brady: Aw, buck up there, little camper. Don't let it get you down. So, uh, maybe time to forget the Society idea and go mingle with the others, eh? Try to play nice with the group for a change? ...I'd go with ya, if ya wanted.

Severa: N-no! I don't want to!

Brady: Why do you always have to be so antisocial? Not like I'm one to talk, but even I—

Severa: Because I want it to be just you and me!

Brady: Muh?

Severa: Gods, you're an idiot! I never cared about that dumb society stuff! ...I just made it all up so we could spend time together.

Brady: Severa...

Severa: But that dream up and blew away. So fine! Go! Run off and be with everyone else! I'll just stay here and eat this dirt! *munch, munch* ...Ptooie! ...Gods, I can't even do that right!

Brady: Oh good grief! Cut that out! I ain't goin' nowhere, doll. Honest! Can't leave half of the S&B Society all on my own now, can I?

Severa: Wait, then you...

Brady: You think I'm an idiot?! I'm crazy for you, Severa! Who else would have put up with all your crazy demands this long?

Severa: Wow, I... I don't know what to say. ...That isn't all snarky, I mean.

Brady: Hey, we're the Snark & Bark Society, but even we gotta' be honest sometime, right?

Severa: I guess I'm...happy. Happy you feel the same, I mean.

Brady: Watching you has taught me something, though. Call it lucky by bad example, but I think it was wrong to cut ourselves off. Two cats can't live alone, and there's no reason to keep tryin'. Anyway, I don't think it'd kill us to make nice with the others a bit more.

Severa: Well, I guess. ...If you help me.

Brady: Of course! I'll help with whatever you like! ...As long as it's not shopping for the Society again, that is.

Morgan (male) (Father/son)

The Morgan (male) father/son dialogue can be found on page 309.

Morgan (female)

MORGAN (FEMALE) X BRADY C

Morgan (female): Hey now, if it isn't Mr. Brady!

Brady: Yeah? What do you want?

Morgan (female): Oh, nothing! Just saying hi!

Brady: Huh. Right. And just were you doing, skulking about out here?

Morgan (female): Skulking? Really, Brady, I was just picking a spot for a little afternoon nap in the sun. Or I would be if the sun was out. ...C'mon already, sun!

Brady: Yeesh. Must be nice, not having a care in the world.

Morgan (female): I've got my share of worries, same as the next person. Well, I did... I mean, I probably did? I assume I did at some point...

Brady: If you gotta ASSUME you did, then ya DON'T! Must be nice havin' all your troubles and painful memories wiped clean. Now that head of yours is all puppies and rainbows and unicorns all the time.

Morgan (female): Yup! Pretty much!

Brady: Aw, you're shinin' me on. Ain't no way an amnesiac can be that bubbly.

Morgan (female): Well, yeah, I lost my memory, but I still have my father.

Brady: Yeah, well... Just don't go thinkin' I trust you or anythin', understand?

Morgan (female): What?! Why not? That's terrible!

Brady: Because you could be an enemy spy, that's why not!

Morgan (female): A spy? That's ridiculous!

Brady:

Morgan (female): But hey, I guess I can't blame you.

Brady: Wha—?!

Morgan (female): Well, when you put it that way, with my convenient amnesia and all... I guess I am pretty suspicious! Ha ha ha!

Brady: Aw, go suck a lemon!

MORGAN (FEMALE) X BRADY B

Brady: *Huff* *pant*

Morgan (female): Brady, are you all right?

Brady: Oh, it's...you... G-go away. *pant*

Morgan (female): Just finished group maneuvers, eh? You look and sound exhausted.

Brady: I'm f-fine!

Morgan (female): I dunno. You look pretty pale.

Brady: I s-said I'm FINE!

Morgan (female): But you don't look fine, is the thing. Want me to rub your back for a bit?

Brady: You'd like that, wouldn't you? You spy! But, oh no! Brady ain't letting you anywhere near his back!

Morgan (female): I thought you started out as a priest, no? Shouldn't you be a little better at taking care of yourself?

Brady: Hey, gimme a break! The point of being a priest is healing other people, not yourself! It's about sacrifice and all that malarkey. You're supposed to put yourself last!

Morgan (female): Yeah, but if you pass out on the field, you're no use to anybody. You need to look out for yourself some if you want to help others, right?

Brady: Q-quiet, you! Who asked you, anyway?

Morgan (female): Okay, okay! Don't go making yourself even more out of breath. Just stay put for a second. I'll get you some water.

Brady: I ain't drinkin' nothin' you give me! And I never asked for your help, so make like bad pants and butt out! *Huff* *pant* *wheeeeeze*

Morgan (female): Oh, Brady...

MORGAN (FEMALE) X BRADY A

Morgan (female): Braaaaaaady... Brady-Brady!

Brady: Ugh, not her again...

Morgan (female): What? Why are you running?! Waaait for meeeeee! ...Ha-hah! Caught ya!

Brady: Gah! What is with you, you crazy dame?!

Morgan (female): I brought you a very special gift today!

Brady: Eh?!

Morgan (female): The perfect panacea for the 90-pound weakling! Ambrosia to the anemic! All in the latest thrilling installment of Morgan's Adventures in Nutrition!

Brady: What, uh... What IS that red sludgy muck, exactly?

Morgan (female): Lifeblood drained from a fell viper! It's sure to put the sheen back in your scales!

Brady: Swear to Naga, if you get that stuff near me, I'll give ya what for!

Morgan (female): But wait! There's more! Ta-daaah! Check it out! Bear gizzards! Put the stuff of bears in you! It's gotta be strong because, hey, BEARS! ...Am I right?!

Brady: No way I'm touching that, neither!

Morgan (female): Aww, no need to be shy because they're exotic delicacies. This one's on the house!

Brady: That ain't what I'm worried about! And stay back! Stay ba—Irghlrghlrgh?!

Morgan (female): There's a nice Brady. Drink up now! Severa...drop. Gosh, yeah! Feel those supercharged bear guts slip down the ol' gullet! And don't forget to wash it down with a tall glass of snake! Mmm, taste that predator!

Brady: B-B-BLEAAARGLE! *cough* *hack!*

Morgan (female): Well? Does it feel like it's working?

Brady: *Cough* Even if it did, it ain't gonna work THAT fast! And just where do you get off thinkin' you can just— Huh?

Morgan (female): Hmm? Brady? Something wrong?

Brady: Wh-what? What's going on?! I feel... I feel power welling up inside me! It's floodin' every inch of my body!

Morgan (female): Now that's what I call fast acting!

Brady: Amazing! I feel...healthy. Weirdly healthy! My body's not used to feeling this spry! This is... Wow! This feels incredible! I take it all back, Morgan. Really, thanks! I, uh... I guess I was wrong about you...

Morgan (female): You're welcome!

Brady: Hey, uh...sorry for all the hullabaloo earlier, yeah? I got all hung up on thinking you was a spy or something. What a loon I was!

Morgan (female): Aw, everybody makes mistakes! Don't even worry about it.

Brady: Well, if you're sure, then thanks. But boy howdy, you really do live in your own world, don't you? Guess all the goofball antics and meddling is sincere. You really do mean well!

Morgan (female): Of course! I may not have my memories, but I can still be myself, and that's just who I am! At least, I'm pretty sure? Ha ha ha! Who knows, right? Oh, I slay me!

Brady: Heh, you're one crazy number, Morg. But, hey...in a good way.

MORGAN (FEMALE) X BRADY S

Brady: Hey, uh, Morgan?

Morgan (female): Something wrong, Brady? Not feeling well again?

Brady: Nah, I feel fine. Great, actually, ever since you force-fed me horrible, horrible things.

Morgan (female): Something else you need, then? Ooh! Maybe a limerick? There once was a man from Ylisse! Whose knickers were ever so—

Brady: Er, no. That ain't it. I just... I wanted to apologize for doubting you all this time.

Morgan (female): You already did apologize, silly!

Brady: Yeah, but I wanted to do it again! I just wasn't sure it took last time.

Morgan (female): Oh, you worry too much! And you weren't wrong to doubt me. Anyone would, given my circumstances.

Brady: Eh, not quite anyone...

Morgan (female): Hmm?

Brady: If our roles were switched, you never would'a doubted me for a second. You'd have welcomed me with open arms. I'm sure of it...

Morgan (female): Hmm... Yeah, I guess I would, huh? But that's just because I'm so spacey.

Brady: No, it ain't! It's 'cause you're so kind!

Morgan (female): Oh? Is that so?

Brady: Look, I can't really explain it, but... Over the course of talking with you, and the chaos and the running and the whatnot... I kept picking up this thread of...kindness? Just real honest-like, ya know? Anyway, it made me... I don't know. I guess I kinda fell for ya, Morg.

Morgan (female): Oh...Brady!

Brady: No, I know! I know! This whole time, I been sayin' these terrible things to you! I swear, I'll make it all up to ya. Just gimme a chance! Please, doll! Lemme love ya!

Morgan (female): *Sniff*... I... I don't... I mean... *sniffle*

Brady: Huh? This, uh... This wasn't supposed to be one of them terrible things I said... C'mon, you're makin' me want to turn on the waterworks here, too!

Morgan (female): I... *sniff* I can't...h-h-help it... I'm just so... So... Soooo happy!

Brady: What?! Y-you are? You sure got an odd way of showin' it!

Morgan (female): I always wanted you to like me... That's why I kept my smile on, even... *sniff* Even when you were cold to me! Now, I... I... Oh, Brady! *sob*

Brady: Gah! I'm sorry! I'm a real Melvin, I know! Just please stop with the crying!

Morgan (female): I'm...sorry... I'll stop... Just as soon as I'm not soooooo happyyyyyy! *sob*

Brady: Oh, brother... I guess when you're this happy all the time, special occasions mean big meltdowns... This is going to take some gettin' used to, but if you're happy, then I'm happy!

Morgan (female) (Brother/sister)

■ MORGAN (FEMALE) X BRADY (BROTHER/SISTER) C

Morgan (female): Let's see here... Birthday? May 5th... Favorite colors? Blue and purple... Favorite food? Probably bear meat...

Brady: Whatcha mumblin' about over there, Morgan?

Morgan (female): Least favorite food? Veggies, apparently. Don't seem to mind them now, though...

Brady: Hey! Morgan!

Morgan (female): Oh! Brady?! Guess I was pretty out of it to miss my own brother paying a visit! Did you need something?

Brady: Just wondering what you were yappin' about over there... What is it? Practicing some new magic spells and all that malarkey?

Morgan (female): Nope! Just going back over my notes on what you told me about myself. I was hoping they'd hold some clue that might help spark my memory. Heh. It's kind of crazy how much you know about me, huh? Like, I really once got five nosebleeds in the same day? I have no memory of that at all. AT ALL! Ha ha ha! I can just imagine...

Brady: Well, you're still as cheerful as that's for sure. And as talkative as ever...

Morgan (female): I am? I mean, I was?! Hmm, now that you mention it, that does sound...right, somehow. ...Heh. Everything still feels funny. Even you being my brother hasn't really clicked.

Brady: If you think it's strange for you, you should see how I feel! My kid sister starts talking to me like a stranger, askin' questions about herself... I had no idea how to even interact with you. Eventually I got used to it, but still...

Morgan (female): Heh, yeah... Sorry about that. But that's just another reason why I'm working hard to get my memories back. Once I do, nobody will have to feel weird or awkward around me again. Pretty noble, huh? I'm such a sweet, selfless girl!

Brady: Heh, and real humble, I see... Anyway, I'm happy to try and help ya get those memories back however I can. Before you know it, we'll be laughin' about the good ol' days—now with feeling!

Morgan (female): Heh, right!

■ MORGAN (FEMALE) X BRADY (BROTHER/SISTER) B

Brady: That's the third time today someone took me for a bandit! Next time, I'm gonna... Uh-oh. Looks like some cat's gone boots up over there. ...W-wait, is that...Morgan?!

Morgan (female): Nn...nngh...

Brady: Morgan! Morgan, are you all right?! Stay outta the light, girl!

Morgan (female): ...Wha—?! Brady! Wh-what am I doing here? Was I asleep?! No, I don't even remember feeling tired... Oh, right! I was bashing that huge tome against my mind when I blacked out. That explains why my face hurts so bad...

Brady: Bashing your... Morgan, why in the WORLD would ya do that?! Wait, were you trying to get your memories back?

Morgan (female): Well, yeah! Obviously. If you ever saw me bludgeoning myself just for fun, I hope you'll put a stop to it.

Brady: I'll stop ya even if it's NOT just for fun, ya damn moron! Look, I know you want your memories back, but hurtin' yourself ain't an option!

Morgan (female): ...But I want to be able to talk with you about old times again.

Brady: I know, Morgan, and I want that, too. But more than that, I want ya safe. You may just be another stranger to you, but to me, you're family. In the future, when Ma and Pop gone, it was just the two of us. You're all I had, Morgan, and I don't know what I'd do if anything happened to ya.

Morgan (female): All right. I'm sorry, Brady.

Brady: As long as you understand.

Morgan (female): ...Heh, that felt really siblingy just now. Don't you think? Me messing up and you scolding me felt... I don't know, it felt really plausible! Maybe if you keep it up, I'll remember something!

Brady: Er, I dunno...

Morgan (female): Yeah! Oh yeah, this will totally work! So go on, keep yelling! C'mon, scream at your amnesiac sister, Brady!

Brady: Huh? Naw, I ain't comfortable with—

Morgan (female): Hey, why don't you use the tome, too? Come on, don't hold back. Really wallop me with that thing! Maybe the simultaneous physical and mental shock will jar some memories loose! It's gotta be twice as effective as either one by itself, right? That's just basic science.

Brady: You're insane! I'm outta here.

■ MORGAN (FEMALE) X BRADY (BROTHER/SISTER) A

Brady: Hey, Morgan. I'm headed into town. Wanna tag along?

Morgan (female): I'd love to! Is there something in particular you need?

Brady: I might pick up a couple of things, yeah. But mostly I think there's somethin' YOU need.

Morgan (female): It doesn't have to do with getting my memories back, does it?

Brady: The opposite, actually. Maybe there ain't no need to worry about your memories, yeah?

Morgan (female): That...makes no sense.

Brady: Look, I been thinkin' about this a lot. Why ya might've lost your memories, I mean. And I'm wonderin' if ya didn't have some awful memory ya just couldn't live with... I know I sure got a few. I see a lot of faces, yeah? Folks we couldn't save...

Morgan (female): I'm sorry you have to bear those dreadful memories.

Brady: Look, it's just a theory, and even if it's true, it ain't like you did it consciously. But I do think that gettin' your memories back might not necessarily be good for ya.

Morgan (female): Hmm... I understand, and believe me, I appreciate the thought... But I want to remember things, no matter how painful they are. Because I'm sure there'll be plenty of great memories mixed with the bad ones. And the truth, whatever it is... I really want to have that back, you know?

Brady: Well, long as you're sure, then I'm happy to help.

Morgan (female): That's really kind of you, Brady, but do you truly realize what you're saying? I mean, it could be years before I remember anything. Or decades. Heck, there's a decent chance I may never get my memories back at all. I don't want to drag you into something that could last forever.

Brady: I'm already stuck with ya forever, ya dimwit! I'm your brother. We're family—memories or no. Ya couldn't keep me away.

Morgan (female): Brady, I... *sniff* Thank you! I'll do everything I can!

Brady: Then start by comin' with me into town.

Morgan (female): Huh? But you said that doesn't have to do with getting my memories back.

Brady: Hey, that's the secret to gettin' 'em back! ...Kidding. Come on, let's go.

Yarne

■ YARNE X BRADY C

Brady:

Yarne: Something wrong, Brady?

Brady:

Brady: Yarne, I took a jab from a spear in the last battle. Hurts like the dickens. Don't suppose ya got some secret taguel wonder medicine, eh?

Yarne: ...Er, actually. Well, it's not taguel, but it's good stuff regardless.

Brady: And it really works? You ain't yankin' ol' Brady's chain here, yeah?

Yarne: It works like a charm, though it smells like rotten socks. Then again, it's a secret recipe—so rotten socks may actually be an ingredient!

Brady: I'll chug soiled undies if it makes this pain go away. Thanks, rabbit! *Glug, glug, glug*

Yarne: Well? How's it feel?

Brady: ...Sweet thunder! I can see the wound sewin' shut before my very eyes!

Yarne: Well, if you ever need more, come see me. Nobody's better stocked on medicine than a hypochondriac. Oh, and be sure to get plenty of rest, too. Maybe take it easy today?

Brady: No can do. We got training exercises after this, remember?

Yarne: Training or no, I'm not a fan of any activity where people swing sharp things at me. That's how accidents happen! Horrible, face-peeling accidents... And the fact that it's mostly safe also means it's slightly deadly! As the last of the taguel, I can't afford to risk it.

Brady: If you go into battle without training at all, it'll be a lot more than slightly deadly! C'mon! Stop flappin' yer gums and start movin' yer legs!

Yarne: H-hey, wait! I told you, I'm not... HEY! Let go! Unhand me, brute!

■ YARNE X BRADY B

Brady: YAAARNE!

Yarne: Gah?! Wh-what did I do? Why are you so angry?

Brady: Don't play the sap with me! What was that sorry show you put on in the last battle?

Yarne: Er... I have no idea what you mean. Ha ha...ha... I was trying my...hardest?

Brady: Aw, go suck a lemon! You never got closer than 50 paces to the enemy! The rest of us are risking our necks! If yer that useless, why not stay home?!

Yarne: I ain't useless! I wanted to! Taguel are far better fighters than humans! You show the enemy and I'll teach 'em! With...with

one paw tied behind my back! Er...that is...if I weren't the last of my kind. I need to stay clear of danger and... You know. Stay alive. Keep the bloodline going?

Brady: It's always the same load of malarkey with you, ain't it?! You brag about how great the taguel are, but you never actually fight! How do you think that makes a guy like me feel? Huh?! I wish I could fight more than I do, but my body can't keep up! It ain't my fault I'm the least athletic guy in the history of the world... But that don't stop me from tryin'!

Yarne: Brady... A-all right... Fine.

Brady: "Fine," what?!

Yarne: Fine, I'll show you what I can do! Next battle, I'm out there! I'll prove once and for all I'm not just some coward!

Brady: Ha! If your promises were wooden nickels, I'd have a... Wait, that's not... Look, you know that means actually joinin' the front lines, yeah? I'll be watchin' to see how long it takes you to turn yellow. ...So impress me!

Yarne: M-maybe I will!

■ YARNE X BRADY A

Brady: Hey, Yarne! I saw you out on the field!

Yarne: ...And? How was I?

Brady: Pretty amazin'! You really held your own!

Yarne: Heh, stop. You'll make me blush!

Brady: Took ya long enough to get serious, but it was worth all the badgering. Now ya just have to keep it up. No more runnin' from the front lines!

Yarne: Wait, what?

Brady: You're tough when you actually bother to fight, yeah? So I'm sayin' you need to make every battle a repeat of today!

Yarne: Er, I don't... That was a one-time thing. I was just proving a point! I thought I could go back to...you know? NOT proving a point?

Brady: You realize we're still at war here, right? Don't make me slap an endangered species!

Yarne: N-no, wait! I just... I just think all my fallen ancestors would be angry if I risked the life of the last taguel!

Brady: You're gonna have a lot more than angry ghosts to worry about here in a sec!

Yarne: Gah! Quit yelling at me! You're freaking me out! Stress is bad for me health! Are you trying to kill me?!

Brady: Don't tempt me, bunny. And seriously, did you completely miss what I meant before?!

Yarne: ...Did I?

Brady: You want to talk about your ancestors? Fine! Let's take a look!

Yarne: Huh? I?

Brady: The taguel are natural born fighters, yeah? So what does that tell ya? They've been fightin' for generations! They valued strength above all in their partners! Fightin' ain't just how they survived, it's who they were! It's your heritage! As the last inheritor of that legacy, ain't it your job to make sure THAT don't die?!

Yarne:

Brady: Whew... Got a little hot under the collar there.

Yarne: ...But you're right. I guess somewhere along the way, I lost sight of what I was trying to protect. No more running. I'll muster up my courage and face life head-on! ...Ish.

Yarne: H-hey, I'm not going to change into a whole new person overnight! I'll give it my best shot, but I'm sure there will still be times I want to run and hide.

Brady: Well, I guess I can stick around to light a fire under that tail of yours when ya do!

Yarne: Thanks, Brady. I'll be counting on you to do just that!

Brady: Oh, it'll be my pleasure, rabbit.

Noire

■ NOIRE X BRADY C

Noire: Oh, this is so embarrassing. Alone on a cot in the medical tent. ...Again! Honestly, everyone is being silly. I was just a little light headed.

Noire: Nnnh? ...Oh. I must have fallen asleep. Wait... I hear footsteps... Eep! They're coming closer! Wh-what if it's someone I don't know?!

Brady: Huh? ...Oh, it's you.

Noire: Brady!

Brady: Gods, another day, another screwup on the battlefield. I'm pathetic!

Noire: Oh no, are you hurt?

Brady: Wouldn't be here otherwise. I dodged an attack wrong and twisted my ankle. My leg'll be fine, but my pride may never recover.

Noire: I see.

Brady: Anyway, looks like we're neighbors for the time being. Cheers, I guess.

Noire: Ch-cheers... I'm actually feeling a lot better, though. I'll probably be going in just a bit...

Brady: I hear ya! I can't wait to bake like a bakery wagon and haul buns outta here. This place is depressing!

Noire: Heh, yeah... W-well, I hope you feel better soon.

■ NOIRE X BRADY B

Brady: Ugh, genius move, Brady. You're a regular [Robin]! Leg heals up just in time to get sent back here for another boneheaded injury.

Noire: Hee hee! Looks like we're neighbors again.

Brady: Am I a court jester? I amuse you? 'Cause I ain't laughing! What kind of idiot blocks a hit and pulls his groin while falling on his ass?! You couldn't even come up with a more pathetic injury if you tried!

Noire: Er, it's better than not blocking at all, right?

Brady: Yeah, I guess... So what's got you back in the tent of shame? Anemia acting up again?

Noire: Mmm-hmm.

Brady: Tough break. ...Ugh, and then there's the boredom to add insult to injury. I want to get outta this two-bit tent. Hit the town, maybe.

Noire: Getting better has to come first, though.

Brady: Yeah, I know. I just wish there was more to do than sleep. I've done more than enough of that already.

Noire: I know how you feel... But what else would you do?

Brady: Hmm, that looks about right... Hurf!

Noire: Brady? What are you doing with that crate? It looks awfully heavy...

Brady: That's kinda the point. May as well use this time to build up a bit of muscle lifting weights.

Noire: B-but you're hurt! Shouldn't you be taking it easy?

Brady: My leg is hurt! No reason I can't work on the old cannons, though. Am I right? Here we go... One! Two! Th-three......... FFFFFffff!

Noire: Are you all right? Don't tell me you hurt your arms?!

Brady: G-guess I should've started with a lighter crate... Hngh!

Noire: I told you you ought to take it easy! Wait right there, I'll go get help. Er, I mean, I guess I'll yell for help. Or...something. Hello? Is anyone there? Brady's hurt! ...Er, more so!

Brady: All right, so I spoke too soon. There IS a more pathetic injury...

■ NOIRE X BRADY A

Noire: Ugh, how many times does this make?

Brady: Heh! And it's always the two of us. This is getting to be our spot!

Noire: You say that like it's a good thing...

Brady: Yeah, well, isn't it? I mean, at least we've been able to talk.

Brady: Talk's about all we can do in here. I think my ill-advised attempt at weight training last time proved that much...

Brady: Well then, what if we talk about the good old days for a bit?

Noire: Like what?

Brady: You probably don't remember, but we used to be regulars at the healers as kids, too. We had a bad habit of passing colds back and forth for weeks on end...

Brady: Oh, I remember! You were always sneezing green goo out yer bitty nose! Guess it ain't so strange for kids to get sick. Happens to all of 'em eventually. But sure did seem like you and me would always go down at the same time.

Noire: I remember lying in a cot across from you when we were both flush and feverish.

Brady: Hah! Yeah, you wouldn't stop bawlin'!

Noire: Oh, sure. Bring that up again!

Brady: Meanwhile, I was busy thinking of how I could toughen up. Guess some things never change, am I right?

Noire: I was always so scrawny. I wished there were some way to stop being frail...

Brady: Heh heh! And just look at us now! What a couple'a saps.

Noire: Still, it's...sort of comforting to know that some things really don't ever change.

Brady: All a matter of perspective, I guess. Seems likely we'll be neighbors here for a long time to come, yet. So, uh... Cheers, I guess.

Noire: Cheers. To the two of us getting stronger, bit by bit.

Brady: You said it, sister!

■ NOIRE X BRADY S

Brady: Urgh... Back to the tent of shame...

Noire: Ah! Brady, are you all right? What happened?

Brady: Just... Hngh! ...Just turned my half-busted shoulder into a whole-busted shoulder.

Noire: What?! You've got to be more careful when you're hurt! Here, lie down...

Brady: You're makin' a mountain outta some pretty small potatoes, Noire. ...So why you back in the sick house? Caught the dreaded red or somethin'?

Noire: I, um... I just came here to find something.

Brady: Then it's finally just us stuck in here. Hey, good for you!

Noire: Brady...

Brady: Naw, ain't nothin'. So don't go gettin' all sad on me! It's a good thing not to be a regular at the infirmary tent. You should be happy.

Noire: B-but...I think...

Brady: Hah! That's crazy talk. Why would you say that?

Noire: ...This is our place. You and me have a lot of memories in here at this point, Brady. Even today, the... The thing I was here looking for is...you. I was hoping I might run into you again, you know?

Brady: Ha ha! Man, you sure know how to make a guy feel like a million bucks! When the infirmary's the first place you look, boy, that's a ringing endorsement!

Noire: No, I didn't mean... There's no reason to be ashamed, Brady. I know what you're doing out there. I've seen you. You're always defending the others by putting yourself in danger. That's why you're always hurt.

Brady: You... You saw that?

Noire: I mean, sure, you're not the sturdiest man on the field... But you're braver than anyone and more selfless about protecting your allies! There's nothing shameful about that.

Brady:

Noire: ...Ah! I'm sorry! Listen to me blabbing on while you're injured! I'll go. You clearly need some rest.

Brady: Hold on. ...I guess I'd thought I'd been subtle about it. Guess I've got a ways to go.

Noire: You shouldn't have to hide it at all...

Brady: I've spent a lot of time in hospital beds, Noire. You know that better'n most. And I'd always spend my time thinking of how to be stronger. Like, how could I help more? And how could I... How could I keep the girl on the bed next to me safe? Because I loved her.

Noire: Oh, Brady.

Brady: I'm saying I love you, Noire! I'm in love with ya! Heck, I think you're the cat's pajamas! So, what say we maybe spend some time together outside of this place for once, when I'm better? I was thinking...forever?

Noire: I'd love to, Brady! Oh, I'm so happy, I feel like I'm walking on air!

Brady: Me, too! Though some of that's probably the healing magic kickin' in...

Nah

■ NAH X BRADY C

Nah: Ah! B-Brady!

Brady: Yeah? Whatcha want?

Nah: I don't, er... Nothing in particular.

Brady: Then why ya makin' eyes at me? You got something to say or what?

Nah: N-nothing!

Brady: Then what? Something wrong with you? You coming down with something?

Nah: N-no, nothing like that. I'm fine.

Brady: Well, you ain't ACTING fine. It's freaking me out! You don't go all quiet when you talk to any of the others.

Nah: That's not true! I'm fine, no it is, but... I'm not being quiet! I'm the same as always...

Brady: Sure, fine. Whatever.

Nah:

Brady: ...You scared of me? Is that it? I give ya the heebie-jeebies?

Nah: I'm not scared! Why would I be scared?! That's crazy talk! You're crazy!

Brady: Oh, really?

Nah: Y-yes, really... I'm not!

Brady: Well, whatever it is, I ain't sticking around so you can gawk. I'm gonna fade.

Nah: *Sigh* I j-just wanted to talk. When I see that face, though, I clam up... It's not my fault he looks so scary!

■ NAH X BRADY B

Brady: Nah! You all right?

Nah: B-Brady? I'm fine. Why wouldn't I be?

Brady: Uh, because you nearly drowned back there? You sure you're okay?

Nah: Absolutely. Really, I'm fine... Thanks to you. At least, I heard it was you who dove in and saved me. My memory is still pretty hazy.

Brady: Ugh, who told ya? I asked everybody not to make a big thing outta it...

Nah: But it is a big thing, Brady! Especially to me. So, thank you.

Brady: Aw, it was nothin'.

Nah: Nothing? I could have died!

Brady: Not sure how. That water was three feet deep, and that's bein' generous.

Nah: Augh... Please, don't remind me. I'm embarrassed half to death as it is.

Brady: What about me? I heard you shout for help, so I dove in thinkin' it was deep! Nearly telescoped my damn spine!

Nah:

Brady: But, hey, I guess we both pulled through. Just be careful in the future, yeah?

Nah: ...You're worried for me?

Brady: What? W-well, sure, Nah! We're on the same team, ain't we?

Nah: You're actually really sweet, you know that?

Brady: What? Where'd that come from?

Nah: I had you wrong. I thought you were colder. ...Scarier.

Brady: So you WERE scared of me! I knew it!

Nah: But not anymore! Now I know you're really a good, kindhearted person!

Brady: Gah, stop already! I ain't used to praise. It feels almost as weird to hear ya say that as it does you calling me scary!

Nah: Good people should be recognized as such. ...Which is why I'm making a point of telling everyone in camp what a sweetie you are.

Brady: Hey, hold on! You don't gotta be tellin' no one nothin', see?!

■ NAH X BRADY A

Brady: Um, Nah?

Nah: Yes, Brady?

Brady: Is it just me, or have you been following me around constantly the last few days? Did you, uh... need something?

Nah: Do I need something to be around you?

Brady: Are ya talkin' legally? 'Cause then I guess not.

Nah: Also, I'll be introducing myself as your little sister from now on. Just so you know.

Brady: Wait, what?

Nah: I always wanted a nice, protective older brother. I'd say rescuing me from drowning qualifies as nice and protective, no?

Brady: Yeah, but not as your brother!

Nah: Oh, don't worry. I'm sure you'll fall into the role with practice.

Brady: That's not the... Gah, I don't even...

Nah: Plus I still feel so terrible for thinking my poor, misunderstood brother was scary. I'll make it up to you from now on as your doting and adorable little sis!

Brady: I told ya! Ain't nothin' to make up for!

Nah: Every debt left unpaid is a threat to the stability of human-manakete relations.

Brady: That your overblown way of saying you're too stubborn to back down on this? ...Fine, then. Do what you want. But ditch the brother-sister stuff! Folks might get the wrong idea.

Nah: ...Oh, all right. It's a grave shame, but I'll concede the point.

Brady: Well, now that that's settled. See you around, Nah.

Nah: But I make no such concession with regards to following you around!

Brady: ...Uh, hold on just a second here.

Nah: I intend to stay by your side until I manage to repay my debt to you.

Brady: Y-yeah, but there's gotta be SOME exceptions! Right? Like, I don't really want ya following me where I'm headed now... It's deeply... I mean I expressly forbid ya from following me! Got it?!

Nah: What? Why?! Where are you going?

Brady: To take a bath!

Nah: Eep! S-sorry! I'll, um... I'll see you around, Brady!

NAH X BRADY S

Nah: So, where are we headed today, Brady?

Brady: "We" aren't headed anywhere. Were you really planning on following me around all day again?

Nah: Well, of course!

Brady: You don't think that's going a little far? Already told ya I release you from any debt you think you owe and all that malarkey.

Nah: Don't be silly. That's not why at all! It's only natural we should be together. We're a couple.

Brady: A couple of what? ...Er, and since when?

Nah: Well, we spend all this time together, but you say we're not siblings.

Brady: 'Cause we ain't! And what kind of crazy jump gets ya from there to being "a couple"?!

Nah: Haven't you felt all the envious looks around camp? The others can't help but long for the sort of passion we share!

Brady: Gah! Is that why everybody's been leering at me everywhere I go?

Nah: They are NOT leering! ...They're celebrating our beautiful union!

Brady: Ugh, I feel like I'm losing my mind here! There IS no beautiful union! And we ain't a "we"!

Nah: You don't have to shout. ...Do you really hate me that much?

Brady: I never said that!

Nah: Then let's get married!

Brady: Slow down, would ya? I need a little time to think here!

Nah: You're divorcing me?!

Brady: SLOW DOWN!

Nah: *Sniff* Used up and cast aside... Who will love poor Nah now?

Brady: Nobody used up anybody! Quit sayin' stuff what gives people funny ideas!

Nah: Oh! Honest?

Brady: I have the worst headache of my life right now...

Nah: Don't overexert yourself, Brady! You're in no condition to weather needless stress. Please, I'm too young to be a widow!

Brady: Just... Can I have a minute here? A quiet one?

Nah: Don't worry, darling. If it comes to that, I'll use a dragonstone to transfer my own life force to you.

Brady: ...Is that a thing? I didn't know you could do that.

Nah: I've never tried it myself, but I heard my mother talk about it. She said it was the stone's true power. ...Probably?

Brady: What was she, guessing?!

Nah: Even if she were, I'll make it work. I'm prepared to give you half of my life. That's what love means to me.

Brady: Cheese and peanuts, this manakete love is heavy! ...Still, it feels pretty good to know someone cares that much.

Nah: Then let's tell everyone the ceremony's tonight! I always wanted to be an eight o'clock bride!

Brady: Er, there ain't no chance I'm getting you to slow down on this, is there?

 Father

FATHER X BRADY C

Brady: Tea's ready. It's the, uh... The whatsit kind. From that place. You know, the expensive junk.

[Robin]: Um...
Chrom: Um...
Frederick: Um...
Virion: Um...
Vaike: Um...
Stahl: Um...
Kellam: Um...
Lon'qu: Um...
Ricken: Um...
Gaius: Um...
Gregor: Um...
Libra: Um...
Henry: Huh...?
Donnel: Um...

Brady: Well...? Whaddya waitin' for? A royal invitation? It's all set and ready to go—just the way ya like it.

[Robin]: Uh, Brady?
Chrom: Uh, Brady?
Frederick: Er, Brady?
Virion: Uh, Brady?
Vaike: Uh, Brady?
Stahl: Uh, Brady?
Kellam: Uh, Brady?
Lon'qu: That's...not the problem.
Ricken: Uh, Brady?
Gaius: Uh, Brady?
Gregor: Uh, Brady?
Libra: Uh, Brady?
Henry: Uh, Brady?
Donnel: Uh, Brady?

Brady: Let's step it up, old-timer! Tea ain't gettin' any hotter!

[Robin]: Oh, right. S-sorry... *sip* ...But, Brady?
Chrom: Oh, right. S-sorry... *sip* ...But, Brady?
Frederick: Oh, right. S-sorry... *sip* ...But, Brady?
Virion: Uh, right. S-sorry... *sip* ...But, Brady?

Vaike: Oh, right. S-sorry... *sip* ...But, Brady?
Stahl: Oh, right. S-sorry... *sip* ...But, Brady?
Kellam: Oh, right. S-sorry... *sip* ...But, Brady?
Lon'qu: Fine... *sip* ...Now, Brady?
Ricken: Oh, right. S-sorry... *sip* ...But, Brady?
Gaius: Oh, right. S-sorry... *sip* ...But, Brady?
Gregor: Oh, right. S-sorry... *sip* ...But, Brady?
Libra: Oh, right. S-sorry... *sip* ...But, Brady?
Henry: Well, all right... *sip* ...Sooo, Brady?
Donnel: Oh, right. S-sorry... *sip* ...But, Brady?

Brady: Yeah?

[Robin]: What did you mean, "just the way I like it"? I hardly ever drink tea.
Chrom: What did you mean, "just the way I like it"? I hardly ever drink tea.
Frederick: What did you mean, "just the way I like it"? I hardly ever drink tea.
Virion: What's with the sudden tea obsession? Isn't this a bit out of the blue?
Vaike: What did ya mean, "just the way I like it"? The Vaike hardly ever drinks tea.
Stahl: What did you mean, "just the way I like it"? I hardly ever drink tea.
Kellam: What did you mean, "just the way I like it"? I hardly ever drink tea.
Lon'qu: What did you mean, "just the way I like it"? I hardly ever drink tea.
Ricken: What did you mean, "just the way I like it"? I hardly ever drink tea.
Gaius: What did you mean, "just the way I like it"? I hardly ever drink tea.
Gregor: Why we sip tea in middle of afternoon like rich man with many servants?
Libra: What did you mean, "just the way I like it"? I'm not much of a tea drinker...
Henry: What did you mean, "just the way I like it"? I hardly ever drink tea.
Donnel: Why'd ya say "just the way I like it"? I hardly ever drink tea.

Brady: Whaddya mean? You drink it every day. You never miss teatime.

[Robin]: I've had the odd cup here or there, but I don't recall ever having "teatime."
Chrom: I've had the odd cup here or there, but I've never had a "teatime" in my life.
Frederick: I've had the odd cup here or there, but I've never had a "teatime" in my life.
Virion: Hah! I enjoy a spot of tea as much as the next man, but I've never done "teatime."
Vaike: Hey, I got nothin' against tea, but I've never had a "teatime" in my life.
Stahl: I've had the odd cup here or there, but I don't recall ever having "teatime."
Kellam: I've had the odd cup here or there, but I don't recall ever having "teatime."
Lon'qu: I've had the odd cup here or there, but I've never had a "teatime" in my life.
Ricken: I've had the odd cup here or there, but I don't recall ever having "teatime."
Gaius: Er, I've had the odd cup here or there, but I've never had a "teatime" in my life.
Libra: I've had the odd cup here or there, but I've never had a "teatime" in my life.
Henry: Nya ha! I've had the odd cup here or there, but I've never had a "teatime" in my life.
Donnel: Shucks, I've had the odd cup here'n there, but I ain't never had "teatime" in m'life.

Brady: ...WHAT?! Ma told me to join ya in your daily tea ritual! Even gave detailed instructions! Wait... Did she make it all up?

[Robin]: Considering I don't even know what a "tea ritual" is, I'm guessing she did.
Chrom: Considering I don't even know what a "tea ritual" is, I'm guessing she did.
Frederick: Considering I don't even have a "daily tea ritual," I suppose she did.
Virion: Considering I don't even have a "daily tea ritual," I suppose she did.
Vaike: Considerin' I don't even know what a "tea ritual" is, I'm guessin' she did.
Stahl: Considering I don't even know what a "tea ritual" is, I'm guessing she did.
Kellam: Considering I don't even know what a "tea ritual" is, I suppose she did.
Lon'qu: Considering I don't even know what a "tea ritual" is, I'm guessing she did.
Ricken: Considering I don't even know what a "tea ritual" is, I'm guessing she did.
Gaius: Considering I don't even know what a "tea ritual" is, I'm guessing she did.
Gregor: Gregor not even know what "tea ritual" means, so...guessing, yes.
Libra: Considering I don't even know what a "tea ritual" is, I suppose she did.
Henry: Considering I don't even know what a "tea ritual" is, I'm guessing she did.
Donnel: Welp, I reckon she must've, 'cause I don't even know what a "tea ritual" is.

Brady: That dirty... I bet she's laughing her head off right about now!

[Robin]: Er, what exactly did she tell you?
Chrom: Er, what exactly did she tell you?
Frederick: ...What exactly did she tell you?
Virion: Er, what exactly did she tell you?
Vaike: Er, what exactly did she tell you?

Stahl: Er, what exactly did she tell you?
Kellam: Er, what exactly did she tell you?
Lon'qu: Er, what exactly did she tell you?
Ricken: Sooo, what exactly did she tell you?
Gaius: So what exactly did she say about you?
Gregor: What other lies did she tell Gregor? Come, spill the bean!
Libra: Er, what exactly did she tell you?
Henry: Er, what exactly did she tell you?
Donnel: Er, what exactly did she tell ya?

Brady: Oh, don't you worry. I'm gonna have me a nice, long chat with dear ol' Ma! You just sit there and drink your damn tea. So long, old-timer!

Brady: ...Oh, and set this on top of the pot. It keeps the tea warm.

[Robin]: ...When did my life get so weird?
Chrom: ...When did my life get so weird?
Frederick: ...When did my life get so strange?
Virion: ...When did my life get so strange?
Vaike: ...When did my life get so weird?
Stahl: ...When did my life get so weird?
Kellam: ...When did my life get so weird?
Lon'qu: ...When did my life get so weird?
Ricken: ...When did my life get so weird?
Gaius: ...When did my life get so weird?
Gregor: ...Gregor's life become very strange as of late, yes?
Libra: ...When did my life get so odd?
Henry: Nya ha! When did my life get so weird?
Donnel: ...Since when did my life get so strange?

FATHER X BRADY B

Brady: Sorry about last time, old-timer.

[Robin]: What, the tea? Hardly something to apologize for. I was happy for the chance to chat.
Chrom: What, the tea? Hardly something to apologize for. I was happy for the chance to chat.
Frederick: What, the tea? Hardly something to apologize for. I was happy for the chance to chat.
Virion: What, the tea? Hardly something to apologize for. I was happy for the chance to chat.
Vaike: What, the tea? Aw, ain't nothin' to apologize for. Ol' Vaike was happy for the chance to chat!
Stahl: What, the tea? Hardly something to apologize for. I was happy for the chance to chat.
Kellam: What, the tea? You don't need to apologize for that. I was happy for the chance to chat.
Lon'qu: What, the tea? Hardly something to apologize for. I was glad for the chance to chat.
Ricken: What, the tea? That's not something you need to apologize for. I was happy for the chance to chat.
Gaius: What, the tea? You don't need to apologize for that. I was glad for the chance to chat.
Gregor: What, the tea? Do not make with the apologizing! Gregor was happy for chance to talk.
Libra: What, the tea? Hardly something to apologize for. I was happy for the chance to chat.
Henry: What, the tea? Come on, you don't have to apologize for that! I was happy for the chance to chat.
Donnel: What, the tea? Shucks, that ain't nothin' to apologize for. I was happy for the chance to jaw.

Brady: Well, good. But I still feel bad you wound up drinking alone. Anyway, I brought my violin by way of apologizin'.

[Robin]: ...I'm sorry?
Chrom: ...I'm sorry?
Frederick: ...I'm sorry?
Virion: ...I'm sorry?
Vaike: ...I'm sorry?
Stahl: ...Sorry?
Kellam: ...I'm sorry?
Lon'qu: ...Sorry?
Ricken: ...I'm sorry?
Gaius: ...Sorry?
Libra: ...I'm sorry?
Henry: ...Sorry?
Donnel: ...I'm sorry?

Brady: Yeah, exactly. I wanna say I'm sorry, and I heard that requires a violin performance.

[Robin]: It...does?
Chrom: It...does?
Frederick: It...does?
Virion: It...does?
Vaike: It...does?
Stahl: It...does?
Kellam: It...does?
Lon'qu: It...does?
Ricken: It...does?
Gaius: It...does?
Gregor: Is true? Gregor has not heard of this custom...
Libra: It...does?
Henry: It...does?
Donnel: It...does?

Brady: What, were ya born in a barn? Course it does! I gotta tickle the catgut for three songs, then do a backflip. That's when you stand up and start clappin' and cheerin' and throwin' roses. ...Er, at least, that's what Ma said.

[Robin]: Brady, listen to me. No one has ever apologized to me that way before. ...EVER. Your mother's having fun with you again.
Chrom: Brady, listen to me. No one has ever apologized to me that way before. ...EVER. Your mother's having fun with you again.
Frederick: Brady, listen to me. No one has ever apologized to me that way before. ...EVER. Your mother's having fun with you again.
Virion: Brady, listen to me. No one has ever apologized to me that way before. ...EVER. Your mother's having fun with you again.
Vaike: Brady, listen to me. I ain't never had anyone apologize to me that way before. ...EVER. Your mother's havin' fun with you again.
Stahl: Brady, listen to me. No one has ever apologized to me that way before. ...EVER. Your mother's having fun with you again.
Kellam: Brady, listen to me. No one has ever apologized to me that way before. ...EVER. Your mother's having fun with you again.
Lon'qu: Brady, listen to me. No one has ever apologized to me that way before. ...EVER. Your mother's messing with you again.
Ricken: Brady, listen to me. No one has ever apologized to me that way before. ...EVER. Your mother's having fun with you again.
Gaius: Brady, listen to me. No one has ever apologized to me that way before. ...EVER. Your mother's having fun with you again.
Gregor: Brady, listen to Gregor. No one ever apologize to Gregor like that before. Not ever. Your mother is making the fun with you again.
Libra: Brady, listen to me. No one has ever apologized to me that way before. ...EVER. Your mother's having fun with you again.
Henry: Nya ha ha! Brady, listen up... No one has ever apologized to me that way before. ...EVER. Your mother's just having fun with you again.
Donnel: Brady, listen up and listen good. Ain't no one EVER apologized to ol' Donny like that 'fore. I think yer ma's havin' some fun with ya again.

Brady: What, AGAIN?! Oh, that tears it! I'm gonna—

[Robin]: Brady, wait.
Chrom: Brady, wait.
Frederick: Brady, wait.
Virion: Brady, wait.
Vaike: Brady, wait.
Stahl: Brady, wait.
Kellam: Brady, wait...
Lon'qu: Brady, wait.
Ricken: Brady, wait.
Gaius: Brady, wait.
Gregor: Brady, wait.
Libra: Brady, wait.
Henry: Brady, wait.
Donnel: Brady, wait.

Brady: What?!

[Robin]: As long as you're here, let's just enjoy a nice chat and forget about Maribelle. I'm almost thankful, really. If not for her japes, you'd probably never have come by.
Chrom: As long as you're here, let's just enjoy a nice chat and forget about Maribelle. I'm almost thankful, really. If not for her japes, you'd probably never have come by.
Frederick: As long as you're here, let's just enjoy a nice chat and forget about Maribelle. I'm almost thankful, really. If not for her japes, you'd probably never have come by.
Virion: As long as you're here, let's just enjoy a nice chat and forget about Maribelle. I'm almost thankful, really. If not for her japes, you probably wouldn't have come by.
Vaike: As long as you're here, let's just hang out and forget about Maribelle for a while. I'm kinda thankful, really. If not for her games, you wouldn't have come by!
Stahl: As long as you're here, let's just enjoy a nice chat and forget about Maribelle. I'm almost thankful, really. If not for her japes, you'd probably never have come by.
Kellam: As long as you're here, let's just enjoy a nice chat and forget about Maribelle. I'm almost thankful, really. If not for her japes, you'd probably never have come by.
Lon'qu: As long as you're here, let's chat a bit. Forget about Maribelle for a while. I'm grateful to her, though. If not for her japes, you probably wouldn't be here.
Ricken: As long as you're here, let's just enjoy a nice chat and forget about Maribelle. I'm almost thankful, really. If not for her japes, you'd probably never have come by.
Gaius: As long as you're here, let's just enjoy a nice chat and forget about Maribelle. I'm grateful, really. If not for her japes, you'd never have come by.
Gregor: As long as you're here, let us enjoy nice chat and forget about Maribelle. After all, if not for her terrible lies, you probably not come visit Gregor, yes?
Libra: As long as you're here, let's just enjoy a nice chat and forget about Maribelle. I'm almost thankful, really. If not for her japes, you probably wouldn't have come by.
Henry: As long as you're here, let's just have a nice chat and forget about Maribelle. I mean, if not for her crazy stories, you probably wouldn't have come by, right?
Donnel: Long as yer here, let's you and me jaw a spell and just forget about yer ma. Heck, if it wasn't for her japes, I reckon you'd have never come by.

Brady: Forget Ma? But she's been playing me like a dancin'-monkey organ guy! Aw, heck. Fine. I guess I can put up with her horseplay a bit longer... It'd be nice to just sit back and chew the fat a bit.

[Robin]: It's settled then! Pull up a seat...
Chrom: It's settled then! Pull up a seat...
Frederick: It's settled then. Pull up a seat...

Virion: It's settled then! Pull up a seat...
Vaike: Great! Pull up a seat!
Stahl: It's settled then! Pull up a seat...
Kellam: It's settled then! Pull up a seat...
Lon'qu: Good. Pull up a seat.
Ricken: It's settled then! Pull up a seat...
Gaius: It's settled then! Pull up a seat...
Gregor: Is wonderful! Come, pull up seat...
Libra: It's settled then! Pull up a seat...
Henry: Great! Pull up a seat!
Donnel: Well, ain't that a kick! Now pull up a seat...

FATHER X BRADY A

Brady: And then Ma pulls out that li'l umbrella of hers, and she says—

[Robin]: Heh heh...
Chrom: Heh heh...
Frederick: Heh heh...
Virion: Heh heh...
Vaike: Heh heh...
Stahl: Heh heh...
Kellam: Heh heh...
Lon'qu: Heh heh...
Ricken: Heh heh...
Gaius: Heh heh...
Gregor: Heh heh...
Libra: Heh heh...
Henry: Nya ha ha!
Donnel: Heh heh... Yer ma sure does love playin' with ya...

Brady: ...What are ya laughing for? I ain't even at the punchline yet.

[Robin]: I'm just glad we're able to talk like this, Brady. I'll admit, I was a little shocked when I first saw you. You seemed a bit...scary.
Chrom: I'm just glad we're able to talk like this, Brady. I'll admit, I was a little shocked when I first saw you. You seemed a bit...scary.
Frederick: I'm just glad we're able to talk like this, Brady. I'll admit, I was a little shocked when I first saw you. You seemed...frightening.
Virion: I'm just glad we're able to talk like this, Brady. I'll admit, I was a little shocked when I first saw you. You seemed a bit...scary.
Vaike: I'm just glad we're able to shoot the breeze like this, Brady. I gotta admit, I was kinda shocked when I first saw ya. Ya seemed a little...scary.
Stahl: I'm just glad we're able to talk like this, Brady. I'll admit, I was a little shocked when I first saw you. You seemed a bit...scary.
Kellam: I'm just glad we're able to talk like this, Brady. I'll admit, I was a little shocked when I first saw you. You seemed a bit...scary.
Lon'qu: I'm just glad we're able to talk like this, Brady. I must admit, I was unsure of you when first we met.
Ricken: I'm just glad we're able to talk like this, Brady. I'll admit, I was kind of shocked when I first saw you. You seemed pretty scary.
Gaius: I'm just glad we're able to talk like this, Brady. I'll admit, I was a little shocked when I first saw you. You seemed kinda...scary.
Gregor: Gregor is just happy we are able to have nice chitchat like this, Gregor admit, when he first saw you, you seemed...very frightening.
Libra: I'm just glad we're able to talk like this, Brady. I'll admit, I was a little shocked when I first saw you. You seemed...scary.
Henry: Aw, I'm just glad we're able to talk like this, Brady. I gotta admit, I was a little weirded out the first time we met.
Donnel: I'm just glad you and me are able to talk like this, Brady. I admit, first time I saw ya, I was... Well, ya scared me somethin' fierce.

Brady: Yeah, well. Sorry I'm all scary. I guess if you don't like it, do a better job raising the real deal.

[Robin]: What, you mean the Brady from this era?
Chrom: What, you mean the Brady from this era?
Frederick: What, you mean the Brady from this era?
Virion: What, you mean the Brady from this era?
Vaike: What, ya mean the Brady from this era?
Stahl: What, you mean the Brady from this era?
Kellam: What, you mean the Brady from this era?
Lon'qu: What, you mean the Brady from this era?
Ricken: What, you mean the Brady from this era?
Gaius: What, you mean the Brady from this era?
Gregor: You mean Brady from this time?
Libra: What, you mean the Brady from this era?
Henry: What, you mean the Brady from this era?
Donnel: What, ya mean the Brady from this era?

Brady: Yeah. I ain't your real son, anyway. I mean, not exactly.

[Robin]: Brady, I...
Chrom: Brady, I...
Frederick: Brady, I...
Virion: Brady, I...
Vaike: Brady, I...
Stahl: Brady, I...
Kellam: Brady, I...
Lon'qu:
Ricken: Brady, I...
Gaius: Brady, I...
Gregor: Brady...
Libra: Brady...

Henry: Brady, I...

Donnel: Brady, I...

Brady: Aw, what? What's with that face? I don't need no pity. Unlike some of the other kids, I ain't jealous of the Brady from this timeline. We're two different cars, yeah? No hard feelings. Once the real one's born, you can forget about me. I'll bow out all graceful-like.

[Robin]: Brady, how can you say that after we've gotten so close? You think I'd just cast you aside once my son is born? I would never do that. You're my friend, Brady. ...And my son.

Chrom: Brady, how can you say that after we've gotten so close? You think I'd just cast you aside once my son is born? I would never do that. You're my friend, Brady. ...And my son.

Frederick: Brady, how can you say that after we've gotten so close? You think I'd just cast you aside once my son is born? I would never do that. You're my friend, Brady. ...And my son.

Virion: Brady, how can you say that after we've gotten so close? You think I'd just cast you aside once my son is born? I would never do that. You're my friend, Brady. ...And my son.

Vaike: How can you say that after we've gotten so close? You think I'd just cast ya aside once my son's born? I'd never do that! You're my friend, Brady. ...And my son. The Son of Vaike!

Stahl: Brady, how can you say that after we've gotten so close? You think I'd just cast you aside once my son is born? I would never do that. You're my friend, Brady. ...And my son.

Kellam: Brady, how can you say that after we've gotten so close? You think I'd just cast you aside once my son is born? I would never do that. You're my friend, Brady. ...And my son.

Lon'qu: How can you say that after we've gotten so close? You think I'd just cast you aside once my son is born? I would never do that. You're my friend, Brady. ...And my son.

Ricken: Brady, how can you say that after we've gotten so close? You think I'd just cast you aside once my son is born? I would never do that. You're my friend, Brady. ...And my son.

Gaius: Brady, how can you say that after we've gotten so close? You think I'd just cast you aside once my son is born? I would never do that. You're my friend, Brady. ...And my son.

Gregor: Brady, you break poor Gregor's heart when you say such things. Gregor would never cast son aside like moldy sandwich. You are Gregor's friend, Brady. ...And my son.

Libra: Brady, how can you say that after we've gotten so close? You think I'd just cast you aside once my son is born? I would never do that. You're my friend, Brady. ...And my son.

Henry: Hey! How can you say that after we've gotten so close? You think I'd just cast you aside once my son is born? I'd never do that! You're my friend, Brady. AND my son!

Donnel: Brady, how can ya say that after we done got so close? Ya think I'd just cast ya aside once m'son is born? I would never! Yer my friend, Brady. ...And my son.

Brady: Pop, I... *sniff* Aw, damn. I'd decided not to cry, and then ya go and say crap like that... *sniffle* I was lyin' about what I said before, Pop! It does matter to me! Please don't forget me! Just...remember that we were good pals once, yeah? Real chums.

[Robin]: I could never forget you, Son. I'll remember you till the day I die and love you as my future self would.

Chrom: I could never forget you, Son. I'll remember you till the day I die and love you as my future self would.

Frederick: I could never forget you, Son. I'll remember you till the day I die and love you as my future self would.

Virion: I could never forget you, Son. I'll remember you till the day I die and love you as my future self would.

Vaike: I could never forget ya, Son. I'll remember ya till the day I die and love you as my future self would.

Stahl: I could never forget you, Son. I'll remember you till the day I die and love you as my future self would.

Kellam: I could never forget you, Son. I'll remember you till the day I die and love you as my future self would...

Lon'qu: I could never forget you, Son. I'll remember you till the day I die and love you as my future self would.

Ricken: Of course! I could never forget you. I'll remember you till the day I die and love you as my future self would.

Gaius: I could never forget you, Son. I'll remember you till the day I die and love you as my future self would.

Gregor: Gregor could never forget you, Son. Gregor will remember you until day he die horrible death!

Libra: I could never forget you, Son. I'll remember you until the gods call me home and love you as my future self would.

Henry: Aw, I could never forget you, Son. I'll remember you until the day I die a horrible, bloody death! Oooooo... Bloooooood!

Donnel: Gosh, I couldn't forget ya if I tried. I'll remember ya till the day they roll me in the shroud, Son.

Brady: Okay, no more talk of dyin'. If you boots up before me, I'll douse your grave in more tea than ya can stand. I'll play my violin and do a backflip if I have to. Don't try me, old-timer!

[Robin]: Well then, it's settled. Guess your pop can't very well die now, can he?

Chrom: Well then, it's settled. Guess your pop can't very well die now, can he?

Frederick: Well then, it's settled. Guess your pop can't very well die now, can he?

Virion: Well then, it's settled. Guess your pop can't very well die now, can he?

Vaike: Don't you worry, kid. Teach ain't goin' anywhere anytime soon!

Stahl: Well then, it's settled. Guess your pop can't very well die now, can he?

Kellam: Well then, it's settled. Guess your pop can't very well die now, can he?

Lon'qu: I suppose I'd better live, then...

Ricken: Well then, it's settled. Guess your pop can't very well die now, can he?

Gaius: Then it's settled. Guess your pop can't very well die now, can he?

Gregor: Oy! Sound like Gregor had better stay very much alive, then...

Libra: Hah! Then I suppose it's settled. I can't very well die now, can I?

Henry: Nya ha! Then it's settled. Guess I've got no choice but to stick around!

Donnel: Well, guess that settles that. Reckon I can't just go and die now!

Kjelle

Avatar (male)

The dialogue between Avatar (male) and Kjelle can be found on page 225.

Avatar (female)

The dialogue between Avatar (female) and Kjelle can be found on page 236.

Sully (Mother/daughter)

Kjelle's mother/daughter dialogue with Sully can be found on page 254.

Lucina

The dialogue between Lucina and Kjelle can be found on page 282.

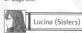
Lucina (Sisters)

The sisters dialogue between Lucina and Kjelle can be found on page 282.

Owain

The dialogue between Owain and Kjelle can be found on page 287.

Inigo

The dialogue between Inigo and Kjelle can be found on page 290.

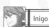
Brady

The dialogue between Brady and Kjelle can be found on page 294.

Severa

■ SEVERA X KJELLE C

Kjelle: Whew! I beat today...

Severa: Does tired equal sloppy in your world? Because your shirt is coming unbuttoned. And I know you're sweaty from combat or whatever, but oh my gosh. ...Ew.

Kjelle: Har! A little skin isn't going to kill anybody. Besides, this area's off limits to the men. And it's not like it's something you haven't seen before.

Severa: That doesn't mean I WANT to see it! Gods, would it kill you to act like a lady once in a while?

Kjelle: At least I enough of a lady to mind my manners and not stare!

Severa: I'm pointing this out for your own sake!

Kjelle: Hah! I've never cared about stuff like this, and you know it.

Severa: It's one thing for a child to be a tomboy, Kjelle, but you're a grown woman now! Augh! Now I can see your stomach! Really, have a little... Wow. Those are serious abs, Kjelle. I should do my laundry on them. No wonder you walk around with your shirt hanging off...

Kjelle: It's not "hanging off." I just untucked it! ...And why the compliment, anyway?

Severa: I...I don't know! It just kind of popped out of my mouth.

Kjelle: You don't have the hots for me or something, do you?

Severa: Hah! You couldn't handle me for an hour, and you know it! I'm just a little jealous is all. You're pretty, yet still so tough and strong.

Kjelle: Well, looking is free, I guess. Knock yourself out.

Severa: Gods, Kjelle! Seriously, could you try and not act like a boor for five minutes?

Kjelle: You compliment me left and right, and then you want me to be more modest? So what should I do? Flee in terror anytime a girl catches a glimpse of my belly?

Severa: That's the general idea, yes. A proper lady never shows skin above the ankles and below the neck. A proper lady understands that less is more!

Kjelle: ...Girls care about the dumbest things sometimes.

Severa: Hello? YOU'RE a girl!

■ SEVERA X KJELLE B

Severa: Augh!

Kjelle: What'll I do now, Severa?

Severa: Don't just drop your old clothes on the floor when you undress!

Kjelle: What, are you worried someone's going to trip?

Severa: No! I mean, yes! ...I mean, that is so not the point of this conversation! We've spoken about this before, remember? Your utter lack of femininity and decorum! You're acting like a crusty old roustabout!

Kjelle: Being a roustabout is honest work. Without them, ships couldn't sail or—

Severa: That is so totally not the point of what I'm saying! ...It was a metaphor. I meant that you act and sound like a ruffian! A male ruffian! *Sigh* All right. I can see I'm going to have to step in here. Since you're apparently hopelessly ignorant of even basic beauty tips, I'll teach you. We'll begin with makeup. I trust you're at least familiar with the concept?

Kjelle: ...I've heard of it, yes.

Severa: Well then, today is your first lesson! Just come over here to my vanity... Now then! The first step is to build a nice foundation that can—

Kjelle: I'm not letting you put this pasty goop on my face, if that's what you're thinking.

Severa: Of course not. ...YOU'RE going to put it on your face! You'll never learn otherwise, right? Now come on! Chop-chop!

Kjelle: ...Wow. That was really, really horrific. Maybe a little demonstration would have been in order after all.

Severa: Makeup should accent and flatter the features, Kjelle. Not act as a disguise. You looked like you were preparing to rob the royal treasury!

Kjelle: Accent? Disguise? What's the difference? They both just hide who you are.

Severa: No need to be hostile, dear. Let's set cosmetics aside for the time being. A woman's charm is the sum of a thousand tiny, yet deliberate, gestures. She does not run roughshod around the camp like an overburdened pack animal. She glides as she walks, using light and nimble steps!

Kjelle: Like, uh... This? *stomp* *tromp* *kerplunk*

Severa: No, no, no! Graceful, Kjelle! Graceful! Be like a peaceful forest stream! One step flows into the next! Arms, too, are easy and fluid! ...Unclench that fist! Eye contact is critical, but do not stare. A demure glance and smile are sufficient. ...Now brushing back your hair must be a conscious, calculated action. ...No! Not like that! TOSS the hair, Kjelle! Don't ruffle it like an old hound's scruff!

Kjelle: I'm never going to remember all of this.

Severa: You will if I make you! With proper training and patience, I'll make you a lady yet!

Kjelle: I'd rather you let me get back to training that actually matters. We're trying to win a war, not a damn beauty pageant!

SEVERA X KJELLE A

Kjelle: Er... G-good afternoon, Severa. You're...looking well?

Severa: Better. Not great. ...Or good, really. But better. Now you need to focus on the delivery. In time, it will be fluid and natural. Still, I suppose I should thank the gods you've come even this far.

Kjelle: If it makes you feel better, I'm tripping less in those absurd shoes you gave me. Oh, and I combed my hair this morning. One hundred strokes exactly.

Severa: And it looks lovely!

Kjelle: There's just so much to remember... I'm always sure I'm forgetting something. I guess it's just good that I'm improving.

Severa: As you will continue to do, I'm sure! Plus, you have the advantage of being naturally beautiful.

Kjelle: Well, um... Thanks, I guess.

Severa: Wait? Is there something on my hands? You keep staring.

Kjelle: Your fingers are so long and pretty. I don't know how I didn't notice before.

Severa: Kjelle! Now THAT is a very sweet and ladylike compliment! I'm so proud of you right now!

Kjelle: Does that mean I pass?

Severa: Pass? You're going to be valedictorian! I hereby name you a graduate of Severa's Finishing School for Warrior Ladies!

Kjelle: Heh heh. Warrior ladies. Oh, that's rich. That's... ...Uh-oh.

Severa: What is it?

Kjelle: I've been so focused on remembering what you taught me, I think I forgot other stuff! ...Oh, gods! I don't remember how to fight!

Severa: What?!

Kjelle: Ack! I'm trying, but nothing's coming back! It's all a big blank! Which end of a sword do you hold? It's the pointy end, right? ...OUCH! Dammit! Wrong end! I knew this girly stuff was a bad idea!

Severa: W-well, worry not, dear. I'm here to help. We'll enroll you in Severa's Combat Class for Lady Warriors next.

Kjelle: You'd better hope I've forgiven you by the time I graduate!

Severa: Just don't go and forget how to act like a lady this time! You'll thank me once this war is over and you're on the prowl for love!

Kjelle: Would you get started already? I can feel my muscles disappearing!

Gerome

■ GEROME X KJELLE C

Kjelle: ...Good. I think that's enough lance practice for today. It will be difficult, but I shall master every weapon in our arsenal. Only then will I be the best and most powerful fighter on the battlefield!

Gerome: ...Ahem.

Kjelle: Are you spying on my practice sessions? Because I find that thought disturbing!

Gerome: No. I just happened to notice you as I was passing by. That's all.

Kjelle: Then keep passing by until I can't see you anymore!

Gerome: All right.

Kjelle: Ta-ta, then.

Gerome: ...Oh, there's just one thing I wanted to say.

Kjelle: What is it?

Gerome: When thrusting with the lance, you should push with your leg and stomach muscles. You used only your arms just now. That technique will betray you in battle.

Kjelle: L-look, I was... That is to say... I was just about to fix that! ...And you were spying on me, weren't you?

Gerome: I'll leave you to it, then.

Kjelle: Oh, that man is insufferable!

■ GEROME X KJELLE B

Gerome: Hello, Kjelle. More weapon work today?

Kjelle: I must be ever vigilant with my training and fitness. A soldier must always be in top condition if she is to survive the rigors of war.

Gerome:

Kjelle: Gods, those meaningful silences of yours are very annoying. ...Anyway, what do you think of my lance work? I fixed that problem you mentioned.

Gerome: Much better. You now place your whole body behind the thrust.

Kjelle: See? I told you I would fix it. In fact, just before you—

Gerome: However, your footwork is lacking.

Kjelle: What's wrong with it?

Gerome: You're throwing too much weight into the thrust and becoming unbalanced. It's a common enough mistake. More practice should fix the problem.

Kjelle: Grrr...

Gerome: You sound displeased.

Kjelle: It's all right for you, isn't it?!

Gerome: I'm not following.

Kjelle: No matter how hard I work or how much I practice and train, I'll never beat you!

Gerome: I wasn't aware that was a consideration.

Kjelle: Don't play dumb! You look down on me because I'm a woman, don't you? The fact that I'll never be as good as you justifies the prejudice in your own mind!

Gerome: Don't be absurd. I'm just offering advice.

Kjelle: Well, I need to get back to my practice, so advise someone else!

Gerome: As you wish. Keep up the training.

Kjelle: Arrrgh! I don't need you to tell me that, you patronizing know-it-all! ...That does it. Next time, I'm going to be perfect just to shut you up!

■ GEROME X KJELLE A

Kjelle: Hello, Gerome.

Gerome: Oh, hello. I was just passing by randomly and thought— Oh, are you training? Forgive me.

Kjelle: Liar! I saw you skulking in the shadows. You were trying to spy on me again!

Gerome: ...It's true.

Kjelle: It is?!

Gerome: I know I shouldn't, but I was curious. I had to see how you were progressing since our last conversation.

Kjelle: Well, to be honest, I did want to show you something...

Kjelle: Nnnnnnnnngh...

Kjelle: Hiyaaah!

Kjelle: What do you think? Not bad, eh?

Gerome: Flawless. I would change nothing.

Kjelle: Yes! You finally admitted I can do something right!

Gerome: ...I'm surprised you're so thrilled to gain my approval. Aren't you putting too much stock in one man's opinion?

Kjelle: When we were children, I decided that you would be my eternal rival... And I've been playing catch-up ever since! I've never been able to do anything that was good enough for you...until today! THAT is why I'm excited!

Gerome: In that case, it appears I have been negligent.

Kjelle: What do you mean?

Gerome: If I am your rival, then I must begin training with renewed intent. If you will excuse me.

Kjelle: I knew picking you as a rival was the right decision! Of course, now that I've inspired you to train more, I have to do the same.

Gerome: I would expect no less from my rival. Best of luck to you.

Kjelle: And to you!

■ GEROME X KJELLE S

Gerome: Hah! Kiya! Aaaaaand, YAAAH! ...Yes. That felt right.

Kjelle: Looks like someone's hard work is paying off.

Gerome: Kjelle! ...I didn't know you were there.

Kjelle: Hah, not such a pleasant feeling being spied upon, is it?

Gerome: Oh, I don't mind. ...If it's just for a while. So, what did you think? See anything that needs work?

Kjelle: You were flawless as ever, Gerome! I thought I was closing the gap, but I've clearly got a long way to go.

Gerome: ...Good. I feared that I was no longer worthy to be your champion.

Kjelle: Er, that's "rival." Not "champion."

Gerome: How could I claim to be protecting you, if you were the stronger of us? It would be nonsense.

Kjelle: I really think you misunderstand the purpose of a rival.

Gerome: It was you who drove me to hone my martial skills with such single-minded dedication. If I neglected my training, even briefly, you would end up having to protect me. And I...could not allow that.

Kjelle: Now hold on a damn minute, is it because I'm a—

Gerome: When it comes to skill with weapons, I will never allow you to best me. For I have sworn an oath... to protect you for as long as I humanly can.

Kjelle: Oh, Gerome... That is... That is... Completely unacceptable!

Gerome: What?

Kjelle: Did you ever consider that maybe I want to protect you? Or that I also swore an oath? That the reason I train so hard is so I might one day keep you safe from harm? ...Look. Maybe we can do it together. Train. Grow strong? Then we'll both be powerful enough to protect each other. Would that be so bad?

Gerome: ...Mmmm...I could accept this arrangement.

Kjelle: Then it's time to start training for real!

Gerome: ...Oh. I'll leave you to it then.

Kjelle: ...I mean together, Gerome! We train together!

Gerome: Ah. Right! Of course! Suppose I'll just...join you then.

Morgan (male)

■ MORGAN (MALE) X KJELLE C

Morgan (male): Is this another training day for you, Kjelle?

Kjelle: ...Every day is a training day.

Morgan (male): Man, that armor must weigh a ton! Can I help you carry anything?

Kjelle: To stay adaptable, I train with every kind of weapon and armor I can find. Sometimes all at once. ...So believe me, I'm fine.

Morgan (male): I guess that explains why you're so much stronger than other girls! ...Er, and guys. I'd barely be able to walk in all that!

Kjelle: This is nothing.

Morgan (male): Well, I think it's amazing! Hey, do you mind if I watch you go through your training routine?

Kjelle: Why?

Morgan (male): Honestly, I'm one of the weakest guys in camp. So if you've got any tips on bulking up, I want to know about 'em!

Kjelle: You're not going to get stronger relying on other people. Figure this out yourself, Morgan.

Morgan (male): No, wait! I'm not asking you to teach me or anything. I just want to...watch.

Kjelle: A knight's training isn't some puppet show. Now leave me be!

Morgan (male): B-but, I didn't mean to... Oh man, it didn't seem like so much to ask...

■ MORGAN (MALE) X KJELLE B

Morgan (male): Oh, here you are! I've been looking for you everywhere!

Kjelle: What do you want? I'm just about to start my training.

Morgan (male): Perfect! I came to observe.

Kjelle: What a short memory you have. I already told you I don't want you watching me.

Morgan (male): Yes, I remember! ...Although I'd be the last person to brag about my memory. But this time I'm not just here to watch. I came to assist you!

Kjelle: ...Assist me?

Morgan (male): Yup! I'll fetch your weapons and armor and bring you water when you're thirsty. I've even brought a stack of towels for when things get sweaty! This is gonna be fun!

Kjelle: Huh?!

Morgan (male): If there's anything I'm leaving out, just let me know. I'm here for you!

Kjelle: Yes, but WHY are you here? Why do you care this much?

Morgan (male): Er, because I want to watch a master at work, of course. Then I can incorporate what I learn here into my own training regimen. I realize now it was selfish to expect you to divulge your secrets for free. So I figure I can pay you back by being a training lackey! ...Or whatever you call it.

Kjelle: It's called a squire. ...And I will admit, you are persistent, at the very least.

Morgan (male): I'm not too strong and I'm not too smart, but I'm as eager as they come!

Kjelle: All right. We can try it. Do not lag behind!

Morgan (male): Yay! Thanks, Kjelle!

Kjelle:

Morgan (male): Ooh, do we have time for one quick question before we get started?

Kjelle: Ugh, what is it now?

Morgan (male): You're super strong for such a pretty girl!

Kjelle: ...That's not a question.

Morgan (male): Yeah, I know. I'm getting to it. Anyway, are you just a mountain of muscle under that armor or what?

Kjelle: The first thing my squire must do is stop talking. Forever, if possible. If you do not, I will show you my muscles by snapping your arms like twigs.

Morgan (male): Eep! I'll, uh... I'll just be quiet now. Eyes open, mouth closed! Won't hear another peep! No sir! Er, ma'am! Still as a church mouse, that's me!

Kjelle: Gods, I haven't even started and already I'm exhausted!

■ MORGAN (MALE) X KJELLE A

Morgan (male): I know you're right in the middle of things, but why don't we take a quick break?

Kjelle: *Pant* S-sure... Thanks for... your help today, Morgan. You've really...made things easier...

Morgan (male): Hey, I get to watch your routine up close. I'm the one who should be thanking you. You always... Er, Kjelle? You all right? You look pale.

Kjelle: "Huff, huff" F-fine... Just a...bit tired.

Morgan (male): Already? That's not like you. Are you sure you're feeling well? Now that I think of it, you seemed unsteady on your feet a few times today...

Kjelle: You're...imagining things... I'm fine.

Morgan (male): Actually, you're very, very pale. ...And your skin is clammy. Let's go get you medical attention. Do you need help walking?

Kjelle: "Wheeze" S-stop it... I-I'm f-fine... Haven't missed... a day's training yet... N-not about...to start today... Anyone weak enough...to let a fever stop them will...n-never become strong...

Morgan (male): Don't be so stubborn, Kjelle!

Kjelle: Nnnngh... J-just go. I don't... Don't want you to see me like this...

Morgan (male): Oh my gosh, you're delirious! Look, stay right where you are. I'll bring help, stat!

Kjelle: Don't! I don't need a...healer! I've got work to do here!

Morgan (male): You can't seriously intend to keep training in your condition!

Kjelle: And you can't seriously... think you can stop me... If you're my squire...then assist me...or get out... of my way! "wheeze"

Morgan (male): A squire cannot sit by and watch a knight die from scurvy...or whatever you have!

Kjelle: N-not...your decision... And it's the end for me, either way... If I stop pushing...others pass me... C-can't afford to...rest...

Morgan (male): ...Fine. But I'm going to watch you like a hawk! A tiny hawk, but still! A hawk!

Kjelle: Still planning to...get in my way?

Morgan (male): I'll train. But the minute I see you wobble, I'm dragging you to the infirmary. I'll hog-tie you if I have to! ...Er, or I'll try, at least.

Kjelle: M-Morgan...

Morgan (male): I know it's not a squire's place to mouth off, but I think—

Kjelle: It's fine. It's good...of you... You...keep watch...

Morgan (male): Yes sir! Er, ma'am!

■ MORGAN (MALE) X KJELLE S

Morgan (male): All right, time to catch another of Kjelle's training sessions. Though some days it's more self-flagellation than training... If it wasn't for me, she'd probably be dead by now. Hey, Kjelle! You here? Kjelle?

Kjelle: Morgan?! Wait, don't—

Morgan (male): Ah, there you— WAAAAAAAAAH!

Kjelle: MORGAAAAAAAAAN!

Morgan (male): N-NAKED! I mean sorry! I'm sorry! I didn't know you were bathing! I'll wait out here, I'm sorry! So sorry! Oh gods, please don't kill me!

Morgan (male): ...So, um, right. Yes. ...Sorry.

Kjelle: It's my own fault. I should have heard you coming.

Morgan (male): Well, hey, I... I don't think you have anything to be ashamed of!

Kjelle: ...What's that supposed to mean?

Morgan (male): Er, I just mean... You're so beautiful! Even more than I'd imagined!

Kjelle: ...You've imagined it?

Morgan (male): Ha ha! No! Of course not! Never! ...Maybe once... Twice. ...Okay, all the time! Oh gods, please don't hurt me. I always thought you'd look like a big side of beef, but you don't! You're so...um... Actually, I think I'll just stop talking now.

Kjelle: Morgan? Some advice for the future... Never tell a girl you thought she'd look like a side of beef.

Morgan (male): R-right! Yeah, I mean, it was just so... Um, are we starting already? Why are you getting out the weapons? And why are you pointing them at me?! It was a compliment?

Kjelle: ...Was it now?

Morgan (male): Aieeeeee! Somebody help—muh?

Kjelle: I should probably kill you right now, but oddly enough, I'm not mad. Heh. Though normally you've got to buy the cow before you get a show like that.

Morgan (male): Th-then sell me the cow! That's a deal only a fool would pass up!

Kjelle: ...Gods, you are really bad at this.

Morgan (male): N-no! That's what I... Er, but that doesn't mean I don't want to... It's not as beefy as I thought, but I think it's still a very nice cow! The best cow! Gah, you're right! I am terrible at this! Look, Kjelle! I really, really like you!

Kjelle: ...I know. You're awful with words, but I could always read you clearly enough.

Morgan (male): Er, so if you know and you haven't killed me yet, does that mean...?

Kjelle: We can try it. But you have to bulk up those scrawny arms of yours. If you can commit to my rigid training regime, you can commit to me. Just know this: if I catch you slacking even once, I'm outta here!

Morgan (male): Yes, sir! Uh, ma'am! If I've learned anything from watching you, it's perseverance! I'll keep working with you till I'm as big and beefy as— Er, I mean... You know what? I'll shut up now.

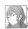
Morgan (female) (Mother/daughter)

The Morgan (female) mother/daughter dialogue with Kjelle can be found on page 312.

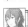
Morgan (female) (Sisters)

■ MORGAN (FEMALE) X KJELLE (SISTERS) C

Morgan (female): Let's see here... Birthday? May 5th... Favorite colors? Blue and purple... Favorite food? Probably bear meat...

Kjelle: What are you mumbling about over there, Morgan?

Morgan (female): Least favorite food? Veggies, apparently. Don't seem to mind them now, though...

Kjelle: Morgan!

Morgan (female): Oh! Kjelle?! Guess I was pretty out of it to miss my own sister paying a visit! Did you need something?

Kjelle: Just wondering what you were chanting over there... You practicing some new magic incantations or something?

Morgan (female): Nope! Just going back over my notes on what you told me about myself. I was hoping they'd hold some clue that might help spark my memory. Heh. It's kind of crazy how much you know about me, huh? Like, I really once got five nosebleeds in the same day? I have no memory of that at all. AT ALL! Ha ha ha! I can just imagine...

Kjelle: Well, you're still as cheerful as that's for sure. And as talkative as ever...

Morgan (female): I am? I mean, I was?! Hmm, now that you mention it, that does sound...right, somehow. ...Heh. Everything still feels funny. Even you being my sister hasn't really clicked.

Kjelle: If you think it's strange for you, imagine how I feel... My kid sister starts talking to me like a stranger, asking questions about herself... I had no idea how to even interact with you then. It was pretty rough, but I got used to it.

Morgan (female): Heh, yeah... Sorry about that. But that's just another reason why I'm working hard to get my memories back. Once I do, nobody will have to feel weird or awkward around me anymore. Pretty noble, huh? Like, I really should advertise the fact. In any case, I'm happy to help you get those memories back however I can.

Someday soon I bet we'll be able to laugh about all the old times—now included!

Morgan (female): Heh, right!

■ MORGAN (FEMALE) X KJELLE (SISTERS) B

Kjelle: Whew! Another long day of combat... I'm bushed. Think I'll hit the hay ear...ly? Is someone passed out over there? Wait, is that Morgan?!

Morgan (female): Nn...nngh...

Kjelle: Morgan! Morgan, are you all right?! What happened?!

Morgan (female): ...Wha—?! Kjelle! Wh-what am I doing here? Was I asleep?! I don't even remember feeling tired... Oh, right! I was bashing that huge tome against my head when I blacked out. That explains why my face hurts so bad...

Kjelle: Bashing your... Morgan, why in the WORLD would you do that?! Wait, were you trying to get your memories back?

Morgan (female): Well, yeah! Obviously. If you ever saw me bludgeoning myself just for fun, I hope you'd put a stop to it...

Kjelle: I'll stop you even if it's NOT just for fun, you fool! Look, I know you want your memories back, but please... Don't do anything reckless.

Morgan (female): ...But I want to be able to talk with you about old times again.

Kjelle: I know, Morgan, and I want that, too. But more than that, I want you safe. I may just be another stranger to you, but to me, you're family. In the future, with Mother and Father gone, it was just the two of us. You're all I had, Morgan... I don't know what I'd do if anything happened to you.

Morgan (female): All right. I'm sorry, Kjelle.

Kjelle: Just as long as you understand.

Morgan (female): ...Heh, that felt really siblingy just now. Don't you think? We messing up and you scolding me felt... I don't know, it felt really plausible! Maybe if you keep it up, I'll remember something!

Kjelle: You...really think so?

Morgan (female): Yeah! Oh yeah, this will totally work! So go on, keep yelling! C'mon, scream at your amnesiac sister, Kjelle!

Kjelle:

Morgan (female): Hey, why don't you use the tome, too? Come on, don't hold back. Really wallop me with that thing! Maybe the simultaneous physical and mental shock will jar some memories loose! It's gotta be twice as effective as either one by itself, right? That's just basic science.

Kjelle: Good night, Morgan...

■ MORGAN (FEMALE) X KJELLE (SISTERS) A

Morgan (female): Hey, Morgan. I'm headed into town. Would you like to come along?

Morgan (female): I'd love to! Is there something in particular you need?

Kjelle: I might pick up a couple of things, yes. But mostly I think there's something YOU need.

Morgan (female): It doesn't have to do with getting my memories back, does it?

Kjelle: The opposite, really. Maybe there's no need to worry about your memories.

Morgan (female): That...makes no sense.

Kjelle: I'll be honest—it does hurt to know you've forgotten me. But...maybe it's better to build new memories than to worry about old ones.

Morgan (female): What do you mean?

Kjelle: I've been thinking about this a lot. Why you might have lost your memories, I mean. And I'm wondering if you didn't have some awful memory you couldn't bear to keep. ...I know I've got a few. I see a lot of faces, you know? People we couldn't save...

Morgan (female): I'm sorry you have to bear those dreadful memories, Kjelle...

Kjelle: Look, this is a theory, and even if it's true, it's not like you did it consciously. But I do think that getting your memories back might not necessarily be a good thing.

Morgan (female): Hmm... I understand, and believe me, I appreciate the thought... But I want to remember things, no matter how painful they are. Because I'm sure there'll be plenty of great memories mixed with the bad ones. And the truth, whatever it is... I really want to have that back, you know?

Kjelle: Well, if you're sure, then I'm happy to help.

Morgan (female): That's really kind of you, Kjelle, but do you truly realize what you're saying? I mean, it could be years before I remember anything. Or decades. Heck, there's a decent chance I may never get my memories back at all. I don't want to drag you into something that could last forever.

Kjelle: I'm already stuck with you forever, you goof. I'm your sister. We're family—memories or no. You couldn't keep me away.

Morgan (female): Kjelle, I... *sniff* Thank you! I'll do everything I can!

Kjelle: Then start by coming with me into town.

Morgan (female): Huh? But you said that doesn't have to do with getting my memories back.

Kjelle: What do you say that says you can't have a little fun while you try. And there's certainly no rule against making some happy new memories while you try. You're young! Live a little! There'll be plenty of time to worry later.

Morgan (female): Right... You're right! Thanks, Sis!

Yarne

■ YARNE X KJELLE C

Yarne: Gah! Kjelle, I didn't expect to run into you here!

Kjelle: Is that a problem?

Yarne: What? N-no! Of course not, I just...

Kjelle: Worried I heard you ran from battle again like a craven dastard? ...Because I have.

Yarne: What? I don't remember doing that...

Kjelle: Sure, play dumb!

Yarne: I'm not playing anything! When I'm in the middle of all that...war, I kind of panic. My memory's all hazy.

Kjelle: Isn't that convenient?

Yarne: No, I'm just... This isn't...

Kjelle: Uh huh. And you can't so much as set foot on a battlefield without blacking out. I'd love to see you

in my training armor. I bet you couldn't take a single step.

Yarne: Er, is training armor different from your usual set?

Kjelle: A bit. It's a custom job.

Yarne: Well, whatever is different, it sure looks sturdy. Must work wonders for you!

Kjelle: ...Don't tell me you actually want to try it on.

Yarne: Well, sure! If it helped you get that strong, of course I'm interested!

Kjelle:

Yarne: So...can I? I bet if I had the right armor and knew I was protected, I'd be less scared in combat.

Kjelle: ...Forget it. If I had the free time to spend babysitting you, I'd spend it training.

Yarne: Aww, come on! Please? You're the one who brought it up in the first place.

Kjelle: Yes, but... Ugh, fine.

Yarne: I can?! Yesss!

Kjelle: I'll bring it by later.

Yarne: Thanks, Kjelle!

■ YARNE X KJELLE B

Yarne: Um, Kjelle?

Kjelle: What?

Yarne: Is it, uh... Is it supposed to be this heavy?

Kjelle: It's solid steel lined with lead weights. ...What do you think?

Yarne: It's impossible to move in this stuff! Don't you have anything lighter?

Kjelle: If it weren't heavy, there'd be no point. Hence the "training armor" part. Start here, and we'll add more weight as you go.

Yarne: Hnnnnngh! ...I'm not "going" anywhere. I can't even walk! I know thick armor means good protection, but I'm a sitting duck here! This is crazy!

Kjelle: So you're giving up. Not ten minutes later, you're surrendering like a coward. Gods, YOU'RE the one who asked for this. It's like all you're capable of is complaining!

Yarne: But I didn't mean to... I'm sorry.

Kjelle: Nobody's sending you into battle in that. I told you it was for training, didn't I? You get used to fighting in that first, then you wear normal armor in actual combat. Suddenly, you feel light as a feather! I imagine it would help you keep calm, too.

Yarne: I guess?

Kjelle: But as soon as something requires effort, you quit. Do you have any guts at all?

Yarne: ...You're right. And I'm sorry. I'll work on getting used to the weight.

Kjelle: Pffft! What, for another ten minutes? ...Whatever. Let's get started. Drop and give me a hundred!

Yarne: A hundred?! Kjelle, I can't even do that without armor on! And what are you, my trainer now?!

Kjelle: You need one. You're far too easy on yourself. What were you planning to do? Stand there? Maybe walk in place?

Yarne: Urk...

Kjelle: Trust me. I know a thing or three about training. You'll be statuesque in no time.

Yarne: Yeah, one of those statues where the arms fell off! I'm telling you, I can't do this!

Kjelle: Then give me back my armor. And don't ever ask me for a favor again.

Yarne: ...F-fine. You don't have to get all scary. I still don't think I can do a hundred, but I'll try if it makes you stop glaring at me. One... Two... Th-threeeee... F-f-fooooooour... Whew... Er, can we take a break?

Kjelle: Yarne.

Yarne: Yeah, this may work for you, but it's too much for mere mortals like me.

Kjelle: What?

Yarne: I'm tapped out here. See you later.

Kjelle: What? Yarne! Get back here!

Yarne: Five minutes, thirty one seconds... That's a new personal best.

■ YARNE X KJELLE A

Kjelle: Care to explain your performance in the last battle, Yarne?

Yarne: Er... Hi, Kjelle.

Kjelle: The minute I showed up to help, you ran off! Thanks a lot for the teamwork. ...Craven.

Yarne: It's not that I was scared! But my arm...

Kjelle: What, the old runner's arm acting up? Did you hit your craven bone?

Yarne: ...Look, all's well that ends well, right? We won, and that's all that matters.

Kjelle: No, "we" didn't. Me and the others who stuck around to fight won. Honestly, I expected more from you. ...But no. You're hopeless.

Yarne:

Kjelle: What, nothing to say? No glib excuse? And why are you clutching your shoulder like that?

Yarne: What? No, I'm not...

Kjelle: It's obviously not a battle wound. Did you trip while you were fleeing? Maybe you ran into something because your eyes were filled with tears?

Yarne: No, that's not... After I left the other day, I went back and put your armor back on. After everything you said, I just couldn't back down. ...Even I have some pride. I got to about fifty push-ups before my arm gave out completely.

Kjelle: ...Is that why you ran? You were fighting with an injured arm until I got there?

Yarne: I would have stayed, but I was afraid I'd only be in your way like this. Better to drop back to the rear and let you handle it, I figured...

Kjelle: You should have said something.

Yarne: No, it was my own dumb fault. Classic Yarne, though, huh? I finally decide to train to get stronger, and I wind up injured and even more useless. Do you think maybe for our next session you could teach me how not to repeat this?

Kjelle: What?

Yarne: Like you say, you're an expert. I bet you know how to avoid sprains and injuries. If I ever going to get stronger and gain that confidence, I'll need your help.

Kjelle: ...If you're committed, and I mean really committed, then I'll be happy to help. We'll start as soon as that arm is better, so gird your loins!

Yarne: R-right! I'll...get right on that.

■ YARNE X KJELLE S

Yarne: Ugh, I'm so pathetic! Stupid legs—why won't you listen to me?! And YOU, arms...

Kjelle: Am I...interrupting something?

Yarne: Oh, it's useless. I mean, I really appreciate all your help, but it's useless. You've been training my hardest to build up confidence, but combat still terrifies me. ...And when the time comes to fight, my legs start to shake. Guess you can't train your guts. I'm just not brave like everyone else...

Kjelle: I think you might have the wrong idea here. There isn't a person alive who doesn't shake when marching into combat. People are trying to kill you, Yarne. Any sane person would be afraid.

Yarne: What, even you?

Kjelle: Of course! We're all fighting two wars: One against the foe. One against our fear. We've got to win both if we want to live. There's nothing pathetic about it, Yarne. Heck, the opposite, really. Admitting your fears and struggling against them takes guts. ...You should be proud.

Yarne: Really?

Kjelle: That's what bravery is, Yarne—the drive to be strong, even when you know you're weak. ...I'm sorry for being so harsh on you this whole time. I may have misjudged you.

Yarne: What? No, you were right.

Kjelle: And as long as we're being forthright, there's one other thing I have to say.

Yarne: Oh? Let's hear it.

Kjelle: I think I may have...grown fond of you.

Yarne: Wh-wh-what?! Me?! How? Why?! And since when?! You haven't exactly been whispering sweet nothings into my ear here.

Kjelle: Hey, I apologized, didn't I? ...And I really did think you were pathetic at first. But since then, I've seen how dedicated you are to getting better. It's kinda...dreamy. ...What, is that a problem?

Yarne: N-no, it's just... It's really sweet of you to say that, Kjelle. Thank you.

Kjelle: Come on, don't leave me hanging here...

Yarne: Oh, sorry! The feeling's mutual! ...I figured you knew that. The only reason I kept training was because I didn't want to lose all respect for me. I may not be the hero type, but I at least want to look good around the girl I like.

Kjelle: Hey, you'd better get back to it, huh? Gimme fifty laps around camp! ...Think of this as payback for making me say all that mushy garbage.

Yarne: G-go easy on me! My dear, sweetheart?! Honey lumps?

Kjelle: In your dreams! I'm going to train you into the ground till you're a fuzzy juggernaut!

Yarne: Eeeek! Y-yes, ma'am!

Laurent

■ LAURENT X KJELLE C

Kjelle: Hah! Yah!... Haaaah!

Laurent: Ah, Kjelle. Busy training?

Kjelle: Just taking practice swings. Nothing fancy.

Laurent: Ah, yes. Excellent. Hmm...

Kjelle: ...You got something to say?

Laurent: You are a bit off today.

Kjelle: What are you talking about? I'm fine—same as ever!

Laurent: It is possible that I am mistaken. But to my eye, your movements lack their customary crispness. Are you quite certain you're feeling well?

Kjelle: Well, I have had a bit of a twinge in my lower back for the last couple of days...

Laurent: That would be a likely culprit. Might I suggest you have it treated? A massage, perhaps.

Kjelle: Pfft. Massages are for princesses! I just need to work through it.

Laurent: Inadvisable. You would be far better served seeking legitimate treatment. As the lower back muscles drive the entire body, they are indispensable to combat. They are also slow to heal. If ignored, your condition may worsen.

Kjelle: All right, fine. I'll get a massage! Maybe paint my nails while I'm at it... *grumble, grumble*

Laurent: I hope it serves you well. Do take care.

■ LAURENT X KJELLE B

Kjelle: Hey, Laurent!

Laurent: Did you need something?

Kjelle: I wanted to thank you for the other day. Er, when you told me to go get that massage.

Laurent: Ah, yes. What of your back since then?

Kjelle: Good as new! So, yeah. Thanks. It was a big help.

Laurent: Please, do not give it another thought. I consider it a part of my duties to keep watch for any anomalies. If I can be of assistance in keeping this army in top condition, I shall do so. And that means scrutinizing every last tick, movement, and gesture.

Kjelle: ...You do what now?

Laurent: Er, have I said anything amiss? Your face is most scrunchy.

Kjelle: No, no. It's just that when you say it like that, it... Well, it makes it sound like you're constantly watching us.

Laurent: Yes, precisely. Constantly watching. Is that a problem?

Kjelle: Not a problem, I guess, but it is kind of creepy. Like a...stalker. Look, you should be careful you don't make anyone feel uncomfortable, okay? Some people don't enjoy being watched.

Laurent: Er, I see. Yes, of course.

Laurent: ...And you, Kjelle? Are you "some people"?

■ LAURENT X KJELLE A

Kjelle: Oh. Hello, Laurent.

Laurent: Kjelle.

Kjelle: You haven't been by to check up on me in a while. Is everything all right?

Laurent:

Kjelle: You said it was your duty to keep watch on us. Keep us in top condition and all that? And then you just stopped coming by. I wondered if you'd given up or what.

Laurent: I still watch everyone else.

Kjelle: Everyone...else?

Laurent: After you cautioned me, I thought it best if I made an exception for you, so I desisted.

Kjelle: Because I told you other people may not like you staring at them?

Laurent: "Some people" were your words. I thought perhaps you were speaking for yourself. It is not uncommon for people to cloak their fears in the guise of an imaginary—

Kjelle: Oh, for hell's sakes! That's not what I was doing! I just meant that SOME people might take offense. That's all I meant.

Laurent: Is it?

Kjelle: Yes, it is! If it bothered me, I'd have told you to knock it off because it bothers me. Sometimes you're too smart for your own good. Stop overthinking everything!

Laurent: ...My apologies. I see my inference was mistaken.

Kjelle: Your advice has already helped me out. I'm a big fan of your advice. So I was HOPING you'd keep watching. If anything looks off to you, point it out. I'd be eager to hear it.

Laurent: Then I shall strive to let no glimmer of potential improvement elude me!

Kjelle: You do that.

■ LAURENT X KJELLE S

Laurent: Hello, Kjelle.

Kjelle: L-Laurent!

Laurent: Is something amiss? Ought I be concerned that the sight of me sends you reeling? I would gladly lend an ear to any troubles you may be having. And troubles I am the cause of, doubly so.

Kjelle: No, you're fine. It's me. I...need to apologize.

Laurent: Oh?

Kjelle: I snapped at you before. When you stopped coming by to check up on me.

Laurent: I would not categorize your behavior as "snapping." What's more, I thought the matter was decided as a misunderstanding on my part.

Kjelle: ...It wasn't.

Laurent: I fear I don't understand.

Kjelle: That was... I was jealous. You started watching everyone but me, and it... It made me a little crazy.

Laurent: ...Now I really do not understand.

Kjelle: Believe me, I'm as shocked as you. And I'm still confused about what it all means. What I feel for you... But I wasn't being honest with you, or with myself. That much is clear. So I wanted to go ahead and apologize for that, no matter what happens down the line.

Laurent: If I may confirm... You feel it's possible—but not definite—that you bear an affection for me?

Kjelle: ...Yes.

Laurent: And you see the potential for growth into some form of relationship "down the line"?

Kjelle: Sorry. I know it's all pretty vague.

Laurent: I see no call for apology. This is a welcome development. For I am quite certain in my affections for you, Kjelle. And as a by-product of possession, jealousy is a favorable addition to the equation. After all, the ultimate goal here is to be possessed, is it not? Still, I must say, the frank compulsion to apologize immediately is very you. Ha.

Kjelle: Laurent...

Laurent: You have asked me to continue to watch you, Kjelle. I would now ask you to do the same.

Kjelle: Well, sure, but... How do you mean?

Laurent: I've only just begun to show my worth as a possible spouse and mate. However, I still have work to do before I am what the layman might call "dreamy." But given proper training, I am confident in my ability to steal your heart. Therefore, I would ask that you observe me in this process and offer advice.

Kjelle: ...Er, you want me to watch your "dreamy" training?

Laurent: That is it exactly.

Kjelle: Well, I've had worse offers...

Father

■ FATHER X KJELLE C

Kjelle: Are you free, Father? I could use a sparring partner.

[Robin]: Oh, Kjelle... I'd love to, but...maybe not today...

Chrom: Oh, Kjelle... I'd love to, but...maybe not today...

Frederick: Oh, Kjelle... I'd love to, but...perhaps not today...

Virion: Ah, Kjelle... I'd love to, but...maybe not today...

Vaike: Hey, Kjelle... I'd love to, but...maybe not today...

Stahl: Oh, Kjelle... I'd love to, but...maybe not today...

Kellam: I'm...surprised you found me. I'd love to, but...maybe not today...

Lon'qu: Oh, Kjelle... Sorry...maybe not today...

Ricken: Oh, Kjelle... I'd love to, but...maybe not today...

Gaius: Oh, Kjelle... I'd love to, but...maybe not today...

Gregor: Gregor would love to...but...maybe not today...

Libra: Oh, Kjelle... I'd love to, but...maybe not today...

Henry: Oh, Kjelle... I'd love to, but...maybe not today...

Donnel: Heya, Kjelle... I'd love to, but...maybe not today...

Kjelle: Father, you're pale as a ghost! And sweating! What's wrong?!

[Robin]: I-it's nothing. I'm f-fine. Save for my gut...

Chrom: I-it's nothing. I'm f-fine. Save for my gut...

Frederick: I-it's nothing. I'm f-fine. Save for my gut...

Virion: I-it's nothing. I'm f-fine... Save for my innards...

Vaike: I-it's nothing. I'm f-fine... Save for my gut...

Stahl: I-it's nothing. I'm f-fine... Save for my gut...

Kellam: It's nothing. I'm f-fine... Save for my gut...

Lon'qu: It's nothing. I'm f-fine... Save for my gut...

Ricken: It's nothing. I'm f-fine... Save for my gut...

Gaius: It's nothing. I'm f-fine... Save for my gut...

Gregor: I-is nothing. Gregor is f-fine... Except for gut...

Libra: It's nothing. I'm f-fine... Save for my gut...

Henry: It's nothing. I'm f-fine... Save for my gut...

Donnel: It's nothin'. I'm f-fine... Save for my gut...

Kjelle: Are you injured? Who did this to you?! Give me a name, and I'll—

[Robin]: B-breakfast...

Chrom: B-breakfast...

Frederick: B-breakfast...

Virion: B-breakfast...

Vaike: B-breakfast...

Stahl: B-breakfast...

Kellam: B-breakfast...

Lon'qu: B-breakfast...

Ricken: B-breakfast...

Gaius: B-breakfast...

Gregor: B-breakfast...

Libra: B-breakfast...

Henry: B-breakfast...

Donnel: B-breakfast...

Kjelle: ...Someone named "Breakfast"?

[Robin]: N-no... I ate breakfast, and then...this happened... N-not just me... Everyone in camp is in...the same shape... If you haven't eaten...s-stay away... Save yourself...

Chrom: N-no... I ate breakfast, and then...this happened... N-not just me... Everyone in camp is in...the same shape... If you haven't eaten...s-stay away... Save yourself...

Frederick: N-no... I ate breakfast, and then...this happened... N-not just me... Everyone in camp is in...the same shape... If you haven't eaten...s-stay away... Spare yourself...

Virion: N-no... I ate breakfast, and then...this happened... N-not just me... Everyone in camp is in...the same shape... If you haven't eaten...s-stay away... Save yourself...

Vaike: N-no... I ate breakfast, and then...this happened... N-not just me... Everyone in camp is in...the same shape... If you haven't eaten...s-stay away... Save yourself...

Stahl: N-no... I ate breakfast, and then...this happened... N-not just me... Everyone in camp is in...the same shape... If you haven't eaten...s-stay away... Save yourself...

Kellam: N-no... I ate breakfast, and then...this happened... N-not just me... Everyone in camp is in...the same shape... If you haven't eaten...s-stay away... Save yourself...

Lon'qu: N-no... I ate breakfast, and then...this happened... N-not just me... Everyone in camp is in...the same shape... If you haven't eaten...s-stay away... Save yourself...

Ricken: N-no... I ate breakfast, and then...this happened... N-not just me... Everyone in camp is in...the same shape... If you haven't eaten...s-stay away... Save yourself...

Gaius: N-no... I ate breakfast, and then...this happened... N-not just me... Everyone in camp is in...the same shape... If you haven't eaten...s-stay away... Save yourself...

Gregor: N-no... Gregor eat breakfast, and then...this happen... N-not just Gregor... Everyone in camp is...feeling like floor of barn... If you have not eaten...s-stay away... Save yourself...

Libra: N-no... I ate breakfast, and then...this happened... N-not just me... Everyone in camp is in...the same shape... If you haven't eaten...s-stay away... Save yourself...

Henry: N-no... I ate breakfast, and then...this happened... N-not just me... Everyone in camp is in...the same shape... If you haven't eaten...s-stay away... Save yourself...

Donnel: N-no... I ate breakfast, and then...this happened... N-not just me... Everyone in camp is...about the same shape... If you haven't eaten...s-stay away... Save yourself...

Kjelle:

[Robin]: Hrrgh... And I thought Sully's cooking was bad... Whoever made this is...is...

Chrom: Hrrgh... And I thought Sully's cooking was bad... Whoever made this is...is...

Frederick: Hrrgh... And I thought Sully's cooking was bad... Whoever made this is...is...

Virion: Hrrgh... And I thought Sully's cooking was bad... Whoever made this is...is...

Vaike: Hrrgh... And I thought Sully's cooking was bad... Whoever made this is...is...

Stahl: Hrrgh... And I thought Sully's cooking was bad... Whoever made this is...is...

Kellam: Hrrgh... And I thought Sully's cooking was bad... Whoever made this is...is...

Lon'qu: Hrrgh... And I thought Sully's cooking was bad... Whoever made this is...is...

Ricken: Hrrgh... And I thought Sully's cooking was bad... Whoever made this is...is...

Gaius: Hrrgh... And I thought Sully's cooking was bad... Whoever made this is...is...

Gregor: Hrrgh... Gregor thought Sully's cooking was horrible... Whoever made this is...is...

Libra: Hrrgh... And I thought Sully's cooking was bad... Whoever made this is...is...

Henry: Hrrgh... And I thought Sully's cooking was bad... Whoever made this is...is...

Donnel: Hrrgh... And I thought Sully's cookin' was bad... Whoever made this is...is...

Kjelle: ...Is your daughter.

[Robin]: ...What?

Chrom: ...What?

Frederick: ...What?

Virion: ...Come again?

Vaike: ...What?

Stahl: ...What?

Kellam: ...What?

Lon'qu: ...What?

Ricken: ...What?

Gaius: ...What?

Gregor: ...What? Is joke, yes?

Libra: ...What?

Henry: ...What?

Donnel: ...Come again?

Kjelle: I'm sorry, Father. ...I thought it turned out so well.

[Robin]: N-no, it's not...that... I mean...urrgh... It was d-delicious... I'm sure the...searing pain is...coincidental...

Chrom: N-no, it's not...that... I mean...urrgh... It was d-delicious... I'm sure the...searing pain is...coincidental...

Frederick: N-no, it's not...that... I mean...urrgh... It was d-delicious... I'm sure the...searing pain is...coincidental, dear...

Virion: N-no, it's not...that... I mean...urrgh... It was d-delicious... I'm sure the...searing pain is...coincidental...

Vaike: N-no, it's not...that... I mean...urrgh... It was d-delicious... I'm sure the...searing pain is...coincidental...

Stahl: N-no, it's not...that... I mean...urrgh... It was d-delicious... I'm sure the...searing pain is...coincidental...

Kellam: N-no, it's not...that... I mean...urrgh... It was d-delicious... I'm sure the...searing pain is...coincidental...

Lon'qu: N-no, it's not...that... I mean...urrgh... It was d-delicious... I'm sure the...searing pain is...coincidental...

Ricken: N-no, it's not...that... I mean...urrgh... It was d-delicious... I'm sure the...searing pain is...coincidental...

Gaius: N-no, it's not...that... I mean...urrgh... It was d-delicious... I'm sure the...searing pain is...coincidental...

Gregor: N-no! It was...good, yes! Do not... Urrgh... Do not blame self! Gregor is sure the...searing pain is...just coincidence... Ha ha...

Libra: N-no, it's not...that... I mean...urrgh... It was d-delicious... I'm sure the...searing pain is...coincidental... The gods do love to...test us sometimes...

Henry: N-no, it's not...that... I mean...urrgh... It was d-delicious... I'm sure the...searing pain is...coincidental...

Donnel: N-no, it's not...that... I mean...urrgh... It was d-delicious... I'm sure this...bellyache is...pure coincidence...

Kjelle: You just said that everyone who ate it got sick! Oh, this is so embarrassing!

[Robin]: W-wait! Kjelle! C-come back! Don't go... I'll... Bluuurp! Oh, gods... H-here it comes...

Chrom: W-wait! Kjelle! C-come back! Don't go... I'll... Bluuurp! Oh, gods... H-here it comes...

Frederick: W-wait! Kjelle! C-come back! Don't go... I'll... Bluuurp! Oh, gods... This is not going to be pleasant...

Virion: W-wait! Kjelle! C-come back! Don't go... I'll... Bluuurp! Oh, gods... H-here it comes...

Vaike: W-wait! Kjelle! C-come back! Don't go... The Vaike'll... Bluuurp! Oh, gods... H-here it comes...

Stahl: W-wait! Kjelle! C-come back! Don't go... I'll... Bluuurp! Oh, gods... H-here it comes...

Kellam: W-wait! Kjelle! C-come back! Don't go... I'll... Bluuurp! Oh, gods... H-here it comes...

Lon'qu: W-wait! Kjelle! C-come back! Don't go... I'll... Bluuurp! Oh, gods... H-here it comes...

Ricken: W-wait! Kjelle! C-come back! Don't go... I'll... Bluuurp! Oh, gods... H-here it comes...

Gaius: W-wait! Kjelle! C-come back! Don't go... I'll... Bluuurp! Oh, gods... H-here it comes...

Gregor: W-wait! Kjelle! C-come back! Don't go... Gregor will... Bluuurp! Uh-oh... H-here comes breakfast...

Libra: W-wait! Kjelle! C-come back! Don't go... I'll... Bluuurp! Oh, gods... H-here it comes...

Henry: W-wait! Kjelle! C-come back! Don't go... I'll... Bluuurp! Oh, gods... H-here it comes... Nya haaa...

Donnel: W-wait! Kjelle! C-come back! Don't go... I'll... Bluuurp! Oh, gods... H-here it comes...

FATHER X KJELLE B

Kjelle: HAH! RRRAGH! YAAAH!

[Robin]: Kjelle, you seem to be training especially hard today.

Chrom: Kjelle, you seem to be training especially hard today.

Frederick: Kjelle, you seem to be training especially hard today.

Virion: Kjelle, you seem to be training especially hard today.

Vaike: Kjelle, you seem to be trainin' especially hard today.

Stahl: Kjelle, you seem to be training especially hard today.

Kellam: Kjelle, you seem to be training especially hard today.

Lon'qu: You seem to be training especially hard today.

Ricken: Kjelle, you seem to be training especially hard today.

Gaius: Kjelle, you seem to be training especially hard today.

Gregor: Kjelle, you are making very hard with the training today.

Libra: Kjelle, you seem to be training especially hard today.

Henry: Kjelle, you seem to be training especially hard today.

Donnel: Kjelle, you seem to be trainin' extra hard today!

Kjelle: If I can't do my share of the cooking, I'll have to do a larger share of the fighting.

[Robin]: Oh, so...you're not cooking again?

Chrom: Oh, so...you're not cooking again?

Frederick: Oh, so...you're not cooking again?

Virion: Oh, so...you're not cooking again?

Vaike: So, uh... You ain't cookin' again?

Stahl: Oh, so...you're not cooking again?

Kellam: Oh, so...you're not cooking again?

Lon'qu: Ah, so...you're not cooking again?

Ricken: Oh, so...you're not cooking again?

Gaius: Oh, so...you're not cooking again?

Gregor: Oh, so...you will not be cooking again, yes?

Libra: Oh, so...you're not cooking again?

Henry: Oh, so...you're not cooking again?

Donnel: Oh, so...you're not cookin' again?

Kjelle: Would you want me to, after last time?! You saw how that day's battle played out. All our soldiers clutching their guts, legs quivering like newborn deer... And the smell... Oh, gods, the smell... If the enemy hadn't been so horrified, we might all be dead!

[Robin]: It was certainly a...challenging day. But nobody's perfect—I'm sure it was just a fluke. I know I, for one, would like to try your cooking again.

Chrom: It was certainly a...challenging day. But nobody's perfect—I'm sure it was just a fluke. I know I, for one, would like to try your cooking again.

Frederick: It was certainly a...challenging day. But nobody's perfect—I'm sure it was just a fluke. I know I, for one, would like to try your cooking again.

Virion: Yes, it was hardly our most shining moment... But nobody's perfect—I'm sure it was just a fluke. I know I, for one, would like to try your cooking again.

Vaike: Yeah, that was pretty ugly, all right. But hey, nobody's perfect. I'm sure it was just a fluke! The Vaike would be happy to give your cookin' another shot.

Stahl: It was certainly a...challenging day. But nobody's perfect—I'm sure it was just a fluke. I know I, for one, would like to try your cooking again.

Kellam: It was certainly a...challenging day. But nobody's perfect—I'm sure it was just a fluke. I know I, for one, would like to try your cooking again.

Lon'qu: It was certainly a...challenging day. But nobody's perfect—I'm sure it was just a fluke. I know I, for one, would like to try your cooking again.

Ricken: It was certainly a...challenging day. But nobody's perfect—I'm sure it was just a fluke. I know I, for one, would like to try your cooking again.

Gaius: It was certainly a...challenging day. But nobody's perfect—I'm sure it was just a fluke. I know I, for one, would like to try your cooking again.

Gregor: Yes, it was quite horrible. But no one is perfect, no? It was probably just crazy fluke. Gregor would like to try your cooking again.

Libra: It was certainly a...challenging day. But nobody's perfect—I'm sure it was just a fluke. I know I, for one, would like to try your cooking again.

Henry: Nya ha! It was certainly a... challenging day... Aw, but nobody's perfect—I'm sure it was just a fluke! I know I, for one, would like to try your cooking again.

Donnel: It was a...challengin' day, for sure. But no one's perfect—I'm sure it was just a fluke. I know I, for one, would love to try your cookin' again.

Kjelle: NO!

[Robin]: ...I'm sorry?

Chrom: ...I'm sorry?

Frederick: ...I'm sorry?

Virion: ...I'm sorry?

Vaike: Muh?

Stahl: ...I'm sorry?

Kellam: ...I'm sorry?

Lon'qu: ...?

Ricken: ...I'm sorry?

Gaius: ...I'm sorry?

Gregor: ...Oy?

Libra: ...I'm sorry?

Henry: Huh?

Donnel: Beg your pardon?

Kjelle: What if it WASN'T a fluke? What if my cooking gets you KILLED next time?! Another breakfast from me could bring our entire army to its knees! Literally! Don't ask me to do that to my fellow soldiers and my family.

[Robin]: Oh now, it wasn't THAT bad...

Chrom: Oh come now, it wasn't THAT bad...

Frederick: Oh come now, it wasn't THAT bad...

Virion: Oh come now, it wasn't THAT bad...

Vaike: Yeesh, it wasn't THAT bad...

Stahl: Oh come now, it wasn't THAT bad...

Kellam: Oh come now, it wasn't THAT bad...

Lon'qu: Oh come now, it wasn't THAT bad...

Ricken: Oh come now, it wasn't THAT bad...

Gaius: Oh come now, it wasn't THAT bad...

Gregor: Now, now. It wasn't THAT bad.

Libra: Oh come now, it wasn't THAT bad...

Henry: Oh come now, it wasn't THAT bad...

Donnel: Oh come now, it wasn't THAT bad...

Kjelle: I still remember the sound...that horrible sound... Dozens of people, all fa—

[Robin]: All right! Fair enough. ...Look, what if I gave you a few pointers? If we manage to come up with something tasty, we can share it with everyone!

Chrom: All right! Fair enough. ...Look, what if I gave you a few pointers? If we manage to come up with something tasty, we can share it with everyone!

Frederick: All right! Fair enough. ...What if I gave you a few pointers? If we manage to come up with something tasty, we can share it with everyone.

Virion: All right! Fair enough. ...Look, what if I gave you a few pointers? If we manage to come up with something tasty, we can share it with everyone!

Vaike: All right! I get it, I get it. ...Look, what if ol' Teach gave ya a few pointers in the kitchen? If we manage to come up with somethin' tasty, we can share it with everyone!

Stahl: All right! Fair enough. ...Look, what if I gave you a few pointers? If we manage to come up with something tasty, we can share it with everyone!

Kellam: All right! Fair enough. ...Look, what if I gave you a few pointers? If we manage to come up with something tasty, we can share it with everyone!

Lon'qu: All right! Fair enough. ...Look, what if I gave you a few pointers? If we manage to come up with something tasty, we can share it with everyone.

Ricken: All right! Fair enough. ...Look, what if I gave you a few pointers? If we manage to come up with something tasty, we can share it with everyone!

Gaius: All right! Fair enough. ...Look, what if I gave you a few pointers? If we manage to come up with something tasty, we can share it with everyone. And if not, well...there's always candy, right?

Gregor: All right! Do not remind Gregor! ...How about this. What if Gregor give you few pointer tips in kitchen? If we come up with tasty meal, Kjelle can share with everyone!

Libra: All right! Fair enough. ...Look, what if I gave you a few pointers? If we manage to come up with something tasty, we can share it with everyone!

Henry: All right! Fair enough. ...Look, what if I gave you a few pointers? If we manage to come up with something tasty, we can share it with everyone!

Donnel: *Ahem!* All right, I get ya. How about I help ya out by givin' ya a few cookin' pointers? If we manage to come up with somethin' tasty, we can share it with everyone! Deal?

Kjelle: Hmm... All right, let's try it! ...And thanks.

FATHER X KJELLE A

[Robin]: The soup smells great, honey! Good job. I'm sure everyone will be eager for a taste.

Chrom: The soup smells great, honey! Good job. I'm sure everyone will be eager for a taste.

Frederick: The soup smells great, dear. Good job. I'm sure everyone will be eager for a taste.

Virion: The soup has such an...elegant aroma! Nicely done, dear. I'm sure everyone will be eager for a taste.

Vaike: The soup smells great, honey! Good job. I'm sure everyone'll be dyin' for a taste.

Stahl: The soup smells great, honey! Good job. I'm sure everyone will be eager for a taste.

Kellam: The soup smells great, honey! Good job. I'm sure everyone will be eager for a taste.

Lon'qu: The soup smells great. Good job. I'm sure everyone will be eager for a taste.

Ricken: The soup smells great, honey! Good job. I'm sure everyone will be eager for a taste.

Gaius: The soup smells great, honey! Good job. I'm sure everyone will be eager for a taste.

Gregor: Mmm, the soup smells delicious! Good job. Gregor is sure everyone will be fighting each other for the tasting.

Libra: The soup smells great, honey! Good job. I'm sure everyone will be eager for a taste.

Henry: Nya ha! The soup smells great! Nice work! I'm sure everyone will be eager for a taste.

Donnel: Mmm, the soup smells great, honey! Good job. I'm sure everyone'll be itchin' for a taste.

Kjelle: Thanks. I had a good teacher. I had no idea you knew so much about cooking!

[Robin]: I learned a lot after marrying your mother. It was that or starve...

Chrom: I learned a lot after marrying your mother. It was that or starve...

Frederick: I learned a lot after marrying your mother. It was that or starve...

Virion: I learned a lot after marrying your mother. It was that or starve...

Vaike: I learned a lot after marryin' your mother. Was that or starve...

Stahl: I learned a lot after marrying your mother. It was that or starve...

Kellam: I learned a lot after marrying your mother. It was that or starve...

Lon'qu: I learned a lot after marrying your mother. It was that or starve...

Ricken: I learned a lot after marrying your mother. It was that or starve...

Gaius: I learned a lot after marrying your mother. It was that or starve...

Gregor: Gregor learn after marrying mother. Was either that or starve...

Libra: I learned a lot after marrying your mother. It was that or starve...

Henry: I learned a lot after marrying your mother. It was that or starve...

Donnel: I learned a lot after marryin' your ma. It was that or starve...

Kjelle: Ha! You two really get along so well, don't you?

[Robin]: Yes, I guess we do...

Chrom: Yes, I guess we do...

Frederick: Yes, I suppose we do...

Virion: Yes, I suppose we do...

Vaike: Yeah, I guess we do...

Stahl: Yes, I guess we do...

Kellam: Yes, I guess we do...

Lon'qu: I suppose so.

Ricken: Yes, I guess we do...

Gaius: Yes, I guess we do...

Gregor: Gregor think so!

Libra: Yes, I guess we do...

Henry: Yes, I guess we do...

Donnel: Yeah, I reckon we do...

Kjelle:Heh heh.

[Robin]: Hmm?

Chrom: Hmm?

Frederick: Hmm?

Virion: Hmm?

Vaike: Hmm?

Stahl: Hmm?

Kellam: Hmm?

Lon'qu: Hmm?

Ricken: Hmm?

Gaius: What's so funny?

Gregor: Hmm?

Libra: Hmm?

Henry: Hmm?

Donnel: Hmm?

Kjelle: Just thinking that this must be what it feels like. ...Having parents, I mean. Being a normal family. I never really got to have that, but...it's nice.

[Robin]: Kjelle...

Chrom: Kjelle...

Frederick: Kjelle...

Virion: Kjelle...

Vaike: Kjelle...

Stahl: Kjelle...

Kellam: Kjelle...

Lon'qu: Kjelle...

Ricken: Kjelle...

Gaius: Kjelle...

Gregor: Kjelle...

Libra: Kjelle...

Henry: Kjelle...

Donnel: Aw, Kjelle...

Kjelle: But hey, enough of that. Didn't mean to get all misty. Let's dig in to this soup! *slurp*

[Robin]: Kjelle, I know you're a strong girl who doesn't like to ask for help... But you can, you know? If there's anything I can ever do, just name it.

Chrom: Kjelle, I know you're a strong girl who doesn't like to ask for help... But you can, you know? If there's anything I can ever do, just name it.

Frederick: Kjelle, I know you're a strong woman who doesn't like to ask for help... But you know that you can, right? If there is anything I can ever do, just name it.

Virion: Kjelle, I know you're a strong girl who doesn't like to ask for help... But you can, you know? If there's anything I can ever do, just name it.

Vaike: Kjelle, I know you're a strong girl who doesn't like to ask for help... But you can, you know? If there's ever anythin' the Vaike can do, you just name it.

Stahl: Kjelle, I know you're a strong girl who doesn't like to ask for help... But you can, you know? If there's anything I can ever do, just name it.

Kellam: Kjelle, I know you're a strong girl who doesn't like to ask for help... But you can, you know? If there's anything I can ever do, just name it.

Lon'qu: Kjelle, I know you're a strong girl who doesn't like to ask for help... But you can, you know. If there's anything I can ever do, just name it.

Ricken: Kjelle, I know you're a strong girl who doesn't like to ask for help... But you can, you know? If there's anything I can ever do, just name it.

Gaius: Kjelle, I know you're a strong girl who doesn't like to ask for help... But you can, you know? If there's anything I can ever do, just name it.

Gregor: Kjelle is very strong girl, yes? She never ask for help... But if ever there is anything Gregor can do, you just ask.

Libra: Kjelle, I know you're a strong girl who doesn't like to ask for help... But you can, you know? If there's anything I can ever do, just name it.

Henry: Kjelle, I know you're a strong type who doesn't like to ask for help... But you can, you know? If there's anything I can ever do, just name it.

Donnel: Kjelle, I know you're a strong girl who doesn't like askin' for help... But you can, you know? If there's ever anythin' I can do, you just name it.

Kjelle: Weeell... I guess one thing comes to mind, actually.

[Robin]: Yes, what is it?

Chrom: Yes, what is it?

Frederick: And that is?

Virion: Do tell.

Vaike: What's that?

Stahl: Yes, what is it?

Kellam: Yes, what is it?

Lon'qu: What's that?

Ricken: Yes, what is it?

Gaius: What's that?

Gregor: What is?

Libra: Yes, what is it?

Henry: Yeah?

Donnel: And what's that?

Kjelle: Keep teaching me how to cook! This soup tastes like dishwater...

[Robin]: *Slurp* ...Oh, gods, it does.
Chrom: *Slurp* ...Oh, gods, it does.
Frederick: *Slurp* ...Oh, gods, it does.
Virion: *Slurp* ...Oh, gods, it does.
Vaike: *Slurp* ...Oh, gods, ya ain't kiddin'.
Stahl: *Slurp* ...Oh, gods, it does.
Kellam: *Slurp* ...Oh, gods, it does.
Lon'qu: *Slurp* ...Yes, it does
Ricken: *Slurp* ...Oh, gods, it does.
Gaius: *Slurp* ...Oh, gods, it does.
Gregor: *Slurp* ...Oy, it does.
Libra: *Slurp* ...Oh, the gods are cruel! It DOES taste like dishwater...
Henry: *Slurp* ...BLECH! You weren't kidding.
Donnel: *Slurp* ...Ooh, you ain't kiddin'.

Kjelle: Actually, I've had better dishwater...

[Robin]: Right, then. I can at least get you cooking food that tastes like food!
Chrom: Right, then. I can at least get you cooking food that tastes like food!
Frederick: Right, then. I can at least get you cooking food that tastes like food...
Virion: Right, then. I can at least get you cooking food that tastes like food.
Vaike: Right then! Teach'll have ya cookin' food that tastes like food in no time.
Stahl: Right, then. I can at least get you cooking food that tastes like food!
Kellam: Right, then. I can at least get you cooking food that tastes like food!
Lon'qu: Right, then. I can at least get you cooking food that tastes like food.
Ricken: Right, then. I can at least get you cooking food that tastes like food!
Gaius: Right, then. I can at least get you cooking food that tastes like food!
Gregor: Right, then! Gregor show you how to cook food that taste like food.
Libra: Right, then. I can at least get you cooking food that tastes like food!
Henry: Right, then. I can at least get you cooking food that tastes like food!
Donnel: Well, don't you worry. I'll have you cookin' food that tastes like food in no time!

Kjelle: That'd be plenty for me! Thanks!

Cynthia
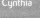

Avatar (male)

The dialogue between Avatar (male) and Cynthia can be found on page 225.

Avatar (female)

The dialogue between Avatar (female) and Cynthia can be found on page 236.

Sumia (Mother/daughter)

Cynthia's mother/daughter dialogue with Sumia can be found on page 263.

Lucina

The dialogue between Lucina and Cynthia can be found on page 283.

Lucina (Sisters)

The sisters dialogue between Lucina and Cynthia can be found on page 283.

Owain

The dialogue between Owain and Cynthia can be found on page 287.

Inigo

The dialogue between Inigo and Cynthia can be found on page 291.

Brady

The dialogue between Brady and Cynthia can be found on page 295.

Severa

SEVERA X CYNTHIA C

Cynthia: Get busy dying, or get busy dying MORE! ...That's my best victory catchphrase yet! I can't wait to use it! Hmm... But do I shout it before the killing blow or after? ...Ooooh! Or DURING?! Oh my gosh, this is going to be so great!

Severa: Oh, gods. Nerd alert. Just make sure I'm not around when you start yelling like a maniac, all right?

Severa: Just appreciating the irony of your situation is all. The more you embrace that "hero" bit, the more of a loser you are.

Cynthia: That is so totally not true! Heroes are completely awesome! And it's also none of your business!

Severa: Oh, you poor girl. Don't you know that everyone in camp is ashamed of you?

Cynthia: Nuh-uh! I get compliments all the time!

Severa: That's called pity. They're trying not to hurt your pathetic wittle feewings.

Cynthia: At least I HAVE feelings! You don't get it because you're emotionally stunted! A cynical ice queen like you can't possibly fathom the awesomeness of a real hero! Y-you're a supervillain, even!

Severa: If having no patience for your sad little fantasies makes me a villain, so be it. ...Meh. I'm bored of making fun of you now. Go back to playing your little games.

Cynthia: I will! Good day! And good riddance!

SEVERA X CYNTHIA B

Cynthia: Cry justice into the dark of night, and it will echo back, "Cynthia!" Any who would face divine judgment, step forward and meet my blade! ...Yes! Nailed it! That's a total keeper!

Severa: As in, keep out of sight? ...Keep secret forever? ...Keep being a big fat loser?

Cynthia: Keep being a huge jerk! What's wrong, jerk? Did you run out of flies to pull the wings off?

Severa: Don't flatter yourself. I was just passing by. ...I should keep walking before someone sees us talking and gets the wrong idea.

Cynthia: I wish you would! You're like a dark cloud that just floats around raining on people. I don't think I've ever heard a single nice thing come out of your mouth!

Severa: All part of being a...what was it again? A cynical little ice queen? If I played along with your sorry delusions, what sort of villain would I be? Yes, I'm afraid you're stuck with me. Mwah ha ha ha ha!

Cynthia: That DOES it! I demand a duel!

Severa: ...Wait. YOU are challenging ME?!

Cynthia: Name your terms, villain! I'll outrun you, out-fence you, or even outEAT you! Whoever loses has to apologize to the winner!

Severa: I'm sure you could win the eating contest easily...

Cynthia: Ha! You talk a big game, but that's all you are—a big bag of hot wind. A supervillain like you wouldn't have the guts to face me in a fair fight!

Severa: I was going to take pity and spare you the humiliation, but so be it. You're on, loser! I hope you're ready to be crushed like a cockroach!

Cynthia: Ha! Ha! Now that's a lame line if I ever heard one! So, what'll it be? Name your challenge. Pick anything you like. Doesn't matter to me. I'm better than you at everything!

Severa: Destroying you at any single event wouldn't prove the spectacular gap in our skills. I'll take you up on all three of the tests.

Cynthia: ...Er, all three?

Severa: That's right! Unless you want to go ahead and concede now?

Cynthia: N-not on your life! I'm going to enjoy grinding you into the dirt!

Severa: Hah! Now who sounds like a villain? Maybe you should drop the prissy little hero act and join me on the snarky side...

Cynthia: Never!

Severa: Then I suggest you stop dreaming up catch-phrases and start drafting that apology. You'll be needing it soon! Mwah ha ha ha!

SEVERA X CYNTHIA A

Cynthia: ...I'm impressed you showed up.

Severa: Oh, I wouldn't miss it. I'm looking forward to that apology.

Cynthia: Yeah? Well I'm looking forward to... Uh... Showing you that justice always prevails!

Severa: Ugh, whatever. It always comes back to that with you, doesn't it?

Cynthia: A hero's fate is to see justice done. Meanwhile, villains like you are fated to get kicked around by us heroes!

Severa: Well, since you seem so full of energy, we'll start with a foot race. Just keep up if you can!

Cynthia: Ha! I'll leave you in the dust!

Severa: "Gasp" "pant" How were you...able to keep up?

Cynthia: "Huff" "gasp" "Keep up"? I was...in the lead!

Severa: What?! "wheeze" That's...ridiculous!

Severa: "Gasp" This whole...duel is ridiculous... One challenge down, and we're no closer to a resolution than when we started. On to round two!

Cynthia: Swordplay, was it? As you wish... Have at you!

Severa: "Smack" Oh my gosh, what?! That hurt, you lunatic! No one cares if YOUR ugly face gets ruined, but I'M pretty!

Cynthia: "Bop" Yowch! Your insults don't hurt as much as these dumb wooden swords!

Severa: Okay, time out! I'm exhausted!

Cynthia: What say we recuperate with a little snack, hmm? On to the eating competition!

Severa: Urrrrrgh! S-so stuffed... C-c-can't...eat...an-other...bite...

Cynthia: D-d-don't...talk...about food... C-can't...even...move...

Severa: I think we tied again. This is stupid! Three rounds and we STILL don't have a winner! I don't even care anymore! I'm completely wiped. I'm not moving another inch today.

Cynthia: Ugh, me too. Let's just forget the whole thing.

Severa: I always thought you were just a loser with big loser fantasies... But you've actually got guts... and heart.

Cynthia: And I guess you're not just an emotionally stunted ice queen. You've got fire in your belly. I could maybe even learn from you.

Severa: We're kind of a weirdly matched pair, huh? How about I let you call the duel a draw and we try being friends?

Cynthia: Let me, huh? Ooooh, so generous! But when you think about it, our mothers were friends as much as they were allies. Maybe we were fated to be the same all along.

Severa: I'm too tired to think about fate.

Cynthia: Ha ha, I'm barely keeping my eyes open here, too. I say we take a nap, then go for a cup of tea.

Severa: Deal... But I get to...pick the nap... Zzz...

Cynthia: Ha ha. You fell asl... Zzz...

Gerome

GEROME X CYNTHIA C

Cynthia: Heya, Gerome!

Gerome:

Cynthia: No, I'm over here! Yoo-hoo! You're going the wrong way!

Gerome: "Sigh" What do you want?

Cynthia: I don't want anything. I'm just wondering if you're free to chat?

Gerome: No. I'm not.

Cynthia: Really? Great! 'Cause I'm anxious to know what you think the perfect hero looks like. For example, you could say he—or she—or he is lovely and powerful and graceful, right? Or that everyone admires her! ...Or him. I suppose it could be a him. Anyway, I'd love to get your opinion on the whole matter. You're very hero-like yourself, especially given that cool, dark demeanor and all.

Gerome: I'm leaving. ...Don't follow me.

Cynthia: No, Gerome, wait! I'm not done! I'm not... done. If I didn't know any better, I'd swear he was trying to avoid me.

GEROME X CYNTHIA B

Cynthia: Hey, Gerome! Can we, already? Pleeeeease?

Gerome: Do what?

Cynthia: Have our hero chat, of course!

Gerome: I never agreed to such a thing. ...I have nothing to say.

Cynthia: Liar! Remember when we were kids? We'd talk for hours and hours!

Gerome: We're not children anymore.

Cynthia: I know. But remember when you told me I looked all strong and graceful like a hero?

Gerome: ...I said that?

Cynthia: Oh, yeah! All the time, actually! I'd love to hear you say it again.

Cynthia: Hee hee! It sent a thrill down my spine when you'd tell me how wonderful I was! I love that about you!

Gerome: W-wait! You love me?!

Cynthia: Well, sure, we grew up together, right? We're the bestest of pals, aren't we? I loved it when you told me I'm a hero! ...And graceful and beautiful and smart.

Cynthia: So, come on! Make with the flattery!

Gerome: We are not children anymore!

Cynthia: Aw, geez. Don't tell me... Does he hate me now...?

GEROME X CYNTHIA A

Gerome: I shouldn't have done it. It was cruel.

Cynthia: What was cruel?!

Gerome: Gyah! ...H-how long have you been hiding there?!

Cynthia: Oh, I've been here forever! You would have noticed too, if you weren't so completely lost in thought. If I was a foe, I could have lopped off your head without you ever realizing it.

Gerome: Yes, but in battle, I would be much more dilig—

Cynthia: Don't forget, you're a proper hero now! You can't afford to let your guard down. ...It just looks bad.

Gerome: Who said I was a hero? Apart from you, I mean.

Cynthia: Oh, Gerome, you don't have to be so modest. I love you anyway!

Gerome: Y-you love me?

Cynthia: Yeah, of course I do, silly. Anyway, that's not why I came to talk to you. I have a question for you. A very important question.

Gerome: Hold! Return to the part about lo—

Cynthia: Do you hate me?

Gerome: What? ...Why do you ask?

Cynthia: Because, it sometimes feels like you're trying very, very hard to avoid me.

Gerome: I find you difficult to be around.

Cynthia: "Gasp" No... Oh I knew it...

Gerome: I'm not finished. You have always been a perpetual ray of sunshine in my life. But sometimes, a man like me wishes to draw the curtains and sit in the dark.

Cynthia: Like a troglodyte?

Gerome: Please don't misunderstand me. I don't dislike you. Your good humor raises people's spirits and dispels the horrors of war. You are a shining beacon of hope, reminding us there can be a better future. You light the fires of optimism and inspire us to keep striving.

Cynthia: Gosh. You make me sound so...important. More of this please! But wait...I guess if you think that, you can't possibly hate me. ...Right?

Gerome: None of your comrades dislike you, myself included.

Cynthia: Phew! That's a relief! Thanks, Gerome! We'll talk again soon, I promise.

Gerome: W-wait! My point was that I do not want to talk!

GEROME X CYNTHIA S

Cynthia: "Rustle, rustle" "Scratch, scratch, scratch" Oh, hey, a peanut! "munch, munch" La da dum de dooooo... Oooooh, I wish I was a hammer ♪ I'd hammer all day loooo—

Gerome: Stop fidgeting! We're on guard duty. ...You need to stay alert.

Cynthia: Vigilant! Right! That's me! ...Got it. See, it's just that I can't stop thinking about when we were kids. Remember how we'd go into the woods and play Justice Cabal?

Gerome: ...Vaguely.

Cynthia: There was that time I pretended to be a paladin and killed all those evil goblins... You said I looked truly heroic, even though the goblins were only snapdragons.

Gerome: You don't forget anything, do you? Perhaps it's only fair that I tell you...

Cynthia: I don't want anything... Is something wrong? Ohm-igosh, there IS something wrong! This is what I've been worried about! Don't leave me hanging! Go ahead! Say it!

Gerome: When I confessed I wasn't comfortable around you, I...lied. Or at least, I wasn't clear about the real reason why...

Cynthia: Wait, so it's not that I'm too bright and cheerful? ...Then what is it? Maybe I can fix it or change it so you don't totally hate you anymore.

Gerome: Gods' bread! I don't hate you! You're just difficult to be around. ...Because of my vertigo.

Cynthia: You mean, like, your being afraid of heights?

Gerome: So do you remember teaching me to fly when we were young?

Cynthia: Yeah, sure! You were so scared of heights you couldn't ride a wyvern! So I took you on my pegasus, and we flew and flew until you weren't afraid anymore. Hee hee! That was so much fun! I haven't thought about that in ages...

Gerome: I had hoped to never think on it again...

Cynthia: So, wait. You hate me because I know your secret weakness?

Gerome: No! That's not it at all! ...Well, maybe it is. Partly, at least. I have been...desperate to impress you, and yet you've already seen me to a fool.

Cynthia: No way! ...You were trying to impress ME?!

Gerome: Is that so unbelievable?

Cynthia: Gerome! I'm crazy about you! Why do you think I keep bugging you all the time?!

Gerome: I...I had always thought...that it was just because we were childhood friends.

Cynthia: Well, there is that, but a girl doesn't hang on your every word for old time's sake! Really, how can someone so wonderful be so darn thick?

Cynthia: ...Heh. Well, look. Now that we've cleared the air, we can start fresh.

Gerome: Yes! I suppose we can! First order of business: what's the best look for a heroic couple...?

Morgan (male)

MORGAN (MALE) X CYNTHIA C

Cynthia: I am Cynthia, Vanquisher of Evil! My sword has judged you and found you wanting! ...Heh. Nice. I'm totally using that next time out.

Morgan (male): You seem as chipper as ever, Cynthia. I feel energized just watching you.

Cynthia: Hey, if I've got anything to offer, it's pep! Belting out catchphrases and awesome hero speeches always gets me going.

Morgan (male): So that's your secret, is it?

Cynthia: Yup! If you're ever feeling worn down, I can't recommend it highly enough. Hey! You should try it right now!

Morgan (male): All right, maybe I will! Let's see... I am Morgan, the, um, unwavering light that makes bad guys...really sad!

Cynthia: ...Well?

Morgan (male): Hey, that does feel good! I bet with a little bit of practice, I could really get used to this!

Cynthia: Oh, yay! It's always great to find someone who appreciates the art of heroism.

Morgan (male): Heh, it does seem like we're something of a matched pair.

Cynthia: And that means it's up to us to keep the speeches coming till everyone is energized!

Morgan (male): Look out, world! I'm gonna shout at you until I'm hoarse!

MORGAN (MALE) X CYNTHIA B

Cynthia: Hrmmm...

Morgan (male): Mmm? Cynthia?

Cynthia: Do they really...? But that would mean...

Morgan (male): Is everything all right?

Cynthia: Oh. Hi, Morgan.

Morgan (male): I don't think I've ever seen you this drained. Is something on your mind?

Cynthia: No, I'm... Well, yes, actually. Lately, it seems like the others have all been...staring at me.

Morgan (male): Er, you mean more than usual or... what?

Cynthia: Well, I'm used to them watching, but not... you know...staring. It's been happening when I give heroic pep talks. People always look, but...

Morgan (male): ...But?

Cynthia: But whenever I do it lately, people just stare. A lot. And hard. It's like they're boring into my soul with twin javelins of shame and regret.

Morgan (male): Oh, that's just your imagination, I'm sure.

Cynthia: No it's not. They pity me, Morgan! They're all embarrassed for me! And so now that's all I can think about. I can't even fight anymore! Seriously, I almost got stabbed by a blind codger on a horse the other day...

Morgan (male): Then I propose a little experiment.

Cynthia: Oh?

Morgan (male): If your heroic boldness is too much for them, why not try acting meek? In our next battle, take the field as a quiet, demure Cynthia. Then watch their reactions and draw conclusions from the experience.

Cynthia: Yeah, but...what will that tell me?

Morgan (male): If they're fed up with how rambunctious you are, they'll be glad you quieted down. But if they like your usual peppy self, they'll clearly be worried about you.

Cynthia: Geez. I'm not sure I even know how to act demure.

Morgan (male): Just think about your mother. Try to act as she would.

Cynthia: All right. I'll give it a try!

Morgan (male): Wonderful! We'll have your answer in no time, I guarantee it!

MORGAN (MALE) X CYNTHIA A

Morgan (male): Hey, Cynthia.

Cynthia: ...Morgan.

Morgan (male): So? How goes it? Have you mastered acting meek and demure yet?

Cynthia: ...Yes.I have.

Morgan (male): Er, right. You know, I'm not sure that's actually how demure works. Maybe you just need a little more time? Yes, I'm sure that's it.

Cynthia: ...No. That isn't...necessary.

Morgan (male): I can actually feel myself growing old waiting for you to finish a sentence. I'm starting to think this was a bad idea.

Cynthia: What? No way! I practiced really hard! Look, I'll even show you my demure face! Mmmmrrrrgggg-hhh...

Morgan (male): ...Please stop that. Er, all this aside, though, how have the others reacted to this new you?

Cynthia: Aw, it was really sweet! They were all very concerned. They kept coming up and asking me what was wrong.

Morgan (male): Oh?

Cynthia: Oh yeah! People were all running up and shouting at me and stuff! "What is wrong with you, Cynthia?!" "You look upset, Cynthia!" "Why do you keep making that horrible face, Cynthia?" So if what you said is true, that means they all miss the old perky me, right?

Morgan (male): Er... R-right! I'm sure that's what they meant. They all want you to be yourself. Your happy, energetic...very loud self.

Cynthia: Yay! It's such a relief to know for sure! Oof, all that worrying had me twisting in knots. But now that it's over, I'm hungry! You wanna grab something to eat? I think they have pottage today!

Morgan (male): Sure. It must be hard to be energetic on an empty stomach, after all.

Cynthia: I know, right? Come on, let's go!

Morgan (male): ...Yeesh. Between the pauses and that face, it's no wonder people thought her ill. I doubt it had anything to do with her missing pep and verve. ...Not that I could tell her that without breaking her heart, though.... Ah, well. At least she's smiling again!

MORGAN (MALE) X CYNTHIA S

Cynthia: Morgaaaan!

Morgan (male): Um, hi?

Cynthia: You're not...hiding anything from me, are you?

Morgan (male): Wh-what makes you say that?

Cynthia: Oh, please. It's written all over your face!

Morgan (male): I really have no idea what you—

Cynthia: The REAL reason everyone was worried when I was acting demure—out with it!

Morgan (male): ...Ah. That.

Cynthia: I knew it! You knew I was wrong, and you just let me believe it! You said everyone's concern about me meant they missed the old me! You lied to me!

Morgan (male): It wasn't a lie! It was a... I mean, I... Wait, how did you come to the conclusion that the others didn't miss the old me?

Cynthia: Someone asked if I was feeling better, and I said yep, and then they said... "Good. The funny talking had us worried it was permanent brain damage." "You've always been crazy, but this time we worried you'd finally snapped." This is your fault, Morgan! I made an even bigger fool of myself than before!

Morgan (male): I'm sorry, Cynthia. Really I am. I didn't mean to lie.

Cynthia: Then why did you?

Morgan (male): Because I missed the old you! The crazy girl with all the speeches and moves! So others may not get it. Well, that's true! ...But me? I just missed you. You, Cynthia! I think you're awesome!

Cynthia: Morgan...

Morgan (male): I love your energy, Cynthia! I love your heroic nature! I...I love YOU!

Cynthia: ...You what?

Morgan (male): I only realized it once you were gone. Er, once you went demure, I mean. But once it happened, I didn't know how to tell you without hurting you. And then, when you changed back, I didn't want to change your mind about why. So I didn't. I was a coward and I just... hoped everything would work out.

Cynthia: ...I forgive you.

Morgan (male): ...Y-you do?

Cynthia: I looked like a fool, and you just confessed that you're in love with me. I think that even the ol' embarrassment scales, don't you?

Morgan (male): Cynthia...

Cynthia: Yes, it may have been embarrassing... But in the end, I'm glad it happened.

Morgan (male): Really?

Cynthia: Yes. ...Because it led me to someone who really loves me for who I am. I hope you know what you're getting into. I can be kinda loud sometimes.

Morgan (male): Heh...I kinda noticed. But I'd have it no other way! *Ahem* By the mighty sword of Morgan, I shall love you forever!

Cynthia: Hey, that was actually pretty good!

Morgan (female) (Mother/daughter)

The Morgan (female) mother/daughter dialogue can be found on page 312.

Morgan (female) (Sisters)

MORGAN (FEMALE) X CYNTHIA (SISTERS) C

Morgan (female): Let's see here... Birthday? May 5th... Favorite colors? Blue and purple... Favorite food? Probably bear meat...

Cynthia: What are you mumbling about over there, Morgan?

Morgan (female): Least favorite food? Veggies, apparently. Don't seem to mind them now, though...

Cynthia: Morgan!

Morgan (female): Oh! Cynthia?! Guess I was pretty out of it to miss my own sister paying a visit! Did you need something?

Cynthia: Just wondering what you were chanting over there... You practicing some new magic incantations or something?

Morgan (female): Nope! Just going back over my notes on what you told me about myself. I was hoping they'd hold some clue that might help spark my memory. Heh. It's kind of crazy how much you know about me, huh? Like, I really once got five nosebleeds in the same day? I have no memory of that at all. AT ALL! Ha ha ha! I just can't imagine...

Cynthia: Well, you're still as cheerful, that's for sure. And as talkative as ever...

Morgan (female): I am? I mean, I was?! Hmm. Now that you mention it, that does sound...right, somehow. ...Heh. Everything still feels funny. Even you being my sister hasn't really clicked.

Cynthia: If you think it's strange for you, imagine how I feel... My kid sister starts talking to me like a stranger, asking questions about herself... I had no idea how to even interact with you. It was pretty rough, but I got used to it.

Morgan (female): Heh, yeah... Sorry about that. But that's just another reason why I'm working hard to get my memories back. Once I do, nobody will have to feel weird or awkward around me again. Pretty noble, huh? I'm such a sweet, selfless girl!

Cynthia: Yeah, and so humble as well... In any case, I'm happy to help you get those memories back however I can. Someday soon I bet we'll be able to laugh about all the old times—now included!

Morgan (female): Heh, right!

■ MORGAN (FEMALE) X CYNTHIA (SISTERS) B

Cynthia: Whew! Another long day of combat... I'm bushed. Think I'll hit the hay ear...ly? Is someone passed out over there? Wait, is that Morgan?!

Morgan (female): Nn...nngh...

Cynthia: Morgan! Morgan, are you all right?! What happened?!

Morgan (female): ...Wha—?! Cynthia! Wh-what am I doing here? Was I asleep?! I don't even remember feeling tired... Uh-oh! I was bashing that tome against my head when I blacked out. That explains why my face hurts so bad.

Cynthia: Bashing your... Morgan, why in the WORLD would you do that?! Wait, were you trying to get your memories back?

Morgan (female): Well, yeah! Obviously. If you ever saw me bludgeoning myself just for fun, I hope you'd put a stop to it.

Cynthia: I'll stop you even if it's NOT just for fun, you nitwit! Look, I know you want your memories back, but please... Don't do anything reckless.

Morgan (female): ...But I want to be able to talk with you about old times again.

Cynthia: I know, Morgan, and I want that, too. But more than that, I want you safe. I may just be another stranger to you, but to me, you're family. In the future, with Mother and Father gone, it was just the two of us. You're all I had, Morgan... I don't know what I'd do if anything happened to you.

Morgan (female): All right. I'm sorry, Cynthia.

Cynthia: Just as long as you understand.

Morgan (female): ...Heh, that felt really siblingy just now. Don't you think? Me messing up and you scolding me felt... I don't know, it felt really plausible! Maybe if you keep at it, I'll remember something!

Cynthia: You...really think so?

Morgan (female): Yeah! Oh yeah, this will totally work! So go on, keep yelling! C'mon, scream at your amnesiac sister, Cynthia!

Cynthia: I... I'm not really comfortable with—

Morgan (female): Actually, why don't you use the tome, too? Come on, don't hold back. Really wallop me with that thing! Maybe the simultaneous physical and mental shock will jar some memories loose! It's gotta be twice as effective as either one by itself, right? That's just basic science.

Cynthia: Good night, Morgan...

■ MORGAN (FEMALE) X CYNTHIA (SISTERS) A

Cynthia: Hey, Morgan. I'm headed into town. Want to come along?

Morgan (female): I'd love to! Is there something in particular you need?

Cynthia: I might pick up a couple of things, yeah. But mostly I think there's something YOU need.

Morgan (female): It doesn't have to do with getting my memories back, does it?

Cynthia: The opposite, really. Maybe there's no need to worry about your memories anymore.

Morgan (female): That...makes no sense.

Cynthia: I'll be honest—it does hurt to know you've forgotten me. But...maybe it's better to build new memories than to worry about old ones.

Morgan (female): What do you mean?

Cynthia: I've been thinking about this a lot. Why you might have lost your memories, I mean. And I'm wondering if you didn't have some awful memory you couldn't bear to keep. ...I know I've got a few. I see a lot of faces, you know? People we couldn't save...

Morgan (female): I'm sorry you have to bear those dreadful memories, Cynthia...

Cynthia: Look, this is just a theory, and even if it's true, it's not like you did it consciously. But I do think that getting your memories back might not necessarily be a good thing.

Morgan (female): Hmm... I understand, and believe me, I appreciate the thought... But I want to remember things, no matter how painful they are. Because I'm sure there'll be plenty of great memories mixed with the bad ones. And the truth, whatever it is... I really want to have that back, you know?

Cynthia: Well, if you're sure, then I'm happy to help.

Morgan (female): That's really kind of you, Cynthia, but do you truly realize what you're saying? I mean, it could be years before I remember anything. Or decades. Heck, there's a decent chance I may never get my memories back at all. I want to drag you into something that could last forever.

Cynthia: I'm already stuck with you forever, you goof. I'm your sister! We're family—memories or no. You couldn't keep me away.

Morgan (female): Cynthia, I... *sniff* Thank you! I'll do everything I can!

Cynthia: Then start by coming with me into town.

Morgan (female): Huh? But you said that doesn't have to do with getting my memories back.

Cynthia: Hey, there's no rule that says you can't have a little fun while you try. And there's certainly no rule against making some happy new memories, either.

You're young! Live a little! There'll be plenty of time to worry later.

Morgan (female): Right... You're right! Thanks, Sis!

Yarne

■ YARNE X CYNTHIA C

Cynthia: Yarne! How's it going this fine— Hey, why the long face?

Yarne: Have you come here to chew me out like everybody else?

Cynthia: What? Why would I do that? And wait, why would THEY do that? What did you do?

Yarne: It's what I didn't do, which is fight. In case you didn't notice, I spent most of the last battle running and hiding. They have every right to be mad at me. Frankly, I'm surprised you aren't.

Cynthia: What, is that all? Why would I be mad?

Yarne: Huh? You mean...you're not?

Cynthia: Come on, I'm not the type to hassle someone for something like that! I walk the hero's path—I defend the weak by defeating the wicked! So I can't very well get MAD at the weak, now can I? You're fine just as you are. Besides, without cravens like you, I'd be out of a job!

Yarne: H-hey! That's not... Oh, am I kidding. Yes I am. Mostly, I'm just surprised to hear you say I'm all right the way I am. You're the only one who thinks so. So, yeah. Thanks.

Cynthia: Aw, come on, buddy! Smile! As a hero, I'm not allowed to leave the scene until you're wearing a grin.

Yarne: R-right. I'll try.

■ YARNE X CYNTHIA B

Yarne: I still can't stop the trembling... Why does war have to be so scary?

Cynthia: Hey, it's Yarne! Aww, are you down again? What happened this time?

Yarne: Same as always... Whenever I stare down an enemy, my legs lock up on me. Heh heh... Pathetic, isn't it? I'm always shouting about how I'm the last taguel, but the reality is that I'm just a big chicken. Bawk, bawk.

Cynthia: Hey, combat can be scary even for the best of us! But if that's who you are, just accept it! We weren't all born to be fighters.

Yarne: But I WANT to fight! I'm tired of feeling so pathetic! Everyone else is fighting with everything they've got, and I'm still turning tail.

Cynthia: Well then, if you want it that bad, maybe you can work through the fear.

Yarne: You think I haven't been trying to do that this whole time?

Cynthia: Well, maybe you've been doing it wrong! I bet I know a way!

Yarne: What is it?

Cynthia: You should become a hero!

Yarne: A...hero?

Cynthia: Yeah! A hero just like me! I mean, I'm still in training myself, but you could join me! It'll be totally great!

Yarne: Sounds like a tall order for a coward...

Cynthia: Pffft! All you have to do is stand up to evil and help anyone who needs helping. If you follow those two rules, anyone can become a hero!

Yarne: Just because it's simple doesn't mean it's easy... The heroes you hear bards sing about have fought in hundreds of epic battles.

Cynthia: You've got at least a few under your belt already, and there's plenty more to come. All you need is the will to act!

Yarne: You really think I can be a hero? Just...poof? Just like that?

Cynthia: If you believe it, ANYTHING is possible!

Yarne: Well...a positive outlook and a good certainly couldn't hurt... And it's not like I could get any LESS brave...

Cynthia: Great! Then from now on, you'll be my faithful ward! With enough work, I might even promote you to sidekick!

Yarne: Er, that sounds like...a deal?

■ YARNE X CYNTHIA A

Yarne: Ah, Cynthia!

Cynthia: What's up, Yarne?

Yarne: I just wanted to thank you.

Cynthia: For what?

Yarne: That talk about heroes.

Cynthia: I should be thanking you! I always wanted a ward. How's it going, anyway?

Yarne: Well, I decided it was a little ambitious to just charge into battle like a true hero. That's why I decided to start with baby steps.

Cynthia: Explain yourself, ward!

Yarne: I was in town the other day, and I saw this scrawny kid getting picked on. I stopped the bullies from their deeds and gave them a stern talking to. And they actually thanked me!

Cynthia: ...Wait, who thanked you? The ne'er-do-wells?

Yarne: Yeah! It was the strangest thing. They all said what I did was "really great, man." I don't know how to react... But I can see the appeal of doing this sort of thing. The adulation is addictive!

Cynthia: Ah ha ha ha! I bet you're already a full-fledged hero to those kids!

Yarne: This must be how heroes are born... People decide to do what's right, and then earn fans and accolades trickle down to all. I know I'm still holding everyone else back in combat, but I'm going to fix that! I want to be someone those kids can look up to and admire!

Cynthia: Ha ha! You have the right of it, ward! Just remember, as a hero it's also your job to keep a smile on everyone's face.

Yarne: Er, right! I'll...work on that part.

Cynthia: That's the spirit! I'll be waiting to see your progress, ward!

■ YARNE X CYNTHIA S

Cynthia: Hait, Bunny Boy!

Yarne: Er, what?

Cynthia: You haven't heard? That's what they're calling you!

Yarne: People are calling me that? But people don't even know I exist!

Cynthia: Well, all the kids in the town sure do! At first, I wasn't sure who they were talking about. But when you think about it, there's only one guy who fits that description.

Yarne: You really think they mean me? I had no idea.

Cynthia: My little ward's all grown up into a sidekick! I couldn't be more proud! ...Even if you HAVE been upstaging me lately.

Yarne: Um, I don't think—

Cynthia: Then why don't I have a nickname yet? Huh? Every kid in town was singing the praises of Bunny Boy, ally to all!

Yarne: I am Yarne, avenger of the taguel and ally to all! Have at you, demon! See if you're brave enough to face Bunny Boy! ...Was that too goofy?

Cynthia: Are you kidding? That was amazing! I got chills, Yarne! But that's so unfair! I want a title! I want to give awesome entrance speeches, too!

Yarne: I always thought they were silly, but it actually feels pretty good. But this isn't about speeches or praise! It's about making a world safe for all...

Cynthia: Wow, you ARE getting good at this!

Yarne: And I want... I want to be your hero, too, Cynthia! I want to fight for the future together! I want to stay by your side!

Cynthia: Er, you mean as a sidekick, right? Or is this...

Yarne: Um, no. This would be...the other thing.

Cynthia: Oh my gosh, that'd be even MORE amazing!

Yarne: R-really? Then, you don't mind...?

Cynthia: You're totally my hero right now!

Yarne: I am? Yeeeeeesss!

Cynthia: You can be my hero, and I'll be yours! And then together we'll be everyone else's! We're going to become a legendary crime-fighting duo! ...But wait, I'm gonna need a name.

Yarne: Er, I don't think you quite understand the gravity of my propos—

Cynthia: I've got it! I am Cynthia, the... the Pigtailed Pugilist! No, wait! The Pigtailed PUNISHER!

Yarne: Heh. Well, you wouldn't be you if you weren't a little up in the clouds... Come, my faithful companion! Let's go serve up some hot justice together!

Laurent

■ LAURENT X CYNTHIA C

Laurent: Cynthia? A word, please.

Cynthia: What is it, Laurent? You look even grimmer than usual.

Laurent: I wish to speak with you about today's training exercises.

Cynthia: Here to tell me what a bang-up job I did? Yeah, I was pretty proud myself.

Laurent: I came to inform you that you were drifting ahead of everyone during the march.

Cynthia: I wasn't drifting, I was executing the Twelve-Point Hero Spinner of Doom! It's my new superpower move, so I was trying it out to make sure—

Laurent: Please take due precaution to ensure you keep pace with the rest of us.

Cynthia: It's called initiative! Look it up sometime!

Laurent: It makes you a prime target for snipers and also inconveniences the entire army.

Cynthia: I'm tougher than I look, you know? And I already look pretty tough.

Laurent: Confidence is meaningless if it leads to wanton hubris. True confidence must—

Cynthia: Okay, okay! Just stop...saying stuff. I'll try to be more careful. Sheesh!

Laurent: I—account for many factors, including the spatial relationship of units, as well as... Er, Cynthia? I wasn't done.

■ LAURENT X CYNTHIA B

Cynthia: Ah... Another day's training done! ...Which means it's just about time for Laurent to show up with his midday lecture. That guy just will NOT let it go! Seriously!

Laurent: Ah, good. Here you are.

Cynthia: ...Oh. Yippee.

Laurent: Do you have a moment, Cynthia? I'd like to inquire as to why you continue to ignore my counsel.

Cynthia: ...Yup. Riiight on time.

Laurent: ...I'm sorry. I don't understand.

Cynthia: I mean I've heard this dumb lecture a bazillion times and I'm tired of it!

Laurent: If you truly wish for me to desist, you need only to agree to my reasonable requests. Caution and cooperation are paramount to any successful military collective. The unit stays close so it can aid individual members and better function as a whole. Thus are victories won. And even knowing this, you still insist on outracing the vanguard and charging in. I'm starting to fear this isn't a valid tactic, but instead a juvenile desire for glory.

Cynthia: Is anything I'm doing really hurting anyone? No, it isn't! Everyone's fine! ...And I've done nothing that isn't befitting a true hero.

Laurent: This army needs soldiers. It does not need heroes. Such antics disrupt the group dynamic and serve no use whatsoever on the battlefield.

Cynthia: How dare you say I'm no use in battle!

Laurent: That is not what I said.

Cynthia: Yes, you did! You've been saying it this whole time!

Laurent: If that is how you interpret my words, I will not attempt to dissuade you.

Cynthia: You won't? Why not?

Laurent: Because I will do whatever it takes to make you stop acting like a selfish child.

Cynthia: Oh, that's it, buster! That is IT! I've done a LOT more for this war effort than you, Mr. Smarty-Pants! I don't have to take this!

Laurent: Everything I'm saying is out of concern for your safety.

Cynthia: And I'm saying that my safety is none of your stupid business! So leave me alone!

Laurent: Cynthia! Hold! So be it. If that is your wish, I am happy to comply.

■ LAURENT X CYNTHIA A

Cynthia: Aw, maybe I was a little too hard on him. Laurent's stubborn, but he means well. ...Whoops! Forgot we were in the middle of a training exercise. Time to focus!

Laurent: C-Cynthia! Hey!

Cynthia: ...Hey? I don't think I've ever heard Laurent say hey bef—

Laurent: Watch out!

Cynthia: Watch out for wha—? Aaah!

Laurent: ...Huh? Geez, that was a hard fall. So why didn't it hurt?

Laurent: Nngh...

Cynthia: Laurent?! Oh my gosh, I didn't see you there!

Laurent: Apparently not... You were staring off into the distance when the army began marching. You were nearly run over by a ballista.

Cynthia: Ooh, I'm sorry! Are you all right? Can you stand?

Laurent: I'm perfectly fi—NNGH! ...Perhaps not.

Cynthia: Don't force it! Wait right here— I'll get a stretcher!

Laurent: Well? Feel any better?

Cynthia: Some minor pain persists, but I am at least ambulatory once more. The healing spell has done its work. Time will do for the aches.

Cynthia: Oh, good... Look, I'm really super sorry. I wasn't paying attention.

Laurent: It's all right.

Cynthia: No, it's not all right! I've been a big dumb jerk, and you got hurt because of it! I was too busy shouting about how I was going to become a hero to listen. If I'd followed your advice, you wouldn't be stuck here now.

Laurent: I'm sorry as well, Cynthia. I know how important your aspirations are to you. I ought not to have spoken so dismissively about them. I was being stubborn.

Cynthia: It's fine.

Laurent: I suppose I'd grown desperate to make you listen. You're strong, and brave, and many of the others look to you as a leader. You're too important to be taking unnecessary risks, however minor. I spoke as I did because we can't afford to lose you, Cynthia.

Cynthia: Well, I promise to listen from now on. Double hero promise, in fact.

Laurent: Perhaps I ought to have had you dislocate my hip sooner.

Cynthia: I said I was sorry!

■ LAURENT X CYNTHIA S

Cynthia: *Sigh*

Laurent: Is something wrong, Cynthia? You seem enervated. You barely touched your plate at dinner. Are you feeling unwell?

Cynthia: Forget about me. How are you? Is your hip all right?

Laurent: The pain is negligible now. It poses no obstacle to daily life or combat.

Cynthia: I'm still really sorry.

Laurent: I believe the numerous apologies I have already received made that clear. I appreciated the flowers, by the way. Oh, and the singing telegram.

Cynthia: Yeah, but still. You busted your hip because my big booty fell on you.

Laurent: Your posterior is not of such ample size that it shattered my bones, Cynthia. And for my part, I was glad you fell atop me.

Cynthia: What? Why?

Laurent: Because it allowed me to be hurt in your place. Men of most cultures enjoy some fantasy of saving the woman they love, yes? True, I'd hoped it to take place in a combat setting, but this served the purp—

Cynthia: Wait, what?! Back up a step!

Laurent: Did you wish me to speak more about the cultural implications of—

Cynthia: No! Back up to the part about the woman you...love.

Laurent: Oh. I see. You did not realize that... Oh my. I thought it clear that my persistence was born from concern for your well-being. If I was more adamant than normal, it's because I care for you all the more.

Cynthia: I... But then... Holy smokes. B-but I said all those horrible things to you!

Laurent: I accept those as the emotional outbursts that they were intended to be. However, there is a favor I might ask of you in return...

Cynthia: Wh-what?

Laurent: I would ask you to take me as your husband.

Cynthia: Laurent, you're a smart guy. Take one look at me and tell me what you think.

Laurent: Mmm... Fluttering eyelashes... Fingers twisting through hair... I believe your answer is in the affirmative?

Cynthia: YES! I love you!

Laurent: Oh, happy day!



Nah

■ NAH X CYNTHIA C

Cynthia: Perfect! There you are!

Nah: Did you need something?

Cynthia: As a matter of fact, I do need one teensy-weensy favor!

Nah: And what might that be?

Cynthia: Could you turn into a dragon? Just for a second! Pretty please?

Nah: Um...why?

Cynthia: Er, um, because... Becaaause... Because I'm going to strike a totally awesome pose on top of you!

Nah: ...What?

Cynthia: A dashing knight, perched atop a dragon's head, crying victory to the four winds! Can you imagine anything more amazing?

Nah: Yeah, actually I can. I mean, I suppose it's kind of amazing for the posing knight... But the dragon's part seems pretty lousy, if you ask me. Sorry, but I'm not going to serve as some kind of elaborate prop.

Cynthia: H-hey! You're not a prop! Knight and dragon stand together as a single unit! Equals in every way! You'll love it, I promise!

Nah: The word "equals" rarely applies when one person's rear is on the other's head.

Cynthia: Aww, you're overthinking this... C'mon, transform! Please? Let me pose on your head!

Nah: No. This whole conversation is silly! Do you know how scarce dragonstones are? Using one to stage your ridiculous farce is simply not going to happen!

Cynthia: Oh you're so stingy! And stubborn! You're being kind of childish here, Nah. I've got to admit.

Nah: Hello, pot. Meet kettle.

Cynthia: Well, I don't give up so easily. I'll be back as many times as it takes!

Nah: Why don't you go find a hobby that doesn't involve me?

■ NAH X CYNTHIA B

Cynthia: I'm back, Nah!

Nah: *Sigh*

Cynthia: So are you ready to transform for me yet or what?

Nah: Hold a moment. Let me check... Nope. Still not going to do it.

Cynthia: See, 'cause I've been thinking it over, and I think I know the problem. It's sitting on your head, right, kind of makes you look like a prop, right?

Nah: That's pretty much exactly what I told you the first time.

Cynthia: Right! That's why I figured out a solution! If we gave you a real role to play, you'd be more than just a piece of theater staging!

Nah: And just what role did you have in mind for me?

Cynthia: Are you curious? Hmm? Someone's cuuu-rious!

Nah: I don't think I've ever been so uninterested in my whole life. Whatever you have planned, I'm sure it's horribly demeaning.

Cynthia: Aww, come on! That hurts! Don't you trust me, Nah? Anyway, since you almost asked, I'll tell you... You'll play my rival!

Nah: Excuse me?

Cynthia: Bound by fate to clash time and again, the bards sing odes of our many battles! You are Nah, Draconic Queen of Darkest Darkness!

Nah: Darkest dark... Wait, what?

Cynthia: Time and again, I rise up to fight you for the sake of good and happiness and light. But time and again you flee like a craven before I can deliver the finishing blow!

Nah: Hey! Who'd play the craven?!

Cynthia: But fate has at long last seen fit to end this epic struggle! Our ten-thousand-year war has finally come to its climax!

Nah: I'm not ten thousand years old. And you'll be lucky to see tomorrow if you keep talking!

Cynthia: The duel is a sight the likes of which the world has never seen, nor will again. At combat's end, the dust clears, revealing the divine hero Cynthia stands victorious! The wicked Nah is vanquished! HUZZAH!

Nah:

Cynthia: Cynthia stands triumphant, one leg perched atop the prone and breathless Nah! She tilts back her head and lets forth a mighty victory roar! The people go wild! Yay! Huzzah! Nice job, Cynthia! We love Cynthia! Hip-hip-hooray! ...And so on. ...Well? What do you think?

Nah: That is the stupidest idea I have ever heard in my life.

Cynthia: What? Really?

Nah: This conversation is over!

Cynthia: What?! Aw, Nah! Don't go! Hey! Come back!

■ NAH X CYNTHIA A

Nah: Unbelievable. Even after that, Cynthia keeps begging me to transform! I'm not a prop, and I'm certainly not the wicked queen of darkness! Really, the nerve!

Cynthia: Heeeeeey, Nah! I'm back again! Miss me?

Nah: Speak of the wicked queen...

Cynthia: Aww, I missed you, too. Anyway, I was hoping you'd finally be ready to transform and let me up on your head!

Nah: Talking to you is like arguing with a wall. ...A stupid wall.

Cynthia: A wall who only wants one teeny-tiny favor that will only take five minutes! Please? I'll climb back down as soon as I'm done!

Nah: *Sniff, sniff* ...Huh? Cynthia, your smell...

Cynthia: What? What smell? I don't smell! I took a bath last week!

Nah: N-no, that's not what I... Manaketes can tell a person's intentions by their scent.

Cynthia: Wow, really? That's kind of amazing.

Nah: I'm sensing that you...actually want to be friends with me.

Cynthia: Well, yeah, of course!

Nah: So that's the reason you've been hanging around me all this time?

Cynthia: Well, what else could it be? You're always so serious! I didn't really know what you liked to do for fun. I figured if I could get you to transform, we could have a few laughs and break the ice.

Nah: I thought you were just...I don't know. Making fun of me or something.

Cynthia: Well, I really was looking to have fun, but not at anybody's expense. It's no fun for me unless you're having fun, too!

Nah: Cynthia... I think I may have misjudged you.

Cynthia: So, is that a yes? Can we be friends?

Nah: Of course we can be friends!

Cynthia: Yay! Friends at last! ...Now transform, and I'll just scurry on up and roar my mighty battle cry!

Nah: I didn't say anything about that!

Father

■ FATHER X CYNTHIA C

Cynthia: Now then, let's see what the flowers say. Option one, option two, option three...

[Robin]: Cynthia? Why are you plucking the petals off that poor dandelion?

Chrom: Cynthia? Why are you plucking the petals off that poor dandelion?

Frederick: Cynthia? Why are you plucking the petals off that poor dandelion?

Gaius: Cynthia? Why are you plucking the petals off that poor dandelion?

Henry: Uh, Cynthia? Why are you plucking the petals off that poor dandelion?

Cynthia: Oh, hello, Father! You're just the person I wanted to see! I'm using flower fortunes to choose an entrance flourish for the next battle! Buuuut I'm still having problems deciding, so I need to know what you think.

[Robin]: Er, I don't know anything about flower fortunes OR "entrance flourishes."

Chrom: Er, I don't know anything about flower fortunes OR "entrance flourishes."

Frederick: Dear, I don't know anything about flower fortunes OR "entrance flourishes."

Gaius: Er, I don't know anything about flower fortunes OR "entrance flourishes."

Henry: Sorry, I don't know anything about flower fortunes OR "entrance flourishes."

Cynthia: Well then, let me just lay them out, and you can decide what sounds best. The first option is to ignite a huge plume of purple smoke and come racing out of it!

[Robin]: ...Oh.

Chrom: ...Oh.

Frederick: ...Oh.

Gaius: ...Oh.

Henry: Wowzers!

Cynthia: Option two is to step onto the field amidst a shower of fluttering violet petals...

[Robin]: ...Ooo-kay.

Chrom: ...Ooo-kay.

Frederick: I...see.

Gaius: ...Ooo-kay.

Henry: ...Ooo-kay.

Cynthia: Option three is to suddenly burst out of a farmhouse in the middle of the battlefield!

[Robin]:

Chrom:

Frederick:

Gaius:

Henry:

Cynthia: So, what do you think, Father? Which would you prefer?

[Robin]: Um... Well, if I had to choose... Maybe the falling-petals one?

Chrom: Um... Well, if I had to choose... Maybe the falling-petals one?

Frederick: Well, I suppose if I had to choose... Maybe the falling-petals one?

Gaius: Um... Well, if I had to choose... Maybe the falling-petals one?

Henry: Well, they all sound pretty crazy, but... Maybe the falling-petals one?

Cynthia: Wait, truly? Well, THAT's a surprise! I didn't think it was your style at all. But if that's what you want, I'll start collecting petals!

[Robin]: Cynthia, this entrance you're planning... It isn't for me, is it?

Chrom: Cynthia, this entrance you're planning... It isn't for me, is it?

Frederick: Cynthia, this entrance you're planning... It isn't for me, is it?

Gaius: Cynthia, this entrance you're planning... It isn't for me, is it?

Henry: Cynthia, this entrance you're planning... It isn't for me, is it?

Cynthia: Of course it is, silly! Why else would I ask your opinion? Hee! I'm surprised you chose the flowers, but I'm glad you did. It's my favorite!

[Robin]: N-no, wait! Just a moment! *Sigh* ...What have I gotten myself into?

Chrom: N-no, wait! Just a moment! *Sigh* ...What have I gotten myself into?

Frederick: N-no, wait! Just a moment! *Sigh* ...What have I gotten myself into?

Gaius: N-no, wait! Just a moment! *Sigh* ...What have I gotten myself into?

Henry: N-no, wait! Hang on, Cynthia! Heh. All right, then..

■ FATHER X CYNTHIA B

Cynthia: I am SO sorry, Father.

[Robin]: I should hope you are! You nearly buried me alive under all those blasted petals!

Chrom: I should hope you are! You nearly buried me alive under all those blasted petals!

Frederick: I should hope you are! You nearly buried me alive under all those blasted petals!

Gaius: I should hope you are! You nearly buried me alive under all those blasted petals!

Henry: I should hope you so! You nearly buried me under all those blasted petals!

Cynthia: I know. I asked Mother to help out, and we ended up collecting thousands!

[Robin]: You roped Sumia into helping you with this ridiculous project?

Chrom: You roped Sumia into helping you with this ridiculous project?

Frederick: You roped Sumia into helping you with this ridiculous project?

Gaius: You roped Sumia into helping you with this ridiculous project?

Henry: You roped Sumia into helping you with this ridiculous project?

Cynthia: Of course! We wanted to do something special for our dear father and husband! But you DID look really dashing and heroic out there in the field! ...At least, you would have, if anyone could have seen you in that blizzard of petals!

[Robin]: Well, in any case, there are to be no more entrance flourishes. Understood?

Chrom: Well, in any case, there are to be no more entrance flourishes. Understood?

Frederick: Well, in any case, there are to be no more entrance flourishes. Understood?

Gaius: In any case, there are to be no more entrance flourishes. Understood?

Henry: "Sigh" In any case, no more entrance flourishes. Understood?

Cynthia: Aww, but I had SO many more wonderful ideas! ...Can I at least pick a special catchphrase for you to shout at the start of battle?

[Robin]: Cynthia! War is a serious business. We're not playing games out there.

Chrom: Cynthia! War is a serious business. We're not playing games out there.

Frederick: Cynthia! War is a serious business. We're not playing games out there.

Gaius: Cynthia! War is a serious business. We're not playing games out there.

Henry: Cynthia, as fun as it is to slay our foes, we're not playing games out there.

Cynthia: ...I-I know. I'm sorry. I just want to make you happy and have something fun to talk about and... Oh, pegasus poop! I just don't know what to do! I mean, what ARE fathers and daughters supposed to do together?

[Robin]: Gods, Cynthia, don't be silly. You don't have to make such an effort to think of fun things for us to share. Just spending time with you is enough for me.

Chrom: Gods, Cynthia, don't be silly. You don't have to make such an effort to think of fun things for us to share. Just spending time with you is enough for me.

Frederick: Cynthia, don't be silly. You don't have to make such an effort to think of fun things for us to share. Just spending time with you is enough for me.

Gaius: Gods, Cynthia, don't be silly. You don't have to make such an effort to think of fun things for us to share. Just spending time with you is enough for me.

Henry: Aw, heck, Cynthia, don't be silly! You don't have to knock yourself out trying to think of fun things for us to share. Just spending time with you is enough for me.

Cynthia: Truly? Just...being together is enough?

[Robin]: Of course.

Chrom: Of course.

Frederick: Of course.

Gaius: Of course.

Henry: Of course.

Cynthia: Oh, Father! You're SUCH a great guy! It's no wonder Mother fell in love with you! Even if you're just being polite, you're doing it because you like me! You're the BEST!

[Robin]: Unnngh... Cynthia... D-don't hug...so tight... Can't b-breathe... C-crushing...ribs...

Chrom: Unnngh... Cynthia... D-don't hug...so tight... Can't b-breathe... C-crushing...ribs...

Frederick: Unnngh... Cynthia... D-don't hug...so tight... Can't b-breathe... C-crushing...ribs...

Gaius: Unnngh... Cynthia... D-don't hug...so tight... Can't b-breathe... C-crushing...ribs...

Henry: Unnngh... Cynthia... D-don't hug...so tight... Can't b-breathe... C-crushing...ribs...

■ FATHER X CYNTHIA A

Cynthia: Father! Will you brush my hair? Pleeease?

[Robin]: Er, I'm sorry, Cynthia, but I'm a little busy at the moment... You haven't left my side lately... Are you sure you don't have other things to do?

Chrom: Er, I'm sorry, Cynthia, but I'm a little busy at the moment... You haven't left my side lately... Are you sure you don't have other things to do?

Frederick: Er, I'm sorry, Cynthia, but I'm a little busy at the moment... You haven't left my side lately... Are you sure you don't have other things to do?

Gaius: Er, I'm sorry, Cynthia, but I'm a little busy at the moment... You haven't left my side lately... Are you sure you don't have other things to do?

Henry: Er, I'm sorry, Cynthia, but I'm a little busy at the moment... You haven't left my side lately... Are you sure you don't have other things to do?

Cynthia: Well, you said that spending time with me was fun! Riiight? Hey, why don't you come to town with me? We'll spend the whole day together!

[Robin]: Er...now?

Chrom: Er...now?

Frederick: Er...now?

Gaius: Uh...now?

Henry: What—now?

Cynthia: Yes, now! We'll walk the streets and visit the market and hold hands the whole time! Then we can find a tasty cake shop and when evening falls we can go caroling and—

[Robin]: All right, Cynthia, that's enough now. Look, I know we're family, but even family needs time apart sometimes.

Chrom: All right, Cynthia, that's enough now. Look, I know we're family, but even family needs time apart sometimes.

Frederick: All right, Cynthia, that's enough now. Look, I know we're family, but even family needs time apart sometimes.

Gaius: All right, Cynthia, that's enough now. Look, I know we're family, but even family needs time apart sometimes.

Henry: All right, Cynthia, that's enough now. Look, I know we're family, but even family needs time apart sometimes.

Cynthia: —and eat pie, and it'll totally be the best day ever!

[Robin]: Are you even listening to me?

Chrom: Are you even listening to me?

Frederick: Are you even listening to me?

Gaius: Are you even listening to me?

Henry: Um, are you even listening?

Cynthia: You...will remember me, won't you, Father? Even once the Cynthia of this world is born?

[Robin]:

Chrom:

Frederick:

Gaius:

Henry:

Cynthia: You see, I DO understand how this time-travel stuff works. I know you're not my real father. That man exists in another history. So as soon as the me from this time is born, I promise to leave you alone. It's just that...until that happens, I want us to spend as much time together as we can. Then, when you have a proper family, at least we'll still have our memories.

[Robin]: I... I didn't realize...

Chrom: I... I didn't realize...

Frederick: I... I didn't realize...

Gaius: I... I didn't realize...

Henry: I guess I didn't realize...

Cynthia: Oh, don't get me wrong. I'm ever so grateful for this time. You've shown me what it's like to have a father, and you've been so nice to me. But I know that, in the end, your love is meant for the other me.

[Robin]: *Sniff*

Chrom: *Sniff*

Frederick: *Sniff*

Gaius: *Sniff*

Henry: Well, heck... *sniff*

Cynthia: Father, are you...crying? Oh, silly! I didn't mean to make you sad... It's nothing to be sad about! Besides, we can't very well have my hero all teary eyed, can we?! I don't want to remember you like this. I want to remember you how you really were. Strong, and kind, and brave... My father, my hero... and my friend.

Severa

Avatar (male)

The dialogue between Avatar (male) and Severa can be found on page 225.

Avatar (female)

The dialogue between Avatar (female) and Severa can be found on page 236.

Cordelia (Mother/daughter)

Severa's mother/daughter dialogue with Cordelia can be found on page 274.

Owain

The dialogue between Owain and Severa can be found on page 287.

Inigo

The dialogue between Inigo and Severa can be found on page 291.

Brady

The dialogue between Brady and Severa can be found on page 295.

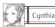
Kjelle

The dialogue between Kjelle and Severa can be found on page 298.

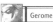
Cynthia

The dialogue between Cynthia and Severa can be found on page 301.

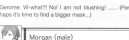
Gerome

■ GEROME X SEVERA C

Severa: Hey, you there! Gerome! Stop!

Gerome: Yes?

Severa: I want to know why you wear that stupid mask everywhere.

Gerome: My mask is not stupid. Nor is it your concern.

Severa: Says you! But I'm the one who has to look at it all the time! It makes you look like a mime or a burglar or an acrobat or something. It's totally weird, and everyone thinks you should take it off.

Gerome: I doubt you speak for everyone.

Severa: Whatever! Are you going to take off your dumb bandit mask or not?

Gerome: You should spend less of your time worrying about others. The mask stays.

Severa: Hey, where do you think you're going? I'm not finished with you! Ooooh! Who does that dumb acrobat think he is, walking out on me like that?!

■ GEROME X SEVERA B

Severa: Gerome!

Gerome: You again?

Severa: I want to talk to you, mister!

Gerome: I am not taking off the mask.

Severa: THIS ISN'T ABOUT YOUR STUPID MASK! Okay, it is. Why do you keep wearing it? Are you disfigured? Or just vain? Or are you trying to keep your distance from the people of the past? Personally, I just think you're a big attention hog and you can't admit it.

Gerome: I will answer this question once, but only in the hope it makes you go away. Listen well. You'll not get another chance... In battle, the mask helps to conceal my emotions and feelings from a foe. It gives me a valuable edge in the midst of any crucial struggle.

Severa: Doesn't it narrow your field of vision? Like horse blinders or whatever?

Gerome: Of course. That is why I have trained myself to razor sharpness. My battle senses are so keen, I can fight—and win—blindfolded.

Severa: You must be great at parties.

Gerome: You've heard your answer. Now leave me be.

Severa: Pfft! That's not the whole story and you know it! What're you hiding?!

Gerome: Leave me be, I say!

Severa: Yeah, sure, the mask hides your emotions from bad guys and blah blah blah. But there's totally another reason, even if you don't know it! And I'm going to figure it out so you take the stupid thing off! I mean, come on! It has to smell terrible by now.

Gerome: I've had enough of this nonsense.

Severa: Gerome! Wait! Get back here!

■ GEROME X SEVERA A

Severa: Gerome?

Gerome: I don't want to hear about the mask. Don't talk about it. Don't point. Don't even look at it. Just... stand there.

Severa: All right, all right! Sheesh. Okay, look. You said why you wear the mask, and I agree it makes sense. But I'm positive there's another reason. ...A secret reason.

Gerome: If my weapon breaks, I can hurl the mask at a foe. ...Satisfied?

Severa: Oh hardy har har. You're not gonna distract me that easily, mister! I know you have a secret reason, and I'm going to find it no matter what! You can hide your face, but you can't hide your true feelings and stuff!

Gerome: ...If I tell you the truth—the real truth—do you swear to let me be?

Severa: I swear!

Gerome: You must also swear to never speak of it to anyone, under pain of death.

Severa: My lips are sealed.

Gerome: ...When I was but a child, I often dreamed of being a warrior. And in my dreams, I always wore a mask, because... Because I thought it looked cool.

Severa: LAAAAAAME!

Gerome: I'm not finished! ...I began to wear masks all the time, just for the thrill. But it's as you know, I don't like to reveal my inner life if it can be helped. And soon, a child's plaything became a tool for keeping people at bay.

Severa: Ah... I knew it must be something like that!

Gerome: Then you were right.

Severa: So, wait. You limit your peripheral vision just to keep people away from you? C'mon, Gerome. Even you have to admit that's pretty dumb.

Gerome: I kept my end of the bargain. See that you keep yours.

Severa: Hoooo! He looked maaaaaad at me. Well, at least I got him talking... That's good enough for one day's work, I'd say!

■ GEROME X SEVERA S

Gerome:

Severa: EEEEEEK! Help! Intruder! Sound the alarm!

Gerome: Severa, it's me! Gerome! I was just washing my face.

Severa: Liar! Gerome would never be caught without his mask!

Gerome: It is me, I tell you! Here, I'll prove it.

Gerome: See?

Severa: Gerome! I-I had no idea... It's... been so long... Wait! I just realized something.

Gerome: What?

Severa: I know why I was so obsessed about removing that silly mask. It's because I wanted to see your totally handsome face!

Gerome: Oh, er... Truly?

Severa: Yes! Sheesh, I'd completely forgotten what you looked like! And man! You've always been easy on the eyes, but now? Oh me, oh my!

Gerome: But when you saw me before, you shrieked as if I was a ghoul!

Severa: I was just surprised is all. Don't be so sensitive!

Gerome: If I am, it is only because of your incredible IN-sensitivity! ...You have no idea how your words can pierce my heart.

Severa: How would I?! You're the one who insists on hiding all your emotions behind a stupid bandit mask! You can't do that and then act all whiny if someone hurts your feelings by mistake!

Gerome: But...don't you see how much I adore you?

Severa: Wha—?

Gerome: You torture me with your presence! You throw my heart into turmoil! I've no idea why I am around you! I must wear the mask—especially around you. Otherwise I simply couldn't function!

Severa: Oh, wow. That's...kind of amazing.

Gerome: What is?

Severa: You! The stuff you said! Everything! Because the truth is, I...I like you, too...

Gerome: You don't know anything about me.

Severa: That's why I've been trying so hard to talk to you. Isn't it obvious?

Gerome: ...Are you sure about this?

Severa: If there's one thing I'm sure about, it's this... So from now on, you take off that idiotic mask around me. Got it?

Gerome: Er, well, I suppose I could. ...On certain occasions. ...Perhaps.

Severa: Hey, are you actually blushing? Your nose has gone all pink!

Gerome: W-what?! No! I am not blushing! (Perhaps it's time to find a bigger mask...)

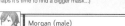
Morgan (male)

■ MORGAN (MALE) X SEVERA C

Morgan (male): Ah! There you are, Severa!

Severa: *Sigh* Yes, Morgan?

Morgan (male): What are you up to?

Severa: I was trying to enjoy a moment of peace and solitude. And you've just ruined it. Thanks.

Morgan (male): Ouch! You don't mince words, do you? But hey, if you're not peaceful anymore, does that mean you're free?

Severa: ...Wow. Someone's pushing their luck.

Morgan (male): Ha! I know. Glass half full—that's me! Anyway, everyone's making dinner in the mess tent. Why don't you come join us?

Severa: If everyone is there, you won't miss me.

Morgan (male): Aww, don't be like that! ...Unless you can't cook.

Severa: I can cook well enough, thank you.

Morgan (male): Then come on! I'd love a chance to sample your cooking.

Severa: Maybe I don't want to cook for you! Ever think of that?

Morgan (male): Look, it doesn't even have to be good. All I ask is that it's edible.

Severa: Oh my gosh, you are so rude!

Morgan (male): I'm not trying to be! I'm just curious about what you eat.

Severa: RUDE! I eat what everyone else eats!

Morgan (male): S-sorry, I didn't mean...

Severa: Fine! If I cook you something, will that shut you up?

Morgan (male): Oh, absolutely!

Severa: ...Then I'll whip up something amazing, and you never get to question me again!

Morgan (male): Ooh! I can't wait!

■ MORGAN (MALE) X SEVERA B

Severa: Ah, there you are. Come here, Morgan.

Morgan (male): Mmm? Did you need me for something?

Severa: You said you wanted to taste my cooking, right? Well, now's your chance. I just finished making something.

Morgan (male): You did? Just for me? Gosh, I'm flattered!

Severa: Not for you! I was just bored. I decided to cook on a lark. ...Here. Try this stew.

Morgan (male): Whoa, it looks amazing. Pretty, too! The red tomato base is balanced by the green beans and the orange carrots.

Severa: Less talking, more chewing!

Morgan (male): Ah, right...mmm... Wow, it's delicious! But...

Severa: ...But?!

Morgan (male): I feel like it's missing something.

Severa: What? Did I leave out a spice?

Morgan (male): No, it's not that... It's missing... Hmm, what is it missing? I can't quite put a finger on it.

Severa: Are you sure you even know what you're talking about?

Morgan (male): Er, I guess not? But it really was good! I mean it! I know it sounds like I'm nitpicking, but that really wasn't my intent.

Severa: You can't just tell someone their amazing stew is missing something and not say what!

Morgan (male): I wish I knew.

Severa: Argh! You are so frustrating me right now!

Morgan (male): I know, I'm sorry! ...Maybe it's fine. I could just be feeling weird. Regardless, I was impressed. I didn't think you'd be much of a cook. I

mean, you seem like more of the spoiled-princess type, you know? But a hearty stew full of fish and veggies feels like classic home cooking.

Severa: Th-that's enough commentary!

Morgan (male): But the fact that you didn't contradict me means you agree, right?

Severa: Shut it! Just finish your stew and get out of here!

Morgan (male): Okay, I'm leaving right now! I promise!

Um, but can I get seconds for the road? I'm really hungry.

Severa: Whatever! Just, out! Now!

■ MORGAN (MALE) X SEVERA A

Morgan (male): Er, h-hello, Severa...

Severa: What? What is it? Why are you cowering or whatever?

Morgan (male): Oh, just... Well, after the other day, I thought you were...a little upset?

Severa: Upset? Me? Oh no! Nooooo, sir. ...Nope. I mean, if you say my stew was missing something, then it was.

Morgan (male): Um, that sounds really sarcastic.

Severa: Oh, you don't say?

Morgan (male): Er, yeah. So does that, actually. Anyway, um, I don't know if you care, but I think I know what the stew needed. It tasted like you were going through the motions of cooking instead of...cooking.

Severa: ...That's the dumbest thing I've ever heard, Morgan.

Morgan (male): No really, hear me out. When cooking for someone, your feelings for them naturally flow into the food! Cooking isn't just about following a recipe. It's a form of expression! Anyway, that's what was missing from the stew, I think. It was emotion.

Severa: Well, gee. I'm sorry that your stew lacked emotional gravitas!

Morgan (male): You know, if you ever want to cook with feeling, I'd love to try it out.

Severa: Oh yeah? Any old feelings? ...Or how about my feelings for you?

Morgan (male): Er... I'm not sure quite what you mean.

Severa: What about feelings of annoyance and outrage at having my cooking insulted? Or perhaps my incredulity at your having the gall to then eat it all afterward? What part of those feelings do you think THOSE might add? Huh, Mr. Master Chef?!

Morgan (male): Eep! S-sorry! I'm sorry! Please don't make me eat all that!

Severa: Ah ha ha ha!

Morgan (male): Nooooo!

Severa: Oh, stop it. I'm not actually going to poison you.

Morgan (male): Yeah, but I can imagine you "accidentally" using way too much chili powder.

Severa: Hah! Now THAT is a great idea!

Morgan (male): ...Oh gods. What have I done?

■ MORGAN (MALE) X SEVERA S

Morgan (male): Hey, Severa. Can I come in?

Severa: So, you decided to show.

Morgan (male): You said you were cooking again, right? I wouldn't miss that for the world! ...Even if it means death by chili powder.

Severa: Well, of course I was going to cook again. I couldn't let that insulting review of yours stand as the final word! The missing ingredient's been pinpointed, and there's nothing left to get in my way. It's time for a grudge match: my food versus your belly!

Morgan (male): Um, I did say the food was tasty last time, didn't I?

Severa: Oh, right. Like I believed THAT. There's no easy outs, Morgan! Now, eat!

Morgan (male): This looks like the same stew you made before.

Severa: Yes. Let's hear whether anything is missing this time!

Morgan (male): All right. Here goes... "Sluuurp" Mmm...

Severa: ...Well?

Morgan (male): Delicious! It's absolutely fantastic! Even better than before! I can really feel the emotion you put in it. It's warming my belly AND my heart!

Severa: ...Good.

Morgan (male): So what were you thinking about while you made this, huh? Puppies? Kittens? Rain falling gently on the tent flap at night?

Severa: Why do you want to know?

Morgan (male): Because the recipe, ingredients, and chef are the same, but the taste is different! I'd like to know what sort of feeling could make a dish that much better.

Severa: None of your business!

Morgan (male): What? Why not? Please?

Severa: No! Absolutely not!

Morgan (male): "Sigh" ...All right, have it your way. Man, I wish I could eat food this tasty every day for the rest of my life.

Severa: What?!

Morgan (male): ...Er, sorry. Did that sound weird?

Severa: I-it sounded like... Like you were implying I should be your wife...

Morgan (male): Did it? Ha ha! Yeah, no wonder you flipped out there. Although I'd be jealous of any guy who married you and got to eat like this.

Severa: ...I don't know. I'd be shy one ingredient if I tried to make it for anyone but you.

Morgan (male): Carrots?

Severa: Ugh, seriously? Gods, Morgan, you are so thick sometimes!

Morgan (male): Is it celery? Bay leaf? Vegetable stock? Beef broth? Foie gras? Abalone? Come on, help me out here!

Severa: Argh! Just forget it! You can ponder it over homemade stew every night for the rest of your life...

Morgan (male): If you cook for me again? Fantastic! Aw, thanks a million, Severa! But wait, every night? That'd be like we were—

Severa: If you're done, you can wash your bowl. And scrub the pots while you're at it, too!

Morgan (male): Wait, wait, wait! You don't... Did you mean... Are we...?! Severa? ...Hey, Severa! Where you going, Severa? ...What just happened here...?

Morgan (female) (Mother/daughter)

The Morgan (female) mother/daughter dialogue with Severa can be found on page 312.

Morgan (female) (Sisters)

■ MORGAN (FEMALE) X SEVERA (SISTERS) C

Morgan (female): Let's see here... Birthday? May 5th... Favorite colors? Blue and purple... Favorite food? Probably bear meat...

Severa: What are you mumbling about over there, Morgan?

Morgan (female): Least favorite food? Veggies, apparently. Don't seem to mind them now, though...

Severa: Morgan!

Morgan (female): Oh! Severa?! Guess I was pretty out of it to miss my own sister paying a visit! Did you need something?

Severa: Why are you standing there muttering like a madwoman? Are you practicing some new magic incantations or something?

Morgan (female): I was making notes on what you told me about myself. I was hoping they'd hold some clue that might help spark my memory. Heh. It's kind of crazy how much you know about me, huh? Like, I really once got five nosebleeds in the same day? I have no memory of that at all. At ALL! Ha ha ha! I can just imagine...

Severa: Well, you're still as cheerful, that's for sure. And as talkative as ever...

Morgan (female): I am? I mean, I was?! Hmm, now that you mention it, that does sound...right, somehow. ...Heh. Everything still feels funny. Even you being my sister hasn't really clicked.

Severa: If you think it's strange for you, imagine how I feel... My kid sister starts talking to me like a stranger, asking questions about herself... I had no idea how to even interact with you. It was pretty rough, but I got used to it.

Morgan (female): Heh, yeah... Sorry about that. But that's just another reason why I'm working hard to get my memories back. Once I do, nobody will have to feel weird or awkward around me again. Pretty noble, huh? I'm such a sweet, selfless girl!

Severa: Heh, and so humble as well... In any case, I'm glad to help you get those memories back however I can. Someday soon I bet we'll be able to laugh about all the old times—now included!

Morgan (female): Heh, right!

■ MORGAN (FEMALE) X SEVERA (SISTERS) B

Morgan (female): Whew! Another long day of combat... I'm spent. Think I'll hit the hay ear...ly? Is someone passed out over there? Wait, is that Morgan?!

Morgan (female): Nn...nngh...

Severa: Morgan! Morgan, are you all right?! What happened?!

Morgan (female): ...Wha—?! Severa! Wh-what am I doing here? Was I asleep?! I don't even remember feeling tired... Oh, right! I was bashing that huge tome against my head when I blacked out. That explains why my face hurts so bad...

Severa: Bashing your... Are you an IDIOT?! Why would you do that?! Wait, were you trying to get your memories back?

Morgan (female): Well, yeah! Obviously. If you ever saw me bludgeoning myself just for fun, I hope you'd put a stop to it...

Severa: I'll stop you even if it's NOT just for fun, you moron! Getting your memories back doesn't do you any good if you're dead. Okay?!

Morgan (female): ...But I want to be able to talk with you about old times again.

Severa: Yeah, I know, Morgan, and I want that, too. But more than that, I want you ALIVE. I may just be another stranger to you, but to me, you're family. In the future, with Mother and Father gone, it was just the two of us. You're all I had, Morgan... I don't know what I'd do if anything happened to you.

Morgan (female): All right. I'm sorry, Severa.

Severa: Sheesh. What a nightmare...

Morgan (female): ...Heh, that felt really siblingy just now. Don't you think? We messing up and scolding me felt... I don't know, it felt really plausible! Maybe if you keep it up, I'll remember something!

Severa: Um, I guess?

Morgan (female): Yeah! Oh yeah, this will totally work! So go on, keep yelling! C'mon, scream at your amnesiac sister, Severa!

Severa: That is the stupidest—

Morgan (female): Hey, why don't you use the tome, too? Come on, don't hold back. Really wallop me with that thing! Maybe the simultaneous physical and mental shock will jar some random memories loose! It's gotta be twice as effective as either one by itself, right? That's just basic science.

Severa: Gawds, you idiot...

■ MORGAN (FEMALE) X SEVERA (SISTERS) A

Severa: Hey, Morgan. I'm headed into town. Want to come with?

Morgan (female): I'd love to! Is there something in particular you need?

Severa: I might pick up a couple of things, yeah. But mostly I think there's something YOU need.

Morgan (female): It doesn't have to do with getting my memories back, does it?

Severa: The opposite, really. Maybe there's no need to worry about your memories.

Morgan (female): That...makes no sense.

Severa: I'll be honest—it does hurt to know you've forgotten me. But I still think it's better to build new memories than to worry about old ones.

Morgan (female): What do you mean?

Severa: I've been thinking about this a lot. Why you might have lost your memories, I mean. And I'm wondering if it just got too awful for you. ...I know I've got a few. I see a lot of faces, you know? People we couldn't save...

Morgan (female): I'm sorry you have to bear those dreadful memories, Severa.

Severa: Look, this is just a theory, and even if it's true, it's not like you did it on purpose. But I do think that getting your memories back might not necessarily be a good thing.

Morgan (female): Hmm... I understand, and believe me, I appreciate the thought... But I want to remember things, no matter how painful they are. Because I'm sure there'll be plenty of great memories mixed with the bad ones. And the truth, whatever it is... I really want to have that back, you know?

Severa: Well, if you're sure, then I gueeess I can help.

Morgan (female): That's really kind of you, Severa, but do you truly realize what you're saying? I mean, it could be years before I remember anything. Or decades. Heck, there's a decent chance I may never get my memories back at all. I don't want to drag you into something that could last forever.

Severa: I'm already stuck with you forever, idiot. I'm your sister. We're family—memories or no. You couldn't keep me away.

Morgan (female): Severa, I... *sniff* Thank you! I'll do everything I can!

Severa: Then start by coming with me into town.

Morgan (female): Huh? But you said that doesn't have to do with getting my memories back.

Severa: Hey, there's no rule that says you can't have a little fun while you try. And there's certainly no rule against making some happy new memories, either. You're young! Live a little! There'll be plenty of time to worry later.

Morgan (female): Right... You're right! Thanks, Sis!

Yarne

■ YARNE X SEVERA C

Severa: Yarne!

Yarne: What's wrong, Severa? You're all out of—

Severa: Don't you "what's wrong" me! What do you call that last battle?! We'd only been on the field a minute when you turned tail and ran!

Yarne: That's not true! I saw it through to the end! ...Er, from a safe distance.

Severa: Pah! What a lame excuse!

Yarne: Look, it's just... It's not like you really needed me there. Our foe was way weaker than us.

Severa: Keep underestimating the enemy like that and you're going to wind up in a coffin!

Yarne: But it's the truth!

Severa: And what happens when we go up against a stronger enemy? Hmm? We prepare that much more carefully. We focus harder, and we fight stronger! And that goes for them, too. Which means we can't afford any carelessness!

Yarne: I...I guess you have a point.

Severa: This army has suffered more injuries from carelessness than from enemies, you know?

Yarne: All right, all right! I'll be careful not to just leave the easy fights to you guys from now on.

Severa: Am I really getting through to you?

Yarne: Yes! I told you, I got it!

Severa: If you think a quick nod and a smile is going to fool me, you're crazy. I'll stay here lecturing you all day if that's what it takes! Now, take a seat, craven!

Yarne: ...There goes the afternoon.

Severa: What was that?

Yarne: N-nothing, ma'am!

■ YARNE X SEVERA B

Severa: ...And another thing about war!

Yarne:

Severa: It's the easily distracted and complacent people like you who get hurt! And every time you get hurt, allies have to risk their hides to save your sorry— Hey! Are you even listening?!

Yarne: ...How does she never get bored of giving the same speech, day after day?

Severa: Yarne! Your internal monologue right now is highly external!

Yarne: Gah! S-sorry! I was just kidding!

Severa: Ugh. Now, what was the last thing you remember?

Yarne: A-all of it! I heard every word!

Severa: Riiight. Then tell me what combat situations you're best suited for.

Yarne: Uh... Ones where...the enemy is really weak?

Severa: Very funny, you dolt. In woodlands and other areas where mounted units' movement is restricted! That's where your speed and mobility are most advantageous. Ring any bells?

Yarne: Er, I'm pretty sure I remember hearing you say... something like that?

Severa: Unbelievable. Why are you even here? If you're not interested in fighting, quit!

Yarne: I AM interested, and I WANT to fight! I just don't understand why you're so fixated on war!

Severa: Because half-baked soldiers like you are a liability to everyone else! You're at least a nominal part of this army, right? So pull your weight for a change!

Yarne: Nominal...? That's pretty harsh!

Severa: Then prove me wrong!

Yarne: Maybe I will!

Severa: Good! Now start paying attention!

Yarne: Fine! I will!

■ YARNE X SEVERA A

Yarne: Ugh, another day of Severa's Basic Training, otherwise known as Pick-on-Yarne Hour. There's got to be a way out of this. Hmm... I could fake the plague... No, wait. I did that last time. ...Fake my own death and run? ...No, that's madness. If she found out, she'd kill me for true.

Severa: And just where do you think you're going, bunny face?

Yarne: S-Severa?! Er, I was just... Just valiantly fighting the impulse to flee!

Severa: Flee? You were going to run away? Just where do you get off, buster?!

Yarne: (Gah! Severa's even more terrifying than usual today!) (Every animal instinct in my body is screaming "RUN!" in a panicked chorus!)

Severa: Don't. You. Dare!

Yarne: "Huff" "pant" Whew... Heh... That'll teach you to...try to outrun a rabbit... W-wait a moment... What's that angry blur coming toward me...? EEEK! SEVERA! I'M GONNA DIE!

Severa: ...HAH! Gotcha! And don't even think of trying to run again!

Yarne: H-how did a human outrun me? And what possible reason could you have to chase me that hard?! You're wasting your time on me! You know that?

Severa: ARGH! Just LOOKING at you makes me see red! There is NOTHING more infuriating than watching someone slack off! You've got about three times the natural strength and potential I do, you know? And yet you're just letting it go to waste while I work my butt off just to keep up! Do you have any idea how that makes me feel?!

Yarne: Severa... I don't... I'm sorry. Truly. I never knew. I always thought I was a lost cause, and I just assumed you'd already given up...

Severa: Some days, I'm tempted.

Yarne: Look, I'll work to improve, okay? I'll give it my honest best.

Severa: ...Promise?

Yarne: I do. I doubt it'll be smooth sailing, and I'll probably still make you mad at first... But I'll do everything I can to be a help to you and the others. I swear.

Severa: And most important, can be sure you're not planning to just run away again? I suppose I'll have to stay close and keep a close watch on you. And...maybe help.

Yarne: Well...having you there certainly can't hurt. Thanks for sticking by me, Severa!

■ YARNE X SEVERA S

Severa: Hello, Yarne.

Yarne: Oh. Hi, Severa.

Severa: Well, this is unusual. That's taguel armor, isn't it? I don't think I've ever seen you maintaining your equipment before.

Yarne: Yeah, it's one of a lot of things I've just been getting around to. After you told me I have potential, I really have no excuse not to make myself of use. Right?

Severa: Yarne... I'm proud of you. You've finally started taking your role in this war seriously.

Yarne: Yeah... Um, say, Severa? Do you think I could maybe ask you a favor?

Severa: Let's hear it.

Yarne: Well, er... I was just...

Severa: What's the problem? I happen to be feeling unusually generous after seeing you shape up. So out with it already!

Yarne: W-will you be my girl?!

Severa: What?!

Yarne: All your lectures made me a better man... It made me realize a basket case like me needs a wise, strong woman to guide him!

Severa: A-are you insane?!

Yarne: Yes! Insane about YOU! Come on, you said it yourself! I shaped up, and it's all thanks to you!

Severa: Y-you have made impressive strides...

Yarne: And I'm committed to getting stronger. Strong enough to stand as your equal! So...please? Whaddya say?

Severa: ...Are you sure you can handle it?

Yarne: Handle what?

Severa: Living with a woman like me is a lot harder than just winning a few battles.

Yarne: Hah! Now THAT I'm prepared for! I've had a lot of practice these last few weeks.

Severa: Well, if you're certain, I SUPPOSE I could do you the honor...

Yarne: YES! Oh, thank you, Severa! I swear I'll become a man worthy of your love!

Severa: Good! Because if you don't, I'll be wearing your pelt for a winter coat!

Laurent

■ LAURENT X SEVERA C

Severa: Mmm, those peaches smell amazing! They were totally worth splurging on!

Laurent: Severa, where did this veritable mountain of fruit come from?

Severa: The market, where else? They just looked too tasty to pass up.

Laurent: I told you last time not to purchase anything that isn't on the list... If we keep buying unnecessary food, it will rot before we can use it. Our treasury is not so great that we can splurge on excess supplies.

Severa: Oh, whatever! It's only a little fruit. And besides, once folks see how great it all looks, they'll finish them off in no time!

Laurent: That does not address the crux of my argument.

Severa: Human beings need a little treat now and then to survive, Laurent. I mean, maybe not you! ...But most of us. And if you take away the joy in life, what's left to fight for? See, so I'm actually helping morale whenever I buy tasty fruit.

Laurent: Starving, however, is bad for morale. And that's precisely what will happen if you continue squandering the food budget. What's more, you make additional work for me when I try to balance the books.

Severa: Pfft! Yeah, whatever! An egghead like you will figure it all out, I'm sure! Besides, what's done is done. The milk is spilt, so quit cryin'! Now cheer up and enjoy some fresh fruit. Wouldn't want it to spoil, after all.

Laurent: I fail to understand how one individual can be so selfish, time and again. It will take me hours to draft a new budget.

Severa: Stop fretting over every little detail! You'll worry yourself to an early grave, Laurent.

Laurent: If anything dooms me to an early grave, it's like to be that insufferable woman...

■ LAURENT X SEVERA B

Severa: Oh. ...You.

Laurent: Hello, Severa.

Severa: *Sigh*

Laurent: Can I help you?

Severa: Oh, just remembering the last procurement run has me exhausted all over again.

Laurent: I would express a similar frustration. It's become almost impossible to handle expenses with you at the helm.

Severa: And just what is that supposed to mean?

Laurent: Precisely what it sounds like. Every time you come back with desserts or silly baubles, I have to make cuts elsewhere.

Severa: Okay, could you try to sound a little more condescending? You're no joy to shop with either, you know! Every time you open your mouth, it's "budget" this, or "unnecessary" that! Shopping should be an adventure, not some boring old list. You have to open up to new discoveries! Go where the moment takes you and stuff!

Laurent: We are procuring supplies for an army, not impulse shopping for our own amusement.

Severa: I know that, but this army has needs, and one of those needs is to have a little fun! Gods, would it kill you to listen to me maybe once?

Laurent: If you're asking me to say that wasting our scant resources is a good idea, I won't. You joke about what will or won't kill me, but it's a question I consider every day. We are at war, Severa. There is no shortage of things that could kill us all. The only thing keeping us alive is prudent and careful planning.

Severa: And that situation is exactly why I'm saying we need a little joy in our lives! Walking around with an abacus all day isn't what I consider good for morale.

Laurent: Frivolous spending isn't going to make anyone's life easier.

Severa: Okay, we're getting nowhere. ...Mostly because someone is being a jerk! So fine. Buy hardtack and stale bread until the cows come home. I'm done shopping with you, mister!

Laurent: If you are resigning from the procurement runs, I gladly accept. If it was up to me, I'd have taken you off the project weeks ago.

Severa: Oh no, I'm not quitting before you! I'm just shopping on my own, thank you! You're on your own, cheapskate!

■ LAURENT X SEVERA A

Severa: I just... I still can't believe it...

Laurent: Severa?

Severa: Oh. Hello.

Laurent: You look dazed. The company must have thanked you as well, then?

Severa: Yes! It's been a total barrage of praise ever since the two of us went shopping. Chrom even searched me out just to offer his compliments.

Laurent: It has been almost surreal... Especially in spite of our prior arguments. It seems we managed to strike a perfect balance. Nothing missing, nothing wasted. People have been especially excited over the more...extraneous items.

Severa: That has to feel pretty good as the guy responsible for the shopping budget.

Laurent: Yes, though I would never have thought to purchase half of what they mentioned. Much of it appeared wasteful to my eye, but it seems you had the right of it. I apologize for doubting your selections.

Severa: Oh, it's fine. Besides, I'd have spent twice as much if you hadn't made me think about the excesses. Stubbornness aside, you really are good with numbers, and you always stay on task.

Laurent: Thank you. Praise from you is a rare treat indeed. I suppose this means that together we were able to do what neither could alone.

Severa: Yeah. For all our arguing, we actually make a pretty good team.

Laurent: I would welcome your help again on the next procurement run. If you wouldn't mind joining me, that is.

Severa: As long as you promise to let me handle the fruit, I'm there!

■ LAURENT X SEVERA S

Severa: Sounds like our last procurement run was another rousing success.

Laurent: And nearly painless, now that I've grown accustomed to your...quirks. These days, I feel like I'm even starting to understand our tastes.

Severa: I dunno, Laurent. I'm a tough woman to figure out sometimes.

Laurent: Believe me, there is much of you that remains a mystery to me. But one thing is clear: I ought never think to go shopping alone again. Your help is invaluable. I do hope you'll continue to join me in the future.

Severa: Hmm...

Laurent: ...Is something the matter, Severa?

Severa: You say you've started to understand my tastes, right? ...But can you guess what I want right now?

Laurent: ...I don't understand. Is this a riddle of some kind? Are you going to ask me what is in your pocket next?

Severa: You should be able to read me pretty well by now, right? So guess what I'm thinking.

Laurent: Telepathy has been scientifically proven to be nothing more than the work of—

Severa: Try.

Laurent: Very well...I suspect it's the same thing I'm thinking.

Severa: And...what might that be?

Laurent: I was hoping you would be my partner not just in shopping, but in all things in life. If that were, in fact, what you were thinking, I should count myself a very happy man.

Severa:

Laurent: Granted, that's less mind reading than wishful thinking.

Severa: No, you're...right on the money.

Laurent: Truly?

Severa: Yeah. Truly.

Laurent: Ah. Well, that is a relief! I was skeptical of what would happen if I said all that, only to be rebuffed.

Severa: For someone who's always needing people, you can be so timid when it counts! Well, you'll never lack for brashness with me at your side!

Laurent: Heh, I have no doubts on that count. What a perfectly mismatched couple we make, eh?

Noire

■ NOIRE X SEVERA C

Noire: Um, so, Severa? I have to... Er... Do you mind?

Severa: Isn't it time you learned to do this by yourself?

Noire: Puh-puh-please?

Severa: Oh, all right! Gods!

Noire: S-sorry! I just scared, is all.

Severa: Too scared of the dark to go to the bathroom by yourself at night? Honestly, Noire! You're a grown woman!

Noire: I'm sorry, okay?! I'm sorry! ...Also, I'm sorry I yelled just there.

Severa: Gods, enough! Stop apologizing and let's go.

Noire: Th-thanks, Severa. You're always so nice to me.

Severa: That must be a pretty low bar if I'm leaping over it. Why not bother someone else from time to time?

Noire: Oh, I'd be too embarrassed...

Severa: And you're not with me?

Noire: You don't tease me for it.

Severa: No, I suppose not. I'm only interested in taking self-important people down a peg. Teasing you would be like kicking a puppy. ...While it's asleep.

Noire: ...W-wait. Is that really the reason why?

Severa: Oh, what does it even matter? At the end of the day, I'm still saddled with guarding you from the bogeyman.

Noire: ...Sorry?

Severa: Never mind. We're old friends. Imposing on me is just what you do... Er, that sounded less harsh in my head.

Noire: I think I know what you meant.

■ NOIRE X SEVERA B

Noire: Hngh... I-it hurts...

Severa: Noire?! Are you all right?

Noire: S-Severa...? I... Ngh!

Severa: What's wrong? Are you hurt?

Noire: I was m-making medicinal tea... A compound of herbs... I boiled them and drank the tea, and now it feels like my stomach is tied in knots!

Severa: Since when do you know how to mix medicines?

Noire: I don't. I just threw in whatever looked like an herb.

Severa: You what?! Gods, are you insane?! Your stomach is fragile enough without you dumping weird potions into it!

Noire: That's what the medicine was supposed to fix... Ungh...

Severa: Oh, this is just too absurd...

Noire: I thought maybe if my body were stronger, I'd be less meek, too. Then I wouldn't be such a scaredy-cat, and... Um... I wouldn't have to bug you all the time.

Severa: Well it totally doesn't help either of us if you turn your guts inside out.

Noire: No, you're right. I'm sorry.

Severa: Look, just...lie down for a bit, okay?

Noire: All right.

Severa: I'll fetch you some water and some REAL medicine. Don't move till I get back, all right?

Noire: Yes, ma'am.

Severa: That's it.

Noire:

Severa: Gods, she is such a handful! And why is it always my hands she's filling?!

■ NOIRE X SEVERA A

Noire: Severa, I am so, so sorry! It was an accident! Honest!

Severa: Gods, it's fine... It's just some spilled stew.

Noire: B-but it was so...so chunky! *sob* *Sniff* I'm always causing trouble for you...

Severa: And every time you do, I tell you it's fine and to stop apologizing, don't I? Besides, there was a ton of stew that you didn't spill... I even had seconds.

Noire: Aw, you're so sweet!

Severa: Although...

Noire: Huh?

Severa: Even at your best—and I say this lovingly—you're not the most together person. But you're still usually not this lame!

Noire: ...What do you mean?

Severa: It's like whenever I'm around, minor slipups turn into full-blown disasters. I'm not sure if it's my fault or yours! ...Am I the only one who has noticed?

Noire: ...Oh.

Severa: Needing an escort to go to the bathroom? Poisoning yourself with amateur potions? Dropping our dinner on the floor? I mean, I'm just saying is all, but why in the heck does this keep happening?

Noire: ...I've been wondering that myself.

Severa: Oh?

Noire: Well, um, see, I'm not doing it intentionally or anything, but... But maybe I'm subconsciously leaning on you for a familiar sense of security! I mean, um... that's my theory.

Severa: Weirdo alert.

Noire: Yeah, I know. I'm sorry, Severa.

Severa: Oh, stop it... I don't mind.

Noire: B-but I'm making so much work for you.

Severa: Yeah, well, I suppose I make some work for you, too.

Noire: What do you mean?

Severa: People don't really rely on me for stuff. I'm more the...prickly type. So it's kind of... You know. ...Nice. Besides, who would keep you out of trouble if I wasn't around?

Noire: Hee hee! You're so right!

Severa: Just, uh... Don't go crazy, yeah? Everything in moderation.

Noire: Heh, it's a deal!

Father

■ FATHER X SEVERA C

Severa: Hey! I think it's time for Daddy-Daughter Day!

[Robin]: Er...what? Why?

Frederick: Er...what? Why?

Virion: Er...what? Why?

Vaike: Er...what? Why?

Stahl: Er...what? Why?

Kellam: Er...what? Why?

Lon'qu: ...Why?

Ricken: Er...what? Why?

Gaius: Er...what? Why?

Gregor: Er...what? Why?

Libra: Oh? And why is that?

Henry: Nice! ...Er, but why?

Donnel: Er...what? Why?

Severa: Does a daughter NEED a reason to spend a little time with her father?! Most fathers would be beside themselves with joy at even being asked! Gawds!

[Robin]: You're right—I should count my blessings. Well, then? Where shall we go?

Frederick: You're right—I should count my blessings. Well, then? Where shall we go?

Virion: You're right—I should count my blessings. Well, then? Where shall we go?

Vaike: You're right—I should count my blessings! Well, then? Where ya wanna go?

Stahl: You're right—I should count my blessings. Well, then? Where shall we go?

Kellam: You're right—I should count my blessings. Well, then? Where shall we go?

Lon'qu: You're right—I should count my blessings. Well, then? Where shall we go?

Ricken: You're right—I should count my blessings. Well, then? Where shall we go?

Gaius: You're right—I should count my blessings. Well, then? Where we headed?

Gregor: Ah, yes. Gregor should count blessing. So, then? Where do we go?

Libra: You're right—I should count my blessings. Well, then? Where shall we go?

Henry: You're right—I should count my blessings. Well, then? Where shall we go?

Donnel: Aw, yer right—guess I should count m'self lucky. So where ya wanna go?

Severa: Into town! I spotted a whole line of shops with the CUTEST dresses...

[Robin]: Dresses, huh? Well, I suppose you're at that age...

Frederick: Dresses, huh? Well, I suppose you're at that age...

Virion: Dresses, is it? Well, I suppose you're at that age...

Vaike: Dresses, eh? Well, I suppose ya are at that age...

Stahl: Dresses, huh? Well, I suppose you're at that age...

Kellam: Dresses, huh? Well, I suppose you're at that age...

Lon'qu: Dresses, huh? Well, I suppose you're at that age...

Ricken: Dresses, huh? Well, I suppose you're at that age...

Gaius: Dresses, huh? I suppose you're at that age...

Gregor: Har har! Gregor often forget you are at age where you want pretty things.

Libra: Dresses, hmm? Well, I suppose you're at that age...

Henry: Dresses, huh? Well, I suppose you're at that age...

Donnel: Dresses, eh? Well, I reckon yer at that age...

Severa: Age? Hee hee! In this timeline, you're not much older than I am, Daddy!

[Robin]: Hmm... No, I suppose I'm not.

Frederick: Hmm... No, I suppose I'm not.

Virion: Hmm... No, I suppose I'm not.

Vaike: Hah! Good point!

Stahl: Hmm... No, I suppose I'm not.

Kellam: Hmm... No, I suppose I'm not.

Lon'qu: Hmm... I suppose I'm not.

Ricken: Hah! I guess I'm not, no.

Gaius: Hmm... No, I guess I'm not.

Gregor: Hmm... Is true, is true.

Libra: Hmm... No, I suppose I'm not.

Henry: Hmm... No, I guess I'm not!

Donnel: Hmm... No, I s'pose I'm not.

Severa: I bet most people seeing us side by side would think we were brother and sister.

[Robin]: Hmm, indeed... An odd thought, now that you mention it.

Frederick: Hmm, indeed... An odd thought, now that you mention it.

Virion: Hmm, indeed... An odd thought, now that you mention it.

Vaike: Hmm, yeah... That would be odd, huh?

Stahl: Hmm, yes... Kind of an odd thought, now that you mention it.

Kellam: Er, yeah... An odd thought, now that you mention it.

Lon'qu: That would be...odd.

Ricken: Hmm, yeah, maybe. Kind of an odd thought, now that you mention it.

Gaius: Hmm, yeah... That's an odd thought, eh?

Gregor: Hmm, yes... Kind of odd thought, when you think about it.

Libra: Hmm, indeed... An odd thought, now that you mention it.

Henry: Um, yeah... Kind of an odd thought, huh?

Donnel: Hmm, yeah... Kind of an odd thought, now ya mention it.

Severa: Odd? Is there something wrong with that? Are you embarrassed to be seen with me?! You'd rather be with Mother, wouldn't I...

[Robin]: Wha—?! N-not at all! You're adorable, honey!

Frederick: Wha—?! N-not at all! You're adorable, honey!

Virion: Wha—?! N-not at all! I am proud to have you at my side, my dear.

Vaike: Wha—?! Aw, come on! That ain't it at all! You're completely adorable, hon!

Stahl: Wha—?! N-not at all! You're adorable, honey!

Kellam: Wha—?! N-not at all! You're adorable, honey!

Lon'qu: What? N-no, not at all... You're adorable, Severa.

Ricken: Wha—?! N-not at all! You're adorable, honey!

Gaius: Wha—?! N-not at all! You're adorable, honey!

Gregor: N-not at all! Darling child is made of utmost adorableness!

Libra: Wha—?! N-not at all, dear! You're adorable!

Henry: Wha—?! N-no way! I think you're totally adorable, honey!

Donnel: Wha—?! N-not at all! Yer cuter'n a pig in slop!

Severa: Aw, you mean it? Yay! That's so sweet! So okay! In town, there's this one dress I really, reeeally want! Would you hate me if I asked you to get it for me? Would Mother be mad?

[Robin]: I could never hate you, Severa. And I'm sure your mother won't mind. You're our daughter, you know? You can have anything you'd like.

Frederick: I could never hate you, Severa. And I'm sure your mother won't mind. You're our daughter, you know? You can have anything you'd like.

Virion: I could never hate you, Severa. And I'm sure your mother won't mind. You are our precious daughter! You can have anything you'd like.

Vaike: I could never hate ya, Severa. And I'm sure your mother won't mind. You're our daughter, you know? You can have anythin' ya want.

Stahl: I could never hate you, Severa. And I'm sure your mother won't mind. You're our daughter, you know? You can have anything you'd like.

Kellam: I could never hate you, Severa. And I'm sure your mother won't mind. You're our daughter, you know? You can have anything you'd like.

Lon'qu: I could never hate you, Severa. And I'm sure your mother won't mind. Just... You know the deal. Keep your distance. And no hand-holding.

Ricken: I could never hate you, Severa. And I'm sure your mother won't mind. You're our daughter, you know? You can have anything you'd like.

Gaius: I could never hate you, Severa. And I'm sure your mother won't mind. You're our daughter, you know? You can have whatever you'd like.

Gregor: Gregor could never hate you, Severa. And he is sure mother will not mind. You are Gregor's daughter, yes? You can have anything you like!

Libra: I could never hate you, Severa. And I'm sure your mother won't mind. You're our daughter, you know? You can have anything you'd like.

Henry: I could never hate you, Severa. And I'm sure your mother won't mind. You're our daughter, you know? You can have whatever you like.

Donnel: I could never hate ya, Severa. And I'm sure yer ma won't mind. Yer our daughter, ya know? You can have whatever ya want!

Severa: Oh, thank you, Daddy! I love you so much!

[Robin]: Heh heh! I love you too, Severa.

Frederick: I love you too, Severa.

Virion: Oh, what a charmer you are!

Vaike: Heh heh! I love you too, kid.

Stahl: Heh! I love you too, Severa.

Kellam: Heh heh! I love you too, Severa ...

Lon'qu: *Sigh* Yeah, me too.

Ricken: Heh heh! I love you too, Severa.

Gaius: Heh, ain't that sweet. I love you too, Severa.

Gregor: It is returned tenfold!

Libra: And I you, dear.

Henry: Nya ha! I love you too, Severa!

Donnel: Aw, shucks! I love ya too, Severa.

Severa: (...Pffft. Too easy.)

■ FATHER X SEVERA B

Severa: Thanks again for all the shopping, Daddy! I felt like a total princess when you bought everything I asked for!

[Robin]: Most royal houses couldn't afford to shop the way you just did...

Frederick: Severa, most royal houses couldn't afford to shop the way you just did...

Virion: Most royal houses couldn't afford to shop the way you just did...

Vaike: I'm pretty sure most royal houses couldn't afford to shop the way you just did...

Stahl: Most royal houses couldn't afford to shop the way you just did...

Kellam: Most royal houses couldn't afford to shop the way you just did...

Lon'qu: Most royal houses couldn't afford to shop the way you just did...

Ricken: Most royal houses couldn't afford to shop the way you just did...

Gaius: Most royal houses couldn't afford to shop the way you just did...

Gregor: ...Oy! Royal houses not have kind of money to shop in way you did.

Libra: Gods above! I've never seen such unbridled avarice...

Henry: Most royal houses couldn't afford to shop the way you just did...

Donnel: I reckon most royal houses couldn't afford to shop the way you just did...

Severa: Daddy, are you listening?

[Robin]: What? Y-yes, dear, I'm listening.

Frederick: What? Y-yes, dear, I'm listening.

Virion: What? Y-yes, dear, I'm listening.

Vaike: What? Y-yes, dear, I'm listenin'.

Stahl: What? Y-yes, dear, I'm listening.

Kellam: What? Y-yes, dear, I'm listening.

Lon'qu: I'm listening.

Gaius: What? Y-yes, dear, I'm listening.

Gregor: What? Y-yes, dear, Gregor always listening.

Libra: What? Y-yes, dear, I'm listening.

Henry: What? Y-yes, dear, I'm listening.

Donnel: What? Y-yes, dear, I'm listenin'.

Severa: Good, good. So! I'd just looove to go on another shopping spree with you! I spotted the most precious little accessory shop in a town near here the other day!

[Robin]: Sorry, pumpkin, but no.

Frederick: Sorry, pumpkin, but no.

Virion: Sorry, my dear, but no.

Vaike: Sorry, pumpkin, but no.

Stahl: Sorry, pumpkin, but no.

Kellam: Sorry, pumpkin, but no.

Lon'qu: ...No.

Ricken: Sorry, pumpkin, but no.

Gaius: Sorry, pumpkin, but no.

Gregor: Er...no. Sorry, child.

Libra: I'm afraid the answer is no.

Henry: Sorry, kiddo, but no can do.

Donnel: Sorry, pun'kin, but I gotta say no.

Severa: Huh? Why not? Did I do something wrong? Daddy, are you... Are you mad at me?

[Robin]: Spare me the wounded treatment, Severa. No means no. We just bought you plenty.

Frederick: Spare me the wounded treatment, Severa. No means no. We just bought you plenty.

Virion: Spare me the wounded treatment, sweetheart. No means no. We just bought you plenty.

Vaike: Urgh, spare me the puppy-dog eyes, please... No means no, kid. We just bought ya all that stuff...

Stahl: Spare me the wounded treatment, Severa. No means no. We just bought you plenty.

Kellam: Spare me the wounded treatment, Severa. No means no. We just bought you plenty.

Lon'qu: Spare me the wounded treatment, Severa. No means no. We just bought you plenty.

Ricken: Spare me the puppy-dog eyes, Severa. No means no. We just bought you plenty.

Gaius: Spare me the wounded treatment, Severa. No means no. We just bought you plenty.

Gregor: Please, spare Gregor the eyes of puppy! No means no. We just bought you plenty.

Libra: Don't make little lamb eyes at me, Severa. No means no. We've already bought you plenty.

Henry: Spare me the wounded treatment. No means no. We just bought you plenty.

Donnel: Don't go makin' puppy-dog eyes at me! No means no. We just bought ya plenty.

Severa: FINE, then! FINE! I guess I'll just wear RAGS! ...GAWDS!

[Robin]: Yeesh, talk about an attitude change. Now, look. I'm not saying I won't buy you anything ever...

Frederick: Boy, talk about an attitude change. Now, look. I'm not saying I won't buy you anything ever...

Virion: Goodness, talk about an attitude change... Now, look. I'm not saying I won't buy you anything ever...

Vaike: Yeesh, talk about an attitude change! Now, look. I ain't sayin' I won't buy ya anythin' ever...

Stahl: Geez, talk about an attitude change. Now, look. I'm not saying I won't buy you anything ever...

Kellam: Yeesh, talk about an attitude change. Now, look. I'm not saying I won't buy you anything ever...

Lon'qu: I wasn't suggesting... Oh, good grief. Look, I'm not saying I won't buy you anything ever...

Ricken: Yeesh, talk about an attitude change. Now, look. I'm not saying I won't buy you anything ever...

Gaius: Yeesh, talk about an attitude change. Look, I'm not saying I won't buy you anything ever...

Gregor: Oy, talk about attitude change... Now, look. Gregor not saying he won't buy you anything ever...

Libra: Goodness, that was a fast change. Now, see here. I'm not saying I won't buy you anything ever...

Henry: Yeesh, talk about an attitude change! Am I gonna have to sling a curse? Look. I'm not saying I won't buy you anything ever...

Donnel: Gosh, talk about yer attitude changes! Now, look. I ain't sayin' I won't buy ya nothin' ever...

Severa: Ooooooh, you're not?!

[Robin]: I'm just saying you'll have to earn it. If you help out around camp with chores and such, I'll treat you to something nice.

Frederick: I'm just saying you'll have to earn it. If you help out around camp with chores and such, I'll treat you to something nice.

Virion: I'm just saying you'll have to earn it. If you help out around camp with chores and such, I'll treat you to something nice.

Ricken: I'm just saying you'll have to earn it. If you help out around camp with chores and such, I'll treat you to something nice.

Gaius: I'm just saying you'll have to earn it. If you help out around camp with chores and such, I'll treat you to something nice.

Vaike: I'm just sayin' you'll have to earn it. If ya help out around camp with chores and such, I'll treat ya to something nice.

Stahl: I'm just saying you'll have to earn it. If you help out around camp with chores and such, I'll treat you to something nice.

Kellam: I'm just saying you'll have to earn it. If you help out around camp with chores and such, I'll treat you to something nice.

Lon'qu: I'm just saying you'll have to earn it. If you help out around camp with chores and such, I'll treat you to something nice.

Ricken: I'm just saying you'll have to earn it. If you help out around camp with chores and such, I'll treat you to something nice.

Gaius: I'm just saying you'll have to earn it. If you help out around camp with chores and such, I'll treat you to something sweet.

Gregor: Gregor just saying you have to earn it! If you help around camp with daily chores, Gregor treat you to something nice.

Libra: But the gods reward those who live in service of others. If you help out around camp with chores and such, I'll treat you to something nice.

Henry: I'm just saying you'll have to earn it. If you help out around camp with chores and stuff, I'll treat you to something nice.

Donnel: I'm just sayin' yer gonna have to earn it. If ya help out around camp with chores and such, I'll treat ya to somethin' nice.

Severa: EXCUSE me? What is this—my allowance?! I'm not a child!

[Robin]: No? Then stop acting like one. This is for your own good, Severa. A little hardship in one's youth builds character.

Frederick: No? Then stop acting like one. This is for your own good, Severa. A little hardship in one's youth builds character.

Virion: No? Then stop acting like one. This is for your own good, Severa. A little hardship in one's youth builds character.

Vaike: No? Then stop actin' like one! This is for your own good, Severa. A little hardship in your youth builds character.

Stahl: No? Then stop acting like one. This is for your own good, Severa. A little hardship in one's youth builds character.

Kellam: No? Then stop acting like one. This is for your own good, Severa. A little hardship in one's youth builds character.

Lon'qu: No? Then stop acting like one. A little hardship in one's youth builds character.

Ricken: Well then stop acting like one! This is for your own good, Severa. A little hardship in one's youth builds character.

Gaius: No? Then stop acting like one. This is for your own good, Severa. A little hardship in one's youth builds character.

Gregor: No? Then please do not act like one. This is for own good, yes? Little hardship in youth makes with the character building!

Libra: No? Then stop acting like one. This is for your own good, Severa. A little hardship in one's youth builds character.

Henry: No? Then why are you acting like one? This is for your own good, Severa. A little hardship at this age builds character.

Donnel: No? Then stop actin' like one. This is for yer own good, Severa. A little hardship in yer youth builds character.

Severa: I dealt with a LOT more than hardship back in the future, thank you!

[Robin]: Well, my decision is final. I won't continue to just buy you whatever you like. If there's something you want, you'll have to work for it.

Frederick: Well, my decision is final. I won't continue to just buy you whatever you like. If there's something you want, you'll have to work for it.

Virion: Well, my decision is final. I won't continue to shower you with whatever gifts you like. If there's something you want, you're going to have to work for it.

Vaike: Well, my mind's made up. I won't continue to just buy ya whatever ya like. If there's somethin' ya want, you'll have to work for it.

Stahl: Well, my decision is final. I won't continue to just buy you whatever you like. If there's something you want, you'll have to work for it.

Kellam: Well, my decision is final. I won't continue to just buy you whatever you like. If there's something you want, you'll have to work for it.

Lon'qu: Well, my decision is final. I won't continue to just buy you whatever you like. If there's something you want, you'll have to work for it.

Ricken: Look, my decision is final. I won't continue to just buy you whatever you like. If there's something you want, you'll have to work for it.

Gaius: Well, my decision is final. I won't continue to just buy you whatever you like. If there's something you want, you'll have to work for it.

Gregor: Well, decision is final. Gregor will not continue to just buy whatever daughter like. If you find something you want, you will have to work for it.

Libra: Well, my decision is final. I won't continue to just buy you whatever you like. If there's something you want, you'll have to work for it.

Henry: No dice. My decision is final. I won't continue to just buy you whatever you want. If there's something you want, you'll have to work for it.

Donnel: Sorry, that's final. I ain't gonna just buy whatever ya like no more. If there's somethin' ya want, you'll have to work for it.

Severa: FINE! Whatever! ...I'll do your stupid chores. But I expect some SERIOUS returns, is that clear?!

[Robin]: *Sigh* I sure hope that character starts building soon.

Frederick: *Sigh* I sure hope that character starts building soon.

Virion: *Sigh* I sure hope that character starts building soon.

Vaike: "Sigh" Sure hope that character starts buildin' soon...

Stahl: "Sigh" I sure hope that character starts building soon...

Kellam: "Sigh" I sure hope that character starts building soon...

Lon'qu: "Sigh" Whatever you say...

Ricken: "Sigh" I sure hope that character starts building soon...

Gaius: "Sigh" I sure hope that character starts building soon...

Gregor: "Sigh" Gregor hope character start building soon...

Libra: "Sigh" I sure hope that character starts building soon...

Henry: Nya ha! We'll see, now, won't we!

Donnel: "Sigh" I sure hope that character starts buildin' soon...

■ FATHER X SEVERA A

Severa: Apply the whetstone to the blade at an angle, and then... Gah, not again! That's the fifth one that broke! Nothing EVER goes right for me!

[Robin]: Er, Severa? What are you doing?

Frederick: Er, Severa? What are you doing?

Virion: Er, Severa? What are you doing?

Vaike: Er, Severa? Whatcha doin'?

Stahl: Er, Severa? What are you doing?

Kellam: Er, Severa? What are you doing?

Lon'qu: Severa? What are you doing?

Ricken: Er, Severa? What are you doing?

Gaius: Er, Severa? What are you doing?

Gregor: Er, Severa? What are you doing?

Libra: Severa? What are you doing?

Henry: Er, Severa? What are you doing?

Donnel: Er, Severa? Whatcha doin'?

Severa: I'm sharpening these stupid weapons that won't stay sharp! Gawds! You told me to help out, right? So I'm helping.

[Robin]: ...And that pile of broken swords behind you?

Frederick: ...And that pile of broken swords behind you?

Virion: ...And that pile of broken swords behind you?

Vaike: ...And that pile of broken swords behind ya?

Stahl: ...And that pile of broken swords behind you?

Kellam: ...And that pile of broken swords behind you?

Lon'qu: ...And that pile of broken swords behind you?

Ricken: ...And that pile of broken swords behind you?

Gaius: ...And that pile of broken swords behind you?

Gregor: ...And what is huge pile of broken swords behind you?

Libra: ...And that pile of broken swords behind you?

Henry: ...And that pile of broken swords behind you?

Donnel: ...And that pile of broken swords behind ya?

Severa: It's not my fault they're defective! They all, like, fell apart and stuff! Sorry I'm not PERFECT at everything like Mother! Sorry I'm SO STUPID! I get it—I'm useless! You should just drown me in a sack...

[Robin]: Severa, I think you're overreact—

Frederick: Severa, I think you're overreact—

Virion: Severa, I think you're overreact—

Vaike: Er, I think you're overreact—

Stahl: Severa, I think you're overreact—

Kellam: Severa, I think you're overreact—

Lon'qu: Severa, I think you're overreact—

Ricken: Severa, I think you're overreact—

Gaius: Severa, I think you're overreact—

Gregor: Gregor thinks you are overreact—

Libra: Severa, I think you're overreact—

Henry: Okay, you miiight be overreact—

Donnel: Hey, hold yer horses now! I think yer overreact—

Severa: I burn everything I try to cook... I just about beheaded a horse while chopping wood... I'm no help to anyone! I'm just a bunch of lame deadweight. You must've had high hopes, too, given Mother's history. I'm such a disappointment.

[Robin]:

Frederick:

Virion:

Vaike:

Stahl:

Kellam:

Lon'qu:

Ricken:

Gaius:

Gregor:

Libra:

Henry:

Donnel:

Severa: ...Well? If you have something to say, just say it!

[Robin]: I'm not disappointed, Severa. I couldn't be happier that you came back to us.

Frederick: I'm not disappointed, Severa. I couldn't be happier that you came back to us.

Virion: I'm not disappointed, Severa. I couldn't be happier that you came back to us.

Vaike: I ain't disappointed, Severa. I couldn't be happier that you came back to us.

Stahl: I'm not disappointed, Severa. I couldn't be happier that you came back to us.

Kellam: I'm not disappointed, Severa. I couldn't be happier that you came back to us.

Lon'qu: I'm not disappointed, Severa. I couldn't be happier that you came back to us.

Ricken: I'm not disappointed, Severa. I couldn't be happier that you came back to us.

Gaius: I'm not disappointed, Severa. I couldn't be happier that you came back to us.

Gregor: Gregor not disappointed. In fact, he could not be happier daughter came back to us.

Libra: I'm not disappointed, Severa. I couldn't be happier that you came back to us.

Henry: I'm not disappointed, Severa. I couldn't be happier that you came back to us!

Donnel: I ain't disappointed, Severa. I couldn't be happier that ya came back to us.

Severa: Oh, please. Are you mocking me? Do you really think I'm that stupid? All my life, every time I mess something up, people compare me to Mother! And you're closer to her than anyone! I KNOW you think I don't measure up.

[Robin]: You're your own woman, Severa. I wouldn't compare you to anyone. You're my daughter and my treasure, and I know your mother feels the same.

Frederick: You're your own woman, Severa. I wouldn't compare you to anyone. You're my daughter and my treasure, and I know your mother feels the same.

Virion: You're your own woman, Severa. I wouldn't compare you to anyone. You're my daughter and my treasure, and I know your mother feels the same.

Vaike: You're your own woman, Severa. I wouldn't compare ya to anyone. You're my daughter and my treasure, and I know your mother feels the same.

Stahl: You're your own woman, Severa. I wouldn't compare you to anyone. You're my daughter and my treasure, and I know your mother feels the same.

Kellam: You're your own woman, Severa. I wouldn't compare you to anyone. You're my daughter and my treasure, and I know your mother feels the same.

Lon'qu: You're your own woman, Severa. I wouldn't compare you to anyone. You're my daughter and my treasure, and I know your mother feels the same.

Ricken: You're your own woman, Severa. I wouldn't compare you to anyone. You're my daughter and my treasure, and I know your mother feels the same.

Gaius: You're your own woman, Severa. I wouldn't compare you to anyone. You're my daughter and my treasure, and I know your mother feels the same.

Gregor: You are own woman, Severa. Gregor would never compare to other! You are daughter and treasure, yes? And Gregor knows mother feels the same.

Libra: You're your own woman, Severa. I wouldn't compare you to anyone. You're my daughter and my treasure, and I know your mother feels the same.

Henry: Come on, Severa! You're your own woman!! I wouldn't compare you to anyone. You're my daughter and my treasure, and I know your mother feels the same.

Donnel: Yer your own woman, Severa. I wouldn't compare ya to anyone. Yer m'daughter and m'treasure, and I know yer ma feels the same.

Severa: Wha—?!

[Robin]: I love you, honey, and I'm behind you no matter what happens. So no more talk of being a disappointment. It makes me feel like I failed you as a father.

Frederick: I love you, and I'm behind you no matter what happens. So no more talk of being a disappointment. It makes me feel like I failed you as a father.

Virion: I love you, my dear, and I'm behind you no matter what happens. So no more talk of being a disappointment. It makes me feel like I failed you as a father.

Vaike: I love ya, kid, and I'm behind ya no matter what. So no more talk of bein' a disappointment! It makes me feel like I failed you as a father.

Stahl: I love you, honey, and I'm behind you no matter what happens. So no more talk of being a disappointment! It makes me feel like I failed you as a father.

Kellam: I love you, honey, and I'm behind you no matter what happens. So no more talk of being a disappointment! It makes me feel like I failed you as a father.

Lon'qu: I'm behind you no matter what happens. So no more talk of being a disappointment. It makes me feel as if I failed you as a father.

Ricken: I love you, honey, and I'm behind you no matter what happens. So no more talk of being a disappointment! It makes me feel like I failed you as a father.

Gaius: I love you, honey, and I'm behind you no matter what happens. So no more talk of being a disappointment! It makes me feel like I failed you as a father.

Gregor: Gregor will make with the standing behind you no matter what happens. So no more talk of being disappointment! It make Gregor feel like failure as father.

Libra: I love you, honey, and I'm behind you no matter what happens. So no more talk of being a disappointment! It makes me feel like I failed you as a father.

Henry: I love you, kiddo, and I'm behind you no matter what happens. So no more talk of being a disappointment! It makes me feel like I failed you as a father.

Donnel: I love ya, honey, and I'm behind ya no matter what. So hush up about bein' a disappointment! It makes me feel like a failure.

Severa: What? No! Daddy, you didn't! "sniff" I'm sorry! I... I didn't... WAAAAAAAAAH...

[Robin]: Don't cry. You've been through a lot, I know, but it's all right now. I'm sorry for saying you needed more hardship before. I know it's been hard... But I'll do all I can to keep you from ever suffering again. And hey—you HAVE been doing your chores. So how about that reward now?

Frederick: Don't cry. You've been through a lot, I know, but it's all right now. I'm sorry for saying you needed more hardship before. I know it's been hard... But I'll do all I can to keep you from ever suffering again. And since you HAVE been doing your chores, how about that reward now?

Vaike: Aw, don't cry. You've been through a lot, I know, but it's all right now. I'm sorry for sayin' ya needed more hardship before. I know it's been hard... But I'll do all I can to keep ya from ever sufferin' again. And hey—ya HAVE been doin' your chores! So how about that reward now?

Stahl: Don't cry. You've been through a lot, I know, but it's all right now. I'm sorry for saying you needed more hardship before. I know it's been hard... But I'll do all I can to keep you from ever suffering again. And hey—you HAVE been doing your chores. So how about that reward now?

Kellam: Don't cry. You've been through a lot, I know, but it's all right now. I'm sorry for saying you needed more hardship before. I know it's been hard... But I'll do all I can to keep you from ever suffering again. And hey—you HAVE been doing your chores. So how about that reward now?

Lon'qu: Don't cry. You've been through a lot, I know, but it's all right now. I'm sorry for saying you needed more hardship before. I know it's been hard... But I'll do all I can to keep you from ever suffering again. And hey—you HAVE been doing your chores. So how about that reward now?

Ricken: Don't cry. You've been through a lot, I know, but it's all right now. I'm sorry for saying you needed more hardship before. I know it's been hard... But I'll do all I can to keep you from ever suffering again. And hey—you HAVE been doing your chores. So how about that reward now?

Gaius: Don't cry. You've been through a lot, I know, but it's all right now. I'm sorry for saying you needed more hardship before. I know it's been hard... But I'll do all I can to keep you from ever suffering again. And hey—you HAVE been doing your chores. So how about that reward now?

Gregor: Oy, do not cry! You go through much, yes, but everything all right now. Gregor is sorry for saying you need more hardship. He know it has been hard... But he will do all he can to keep daughter from suffering again. And you HAVE been making with the daily chores, yes? So let's give reward!

Libra: Don't cry. You've been through a lot, I know, but it's all right now. I'm sorry for saying you needed more hardship before. I know it's been hard... But I'll do all I can to keep you from ever suffering again. And hey—you HAVE been doing your chores. So how about that reward now?

Henry: Don't cry. You've been through a lot, I know, but it's all right now. I'm sorry for saying you needed more hardship before. I know it's been hard... But I'll do all I can to keep you from ever suffering again. And hey—you HAVE been doing your chores. So how about that reward now?

Donnel: Don't cry now. Ya been through a lot, but it's all right now. I'm sorry I said ya needed more hardship 'fore. I know it's been rough... But I'll do all I can to keep ya from ever sufferin' again. And hey—ya HAVE been doin' yer chores. So how's about that reward now?

Severa: No. I don't need it. I don't need anything but you, Daddy! But if you die on me again, I'll never forgive you!

[Robin]: I'm not going anywhere this time, honey. I promise.

Frederick: I'm not going anywhere this time, Severa. I promise.

Virion: I'm not going anywhere this time. I promise.

Vaike: I ain't goin' anywhere this time. I promise.

Stahl: I'm not going anywhere this time. I promise.

Kellam: I'm not going anywhere this time, honey. I promise.

Lon'qu: I'm not going anywhere this time. I promise.

Ricken: I'm not going anywhere this time. I promise.

Gaius: I'm not going anywhere this time. I promise.

Gregor: Gregor is not going anywhere, child. Is promise.

Libra: I'm not going anywhere this time, dear. I swear it in Naga's name.

Henry: I'm not going anywhere this time. I promise.

Donnel: I ain't goin' nowhere this time, hon. Cross m'heart and hope to spit!

Gerome

Avatar (male)

The dialogue between Avatar (male) and Gerome can be found on page 225.

Avatar (female)

The dialogue between Avatar (female) and Gerome can be found on page 236.

Cherche (Mother/son)

Gerome's mother/son dialogue with Cherche can be found on page 280.

Lucina

The dialogue between Lucina and Gerome can be found on page 283.

Inigo

The dialogue between Inigo and Gerome can be found on page 291.

Kjelle

The dialogue between Kjelle and Gerome can be found on page 298.

Cynthia

The dialogue between Cynthia and Gerome can be found on page 301.

Severa

The dialogue between Severa and Gerome can be found on page 303.

Morgan (male) (Father/son)

Morgan's (male) father/son dialogue can be found on page 309.

Morgan (female)

■ MORGAN (FEMALE) X GEROME C

Morgan (female): Everyone's busy sparring. Or training. Or throwing fireballs around. This camp is boring as all get-out! Time to make my OWN fun!

Gerome:

Morgan (female): Oh, hey, Gerome. What's up? ...Er, do you always stand around like a statue and stare at people? Or am I just particularly enchanting?

Gerome: Not particularly, no. However, for someone without memory, you are unusually...peppy.

Morgan (female): You think so? Hmm... Well, it's better than being unusually glum, I guess! Besides, everything is fresh and new for me. I can't help but be excited!

Gerome: I suppose that makes sense.

Morgan (female): Hey, so what's up with the mask? Is it for effect or what? Oh, wait! Are you a mask collector? Do you wear a different one every day?

Gerome: It's complicated.

Morgan (female): No, calculus is complicated. ...That's a mask.

Gerome: And it's none of your concern!

Morgan (female): Huh? Hey, Gerome? ...Hullo? He just walked away! How rude!

■ MORGAN (FEMALE) X GEROME B

Morgan (female): Hey, Gerome!

Gerome: What do you want?

Morgan (female): I've been thinking about it, and I've decided you'd be better off without the mask.

Gerome: You decided this, did you?

Morgan (female): Sure did! I mean, think about it! A mask is just a fake face, you know? And that means you're not being honest with yourself about who you truly are! Also, it's scaring the village kids. So there's that.

Gerome: ...I know your words, but what you are saying makes no sense at all. This mask stays.

Morgan (female): Gods, so stubborn! Come on, tell me why you're so attached to that thing. Did an old girlfriend give it to you or something?

Gerome: No.

Morgan (female): Or maybe... Ah, so THAT'S it! Yeah, I'd want to wear a mask too, if that was the case.

Gerome: What are you talking about? What is this theory of yours?

Morgan (female): I think you're just really, really shy! I bet every time you look someone in the eye, you turn redder than a tomato!

Gerome: I-I do not! That's simply not true!

Morgan (female): Oh, it's okay. You don't have to be upset. I think it makes you even MORE charming!

Gerome: Are you listening to me?! I said it's not true!

Morgan (female): Then what IS the truth? ...Hm-mmmmmmmm?

Gerome: None of your business!

Morgan (female): Ha ha! You're shy! You are SO shy! I bet really shy people hold their convention in your tent. That's how shy YOU are!

Gerome: For the last time, NO! Argh! I've had enough of this! I'm leaving!

Morgan (female): There's no point denying it! I know the truth now! But don't worry, your secret is safe with meeeeeeee! ...Aaaand, he's gone.

■ MORGAN (FEMALE) X GEROME A

Morgan (female): Ah-HAH!

Gerome: Gya! Wh-why are you leaping out of the bushes at me?!

Morgan (female): 'Cause I've got an extra-special present for you!

Gerome: ...Oh?

Morgan (female): Yep! Here, check it out! I made you a bunch of new masks!

Gerome: Er...

Morgan (female): Clearly it's hard for you to ditch the mask completely, so I came up with this idea. This way you can pick different masks based on how you feel that day!

Gerome: I don't understand.

Morgan (female): I made a whole boatload of masks—one for every occasion and mood. Go on, don't be shy. Try one on!

Gerome: I told you, I'm not shy!

Morgan (female): This one is patterned like a butterfly, for when you're feeling extra jolly. And this one has little hearts all over it. It's more for when you feel happy.

Gerome: That's the same thing.

Morgan (female): Oh, there's a difference. My masks show even subtle changes in emotion! This is just the first batch, of course, so there are some moods you can't do. Rampant Greed isn't quite finished yet. And Morose is still in the design phase... But think of the fun you'll have with all of these right here! So, anyway, go ahead and pick one.

Gerome:

Morgan (female): I'm waaaaaiting! ♪

Gerome: I cannot!

Morgan (female): H-hey! Don't run away! You forgot your masks! I spent forever on theeeeeeeese!

Gerome: I suppose she means well... But I'll dance with the Risen before I wear one of those damnable masks!

■ MORGAN (FEMALE) X GEROME S

Gerome: Morgan? Might I have a word?

Morgan (female): Maybe... And maybe NOT!

Gerome: Er, are you angry at me?

Morgan (female): I went to a LOT of time and trouble to make those masks for you! And you just ran away! RAN! At top speed over hill and dale!

Gerome: I know you are upset, but I simply cannot wear my masks. Perhaps, however, it would offer some measure of apology if I removed this one?

Morgan (female): ...You'd do that?

Gerome: If you are so determined to know what I am feeling, this is the easiest way.

Morgan (female): I dunno. My masks are pretty great. I just finished Miffed last night... Ah, what's it matter? You don't need my masks if you walk around all barefaced.

Gerome: This is not for everyone, Morgan. It is for you alone.

Morgan (female): SAAAAAAAAY!

Gerome: Well. Here I am. In the flesh, so to speak.

Morgan (female): Hubba hubba! Awoooooo-ga! Hee hee! I KNEW it! You're turning red as a boiled ham!

Gerome: Even my nose?!

Morgan (female): ESPECIALLY your nose! Why are you so embarrassed?

Gerome: I suppose it's because... Well, I like you. Very much, in fact.

Morgan (female): Seriously? Because I suppose it's obvious, but I...um...like you, too.

Gerome: Er...

Morgan (female): ...This IS embarrassing, isn't it?

Gerome: I see you're turning red as well.

Morgan (female): Er, I don't suppose I could maybe... borrow your mask?

Gerome: Use your own! You have a whole bag of them right there!

Morgan (female): Oh, right. Here, you can have the butterfly one, because you're so jolly... And I'll wear this one with the hearts, because I'm feeling so... excited.

Gerome: I have to wear one?

Morgan (female): Look, this may be the only chance I get to use these. Don't screw it up!

Gerome: I hardly think it's so... Oh, maybe just this once.

Morgan (female): So does wearing matching masks make us all official as a couple?

Gerome: Perhaps it does.

Morgan (female) (Brother/sister)

■ MORGAN (FEMALE) X GEROME (BROTHER/SISTER) C

Morgan (female): Let's see here... Birthday? May 5th... Favorite colors? Blue and purple... Favorite food? Probably bear meat...

Gerome: What are you mumbling about over there, Morgan?

Morgan (female): Least favorite food? Veggies, apparently. Don't seem to mind them now, though...

Gerome: Morgan!

Morgan (female): Oh! Gerome?! Guess I was pretty out of it to miss my own brother paying a visit! Did you need something?

Gerome: Just wondering what you were chanting over there... You practicing some new magic incantations?

Morgan (female): Nope! Just going back over my notes on what you told me about myself. I was hoping they'd hold some clue that might help spark my memory. Heh. It's kind of crazy how much you know about me, huh? Like, I really once got five nosebleeds in the same day? I have no memory of that at all. AT ALL! Ha ha ha! I can just imagine...

Gerome: You're still as cheerful, that's for sure. And as talkative as ever...

Morgan (female): I am? I mean, I was?! Hmm, now that you mention it, that does sound...right, somehow. ...Heh. Everything still feels funny. Even you being my brother hasn't really clicked.

Gerome: If you think it's strange for you, consider my position... My sister starts talking to me like a stranger, asking questions about herself... For a while there, I had no idea how to even interact with you.

Morgan (female): Heh, yeah... Sorry about that. But that's just another reason why I'm working hard to get my memories back. Once I do, nobody will have to feel weird or awkward around me again. Pretty noble, huh? I'm such a sweet, selfless girl!

Gerome: ...And so humble, too. Anyway, I'm happy to try and help you get those memories back however I can. I'm looking forward to having someone to laugh with about old times—now included.

Morgan (female): Heh, right!

■ MORGAN (FEMALE) X GEROME (BROTHER/SISTER) B

Gerome: Whew... Another long day of combat... Time to prepare Minerva for... Is someone passed out over there? Wait, is that Morgan?!

Morgan (female): Nn...nngh...

Gerome: Morgan, are you all right?! What happened?

Morgan (female): ...Wha—?! Gerome! Wh-what am I doing here? Was I asleep?! I don't even remember feeling tired... Oh, right! I was bashing that huge tree against my head when I blacked out. That explains why my face hurts so bad...

Gerome: Why in the world would you do something like that?! ...Wait, were you trying to get your memories back?

Morgan (female): Well, yeah! Obviously. If you ever saw me bludgeoning myself just for fun, I hope you'd put a stop to it.

Gerome: I'll stop you even if it's NOT just for fun! Look, I know you want your memories back, but please... Don't do anything reckless.

Morgan (female): ...But I want to be able to talk with you about old times again.

Gerome: I know, Morgan, and I want that, too. But more than that, I want you safe. I may just be another stranger to you, but to me, you're family. In the future,

with Mother and Father gone, it was just the two of us and Minerva. You're all I had, Morgan... I don't know what I'd do if anything happened to you.

Morgan (female): All right. I'm sorry, Gerome.

Gerome: Just as long as you understand.

Morgan (female): ...Heh, that felt really sibling just now. Don't you think? Me messing up and you scolding me felt... I don't know, it felt really plausible! Maybe if you keep it up, I'll remember something!

Gerome: You think so?

Morgan (female): Yeah! Oh yeah, this will totally work! So go on, keep yelling! C'mon, scream at your amnesiac sister, Gerome!

Gerome:

Morgan (female): Hey, why don't you use the tome, too? Come on, don't hold back. Really wallop me with that thing! Maybe the simultaneous physical and mental shock will jar some memories loose! It's gotta be twice as effective as either one by itself, right? That's just basic science.

Gerome: ...Good night, Morgan.

■ MORGAN (FEMALE) X GEROME (BROTHER/SISTER) A

Gerome: I'm headed into town, Morgan. Care to come along?

Morgan (female): I'd love to! Is there something in particular you need?

Gerome: I might pick up a couple of things, yes. But mostly I think there's something YOU need.

Morgan (female): It doesn't have to do with getting my memories back, does it?

Gerome: The opposite, really. Perhaps there's no need to worry about your memories.

Morgan (female): That...makes no sense.

Gerome: In truth, I find it a bit hard to swallow that you've forgotten me... But perhaps it's better to build new memories than to worry about old ones.

Morgan (female): What do you mean?

Gerome: I've given this a lot of thought. Why you might have lost your memories, I mean. And I'm wondering if you didn't have some awful memory you couldn't bear to keep. I know we saw so many people we couldn't save... Lives needlessly wasted...

Morgan (female): I'm sorry you have to bear those dreadful memories, Gerome...

Gerome: It is only a theory, and even if true, I don't believe it's anything you did consciously. But I do think that getting your memories back might not be a good thing.

Morgan (female): Hmm... I understand, and believe me, I appreciate the thought... But I want to remember things, no matter how painful they are. Because I'm sure there'll be plenty of great memories mixed with the bad ones. And the truth, whatever it is... I really want to have that back, you know?

Gerome: Well, if you're sure, then I am happy to help.

Morgan (female): That's really kind of you, Gerome, but do you truly realize what you're saying? I mean, it could be years before I remember anything. Or decades. Heck, there's a decent chance I may never get my memories back at all. I don't want to drag you into something that could last forever.

Gerome: I'm already stuck with you forever. I'm your brother. We're family—memories or no. You couldn't keep me away.

Morgan (female): Gerome, I... *sniff* Thank you! I'll do everything I can!

Gerome: Then climb up on Minerva and come with me to town.

Morgan (female): Huh? But you said that doesn't have to do with getting my memories back.

Gerome: There's no rule that says you can't have a little fun while you try. And there's certainly no rule against making happy new memories, either. You're young yet. There will be plenty of time for worry later.

Morgan (female): Right... You're right! Thanks, Brother!

Laurent

■ LAURENT X GEROME C

Laurent: Ah, Gerome. I was looking for you. Do you have a moment?

Gerome: What is it, Laurent?

Laurent: I'm here to give my regular report, as per our arrangement.

Gerome: Oh, yes, of course. How could I forget?

Laurent: Ahem! I'm happy to report that today everyone continues to be in good health. There have been no reported instances of brawls or other insubordination. Logistics are running smoothly, and we have sufficient stockpiles of military supplies.

Gerome: ...Right. Er, thank you as always.

Laurent: Keeping a careful eye on things is one of my particular talents. However, there is one matter...

Gerome: Yes?

Laurent: Er, perhaps I'm overstating its import. Please forget I mentioned it.

Gerome: ...Very well.

■ LAURENT X GEROME B

Laurent: ...And in conclusion, everything is going smoothly, as usual.

Gerome: Very good. But one thing, before you go...

Laurent: What is it?

Gerome: In your report just now, you neglected to suggest that we stock up on arrows.

Laurent: Is that a particular concern?

Gerome: We're likely to march within the week and can expect to encounter aerial forces. I strongly suspect we'll need extra arrows in the baggage train.

Laurent: An astute observation. I shall make the necessary adjustments to the supply line.

Gerome: The report was otherwise acceptable.

Laurent: Forgive me for saying this, but you are more involved than you seem.

Gerome: How so?

Laurent: You ask me to make daily reports on the health and status of the Shepherds, yes? It's almost like you...care about us.

Gerome: I care about victory, Laurent. And victory demands preparation. I hate it when something—or someone—lets me down in a battle.

Laurent: Nevertheless, I'd like to thank you. On behalf of everyone, of course.

Gerome:

Laurent: There is one other thing, though...

Gerome: Yes?

Laurent: Oh, er, well... I suppose it's nothing that can't wait.

Gerome: Come now. What's on your mind?

Laurent: ...It is, I admit, a bit of a whimsical notion on my part, but... Well, I was hoping you might consider speaking with the others more often.

Gerome: ...I don't understand.

Laurent: Instead of using me as a proxy, you could confer with them directly. You might even build a stronger rapport with the company as a result.

Gerome: I'm not the rapport-building type.

Laurent: Perhaps an idea whose time has not come. At any rate, I'll report again tomorrow.

Gerome: Good. And, er...thank you.

■ LAURENT X GEROME A

Gerome: Laurent, do you have a moment?

Laurent: Instigating a conversation with me? This is truly a singular event!

Gerome: Tell me, are you going to check on the soldiers and supplies today?

Laurent: I was about to begin my rounds, yes.

Gerome: Would you mind if I accompany you? I'd like to help if I could.

Laurent: ...But I thought you preferred to stay in the background?

Gerome: I've been thinking about what you suggested when last we talked... It's true that I shouldn't rely solely on you to learn about conditions in the camp. I should stop hiding like a craven and talk to my comrades face-to-face.

Laurent: I didn't mean to imply that—

Gerome: My words, Laurent. Not yours. But they are true nonetheless. I've been giving you the brunt of the work while I hid in my tent pretending to help.

Laurent: You're being too hard on yourself.

Gerome: No I'm not. I should have done this a long time ago. So, will you let me come with you? I'm anxious to learn what you do.

Laurent: Of course. I know the troops are all quite anxious to speak to you.

Gerome: Well, I'm anxious to meet them as well.

Laurent: Right this way then, if you please...

Noire

■ NOIRE X GEROME C

Noire: Phew! I'm exhausted!

Gerome:

Noire: Er, hullo?

Gerome:

Noire: Gerome? Is that you?

Gerome: Yes.

Noire: Eeek! H-how long were you going to stand there and...stare at me? You weren't...just watching me...were you? ...What do you want, anyway?!

Gerome: I don't want anything.

Noire: Um, okay. So then why—

Gerome: Do you wish for me to go?

Noire: I don't know. ...I suppose not. I'm finished now, so it doesn't really matter either way.

Gerome: Because if I am bothering you, I can stand farther away. Over there, perhaps?

Noire: No, no. It's okay, you don't have to...

Noire: Oh. He's gone. That's...mildly disturbing. W-wait! Could it be that someone sent him to spy on me? Because then... Oh no!

■ NOIRE X GEROME B

Noire: H-hey, Gerome.

Gerome:

Noire: Um, so, are you sure you don't need anything from me? Because you're spending a lot of time just... hovering around.

Gerome: I desire nothing.

Noire: Oh, er, okay. Nothing on your mind at all, then. Is that right?

Gerome:

Noire: Right. That's...certainly not creepy or anything.

Gerome:

Noire: Okay, what is your deal, mister?!

Gerome: Hmm?

Noire: BLOOD AND THUNDER! WERE YOU SENT TO SPY ON ME OR NO?! SPEAK! SPEAK BEFORE I RIP YOUR TONGUE FROM YOUR MAW!

Gerome: B-b-but—

Noire: BWAAA HA HA HA HA!

Gerome: F-forgive me! I was only trying to help! I was worried about you.

Noire: ...W-worried?!

Gerome: Yes! You've been working far too hard, and I was concerned for your health.

Noire: So...that's why you've been hanging around like a starving vulture?

Gerome: It's no secret that you possess a somewhat delicate constitution. I feared you'd work too hard, fall ill, and be unable to march with the army. I'm sorry if I made you uncomfortable. It was not my intention.

Noire: Er, well, I guess you meant well...

Gerome: I will leave you in peace now.

Noire: Aw, crackers! I scared him away again!

■ NOIRE X GEROME A

Noire: Hey-ho... Oomph! Ungh... This crate's...so heavy...

Gerome: Noire?!

Noire: I-I've got it! Unnngh... Totally got... Uh-oh, no I don't—! Waaaaaaaaaargh! ...Whew, I'm still standing. But I was tipping backwar—

Gerome: Are you all right, Noire?!

Noire: Gerome? Did you save me? Oh, wow. Y-you did, didn't you?! Oh gee, that's kind of... Ungh...

Gerome: Look out!

Noire: Whoops! Sorry! Guess I'm still a little light headed there.

Gerome: You must stop pushing yourself so hard! You can barely walk from exhaustion!

Noire: Yeah, but I didn't think it would be so hard to move a couple of crates. ...Sorry you had to rescue me.

Gerome: You always push hardest when you think no one is around.

Noire: ...Yeah, maybe. Look, I'll try to be more careful, all right?

Gerome: Next time, ask for help. It benefits no one if you injure yourself.

Noire: Yeash, I know, I know... I'm sorry.

Gerome: ...Apologies if I spoke harshly. I'm only concerned for your well-being.

Noire: Oh, it's all right. ...Besides, I should apologize for calling you creepy earlier. I kind of meant it at the time, but I don't anymore.

Gerome: Well, I suppose I might have come across strangely, just standing there...

Noire: Great! Glad that's settled! Now I've I've got some crates to move! You can stay and help if you want. Just to make sure I don't...overdo it?

Gerome: Of course.

Noire: Hee hee! Thanks, Gerome!

■ NOIRE X GEROME S

Noire: Hello again. Seems like I've been seeing a lot of you recently.

Gerome: *Cough* Just wondering if there's anything I can...help you with.

Noire: Gerome, you are far too kind. ...Actually, you really are far too kind! What are you up to?

Gerome: Nothing!

Noire: Are you sure? You're sure it's not actually that... You're starting to fall in love with me?

Gerome: P-preposterous!

Noire: Really? ...Oh. Then we'll just forget I ever said anything, okay? If I need a hand in the future, I'll ask someone else. Not fair that you always—

Gerome: Wait!

Noire: Hmm?

Gerome:

Noire: Well, come on. Out with it. I'm waiting.

Gerome: You are?

Noire: Gods, but you sure can be a wet fish sometimes!

Gerome: I am not a wet fish!

Noire: You do understand what I'm trying to get at here, don't you? I'm lining up the practice dummies! All you have to do is swing blindly! Is it really so hard to tell a girl that you like her?!

Gerome: Er... Well, that is to say...

Noire: Come on, Gerome! Man up! Just tell me, plainly and clearly, what you think of me!

Gerome: You see, sometimes when two people... Things happen... Stuff... *mumble* ...Okay, I like you.

Noire: Really? Are you serious? Hee hee! Oh, how embarrassing!

Gerome: ...B-but you made me say it!

Noire: It's just so sudden! You'll give me time to think about this, won't you?

Gerome: Are you making fun of me?

Noire: Not at all! I feel overwhelmed, actually. And surprised. ...And honored. And I'm also delighted you finally managed to express yourself! So, um, you'll keep helping me out, won't you?

Gerome: Of course. I don't want you dropping more crates on yourself. But I won't be lurking in the shadows anymore. I'll be right at your side.

Noire: Well that would be a lovely change of pace! Hee hee!

Nah

■ NAH X GEROME C

Gerome: Someone is following me.

Nah: So you finally noticed.

Gerome: You.

Nah: I have a name. It's Nah.

Gerome: Why are you following me?

Nah: You interest me.

Gerome: In what way?

Nah: You're always skulking about on your own... That makes you different. I'm interested in "different."

Gerome: That still doesn't explain why you are following me.

Nah: I wanted to see how you'd react when you discovered me. Out of enlightened curiosity, of course.

Gerome: You wanted to scare me? Is that it? I don't have time for games. Don't talk to me again. ...Minerva, away!

Nah: No. Wait!

Nah: ...He flew off. If only I could follow him somehow... I am a dragon. I could just transform and then... Er... Drat. He's long gone now.

■ NAH X GEROME B

Gerome: ...I'm being followed again. Come out and show yourself! I know you're there!

Nah: Ah. Caught me again!

Gerome: I should have known.

Nah: Gerome, I have a favor to ask.

Gerome: *Sigh* What is it?

Nah: Will you let me touch your mask?

Gerome: No.

Nah: Why not? I don't care about seeing your face. I'll even close my eyes if it makes you feel better. Again, I'm just curious, is all.

Gerome: Even so: no. ...And whatever for? It's just a simple mask.

Nah: But I won't know that until I touch it. So come on!

Gerome: No. End of discussion.

Nah: Now you're just being stubborn! You know you don't need it! If you thought about it for a second or two, you'd see that.

Gerome: Hmph.

Nah: Done thinking about it yet? Then go ahead, take it off!

Gerome: What are you blathering about? I thought you didn't want to see my face?! The mask stays and that's that!

Nah: Oh, very well! It's not that important anyway. Calm down, Gerome... It's not like I think you're ugly under there or anything. I'm just curious.

Gerome: That's not the point.

Nah: All right. I'll go. GIMME THAT! Just...give me...that... *grunt*

Gerome: Get back, you madwoman! Ow! Argh! Put that stick down! Put it down, I say!

Nah: Not so tough now, are you?! Now! Give me that mask! Hrrngh!!!

Gerome: I don't have a stick! ...Ow! ...Right, that's enough! Minerva, to me!

Nah: Don't you dare! Come back here right now! ...Blast it! He flew off again!

■ NAH X GEROME A

Gerome: Huh? Is that...?

Nah: GEROOOOOOME!

Gerome: Does that woman never rest?! ...Wait, what's she—? Oh, gods! She's charging right at me!

Nah: The mask! The mask! Give me that mask!

Gerome: Heavens save me, she's gone insane! Must get out of here! Minerva, to me!

Nah: WHY ARE YOU RUNNING AWAAAAAAAAAAAAY?!

Gerome: Egads, the very ground trembles when she roars! How can such a diminutive figure produce such a bloodcurdling scream?!

Nah: *Pant, pant*

Gerome: Why, damn you?! Why are you chasing me with such desperation?

Nah: I thought I told you? Curiosity!

Gerome: That hardly justifies your obsessive ferocity!

Nah: ...Well, your obstinance isn't helping!

Gerome: W-what's that supposed to mean? Aaargh! You're like a small child throwing fits for no reason! ...Wait. You are a child, aren't you?

Nah: Well, in manakete years I'm practically a mewling babe. But in human years I'm the same age as you.

Gerome: So, you're just playing with me, then? Is this all some...game?

Nah: Well, by now it is, yes. Take a good look. It's rare that I ever get this way. Never toy with my voracious curiosity!

Gerome: Why didn't you just tell me?! It would have saved a lot of aggravation!

Nah: Because puzzles are more fun if you must put in a little work to solve them! Besides, you wouldn't have played if I told you! You're always so grumpy. I couldn't even keep you in one spot long enough to talk to until now!

Gerome: I don't know...

Nah: Come, now. Admit it. You would have brushed me off like an annoying child. Actually, you've been doing just that, no?

Gerome: ...So this started out as curiosity, and gradually devolved to...this? You were afraid I'd refuse if you asked directly. So instead, you've been playing these annoying games?

Nah: Well it's all over now that you've discovered my fiendishly clever plan. *Sigh*

Gerome: Nah, wait! Come back. ...Damn. She's gone. ...Perhaps next time we meet it wouldn't hurt to play along...?

■ NAH X GEROME S

Gerome: Hello, Nah.

Nah: EEEEEEK!

Gerome: Hey, careful with those claws! They're sharp!

Nah: Well, you're the one who snuck up on me! Er... what do you want, anyway?

Gerome: I want to clear the air... I think you may have the wrong idea. I don't dislike you, Nah. Far from it, in fact.

Nah: So why do you jump on Minerva and fly off in the middle of conversations?

Gerome: I don't know. Perhaps I don't know how to respond to a woman so...interested in me. Though honestly, I've never been good at talking to people in general. I do wear this mask for a reason...

Nah: So I see. I guess I can understand... But really, I'm just like everyone else, underneath it all.

Gerome: I...know that now. It just...took me some time to come to that realization. So...

Nah: So...?

Gerome: So in the interest of starting over... I'm wondering if you'd like to play a game together? You can choose it. I promise I won't fly away on Minerva this time.

Nah: Really? You'd do that for me?

Gerome: Yes, I feel like... I owe it to you, after all. And, I suppose I could...loosen up a bit... Plus, if we're going to be friends, then I have to do things for you. Friends do that...right?

Nah: Can we can get married, then?

Gerome: Er, is that what the game is called? I'm not quite familiar with the rules...

Nah: No, you silly man. I mean for real!

Gerome: Wh-where is this coming from?!

Nah: Don't you realize why I've been following you around all this time? It's because I've fallen in—

Gerome: Stop! That's enough. Look. Why don't we pretend to marry for now and get to know each other? That would be fun, right?

Nah: No! I don't want to pretend! I truly want to get married.

Gerome: Yes, but perhaps if we wait until we're both a little older—

Nah: Then you have to promise!

Gerome: I swear, on my honor as a soldier, that I will consider it. ...Eventually.

Nah: I'm more than willing to wait for a man that piques my curiosity like you do... After all, what's a few years to a manakete?

Father

■ FATHER X GEROME C

[Robin]: Hello, Gerome.

Frederick: Hello, Gerome.

Virion: Hello, Gerome.

Vaike: Hey, Gerome.

Stahl: Hello, Gerome.

Kellam: Hello, Gerome.

Lon'qu: Hello, Gerome.

Ricken: Hello, Gerome.

Gaius: Hello, Gerome.

Gregor: Hello, Gerome.

Libra: Hello, Gerome.

Henry: Hey-o, Gerome.

Donnel: Howdy, Gerome.

Gerome: What do you want?

[Robin]: Oh, nothing in particular. I just—

Frederick: Oh, nothing in particular. I just—

Virion: Oh, nothing in particular. I just—

Vaike: Oh, nothin' in particular. I just—

Stahl: Oh, nothing in particular. I just—

Kellam: Oh, nothing in particular. I just—

Lon'qu: Nothing in particular. I just—

Ricken: Oh, nothing in particular. I just—

Gaius: Oh, nothing in particular. I just—

Gregor: Is nothing in particular. Gregor just—

Libra: Oh, nothing in particular. I just—

Henry: Oh, nothing in particular. I just—

Donnel: Oh, nothin' in particular. I just—

Gerome: Then why are you talking to me? I'm not here to make friends.

[Robin]: Apparently not. But what of your family?

Frederick: Apparently not. But what of your family?

Virion: Apparently not. But what of your family?

Vaike: Apparently not... But what about family?

Stahl: Apparently not. But what about your family?

Kellam: Apparently not. But what about your family?

Lon'qu: So I see. But what of your family?

Ricken: Apparently not. But what about your family?

Gaius: Apparently not. But what about your family?

Gregor: Apparently not. But what about family?

Libra: Apparently not. But what of your family?

Henry: Apparently not! But what about family?

Donnel: Seems that way. But what of yer family?

Gerome:

[Robin]: I was thinking: we're father and son... Perhaps it's time we started acting like it? Lucina calls Chrom "Father," you know? We could start there.

Frederick: I was thinking: we're father and son... Perhaps it's time we started acting like it? Lucina calls Chrom "Father," you know? We could start there.

Virion: I was thinking: we're father and son... Perhaps it's time we started acting like it? Lucina calls Chrom "Father," you know? We could start there.

Vaike: I been thinkin': we're father and son... Perhaps it's time we started actin' like it. Lucina calls Chrom "Father," right? Maybe you should try that with me?

Stahl: I was thinking: we're father and son... Perhaps it's time we started acting like it. Lucina calls Chrom "Father," you know? We could start there.

Kellam: I was thinking: we're father and son... Perhaps it's time we started acting like it. Lucina calls Chrom "Father," you know? We could start there.

Lon'qu: I was thinking we should start acting more like a family now that we're reunited. Lucina calls Chrom "Father," you know. We could start there.

Ricken: I was thinking: we're father and son... Perhaps it's time we started acting like it? Lucina calls Chrom "Father," you know? We could start there.

Gaius: I was thinking: we're father and son... Perhaps it's time we started acting like it. Lucina calls Chrom "Father," you know? We could start there.

Gregor: Gregor was thinking: we are father and son, yes? Perhaps we should start acting like it. Lucina call Chrom "Father," you know? Is good place for us to start.

Libra: I was thinking: we're father and son... Perhaps it's time we started acting like it. Lucina calls Chrom "Father," you know? We could start there.

Henry: I was thinking: we're father and son... Maybe it's time we started acting like it. Lucina calls Chrom "Father," you know? We could start there!

Donnel: I was thinkin': we're father and son... Maybe it's time we started actin' like it. Lucina calls Chrom "Father," ya know? We could start there.

Gerome: You may look like my father, but you are not the same man. My father is dead and gone. ...You are a stranger.

[Robin]: Gods, is everyone so tactless in the future? I know your true father is gone, and I know you must miss him greatly... But I thought perhaps our relationship could help heal that wound.

Frederick: Gods, is everyone so tactless in the future? I know your true father is gone, and I know you must miss him greatly. ...But I thought perhaps our relationship could help heal that wound.

Virion: Gods, is everyone so tactless in the future? I know your true father is gone, and I know you must miss him greatly. ...But I thought perhaps our relationship could help heal that wound.

Vaike: Ouch! That was pretty cold, friend. (And Chrom wins yet again...) Look, I know your true father is gone, and I know you must miss him greatly. ...But I thought maybe our relationship could help heal that wound.

Stahl: Gods, is everyone so tactless in the future? I know your true father is gone, and I know you must miss him greatly. ...But I thought perhaps our relationship could help heal that wound.

Kellam: Gods, is everyone this tactless in the future? I know your true father is gone, and I know you must miss him greatly. ...But I thought perhaps our relationship could help heal that wound.

Lon'qu: That may be true, but you're far too adept at pushing others away. I know your true father is gone, and I know you must miss him greatly. ...But I thought perhaps our relationship could help heal that wound.

Ricken: Gods, does everyone talk like this in the future? Look, I know your true father is gone, and I know you must miss him greatly. ...But I thought perhaps our relationship could help heal that wound.

Gaius: Gods, is everyone this tactless in the future? I know your true father is gone, and I know you must miss him greatly. ...But I thought perhaps our relationship could help heal that wound.

Gregor: Oy! Such words tear bear-sized hole in Gregor's sad heart. Gregor know that your true father is gone and that you must miss him muchly. ...So Gregor think: perhaps our relationship could help heal that wound for you.

Libra: I suppose what you say is true, but you could stand to open your heart a bit more... I know your true father is gone, and I know you must miss him greatly. ...But I thought perhaps our relationship could help heal that wound.

Henry: Wow! Is everyone this blunt in the future? Nya ha! Look, I know your true father is gone, and I'm sure you must miss him greatly. ...But I thought maybe our relationship could help heal that wound.

Donnel: Gosh! Is everyone as soreheaded as you in the future? I know yer true pa is gone, and I know ya must miss him somethin' fierce. ...But I thought perhaps our relationship could help heal that wound.

Gerome: Then you are a fool.

[Robin]: Mind your mouth, Gerome. I'm only offering this out of a sense of—

Frederick: Mind your mouth, Gerome. I'm only offering this out of a sense of—

Virion: Goodness! From the mouth of my own child! I'll have you know, Gerome, that I'm only offering this out of a sense of—

Vaike: Hey! That kinda talk is uncalled for! I'm only offerin' this out of a sense of—

Stahl: Mind your mouth, Gerome. I'm only offering this out of a sense of—

Kellam: Hey! Mind your mouth, Gerome. I'm only offering this out of a sense of—

Lon'qu:

Ricken: Hey, mind your mouth, Gerome! I'm only offering this out of a sense of—

Gaius: Hey, come on, Gerome! I'm only offering this out of a sense of—

Gregor: Oy! Mind your mouth, child! Gregor only make this offer out of sense of—

Libra: Oh, gods, labeled a fool by my own child... You should know, Gerome, that I'm only offering this out of a sense of—

Henry: Hey! Mind your mouth! I'm only offering this out of a sense of—

Donnel: H-hey now! I'm only makin' this here offer out of a sense of—

Gerome: This conversation is over. I have business elsewhere. I must feed and clean Minervykins before bedtime.

[Robin]: ...Minervykins?
Frederick: ...Minervykins?
Virion: ...Minervykins?
Vaike: ...Minervykins?
Stahl: ...Minervykins?
Kellam: ...Minervykins?
Lon'qu: ...Minervykins?
Ricken: ...Minervykins?
Gaius: ...Minervykins?
Gregor: ...Minervykins?
Libra: ...Minervykins?
Henry: ...Minervykins?
Donnel: ...Minervykins?

Gerome: Er, that is... I did not mean to... Bah! Your stupidity is contagious!

[Robin]: *Sigh* That boy...
Frederick: *Sigh* That child...
Virion: *Sigh* That child...
Vaike: Sheesh. That kid...
Stahl: *Sigh* That boy...
Kellam: *Sigh* That boy...
Lon'qu: *Sigh*
Ricken: *Sigh* That boy...
Gaius: *Sigh* That boy...
Gregor: *Sigh* That boy...
Libra: *Sigh* That boy...
Henry: *Sigh* That boy...
Donnel: Sheesh! He's meaner than a gut-shot grizzly...

■ FATHER X GEROME B

[Robin]: Hello, Gerome. Have you been taking good care of little Minervykins?

Frederick: Hello, Gerome. Have you been taking good care of little Minervykins?

Virion: Hello, Gerome. Have you been taking good care of little Minervykins?

Vaike: Heya, Gerome. Have ya been takin' good care of little Minervykins?

Stahl: Hello, Gerome. Have you been taking good care of little Minervykins?

Kellam: Hello, Gerome. Have you been taking good care of little Minervykins?

Lon'qu: Hello, Gerome. Have you been taking good care of...Minervykins?

Ricken: Hello, Gerome. Have you been taking good care of little Minervykins?

Gaius: Hello, Gerome. Have you been taking good care of little Minervykins?

Gregor: Ah, Gerome! You have been taking the care of Minervykins, yes?

Libra: Hello, Gerome. Have you been taking good care of little Minervykins?

Henry: Hey-o, Gerome. Have you been taking good care of little Minervykins?

Donnel: Howdy, Gerome. Have you been takin' good care of little Minervykins?

Gerome: I did NOT call her that! The very idea is ludicrous! ...You must have misheard.

[Robin]: Heh, don't get your smallclothes in a twist, Gerome. Cherche sometimes calls her Minervykins, too. Eventually, I picked up the habit as well.

Frederick: There's no need to get so upset. Cherche sometimes calls her wyvern Minervykins, too. Eventually, I picked up the habit as well.

Virion: Ho ho, no need to get your smallclothes in a twist, Gerome. Cherche sometimes calls her wyvern Minervykins, too. Eventually, I picked up the habit as well.

Vaike: Aw, no need to get your smallclothes in a twist, Gerome. Cherche sometimes calls her wyvern Minervykins, too. Eventually, I picked up the habit as well.

Stahl: Hey, don't get your smallclothes in a twist, Gerome! Cherche sometimes calls her wyvern Minervykins, too. Eventually, I picked up the habit as well.

Kellam: Hey, don't get your smallclothes in a twist, Gerome... Cherche sometimes calls her wyvern Minervykins, too. Eventually, I picked up the habit as well!

Lon'qu: Don't get your smallclothes in a twist, Gerome. Cherche sometimes calls her wyvern Minervykins, too. Eventually, I picked up the habit.

Ricken: Hey, don't get your smallclothes in a twist, Gerome. Cherche sometimes calls her wyvern Minervykins, too. Eventually, I picked up the habit as well.

Gaius: Heh, don't get your smallclothes in a twist, Gerome. Cherche sometimes calls her wyvern Minervykins, too. I eventually picked up the habit as well.

Gregor: Oy, is no need for such surliness. Cherche sometimes call her wyvern Minervykins, too. Gregor pick up habit.

Libra: Peace, Gerome. It was an innocent remark and nothing more. Cherche sometimes calls her wyvern Minervykins, too. Eventually, I picked up the habit as well.

Henry: Nya ha! No need to get your smallclothes in a twist. Cherche sometimes calls her wyvern Minervykins, too. Eventually, I picked up the habit as well.

Donnel: Hey, ain't no need to get yer smallclothes in a twist, now. Cherche sometimes calls her wyvern Minervykins, too. Eventually, I picked up the habit as well!

Gerome: Oh... Er, right. I knew that.

[Robin]: Heh heh. You know, you're adorable when you're flustered.

Frederick: Heh heh. You know, you're adorable when you're flustered.

Virion: You know, you're kind of adorable when you're flustered!

Vaike: Heh heh. You know, you're adorable when you're flustered!

Stahl: Heh heh. You know, you're adorable when you're flustered.

Kellam: Heh heh. You know, you're adorable when you're flustered.

Lon'qu: You know, you're kind of adorable when you're flustered.

Ricken: Heh heh. You know, you're adorable when you're flustered.

Gaius: Heh heh. You know, you're adorable when you're flustered.

Gregor: Heh heh, you are very adorable child when you are becoming flustered.

Libra: Heh heh. You know, you're adorable when you're flustered.

Henry: Heh heh. You're kinda adorable when you're flustered.

Donnel: Heh heh. Ya know, yer adorable when yer flustered.

Gerome:

[Robin]: All right, all right. No need to glare now. I meant no offense...

Frederick: All right, all right. No need to glare now. I meant no offense...

Virion: All right, all right. No need to glare now. I meant no offense...

Vaike: All right, all right. No need to glare! I didn't mean nothin' by it...

Stahl: All right, all right. No need to glare now. I meant no offense...

Kellam: H-hey, no need to glare! I meant no offense...

Lon'qu: Are you glaring at me? Two can play at that game.

Ricken: All right, all right! No need to glare now. I guess I was being a little childish...

Gaius: All right, all right. No need to glare now. I meant no offense... Here, have a sugar cookie. Or one of these freshly baked cakes. Okay?

Gregor: All right, all right. No need for glaring. Just a little familial jest? Gregor meant no offense...

Libra: All right, all right. No need to glare now. I meant no offense...

Henry: Don't you glare at me, young man, or I'll curse you into next week! I don't want to curse my own son, but I totally will.

Donnel: Whoa now, no need to glare! I didn't mean no offense...

Gerome: ...Apology accepted.

Gerome (to Lon'qu): ...Enough. This is foolish.

Gerome (to Henry): ...I am not afraid of you.

[Robin]: Heh, well that is most generous of you, Your Grace... Though I must say, seeing you so angry reminds me quite a bit of Cherche.

Frederick: Heh, well that is most generous of you, Your Grace... Though I must say, seeing you so angry reminds me quite a bit of Cherche.

Virion: Heh, well that is most generous of you, Your Grace... Though I must say, seeing you so angry reminds me quite a bit of Cherche.

Vaike: Heh. Thanks very much, Your Grace. I gotta say, seein' ya so angry reminds me quite a bit of Cherche.

Stahl: Heh, well that is most generous of you, Your Grace... Though I must say, seeing you so angry reminds me quite a bit of Cherche.

Kellam: Heh, well that's very generous of you, Your Grace... Though I must say, seeing you so angry reminds me quite a bit of Cherche.

Lon'qu: I must say, seeing you so angry reminds me quite a bit of Cherche.

Ricken: I'll take what I can get, I suppose. But I have to say, seeing you so angry reminds me quite a bit of Cherche.

Gaius: Heh, well that's most generous of you, Your Grace... Though I must say, seeing you so angry reminds me quite a bit of Cherche.

Gregor: Is appreciated. Though Gregor must say, seeing you this angry remind him very much of Cherche.

Libra: That's very kind of you. Though I must say, seeing you so angry reminds me quite a bit of Cherche.

Henry: Yeah, I know. It's because I'm not very scary. Nya ha ha! Though I gotta say, seeing you so angry reminds me quite a bit of Cherche.

Donnel: Heh, well that's right kind of ya, Your Grace... Though I gotta say, seein' ya so angry reminds me quite a bit of Cherche.

Gerome: What do you mean?

[Robin]: Mmm? Oh, er, nothing... Hey! Is that your Minerva over there?

Frederick: Mmm? Oh, er, nothing... Hey! Is that your Minerva over there?

Virion: Hmm? Oh, er, nothing... Hey! Is that your Minerva over there?

Vaike: Mmm? Oh, er, nothin'... Hey! Is that your Minerva over there?

Stahl: Mmm? Oh, er, nothing... Hey! Is that your Minerva over there?

Kellam: Mmm? Oh, er, nothing... Hey! Is that your Minerva over there?

Lon'qu: Mmm? Oh, nothing. Hey, is that your Minerva over there?

Ricken: Mmm? Oh, er, nothing... Hey! Is that your Minerva over there?

Gaius: Mmm? Oh, er, nothing... Hey! Is that your Minerva over there?

Gregor: Mmm? Oh, never the mind... Hey! Is that Gerome's Minerva over there?

Libra: Mmm? O-oh, nothing... Hey, is that your Minerva over there?

Henry: Mmm? Oh, er, nothing... Hey! Is that your Minerva over there?

Donnel: Mmm? Oh, er, nothin'... Hey! Is that yer Minerva over there?

Gerome: It is.

[Robin]: Hmm, more intimidating than Cherche's... Scarier, more ferocious...

Frederick: Hmm, more intimidating than Cherche's... Scarier, more ferocious...

Virion: Hmm, more intimidating than Cherche's... Scarier, more ferocious...

Vaike: Hmm, more intimidatin' than Cherche's... Scarier, more ferocious...

Stahl: Hmm, more intimidating than Cherche's... Scarier, more ferocious...

Kellam: Hmm, more intimidating than Cherche's... Scarier, more ferocious...

Lon'qu: Hmm, more intimidating than Cherche's... Scarier, more ferocious...

Ricken: Hmm, more intimidating than Cherche's... Scarier, more ferocious. .

Gaius: Hmm, more intimidating than Cherche's... Scarier, more ferocious...

Gregor: Hmm, more intimidating than Cherche's... She seem scarier, more ferocious...

Libra: Hmm, she seems more intimidating than Cherche's. Scarier, more ferocious...

Henry: Hmm, more intimidating than Cherche's... Scarier, more ferocious...

Donnel: Hmm, more intimidatin' than Cherche's... Scarier, more ferocious...

Gerome: Truly? In the future, people oft remarked she was the prettiest wyvern in the realm. Just look at those big, smoky eyes... She's such a cutey-poo! Er, I mean... Um... You tricked me into saying that!

[Robin]: I didn't trick you into anything... You said it all by yourself.

Frederick: I didn't trick you into anything... You said it all by yourself.

Virion: I didn't trick you into anything... You said it all by yourself.

Vaike: I didn't trick you into anythin'! You said it all by yourself!

Stahl: I didn't trick you into anything... You said it all by yourself.

Kellam: I didn't trick you into anything... You said it all by yourself.

Lon'qu: I did no such thing. You said it all by yourself.

Ricken: I didn't trick you into anything... You said it all by yourself.

Gaius: I didn't trick you into anything... You said it all by yourself.

Gregor: Gregor trick no one! You made with the saying all by yourself!

Libra: Oh? I didn't trick you into anything... You said it all by yourself!

Henry: Nya ha! I didn't trick you into anything! You said it all by yourself!

Donnel: I did nothin' of the sort! You said that all by yerself!

Gerome: That's it. I'm leaving. WE'RE leaving. ...Minerva, to me!

[Robin]: Heh, adorable when he's flustered indeed...

Frederick: Heh heh. Adorable when he's flustered indeed...

Virion: Heh, adorable when he's flustered indeed...

Vaike: Heh, he really is adorable when he's flustered...

Stahl: Heh, adorable when he's flustered indeed...

Kellam: Heh, adorable when he's flustered indeed...

Lon'qu: Heh. He really is adorable when he's flustered...

Ricken: Heh, he really is adorable when he's flustered...

Gaius: Heh, adorable when he's flustered indeed...

Gregor: Heh, Gregor was right. He is indeed adorable child when flustered...

Libra: Heh, he is indeed adorable when he's flustered...

Henry: Nya ha ha! He really is adorable when he's flustered...

Donnel: Shucks. He really is adorable when he's flustered...

■ FATHER X GEROME A

[Robin]: Hello, Gerome. Spending quality time with Minerva again, I see?

Frederick: Hello, Gerome. Spending quality time with Minerva again, I see?

Virion: Hello, Gerome. Spending quality time with Minerva again, I see?

Vaike: Hey, Gerome. Spendin' some quality time with Minerva again, are ya?

Stahl: Hello, Gerome. Spending quality time with Minerva again, I see?

Kellam: Hello, Gerome. Spending quality time with Minerva again, I see?

Lon'qu: Hello, Gerome. Spending quality time with Minerva again, are you?

Ricken: Hello, Gerome. Spending quality time with Minerva again, I see?

Gaius: Hello, Gerome. Spending quality time with Minerva again, I see?

Gregor: Hello, Gerome. Spending quality time with Minerva again, yes?

Libra: Hello, Gerome. Spending quality time with Minerva again, I see?

Henry: Hey-o, Gerome. Spending some quality time with Minerva again, I see?

Donnel: Howdy, Gerome. Spendin' some quality time with Minerva again, are ya?

Gerome: ...Why do you insist on following me everywhere?

[Robin]: It's nothing so sinister as your tone implies, I assure you. I just wanted to talk about our relationship again. About being father and son... Now that I've seen your sensitive side, I thought we might—

Frederick: It's nothing so sinister as your tone implies, I assure you. I just wanted to talk about our relationship again. About being father and son... Now that I've seen your sensitive side, I thought we might—

Virion: It's nothing so sinister as your tone implies, I assure you. I just wanted to talk about our relationship again. About being father and son... Now that I've seen your sensitive side, I thought we might—

Vaike: Ain't nothin' as sinister as your tone implies. I can promise you that. I just wanted to talk about our relationship again. About bein' father and son... Now that I've seen your sensitive side, I thought we might—

Stahl: It's nothing so sinister as your tone implies, I assure you... I just wanted to talk about our relationship again. About being father and son... Now that I've seen your sensitive side, I thought we might—

Kellam: It's nothing so sinister as your tone implies, I assure you. I just wanted to talk about our relationship again. About being father and son... Now that I've seen your sensitive side, I thought we might—

Lon'qu: It's nothing so sinister as your tone implies, I assure you... I wanted to talk about our relationship again. About being father and son... Now that I've seen your sensitive side, I thought we might—

Ricken: It's nothing so sinister as your tone implies, I assure you. I just wanted to talk about our relationship again. About being father and son... Now that I've seen your sensitive side, I thought we might—

Gaius: It's nothing so sinister as your tone implies, I assure you. I just wanted to talk about our relationship again. About being father and son... Now that I've seen your sensitive side, I thought we might—

Gregor: You make Gregor sound like crazy stalker man! He just wanted to talk about relationship again. About being father and son... Now that Gregor has seen sensitive side, he thought we might—

Libra: It's nothing so sinister as your tone implies, I assure you... I just wanted to talk about our relationship again. About being father and son... Now that I've seen your sensitive side, I thought we might—

Henry: Geez, you make my rampant stalking sound so sinister! I just wanted to talk about our relationship again. About being father and son... Now that I've seen your sensitive side, I thought we might—

Donnel: It's nothin' as sinister as your tone implies, that's for sure! I just wanted to talk about our relationship again. About bein' pa and son... Now that I've seen your sensitive side, I reckoned we might—

Gerome: I have no sensitive side.

[Robin]: Er, right. But remember when you said Minerva was a cutey-poo? The look of love that flitted across your face was so tender and sincere, I—

Frederick: Er, right. But remember when you said Minerva was a cutey-poo? The look of love that flitted across your face was so tender and sincere, I—

Virion: Ah, right. And what about when you said Minerva was a cutey-poo? The look of love that flitted across your face was so tender and sincere, I—

Vaike: Er, right. But remember when ya said Minerva was a cutey-poo? The look of love that flitted across your face was so tender and sincere, I—

Stahl: Er, right. But remember when you said Minerva was a cutey-poo? The look of love that flitted across your face was so tender and sincere, I—

Kellam: Er, right. But remember when you said Minerva was a cutey-poo? The look of love that flitted across your face was so tender and sincere, I—

Lon'qu: Sure you don't. What about when you said Minerva was a cutey-poo? The look of love that flitted across your face was so tender and sincere, I—

Ricken: Er, right. But remember when you said Minerva was a cutey-poo? The look of love that flitted across your face was so tender and sincere, I—

Gaius: Er, right. But remember when you said Minerva was a cutey-poo? The look of love that flitted across your face was so tender and sincere, I—

Gregor: Er, but Gregor heard you say Minerva is cutey-poo. The look of love that flitted across face was so tenderful and sincere, and—

Libra: Er, right. But remember when you said Minerva was a cutey-poo? The look of love that flitted across your face was so tender and sincere, I—

Henry: Uh, right. But remember when you said Minerva was a cutey-poo? The look of love that flitted across your face was so tender and sincere, I—

Donnel: Er, sure. But don't ya remember sayin' how Minerva was a cutey-poo? The look of love that flitted 'cross yer face was so tender and sincere, I—

Gerome: MINERVA, ATTACK! RIP HIS LYING MOUTH OFF HIS FAT, LYING FACE! Er, Minerva?

[Robin]: Minerva would never attack me, Gerome. She knows me, don't you? There, there, little Minerva. You remember me, don't you?

Frederick: Minerva would never attack me, Gerome. She knows me. There, there, little Minerva. You remember me, don't you?

Virion: Minerva would never attack me, Gerome. She knows I am family. There, there, little Minerva. You remember me, don't you?

Vaike: Minerva would never attack me, Gerome. She knows I'm family. Hey there, little Minerva. You remember Ol' Vaike, don't ya?

Stahl: Minerva would never attack me, Gerome. She knows I'm family. There, there, little Minerva. You remember me, don't you?

Kellam: Minerva would never attack me, Gerome. She knows I'm family. There, there, little Minerva. You remember me, don't you?

Lon'qu: Minerva would never attack me, Gerome. There, there, little Minerva. You remember me, don't you?

Ricken: Minerva would never attack me, Gerome. She knows I'm family. There, there, little Minerva. You remember me, don't you?

Gaius: Minerva would never attack me, Gerome. She knows I'm family. There, there, little Minerva. You remember me, don't you?

Gregor: Minerva would never attack Gregor. Gregor is family! There, there, little Minerva. You remember Gregor, yes?

Libra: Minerva would never attack me, Gerome. She knows I'm family. There, there, little Minerva. You remember me, don't you?

Henry: Nya ha! Minerva would never attack me! She knows I'm family. There, there, little Minerva. You remember me, don't you?

Donnel: Minerva ain't gonna attack me, Gerome. She knows I'm family. There, there, little Minerva. You remember Donny, don't ya?

Gerome: M-Minerva? ...Do you truly consider this buffoon part of our family?I see. Very well, Minerva. If that is your wish.

[Robin]: Er, what did Minerva say?
Frederick: So what did Minerva say?
Virion: And what did Minerva say?
Vaike: Er, what'd Minerva say?
Stahl: Er, what did Minerva say?
Kellam: Er, what did Minerva say?
Lon'qu: What did she say?
Ricken: Er, what did Minerva say?
Gaius: Er, what did Minerva say?
Gregor: What does Minerva say?
Libra: What did Minerva say?
Henry: Sooo...what did Minerva say?
Donnel: So what'd Minerva say?

Gerome: Hmph. You claim to be part of the family, but you can't understand her?

[Robin]: Er, well... It's an acquired skill.
Frederick: Er, well... It's an acquired skill.
Virion: Er, well... It's an acquired skill.
Vaike: Er, well... It's an acquired skill
Stahl: Er, well... It's an acquired skill.
Kellam: Um, well... It's an acquired skill.
Lon'qu: ...It's an acquired skill.
Ricken: Er, well... It's an acquired skill.
Gaius: Er, well... It's an acquired skill.
Gregor: Um... It's an acquired skill, you see.
Libra: Well... It's an acquired skill.
Henry: Usually I can, yeah. ...But she was mumbling.
Donnel: I reckon that kinda learnin' takes a fair bit of time...

Gerome: It matters not. Minerva says you are family, and I am thus duty bound to accept you. I'm... I'm sorry I treated you poorly. ...Father.

[Robin]: ...Did you just call me Father?
Frederick: ...Did you just call me Father?
Virion: ...Did you just call me Father?
Vaike: ...Did you just call me Father?
Stahl: ...Did you just call me Father?
Kellam: ...Did you just call me Father?
Lon'qu: ...Did you just call me Father?
Ricken: ...Did you just call me Father?
Gaius: ...Did you just call me Father?
Gregor: ...Did you just call Gregor Father?
Libra: ...Did you just call me Father?
Henry: ...Did you just call me Father?
Donnel: Hold on, now. Did you just call me yer pa?!

Gerome: Don't get used to it. ...Minerva, to me! We're leaving!

[Robin]: W-wait, Gerome! Son! Let's hear it just one more time!
Frederick: W-wait, Gerome! Son! Let's hear it just one more time!
Virion: W-wait, Gerome! Son! Let's hear it just one more time!
Vaike: W-wait, Gerome! Son! Say it once more! Say it in front of Chrom!
Stahl: W-wait, Gerome! Son! Let's hear it just one more time!
Kellam: W-wait, Gerome! Son! Let's hear it just one more time!
Lon'qu: Wait, Gerome. I...couldn't hear you. Say it for me one more time.
Ricken: W-wait, Gerome! Son! Let's hear it just one more time!
Gaius: W-wait, Gerome! Say it one more time! I'll give you some candy!
Gregor: W-wait, Gerome! My son! Say it once more for Gregor
Libra: W-wait, Gerome! Son! Let's hear it just one more time!
Henry: Wait! Say it again! Come on! Don't make me curse you!
Donnel: W-wait, Gerome! Son! Lemme hear it one more time!

Gerome: Bah, enough already!

Morgan (male)

Avatar (female) (Mother/son)
The Morgan (male) mother/son dialogue with Avatar (female) can be found on page 237.

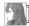
Lucina
The dialogue between Lucina and Morgan (male) can be found on page 283.

Lucina (Brother/sister)
The brother/sister dialogue between Lucina and Morgan (male) can be found on page 284.

Owain
The dialogue between Owain and Morgan (male) can be found on page 288.

Kjelle
The dialogue between Kjelle and Morgan (male) can be found on page 298.

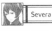
Cynthia
The dialogue between Cynthia and Morgan (male) can be found on page 301.

Severa
The dialogue between Severa and Morgan (male) can be found on page 303.

Yarne

■ YARNE X MORGAN (MALE) C
Morgan (male): Ha ha, those guys are hilarious! Eating dinner as a big group is so much fun! And oof—I am stuffed! I'm gonna sleep well tonight...

Morgan (male): Oh, hey Yarne!

Yarne: Oh, uh... Hi, Morgan.

Morgan (male): What are you up to all off by yourself? The rest of us just finished dinner.

Yarne: You're chipper as always.

Morgan (male): Yarne, is everything all right? If you're not feeling well, I can get you something.

Yarne: No, nothing like that. I'm fine. I'm just surprised you can stay so cheery all the time. The war's got us in a constant panic, and you're an amnesiac on top of it! How do you do it?

Morgan (male): I never really stopped to think about it... I guess I was just born this way?

Yarne: Well, I'm jealous. I bet you're all smiles wanting in the middle of combat, too, huh? I can't imagine wanting to fight, even if I were all bubbly...

Morgan (male): Well, maybe you wouldn't be so scared if I stuck close and kept you safe!

Yarne: You... You'd do that?

Morgan (male): Well, sure! We're in this thing together, aren't we? I'm happy to do what I can to help.

Yarne: Wow, Morgan. Thank you. I really appreciate that! If things get hairy out there, I'll be counting on you to save me!

Morgan (male): Ha! It's a promise!

■ YARNE X MORGAN (MALE) B
Morgan (male): Hey, Yarne.

Yarne: Oh, hey. Did you need me?

Morgan (male): Off by yourself again? You should come eat with the rest of us!

Yarne: That's just it. I'm not exactly part of the rest of us. Two days after you showed up, you were already everybody's best friend. What's your secret?

Morgan (male): Aw, heck. I dunno!

Yarne: All I ever hear from the others is that I'm a big coward.

Morgan (male): But you're just doing what you have to in order to keep the taguel bloodline going.

Yarne: See, YOU get it!

Morgan (male): Well, sure! You're the last of an entire race! Who wouldn't understand that?

Yarne: Literally everyone but you...

Morgan (male): Well, I think you're pretty brave to be fighting, given all that's riding on you. ...Hey, maybe that's why I'm so upbeat? Because I lost my memories?

Yarne: How would that make you happier?

Morgan (male): I don't have any grand fate or dark past to weigh me down. No heritage to carry on. I can just be me.

Yarne: And "just you" is a cheery guy?

Morgan (male): Apparently! Besides, in times this harsh, every group needs one joker to lighten the mood. I guess I fell into the role and I've been having too much fun to stop!

Yarne: You're something else, Morgan...

Morgan (male): Give it a try! I bet you'll be pleasantly surprised!

■ YARNE X MORGAN (MALE) A
Yarne: Morgan! You're not gonna believe this!

Morgan (male): What? What happened?

Yarne: After we spoke, I decided to reach out and join the group. I've been talking to the others more, and I make it a point to keep smiling. Not like an idiot, mind you, but just... you know. All friendly-like.

Morgan (male): Great! How's it working out?

Yarne: It was pretty awkward at first, and everyone was still a bit cold. But they've since warmed up! Now I've got people dropping by to chat all the time!

Morgan (male): Hey, that's wonderful!

Yarne: For the first time, I actually feel like part of a team.

Morgan (male): Well, I'm really glad to hear it, Yarne.

Yarne: It never would have happened without your advice, Morgan. I'm really glad we started talking. I'd always watched you and wished I could be like that. Now I think I'm ready to take the lead in combat and start protecting my friends!

Morgan (male): I don't know what to say, Yarne. I'm blown away. *sniff*

Yarne: Whoa, whoa, whoa—! Why are you tearing up?

Morgan (male): I'm just really, really happy for you! I'd noticed you before, you know? You always looked so lonely.

Yarne: I guess I was, until you came along. You're the best friend a taguel could ask for! And I'm going to keep at it until I'm as good a friend to you!

Morgan (male): I know it won't take but a week, tops!

Noire

■ NOIRE X MORGAN (MALE) C
Noire: Aah! Aiiieee! N-no, stop! STOP! STAY AWAY!

Morgan (male): What?! ...That's Noire! Noire, hold on!

Morgan (male): Noire, hurry! Heeelp!

Morgan (male): What's wrong?! Are we under attack?! Are you all right? And, uh... Why are you squirming around like that?

Noire: Buh... B-b-b-buh...

Morgan (male): ...Buh?

Noire: BUG! BACK! BUG ON MY BACK!

Morgan (male): Hmm? Oh, will you look at that! It's a little red guy with black spots.

Noire: J-just get it off me!

Morgan (male): Aaand...got it! Aww, up close it's so adorable!

Noire: Augh, stop! Go! Get it out of here! It's crawling all over your hand!

Morgan (male): All right, all right, it's outside now. Geez, Noire. I didn't think anyone could be scared of a little ol' ladybug.

Noire: It doesn't scare you? It was ON you!

Morgan (male): Oh, I don't mind. I love bugs!

Noire: ...All bugs?

Morgan (male): Hmm, I suppose there are probably some exceptions. Roaches and other creepy-crawlies that scuttle around in the dark are a bit gross. ...And giant fire-breathing scorpions aren't fun to be around.

Noire: Even the tiniest bugs terrify me... Pathetic, isn't it? We're trying to win a war, and I can't even face down a bug.

Morgan (male): I wouldn't call it pathetic, but I guess it's better not to be scared if you can help it.

Noire: I know, right? Morgan, if I... If I asked you to help me get over my fear, would you do it?

Morgan (male): You mean your bug phobia? Sure, why not? I'll go collect up a bunch of my favorites and show them to you. Once you've seen a whole mess of 'em, you'll be used to them. Problem solved!

Noire: M-maybe not...too many of them... Er, Morgan? Wait, Morgan, I... Hello?

■ NOIRE X MORGAN (MALE) B
Morgan (male): Oh, hi Noire!

Noire: Mmm? Hello, Morgan... Wh-what's in the big cage?

Morgan (male): It's for you. Come here and take a nice, close look...

Noire: Hmm? Why, what's in— ...Hurk!

Morgan (male): Noire? Noire, answer me! ...Oh no, you're frothing from the mouth! Gotta elevate your head...

Noire: ...Nguh?! M-Morgan?! Wh-what happened? How long was I out?

Morgan (male): A few minutes. You took one look at the insects I brought you and passed out.

Noire: Insects...? Augh, the insects! I remember now! *shudder* W-wait. You brought them for me?

Morgan (male): That was the plan, right? You wanted help getting used to the sight of them? I guess I set the bar a little high for our first attempt.

Noire: I was expecting... I don't know, butterflies or something. Definitely not those black horned monstrosities!

Morgan (male): Aren't they awesome?! I've got beetles with horns, other guys with pincers... Anybody who was ever a little boy knows these are the best bugs ever! So... Did you want another look?

Noire: NO! No, that...won't be necessary, thank you.

Morgan (male): No? These are some prime specimens. I'm pretty proud of 'em, but...

Noire: I'm sorry, Morgan. I know you went to a lot of effort to catch these for me. But I don't know if I can get used to something I can't even look at.

Morgan (male): No, no, I'm the one who should apologize. I think my selections were a bit off, given the audience. We've started smaller. I'll come back once I've tracked down some cuter critters.

Noire: Um, thank you?

Morgan (male): Sure thing! I'll get started right away! But, hmm... Cute insects... Maybe start with butterflies and go from there? Just have to make sure I don't accidentally grab an Ylissean screeching moth! Ha ha!

Noire: Screeching...moth? They screech?! Wait a minute, why would a moth even need to screech?!

■ NOIRE X MORGAN (MALE) A
Morgan (male): Hey, Noire.

Noire: Oh, hello, Morg— Wait. Why do you have a cage? ...What's in the cage, Morgan?!

Morgan (male): Only the cutest of the most nonthreatening of bugs! ...Promise!

Noire: And...how many of them? Hopefully not dozens like you brought last time...

Morgan (male): Nope, I learned my lesson. I think there are maybe four or something? Didn't want you going all frothy and unconscious on me again. Anyway... Here you go!

Noire: Ah! They glow!

Morgan (male): Yeah! The males of that species flash in the dark to attract mates.

Noire: It's beautiful... I've never seen anything like it.

Morgan (male): Good! I'd hoped you'd be all right with something like this.

Noire: Oh my gosh... I could watch these little guys for hours.

Morgan (male): That's great! Mission accomplished! ...Muh? What's that?

Noire: ...That buzzing. What's making that sound?

Morgan (male): Probably—and don't panic—but probably a gnat or fly or some tiny thing.

Noire: It's very... Very, very, very, very...

Morgan (male): Hmm?

Noire: Very, very IRRITATING! INSOLENT CREATURE! YOU PUNY, GALLING FOOL OF AN INSECT! YOU DARE INVITE MY WRATH?!

Morgan (male): Er...Noire?!

Noire: Show yourself! Where is this hateful beast with the hubris to vex my ears?!

Morgan (male): It's, uh... Ooh, there!

Noire: NOW FACE YOUR IMPLACABLE FATE!

Morgan (male): Ack! Good gods, watch out!

Noire: ...Ahhhhh. ...Huh? What did... Oh, YEARGH! Eeeeeew! What have I dooooooone?!

Morgan (male): Ah ha ha ha! That was amazing! You just snatched it from the air and crushed it with your bare hand! I'd say that proves you've gotten over your bug troubles, Noire.

Noire: No, I... I wasn't even thinking! My hand just shot out!

Morgan (male): That proves your instinctive fear is gone!

Noire: It...does?

Morgan (male): Absolutely! Looks like you've got an iron constitution now when it comes to bugs!

Noire: I... I do? M-maybe you're right, I... I do feel stronger!

Morgan (male): Just keep acclimatizing yourself bit by bit, and you'll have no trouble at all. Don't even think about it. Just take it one encounter at a time!

Noire: Oh, thank you, Morgan!

■ NOIRE X MORGAN (MALE) S
Noire: Eeeeek, I take it back! I can't do it!

Morgan (male): S-sorry! Okay, taking it away now! I guess it's still a little early for the big guys, huh?

Noire: I'm sorry... I'm hopeless, I know. I haven't cured my insect phobia at all.

Morgan (male): ...Maybe you should view this as one facet of a bigger process. It'd be great if you could easily grow less scared in general, and not just by bugs. So, um, yeah. Maybe you really don't have to stop disliking bugs at all. ...You know?

Noire: Are you all right, Morgan? You seem quiet today.

Morgan (male): N-no, I'm fine!

Noire: Are you sure? Even your encouragement has an oddly defeatist undertone.

Morgan (male): Does it? I'm sorry. I guess I just... Noire, let's stop doing this.

Noire: ...So you think it's hopeless, too?

Morgan (male): What? No, that's not what I meant.

Noire: Please, Morgan. If you think I'm a lost cause, feel free to say so. I've already accepted that about myself for years now...

Morgan (male): But that's not true! You are not a lost cause!

Noire: ...Really?

Morgan (male): I just... I don't want you to change! You're perfect. Even your fear of bugs is... Well, it's adorable. Plus this way I get to feel like you have a use for me!

Noire: What?! Th-then you... You're... I mean...

Morgan (male): I'm head over heels for you! If I had one wish, it'd be to stay with you forever. To keep you safe from everything that scares you... I want to be the one you shout for when you need help, Noire!

Noire: Morgan, I... Thank you. I'm flattered. And really, really happy...

Morgan (male): Then does that mean...?

Noire: How could I not love you, after all the times you've given me courage and support? Look, I don't want you to feel like you have to guard me from the world. But I hope you'll continue to help me grow into a better, braver woman.

Morgan (male): I'll be your one-man cheering section! But, um... If you still want to shriek when you see a bug, it really is cute!

Noire: E-enough talk about bugs! You'll ruin the moment!

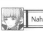
Nah

■ NAH X MORGAN (MALE) C
Morgan (male): Hmm? Hey, that's Nah... Why is she all hunched over...?

Nah:

Morgan (male): Nah! Are you all right?

Nah: Um, yes? Should I not be?

Morgan (male): You were hunched over! Are you sick?

Nah: ...No, I was praying.

Morgan (male): Praying?

Nah: Yeah. Like this. You close your eyes, see? ...Well, keep yours open to watch. "Great and wise Naga, heed my prayer!" ...And then you offer up your prayer. Naga is an incredibly important deity to the manaketes. If you pray to her, she'll guide you to happiness.

Morgan (male): Wow, sounds impressive! She must be awfully busy.

Nah: Yes! But she still takes time to speak to my kind every so often.

Morgan (male): Really? That's amazing!

Nah: She spoke to me just now, actually.

Morgan (male): Wow! What did she say?

Nah: "Kids your age shouldn't stay up so late."

Morgan (male): Ha ha! Your god is a real mother hen! So, um, can I ask what you were praying for?

Nah: I wished for happiness and peace in the world.

Morgan (male): And did she respond?

Nah: No. She never does when I ask for that.

Morgan (male): Hmm, I see... Maybe that's her way of saying we shouldn't rely on divine intervention. We need to build happiness and peace with our own hands!

Nah: Hmm... Maybe so. That's certainly a very Morgan-like interpretation. You're always so gung ho and optimistic.

Morgan (male): Better to have more hope than less, I always say!

Nah: No arguments there!

■ NAH X MORGAN (MALE) B
Nah: O great and wise Naga...

Morgan (male): Oh hey, it's Nah.

Nah:

Morgan (male): She's hard at prayer again today.

Nah:That should do it. Oh! Hello, Morgan.

Morgan (male): Hey there. Any responses from Naga today?

Nah: Yes, but not exactly the revelation I was hoping for. She asked me for more offerings!

Morgan (male): Oh? Hey, what do you offer a jealous god, anyway? Fatted calves and such?

Nah: Naga is not a jealous god! ...And I was told to bring a flower.

Morgan (male): Oh? Any particular kind?

Nah: Naga's bell. It blooms once every 200 years, and only beneath a full moon. ...That's what the legends say, at least. I've never seen one for myself. They only grow in remote, craggy terrain far removed from human settlement.

Morgan (male): Wow. That's a pretty tall order. Very specific, too.

Nah: It's supposed to be near impossible to find. I'm afraid Naga's given me a doozy this time... But you can't exactly ignore a direct request from a deity, right?

Morgan (male): Say, do you want help looking for it?

Nah: That would be great, Morgan. But at the moment...I don't even know where to start looking. Give me a little time to come up with an idea, all right?

Morgan (male): Hey, yeah! And I'll find some dusty old tomes to read. ...Just in case.

■ NAH X MORGAN (MALE) A
Morgan (male): Hey, Nah! I was looking for you.

Nah: Er, sorry, Morgan. I stopped to pray a while ago, and Naga told me not to move from this spot.

Morgan (male): Hmm. Interesting. ...Maybe it was because she saw THIS coming!

Nah: Huh?

Morgan (male): Ta-dah!

Nah: Oh my gosh! That's the Naga's bell I was ordered to find as an offering!

Morgan (male): Ding ding ding! Correct! You win a meat pie! ...Oh, and the flower, too.

Nah: Morgan, where...? How did you...? I... I'm absolutely stunned! How did you know where to find one? They're legendarily impossible to find. And even then, they're supposed to grow only along high crags and cliffs!

Morgan (male): I guess I just got lucky. I found it entirely by accident, really. Just walking down the road, minding my own business, and then I plucked it up on the off chance this was your flower, and what do you know? I guess sometimes they take pity on us and sprout up right under our noses!

Nah: ...Do they?

Morgan (male): Yup! Pretty fortunate thing, huh? Maybe Naga sent us a bit of good luck.

Nah: Well, thank you for doing this, Morgan. I'm sure she'll be pleased. I know I am!

Morgan (male): Well, if you're happy, I'm happy! Let's hope Naga will decide to grant that prayer of yours now!

Nah: I'm sure the message will get through with this!

Morgan (male): ...Anyway, I should get back to work. So long, Nah!

Nah: Good-bye, and thanks again!

Nah: Oh Morgan, you generous fool. Don't think I didn't notice those cuts and bruises...

■ NAH X MORGAN (MALE) S
Nah: Morgan!

Morgan (male): Heya, Nah! Still chattin' up the big lady upstairs?

Nah: No. I got what I was asking for.

Morgan (male): Oh! Well, congratulations! That's wonderful! Er, wait. You were asking for world peace and happiness, weren't you? ...Did I miss something? 'Cause I'm pretty sure the bad guys are still trying to kill us.

Nah: ...Oh no, I meant my other request.

Morgan (male): You had a second wish? What was it?

Nah: ...For the person I love to love me back. But now there's no need to ask Naga, because he cared for me all along.

Morgan (male): Oh, that's... That's great, Nah. But, hey I don't think I can... Er, it would be rude to pry any further.

Nah: No! I want you to hear this! I... I'm in love with you, Morgan!

Morgan (male): ...What?!

Nah: When I saw how you'd risked your life to find the Naga's bell for me, I... I was overjoyed to know you cared! Even Naga is happy! ...She told me the flower was delicious.

Morgan (male): Really? That's great news! And I'm really, really happy to hear you saying all this to me, Nah. ...Still feels a little ticklish coming out and saying I love you, though.

Nah: But you've said it through so much more than just words, Morgan. When you handed me that flower, I could feel it rushing through me like a wave!

Morgan (male): Good... I'm glad. B-but words are still important, too, so lemme try those, too: I love you, Nah!

Nah: I love you, too!

Morgan (male): ...Yeah, that's gonna take a while to get used to. But it feels good! So, um, did Naga have anything to say about all this?

Nah: Hold on, I'll ask.She said to get a room.

Morgan (male): Ha! I'd say that counts as giving us her blessing!

Nah: I would say so!

Father

■ FATHER X MORGAN (MALE) C
Morgan (male): Hmm... I wonder why I have no memory of my father... All my memories of Mother are so crisp and clear. I remember what an amazing tactician she was, all the time we studied together... but nothing at all about my father. It's one big blank.

Chrom: What are you up to, Morgan?
Frederick: What are you up to, Morgan?
Virion: What are you up to, Morgan?
Vaike: Whatcha up to, Morgan?
Stahl: What are you up to, Morgan?
Kellam: What are you up to, Morgan?
Lon'qu: ...What's going on, Morgan?
Ricken: What are you up to, Morgan?
Gaius: What are you up to, Morgan?
Gregor: Hello, Morgan. What is up?
Libra: What's going on, Morgan?
Henry: Whatcha up to, Morgan?
Basilio: What are you up to, boy?
Donnel: Howdy, Morgan. Whatcha up to?
Owain: How goes it, Morgan?
Inigo: What are you up to, Morgan?
Brady: Hey! Whatcha mumblin' about over there?
Gerome: What's going on, Morgan?
Yarne: What are you up to, Morgan?
Laurent: Morgan? What are you doing?
Gangrel: And what are you up to?
Walhart: What is the meaning of all this navel-gazing?
Yen'fay: How does the day find you, Morgan?
Priam: What are you up to, Morgan?

Morgan (male): Father! That's amazing! I was just thinking about you! Is this fate?! This is totally fate! Family-style fate! ...Wait, no. How did Mother put it? "We're not pawns of some scripted fate. It's the invisible ties we forge that bind us." So yeah, it's not fate. It's the whole invisible bond-link...thing!

Chrom: Heh, is that so?
Frederick: Heh, is that so?
Virion: You don't say!
Vaike: Heh, no kiddin'?
Stahl: Heh, is that so?
Kellam: Heh, is that so?
Lon'qu: Is that so?
Ricken: Heh, is that so?
Gaius: Heh, is that so?
Gregor: Hah! Is that so?
Libra: I see. That sounds wonderful.

Henry: If you say so.

Basilio: Hah! Is that so?

Donnel: Heh, is that so?

Owain: Really! Intriguing...

Inigo: Heh, is that so?

Brady: Huh. Is that so?

Gerome: Is that so?

Yarne: Heh, is that so?

Laurent: That is a most unscientific analysis. And yet, oddly plausible...

Gangrel: Heh. Really...

Walhart: Absurd. It is through strength alone that man—

Yen'fay: Is that so?

Priam: Heh, is that so?

Morgan (male): Yup! Even without my memories, there's an invisible thread that links us. Er, but that reminds me... I was just wondering how I could have possibly forgotten you, Father. Do you think maybe you could help me get those memories back?

Chrom: I'd be happy to try. After all—

Frederick: I'd be happy to try. After all—

Virion: I'd be happy to try. After all—

Vaike: Hey, I'd be happy to try. After all—

Stahl: I'd be happy to try. After all—

Kellam: I'd be happy to try. After all—

Lon'qu: I'd be honored. After all—

Ricken: I'd be happy to try. After all—

Gaius: I'd be happy to try. After all—

Gregor: Gregor would love to assist! After all—

Libra: I'd be happy to try. After all—

Henry: I suppose I could help. After all—

Basilio: Sure, I'd be happy to! After all—

Donnel: Gosh, I'd be happy to! After all—

Owain: Well, as your trusted protector, I suppose—

Inigo: I'd be happy to try. After all—

Brady: I suppose I could pitch in, yeah? After all—

Gerome: Sure, why not. After all—

Yarne: I'd be happy to try. After all—

Laurent: I would be delighted to try. After all—

Gangrel: Why not? I've got nowhere—

Walhart: I would prefer to train you in the arts of warfare, death, and—

Yen'fay: It would be an honor. After all—

Priam: I'd be happy to try. After all—

Morgan (male): Yay! Thanks so much! I'll start preparing. Oh, I can't wait to get started!

Chrom: Well, he's certainly got energy to spare...

Frederick: Well, he's certainly got energy to spare..

Virion: That boy sure loves to talk...

Vaike: He sure is energetic...

Stahl: Well, he's certainly got energy to spare...

Kellam: Boy, he sure is energetic...

Lon'qu: *Sigh* He's nothing if not energetic...

Ricken: Boy, he sure is got energy to spare...

Gaius: Well, he's certainly got energy to spare...

Gregor: Oy! That is...energetic boy...

Libra: Well, he's certainly energetic...

Henry: Nya ha ha! He sure is full of beans, that kid...

Basilio: Well, at least he's full of energy... Reminds me of me! Ha ha!

Donnel: Heh, he sure is a spitfire, that one...

Owain: The blood boils strong in that boy...

Inigo: Well, he's certainly got energy to spare...

Brady: Why do I get the feeling I'm gonna regret this...

Gerome: Where does he get all that energy...

Yarne: ...What was that all about?

Laurent: The loquaciousness of that boy is unparalleled...

Gangrel: That kid sure is energetic...

Walhart: Bah. Useless!

Yen'fay: Well, he's certainly energetic...

Priam: Well, he's certainly energetic...

■ FATHER X MORGAN (MALE) B

Morgan (male): Father? Do you have a moment?

Chrom: Yes, of course.

Frederick: Yes, of course.

Virion: Yes, of course.

Vaike: Sure do!

Stahl: Yes, of course.

Kellam: Yes, of course.

Lon'qu: Sure.

Ricken: Of course.

Gaius: Sure.

Gregor: Of course! Gregor always have moments for precious son.

Libra: Yes, of course.

Henry: Sure do!

Basilio: Of course!

Donnel: Course I do!

Owain: Yes, I have time. Fortunately, my rage has been quelled for the moment.

Inigo: Sure, I have time.

Brady: Sure. What's up?

Gerome: Sure.

Yarne: Yeah, of course.

Laurent: Yes, of course.

Gangrel: I can carve a moment from my busy schedule, sure. Bwa ha ha!

Walhart: Only if you vow not to waste my time with insignificant prattle.

Yen'fay: I do.

Priam: Yes, of course.

Morgan (male): Perfect! Then let's get started on Project Get Memories of Dad Back! Step one—figure out how we're going to trigger some flashbacks. I've already tried banging my head against a post, but nothing. I mean, it made me dizzy and nauseated, but it didn't unearth any hidden memories. What do you think, Father? Perhaps a stone wall would work better?

Chrom: Let's just...hold off on the head smashing for now, shall we? Perhaps you could try just staring at me for a bit? Right into my eyes.

Frederick: Let's just...hold off on the head smashing for now, shall we? Perhaps you could try just staring at me for a bit? Right into my eyes.

Virion: Let's just...hold off on the head smashing for now, shall we? Perhaps you could try just staring at me for a bit? Into my mesmerizing eyes.

Vaike: Let's uh...hold off on the head smashin' for now, all right? Maybe you could try starin' at Ol' Vaike for a while, eh? Right into these eyes.

Stahl: Let's just...hold off on the head smashing for now, shall we? Perhaps you could try just staring at me for a bit? Right into my eyes.

Kellam: Let's just...hold off on the head smashing for now, all right? Perhaps you could try just staring at me for a bit? Right into my eyes.

Lon'qu: I think...Let's hold off on the head smashing for a bit, Morgan. Perhaps you could try staring at me for a while. It might trigger something.

Ricken: Hey, let's just...hold off on the head smashing for now, okay? Why don't you just try staring at me for a bit? Right into my eyes.

Gaius: Let's hold off on the head smashing for now, shall we? Perhaps you could try staring at me for a while? Right into my eyes.

Gregor: Maybe it best to hold off on the head smashing for now, yes? Why not try staring at Gregor for little while? Right into big, beautiful eyes.

Libra: Let's just...hold off on the head smashing for now, shall we? Perhaps you could try staring at me for a bit? Right into my eyes.

Henry: Um... Let's hold off on the head smashing for now, all right? Let me think... Hmm, there is that one curse, but... yeah, it'd probably kill you. Oh, I know! Maybe you could try staring at me for a while. You know, into my eyes.

Basilio: Let's...hold off on the head smashing for now, all right? Why don't you just try staring at me for a bit? Right into my eyes.

Donnel: Uh... I don't reckon bangin' yer head will help none, Son. Maybe ya could try just starin' at me for a while? Right into these here eyes.

Owain: Let's just...hold off on the head smashing for now, shall we? Perhaps you could try just staring at me for a bit? I imagine one strong gaze at my heroic face should shock your memory back into place.

Inigo: Let's just...hold off on the head smashing for now, shall we? Perhaps you could try just staring at me for a bit? Right into my eyes.

Brady: Let's hold off on the head smashing for a bit, yeah? Why don't ya try takin' a gander at me for a while? Stare into my eyes and stuff.

Gerome: Let's...hold off on the head smashing, all right? Why don't you just try staring at me for a while? Right into my eyes.

Yarne: How about we hold off on the head smashing for now, hmm? Maybe you could try staring at me for a bit? That might help.

Laurent: I see no point in further damaging your already fragile cranium. Perhaps you could try staring at me for a while? It might help trigger a memory.

Gangrel: Hey, I love a bloody head-banging as much as the next guy. ...Probably more so. But let's take it easy on that for a bit. Maybe just try staring at me instead.

Walhart: Perhaps that plan would work if I drove your head through it... Or perhaps you could gaze upon your father's noble visage for a while.

Yen'fay: Perhaps it best we...dispense with the head smashing for now, lad. Why not try staring into my eyes? It might help to trigger a memory.

Priam: I don't think banging your head against a wall is going to accomplish anything. Here, why don't you try staring at me for a while? Right into my eyes.

Morgan (male): Argh, that's perfect! You're a genius! I must have seen your face a million times in the future. It's bound to bring SOMETHING back if I stare at it long enough. Okay, sorry to invade your personal space here, but... Here goes... Drats! It's not working. I don't remember a thing. It's like... Have you ever stared at a word so long it kind of fell apart? And you think, "Is that how that's spelled?" Wait, is that even a real WORD?!" Except here it's "Is that what Father looked like?"

Chrom: Er, right. Perhaps that's enough of the memory project for one day.

Frederick: Er, right. Perhaps that's enough of the memory project for one day.

Virion: Er, right. Perhaps that's enough of the memory project for one day, hmm?

Vaike: Er...sure. Look, maybe that's enough of the memory project for one day, eh?

Stahl: Er, right. Perhaps that's enough of the memory project for one day.

Kellam: Er, right. Perhaps that's enough of the memory project for one day...

Lon'qu: ...Er, right. Perhaps that's enough of the memory project for one day.

Ricken: Er, right. Perhaps that's enough of the memory project for one day?

Gaius: Er, right. Perhaps that's enough of the memory project for one day?

Gregor: Er, right. Gregor think maybe it time to shelve memory project for today.

Libra: Er, right. Perhaps that's enough of the memory project for one day?

Henry: Er, right. Welp, back to the drawing board, I suppose.

Basilio: Er, right. Perhaps that's enough of the memory project for now.

Donnel: Er, right. What say we put the memory project on the shelf for today?

Owain: Er, right. Perhaps that's enough of the memory project for one day.

Inigo: Er, right. Perhaps that's enough of the memory project for one day.

Brady: Er, yeah...sure. Maybe we should table this memory malarkey for now.

Gerome: Er, right. Perhaps that's enough of the memory project for one day.

Yarne: Er, right. Maybe that's enough of the memory project for one day...

Laurent: Oh, dear. It would seem this experiment is also a failure... Let's take a break from the memory project for today, shall we?

Gangrel: Er, right. Perhaps that's enough of the memory project for now.

Walhart: Bah. You waste my time anew! That's enough of this for today.

Yen'fay: Er...right. Perhaps we should halt the memory project for today.

Priam: Er, right. Perhaps that's enough of the memory project for one day...

Morgan (male): Sure... I'm still a little dizzy from banging the post earlier, to be honest... But this doesn't end here! I'm not giving up until I remember you, Father!

■ FATHER X MORGAN (MALE) A

Morgan (male): *Sigh* No luck today, either... I'm going crazy trying to remember you. I feel so useless! I'm just so... *sniff* Why can't I... *sob*

Chrom: Come now, Morgan. No tears.

Frederick: Come now, Morgan. No tears.

Virion: Come now, Morgan. No tears.

Vaike: Hey now! Cryin' ain't gonna help.

Stahl: Come now, Morgan. No tears.

Kellam: Come now, Morgan. No tears.

Lon'qu: Do not cry, Morgan. It is...unpleasant to watch.

Ricken: Come now, Morgan. No tears.

Gaius: Hey, now. No need for the old waterworks.

Gregor: Oy, oy! What is this crying? Please, Morgan. No more tears.

Libra: Come now, Morgan. No tears.

Henry: Huh? Are you crying?

Basilio: Aw, come on, Morgan. No need for tears!

Donnel: Hey now, Morgan, ain't no need for tears!

Owain: Come now, Morgan. Such crying is unbecoming of a hero.

Inigo: Come now, Morgan. No tears.

Brady: Hey now! Stop that before ya get me all teary too, yeah?

Gerome: This is hardly worth crying over, Morgan.

Yarne: Come now, Morgan. No tears.

Laurent: Morgan, I don't believe crying is necessary at this juncture.

Gangrel: Now, now. Enough with the crying already.

Walhart: SILENCE! This display demeans us both!

Yen'fay: Stay your tears, Morgan.

Priam: Come now, Morgan. Pull yourself together.

Morgan (male): B-but I know I must have loved you just as much as I loved Mother. I never had memories with Mother, either, and the thought of having lost them... I feel like I failed you. Like I... Like I... *sob*

Chrom: Morgan...

Frederick: Morgan...

Virion: Morgan...

Vaike: Morgan...

Stahl: Morgan...

Kellam: Morgan...

Lon'qu:

Ricken: Morgan...

Gaius: Morgan...

Gregor: Morgan...

Libra: Morgan...

Henry: Morgan...

Basilio: Morgan...

Donnel: Morgan...

Owain: Morgan...

Inigo: Morgan...

Brady: Oh, for the love'a...

Gerome: Morgan...

Yarne: Morgan...

Laurent: Morgan...

Gangrel: Yeesh...

Walhart: I should put a sword in you and be done with it...

Yen'fay: Morgan...

Priam:

Morgan (male): *Sniff* S-sorry. I guess I got a little carried away there... Ngh! M-my head! ...Wha—?!

Chrom: What's wrong?!

Frederick: What's wrong?!

Virion: What's wrong?!

Vaike: What's wrong?!

Stahl: What's wrong?!

Kellam: What's wrong?!

Lon'qu: What's wrong?!

Ricken: What's wrong?!

Gaius: What's wrong?!

Gregor: What is the matter?

Libra: What's wrong?!

Henry: Uh-oh. Head wounds are the worst. Are you okay?!

Basilio: What is it?!

Donnel: What's wrong?!

Owain: What's wrong?!

Inigo: What's wrong?!

Brady: What's wrong?!

Gerome: What's wrong?!

Yarne: What's wrong?! Migraine headache? Embolism? Brain aneurysm?

Laurent: What's wrong?!

Gangrel: What's going on?

Walhart: Pray, what calamity has befallen you now?!

Yen'fay: What troubles you?!

Priam: What's wrong?!

Morgan (male): I...I remembered something! Just one tiny little memory, but...I remember! You were smiling at me...and you called my name... Ha ha! Yes! You looked a little bit older, but it was DEFINITELY you! Oh thank you, Father. I never would have remembered without your help. And hey, this is great! If I can get one memory back, maybe I can get the rest! It may take time, but I won't stop trying until I remember everything about you.

Chrom: Take all the time you need. I'll always be here for you... You know that, right?

Frederick: Take all the time you need. I'll always be here for you... You know that, right?

Virion: Take all the time you need, boy. I'll always be here for you.

Vaike: Take all the time ya need. And I'll do everything I can to help ya!

Stahl: Take all the time you need. I'll always be here for you... You know that, right?

Kellam: Take all the time you need. I'll always be here for you... You know that, right?

Lon'qu: Take as much time as you need. I promise to aid you in any way I can.

Ricken: Take all the time you need. I'll always be here for you!

Gaius: Take all the time you need, all right? I'll always be here for you.

Gregor: Great! Take all time you need, boy. Gregor always be here for you, yes?

Libra: Take all the time you need. I'll be here for you always.

Henry: Hey, neat! Take all the time you need. I'll be sure to help out however I can.

Basilio: Take all the time you need. I'll always be here for you, kid.

Donnel: Take all the time ya need. I'll always be here for ya... Ya know that, right?

Owain: Take all the time you need. I'll always be here for you... You know that, right?

Inigo: Take all the time you need. I'll always be here for you... You know that, right?

Brady: Take all the time ya need, kid. I'll always be here for ya...

Gerome: Take all the time you need. I will lend my aid to your cause.

Yarne: Whew! I was worried you were going extinct there for a second! Anyway, take all the time you need. I'll always be here for you!

Laurent: Take as much time as you need. I'll be happy to assist you in this endeavor.

Gangrel: Yes, well, take all the time you need, Son. I'm not going anywhere anytime soon. .

Walhart: Such pitiful goals. *sigh* Oh, very well. I shall do what I can to assist you.

Yen'fay: Take all the time you need. I'll always be here for you.

Priam: Take all the time you need. I'll always be here for you.

Morgan (male): Aw... Thanks, Dad.

The father/daughter dialogue between Avatar (male) and Morgan (female) can be found on page 226.

The dialogue between Owain and Morgan (female) can be found on page 288.

The brother/sister dialogue between Owain and Morgan (female) can be found on page 288.

The dialogue between Inigo and Morgan (female) can be found on page 292.

The brother/sister dialogue between Inigo and Morgan (female) can be found on page 292.

The dialogue between Brady and Morgan (female) can be found on page 295.

The brother/sister dialogue between Brady and Morgan (female) can be found on page 296.

The sisters dialogue between Kjelle and Morgan (female) can be found on page 299.

Cynthia (Sisters)

The sisters dialogue between Cynthia and Morgan (female) can be found on page 301.

Severa (Sisters)

The sisters dialogue between Severa and Morgan (female) can be found on page 304.

The dialogue between Gerome and Morgan (female) can be found on page 306.

The brother/sister dialogue between Gerome and Morgan (female) can be found on page 306.

■ YARNE X MORGAN (FEMALE) C

Morgan (female): Bunny!

Yarne: Um, are you referring to me?

Morgan (female): Oh, look at those ears! So adorable! Goochie goochie goo!

Yarne: Gah! Quit pulling, you maniac! You'll yank them clean off!

Morgan (female): Aw, I'm just touching 'em.

Yarne: Ahhhh, it hurts! It hurts! It huuuuuuurts!

Morgan (female): Aww, even your little wince and your tiny tears of pain are adorable!

Yarne: Will you stop that?! Be gentle with the goods! I'm the last of my kind, so if you break something, that's it!

Morgan (female): Ooh, that's...a really good point!

Yarne: ...It is? Well, that was easy.

Morgan (female): Well, sure! This is the only place in the whole world you can see a taguel wince! That majestic cringe must be preserved for posterity. I should have a portrait done.

Yarne: Don't even joke!

Morgan (female): Aw, no need to be shy. I'll make sure nothing's permanently damaged.

Yarne: I'm starting to think YOU'RE permanently damaged! I'm out of here! Oh, and stop calling me Bunny!

Morgan (female): Whaaat? Don't go! Hey, come back! Bad Bunny! Bad! Come baaack!

■ YARNE X MORGAN (FEMALE) B

Yarne: Ah! There you are, Bunny!

Yarne: Ugh, are we doing this again, Morgan. You dropped it for a while, why start now?

Morgan (female): Let me feel up those fwuffy widdle ears.

Yarne: G-get away from me! Are you just doing this to get a rise out of me?

Morgan (female): No! I'm acting as an ambassador from my race to yours! ...Now let me touch 'em. Give 'em to me! Gimme... Argh!

Yarne: You are a terrible diplomat.

Morgan (female): Ooh! Do your ears have bones? Do they stand up? What do I sound like to you?

Yarne: An annoying buzz, mostly. Do you really not have anything better to do right now?

Morgan (female): I think documenting an endangered race is plenty important.

Yarne: Even if said endangered race doesn't want to be documented?

Morgan (female): Yup! Science demands it! ...Your ears are really long. I bet I could tie them in a bow.

Yarne: We are not finding out! And how is this any way to treat an endangered race? Or any race, for that matter?!

Morgan (female): If you ask me, it's your ears' fault for being so inviting! They're all soft and floppy and just lie there all droopy. Like you, on the battlefield.

Yarne: Just because you're smiling when you say it doesn't make it okay. ...And you ARE just doing this to get a rise out of me! I knew it!

Morgan (female): I'm just instinctively drawn to cute stuff. ...It's a girl thing.

Yarne: First it's for science, now it's because I'm cute? Your story keeps changing, Morgan. I think you just want an excuse, and you don't care what it is!

Morgan (female): Do you really want to know the truth?

Yarne: I...thought I did. Now I'm not so sure.

Morgan (female): Seeing cute, defenseless things just brings out the sadist in me. I can't help myself!

Yarne: Yeesh, you're a real piece of work under all that cheer, you know that? So seriously, what will it take to get you to leave me alone?

Morgan (female): I think it's your job to figure that out. Consider it homework.

Yarne: What did I ever do to deserve this?

■ YARNE X MORGAN (FEMALE) A

Morgan (female): Hey, Yarne!

Yarne: Urk— Q-quick! Gotta hide!

Morgan (female): Why the eyes wide as dinner plates?

Yarne: Because you're always tugging on my ears and tormenting me!

Morgan (female): Ah ha ha, I wouldn't do anything like that anymore, silly!

Yarne: Uh, why not? I mean, I'm glad, but... Hey, you called me by my name today. What happened to Bunny?

Morgan (female): You've been a changed man in the last few battles. It's only fun teasing you when you squirm and squeak and try to run away. There's no reason for any of that now.

Yarne: So all that torment was your way of encouraging me to be braver?

Morgan (female): Nah. Growing up, all girls know that boys overreact when they're teased. I figured it was worth trying, so I gave you a little push and watched what happened.

Yarne: You call that a little push?!

Morgan (female): Tee hee!

Yarne: Don't you "tee hee" me, you monster! ...But at least now it all makes sense.

Yarne: Did you want me to shape up, or didn't you?

Morgan (female): Eh, either way has its merits! Ooh, but anytime you decide you want to be teased some more, just run from battle. I'll chase you down!

Yarne: You ARE a monster!

■ YARNE X MORGAN (FEMALE) S

Morgan (female): Hi, Yarne! How goes?

Yarne: You again? What do you want, Morgan?

Morgan (female): You're the talk of the camp lately. Everyone is impressed with how much you've grown.

Yarne: Yeah, well... Thanks, I guess.

Morgan (female): Thanks for what?

Yarne: It was the fear that you'd cuddle me to death that "encouraged" me in combat. I guess I owe you one for taking my ears hostage. ...Which is weird.

Morgan (female): Huh. So, what, I don't get to play with you anymore?

Yarne: You're the one who said it was no fun to pick on me now. Hey, so I've got to ask... In the end, were you trying to cheer me on, or were you really just torturing me for fun?

Morgan (female): Both, I suppose. But more than either of those, I just... I just wanted to play with you. To...touch you.

Yarne: ...What's that supposed to mean?

Morgan (female): Rrgh, are you really going to make me say it in so many words? I like you! Okay?!

Yarne: ...Oh. I guess that makes sense.

Morgan (female): So from here on, I hope we can have real fun together. Fun for both of us, I mean. No more teasing, I promise!

Yarne: Hmm, I suppose you did help me to become less of a coward. ...And I guess I like you, too. Don't ask me why.

Morgan (female): Really? Yay! Woo-hoo!

Yarne: Isn't that going a little overboard?

Morgan (female): Can I still call you Bunny?!

Yarne: No.

Morgan (female): Ooh, and can I play with your ears every now and again? Maybe give you an updo?

Yarne: NO.

Morgan (female): Aw, worst boyfriend ever! You're no fun at all...

Yarne: You don't want a boyfriend. You want a rag doll you can abuse!

Morgan (female): Ah ha ha, I totally do! Good thing there's no rule that says you can't be both, Bunny!

Yarne (Brother/sister)

■ YARNE X MORGAN (FEMALE) (BROTHER/SISTER) C

Morgan (female): Let's see here... Birthday? May 5th... Favorite colors? Blue and purple... Favorite food? Probably bear meat...

Yarne: What are you mumbling about over there, Morgan?

Morgan (female): Least favorite food? Veggies, apparently. Don't seem to mind them now, though...

Morgan (female): Morgan!

Morgan (female): Oh! Yarne?! Guess I was pretty out of it to miss my own brother paying a visit! Did you need something?

Yarne: Just wondering what you were chanting over there... You practicing some new magic incantations or something?

Morgan (female): Nope! Just going back over my notes on what you told me about myself. I was hoping they'd hold some clue that might help spark my memory. Heh. It's kind of crazy how much you know about me, huh? Like, I really once got five nosebleeds in the same day? I have no memory of that at all. AT ALL! Ha ha ha! I can just imagine...

Yarne: Well, you're still as cheerful, that's for sure. And as talkative as ever...

Morgan (female): I am? I mean, I was?! Hmm, now that you mention it, that does sound...right, somehow. ...Heh. Everything still feels funny. Even you being my brother hasn't really clicked.

Yarne: If you think it's strange for you, imagine how I feel! My kid sister starts talking to me like a stranger, asking questions about herself... I had no idea how to even interact with you. It was pretty rough, but I got used to it.

Morgan (female): Heh, yeah... Sorry about that. But that's just another reason why I'm working hard to get my memories back. Once I do, nobody will have to feel weird or awkward around me again. Pretty noble, huh? I'm such a sweet, selfless girl!

Yarne: Heh, and so humble as well... In any case, I'm happy to help you retrieve those memories back however I can. Someday soon I bet we'll be able to laugh about all the old times—now included!

Morgan (female): Heh, right!

■ YARNE X MORGAN (FEMALE) (BROTHER/SISTER) B

Yarne: The day's almost over and I'm still alive! But I still have to make it to my...tent? ...Is someone passed out over there? Wait, is that Morgan?

Morgan (female): Nn...nngh...

Yarne: Morgan! Morgan, are you all right?! What happened?!

Morgan (female): ...Wha—?! Yarne! Wh-what am I doing here? Was I asleep?! I don't even remember feeling tired... Oh, right! I was bashing that huge tome against my head when I blacked out. That explains why my face hurts so bad...

Yarne: Bashing your... Morgan, why in the WORLD would you do that?! Wait, were you trying to get your memories back?

Morgan (female): Well, yeah! Obviously. If you ever saw me bludgeoning myself just for fun, I hope you'd put a stop to it...

Yarne: I'll stop you even if it's NOT just for fun, you nitwit! Look, I know you want your memories back, but please... Don't do anything reckless.

Morgan (female): ...But I want to be able to talk with you about old times again.

Yarne: I know, Morgan, and I want that, too. But more than that, I want you safe. I may just be another stranger to you, but to me, you're family. In the future, with Mother and Father gone, it was just the two of us. You're all I had, Morgan... I don't know what I'd do if anything happened to you. Besides, your taguel blood is precious! We need you to help keep the species alive!

Morgan (female): All right. I'm sorry, Yarne.

Yarne: As long as you understand...

Morgan (female): ...Heh, that felt really siblingy just now. Don't you think? Me messing up and you scolding me felt... I don't know, it felt really plausible! Maybe if you keep it up, I'll remember something!

Yarne: You...really think so?

Morgan (female): Yeah! Oh yeah, this will totally work! So go on, keep yelling! C'mon, scream at your amnesiac sister, Yarne!

Yarne: I... I'm not really comfortable with—

Morgan (female): Hey, why don't you use the tome, too? Come on, don't hold back. Really wallop me with that thing! Maybe the simultaneous physical and mental shock will jar some memories loose! It's gotta be twice as effective as either one by itself, right? That's just basic science.

Yarne: Good night, Morgan...

■ YARNE X MORGAN (FEMALE) (BROTHER/SISTER) A

Yarne: Hey, Morgan. I'm headed to the woods. Want to come along?

Morgan (female): I'd love to! Is there something in particular you need?

Yarne: I might pick up a couple of things, yeah. But mostly I think there's something YOU need.

Morgan (female): It doesn't have to do with getting my memories back, does it?

Yarne: The opposite, really. Maybe there's no need to worry about your memories.

Morgan (female): That...makes no sense.

Yarne: I'll be honest—it does hurt to know you've forgotten me. But...maybe it's better to build new memories than to worry about old ones.

Morgan (female): What do you mean?

Yarne: I've been thinking about this a lot. Why you might have lost your memories, I mean. And I'm wondering if you didn't have some awful memory you couldn't bear to keep. ...I know I've got a few. I see a lot of faces, you know? People we couldn't save...

Morgan (female): I'm sorry you have to bear those dreadful memories, Yarne.

Yarne: Look, this is just a theory, and even if it's true, it's not like you did it consciously. But I do think that getting your memories back might not necessarily be a good thing.

Morgan (female): Hmm... I understand, and I appreciate the thought... But I want to remember things, no matter how painful they are. Because I'm sure there'll be plenty of great memories mixed with the bad ones. And the truth, whatever it is... I really want to have that back, you know?

Yarne: Well, if you're sure, then I'm happy to help.

Morgan (female): That's really kind of you, Yarne, but do you truly realize what you're saying? I mean, it could be years before I remember anything. Or decades. Heck, there's a decent chance I may never get my memories back at all. I don't want to drag you into something that could last forever.

Yarne: I'm already stuck with you forever, you goof. I'm your brother! We're family—memories or no. You couldn't keep me away.

Morgan (female): Yarne, I... *sniff* Thank you! I'll do everything I can!

Yarne: Then start by coming with me to the woods!

Morgan (female): Huh? But you said that doesn't have to do with getting my memories back.

Yarne: Hey, there's no rule that says you can't have a little fun while you try. And there's certainly no rule against making some happy new memories, either. You're young! Live a little! There'll be plenty of time to worry later.

Morgan (female): Right... You're right! Thanks, Brother!

Laurent

■ LAURENT X MORGAN (FEMALE) C

Morgan (female): Heh heh. Sorry, Laurent.

Laurent: I'm still just flabbergasted! What made you think it would be fun to build a tower of stacked tomes? You nearly crushed your father when they came crashing down!

Morgan (female): Hey, I said I was sorry. And besides, it was super fun stacking them up. You should try it sometime!

Laurent: I'll pass, thank you.

Morgan (female): Aww, come on. Live a little!

Laurent: No. Honestly, must you always be like this? Do you think it's appropriate to flit about all day playing games and making trouble? We fight for the fate of the world, Morgan. You would do well to remember that.

Morgan (female): No, I remember. And I'm totally serious! Here, look into my eyes... See that? See it? These are the eyes of a totally serious woman.

Laurent:

Morgan (female): These are the eyes of someone fighting to save the world from ruin. These are...SERIOUS EYES! Rrrrr! Not...gonna...blink...

Laurent: The only thing serious is your commitment to chicanery! You ought to learn from your father's example.

Morgan (female): If I did, would you play a round of tome stackers with me?

Laurent: I've quite enough nonsense in my life already. Good day!

Morgan (female): H-hey, wait! Laurent! Don't be like that!

■ LAURENT X MORGAN (FEMALE) B

Laurent: Morgan will drive me to madness or an early grave. Of this there's little doubt. We are in the throes of a battle for human survival, and she wants to play games! Does the woman honestly not grasp the severity of our plight?

Morgan (female): Five hundred...tweeeeenty...THREE!

Laurent: Hmm? What's this, then?

Morgan (female): Five hundred...tweeeeenty...FOUR!

Laurent: Morgan?

Morgan (female): Phew! ...Oh! Hi, Laurent! What brings you out here?

Laurent: I was simply passing by and... What are you doing?

Morgan (female): Sit-ups, silly! Isn't it obvious? Even as a future tactician of legend, I need to hold my own on the battlefield!

Laurent: And you always do five hundred repetitions?

Morgan (female): Six hundred, actually. But who's counting? A well-toned body is a wellspring of confidence in the heat of battle! With abs like these, victory is ab-solutely assured! Who needs memories when your stomach is a tempered twelve-pack of solid steel? ...And so on. Anyway, I don't get playtime until I've done my daily training regimen.

Laurent: ...It seems I haven't been giving you due credit.

Morgan (female): Credit for what?

Laurent: Your diligence. This shows an admirable commitment to winning this war. I fear I may have been a fool telling you to take a lesson from your father. I could stand to model myself after you!

Morgan (female): Aw, it's fine! Water under the bridge. Although... If you really wanted to make it up to me, you'd play a round of tome stackers!

Laurent: ...I see I was hasty in commending you. Absolutely not.

Morgan (female): ...Next time, then?

Laurent: ABSOLUTELY NOT!

■ LAURENT X MORGAN (FEMALE) A

Laurent: *Sigh* It's anyone's guess which is the real her. Hmm...

Morgan (female): Everything all right, Laurent? You've been staring off into space and mumbling.

Laurent: Oh, er... Salutations.

Morgan (female): Something on your mind? If anything's troubling you, I'm happy to lend an ear. We can talk it over while stacking up some big ol' tomes!

Laurent: Any troubles I have now are a direct result of you.

Morgan (female): What? How do you mean?

Laurent: I am ill-equipped to figure you out. One Morgan is a grinning fool, always thinking up bizarre games and pranks. The other is a commendably diligent warrior, rigorous and eager in her training! Which is the truth, though? Which is the real Morgan?!

Morgan (female): Oh. Is that what's bothering you, you big dummy?

Laurent: YOU would accuse ME of lacking in intelligence?!

Morgan (female): Ah ha ha, sorry! No, I didn't mean that. I just meant you're overthinking it. They're both the real me!

Laurent: Both? What manner of trickery is this?

Morgan (female): Look, it's true that I want to have fun and I like fooling around. But I also want to be a great tactician like my father, and I'll work to make it happen. There's no rule that says I can't be both! ...Er, there isn't, right?

Laurent: Well no, I suppose not... I'd simply like to know for certain whether you're a serious person or a reprobate.

Morgan (female): Hmm... Prrrobably serious? ...Ish?

Laurent: When you can't even offer a serious answer to the question, I have my doubts.

Morgan (female): Aw, don't be such a sourpuss! Can't a girl tease her friend a little?

Laurent: I had not thought of us in those terms before. We are more brother-and-sister-in-arms, our bond forged in the heat of battle.

Morgan (female): Nice! That sounds way more poetic than saying we're just chums! Now what do you say we deepen that bond with a brisk game of tome stackers?!

Laurent: No.

Morgan (female): Awww, come ON!

■ LAURENT X MORGAN (FEMALE) S

Morgan (female): Laurent, can I talk to you?

Laurent: You never seemed to require my permission before.

Morgan (female): Yeah, but I've never told you I'm in love with you before. So I thought—

Laurent: Pardon me?!

Morgan (female): Well, yeah! I want us to be together forever, Laurent.

Laurent: Is this some new game of yours? Some mad new jape? I refuse to be a party to this foolishness!

Morgan (female): What? No! I'm serious!

Laurent: Are you...?

Morgan (female): Laurent! I may like to play around, but I would never joke about stuff like this! Remember before when you described us as brother-and-sister-in-arms? Well, I thought about it, and it ended up totally bumming me out. I don't want to just be your sister!

Laurent: An intriguing theory, but you fail to take into account—

Morgan (female): Anyway, I... I just had to tell you, is all. But I know it's pretty stupid. I mean, you'd never be interested in a girl like me, right?

Laurent: In truth, I would be thrilled.

Morgan (female): Say wha—?

Laurent: ...But I fear I'm not ready after my show of self-important buffoonery in censuring you. I have too much maturing to do before I can entertain a romantic liaison.

Morgan (female): You've got it backward! Love makes a person grow! It makes you stronger! Come on, Laurent. Why do you think I started that crazy training regimen? Gah, I can't believe I'm telling you this...

Laurent: So when I saw you honing your body, that was for my sake?

Morgan (female): ...Yes. I thought if I toughened up, you'd be proud of me and see that I really was serious. Before that, I wasn't putting half as much into training as I do now.

Laurent: ...I see. It's true that your efforts of late have been positively astounding. If that is the result of amorous intent, then perhaps I needn't bridle my feelings either.

Morgan (female): Okay, so...translation, please?

Laurent: I'm quite smitten with you as well.

Morgan (female): Oh, Laurent! You really mean that?

Laurent: Absolutely.

Morgan (female): Yay! This is going to be the best! We'll push each other to improve until we've saved the world, the future, and everyone!

Laurent: If being with you grants me even half of that energy and blind confidence, I'll be happy. ...But I hereby forbid all future mention of tome stackers!

Morgan (female): Oh? But why?

Laurent: When I looked through the collapsed pile, I saw manuscripts of mine and my mother's! It makes me half-mad with worry to think I might have lost all that knowledge!

Morgan (female): *Sigh* Well, I suppose I could always start stacking your alchemy flasks instead...

Laurent (Brother/sister)

■ LAURENT X MORGAN (FEMALE) (BROTHER/SISTER) C

Morgan (female): Let's see here... Birthday? May 5th... Favorite colors? Blue and purple... Favorite food? Probably bear meat...

Laurent: What are you going on about over there, Morgan?

Morgan (female): Least favorite food? Veggies, apparently. Don't seem to mind them now, though...

Morgan (female): Morgan!

Morgan (female): Oh! Laurent?! Guess I was pretty out of it to miss my own brother paying a visit! Did you need something?

Laurent: I was simply curious as to the reason behind your frantic muttering. Were you perhaps practicing some new magical incantations?

Morgan (female): Nope! Just going back over my notes on what you told me about myself. I was hoping they'd hold some clue that might help spark my memory. Heh. It's kind of crazy how much you know about me, huh? Like, I really once got five nosebleeds in the same day? I have no memory of that at all. AT ALL! Ha ha ha! I can just imagine...

Laurent: Ah, yes. Well, you're still as jocular and garrulous as ever...

Morgan (female): I am? I mean, I was?! Hmm, now that you mention it, that does sound...right, somehow. ...Heh. Everything still feels funny. Even you being my brother hasn't really clicked.

Laurent: If you think the experience odd for you, imagine how I perceive it... My sibling starts speaking to me as if I were a stranger, asking peculiar questions... In truth, I was somewhat perplexed as to how to even interact with you.

Morgan (female): Heh, yeah... Sorry about that. But that's just another reason why I'm working hard to get my memories back. Once I do, nobody will have to feel weird or awkward around me again. Pretty noble, huh? I'm such a sweet, selfless girl!

Laurent: Indeed. And oh so humble... In any case, I'm happy to try and help you retrieve your memories however I can. It would be most satisfying to one day laugh together about old times—now included!

Morgan (female): Heh, right!

■ LAURENT X MORGAN (FEMALE) (BROTHER/SISTER) B

Laurent: Whew... That was a fierce battle today. Perhaps I shall retire a bit ear...ly? Wait, is that Morgan unconscious over there? Wait, is that Morgan?!

Morgan (female): Nn...nngh...

Laurent: Morgan! Morgan, are you all right?! What happened?!

Morgan (female): ...Wha—?! Laurent! Wh-what am I doing here? Was I asleep?! I don't even remember feeling tired... Oh, right! I was bashing that huge tome against my head when I blacked out. That explains why my face hurts so bad...

Laurent: For the love of all that's holy, why in the WORLD would you do that?! I postulate this was a misguided attempt to try and get your memories back?

Morgan (female): Well, yeah! Obviously. If you ever saw me bludgeoning myself just for fun, I hope you'd put a stop to it...

Laurent: I would have stopped you regardless of the reason, Morgan! I know you long to have your memories back, but you cannot place yourself at risk!

Morgan (female): I know, and I desire that as well. But more than that, I want you safe. I may just be another stranger to you, but to me, you are family. In the future, with Mother and Father gone, it was just the two of us. You're all I had, Morgan... I don't know what I'd do if anything happened to you.

Morgan (female): All right. I'm sorry, Laurent.

Laurent: Just as long as you understand.

Morgan (female): ...Heh, that felt really siblingy just now. Don't you think? Me messing up and you scolding me felt... I don't know, it felt really plausible! Maybe if you keep it up, I'll remember something!

Laurent: An intriguing theory, but you fail to take into account—

Morgan (female): Yeah! Oh yeah, this will totally work! So go on, keep yelling! C'mon, scream at your amnesiac sister, Laurent!

Laurent: Er, the causation for such a—

Morgan (female): Hey, why don't you use the tome, too? Come on, don't hold back. Really wallop me with that thing! Maybe the simultaneous physical and mental shock will jar some memories loose! It's gotta be twice as effective as either one by itself, right? That's just basic science.

Laurent: Now see here! There is no rational basis for any of this!

■ LAURENT X MORGAN (FEMALE) (BROTHER/SISTER) A

Laurent: I'm headed into town, Morgan. Perhaps you would care to join me?

Morgan (female): I'd love to! Is there something in particular you need?

Laurent: I might pick up a couple of items, yes. But mostly I believe there is something YOU need.

Morgan (female): It doesn't have to do with getting my memories back, does it?

Laurent: The opposite, really. Perhaps there is no need to concern yourself with recovering your memories.

Morgan (female): That...makes no sense.

Laurent: In truth, the fact that you have forgotten me has been rather harrowing. But...perhaps it would be better to build new memories than to worry about old ones.

Morgan (female): What do you mean?

Laurent: I have formulated a hypothesis about your present condition. Your amnesia, that is. I wonder if perhaps you didn't have some awful memory you couldn't bear to keep. ...I know I have quite a few myself. I often see the faces of fallen comrades... Innocents we were unable to save...

Morgan (female): I'm sorry you have to bear those dreadful memories, Laurent.

Laurent: Granted, it's just a hypothesis. Even if it were true, it's not like you could have consciously suppressed your memories. But I do believe that retrieving those lost memories might cause unforeseen harm...

Morgan (female): Hmm... I understand, and believe me, I appreciate the thought... But I want to remember things, no matter how painful they are. Because I'm sure there'll be plenty of great memories mixed with the bad ones. And the truth, whatever it is... I really want to have that back, you know?

Laurent: Well, if you are certain, then I'm happy to help.

Morgan (female): That's really kind of you, Laurent, but do you truly realize what you're saying? I mean, it could be years before I remember anything. Or decades. Heck, there's a decent chance I may never get my memories back at all. I don't want to drag you into something that could last forever.

Laurent: As your brother, I am already sworn to you forever. We are family—memories or no. You couldn't keep me away.

Morgan (female): Laurent, I... *sniff* Thank you! I'll do everything I can!

Laurent: Then start by accompanying me into town.

Morgan (female): Huh? But you said that doesn't have to do with getting my memories back.

Laurent: I am unaware of any rule that states you can't enjoy a little fun while you try. And there's certainly no rule against making some happy new memories, either. You are young and full of promise! There will be ample time for worry later.

Morgan (female): Right... You're right! Thanks, Brother!

Noire

■ NOIRE X MORGAN (FEMALE) C

Noire (off screen): Heh heh heh ha ha ha ha...

Morgan (female): Hm? What was that?

Noire (off screen): MWAAAH HA HA HA HA HA!

Morgan (female): D-don't tell me...

Noire: A POX ON THESE ENDLESS MARCHES! May camping outdoors burn in perdition! The blood and the thunder demand a bed with pillows of softest down! SOFTEST DOWN, DAMN YOU!

Morgan (female): Er... Are you all right, Noire?

Noire: Ack! M-Morgan?! I... Oh, dear.

Morgan (female): Um, look. I know we've been on the road for a while since the last town, but... Well, I didn't know it was bothering you this much. I'm right there with you, though. A nice, fluffy bed sounds amazing right now.

Noire: N-no, I... It's all right, Morgan. I was just... Whenever I feel stressed and frustrated, I let it out like that. Shouting out loud helps relieve the pressure, you know? I do this fairly often, actually...

Morgan (female): Fairly often?!

Noire: Well, it's better to let it all out than have it build up inside me, right?

Morgan (female): So, wait. You're really this stressed over not being able to sleep in a bed?

Noire: Um, yes and no. That was mostly just the first thing that came to mind. It's never that simple, though. Stress is a sum of all the little things in life.

Morgan (female): Yeah, I suppose it is. Anyway, I'm sorry you feel so frustrated.

Noire: No, it's all right. I'm sorry to have startled you, Morgan. I'll be going now.

Morgan (female): She always seemed so quiet and gentle...

■ NOIRE X MORGAN (FEMALE) B

Noire (off screen): Heh heh heh ha ha ha ha...

Morgan (female): Oh, geez... Not again.

Noire (off screen): MWAH HA HA HA HA HA!

Noire: MY TANGLED HAIR DEMANDS JUSTICE! My skin is as dry as the wastes of our forsaken future! This bleak and desiccated life of scavenging meals and endless night marches must end! END, DAMN YOU!

Morgan (female): A-are you sure you're all right? Should I get a healer? Or, um, a psychiatrist?

Noire: Ack! M-Morgan?! Um, hi. I'm afraid you've... caught me again. I don't, uh... I mean, this isn't... This is all so embarrassing.

Morgan (female): Is everything okay? Did something happen?

Noire: Honestly, even I don't really know why I'm feeling so pent up of late.

Morgan (female): Well, I hope you can find the source soon. It must be awful! And it, uh... It sounds like it's getting louder every time. To be honest, I'm a little worried about where this may go...

Noire: I know. I'm kinda worried, too.

Morgan (female): Well, no sense stressing over your stress levels! Get some rest and you'll feel better. Take it from me, the best thing to do in situations like this is forget your troubles! Just slap on a big grin and tell yourself everything's coming up Noire!

Noire: So... I should act like you?

Morgan (female): Hey, not to brag, but you could do a lot worse than follow my lead on this one. Give it a try, and see where it gets you!

Noire: Heh, I may just do that. Thank you, Morgan.

Morgan (female): My pleasure! And if there's ever anything on your mind, I'm always happy to listen. Honestly, I'm feeling pretty lucky after spotting one of your screaming sessions. Maybe some of that good fortune will rub off on you, too!

Noire: You make it sound like finding me screaming is like finding a four-leaf clover.

Morgan (female): What? No, not at all! That would be rude. ...It's more like seeing a shooting star.

Noire: Oh, well that's... Wait, how is that different?

■ NOIRE X MORGAN (FEMALE) A

Noire: Dum tee dum doo... Tra la la tee da...

Morgan (female): Heya, Noire.

Noire: M-Morgan! You've caught me in the act yet again.

Morgan (female): Yeah, but it's the act of humming! And you look so...cheery?

Noire: Do I? Oh, that's a relief! A while back, I finally pinpointed the source of my stress.

Morgan (female): Really? Congratulations! That's great!

Noire: Yes, right. See, because it's not exactly an easy problem to fix... The chief source of my stress is my own tendency to suddenly snap.

Morgan (female): Wait, what?

Noire: Well, I'd get angry, then feel ashamed of my outburst. Then that creates stress and... Well, I just end up in a big shame spiral.

Morgan (female): So getting stressed was getting you...stressed? Yeah, that does sound like a tricky problem.

Noire: It's hopeless unless I find some way to break this vicious cycle...

Morgan (female): Then wait, how come you were so happy a second ago?

Noire: Well, I figured that if my getting angry was the problem, I needed to be happy instead. Even if it meant just clearing my head of thought and enjoying a little mindless break. So I, um...

Morgan (female): Yes?

Noire: I tried to do my best to emulate you. No one rivals you for mindless happiness. ...And I mean that in the nicest possible way. So I hoped that even just going through the motions might brighten me up a bit.

Morgan (female): Huh. Well, I'll be.

Noire: B-but please don't get the wrong idea! I know you must have your own troubles. I don't mean to dismiss them at all.

Morgan (female): Aw, don't worry about that! If it helps you, I think it's a great idea! Besides, I don't actually have any troubles, so don't worry in the least.

Noire: Yes, and I'm very sor— Wait, you don't?

Morgan (female): Yup! No worries here! Emulate away. Heck, I'll even teach you! Tips and Tricks to Mindless Bliss, by Morgan!

Noire: Are there really... Do you actually HAVE tips and tricks?

Morgan (female): Well, sure! Step one: Always wake up early to give yourself time to say hi to the songbirds.

Noire: W-wait, I should be writing these down! Oh, Morgan, will you train me in the ways of airheaded joy?

Morgan (female): You bet! We'll start with the easy stuff. Prepare for some intense nap lessons!

Noire: Er... How does one train at napping? To say nothing of doing it "intensely."

Morgan (female): You don't even KNOW! It takes constant focus to cease all conscious thought! But don't worry—I'll have you spacing with the best of them in no time!

Noire: R-right!

 Noire (Sisters)

■ NOIRE X MORGAN (FEMALE) (SISTERS) C

Morgan (female): Let's see here... Birthday? May 5th... Favorite colors? Blue and purple... Favorite food? Probably bear meat...

Noire: What are you mumbling about over there, Morgan?

Morgan (female): Least favorite food? Veggies, apparently. Don't seem to mind them now, though...

Noire: Morgan!

Morgan (female): Oh! Noire?! Guess I was pretty out of it to miss my own sister paying a visit! Did you need something?

Noire: J-just wondering what you were chanting over there... Whenever I hear something like that, it usually involves a curse...

Morgan (female): Nope! Just going back over my notes on what you told me about myself. I was hoping they'd hold some clue that might help spark my memory. Heh. It's kind of crazy how much you know about me, huh? Like, I really once got five nosebleeds in the same day? I have no memory of that at all. AT ALL! Ha ha ha! I can just imagine...

Noire: Well, you're still as cheerful, that's for sure. And as talkative as ever...

Morgan (female): I am? I mean, I was?! Hmm, now that you mention it, that does sound...right, somehow. ...Heh. Everything still feels funny. Even you being my sister hasn't really clicked.

Noire: If you think it's strange for you, imagine how I feel... My kid sister starts talking to me like a stranger, asking questions about herself... I had no idea how to even interact with you. It was pretty rough, but I got used to it.

Morgan (female): Heh, yeah... Sorry about that. But that's just another reason why I'm working hard to get my memories back. Once I do, nobody will have to feel weird or awkward around me again. Pretty noble, huh? I'm such a sweet, selfless girl!

Noire: Heh, and so humble as well... In any case, I'm happy to help you get those memories back however I can. Someday soon I bet we'll be able to laugh about all the old times—now included!

Morgan (female): Heh, right!

■ NOIRE X MORGAN (FEMALE) (SISTERS) B

Noire: Whew! Managed to survive another day... I think I'll hit the hay a bit ear...ly? Is someone passed out over there? Wait, is that Morgan?!

Morgan (female): Nn...nngh...

Noire: Morgan! Morgan, are you all right?! What happened?!

Morgan (female): ...Wha—?! Noire! Wh-what am I doing here? Was I asleep?! I don't even remember feeling tired... Oh, right! I was bashing that huge tome against my head when I blacked out. That explains why my face hurts so bad...

Noire: Bashing your... Morgan, why in the WORLD would you do that?! Wait, were you trying to get your memories back?

Morgan (female): Well, yeah! Obviously. If you ever saw me bludgeoning myself just for fun, I hope you'd put a stop to it...

Noire: I'll stop you even if it's NOT just for fun! Look, I know you want your memories back, but please... Don't do anything reckless.

Morgan (female): ...But I want to be able to talk with you about old times again.

Noire: I know, Morgan, and I want that, too. But more than that, I want you safe. I may just be another stranger to you, but to me, you're family. In the future, with Mother and Father gone, it was just the two of us. You're all I had, Morgan... I don't know what I'd do if anything happened to you.

Morgan (female): All right. I'm sorry, Noire.

Noire: Just as long as you understand.

Morgan (female): ...Heh, that felt really siblingy just now. Don't you think? Me messing up and you scolding me felt... I don't know, it felt really plausible! Maybe if you keep it up, I'll remember something!

Noire: You...really think so?

Morgan (female): Yeah! Oh yeah, this will totally work! So go on, keep yelling! C'mon, scream at your amnesiac sister, Noire!

Noire: Um, I'm not really comfortable with—

Morgan (female): Hey, why don't you use the tome, too? Come on, don't hold back. Really wallop me with that thing! Maybe the simultaneous physical and mental shock will jar some memories loose! It's gotta be twice as effective as either one by itself, right? That's just basic science.

Noire: I am NOT doing that!

■ NOIRE X MORGAN (FEMALE) (SISTERS) A

Noire: Hey, Morgan. I'm headed into town. Want to come along?

Morgan (female): I'd love to! Is there something in particular you need?

Noire: I might pick up a couple of things, yes. But mostly I think there's something YOU need.

Morgan (female): It doesn't have to do with getting my memories back, does it?

Noire: The opposite, really. Maybe there's no need to worry about your memories.

Morgan (female): That...makes no sense.

Noire: I'll be honest—it does hurt to know you've forgotten me. But...maybe it's better to build new memories than to worry about old ones.

Morgan (female): What do you mean?

Noire: I've been thinking about this a lot. Why you might have lost your memories, I mean. And I'm wondering if you didn't have some awful memory you couldn't bear to keep. ...I know I've got a few. I see a lot of faces, you know? People we couldn't save...

Morgan (female): I'm sorry you have to bear those dreadful memories, Noire...

Noire: Look, this is just a theory, and even if it's true, it's not like you did it consciously. But I do think that getting your memories back might not necessarily be a good thing.

Morgan (female): Hmm... I understand, and believe me, I appreciate the thought... But I want to remember things, no matter how painful they are. Because I'm sure there'll be plenty of great memories mixed with the bad ones. And the truth, whatever it is... I really want to have that back, you know?

Noire: Well, if you're sure, then I'm happy to help.

Morgan (female): That's really kind of you, Noire, but do you truly realize what you're saying? I mean, it could be years before I remember anything. Or decades. Heck, there's a decent chance I may never get my memories back at all. I don't want to drag you into something that could last forever.

Noire: BLOOD AND THUNDER! WE ARE KIN, FOOL! TWO SOULS CONNECTED BY BIRTH AND BLOOD! NEVER AGAIN SHOULD I MIGHT BE SO SHAMELESS AS TO ABANDON YOU!

Morgan (female): Eek! I'm sorry, Noire! Really! P-please, let me make it up to you!

Noire: ...V-very well. You can start by coming with me into town.

Morgan (female): Huh? But you said that doesn't have to do with getting my memories back.

Noire: Hey, there's no rule that says you can't have a little fun while you try. And there's certainly no rule against making some happy new memories, either. You're young! Live a little! There'll be plenty of time to worry later.

Morgan (female): Right... You're right! Thanks, Sis!

 Nah

■ NAH X MORGAN (FEMALE) C

Nah: Hah! ...Yah! ...Shah! ...Hrah!

Morgan (female): Um...are you all right, Nah? You've been clapping your hands over your head for a while now.

Nah: Oh! Morgan, I was... I was hoping no one would see me. I'm training in secret to overcome my one critical weakness.

Morgan (female): You have a weakness? Seriously? But, um, you're a dragon. How can you have a weakness?

Nah: Unfortunately, there is a rare subset of weapons that are a bane to my kind... Wyrmslayers.

Morgan (female): Oh, right! The swords said to cleave even the mighty scales of a manakete.

Nah: Correct. So to defend against it, I'm training in the art of blade grasping.

Morgan (female): Blade what-ing?

Nah: Grasping. It's a foreign technique used by the greatest of swordmasters. You stop the opponent's sword midswing by clasping it between your open palms.

Morgan (female): That seems really...hard. Like impossible hard. Still, I guess it would be a pretty good way to stop a Wyrmslayer, if you could.

Nah: Yes, I know. But I'm having a difficult time figuring it out. Maybe I just don't have what it takes...

Morgan (female): No, Nah! It's way too early to give up on something so completely awesome! In fact, I'm gonna help you train!

Nah: Huh? Really?

Morgan (female): I don't know much about swordplay, but two heads are better than one, right? Just let me know what I can do!

Nah: Thanks, Morgan! That's very generous of you. Okay, then. Why don't you attack me, and I'll try to catch your strike.

Morgan (female): All right, got it! We'll start with a bare-handed chop. Ready? ...Yah!

Nah: Ow! That hurt!

Morgan (female): Aah! Sorry! I'm sorry, Nah!

Nah: If I can't even stop that, it's going to be a long time before I'm stopping swords...

Morgan (female): Don't worry, Nah! I'm sure of it! Just take it one step at a time. Together, we'll be unstoppable!

Nah: Aw, thanks, Morgan!

■ NAH X MORGAN (FEMALE) B

Morgan (female): Hyah!

Nah: Hah! Caught it!

Morgan (female): I'd say you're about ready to graduate from standard chops. That's ten in a row!

Nah: Yay!

Morgan (female): How about this? ...Yah!

Nah: Hah! ...Muh?! Wait, what happened? Did I miss?

Nah: ...Gah!

Morgan (female): Oops! You all right? That one kinda snuck past, huh?

Nah: No fair, Morgan. You swung a second AFTER shouting!

Morgan (female): Well, there's no guarantee that your enemy will always play fair, is there?

Nah: Urk... No, I suppose not.

Morgan (female): SNEAK ATTACK!

Nah: Wha—Yah! ...H-hey! I caught it!

Morgan (female): Whoa! That was amazing! You're getting really good at this!

Nah: And you're getting really sneaky!

Morgan (female): But you still caught it! You've got the reflexes of a master, Nah!

Nah: Although my head's still pounding from all the beatings it took to get there...

Morgan (female): Still, I'd say you've cleared this stage. Next, let's work on switching things up like I did just now.

Nah: It's tough to judge the other person's timing with no clear warning.

Morgan (female): But in real combat situations, you'll need to make those judgments on the fly. Why don't we up the stakes a bit and have me start swinging a heavy tome!

Nah: Eep... That sounds a lot more painful than a bare-handed chop.

Morgan (female): That's the point! It'll be a good incentive.

Nah: Also, is it okay to be smacking me in the face with a magical tome?

Morgan (female): This is serious training! ...The tomes will understand.

Nah: ...Erm, all right. Go for it, then!

Morgan (female): Here comes!

Nah: Ready!

■ NAH X MORGAN (FEMALE) A

Morgan (female): Yaaah!

Nah: Hah! ...Caught it!

Morgan (female): Wow, that was perfect! You could stop a tome in your sleep by now, Nah! Congratulations!

Nah: Come at me anytime, anywhere!

Morgan (female): Anywhere? Hmm... then let's change things up again with...THIS!

Nah: Hnngh! OW, Morgan! Why did you throw the book at my gut?!

Morgan (female): It's a legitimate combat scenario! You need to be ready for arrows and other flying junk, too.

Nah: Morgan, it's called BLADE grasping! You're missing the point! Besides, I'm only worried about a Wyrmslayer here. Nobody's crazy enough to take a sword that rare and just chuck it at someone!

Morgan (female): Ah, right. Sorry. I guess I lost track of what we were doing here for a sec. ...Actually, wait a second. Nah, I'm just realizing this now, but...

Nah: Hmm?

Morgan (female): When you're in your dragon form... you have those short little arms, right? Can they even reach over your head?

Nah: What?! They... I...

Morgan (female): ...They're short, aren't they? ...By about four feet.

Nah: ...If not more. Wow, that's depressing. All those bumps on the noggin for nothing...

Morgan (female): Aww, don't get down. We'll just find another way! As long as we keep looking, we'll find a way to keep you safe from a Wyrmslayer!

Nah: ...Right. You're right. I'll keep thinking. Thank you, Morgan. It's great having a friend who's always so optimistic.

Morgan (female): Ha! That's about my only virtue, but thanks! So buck up, little camper! We'll beat this thing yet!

Nah: Right! Thanks, Morgan!

 Nah (Sisters)

■ NAH X MORGAN (FEMALE) (SISTERS) C

Morgan (female): Let's see here... Birthday? May 5th... Favorite colors? Blue and purple... Favorite food? Probably bear meat...

Nah: What are you mumbling about over there, Morgan?

Morgan (female): Least favorite food? Veggies, apparently. Don't seem to mind them now, though...

Nah: Hey! Don't ignore me!

Morgan (female): Oh! Nah?! Guess I was pretty out of it to miss my own sister paying a visit! Did you need something?

Nah: Just wondering what you were chanting over there... Are you practicing some new magic incantations or something?

Morgan (female): Nope! Just going back over my notes on what you told me about myself. I was hoping they'd hold some clue that might help spark my memory. Heh. It's kind of crazy how much you know about me, huh? Like, I really once got five nosebleeds in the same day? I have no memory of that at all. AT ALL! Ha ha ha! I can just imagine...

Nah: Well, you're still as cheerful, that's for sure. And as talkative as ever...

Morgan (female): I am? I mean, I was?! Hmm, now that you mention it, that does sound...right, somehow. ...Heh. Everything still feels funny. Even you being my sister hasn't really clicked.

Nah: If you think it's strange for you, imagine how I feel... My kid sister starts talking to me like a stranger, asking questions about herself... I had no idea how to even interact with you. It was pretty rough, but I got used to it.

Morgan (female): Heh, yeah... Sorry about that. But that's just another reason why I'm working hard to get my memories back. Once I do, nobody will have to feel weird or awkward around me again. Pretty noble, huh? I'm such a sweet, selfless girl!

Nah: Heh, and so humble as well... In any case, I'm happy to help you get those memories back however I can. Someday soon I bet we'll be able to laugh about all the old times—now included!

Morgan (female): Heh, right!

■ NAH X MORGAN (FEMALE) (SISTERS) B

Nah: Whew! Another long day of combat... I'm bushed. Think I'll hit the hay ear...ly? Is someone passed out over there? Wait, is that Morgan?!

Morgan (female): Nn...nngh...

Nah: Morgan! Morgan, are you all right?! What happened?!

Morgan (female): ...Wha—?! Nah! Wh-what am I doing here? Was I asleep?! I don't even remember feeling tired... Oh, right! I was bashing that huge tome against my head when I blacked out. That explains why my face hurts so bad...

Nah: Bashing your... Morgan, why in the WORLD would you do that?! Wait, were you trying to get your memories back?

Morgan (female): Well, yeah! Obviously. If you ever saw me bludgeoning myself just for fun, I hope you'd put a stop to it...

Nah: I'll stop you even if it's NOT just for fun, you nitwit! Look, I know you want your memories back, but please... Don't do anything reckless.

Morgan (female): ...But I want to be able to talk with you about old times again.

Nah: I know, Morgan, and I want that, too. But more than that, I want you safe. I may just be another stranger to you, but to me, you're family. In the future, with Mother and Father gone, it was just the two of us. You're all I had, Morgan... I don't know what I'd do if anything happened to you.

Morgan (female): All right. I'm sorry, Nah.

Nah: Just as long as you understand.

Morgan (female): ...Heh, that felt really siblingy just now. Don't you think? Me messing up and you scolding me felt... I don't know, it felt really plausible! Maybe if you keep it up, I'll remember something!

Nah: You...really think so?

Morgan (female): Yeah! Oh yeah, this will totally work! So go on, keep yelling! C'mon, scream at your amnesiac sister, Nah!

Nah: I... I'm not really comfortable with—

Morgan (female): Hey, why don't you use the tome, too? Come on, don't hold back. Really wallop me with that thing! Maybe the simultaneous physical and mental shock will jar some memories loose! It's gotta be twice as effective as either one by itself, right? That's just basic science.

Nah: Good night, Morgan...

■ NAH X MORGAN (FEMALE) (SISTERS) A

Nah: Hey, Morgan. I'm headed into town. Want to come along?

Morgan (female): I'd love to! Is there something in particular you need?

Nah: I might pick up a couple of things, yeah. But mostly I think there's something YOU need.

Morgan (female): It doesn't have to do with getting my memories back, does it?

Nah: The opposite, really. Maybe there's no need to worry about your memories.

Morgan (female): That...makes no sense.

Nah: I'll be honest—it does hurt to know you've forgotten me. But...maybe it would be better to build new memories than to worry about old ones.

Morgan (female): What do you mean?

Nah: I've been thinking about this a lot. Why you might have lost your memories, I mean. And I'm wondering if you didn't have some awful memory you couldn't bear to keep. ...I know I've got a few. I see a lot of faces, you know? People we couldn't save...

Morgan (female): I'm sorry you have to bear those dreadful memories, Nah...

Nah: Look, this is just a theory, and even if it's true, it's not like you did it consciously. But I do think that getting your memories back might not necessarily be a good thing.

Morgan (female): Hmm... I understand, and believe me, I appreciate the thought... But I want to remember things, no matter how painful they are. Because I'm sure there'll be plenty of great memories mixed with

the bad ones. And the truth, whatever it is... I really want to have that back, you know?

Nah: Well, if you're sure, then I'm happy to help.

Morgan (female): That's really kind of you, Nah, but do you truly realize what you're saying? I mean, it could be years before I remember anything. Or decades. Heck, there's a decent chance I may never get my memories back at all. I don't want to drag you into something that could last forever.

Nah: I'm already stuck with you forever, you goof. I'm your sister! We're family—memories or no. You couldn't keep me away.

Morgan (female): Nah, I... *sniff* Thank you! I'll do everything I can!

Nah: Then start by coming with me into town.

Morgan (female): Huh? But you said that doesn't have to do with getting my memories back.

Nah: Hey, there's no rule that says you can't have a little fun while you try. And there's certainly no rule against making some happy new memories, either. You're young! Live a little! There'll be plenty of time to worry later.

Morgan (female): Right... You're right! Thanks, Sis!

 Mother

■ MOTHER X MORGAN (FEMALE) C

Morgan (female): Hmm... I wonder why I have no memory of my mother... All my memories of Father are so crisp and clear... I remember what an amazing tactician he was, all the time we studied together... But nothing at all about my mother. It's one big blank.

Lissa: What's up, Morgan?

Sully: What are you up to, Morgan?

Miriel: Morgan?

Sumia: What are you up to, Morgan?

Maribelle: What are you doing, Morgan?

Panne: What are you mumbling about?

Cordelia: What are you up to, Morgan?

Nowi: Whatcha up to, Morgan?

Tharja: What are you doing?

Olivia: What are you up to, Morgan?

Cherche: What are you up to, Morgan?

Lucina: What are you up to, Morgan?

Say'ri: What are you doing here, Morgan?

Flavia: What are you up to, Morgan?

Anna: What are you up to, Morgan?

Kjelle: What are you up to, Morgan?

Cynthia: What's up, Morgan?

Severa: What are you up to, Morgan?

Noire: Eek! Morgan, what are you doing here?

Nah: What are you up to, Morgan?

Tiki: What are you up to, Morgan?

Emmeryn: ...M-Morgan?

Aversa: What are you doing, squirt?

Morgan (female): Mother! That's amazing! I was just thinking about you! Is this fate? This is totally fate! Family-style fate! ...Wait, no. How did Father put it? "We're not pawns of some scripted fate. It's the invisible ties we forge that bind us." So yeah, it's not fate. It's the whole invisible bond-link...thing!

Lissa: Hee hee! That's an interesting take.

Sully: Ha! Whatever you say.

Miriel: An unscientific analysis if ever I have heard one. But you seem convinced...

Sumia: Oh? That's wonderful!

Maribelle: Sure it is, dear. Sure it is.

Panne: If you say so...

Cordelia: Heh, is that so?

Nowi: Oh yeah? That's an interesting take!

Tharja: You don't say?

Olivia: Heh, is that so?

Cherche: Heh, is that so?

Lucina: Heh, is that so?

Say'ri: You don't say...

Flavia: Heh, is that so?

Anna: Mm, I do like bonds. And stocks.

Kjelle: Heh, is that so?

Cynthia: Wow! Pretty amazing, huh?

Severa: Um, okay? Whatever.

Noire: O-oh, really? That's great, dear.

Nah: Heh, is that so?

Tiki: Is that so?

Emmeryn: I...see.

Aversa: Well, I suppose that's...something.

Morgan (female): Yup! Even without my memories, there's an invisible thread that links us. Er, but that reminds me... I was just wondering how I could have possibly forgotten you, Mother. Do you think you could help me get those memories back?

Lissa: Hey, I'd be happy to try! After all—

Sully: Sure, I'd be happy to try. After all—

Miriel: I find your proposal acceptable.

Sumia: I'd be happy to try! After all—

Maribelle: Of course, darling. I'd be happy to.

Panne: I suppose I could make time. After all—

Cordelia: Of course, dear. I'd be happy to try. After all—

Nowi: Hey, sure! I'd be happy to try! After all—

Tharja: Well, I SUPPOSE I could spare the time.

Olivia: Of course, dear. I'd be happy to try. After all—

Cherche: Of course, dear. I'd be happy to try. After all—

Lucina: Of course, dear. I'd be happy to try. In fact, I—

Say'ri: Aye, of course, dear. I'd be glad to. After all—

Flavia: Of course! Leave it to me! After all—

Anna: I'd be happy to try! After all—

Kjelle: Sure, I suppose I could carve a little time from my training regi—

Cynthia: Sure! That sounds like fun.

Severa: Sure, why not? I was totally bored any—

Noire: Oh! Um, yes, of course. I mean—

Nah: I'd be happy to try! After all—

Tiki: Sure, I'd be happy to try. After all—

Emmeryn: I'd be...happy to...

Aversa: ...Oh, all right. If I must. After all—

Morgan (female): Yay! Thanks so much! I'll start preparing. Oh, I can't wait to get started!

Lissa: Boy, she sure is full of energy!

Sully: Well, she's certainly got energy to spare.

Miriel: She certainly is boisterous...

Sumia: Hee hee. She sure is energetic...

Maribelle: Well, she's an energetic one...

Panne: For only half a taguel, she sure was born with energy to spare...

Cordelia: She's certainly got energy to spare...

Nowi: Well, she's certainly got energy to spare...

Tharja: ...Sometimes I can't deal with that child.

Olivia: Well, she's certainly got energy to spare...

Cherche: Well, she's certainly got energy to spare...

Lucina: Heh. She's certainly got energy to spare.

Say'ri: She's certainly full of energy...

Flavia: She's certainly got energy to spare.

Anna: Well, she's certainly got energy to spare.

Kjelle: Wait! We still have time to spar!

Cynthia: She asked me for help! This is so exciting!

Severa: Gawds, she's so energetic...

Noire: Sh-she's so full of energy...

Nah: Whew... She sure is energetic...

Tiki: Such an energetic child...

Emmeryn: She's so...energetic...

Aversa: Heh. She's certainly full of energy, I'll give her that...

■ MOTHER X MORGAN (FEMALE) B

Morgan (female): Mother? Do you have a moment?

Lissa: For you? Of course!

Sully: Sure. What's up?

Miriel: I have no pressing engagements for the time being.

Sumia: For you, dear? Anytime.

Maribelle: For you, dear? Of course.

Panne: Yes. What is it?

Cordelia: For you, dear? Of course!

Nowi: For you, dear? Of course!

Tharja: If it's quick...

Olivia: For you, dear? Of course.

Cherche: For you, dear? Of course.

Lucina: For you? Of course.

Say'ri: Aye, of course.

Flavia: Of course, Morgan.

Anna: Yes, of course, dear. The shop's closed today.

Kjelle: Sure. What's up?

Cynthia: Of course!

Severa: I guess?

Noire: Of course, Morgan.

Nah: Of course.

Tiki: For you? Of course.

Emmeryn: Y-yes, of course...

Aversa: I suppose.

Morgan (female): Perfect! Then let's get started on Project Get Memories of Mom Back! Step one—figure out how we're going to bring back flashbacks. I've already tried banging my head against a post, but nothing. I mean, it made me dizzy and nauseated, but it didn't unearth any hidden memories. What do you think, Mother? Perhaps a stone wall would work better?

Lissa: Uh, for starters, I would recommend against the head-smashing thing. Why don't you try staring at me for a while? Maybe it'll help trigger something.

Sully: You know...that head-smashing thing? Maybe you should stop that. How about if you just tried staring at my ugly mug for a while?

Miriel: The human psyche has a demonstrated connection to facial images. Perhaps if you stared at me, it would aid in your recollection efforts.

Sumia: Let's just...hold off on the head smashing for now, okay? Now let's see... I know. What if you tried staring at me for a bit? Maybe that'll help!

Maribelle: First things first—no more head smashing, understood? Children these days, I swear... As for your dilemma... Have you considered just staring at my face for a while?

Panne: ...Or perhaps you could stop smashing your head and try staring at me instead.

Cordelia: Let's just...hold off on the head smashing for now, shall we? Perhaps you could try just staring at me for a bit? Maybe that'll trigger something.

Nowi: Umm, I'm not so sure that head-smashing thing is the greatest idea... Why don't you try staring at me? Maybe that'll help trigger something!

Tharja: Look, maybe you'd better take a break from all the head smashing, all right? Here, why don't you try staring at me for a bit? Maybe something'll come to you.

Olivia: Let's just...hold off on the head smashing for now, shall we? Now, this is a little embarrassing, but... maybe you could try staring at me?

Cherche: Let's just...hold off on the head smashing for now, shall we? Perhaps you could try just staring at me for a bit? Maybe that'll trigger something.

Lucina: Let's just...hold off on the head smashing for now, all right? I don't seem to have anything in stock that cures amnesia. Perhaps you could just try staring at me for a bit? Right into my eyes.

Say'ri: Let's pull back on the head smashing for now, shall we? Perhaps you could try staring at me for a bit? Right into my eyes.

Flavia: I think all that head smashing is going to turn you into an oaf. Why don't you try staring at me for a while? Maybe it'll help trigger something.

Anna: Let's just...hold off on the head smashing for now, shall we? Now let's see here... I don't seem to have anything in stock that cures amnesia. Perhaps you could try just staring at me for a bit? You know, right into my eyes.

Kjelle: Let's just...hold off on the head smashing for now, shall we? Perhaps you could try just staring at me for a bit? Maybe that'll trigger something.

Cynthia: Aw, dear? Let's not do the head-smashing thing anymore, all right? I know. Why don't you try staring at me for a while? Maybe that'll help!

Severa: Let's just...hold off on the head smashing for now, all right? I dunno. What if you tried staring at me for a while? Maybe it'll trigger something.

Noire: You know, I'd put a stop to all the head smashing if I were you... Anyway, hmm... Nothing comes to mind. How about staring at me for a while?

Nah: Let's just...hold off on the head smashing for now, okay? Perhaps you could try just staring at me for a bit? Maybe that'll trigger something.

Tiki: Let's put an end to the head smashing, shall we? No good will come of it. You know, faces from the past can sometimes trigger long-forgotten emotions. Why not try staring at mine for a while?

Emmeryn: Maybe you...could stare at me?

Aversa: Let's just...hold off on the head smashing for now, shall we? I guess you could try just staring at me? ...It works for men, anyway.

Morgan (female): Argh, that's perfect! You're a genius! I must have seen your face a million times in the future. It's bound to bring SOMETHING back if I stare at it long enough. Okay, sorry to invade your personal space here, but... Here goes... Drats! It's not working. I don't remember a thing. It's like... Have you ever stared at a word so long it kind of fell apart? And you think, "Is that how that's spelled? Wait, is that even a real WORD?!" Except here it's "Is that what Mother looked like?"

Lissa: Oh, boy... Listen, maybe that's enough of the memory project for one day, okay?

Sully: Er, right. Perhaps that's enough of the memory project for one day.

Miriel: Er, right. Dear, perhaps we should put this memory experiment on hold for the moment.

Sumia: Ooookay, then... Maybe that's enough of the memory project for today, dear.

Maribelle: Er, right. Perhaps that's enough of the memory project for one day?

Cordelia: Er, right. Perhaps that's enough of the memory project for one day?

Nowi: Er, riiight. Listen, maybe we should put this memory project to bed for today?

Tharja: *Sigh* Perhaps that's enough of the memory project for one day.

Olivia: Er, right, dear. Perhaps that's enough of the memory project for one day?

Cherche: Er, right. Perhaps that's enough of the memory project for one day?

Lucina: Er, right. Perhaps that's enough of the memory project for one day?

Say'ri: Right... Well, dear, perhaps that's enough of the memory project for one day?

Flavia: Er, right. Perhaps that's enough of the memory project for one day?

Anna: Er, right. Perhaps that's enough of the memory project for one day?

Kjelle: Er, right. Perhaps that's enough of the memory project for one day?

Cynthia: Um...sure? Anyway, maybe that's enough of the memory project for today, hmm?

Severa: Er, right. Perhaps that's enough of the memory project for one day?

Noire: Er, right. Maybe that's enough of the memory project for one day?

Nah: Er, right. Maybe that's enough of the memory project for one day?

Tiki: Er, right. Perhaps that's enough of the memory project for one day?

Emmeryn: Maybe...you should take...a break... for today...

Aversa: Er, right. Maybe that's enough of the memory project for one day, hmm?

Morgan (female): Sure... I'm still a little dizzy from banging the post earlier, to be honest... But this doesn't end here! I'm not giving up until I remember you, Mother!

■ MOTHER X MORGAN (FEMALE) A

Morgan (female): *Sigh* No luck today, either... I'm going crazy trying to remember you. I feel so useless! I'm just so... *sniff* Why can't I... *sob*

Lissa: Aw, come on, Morgan. Don't cry.

Sully: Come on, now. Stop crying.

Miriel: Morgan, I fail to see the reasoning behind such a pitiful display. Dry your eyes.

Sumia: Come now, Morgan. No tears.

Maribelle: Come now, darling. No tears.

Panne: Please, stop. Do not cry.

Cordelia: Come now, Morgan. No tears.

Nowi: Aw, come on, Morgan. Don't cry.

Tharja: Aw, you're crying now? Wonderful...

Olivia: Aw, don't cry, dear. It's okay!

Cherche: Come now, Morgan. No tears.

Lucina: Come now, Morgan. No tears.

Say'ri: Come now, Morgan. No tears.

Flavia: Now, now, Morgan. Don't you start crying on me...

Anna: Come now, Morgan. No tears.

Kjelle: Hey, come on, Morgan. Don't cry.

Cynthia: Aw, come on, Morgan. Don't cry

Severa: Oh, please. Stop crying.

Noire: Come now, Morgan. No tears...

Nah: Come now, Morgan. Don't cry.

Tiki: Come now, Morgan. No tears.

Emmeryn: Don't...cry...

Aversa: Come now, Morgan. Is this REALLY worth crying over?

Morgan (female): B-but I know I must have loved you just as much as I loved Father. I bet we had a million memories together, and the thought of having lost them... I feel like I failed you. Like I... Like I... *sob*

Lissa: Morgan...

Sully: Morgan...

Miriel:

Sumia: Morgan...

Maribelle: Morgan...

Panne:

Cordelia: Morgan...

Nowi: Morgan...

Tharja:

Olivia: Morgan...

Cherche: Morgan...

Lucina: Morgan...

Say'ri: Morgan...

Flavia: Morgan...

Anna: Morgan...

Kjelle: Morgan...

Cynthia: Morgan...

Severa:

Noire: Morgan...

Nah: Morgan...

Tiki: Morgan...

Emmeryn: Morgan...

Aversa: For the love of the gods, child, pull yourself together.

Morgan (female): *Sniff* S-sorry. I guess I got a little carried away there... Ngh! M-my head!... Wha—?!

Lissa: What's wrong?!

Sully: What's wrong?!

Miriel: What is the matter?!

Sumia: What's wrong?!

Maribelle: What's wrong?!

Panne: What's wrong?!

Cordelia: What's wrong?!

Nowi: What's wrong?!

Tharja: What now?

Olivia: What's wrong?!

Cherche: What's wrong?!

Lucina: What's wrong?!

Say'ri: What is it?!

Flavia: What's wrong?!

Anna: What's wrong?!

Kjelle: What's wrong?!

Cynthia: What's wrong?!

Severa: What's wrong?!

Noire: Eek! Wh-what's wrong?!

Nah: What's wrong?!

Tiki: What's wrong?!

Emmeryn: What's...wrong?

Aversa: What now?!

Morgan (female): I...I remembered something! Just one tiny little memory, but...I remember! You were smiling at me...and you called my name... Ha ha! Yes! You looked a little bit older, but it was DEFINITELY you! Oh thank you, Mother. I never would have remembered without your help. And hey, this is great! If I can get one memory back, maybe I can get the rest! It may take time, but I won't stop trying until I remember everything about you.

Lissa: Take all the time you need, Morgan. I'll help out however I can!

Sully: Take all the time you need. I'll always be here for you... You know that, right?

Miriel: Take all the time you need. And I promise to continue to rigorously assist you in these efforts.

Sumia: Take all the time you need, dear. I'll help out in any way I can.

Maribelle: You just take all the time you need, dear. Mother will always be here for you.

Panne: Then I'll do my best to help you.

Cordelia: Take all the time you need. I'll always be here for you... You know that, right?

Nowi: Sounds great! Take all the time you need—I'll be around for sure!

Tharja: Well... good luck with that.

Olivia: Take all the time you need, dear. I'll always be here for you... You know that, right?

Cherche: Take all the time you need. I'll always be here for you... You know that, right?

Lucina: Take all the time you need. I know things'll turn out just fine, Morgan.

Say'ri: Take all the time you need. I'll always be here for you... You know that, right?

Flavia: You're my daughter, Morgan—I have every confidence you can do this! And of course, I'll be there with you the whole way.

Anna: Take all the time you need, dear. I'm not going anywhere!

Kjelle: That's great, dear. Take all the time you need. I'll always be here for you.

Cynthia: Take all the time you need, dear. I'll help out however I can!

Severa: And I suppose you want me to keep helping, right? ...Oh, all right. Sheesh.

Noire: Take all the time you need. I'll always be here for you, dear...

Nah: Take all the time you need, dear. I'll always be here for you.

Tiki: Take all the time you need. I'll always be here for you... Yes?

Emmeryn: I'm so...happy...

Aversa: Take all the time you need, Morgan. I'm not going anywhere...

Morgan (female): Aw... Thanks, Mom.

Yarne

Avatar (male)

The dialogue between Avatar (male) and Yarne can be found on page 226.

Avatar (female)

The dialogue between Avatar (female) and Yarne can be found on page 237.

Panne (Mother/son)

Yarne's mother/son dialogue with Panne can be found on page 271.

Lucina

The dialogue between Lucina and Yarne can be found on page 284.

Brady

The dialogue between Brady and Yarne can be found on page 296.

Kjelle

The dialogue between Kjelle and Yarne can be found on page 299.

Cynthia

The dialogue between Cynthia and Yarne can be found on page 302.

Severa

The dialogue between Severa and Yarne can be found on page 304.

Morgan (male)

The dialogue between Morgan (male) and Yarne can be found on page 309.

Morgan (male) (Father/son)

The father/son dialogue between Morgan (male) and Yarne can be found on page 309.

Morgan (female)

The dialogue between Morgan (female) and Yarne can be found on page 310.

Morgan (female) (Brother/sister)

The brother/sister dialogue between Morgan (female) and Yarne can be found on page 311.

Laurent

■ LAURENT X YARNE C

Yarne: Ugh. I reeeally don't want to fight today.

Laurent: What are you doing here, Yarne?

Yarne: Ack! L-Laurent?!

Laurent: Preparations for the coming battle are underway. The others are waiting.

Yarne: Yeaah, I'd love to go, but my, uh... My stomach is just killing me!

Laurent: Then why are you clutching your head?

Yarne: I meant head!

Laurent: If you're going to malinger, put some effort into it. Now come along.

Yarne: I'm not! It's the change of the seasons! Us taguel suffer from migration headaches!

Laurent: *Sigh* I'm disappointed in you, Yarne. I know you abhor fighting, but I thought you above juvenile antics and feigned illness.

Yarne: I'm not faking anything! I just really don't feel well today, all right?! I'll have you know I'm a great fighter! I could beat anybody if I wanted to!

Laurent: Judging by the fervor of your shouting, your headache is in remission. Shall we join the others, then?

Yarne: What?! I... No, I think I...I pulled my spleen in that outburst! I've got a trick liver! Runner's elbow! The grippe! Sleeping sickness! ...Ugh, fine. Wait up.

■ LAURENT X YARNE B

Laurent: Yarne? We need to speak.

Yarne: Well, that doesn't sound foreboding at all...

Laurent: Halfway through the last battle, you elected to disregard orders and flee.

Yarne: I... er... I can see how it would look that way, but there was a really good reason for—

Laurent: I have no interest in your excuse. Are you aware that your actions bear repercussions for the rest of us?

Yarne: Sure, but I, uh...I twisted my septum! I'd have only gotten in the way.

Laurent: You sprained your nose? ...Really?

Yarne:Yes?

Laurent: Chrom gave you orders with the expectation you would carry them out. He trusted you. Are you content to blithely betray others' faith in you?

Yarne:

Laurent: I fear I've passed disappointment and find myself between astonishment and disgust.

Yarne: Hey, who do you think you are to judge me, anyway?! You're not Chrom, so don't go speaking for him! You make it sound like you know best for everybody, but you don't know a thing!

Laurent:

Yarne: And you definitely don't know what it's like to be me! Sure, I'm not the bravest guy around, but did you ever stop to wonder why that is? If I go charging out into combat and make one mistake, an entire race goes extinct! I hold back because I have to, all right? So stop presuming and just back off!

Laurent: There we are. Excellent.

Yarne: ...What's excellent?

Laurent: I hypothesized that there was fire in you, so I stoked it. You've proven me correct. If you nurture that fire and preserve it, you need never lack for courage in battle.

Yarne: What?!

Laurent: Your enemy isn't cowardice so much as inertia. Your legitimate quest for self-preservation has become a habit. An obstacle.

Yarne: Wait, so all that stuff you said... You were trying to make me mad?

Laurent: A regrettable necessity. But I think the results speak for themselves. You aren't wrong to approach battle with trepidation, of course. The risks are real. But given your fire and connate combat prowess as a taguel, you will manage.

Yarne: You make it sound so simple. But war isn't so cut and dry...

Laurent: I'm afraid it's time we joined the others. Battle calls! Fight bravely, Yarne. I have the utmost faith in you.

Yarne: Maybe I'll... Hey, Laurent, why are you grabbing my— Ow! Quit tugging! My race needs that arm!

■ LAURENT X YARNE A

Yarne: Ugh, I'm sore. Guess I went a little overboard out there.

Laurent: Yarne!

Yarne: G-go easy, Laurent! I actually tried my—

Laurent: You were superb!

Yarne: ...What, that's it? No lecture?

Laurent: What's to lecture about? Your performance was beyond reproach. You were unanimously pronounced the hero of yesterday's battle.

Yarne: Hey, all I did was play decoy. Everyone else did the real work.

Laurent: You're too modest! Yours was the most critical role, and the most dangerous. And you saw it through brilliantly. Truly, an impressive performance.

Yarne: Well hey, if you say so! It feels pretty good to hear that from you.

Laurent: I knew that you could manage any challenge if you shed your habit of running.

Yarne: And I said I was a great fighter when I really got serious!

Laurent: I'm pleased that day has finally come. Now you need only preserve this momentum for future battles!

Yarne: Future...battles?

Laurent: Just so. Anyone able to execute orders as exacting as yesterday's is a great asset. I'm certain Chrom will be making extensive use of your skills in the days to come.

Yarne: Er, but...what about days when my stomach's acting up?

Laurent: Worry not. I've already given word to everyone on the cooking rotation. You'll be served a special gruel specially prepared for maximum ease of digestion.

Yarne: Bleagh... Wh-what about my insomnia? My migration headaches?

Laurent: I'll be by your tent each night to put you to bed. By magic or blunt trauma, as needed. Also, "migration headaches" aren't a thing.

Yarne: My trick liver!

Laurent: ...Can be removed.

Yarne: Eek!

Laurent: Now, now. Cheer up, Yarne. And walk while you do it or we'll be late for today's battle.

Yarne: I get the feeling staying angry won't be hard with you around, Laurent...

Noire

■ NOIRE X YARNE C

Yarne: *Huff* *pant* N-Noire! You've got to...h-help me!

Noire: Eeep! Y-Yarne, what's wrong? You look like you've seen a ghost!

Yarne: Long story! No time! Very convoluted! You've just gotta hide me!

Noire: Er, there's a blanket in the corner you can hide under if you want?

Yarne: ...Wait, that's it? No questions asked? You'll just help?

Noire: Er, you said it was convoluted and there wasn't time. But if you want to tell me, I'm happy to—

Yarne: Thanks, Noire. I owe you one!

Noire: Don't mention it. But since you offered, maybe you could tell me—

Yarne: Shhh! I think someone's coming!

NOIRE X YARNE B

Yarne: Hey, Noire! I brought you a little treat today.

Noire: Oh, is that a fruit tart? It looks scrumptious! This must have been hard to find, given the state of things. What's the occasion?

Yarne: It's a thank-you for before. When you hid me?

Noire: Oh geez! You didn't have to bring anything! I just threw an old blanket on you!

Yarne: Tut tut! I won't hear it. You really saved my bushy tail, so let me repay you.

Noire: Well, if you're sure, then thank you. Would you care to join me? I could get us something to drink... Oh, wait! We have those simulated combat drills today... Darn. There won't be enough time to enjoy this tasty tart.

Yarne: Oh... B-but...I've already done mine! Yep! That's it! I'm sure Mother always said, the early rabbit gets the...thingy! Heh heh...

Noire: I...see? Well, in that case...

Yarne: A-anyway, let's eat! I'm ready to forget all about those drills.

Noire: They do say that sweets help to ease the body after physical exertion.

Yarne: Y-yeah...

NOIRE X YARNE A

Yarne: Hey, Noire! I brought some cake this time! Want to split it with me?

Noire: I'd love to, but I'm afraid I can't. I have to prepare for combat.

Yarne: You're fighting in the next battle?

Noire: I am.

Yarne: ...Ah. I see.

Noire: For all my faults, the others still trust me enough to rely on me...

Yarne: But aren't you scared?

Noire: Of course I am! Even now, my hands are shaking...

Yarne: Then why force yourself? Wouldn't it be easier to just stay here and—

Noire: It would, but I don't want to do what's easy. I want to do what's right. ...Yarne, if you don't want to fight, you don't have to. I won't judge you. I don't want to go out there either.

Yarne: Then why go?!

Noire: B-because we have to win this war, and it's time for me to make a stand! So, yeah. I'm scared, but I'm going.

Yarne: Noire...

Noire: She's so tiny. And she's trembling, for crying out loud! ...Gods, what a craven. I'm in here hiding while she fights for a better future. That's it! No more being a coward! I'm volunteering for today's battle too! Hey, Noire, wait up! I'm coming tooooo!

NOIRE X YARNE S

Noire: Combat again? I'm already shaking... But if there's some way I can help, I need to muster up the courage to do it!

Yarne: H-hey, Noire!

Noire: Yarne?

Yarne: I'll go with you. I'll fight today.

Noire: You've been volunteering to fight a lot lately. Is everything all right?

Yarne: It's fine. I just... Watching you suit up and head off to battle made me realize I needed to shape up. No more hiding in your tent because I'm too scared to fight! No more skipping out on training with lies and tarts! Er, although the tart was very good... Anyway, no more being a chicken is what I'm saying. I'm fed up with being that guy.

Noire:

Yarne: And that's why I'm fighting with you!

Noire: I'm really glad, Yarne.

Yarne: I'm sorry you had to watch me act like such a craven. That must have been frustrating. How come you never stood up and gave me what for like you usually do? You know? "Blood and thunder" and all that?

Noire: Hee hee. Because I didn't have to! If I yelled, you would have run away. Guilt was far more effective.

Yarne: Wait, so all that trembling was an act? ...Oh, you're good. AND you know me far too well! I love that about you, you know? How attentive you are...especially about me. In fact, I just love you, period. I always wanted to tell you, but I was too... Well, you know.

Noire: Yarne...

Yarne: Look, this is nuts, but would you be my girl? Once the war's over, I mean?

Noire: Oh, Yarne. I've always hoped you thought as much. That's the real reason I never got mad at you, you know? Because...I love you, too. But I had to be sure you'd do what was right for you on your own terms.

Yarne: Thanks, Noire.

Noire: Hee hee! Don't thank me for loving you! That's just weird.

Yarne: No, I mean, thanks for giving me one more thing to fight for. Plus, this war will be less scary knowing we're both there to keep each other safe. So let's get out there and kick some heinie!

Noire: I'm right beside you!

Nah

NAH X YARNE C

Nah: Huh? Is that...Yarne?

Yarne: Haaaaaah...

Nah: Whoa, what was that? Some kind of secret taguel focus training?

Yarne: It was a sigh.

Nah: That was pretty impressive for a sigh. I thought it was part of an ancient form of meditation or something.

Yarne: You've got some imagination, Nah. I guess the world looks different when you can turn into a dragon. ...Gods, I'm so jealous.

Nah: What? Where did that come from?

Yarne: Nah, can you blame me? There's the claws, and the fangs, and the breath, and the part where you're all huge! Who wouldn't be jealous of all that?

Nah: Hey, us dragons have our share of problems too! You're a pretty obvious target when you're as big as a barn!

Yarne: Yeah, I guess. But still...

Nah: Besides, you can transform, too!

Yarne: Yeah, into a rabbit! Not exactly feared as nature's deadliest killers, are they?

Nah: Maybe not, but they're quicker than most. That makes them perfect for quick tactical strikes and diversionary runs. I mean, come on. Bunnies have their strengths.

Yarne: Calling them "bunnies" is not helping. Ugh, let's not talk about it. It's depressing.

Nah: You were the one who brought it up!

NAH X YARNE B

Yarne: HAAAAAAH!

Nah: Okay, that one HAD to be secret taguel focus training!

Yarne: Nope! Still just a sigh.

Nah: Who sighs that aggressively? I thought you were channeling energy to smash a boulder or shoot fire or something.

Yarne: It won't be the last time I disappoint you, I'm sure...

Nah: Geez. You're a real downer, you know that? So what's the problem? Tell me. Manaketes and taguel are practically cousins, so I'm sure I'd understand.

Yarne: I was just thinking how much I hate fighting and how I wish the war were over already.

Nah: It sounds like someone needs to get in touch with his inner warrior.

Yarne: What makes you think I even have one?

Nah: You're a taguel! Your people have always been fighters, the same as us manaketes. If you can tap into that innate clan instinct, you'll be a whirlwind of death in no time.

Yarne: But it's also up to me to keep that clan alive. If I die, we go extinct.

Nah: I agree, that's a weighty responsibility. But this war could just as easily kill you whether you fight or not.

Yarne: And this is supposed to encourage me how?

Nah: If you're not truly safe either way, why not stop worrying and fight like a taguel?

Yarne: If it were that easy to just stop worrying, we wouldn't be having this conversation.

Nah: Grow a spine, Yarne! Gods! I'm half your size, and I'M fighting!

Yarne: Yeah, until you turn into a dragon! Then you're nine times my size! You know what? This is dumb. We're not the same at all! Plus, there are other manakete out there if something happens to you! So quit talking like you have any idea what it's like!

Nah:

Yarne: Nah... Look, I'm sorry. I should go.

Nah: Yarne, wait.

Nah: ...See you around, I guess.

NAH X YARNE A

Yarne: I still feel bad for barking at Nah like that. I should probably go apologize. Let's see... Is this her tent? Yeah, I think so... Yarne? Nah? Is this a good time?

Soldier: Aw, cheese it, boys! We got company!

Yarne: Wh-who are you people?!

Nah: Nnngh! NNNNNGH!

Yarne: Nah, you're going to have to enunciate if you want me to— ...Wait a sec, is this a kidnapping?!

Soldier: Oy, he's seen us! Gut him like a fish, boys! Gya ha ha!

Yarne: You can try, scum!

Yarne: You all right, Nah? You seem pretty shaken up.

Nah:

Yarne: That was pretty bold of those bandits to sneak into the camp like that... They must have thought you were just some kid they could sell into slavery. Monsters!

Nah: ...Th-thank you.

Yarne: Don't be silly! I, uh...I'm glad to lend a hand. ...Surprised you needed my help, though. I would think a couple scraggly bandits would be a quick snack for a dragon.

Nah: They snuck up and grabbed me from behind. I reached for a dragonstone, but...

Yarne: No worries. Happens to all of us from...um... time to time.

Nah: I'm just so glad you came...

Yarne: Y-yeah... Me, too.

Nah: I've never seen you that fierce. I didn't know you had it in you!

Yarne: Heh. Neither did I, honestly!

Nah: I was just...so scared. Even now, when I think of what could have happened...

Yarne: Hey, believe me, I'm the last guy to blame anyone for being scared. But you're safe now, thanks to a certain killer bunny!

Nah: You know, you really were amazing...

Yarne: Aw, it's nothing anyone else wouldn't have done. But if you're ever in trouble again, you know you can count on me.

Nah: I will!

Yarne: ...Sweet carrots! It feels good to play the hero for a change.

NAH X YARNE S

Yarne: Nah, I—

Nah: Eek!

Yarne: Whoa, hey, it's just me! It's Yarne! What's with the scream?

Nah: O-oh, I'm... I'm sorry, Yarne.

Yarne: Are you still shook up from those dumb bandits? I'd been wondering. I've heard the others say you've been jumpy lately.

Nah: I can't help it. I know it's silly, but I still get nightmares. Crazy, right? I mean, I'm a manakete! But now I can't even sleep without seeing kidnappers everywhere. It's stupid... I'm stupid.

Yarne: You're not stupid, Nah! It was a terrible experience, you know? Have you talked to anyone else about this?

Nah:

Yarne: I guess it's tough to come out and say a giant dragon is afraid of bandits, huh? Look, nobody will ever laugh at you for it, but I won't pressure you. However, I WILL promise to keep you safe! I'll stand guard by your tent if I have to.

Nah: What?

Yarne: No one deserves to live their life in fear, no matter how strong they are.

Nah: You really mean that?

Yarne: Of course! So rest easy. I'm here for you.

Nah: That's so kind... I'm...I'm so grateful, but... *sniff* But I can't ask you to—

Yarne: Hey, don't cry. It's just what you do for...the girl that you love.

Nah: What?

Yarne: It spooked me so bad when I saw them try to take you. I think that's when it hit me... I'd fight anyone to keep you safe, Nah. I never want to lose you.

Nah: Oh, Yarne! You're my hero!

Yarne: Nah, I guess I owe those bandits one.

Nah: Oh, don't even— That's awful!

Yarne: Heh. Funny to think about, though, isn't it? A cuddly bunny rabbit protecting a dragon? Heh heh... Ha ha ha!

Nah: ...Hee hee! Yeah...maybe just a bit. Oh, c'mere, cuddles!

Father

FATHER X YARNE C

Yarne:

[Robin]: Um, Yarne? Is there a reason you're staring at me like that?

Frederick: What is it, Yarne? Why are you staring at me like that?

Virion: I say, Yarne. Is there a reason you're gawking at me like that?

Vaike: Um, Yarne? Why are you starin' at me like that?

Stahl: Um, Yarne? Is there a reason you're staring at me like that?

Kellam: Um, Yarne? Is there a reason you're staring at me like that?

Lon'qu: ...Yarne, what are you staring at?

Ricken: Um, Yarne? Is there a reason you're staring at me like that?

Gaius: Yarne, why are you staring at me like that? Do I have sugar on my face?

Gregor: Yarne, why do you stare at Gregor so?

Libra: Um, Yarne? Is there a reason you're staring at me like that?

Henry: Hey, Yarne? Is there a reason you're staring at me like that?

Donnel: Um, Yarne? Is there a reason yer starin' at me like that?

Yarne: I'm trying to read your face and find out if you're cheating on Mother.

[Robin]: Wh-what?! Cheating? I'd never do such a thing! I've been faithful to Panne since the day I proposed!

Frederick: Wh-what?! Cheating? I would never do such a thing! I've been faithful to Panne since the day I proposed!

Virion: Wh-what?! Cheating? I would never do such a thing! I have been faithful to Panne since the day I proposed!

Vaike: Wh-what?! Cheatin'?! I'd never do such a thing! Ol' Vaike's been faithful to Panne since the day I proposed!

Stahl: Wh-what?! Cheating? I'd never do such a thing! I've been faithful to Panne since the day I proposed!

Kellam: Wh-what?! Cheating? I'd never do such a thing! I've been faithful to Panne since the day I proposed!

Lon'qu: What?! Cheating? I'd never do such a thing! You know Panne is the only woman I can stand to be near.

Ricken: Wh-what?! Cheating? I'd never do such a thing! I've been faithful to Panne since the day I proposed!

Gaius: What?! Cheating? I'd never do such a thing! I've been faithful to Panne since the day I proposed!

Gregor: Wh-what?! Cheating? Gregor never do such thing! Gregor has been faithful to Panne since day of proposal!

Libra: By the gods, Yarne! Cheating? I'd never do such a thing! I've been faithful to Panne since the day I proposed!

Henry: Wh-what?! Cheating? I'd never do such a thing! I've been faithful to Panne since

Donnel: Wh-what?! Cheatin'? I'd never do such a low-down thing! I've been faithful to yer ma since the day I proposed!

Yarne: Oh, all right then... IF you're telling the truth...

[Robin]: Why would you think I was cheating?! ...Is someone spreading rumors?

Frederick: Why would you think I was cheating? ...Is someone spreading rumors?

Virion: Why would you think I was cheating? ...Is someone spreading rumors?

Vaike: Why would ya think I was cheatin'? ...Is someone spreadin' rumors?

Stahl: Why would you think I was cheating?! ...Is someone spreading rumors?

Kellam: Why would you think I was cheating?! ...Is someone spreading rumors?

Lon'qu: Why would you think I was cheating?! ...Is someone spreading rumors?

Ricken: Why would you think I was cheating?! ...Is someone spreading rumors?

Gaius: Why would you think I was cheating?! ...Is someone spreading rumors?

Gregor: Why you think Gregor make with the cheating? Is someone spreading rumor?

Libra: Why would you think I was cheating?! ...Is someone spreading rumors?

Henry: Why would you think I was cheating?! ...Is someone spreading rumors?

Donnel: Why would ya think I was cheatin'? ...Is someone spreadin' gossip?

Yarne: Thirteen yesterday, eight the day before. You know what I'm talking about?

[Robin]: Um... The number of masterful blows I struck against our foes?

Frederick: Um... The number of masterful blows I struck against our foes?

Virion: The number of times I looked upon my beautiful visage in the mirror?

Vaike: Um... The number of times I lost my axe?

Stahl: Um... The number of masterful blows I struck against our foes?

Kellam: Um... The number of masterful blows I struck against our foes?

Lon'qu: The number of decisive blows I struck against our foes?

Ricken: Um... The number of masterful blows I struck against our foes?

Gaius: Um... The number of sweets I ate per hour?

Gregor: Um... The number of killing blows Gregor strike against puny foes?

Libra: Hmm... The number of times I knelt down in prayer?

Henry: Um... The number of fatal curses I slung upon our foes?

Donnel: Um... The number of crushin' blows I done struck against our foes?

Yarne: NO! The number of times you spoke to a woman who WASN'T my mother! To think I actually believed you when you said you had no intention of cheating! You have no self-control at all, and I'm going to vanish as a result! I just know it!

[Robin]: Yarne, calm down. I was just being polite. Pleasantries and tactics and such.

Frederick: Yarne, calm down. I was just being polite. Pleasantries and tactics and such.

Virion: Yarne, please. I was just being polite. Pleasantries and tactics and such.

Vaike: Yarne, take it easy! I was just bein' polite. Ya know, pleasantries and tactics and stuff.

Stahl: Yarne, calm down. I was just being polite. Pleasantries and tactics and such.

Kellam: Yarne, calm down. I was just being polite. Pleasantries and tactics and such.

Lon'qu: Yarne, settle down. I was just being polite. They approached me and I responded.

Ricken: Yarne, calm down. It wasn't anything bad. They think of me as a cute little kid...

Gaius: Yarne, relax. I was just being polite. Pleasantries and tactics and such.

Gregor: Yarne, please to be relaxing. Gregor was just being polite.

Libra: Yarne, calm down. I was just being polite. Pleasantries and tactics and such.

Henry: Easy, Yarne. I was just being friendly. Pleasantries and tactics and all.

Donnel: Yarne, cool down. I was just bein' polite. Pleasantries and tactics and all.

Yarne: It sounded like more than that to me! Remember, taguel have excellent hearing.

[Robin]: *Sigh* Believe me, I know all about that... But you have to understand, I must talk to my fellow soldiers—men and women both. When you're in the thick of a battle, it's vital you know who you're fighting with. I mean, what if someone said you couldn't talk to Lucina ever again?

Frederick: *Sigh* Believe me, I know all about that... But you need to understand, I must talk to my fellow soldiers—men and women both. When you're in the thick of a battle, it's vital you know who you're fighting with. Think about it—what if someone said you couldn't talk to Lucina ever again?

Virion: Y-you were listening?! Er, I mean... But you have to understand, I must talk to my fellow soldiers—men and women both. When you're in the thick of a battle, it's vital you know who you're fighting with. I mean, what if someone said you couldn't talk to Lucina ever again?

Vaike: *Sigh* Believe me, I know all about that... But ya gotta understand, I need to talk to my fellow soldiers—men and women both. When you're in the thick of a battle, it's vital ya know who you're fighting with. I mean, what if someone said ya couldn't talk to Lucina ever again?

Stahl: *Sigh* Believe me, I know all about that... But you have to understand, I must talk to my fellow soldiers—men and women both. When you're in the thick of a battle, it's vital you know who you're fighting with. I mean, what if someone said you couldn't talk to Lucina ever again?

Kellam: *Sigh* Oh, believe me, I know all about that... But you have to understand, I must talk to my fellow soldiers—men and women both. When you're in the thick of a battle, it's vital you know who you're fighting with. I mean, what if someone said you couldn't talk to Lucina ever again?

Lon'qu: *Sigh* Believe me, I know all about that... But you need to understand, talking to my fellow soldiers—even women—is key. When you're in the thick of a battle, it's vital you know who you're fighting with. Think about it—what if someone said you couldn't talk to Lucina ever again?

Ricken: *Sigh* Believe me, I know all about that... But you have to understand, I must talk to my fellow soldiers—men and women both. When you're in the thick of a battle, it's vital you know who you're fighting with. I mean, what if someone said you couldn't talk to Lucina ever again?

Gaius: *Sigh* Believe me, I know all about that... But you have to understand, I must talk to my fellow soldiers—men and women both. When you're in the thick of a battle, it's vital you know who you're fighting with. I mean, what if someone said you couldn't talk to Lucina ever again?

Gregor: Oy, Gregor know all about that... But please understand, Gregor must talk to fellow soldiers—men and women both. When in thick of battle, it is important to know one's comrades, yes? What if someone said you could not talk to Lucina again? Hmm?

Libra: Believe me, I know all about that... But you have to understand, I must talk to my fellow soldiers—men and women both. When you're in the thick of a battle, it's vital you know who you're fighting with. I mean, what if someone said you couldn't talk to Lucina ever again?

FATHER X YARNE B

Yarne: Ah. Hello, Father.

[Robin]: What's wrong, Yarne? You look as if your world is about to end.

Frederick: What's wrong, Yarne? You look as if your world is about to end.

Virion: What's wrong, Yarne? You look as if your world is about to end.

Vaike: What's wrong, Yarne? Ya look like your world's about to end.

Stahl: What's wrong, Yarne? You look as if your world is about to end.

Kellam: What's wrong, Yarne? You look as if your world is about to end.

Lon'qu: What's the matter, Yarne? You look as if your world's about to end.

Ricken: What's wrong, Yarne? You look like your world's about to end.

Gaius: What's wrong, Yarne? You look like someone stole your dessert.

Gregor: What is wrong, Yarne? You look like dog stole your lunch.

Libra: What's wrong, Yarne? You look as if your world is about to end.

Henry: What's wrong, Yarne? You look like someone painted your coffin white.

Donnel: What's wrong, Yarne? Ya look sadder'n a pig without slop.

Yarne: Nope. The idea just popped into my head the other day. You see, I got to thinking... What would happen to me if you suddenly decided Mother wasn't good enough?

[Robin]: Huh?

Frederick: Huh?

Virion: Huh?

Vaike: Huh?

Stahl: Huh?

Kellam: Huh?

Lon'qu: ...Huh?

Ricken: Huh?

Gaius: Huh?

Gregor: Gregor is...confused.

Libra: Huh?

Henry: Huh?

Donnel: I reckon I don't rightly know.

Yarne: See, I'd been assuming that all I had to do was make sure you both stayed alive. Eventually you'd have me, and poof! My existence would be guaranteed. But that would all change if you left Mother for another woman before I was born. The very instant you made the decision, I would just wink out of existence! The thought of it sends a chill down my spine. Brrrrr...

[Robin]: ...Huh. I guess I see your point.

Frederick: ...Huh. I guess I see your point.

Virion: ...Huh. Perhaps I see your point.

Vaike: ...Huh. I guess I see your point.

Stahl: ...Huh. I guess I see your point.

Kellam: Huh. I guess I see your point...

Lon'qu: This is ridiculous...

Ricken: ...Huh. I guess I see your point.

Gaius: ...I suppose you've got a point.

Gregor: ...Hmm. You make decent point.

Libra: ...Huh. I guess I see your point.

Henry: Nya ha! Yeah, that would stink, eh?

Donnel: ...Gosh. I guess I see yer point.

Yarne: So I'm going to be keeping a VERY close eye on you to make sure you toe the line!

[Robin]: Now hold on just one minute!

Frederick: Now hold on just one minute!

Virion: Now hold on just one minute!

Vaike: Now hold on just a minute!

Stahl: Now hold on just one minute!

Kellam: Now hold on just one minute!

Lon'qu: Now hold on just one minute!

Ricken: Now hold on just one minute!

Gaius: Now hold on just one minute!

Gregor: Now hold on one minute!

Libra: Now hold on just one minute!

Henry: Now hold on just one minute!

Donnel: Now wait just a cotton-pickin' minute!

Yarne: Don't worry, I'll make an exception for temporary dalliances during battle. ...Just so long as the fraternizing STAYS on the battlefield! Anyway, I've got to be going. But remember: I'm watching you!

[Robin]: Oh, for gods' sake...

Frederick: Oh, for gods' sake...

Virion: Oh, for gods' sake...

Vaike: Oh, for gods' sake...

Stahl: Oh, for gods' sake...

Kellam: Oh, for gods' sake...

Lon'qu:

Ricken: Oh, for gods' sake...

Gaius: ...The heck was all that about?

Gregor: Oy, Gregor need this like he need hole in head.

Libra: *Sigh* Naga, give me strength.

Henry: Sheesh! What a worrywart...

Donnel: Aw, horse pucky...

Henry: *Sigh* Believe me, I know all about that... But you have to understand, I must talk to my fellow soldiers—men and women both. They often have great ideas about how to really mess with an enemy. I mean, what if someone said you couldn't talk to Lucina ever again?

Donnel: *Sigh* Believe you me, I know all about that... But ya gotta understand, I needs to talk to my fellow soldiers—fellas and gals both. When yer in the thick of battle, it's vital ya know who yer fightin' with. I mean, what if someone said you couldn't talk to Lucina ever again?

Yarne: ...Well, I guess that would be a problem.

[Robin]: I'm glad you understand. But I wish you would just trust me when I say I would never cheat on your mother!

Frederick: I'm glad you understand. But I wish you would just trust me when I say I would never cheat on your mother!

Virion: I'm glad you understand. But I wish you would just trust me when I say I would never cheat on your mother!

Vaike: I'm glad ya understand. But I wish you'd just trust me when I say I would never cheat on your mother!

Stahl: I'm glad you understand. But I wish you would just trust me when I say I would never cheat on your mother!

Kellam: I'm glad you understand. But I wish you would just trust me when I say I would never cheat on your mother!

Lon'qu: I'm glad you get it. You should know by now that I'm not the cheating type.

Ricken: I'm glad you understand. But I wish you would just trust me when I say I would never cheat on your mother!

Gaius: I'm glad you understand. But I wish you would just trust me when I say I would never cheat on your mother!

Gregor: Is good you understand. But you must believe Gregor when he say he would never cheat on your mother!

Libra: I'm glad you understand. But I wish you would just trust me. I swear in Naga's good name I would never cheat!

Henry: Of course it would! But I wish you would just trust me when I say I would never cheat on your mother...

Donnel: I'm glad ya understand. But I wish you'd just trust me when I say I got no intention of cheatin' on yer ma!

Yarne: Well, you say that now... And perhaps you even mean it now... But what about the future? How do I know you'll never change your mind? I mean, you once promised me that you'd return home...but you never did...

[Robin]: ...Ah.
Frederick: ...Ah.
Virion: ...Ah.
Vaike: ...Ah.
Stahl: ...Ah.
Kellam: ...Ah.
Lon'qu: ...Ah.
Ricken: ...Ah.
Gaius: ...Ah.
Gregor: ...Ah.
Libra: ...Ah.
Henry: ...Ah.
Donnel: ...Ah.

Yarne: ...Er, forget I said that. It doesn't matter. I won't spy on you anymore. But if you break another promise and cheat on Mother, I won't ever forgive you!

[Robin]: ...Hmm, I think I understand now. In Yarne's future, I die and become the memory of a broken promise...

Frederick: ...Hmm, I think I understand now. In Yarne's future, I die and become the memory of a broken promise...

Virion: ...Hmm, I think I see now. In Yarne's future, I die and become the memory of a broken promise...

Vaike: ...Hmm, I think I get it now. In Yarne's future, I die and become the memory of a broken promise...

Stahl: ...Hmm, I think I understand now. In Yarne's future, I die and become the memory of a broken promise...

Kellam: ...Hmm, I think I understand now... In Yarne's future, I die and become the memory of a broken promise...

Lon'qu: ...Hmm, I think I understand now. In Yarne's future, I die and become the memory of a broken promise...

Ricken: ...Hmm, I think I understand now. In Yarne's future, I die and become the memory of a broken promise...

Gaius: ...Hmm, I think I understand now. In Yarne's future, I die and become the memory of a broken promise...

Gregor: ...Hmm, Gregor think he understand now. In Yarne's future, Gregor dies and becomes memory of broken promise...

Libra: ...Hmm, I think I understand now. In Yarne's future, I die and become the memory of a broken promise...

Henry: ...Ahh, I get it now. In Yarne's future, I die and become the memory of a broken promise...

Donnel: ...Hmm, I think I get it now. In Yarne's future, I die and become the memory of a broken promise...

■ FATHER X YARNE A

[Robin]: There you are, Yarne. I was looking for you.
Frederick: There you are, Yarne. I was looking for you.
Virion: There you are, Yarne. I was looking for you.
Vaike: Yarne! There you are. I was looking for ya.
Stahl: There you are, Yarne. I was looking for you.
Kellam: There you are, Yarne. I was looking for you.
Lon'qu: There you are. I was looking for you.
Ricken: There you are, Yarne. I was looking for you.
Gaius: There you are, Yarne. I was looking for you.
Gregor: There you are, Yarne. Gregor was looking for you.

Libra: There you are, Yarne. I was looking for you.
Henry: There you are, Yarne. I was looking for you.
Donnel: There ya are, Yarne! I was lookin' for ya.

Yarne: What do you want, Father? I told you, I won't spy on you anymore.

[Robin]: That's not why I wanted to see you. I...want to apologize. In the future, I promised to come back to you and...I didn't. I'm sorry.

Frederick: That's not why I wanted to see you. I...want to apologize. In the future, I promised to come back to you and...I didn't. I'm sorry.

Virion: That's not why I wanted to see you. I...want to apologize. In the future, I promised to come back to you and...I didn't. I'm sorry.

Vaike: That ain't why I wanted to see ya. I...wanna apologize. In the future, I promised to come back to ya and...I didn't. I'm sorry.

Stahl: That's not why I wanted to see you. I...want to apologize. In the future, I promised to come back to you and...I didn't. I'm sorry.

Kellam: That's not why I wanted to see you. I...want to apologize. In the future, I promised to come back to you and...I didn't. I'm sorry.

Lon'qu: That's not why I wanted to see you. I...want to apologize. In the future, I promised to come back to you and...I didn't. I'm sorry.

Ricken: That's not why I wanted to see you. I...want to apologize. In the future, I promised to come back to you and...I didn't. I'm sorry.

Gaius: That's not why I wanted to see you. I...want to apologize. In the future, I promised to come back to you and...I didn't. I'm sorry.

Gregor: Gregor did not come to yell about spying. ...Gregor come to apologize. In bleak future, Gregor promised to come back and...didn't. He is sorry for this.

Libra: That's not why I wanted to see you. I...want to apologize. In the future, I promised to come back to you and...I didn't. I'm sorry.

Henry: That's not why I wanted to see you. I...wanna apologize. In the future, I promised to come back to you and...I didn't. I'm sorry.

Donnel: This ain't about that. I just wanted to apologize. In the future, I promised to come back to ya and...well, didn't. I'm sorry.

Yarne: What does it matter if YOU apologize?! It wasn't YOU who abandoned me! It was a different you from a different time!

[Robin]: Yes, I understand that. And I also know you're not my son. ...Not exactly, anyway.

Frederick: Yes, I understand that. And I also know you're not my son. ...Not exactly, anyway.

Virion: Yes, I understand that. And I also know you're not my son. ...Not exactly, anyway.

Vaike: Yeah, I get that. And I also know you're not my son. ...Not exactly, anyway.

Stahl: Yes, I understand that. And I also know you're not my son. ...Not exactly, anyway.

Kellam: Yes, I understand that. And I also know you're not my son. ...Not exactly, anyway.

Lon'qu: Yes, I know. And I also know that you're not my son. ...Not exactly, anyway.

Ricken: Yes, I understand that. And I also know you're not my son. ...Not exactly, anyway.

Gaius: Yeah, I understand that. And I also know you're not my son. ...Not exactly, anyway.

Gregor: Gregor knows you are not his son. ...Not exactly, anyway.

Libra: Yes, I understand that. And I also know you're not my son. ...Not exactly, anyway.

Henry: Yeah, I understand that. And I also know you're not my son. ...Not exactly, anyway.

Donnel: Yeah, I get that. And I also know ya ain't my son. ...Not exactly, anyway.

[Robin]: We're not just from different times, but from different versions of time. And yet I think of you as my family all the same. I hope to give you the things that the father in your future couldn't. ...That is what you want, isn't it?

Frederick: We're not just from different times, but from different versions of time. And yet I think of you as my family all the same. I hope to give you the things that the father in your future couldn't. ...That is what you want, isn't it?

Virion: We are not just from different times, but from different versions of time. And yet I think of you as my family all the same. I hope to give you the things that the father in your future couldn't. ...That is what you want, is it not?

Vaike: We ain't just from different times—we're from different VERSIONS of time. And yet Ol' Vaike thinks of ya as family all the same. I hope to give you the things that the father in your future couldn't. ...That is what you want, ain't it?

Stahl: We're not just from different times, but from different versions of time. And yet I think of you as my family all the same. I hope to give you the things that the father in your future couldn't. ...That is what you want, isn't it?

Kellam: We're not just from different times, but from different versions of time. And yet I think of you as my family all the same. I hope to give you the things that the father in your future couldn't. ...That is what you want, isn't it?

Lon'qu: We're not just from different times. We're from different versions of time. And yet I think of you as my family all the same. I hope to give you the things that the father in your future couldn't. ...That is what you want, isn't it?

Ricken: We're not just from different times, but from different versions of time. And yet I think of you as my family all the same. I hope to give you the things that the father in your future couldn't. ...That is what you want, isn't it?

Gaius: We're not just from different times, but from different versions of time. And yet I think of you as my family all the same. I hope to give you the things that the father in your future couldn't. ...That is what you want, isn't it?

Gregor: We're not just from different time, but from different versions of time. And yet Gregor think of you like family all the same. He hope to give you the things that father in future could not. ...Er, that is what you want, yes?

Libra: We're not just from different times, but from different versions of time. And yet I think of you as my family all the same. I hope to give you the things that the father in your future couldn't. ...That is what you want, isn't it?

Henry: We're not just from different times, but from different versions of time. And yet I think of you as my family all the same, you know? I hope to give you the things that the father in your future couldn't. ...That is what you want, isn't it?

Donnel: We ain't just from different times, but from different versions of time. And yet I think of ya as my family all the same. I hope to give ya the things that the father in yer future couldn't. ...That is what ya want, ain't it?

Yarne: I...I guess it is, yes. I know it's not right, but I can't help but think of you as my father. That's why I get scared whenever you talk to other women. I couldn't bear the thought of you leaving Mother and being someone else's father. It would be like losing him all over again.

[Robin]: Yarne, what if I made another promise? I swear by all I hold dear that I will survive and that I will never abandon your mother. I love you both more than anything in this world. I would do anything for you.

Frederick: Yarne, what if I made another promise? I swear by all I hold dear that I will survive and that I will never abandon your mother. I love you both more than anything in this world. I would do anything for you.

Virion: Yarne, what if I made another promise? I swear by all I hold dear that I will survive and that I will never abandon your mother. I love you both more than anything in this world. I would do anything for you.

Vaike: Yarne, what if I made ya another promise? I swear by all I hold dear that I'll survive and that I'll never abandon your mother. I love ya both more than anything in this world. I'd do anything for ya.

Stahl: Yarne, what if I made another promise? I swear by all that I hold dear that I will survive and that I will never abandon your mother. I love you both more than anything in this world. I would do anything for you.

Kellam: Yarne, what if I made another promise? I swear by all I hold dear that I will survive and that I will never abandon your mother. I love you both more than anything in this world. I would do anything for you.

Lon'qu: Then I shall make you another promise. I swear by all I hold dear that I will survive and that I won't abandon your mother. I love you both more than anything in this world. I would do anything for you.

Ricken: Yarne, what if I made another promise? I swear by all I hold dear that I will survive and that I will never abandon your mother. I love you both more than anything in this world. I would do anything for you.

Gaius: Yarne, what if I made another promise? I swear by all I hold dear that I'll survive and that I won't ever abandon your mother. I love you both more than anything in this world. I would do anything for you.

Gregor: Yarne, what if Gregor make another promise? He swears by all he hold dear to survive and to never abandon wife and mother. Gregor love you both more than anything in this world. Would do anything for you!

Libra: Yarne, what if I made another promise? I swear by all that's holy that I will survive and that I will never abandon your mother. I love you both more than anything in this world. I would do anything for you.

Henry: Yarne, what if I made another promise? I swear by all I hold dear that I will survive and that I will never abandon your mother. I love you both more than anything in this world. I would do anything for you.

Donnel: Yarne, what if I made ya another promise? I swear by all I hold dear that I'll survive and that I won't ever abandon yer ma. I love ya both more'n anythin' in this here world. I'd anythin' for ya.

Yarne: I...I don't know what to say. Except...thank you. Because this time, I believe you'll keep your promise.

[Robin]: Good!
Frederick: Good.
Virion: Fantastic!
Vaike: Great!
Stahl: Good!
Kellam: Good!
Lon'qu: Excellent.
Ricken: Good!
Gaius: Great.
Gregor: Is good!
Libra: Good!
Henry: Nya ha! Great!
Donnel: Great!

Yarne: Phew! Now maybe I can relax and stop worrying about vanishing from history... You're such a great father! Who's a good father? Yes, whooo's a good father?!

[Robin]: I appreciate the sentiment, Yarne, but must you pet me like a dog while you say it?

Frederick: I appreciate the sentiment, Yarne, but must you pet me like a dog while you say it?

Virion: I appreciate the sentiment, Yarne, but must you pet me like a dog while you say it?

Vaike: I appreciate the sentiment, Yarne, but do ya have to pet me like a dog while ya say it?

Stahl: I appreciate the sentiment, Yarne, but must you pet me like a dog while you say it?

Kellam: I appreciate the sentiment, Yarne, but must you pet me like a dog while you say it?

Lon'qu: I appreciate the sentiment, Yarne, but must you pet me like a dog while you say it...?

Ricken: I appreciate the sentiment, Yarne, but must you pet me like a dog while you say it?

Gaius: I appreciate the thought, Yarne, but is the whole dog-petting thing really necessary?

Gregor: Gregor appreciate thought, Yarne, but you pet him like dog, too?

Libra: I appreciate the sentiment, Yarne, but must you pet me like a dog while you say it?

Henry: I appreciate the sentiment, Yarne, but do you really have to pet me like a dog?!

Donnel: I appreciate the sentiment, Yarne, but must ya pet me like a dog while you say it?

Laurent

 Avatar (male)

The dialogue between Avatar (male) and Laurent can be found on page 226.

 Avatar (female)

The dialogue between Avatar (female) and Laurent can be found on page 237.

 Miriel (Mother/son)

Laurent's mother/son dialogue with Miriel can be found on page 261.

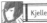 Lucina

The dialogue between Lucina and Laurent can be found on page 284.

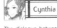 Kjelle

The dialogue between Kjelle and Laurent can be found on page 299.

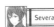 Cynthia

The dialogue between Cynthia and Laurent can be found on page 302.

 Severa

The dialogue between Severa and Laurent can be found on page 304.

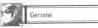 Gerome

The dialogue between Gerome and Laurent can be found on page 307.

 Morgan (male) (Father/son)

The father/son dialogue between Morgan (male) and Laurent can be found on page 309.

 Morgan (female)

The dialogue between Morgan (female) and Laurent can be found on page 311.

 Morgan (female) (Brother/sister)

The brother/sister dialogue between Morgan (female) and Laurent can be found on page 311.

 Yarne

The dialogue between Yarne and Laurent can be found on page 313.

Noire

■ NOIRE X LAURENT C

Noire: All right... On to the next task.

Laurent: You seem exceptionally busy, Noire. What has you so occupied?

Noire: Oh, nothing. Just on my way to draw water for tonight's dinner.

Laurent: In that enormous bucket?

Noire: W-well, yes?

Laurent: Then pray, allow me.

Noire: What? No, I couldn't ask you to do that.

Laurent: A slight person like yourself oughtn't put undo strain on their frame. I won't explain the physics behind it, save to say it may bring about a fracture.

Noire: B-but, this is the same bucket I've been using for years.

Laurent: What if your anemia acted up and you grew light headed? You could be badly injured.

Noire: But, Laurent, I feel fine! ...Oh, okay! You can help! But just for today.

Laurent: Excellent. Leave it to me. And this water is bound for the mess-tent team, correct?

Noire: Yes, that's right. Thank you.

Laurent: Thanks are not required. I insisted, did I not?

■ NOIRE X LAURENT B

Laurent: How are you feeling, Noire? Taking care not to overexert yourself, I trust?

Noire: I'm fine, thank you. I've been feeling quite well for some time now.

Laurent: Excellent news. But pray, stay wary. Our marches have been grueling of late, and exhaustion is a relentless foe.

Noire: R-really, Laurent, I'm fine. You don't have to worry so.

Laurent: You ought to express this level of concern as well. Frankly, your body is rather frail. You must be realistic and cautious in how you treat it.

Noire: Look, everyone else is busy keeping the camp clean and well supplied. I can't be the only one lounging about!

Laurent: And yet, I would impress on you that resting adequately is your greatest responsibility.

Noire: Even if I tried, I don't think I could sit still with everyone else buzzing around. If the guilt didn't keep me up, the sheer amount of activity around me would.

Laurent: And what if thinking of you pushing yourself beyond reason keeps the rest of us awake?

Noire:

Laurent: Have you eaten today, Noire?

Noire: N-not yet, no.

Laurent: This is unacceptable. Run along and eat.

Noire: I don't really... I'm not hungry.

Laurent: Caloric intake is critical for success in all areas of life. ...Unless this lack of appetite is a symptom of some ailment you've contracted?

Noire: Laurent, I'm fine, okay? I. Feel. Fine.

Laurent: Maintaining energy levels is critical, and yet you leave food uneaten at every meal. This cannot continue. It's the duty of every soldier to clean his or her plate.

Noire: Look, would you... Can you just... ...Fine. I'll eat more.

■ NOIRE X LAURENT A

Laurent: Noire, might I have a moment?

Noire: What? Why? What did I do now?

Laurent: I fear it's what you haven't done. I haven't seen you maintaining your weapons of late. Are you caring for them properly?

Noire: Er... I haven't really had the time this week.

Laurent: Being busy is no excuse. Your own life and those of your allies depend on that equipment. I should think a cursory inspection every day is not too much to ask.

Noire: ...Anything else?

Laurent: Weapon maintenance really must be done by the one wielding the weapon. You alone have a complete grasp of its characteristics and idiosyncrasies. Now then, when examining a weapon, it behooves the user to first grasp it...

Noire: ...um

Laurent: What was that? Speak up, please.

Noire: ...Shut up.

Laurent: I beg your pardon? It sounded as if—

Noire: STILL YOUR CHATTERING TONGUE, YOU BLITHERING IDIOT!

Laurent: N-Noire?!

Noire: Day after day after day you prattle on with your ceaseless picking of nits! If you are so haunted by doubts of my weapon's bite, we shall test it! On you! IF YOU WANT ME TO EAT, I SHALL FEAST UPON YOUR SOUL!

Laurent: W-wait! L-let's not be hasty here, Noire! All I said, I said out of concern for you!

Noire: BLOOD AND THUNDER! Your concern is unfounded, unsolicited, and most unwelcome! It takes more than drawing water and meager sustenance to lay low this vessel! I've no need for a nagging mother-in-law! IT WILL NOT STAND!

Laurent: N-no, I'm not your... I never meant to... I'm... I'm sorry?

Noire: Bwaaaaa ha ha ha ha ha! Yes! You are sorry now, aren't you, whelp? YOUR CONTRITION IS SWEET AMBROSIA!

Laurent: W-well, all right, then. I'll, uh... I'll be more careful in the future. Really, I... I meant...well. ...I'll just be going now.

Noire: Ah! Oh, dear, I think I... I think I lost control again. Laurent must think me a monster! Oh, this is so embarrassing!

■ NOIRE X LAURENT S

Noire: I still feel terrible for exploding at Laurent like that. He was concerned for me, and I...

Laurent: Erm, Noire?

Noire: Eek! L-Laurent!

Laurent: I'm sorry, but... It seems I couldn't help but come by and check up on you again. I know it's an unwelcome intrusion. You've made that very clear...

Noire: Laurent, I'm sorry for...all the yelling. You were only speaking out of concern, and I turned into a screaming terror.

Laurent: No, you had every right. And I regret the constant pestering I subjected you to. I will strive to listen in the future, rather than simply run my own mouth. I was merely surprised. I'd not thought it possible for you to be so...upset.

Noire: Ugh, please, don't remind me... That was me, but it wasn't really me, if that makes any sense.

Laurent: I don't think I've ever been tongue-lashed quite so thoroughly before. And in truth... It had my heart racing. I was agog at seeing you true for the first time. I nearly fell right then and there!

Noire: Fell...over?

Laurent: In love. I nearly fell in love with you, Noire.

Noire: Oh, well that makes... Wait—what?! Because I flew into a blind rage?!

Laurent: I live to see you channel that fire again! Preferably when it's just us two! If there was ever anything I did that met with your displeasure, you must get angry! E-even if there isn't anything, become angry anyway! Rage! Rage against the world! Just please let me be the one you show when your true self spills forth!

Noire: ...I-I don't know what to say right now. I really do appreciate all your advice... And I...do have feelings for you, too...

Laurent: Then will you be my very own smouldering volcano of pitch-black vitriol?!

Noire: Er... It's not something I can just switch on at will, you know?

Laurent: Regrettable, but hardly insurmountable. I'll simply stay at your side at all times and await the next eruption.

Noire: ...Laurent? Why are you so keen on getting yelled at?

Laurent: I do not have an explanation that makes any manner of logical sense. But when I felt the full force of your feelings crash against me, it set my heart ablaze! Hearing you expose my flaws and deride me made me happier than I have ever been.

Noire: And here I thought I was the odd one... Um, look. Are you sure about this?

Laurent: Indubitably! I live for who you are, Noire... Both of you! Sublime in your dual perfection. Oh, the anticipation of another passionate paroxysm is almost too much to bear...

Noire: I still feel like something about this is just a little bit...off. But if this is what you want, then, um...okay. I guess I'll...make it work. I, um, look forward to watching our love blossom over the years, Laurent.

Laurent: Could you try saying that just a bit more forcefully? ...Perhaps insult me a little?

Noire: Oh dear...this is going to take some getting used to...

 Nah

■ NAH X LAURENT C

Nah: Ah! Laurent!

Laurent: Hello, Nah. I thought perhaps we might chat for a—

Nah: No! Stay back!

Laurent: ...I beg your pardon?

Nah: D-don't come any closer, you...you creep!

Laurent: Nah, have I given some offense without realizing?

Nah: Don't try to play dumb! You're always leering at me! It's like you're undressing me with your eyes!

Laurent: Good heavens! What a dreadful accusation! ...And I'll thank you to lower your voice. First, I'm not "leering" at you, and second, I observe everyone in camp equally. My role in this army is to monitor and maintain the physical state of its people.

Nah: Ha! Nice try, you lecherous lout! You can't fool me that easily! You're always staring at me because I'm vulnerable and cute and demure! So don't bother with your lame excuses. Just knock it off!

Laurent: Nah, wait! ...The poor girl has completely misunderstood my intentions. If left uncorrected, it will stand as a stain on my good name!

■ NAH X LAURENT B

Laurent: H-hello, Nah. I need to speak with you. Might I have a moment?

Nah: Eek! Creep! Get away!

Laurent: Ah, no! Please don't run! I just want to clear up a misunderstanding!

Nah: ...Misunderstanding?

Laurent: Indeed. The other day, you claimed I leered at you. But I assure you, my intentions in observing you are strictly professional. I consider it my duty to monitor everyone's condition in order to preserve their health. It is entirely chaste, and free of any and all lascivious intent. I give you my word.

Nah: ...I still don't believe you!

Laurent: Why do you refuse to believe me?!

Nah: Manaketes can smell dishonesty. And you reek of lies!

Laurent: You're being absurd! There is no scientific basis for such a claim.

Nah: You smell like you're completely taken in by my adorable veneer! Ah, it's my own fault for being stuck at such an insanely cute age...

Laurent: I'll grant you "insane"!

Nah: Augh! What am I doing standing around talking to you? I've got to get out of here before you throw me in a sack and run for the hills!

Laurent: ...W-wait! I don't even own a sack! ...Nah? Oh, this is terrible. I've made no progress whatsoever...

■ NAH X LAURENT A

Laurent: Ah, there you are. I really must insist that you allow me to lay this misunderstanding to rest.

Nah: Creeps like you never know when to give up, do you?

Laurent: I've told you time and again, I have no untoward inclinations toward you! None! Zero! Zip! Nought! Negatory! Absolutely, positively none!

Nah: So, you still refuse to fess up and mend your wicked ways? Then I have no choice but to call for aid!

Laurent: ...What?

Nah: Everybody, help! Come quick! Laurent is chasing me!

Laurent: Augh! Stop it, you lunatic! I'll be run out of camp!

Nah: It's your own fault for going around ogling defenseless, adorable girls!

Laurent: That is NOT what I'm doing!

Nah: So you're sticking with the claim that it's all just a big misunderstanding? Repeating it over and over won't make it true, Laurent. You'll have to do better.

Laurent: I have little alternative, given that it is the truth! What else could I possibly say?

Nah: ...All right, then.

Laurent: Oh, thank the gods!

Nah: Let's pretend for a moment that you're telling the truth and I'm mistaken. That would mean that you DON'T think I'm hopelessly adorable.

Laurent: You're quite charming, Nah, but that doesn't mean I bear any untoward desires. You are an ally, the same as anyone else in the camp. I feel responsible for observing your actions and physical condition as part of my work. My only desire is to preserve your health.

Nah: Oh! Well, if it's required for you to do your job, I suppose there's no helping it.

Laurent: ...I've been saying that for weeks now.

Nah: Look, I'll try not to jump to any conclusions again in the future. Deal? ...Deal.

Laurent: Oh, thank heavens. My good reputation is preserved...

■ NAH X LAURENT S

Nah: Here to check up on me, Laurent? I'll just stand super still then, okay?

Laurent: Nah, if I am here to observe you, I would need to see you in your normal routine.

Nah: What, so not standing completely still, then? Should I jump around or something?

Laurent: That's not... Please don't make my job harder than it already is, Nah.

Nah: Very well. You don't have to be so cold. ...Unless you just hate me now? You said I was charming before, right? So was that just another lie?

Laurent: *Sigh* I find you to be demonstrably cute. ...Objectively speaking.

Nah: And...?

Laurent: And what?

Nah: Come now, Laurent. Spit it out.

Laurent: ...What?

Nah: You're lying again. I can smell it. No one can possibly be this dense. Well, there's only one thing for it... I'll turn into a dragon and go on the rampage until you shape up!

Laurent: All right, now I am completely lost! What are you talking about?

Nah: It made me happy to hear you say that you think I'm cute. ...I was even happy when you were chasing me around, if we're being honest now. And I can smell it on you, even now, but... It's not enough!

Laurent: Not...enough?

Nah: I don't just want to smell the way you feel about me. I want to hear you say it.

Laurent: I...I see. It appears I was...being rather dense. I apologize. Or perhaps I was held back by my own doubts and insecurities... But at any rate, I guess you're right. I admit it. I...I love you.

Nah: And you're sure? No more doubts?

Laurent: I'm positive.

Nah: Well it's about time! Sheesh!

Laurent: I'm sorry to have made you wait so long. It seems you were far quicker to realize how I felt than I was myself.

Nah: No kidding! Nothing was working! I had to treat you like a creep just to push you to see it yourself!

Laurent: Please, Nah, for the love of everything, use a more direct approach next time!

 Father

■ FATHER X LAURENT C

Laurent: This is yours, I presume, Father? I found it lying on the ground. Do try to better secure your belongings in the future.

[Robin]: Ha! You sound just like your mother, Laurent.

Frederick: Heh. You sound just like your mother, Laurent.

Virion: Ha! You sound just like your mother, Laurent.

Vaike: Ha! Ya sound just like your mother, Laurent.

Stahl: Ha! You sound just like your mother, Laurent.

Kellam: You sound just like your mother, Laurent.

Lon'qu: You sound like your mother.

Ricken: Ha! You sound just like your mother, Laurent.

Gaius: Heh. You sound just like your mother, Laurent.

Gregor: Bwa ha ha! Laurent, you sound just like mother.

Libra: Ha! You sound just like your mother, Laurent.

Henry: Nya ha! You sound just like your mother, Laurent.

Donnel: Heh! You sound just like yer ma, Laurent!

Laurent: Naturally. She IS my mother.

[Robin]: Well, yes, but still... You two are so alike, I sometimes wonder if you inherited anything from me.

Frederick: Well, yes, but still... You two are so alike, I sometimes wonder if you inherited anything from me.

Virion: Well, yes, but still... You two are so alike, I sometimes wonder if you inherited anything from me...

Vaike: Well, yeah, but still... You two are so alike, I sometimes wonder if ya inherited anything from me.

Stahl: Well, yes, but still... You two are so alike, I sometimes wonder if you inherited anything from me.

Kellam: Well, yes, but still... You two are so alike, I sometimes wonder if you inherited anything from me.

Lon'qu: Well, yes, but still... You two are so alike, I sometimes wonder if you inherited anything from me.

Ricken: Well, yes, but still... You two are so alike, I sometimes wonder if you inherited anything from me.

Gaius: Well, yeah, but still... You two are so alike, I sometimes wonder if you inherited anything from me.

Gregor: Gregor understand this, but still... You two are peas in a pod, yes? Gregor often wonder if you inherit anything from him.

Libra: Well, yes, but still... You two are so alike, I sometimes wonder if you inherited anything from me.

Henry: Well, yeah, but still... You two are so alike, I sometimes wonder if you inherited anything from me.

Donnel: Well, sure, but still... You two're so alike, I sometimes wonder if ya inherited anythin' from me!

Laurent: Don't be absurd, Father. Of course I did.

[Robin]: Oh? Like what?

Frederick: Oh? Like what?

Virion: Oh? Like what?

Vaike: Oh? Like what?

Stahl: Oh? Like what?

Kellam: Oh? Like what?

Lon'qu: ...Like?

Ricken: Oh? Like what?

Gaius: Oh? Like what?

Gregor: Oh? For the example?

Libra: Oh? Like what?

Henry: Oh yeah? Like what?

Donnel: Like what?

Laurent: Like...the color of my hair.

[Robin]: Er, well, that's true, but it's not exactly what I was talking about. Anything more substantive? Any memory

Frederick: Er, well, that's true, but it's not exactly what I was talking about. Anything more substantive? An over-abundance of outdoor skills, perhaps?

Virion: Er, well, that's true, but it's not exactly what I was talking about. Anything more substantive? Perhaps a fondness for mirrors?

Vaike: Er, well, that's true, but that ain't exactly what I meant. Anything more substantive? You ever forget things, and then forget you forgot 'em?

Stahl: Er, well, that's true, but it's not exactly what I was talking about. Anything more substantive? Maybe you prefer second and third breakfasts?

Kellam: Er, well, that's true, but it's not exactly what I was talking about. Anything more substantive? Maybe people tend to ignore you a lot?

Lon'qu: Well, yes, but that's not what I meant. Anything more substantive? Maybe you have trouble with women as I do?

Ricken: Er, well, that's true, but it's not exactly what I was talking about. Anything more substantive? Maybe your hat blows off a lot like mine?

Gaius: Er, well, yeah, but that's not exactly what I was talking about. Anything more substantive? An undying affinity for sweets, perhaps?

Gregor: Er, perhaps, yes, but that not exactly what Gregor was talking about. Anything more sizable? Do you enjoy bear wrestling and clinking of coin?

Libra: Ah, well, that's true, but it's not exactly what I was talking about. Anything more substantive? Perhaps you enjoy visiting old chapels?

Henry: Well, yeah, but that's not exactly what I was talking about. Anything more substantive? Maybe you have a gift for cursing folks?

Donnel: Er, well, that's true, but I reckon that ain't quite what I had in mind. Anythin' more meanin'ful? Maybe ya like to put pots on yer head and the like?

Laurent: Hmm, no. My bearing in that respect is profoundly normal. Very much to my relief, if I might be perfectly frank.

[Robin]: See, that's what I mean. You're always so serious and verbose... You could stand to loosen up a bit. Maybe act a bit more your age.

Frederick: See, this is what I mean. You're always so serious and verbose... You could stand to loosen up a bit. Maybe act a bit more your age.

Virion: See, this is what I mean. You are always so serious and verbose... You could stand to loosen up a bit. Maybe act a bit more your age.

Vaike: See, this is what I mean. You're always so serious and uptight... Ya could stand to loosen up a bit. Maybe act a bit more your age.

Stahl: See, that's what I mean. You're always so serious and verbose... You could stand to loosen up a bit. Maybe act a bit more your age.

Kellam: See, that's what I mean. You're always so serious and verbose... You could stand to loosen up a bit. Maybe act a bit more your age.

Lon'qu: See, that's what I mean. You're always so serious and verbose... You could stand to loosen up a bit. Maybe act a bit more your age.

Ricken: See, that's what I mean. You're always so serious and wordy... You could stand to loosen up a bit. Maybe act a bit more your age.

Gaius: See, that's what I mean. You're always so serious and uptight... You could stand to loosen up a bit. Maybe act a bit more your age.

Gregor: Oy, see what Gregor mean? Always with the serious... You should try loosen up a little. Maybe act more like your age.

Libra: See, that's what I mean. You're always so serious and verbose... You could stand to loosen up a bit. Maybe act a bit more your age.

Henry: See, that's what I mean. You're always so serious and...wordy. You should try loosening up a bit. Maybe act a little more your age.

Donnel: See, that's what I mean. Yer always so serious and uptight. You could stand to loosen up a bit, maybe act a bit more yer age.

Laurent: We're at war, Father. Acting like a child is hardly behavior to be encouraged. Besides, I'm a grown man. Older than Lucina at this point, I suspect.

[Robin]: Wait, how could you be older than Lucina? She's already been born here, but your mother and I still haven't had you.

Frederick: Wait, how could you be older than Lucina? She's already been born here, but your mother and I still haven't had you.

Virion: Wait, how could you be older than Lucina? She's already been born here, but your mother and I still haven't had you.

Vaike: Wait, how could ya be older than Lucina? She's already been born here, but your mother and I still ain't had you.

Stahl: Wait, how could you be older than Lucina? She's already been born here, but your mother and I still haven't had you.

Kellam: Wait, how could you be older than Lucina? She's already been born here, but your mother and I still haven't had you.

Lon'qu: Wait, how could you be older than Lucina? She's already been born here, but your mother and I still haven't had you.

Ricken: See, that's what I mean. You're always so serious and wordy... You could stand to loosen up a bit. Maybe act a bit more your age.

Gaius: Wait, how could you be older than Lucina? She's already been born here, but your mother and I still haven't had you.

Gregor: Eh? Older than Lucina? How is this possible? Lucina already born here, but mother and Gregor still not give birth to you.

Libra: Wait, how could you be older than Lucina? She's already been born here, but your mother and I still haven't had you.

Henry: Wait, how could you be older than Lucina? She's already been born here, but your mother and I still haven't had you.

Donnel: Wait, how could ya be older'n Lucina? She's already been born here, but yer ma and I still ain't birthed you.

Laurent: I...I fear I've no more time to chat today. Now, if you'll excuse me.

[Robin]: Laurent, wait! ...What was all that about?

Frederick: Laurent, wait! ...What was all that about?

Virion: Laurent, wait! ...What was all that about?

Vaike: Laurent, wait! ...What the hey was that all about?

Stahl: Laurent, wait! ...What was all that about?

Kellam: Laurent, wait! ...What was all that about?

Lon'qu: ...What was all that about?

Ricken: Laurent, wait! ...What was all that about?

Gaius: Laurent, wait! ...The heck was that about?

Gregor: Laurent, wait! Gregor still have many questions!

Libra: Laurent, wait! ...What was all that about?

Henry: Laurent, wait! ...What was that all about?

Donnel: Laurent, wait! ...Now what in tarnation was all that about?

■ FATHER X LAURENT B

[Robin]: Hello, Laurent.

Frederick: Hello, Laurent.

Virion: Hello, Laurent.

Vaike: Heya, Laurent.

Stahl: Hello, Laurent.

Kellam: Hello, Laurent.

Lon'qu: Hello, Laurent.

Ricken: Hello, Laurent.

Gaius: Hello, Laurent.

Gregor: Hello, Laurent.

Libra: Hello, Laurent.

Henry: Hey-o, Laurent!

Donnel: Heya, Laurent.

Laurent: Father. How may I help you?

[Robin]: I was thinking about how you said you were older than Lucina... Can you explain that? I'm a little lost.

Frederick: I was thinking about how you said you were older than Lucina... Can you explain that? I'm a bit confused.

Virion: I was thinking about how you said you were older than Lucina... Can you perhaps explain? I don't quite understand.

Vaike: I been thinking about how ya said you were older than Lucina... Can you explain that? I'm a little lost.

Stahl: I was thinking about how you said you were older than Lucina... Can you explain that? I'm a little lost.

Kellam: I was thinking about how you said you were older than Lucina... Can you explain that? I'm a little lost.

Lon'qu: I was thinking about how you said you were older than Lucina... Care to explain?

Ricken: I was thinking about how you said you were older than Lucina... Can you explain that? I'm a little lost.

Gaius: I was thinking about how you said you were older than Lucina... Can you explain that? I'm a little lost.

Gregor: Gregor has been thinking about how you are older than Lucina... He...does not understand. Very confusing, yes?

Libra: I was thinking about how you said you were older than Lucina... Can you explain that? I'm a little lost.

Henry: I've been thinking about how you said you were older than Lucina... That makes no sense to me. Care to explain?

Donnel: I been thinkin' 'bout how ya said you were older'n Lucina. Can you try explainin' that? I'm a mite bit lost.

Laurent: It's fairly straightforward. Travel among eras is imprecise. There are...variables. Lucina arrived at the onset of the war with Plegia some two years ago. I, on the other hand, have been here for nearly five years.

[Robin]: There's that much of a spread between where you landed? Er, when you landed?

Frederick: There's that much of a spread between where you landed? Er, when you landed?

Virion: There's that much of a spread between where you landed? Er, when you landed?

Vaike: There's that much of a spread between where ya landed? Er, when ya landed?

Stahl: There's that much of a spread between where you landed? Er, when you landed?

Kellam: There's that much of a spread between where you landed? Er, when you landed?

Lon'qu: There's that much of a difference?

Ricken: There's that much of a spread between where you landed? Er, when you landed?

Gaius: There's that much of a spread between where you landed? Er, when you landed?

Gregor: Oy! That much difference between when you and Lucina arrive?

Libra: There's that much of a spread between where you landed? Er, when you landed?

Henry: Ack, there's that much of a spread between where you landed? Er, when you landed?

Donnel: Hoo-ee! There's that much of a spread between when you two landed?

Laurent: ...Indeed. Hence, I have aged three years more than she in the course of reaching this moment. Somewhere along the way, I passed her in terms of physical age.

[Robin]: So you've been in this era for five years all by yourself?

Frederick: So you've been in this era for five years all by yourself?

Virion: So you've been in this era for five years all by yourself?

Vaike: So ya been in this era for five years all by yourself?

Stahl: So you've been in this era for five years all by yourself?

Kellam: So you've been in this era for five years all by yourself?

Lon'qu: So you've been in this era for five years all by yourself?

Ricken: So you've been in this era for five years all by yourself?

Gaius: You've been in this era for five years all by yourself?

Gregor: You have been living in this era five years, all by lonesome...?

Libra: So you've been in this era for five years all by yourself?

Henry: Yikes. So you've been in this era for five years all by yourself?

Donnel: So ya been 'round these parts for five years all by yourself...?

Laurent: Yes. So as you see, I'm far too old to be indulging in childish behaviors. I trust that explanation has cleared up your confusion? Now, if you'll excuse me...

[Robin]: Laurent, wait! Why have you never mentioned any of this before? You were cut off from everyone else for five whole years. You must have been so...lonely.

Frederick: Laurent, wait! Why have you never mentioned any of this before? You were cut off from everyone else for five whole years. You must have been... lonely.

Virion: Laurent, wait! Why have you never mentioned any of this before? You were cut off from everyone else for five whole years. You must have been... lonely.

Vaike: Laurent, wait! Why have you never mentioned any of this before? You were cut off from everyone else for five whole years. Ya musta been so...lonely.

Stahl: Laurent, wait! Why have you never mentioned any of this before? You were cut off from everyone else for five whole years. You must have been so...lonely.

Kellam: Laurent, wait! Why have you never mentioned any of this before? You were cut off from everyone else for five whole years. Weren't you...lonely?

Lon'qu: Laurent, wait. Why have you never mentioned any of this before? You were cut off from everyone else for five whole years. You must have been...lonely.

Ricken: Laurent, wait! Why have you never mentioned any of this before? You were cut off from everyone else for five whole years. You must have been so...lonely.

Gaius: Laurent, wait! Why haven't you ever mentioned any of this before? Cut off from everyone for five whole years. You must've been...lonely.

Gregor: Laurent, wait! Why did you not make with the telling of this sad tale before? Being cut off for five years is long time. Must have been very lonely.

Libra: Laurent, wait! Why have you never mentioned any of this before? You were cut off from everyone else for five whole years. You must have been so...lonely.

Henry: Laurent, wait! Why didn't you ever mention any of this before? Cut off from everyone else for five whole years... You must've been lonely.

Donnel: Laurent, wait! Why haven't ya ever mentioned any of this 'fore? You were cut off from everyone else for five years. Musta been lonely somethin' fierce...

Laurent: As I've said time and again, I am a grown man. ...I managed fine on my own.

[Robin]: Laurent...

Frederick: Laurent...

Virion: Laurent...

Vaike: Laurent...

Stahl: Laurent...

Kellam: Laurent...

Lon'qu:

Ricken: Laurent...

Gaius: Laurent...

Gregor: Laurent...

Libra: Laurent...

Henry: Laurent...

Donnel: Laurent...

■ FATHER X LAURENT A

[Robin]: Laurent.

Frederick: Laurent.

Virion: Laurent.

Vaike: Laurent.

Stahl: Laurent.

Kellam: Laurent.

Lon'qu: Laurent.

Ricken: Laurent.

Gaius: Laurent.

Gregor: Laurent.

Libra: Laurent.

Henry: Laurent.

Donnel: Laurent.

Laurent: More questions, Father? I thought I was quite clear before.

[Robin]: Yes, you were. But today is different. Because today... Coochy coochy coo!

Frederick: Yes, you were. But today is different. Because today... Coochy coochy coo!

Virion: Yes, you were. But today is different. Because today... Coochy coochy coo!

Vaike: Yeah, ya were. But today's different. Because today... Coochy coochy coo!

Stahl: Yes, you were. But today is different. Because today... Coochy coochy coo!

Kellam: Yes, you were. But today is different. Because today... Coochy coochy coo!

Lon'qu: Yes. You were. But today is different. Because today... Come here!

Ricken: Yes, you were. But today is different. Because today... Coochy coochy coo!

Gaius: Yeah, you were. But today's different. Because today... Coochy coochy coo!

Gregor: Yes, you were. But today is different. Because today... Coochy coochy coo!

Libra: Yes, you were. But today is different. Because today... Coochy coochy coo!

Henry: Yep, you were. But today's different. Because today... Coochy coochy coo!

Donnel: Oh, ya were. But today's different. 'Cause today... Coochy coochy coo!

Laurent: Gah! Ah ha! Ah ha ha ha! S-stop that! F-Father, have you gone mad?!

[Robin]: Ah-hah! So you CAN smile!
Frederick: Ah-hah! So you CAN smile!
Virion: Ah-hah! So you CAN smile!
Vaike: Ah-hah! So ya CAN smile!
Stahl: Ah-hah! So you CAN smile!
Kellam: Ah-hah! So you CAN smile!
Lon'qu: ...So you CAN smile!
Ricken: Ah-hah! So you CAN smile!
Gaius: Ah-hah! So you CAN smile!
Gregor: Ah-hah! So you CAN smile!
Libra: Hah! So you CAN smile!
Henry: Ah-hah! So you CAN smile!
Donnel: Shuck my corn! Ya CAN smile!

Laurent: I beg your pardon?!

[Robin]: You're always so bent on being such a serious, proper grown-up. I worry that you put too much pressure on yourself.
Frederick: You're always so bent on being such a serious, proper grown-up. I worry that you put too much pressure on yourself.
Virion: You're always so bent on being such a serious, proper grown-up. I worry that you put too much pressure on yourself.
Vaike: You're always so bent on being such a serious, proper grown-up. I worry that ya put too much pressure on yourself.
Stahl: You're always so bent on being such a serious, proper grown-up. I worry that you put too much pressure on yourself.
Kellam: You're always so bent on being such a serious, proper grown-up. I worry that you put too much pressure on yourself.
Lon'qu: You're always so bent on being such a serious, proper grown-up. I worry that you put too much pressure on yourself.
Ricken: You're always so bent on being such a serious, proper grown-up. I worry that you put too much pressure on yourself.
Gaius: You're always so bent on being such a serious, proper adult. I worry that you put too much pressure on yourself.
Gregor: Laurent always so bent on being serious, proper grown-up. Gregor worry you put too much pressure on self.
Libra: You're always so bent on being such a serious, proper grown-up. I worry that you put too much pressure on yourself.
Henry: You're always so bent on being such a serious, proper adult. I worry that you put too much pressure on yourself.
Donnel: Yer always so bent on bein' the serious, grown-up type. I worry ya put too much pressure on yerself.

Laurent: For the last time, I am not a child!

[Robin]: Age has nothing to do with it. It doesn't matter if you're older than Lucina. Or heck, older than me! You're still a child. You're MY child. ...You're my son.
Frederick: Age has nothing to do with it. It doesn't matter if you're older than Lucina. Or heck, older than me! You're still a child. You're MY child. ...You're my son.
Virion: Age has nothing to do with it. It doesn't matter if you're older than Lucina. Or even older than me! You're still a child. You're MY child. ...You're my son.
Vaike: Age ain't got nothin' to do with it. It don't matter if you're older than Lucina. Or heck, older'n me! You're still a child. You're MY child. ...You're my son.
Stahl: Age has nothing to do with it. It doesn't matter if you're older than Lucina. Or heck, older than me! You're still a child. You're MY child. ...You're my son.
Kellam: Age has nothing to do with it. It doesn't matter if you're older than Lucina. Or heck, older than me! You're still a child. You're MY son.
Lon'qu: Age has nothing to do with it. You're still a child. You're MY child. ...You're my son.
Ricken: Age has nothing to do with it. It doesn't matter if you're older than Lucina. Or heck, older than me! You're still a child. You're MY son.
Gaius: Age has nothing to do with it. It doesn't matter if you're older than Lucina. Or heck, older than me! You're still a child. You're MY child. ...You're my son.
Gregor: Age is not issue here, my boy. Makes no difference if you are older than Lucina or even older than Gregor! You are still child. Gregor's child. ...Gregor's son.
Libra: Age has nothing to do with it. It doesn't matter if you're older than Lucina. Or heck, older than me! You're still a child. You're MY child. ...You're my son.
Henry: Age has nothing to do with it. It doesn't matter if you're older than Lucina. Or even older than me! You're still a child. You're MY child. ...You're my son.
Donnel: Age ain't got nothin' to do with it. It don't matter if yer older'n Lucina. Or heck, older'n me! Yer still a child. Yer MY child. ...My son.

Laurent: Er, I...

[Robin]: And you're not alone anymore, so stop isolating yourself. You've got friends, and you've got me.
Frederick: And you're not alone anymore, so stop isolating yourself. You've got friends, and you've got me.
Virion: And you're not alone anymore, so stop isolating yourself. You've got friends, and you've got me.
Vaike: And ya ain't alone no more, so stop isolatin' yourself. Ya got friends, and ya got Ol' Vaike.
Stahl: And you're not alone anymore, so stop isolating yourself. You've got friends, and you've got me.
Kellam: And you're not alone anymore, so stop isolating yourself. You've got friends, and you've got me.
Lon'qu: And you're not alone anymore, so stop isolating yourself. You've got friends, and you've got me.
Ricken: And you're not alone anymore, so stop isolating yourself. You've got friends, and you've got me.
Gaius: And you're not alone anymore, so stop isolating yourself. You've got friends, and you've got me.

Gregor: And you are not alone anymore, so no more isolating yourself. You have friends and you have Gregor. Honestly, what else does man need?
Libra: And you're not alone anymore, so stop isolating yourself. You've got friends, and you've got me.
Henry: And you're not alone anymore, so stop isolating yourself. You've got friends, and you've got me.
Donnel: And ya ain't alone no more. So stop isolatin' yerself already. Ya got friends, and ya got me.

Laurent: You're right. All that time, it was... I was so lonely. Year after year, all alone... Wandering an era where I knew no one. Hoping to meet up with the others but knowing how minuscule my chances were... I had no one to help me. No one to lend an ear to my despair. It was...awful. Many nights, I thought I'd die alone. That the pain would kill me, or...

[Robin]: I'm so sorry I didn't find you earlier, Laurent. Please forgive me. And know that I will never leave your side again...
Frederick: I'm so sorry I didn't find you earlier, Laurent. Please forgive me. And know that I will never leave your side again...
Virion: I'm so sorry I did not find you earlier, Laurent. Please forgive me. Just know that I will never leave your side again...
Vaike: I'm so sorry I didn't find ya earlier, Laurent. You forgive me, right? Ya got my word, I'll never leave your side again.
Stahl: I'm so sorry I didn't find you earlier, Laurent. Please forgive me. And know that I will never leave your side again...
Kellam: I'm so sorry I didn't find you earlier, Laurent. Please forgive me. And know that I'll never leave your side again...
Lon'qu: ...I'm sorry I didn't find you earlier, Laurent. Please forgive me. Rest assured, I will never leave your side again...
Ricken: I'm so sorry I didn't find you earlier, Laurent. Please forgive me. And know that I will never leave your side again...
Gaius: I'm so sorry I didn't find you earlier, Laurent. Please forgive me. And know that I'll never leave your side again...
Gregor: Laurent... Gregor feels much shame that he was not able to find you earlier. But know this: Gregor will never leave your side again.
Libra: I'm so sorry I didn't find you earlier, Laurent. Gods forgive me. But know that I will never leave your side again.
Henry: Aw, I'm sorry I didn't find you earlier, Laurent. You forgive me, right? The important thing is, I'm here now, and I'm never gonna leave again!
Donnel: I'm awful sorry I didn't find ya earlier, Laurent. Please forgive me. Just know that I ain't never gonna leave ya again! Cross m'heart and hope to spit!

Noire

Avatar (male)

The dialogue between Avatar (male) and Noire can be found on page 226.

Avatar (female)

The dialogue between Avatar (female) and Noire can be found on page 237.

Tharja (Mother/daughter)

Noire's mother/daughter dialogue with Tharja can be found on page 278.

Owain

The dialogue between Owain and Noire can be found on page 288.

Inigo

The dialogue between Inigo and Noire can be found on page 292.

Brady

The dialogue between Brady and Noire can be found on page 296.

Severa

The dialogue between Severa and Noire can be found on page 305.

Gerome

The dialogue between Gerome and Noire can be found on page 307.

Morgan (male)

The dialogue between Morgan (male) and Noire can be found on page 309.

Morgan (female)

The dialogue between Morgan (female) and Noire can be found on page 311.

Morgan (female) (Mother/daughter)

The mother/daughter dialogue between Morgan (female) and Noire can be found on page 312.

Morgan (female) (Sisters)

The sisters dialogue between Morgan (female) and Noire can be found on page 312.

Yarne

The dialogue between Yarne and Noire can be found on page 313.

Laurent

The dialogue between Laurent and Noire can be found on page 315.

Father

FATHER X NOIRE C

Noire: *Sniff* *sniffle*

[Robin]: Noire? What's wrong? Why are you crying?
Frederick: Noire? What's wrong? Why are you crying?
Virion: Noire? Good heavens, what is it? Why are you crying?
Vaike: Noire? What's wrong? Why are ya cryin'?
Stahl: Noire? What's wrong? Why are you crying?
Kellam: Noire? What's wrong? Why are you crying?
Lon'qu: What's wrong? Why are you crying?
Ricken: Noire? What's wrong? Why are you crying?
Gaius: Noire? What's wrong? Why are you crying?
Gregor: Noire? What is wrong? Why do you make with the crying?
Libra: Noire? What's wrong? Why are you crying?
Henry: Hey-o, Noire! What's wrong? Why are you crying?
Donnel: What's wrong, Noire? Why ya cryin'?

Noire: *Sniff* I'm not... Mother cursed me to have a *sniff* runny nose for three days straight.

[Robin]: That's...an oddly specific hex. But wait, why would she do that in the first place?
Frederick: That's...an oddly specific hex. Why would she do something like that?
Virion: That's...an oddly specific hex. But wait, why would she do that in the first place?
Vaike: What the heck? Why would she do somethin' like that?
Stahl: That's...an oddly specific hex. But wait, why would she do that in the first place?
Kellam: That's...an oddly specific hex. But wait, why would she do that in the first place?
Lon'qu: That's an...odd hex. Why would she do something like that?
Ricken: That's an awfully strange hex. But wait, why would she do that in the first place?
Gaius: That's an awfully specific hex. But wait, why would she do that in the first place?
Gregor: Oy! What a horrible night to have curse, yes?
Libra: By the gods, why would she do something like that?
Henry: Nya ha ha! I'd never inflict such a useless curse on someone!
Donnel: Now why'd she go and do that? ...And why a snifflin' nose, of all things?

Noire: It's nothing new. *sniffle* Mother is always trying out some new spell or another. Every time she comes up with one, she *sniiif* uses me as her guinea pig.

[Robin]: Poor dear. Here, take my handkerchief.
Frederick: Poor dear. Here, take my handkerchief.
Virion: Poor dear... Here, take my handkerchief.
Vaike: Poor kid. Here, blow your nose in my hanky.
Stahl: Poor dear. Here, take my handkerchief.
Kellam: Poor dear... Here, take my handkerchief.
Lon'qu: Heh. Here, take my handkerchief.
Ricken: That's terrible! Here, take my handkerchief.
Gaius: Heh, poor kid. Here, take this candy wrapper.
Gregor: Poor child... Here, take Gregor's handkerchief.
Libra: Poor dear... Here, take my handkerchief.
Henry: Aw. Here, take my handkerchief.
Donnel: Poor thing... Here, take m'lucky handkerchief.

Noire: Th-thank you... *HOOONK!*

[Robin]: I can't let you suffer like this for three whole days... Don't worry, Noire. I'll have a talk with your mother and get this cleared up.
Frederick: I can't let you suffer like this for three whole days... Don't worry, Noire. I'll have a talk with your mother and get this cleared up.
Virion: I can't let you suffer like this for three whole days... Don't worry, Noire. I'll have a talk with your mother and get this cleared up.
Vaike: Well, I can't let ya suffer like this for three whole days... The Vaike's gonna go have a talk with your mother and get this cleared up!
Stahl: I can't let you suffer like this for three whole days... Don't worry, Noire. I'll have a talk with your mother and get this cleared up.
Kellam: I can't let you suffer like this for three whole days... Don't worry, Noire. I'll have a talk with your mother and get this cleared up.
Lon'qu: I can't let you suffer like this for three whole days... I'll have a talk with your mother and get this cleared up.
Ricken: I can't let you suffer like this for three whole days... Don't worry, Noire. I'll have a talk with your mother and get this cleared up.
Gaius: I can't let you suffer like this for three whole days... Don't worry, Noire. I'll have a talk with your mother and get this cleared up.

Gregor: Gregor cannot let you suffer like this for three whole days... Do not worry. He will go talk with mother and fix situation.
Libra: I can't let you suffer like this for three whole days... Don't worry, Noire. I'll have a talk with your mother and get this cleared up.
Henry: Welp, I'm not exactly sure how to break a curse this strange, actually... But don't worry. I'll have a talk with your mother and get it cleared up.
Donnel: I can't letcha suffer like this for three whole days! Don't worry, Noire. I'll have me a talk with yer ma and get this cleared up.

Noire: Er...are you sure? That never really worked out for you in the future. Every time you talked back, Mother cursed you up to your eyeballs. ...Or sometimes she just cursed your eyeballs, and you cried yourself to sleep.

[Robin]: Gosh, that's...kind of pathetic.
Frederick: That's...rather pathetic.
Virion: Oh, dear. That's...rather pathetic.
Vaike: Gods. That's...kind of pathetic.
Stahl: Ouch. That's...kind of pathetic.
Kellam: Gosh, that's...kind of pathetic.
Lon'qu: That's...kind of pathetic.
Ricken: Gosh, that's...kind of pathetic.
Gaius: Damn, that's...kind of pathetic.
Gregor: Oy! Future Gregor sound like pathetic man-child!
Libra: Oh dear. That's...rather pathetic.
Henry: Nya ha! That's...kind of pathetic.
Donnel: Golly, that's right pathetic...

Noire: ...Yep. *sniff*

[Robin]: B-but that was a different me, right? Just wait—I'll prove you can depend on me!
Frederick: B-but that was a different me, right? Just wait—I'll prove you can depend on me!
Virion: B-but that was a different me. Just wait—I shall prove my worth to you anew!
Vaike: B-but that was a different me, right? Just wait—I'll prove ya can depend on me!
Stahl: B-but that was a different me, right? Just wait—I'll prove you can depend on me!
Kellam: B-but that was a different me, right? Just wait—I'll prove you can depend on me!
Lon'qu: B-but that was a different me. Just wait—I shall prove my worth to you!
Ricken: B-but that was a different me, right? Just wait—I'll prove you can depend on me!
Gaius: Well, whatever. That was a different me. Just wait—I'll prove you can depend on me!
Gregor: But that was different Gregor, yes? THIS Gregor much more dependingable!
Libra: B-but that was a different me, right? Just wait—I'll prove you can depend on me!
Henry: B-but that was a different me, right? Just wait—I'll prove you can depend on me!
Donnel: B-but that was a different me, right? Just wait—I'll prove ya can depend on me!

Noire: Eep! W-well, you never talked like that before! Maybe things really can be different this time around. *sniiiff*

FATHER X NOIRE B

[Robin]: *Sniff* I'm sorry, Noire... I feel like I really let you down... *sniff*
Frederick: *Sniff* I'm sorry, Noire... I feel like I really let you down... *sniff*
Virion: *Sniff* Gods, how embarrassing. Especially for a noble like myself... *sniff*
Vaike: *Sniff* Sorry, Noire... Looks like the Vaike letcha down... *sniff*
Stahl: *Sniff* I'm sorry, Noire... I feel like I really let you down... *sniff*
Kellam: *Sniff* I'm sorry, Noire... I feel like I really let you down... *sniff*
Lon'qu: *Sniff* I'm sorry, Noire... It seems I let you down... *sniff*
Ricken: *Sniff* I'm sorry, Noire... I feel like I really let you down... *sniff*
Gaius: *Sniff* Sorry, Noire... Looks like I let you down... *sniff*
Gregor: *Sniff* Gregor is sorry, Noire... Plan was big failure... *sniff*
Libra: *Sniff* I'm sorry, Noire... I feel like I really let you down... *sniff*
Henry: *Sniff* I'm sorry, Noire... Seems like I really let you down... *sniff*
Donnel: *Sniff* I'm dreadful sorry, Noire... I feel like I really let you down... *sniff*

Noire: It's all right. I honestly expected this from the very beginning... But there's no need to cry. You tried, and that's all you could do.

[Robin]: I'm not crying. *sniff* Your mother hit me with a five-day runny-nose curse.
Frederick: I'm not crying. *sniff* Your mother hit me with a five-day runny-nose curse.
Virion: I'm not crying. *sniff* Your mother hit me with a five-day runny-nose curse.
Vaike: I ain't cryin'. *sniff* Your mother hit me with a five-day runny-nose curse.
Stahl: I'm not crying. *sniff* Your mother hit me with a five-day runny-nose curse.
Kellam: I'm not crying. *sniff* Your mother hit me with a five-day runny-nose curse.
Lon'qu: I'm not crying. *sniff* Your mother hit me with a five-day runny-nose curse.
Ricken: I'm not crying. *sniff* Your mother hit me with a five-day runny-nose curse.
Gaius: I'm not crying. *sniff* Your mother hit me with a five-day runny-nose curse.

Gregor: G-Gregor not crying! *sniff* Gregor hit with five-day running-nose curse...
Libra: I'm not crying. *sniff* Your mother hit me with a five-day runny-nose curse.
Henry: I'm not crying. *sniff* Your mother hit me with a five-day runny-nose curse.
Donnel: I ain't cryin'. *sniff* Yer ma hit me with a five-day runny-nose curse.

Noire: Just like before...

[Robin]: Urgh... You did say this was how it played out in the future... *sniff* Well, look at the bright side—at least your hex is broken now. *sniffle*
Frederick: Urgh... You did say this was how it played out in the future... *sniff* Well, look at the bright side—at least your hex is broken now. *sniffle*
Virion: Urgh... You did say this was how it played out in the future... *sniff* Well, look at the bright side—at least I broke your hex. *sniffle*
Vaike: Urgh... Ya did say this was how it played out in the future... *sniff* But hey, at least your hex is broken now, right? *sniffle*
Stahl: Urgh... You did say this was how it played out in the future... *sniff* Well, look at the bright side—at least your hex is broken now. *sniffle*
Kellam: Urgh... You did say this was how it played out in the future... *sniff* Well, look at the bright side—at least your hex is broken now. *sniffle*
Lon'qu: Urgh... You did say this was how it played out in the future... *sniff* But hey—at least your hex is broken now. *sniffle*
Ricken: Urgh... You did say this was how it played out in the future... *sniff* But look at the bright side—at least your hex is broken now! *sniffle*
Gaius: Urgh... You did say this was how it played out in the future... *sniff* Well, look at the bright side—at least your hex is broken now. *sniffle*
Gregor: Oy... You did say this how it played out in bleak, terrible future... *sniff* But look at brightest side—at least hex is broken now, yes? *sniffle*
Libra: Urgh... You did say this was how it played out in the future... *sniff* Well, look at the bright side—at least your hex is broken now. *sniffle*
Henry: Urgh... Guess you did say this was how it played out in the future... *sniff* But look at the bright side—at least your hex is broken now! *sniffle*
Donnel: Urgh... Ya did warn me this is how it used to play out in the future... But look at the bright side—at least yer hex is broken! *sniffle*

Noire: Yep, juuust like before. You'd always come to my rescue by taking on Mother's curses yourself.

[Robin]: I guess some things were simply meant to be...
Frederick: I guess some things were simply meant to be...
Virion: Perhaps some things were simply meant to be...
Vaike: I guess some things were just meant to be...
Stahl: I guess some things were simply meant to be...
Kellam: I guess some things were simply meant to be...
Lon'qu: I guess some things were simply meant to be...
Ricken: I guess some things were just meant to be...
Gaius: I guess some things were just meant to be...
Gregor: Perhaps some things were simply meant to be...
Libra: I guess some things were simply meant to be...
Henry: I guess some things were just meant to be...
Donnel: I guess some things were just meant to be...

Noire: Maybe you're right. Maybe we're all fated to trace the same path as we did before.

[Robin]: Hmm?
Frederick: Hmm?
Virion: Hmm?
Vaike: Muh?
Stahl: Hmm?
Kellam: Hmm?
Lon'qu:
Ricken: Hmm?
Gaius: Huh?
Gregor: Hmm?
Libra: Hmm?
Henry: Huh?
Donnel: How's that now?

Noire: My coming back didn't change you, Father. So why should it change anything? It'll all happen again. My parents will die, and I'll be left alone... Why did I even bother coming back if it means watching my life fall apart again? Why... *sniff*

[Robin]: *Sniff* Oh, don't cry, sweetie.
Frederick: *Sniff* Oh, don't cry, sweetheart.
Virion: *Sniff* Oh, don't cry, my dear.
Vaike: *Sniff* Aw, don't cry, sweet cheeks.
Stahl: *Sniff* Oh, don't cry, dear.
Kellam: *Sniff* Oh, don't cry, sweetie.
Lon'qu: *Sniff* Don't cry, Noire.
Ricken: *Sniff* Aw, don't cry, kiddo.
Gaius: *Sniff* Hey, don't cry, cupcake.
Gregor: *Sniff* Oy, do not cry, pumpkin.
Libra: *Sniff* Oh, don't cry, love.
Henry: *Sniff* Hey, don't cry!
Donnel: *Sniff* Aw, don't cry, sweet pea.

Noire: FOOL! THESE ARE NO TEARS!

[Robin]: Er...sweetie?
Frederick: Er...sweetheart?
Virion: Er...my dear?
Vaike: Er...sweet cheeks?

Stahl: Er...dear?

Kellam: Er...sweetie?

Lon'qu: Er...Noire?

Ricken: Er... kiddo?

Gaius: Er... cupcake?

Gregor: Er... pumpkin?

Libra: Er... love?

Henry: Uh-oh. Here we go...

Donnel: Er... sweet pea?

Noire: Bwa ha ha! Such trifling matters cannot free the waters of my icy ducts, mortal! The only dribbling here is the unseemly nose flood seeping from your craven face!

[Robin]: Noire?! What are you...

Frederick: Noire?! What are you...

Virion: Noire?! What are you...

Vaike: Noire?! What in blazes...?

Stahl: Noire?! What are you...

Kellam: Noire?! What are you...

Lon'qu: Noire?! What are you...

Ricken: Noire?! What are you...

Gaius: Noire?! What in blazes...

Gregor: Oy! Why you make with the yelling and the screaming and so forth?!

Libra: Noire?! What are you...

Henry: Er, Noire? Come back, Noire.

Donnel: What in the heck?!

Noire: *Ahem* ...I'm sorry, Father. I think I need to step out and clear my head...

[Robin]: Noire, wait! There's no such thing as predetermined destiny! *sniff*

Frederick: Noire, wait! There's no such thing as predetermined destiny! *sniff*

Virion: Noire, wait! There's no such thing as predetermined destiny! *sniff*

Vaike: Noire, wait! Ain't no such thing as predetermined destiny! *sniff*

Stahl: Noire, wait! There's no such thing as predetermined destiny! *sniff*

Kellam: Noire, wait! There's no such thing as predetermined destiny! *sniff*

Lon'qu: Noire, wait! There's no such thing as predetermined destiny! *sniff*

Ricken: Noire, wait! There's no such thing as predetermined destiny! *sniff*

Gaius: Noire, wait! Is no such thing as predetermined destiny! *sniff*

Gregor: Noire, wait! Is no such thing as predetermined destiny! *sniff*

Libra: Noire, wait! There's no such thing as predetermined destiny! *sniff*

Henry: Noire, wait! There's no such thing as predetermined destiny! *sniff*

Donnel: Noire, wait! There ain't no such thing as predetermined destiny! *sniff*

■ FATHER X NOIRE A

[Robin]: Do you have a moment, Noire?

Frederick: Do you have a moment, Noire?

Virion: Do you have a moment, Noire?

Vaike: Ya got a moment, Noire?

Stahl: Do you have a moment, Noire?

Kellam: Do you have a moment, Noire?

Lon'qu: Do you have a moment, Noire?

Ricken: Do you have a minute, Noire?

Gaius: Got a minute, Noire?

Gregor: Hello, Noire. You have moment, yes?

Libra: Do you have a moment, Noire?

Henry: Got a second, Noire?

Donnel: Ya got a moment, Noire?

Noire: Oh... Hello, Father. What is it?

[Robin]: Have a look.

Frederick: Have a look.

Virion: Have a look.

Vaike: Take a look.

Stahl: Have a look.

Kellam: Have a look.

Lon'qu: Have a look.

Ricken: Have a look.

Gaius: Have a look.

Gregor: Here, have a look.

Libra: Have a look.

Henry: Ta-daaa!

Donnel: Have a look.

Noire: Eeeek! M-Mother's cursing implements! Gods, there's so many... Father, what are you planning to do to me?

[Robin]: Ha ha, nothing to you, Noire. I confiscated these from your mother so she couldn't put any more weird hexes on you.

Frederick: Ha ha, nothing to you, Noire. I confiscated these from your mother so she couldn't put any more weird hexes on you.

Virion: Ha ha, nothing to you, Noire. I confiscated these from your mother so she couldn't put any more weird hexes on you.

Vaike: Ha ha! A whole lotta nothin'! I stole these from your mother so she couldn't put any more weird hexes on ya.

Stahl: Hah, nothing to you, Noire. I confiscated these from your mother so she couldn't put any more weird hexes on you.

Kellam: Hah, nothing to you, Noire. I confiscated these from your mother so she couldn't put any more weird hexes on you.

Lon'qu: Heh, nothing to you, Noire. I confiscated these from your mother so she couldn't put any more weird hexes on you.

Ricken: Ha ha, nothing to you, Noire. I swiped these from your mother so she couldn't put any more weird hexes on you.

Gaius: Heh, nothing to you, Noire. I swiped these from your mother so she couldn't put any more weird hexes on you.

Gregor: Ho ho! Nothing to Noire, of course. Gregor take these from mother so she not put weird hex on you again.

Libra: Hee hee, nothing to you, Noire. I confiscated these from your mother so she couldn't put any more weird hexes on you.

Henry: Nya ha, nothing to you, Noire. I stole these from your mother so she couldn't put any more curses on you.

Donnel: Hah! Nothin' to you, Noire. I done stole these from yer ma what so she can't be puttin' weird hexes on ya.

Noire: You...you took away Mother's tools? But...you never did anything like this before...

[Robin]: Before, you said we couldn't change anything. That we're bound by fate. Well, I thought maybe I could lay that fear to rest. If I did something the future me couldn't, it would prove everything can change.

Frederick: Before, you said we couldn't change anything. That we're bound by fate. Well, I thought perhaps I could try and lay that fear to rest. If I did something the future me couldn't, it would prove everything can change.

Virion: Before, you said we couldn't change anything. That we're bound by fate. Well, I thought maybe I could lay that fear to rest. If I did something the future me couldn't, it would prove everything can change.

Vaike: Before, ya said we couldn't change anything. That we're bound by fate. Well, I thought maybe I could lay that fear to rest. If I did something the future me couldn't, it would prove everything can change.

Stahl: Before, you said we couldn't change anything. That we're bound by fate. Well, I thought maybe I could lay that fear to rest. If I did something the future me couldn't, it would prove everything can change.

Kellam: Before, you said we couldn't change anything. That we're bound by fate. Well, I thought maybe I could lay that fear to rest... If I did something the future me couldn't, it would prove everything can change.

Lon'qu: Before, you said we couldn't change anything. That we're bound by fate. Well, I thought I might lay that fear to rest. If I did something the future me couldn't, it would prove everything can change.

Ricken: Before, you said we couldn't change anything. That we're bound by fate. Well, I thought maybe I could lay that fear to rest. If I did something the future me couldn't, it would prove everything can change.

Gaius: Before, you said we couldn't change anything. That we're bound by fate. Well, I thought I'd see if I couldn't lay that fear to rest. If I did something the future me couldn't, it would prove everything can change.

Gregor: You said we could change nothing, yes? That we are bounded by fate. But if Gregor do something future Gregor could not, then fate have no hold on life.

Libra: Before, you said we couldn't change anything. That we're bound by fate. Well, I thought I could lay that fear to rest. If I did something the future me couldn't, it would prove everything can change.

Henry: Before, you said we couldn't change anything. That we're bound by fate. Well, I thought maybe I could lay that fear to rest. If I did something the future me couldn't, it would prove everything can change!

Donnel: 'Fore, ya said we couldn't change nothin'. That we was bound by fate. I reckoned I'd see if I couldn't lay that ol' fear to rest. If I did somethin' the future me couldn't, it would prove that stuff can change.

Noire: Hmm... I guess that's true. The father I knew wouldn't even get near these tools, let alone take them.

[Robin]: I only changed because you came back to me. And together, we can change anything. All of us—you, me, your mother...everyone.

Frederick: I only changed because you came back to me. And together, we can change anything. All of us—you, me, your mother...everyone.

Virion: I only changed because you came back to me. And together, we can change anything. All of us—you, me, your mother...everyone.

Vaike: I only changed because ya came back to me. And together, we can change anything. All of us—you, me, your mother...everyone.

Stahl: I only changed because you came back to me. And together, we can change anything. All of us—you, me, your mother...everyone.

Kellam: I only changed because you came back to me. And together, we can change anything. All of us—you, me, your mother...everyone.

Lon'qu: I only changed because you came back to me. And together, we can change anything. All of us. You, me, your mother...everyone.

Ricken: I only changed because you came back to me. And together, we can change anything. All of us—you, me, your mother...everyone.

Gaius: I only changed because you came back to me. And together, we can change anything. All of us—you, me, your mother...everyone.

Gregor: Gregor only change because pumpkin came back to him. Together, we can change anything. All of us—you, me, mother...everyone!

Libra: I only changed because you came back to me. And together, we can change anything. All of us—you, me, your mother...everyone.

Henry: I only changed because you came back to me, you know? And together, we can change anything. All of us—you, me, your mother...everyone.

Donnel: I only changed 'cause ya came back to me. And together, we can change anythin'. All of us—you, me, yer ma...everyone.

[Robin]: Nothing's taking me away from you again. Not even death.

Frederick: Nothing's taking me away from you again. Not even death.

Virion: Nothing's taking me away from you again. Not even death.

Vaike: Nothing's takin' me away from ya again. Not even death!

Stahl: Nothing's taking me away from you again. Not even death.

Kellam: Nothing's taking me away from you again. Not even death.

Lon'qu: Nothing's taking me away from you again. Not even death.

Ricken: Nothing's taking me away from you again. Not even death.

Gaius: Nothing's taking me away from you again. Not even death.

Gregor: Nothing will take Gregor away from you again. Not even death.

Libra: Nothing's taking me away from you again. Not even death.

Henry: Nothing's taking me away from you again. ...Not even death.

Donnel: Nothing's takin' me away from you again. Not even death!

Noire: That's...a little much, perhaps? But thanks.

[Robin]: Wait... Do you feel that? A sudden sense of foreboding; a fury rising from the shadows... A Risen ambush? No... Bears? Is it bears? No... Urk! I-it's your mother! And she's FURIOUS!

Frederick: Hmm... Do you feel that? A sudden sense of foreboding; a fury rising from the shadows... A Risen ambush? No... Bears? Is it bears? No... Urk! I-it's your mother! And she's FURIOUS!

Virion: Wait... Do you feel that? A sudden sense of foreboding; a fury rising from the shadows... A Risen ambush? No... Bears? Is it bears? No... Gods! I-it's your mother! And she's FURIOUS!

Vaike: ...Hey, you feel that? That sudden sense of darkness and foreboding... A Risen ambush? No... Bears? Is it bears? No... Yikes! It's your mother! And she's FURIOUS!

Stahl: Wait... Do you feel that? A sudden sense of foreboding; a fury rising from the shadows... A Risen ambush? No... Bears? Is it bears? No... Urk! I-it's your mother! And she's FURIOUS!

Kellam: Wait... Do you feel that? A sudden sense of foreboding; a fury rising from the shadows... A Risen ambush? No... Bears? Is it bears? No... Urk! I-it's your mother! And she's FURIOUS!

Lon'qu: ...Do you feel that? A sudden sense of foreboding; a fury rising from the shadows... A Risen ambush? No... Bears, perhaps? Is it bears? No... Urk! I-it's your mother! And she's FURIOUS!

Ricken: Wait... Do you feel that? A sudden sense of foreboding; a fury rising from the shadows... A Risen ambush? No... Bears? Is it bears? No... Urk! I-it's your mother! And she's FURIOUS!

Gaius: Wait... Do you feel that? A sudden sense of foreboding; a fury rising from the shadows... A Risen ambush? No... Bears? Is it bears? No... Urk! I-it's your mother! And she's FURIOUS!

Gregor: Hmm... Gregor suddenly have strange feeling... Like fury rising from shadows... A Risen ambush? No... Bears? Is bears? No... Urk! Is your mother! And she's FURIOUS!

Libra: Wait... Do you feel that? A sudden sense of foreboding; a fury rising from the shadows... A Risen ambush? No... Bears? Is it bears? No... Urk! I-it's your mother! And she's FURIOUS!

Henry: Say, do you feel that? A sudden sense of foreboding? Fury rising from the shadows... A Risen ambush? No... Bears? Is it bears? No... Oh, gods! I-it's your mother! And she's FURIOUS!

Donnel: Say, do you feel that? A sudden rush of forebodin' fury comin' from them shadows? A Risen ambush? No... Bears? Is it bears? No... Urk! I-it's yer ma! And she's FURIOUS!

Noire: She must have realized you took all her toys.

[Robin]: Yikes! I'd better get outta here before I test that whole "not even death" promise... Bye, Noire! Love you!

Frederick: *Sigh* I'd better disappear before I test that whole "not even death" promise... Bye, Noire! Love you!

Virion: I had better make my escape before I put that "not even death" promise to the test... Farewell, Noire! Love you!

Vaike: I'd better make tracks before I put that "not even death" promise to the test... See ya, sweet cheeks! Love ya!

Stahl: Uh-oh. I'd better get outta here before I test that whole "not even death" promise... Bye, Noire! Love you!

Kellam: Oh, man... I'd better get outta here before I test that whole "not even death" promise... Bye, Noire! Love you!

Lon'qu: Gods. I'd better leave before I test that whole "not even death" promise... I'll see you later, Noire.

Ricken: Yikes! I'd better get outta here before I test that whole "not even death" promise... Bye, Noire! Love you!

Gaius: Drat, I'd better get outta here before I test that whole "not even death" promise... See ya, Noire! Love you!

Gregor: Oy, this bad. Gregor best flee before testing "not even death" promise... Bye for now, Noire! Much love!

Libra: Oh, dear. I'd better get out of here before I test that whole "not even death" promise... Good-bye, Noire! Love you!

Henry: I'd better take off before I test that whole "not even death" promise! Nya ha! Bye for now, Noire!

Donnel: *Gulp* I better skedaddle 'fore I test that whole "not even death" promise... Bye for now, Noire! Love ya!

Noire: Wow, he's faster than I remember... And I can't recall Mother ever coming after him like this, either... Hey, maybe things really can change for the better!

Noire: Just please don't ever leave me again.

 Nah

 Avatar (male)

The dialogue between Avatar (male) and Nah can be found on page 226.

 Avatar (female)

The dialogue between Avatar (female) and Nah can be found on page 237.

 Nowi (Mother/daughter)

Nah's mother/daughter dialogue with Nowi can be found on page 276

 Owain

The dialogue between Owain and Nah can be found on page 289.

 Inigo

The dialogue between Inigo and Nah can be found on page 292.

 Brady

The dialogue between Brady and Nah can be found on page 296.

 Cynthia

The dialogue between Cynthia and Nah can be found on page 302.

 Gerome

The dialogue between Gerome and Nah can be found on page 307.

 Morgan (male)

The dialogue between Morgan (male) and Nah can be found on page 309.

Morgan (female)

The dialogue between Morgan (female) and Nah can be found on page 312.

 Morgan (female) (Mother/daughter)

The mother/daughter dialogue between Morgan (female) and Nah can be found on page 312.

Morgan (female) (Sisters)

The sisters dialogue between Morgan (female) and Nah can be found on page 312.

 Yarne

The dialogue between Yarne and Nah can be found on page 314.

 Laurent

The dialogue between Laurent and Nah can be found on page 316.

Tiki

■ TIKI X NAH C

Nah: Hey, Tiki. There you are!

Tiki: Yes, Nah. Here I am.

Nah: Could you do me a favor?

Tiki: If I'm capable, then of course. What do you need?

Nah: I, er... I actually want you to tell me about something.

Tiki: What, specifically?

Nah: Well, about when you were young. A long, long, long time ago. People say you were alive back during the age of legends, right? Well, I'm curious about history. Manakete history, especially. How did our kind live back then?

Tiki: Ah, yes. You have manakete blood in your veins.

Nah: I do indeed.

Tiki: You have the blood, yet you are not a true member of the tribe.

Nah: B-but I'm just like you... Aren't I?

Tiki: Throughout my millennia of life in this world, every manakete has been of pure blood. ...Until you. You are unique—the first of our kind to have a human father. I can tell you our history, though I doubt it would mean much to you now.

Nah: But that's not fair. I have the right to know, even if I'm not a full-blooded manakete!

Tiki: I don't mean it like that. You are a unique existence, the likes of which we have never known before. Our story may be difficult for you to hear... Painful even. Are you sure you wish to hear it?

Nah: Yes. Yes, I am!

Tiki: Then I shall tell you the tale someday. ...But not today.

Nah: I...I understand. Thank you, Tiki!

■ TIKI X NAH B

Nah: Tiki? I'm ready to hear the story now.

Tiki: Oh, yes. I did promise, didn't I? *Yawn* But I'm feeling very tired at the moment. Can it wait?

Nah: Er, okay. What about tomorrow?

Tiki: Yes, thank you. I'd appreciate that.

Nah: So do you snooze so much because you slept for thousands of years?

Tiki: ...I don't know. I suppose I do sleep a little more than most people.

Nah: You sure do.

Tiki:

Nah: Tiki.

Tiki:

Nah: Tiki! What is it, Nah? I thought we agreed to talk another day.

Nah: No, the history lesson can wait. It's just...there's something else.

Tiki: What is it?

Nah: When you turn into a dragon... Well, your jaws are bigger than mine.

Tiki: Er, yes. I suppose they are.

Nah: Why is that?

Tiki: It's because I am pure blooded. Manakete blood runs thick in my veins, and makes me look more... dragon-like.

Nah: Is that also why your fangs and claws are sharper than mine?

Tiki: That is a matter only of age. As I have lived many, many more centuries than you. As dragons get older and become more powerful, our claws and fangs sharpen. It will be the same for you when you reach my age, though it will take millennia.

Nah: That'll be sweet... I see... So, why is your skin so much thicker and harder than mine?

Tiki: That comes from fighting in countless battles. The more times a dragon is struck by blows, the thicker and harder our hide becomes.

Nah: I see. That's useful! ...Thanks for explaining everything, Tiki.

Tiki: Not at all. Er, but would you mind leaving me now? I'm starting to feel drowsy.

Nah: Oh, of course. Sleep well, Tiki. See you again soon!

Tiki: Questions upon questions. I suppose I'll have to tell her soon...

■ TIKI X NAH A

Tiki: ...And that is how I became friends with the legendary King Marth.

Nah: So were you released from the ice?

Tiki: Oh, yes. After what seemed an eternity in that frozen prison. It was by Marth's hand alone that I was able to feel warmth once more. It was magic...

Nah: ...Tiki?

Tiki: Oh, listen to me! I sound like a sentimental old fool. It was such a long time ago...

Nah: Did you love him? King Marth, I mean?

Tiki: He was human. I was manakete. The gulf between us was too great.

Nah:

Tiki: But you'll never have that problem, will you? With your mixed blood, you can love anyone you like, human or manakete.

Nah: Yes, I suppose that's right!

Tiki: ...Hear me, Nah. Remember when I said I had to tell you something difficult? We manaketes are destined to suffer because of our love for humankind.

Nah: Destined to...suffer?

Tiki: We live for millennia, while humans flicker out like candles. The greatest friendship I ever knew lasted just a few short decades... And when King Marth died, I was left to wander the centuries alone.

Nah: ...I see. I have to be prepared to lose everyone I love.

Tiki: The dragon blood in your veins curses you to such a fate.

Nah: ...Wow. That's...depressing.

Tiki: It can be very sad, yes. But it can make you strong as well. You will learn to cherish the memories of those wonderful people you meet. You will make them a part of you so they can give you courage always.

Nah: Like a family inside your mind?

Tiki: Yes, exactly! You will be able to pass on the memories to your friends' children! And then to their children and to countless generations to come. In this way can you keep them alive through the long march of time.

Nah:

Tiki: Do you understand?

Nah: ...I think so.

Tiki: Never allow your fate to dissuade you from living a full, rewarding life, Nah. You must go out into the world and seek out friends. ...Seek out love. And when their end comes, as it will, you must keep them alive forever. You have the gift of near immortality, and must find a way to share it. And what better time to start than now? Nah, let us you and I be friends.

Nah: I'd like that. Thank you, Tiki.

Tiki: Now no more brooding on destiny. Next time we shall talk of joyful things.

Nah: That would be a nice change of pace!

Father

■ FATHER X NAH C

Nah: *Sigh* Dealing with Mother is just so exasperating! All she ever does is play, play, play, as if she hasn't a care in the world!

[Robin]: What's wrong, Nah? You seem like you're in quite a mood.

Frederick: What's wrong, Nah? You seem like you're in quite a mood.

Virion: What's wrong, Nah? You seem like you're in quite a mood.

Vaike: What's wrong, Nah? You seem pretty sour there.

Stahl: What's wrong, Nah? You seem like you're in quite a mood.

Kellam: What's wrong, Nah? You seem like you're in quite a mood.

Lon'qu: What's wrong, Nah? You seem like you're in quite a mood.

Ricken: What's wrong, Nah? You seem like you're in a bad mood.

Gaius: What's wrong, Nah? You seem like you're in quite a mood.

Gregor: What is wrong, Nah? You seem to be in foul mood.

Libra: What's wrong, Nah? You seem like you're in quite a mood.

Henry: What's wrong, Nah? You seem like you're in quite a mood.

Donnel: What's wrong, Nah? Ya seem awfully peeved.

Nah: Oh, hello, Father. I was just thinking about Mother again... How do you stand her? Don't you find her incredibly childish? Annoying, even? She spends almost all of her time running around camp playing games.

[Robin]: How odd. I was just thinking how the two of you are so alike in many ways... But no, I don't find her annoying. It's who she is—I wouldn't want her to change.

Frederick: How odd. I was just thinking how the two of you are so alike in many ways... But no, I don't find her annoying. It's who she is—I wouldn't want her to change.

Virion: How odd. I was just thinking how the two of you are so similar... But no, I don't find her annoying. I don't find ANY woman annoying! You know this!

Vaike: Weird. I was just thinkin' how the both of ya are so alike in many ways... But no, I don't find her annoyin'. It's who she is, and I don't expect her to change.

Stahl: How odd. I was just thinking how the two of you are so alike in many ways... But no, I don't find her annoying. It's who she is—I wouldn't want her to change.

Kellam: How odd. I was just thinking how the two of you are so alike in many ways... But no, I don't find her annoying. It's who she is—I wouldn't want her to change.

Lon'qu: How odd. I was just thinking how the two of you are so similar... But no, I don't find her annoying. It's who she is—I wouldn't want her to change.

Ricken: Hah! I was JUST thinking how the two of you are so alike in many ways... But no, I don't find her annoying. It's who she is—I wouldn't want her to change.

Gaius: Odd, I was just thinking how the two of you are so alike in many ways... But no, I don't find her annoying. It's who she is—I wouldn't want her to change.

Gregor: Strange. Gregor was just thinking how you two are so alike in many ways... But no, mother is not annoying. She is mother. Gregor not want her to change.

Libra: How odd. I was just thinking how the two of you are so alike in many ways... But no, I don't find her annoying. It's who she is—I wouldn't want her to change.

Henry: Nya ha! I was JUST thinking how the two of you are so alike in many ways... But no, I don't find her annoying. It's who she is—I wouldn't want her to change!

Donnel: Ain't that a kick? I was just thinkin' how alike the two of you are. But no, I don't find her annoying. It's who she is—I wouldn't want her to change.

Nah: Tsk! Father, you're MUCH too kind. If you're always this tolerant, she'll never learn to act her age!

[Robin]: Well, I...
Frederick: Well, I...
Virion: Well, perhaps, but...
Vaike: Well, I...
Stahl: Well, I...
Kellam: Well, I...
Lon'qu:
Ricken: Well, I...
Gaius: Well, I...
Gregor: Well, I...
Libra: Well, I...
Henry: Well, I...
Donnel: Well, I...

Nah: What do you like about her, anyway? You're so serious and responsible, and she runs around like a headless chicken! I have no idea what you see in her... Unless...you rushed into marriage for some reason? Like you got her—

[Robin]: What?! D-don't be ridiculous! I knew exactly what I was getting into.

Frederick: What?! D-don't be ridiculous! I knew exactly what I was getting into.

Virion: What?! D-don't be ridiculous! I knew exactly what I was getting into.

Vaike: What?! D-don't be ridiculous! The Vaike knew exactly what he was gettin' into!

Stahl: What?! D-don't be ridiculous! I knew exactly what I was getting into.

Kellam: What?! D-don't be ridiculous! I knew exactly what I was getting into.

Lon'qu: D-don't be ridiculous! I knew exactly what I was getting into.

Ricken: What?! D-don't be ridiculous! I knew exactly what I was getting into.

Gaius: What?! D-don't be ridiculous! I knew exactly what I was getting into.

Gregor: What?! D-don't be silly! Gregor knew just what he was getting into!

Libra: What?! D-don't be ridiculous! I knew exactly what I was getting into.

Henry: What?! That's just crazy talk! I knew exactly what I was getting into!

Donnel: What?! D-don't be ridiculous! I knew exactly what I was gettin' into!

Nah: Oh? That's quite a protest there... I guessed right, didn't I?

[Robin]: No, no... I was well aware of her...frivolous side. I find it charming. Yes, that's it. Charming.

Frederick: No, no... I was well aware of her...frivolous side. I find it charming. Yes, that's it. Charming.

Virion: No, no... I was well aware of her...frivolous side. I find it charming. Yes, that's it. Charming.

Vaike: N-no! I was plenty aware of her frivolous side! I found it...charming. Yeah, that's it. Charming.

Stahl: No, no... I was well aware of her...frivolous side. I find it charming. Yes, that's it. Charming.

Kellam: No, no... I was well aware of her...frivolous side. I find it charming. Yes, that's it. Charming.

Lon'qu: No. I was well aware of her...frivolous side. I find it charming. Yes... Charming.

Ricken: No, no... I was well aware of her...frivolous side. I find it charming. Yeah, that's it. Charming.

Gaius: Not at all. I was well aware of her...frivolous side. I find it charming. Yes, that's it. Charming.

Gregor: Not even close. Gregor find Nowi, how you say, charming? ...That is word, yes?

Libra: No, no... I was well aware of her frivolous side. I find it charming. Yes, indeed. Charming.

Henry: No, no, no. I was well aware of her frivolous side. I find it...charming. Yeah, that's it. Charming.

Donnel: Heck no! I knew yer ma was a bit...flighty at times. I just find it charmin'.

Nah: You know what, Father? I don't believe you one bit. Come now, spit it out. Why DID you marry her?

[Robin]: Enough! You shouldn't be talking about your mother like this.

Frederick: Enough! You shouldn't be talking about your mother like this.

Virion: Enough! You shouldn't be talking about your mother like this.

Vaike: Enough! Ya shouldn't be talkin' about your mother like this!

Stahl: Enough! You shouldn't be talking about your mother like this.

Kellam: Enough! You shouldn't be talking about your mother like this.

Lon'qu: Enough! You shouldn't be talking about your mother like this.

Ricken: Enough! You shouldn't be talking about your mother like this.

Gaius: Enough! You shouldn't be talking about your mother like this. H-here, have some candy!

Gregor: Enough! You should not speak of mother in such ways.

Libra: Enough! You shouldn't be talking about your mother like this.

Henry: Hey, that's enough! You shouldn't be talking about your mother like this.

Donnel: Enough! It ain't right to be talkin' 'bout yer ma like this!

Nah: Hey, stop! Don't run away from me! WAAAAAAIT!

FATHER X NAH B

Nah: Father! Cornered you at last! It's time we finished our conversation.

[Robin]: Nah, you're incredibly persistent, but that discussion is over. I'm not getting into any more detail about why I chose your mother, and that's final!

Frederick: Nah, you're incredibly persistent, but that discussion is over. I'm not getting into any more detail about why I chose your mother, and that's final!

Virion: Nah, I admire your persistence, but that discussion is over. I'm not getting into any more detail about why I chose your mother, and that's final!

Vaike: Nah, you're awfully persistent, but that discussion's over. I'm not gettin' into any more detail about why I chose your mother, and that's final!

Stahl: Nah, you're incredibly persistent, but that discussion is over. I'm not getting into any more detail about why I chose your mother, and that's final!

Kellam: Nah, you're incredibly persistent, but that discussion is over. I'm not getting into any more detail about why I chose your mother, and that's final!

Lon'qu: Nah, I'm not getting into any more detail about why I chose your mother. That's final.

Ricken: Nah, you're awfully persistent, but that discussion is over. I'm not getting into any more detail about why I chose your mother, and that's final!

Gaius: Nah, you're incredibly persistent, but that discussion is over. I'm not getting into any more detail about why I chose your mother, and that's final!

Gregor: You are very persistent, Nah, but previous discussion is over. Gregor not going into detail for choosing of Nowi, and that is last straw on camel!

Libra: Nah, you're incredibly persistent, but that discussion is over. I'm not getting into any more detail about why I chose your mother, and that's final!

Henry: Nah, you're insanely persistent, but that discussion is over. I'm not getting into any more detail about why I chose your mother, and that's that!

Donnel: Yer stubborn as an old mule, Nah, but that discussion is over now. I ain't gettin' into more detail about why I chose yer ma, and that's final!

Nah: AWWWWWW. Why not?! A daughter simply MUST know how her parents fell in love! You don't understand how a woman's heart works. You're so CRUEL!

[Robin]: Heh, you're a little young to understand about a "woman's heart," yourself.

Frederick: Heh, you're a little young to understand about a "woman's heart," yourself.

Virion: Aren't you a bit young to be understanding a "woman's heart," yourself?

Vaike: Heh, you're a little young to be worryin' about a "woman's heart," yourself.

Stahl: Heh, you're a little young to understand about a "woman's heart," yourself.

Kellam: You're a little young to understand about a "woman's heart," yourself, you know...

Lon'qu: Aren't you a little young to be worrying about a "woman's heart"?

Ricken: Hey, you're a little young to understand about a "woman's heart," yourself.

Gaius: Heh, you're a little young to understand about a "woman's heart," yourself.

Gregor: Heh, you are too young to understand about a "woman's heart," yourself.

Libra: Heh, you're a little young to understand about a "woman's heart," yourself.

Henry: Heh, you're a little young to understand about a "woman's heart," yourself.

Donnel: Heh, I think ya're a mite young to be worryin' about yer "woman's heart."

Nah: ...Did you just mention my AGE?! Gods, forget what I said. It's a wonder any woman deigned to choose YOU.

[Robin]: Nah, I know what you're trying to do here. But don't forget, I AM your father. If you keep this up, I WILL get upset, and I WILL punish you...

Frederick: Nah, I know what you're trying to do here. But don't forget, I AM your father. If you keep this up, I WILL get upset, and I WILL punish you...

Virion: Nah, I know what you're trying to do here. But don't forget, I AM your father! If you keep this up, I WILL get upset, and I WILL punish you...

Vaike: Hey, I know what you're tryin' to do here. But don't forget, I AM your father. Ya keep this up, I WILL get upset, and I WILL punish ya...

Stahl: Nah, I know what you're trying to do here. But don't forget, I AM your father. If you keep this up, I WILL get upset, and I WILL punish you...

Kellam: Nah, I know what you're trying to do here. But don't forget, I AM your father. If you keep this up, I WILL get upset, and I WILL punish you...

Lon'qu: Nah, I know what you're trying to do here. But don't forget, I AM your father. If you keep this up, you're going to make me very upset.

Ricken: Nah, I know what you're trying to do here. But don't forget, I AM your father. If you keep this up, I WILL get upset, and I WILL punish you!

Gaius: Nah, I know what you're trying to do here. But don't forget, I AM your father. If you keep this up, I WILL get upset, and I WILL withhold your candy allowance!

Gregor: Nah, Gregor see what you are trying to do. But don't forget, Gregor IS your father. If you keep this up, Gregor WILL get upset, and Gregor WILL punish you...

Libra: Nah, I know what you're trying to do here. But don't forget, I AM your father. If you keep this up, I WILL get upset, and I WILL punish you...

Henry: Nah? I know what you're trying to do here. But don't forget, I AM your father. If you keep this up, I WILL get upset, and I WILL punish you...

Donnel: Nah, I know what yer tryin' to do here. But don't forget, I AM yer father. If ya keep this up, I WILL get angry, and I WILL punish ya.

Nah: Eep! S-sorry, Father. I didn't mean to make you angry... I swear.

[Robin]: All right, all right then... I appreciate the apology.

Frederick: All right, all right then... I appreciate the apology.

Virion: All right, all right then... I appreciate the apology.

Vaike: All right, all right then... I appreciate the apology.

Stahl: All right, all right then... I appreciate the apology.

Kellam: All right, all right then... I appreciate the apology.

Lon'qu: All right. ...I appreciate the apology.

Ricken: All right... I appreciate the apology.

Gaius: All right, all right then... I appreciate the apology.

Gregor: Very well, then... Gregor accepts apology.

Libra: All right... I appreciate the apology.

Henry: All right, then... I appreciate the apology.

Donnel: All right, all right then... I 'preciate the 'pology.

Nah: I've been selfish and unreasonable. Please find it in yourself to forgive me.

[Robin]: Yes, of course. But—
Frederick: Yes, of course. But—
Virion: Yes, of course. But—
Vaike: Yeah, of course. But—
Stahl: Yes, of course. But—
Kellam: Yes, of course. But—
Lon'qu: Yes, of course. But—
Ricken: Yes, of course. But—
Gaius: Yes, of course. But—
Gregor: Yes, of course. But—
Libra: Yes, of course. But—
Henry: Yeah, of course. But—
Donnel: Well, sure. But—

Nah: I guess I've wasted enough of your time. I'll just be...going now.

[Robin]: No, wait, Nah.
Frederick: No, wait, Nah.
Virion: No, wait.
Vaike: No, wait.
Stahl: No, wait, Nah.
Kellam: No, wait, Nah.
Lon'qu: Wait.
Ricken: H-hold on!
Gaius: No, wait, Nah.
Gregor: No, wait.
Libra: No, wait, Nah.
Henry: No, wait.
Donnel: No, wait, Nah.

Nah: Yes?

[Robin]: You seem so crestfallen... Are you all right?

Frederick: You seem so crestfallen... Are you all right?

Virion: You seem so crestfallen, my dear... Are you all right?

Vaike: Ya seem so crestfallen... You all right?

Stahl: You seem so crestfallen... You all right?

Kellam: You seem so crestfallen... Are you all right?

Lon'qu: You seem so...crestfallen... Are you all right?

Ricken: You seem so crestfallen... Are you all right?

Gaius: You seem so crestfallen... Are you all right?

Gregor: You seem like crest has fallen... Are you all right?

Libra: You seem so crestfallen... Are you all right?

Henry: You seem so crestfallen... Are you all right?

Donnel: Ya just seem so crestfallen. Are ya all right?

Nah: *Sigh* I suppose I'll just have to deal with the crushing disappointment, won't I? I mean, if my father is going to become so angry over a simple, innocent question...

[Robin]: Um, yes, well... See, it's—
Frederick: Um, yes, well... See, it's just—
Virion: Um, yes, well... See, it's just—
Vaike: Um, yeah, well... See, it's just—
Stahl: Um, yes, well... See, it's just—
Kellam: Um, yes, well... See, it's just—
Lon'qu: Um, yes, well... It's just—
Ricken: Um, yes, well... See, it's just—
Gaius: Um, yes, well... See, it's just—
Gregor: Um, yes, well... See, it just—
Libra: Um, yes, well... See, it's just—
Henry: Um, yeah, well... See, it's just—
Donnel: Um, right, well... See, it's just—

Nah: No, no. You don't have to explain. I'm used to dealing with hardship. Being spurned by my own father is just another drop in my bucket of torment. Hardly worth mentioning at all. Truly! ...Anyway, have a nice day.

[Robin]: B-b-but... ...Gods, is this really what I have to look forward to for the next decade?

Frederick: B-but... ...Is this really what I have to look forward to for the next decade?

Virion: B-b-but... ...Gods, is this really what I have to look forward to for the next decade?

Vaike: B-b-but... ...Gods, is this really what I have to look forward to for the next decade?

Stahl: B-b-but... ...Is this really what I have to look forward to for the next decade?

Kellam: B-b-but... *Sigh* Is this really what I have to look forward to for the next decade?

Lon'qu: Hold on! ...Ugh. Is this really what I have to look forward to for the next decade?

Ricken: B-b-but... ...Is this really what I have to look forward to for the next decade?

Gaius: B-b-but... ...Gods, is this really what I have to look forward to for the next decade?

Gregor: B-b-but... ...Oy, is this what Gregor must look forward to for next decade?

Libra: B-b-but... ...Is this really what I have to look forward to for the next decade?

Henry: B-b-but... Geez, is this really what I have to look forward to for the next decade?

Donnel: B-b-but... ...Well, shucks. Is this really what I got to look forward to for the next decade?

FATHER X NAH A

[Robin]: Nah...
Frederick: Nah...
Virion: Nah...
Vaike: Nah...
Stahl: Nah...
Kellam: Nah...
Lon'qu: Nah...
Ricken: Nah...
Gaius: Nah...
Gregor: Nah...
Libra: Nah...
Henry: Nah...
Donnel: Nah...

Nah: Why, hello, Father. What can I do for you?

[Robin]: About the other day, when you said you were used to disappointment... What exactly did you mean by that?

Frederick: About the other day, when you said you were used to disappointment... What exactly did you mean by that?

Virion: About the other day, when you said you were used to disappointment... What exactly did you mean by that?

Vaike: About the other day, when ya said ya were used to disappointment... What exactly did ya mean by that?

Stahl: About the other day, when you said you were used to disappointment... What exactly did you mean by that?

Kellam: About the other day, when you said you were used to disappointment... What exactly did you mean by that?

Lon'qu: About the other day, when you said you were used to disappointment... What exactly did you mean by that?

Ricken: About the other day, when you said you were used to disappointment... What exactly did you mean by that?

Gaius: About the other day, when you said you were used to disappointment... What exactly did you mean by that?

Gregor: About other day, when you said you were used to disappointment... Gregor is confused by this, yes?

Libra: About the other day, when you said you were used to disappointment... What exactly did you mean by that?

Henry: About the other day, when you said you were used to disappointment... What exactly did you mean by that?

Donnel: About the other day, when ya said ya were used to disappointment? What exactly did ya mean by that?

Nah: Oh, that... I was talking about growing up in my foster home.

[Robin]: Wait, you mean Nowi wasn't around to raise you?

Frederick: Wait, you mean Nowi wasn't around to raise you?

Virion: Wait, you mean Nowi wasn't around to raise you?

Vaike: What, ya mean Nowi wasn't around to raise ya?

Stahl: Wait, you mean Nowi wasn't around to raise you?

Kellam: Wait, you mean Nowi wasn't around to raise you?

Lon'qu: Wasn't Nowi there to raise you?

Ricken: Wait, you mean Nowi wasn't around to raise you?

Gaius: Wait, you mean Nowi wasn't around to raise you?

Gregor: Wait, you mean Nowi was not around to raise you?

Libra: Wait, you mean Nowi wasn't around to raise you?

Henry: Wait, so Nowi wasn't around to raise you?

Donnel: Wait, ya mean Nowi warn't around to raise ya proper?

Nah: No. I never knew either of my parents. I was sent to live with the family of one of my father's soldier friends. But my new family wasn't very welcoming to their semihuman-mongrel foster child.

[Robin]: Don't say that.
Frederick: Don't say that.
Virion: Don't say that.
Vaike: Don't say that.
Stahl: Don't say that.
Kellam: Don't say that.
Lon'qu: Don't say that.
Ricken: Don't say that...
Gaius: Don't say that.
Gregor: Do not say such things.
Libra: Don't say that.
Henry: Don't say that.
Donnel: Don't say that.

Nah: I soon learned that I'd have to work hard to fit in and survive in my new home. I did chores before I was asked. I helped defend the house from marauding Risen. I thought that if I could make myself useful, they would stop...hating me. I mean, how could they resent a child that always helped and never asked for anything? But they never accepted me... I just learned to deal with disappointment. I had no friends. No one to talk to. ...I was utterly alone. And I never once mentioned how much I missed my father and mother. *Sniff* I...I didn't even ask...when...when would they come back for me...

[Robin]: ...Nah, I...
Frederick: ...Nah, I...
Virion: ...Nah, I...
Vaike: ...Nah, I...
Stahl: ...Nah, I...
Kellam: ...Nah, I...
Lon'qu:
Ricken: ...Nah, I...
Gaius: ...Nah, I...
Gregor: ...Nah...
Libra: ...Nah...
Henry: ...Nah, I...
Donnel: ...Nah, I...

Nah: Wh-when I arrived here, I wanted to find out everything I could about them. *sniff* Th-that's why I keep asking so many questions and making you angry...

[Robin]: I'm sorry, Nah. I've been blind this whole time... I'll tell you anything you want to know—even the embarrassing story of our courtship... And if you're ever feeling lost or sad, I'll be right here for you. As long as I'm around, you won't ever be lonely again.

Frederick: I'm sorry, Nah. I've been blind this whole time... I'll tell you anything you want to know—even the embarrassing story of our courtship... And if you're ever feeling lost or sad, I'll be right here for you. As long as I'm around, you won't ever be lonely again.

Virion: I'm sorry, Nah. I've been blind this whole time... I'll tell you anything you want to know—even the embarrassing story of our courtship... And if you're ever feeling lost or sad, I'll be right here for ya. As long as I'm around, you won't ever be lonely again.

Vaike: I'm sorry, Nah. I've been a real heel about this whole thing... I'll tell ya anythin' ya wanna know about your mother. ...Even how we fell in love. And if you're ever feeling lost or sad, I'll be right here for ya. As long as I'm around, ya won't ever be lonely again.

Stahl: I'm sorry, Nah. I've been blind this whole time... I'll tell you anything you want to know—even the embarrassing story of our courtship... And if you're ever feeling lost or sad, I'll be right here for you. As long as I'm around, you won't ever be lonely again.

Kellam: I'm sorry, Nah. I've been blind this whole time... I'll tell you anything you want to know—even the embarrassing story of our courtship... And if you're

ever feeling lost or sad, I'll be right here for you. As long as I'm around, you won't ever be lonely again.

Lon'qu: I'm sorry, Nah. I've been blind this whole time... I'll tell you anything you want to know—even the embarrassing story of our courtship... And if you're ever feeling lost or sad, I'll be here for you. As long as I'm around, you won't ever be lonely again.

Ricken: I'm sorry, Nah. I've been blind this whole time... I'll tell you anything you want to know—even the story of why I chose your mother... And if you're ever feeling lost or sad, I'll be right here for you. As long as I'm around, you won't ever be lonely again.

Gaius: Sorry, Nah. I've been blind this whole time... I'll tell you anything you want to know—even the embarrassing story of our courtship... And if you're ever feeling lost or sad, I'll be right here for you. As long as I'm around, you won't ever be lonely again.

Gregor: ...Gregor is sorry, Nah. He has been blind all this time, yes? Gregor tell any story you want to know about mother. Even how we fall in love... And if you ever make with the sadness, Gregor will be right here by side. Long as he around, you will never be lonely again.

Libra: I'm sorry, Nah. I've been blind this whole time... I'll tell you anything you want to know—even the embarrassing story of our courtship... And if you're ever feeling lost or sad, I'll be right here for you. As long as I'm around, you won't ever be lonely again.

Henry: I'm sorry, Nah. I've been blind this whole time... I'll tell you anything you want to know—even the embarrassing story of how we met... And if you're ever feeling lost or sad, I'll be right here for you. As long as I'm around, you won't ever be lonely again!

Donnel: I'm sorry, Nah. Reckon I've been blind this whole time... I'll tell ya anythin' ya wanna know—even the embarrassin' story of our courtship... And if yer ever feelin' lost or sad, I'll be right here for ya. Long as I'm around, ya won't ever be lonely again.

Nah: T-truly? Do you really mean it?! Oh, thank you, Father!

[Robin]: Not at all, Nah. Now, tell me, what do you want to know?

Frederick: Not at all, Nah. Now, tell me, what do you want to know?

Virion: Not at all, Nah. Now, tell me, what do you want to know?

Vaike: Not at all, Nah. Now, tell me, what do ya wanna know?

Stahl: Not at all, Nah. Now, tell me, what do you want to know?

Kellam: Not at all, Nah. Now, tell me, what do you want to know?

Lon'qu: Not at all, Nah. Now, tell me, what do you want to know?

Ricken: Not at all, Nah. Now, tell me, what do you want to know?

Gaius: No problem, Nah. Now, tell me, what do you want to know?

Gregor: Think nothing of it. Now tell Gregor what you want to know.

Libra: Not at all, Nah. Now, tell me, what do you want to know?

Henry: Nya ha! Of course! Now tell me, what do you want to know?

Donnel: Not at all, Nah. Now, tell me, whatcha wanna know?

Nah: Let's start with how you proposed to Mother! What'd you say? What'd you do?! I want to hear EVERYTHING, and don't leave out even the smallest detail!

[Robin]: *Sigh* All right, well...as you know, your mother has always looked young, and...

Frederick: *Sigh* All right, well...as you know, your mother has always looked young, and...

Virion: *Sigh* Well, as you know, your mother has always looked young, and...

Vaike: *Sigh* Well...as ya know, your mother's always looked real young, and...

Stahl: *Sigh* All right, well...as you know, your mother has always looked young, and...

Kellam: *Sigh* All right, well...as you know, your mother has always looked young, and...

Lon'qu: ...How did I know this was coming? *Sigh* Well...as you know, your mother has always looked young, and...

Ricken: *Sigh* All right, well...as you know, your mother has always looked young, and...

Gaius: Urgh... All right, well...as you know, your mother has always looked young, and...

Gregor: Oy... Is tall order, but very well. As you know, Nowi always look young, and...

Libra: Oh, dear. All right, well...as you know, your mother has always looked young, and...

Henry: Yikes. All right, well...as you know, your mother's always looked young, and...

Donnel: Gosh... Alrighty, well...as ya know, yer ma has always looked right young, and...

Tiki

The dialogue between Avatar (male) and Tiki can be found on page 227.

The dialogue between Avatar (female) and Tiki can be found on page 238.

The dialogue between Lucina and Tiki can be found on page 284.

The dialogue between Say'ri and Tiki can be found on page 285.

The dialogue between Anna and Tiki can be found on page 286.

The mother/daughter dialogue between Morgan (female) and Tiki can be found on page 312.

The dialogue between Nah and Tiki can be found on page 318.

Gangrel

The dialogue between Avatar (male) and Gangrel can be found on page 227.

The dialogue between Avatar (female) and Gangrel can be found on page 238.

The Morgan (male) father/son dialogue with Gangrel can be found on page 309.

Walhart

The dialogue between Avatar (male) and Walhart can be found on page 227.

The dialogue between Avatar (female) and Walhart can be found on page 238.

The Morgan (male) father/son dialogue with Walhart can be found on page 309.

Emmeryn

The dialogue between Avatar (male) and Emmeryn can be found on page 227.

The dialogue between Avatar (female) and Emmeryn can be found on page 238.

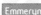

The mother/daughter dialogue between Morgan (female) and Emmeryn can be found on page 312.

Yen'fay

The dialogue between Avatar (male) and Yen'fay can be found on page 228.

The dialogue between Avatar (female) and Yen'fay can be found on page 239.

The Morgan (male) father/son dialogue with Yen'fay can be found on page 309.

Aversa

The dialogue between Avatar (male) and Aversa can be found on page 228.

The dialogue between Avatar (female) and Aversa can be found on page 239.

The mother/daughter dialogue between Morgan (female) and Aversa can be found on page 312.

Priam

The dialogue between Avatar (male) and Priam can be found on page 228.

The dialogue between Avatar (female) and Priam can be found on page 239.

The Morgan (male) father/son dialogue with Priam can be found on page 309.